THE MIND'S EYE

THE MIND'S EYE

*Art and Theological Argument
in the Middle Ages*

**Edited by Jeffrey F. Hamburger
and Anne-Marie Bouché**

DEPARTMENT OF ART AND ARCHAEOLOGY
PRINCETON UNIVERSITY

IN ASSOCIATION WITH
PRINCETON UNIVERSITY PRESS

Published by the Department of Art and Archaeology,
Princeton University, Princeton, New Jersey 08544-1018

Distributed by Princeton University Press,
41 William Street, Princeton, New Jersey 08540-5237
pup.princeton.edu

Library of Congress Cataloging-in-Publication Data

The mind's eye : art and theological argument in the Middle Ages /
edited by Jeffrey F. Hamburger and Anne-Marie Bouché.
p. cm.
Two contributions in French.
Includes bibliographical references and index.
ISBN-13: 978-0-691-12475-9 (cloth : alk. paper)
ISBN-10: 0-691-12475-2 (cloth : alk. paper)
ISBN-13: 978-0-691-12476-6 (pbk. : alk. paper)
ISBN-10: 0-691-12476-0 (pbk. : alk. paper)
1. Art, Medieval. 2. Christian art and symbolism—Medieval, 500–1500. 3. Christianity and art—Europe.
4. Image (Theology) 5. Theology. I. Hamburger, Jeffrey F., 1957– II. Bouché, Anne-Marie.
N7850.M56 2005 261.5'7'0902—dc22 2005049252

British Library Cataloging-in-Publication Data is available

Books published by the Department of Art and Archaeology, Princeton University,
are printed on acid-free paper and meet the guidelines for permanence
and durability of the Committee on Production Guidelines for Book Longevity
of the Council on Library Resources.

This book has been composed in Trump Medieval by Jane Rundell

Printed in the United States by CRW Graphics, Inc.

Managing Editor: Christopher Moss
Copy Editor: Sharon R. Herson
Indexer: Kathleen M. Friello
Designer and Production Manager: Laury A. Egan

3 5 7 9 10 8 6 4 2

Contents

List of Illustrations

JEAN-CLAUDE SCHMITT
"L'Exception corporelle: à propos de l'Assomption de Marie" (pages 151–185)

BERNARD MCGINN
"Theologians as Trinitarian Iconographers" (pages 186–207)

CAROLINE WALKER BYNUM
"Seeing and Seeing Beyond: The Mass of St. Gregory in the Fifteenth Century" (pages 208–240)

JEFFREY F. HAMBURGER
"The Medieval Work of Art: Wherein the 'Work'? Wherein the 'Art'?" (pages 374–412)

Abbreviations

AbhGött, Philol.-hist.Kl.	Akademie der Wissenschaften, Göttingen, Philologisch-historische Klasse, Abhandlungen
AbhHeid, Phil.-hist.Kl.	Akademie der Wissenschaften zu Heidelberg, Philosophisch-historische Klasse, Abhandlungen
AHR	*American Historical Review*
Annales ESC	*Annales: Economies, sociétés, civilisations*
Annales HSS	*Annales: Histoire, sciences sociales*
ArtB	*Art Bulletin*
AASS	*Acta Sanctorum*, 71 vols. (Paris, 1863–1940)
BEC	*Bibliothèque de l'École des Chartes*
BEFAR	Bibliothèque des Écoles françaises d'Athènes et de Rome
BullMon	*Bulletin monumental*
CahArch	*Cahiers archéologiques*
CahCM	*Cahiers de civilisation médiévale, Xe–XIIe siècles*
CCCM	Corpus Christianorum, Continuatio Mediaevalis
CCSL	Corpus Christianorum, Series Latina
CSEL	Corpus Scriptorum Ecclesiasticorum Latinorum
ChHist	*Church History*
DOP	*Dumbarton Oaks Papers*
EETS	Early English Text Society
FS	*Frühmittelalterlichen Studien*
GBA	*Gazette des Beaux-Arts*
HTR	*Harvard Theological Review*
JEH	*Journal of Ecclesiastical History*
JMedHist	*Journal of Medieval History*
JTS	*Journal of Theological Studies*
JWalt	*Journal of the Walters Art Gallery*
JWarb	*Journal of the Warburg and Courtauld Institutes*
London, B.L.	London, British Library
LP	Liber Pontificalis, see MGH, GestPontRom
MarbJb	*Marburger Jahrbuch für Kunstwissenschaft*
MedSt	*Mediaeval Studies*, Pontifical Institute of Mediaeval Studies
MEFR	Mélanges de l'École française de Rome
MEFRM	Mélanges de l'École française de Rome: Moyen-Âge, temps modernes
MGH, Conc	Monumenta Germaniae Historica, Concilia
MGH, EpKarA	Monumenta Germaniae Historica, Epistolae Karolini Aevi

MGH, *GestPontRom*	Monumenta Germaniae Historica, *Gesta pontificum Romanorum*, I (=Libri Pontificalis pars prior, ed. Th. Mommsen) (Berlin, 1898, reprint 1982)
MGH, SS	Monumenta Germaniae Historica, Scriptores
MünchJb	*Münchner Jahrbuch der bildenden Kunst*
Oxford, Bodl.	Oxford, Bodleian Library
Paris, B.N.F.	Paris, Bibliothèque Nationale de France
PG	Patrologiae Cursus Completus, Series Graeca, ed. J.-P. Migne, 161 vols. in 166 pts. (Paris, 1857–66)
PL	Patrologiae Cursus Completus, Series Latina, ed. J.-P. Migne, 221 vols. (Paris, 1844–55)
RBén	*Revue bénédictine*
Rome, Bibl. Vat.	Rome, Biblioteca Apostolica Vaticana
RQ	*Römische Quartalschrift für christliche Altertumskunde und für Kirchengeschichte*
RSR	*Revue des sciences religieuses*
SC	Sources chrétiennes
StMed	*Studi medievali*
TAPA	*Transactions of the American Philosophical Society*
ThQ	*Theologische Quartalschrift*
ZChrK	*Zeitschrift für christliche Kunst*
ZKircheng	*Zeitschrift für Kirchengeschichte*
ZKunstg	*Zeitschrift für Kunstgeschichte*

Acknowledgments

I am delighted that this last, lightest, and most welcome task of all falls to me, for it is an unalloyed pleasure to acknowledge the many people who made *The Mind's Eye* conference and the publication of its papers possible. Jeffrey Hamburger and I would like to thank our speakers for making the occasion such a memorable one. For acting as moderators for the sessions, we are grateful to Professors Michael Curschmann of Princeton University and Giles Constable of the Institute for Advanced Study. Professors John Wilmerding and Patricia Fortini Brown, successive department chairs, and our other colleagues, especially fellow medievalist Professor Slobodan Čurčic, and Colum Hourihane, director of the Index of Christian Art, provided sound advice and welcome support. The conference was funded through the generosity of the Spears Fund of the Department of Art and Archaeology, Princeton University, and the department's Publications Committee generously financed the publication of this volume.

The staff of the Department of Art and Archaeology did a remarkable job of planning and carrying out the practical details of the conference. I would particularly like to recognize the contributions of six people. Susan Lehre, department manager, oversaw the preparations and, ably seconded by Diane Schulte, made sure that everything ran smoothly on the conference days. Julie Angarone designed our conference Web site and provided computer-related support. Marilyn Gazzillo made it possible for speakers and attendees alike to enjoy the rare luxury of an art history conference entirely unmarred by media malfunctions. Betty Harris, who did the largest share of the actual work, took care of such essentials as printing, publicity, and local arrangements with efficiency and unfailing good cheer. Ludovico Geymonat, then a graduate student in this department, volunteered with his usual forethought and kindness to be available as a general problem-solver during the conference, thereby anticipating countless needs and saving us from many awkward dilemmas.

The transition from podium to print would never have occurred without the engagement and assistance of the department's editor of publications, Christopher Moss, who coordinated and oversaw editing and production with his usual skill and aplomb. In Sharon Herson we found a helpful and rigorous copy editor with welcome experience in dealing with the particular problems posed by publications in medieval art history. Both saw the proceedings through the publication process with uncommon skill and efficiency.

Finally, I would like to express my heartfelt appreciation to my collaborator and co-organizer, Harvard University Professor Jeffrey Hamburger, who proposed the project in the first instance, and whose energy and experience were indispensable to its success. Jeffrey joins me in thanking all those who made possible the conference and this volume. It has been a pleasure and a privilege to work with him.

Anne-Marie Bouché

THE MIND'S EYE

Introduction

Jeffrey F. Hamburger

Few terms have less critical currency than "theology" and "theological." Despite the unsettling re-emergence of theological concerns in the public sphere at home and abroad, theology, once of pivotal importance, now occupies the margins of academic, if not political, discourse. The reasons for this disfavor are not difficult to discern. Whereas theology once claimed supremacy over all the arts, today she no longer serves even as the handmaiden of iconography. In art history, if not always the humanities as a whole, the "visual turn" champions the visual at the expense of the discursive, despite the resilience of methods, rooted in structuralism and semiotics, that insist on reading images as "texts." Moreover, the forms and methods of historical inquiry—be it institutional or intellectual history—that fostered an interest in theology have long since been supplemented, if not dislodged, by other perspectives that recommend a less lofty, less commanding purview of the past. To most modern observers, the heretical and the heterodox offer a subversive (and certainly more sympathetic) set of subjects than the authority of medieval professors expounding ex cathedra. In the words of Clifford Geertz, "We hawk the anomalous, peddle the strange. Merchants of astonishment."[1] Less confident of their own objectivity, postmodern historians have abandoned the appearance of God-like omniscience for a more openly partial perspective on the past. The late Edward Said spoke for many in declaring, "What could be more Platonic (in a debased way) than seeing literature as a copy, expression as an original, and history as a line moving from origin to present? Once thinking of this kind is revealed for the theology it really is, a secular reality for writing is enabled."[2] Jacques Derrida is still more emphatic: "The motif of homogeneity, the theological motif par excellence, is what must be destroyed."[3]

The purpose of this volume is not to restore theology to its rightful place as mistress of the arts or to reinvest it with discredited forms of academic authority. As with any idol that has been dashed to pieces, attempts at reassembly would only draw attention to irreparable fissures and seams. The critique of theology, however, must itself be deconstructed. One need not be a true believer to wonder what medieval theologians might have made of Roland Barthes's declaration that "the text is not a line of words releasing a single 'theological' meaning (the message of an Author-God) but a multi-dimensional space in which a variety of writings, none of them original, blend and clash."[4] *Sic et non?* For all their originality, theologians made the opposition of apparently contradictory authorities ("a variety of writings, none of them original") a principle of method. Only the stalest textbook accounts would maintain that medieval theological discourse did not offer clashing views aplenty. The questions that prompted such debates may no longer al-

ways move us, yet to the authors who engaged in these controversies, they dealt, quite literally, with matters of life and death. As for any conception of "the text" as "a line of words releasing a single 'theological' meaning (the message of an Author-God)," medieval exegetes would have been sorely perplexed at the notion that the Scriptures they treated could ever be limited to a single, literal meaning, any more than the proverbial mustard seed (Matt. 13:31–32) could be prevented from growing "like to" . . . "the kingdom of heaven." There can be no doubt of the teleological nature of theological commentary, but within the boundaries prescribed by its vast sphere, it offers some of the most sophisticated, if also some of the most fanciful, meditations on the character and function of signs and signification in all of Western literature.

Theology itself may deal with abstractions, but, in writing its history, it would be better to speak of theologies and theologians, a pluralism that acknowledges the historical context and contested character of theological arguments in their own time. At the universities, theology was, or became, an independent activity, increasingly divorced from diverse forms of scriptural exegesis. In the spirit of what Barbara Newman has recently called "imaginative theology," this volume, however, acknowledges overlaps and crosscurrents among theology, exegesis, literature, and the visual arts.[5] Twenty years ago, Jean Leclercq could speak of the increasing acceptance of a "diversity of theologies in the twelfth century," not simply the monastic and the scholastic, but a "'plurality of monastic theologies.'"[6] Art history has been slower to acknowledge this diversity, let alone its implications.[7] The middle ground comprehends far more than the movements on the margins of orthodoxy, many of which were openly hostile to the arts as an especially brazen embodiment of ecclesiastical corruption and materiality.[8] Opposition to the arts, however, did not always take the form of resistance from below. It can also be located at what might be called the epicenter of medieval theological output, the university itself (as in the case of Oxford, where Wycliffe and his circle played a key role in providing the arguments put into play by the Lollards).[9]

Medieval theology had many branches—moral, natural, eschatological, soteriological, eucharistic, pastoral, mystical, to name but a few—all of which had far-reaching ramifications when it came to the reception as well as the formulation of medieval images. In all their variety, theology and exegesis have provided (and will continue to provide) an essential point of reference for writing on medieval art, especially when it comes to the identification and interpretation of the subject matter of medieval images. Many of the most complex monuments of medieval art, from the hieratic programs of Romanesque basilicas to the narrative portals of Gothic cathedrals, directly engage theological issues.[10] The illustration of theological treatises and commentaries, the use of images to expound or disseminate doctrine or, vice versa, the role of images within theological discourse and the development of doctrine in response to images, the place of images and, more generally, of vision and the visual in theological thought: all these topics offer relevant areas of inquiry and all are explored in the essays that make up this volume.

"The Mind's Eye": the first part of our title seeks to frame the relationship between thinking and seeing, perception and the imagination, topics that were themselves of central importance to medieval theologians interested in the nature of human knowledge, of God, as well as of his creation. At issue are not only the ways in which theologians responded to the images that we call art, but also the many different ways in which images entered into dialogue with theological discourse. "Art and Theological Argument": the subtitle presumes two clearly defined spheres of thought and practice but seeks to relate them in specific ways. In what ways could medieval art be construed as argumentative in structure as well as in function? Are any of the modes of representation that can be identified in medieval art analogous to any of those found in texts, and in

what ways did images function as vehicles, not merely vessels, of meaning and signification? To what extent can exegesis and other genres of theological discourse shed light on the form, as well as the content and function, of medieval images?

In asking these questions, we take for granted that theology should remain a source for art-historical scholarship on medieval art. The question is not *if*, but *how*, and *in what ways*. At the risk of offering a caricature, it could be said that art history has often reduced the complex set of social and discursive practices grouped under the heading of theology to a corpus of texts (and a rather limited one at that, despite talk of indiscriminate browsing in the *Patrologia Latina*). We have learned a great deal about the conditional nature of the texts we call sources, the methods by which they were assembled, and the purposes to which they were put.[11] In keeping with the traditional methods of iconography, the content of theological teaching can contribute to the identification and understanding of subject matter in medieval art. Theology, however, has come to mean much more than it did when the prestige of the iconographic method went unchallenged. No longer can the art historian play the high priest, unveiling the mysteries of meaning that lie beneath the veil of appearances. Many of the essays in this volume frame the relationship of art to theology or of theology to art in terms of the relationship between text and image. They do not, however, read images as illustrations of texts, any more than the texts are seen simply as commentaries on the images.

What has changed, in part, is the place of theological discourse within the act of interpretation, medieval as well as modern; there is also an increased self-consciousness concerning the interdependence of these two different perspectives, which can never be made to converge within a single frame. Many works of medieval art, whether the portal of a cathedral or a textbook diagram, represent or at least imply a cosmos, an ordered whole. Medieval images, however, are anything but closed systems. Issues of coherence, condition, and consistency aside, they remained and remain open to interpretation, by other artists, patrons or viewers.[12] Although occasionally caricatured as closed systems that operated according to fixed rules, medieval theology and exegesis were varied in approach and self-conscious when it came to the limits as well as the possibilities of interpretation. Whether on the nature of language, semiotics, or representation, theology offers among the most elaborate and nuanced systems of thought ever developed. Medieval writings on art, even those written by theologians, offer nothing even remotely comparable. This discrepancy, however, does not simply point to a divergence between theory and practice, text and image. Theology and exegesis can still tell us an enormous amount about medieval art; it is simply a question of how we read and use their riches. No one would argue that exegesis be taken as a model for modern readings of medieval art. Nor can medievalists content themselves with retracing the intricate patterns drawn by medieval exegetes. At worst, this kind of recapitulation devolves into catechism. At best, it contributes to an understanding of content and context. If, however, one reads commentaries less for what they say than for how they say it, exegesis and theology can once again shed light on the ways, means, and methods of medieval images. At issue is less what medieval images mean than the means by which that significance was created and conveyed.

In keeping with this way of reading, the essays gathered here do not focus primarily on the decoding of theological subject matter or even on the treatment of broader themes informed by theological thought. Rather, in response to an invitation to "examine fundamental notions of image, imagination, likeness, resemblance, analogy, symbolism, mimesis, imitation, and exemplar (the list could be extended considerably) as they relate to the language of visual images and the rhetoric of theological argument," they draw on theology and exegesis as a set of interpretive

practices that can inform, without being allowed to control, modern readings of medieval images. The focus is on modes of theological discourse, whether in texts or images, as ways of seeing and shaping the world, and as ways of framing and forming religious experience.[13] In short, the emphasis is less on what theologians actually said about images than on how they used images and conceptions of the visual as instruments of argument and demonstration.[14]

In this spirit, these essays consider the place of theology within frameworks that conditioned the reception as well as the production and patronage of medieval art. If theology offers various ways of making the world meaningful, how were these systems communicated visually, and to which audiences? To what extent is piety inflected by theology, or theology by piety? To what extent are top-down (or, for that matter, bottom-up) models of medieval piety adequate to complex social situations in which medieval images and theological learning were coined and disseminated? Do the metaphors and images propagated in theology and exegesis take on a different inflection in the vernacular or in visual expressions, or, conversely, to what extent did theologians and exegetes pay attention to images and, more broadly, visual experience? In what ways did theories of perception coined in the context of theological speculation condition or change the ways in which viewers, be it the laity or clerics, viewed works of art? These are just some of the questions that arise when theology is considered not as an abstraction or as a discrete discursive practice, but instead as a set of ideas and institutions that enjoyed enormous prestige and powers that affected, directly and indirectly, all aspects of society.

Reflecting the range and reach of theological discourse in medieval society, the essays in this collection draw on a diverse selection of historical disciplines, from the history of science and philosophy to the histories of art, literature, piety, and mysticism, the history of theology itself, and (at the conference, though not in this volume) music and the liturgy as well. Theology, however, does not provide the center, with other disciplines or discourses serving simply as its satellites or dependencies. Instead, the essays offer an open, flexible constellation in which new and changing sets of relationships can emerge. Barbara Newman's essay on "Christ as Cupid," in which she explores "the medieval practice of 'crossover'" between secular and religious forms of expression, sets the tone in this respect, as does Caroline Bynum's close look at the Mass of St. Gregory, which reads the image not as a fixed iconographic type, with a single function, but rather as a flexible matrix, open to a range of meanings and formulations, amidst a range of responses that reach from high church doctrine to popular piety.

Although the essays deal with a discipline that defined itself as the apex of human intellectual endeavor, they eschew a "top-down" approach that takes theology as a God-given point of departure unmoved or unshaped by the contexts in which theological positions evolved and were elaborated. Anne-Marie Bouché's contribution, "Vox Imaginis," treats, on the one hand, a frontispiece to the Floreffe Bible whose erudite program was fashioned for "an elite, cloistered community of highly educated clerics" and, on the other hand, the tympanum at Conques, a work of monumental sculpture "intended for a mixed and transient population of pilgrims" in which, despite their differences, similar strategies of rhetorical address, based on what Bouché calls "anomaly and enigma," can be identified. Like her title, "Replica: Images of Identity and the Identity of Images in Prescholastic France," Brigitte Bedos-Rezak's essay captures the reciprocity inherent in an approach that sees theology as responding to, not simply shaping, social practice. In a generalization that has broad implications, Bedos-Rezak insists that "every new technology alters human subjectivity. A tool is not simply the instrument of a human competence; it transforms that competence." Bedos-Rezak focuses on the technology of sealing, as a semantic field as well as a social

practice, but much the same point could be made about the full range of strategies of visualization explored in other essays, for example, the framing techniques discussed by Jeffrey Hamburger, the rhetorical tropes of memory and invention canvassed by Mary Carruthers, or the diagrammatic modes charted by Christopher Hughes in his essay on typology in the *Bibles moralisées* and Celia Chazelle in her analysis of the Codex Amiatinus. Like Bedos-Rezak, Carruthers emphasizes the practical dimensions of the medieval picturing, whether concrete or imaginary, which saw both in the making and in the reading of certain types of images an exercise focused on visualized exemplars. Contemplation itself involved not only inspiration, but also a self-conscious sense of "craft," to use Carruthers's term. In examining the interaction of image and inscription as inflected by the liturgy, in both a large-scale monument and an illuminated manuscript, Bouché explains in detail the degree to which images enhanced the injunctions inscribed in the form of written words with a visual rhetoric that, ironically, would have been both unimaginable and unintelligible for an illiterate audience.

Reconsiderations of the iconographic method have led, in turn, to a reevaluation of the relationship of text and image in medieval art. No longer can it be said, with Émile Mâle, that "the Middle Ages . . . organized art as it organized dogma, human knowledge, and society."[15] In adding that "the art of the Middle Ages is first of all a sacred writing whose elements every artist had to learn," Mâle further implied that the art historian, no less than the medieval artist, was obliged to learn the rules of this visible writing, to which his magisterial volumes provided the indispensable guide. In recent years, Mâle's dictates have been subjected to withering critique, most notably by Michael Camille.[16] In addition to assuming an easy congruence of art and society where none existed, Mâle's formula tended to reduce images to passive illustrations of texts, rather than enabling them to be seen as active social agents in their own right.

As part of a broader movement to redress so prejudicial a view of images, the essays in this volume elucidate ways in which images assert their own powers. In looking at medieval representations of the Ark of the Covenant, an archetypal image that embodied scriptural authority, Hamburger explores ways in which medieval artists sought to employ it as a vehicle to assert their own mastery and to endow their own images with an authenticity traditionally reserved to texts. In her discussion of the illustrations to the Codex Amiatinus, Celia Chazelle takes a different approach, arguing from their content and codicology that they can only be understood as a complex, creative response to the historical moment of their making.

Reconsideration of the relationship between text and image can lead, in turn, to a reevaluation of texts that have traditionally served art history as a point of departure. For example, Andreas Speer, building on the foundation provided by his new edition of some of Abbot Suger's writings, meditates on the methodological implications of the relationship between text and image, and, in the specific instance he discusses, architecture. In posing the question, "Is There a Theology of the Gothic Cathedral," his essay insists on a critical analysis of the textual sources on their own terms independent of any a priori assumptions of their theological character or content. Only in this way, Speer argues, can one arrive at readings of medieval "art" and of the texts that describe the ways in which it was experienced by medieval observers that are not anachronistic. Speaking from the standpoint of a historian of theology and mysticism, Bernard McGinn's essay on "Theologians as Trinitarian Iconographers" offers a different perspective on the relationship of text and image. Taking Trinitarian iconography as his subject, McGinn proposes that, far from being inimical to images, medieval thinkers and theologians found them indispensable, above all, ironically, when attempting to characterize and define the paradox that represented the sum and summit of

Christian doctrine. Jean-Claude Schmitt's study of images of the Assumption of the Virgin tackles similar issues, arguing that images did anything but follow theological dictates and in fact developed what he calls their own "pensée figurative."

Most of the essays in this volume chart a middle course, insisting, if not on the independence of image from text, then on their equality and interdependence as instruments of thought and invention. On this score, Alfred Acres's essay on "Porous Subject Matter and Christ's Haunted Infancy" is emphatic: "Despite vivid parallels between demonic incursions in drama and the sorts of things we have been considering in painting, there is little reason to think that any one text or even group of them provided a discrete source for such expressions." Christian Heck's essay testifies eloquently to the literal shaping of text by image, to the point that, as in so many medieval manuscripts, one can no longer speak of text and image, but rather only of image as text and text as image. Christopher Hughes's essay on "Typology and Its Uses" offers a nuanced analysis of typological imagery in the thirteenth-century *Bibles moralisées*, as complex and ambitious an example of the interrelationship of text and image as one could hope to find. Hughes acknowledges the often uncompromising messages imparted by these vast typological compendia, but ends by emphasizing that content is one thing, and the way in which it is mediated to the observer's eye, quite another. What we are left with is the productive tension between a compendium that aspires to a perfectly ordered visual cosmos and what Hughes aptly calls the "open-ended heteroglossia" of a visual system that, try as it might, cannot be completely controlled.

Art and theology might seem inimical to one another insofar as one deals with the visible and the other with what the Apostle Paul (Heb. 11:1) calls "the substance of things hoped for, the evidence of things not seen." Sight, both as a concept and as a series of practices, was central to theological discourse, which dealt with the division between the visible and invisible world by dividing vision itself in various ways among a series of interconnected levels, as if along the rungs of a ladder. Following the scriptural account of Jacob's ladder, along which angels descended and rose up again (Gen. 28:12), medieval images give literal incarnation to the idea of God's creation as a ladder connecting the invisible with the visible world.[17] Christian Heck's essay on the representation of spatial and spiritual topographies in medieval art touches on ladder imagery, but goes further in demonstrating just how complex and various were the strategies evolved to evoke the invisible in the visible. The sophistication of medieval images in addressing the intimation of the invisible provides the best and most effective rejoinder to the position laid out so categorically in the *Opus Caroli Regis (Libri Carolini)* and analyzed by Karl Morrison's essay, "Anthropology and the Use of Religious Images": "Rightly used, art was irrelevant to religion."

Several of the contributions to this volume, for example, those by Katherine Tachau, Thomas Lentes, and Caroline Bynum, address the issue of visibility and invisibility head on. Tachau looks at medieval theories of vision, their origins in ancient and Arab philosophy, and their subsequent elaboration in medieval philosophy and theology in terms of the tension between action and passivity. In Tachau's account, medieval theories of illumination do not merely inform images, let alone provide a textual basis for their iconography, they also provide a key to how they would have been perceived by medieval viewers. As Tachau makes clear, scholarly paradigms of vision were not divorced from everyday experience or the process of artistic creation; in her words: "Like all such paradigms, this one . . . remained subject to debate, to misunderstanding, to refinement, to correction, and to popularization in many literary and artistic media."[18] Thomas Lentes takes an equally broad view of vision as a paradigm, but he subjects influential models of modern scholarship, above all, the notion of *Schaufrömmigkeit*, or "visual piety," to a searching critique. Con-

cepts of eucharistic representation have long provided a touchstone in discussions of vision and realism as they relate to later medieval art, but in this context Lentes pleads for a far more differentiated taxonomy of vision and its place in a broad spectrum of pious practices, especially as they relate to ritual and the liturgy.[19]

Whereas Tachau takes as her point of departure medieval theories of vision, elaborated, in part, in theological discourse, and moves from there to practices of picturing and looking, such as those discussed by Lentes, Bynum, in contrast, begins with an image that has been pigeonholed by modern observers as a visible demonstration of eucharistic presence. Noting the extraordinary differentiation that characterizes the images themselves, Bynum works out a much more complicated series of interconnections between various incarnations of the image and its multiple audiences. The theme of visibility is also a constant presence in Alfred Acres's essay, in which he characterizes Rogier van der Weyden's *Bladelin Nativity* as "an early instance of a growing number of images to recognize that the devil moves more effectively in the mind than in the visible world." For Acres, as for Bynum, images not only invite close scrutiny, they also open themselves up to structured, yet open-ended forms of interpretation. This too forms part of what Bynum calls "looking beyond." The concluding essay, by Herbert Kessler, which he was asked him to contribute after the conference, serves less as a retrospective postscript than as a prospective commentary. It also examines issues of vision, detailing with many specific examples how medieval religious art, no matter how effectively it engages the eye, always fell short insofar as it sought to "disable" carnal vision and insist on its insufficiency. In providing for a passage from visibility to invisibility, the mind's eye, in Kessler's formulation, was always in some ways self-consciously "blind."

Intended as a series of experiments rather than as a template, this volume offers explorations of various ways, some new, some old, in which theology, differently and perhaps all too loosely defined, might once again be usefully employed within a history of art that understands theology not just as a set of prescriptions, but also as a set of possibilities, and that sees itself as anything but theological in character, method, or intent.

Notes

1. C. Geertz, *Local Knowledge: Further Essays in Interpretive Anthropology* (New York, 1983), 275; quoted by W. Kemp, *Christliche Kunst: Ihre Anfänge, Ihre Strukturen* (Munich, 1994), 281.

2. E. Said, "On Originality," in *The World, the Text, the Critic* (Cambridge, Mass., 1983), 139. For commentary and critique of Said's use of religious terminology, see W. S. Hart, *Edward Said and the Religious Effects of Culture* (Cambridge, 2000).

3. J. Derrida, *Positions* (Chicago, 1981), 64.

4. R. Barthes, *Image, Music, Text* (New York, 1977), 148; quoted by J. Culler, *On Deconstruction: Theory and Criticism after Structuralism* (Ithaca, 1982), 32–33.

5. B. Newman, *God and the Goddesses: Vision, Poetry, and Belief in the Middle Ages* (Philadelphia, 2002), 305.

6. M. Neuman, "Monastic Theology and the Dialogue with Cultural Humanism," *Monastic Studies* 12 (1976), 85–119, esp. 86; quoted by J. Leclercq, "The Renewal of Theology," in *Renaissance and Renewal in the Twelfth Century*, ed. R. L. Benson and G. Constable, with C. D.

Lanham (Cambridge, Mass., 1982), 68–87, esp. 70–71.

7. A notable exception is C. Rudolph, "In the Beginning: Theories and Images of Creation in Northern Europe in the Twelfth Century," *Art History* 22 (1999), 3–55, who predicates his argument on theological diversity even though accounts of various theological points of view and his manner of relating them to works of art remain somewhat mechanical. As Rudolph remarks: "On many important matters, no Church view existed which could actually claim the unquestioned force of dogma—something that typically only resulted from current debates, rather than preceded them" (46).

8. B. Newman (*God and the Goddesses* [as in note 5], 305), however, offers a salutary reminder that "the term 'heresy' tends to be used more freely by literary critics than by historians. We often see texts, ideas, or even metaphors designated 'heretical' because they impress a modern reader as subversive or in violation of some preconceived theological norm, a norm that may actually be patristic or modern rather than medieval. To avoid such

anachronistic usage, it is helpful to recall that medieval heresy was a juridical concept."

9. See, most recently, *Images, Idolatry, and Iconoclasm in Late Medieval England: Textuality and the Visual Image*, ed. J. Dimmick, J. Simpson, and N. Zeeman (Oxford, 2002). J. J. G. Alexander ("Iconography and Ideology: Uncovering Social Meanings in Western Medieval Christian Art," *Studies in Iconography* 15 [1993], 1–44) assumes too readily that criticisms of art and opulence had their origins among the peasantry and the poor.

10. See, e.g., the collected essays of H. L. Kessler, *Studies in Pictorial Narrative* (London, 1994), and *Old St. Peter's and Church Decoration in Medieval Italy* (Spoleto, 2002); and B. Boerner, *Per caritas par meritum: Studien zur Theologie des gotischen Weltgerichtsportals in Frankreich—am Beispiel des mittleren Westeingangs von Notre-Dame in Paris*, Scrinium Friburgense: Veröffentlichungen des Mediaevistischen Instituts der Universität Freiburg 7 (Freiburg, Switzerland, 1998).

11. See, e.g., H. R. Bloch, *God's Plagiarist: Being an Account of the Fabulous Industry and Irregular Commerce of the Abbé Migne* (Chicago, 1994).

12. M. Schapiro, "The Artist's Reading of a Text," in *Words, Script, and Pictures: Semiotics of Visual Language* (New York, 1996), 11–23, 96–97.

13. The classic study of modes in art history as they relate to the study of style remains J. Białostocki, "Das Modusproblem in den bildenden Künsten: Zur Vorgeschichte und zum Nachleben des 'Modusbriefes' von Nicolas Poussin," *ZKunstg* 24 (1961), 128–41, reprinted in *Stil und Ikonographie: Studien zur Kunstwissenschaft* (Cologne, 1981), 12–42.

14. For an analogous approach, which explores the relationship between new content and new media, see D. Hansen, *Das Bild des Ordenslehrers und die Allegorie des Wissens: Ein gemaltes Programm der Augustiner* (Berlin, 1995).

15. É. Mâle, "General Character of Medieval Iconography," in *Religious Art in France: The Thirteenth Century. A Study of Medieval Iconography and Its Sources*, ed. H. Bober (Princeton, 1984), 4.

16. M. Camille, *The Gothic Idol: Ideology and Image-Making in Medieval Art* (Cambridge, 1989).

17. See W. Cahn, "Ascending to and Descending from Heaven: Ladder Themes in Early Medieval Art," in *Santi e demoni nell'Alto Medioevo occidentale (secoli V–XI)*, Settimane di studio del Centro italiano di studi sull'Alto Medioevo 36 (Spoleto, 1989), 697–724; and C. Heck, *L'Échelle céleste dans l'art du Moyen Âge: Une image de la quête du ciel* (Paris, 1997).

18. Recent contributions that explore aspects of this process include C. P. Collette, *Species, Phantasms, and Images: Vision and Medieval Psychology in "The Canterbury Tales"* (Ann Arbor, Mich., 2001); S. K. Hagen, *Allegorical Remembrance: A Study of "The Pilgrimage of Man" as a Medieval Treatise on Seeing and Remembering* (Athens, Ga., 1990); M. Camille, "The Eye in the Text: Vision in the Illuminated Manuscripts of the Latin Aristotle," in *La Visione e lo sguardo nel Medio Evo/View and Vision in the Middle Ages*, Micrologus: Natura, scienze, e società medievali 6 (Florence, 1998), 129–45; and S. Biernoff, *Sight and Embodiment in the Middle Ages* (New York, 2002).

19. On this topic, see also M. Kobialka, *This Is My Body: Representational Practices in the Early Middle Ages* (Ann Arbor, Mich., 1999).

The Place of Theology in Medieval Art History: Problems, Positions, Possibilities

Jeffrey F. Hamburger

On the subject of art and theology, medieval commentators wasted relatively few words. Confronted with so many monuments, the clerics, monks, and mendicants who made up what could be called the theological class remain remarkably silent. The sermon that takes an extant image as its point of departure, the commentary that invokes a particular work of art, the treatise that discusses the role of images, real or imagined, in devotional experience or monastic life, let alone popular piety: all remain rare compared to the enormous corpus of exegesis and theological writings. Even if, as recent research has revealed, there are a great many more texts—exempla, visions, prayers, sermons, and saints' lives—that mention works of art than the standard anthologies suggest, few of these testimonies take images as their primary point of reference. Most of the theological texts that have been claimed for a history of medieval aesthetics, whether by Edgar de Bruyne or, more recently, by Umberto Eco, belong to other realms of discourse, and to try to press them into service without taking into account profound historical differences of typology and function cannot make good on the more fundamental deficit represented by the absence of medieval art theory per se.[1] As David Summers has shown, modern theories of art and the artistic imagination drew extensively on medieval traditions, be it in optics or epistemology.[2] Nonetheless, art theory as such did not exist in the Middle Ages. Despite prolonged efforts to match medieval texts with medieval works of art, there remain few points of contact. The often radical disjunction between medieval texts and images could in itself be read as confirmation of the importance and independence of artistic media as means of visual communication. We appear, for the most part, to be dealing with two divergent discourses.

Despite this dilemma, can historians of medieval art afford to write off medieval theology and exegesis? At issue is less the use of such texts as sources than the means by which they were generated and used as tools of thought and, more generally, as ways of framing and perceiving nature, history, and human experience. Medieval memory as it has been defined and discussed by Mary Carruthers could be considered one such set of tools: a method of conceiving, inventing, even envisioning meaning, that was prospective, not retrospective, productive, not reproductive, and that, in the words of Sylvia Huot, "include[d] the reception, processing, storing, retrieval, and recombination of material gleaned from reading in its largest sense: attention to the texts, images, and teachings offered by the world at large."[3] Theology as a diverse set of procedures,

habits, and techniques that can inform our own readings of medieval texts and images, not as the key that can unlock or uncover their content—that is the possibility that this essay seeks to explore. First, however, it is necessary to consider the place of theology in medieval art history today, and in the past.

Positions

Theology and exegesis have hardly been absent from some of the most compelling recent writing on medieval art, but their presence has been cast almost entirely in negative terms. Theology has been characterized, if not as irrelevant to the formation of medieval images, as a baleful influence on the history of medieval art. To theology is opposed anthropology, and to "art," the "image." These oppositions are useful, but only as long as they are not allowed to become orthodoxies of their own.[4] The prime mover behind this new art-historical credo has been Hans Belting, whose magisterial history of the medieval image, *Likeness and Presence: A History of the Image before the Era of Art*, takes as its point of departure the heading "The Power of Images and the Limitations of Theologians."[5] Belting's German, "Die Macht der Bilder und die Ohnmacht der Theologen," could have been more provocatively and accurately translated as "the impotence of the theologians." Belting elaborates his revelatory indictment in terms that allow theology, however it is defined, few if any productive powers when it comes either to the fashioning of Christian art (a term whose applicability to the subject at hand Belting also rejects) or to effectively curbing or conditioning its use: "Whenever images threatened to gain undue influence within the church, theologians have sought to strip them of their power. As soon as images became more popular than the church's institutions and began to act directly in God's name, they became undesirable."[6]

If Belting's position on the relationship of art and theology requires extended consideration, it is not only on account of its influence, but also its persuasive power. Belting's caveats apply to cult images, but he generalizes in ways that are, perhaps, less tenable: "It was never easy to control images with words because, like saints, they engaged deeper levels of experience and fulfilled desires other than the ones living church authorities were able to address. Therefore when theologians commented on some issue involving images, they invariably confirmed an already-existing practice."[7] In this construction, theologians take at best a passive role, responding to images, criticizing or canonizing various forms of use, but never taking the initiative, be it as patrons or, more important, in formulating ways and means of conceptualizing experience that structured and shaped how images were both conceived and perceived. Theologians act either as iconoclasts or (not much better) as iconographers: "Rather than introducing images, theologians were all too ready to ban them. Only after the faithful had resisted all such efforts against their favorite images did theologians settle for issuing conditions and limitations governing access to them. Theologians were satisfied only when they could 'explain' the images."[8] In a subsequent essay, Belting goes further, calling for a history of the image to complement standard histories of art and holding medieval theology responsible for the fact that no such history has yet been written: "Images exist not only outside of art, but also emerged in periods in which the idea of art itself did not exist. The medieval theology of the image passed the baton to modern art theory, which accounts for the failure of a genuine theory of the image to develop. Modern theories of media were the first to connect once again with the old questions of the image."[9] In Belting's uncompromis-

ing construction, academicians, followed by art historians, are the culprits who, aping the masters of the Word, have clouded the history of images with words that diminish their power and obscure their character and function.

David Freedberg's ambitious account of human responses to images has often been compared to Belting's (including by Freedberg himself), although Freedberg assigns theology a very different role.[10] Whereas Belting sees art history as akin to theology insofar as it quashes the age-old identification of images with bodies, Freedberg distinguishes between the two, assigning theology a constructive role: "It is not just psychology that is at stake, but also the relations between theology and psychology," Freedberg explains, adding that Belting "fails to see that the general psychological theory is already present in the Byzantine theory of images."[11] Rather than characterizing theologians as censors, Freedberg casts them as agents provocateurs, exploiting the powers inherent in images to their own ends.[12] At the same time, Freedberg, in his forceful statement, "the ontology of holy images is exemplary for all images," goes further than Belting in claiming that what he considers typical for the Middle Ages is in fact normative for all human history, not just the Western tradition.[13]

Medievalists might be expected to welcome Freedberg's view, which makes the Middle Ages central in ways other than the pejorative term was originally intended. There are, however, reasons for pause. The celebration of the body in medieval art has freed medieval images from the tyranny of texts and has worked wonders in bringing the subject back to life.[14] But the body itself has a history.[15] As framed by Freedberg, response risks devolving into a Pavlovian reaction, prediscursive, unreflective, and nonverbal. Despite the richness of the historical record, much of which is reflected in the copiousness of his own account, Freedberg tends to reduce history to a selective series of examples of what, in his view, is an unchanging common denominator of human nature. Issues of representation are pushed into the background, if not altogether out of the picture, and any attempt to historicize the phenomenon in question is dismissed as "repression."

In keeping with the rest of his argument, Freedberg diminishes distinctions between popular piety and the spirituality of elites, theologians included. Belting, however, tends in the opposite direction, arguing that whereas theologians policed images, the populace promoted and protected them. Besides being undifferentiated, Belting's construction of the "faithful" belies the nuances of his own historical account, let alone recent theoretical work on the status or viability of "popular piety" as a critical category in writing about medieval religion.[16] It is not clear that a "bottom-up" approach can do any more justice to the complexity of their interrelationship than traditional "top-down" models: theology was hardly divorced from piety, any more than the Aquinas who wrote the eucharistic hymn "Pange lingua gloriosi corporis mysterium" or the prayer "Adoro te devote latens deitas" was a different man from the author of the *Summa theologiae*.[17] Recently developed concepts such as "vernacular theology" break down traditional high-low oppositions, as does the notion of *Frömmigkeitstheologie* (a theology of piety), to comprehend what Berndt Hamm, speaking of the later Middle Ages, has called "the opening-up of the content and language of theology for non-experts."[18] If one looks beyond cult images, the category of immediate concern to Belting, and considers a range of genres, not just didactic imagery but the full gamut of devotional imagery that defies easy classification, it is difficult to think of the theologians and professors who paced the aisles and cloisters of medieval churches as having somehow been hoodwinked by the images that surrounded them on all sides, indifferent to their qualities or oblivious to the ways in which they could stir, stimulate, and structure the passions of observers.

Theology as Form / Forms of Theology

The silence and insensibility of the sources is at times only apparent. There are far more texts that speak to the history of attitudes toward images—how they were seen, how they were experienced—than the classic anthologies allow. Sermons offer a typical example. As recorded or transmitted, few refer to works of art. That does not mean that sermons as actually delivered in situ were not punctuated with gestures to the images that would have surrounded the speaker.[19] Jean Gerson, chancellor of the University of Paris and a vocal critic of images, compared a good sermon to a pious painting when he remarked that "good, saintly, and devout words, paintings and texts inspire devotion, as Pythagoras said," adding "that is why sermons are composed and images painted in churches."[20] Preaching to nuns in France, Bonaventure apologized for his imperfect command of the vernacular by comparing a well-ordered sermon, beautifully spoken, to the crystalline clarity of a well-designed stained-glass window.[21] In another sermon, *De imagine Dei*, the Franciscan theologian differentiates among the media of sculpture, painting, and illumination, comparing the first to God's creation, the second to his Passion, and the third to the process of redemption and the life to come. The various media are made to encompass the whole of the history of salvation.[22]

Pace Belting, theology and theological modes of thought had a profound impact on the form as well as the content of medieval art. Without forcing the analogy, one can frame the relationship between form and content in terms of various theological constructions of the relationship of body and soul, or at least suggest that such constructions had an impact on Gothic sculpture. Paul Binski is among those who argue in this vein. Commenting on the spirited animation of thirteenth-century figural programs, Binski suggests that the works' "acknowledgment of the manipulative power of the image had theoretical bases." Following Caroline Bynum, Binski locates this theoretical foundation in theology, noting "a parallel bonding of cognition and emotion in the didactic strategies of Gothic art" and "in the writings of Aquinas and St. Bonaventura on images."[23] In this construction, affective response hardly precedes attempts to channel and control it. Rather, it is the product of an exquisite calculation that is literally incorporated into the image. Bonaventure's desire to generate, not merely control, response was what led him to argue that "the introduction of images into the church was not without a rational cause."[24]

To maintain that theologians such as Bonaventure always speak ex post facto, that they always seek to overwrite experience, runs the risk of positing, if only implicitly, a notion of common human experience uninformed by discursive models of any kind.[25] If nothing else, however, the interrelated histories of devotion, mysticism, liturgy, and theology testify to their power (or at least their will) to reshape, in profound and manifold ways, human subjectivity.[26] Within this web of experience and example, pattern and response, mediated by the historical record, which in turn reworks it, "raw" experience proves almost impossible to locate. The sources that supposedly testify to that record of response are themselves historical documents, shaped by the contexts in which they were written, the institutional histories by which they were passed down, and the conscious and unconscious desires of those who transmitted them.[27]

The adaptations of the Gregorian dictum over the course of a millennium testify to the ways in which pastoral theology provided a matrix for experience, not just a stamp of approval.[28] Bonaventure folds various strands of the Gregorian tradition into his own threefold rationale for images:

In fact they [images] were introduced for a triple reason, namely, because of the igno-
rance of humble people, so that they who cannot read the scriptures can read the sacra-
ments of our faith in sculptures and paintings just as one would more manifestly in writ-
ings. They are likewise introduced because of the sluggishness of feelings, namely so
that men who are not stimulated to devotion by the things that Christ did for us when
they hear about them are excited at once when they become aware of the same things
in statues and pictures, as if present to the body's eyes. Our feeling is more excited by
things it sees than by things it hears . . . because of the unreliability of memory, in that
things that are only heard fade into oblivion more easily than those that are
seen. . . . Hence it has been established by the grace of God that images appear especially
in churches, so that, seeing them, we will be reminded of the benefits bestowed on us
and of the worthy deeds of the saints.[29]

The *ratio triplex* is usually characterized as a kind of straitjacket, a set of strictures that chokes
off a broader range of response. In fact, neither Bonaventure nor many of his contemporaries ex-
press any open antagonism toward images, quite the contrary. In some ways, they maintain, see-
ing is superior to hearing or even to reading.

Similar sentiments permeate a Cistercian sermon, delivered to a monastic audience by an
anonymous contemporary of the Franciscan theologian. Taking as its point of departure Psalm
86:6 ("Dominus narrabit in scripturis populorum" [The Lord shall tell in writing of peoples]), the
sermon speaks of the "various writings of humanity," by which it means both texts and images:
"Our Lord has also given us another scripture, that is, the scripture of the laity, for there are many
people who can not read what is written in books. God has therefore given them another form of
writing, from which they learn how they should strive to enter heaven."[30] This writing, the
preacher explains, "consists of the paintings of the saints in the churches, how they lived, and
what they did through God, and what they suffered on his account." Looking at the lives of the
saints, he argues, strengthens one's faith and hope in salvation.[31] Continuing in a less conven-
tional vein, he weaves together, with a few deft strokes, strands from Scripture, moral theology,
the *ars memorativa*, theories of perception, and a justification of images:

When our heart is unsteady and unfortunately seldom at rest with itself, then the person
[looking at the paintings] finds his heart in the paintings ["sin hertze denne an dem
gemålde vindet"] as he looks at the things that are painted before him and then afterwards
considers it inwardly [or by heart, "inwendig"]. So says the proverb "I have found my
heart" [cf. Ecclus. 51:27–28]. Now note well: whatever a person finds must first have been
lost. It often happens that a person who unfortunately loses his heart with vain thoughts,
he should find it again in the paintings.

The sermon taps into ancient sources, not only Paul's epistles and Gregory the Great's partly spu-
rious letter to Secundinus, but also the same pope's widely read *Regula pastoralis*, where Gregory
likewise framed his moral theology in pictorial terms predicated on a theory of perception: "Just
as the forms of exterior things are carried away with one in an interior fashion, so too, whatever
is thought when considering formed images *(fictis ymaginibus)* is immediately painted in the
heart."[32] In the *Rationale divinorum officiorum* (Rat. I.iii.4), Durandus of Mende (1230/31–1296)
quotes the same passage to underscore the efficacy of images, implying their equality with texts

as instruments of edification.[33] Propagated by authorities such as these, a single image can spawn a vast sphere of "experience." In this instance, the imagery of the heart as a painted chamber was taken up in innumerable didactic texts, which encouraged the reader to expunge demonic images with "paintings" of pious thoughts.[34] The practice of piety itself becomes pictorial, with paintings providing not only the substance but also the model and method for a devotional regime.

In light of the complex circulation of ideas and images between theory and practice, reading and seeing, the relationship between theology and art cannot be cast solely in terms of reproaches and restrictions. Like images, theology played a formative role. Moreover, the idea of the image could never free itself of theological connotations. The power of images to persuade rested in part on theories and practices of participation, of which the idea of the *imago*, God's image and like-ness in man, was only the most important. These ideas drew on Scripture as well as Christian Neoplatonism. Medieval works of art, moreover, did not depend on theologians to rein them in or to channel responses (although instances of such efforts can be documented).[35] Many images in-corporate visual devices, of which frames offer only one example, or employ differentiated modes of representation that mediate between the image and the viewer, providing built-in barriers, the visual equivalents of trip wires designed to remind onlookers of the limits of representation.[36] To this extent, some categories of image could be said to provide an implicit theory of art where the written sources themselves supply none.

Just as the Middle Ages entertained viable notions of artistry that were not entirely dissimi-lar from those that emerged in the modern era, so too the modern era held to the idea of the cult image in ways that continued, even as they modified, age-old traditions and practices.[37] Idealized notions of the dignity of craftsmanship emerged in the context of scriptural commentary, for ex-ample, in the prefaces to Theophilus's *De diversibus artibus*, which are notable for the sophisti-cation of their theological content.[38] Some theologians, even those as hostile to inventive iconog-raphies as Lucas of Tuy (who sought, unsuccessfully, to associate some with heresy), distinguish between *doctrina* and *decor*. As Creighton Gilbert has argued, this distinction admitted "a beauty that is separate from function, in a way that might even be parallel to our notions of style and iconography or even form and content."[39] The cult of relics fostered self-conscious rituals of dis-play that, once reflected and reenacted within the containers that displayed the objects of cult, contributed decisively to their aestheticization.[40] The history of cult images testifies to frequent moments of recursive reference to authoritative models, in which the quotation and elaboration of elements of what today might be called "style" form part of the image's notational structure.[41] Theology did not always respond to existing practices, especially when it came to the use of im-ages in the liturgy, where figures of every conceivable kind were brought to life within the drama of the Mass.[42] Similar reservations could be extended to many genres of church decoration, not only liturgical props, but also wall paintings, even to some icons themselves, which, in Herbert Kessler's trenchant formulation, exemplify "art as argument."[43]

As early as 1937, Rudolf Berliner sketched an alternative to Belting's position in an important, if not very influential, article, "The Freedom of Medieval Art," one of many essays in which Berliner argued for the theological *gravitas* of medieval art, even in some of its more outlandish incarnations.[44] Published only in 1945, at a time when the struggle between freedom and subjec-tion remained the order of the day, Berliner's article addresses the respective roles of patrons, the-ologians, artists, and audiences in shaping medieval images, and, closely related, the interplay be-tween production and reception. (Berliner speaks of the theological sanction given to the role of subjectivity in shaping subject matter, even if that subject matter could not always be considered

orthodox). In contrast to Meyer Schapiro, who located artistic autonomy at the margins, and associated it with secularism, Berliner found room for it at the center, where, as he saw it, artists could innovate because theologians—very often the same theologians who had a hand in commissioning the works in question—openly acknowledged the pastoral utility of innovations in encouraging affective response, even if they implied doctrinal inaccuracy.[45] Medieval art, Berliner claimed, owed what he characterized as its freedom, not to an absence of interference from theologians, or even, as Belting would have it, to the power of images to defy all such attempts, but rather to "theological concepts of [art's] role in the realm of religion."[46]

What Berliner called "freedom" could be attributed to the fact that, in comparison with the East, images were theologically less burdened with being vehicles, let alone, embodiments, of Truth. Paradoxically, it was in part precisely because less importance was attributed to images in the Latin tradition that they so successfully escaped most attempts to control them, and were regarded in most quarters neither as necessary evils nor even as benign concessions to popular piety, but, quite simply, as essential aids that could be accepted, even encouraged, as long as they did not become ends in themselves.[47] Assigned various roles, as pastoral aids or instruments of devotion, didactic devices, or prompts to memory, images developed in a myriad of ways, not only because they met essential human needs, but also because the relative absence of prescriptive legislation and liturgical strictures created by default a variety of imaginative spaces in which they could flourish. As Jean-Claude Schmitt has remarked, "Il n'existe en effet pas de 'loi' (lex), ni de 'droit' (jus) régissant la production des images au Moyen Âge: aucun texte officiel, telle une ordonnance royale ou une bulle pontificale, ne dit comment faire les images, ne fixe un canon iconographique, n'interdit telle ou telle représentation."[48] One would never guess from Belting's book that of the few theologians who felt moved to say anything at all about images, the majority did so in order to defend their use against iconoclasts.[49] In large measure, the "normalization" of Christian iconography and of practices regarding the proper uses of images had to await what Belting calls the "age of art," be it under the aegis of the Reformation or the Counter-Reformation.[50] In the Middle Ages, passing remarks on images and their status are infrequent enough, extensive commentaries, very rare, and even then almost always, as in Bernard of Clairvaux's *Apologia*, in the context of commentary on other issues. On those rare occasions when commentators did turn their attention to images, it was often in conventional terms, derived from predictable passages in Scripture (for example, descriptions of the furnishings of the Temple) or developed from the dicta attributed to Gregory the Great.[51] The contexts in which such comments occur—sermons, glosses on the Song of Songs, justifications of visionary experience, catechetical manuals—indicate that images, far from being ends in themselves, always stood in service of other goals. Within the Christian tradition, or even in the traditions on which it drew, the image was never free of the constraints of culture.

The Cathedral as Proving Ground

For generations, the cathedral has provided a proving ground for any proposition concerning the relationship between art and theology in the Middle Ages. For some scholars, the cathedral stands as a nostalgic image of a world order that never existed.[52] At best a projection, not a reflection, of order, be it social or heavenly, the cathedral can be construed as a perfectly ordered cosmos, a *Zeitenraum* (to paraphrase Friedrich Ohly), only if one willfully ignores the many ways in which so-

ciety and the *saeculum* impinged on its spaces and shaped it from without as well as within.[53] Applied in this way, so as to assume an ordered whole where none ever existed, theology could indeed be considered anathema, a closed system that confirms its own conclusions by inevitably explaining (or seeming to explain) everything.

A cathedral had many functions: political, pastoral, liturgical. Within all these spheres, however, theology played a prominent role.[54] Far from a rarefied activity divorced from everyday life, theology enjoyed or claimed for itself enormous prestige and a prominent place in the public sphere. For example, at Notre-Dame in Paris, clerics shared appointments between the university and the chapter that took primary responsibility for the construction of the cathedral.[55] Portals present sacred history, not as a given, nor even in strict narrative sequence, but rearranged according to the dictates of the liturgy and a theologically informed ordering of time and space. The vagaries of planning, let alone financing, ensure that portal programs are by no means always coherent, but their size and structure lend their content the aura and authority of inevitability, as if their tendentious messages were in fact God-given. At issue is less what cathedrals mean than how that meaning was orchestrated to convey certain messages to its publics, and to what degree those messages were pastoral or propagandistic in purpose.

For Émile Mâle, the matter was quite simple. "The Middle Ages," he famously declared, "had a passion for order. It organized art as it organized dogma, human knowledge, and society. The representation of sacred subjects was a science with its own principles; it was never left to individual fantasy. . . . The art of the Middle Ages is first of all a sacred writing whose elements every artist had to learn."[56] Adolf Katzenellenbogen's classic study of the sculpture of the facades of Chartres cathedral elaborated on Mâle's premises, but it did not depart from them in any fundamental manner.[57] In keeping with the dictates of the iconographic method, these studies made images subservient to texts, giving little, if any, consideration to the roles of craftsmen or viewers.

Any attempt to trace the critical fate of efforts to match medieval art and theology inevitably encounters the colossus of Erwin Panofsky, not only his partial edition of Abbot Suger's writings on the Abbey of St.-Denis, but also his *Gothic Architecture and Scholasticism*.[58] Panofsky's thesis concerning the influence of the Pseudo-Dionysius on the aesthetics of the abbey's architecture has perhaps been definitively debunked.[59] Panofsky's eloquent essay on Gothic architecture might also be considered a period piece, one in a long line of now largely discredited attempts to interpret medieval ecclesiastical architecture as a manifestation of metaphysics in stone.[60] Despite its incisive characterization of certain aspects of scholastic theology and of Gothic structure as argument, the book tends (to use scholastic terminology) to reduce scholasticism to an effective cause. Not even scholastics viewed medieval buildings in this way.[61] Panofsky's apparent *apercu*—an unfolding analogy between the forms of Gothic architecture and the formal structures of scholastic theology—gestures to a Hegelian mode in locating the impetus of historical development outside the sphere of individual human actions and subjecting the material entirely to the dictates of the realm of disembodied ideas.

Panofky's brilliant, if flawed, *jeu d'esprit* has its own genealogy within German art history. Its ancestry, worth tracing, would have to include a book that has largely been forgotten, Ferdinand Piper's *Einleitung in die monumentale Theologie*, published in Gotha in 1867.[62] Piper's title underscored his conviction that the monuments that made up the archaeological and art-historical record were no less important as sources for the history of theology than the texts on which theologians had traditionally depended. Not unlike Panofsky's iconology, Piper's method addresses what he, in an earlier work, *Die Mythologie der christlichen Kunst von der ältesten Zeit bis in's*

sechzehnte Jahrhundert (Weimar, 1847–1851), characterized as "den ganzen Ideenkreis, das wissenschaftliche und volkstümliche Bewußtsein, in welchem dieselben begründet sind," "the entire complex of ideas, the scholarly and the popular consciousness, in which this [the content of the work] is founded."[63] In terms that echo down to Panofsky, Piper declares: "At the height of medieval formation *(Bildung)*, the scholastic system and the Gothic cathedral reveal themselves side by side in wonderful perfection as related to one another, in that they exchange properties *(Eigenschaften)* with one another: the one displaying a rich architectonic construction, the other an abundance of subtly arranged thoughts."[64]

Having casually introduced the analogy between Gothic architecture and scholasticism, Piper develops it in another direction, arguing in a decidedly Romantic vein that works of visual art, including architecture, appeal to the eye with a directness and immediacy of which discursive prose is incapable. The difference between Piper and Panofsky is instructive, in that it robs Panofsky's argument by analogy of its apparently irrefutable logic. Taking as his point of departure the distinctions between visual and verbal expression drawn in Lessing's *Laocoön* (1766), Piper inverts them, so that the image, far from being merely or properly descriptive, becomes a vehicle for contemplative thought. Piper champions both the image and the visual, arguing that "art has a thoroughly different form of expression than speech: it also addresses itself to the entire person, not through the faculty of concepts *(Begriffe)*, but rather through the higher faculty of vision *(Anschauung)*, for which corporal sight *(leibliche Sehen)* is only the medium *(Medium)*."[65] In celebrating sight in this manner, Piper stands squarely in a Romantic tradition not yet deconstructed by those modernists and postmodernists who, in Martin Jay's trenchant formulation, "denigrated" vision and questioned its status as the most privileged of the senses.[66] Piper continues: "The difference lies in the fact that, whereas in thinking the object is divided up *(zersetzt)*, that is, the perception *(Erkenntnis)* is a fluid one, bound to a series of moments, the work of art allows the whole *(das Ganze)* to be recognized in its spatial entirety, undivided and in the immediacy of all its moments."[67] Piper notes a remark attributed to Napoleon, that Chartres cathedral might make an atheist feel uncomfortable. He then adds that whereas a rationalist could well use the scholastic method against itself to demolish the structure of Christian belief, the "speaking stones" of the cathedral testify eloquently to the overwhelming character of communal devotion and piety.

In coining the term "monumental theology," Piper sought an all-embracing concept that would effectively encompass the physical as well as the written record so that, as he put it, "this science *(Wissenschaft)* . . . might conduct itself as a principal branch in relation to the whole of theology, equal to its other forms, exegetical, historical, and so on and so forth."[68] Piper's call to take medieval images seriously, not just as historical documents, but as forms of expression that speak to the senses in their own voice remains curiously unfulfilled in his own work, which, at close to a thousand pages, is a monument in itself, but one that, ironically, devotes most of its length to a digest of texts, from Scripture and the Church Fathers through Beleth, Sicardus, and Durandus, to whom are appended reformers such as Savonarola and Luther and, not least, a host of often obscure archaeologists and antiquarians who worked at the papal court well into the modern period. Writing at a time when Christian iconography was still in its infancy, Piper nonetheless defines the visual arts as a separate branch of study, subject to its own protocols and prerogatives.

Lest Piper's categories or even his goal of uniting the study of art and theology seem too far removed from more recent debates, consider the conclusion to Otto Pächt's review of Panofsky's *Early Netherlandish Painting*, the first and one of the few critical responses to a work that, to all

intents and purposes, defined iconographic method in American art history for several decades.[69] Although an averred anti-Romantic, Pächt summed up his objections to the iconographic method by observing "I fail to see how they [the iconographic and stylistic approaches] can be co-ordinated if each is based on a different notion of artistic creation (the one implying a rational, the other an irrational structure) and each claims it can seize the very essence of the artistic phenomenon and grasp it in its totality."[70] According to Pächt, iconographers, in reducing images to illustrations of texts, "are failing to grasp the vital fact that visual art, like music, can say things in its own medium that cannot be said in any other. This is ultimately what is meant when art is spoken of as an 'autonomous expressive sphere.'"[71] Like Belting, but for different reasons, Pächt makes theologians scapegoats for the notion that texts delimit the expressive possibilities of images: "*Pace* the Church Fathers and the medieval theologians, there is more even to the Christian art of the Middle Ages than 'speaking through images', standing in for writing. Even medieval art is something more than a post room in which intellectual and religious values are wrapped and unwrapped on their way from consignor to consignee. Even medieval art, in very many of its manifestations, is a statement in its own terms, *sui generis*, concerning the universe, existence, everyday life and the Last Things: a statement that neither is a substitute nor can be substituted."[72] Pächt predictably excoriated allegorical readings of medieval art, for example, those found in liturgical commentaries, as "examples in inductive logic, of mystical allegorical interpretation which subordinates meaning and motive and plays no part in the genesis of the pattern in question," adding that "these examples, which could almost be called theological word games, tell us much about the intellectual habit of moralizing but nothing about the essence of the work they interpret."[73] Pächt saw modern iconographic analysis as little more than an extension of these theological habits, lamenting, "Unfortunately allegorical exegesis has become very fashionable again in art history, despite the fact that it obscures those paths which lead to a true understanding of the historical monuments."[74] Pächt sums up his position by acknowledging that "the history of art is to be understood as a part of universal history; but, with its special reference to the aesthetic object, it is a discipline equal in status to any other. There is more to it than a mere illustration of the humanities."[75]

As framed by Pächt, the iconographer sets himself up as high priest, creating for compliant readers the illusion that he and he alone can reveal the mystery beneath the veil of the work's superficial appearance. No less than Piper, Pächt opposes text and image, reason and imagination, in terms that would seem to bear out W. J. T. Mitchell's observations that "words and images seem inevitably to become implicated in a 'war of signs' (what Leonardo called a *paragone)* in which the stakes are things like nature, truth, reality, and the human spirit."[76] "Each art, each type of sign or medium, lays claim to certain things that it is best equipped to mediate, and each grounds its claim in a certain characterization of its 'self,' its own proper essence. Equally important, each art characterizes itself in opposition to its 'significant other.'"[77] In arguing that the "history of culture is in part the story of a protracted struggle for dominance between pictorial and linguistic signs, each claiming for itself certain proprietary rights on a 'nature' to which only it has access," Mitchell rejects any holistic, Romantic vision, in which Piper's project certainly participates (as does Pächt's, albeit it indirectly and in different ways).[78] Piper took for granted a relationship between "Kirche" and "Kunst," between the Church and Art, that others, most notably Meyer Schapiro, construed in radically different terms. In keeping with his pious Protestantism and a communitarian vision of the Middle Ages that was by no means a monopoly of conservative Catholics, Piper took the Church to mean not just its institutional structures, but also the entire

community of the faithful *(Gemeinde)*. By "Art," in turn, Piper understood far more than visible appearances. Piper defines art as imitation, but as the imitation of God as well as Nature.[79] As a result, imitation included in its purview both the sensory and the suprasensory. It has, in Piper's words, "the power of ideas."[80]

In his desire to establish images as a supplement to Scripture and biblical commentary, Piper could be considered a forerunner of Émile Mâle. Mâle's analysis is sweeping, systematic, and, hence, seductive. If the cathedral is a *summa*, however, Mâle does not ask who could read it, and how.[81] Mâle also makes of the medieval artist an automaton, the artistic equivalent of an amanuensis who simply carries out the dictates of his patrons. Lest Mâle's point of view be dismissed as hopelessly old-fashioned, it might be recalled that a great deal of recent writing on methods of manuscript production also leaves little leeway for artistic invention, submitting production to the dictates of programmers (many of whose explicit instructions, however, it can be shown, were often ignored).[82] The construction of a cathedral, however, complete with all its decoration, is considerably more complex than that of even the most ambitious manuscript. According to the most recent accounts, the threefold transept portals at Chartres, much like those at other edifices, were subject to radical revisions and displacements in the course of construction. Any comparison of the building to a book must therefore be subject to skepticism.[83] In addition to undergoing transformations due to practical and political pressures, many of them linked to evolving patterns of patronage or quite simply to changing constellations of craftsmen, the complex iconographic arrays with which cathedrals were encrusted represented anything but closed systems. Issues of coherence and consistency aside, medieval works of art remained open to interpretation, both by other artists and by viewers.[84] In this spirit, a great deal of recent literature, not just on medieval sculpture and stained glass, but on all types of medieval art, focuses less on its production and patronage than on issues of reception: who was "reading" these images, and how? In what circumstances, and from what point of view? To what degree was any given group of viewers conversant with whatever symbolic codes and systems of representation the images demanded of them? All these questions return us to larger questions of reading and interpretation, in the present as well as in the Middle Ages.

Theology and Theory

Theology, by definition, consists of words about God. Art history, however, consists of words about art. To insist too much on the autonomy of visual experience would be to risk a Romantic analogy between the art historian and the mystic, who, having "seen" God, translates that ineffable encounter into a discursive mode. Pächt's proposition that the integrity of art history depends on the autonomy of the aesthetic object seems much more parlous today than it did at the time he first proposed it. Confronted with visual culture, some (although hardly all) art historians are anything but inclined to insist on the autonomy of their own profession, let alone that of art.[85] As noted by Michael Baxandall, it is, on the whole, not difficult to match texts with images. The danger is in assuming any kind of congruency, even when the text and image can be shown to stem from what, at first blush, appears to be the same historical context. In Baxandall's formulation, "painting, on the one hand, and theological exegesis . . . on the other, are, in a consequential way, incommensurable and divergent discourses."[86] At issue is not whether historians of medieval art should come to terms with theology, but how.

No one today would hold that exegesis be taken as a model for modern readings of medieval art or that medievalists content themselves with retracing the intricate patterns drawn by medieval exegetes. Interpretations of this kind, which once were common, run the risk of flirting with catechism. Even the most brilliant iconographic interpretations can reduce images to ciphers linked more by what they signify than the means by which that significance was created and conveyed. If, however, one reads commentaries less for what they say than for how they say it, exegesis and theology can once again shed light on the ways, means, and methods of medieval images.

Paul Binski points in this direction when, in speaking of the sculpture of the Angel Choir at Lincoln, he identifies his own argument as an "exegesis" that seeks a "critical link . . . between signification and idiom."[87] In dealing with its own materials, above all, the books of the Bible, which varied greatly in character and content, the commentary tradition looked for similar links, and defined them in very precise ways. Abelard, for example, identified a range of rhetorical modes or tropes at work in Scripture, among them *figuratio, similitudo, exemplum, involucrum, velamen, translatio, obscuritas, parabla*, and *aenigma*.[88] To paraphrase Peter von Moos, these and similar terms provided, albeit "accidentally," a theory of literary language rooted in theological practice.[89] In von Moos's formulation, "*Theologia*, understood as the speech appropriate to the highest object and as the theory of speech that dealt with this object, the most ambitious form of 'linguistics,' was the place in which the poetic as a value in itself, not simply as a trivial instrument of didacticism, became thinkable. The legitimizing basis for a self-conscious, creative imitation of the 'prophetic' word and later, the philosophic emancipation of secular fiction, which belong to the pre-history of the modern aesthetics of autonomy, come from theology."[90] If historians of medieval literature can look to theology to posit the possibility, not only of "literature," but also of "literary theory," why, one might ask, shouldn't art historians, *mutatis mutandis*, postulate, with all necessary provisos, analogous possibilities when it comes to "art" and "art theory"? Theories of a "Christian aesthetic," from Hegel to Auerbach and Jauß, have all gestured to the commentary tradition in various ways, in particular, to the notion of an "incarnational aesthetic" that, in this line of interpretation, has been read as underwriting various forms of realism.[91] Drawing on theological modes, without seeking to reproduce them, Georges Didi-Huberman invokes this same trope, arguing that "just as the doctrine of the Incarnation demanded a palpable effort at the replacement of the visible (a exigé et produit un travail de la relève du visible) the notion of holy Scripture demanded and produced an effort at the replacement of the readable (un travail de la relève du lisible)."[92] This dialectic he then fleshes out with an entire spectrum of possibilities, which he goes so far as to call the "ten commandments" for the interpretation of Christian art: *translatio, memoria, praefiguratio, veritas, virtus, defiguratio, desiderium, praesentatio, collocatio*, and *nominatio*, all of which allow him to read a wide range of objects and images as figurations of the divine. None of these terms is binding, and some could even be said to be arbitrary, yet they at least offer avenues of interpretation that allow one to look beyond the limits imposed by the didacticism of the *ratio triplex* to the rhetorical complexity of the objects themselves.

Modes of address and organization related to, if not strictly rooted in, exegesis informed the making as well as the reading of medieval images. Of these, some are so well known that they can be canvassed briefly, which is not to imply that their potential as instruments of interpretation has in any way been exhausted. Among the most important is diagrammatic exposition, which, as Madeline Caviness has argued, represents an overarching system of figuration, independent of stylistic categories and closely related to different types of visual experience.[93] Diagrams represent more than the backbone of what, in an all too easy elision of *pictura* and *scriptura*, image and

text, has been called "visual exegesis."[94] Wolfgang Kemp has argued that certain forms of structure, related to, but not dependent on, either exegesis or the diagrammatic mode, constitute distinguishing features not just of Christian art, but of Christianity *tout court*. Kemp invokes theological modes of organizing time and space but resists seeing images as having depended on them directly.[95] Independent of Belting's account, and devoid of gestures to context, Kemp focuses neither on the image nor on narrative as normalized by the Gregorian dictum; instead, his emphasis is on what he calls *Weltbilder*, structural relationships that construct a *Kosmos*, an ordered whole.[96] As with any such analysis, one possible weakness is what is omitted, some might say suppressed, from the field of vision. Had Kemp been more interested in exploring parallels, if not sources, in texts other than the "great code" of the Bible itself, he might well have found some in the reordering of Scripture represented by liturgical ritual, which in turn would have provided a link to various social imperatives. Kemp defines the typologies he seeks in terms of a structuralist grammar, independent from, if not unrelated to, the patterns established by the exegetical procedures of typology and allegorization.[97] As Kemp himself acknowledges, however, typology represents a form of what Auerbach identified as the trope of *figura*, and it involves more than the incarnation of a pre-existent content in visible form. The form is part of the content. Typology in itself provides a way of thinking in formal terms, according to a particular, flexible set of rules, and its implications often become manifest only after they have been worked out in the visual parallelisms that images made both possible and palpable.[98]

Among these various modes of representation, perhaps the most potent was that of *imago* itself.[99] For the Byzantine tradition, its explanatory potential has been explored by Jaroslav Pelikan and, before him, Gerhard Ladner.[100] In the West, however, *imago*, less inscribed in institutional structures, always had a different power, one that resided precisely in its lack of determinacy: it was at once material and immaterial, an idea and a thing. Under the playful pens of exegetes, the term expanded easily to encompass related concepts such as imitation (*imitatio*) and imagination (*imaginatio*).[101] The complex interlocking of the various inferences that could be drawn from the term emerges from its application in the liturgy.[102] A prayer for Easter Saturday first found in the Gelasian Sacramentary proclaims: "O Lord, who through the Passion of Christ, our Lord, dissolved the death inherited from ancient sin, which posterity of both sexes had inherited, make us like unto him (*conformes eidem facti*); just as we bear, by necessity of nature, the image of the earthly Christ our Lord (*imaginem terreni*), thus too we bear, through the healing of grace, the image of the celestial (*imaginem caelestis*) Christ."[103] A similarly complex formulation occurs in the Leonine Sacramentary: "May today's festive sacrifice please you, O Lord, so that we, in accordance with your grace, through these sacrosanct dealings may become acquainted with the form (*in illius inveniamur forma*) of that thing in which our substance (*nostra substantia*) is together with you."[104] In these and other, similar prayers, which were the words with which ordinary Christians formulated their aspirations, the theology of the *imago Dei* in was linked to the reception of the Eucharist, which itself involved a linking of the terrestrial and the heavenly. Medieval texts may not disclose anything resembling a theory of art per se, but in sources such as these, one can find intimations of theory or, at the very least, complex meditations on the nature of representation, framed in specifically Christian terms.

Closely related terms, all of which receive intricate, even flamboyant, elaboration in the exegetical literature, include *figura*, *exemplum*, *vestigium*, and *repraesentatio*.[105] More than most, the term *vestigium* nicely captures an ambiguity that commentators and mystics exploited to the hilt: in addition to meaning a ghostly vestige or trace, it also carried the much more corporeal

meaning of "footprint." The *imago Dei* was a vestige of God in the soul, but Christ's bloody footsteps toward Calvary were seen as vestiges as well.[106] One can decry the lack of precision in medieval descriptions of what we call works of art, but the flexibility of *imago* as a catch-all designation allowed it to serve as a middle term that mediated effectively between concrete, corporeal images and their immaterial counterparts, be it dreams or visions.[107] On this sliding scale, dissemblance, by being both the measure of distance from the divine and the paradoxical means of collapsing that same divide, was more, not less, important that resemblance itself. In this system of representation, in which imitation was crucial but mimesis was not, few images represented the two sides of this curious equation more persuasively than the veil of Veronica, which served both as a barrier and as an invitation to entrance, like the Temple curtain, rent at the Crucifixion.[108] Christian images do not simply depict these mysteries, they actively participate in them. In this formulation, the ultimate paradox of a visual economy predicated on the *imago* is that only in abandoning any notion of likeness can one be restored to the ultimate exemplar.

At the root of all encounters with images was vision. Visual experience was elaborately classified and categorized by commentators. Theologians, however, did more than gloss visual experience; as if to put blinders on it, they defined it, if not an end in itself, then as an indispensable vehicle for all forms of knowledge, from the corporeal to the celestial.[109] In his commentary on John 1:10 ("He was in the world, and the world was made by him, and the world knew him not"), Albertus Magnus argued, God became not simply incarnate, but visible: "'He was in the world,' that is, made visibly in the world. . . . not simply changing place because he is everywhere, but also making himself manifest visibly."[110] As noted by Michael Camille, the hierarchies of vision variously worked out in medieval commentaries on the Apocalypse and other texts were "not just theological distinctions. They were directly related to the kinds of images that artists made and that their patrons wanted to see."[111] Theology did not merely repress or even sanction sensory experience; it made vision meaningful in specific ways that defined several forms of visuality within a much broader spectrum of possibilities.[112]

If, as John's Gospel would have it, "In the beginning was the Word," then art historians remain inevitably at odds with theological discourse: within this framework, defined by the first and perhaps most potent theological statement in the Christian tradition, the image has no choice but to serve as a supplement. This would indeed, to paraphrase Edward Said, be art history as a debased form of Platonism.[113] One could, however, counter that it was precisely because of the first chapter of John's Gospel that Christian theologians asserted with the confidence of faith that Christ, a coequal member of the Trinity, was the perfect image of the Father.[114] If Christ is an image, then everything in God's creation could be seen as participating in that reality. Christianity defines itself as a religion predicated on immanence as well as transcendence, presence as well as immateriality, and it was to this relationship that many theologians referred, as if to an article of faith, when seeking to justify images. This theology of immanence does not run counter to the culture of response celebrated in anthropological approaches to the image; quite the contrary, in addition to lending those practices theological sanction, it gave them deep religious meaning.[115] In the context of Christian doctrine, image and text were tied one to the other as Christ's visible humanity was indissolubly, if mysteriously, linked to his divinity as the Logos.

Manmade images, however, belong to a different order of reality than the images that, according to Christian doctrine, were conceived in the Logos and fashioned by the hand of God.[116] Much of the tension, even incompatibility, between images and theological discourse could be traced to this discrepancy. Similarly, the history of changing attitudes toward images in the Middle Ages

could, in turn, be traced in terms of the gradual dissolution of the claims images made to truth. Recognition of the power of the images to present fictions in turn enabled an enhanced appreciation of the complexity and dignity of human artifice and the possibilities, not only the pitfalls, of the imaginative faculties.[117] By its nature, theology involves a search for origins. In contrast, the perspective of art history inevitably is a belated one. If, however, theology is viewed not as a vessel of truth, but instead as an historical artifact in its own right, less a body of doctrine than itself a variety of methods, it once again can take a constructive, if not constitutive, place within a larger history of medieval art.

Notes

1. E. de Bruyne, *Études d'esthétique médiévale*, 3 vols. (Bruges, 1946; reprinted Geneva, 1975); and U. Eco, *Art and Beauty in the Middle Ages*, trans. H. Bredin (New Haven and London, 1986). For a recent essay in this vein, see L. Karfíková, *"De esse ad pulchrum esse": Schönheit in der Theologie Hugos von St. Viktor*, Bibliotheca Victorina 8 (Turnhout, 1998).

2. D. Summers, *The Judgment of Sense: Renaissance Naturalism and the Rise of Aesthetics* (Cambridge, 1987).

3. S. Huot, "Inventional Mnemonics, Reading and Prayer: A Reply to Mary Carruthers," *Connotations* 3 (1993–94), 103–9, esp. 109, with reference to M. Carruthers, *The Book of Memory: A Study of Memory in Medieval Culture* (Cambridge, 1990). See also the meditations of A. Assmann, *Erinnerungsräume: Formen und Wandlungen des kulturellen Gedächtnisses* (Munich, 1999), chap. 3 ("Bild").

4. Cf. "Medieval Art without 'Art'?," a collection of essays introduced by H. Maguire in *Gesta* 34, no. 1 (1995); the remarks of R. Recht, "'Lieu théologique' et officine des images," 5–8, esp. 5; and Recht's preface to F. Boespflug, *La Trinité dans l'art d'occident (1400–1460): Sept chefs-d'œuvre de la peinture* (Strasbourg, 2000): "'Œuvre d'art' et 'image' sont des termes réducteurs qui ne restituent guère l'incroyable richesse de cette réalité complexe."

5. H. Belting, *Likeness and Presence: A History of the Image before the Era of Art*, trans. E. Jephcott (Chicago, 1994), originally published as *Bild und Kult: Eine Geschichte des Bildes vor dem Zeitalter der Kunst* (Munich, 1990).

6. Belting, *Likeness and Presence* (as in note 5), 1.

7. Belting, *Likeness and Presence* (as in note 5), 1.

8. Belting, *Likeness and Presence* (as in note 5), 1.

9. H. Belting, *Bild-Anthropologie: Entwürfe für eine Bildwissenschaft* (Munich, 2001); and Belting, "Vorwort: Zu einer Anthropologie des Bildes," in *Der zweite Blick: Bildgeschichte und Bildreflexion*, ed. H. Belting and D. Kamper (Munich, 2000), 7–10, esp. 8: "Bilder sind nicht nur außerhalb der Kunst, sondern auch in Zeiten entstanden, in denen ein Kunstgebegriff fehlte. Die mittelalterliche Bildtheologie gab den Stab an die neuzeitliche Kunsttheorie ab, womit eine echte Bildtheorie in Europa wirksam verhindert wirde. Erst die moderne Medientheorie schließt an die alten Bildfragen wider an." See also *Quel corps? Eine Frage der Repräsentation*, ed. H. Belt-ing, D. Kamper, and M. Schultz (Munich, 2002).

10. D. Freedberg, *The Power of Images: Studies in the History and Theory of Response* (Chicago, 1989).

11. D. Freedberg, "Holy Images and Other Images," in *The Art of Interpretation*, Pennsylvania Papers in the History of Art, ed. S. C. Scott (State College, Penn., 1996), 71. Freedberg continues: "I find the Byzantine theory of images to be both *massgebend* and paradigmatic, in the historical as well as in the psychological sense."

12. Freedberg, *Power of Images* (as in note 10), esp. chap. 8 ("*Invisibilia per visibilia*: Meditation and the Uses of Theory"), 161–91.

13. D. Freedberg, "Holy Images and Other Images," (as in note 11), 69–89, esp. 69, in which Freedberg addresses Belting's book in detail.

14. Most notably in the work of Michael Camille; see, e.g., his "Mouths and Meanings: Towards an Anti-Iconography of Medieval Art," in *Iconography at the Crossroads: Papers from the Colloquium Sponsored by the Index of Christian Art, Princeton University, 23–24 March 1990*, Index of Christian Art Occasional Papers 2 (Princeton, 1993), 43–58.

15. See *Framing Medieval Bodies*, ed. M. Rubin and S. Kay (Manchester, 1994).

16. See, e.g., D. Alexandre-Bidon, "Une foi en deux ou trois dimensions? Images et objets du faire croire à l'usage des läics," *Annales ESC* 53 (1998), 1155–90; C. Burger, "Theologie und Laienfrömmigkeit: Transformationsversuche im Spätmittelalter," in *Lebenslehren und Weltentwürfe im Übergang vom Mittelalter zur Neuzeit*, ed. H. Boockman, B. Moeller, and K. Stackmann, *AbhGött, Philol.-hist.Kl.*, ser. 3, vol. 179 (1979), 400–420; P. Dinzelbacher, "'Volksreligion,' 'gelebte Religion,' 'verordnete Religion': Zu begrifflichem Instrumentarium und historischer Perspektive," *Bayerisches Jahrbuch für Volkskunde* (1997), 77–98; and J.-C. Schmitt, "Der Mediävist und die Volkskultur," in *Volksreligion im hohen und späten Mittelalter*, ed. P. Dinzelbacher and D. R. Bauer, Quellen und Forschungen aus dem Gebiet der Geschichte n.s.13 (Paderborn, 1990), 29–40.

17. Both examples cited by A. Speer, "Thomas von Aquin und die Kunst: Eine hermeneutische Anfrage zur mittelalterlichen Ästhetik," *Archiv für Kulturgeschichte* 72 (1990), 323–45, esp. 345. See also R. Wielockx, "Poetry and Theology in the *Adoro te deuote*. Thomas Aquinas on the Eucharist and Christ's Uniqueness," in *Christ among*

the *Medieval Dominicans: Representations of Christ in the Texts and Images of the Order of Preachers*, ed. K. Emery Jr. and J. Wawrykow (Notre Dame, Ind., 1998), 157–74.

18. See B. Hamm, *Frömmigskeitstheologie am Anfang des 16. Jahrhunderts*, Beiträge zur historischen Theologie 65 (Tübingen, 1982); and B. Hamm, "Normative Centering in the Fifteenth and Sixteenth Centuries: Observations on Religiosity, Theology, and Iconology," *Journal of Early Modern History* 3 (1999), 307–54, esp. 328–29. Hamm, however, underestimates the extent to which late medieval devotional imagery cannot be accommodated within his vision of "normative centering." For "vernacular theology," see N. Watson, *Richard Rolle and the Invention of Authority*, Cambridge Studies in Medieval Literature 13 (Cambridge, 1991).

19. See N. Bériou, "De la lecture aux épousailles: Le rôle des images dans la communication de la Parole de Dieu au XIIIe siècle," *Cristianesimo nella storia* 14 (1993), 535–68; N. Bériou, *L'Avènement des maîtres de la Parole: La Prédication à Paris au XIIIe siècle*, Collection des Études Augustiniennes: Série Moyen Âge et Temps Modernes 31 (Paris, 1998); and J. F. Hamburger, "The 'Various Writings of Humanity': Johannes Tauler on Hildegard of Bingen's *Liber Scivias*," in *Images and Objects: Visual Culture and the German Middle Ages*, ed. K. Starkey and H. Wenzel (London, forthcoming).

20. *Contre le Roman de la Rose*, in *Œuvres complètes*, ed. P. Glorieux (Paris, 1996); quoted by B. Buettner, "Profane Illuminations, Secular Illusions: Manuscripts in Late Medieval Courtly Society," *ArtB* 74 (1992), 75–90, note 67. B. Newman (*God and the Goddesses: Vision, Poetry, and Belief in the Middle Ages* [Philadelphia, 2002], 283–84) notes of Gerson's objections to images that "what bothered Gerson and his successors was less a doctrinal error than the sheer, goddess-like grandeur and autonomy of the *Vierge ouvrante*—not to mention the female mystics who emulated her and aspired in their turn to become the Trinity's brides."

21. Bériou, *L'Avènement* (as in note 19), vol. 1, 231.

22. The sermon requires a more extensive analysis; see Bonaventure, *Opera theologica selecta*, vol. 5, *Tria opuscula, sermones theologici* (Florence, 1954), 368–74.

23. P. Binski, "The Angel Choir at Lincoln and the Poetics of the Gothic Smile," *Art History* 20 (1997), 350–74, esp. 356. Binski draws on ideas in C. W. Bynum, *The Resurrection of the Body in Western Christianity, 200–1336* (New York, 1995).

24. Quoted from C. Gilbert, *The Saints' Three Reasons for Paintings in Churches* (Ithaca, N.Y., 2001), 7.

25. For approaches to the history of "experience" as a historical category within the traditions relevant here, see *Religiöse Erfahrung: Historische Modelle in christlicher Tradition*, ed. W. Haug and D. Mieth (Munich, 1992). Cf. the comments of M. Jay, "Songs of Experience: Reflections on the Debate over *Alltagsgeschichte*," in *Cultural Semantics: Keywords of Our Time* (Amherst, 1998), 37–46, esp. 46: "My larger point is that whatever the historical era, the simple opposition between a historiography based on empathetic reexperiencing of subjective experiences and one seeking to explain the structural workings of the system as a whole is untenable. For the term 'experience' cannot be simply used as the antithesis of conceptual or

explanatory theory; like all other placeholders of immediacy, it is inevitably mediated as soon as we try to think it through."

26. See, e.g., R. Fulton, *From Judgment to Passion: Devotion to Christ and the Virgin Mary, 800–1200* (New York, 2002). See also R. L. A. Clark, "Constructing the Female Subject in Late Medieval Devotion," in *Medieval Conduct*, ed. K. Ashby and R. L. A. Clark, Medieval Cultures 29 (Minneapolis, 2001), 160–82.

27. See, e.g., J. F. Hamburger, "The Reformation of Vision," in *The Visual and the Visionary: Art and Female Spirituality in Late Medieval Germany* (New York, 1998).

28. See H. L. Kessler, "Gregory the Great and Image Theory in Northern Europe in the Twelfth and Thirteenth Centuries," in *A Companion to Medieval Art: Romanesque and Gothic in Northern Europe*, Blackwell Companions to Art History, ed. C. Rudolph (Oxford, forthcoming).

29. Gilbert, *The Saints' Three Reasons* (as in note 24), 7.

30. *Der sogenannte St. Georgener Prediger aus der Freiburger und der Karlsruhe Handschriften*, ed. K. Rieder, Deutsche Texte des Mittelalters 10 (Berlin, 1908), 248: "In zwo wis wil úns Got kúnden an der hailgen schrift: an den rehten weg ze hýmelriche und an rehtes leben. won alz dú sunne erlýtet den úns Gottes sun lerte mit sin selbes munde, und die hailgen propheten und die hailgen zwelfbotten und ander hailgen, den der hailig gaist kunte und lerte wie si die hailig cristenhait leren soltent. Ain ander schrift hat úns ôch únser herre gegeben, daz ist der laýgen schrift; won der lúte ist vil die der schrift nit kunnent die an den búchen ist geschriben, und dar umb hât in Got ain ander schrift geben, da si an lernent wie si nach dem hymelriche sont werben. dú schrift ist daz gemålde in der kirchen von den hailgen, wie sú lebtent und waz si durch Got tatent und waz si durch in arbait littent."

31. For detailed case studies of this theology of vision, see C. Hahn, *Portrayed on the Heart: Narrative Effect in Pictorial Lives of Saints from the Tenth through the Thirteenth Century* (Berkeley, 2001).

32. Gregorius Magnus, *Reg. pastoralis* II.10 (SC 381, 242); quoted by K. Faupel-Drevs, *Vom rechten Gebrauch der Bilder im liturgischen Raum: Mittelalterliche Funktionsbestimmungen bildender Kunst im Rationale divinorum officiorum des Durandus von Mende (1230/1–1296)* (Leiden, Boston, and Cologne, 2000), 268: "Dum exteriorum rerum intrinsecus species attrahuntur, quasi in corde depingitur, quicquid fictis ymaginibus deliberando cogitatur."

33. See the commentary in Faupel-Drevs, *Vom rechten Gebrauch der Bilder im liturgischen Raum* (as in note 32), 269.

34. Hamburger, "Von Jhesus bettlein," in *The Visual and the Visionary* (as in note 27), 383–426. See also G. Bauer, *Claustrum animae: Untersuchungen zur Geschichte der Metapher vom Herzen als Kloster*, vol. 1, *Entstehungsgeschichte* (Munich, 1973); A. Sauvy, *Le Miroir du cœur: Quatre siècles d'images savantes et populaires* (Paris, 1989); E. Jager, *The Book of the Heart* (Chicago, 2000); and, for still later applications of the theme, K. Krüger, "Innerer Blick und ästhetisches Geheimnis: Caravaggios 'Magdalena'," in *Barocke Inszenierung: Akten des Internationalen Forschungscolloquiums an der Tech-*

nischen *Universität Berlin, 20.–22. Juni 1996*, ed. J. Imorde, F. Neumeyer, and T. Weddingen (Emsdetten and Zurich, 1999), 33–49.

35. See R. Bugge, "Effigiem Christi, qui transis, semper honora: Verses Condemning the Cult of Sacred Images in Art and Literature," in *Acta ad archaeologiam et artium historiam pertinentia* 6 (1975), 133–36; A. Arnulf, *Versus ad picturas: Studien zur Titulusdichtung als Quellengattung der Kunstgeschichte von der Antike bis zum Hochmittelalter* (Munich and Berlin, 1997), 276; and, for a specific example, N. Zchomelidse, "Das Bild im Busch: Zu Theorie und Ikonographie der alttestamentlichen Gottesvision im Mittelalter," in *Die Sichtbarkeit des Unsichtbaren: Zur Korrelation von Text und Bild im Wirkungskreis der Bibel. Tübinger Symposion*, ed. B. Janowski and N. Zchomelidse (Stuttgart, 2003), 165–89, 273–84.

36. See H. L. Kessler, "Real Absence: Early Medieval Art and the Metamorphosis of Vision," in *Morfologie sociali e culturali in Europa fra Tarda Antichità e Alto Medioevo, 3–9 aprile 1997*, Settimane di studio del Centro italiano di studi sull'Alto Medioevo 45 (Spoleto, 1998), 1157–1211, reprinted in H. L. Kessler, *Spiritual Seeing: Picturing God's Invisibility in Medieval Art* (Philadelphia, 2000), 104–48; and J. F. Hamburger, "Seeing and Believing: The Suspicion of Sight and the Authentication of Vision in Late Medieval Art," in *Imagination und Wirklichkeit: Zum Verhältnis von mentalen und realen Bilder in der Kunst der frühen Neuzeit*, ed. A. Nova and K. Krüger (Mainz, 2000), 47–70.

37. See, for the former, C. Barber, *Figure and Likeness: On the Limits of Representation in Byzantine Iconoclasm* (Princeton, 2002), and, for the latter, K. Krüger, *Das Bild als Schleier des Unsichtbaren: Ästhetische Illusion in der Kunst der frühen Neuzeit in Italien* (Munich, 2001), forthcoming as *The Image as a Veil of the Invisible: Aesthetic Illusion in the art of Early Modern Italy*, trans. D. Hamburger (New York, 2005). In various essays, Andreas Speer has taken a more stringent position, but in most cases he is arguing only from textual sources, not from the images themselves; see, e.g., "Thomas von Aquin und die Kunst: Eine hermeneutische Anfrage zur mittelalterlichen Ästhetik," *Archiv für Kulturgeschichte* 72 (1990), 323–45, and the essays gathered in *Mittelalterliches Kunsterleben nach Quellen des 11. bis. 13. Jahrhunderts*, ed. G. Binding and A. Speer (Stuttgart, 1993), where, as in his essay in this volume, he argues for the importance of the liturgy as a defining context for the experience of medieval art and architecture. See also A. Speer, "Kunst als Liturgie: Zur Entstehung und Bedeutung der Kathedrale," in " . . . kein Bildnis machen": Kunst und Theologie im Gespräch, ed. C. Dohmen and T. Sternberg (Würzburg, 1987), 97–117; and A. Speer, "Lux mirabilis et continua: Anmerkungen zum Verhältnis von mittelalterlicher Lichtspekulation und gotischer Glaskunst," in *Himmelslicht: Europäische Glasmalerei im Jahrhundert des Kölner Dombaus (1248–1349)*, exh. cat., ed. R. Becksmann and H. Westermann-Angerhausen (Cologne, 1998), 89–94.

38. See J. van Engen, "Theophilus Presbyter and Rupert of Deutz: The Manual Arts and Benedictine Theology in the Early Twelfth Century," *Viator* 11 (1980), 147–63; and B. Reudenbach, "'Ornatus materialis domus Dei': Die theologische Legitimation handwerklicher Künste bei

Theophilus," in *Studien zur Geschichte der Europäischen Skulptur im 12./13. Jahrhundert*, ed. H. Beck and K. Hengevoss-Dürkopp (Frankfurt am Main,1994), vol. 1, 1–16.

39. C. Gilbert, "A Statement of the Aesthetic Attitude around 1230," *Hebrew University Studies in Literature and the Arts* 13 (1985), 139.

40. As Belting himself has shown; see H. Belting, "Die Reaktion der Kunst des 13. Jahrhunderts auf den Import von Reliquien und Ikonen," in *Ornamenta Ecclesiae: Kunst und Künstler der Romanik*, exh. cat., ed. A. Legner; 3 vols. (Cologne, 1985), 173–83; and the essays on relics and reliquaries edited by C. W. Bynum and P. Gerson in *Gesta* 35, no. 1 (1997). See also P. Dinzelbacher, "Die 'Realpräsenz' der Heiligen in ihren Reliquaren und Gräbern nach mittelalterlichen Quellen," in *Heiligenverehrung in Geschichte und Gegenwart*, ed. P. Dinzelbacher and D. R. Bauer (Ostfildern, 1990), 115–74; A. Angenendt, *Heilige und Reliquien: Die Geschichte ihres Kultes vom frühen Christentum bis zur Gegenwart* (Munich, 1994); and J.-C. Schmitt, "Les Reliques et les images," in *Les Reliques: Objets, cultes, symboles. Actes du colloque international de l'Université du Littoral-Côte d'Opale (Boulogne-sur-Mer), 4–6 septembre 1997*, ed. E. Buzóky and A.-M. Helvétius (Turnhout, 1999), 145–67.

41. See B. Decker, *Das Ende des mittelalterlichen Kultbildes und die Plastik Hans Leinbergers*, Bamberger Forschungen zur Kunstgeschichte und Denkmalpflege 3 (Bamberg, 1985); and B. Decker, "Kultbild und Altarbild im Spätmittelalter," in *"Ora pro nobis": Bildzeugnisse spätmittelalterlicher Heiligenverehrung: Vortragsreihe*, exh. cat., ed. H. Siebenmorgen (Karlsruhe, 1994), 55–87.

42. See J. Tripps, *Das handelnde Bildwerk in der Gotik: Forschungen zu den Bedeutungsschichten und der Funktion des Kirchengebäudes und seiner Ausstattung in der Hoch- und Spätgotik* (Berlin, 1998), 26–27. Unfortunately, Tripps is uncritical regarding the literature on the symbolism of the Gothic cathedral.

43. See also G. Henderson, "Narrative Illustration and Theological Exposition in Medieval Art," in *Religion and Humanism: Studies in Church History* 17 (1981), 229–53; and H. L. Kessler, "Medieval Art as Argument," in *Iconography at the Crossroads* (as in note 14), 59–74.

44. R. Berliner, "The Freedom of Medieval Art," *GBA* 6, no. 28 (1945), 263–88; reprinted with other essays that touch on the relationship of art and theology in *Rudolf Berliner (1886–1967): "The Freedom of Medieval Art" und andere Studien zum christlichen Bild*, ed. R. Suckale (Munich, 2003), 60–75. Berliner's article has not been entirely ignored; Gilbert ("Aesthetic Attitude" [as in note 39]) takes issue with some of its conclusions. J.-C. Schmitt ("Normen für die Produktion und Verwendung von Bildern im Mittelalter," in *Prozesse der Normbildung und Normveränderung im mittelalterlichen Europa*, ed. D. Ruhe and K.-H. Spieß [Stuttgart, 2000], 5–26; translated and reprinted as "Liberté et normes des images occidentales," in *Le Corps des images: Essais sur la culture visuelle au Moyen Âge* [Paris, 2002], 136–64, 137) notes, "Rares sont ceux qui ont tenté de poser au fond la question de l'explication de la norme et de l'art chrétien. L'exception qui confirme la règle est l'article de Rudolf Berliner."

45. For three different views of Schapiro, see O. K. Werckmeister, review of M. Schapiro's *Romanesque Art* in *Art*

Quarterly, n.s. 2 (1979), 211–18; M. Camille, "'How New York Stole the Idea of Romanesque Art': Medieval, Modern, and Postmodern in Meyer Schapiro," *The Oxford Art Journal* 17 (1994), 65–75; and, most recently, J. Williams, "Meyer Schapiro in Silos: Pursuing an Iconography of Style," *ArtB* 85 (2003), 442–68.

46. Berliner, *"The Freedom of Medieval Art"* (as in note 44), 60.

47. Schmitt ("Liberté et normes" [as in note 44], 163) makes much the same point.

48. Schmitt, "Liberté et norms" (as in note 44), 138.

49. The literature on iconoclasm is too vast to be surveyed here. Recent studies outstanding for their scope include S. Michalski, *The Reformation and the Visual Arts: The Protestant Image Question in Western and Eastern Europe* (London and New York, 1993); and A. Besançon, *The Forbidden Image: An Intellectual History of Iconoclasm*, trans. J. M. Todd (Chicago, 2000).

50. For this later development, see C. Hecht, *Katholische Bildertheologie im Zeitalter von Gegenreformation und Barock* (Berlin, 1997); Molanus, *Traité des saintes images*, intro., trans., and ed. F. Boespflug, O. Christin, and B. Tassel, 2 vols. (Paris, 1996); and F. Boespflug, *Dieu dans l'art: Sollicitudini Nostrae de Benoît XIV (1745) et l'affaire Crescence de Kaufbeuren*, preface A. Chastel, afterword L. Ouspensky (Paris, 1984).

51. See, e.g., Kessler, "Medieval Art as Argument" (as in note 43).

52. See the essays gathered in *Artistic Integration in Gothic Buildings*, ed. V. C. Raguin, K. Brush, and P. Draper (Toronto, 1995).

53. See F. Ohly, "Die Kathedrale als Zeitenraum: Zum Dom von Siena," in *Schriften zur mittelalterlichen Bedeutungsforschung* (Darmstadt, 1977), 171–73. Ohly speaks of the structure and its many different decorative programs in terms of "Das Sehen des Ganzen" without considering the building's checkered construction history and many changes of plan.

54. See, e.g., R. Suckale, "La théorie de l'architecture au temps des cathédrales," in *Les Bâtisseurs des cathédrales gotiques*, exh. cat., ed. R. Recht (Strasbourg, 1989), 41–50.

55. See, e.g., B. Boerner, *Par caritas par meritum: Studien zur Theologie des gotischen Weltgerichtsportals in Frankreich—am Beispiel des mittleren Westeingangs von Notre-Dame in Paris*, Scrinium Friburgense: Veröffentlichungen des Mediaevistischen Instituts der Universität Freiburg 7 (Freiburg, Switzerland, 1998).

56. É. Mâle, "General Character of Medieval Iconography," in *Religious Art in France: The Thirteenth Century. A Study of Medieval Iconography and Its Sources*, ed. H. Bober (Princeton, 1984), 4.

57. A. Katzenellenbogen, *The Sculptural Programs of Chartres Cathedral: Christ, Mary, Ecclesia* (New York, 1959).

58. For Suger and St.-Denis, see the literature cited by A. Speer in his contribution to this volume.

59. See the contribution of A. Speer to this volume.

60. See P. Crossley, "Medieval Architecture and Meaning: The Limits of Iconography," *Burlington Magazine* 130 (1988), 116–21; and his invaluable introduction, "Frankl's Text: Its Achievement and Significance," to P. Frankl, *Gothic Architecture*, revised by P. Crossley (New Haven and London, 2000), 7–34.

61. On Panofsky's *Gothic Architecture and Scholasticism*, see most recently E. Inglis, "Gothic Architecture and a Scholastic: Jean de Jandun's *Tractatus de laudibus Parisius* (1323)," *Gesta* 42 (2003), 63–85.

62. F. Piper, *Einleitung in die Monumentale Theologie: Eine Geschichte der christlichen Kunstarchäologie und Epigraphik. Nachdruck der Ausgabe Gotha 1867*, intro. H. Bredekamp, Kunstwissenschaftliche Studientexte 4 (Mittenwald, 1978). Bredekamp's introduction includes a careful parsing of the changing connotations of the terms "monument" and "monumental" in eighteenth- and nineteenth-century thought.

63. Quoted by Bredekamp, in Piper, *Einleitung in die Monumentale Theologie* (as in note 62), E14.

64. Piper, *Einleitung in die Monumentale Theologie* (as in note 62), 33.

65. Piper, *Einleitung in die Monumentale Theologie* (as in note 62), 33.

66. M. Jay, *Downcast Eyes: The Denigration of Vision in Twentieth-Century French Thought* (Berkeley, 1994).

67. Piper, *Einleitung in die Monumentale Theologie* (as in note 62), 33.

68. Piper, *Einleitung in die Monumentale Theologie* (as in note 62), 33.

69. See also O. Pächt, "Panofsky's 'Early Netherlandish Painting,'" *Burlington Magazine* 98 (1956), 110–16 and 267–79; C. Wood, ed., *The Vienna School Reader: Politics and Art Historical Method in the 1930s* (New York, 2000), 38–40; and Wood, "Introduction," in O. Pächt, *The Practice of Art History: Reflections on Method*, trans. D. Britt (London, 1999), 13–14.

70. Pächt, review of Panofksy (as in note 69), 276. .

71. Pächt, *Practice of Art History* (as in note 69) 84.

72. Pächt, *Practice of Art History* (as in note 69), 84–85.

73. O. Pächt, *Book Illumination in the Middle Ages: An Introduction*, preface J. J. G. Alexander, trans. K. Davenport (London and Oxford, 1986), 44. For allegorical readings of initials of the kind addressed by Pächt, see R. Suntrup, in *"Te-igitur* Initialen und Kanonbilder in mittelalterlichen Sakramentarhandschriften," in *Text und Bild: Aspekte des Zusammenwirkens zweier Künste in Mittelalter und früher Neuzeit*, ed. C. Meier and U. Ruberg (Wiesbaden, 1980), 278–382.

74. Pächt, *Book Illumination in the Middle Ages* (as in note 73), 44.

75. Pächt, *Practice of Art History* (as in note 69), 137.

76. W. J. T. Mitchell, *Iconology: Image, Text, Ideology* (Chicago, 1986), 47.

77. Mitchell, *Iconology* (as in note 76), 47.

78. Mitchell, *Iconology* (as in note 76), 47. This despite the observation made by Wood in Pächt, *Practice of Art History* (as in note 69), 13–14, that "Pächt considered himself a scientific historian" who mistrusted "Romantic or idealist notions about genius or beauty."

79. Piper, *Einleitung in die Monumentale Theologie* (as in note 62), 27–28.

80. Piper, *Einleitung in die Monumentale Theologie* (as in note 62), 27: "sie reicht auch an das Uebersinnliche und hat die Macht der Ideen."

81. M. Camille, *The Gothic Idol: Ideology and Image-Making in Medieval Art* (Cambridge, 1989).

82. See, e.g., J. J. G. Alexander, *Medieval Illuminators and Their Methods of Work* (New Haven, 1992), and S.

Hindman, "The Roles of the Author and the Artist in the Procedure of Illuminating Late Medieval Texts," in *Text and Image, Acta*, vol. 10 (Binghamton, N.Y., 1983), 27–62.

83. See B. Kurmann-Schwarz and P. Kurmann, *Chartres: Die Kathedrale* (Regensburg, 2001), 217–23, with reference to previous scholarship. Years ago, Ernst Gombrich made a similar point about the iconography of the Stanze della Segnatura; see E. Gombrich, "Raphael's *Stanza della Segnatura* and the Nature of Its Symbolism," in *Symbolic Images*, Studies in the Art of the Renaissance 2 (Oxford, 1972), 85–101.

84. M. Schapiro, "The Artist's Reading of a Text," in *Words, Script, and Pictures: Semiotics of Visual Language* (New York, 1996), 11–23, 96–97.

85. See, e.g., the range of responses represented in "Questionnaire on Visual Culture," *October* 77 (1996), 25–70.

86. M. Baxandall, "Pictorially Enforced Signification: St. Anthonius, Fra Angelico, and the Annunciation," in *Hülle und Fülle: Festschrift für Tilman Buddensieg*, ed. A. Beyer, V. Lampugnani, and G. Schweikhart (Alfter, 1993), 31–39.

87. Binski, "Angel Choir" (as in note 23), 361.

88. Identified and discussed by P. von Moos, "Was galt im lateinischen Mittelalter als das Literarische an der Literatur? Eine theologisch-rhetorische Antwort des 12. Jahrhunderts," in *Literarische Interessenbildung im Mittelalter: DFG-Symposion 1991*, ed. J. Heinzle (Stuttgart, 1993), 431–51.

89. Von Moos, "Eine theologisch-rhetorische Antwort" (as in note 88), 432: "Zu besagter 'versehentlicher Entdeckung' kam es beim Studium sprachlogischer Reflexionen des 12. Jahrhunderts hauptsächlich im Bereich der Theologie, die das Verhältnis rhetorischer und dialektischer Argumentationsstrukturen klären sollten und unerwartet ein Licht auf das historisch wichtigste Unterscheidungskriterium von Literatur und Nicht-Literatur warfen: die sprachliche *transsumptio*."

90. Von Moos, "Eine theologisch-rhetorische Antwort" (as in note 88), 432: "Die *theologia*, verstanden als die dem höchsten Gegenstand angemessene Sprache und als die damit beschäftigte Sprachtheorie, die anspruchsvollste 'Linguistik,' war der Ort, an dem das Poetische als eigener Wert, nicht bloß als triviales Instrument der Didaktik denkbar wurde. Aus der Theologie stammt die Legitimationsbasis einer bewußten kreativen Imitatio des 'prophetischen' Worts und später einer philosophischen Emanzipation profaner Fiktionalität, die zur Vorgeschichte neuzeitlicher Autonomie-Ästhetik gehört." On this same subject, see also *Medieval Literary Theory and Criticism, c. 1100–c. 1375: The Commentary-Tradition*, ed. A. J. Minnis and A. B. Scott, with the assistance of D. Wallace (Oxford, 1988).

91. See H. R. Jauß, "Über religiöse und aesthetische Erfahrung: Zur Debatte um Hans Beltings *Bild und Kult* und Georg Steiners *Von realer Gegenwart*," *Merkur: Deutsche Zeitschrift für europäisches Denken* 45 (1991), 934–46; H. R. Jauß, "Die klassische und die christliche Rechtfertigung des Häßlichen in mittelalterlichen Literatur," in *Die nicht mehr Schönen Künste: Grenzphänomene des Ästhetischen*, Poetik und Hermeneutik 3 (Munich, 1968), 143–68, esp. 156–58, reprinted in H. R. Jauß, *Alterität und Modernität der mittelalterlichen Literatur: Gesam-*

melte Aufsätze, 1956–1976 (Munich, 1977), 385–409; and W. Haug, "Die Voraussetzungen antiker Rhetorik und christlicher Ästhetik," in *Literaturtheorie im deutschen Mittelalter von den Anfängen bis zum Ende des 13. Jahrhunderts* (Darmstadt, 1992), 7–24, translated as *Vernacular Literary Theory in the Middle Ages: The German Tradition, 800–1300, in Its European Context*, trans. J. M. Catling (Cambridge, 1997).

92. G. Didi-Huberman, "Puissance de la figure: Exégèse et visualité dans l'art chrétien," in *Encyclopedia Universalis: Symposium* (Paris, 1990), 608–21, translation from *The Power of the Figure: Exegesis and Visuality in Christian Art*, trans. K. Burman and R. Spolander (Umeå, Sweden, n.d.), 23. For a very different way of construing links between art and theology, in particular as they related to the origins of naturalism in the visual arts, see J. Wirth, "Les Scholastiques et l'image," in *La Pensée de l'image: Signification et figuration dans le texte et dans la peinture*, ed. G. Mathieu-Castellani (Vincennes, 1994), 20–30.

93. M. H. Caviness, "Images of Divine Order and the Third Mode of Seeing," *Gesta* 22 (1984), 99–120.

94. See, e.g., A. C. Esmeijer, *Divina quaternitas: A Preliminary Study in the Method and Application of Visual Exegesis* (Amsterdam, 1978). The literature on diagrams is too large to be summarized here. In addition to the pioneering studies of H. Bober, "An Illustrated Medieval School-Book on Beda's 'De natura rerum'," *JWalt* 19–20 (1956), 65–97, and "*In principio*: Creation before Time," in *De artibus opuscula XL: Essays in Honor of Erwin Panofsky* (New York, 1961), 13–28, see A. Krüger and G. Runge, "Lifting the Veil: Two Typological Diagrams in the *Hortus deliciarum*," *JWarb* 60 (1997), 1–22; and K.-A. Wirth, "Von mittelalterlichen Bildern und Lehrfiguren im Dienste der Schule und des Unterrichts," in *Studien zum städtischen Bildungswesen des späten Mittelalters und der frühen Neuzeit: Bericht über Kolloquien der Kommission zur Erforschung der Kultur des Spätmittelalters, 1978 bis 1981*, ed. B. Moeller, H. Patze, and K. Stackmann, with the assistance of L. Grenzmann, *AbhGött, Philol.-hist.Kl.*, ser. 3, vol. 137 (1983), 256–370.

95. See, e.g., W. Kemp, *Christliche Kunst: Ihre Anfänge, Ihre Strukturen* (Munich, 1994): "Die bildende Kunst der Christen ist aber auch und erst recht keine nachgeordnete Illustration ihrer Theologie. Die Kunst hat die frühe Obsession der Theologie mit der Allegorese nicht geteilt. . . . Sie ist unabdingbares Agens in jenem unabschließbaren Prozeß, der Christentum heißt und der gleichermaßen von der Faszination wie von den Desideraten seiner Textgrundlage lebt, die zuallerst Erzählung ist" (19); and "Theologie konstituiert sich auf der Basis des Kanons als Schrifttheologie, aber nicht eigentlich als Philologie oder Hermeneutik einer großen Erzählung" (94). Script is the foundation, exegesis the superstructure. One might ask, what about the prophetic and the wisdom books, as well as the psalms, the Pauline Epistles, and the Apocalypse, not to mention the parables and typological passages placed in the mouth of Jesus by the Gospels?

96. For a representative statement, see Kemp, *Christliche Kunst* (as in note 95), 72: "Die Heilige Schrift ist für die christliche Kunst nicht nur 'Grund und Quelle', sie und ihre Vertreter bilden vielmehr ein unverzichtbares Aufbau- und Verstrebungselement jener Weltsummen, an denen die Bildsysteme bauen." Kemp's approach differs

from that represented by the essays in *Der Himmel über der Erde: Kosmossymbolik in mittelalterlicher Kunst*, ed. F. Möbius (Leipzig, 1995), which tends to treat art merely as a vessel for theological content.

97. See, e.g., Kemp, *Christliche Kunst* (as in note 95), 265: "Die Kunst folgt einem anderen Offenbarungsverständnis, einem 'geschichtlichen Credo.' Ihre Distanz zur Deutungsart der Allegorese schließt nicht aus, daß sie von der Theologie und von der christlichen Literatur profitiert: Die Kunst pflegt die Typologie, wie es die Väterexegese tut, aber aus dem anderen Grund, daß sie ihr hilft, Geschichte durch Analogien thematisch durchsichtig zu machen." Despite their conceptual clarity, one possible problem with such statements is the way in which they elevate "art" to an abstract principle divorced from artists, patrons, or any form of context, however construed.

98. See M. Pippal, "Von der gewußten zur geschauten similitudo: Ein Beitrag zur Entwicklung der typologischen Darstellungen bis 1181," *Kunsthistoriker: Mitteilungen des Österreichischen Kunsthistorikerverbandes* 4 (1987), 53–61; C. Hughes, "Visual Typology: An Ottonian Example," *Word & Image* 17 (2001), 185–98; and, more generally, H. Holländer, " . . . inwendig voller Figur": Figurale und typologische Denkformen in der Malerei," in *Typologie: Internationale Beiträge zur Poetik*, ed. V. Bohn (Frankfurt am Main, 1988), 166–205. Often ignored, but of continuing interest on typological imagery, is F. Pickering, *Literature and Art in the Middle Ages* (Coral Gables, 1970), esp. 223–307.

99. Among the considerable literature on the subject, see K. Bauch, "Imago," in *Beiträge zu Philosophie und Wissenschaft. Wilhelm Szilasi zum 70. Geburtstag* (Munich, 1960), 9–28, reprinted in Bauch, *Studien zur Kunstgeschichte* (Berlin, 1967), 1–20; S. Otto, *Die Funktion des Bildbegriffes in der Theologie des 12. Jahrhunderts* (Münster, 1963); and R. Javelet, *Image et ressemblance au douzième siècle de Saint Anselme à Alain de Lille*, 2 vols. (Strasbourg, 1967).

100. J. Pelikan, *Imago Dei: The Byzantine Apologia for Icons*, Bollingen Series 35 (Princeton, 1990); and G. B. Ladner, "The Concept of the Image in the Greek Fathers and the Byzantine Iconoclastic Controversy," *DOP* 7 (1953), 1–34, reprinted in Ladner, *Images and Ideas in the Middle Ages: Selected Studies in History and Art*, 2 vols., Storia et Letteratura 155 (Rome, 1983), vol. 1, 73–111.

101. See, e.g., G. B. Ladner, *"Ad imaginem dei": The Image of Man in Medieval Art* (LaTrobe, Pa., 1965); J.-C. Schmitt, "La Culture de l'imago," *Annales HSS* 1 (1996), 3–36; and J. F. Hamburger, *St. John the Divine: The Deified Evangelist in Medieval Art and Theology* (Berkeley, 2002).

102. See W. Dürig, *Imago: Ein Beitrag zur Terminologie und Theologie der römischen Liturgie*, Münchener Theologische Studien II. Systematische Abteilung 5 (Munich, 1952).

103. See *Corpus orationum*, ed. E. Moeller, J. M. Clément, and B. Coppieters 't Wallant, CCSL 160B (Turnhout, 1993), no. 1962, vol. 3, 121: "Deus, qui peccati veteris hereditariam mortem, in qua posteritatis genus omne successerat, Christi tui domini nostri passione solvisti, dona, ut, conformes eidem facti, sicut imaginem terreni naturae necessitate portavimus, ita imaginem caelestis gratiae sanctificatione portemus." On the imagery of the prayer,

portions of which paraphrase Romans 8:29 and I Corinthians 15:45–49, see Dürig, *Imago* (as in note 102), 69. Cf. *Corpus orationum*, CCSL 160C, no. 2608, vol. 4, 109: "Fac, omnipotens deus, ut, qui paschalibus remediis innovati, similitudinem terreni parentis evasimus, ad forman caelestis transferamur auctoris."

104. *Corpus orationum*, CCSL 160C, no. 2736a, vol. 4, 169: "Gratia tibi sit, domine, quaesumus hodiernae festivitatis oblatio, ut, tua gratia largiente, per haec sacrosancta commercia in illius inveniamur forma, in quo tecum est nostra substantia." Discussed by Dürig, *Imago* (as in note 102), 74–75.

105. See, e.g., *Der Begriff der Repraesentatio im Mittelalter*, ed. A. Zimmermann and G. Vuillemin-Diem (Berlin, 1971); and S. Michalski, "Bild, Spiegelbild, Figura, Repraesentatio: Ikonitätsbegriffe im Spannungsfeld zwischen Bilderfrage und Abendmahlskontroverse," *Annuarium Historiae Conciliorum: Internationale Zeitschrift für Konziliengeschichtsforschung* 20 (1988), 458–88.

106. Gertrude of Helfta combines the two meanings in the Legatus; see Hamburger, *The Visual and the Visionary* (as in note 27), 350–59. The two poles come together in the case of the traces of Christ's footprints in the Holy Land; see A. Worm, "Steine und Fußspuren Christi auf dem Ölberg: Zu zwei ungewöhnlichen Motiven bei Darstellungen der Himmelfahrt Christi," *ZKunstg* 66 (2003), 297–320.

107. See, inter alia, J.-C. Schmitt, "*Imago*: de l'image à l'imaginaire," in *L'image: Fonctions et usages des images dans l'Occident médiéval*, ed. J. Baschet and J.-C. Schmitt, Cahiers du Léopard d'Or 5 (Paris, 1996), 29–37.

108. Hamburger, *The Visual and the Visionary* (as in note 27), and G. Wolf, *Schleier und Spiegel: Traditionen des Christusbildes und die Bildkonzepte der Renaissance* (Munich, 2002). For some related concepts, K. Krüger, " . . . figurano cose diverse da quelle che dimonstrano': Hermetische Malerei und das Geheimnis des Opaken," in *Das Geheimnis am Beginn der europäischen Moderne*, ed. G. Engel et al. (Frankfurt am Main, 2002), 408–35.

109. See K. H. Tachau, *Vision and Certitude in the Age of Ockham: Optics, Epistemology, and the Foundations of Semantics, 1250–1345*, Studien und Texte zur Geistesgeschichte des Mittelalters 22 (Leiden and New York, 1988); D. Appleby, "The Priority of Sight according to Peter the Venerable," *Mediaeval Studies* 60 (1998), 123–57; Kessler, *Spiritual Seeing* (as in note 36); and *La visione e lo sguardo nel Medio Evo/View and Vision in the Middle Ages*, Micrologus: Natura, scienze e società medievali, 5–6 (Florence, 1997–98).

110. See *B. Alberti Magni, Ratisbonensis episcopi, Ordinis Praedicatorum, Opera Omnia*, ed. A. and E. Borgnet, vol. 24, Enarrationes in Joannem (Paris, 1890), 44: " 'In mundo erat,' id est, visibiliter factus in mundo. . . . Non quidem locum mutando quia ubique est, sed tantum visibilis apparens."

111. M. Camille, *Gothic Art, Glorious Visions* (New York, 1996), 17, as well as the essays in *Visuality before and beyond the Renaissance: Seeing as Others Saw*, ed. R. S. Nelson (Chicago, 2000).

112. Binski ("Poetics" [as in note 23], 369) points out the possible role of Neoplatonic theologies, noting that "the standard line on late-medieval naturalism, . . . argues precisely that it stemmed from Aristotelan nominalism.

This argument, stressing the impact of the thirteenth-century rediscovery of Aristotelian natural philosophy, has been extraordinarily influential." In this respect, Michael Camille's otherwise original work on the illustration of commentaries on Aristotle does not break new ground; see, e.g., Aristotle's *Libri Naturales* in Thirteenth-Century England," in *England in the Thirteenth Century* (1986), 31–43, and "The Discourse of Images in Philosophical Manuscripts of the Late Middle Ages: Aristotle Illuminatus," in *Album: I luoghi dove si accumulano i segni (dal manoscritto alle reti telematiche)*, ed. C. Leonardi, M. Marcello, and F. Santo (Spoleto, 1996).

113. See my Introduction to this volume.

114. In addition to D. N. Bell, *The Augustinian Spirituality of William of St. Thierry* (Kalamazoo, 1984), see F. Boespflug, "Note sur l'iconographie du Prologue de Jean," in *Autour du Prologue de Jean: Hommage à Xavier Léon-Dufour SJ* = *Recherches de science religieuse* 83 (1995), 293–303; and Boespflug, *La Trinité* (as in note 4).

115. See, above all, the contributions of C. W. Bynum: in addition to *Resurrection of the Body* (as in note 23), *Holy Feast and Holy Fast: The Religious Significance of Food to Medieval Women* (Berkeley, 1987); and *Fragmentation and Redemption: Essays on Gender and the Human Body in Medieval Religion* (New York, 1991).

116. Camille, *The Gothic Idol* (as in note 81), 27–72.

117. See J. F. Hamburger, "Speculations on Speculation: Vision and Perception in the Theory and Practice of Mystical Devotions," in *Deutsche Mystik im abendländischen Zusammenhang: Neu erschlossene Texte, neue methodische Ansätze, neue theoretische Konzepte*, Kolloquium Kloster Fischingen, ed. W. Haug and W. Schneider-Lastin (Tübingen, 2000), 353–408.

Anthropology and the Use of Religious Images in the *Opus Caroli Regis (Libri Carolini)*

Karl F. Morrison

Introduction

My subject is what happened to one souvenir of the classical tradition at the court of Charlemagne, the little axiom, "Nothing in excess." In the form *"Ne quid nimis,"* this aphorism acted as the leavening of an enormous book. The story is all the more interesting since Charlemagne himself was the purported author of the treatise. He and his ghostwriter, Theodulf of Orléans (ca. 750–821), were suspicious of things pagan. Evidently, Charlemagne and Theodulf had no inkling of the heathenish origins of "Nothing in excess," carved at the door of Apollo's temple in Delphi, and knew it only as a "proverb" sanctified by use in Benedict's *Rule* and other impeccably Christian texts.

The large treatise is the one that used to be called the *Caroline Books (Libri Carolini)* and is now known as *King Charles's Work (Opus Caroli Regis)*. *King Charles's Work* is a polemic against the Byzantine Council of Nicaea (787), which restored the veneration of sacred images after a period of iconoclasm.[1] Evidently, it was originally intended, with the Synod of Frankfurt (794) in view, to serve as a "position paper" for a debate over the long-running Byzantine controversy. But when the synod met, the debate had been aborted and the treatise shelved. When prospects for both were bright, Theodulf, speaking through the mouth of "Charles," wrote that the treatise was "about images." In this essay, I suggest that, in taking "Nothing in excess" as his leitmotiv, Theodulf actually recovered the original meaning of the axiom "Know thyself." The two Delphic axioms, "Nothing in excess" and "Know thyself," were equivalent and interchangeable; in using them as the spine of his theological polemic, Theodulf constructed a devastating argument against the use of sacred images as tools of self-knowing, an argument that had a vigorous afterlife in the Reformation and Counter-Reformation.[2] Needless to say, I was inspired to look again at the *Opus Caroli Regis* by the magnificent edition lately published by Ann Freeman, with the collaboration of Paul Meyvaert, a work that manages, pace Plato, to realize the ideal.

"Know Thyself"

One fascination of *King Charles's Work* is that Charlemagne commissioned its portrayal of himself, as surely as he later commissioned the portrait bust on his coins, and in some way oversaw

its composition as a state portrait. The title, *King Charles's Work*, means that the treatise was a bit of autobiographical fiction. It is perfectly true that, in the masquerade of ghostwriting, Theodulf speaks through the mask of Charles. The mask was so well in place, however, that in the seventeenth century, Cardinal Robert Bellarmine found it necessary to dispute the authenticity of Charles's authorship. It seemed impossible that Charlemagne could have written this treatise, Bellarmine argued. The king was devoted to Pope Hadrian I, yet the treatise portrayed Charles as vehemently opposed to doctrines set forth by the Second Council of Nicaea and approved by Hadrian. Charles was fluent in Greek and Latin, prudent, and of a lively intellect, while the author of the treatise was "barbaric" (i.e., unskilled in the classical languages), inept, light-minded and almost stupid, making gross errors of fact and attributing to Nicaea positions that it in fact condemned. Was it a modern fabrication? Bellarmine smelled fraud in the general anonymity of its publication. After attacking the anomaly from several angles, he had to ask: What authority would the work carry, with its manifest stupidity, even if it were by Charlemagne? Charlemagne was a layman and a warrior, and, as John Damascene said repeatedly, "Christ confided the Church to bishops and pastors, not to kings and emperors."[3] At any rate, I suggest that *King Charles's Work* is a dramatic soliloquy in which "Charles" constructs a narrative of himself. I make that suggestion, characteristically, in a roundabout way.

As Theodulf worked out the theme "Nothing in excess," he keyed his whole composition to the function of art in Christian worship. The Second Council of Nicaea (787) had affirmed the veneration of sacred images as an essential way to pass from the visible things of this world into God's invisible truths, comparable in some ways with Scripture and sacraments. In taking this stance, the Council had stretched every nerve to kill and bury the judgment of an earlier, quite different, assembly. Crowning thirty years of iconoclastic reform, the Synod of Hiereia (754) abolished the devotional use of images. In laying out its defense of images, Nicaea frequently quoted this enemy, and, in the tangle of argument and counterargument, Theodulf/"Charles" found a clash of two extremes. Both church assemblies, he judged, had violated the axiom "Nothing in excess." They had done so because all parties to the conflict had failed in the essential task of self-knowing. Impelled by arrogance, Greeks of both factions lost all sense of proportion and made the abolition or the use of religious images the keystone of Christian belief.[4]

"Charles" fired the same blast against image-breakers and image-worshipers alike. Images, he declared, had nothing to do with the work of salvation. In fact, they had almost no functions at all, other than as displays of artists' abilities, ornaments, reminders for those of pitiably defective memory, and, perhaps, given the fact that the poor could not afford them, displays of wealth.[5] To achieve the golden mean in doctrine about the use of images, the Greeks would first have to achieve it in ways they knew themselves.

This is where "Charles's" narrative of himself comes into view. Although Theodulf/"Charles" referred to *King Charles's Work* as "our special work about images," it was an elaborate discourse on the possibilities and limits of self-knowing through the use of religious images.[6] Theodulf portrayed Charlemagne, the treatise's putative author (or soliloquist), in the act of self-disclosure, balancing with careful symmetry the errors of the Greeks against the correct beliefs of the Franks. The Greeks did it wrong; the Franks, under Charles, did it right.

Naturally, much is not said in any narrative. In this narrative, what is not said is that worship of images was a real and present danger to the Franks, not among the distant Greeks, but among the unconverted peoples who lived around and among them, traded in their markets and sometimes walked in their monasteries, and often fought against them. Condemned by synods and councils as superstitious under such names as "necromancy" and "sorcery," cult uses of im-

ages was a real and present danger in folk practices among the Franks themselves. Dread of idol-atry runs throughout Carolingian literature because the Franks knew that their own backyard was infested with it; it coiled through their huts and palaces. I believe that this immediate fear is packed into Theodulf/"Charles's" identification of Byzantine veneration with "barbarism" and "paganism," tidily concealed under allusions to survivals of the empire's pre-Christian era. This, as I noted, is unsaid by Theodulf.

The treatise depicts Charles under fire. The Second Council of Nicaea condemned as heretics those for whom the veneration of sacred images was not an article of faith. "We are judged heretics," "Charles" said in the treatise, "because we do not serve images," but "the one and only God," and God alone. The Council had heaped its heaviest condemnations on image-smashers. Though this judgment did not come as close to home as the other, "Charles" still felt obliged to fend off his "enemies" by exonerating the Franks of what was called the crime of iconoclasm.[7]

"Charles's" counterattack against Nicaea required him to defend his credit as king and advo-cate: in other words, to portray himself. As his self-referential argument widened, "Charles" de-fined himself by contrast with those he censured. He was not a woman, born for the relief of men yet despite the God-established frailty and subordination of her sex, presuming to teach men, as did the Byzantine empress Irene. He was not a "perfidious" Jew, or a *barbarus*, generally equiv-alent either with "pagan" or, surprisingly, with "Greek."[8] The religion of the Jews had been tinged with superstition, and, among the Byzantines, the flamboyant superstitions of pagan antiquity continued to flourish both in the cult of images and in the etiquette and language of the imperial court.[9] His religion had no part of superstition. The Franks held to the apostolic tradition of the universal Church, from which the Greeks had cut themselves off when they anathematized their own teachers and consecrators and, indeed, the churches of the whole world.[10] He was not one of the poor, who could not afford to own images. In fact, he adorned the churches in his lands with every conceivable ornament, flashing with gold and silver, costly jewels, and pearls.[11] He was a king, the son of a king, in some way analogous with the holy kings David and Solomon, and with Christ, king and priest.[12] He was not among the simple, who smelled "rustic."[13]

There is no need to indicate here all the points of comparison Theodulf/"Charles" raised in this astonishing parade balancing Byzantine vices against Frankish virtues. Still, the contrast be-tween ignorance and wisdom is worth elaborating. My starting point must be Theodulf's defini-tion of human being (*homo*) as animal (and therefore sensate), rational, and mortal, and having the capacity to laugh. "Charles" argues consistently and at every turn that the Byzantines, rulers and clergy alike, were disqualified for spiritual reasoning because they had not risen above their human nature. To be sure, God had made them in his image and likeness. Yet, as "Charles" put it, by their carnal-mindedness, they had fallen into pride and ignorance; they had lost sight of their divine calling and thereby degraded themselves to the level of irrational beasts.[14]

With devotion that can only be called ruthless, Theodulf portrayed "Charles" as a paragon of theological learning, and more, since mastery of the liberal arts was the prerequisite for competent interpreters of Scripture.[15] Erudition breaks forth in full glory when "Charles" discourses on great subjects of theology (such as the nature of God, the mission of Christ, the sacraments, and miracles), techniques of interpreting Scripture, and methods of textual criticism.[16] Theodulf intended the won-der of "Charles's" learning, apparent on every page, to confound the ignorance of the Greeks.

"Charles" recognized that self-knowing was prone to error. Fools thought themselves wise; knaves thought themselves noble. They looked at themselves, "Charles" said, with closed eyes, as though in a dream.[17] What gave "Charles" his assurance that he too had not mistaken anthro-

pology for theology? It was that he saw Christ daily (*quotidie*) and, in seeing him, received divine virtues from him, the mediator between God and human beings.[18]

Being a Christian made a difference to anyone who wanted to assimilate the pre-Christian classical tradition—even so small a fragment of it as "Know thyself" or "Nothing in excess." Christian assimilators had to reframe even those little axioms with reference to three coordinates: the church (collective order and discipline of a group), Christianity (doctrine accepted by the body of believers as basic to its existence), and Christ (the mediator of sacred mysteries from God to believers, as individuals and as the church corporation). Some Christians identified themselves with reference to Jesus—that is, with the human, suffering side of the Incarnation—rather than with the kingly, prophetic, and priestly offices of Christ. All three coordinates (church, Christianity, and Christ) figure in *King Charles's Work*.

"Charles" took great pains to assert that the Franks conformed with norms of the universal Church. His reframing the pagan axiom "Nothing in excess" in light of the first Christian coordinate, the church, led "Charles" to invoke numerous external authorities, including his obedience to Scripture and apostolic tradition, and to the consensus of the universal Church as declared by ecumenical councils in their creeds and canons. He invoked his adherence to the Roman church, which the Lord made arbiter of authentic teachers, writings, and doctrines by giving it precedence over all other churches, even over other apostolic churches. Perhaps, there was an oblique, reproachful glance at Byzantium in "Charles's" observation that many churches had withdrawn from Rome's "holy and venerable communion." By contrast, the church in his region, he said, had never broken communion with Rome. To the contrary, his father, Pippin, and he had brought into conformity with Roman belief and liturgy an ever-widening circle of peoples in Gaul, Germany, Italy, Saxony, and northern territories, and they had continually received charismata from Rome's apostolic teaching and from God, the source of every good and perfect gift.[19]

Moreover, "Charles" asserted that he upheld the faith in its original and timeless truth, ever old and ever new.[20] Here, we see "Charles" re-contextualizing "Nothing in excess" to suit the second coordinate, Christianity (or doctrine). That was the faith foreshadowed in the Old Testament, preached by Christ, transmitted by the apostles and the pastors of the church who followed them, and incorporated in the decrees of the (then) six ecumenical councils. Driven by pride, ignorance, and sheer insanity, the Greeks had run after new and unprecedented doctrines. In their linguistic ineptitude, they had invented a new vocabulary, violating the apostle Paul's injunction to "avoid all gimcrack words" (1 Tim. 6:20, *profanas vocum novitates*), a verse often invoked in *King Charles's Work*. Nicaea had tried to replace the old beauty Christ gave the church with a new ugliness. They had presumed to command what the Fathers forbade.[21] By contrast with the Greeks, "Charles" asserted, the Franks avoided all disordered verbal follies and kept to the middle of the road ("the path of mediocrity"), upholding the church of apostles, Fathers, and authentic councils.[22]

The core of self-knowing and avoiding profane innovations lay deeper than external conformity with institutional doctrine and order. The core of personal inwardness, recognizably like Abelard's three hundred years later, appears in "Charles's" teaching that God, who searches the heart, judges intentions rather than actions, the will rather than the deed.[23] What made intentions godly was God inhabiting the individual mind, making it his temple and city, irradiating it with divine virtues and spiritual understanding.[24] God himself, the timeless Ancient of Days, was in the heart.

Thus, as "Charles" domesticated "Nothing in excess" to Christian ways, the two coordinates of church and Christianity paled in comparison with the third: namely, Christ. "Charles's" teach-

ings acknowledged only Christ—not the church or its doctrines—as the mediator between God and human beings, the only conduit by which human beings could pass from visible things of the material world to the invisible things of God, who was spirit.[25] "Charles's" recasting of "Nothing in excess" to suit Christian belief has its clearest expression in his emphatic repetition of the apostle Paul's reference to Christ as "the [only] mediator between God and human beings" (1 Tim. 2:5). This phrase occurs so often in *King Charles's Work* as to be a theological signature of the whole book. "Charles's" ideas about mediation powerfully entered into his narrative of himself. Epitomized in the belief that Christ was "our king . . . our emperor,"[26] they sharpened the self-knowing of the Franks as a chosen people, the "spiritual Israel," and set a vivid contrast between them and the Byzantines with their spiritually blind emperors and councils running back and forth between extremes.

For "Charles" himself, the thought that Christ's mediation took place by the actual presence of Christ in the soul heightened the parallel between "Charles" and David, the prophet-king, speaking in the persona of Christ.[27] This implied analogy is closest in passages where "Charles" declares Christ's prophecies of the world's end and Last Judgment. Human skills passed from experts to learners in the liberal arts and medicine, just as farmers learned to farm from other farmers and artists taught their craft to others.[28] But true faith did not pass from experts to beginners.

Theodulf/"Charles" spelled out in some detail how God (or Christ) came to dwell in believers (i.e., in "Charles"), how "we can become gods."[29] Despite his emphasis on history, Theodulf's ideas centered on mediation, unconditioned by time or place.[30] The give-and-take of mediation, he thought, could happen only between individuals who were alike in some essential way. For mediation to occur, there had to be likeness in more than material resemblance on the surface. Thus, there could be no mediation between human beings and pictures, no matter how close a superficial resemblance a portrait might have to its subject. For there was no essential likeness between a "real human being" (*homo verus*), alive and having powers of reason and senses, and a "painted human being" (*homo pictus*), inert and lifeless, without any quickening powers.[31] Beyond image and likeness, a third category of relationship—equivalence or parity—was needed: the give-and-take of mediation.[32]

God had neither like nor equal. But, in the mysterious workings of the Trinity, Christ had the fullness of divinity and took on "all human nature."[33] In his humanity, Christ lived in two zones, exterior (body) and interior (soul or spirit).[34] In his humanity, he was, like all human beings, a "rational and mortal animal, capable of laughter and sensation."[35] Through Christ's equivalence to God and to them, human beings were able to be God, though not until they had put on immortality. Only through this mediation could human beings transcend their humanity, suffer and die with God, who is impassible and immortal, and, finally, when they had put off their mortality, be changed and made like Christ, and reign eternally with him.[36]

In his soliloquy, "Charles" enlarged upon the divine nature of Christ, the Word of God. But, for his doctrine of mediation, Christ's mortal flesh was essential. "Charles" insisted on the concrete when he contrasted the veneration of lifeless images with the veneration of the bodies, clothes, and other physical relics of saints. He defended the cult of relics because holiness inhered in their bodies, even after they had decayed into dust. Even then, saints lived and reigned in heaven with Christ, and hereafter their bodies would be raised and live forever in glory.[37]

With the same concreteness, "Charles" held that Christ descended from heaven by assuming flesh. The cross raised up the mortality of his, and all, flesh. Through the cross, we too shall put off "the tunic of this mortality." With the eye of his mind, "Charles" described Christ as he is,

risen and glorified. He was not concerned with Christ as he had been when he too was robed in the tunic of mortality, but with him as he is, having placed on the Father's right hand the flesh that he had assumed from the Virgin. In Christ's flesh was contained the complete mystery foreshadowed by the Ark of the Covenant that Moses made at God's command.[38] For, in that human and glorified flesh, as in the Ark, were contained the spiritual fulfillment of Aaron's rod (in that Christ ruled as king and priest), the tablets of the Law (the Old and New Testaments), and manna (the bread of heaven). Through the mouth of "Charles," Theodulf described Christ as he thought he had become after the Resurrection and as believers would be when, immortal and glorious, they had been changed into Christ's likeness and lived and reigned with him.[39]

Theodulf/"Charles" left no doubt that Christ's mediation came about through his complete presence, body and soul, in the believer. The sacraments imparted his body and blood. Adhering to Christ spiritually came through reason, the faculty in which God originally planted his image. For, in contemplating Christ, God's power and wisdom, within us, reason is pervaded directly with powers (*virtutes*) from him, divine powers essential to understanding the spiritual meanings of Scripture and thus to imitating Christ's life of self-denial and crucifixion to the world.[40] By contemplating Christ, the light of God's countenance is set upon us; for Christ is that brightness, that countenance, that saving knowledge of Godhood (*cognitio divinitatis*).[41]

Christ, the invisible image of the invisible God, becomes invisibly present to the eye of the mind. God must be sought, "Charles" taught, not among visible things but in the heart, and not with eyes of the body, but only with the eye of the mind.[42] We perceive Christ and the virtues emanating from him, not by bodily sight, which we have in common with animals lacking reason and incapable of self-knowing, but with spiritual vision.[43] We see through the foreshadowings of the Old Testament; we see through the terrible sufferings of Christ himself. We look at Jesus, raised up on the cross like Moses' brazen serpent, and, seeing with inward eyes and eager mind, we escape eternal death.[44]

How was it that the Greeks had wandered so far from truth into their insane novelties? "Our enemies," "Charles" said, "are still images of God."[45] They too had been created in the image and likeness of God, and, through Christ's mediation in baptism, the light of God's countenance had been sealed upon them.[46] Yet, the eye of the mind could be blinded, as it was in pagans. The eye of the mind in participants at Nicaea had been closed in the sleep of infidelity.[47] Some such reasoning explained why, in "Charles's" mind, Nicaea managed to render almost none of its myriad Scriptural citations correctly, to mutilate its citations of church fathers, and, generally, to demonstrate its incompetence even to distinguish genuine from spurious texts.

Understanding through charisms of Christ came only by grace, through the Spirit of adoption.[48] "We do not make ourselves worthy of adoring the Divine Majesty," "Charles" declared, "but we are made worthy by Him of adoring Him in Spirit and in Truth."[49] We cannot even understand the ordinary mysteries of human life, such as childbirth, "Charles" said. How can we grasp the mysteries of divine nature without grace?[50] Thus, "Charles" wrote, he put his hopes for this treatise, not in a controversialist's proofs, but in Christ, who assured his disciples when he was physically present, "It is not you who speak, but the Spirit of your Father who speaks in you," and who once had said through David, the prophet-king, "Open your mouth, and I shall fill it." The words of psalms, sung by David, "Charles" recalled, were uttered by the Holy Spirit, and full of mysteries.[51] "Charles" applied these verses by analogy to himself, the Frankish David.

Discovering the truth beneath the shadows of the material world required God's own mediation across the great divide of body and spirit.[52] This was the main reason why Theodulf/

"Charles" denied that human beings could know themselves through art, even religious art. Images presented them with material objects, with the works of human minds and hands. Images delivered nothing but human artifacts from which nothing but humanity could be known, and that knowledge came through the bodily senses. The eyes of image-venerators remained half-closed as they bowed before their painted figures, unseeing as the eyes of their minds.[53] They had no access to the truth beneath the shadows, least of all to the truth about themselves.

By upholding the original and changeless faith, "Charles" might hope to impel their conversion from error to the way that leads to life.[54] After all, in love, he had impaled them on their own spears. But, he wrote with a torturer's delight, it was enough for him to use the sword of spiritual understanding to cut the wings and tendons of their argument, leaving it unable to fly or walk.[55]

The besetting danger of theology is that it will turn out to be anthropology in disguise. Theodulf/"Charles" contended that this was exactly what happened at Nicaea. The Greeks had put the works of human minds and hands at the center of faith, mistaking anthropology for theology. Theodulf spoke through Charlemagne to assert a middle way between Hiereia and Nicaea.

In the narrative of himself, Theodulf/"Charles" came closest to illustrating the place images had in his devotional thought when he wrote about Moses' Ark of the Covenant, a sacred object of the Old Testament so central to his New Testamental theology that he had it depicted in the apse ceiling above the altar in his own chapel at St.-Germigny-des-Près (see J. F. Hamburger, "The Medieval Work of Art," fig. 5, in this volume).[56] Nicaea had seized upon the Ark as proof that God himself commanded that sacred images be made: namely, the two cherubim mounted on the lid of the Ark. "Charles" dismissed the analogy. The Ark and its contents foreshadowed Christ's Incarnation, and the mysteries contained in his flesh. The cherubim belonged, not to the Ark, but to the mercy seat (or "atonement cover"). God commanded that the mercy seat be placed on top of the Ark because we are saved, not by God's commandments in the Law and the Gospels, fulfilled in Christ, but by his mercy, which overarches the Incarnation.

The cherubim, "Charles" continued, represented knowledge. Moving, as usual, from visible to invisible, "Charles" argued that the heart of the composition was not the Ark and its contents, representing Christ's Incarnation, or the cherubim, but the empty space above the mercy seat which the cherubim sheltered with their wings. God promised that he would speak to Moses from that sacred, empty space, opening knowledge of the divine to the Israelites. How could images be equated with the Ark and the cherubim, leaving the mercy seat and the space above it out of the picture? No oracles of God had come from those all too visible objects, and we do not come by them to the "Truth who is Christ." Under grace, presence in the empty space above the mercy seat was to be sought invisibly in the heart by the mind's eye.[57]

Thinking without Images

"Charles's" narrative of himself takes us to his basic assumptions about knowing truth. How could you know that you were knowing, actually thinking, instead of hallucinating as the sick do, or dreaming? How could you know true from false? The norms of Scripture, tradition, and apostolic authority (in popes and councils) set external criteria. Theodulf/"Charles's" philosophical stance gave him internal criteria as well, and they were hostile to visual thinking.

Holding to the middle road, between extremes, took careful thought, "Charles" said. It took conscious judgment to chart the course, and to reach the point of judgment by deliberation and a

sifting of proof.[58] Enough has been said about "Charles's" project of self-knowing to indicate, in broad outline, some general propositions Theodulf used in moving from deliberation to judgment, which is also to say from visible to invisible. For Theodulf, that movement was crossing a great divide between body and spirit, rather than ascending a continuous, metaphysical ladder of being.

In the range of philosophical options, Theodulf stands close to empiricism. Whatever the subject, he looked to the authority of direct, concrete experience. His empirical bias appears in his references to medicine,[59] in his inventory of skills transmitted by practice from teacher to student,[60] and in his own virtuoso performances in grammar, rhetoric, and logic. Experience figures directly in his comments on artistic products of human hands. Theodulf proved himself a practiced connoisseur when he wrote about the materials with which works were made, the various techniques required to meld raw materials into a single finished object, the crucial importance an artisan's skill made in the relative values of objects, and common causes for deterioration.[61] Experience was also his rule in spiritual matters, above all, in his insistence on Christ's direct mediation between God and every individual believer.

Characteristically, "Charles" used a practical, empirical metaphor to illustrate how theologians assayed texts to separate those with spiritual understanding from those with tainted doctrine. He used a thoroughly physical metaphor—one, in fact, alluding to Charlemagne's magnificent standardization of coinage: the sifting of counterfeit from genuine coins.[62] (Given the immensely detailed discussion of the use and abuse of religious images, "Charles's" comment on coin portraiture seems unduly fleeting. When discussing Jesus's counsel on the tribute penny, "Render unto Caesar the things that are Caesar's," he gave the straightforward comment, "We ought to render Caesar's image to Caesar," and quickly went on to deny that "Caesar's image" was in any way analogous to the cross, as Nicaea had asserted.[63]) Saints and the most eloquent of men performed the assay with their earthbound experience, but they relied for the final assay on something entirely beyond their ken: "Fire from heaven," the Spirit illuminating believers' minds, "the unspeakable Light who also appeared upon the disciples in fire."[64]

Theodulf's devastating neutralization of images began with his understanding of human nature—animal, rational, mortal, and capable of laughter and sensation.[65] In his judgment, Nicaea went wrong by cutting theology to fit its anthropology; but Theodulf gave no evidence of understanding that he himself was captive to his own anthropology, a concept of human reasoning detached from metaphysical unity and dependent on direct personal experience. His sharp division between matter and spirit would have been less easy to draw had Theodulf conceived of all creatures and categories of creatures in the framework of some great metaphysical order, above all, the order set forth in Neoplatonism as emanating from and imaging God, the universal archetype, with human being as a microcosm of the great whole. Very incomplete traces of this cosmology appear in the records of Nicaea. Within this metaphysical order, human reason replicated reason in the cosmos. Therefore, the analogy between God and artists related the movement from archetype to image in the cosmos to the cognitive movement from concept to actual work in an artist's shop, and paralleled God's love for Creation with artists' love of their handiwork. Another analogy accepted the beauty in physical objects made by hands as sensual links in a chain of beauties by which human reason could move upward to God, the archetype of all beauties.

Bound as he was to the text of Scripture, Theodulf accepted the portrayal of God as "the eternal and ineffable artisan in heaven."[66] "Charles" insisted, however, that God's method of Creation—whether in the original Creation of heaven and earth or in the new Creation achieved through Christ's Incarnation—had no analogy to human cognition, including ways in which

human artists conceived and made their works.[67] "Charles" sharply rejected as impious any suggestion of likeness between God and the physical universe. Consequently, he set aside cosmologies that metaphysically linked human reasoning with divine being through chains of images and archetypes. With them, he also discarded the argument that, even in physical manifestations, beauty participated in and reflected God, the universal Beauty.

The importance Theodulf gave to history is a measure of how thoroughly his ideas about cognition discounted metaphysical unities and relied on experience.[68] According to his account, religious art did not spring from human nature, but from the invention of one man, Cecrops, king of Athens. Scripture gave no hint of pictorial art in the first stages of human existence; God was worshiped before there was art. Whether a given people used or ignored it, or used it at one time and abolished it at another, depended on circumstances, even as the Byzantine image-worshipers corrupted themselves by assimilating to the church pagan uses embalmed in imperial ceremonies, heathenisms which Christ's Incarnation should have eradicated.[69] Religious images expressed no metaphysical truths about beauty or human nature. They were simply tools capable of many uses, like iron which warriors could use to harm and physicians, to heal. Piety or impiety was not in the subject or making of a picture, but in the will, or intention, with which a person used or abandoned it.[70] History was against metaphysical unities, especially those having to do with beauty.

Scripture gave no evidence of image-worship among God's chosen people apart from episodes of reprehensible backsliding. Were infants, baptized and fed with Christ's Body and Blood, to perish eternally if they died before they could adore images? Many ascetics dedicated their souls to God and lived in hovels, without the beauty of churches and sacred images. There were saints resplendent in virtues, and many saints in heaven, some of them martyrs, who never venerated images in this life. Even now, devout Christians in many parts of the world happily adored God's power, though they lacked any idea of pictorial arts.[71]

Remote as it was from metaphysics, Theodulf/"Charles's" idea of cognition was also very far from aesthetics. "Charles" spoke of beauty in physical beings (such as pictures, churches and their ornaments, colors, and women), beauty in the use of language. He spoke of something more sublime, the radiance of spiritual understanding, in justice, wisdom, and doctrine, that caused the whole Church to shine with beauty.[72] He praised beauty and scorned ugliness.[73] Still, nothing suggests that he conceived of Beauty as a universal archetype, drawing individuals into cognitive relationship with each other by their likeness to it.

Instead of an aesthetic world of formal beauty, Theodulf presents an empirical world of utility grasped by practical reasoning. "Where there is no utility, there is no profit (emolumentum)," "Charles" said. "Where there is no profit, there is supreme vanity."[74] There was no profit in venerating images; the practice was as "useless" as Nicaea's doctrines supporting it.[75] Images had almost no "utility" except as prompts to notably poor memories, and it was a sign of weakness to need them.[76] Indeed, to be useful even in this limited way, images required identifying words; the memories they prompted depended upon their names.[77]

So rigorously did Theodulf hold to the doctrine that Christ alone was mediator between God and humans beings that he rejected any concept of outward physical beauty—in cult images, for example—as a cognitive stepping-stone to God. Likewise, he could not admit any doctrine that the soul, by looking within itself, could pass into God through mediating images in its mind.

Evidently, as an empiricist, Theodulf mistrusted both the visual imagination and introspection. Augustine of Hippo, one of Theodulf's chief theological anchors, characterized the soul's movement toward God as an introspective ascent, beginning with the physical senses and rising

through levels of abstraction to images left in the memory by sensory experiences and on through disembodied categories to God. Lacking introspection, Theodulf also lacked this spiritual ascent through and beyond all images, even beyond the self, into self-forgetting absorption in the divine.

He accepted that, in all animals, physical experiences left images in the memory, and that sustaining our animal existence depended on manipulating images in the memory bank. Animals, however, lacked reason and, with it, the higher powers of understanding that enabled human beings to know themselves and properly to know what their eyes saw. These higher intellectual powers required neither direct physical contact nor bodily images in the memory. Through them, we see justice, love, God, and the very mind of a human being, which has no body at all.[78]

Theodulf's insistence on the immediate experience of God in the soul, his rejection of any mediation between God and human being other than Christ's, and his techniques of practical reasoning disparaged all products of the visual imagination, whether in the ingenuity of craftsmen who made cult images or the "insanity" of using material images as reminders of Christ, or the "most thorough insanity" of translating words into images, rendering interpretations of Scripture into visual form. For, in such ways, people assimilated divine mysteries to their own meanings, or their own superstitions.[79] In any case, cult images served the needs of bodily sight, not the heart's love.[80]

Conclusion

Cognition, in the form of practical reasoning, was part of the narrative "Charles" constructed of himself. Enough may have been said to indicate Theodulf/"Charles's" hostility to visual imagination, which is also to say introspection, as a way to truth.

It is tempting to read Theodulf's treatise—"Charles's" soliloquy—as a souvenir of one battle in the long warfare for dominance between words and images.[81] But both words and images fall on the human side of the frontier that Theodulf/"Charles" saw all too sharply between anthropology and theology. Theodulf gave the victor's palm to words; victory was not unconditional. "Charles" had two sets of terms in his mind. The first was the distinction between words and images. The second was the distinction between words (or images) and meanings. Rhetoricians conventionally distinguished verba from sensus; and this polarity runs throughout "Charles's" entire discussion. Whatever theory and practice might hold regarding human communication, Scripture had a unique status. The words of Scripture, divinely inspired as they were believed to be, were by no means equivalent to words in human discourse. Penetrating to the senses of Scripture was possible only by miracle, the miracle of grace.

There were no divine meanings in images, designed and made by human beings. There were divine meanings in the words of Scripture, uttered by God, and written by God's finger, the Holy Spirit. Those senses are closed unless mediation of Christ—a miracle—is first present. Grace is the key to the sense of Scripture. The Greeks do not have it; they read Scripture with their humanity only.

In his self-portrayal, "Charles" rejected the use of pictures to create illusions of the numinous. However, at least in theology, the same distinction between mind and body that excluded paintings as means of spiritual communication applied to words. After all, "learned painters" took their mythological falsehoods from verbal texts.[82] Every syllable Theodulf launched against Nicaea witnessed to the power of words in its debates and canons to tell lies more colossal, if anything, than painting could. While he never wearied of lambasting Nicaea for stupidity, ignorance, and in-

eptitude, "Charles" also acknowledged, when his invective guard was down, a certain over-ripe finesse in Nicaea's word-play, its sophistry, forensic skill, and intricate argument. After all, the devil and wicked men could quote the words of Scripture.[83]

Moreover, the "hearing" that advanced salvation was no more physical than seeing with eyes of the mind. God, as spirit, heard prayers, not with bodily ears, but with perception attuned to feelings of the heart. And human beings were bound to listen to words of Scripture spiritually, with "interior ears," the soul's rational perceptions. Nicaea was deaf as adders, incapable of hearing the words of Scripture with the interior ear.[84] At any rate, human users of words unaided by grace were still trapped in their own humanity. Truth was not equivalent with words; the *cognitio Dei* was Christ, the countenance of God, impressed on the flesh of believers at Baptism, by water and the spirit.[85]

Grace opened the organs of communication known as inward eyes and ears, whether in personal devotion or in liturgies of the community, when angels carried prayers and sacrifices to God's presence in heaven and the *lectio divina* refreshed dry hearts.[86]

It should be clear by now how intensely "Charles" struggled in the narrative of himself to escape most of what he thought were the defining characteristics of humanity: human beings, he had said, were animals (and therefore capable of bodily sensation), rational, and mortal. To these characteristics, I should like to add, without explanation, that Theodulf/"Charles" also considered human beings to be distinctively historical.[87] History, too, was to be escaped in the double venture of knowing God and the self. The Greeks were still captive to these fetters of humanity.

Among the characteristics of human being, Theodulf/"Charles" also counted the capacity for laughter. Laughter defined being human, he wrote, as precisely as neighing defined being a horse.[88] This one characteristic he did not seek to escape.

Laughter brings us squarely to the subject of empathy. Empathy is the key to visceral participation by viewers in pictures, a kind of passport into the looking-glass world. As we see in the sweet, Buddha-like smile of Gothic sculpture and the gentle laughter of courtly romance, laughter can be one of love's most endearing expressions. Though he wrote much about love, the kinds of love Theodulf/"Charles" approved are anything but ardent, self-forgetting and self-giving. He recognized no experience of being lost in love and absorbed in union with the beloved. By contrast, the wrong love of image-worshipers blazed hot to the point of insanity. In his narrative of himself, "Charles" comes down on the side of a chilly love without passion or empathy.

Some kinds of laughter express empathy, others exclude it. Theodulf scarcely admitted that believers could feel compassion with Christ crucified. Though he rebuked the Greeks for their cruelty, preached mercy, and insisted that no one could love God and practice cruelty,[89] the laughter displayed in *King Charles's Work* exhibits mercy, if any, without hope of empathy. His analogy of the Greeks with adders and spiders accents what he meant by "mercy."[90]

Theodulf's humor ran strongly to irony, even deep shades of the sardonic. Did sarcasm gratify awareness that, despite his massive efforts, his enemies would without grace remain inwardly blind and deaf to the truth he preached at them? At any rate, laughter appears in his treatise only in the ironic contrast between the Byzantine emperors, who, calling themselves "equals of the apostles," laugh in this life and will weep in the next, and the apostles themselves, who, weeping in this world, exulted in the next, secure in their eternal reward. Laughter, Theodulf/"Charles" wrote, was always mixed with pain.[91] For the moment, the image-worshipers rejoiced, viewing themselves with closed eyes like people asleep and rapt away from reality in their dreams, just as they bowed themselves to the floor venerating images but not seeing them with their half-closed eyes. The eyes

of their minds were blind; but, at death, they would waken from their self-deluding, happy dreams. Seeing themselves as they really were, they would go in great fear to judgment.[92]

Meanwhile, Theodulf/"Charles" and all others who held by grace to the middle way of righteousness could relish what was coming. Whatever pain they felt by being condemned as heretics by the Greeks could be mixed with joy at knowing how the tables would be turned, how point after point solemnly decreed by Nicaea was not only demented, superstitious, blind, and useless, but laughable.[93] They could see how solemnly Nicaea had gone about its work, condemning the universal Church and blind to the apocalyptic terrors hanging over it, so like unskilled artisans whose inept works sink under gales of ridicule.[94] As history moved from invisible prophecy to visible fulfillment, even predestination achieved a functional beauty like the one rhetoricians and philosophers constructed when they balanced contraries in antitheses.[95]

"Charles's" exclusion of empathy was one reason his ideas negated the use of religious images as tools of self-knowing. In fact, history's laugh was on Theodulf/"Charles" twice over. The assumption that inspired *King Charles's Work*—that Nicaea commanded image-worship—was wrong. Theodulf's enormous effort was really fighting a mirage-windmill induced by the poor translation of Nicaea's decrees that somehow reached Charlemagne's court. A further irony was that, within two generations, the Franks had taken up, in the use of statue reliquaries, exactly the cult of images that Theodulf/"Charles" derided.[96] Nonetheless, his doctrine that the devotional use of images was superstitious and laughably insane is an invaluable witness to the thinking at Charlemagne's court, and it had a direct impact on ideas in the Reformation and Counter-Reformation.

In this essay, I have sketched out one writer's argument that art was a morally neutral tool, of no particular value in the two-pronged task of knowing the self and knowing God. Despite his sense that iconoclasm was the better of the two Byzantine extremes, Theodulf was willing to tolerate the use of images for adornment and for prodding weak memories. Rightly used, art was irrelevant to religion. Wrongly used, it disastrously engaged the passions and intruded humanity into sacred things. It is evident from *King Charles's Work* that pursuing the double project of knowing the self and God was a game open only to the privileged orders of society. It was closed to the poor, the simple, and women. By grace, however, even such as these could ignorantly possess the substance of things unseen.

Acknowledgments

I completed this study during my appointment as Carey Senior Fellow in the Erasmus Institute, at the University of Notre Dame. It is a pleasure to record my gratitude to the Institute for providing an exceptionally happy and fruitful intellectual home away from home. I am grateful to Professor T. F. X. Noble for a helpful reading of a preliminary draft of this study.

Notes

1. See H. G. Thummel, "Die fränkische Reaktion auf das 2. Nicaenum 787 in den Libri Carolini," in *Das frankfurter Konzil von 794: Kristallisationspunkt karolingischer Kultur*, ed. R. Berndt (Mainz, 1997), vol. 2, 965–80. See also the still useful studies by G. Ladner, "Origin and Significance of the Byzantine Iconoclastic Controversy," *Medieval Studies* 2 (1940), 127–49, and S. Gero, "The *Libri Carolini* and the Image Controversy," *Greek Orthodox Theological Review* 17 (1973), 7–34.

2. See A. Freeman, ed., *Opus Caroli Regis contra Synodum (Libri Carolini)*, MGH, Conc 2, suppl. 1 (Hanover, 1998), 12–13, 73–74, 78–79. See also Freeman, "Carolin-

gian Orthodoxy and the Fate of the *Libri Carolini*," Viator 16 (1985), 65–108, on the composition of the book and its relegation to the archives in the eighth century; and J. R. Payton Jr., "Calvin and the *Libri Carolini*," *Sixteenth Century Journal* 28 (1997), esp. 470–80.

3. R. Bellarmine, *Controversarium de Ecclesia Triumphante*, Book 2, "De reliquiis et imaginibus sanctorum," in R. Bellarmine, *Opera Omnia*, ed. J. Fevre, vol. 3 (Paris, 1870; reprint, Frankfurt a. M., 1965), 2.11, 12, 15: 20, 233, 244–45. Bellarmine was unaware both of how, in the imperfect three-cornered communications among Aachen, Rome, and Byzantium, the treatise came to be written and then abandoned, and of how the treatise was rediscovered and published in the sixteenth century. Both have been clarified in fairly recent times.

4. 2.12; 3.6, 7; 4.27: 259, 364, 366–67, 556. The numbers cited in this and subsequent notes refer to Ann Freeman's edition of *Opus Caroli regis* (as in note 2); the numbers preceding the colon are text section numbers, while those following the colon are the pages in this edition.

5. 1.10; 2.9, 22; 3.27; 4.2, 21, 27: 155–56, 254, 276–77, 466–68, 493, 541, 556–57.

6. 2.13: 259.

7. 3.18; 4.4, 5: 420, 495, 500. See 2.7: 251: People who adore images think that we, who don't, are sinners.

8. "Charles" equated barbarism with paganism; and although he knew the Greek text of the Second Council of Nicaea only in Latin translation, he did not hesitate to find barbarisms in the Council's language. See 3.9; 4.6: 373, 505–6.

9. See 1.3, 18; 2.6, 13, 19; 3. 16: 123, 190 (the Jews worshiped *"vano cultu et superstitiosa religione"*), 250, 259–60, 268–69, 408–10.

10. 2.31; 3.11; 4.6–7: 322–25, 376–78, 505–8.

11. 3.24; 4.27: 452, 556–57. See also note 20 below.

12. E.g., 1.6; 2.9, 29; 4.3, 13: 136, 253–54, 301, 494–95, 520. "Charles" also remembered analogously King Joash, the repairer of the Temple, as well as David, its designer, and Solomon, its builder (3.4: 451). A particularly important parallel—in the divine inspiration of the king—exists between "Charles's" own writing on theology and his many quotations of scriptural texts attributed to David and Solomon.

13. 4.5: 498.

14. 1.20; 2.3, 19: 196, 242, 271.

15. 2.30: 313–22.

16. The scope of subjects passed in review is so formidable that the *Opus Caroli regis* has been called a "basic course in theology." See R. Berndt, "Das Frankfurter Konzil von 794: Kristallisationspunkt theologischen Denkens in der frühen Karolingerzeit," in *Das Frankfurter Konzil von 794* (as in note 1), 537–42.

17. 2.3: 243.

18. 2.2: 240. See also 1.16: 178. At the Last Supper, John the Evangelist, reclining on the bosom of the Mediator between God and human beings, drank from the source of eternal light. Now, John daily (*quotidie*) gives Christian minds the nectar of ambrosial liquor to drink.

19. 1.6: 132, 135–36.

20. 1.1; 2.27: 105–7, 295 (*nova antiquitas et antiqua novitas*).

21. 4.14, 23: 523, 552 (*omnes novitates vocum*).

22. Pref.; 2.24; 3.pref., 1, 4, 12; 4.pref., 14, 28: 101, 282,

328–30, 336–40, 359, 379, 486, 523–24, 557.

23. 3.19, 22: 423, 439.

24. 1.12, 23; 2.3, 16 (on Baptism); 3.27: 162–63, 211, 241–43, 266–67, 467, 469.

25. The phrase "Mediator of God and men" from 1 Tim. 2:5 occurs very frequently, e.g.: 2.11, 27; 3.6, 21, 24; 4.11, 13, 16, 18: 257, 290, 361, 428, 433–34, 448, 514, 516, 527, 534.

26. 2.28: 296.

27. 2.30: 307.

28. 3.15: 399.

29. 1.3: 121–22.

30. On general background, see U. R. Jeck, "Die frühmittelalterliche Rezeption der Zeittheorie Augustins in den *Libri Carolini* und die Temporalität des Kultbildes," in *Das frankfurter Konzil von 794* (as in note 1), 861–84.

31. 1.9; 2.24: 149, 281. See also 1.8; 145–46. Cf. 3.20: 426, contrasting a painted angel with a real one, and 4.1: 490, contrasting a painted lion with a real one and a picture of Christ with Christ himself.

32. 1.8: 145–46.

33. 2.24; 4.14, 20: 280, 524, 539.

34. 1.7: 140.

35. See the variant readings of this definition, which Theodulf took from Isidore of Seville (1.2, 4.21: 117, 541).

36. 1.1; 3.1; 4.14: 112–15, 117, 338, 524.

37. 1.2; 3.24: 118, 448–52. On prayers for the run-of-the-mill faithful dead as well as veneration of saints; see 2.31: 324–25, 327.

38. See the illuminating discussion of the ark in C. Chazelle, *The Crucified God in the Carolingian Era: Theology and Art of Christ's Passion* (Cambridge and New York, 2001), 43–45. See also references in note 56 below.

39. 1.1, 15; 2.15; 3.24: 114–15, 175, 263, 430, 448–52. See Chazelle, *Crucified God* (as in note 38), 49: "The reality of Jesus's mortal flesh almost disappears from view." I agree completely in the sense that Theodulf gave little attention to gospel narratives of the life and deeds of Jesus.

40. The powers included love, justice, mercy, and holiness (1.1: 144). See also 1.15–16, 2.28: 170, 175–76, 180–81.

41. 1.23: 209–10.

42. 4.2: 493. Cf. 1.15: 175.

43. 2.22; 4.2: 272, 492–93.

44. 1.18: 190 (*aeterna mors*). Cf. 2.30: 304 (*perpetua mors*).

45. 4.5: 500.

46. 1.23: 211. The countenance of God is sealed on us by anointing, with the sign of the cross, at baptism by the Spirit, who proceeds from the Father and the Son (*qui a Patre Filioque procedit*), an important witness to the doctrine of the *Filioque*, which came to be a rock of division between Eastern and Western churches. See a full exposition on the *Filioque* in 3.3: 346–52.

47. 2.13, 26; 3.18: 259, 288, 419.

48. 1.15: 175.

49. 4.21: 541.

50. 3.3: 352.

51. 2.pref., 4: 233–34 (quoting Matt. 10:20 and Ps. 80:11), 244. See also 3.12: 382: Moses waited patiently and God imparted to him the secrets of many mysteries.

52. Cf. 2.9: 253.

53. 4.19: 535.

54. 4.22: 544.

55. 3.pref; 4.22: 328–29, 542. See also 1.8: 148 (broken wings).

56. See now the fundamental study by A. Freeman and P. Meyvaert, "The Meaning of Theodulf's Apse Mosaic at Germigny-des-Près," *Gesta* 40 (2001), 125–39. Freeman and Meyvaert demonstrate that the mosaic visually articulates interpretations of Scripture set forth verbally in the *Opus Caroli regis*, and that Theodulf took the mosaic's iconography from mosaics that he saw in Roman churches during his visit (799–ca. 801) around the time of Charlemagne's imperial coronation, embellishing them from his own theological convictions, of which the wounded hand of God is one spectacular result. The authors draw careful analogies between Theodulf's mosaic and surviving works in the Roman churches of Sta. Maria Maggiore and SS. Cosma and Damiano. In a further study, Meyvaert traces how Theodulf's mosaic survived the close call of destruction by putative restoration in the nineteenth century. See P. Meyvaert, "Maximilien Théodore Chrétin and the Apse Mosaic at Germigny-des-Près," *GBA* 143 (2001), 203–20.

57. 1.15, 20; 2.26: 169–75, 196–98, 289.

58. 4.8: 509.

59. 3.2, 15, 22, 25; 4.15, 17: 341, 399, 438–39, 455, 525, 530.

60. 3.15: 399.

61. E.g., 1.2; 2.27; 3.30; 4.20: 119, 290, 295, 479–80, 540.

62. 4.11: 513. Cf. 2.9; 4.13: 313, 521. Theodulf refers to gold coins, though Charlemagne's mints are only known to have issued silver.

63. 2.28: 300, quoting Matt. 22:18–21. Inscriptions are kept as a test of authenticity in 4.11: 513, admittedly without citation of the passage in Matthew.

64. 1.10, 23: 158, 211.

65. 1.2; 4.21: 117, 541.

66. 4.21: 540.

67. 1.5, 7, 10; 2.5, 24; 4.14: 129, 144–45, 155, 214–16, 523–24.

68. On the extensive weight given historical argument in *King Charles's Work*, see T. F. X. Noble, "Tradition and Learning in Search of Ideology: The *Libri Carolini*," in *"The Gentle Voices of Teachers": Aspects of Learning in the Carolingian Age*, ed. R. E. Sullivan (Columbus, Ohio, 1995), 227–60.

69. 1:29; 2.30; 3.15; 4.2, 18, 20: 230, 304–10, 404–5, 491–92, 531–32, 538.

70. 3.22; 4.9: 438–40, 510.

71. 1.29; 2.27; 3.17, 28; 4.2, 18: 230, 295–96, 416, 470–71, 491, 532.

72. 2.30, 4.11: 312, 513.

73. E.g., 4.5, 27: 497, 555.

74. 1.26: 218. See 1.23: 210, on the *emolumentum* God promises to those who seek him (i.e., they will lack nothing good).

75. 1.26; 2.30 (on *utilitates vitae*); 3.19, 23, 26, 28: 218, 303–22, 421, 440, 460, 470. Cf. 3.6: 364.

76. 1.9; 2.22; 3.27; 4.2: 156, 277, 466, 493.

77. See 3.15: 399.

78. 3.26: 464–65, quoting a treatise wrongly attributed to Augustine.

79. 1.16, 18; 2.9, 22; 3.16: 181, 190–92, 253–54, 277, 409–10.

80. 2.22; 3.27; 4.2: 277, 466, 493.

81. See Chazelle, *Crucified God* (as in note 38), 46.

82. 3.23: 446 (*pictores eruditi*).

83. 3.31: 482. There was no need to assume that apparent miracles had been performed by God, since signs and sham miracles could be performed by fallen angels, demons, and their followers (3.25: 452–54).

84. Pref.; 2.22; 4.22: 97–98, 275–76, 542–43. In Paradise, the dominance of hearing over seeing would be reversed. For there, all prophecies, which we now hear, will be fulfilled, and we shall see what we now hear in the hardships of this mortal state (1.30: 231).

85. 1.23: 209–12.

86. 2.27; 4.2: 290, 494.

87. On the wealth and density of historical argument in *King Charles's Work*, see Noble, "Tradition and Learning in Search of Ideology" (as in note 68), 227–60.

88. 4.23: 547–48.

89. 4.5: 499.

90. 4.22: 543–44.

91. 4.20: 538.

92. 2.3; 4.19, 20: 243–44, 535, 538.

93. E.g., 1.25; 2.12; 3.6, 15, 19, 20; 4.1, 14: 216–17, 259, 364, 399, 421, 479, 489, 523.

94. 3.15: 399.

95. Cf. 2.25: 285.

96. J. Herrin, *Formation of Christendom* (Oxford, 1987), 472. Considering that *King Charles's Work* was abruptly ended and sent to the archives, Henry Mayr-Harting has argued that Theodulf was not "a mere lone voice in Carolingian culture," but that his work expressed widely held ideas which did in fact enter into the design and making of works of art, especially book illuminations (H. Mayr-Harting, "Charlemagne as a Patron of Art," in *The Church and the Arts*, ed. D. Wood [Oxford, 1992], 50, 66–75).

Replica: Images of Identity and the Identity of Images in Prescholastic France

Brigitte Miriam Bedos-Rezak

[The following scene takes place in Sri Lanka (Ceylon).]

There is a ceremony to prepare the artificer during the night before he paints. You realize, he is brought in only to paint the eyes on the Buddha image. The eyes must be painted in the morning, at five. The hour the Buddha attained enlightenment. The ceremonies therefore begin the night before, with recitations and decorations in the temples.

Without the eyes there is not just blindness, there is nothing. There is no existence. The artificer brings to life sight and truth and presence. Later he will be honored with gifts. Lands or oxen. He enters the temple doors. He is dressed like a prince, with jewellery, a sword at his waist, lace over his head. He moves forward accompanied by a second man, who carries brushes, black paint and a metal mirror.

He climbs a ladder in front of the statue. The man with him climbs too. This has taken place for centuries, you realize, there are records of this since the ninth century. The painter dips a brush into the paint and turns his back to the statue, so it looks as if he is about to be enfolded in the great arms. The paint is wet on the brush. The other man, facing him, holds up the mirror, and the artificer puts the brush over his shoulder and paints in the eyes without looking directly at the face. He uses just the reflection to guide him—so only the mirror receives the direct image of the glance being created. No human eye can meet the Buddha's during the process of creation. . . . He never looks at the eyes directly. He can only see the gaze in the mirror.

—Michael Ondaatje, *Anil's Ghost*

During the eleventh and twelfth centuries, the understanding of images among prescholastic scholars active in the cathedral and monastic schools of northern France promoted a conception of image as imprint over one of mirror-image. The prescholastic interpretation of image as imprint formed a seminal moment in the history of representation since it fused *signum* and *imago*, and since it was also as imprint that the image entered the field of social praxis. Once established within the field of social praxis, *imago* further evolved into a replica. For each of these three formulas—mirror, imprint, and replica—I will analyze the meaning of the mode of operation and examine how their intersection and interaction with definitions of the person, and of identity, ultimately produced a practice of personal representation which, in turn, reciprocally affected the

body social and the world of images. While the techniques productive of material images may be seen to embody and (ad)dress doctrine,[1] they also achieved a wider significance as they themselves participated in the meaning of the images they shaped.

The prescholastic term *imago* had currency in several fields. In anthropological theology, *imago* articulated the essential relationship of man to his maker, God. In incarnational theology, *imago* was the image of God who took human form in the person of his son, and who was on earth "the image of the father." In linguistics, the concept of *imago* extended to textual metaphors. In what we would call psychology, *imago* referred to mental images produced by dreams, to the memory, to the imagination. In prescholastic theories of cognition, *imago* underlay perceptions of the mind; it was a sign that enabled the contemplation of things. In the world of material symbols, *imago* designated the representation of forms, and thus, in the diplomatic discourse of charters, *imago* meant seal.[2] The primary sense of *imago* was mimesis, which afforded a conceptual tool allowing comparison and appraisal in two fundamental circumstances: that of humanity created in the image of God, and that of things experienced in multiple forms (actual, linguistic, iconic, etc.). Thus, the prescholastic *imago* was first and foremost an agent for the conceptualization of referentiality, bringing images within the hermeneutical sphere of semiotics.

The centrality of *imago* in the eleventh- and twelfth-century theological discourse of Northern European schoolmen was fostered by their interest in creation: the creation of man in the image of God, the creation of Christ as the image of God. Just as *imago* was used to explain relationships of man and Christ to the Godhead, incarnation and human creation were used to explain the relationship between images and their referents. Twelfth-century theology and anthropology both thus came to be articulated through, and dependent upon, a fully elaborated theory of imagery. For that very reason, the economy of representation through images became inseparable from its anchor in personality, whether human or divine.

Byzantine theologians had already probed the nature of the relationship between images and physical persons. From the eighth century onward, anti-iconoclasts insisted that images could represent human beings such as Jesus because images always represent persons who exist within a human body. Thus Christ-the-man was visible in his image; but how could the invisible God be said to have been rendered visible in Christ as in an image? Attempts to answer this question led to the notion that the Christ-image contained its own archetype: God, the archetype, was materialized in the Son of man as in an image, a formula that owed much to familiarity with Platonic thought.[3] This image (Christ), however, was engendered, and iconoclasts insisted that it should thus be distinguished from images created by imitation.

The iconophile Theodore of Studios (759–826), drawing further upon Neoplatonism, rehabilitated the created, artificial image by stating that all types of image originate in a prototype: "As a seal belonged to an impression, so a likeness belonged to a model."[4] Here, the seal metaphor articulates a central aim of Byzantine theology, which was to trace the image back to the truth of its archetype.[5] Of interest here is the notion that the truth of images rests upon a mechanical imitation of the model's forms and specific features, that an image actually depicts the person who was the model. Since an image's truth derived from its figural identity with its archetype, and since everything was created from an archetype, nothing could claim to be real that did not lend itself to being represented by an image. Though archetype and image share an identity of forms, they do differ in substance. Theodore of Studios, who had used the seal metaphor to establish formal identity, resorted once again to this metaphor to illustrate differences in substance: "Take the

example of a signet ring engraved with the imperial image, and let it be impressed upon wax, pitch, and clay. The impression is one and the same in the several materials which, however, are different with respect to each other; the impression remained identical [precisely] because it was entirely unconnected with the material. . . . The same applies to the likeness of Christ irrespective of the material upon which it is represented."[6] In this metaphor, the materiality of the imprinted, or representing, object itself is ignored; the substance of the image has no significance.

The eleventh-century theologian Michael Psellus further elaborated this position in his treatise on Genesis 1:26–27 (where God said, "Let us make man in our image, after our likeness . . . and God created man in His own image, in the image of God created He him"), arguing that there was no intermediate image between God the invisible and man who was made in God's image; there was no Christ serving as a visible model that could be distinguished from the invisible model of God himself. This undermined the possibility of an actual resemblance between man and God, and indeed Psellus interpreted the nature of image in Genesis 1:26–27 philosophically, as the capacity of imperfect human beings to progress toward God and to perfect themselves.[7] Psellus, who explicitly rejected Plato's comparison of images with shadows, who insisted that an icon's true prototype was the "real being" of which the icon was a living representation, could not fit human anthropology into such a theory of image.[8]

My reason for offering an overview of the Byzantine theology of images is that, from the ninth century onward, this theology had provided a theory about the relation between image and person, manipulating metaphors (such as the seal) and a vocabulary of imprinting, both of which came to characterize the Western prescholastic discourse on images.[9] However, I do not wish to give the impression that Byzantine theology directly influenced European schoolmen. Both parties, to be sure, were drawing upon a common Neoplatonic heritage which, in the case of the West, was mediated mostly through Augustine.[10] Yet, both sides transformed the conceptual tools of Platonism, interpreting them differently and mobilizing them for different purposes. Whereas the Byzantines were considering actual images, their power, and the legitimacy of their veneration, Western prescholastics did not theorize primarily about material images per se.[11] The property of image that attracted Western theoretical attention was more ontological.[12] They pondered the relationship of likeness said by Genesis 1:27 to exist between God and man-made-in-the-image-of-God. In so doing, they necessarily reflected upon image, and its modes of and capacity for representation. They also had to confront unlikeness because they thought about image in terms of the resemblance between God and man, and among the divine persons of the Trinity. They were struck by the realization of difference (in the case of God and man) and the need for distinction (in the case of the persons of the Trinity). Contemplating the dialectic of distinction and resemblance, they veered away from a definition of images as synonymous with visual likeness. They thereby displaced likeness from the visual world of appearances and reformulated it as an active principle, as a relationship between form and matter which involved gradations of contact and presence. Whereas the Byzantine image was material but insubstantial, and referred to its model through visual likeness, the image conceived in the prescholastic West was conceptual, rooted in substance, referring to its model through participation. Prescholastic interest in matters of identity, *identitas*, arose as a concern for the extent to which Christ, whom they conceived to be the image of God, was identical to what he represented, that is, the Godhead, and to what represented him, the Eucharist. *Identitas* at this time therefore involved reflections on identicality, so that the prescholastic theory of image intersected incarnational thinking and the doctrine of real pres-

ence. In asserting that the Eucharist was not a figure of speech but truly the image of God and the substance of the God-man, prescholastic theologians defined the Eucharist as actually being what it signifies. Although this mode of signification pertained strictly only to the Eucharist, its principle of immanence ultimately realigned theories of representation, with consequences for society as a whole. Images came also to be invested with powers necessary to represent persons in situations requiring commitment and future accountability.[13]

Prescholastic notions of image, as of so many other matters, drew extensively upon the Augustinian corpus.[14] Augustine had insisted upon a concept of image which included the idea of likeness, proposing that while some likenesses can be images, all images are likenesses, but of a certain kind. For, as he wrote in his *Unfinished Commentary on Genesis*, an image is dependent on an original model from which it is expressed; if one thing is not born of another, it cannot be called an image.[15] When giving examples of likeness which are also images, in the *Unfinished Commentary on Genesis* and in the *Liber Quintus (Quaestiones in Deuteronomium)* of his *Quaestionum in Heptateuchum libri septem,* Augustine listed without distinction the likeness of a child to its parents, of a painting to its subject, or of a mirror-image to the source of its reflection. Although Augustine insisted once again that an image must be expressed from a model, he now distinguished between two types of expressed images: the first, where originator/progenitor/prototype and image are of the same substance, as in the case of Father and Son; and the second, where they are not, as in the case of painter and painting.[16] This distinction between the two types of images parallels another difference, dear to Augustine and to the prescholastic tradition: that between an image begotten (*genita*) and an image made (*facta*). For Augustine, therefore, an image could partake of substance and of form, and likeness similarly might either inhere in substance or be present by virtue of form (qualities). Thus, likeness is localized, but it is not thereby explained. Augustine accounted for the likeness in an image by invoking the principle of participation, an idea he directly adopted from Neoplatonic thought in which a thing is, not by virtue of its own being, but simply because it emanates from and therefore participates in True Being. For Augustine the Christian, however, such participation could not be the result of emanation as it was for Plato but must be the result of God's will.[17]

This Augustinian legacy, which considered images in terms of the wider concept of likeness, presented difficulties for eleventh- and twelfth-century thought and practice. First, Augustine's notion of resemblance in substance between God and his son was problematic, for that which is identical in substance cannot be said merely to resemble or to "be like."[18] Second, although Augustine invoked the participation of man in God to explain man's resemblance, he was satisfied that God was the principle of all participation and therefore did not find it necessary to prove the principle of participation nor to present a systematic theory of participation. Third, Augustine, who employed reflected, imprinted, and copied images indiscriminately in his treatises, does not seem to have explored the distinctions suggested by the different iconic modes per se. While all images were expressed from a model, the mode of their "expression" seems to have been a matter of indifference to the bishop of Hippo.[19] Not so, however, for the prescholastics who added additional levels of complexity to the Augustinian corpus of thoughts on images. Even while focusing upon the mimetic economy of the image, the prescholastics innovated. They explored the nature of reproductive modalities, the role these played in the image's capacity to represent its model, and the meaning these modalities imparted to the resemblance between archetype and image. In distinguishing between reproductive modes, prescholastics brought into the heuristic of signification the

mechanics of likeness between an image and its prototype, thereby providing a means for engaging and defining resemblance and participation. Thus, prescholastics actively considered the modulation of mimesis between object and model, and it is to their intellectual constructs, and their import, that I now wish to turn—but not before, once again, considering Augustine.

Mirror

From Augustine onward, the creation of man in the image of God had meant that human intellect, will, and memory were vestiges of the Trinity. Though Augustine likened these divine vestiges in the human soul to a mirror tarnished by the stain of sin, he nevertheless considered that they, as images of God, were adapted to the understanding of God.[20] Consequently, man needed to turn inward to recover the original *imago Dei*, rather than outward to the natural world.[21] While prescholastics continued to argue that God is best perceived within the soul, the Victorines Hugh and Richard, for instance, proposed that, properly observed, Nature might also reveal the Creator.[22]

In these formulations of the mirror simile, the image as mirror was primarily associated with knowledge of God and, consequently, with the human means to achieve that knowledge, that is, with reason—the mind, the rational part of the soul. The rational mind alone was made in the image of God so that, as Hugh and Richard of St.-Victor stated eloquently, it was in the best position to serve as the principal and privileged mirror to see God.[23] Yet, even though the mirror locates the frame of God's identity in the field of vision, the ambiguity of veiled and stained mirrors challenges the mind-mirror's capacity to reflect and thus to represent accurately.[24] For the mirror-mind to capture the divine image, it must be properly oriented and, most importantly, be pure and clean. The soul must be polished so as better to reflect the divine beam.[25]

Such mirror metaphors suggest several interpretations. First, man's resemblance to God is spiritual, which stresses spiritual reform. Located in the mind, that is, in the rational part of the soul, such resemblance excludes incarnational image-likeness.[26] Second, the mirror metaphor manifests a certain distrust of image per se; mirrors seem to need lots of cleansing. Third, after polishing, the mirror-mind is held both to reflect its prototype, that is, God, and to see that reflection. In this version of the mirror simile, the image of God in man has itself become an eye which sees; human speculation discovers the inner self as the reflection of another.[27] This other, God, however clearly reflected nevertheless remains ultimately unseen since a mirror-image can not actually be its own prototype. Such an image can only reveal that the presence of God is hidden, and a principal implication of the image-become-vision is simply that image is insubstantial. Thus, prescholastics wondered what one sees when one views, as Paul said, *per speculum, in aenigmate*, through a mirror, in an enigma, or through a glass darkly (1 Cor. 13:12).

Hugh of St.-Victor, specifically commenting upon the Pauline passage, said that to see by means of a mirror meant to see an image; to see something face-to-face was to see reality.[28] For Richard, even to see through the mirror of a purified heart was not to see God himself.[29] For Hervé de Bourg-Dieu, to see in a mirror is to see nothing but an image.[30] One can only be struck by the negative character of these definitions. Even when the Cistercian Ernald recognized that the image he sees of himself in a mirror expresses his own features, he still needed to state that in contemplating this image, he was not seeing himself.[31] Thus, while Ernald's mirror simile testifies that physical similarity existed between an image of man and the man himself, he too emphasized the

extent to which man's relation to himself and to the world was not analogous to direct visual perception through a mirror.

To sum up, the mirror-image was ambiguous for prescholastics.[32] Its evocation articulated their distrust of any image that might blur the divine reflection. By conceptualizing the mirror-image, and also the soul, as an image that can see, prescholastics displayed their doubts about the principle of a mirror's reflection, perceiving, as did Paul, that a mirror does not merely reflect but transforms. For when a mirror produces an image, it converts an origin into a result, which process posits the origin as un-representable. Furthermore, in a mirror, things appear where they are not, and in this sense, there might be no presence of God in man. The idea that truth is not in man, that God and human interiority might not coincide, prompted a tension between self-knowledge and the knowledge of God, a tension which prescholastics, who were very eager to promote self-knowledge as a divine capacity, sought to alleviate.[33] Responding to the unease brought about by the implication of the mirror-image, they developed the interpretive potential of another form of image, the imprint.[34]

Imprint

The topos of the *imago impressa* and of its corollary, the *sigillum*, is massively present in prescholastic rhetoric.[35] Though not systematic, the medieval lexicon of the twelfth century tended to use *sigillum* to designate the material of the die and the motif engraved upon it, reserving *imago* for the imprinted image. The following representative sampling of seal similes will suffice, I trust, to illustrate and to support my analysis. With a simple statement, "Imago, id est similitudinis impressio,"[36] prescholastics indicated that the imprinted image actualizes the resemblance to its prototype. Gilbert de Holland expressed this notion more specifically: "Imprime te illi, ut ejus in te velut expressa reformetur imago, huic fias conformis sigillo."[37] A text from the school of Laon reads: "Homo enim, ut mihi videtur, ad imaginem Dei factus est per rationem. Sicut enim per imaginem vel sigillum aliqua res vel aliqua persona cognoscitur, sic Creator per rationem quasi per sigillum a creatura cognoscitur."[38] In short, man's reason is God's seal, or Christ's seal, as the prescholastics were fond of saying, following Peter Lombard's commentary on Psalm 4:7: "Lumen vultus tui, scilicet lumen gratiae tuae, quo reformatur imago tua in nobis, qua tibi similes sumus, est signatum super nos, id est impressum rationi quae superior vis animae est qua Deo similes sumus, cui impressum est illud lumen, ut sigillum cerae."[39]

Commentaries from the School of Laon, from Abélard, and from the canons of St.-Victor held that the human soul in God's image is different from the Son who is also in God's image, in proportion to the difference between the king's image on a seal and the king's generated image in his son.[40] In the transcendental terms of this metaphor, only the engendered image of the Son shares properties and is consubstantial with its divine model. The created image (man), on the other hand, bears only an analogy to its model: the human being is in the image of God. Abélard and the School of Laon tempered this transcendental ontology with a particular vision of immanence, which insisted upon the presence of God within the begotten Son and, through the Son, within the created human being as well. Here again, Abélard and the Laon scholars resorted to a seal metaphor, this time evoking the die's material (*aes*, the bronze), the image engraved upon it (*sigillum*), and its waxen imprint (*imago*). In this metaphor marshaling the seal's substance, its en-

graved figure, and the imprinted/expressed image, God is the seal's inherent material (the very substance of its matrix); the Son is the figure of God's substance, the image of God engraved within the matrix, which in turn imprints itself upon the pliable human soul (reason, heart, memory), enabling that soul to be marked and configured as the Son.[41]

Yet another prescholastic application of the seal metaphor, to angels, gives further insight into the interpretive depth of the sigillographic motif. Gregory the Great (d. 604) derived from a passage in Ezekiel that the Bible spoke of angels as *signacula similitudinis*, seals of resemblance. Gregory inaugurated an enduring exegetical tradition when he concluded that angels were seals of resemblance because, as purely rational beings, they had more likeness to God than man, who, as a corporeal being, was merely an *imago Dei*.[42] Prescholastics massively exploited the Gregorian theme. Peter of Blois (d. ca. 1211), for instance, wrote that the angel was created close to and in such conformity with God that the angel is a seal (*signaculum*) rather than, as man is, a seal impression.[43] This reveals an interesting hierarchy which Alan of Lille enlarged significantly. Alan analogized the Son/Christ to a *sigillum* because, he wrote, Christ and the Father are consubstantial. This confirms that *sigillum*, in this context as elsewhere, means seal matrix, that is, the die and the image incised in it. Given Peter's and Alan's differentiated use of *sigillum* and *signaculum*, it is also relevant to note that *sigillum* then normally designated the great seal of contemporary elites, whereas *signaculum* was the contemporary term for a personal signet ring, a seal to be sure, but lacking the great seal's import and authority. Alan used the term *signaculum* as an analogue for the angel whose rational nature resembles God. In Alan's construct, man is analogized to *imago*, the imprinted image in wax which may lose its initial resemblance once it has been imprinted because this resemblance is simply one of form rather than substance. Lastly, a nonrational creature is termed *signum*, a sign indicating God indirectly by its beauty, its life, its structure, its function, but which has neither direct resemblance nor consubstantiality with the divine.[44]

The topos of imprint emerged primarily as prescholastics refined their understanding of the creation of man in God's image, in the confused light of Paul's contention that man is the image of God (1 Cor. 11:7), and of the general patristic doctrine that Christ is the image of God—and the instrument of man's reformation. In other words, they considered that the imprinted image motif particularly clarified the issues of creation, incarnation, and divine modeling of the individual soul.[45] Why? How did they understand the metaphor?

First, such images posited an impression present within the very fabric of the inner man. Image had acquired the additional dimensions of materiality and relief.

Second, the imprinted image expresses an undoubted relationship to its origin. Eschewing the displacement of origin that characterizes the mirror reflection, the imprint retains the marks of its derivation. From the imprint, an origin can be traced, which fact may account for the extensive use of the term *impressio* to articulate the filiation, kinship, and affinity between God and the creature marked by the imprint of his Creator. *Impressio* thus came to project the notion of image as personal.[46] This association between imprint and person was greatly reinforced by an abundance of metaphorical references to sealing in texts that placed great emphasis on the necessity and the possibility of self-knowledge.[47] It was the inner nature of man, that fabric imprinted by God, which enabled him to comprehend his "being-image,"[48] and to aspire to an ontological trajectory which might draw him closer to the divine prototype. Such a potential trajectory was predicated upon the multiple affinities between God and his imprinted man. The imprint not only articulated the formal resemblance (even in the presence of a difference in substance) between

image and archetype, which was necessary for man to be able to evolve a knowledge of God, it also implied that direct contact which rendered man's soul God-like as it took on the sculptural form of the divine seal. In manipulating the notion of image-as-imprint, prescholastics ultimately came to conceive that the motifs of divine presence impressed within the human fabric were in fact constitutive of that very fabric. They were no longer comparing the resemblance between two distinct entities, the immortal human soul and the eternal God. Through the metaphor of imprinting, this resemblance was reified, becoming both substantial and essential. In the words of Peter Lombard and Hugh of St.-Victor, for instance, the soul was no longer simply an image that resembled; it had actually become the immortal nature of man.[49] Thus, in embracing the imprint as metaphor, the prescholastics settled on an essentialist concept of image.

It may be useful here to recapitulate the implications of the prescholastic tilt away from the mirror and toward the seal metaphor before embarking on an analysis of this shift for prescholastic strategies of representation.

The mimetic economy of the mirror reflection confused the issue of origin, whereas in the mimetic economy of the imprint, an origin is traced which cannot be contested. The imprint therefore signified how man proceeded from the image of God, closely linking the notion of image with those of filiation, derivation, and contact. The imprint implied affinity and participation, whereas the mirror had evoked imitation, displacement, and discontinuity.

The imprint demonstrates that the resemblance of an image to its model results from a comprehensive process involving both form and matter. The nature of imprinting makes manifest how the very receptacle of the form can be made to participate in the mimetic economy of the image. As the following text from the school of Laon put it: "sciendum est enim quoniam imago impressa in re aliqua et ipsa res in qua imprimitur imago appellatur."[50] In extending the sphere of *imago* from the field of vision to the material and tactile dimension of imprinting, prescholastics rooted likeness in empirical experience. (Recall that Augustine had left the notion of likeness essentially unexplained by subsuming it within the Neoplatonic principle of participation.)

Whereas the mirror-image had evoked a being barely capable of seeing a God located outside himself, the image-imprint evoked a being whose very soul was constituted by God's mark. The mirror's image, often jeopardized by dross, was desubstantialized; the imprint-image configured the person. In locating a mark of God within man, the imprint became the index of an unimpeachable inner presence. Corresponding to the mirror is a man who sees and believes; the imprint evokes a man touched by God's very presence within him.

The imprinted image was thus closely bound to incarnational thinking and its concern for real presence in the Eucharist which agitated the prescholastic world of Northern France.[51] The radical doctrine that the eucharistic sign was actually what it also represented produced a conflation of sign and thing. Such conflation disables the dynamics of reference and undermines the semiotics of representation. Prescholastic schoolmen, however, retained the axis of eucharistic reasoning when they argued that signs represented objects by actualizing their characteristics in matter.[52] Their new sign theory paralleled the discourse on images which they articulated by means of the imprint. The new theory also underlay sealing, a rapidly expanding practice enacted by imprinted images, which entered the field of social praxis, becoming signs-in-action.[53]

I have argued elsewhere that the practice of sealing documents spread within society from prescholastic milieus where schoolmen launched this new experiment in documentary signing as part of the new immanent, or essentialist, semiotics they were elaborating in their theological dis-

cussion.[54] Suffice it here to say that the eleventh and twelfth centuries saw the new and sustained use of nonroyal sealed charters, and that initially the seal's performance and significance instantiated the new sign theory from two points of view. First, seal impressions, affixed to charters from a matrix, actualized the presence of their owners as they shared with them the property of definition: both were imprinted images. That the seal was conceived primarily as an imprinted image may be inferred from the final clauses of the charters' texts. For instance, in charters given in their own names, such diverse rulers as the bishops of Laon and archbishops of Rheims, the counts of Ponthieu, and several kings of France are recorded as having ordered that "their transaction be reinforced with the imprint of their image.[55] By the thirteenth century, however, this vocabulary of imprinting had virtually disappeared, replaced by the standard testimonial formula: *in cujus rei testimonium presentam cartam sigillo nostro fecimus roborari*. Second, prescholastic insistence on the seal as imprint brought to the fore the question of its origin. The wax applied to the seal owner's matrix embodied his person as the true origin. The authorship and authority of the seal depended on the person and the personal participation of its owner—often rendered even more tangible by the inclusion of bodily marks in the seal. The seal impression was appreciated as a relic of the sealer's physical contact and participation.

It is my contention that the progressive sealing of documents during the eleventh and twelfth centuries created a new horizon of social values that ultimately transformed the very representational system that had initially governed the rapport between the seal and its referent, the sealer.

Seal impressions were products of mechanical reproductive techniques which assured the multiplication of identical images. Such techniques tended to deflect attention from human agency and toward the mechanistic aspect of seal origin. The identicality of imprints came to guarantee both the same origin (the sealer) and a unique original (the seal matrix). It was thus as true replicas one of another that seal impressions now expressed (instantiated), though no longer embodied (substantiated), that presence which assured the authority these impressions conveyed. That contact between the sealing person's body and the seal, which had originally been so important a factor in establishing the seal's authority, thus came to be displaced by the relationship between image and image. Some Norman lords, for instance, deposited multiple impressions of their seals in different abbeys by which to guarantee, through publicity and comparison, any charters they might later seal.[56]

The sameness of the seal impressions, to be sure, did not fully displace the necessary existence of an original, but the adequacy of such impressions was not in practice tested against an original; to the contrary. Since, as a result of the mechanical reproductive technique, all impressions of a given matrix were assumed to be identical copies, they all ended up functioning as originals generating their own accuracy, truth, and validity. In practice, replicated seal impressions were understood and treated as both copies and originals. This perception, and the very centrality and potency of sealed documents, intensified medieval confusion and concern about the nature of forgery. For forgery is but an extreme form of replication, and replicability had, by the thirteenth century, become the main criterion used to certify the authenticity of seal impressions. Replication, by rendering moot the distinction between original and duplicate, undermined those differences upon which law bearing on originals and fakes might be based. Replication, replicability, in this sense, made it very difficult, if not impossible, to prove the real, which led twelfth- and thirteenth-century canon lawyers into many contradictory pronouncements on seal genuineness.[57]

Canon lawyers and legal scholars translated the question of authenticity into a concern for authority, and they especially struggled to define theoretically and practically the capacity of seals to confer full validity upon documents to the signing of which there had been no witnesses. In this context, jurists asserted, quite vaguely and redundantly, that the authority of a seal depended upon the seal itself being well known.[58] Surviving medieval legal treatises about seals testify amply to the difficulty legal scholars had in articulating the fundamental values and beliefs which underlay the utility and force of seals. Their uncertainty cannot today be appreciated without investigating the complex contemporary competing ideas concerning seals.

As we have seen, these ideas had originated in an eleventh- and twelfth-century theological discourse where the imprinted image had permitted the quality of authenticity to derive from an attributed origin. By the time seals entered legal discourse in the thirteenth century, they had largely ceased to be an active motif within theology. The seals themselves were by then functioning as replicated images without a readily referenced original to confer authority and authenticity. Thus, in the thirteenth century, as these ideas—old and new, theological and legal, conceptual and practical—competed for hegemony over the future, a battle was fought about the question of who, or what, might guarantee signification. For, by then, these two distinct concepts of seals—as impressions of presence and as replicated images—had blurred the very concepts of authenticity and of authority.

Every new technology alters human subjectivity. A tool is not simply the instrument of a human competence; it transforms that competence.[59] And so it was with the technology of imprinting and of replication, which provided the framework and the model for the formulation of personal identity.

Eleventh- and twelfth-century seal iconography projected conventional images of their owners, portraying the social status of the person represented (king, bishop, warrior, abbess). The human body was displayed, not in an individualized manner, but in one subordinated to the presentation of that status. When the seal was conceived to operate as *imago*, as an ontological image, it modeled the essence of individuality, that is, the realization of a self in conformity with an internalized prototype. When the technology of replication later, in the course of the thirteenth century, displaced the seal's former incarnational mode, it was the similarity between generic seal images, their very recurrence as conventional types, that took on significance. Seal iconography thus necessarily rested upon clichéd portraits. Particularized portraits, too closely identified with one person or another, would not have achieved cultural relevance because they did not signify conventionality.[60] As a result, the semiotic principle at work in seal imagery tended to thwart individualized references—as distinguished from references to persons in their official capacity.[61] Seal images, bound by and meaningful through conventions of similitude, formed a referential system in which one image referred primarily to another. Here again, reference to an origin, and to an originator, was obscured. Rather, cultural templates were highlighted as generative models, and each use of a conventional and replicated image instantiated these templates as both natural and normative.

The technology of impression and of replication appears to have served as a model for the formulation of medieval identity. Seal users came to develop a new awareness of themselves in relation to an object, the seal, whose operational principles as a sign were essentialism, categorization, and verification. The culture of the replica promoted a particular notion of personal identity, pro-

ducing and presenting identity as a figure of sameness rather than as a ground for individual differentiation.

Permit me to jump through time, and to conclude with the question raised by the poet Edward Young in the eighteenth century: "Born Originals, how comes it to pass that we die Copies?"[62]

Notes

1. In the felicitous words of J. Baschet, "Inventivité et sérialité des images médiévales: Pour une approche iconographique élargie," *Annales HHS* 51, no. 1 (1996), 93–133, at 97.

2. J.-C. Schmitt, "La Culture de l'imago," *Annales HHS* 51, no. 1 (1996), 4; B. Bedos-Rezak, "Une image ontologique: Sceau et ressemblance en France préscolastique (1000–1200)," in *Études d'histoire de l'art offertes à Jacques Thirion: Des premiers temps chrétiens au XXe siècle* (Paris, 2001), 39–50, at 42–44; R. Javelet, *Image et ressemblance au 12e siècle, de saint Anselme à Alain de Lille*, 2 vols. (Paris, 1967), vol. 1, xix–xxiii.

3. H. Belting, *Likeness and Presence: A History of the Image before the Era of Art*, trans. E. Jephcott (Chicago and London, 1994), 152. Belting carefully demonstrates how the theory of images produced to oppose the iconoclasts was revolutionary in that it considered the image and the word of God to be equal media of revelation; in earlier theories revelation had rested solely on God's written word. Nevertheless, the anti-iconoclastic theologians also sought to justify their doctrine of images by drawing upon the patristic tradition. Church fathers (Basil the Great, ca. 330–379, in particular) were not concerned about images per se but had invoked them as an explanatory device to elucidate the two natures of Christ. Resorting to the Platonic concept of archetype (God) and image (Christ, bearer of its archetype), they in effect provided later theologians with a justification to venerate images in the name of the person they represented, in the same way that the Father, contained in the Son as in an image, could be honored in Christ (149–55).

4. PG 95:163; 99:432–33; quoted in Belting, *Likeness and Presence* (as in note 3), 153. On Theodore's argument that the icon affirms and proves the truth of Christ's Incarnation, see C. Scouteris, "La Personne du verbe incarné et l'icône: L'Argumentation iconoclaste et la réponse de saint Théodore Studite," in *Nicée II, 787–1987: Douze siècles d'images religieuses*, ed. F. Boespflug and N. Lossky (Paris, 1987), 121–33.

5. Belting, *Likeness and Presence* (as in note 3), 150.

6. Quoted in G. Vikan, "Ruminations on Edible Icons," in *Retaining the Original: Multiple Originals, Copies, and Reproductions*, Center for Advanced Study in the Visual Arts, Symposium Papers 7, Studies in the History of Art, vol. 20 (Washington, D.C., 1989), 47–59, at 51. See a translation of Theodore's text in C. Mango, *The Art of the Byzantine Empire, 312–1453: Sources and Documents* (Englewood Cliffs, N.J., 1972), 174. For additional texts by

Theodore of Stoudios employing the seal metaphor to legitimate a theory of images, indeed attaching image making to the Incarnation itself, see H. L. Kessler, "Configuring the Invisible by Copying the Holy Face," in *The Holy Face and the Paradox of Representation*, Villa Spelman Colloquia 6, ed. H. L. Kessler and G. Wolf (Bologna, 1998), 129–51, at 133–34, 150, reprinted in Kessler, *Spiritual Seeing: Picturing God's Invisibility in Medieval Art* (Philadelphia, 2000), 64–103.

7. Belting, *Likeness and Presence* (as in note 3), 263; a résumé of Psellus's commentary on Genesis 1:26 is given at 529–30, while the full text of the commentary is available in Michael Psellus, *Scripta minora*, ed. E. Kurtz and F. Drexl (Milan, 1936), vol. 1, 411–14.

8. Belting, *Likeness and Presence* (as in note 3), 261–64, and 528–29, where Belting provides a translation of Psellus's literary description of an icon of the Crucifixion; see above at note 7 for Psellus's commentary on Genesis 1:26. In rejecting the Platonic argument that linked image to prototype in a static relationship, Psellus freed icons to act as their own models and to assign lifelike expressions to the person represented. As figures in icons could be seen as models of spiritual perfection, the image itself acquired a programmatic dimension. Psellus's focus on the ethical meaning of images, together with his insistence that expressive icons resembled more exactly what they represented, led him to conclude that likeness between man and God was not a matter of resemblance but the capacity for human being to perfect themselves.

9. Eighth-century Western justification of images, held in response to and contemporary with Eastern iconoclasm and with the more moderate anti-image texts of the so-called *Libri Carolini*, was developed within the framework of Pope Gregory the Great's writings on the pedagogical utility, and commemorative and spiritual functions, of images (J.-C. Schmitt, "L'Occident, Nicée II et les images du VIIIe au XIIIe siècle," in *Nicée II* [as in note 4], 271–301, at 274–77). Yet, whereas Gregory had assigned to Christ's Incarnation, and not to image, the capacity to lead from visible to invisible things, an eighth-century interpolation to Gregory's Letter to Secundinus applied this capacity to the picture of Christ itself. Widely quoted thereafter by Western supporters of images, the interpolated passage asserted that the image of Christ elicited feelings of love which carried the mind toward a contemplation of God in the spirit. According to this theory, feelings, not images, lead the mind to contemplation of the invisible God; the role of images, thus, was purely affec-

tive; see H. L. Kessler, "Real Absence: Early Medieval Art and the Metamorphosis of Vision," in *Morfologie sociali e culturali in Europa fra tarda antichitá e alto medioevo* (Spoleto, 1998), 1157–1211, reprinted in Kessler, *Spiritual Seeing* (as in note 6), 105–48, with further bibliography.

10. The sixth-century Neoplatonic writings of Pseudo-Dionysius the Areopagite scarcely affected Western thought until the twelfth century, and their impact thereafter is very much debated. On the influence these writings had on Suger (d. 1151), see, for instance, G. Zinn Jr., "Suger, Theology, and the Pseudo-Dionysian Tradition," in *Abbot Suger and Saint-Denis*, ed. P. Gerson (New York, 1986), 33–40; H. L. Kessler, "The Function of *Vitrum Vestitum* and the Use of *Materia Saphirorum* in Suger's St.-Denis," in *L'Image: Fonctions et usages des images dans l'Occident médiéval*, ed. J. Baschet and J.-C. Schmitt (Paris, 1996), 179–203, reprinted in Kessler, *Spiritual Seeing* (as in note 6), 190–205, at 193–94, with relevant bibliography. The influence of the Pseudo-Dionysius is also found in the theology of Hugh of St.-Victor (d. 1141); see Schmitt, "L'Occident" (as in note 9), 292.

Conrad Rudolph (*Artistic Change at St.-Denis: Abbot Suger's Program and the Early-Twelfth-Century Controversy over Art* [Princeton, 1990]) argued for the primacy of an Augustinian influence on Hugh and Suger, an argument further supported by Sarah Spence (*Texts and the Self in the Twelfth Century* [Cambridge, 1996], 28–33).

11. A suggestive comparison of Eastern and Western attitudes toward images is given by D. Barbu, "L'Image byzantine: Production et usages," *Annales HHS* 51, no. 1 (1996), 71–92. For an analytic survey of postmillennial debates about and attitudes toward sacred images, see Schmitt, "L'Occident" (as in note 9), 282–301. Further appreciations of the role and meaning of actual images in eleventh- and twelfth-century Western culture may be found in J.-C. Schmitt, "Les Images classificatrices," *BEC* 147 (1989), 311–41, and "La Culture de l'*imago*," *Annales HHS* 51, no. 1 (1996), 3–36; G. Constable, *Three Studies in Medieval Religious and Social Thought* (Cambridge, 1995), 179–217; *L'Image: Fonctions et usages* (as in note 10), particularly the contributions by J. Baschet, "Introduction: L'Image objet," 7–26, and J.-C. Schmitt, "Imago: De l'image à l'imaginaire," 29–37; *La Visione e lo sguardo nel medio evo/View and Vision in the Middle Ages*, I, *Micrologus* 5 (1997), in particular the essay by T. Ricklin, "Vue et vision chez Guillaume de Conches et Guillaume de Saint-Thierry: Le Récit d'une controverse," 19–41; *La Visione e lo sguardo nel medio evo/View and Vision in the Middle Ages*, II, *Micrologus* 6 (1998), especially M. C. Ferrari, "*Imago visibilis Christi*: Le *volto santo* de Lucques et les images authentiques au Moyen Age," 29–42. Prescholastic focus on the ontological property of image may explain schoolmen's neglect of Carolingian debates (see note 9 above). Furthermore, in prescholastic times, any danger of religious materialism was connected primarily with relics since most of the images that populated the religious world then assumed the appearance of relics and gained power from their coexistence with relics. Such images had the bodily appearance of a sculpture; they represented the reality of the presence of the holy within the world, on terms similar to those of the relic (Schmitt,

"L'Occident" [as in note 9], 285–86; Belting, *Likeness and Presence* [as in note 3], 297–98, 301–2).

Nevertheless, there also existed between the seventh and the twelfth centuries pictorial holy images and texts on sacred images, both of which explicitly distinguished art from its invisible archetype while endowing depictions of holy persons with the sole power to evoke spiritual visions (Kessler, "Real Absence" [as in note 9], 112–34). In the mid-twelfth century, Suger liberated such images from their restriction to the corporeal world with the idea, exemplified at St.-Denis, "that the sensible world can mediate between God and man" (Kessler, "Real Absence" [as in note 9], 112–34, 148; J.-C. Bonne, "Entre l'image et la matière," in *Les Images dans les sociétés médiévales: Pour une histoire comparée* [Brussels and Rome, 1999], 77–111, and "Pensée de l'art et pensée théologique dans les écrits de Suger," in *Artistes et philosophes: éducateurs?* [Paris, 1994], 1–38). In her *Texts and the Self in the Twelfth Century* (as in note 10), Spence's analysis of Suger's *De administratione* concludes that, for Suger, that which is signified is anchored in its signifier, that is, an object belonging to this world (50). Further discussion of this relative collapse of a distinction between physical and spiritual in the signifying mode of images, and of signs in general, is one object of the present essay.

12. The fundamental work is Javelet, *Image et ressemblance* (as in note 2). For additional insights, see D. N. Bell, *The Image and Likeness: The Augustinian Spirituality of William of Saint-Thierry* (Kalamazoo, 1984); G. B. Ladner, *Ad Imaginem Dei: The Image of Man in Medieval Art* (Latrobe, 1965), and *Images and Ideas in the Middle Ages* (Rome, 1983); J. E. Sullivan, *The Image of God: The Doctrine of St. Augustine and Its Influence* (Dubuque, Iowa, 1963).

13. Despite my great admiration for Hans Belting's sensitive and formidable work on images, I cannot concur with his conclusion in *Likeness and Presence* (as in note 3), 305, that "while [in the West] images were invested with powers necessary to represent a legal person, this custom was not seen as a philosophical problem." It is true that no specific treatise was produced on the representational capacity of images, but the schools, scriptoria, and chanceries responsible for the earliest production of nonroyal sealed charters were staffed by theologians preoccupied with the definitions of person, image, and identity; see B. M. Bedos-Rezak, "Medieval Identity: A Sign and a Concept," *AHR* 105, no. 5 (2000), 1489–1533. On the reciprocal interaction between prescholastic theory of image, incarnational thinking, and the doctrine of real presence, see note 54 below.

14. Augustine deals with the doctrine of image principally in *De Genesi ad litterarum imperfectus* LVII (A.D. 393–426) (PL 34:242; see text in note 15 below); *De diversis quaestionibus* LXXXIII,51.4 (A.D. 388–396) (PL 40:33–34); and *Quaestiones in Heptateuchum* V.4 (A.D. 419) (PL 34:749–50; see text in note 16 below). In the compilation that he made of Augustine's comments on the nature of images, J. Heijke gathered 142 texts: "St. Augustine's Comments on *Imago Dei* (Exclusive of the *De Trinitate*)," *Classical Folia*, suppl. 3 (April 1960).

15. "Et dixit Deus, Faciamus hominem ad imaginem et

similitudinem nostram. Omnis imago similis est ei cujus imago est; nec tamen omne quod simile est alicui, etiam imago est ejus: sicut in speculo et pictura, quia imagines sunt, etiam similes sunt; tamen si alter ex altero natus non est, nullus eorum imago alterius dici potest. Imago enim tunc est, cum de aliquo exprimitur" (*De Genesi ad litterarum imperfectus* LVII [PL 34:242], summarized in English by Bell, *The Image and Likeness* [as in note 12], 36).

Augustine's statement that likeness does not necessarily include the idea of image is also found in passages from *De diversis quaestionibus* LXXXIII, 51 (PL 40:33–34), and from the *Quaestiones in Heptateuchum* (see note 16 below), where the difference between image and resemblance is further illustrated by the fact that though twins are alike, one is not the image of the other.

16. " 'Ne feceritis iniquitatem, et faciatis vobis ipsis sculptilem similitudinem, omnem imaginem.' Quid intersit inter similitudinem et imaginem quaeri solet. Sed hic non video quid interesse voluerit, nisi aut duobus istis vocabulis unam rem significaverit, aut similitudinem dixerit, si, verbi gratia, fiat statua vel simulacrum habens effigiem humanam, non tamen alicujus hominis exprimantur lineamenta, sicut pictores vel statuarii faciunt, intuentes eos quos pingunt seu fingunt. Hanc enim imaginem dici nemo dubitaverit: secundum quam distinctionem omnis imago etiam similitudo est, non omnis similitudo etiam imago est. Unde si gemini inter se similes sint, similitudo dici potest alterius cujuslibet in altero, non imago. Si autem patri filius similis sit, etiam imago recte dicitur; ut sit pater prototypus, unde illa imago expressa videatur: quarum aliae sunt ejusdem substantiae, sicut filius; aliae non ejusdem, sicut pictura. Unde illud quod in Genesi scriptum est, *Fecit Deus hominem ad imaginem Dei;* manifestum est ita dictum, ut non ejusdem substantiae sit imago quae facta est. Si enim ejusdem esset, non facta, sed genita diceretur. Sed quod non addidit, 'et similitudinem,' cum superius dictum esset, *Faciamus hominem ad imaginem et similitudinem nostram* (Gen. I, 27, 26); quibusdam visum est similitudinem aliquid amplius esse quam imaginem, quod homini reformando per Christi gratiam postea servaretur (*Quaestiones in Heptateuchum* [PL 34:749]). See R. A. Markus, " 'Imago' and 'Similitudo' in Augustine," *Revue des études augustiniennes* 10 (1964), 125–43, reprinted in *Sacred and Secular: Studies on Augustine and Latin Christianity* (Aldershot, 1994), no. 16; Markus, "Signs, Communication, and Community in Augustine's *De Doctrina Christiana,*" in *De Doctrina Christiana: A Classic of Western Culture,* ed. D. W. H. Arnold and P Bright (Notre Dame, Ind., 1995), 97–108; and Bell, *The Image and Likeness* [as in note 12], 36.

17. Bell, *The Image and Likeness* (as in note 12), 24–25.

18. Already in his treatise against Arianism (*Adversus Arium* [PL 8:1039D]), Marius Victorinus (d. 370) had applied Aristotle's *Categories* (11a17) to the Trinitarian problems of his time, proposing a definition of likeness as that which exists between things by virtue of their qualities, not their substances, for things of the same substance are said to be of the same substance, not like: "Arius dicit: *Filium factum,* scilicet *plenum Deum, unigenitum, immutabilem, qui antequam crearetur non fuerit, propterea quod non sit ingenitus.* Haec eadem Eusebius, adjiciens,

quod filius omnia facienti sit similis: nos contra, non enim similem, sed eumdem dicimus, quippe ex eadem substantia" (Markus, " 'Imago' and 'Similitudo' in Augustine" [as in note 16], 128). In prescholastic times, the operative nature of the resemblance between the persons of the Trinity provoked much controversy. Abélard, in particular, was condemned as "Arian" for his proposition that identity between things can be described in at least five ways: by essence and number, in property, by definition, by likeness, and by incommunicability (J. Jolivet, "Sur quelques critiques de la théologie d'Abélard," *Archives d'histoire doctrinale et littéraire du Moyen* Age 38 [1963], 7–51, at 29–32, 34–35, 50; J. Marenbon, *The Philosophy of Peter Abelard* [Cambridge, 1997], 150–55).

19. Javelet, *Image et ressemblance* (as in note 2), vol. 1, 139–45; Bell, *The Image and Likeness* (as in note 12), 22–23. See below at p. 53 and note 50.

20. Augustine links *speculum* and *imago* in several passages of the *De Trinitate:* "De creatura etiam quam fecit Deus, quantum valuimus, admonuimus eos qui rationem de rebus talibus poscunt, ut invisibilia ejus, per ea quae facta sunt, sicut possent, intellecta conspicerent (Rom. I, 20), et maxime per rationalem vel intellectualem creaturam, quae facta est ad imaginem Dei; per quod velut speculum, quantum possent, si possent, cernerunt Trinitatem Deum, in nostra memoria, intellegentia, voluntate" XV, 20.39 (PL 42:1088). See further examples in *De Trinitate* XV, 8.14 (PL 42:1067–69); XV, 17.23 (PL 42:1055); XV, 24.44 (PL 42:1091). These passages may also be consulted in *De Trinitate,* ed. W. J. Mountain, 2 vols. (Turnhout, 1968), and in *On the Trinity,* trans. A. W. Haddam, revised and annotated by W. T. Shedd (reprint Grand Rapids, Mich., 1956), 208; see E. P. Nolan, *Now through a Glass Darkly: Specular Images of Being and Knowing from Vergil to Chaucer* (Ann Arbor, 1990), 58–59, 84–85.

21. J. F. Hamburger, "Speculations on Speculation," in *Deutsche Mystik im abendländischen Zusammenhang,* ed. W. Haug and W. Schneider-Lastin (Tübingen, 2000), 353–408, at 369.

22. Richard of St.-Victor, *Benjamin major,* II, 12, *De tertio contemplationis genere:* "Nunc vero de tertio contemplationis genere videamus. Ad hoc itaque genus pertinet quoties per rerum visibilium similitudinem rerum invisibilium qualitatem deprehendimus, quoties per visibilia mundi invisibilia Dei cognoscimus, ut constet quod scriptum reperitur, quia invisibilia Dei a creatura mundi per ea quae facta sunt intellecta conspiciuntur" (PL 196:89D; text translated in *The Twelve Patriarchs, the Mystical Art, Book Three of the Trinity,* trans. and intro. G. Zinn [New York, 1979], 190).

23. P. Courcelles, *Connais-toi toi-même, de Socrate à Saint-Bernard,* 3 vols. (Paris, 1974), vol. 1, 240–44; Javelet, *Image et ressemblance* (as in note 2), vol. 1, 377–78, 384; R. Javelet, "Psychologie des auteurs spirituels au XIIe siècle," *RSR* 33 (1959), 18–64, 97–164, 209–66, at 230–55; Richard of St.-Victor, in *De praeparatione animi ad contemplationem liber dictus Benjamin minor, caput lxxii: Quomodo per plenam cognitionem sui, sublevetur animus ad contemplationem Dei:* "Praecipuum et principale speculum ad videndum Deum, animus rationalis, absque dubio invenit seipsum. Si enim invisibilia Dei per ea quae facta sunt, intellecta conspiciuntur, ubi, quaeso, quam in

ejus imagine cognitionis vestigia expressius impressa, reperiuntur? Hominem secundum animam ad Dei similitudinem factum et legimus, et credimus, et idcirco quandiu per fidem, et non per speciem ambulamus, quandiu adhuc per speculum et in aenigmate videmus, ad ejus, ut ita dixerim, imaginariam visionem aptius speculum, quam spiritum rationalem invenire non possumus. Tergat ergo speculum suum, mundet spiritum suum, quisquis sitit videre Deum suum" (PL 196:51C–D; text translated in *The Twelve Patriarchs* [as in note 22], 129–30]; Hugh of St.-Victor, *De sacramentis* I, 3, *De cognitione divinitatis* V, 1, *De illo cognitionis genere quo mens rationalis in se Deum videre potest:* "et primum quod in ea [ratione] erat, quoniam et hoc illi erat primum et principale speculum veritatis contemplandae inspiciamus. In eo igitur primum et principaliter invisibilis Deus, quantum ad manifestationem expositum est, videri poterat quod illius imagini et similitudini proximum et cognatum magis factum erat. Hoc autem ipsa ratio erat et mens ratione utens quo ad primam similutidinem Dei facta erat ut per se invenire posset eum a quo facta erat" (PL 176:219A; for the text in English, see Hugh of St.-Victor, *On the Sacraments of the Christian Faith,* trans. R. J. Deferrari [Cambridge, Mass., 1951], 42–43: "let us examine what was in the rational mind, because this indeed was man's first and principal mirror for contemplating truth. In this mirror, therefore, first and principally the invisible God, in so far as this was exposed to manifestation, could be seen, since it had been made nearest and most related to His image and likeness. Now this was reason itself and mind using reason whereby it had been made to the first likeness of God, so that through itself it might find Him by whom it was made."] John of Salisbury deftly evokes how human reason is an image that sees: "Est igitur ratio speculum quo cuncta videntur/officioque oculi fungitur atque manus/conscia naturae verum scrutatur et aequi/arbitra virtutum sola ministrat opes" (*Entheticus,* verses 655–70 [PL 199:979C]). On the importance of the relationship between divine reason, human reason, and the notion of image for prescholastic anthropology, see Javelet, *Image et ressemblance* [as in note 2], vol. 1, 169–81, 378–79. A typical statement is that of Peter Lombard: "Imago creationis est in qua creatus est homo, scilicet ratio" (*Commentarius in psalmos Davidicos, Psalmus IV* [PL 191:88B]). Hugh of St.-Victor (in *De sacramentis christiane fidei* I, 10, De fide, chap. 9, *De sacramento fidei et virtute*) stresses the visual dimension of faith, which he considers to be an act of vision undertaken by a purified being through the mediation of images in order to reach contemplation of the divine: "Sed quod est aenigma, et quod est speculum in quo videtur imago donec ipsa res videri possit? Aenigma est Scriptura sacra. Quare? quia obscuram habet significationem. Speculum est cor tuum, si tamen mundum fuerit et extersum et clarificatum. Imago in speculo fides in corde tuo. Ipsa enim fides imago est, et sacramentum. Contemplatio autem futura, res et virtus sacramenti. Qui fidem non habent nihil vident; qui fidem habent jam aliquid videre incipiunt, sed imaginem solam. Si enim fidelis nihil videret, ex fide illuminatio non esset, nec dicerentur illuminati fideles. Si autem jam ipsam rem viderent, et non amplius videndum aliquid exspectarent, non per speculum in aenigmate, sed facie ad faciem viderent" (PL 176:342C–D]; English trans. in *On the Sacraments of the Christian Faith* (as in this note), 181: "The dark manner is Sacred Scripture. Why? Because it has obscure meaning. The glass is your heart, if, however, it be clean and clear and clarified. The image in the glass is the faith in your heart. For faith itself is image and sacrament. But future contemplation is the thing and the virtue of the sacrament. Those who have no faith see nothing, those who have faith already begin to see something but only the image. For if the faithful see nothing, there would be no enlightenment from faith nor would the faithful be called enlightened. But if they already saw the thing itself and did not await something more to be seen, they would not see through a glass in a dark manner but face to face."

24. It may not be straining the prescholastic position too much to refer here to "the glassy metaphorics of the mirror"; the expression is H. Bhabha's, "Interrogating Identity," in *The Real Me: Postmodernism and the Question of Identity,* ed. L. Appignanesi, ICA Documents 6 (London, 1986), 5–12, at 6. Courcelles, *Connais-toi toi-même* (as in note 23), vol. 1, 240, quoting Hugh of St.-Victor, who denounced the soul's bad sight in *Soliloquium de arrha animae* (PL 176:953D): "ANIMA: oculus cuncta videt, seipsum non videt, et eo lumine, quo reliqua cernimus, ipsam, in qua positum est lumen, faciem nostram non videmus . . . HOMO: . . . oculus tuus nihil bene videt si seipsum non videat."

In discussing the representative capacity of the mirror-image, Robert of Melun went beyond the issue of stained opacity to dwell on the imperfect mediation of the mirror-image: "nulla tamen creatura ipsam sapientiam Dei rationem habuit nisi creatura rationalis, quae sola sapientiam Dei potest imitari per intelligentiam et cognitionem veri et amorem boni. Habet enim naturam discernendi inter verum et falsum et bonum et malum, appetendi bonum malumque spernendi. Ideo etiam solus homo de creaturis corporeis ad imaginem Dei et similitudinem conditus esse discebatur. Est autem aliud ipsam sapientiam Dei imaginem habere et aliud in ipsa imaginem habere. Sicut aliud est aliquid in speculo imaginem habere et aliud est ad imaginem speculi aliquid factum esse. Non enim verum est quod omne illud quod in speculo apparet, ad imaginem speculi factum sit. Nam quod ad imaginem speculi factum est, ipsum imaginum, rerum ac formarum capax esse necesse est et eas repraesentare posse" (*Sententiae magistri Roberti de Meleduno, liber primus, pars undecima,* Bruges, Bibliothèque publique de la Ville, Cod. lat. 191, f. 136 recto-a, quoted in Javelet, *Image et ressemblance* [as in note 2], vol. 2, 140, 288]. On the works of Robert of Melun, see F. Bliemetzfrieder, "Robert von Melun und die Schule Anselmus von Laon," *ZKircheng* 53 (1934), 117–70; *Œuvres de Robert de Melun,* ed. R. M. Martin, 3 vols. in 4 (Louvain, 1932–52), includes the *Quaestiones de divina pagina* (vol. 1), the *Quaestiones de epistolis Pauli* (vol. 2), and the first book (parts 1–6) of the *Sententiae* (vol. 3, 1–2); parts 7–11 and Book 2 (parts 1–2) remain unpublished. B. Smalley (*The Study of the Bible in the Middle Ages* [Notre Dame, Ind., 1964], 68, n. 1) reports O. Lottin's suggestion that Robert might have used a commentary by Anselm of Laon on the Pauline epistles.

On Alan of Lille and the mirror, see Nolan, *Now*

through a Glass Darkly (as in note 23), 98–102. Alan of Lille, in urging the purification of the soul-mirror, pointed out that such purification should involve bypassing the images reflected in or seen by the soul since such images in fact stand in the way of contemplating eternal realities (*Exposition pr. de angelis*, in *Alain de Lille, Textes inédits*, ed. M.-T. D'Alverny [Paris, 1965], 205–6): "Sequitur: 'mentibus defecatis ab ymaginibus' [quote from the Ps. John Scotus], id est ab imaginationibus purgatis. Cum enim contemplamur Deum, ut testatur summus Boetius in libro de Trinitate, non oported nos ad ymaginationes deduci, ut antropomorphonite [sic] deducti sunt, qui Deum corporalibus lineamentis distentum esse crediderunt." A similar idea is found in *Sermo 31, In nativitate B. Virginis Mariae* of Garnier of Rochefort (abbot of Clairvaux 1186, and bishop of Langres ca. 1193): "A specula vero speculatio dicitur, quando mens ita sursum ducitur, ut nullis signis praecedentibus, nullis causis subsistentibus, mens ab omni imagine defaecata, ad superessentialem et infinitivam originem simpliciter et reciproce refertur" (PL 205:766B).

Hervé de Bourg-Dieu and Robert of Melun note the obscurity of the image produced by the soul-mirror. Hervé de Bourg-Dieu, *Commentaria in epistolas divi Pauli, In epistolam I ad Corinthios*: "Speculum est anima rationalis, in cujus consideratione aliquo modo videmus Deum, sed obscure" (PL 181:957A). In his *Sententiae*, I, 6, chap. 49, "Qualiter imago Trinitatis in principali mentis humane possit inveniri," Robert of Melun thus commented the Pauline's *per speculum in enigmate* and Augustine's passages of the *De Trinitate* dealing with the image of the Trinity in man's mind: "Multi vero aenigma vident, id est mentem que Trinitatis imago est; sed pauci in enigmate Trinitatem vident" (*Œuvres de Robert de Melun*, ed. R. M. Martin and R. M. Gallet, vol. 3, part 2, 367).

25. Javelet, *Image et ressemblance*, vol. 1, 378–79 (as in note 2). Gerhoh of Reichersberg (d. 1169), *Commentarius aureus in psalmos et cantica ferialia, pars sexta, Psalmus liv*: "Mali operis, quod ego feci, tu obliviscere, ac de libro memoriae tuae dele, sed *intende mihi* vel *in me*, quem tu ad imaginem et similitudinem tuam fecisti. Specie tua et pulchritudine tua intende in me tanquam in speculum, neque desinas polire, donec videas in me relucentem tuae imaginis ac similitudinis pulchram faciem" (PL 193: 1656A–B); Hugh of St.-Victor, "Speculum est cor tuum, si tamen mundum fuerit et extersum et clarificatum" (see note 23 above).

26. Ladner, *Ad Imaginem Dei* (as in note 12), 14. See, for instance, Anselm of Laon: "Plasmavit Deus hominem de materia, videlicet de terra fecit, de non materia, id est de anima ad imaginem et similitudinem suam," in Munich, Staatsbibliothek, Ms. Clm. 13109, f. 30 verso-a. See note 24 above for Alan of Lille's denunciation of the "anthropomorphonite" who believed that the resemblance between God and man was corporeal.

27. Herbert de Boseham, in his *Liber melorum*, stated that our interior eye could reveal what is within man as the reflection of the Other: "Verum hic noster rationis oculus quid tam longe tam late per aetherea et aeria, per coelestia et terrestria sic evagatur? In nobismet est quod quaerimus, in nobis ipsis prae caeteris est, unde haec prima nostra unitas nobis manifestari possit, et quod est et etiam ex parte aliqua quid ipsa sit. In nobis, inquam, qui prae caeteris ad ipsius sumus imaginem et similitudinem conditi. Unde et nobis ex nobis ipsis et in nobis familiarior cognitio haec. Nostrum igitur rationis oculum retorqueamus in nos ipsos. Ecce enim quia mens nostra rationalis rationis habet judicium ad discernendum, voluntatis arbitrium ad eligendum, et memoriae thesaurum ad reponendum. Hoc quod nunc dicimus rationis nostrae oculo videmus et experimur in nobis. Nihilominus etiam quod non a nobis haec nostra nobis sunt sed ab alio. Quid enim habes quod non acceperis?" (PL 190:1358A–B). Courcelles (*Connais-toi toi-même* [as in note 23], vol. 1, 237–53) quotes texts by Anselm of Canterbury (d. 1109) and by the Victorines in which introspection is held to reveal to man that everything he sees in himself is in fact not himself.

28. *De sacramentis* I, 10, *De fide*, 9, *De sacramento fidei et virtute*: "Quid est per speculum videre? Imaginem videre. Quid est facie ad faciem videre? Rem videre. Puta aliquem esse post te, vel supra te, aversus es ab illo, nec vides facie ad faciem, facie tua ad faciem illius. Aversa est enim facies tua ab illo: et si forte ille respicit ad te, non tamen tu similiter ad illum. Quandiu igitur sic eris, non poteris illum videre facie ad faciem. Exhibe speculum et pone ante te, statim videbis in eo imaginem illius, qui est ad dorsum tuum, vel supra verticem tuum, et dices: Video te. Quid vides? Jam aliquid vides, sed imaginem solam. Vides illum, sed in imagine sua, nondum in facie sua" (PL 176:342A–B); Hugh of St.-Victor, *On the Sacraments of the Christian Faith*, trans. Deferrari (as in note 23), 180–81.

29. Javelet, *Image et ressemblance*, vol. 1, 386 (as in note 2), where the author summarizes the limits such prescholastics as Richard of St.-Victor and Adam Scotus attached to the image obtained through a mirror. See, for instance, Richard of St.-Victor, *De Trinitate* V, 6, *Quod processio personae de persona alia sit tantum immediata, alia mediata, alia mediata simul et immediata*: "Ubi ad alta quidem ascendere volumus, scala quidem uti solemus, nos qui homines sumus et volare non possumus. Rerum ergo visibilium similitudine pro scala utamur, ut quae in semetipsis per speciem videre non valemus, ex ejusmodi specula, et velut per speculum videre mereamur" (PL 196:952D); and Adam Scotus, *De triplici genere contemplationis*: "Et hoc modo video in me imaginem tuam, ad quam fecisti me: et te secundum aliquem modum video in hac imagine. Nondum plene te video in ipsa re, hoc est speculum per quod te video in aenigmate, nondum facie ad faciem. Speculum quidem per quod te video cor meum est: si tamen sic extersum, tamque clarificatum et purificatum a te fuerit, ut evidens in eo vultus perspici possit. . . . luce gratiae tuae illuminatus videre quidem te possum, sed in speculo meo: nondum in teipso intueri te possum: sed in imagine, nondum in ipsa re" (PL 198:834B–D).

30. Hervé de Bourg-Dieu, *In epistolam II ad Corinthios* 3: "In speculo autem non nisi imago cernitur" (PL 181: 1031D). Earlier in the same treatise, Hervé wrote: "speculum est anima rationalis in cujus consideratione aliquo modo videmus Deum, sed obscure" (PL 181:957A; see note 24 above).

31. Ernald, *De opere sex dierum*: "Ego cum me in speculo vel in purissimo fonte intueor, non meipsum

video, sed exprimit mihi imago mea omnem habitum meum vel gestum, et, quantum ex facie indicari potest, ipsum mentis affectum, ut ibi videas utrum decolor sim an coloratus, et manifeste intelligas utrum turbatus videar, an quietus" (PL 189:1533B–C).

32. In the section of *Image and Ressemblance* (as in note 2) that he devotes to the twelfth-century reception of the Pauline text, "Per speculum in aenigmate" (vol. 1, 376–90), Javelet gives voice to the frequent comments by prescholastics that the knowledge to be had from a mirror was imperfect and limited. Javelet also reports (382) the prescholastic fears that a soul-mirror could present two dangers: first, that the need to be totally transparent to God might imply an undesirable self-annihilation, and second, that an unpolished soul might be positioned to reject the divine beam. Javelet, however, does not conclude, as I do, that the negative connotations of mirror metaphor inspired the prescholastics to privilege the metaphor of the imprint, nor does he compare the semantic fields covered by the two metaphors.

Those theologians who leaned toward meditation, who sought an itinerary from image to contemplation, favored a vision of the rational soul as a mirror whose purification led to conversion and to ecstatic vision of the divine. Thus associated with spirituality, if somewhat less with theology, the mirror-image was to remain a powerful trope of mystical experience (Hamburger, "Speculations on Speculation" [as in note 21]; R. Bradley, "The Speculum Image in Medieval Mystical Writers," in *The Medieval Mystical Tradition in England*, ed. M. Glascoe [Cambridge, 1984], 9–27).

In his *Eruditionis didascalicae (Didascalicon)* III, 14, *De humilitate*, Hugh of St.-Victor advocates: "dicta sapientium intellecta diligat, et ea semper coram oculis quasi speculum vultus sui tenere studeat" (PL 176:775A). I. Illich (*In the Vineyard of the Text: A Commentary to Hugh's Didascalicon* [Chicago, 1993], 25) understands the passage to mean that readers must keep the sayings of the wise before their eyes like a mirror before their faces, while J. Taylor (*The Didascalicon of Hugh of St. Victor: A Medieval Guide to the Arts* [New York, 1961], 97) has: "The good student ought . . . to love such words of the wise as he has grasped, and ever to hold those words before his gaze as the very mirror of his countenance."

It is my contention, however, that for prescholastic writers, the mirror as a means toward the truth—whether of the self or of the divine—implied a mediation of resemblances which carried a somewhat heavy conceptual baggage of alienation and obfuscation. Furthermore, prescholastics feared the connotation of passivity carried by the mirror-image and its mechanism of static resemblance. They held that the rapport between the Creator and his creature could not be a matter of simple reflection because there had been an act of creation. The created image, therefore, is dynamic: man tends toward God in a creative movement that resembles God's act of creation. As I argue below, the dynamism of the image, so central to prescholastic anthropology, linked the concept of image to that of filiation, thereby providing a cogent metaphor for the discussion of human perfectability.

Pierre Legendre gives startling interpretations of the role of images and mirrors in the reproduction of man and of society in his *Dieu au miroir: Études sur l'institution des images* (Paris, 1994); this wide-ranging study is layered with Lacanian insights.

33. A tension which is well known to have been experienced by Augustine himself; see G. Maertens, "Augustine's Image of Man," in *Studia Gerardo Verbeke* (Louvain, 1976), 175–98, at 190. Prescholastic commitment to and forms of self-knowledge were very much part and parcel of their exegetical commentaries; see Javelet, *Image et ressemblance* (as in note 2), vol. 1, 142, 368–71; C. W. Bynum, *The Resurrection of the Body in Western Christianity, 200–1326* (New York, 1995), who argues that medieval eschatology expressed a sense of self as psychosomatic unity; M.-D. Chenu, *L'Éveil de la conscience dans la civilisation médiévale* (Montreal, 1969); Illich, *In the Vineyard* (as in note 32), 17–28. Expressions of medieval attitudes toward the self and selfhood beyond exegetical considerations are analyzed in J. Benton, "Consciousness of Self and Perceptions of Individuality," in *Renaissance and Renewal in the Twelfth Century*, ed. R. L. Benson and G. Constable (Cambridge, Mass., 1982), 263–95; C. W. Bynum, "Did the Twelfth Century Discover the Individual?" in *Jesus as Mother: Studies in the Spirituality of the High Middle Ages* (Berkeley, Los Angeles, and London, 1982), 82–109, at 85–90; Courcelles, *Connais-toi toi-même* (as in note 23); L. Dumont, "A Modified View of Our Origins: The Christian Beginnings of Modern Individualism," *Religion* 12 (1982), 1–27; Spence, *Texts and the Self in the Twelfth Century* (as in note 10); M. Stevens, "The Performing Self in Twelfth-Century Culture," *Viator* 9 (1978), 193–212; C. Taylor, *Sources of the Self: The Making of Modern Identity* (Cambridge, Mass., and London, 1989). These citations do not exhaust the list of studies devoted to the question of the medieval self.

34. Although Richard of St.-Victor developed at some length the mirror simile throughout his oeuvre, he also mixed his metaphors, as, for instance, when he speaks of the divine beam imprinting itself in limpid water, in *De gratia contemplationis libri quinque, liber quintus, caput xi*: "Sed cum aqua radium in se superni luminis accipit, fulgorem quoque luminis et ipsa, ut dictum est, ad superiora emittit, et mirum in modum illuc utique radium luminis ex se levat, quo ipsa per se nullo modo ascendere valet. Et cum tanta sit differentia aquae, et luminis, ei tamen quem de se luminis radio emittit, nonnihil suae similitudinis imprimit, ita ut tremula tremulum, quieta quietum, purior puriorem, diffusior diffusiorem efficiat" (PL 196:189B). See also note 23 above, where Richard and Hugh of St.-Victor spoke of the soul as a mirror for seeing God *and* as his image imprinted with the traces of divine knowledge.

35. In his explanation of Psalm 4:7 ("signatum est super nos lumen vultus Dei"), Augustine had preferred the metaphor of the coin; see Bell, *The Image and Likeness* (as in note 12), 53; J. Wirth, "Structure et fonctions de l'image chez saint Thomas d'Aquin," in *L'Image: Fonctions et usages* (as in note 10), 39–57, at 41; G. Wolf, "From Mandylion to Veronica: Picturing the 'Disembodied' Face and Disseminating the True Image of Christ in the Latin West," in *The Holy Face and the Paradox of Representation* (as in note 6), 153–79, at 154; and Pierre de Celle, in *Sermo 21, in festo S. Benedicti*: "Notandum

quoque quia in pecunia propter imaginem signatam, ratio, quae est imago Dei, signatur, ut reddantur Deo quae Dei sunt" (PL 202:704C). The vast majority of prescholastic authors, however, turned to the seal metaphor. By the time of Aquinas, the coin metaphor was once again the preferred analogy; see W. J. Courtenay, "The King and the Leaden Coin: The Economic Background of 'Sine qua non' Causality," *Traditio* 28 (1972), 185–209, reprinted in *Covenant and Causality in Medieval Thought: Studies in Philosophy, Theology, and Economic Practice* (London, 1984), no. 6; R. Imbach and F.-X. Putallaz, "Notes sur l'usage du terme *imago* chez Thomas d'Aquin," in *La visione e lo sguardo nel medio evo,* I (as in note 11), 69–88.

36. Hervé de Bourg-Dieu, *Commentaria in epistolas divi Pauli, In epistolam 1 ad Cor.* X, 1: "Vir quidem non debet velare caput suum, id est non debet habere signum servitutis vel potestatis super se, sed libertatis, quia non habet aliquid super se nisi Deum. Quoniam imago et gloria est Dei. Imago, id est similitudinis impressio, et gloria Dei cernitur in viro, quia unus Deus unum fecit hominem" (PL 181:926B).

37. "Imprint yourself to him [God] so that his image may be expressed in you, make yourself conform to his seal." The full sentence is even more revealing: "Si quaesisti, si invenisti, si tenuisti dilectum tuum, tene quem tenes; tene, inhaere; imprime te illi, ut ejus in te velut expressa reformetur imago, huic fias conformis sigillo. Eris autem si adhaeseris: qui enim adhaeret Deo, unus est spiritus. Forte sicut durae materiae difficulter in te primo fit ejus impressio: etsi laboriosa impressio, sed dulcis adhaesio" (*Sermones in canticum Salomonis, Sermo xi* [PL 184:60A]).

38. "Man, it seems to me, has been created in the image of God, in his reason. For as we recognize something by its image or somebody by his seal, similarly the Creator is recognized by his creature, by reason as by His seal" (*Sententiae Berolinenses,* ed. F. Stegmüller, *Recherches de théologie ancienne et médiévale* 11 [1939], 33–61, at 44; also quoted in Javelet, *Image et ressemblance* [as in note 2], vol. 2, 141).

39. "The brightness of your face [that is, the Son, Christ] by which your image is formed in us, by which image we are similar to you, this brightness is signed upon us, that is, it is impressed in our reason which is the highest part of the soul by which we are similar to God; the brightness is imprinted in our reason like a seal in wax" (*Commentarius in psalmos Davidicos, Psalmus 4* [PL 191:88A–D at A]; quoted in Javelet, *Image et ressemblance* [as in note 2], vol. 2, 142–43, n. 32, and discussed in vol. 1, 173. Peter Lombard attended the school of St.-Victor before becoming chancellor and master at Notre-Dame of Paris, and ultimately bishop of Paris.

40. Quoting Robert of Melun, a student of Abélard and an admirer of Hugh of St.-Victor: "quae tamen distat ab imagine Dei quae Deus est quantum imago regis quae in sigillo ejus est ab imagine quae in ejus filio est . . . quamvis ergo nullam habet anima humana communem cum Deo proprietatem, non falso dicitur ad imaginem Dei esse facta et similitudinem" (Bruges, Bibliothèque publique de la Ville, Cod. lat. 191, ff. 186v–187r); see Javelet, *Image et ressemblance* [as in note 2], vol. 2, 41; Bedos-Rezak, "Medieval Identity" (as in note 13), 1525.

41. Bedos-Rezak, "Medieval Identity" (as in note 13), 1525. The text of the school of Laon is in *Sententiae,* Paris, B.N.F., Ms. lat. 651, f. 49v: "ratio est imago Dei, id est retinens in se ipsa de Deo notitiam; sicut enim cera, cui sigillum imprimitur, ipsius sigilli imaginationem retinet et ad memoriam reducit, ita ipsa ratione quasi quaedam materia et cera in qua Deus ad memoriam nostram reducitur"; also quoted in Javelet, *Image et ressemblance* (as in note 2), vol. 2, 46–47, n. 61.

Abélard's text comes from *Introductio ad theologiam,* II, 13: "Quomodo autem philosophi hanc personarum distinctionem in una divinitatis essentia, per similitudinem alicujus mundanae creaturae, et eorum quae in ipsa sunt creatura vestigare poterunt atque invenire, facile, credo, poterit assignari in his quae ex materia et forma, vel ad similitudinem materiae et formae dixerunt consistere, verbi causa: Aes quidem est inter creaturas, in quo artifex operans, et imaginis regiae formam exprimens, regium facit sigillum, quod scilicet ad sigillandas litteras, cum opus fuerit, cerae imprimatur. Est igitur in sigillo illo ipsum aes materia, ex quo factum est, figura vero ipsa imaginis regiae, forma ejus; ipsum vero sigillum ex his duobus materiatum atque formatum dicitur, quibus videlicet sibi convenientibus ipsum est compositum atque perfectum. . . . Sicut enim ex aere sigillum est aereum, et ex ipso quodammodo generatur, ita ex ipsa Dei Patris substantia Filius habet esse, et secundum hoc ex ipso dicitur genitus" (PL 178:1068C–D, 1069B–C); see Javelet, *Image et ressemblance* (as in note 2), vol. 1, 73, 82–83, and vol. 2, 46–47, n. 61, where are given additional uses of the seal metaphor in which the metaphor serves to stress the absolute resemblance and equality between God and Christ.

See also Gerhoh of Reichersberg, *Commentarius aureus in Psalmos,* XXX, commenting on the verse "illustra faciem tuam super servum tuum": "*Hanc faciem tuam illustra super me servum tuum,* et super alium quemlibet servum tuum. Tu es quasi aurea substantia, et filius tuus cum sit splendor gloriae et figura substantiae tuae, tanquam regalis aut pontificalis imago in auro purissimo exhibet se ipsum pro incorruptibili sigillo cúilibet servo suo sibi conformando se imprimens. Tuque, Pater, hoc ipsum sigillationis opus per ipsum, et cum ipso, et in ipso perficis in servis tuis eidem filio configurandis" (PL 193: 1306D–1307A).

42. "Ut enim Gregorius exponit: Ille primus angelus ideo ornatus et opertus ordinibus angelorum extitit quia dum cunctis agminibus angelorum praelatus est . . . qui non solum ad imaginem Dei ut homo, sed et signaculum similitudinis appellatus est" (*Deus summe* [from the school of Laon], Munich, Staatsbibliothek, Ms. Clm. 22307, f. 86v. Gregory's commentary on Ezechiel 28:12–13 ("Tu signaculum similitudinis, plenus sapientia et perfectus decore, in deliciis Paradisi Dei fuisti," a text that refers to the fall of the king of Tyre) is found in *Homiliarum in Evangelia libri duo,* II, 34: "Unde et ipsi angelo, qui primus est conditus, per prophetam dicitur: Tu signaculum similitudinis, plenus sapientia, et perfectus decore, in deliciis paradisi Dei fuisti (Ezek. XXVIII, 12). Ubi notandum quod non ad similitudinem Dei factus, sed signaculum similitudinis dicitur, ut quo in eo subtilior est natura, eo in illo imago Dei similius insinuetur expressa" (PL 76:1250B).

43. *De charitate Dei et proximi,* cap. XX, and PL 184:617C–D, and *De amicitia christiana et de dilectione Dei et proximi,* ed. and trans. M. M. Davy, *Un traité d'amour au XIIe siècle* (Paris, 1932), 358–60: "Tale signaculum ante praevaricationem suam se angelus apostata exprimebat, testimonio Ezechielis dicentis: *Tu signaculum similitudinis, plenus sapientia et perfectus decore.* Angelus siquidem in sua creatione tanta Deo conformitate est unitus, ut esset potius signaculum similitudinis, quam simile vel signatum. De sigillo quippe talis similitudo imaginaliter exprimitur qualis in eodem sigillo essentialiter habetur, et hoc homini competit. Angelis vero pro sua subtilitate naturae Deo expressiori similitudine adhaerebat, quia totus et tantummodo spiritus erat" (PL 207:918A–B). This text is also found in an anonymous work, the *Liber seu tractatus de charitate,* which is a compilation of works by Richard of St.-Victor, Peter of Blois, and Bernard of Clairvaux (PL 184:617C–D). See a commentary on Peter's text in Javelet, *Image et ressemblance* (as in note 2), vol. 1, 162–63, and vol. 2, 130–31. Peter of Blois (d. ca. 1211) was in charge of the royal seal at the court of Marguerite of Sicily during the regency of King William II (1166) and was, by 1174, chancellor of Richard, archbishop of Canterbury (d. 1184).

44. "Aliud est enim signaculum Dei, aliud sigillum, aliud ymago, aliud signum. Sigillum Dei Patris est Filius quasi in omnibus signans illum. . . . Angelus vero est Dei signaculum, quasi in aliquibus signans illum, quia in pluribus similis est Deo angelus etsi non in omnibus. Unde et de Lucifero dicitur secundum statum quem habuit ante casum: Tu signaculum similitudinis Dei. Sed Filius est sigillum Patris secundum unitatem essentie, angelus vero signaculum imitationis ratione. Homo vero dicitur ymago Dei quasi *imitago,* qui non ita similis est expresse Deo sicut angelus. Quelibet vero creatura dicitur signum Dei, qui sui essentia, sui ordinatione, sui pulcritudine predicat Deum" (Alan of Lille, *In die s. Michaelis,* in *Alain de Lille, Textes inédits* [as in note 24], 250; Javelet, *Image et ressemblance* [as in note 2], vol. 1, 162–63, and vol. 2, 129–33).

45. The emphasis on reason as God's imprint sometimes extends to the organ of love: it is thus the human heart that God is said to have formed with his seal so that his image is expressed there *trait pour trait,* in the words of Baldwin of Canterbury, *Tract. X, Pone Me ut signaculum super cor tuum:* "Amans nos Deus, et amari desiderans, signaculum formavit, habens imaginem amoris insculptam, quo cor nostrum pressius signavit, ut coimaginatum similitudinem imaginis in seexciperet, et configuraliter exprimeret. . . . Aufer a me, Domine, cor lapideum, aufer cor coagulatum, aufer cor incircumcisum; da mihi cor novum, cor carneum, cor mundum! Tu cordis mundator, et mundi cordis amator, posside cor meum et inhabita, contines et implens, superior summo meo et interior intimo meo! Tu forma pulchritudinis et signaculum sanctitatis, signa cor meum in imagine tua" (PL 204:511B, 516A–B).

46. Javelet, *Image et ressemblance* (as in note 2), vol. 1, 138–39.

47. See note 33 above.

48. I borrow the expression from G. Maertens, "Augustine's Image of Man" (as in note 33), 191. See also G. Con-

stable, "The Ideal of the Imitation of Christ," in *Three Studies* (as in note 11), 156–92.

49. Javelet, *Image et ressemblance* (as in note 2), vol. 1, 218–20. Hugh of St.-Victor, *De sacramentis christiane fidei,* cap. ii, *Qualiter homo ad imaginem et similitudinem Dei factus est:* "Factus est homo ad imaginem et similitudinem Dei, quia in anima (quae potior pars est hominis, vel potius ipse homo erat) fuit imago et similitudo Dei. Imago secundum rationem, similitudo secundum dilectionem; imago secundum cognitionem veritatis, similitudo secundum amorem virtutis. Vel imago secundum scientiam, similitudo secundum substantiam. Imago, quia omnia in ipsa secundum sapientiam; similitudo, quia una et simplex ipsa secundum essentiam. Imago quia rationalis, similitudo quia spiritualis. Imago pertinet ad figuram, similitudo ad naturam. Haec autem in anima sola facta sunt, quia corporea natura similitudinem capere non potuit Divinitatis, quae ab ejus excellentia et similitudine in hoc ipso longe fuit quod corporea fuit" (PL 176: 264C–D). Peter Lombard, *Sententiarum* IV: "Vel imago consideratur in cognitione veritatis, similitudo in amore virtutis; vel imago in aliis omnibus, similitudo in essentia, quia et immortalis et indivisibilis est. Unde August., tom. 2, in lib. de Quantitate animae, c. 1: Anima facta est similis Deo, quia immortalem et indissolubilem fecit eam Deus. Imago ergo pertinet ad formam, similitudo ad naturam. Factus est ergo homo secundum animam, ad imaginem et similitudinem non Patris vel Filii vel Spiritus sancti, sed totius Trinitatis: ita et secundum animam dicitur homo esse imago Dei, quia imago Dei in eo est. Sicut imago dicitur et tabula et pictura quae in ea est; sed propter picturam quae in ea est, simul et tabula et imago appellatur: ita propter imaginem Trinitatis etiam illud in quo est imago, nomine imaginis vocatur" (PL 192:684– 85). On the simile of the painting in Augustine's works, see note 50 below.

50. *Deus Summe,* Munich, Staatsbibliothek, Ms. Clm. 22307, ff. 90v–91r: "unde quoniam ratio hominis justi lumine divino, justitia Dei, aliisque virtutibus informata, homo propter talem rationem imago Dei est. Sciendum est enim quoniam imago impressa in re aliqua et ipsa res in qua imprimatur imago appellatur" (text cited in Javelet, *Image et ressemblance* [as in note 2], vol. 2, 140). This sentence, "sciendum est enim . . . etc." (thereafter "the formula"), is also found in two twelfth-century treatises, the *Tractatus theologicus* (PL 171:1118C–D) and the *Summa sententiarum* (PL 176:91C–D), spuriously ascribed respectively to Hildebert of Lavardin and Hugh of St.-Victor. The list of texts unquestionably authored by Hildebert has been established by Peter von Moos, *Hildebert von Lavardin, 1056–1133: Humanitas an der Schwelle des höfischen Zeitalters* (Stuttgart, 1965), 359–77. Numerous discussions have inclined toward denying the attribution of the *Summa* to Hugh; see R. Baron, *Science et sagesse chez Hugues de Saint-Victor* (Paris, 1957), 238–42. In both treatises, the formula appears in a chapter devoted to the Creation of man ("De creatione hominis"). The paragraphs containing the formula are identical but for a few stylistic variations. They begin with the statement that man was made in the image of the whole Trinity, continue with the formula, and conclude in the following fashion (the text is from the *Tractatus*): "Unde et ipsa

ratio imago dicitur, quia tanquam sigillum impressa est animae, et homo imago Dei dicitur. Augustinus in libro De civitate Dei (lib. XI, c. 26, 28): Aliud est Trinitas res ipsa, aliud imago Trinitatis in re aliqua. Propter quam imaginem, similiter et illud in qua ipsa impressa est, imago dicitur. Sic imago dicitur simul et tabula, et quod in ea pictum est, non propter tabulam ipsam, sed propter picturam quae in ea est. Ad similitudinem Dei factus est homo, quia innocens et sine vitio factus est."

According to the three twelfth-century texts, *imago* involved a process of image production, the imprint, which fused image and medium. Thus, body and form, type and model were dialectically conjugated. The Augustinian origin of the formula is worth noting. Augustine, however, did not expand upon the implications of the *imago impressa,* using the simile of the painting and its connotations of surface tracing, whereas his twelfth-century commentators, in deploying the seal metaphor, remained firmly within the semantic field of the imprint and its connotations of indepth marking. In Augustine's simile the medium, though termed *imago,* is distinct from the image. With the seal metaphor, the image has penetrated the medium.

51. Caroline W. Bynum has recently expressed concern that "recent work seems to find the Eucharist everywhere" ("The Blood of Christ in the Later Middle Ages," *ChHist* 71, no. 4 [2002], 685). During the late eleventh and twelfth centuries, the Berengar-Lanfranc eucharistic controversy of the 1050s fueled ardent debates on the representational nature of the eucharistic sign; see H. Chadwick, "Ego Berengarius," *JTS* 40, no. 2 (1989), 414–45; J. Geiselmann, *Die Eucharistielehere der Vorscholastik* (Paderborn, 1926); L. Hödl, "Die confessio Berengarii von 1059, eine Arbeit zum frühscholastischen Eucharistietraktat," *Scholastik* 37 (1962), 370–94. These debates, held particularly among North European schoolmen, had a strong semiotic component since the central question revolved around the extent to which the eucharistic sign (*sacramentum*) remained distinct from its thing (*res*). Northern schoolmen tended to favor a solution, later to be adopted at Lateran IV as the doctrine of transubstantiation, that secured the real and substantial presence of Christ in the Eucharist. They also recognized, however, that the Eucharist, as the true body of Christ, could in turn signify the spiritual body of Christ or Christian unity; see G. Macy, *The Theologies of the Eucharist in the Early Scholastic Period* (Oxford, 1984).

52. Bedos-Rezak, "Medieval Identity" (as in note 13), 1501–3 with further bibliography on the eucharistic debates during the prescholastic period.

53. On this terminology, developed by Peter Sahlins, see A. Biersack, "Local Knowledge, Local History: Geertz and Beyond," in *The New Cultural History,* ed. L. Hunt (Berkeley, Los Angeles, and London, 1989), 72–96, at 87.

54. Since my essay "Medieval Identity" (as in note 13), I have furthered my argument of a relationship between the diffusion of sealing and the shift toward an essentialist semiotic paradigm in "Une image ontologique" (as in note 2) and "The Bishop Makes an Impression: Seals, Authority, and Episcopal Identity," in *A Royal and Priestly Race: The Bishop at the First Millennium,* ed. S. Gilsdorf (Munster, 2003), 101–13.

55. J. Dufour, *Recueil des actes de Louis VI roi de France (1108–1137),* 4 vols. (Paris, 1992–94), vol. 1, 375, no. 180 (A.D. 1121): "ut vero firmior nostra concessio habeatur, nostre regie imaginis inpressione confirmari precepimus." For the many charters containing, in their validating clauses, the expression "nostre imaginis impressione," see *acta* nos. 72 (1115), 74 (1116), 77 (1116), 89 (1120), 90 (1121), 91 (1121), 93 (1121), 95 (1121), 98 (1122), and 160, 161, and 162 (1134) in A. Dufour-Malbezin, *Actes des évêques de Laon antérieurs à 1151* (Paris, 2001). The same formula is also found in the *acta* of the archbishops of Rheims between 1096 and 1139; see P. Demouy, "Les Sceaux des archevêques de Reims des origines à la fin du XIIIe siècle," in *Actes du 109e Congrès national des Sociétés savantes, Dijon, 1984: Section d'histoire médiévale et de philologie,* vol. 1 (Paris, 1985), 687–720, at 687; idem, "Actes des archevêques de Reims d'Arnoul à Renaud II, 997–1139" (Ph.D. diss., Université de Nancy II, 1982), 183–84. The corpus of charters given in the name of the counts of Ponthieu between 1026 and 1279 indicates a preference in early charters for announcing the application of the seal by the formula *sigilli impressione,* which insists on the imprinting process. This formula came to be replaced in later charters by such expressions as *sigilli appensione* or *sigilli appositione,* which focus on the affixation of the seal to the charter (C. Brunel, *Recueil des actes des comtes de Pontieu, 1026–1279* [Paris, 1930], LI, n. 13, where Brunel gives a typology of the various documentary clauses announcing the seal).

56. B. Poulle, "Renouvellement et garantie des sceaux privés au XIIIe siècle," *BEC* 146 (1988), 369–80.

57. M. Weber, *Sigillografia,* vol. 3, *I sigilli nella storia del diritto medievale italiano* (Milano, 1984); the chapter on canon law and seal forgery (153–80) concerns the whole of Christendom.

58. The expression "sigillo autentico, bene cognito et famoso" is from Conrad of Mure (d. 1275); see Weber, *Sigillografia* (as in note 57), 205, and 181–226, where there is a lucid analysis of "the theory of the authentic seal" in canon law.

59. R. Debray, *Vie et mort de l'image* (Paris, 1992), 177.

60. In this way, replica did not simply signal a cultural convention but conventionality itself (R. Parmentier, *Signs in Society: Studies in Semiotic Anthropology* [Bloomington, Ind., 1994], 133).

61. In a recent article ("Du sujet à l'objet: La Formulation identitaire et ses enjeux culturels," in *Identité personnelle et identification avant l'époque moderne/Persönliche Identität und Identifikation vor der Moderne,* ed. P. von Moos [Cologne, Weimar, and Vienna, 2004], 63–83) I analyzed individuals' attempts to personalize their seals, for instance, through heraldic devices, and the recurrent failure of such attempts whereupon heraldry immediately acquired a generic connotation applicable to an entire lineage. The best approach to the socio-cultural implications of French medieval heraldry is by M. Pastoureau, *Les Armoiries* (Turnhout, 1976) and *Traité d'héraldique,* 2nd ed. (Paris, 1993).

62. Quoted in D. Lowenthal, "Authenticity? The Dogma of Self-Delusion," in *Why Fakes Matter: Essays on Problems of Authenticity,* ed. M. Jones (London, 1992), 189. Edward Young (1683–1765) was an English proto-Romantic literary critic, poet, and dramatist.

Is There a Theology of the Gothic Cathedral?
A Re-reading of Abbot Suger's Writings
on the Abbey Church of St.-Denis

Andreas Speer

Panofsky's Paradigm

Erwin Panofsky had originally planned his famous edition and translation of three of Abbot Suger's writings to coincide with the eight-hundredth anniversary on June 11, 1944, of the solemn consecration of the rebuilt choir of the abbey church of St.-Denis (Fig. 4), north of Paris, which up to the present time has been considered the birthplace of Gothic architecture, or, in Panofsky's own words, "the parent monument of all Gothic cathedrals."[1] Its construction was overseen by Abbot Suger himself, who recorded this landmark historical event in his own writings, with their precise descriptions of how things proceeded from the laying of the cornerstone to the consecration of the finished choir, and with singular reflections regarding the goals of the medieval "architectus," and the place of a Pseudo-Dionysian light-metaphysics within them. This influential picture, which still provides the dominant paradigm for the understanding of medieval art, was mainly Panofsky's creation, established in his highly suggestive introduction to the edition.[2] But, as we can read in the exchange of letters between Panofsky and his friend Booth Tarkington, the printing was delayed, and finally on August 6, 1945, the first atomic bomb was dropped upon Hiroshima. One consequence was that Princeton University Press stopped work on the Suger edition and gave priority to the so-called Smyth report, the "atomic best-seller," as Panofsky called it later.[3] On September 20, 1945, Panofsky wrote to Booth Tarkington: "The bomb, incidentally, has hit Suger, among other things: the Princeton Press prints untold numbers of the Smyth report and had to shelve everything else for the time being." And he added sarcastically: "However, since the world has waited 801 years for a translation, it can just as well wait some more—unless the whole question becomes irrelevant in view of further developments in the atomic field."[4] This was a serious concern for Panofsky, as we can read in his many letters of this period. Actively involved in the discussions of the Princeton scholarly community regarding the technical and political implications of the new nuclear power, he also reflected upon the aesthetic connotations with which the atomic explosions were reported.

This story, however, is more than an accidental incident of history. It points to the very idea of Panofsky's enterprise, which in fact never intended to portray Suger as a medieval statesman and thinker. Instead, Panofsky meant to present him as the exponent of a transhistorical continuity, a viable intellectual tradition born in antiquity and enduring to the present day. Panofsky's notion of "tradition" was something that continued to exist amid a host of threats. Against the background of World War II, Panofsky's portrait of Suger expressed an alternative to fascist barbarism as an inheritance of Western humanism.[5] In his treatise "The History of Art as a Humanistic Discipline" of 1940, Panofsky defines humanism as a belief in man's dignity.[6] This stylization of Suger—"our mutual friend," as he wrote to Tarkington[7]—as a humanistic figure rests upon his being placed within a timelessly relevant intellectual tradition that bridges diverse historical epochs. Panofsky found this tradition in the continuity and transformation of Platonic philosophy. As early as his famous treatise "Idea" of 1924, he had mentioned Neoplatonic light-metaphysics as a leitmotif in Western thought. This reflects (following the Warburg approach) the continuity of the ancient world from Augustine to Dante, Ficino, Bruno, and even to quantum mechanics, which seems to function according to measure, number, and weight, in accordance with the famous saying from the Book of Wisdom (11:20).[8] From this perspective, Gothic architecture became the embodiment of a metaphysical system. The "architecture of light" gives expression to an intellectual experience, a creative process within an artist's mind; it enables us to experience the supernatural divine light in worldly materiality, leading the human intellect to a knowledge of God. "Suger had the great fortune"—as Panofsky states—"to discover, in the very words of the thrice-blessed Saint Denis, a Christian philosophy that permitted him to greet material beauty as a vehicle of spiritual beatitude instead of forcing him to flee from it as if from temptation; and to conceive of the moral as well as the physical universe, not as a monochrome in black and white, but as a harmony of many colors."[9]

The idea, however, that Gothic architecture is to be understood as an embodiment of a metaphysical or theological system, is commonly related to Pseudo-Dionysius the Areopagite, who in a legend originating in St.-Denis and propagated by Abbot Hilduin in order to establish the royal abbey as the "altera Roma," became identified with Saint Denis, the first bishop-martyr of Paris, whose relics are preserved in the abbey church of St.-Denis. But, in fact, this idea is based on a transhistorical assumption of a congruity between modern and medieval notions of aesthetics.[10] Even if one replaces the term "light-metaphysics" with the more accurate phrase "theology of light" (by referring to light as a divine name), the fundamental hermeneutical problem remains.[11] Can we really speak of a formal effectiveness or even causality between a theological (or philosophical) idea and an art work, particularly with respect to innovations or the invention of a new style? Does an art work need a theoretical foundation at all, or is this nothing but a modern projection? We must remember that a distinct concept of the fine arts did not appear earlier than the Italian Renaissance; that the foundation of philosophical aesthetics did not precede Alexander Gottlieb Baumgarten and Immanuel Kant; and that it was Hegel who restricted the proper object of the "aesthetica"—defined by Baumgarten as "scientia cognitionis sensitivae"—to the "schöne Künste," the fine arts.[12]

This same problem remains when attempts are made to replace Dionysius the Areopagite with, for example, Hugh of St.-Victor in searching for a contemporary theological source. Therefore, Conrad Rudolph's endeavor to establish Hugh as the true creative theological genius responsible for the fundamental "artistic change" at St.-Denis—a thesis lacking any support in the

sources and based only on Rudolph's presumption of a close connection between the two abbeys of St.-Denis and St.-Victor with respect to theology and church policy[13]—seems to be driven by the conviction that there must be a formal link between a leading creative idea, whether metaphysical or theological, and the architectural principles of an art work, in this instance, the Gothic cathedral.[14] Otto von Simson had made a similar effort in his book *The Gothic Cathedral*. Whereas Panofsky in his introduction of 1944 had attempted only through association to relate philosophical and theological speculations on light to the lustrous art treasure and radiant stained-glass windows,[15] von Simson tried to demonstrate a formal causality between Neoplatonic Dionysian philosophy and Gothic architecture. Von Simson's enterprise failed, as did Panofsky's later, ambitious endeavor to unite the system of Gothic architecture with the intellectual character of the High Middle Ages by elucidating the "genuine cause-and-effect relation" between the Scholastic method (above all, that of Thomas Aquinas) and the architectural principles of the Gothic cathedral.[16]

In any case, most of the various attempts to criticize Panofsky, or even to replace his vision while nevertheless referring to the "birth of the Gothic," have not overcome his paradigm, which is driven by a Hegelian understanding of aesthetics that serves as the leading narrative. That is, we see "a common idea" underlying particular historical manifestations, something that we can analyze, which makes art a part of history. The Hegelian assumption, that to speak about art is to speak about something which is, by definition, in the past, lies at the deepest roots of the discipline of art history.[17] This insight helps us to understand the continuing fascination of Panofsky's paradigm. The great Princeton scholar was able to establish a working and suggestive model to interpret a famous medieval architectural enterprise vis-à-vis a speculative theological ideal, which points to the always thrilling question: "why?" What exactly brought about the principles of a new architectural style? What are the reasons for and the creative ideas behind the new Gothic choir? Let us freely admit now that these are our questions and not Suger's!

Suger's Enterprise

Suger himself in the prooemium to his *De consecratione* reveals clearly his method and his intentions: "We have endeavored," he wrote, "to commit to writing, for the attention of our successors, the glorious and worthy consecration of this church sacred to God and the most solemn translation of the most precious martyrs Denis, Rusticus and Eleutherius, our Patrons and Apostles, as well as of the other saints upon whose ready tutelage we rely. We have put down why, in what order, how solemnly and also by what persons this was performed, in order to give thanks as worthy as we can to Divine grace for so great a gift, and to obtain, both for the care expended on so great an enterprise and for the description of so great a celebration, the favorable intercession of our Holy Protectors with God."[18]

A cursory glance at our primary source shows that the "accessus" to Suger's *De consecratione* enunciates the idea that liturgy is the main topic and also the key to what Suger is expressing, what we commonly conceptualize in terms of medieval art. That a modern architectural historian like Otto von Simson finds Suger's way of reporting and describing architectural structures "disappointing"[19] echoes the same lack of understanding regarding context already noted in Panofsky. Both historians overlook the central importance for Suger of liturgy and a general history of wor-

ship. Contrary to Panofsky's portrayal, Abbot Suger did not behave like a modern movie producer.[20] He did not relate all that he has written to the overarching goal of building a career. As von Simson rightly maintains, Suger was not interested in aesthetics as such; he was—as I would emphasize—guided much more by liturgical needs. The structure of his treatise shows that there can be no doubt about this; it is articulated according to the liturgical order of the three famous liturgical events reported by Suger: the consecration of the renewed western part on June 9, 1140; the laying of the cornerstone for the renovation of the eastern part on July 14, 1140; and, finally, the consecration of the rebuilt choir on June 11, 1144, the most central part and pinnacle of Suger's enterprise.[21]

Before we become more heavily involved in textual analysis, allow me to step back and present a general account of the intent as well as of the methodological approach, of the new critical edition of Suger's three writings that relate to the abbey church, the monastery of St.-Denis, and Suger's activities as abbot. These writings are in many ways interconnected and follow a strict chronological order, which should not be confused: the points of reference are the three previously mentioned major liturgical events linked with the rebuilding campaign of the abbey church in the third and fourth decades of the twelfth century.[22]

In order to avoid the above-mentioned paradigms and, more importantly, the methodological traps linked to them, I have attempted to reconstruct the sources from the ground up, from the "sol vièrge," so to speak. This means suspending all interpretations, especially the question of the relationship between text and architecture, followed by reconstructing the manuscript texts using the stringent criteria of the historico-critical method. This includes a thorough analysis of the structure of the three writings and a careful investigation of their sources. The results are striking and lead to more than a few revisions. For example, not only is Panofsky's famous thesis that Suger found his inspiration from reading the works of Pseudo-Dionysius called into question, but also—as I have already indicated—the possibility of answering the "why-question" in a definite manner. We should instead favor a plurality of modes which relate theology and images, as the editors of this volume have suggested. I shall supply the necessary evidence with respect to four items: liturgy, architectural description in a liturgical context, inscriptions, and theology.

Liturgy

Suger himself gives the idea that liturgy was the key to understand his "creative" enterprise. This becomes clear as one uncovers the reasons for the rebuilding of the abbey church. These are found in a detailed and urgent report about dangerous overcrowding, particularly on feast days. On these days, the church became so full with pilgrims that "the outward pressure of the foremost ones not only prevented those attempting to enter from entering but also expelled those who had already entered."[23] This problem obviously arose in the area of the transept crossing and the original apse (Figs. 3, 5), the place where pilgrims entered the crypt.[24] There, because of the narrowness, "the brethren partaking of the most holy Eucharist could not stay" and "oftentimes they were unable to withstand the unruly crowd of visiting pilgrims without great danger."[25] Evidently, the leading motive for the rebuilding campaign was liturgical. It was for the sake of the liturgy that Suger tried to restore the damaged parts of the abbey church, to enlarge and reconstruct others, and to revive forgotten elements of the ancient tradition of worshiping, especially those linked to the Merovingian and Carolingian kings Dagobert, Pippin, and Charles the Bald. Indeed, Suger began his building campaign at the grave of the second Charles (the Bald) adjacent to the altar devoted

to the Trinity, and continued it onward to the western part, where Charlemagne had buried his father Pippin (Fig. 1). Finally, Suger concluded restorations in the eastern part, where in the crypt King Dagobert had established the tradition of perennial prayer at the tombs of Saint Denis and his holy companions Eleutherius and Rusticus (Fig. 2).[26]

A comprehensive monograph by Anne Walters Robertson discusses extant liturgical sources from St.-Denis and shows how Suger's liturgical enhancements were related to his building campaign and were carried over into the ordinaries of the thirteenth century.[27] Moreover, Edward B. Foley's detailed study of the first ordinary of the royal abbey of St.-Denis (Paris, Bibliothèque Mazarine 526) provides additional evidence for the relationship of this liturgical model to the spatial requirements of the multiple altars in Suger's basilica.[28] Suger's report of the consecration carefully followed (as I have shown) the liturgical order of the twelfth-century *Pontificale romanum*, an ideal liturgical type that has been painstakingly reconstructed by Michel Andrieu.[29] Despite some departures from and additions to the traditional order, which expressed local customs or were desired by Suger, one recognizes immediately the importance of the consecration of the eastern part of the abbey church. Suger connected the consecration of the rebuilt part of the abbey church with the *translatio* of the relics of its holy patrons and with the consecration of the new altar.[30] Thus, the consecration of only one part of the abbey church assumed the character of an initial consecration for the entire church. In this context, it becomes significant that Suger interpreted the consecration of the central eastern area by analogy to the legendary consecration performed by Christ himself of the old basilica, the so-called "consécration légendaire."[31] Furthermore, in the introductory part of *De consecratione*, Suger linked the worship tradition of the holy patrons to both the legendary founding of St.-Denis by King Dagobert and the Dagobert cult.[32] In so doing, he renewed and strengthened the ecclesiastical and dynastic connections between the French kingdom and the French royal abbey. The new upper church and the new altar with the relics of the holy patrons became the preeminent place for the *summi pontifices* (the bishops) and for the *persone authentice* (persons of authority).[33] The lower church retained the relics of Christ's Passion, the principal object of popular cult.[34] Suger reflected upon this ordering in his allegorical explanation of the liturgy. It is thus in the liturgy that, to quote his epilogue, "the material conjoins with the immaterial, the corporeal with the spiritual, the human with the Divine."[35] Here lies the real foundation of the interconnection among the different parts of the abbey church.

Architectural Description

Now we must ask whether and how Suger's descriptions are related to the existing building. What is the nature of the information provided? I have already cited the statement of a disappointed art historian regarding the abbot's way of reporting and describing architectural structures,[36] but there are a number of scholars who take Suger's writings as the main sources to fill in missing gaps within the archaeological reconstruction. I shall not go into further detail here as I have done so elsewhere.[37] Rather, I shall point to another question, one that is much more central to the topic of this conference volume.

Upon close examination of the passages in which Suger speaks about the basilica of St.-Denis, two things may be stated: first, Suger's descriptions, based on his vocabulary, appear to be very general and not highly imaginative.[38] This impression changes radically once the context is taken into account: all descriptions—and this is my second observation—are more or less part of a liturgical context, for which there are three models.

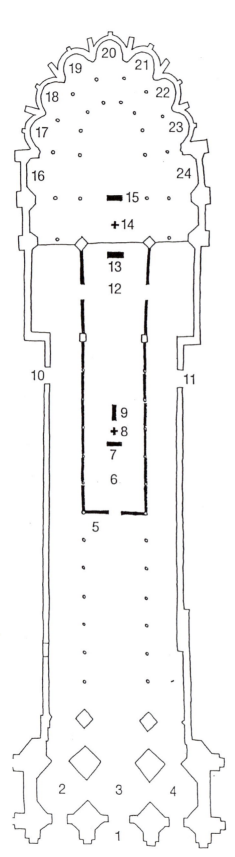

1. Abbey church of St.-Denis, reconstructed ground plan in Suger's time (after *Atlas historique de Saint-Denis*, ed. M. Wyss), showing the liturgical places

1. Upper floor: Romanus (Michael, Maria)
2. Hippolytus (Laurentius, Sixtus, Felicissimus, Agapitus)
3. Grave of Pippin
4. Bartholomaeus (Nicolaus)
5. Ambo
6. The golden eagle
7. "Holy Altar" dedicated to the Trinity
8. The Great Cross at the tomb of Charles the Bald
9. Tomb of Charles the Bald
10. Doorway from northern portal to cemetery
11. Doorway from southern portal to cloister
12. "Inter duo altaria"
13. Main altar dedicated to the Savior (Salvator)
14. The golden cross
15. Altar with the shrine of the relics of Saint Dionysius and his companions Eleutherius and Rusticus
16. Innocentius and Mauritius
17. Osmana
18. Eustachius
19. Peregrinus
20. Maria
21. Cucuphas
22. Eugenius
23. Hilarius
24. John the Baptist and John the Evangelist

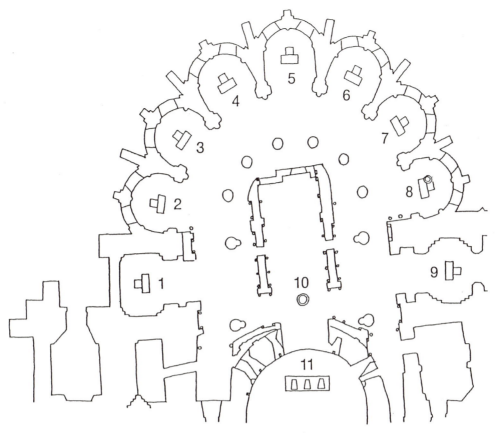

2. Abbey church of St.-Denis, reconstructed ground plan of the crypt in Suger's time (after J. Formigé) showing the liturgical places

1. Luke
2. Georgius, Gauburga
3. Barnabas
4. Sixtus, Felicissimus, Agapitus
5. Maria
6. Christopher
7. Stephanus
8. Edmundus
9. Benedictus
10. Fountain (well)
11. Confessio with the original tombs of the holy martyrs Dionysius, Eleutherius, and Rusticus

(a) The liturgical processions. In highlighting the liturgical processions, Suger assigned the liturgical functions of the enlargements of the western and eastern parts to the original basilica of King Dagobert, which was consecrated by Christ himself, and thus presented the entire basilica as a unified liturgical space (Fig. 1). When he mentions the consecration of the western part, he emphasizes the procession of the bishops and names the various chapels. The *detectio* of the relics at the altar of the Trinity begins with a solemn procession, one that conducts the witnesses to the place of the liturgical event (it also brought to light a charter of Charles the Bald containing detailed instructions about the old liturgical traditions, which Suger wanted to revive). When his discussion reaches the consecration of the eastern part, Suger stresses the movement through the entire sacred space. Before the aspersion of the church, he describes a kind of liturgical round (*chorea*) of the bishops stepping around the holy water font between the tombs of the martyrs and the altar dedicated to the Savior (this place *inter duo altaria*—between the two altars—is also mentioned in the first ordinary of St.-Denis when the anniversary of King Dagobert is related).[39] The *translatio* of the relics is also accompanied by a liturgical procession that now strides across the entire basilica, giving a liturgical function to all of its parts.[40] Thus, the culmination, the si-

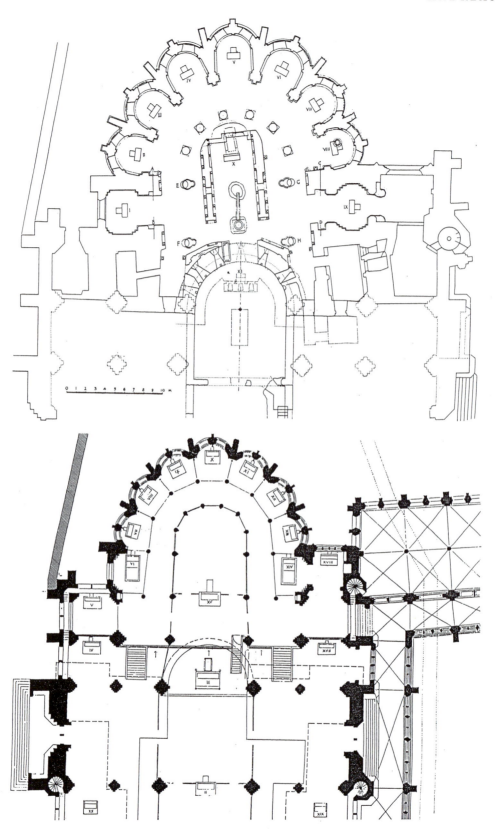

3. Abbey church of St.-Denis, ground plans (after J. Formigé): (a) eastern part with transept crossing and choir; (b) the crypt

multaneous consecration by the bishops present of the twenty altars in the upper choir (Fig. 1) and in the crypt (Fig. 2) included the entire church in the single sacred event.[41]

(b) The order of the altars and of the patron saints. The new altar lies on the central axis of the choir (Fig. 1), the easternmost end of which is the new, central ambulatory chapel dedicated to the Virgin Mary (Fig. 1.20). This central axis connects the chapel of the Virgin at the east with the symbols of the Merovingian and Carolingian rulers in the nave and at the western end of the church: the main altar of Dagobert (Fig. 1.13), the tomb of Charles the Bald (Fig. 1.9), adjacent to the altar of the Trinity (Fig. 1.7), and finally the tomb of Pippin (Fig. 1.3) within the architecturally and liturgically renovated western *augmentum*. The configuration of these monuments emphasizes the central longitudinal axis ("ut . . . medium antique testitudinis ecclesie augmenti noui medio equaretur") that joins the old basilica and the eastern enlargement (*augmentum*) (Fig. 5) to which Suger gave such conscientious attention.[42] Suger's focus was not on the construction per se, since the plan of the upper choir was dictated by that of the crypt (Fig. 3a, b); rather, he concentrated on the liturgical unity between nave and choir. Moreover, if one carefully examines Suger's building campaign, it is clear that he left a much larger construction site than he found when he began about twenty years earlier. There is much evidence in Suger's writings and in later sources that no part of the basilica had already been finished when he called for the consecration in 1140 and in 1144. He wanted his work to be completed according to the liturgical intentions, which he outlines in his writings. In fact, the extension of the side aisles did not rise beyond the foundations, which "will be completed either through us or through those whom the Lord shall elect, he himself helping."[43] According to thirteenth-century sources it was only after Suger's death, some eighty years later, that the construction projects were continued at St.-Denis under Abbot Odo and completed under the direction of Pierre de Montreuil.[44] Thus, for nearly a century, the first "perfect Gothic choir" existed only in liturgical descriptions.

(c) The order of all items of furniture and treasures, the *ornamenta* and *thesauri*, as well as the order of the verses and *tituli*.[45] This order should be read as a reference system by which Suger guides the reader through his basilica—as he does in the first part of his *De administratione*, when he takes the reader on an imaginary tour through the abbey's possessions.[46] Although he begins in the western part of the basilica,[47] he immediately embraces the new choir (Fig. 1).[48] Then he walks down the central axis, first to the shrine with the relics of the holy patrons and the "golden cross" (Fig. 1.15, 14), down to the altar of the Savior[49] (Fig. 1.13) and to the altar of the Trinity (Fig. 1.7), the "Holy Altar" (*altare sanctum*) in the monks' choir.[50] Then, led by other objects like the cross near the grave of Charles the Bald—which, as the story goes, was decorated with a necklace of Queen Nantildis, wife of King Dagobert (Fig. 1.8), and with the golden eagle (Fig. 1.6)[51]— he turns again to the choir and leads the reader to the stained-glass windows (Fig. 4) in the central chapel dedicated to the Virgin Mary (Fig. 1.20; Life of Mary and the Tree of Jesse). After this, he follows the northern circle of the ambulatory according to the liturgical order: the Moses window first, followed by the so-called anagogical window.[52]

Light and Beauty

The inscriptions on these stained-glass windows and also on various epitaphs, made by Suger himself and carefully reported in his writings, were taken by Panofsky as argument in support of his already mentioned thesis regarding the strong influence of Neoplatonic, in particular Dionysian,

speculations on light vis à vis Suger's creative enterprise. As an example, let us examine Suger's famous epitaph, which documents the date of the consecration of the choir in 1144:

> Annus millenus et centenus quadragenus
> Quartus erat uerbi, quando sacrata fuit.
> Pars noua posterior dum iungitur anteriori,
> Aula micat medio clarificata suo.
> Claret enim claris quod clare concopulatur,
> Et quod perfundit lux noua, claret opus
> Nobile, quod constat auctum sub tempore nostro,
> Qui Sugerus eram, me duce dum fieret.[53]

For Panofsky, Suger's poetry provides evidence of a purely aesthetic experience of the new architecture expressed in Neoplatonic language.[54] A careful analysis, however, discloses quite a different background: epigrams of Prosper of Aquitaine (which belonged to the reading matter of the schools at this time); poetry of Venantius Fortunatus; the sequence of the church's consecration of Notker of St. Gall; and, not least, verses of the Irish monk Dungal, and the *Carmina* of Paulinus of Nola, which reflect upon the enlargement of the basilica of St. Felix.[55] These results are confirmed by the verses on the gilded bronze reliefs at the entrance,[56] which, according to Panofsky, give us a condensed statement of the whole theory of anagogical illumination.[57] But even the famous passage of the dull mind rising to truth and to the immaterial through that which is material belongs to ordinary biblical hermeneutics and can be found, for example, as early as Ambrose of Milan's commentary on the Psalms.[58]

In fact, there is no evidence that Suger ever read the works of Pseudo-Dionysius or of any of his great commentators, like Eriugena or Hugh of St.-Victor.[59] This is even more striking since Suger's writings have extensive citations of Abbot Hilduin's historical sources, especially his *Gesta Dagoberti*.[60] Moreover, these sources are at the very center of his various attempts to justify his enterprise.[61] It is not surprising, therefore, that nowhere does he speak of beauty in the Dionysian idiom, lauding its *claritas*, *splendor*, or *consonantia*. Nor does he speak of beauty with reference to the Augustinian model in which "beauty" is defined by *proportio*, *harmonia*, and *consonantia*.[62] And we should not forget: the passage in Suger's *De consecratione* in which one can find a certain accumulation of "aesthetic" terminology is linked to his description of the old Carolingian basilica founded by King Dagobert, which "was shining with every terrestrial beauty and with inestimable splendor" (*inestimabili decore splendesceret*).[63]

The fascination with what is called medieval aesthetics—or shall I say the prejudice—has led to a methodological circle: one finds what one is looking for. Even a great idea can obscure one's view of the obvious facts! By closely following the criteria of the historico-critical method, we are able to gain new insights into Suger's library. In the critical apparatus of our new edition, we find theological sources that come from the "living liturgy": from the liturgical offices and the celebration of the Eucharist, from the Scriptures, and—as we have already seen—from religious poetry. Moreover, all motifs pertaining to light can be found in the liturgy, and within the prayers of the liturgy of the church's consecration contained in the *ordinarium* of the twelfth century. In fact, Suger does not belong to the group of learned abbots like Bernard of Clairvaux, William of St. Thierry, and Peter the Venerable.[64] There is no evidence that he ever participated in the learned theological discourse of his time; rather, the opposite, if one accepts, for example, the portrait of

Suger by John of Salisbury in his *Historia pontificalis*.[65] Suger, however, was a great historian of his time. His writings are full of historical documentation. He was aware of the history of his place, St.-Denis, and his building campaign was driven by the conviction to restore this place in the spirit of its traditions. In this context, Suger has searched for historical models: his *De consecratione* contains explicit references to two chronicles from Cassino (to which Panofsky already had randomly pointed), which are related to a similar enterprise, namely, the rebuilding of the basilica of Montecassino under Abbot Desiderius (1058–1087).[66]

Theology

Considering these rather consistent results and the evidence discussed above, the question arises anew as to whether there is a theology of the Gothic cathedral.[67] But what does "theology" mean in this context? Let us glance again at the *locus classicus* for Suger's emphasis on the aesthetics of light. His description of the enlarged stained-glass windows must be read in context. From a grammatical point of view, the phrase in which Suger speaks about the "elegant and praiseworthy extension of the radiating chapels (*in circuitu oratoriorum*), by virtue of which the whole church would shine by the wonderful and uninterrupted light of the most luminous, radiant windows passing through the beauty of the inside"[68] is a simple addition or appendix to the description of the complex space analyzed above, where the transept crossing meets the choir (Figs. 4, 5). The radiating chapels are not part of Suger's crucial effort to balance the "medium" by geometrical and arithmetical means, by relating the axis of the old basilica and of the new enlargement (*medio novi augmenti*) to the dimensions of the new side aisles (Fig. 3a).[69] Suger does indeed mention the chapels because of their enlarged stained-glass windows. But compare the description of the old Carolingian church and its liturgical background, and remember that Suger tried to reestablish the old traditions of the Merovingian and Carolingian kings, including the "laus perennis," the perennial praise before the tombs of the holy patrons and martyrs.[70] One can imagine a monk who experienced the liturgical offices year after year.[71] Light passing through the sanctuary might have impressed him in the same way that it does a modern visitor. Yet it is precisely here that we can see the difference: the medieval monk at St.-Denis would *never* have celebrated a "creative artistic event" with which the history of Gothic stained glass may be said to have begun.[72] Suger certainly never did. Perhaps he would have perceived the light streaming through the window as a symbol of the perennial liturgical order within the changing hours of the office,[73] as a representation of God's own beauty and goodness to which all creatures are called and in which all are able to participate.

The theology we must recognize here is not a speculative one that follows a Hegelian aesthetic paradigm as the leading creative idea behind an artistic enterprise, inspiring a new architecture. Suger's theological approach is deeply rooted within the living history of a medieval monk, and within a tradition that I call "living theology": a combination of schooling, of liturgy-rooted, monastic piety, of the personal literary interest of a learned monk.[74] By Suger's era, this living theology had lasted more than a millenium, mainly in the monasteries. A careful re-reading of the abbot's writings reveals that liturgy and the history of worship are the keys in which Suger expresses what we commonly conceptualize in terms of medieval art. Moreover, as we have seen, it is only through the imagination of liturgy, and Suger's way of reporting and describing architectural structures within a liturgical framework, that modern interpreters (who remained

4. Abbey church of St.-Denis, ambulatory with stained-glass windows, the so-called Suger choir

5. Abbey church of St.-Denis, transept crossing

largely ignorant of the liturgical context) could have obtained the impression of an already completed building. In fact, this is a total fiction (even with respect to the choir), based on a misreading of Suger's liturgical and theological vision. His legacy—let me repeat—was indeed a larger construction site than he had found when he became abbot more than twenty years before. Can we really speak of the origin of Gothic architecture?[75]

Experiencing Art

The re-reading of Suger's writings reflects the striking difference between the perception of the modern visitor and that of the medieval monk regarding what we are accustomed to call "medieval art." This should open the mind's eye to rethink the standard paradigms for the understanding of medieval art. Can any universal aesthetic paradigm which invokes transhistorical categories of beauty and art improve our understanding of medieval art? Allow me to indicate that, on the one hand, more or less all histories of medieval aesthetics, including those of Edgar de Bruyne or Umberto Eco, are based on equating "*pulchrum*" and "beautiful," "*ars*" and "art," "*artifex*" and "artist,"[76] and that these are abstractions without any historical basis. On the other hand, we know that our own concepts and presuppositions are the necessary starting point for understanding what medieval art is, as they are for every act of understanding. Panofsky's ingenious book— and there is no doubt that it *is* ingenious—is a good example of how one's own, as well as the historical, horizon can become intertwined in manifold ways. The hermeneutic circle, however, does have another side. We are obviously not interested merely in understanding our own perceptions, but also in understanding wider horizons: that which is unknown, that which is unfamiliar, and that which is foreign. What is needed and what, moreover, cannot be avoided, is a careful reconstruction of how a medieval figure like Suger experienced art, and what expression he has given to these experiences.

This is also the only appropriate methodology for an "integrated" view of artistic phenomena—say, of Gothic cathedrals. But it might be the case that the sources do not provide the answer to the "why-question" we are used to: What generated Gothic architecture? Here, the history of style ("Stilgeschichte") could supply an appropriate methodology on the basis of a serious chronology utilizing archaeological data. Following this approach, Suger's new choir, which was part of his building campaign and the restoration of the dynastic cult tradition of the "monasterium ter beati Dionysii sociorumque ejus,"[77] might be seen as part of an ongoing architectonic change that finally led to the vision of an integrated church: the idea of the Gothic cathedral.[78]

Considerations of this kind serve as a strong reminder that a specific hermeneutic approach is necessary if reflection on a modern or medieval understanding of art is to penetrate reflections on our own perceptions, those guided by a germane aesthetic. What I have introduced for the purpose of St.-Denis as "a reconstructive hermeneutics for the experience of medieval art" ("eine rekonstruktive Hermeneutik mittelalterlichen Kunsterlebens") may act as a working hermeneutic model also for the more general question of how philosophical or theological aesthetics can proceed vis à vis an art world unstructured by any master narrative.[79] The point of departure for this kind of hermeneutics is the entity that one identifies as art, and the question of how that entity is perceived and how it is experienced.

Notes

1. See the preface to the first edition of E. Panofsky, *Abbot Suger on the Abbey Church of St.-Denis and Its Art Treasures* (Princeton, 1946), vii. Panofsky signed his preface (on p. ix) with "June 11, 1944," the date of the eight-hundredth anniversary of the consecration of the abbey's choir, as mentioned above. On Panofsky's intentions, see also B. Reudenbach, "Panofsky und Suger von St. Denis," in *Erwin Panofsky: Beiträge des Symposions Hamburg 1992*, Schriften des Warburg-Archivs im Kunstgeschichtlichen Seminar der Universität Hamburg 3, ed. B. Reudenbach (Berlin, 1994), 109–22, esp. 109–10.

2. E. Panofsky, *Abbot Suger on the Abbey Church of Saint-Denis and Its Art Treasures*, 2nd ed. by G. Panofsky-Soergel (Princeton, 1979).

3. *Dr. Panofsky and Mr. Tarkington, An Exchange of Letters, 1938–1946*, ed. R. M. Ludwig (Princeton, 1974), 116.

4. *Dr. Panofsky and Mr. Tarkington* (as in note 3), 83.

5. See Reudenbach, "Panofsky und Suger" (as in note 1), 118–19.

6. This little treatise became the introduction to Panofky's *Meaning in the Visual Arts: Papers in and on Art History* (Garden City, N.Y., 1955).

7. *Dr. Panofsky and Mr. Tarkington* (as in note 3), 78.

8. See Panofsky's letter to Harry Bober from September 18, 1945, cited in Reudenbach, "Panofsky und Suger" (as in note 1), 118, n. 39 (from *A Commemorative Gathering for Erwin Panofsky at the Institute of Fine Arts in Association with the Institute for Advanced Studies, March the Twenty-First* [Princeton, 1968], 19).

9. So Panofsky, in his famous introduction to *Abbot Suger* (as in note 1), 25–26 (2nd ed. [as in note 2], 26).

10. For a survey, see *Lexikon des Mittelalters*, vol. 3, s.v. "Dionysius" (Munich and Zurich, 1986), 1076–83; also É. Jeauneau, "L'Abbaye de Saint-Denis introductrice de Denys en Occident," in *Denys l'Aréopagite et sa postérité en Orient et en Occident*, Collection des Études Augustiniennes, Série Antiquité 151, ed. Y. de Andia (Paris, 1997), 361–78.

11. For the understanding of the "motif of light" in the Dionysian tradition, see A. Speer, "Lichtkausalität: Zum Verhältnis von dionysischer Lichttheologie und Metaphysik bei Albertus Magnus und Thomas von Aquin," in *Die Dionysius-Rezeption im Mittelalter: Akten des internationalen Kolloquiums vom 8. bis 11. April 1999 in Sofia unter der Schirmherrschaft der S.I.E.P.M.*, Rencontres de Philosophie Médiévale 9, ed. T. Boiadjiev, G. Kapriev, and A. Speer (Louvain-la-Neuve and Turnhout, 2000), 343–72.

12. A. G. Baumgarten, *Aesthetica* (Frankfurt, 1750; repr. Hildesheim, 1961), § 1: "AESTHETICA (theoria liberalium artium, gnoseologia inferior, ars pulchre cogitandi, ars analogi rationis) est scientia cognitionis sensitivae." With respect to the Renaissance, I would cite especially the *paragone* and the canonization of the fine arts by Giorgio Vasari; see B. Roggenkamp, *Die Töchter des "Disegno": Zur Kanonisierung der Drei bildenden Künste durch Giorgio Vasari* (Münster, 1996); see also B. Roggenkamp,

"Vom 'Artifex' zum 'Artista': Benedetto Varchis Auseinandersetzung mit dem aristotelisch-scholastischen Kunstverständnis 1547," in *Individuum und Individualität im Mittelalter*, Miscellanea Mediaevalia 24, ed. J. A. Aertsen and A. Speer (Berlin and New York, 1996), 844–60.

13. C. Rudolph, *Artistic Change at St.-Denis: Abbot Suger's Program and the Early Twelfth-Century Controversy over Art* (Princeton, 1990), 32–47 and 69–75. See, with critical remarks, A. Speer, "L'Abbé Suger et le trésor de Saint-Denis: Une approche de l'expérience artistique au Moyen Âge," in *L'Abbé Suger, le manifeste gothique de Saint-Denis et la pensée victorine: Actes du Colloque international à la Fondation Singer-Polignac (Paris), le mardi, 21 novembre 2000*, Rencontres médiévales européennes 1, ed. D. Poirel (Turnhout, 2001), 59–82, esp. 62–64.

14. W. Beierwaltes speaks of an "implizit philosophische(n) und prononciert theologische(n) Idee" which as a creative element "Architektur in ihrer formalen Gestaltung von Grund auf bestimmt und damit geradezu den Anfang einer neuen Epoche setzt"; see Beierwaltes, "*Negati affirmatio*: Welt als Metapher. Zur Grundlegung einer mittelalterlichen Ästhetik durch Johannes Scotus Eriugena," in W. Beierwaltes, *Eriugena: Grundzüge seines Denkens* (Frankfurt am Main, 1994), 115–58, esp. 115 and 158.

15. O. von Simson, *The Gothic Cathedral: Origins of Gothic Architecture and the Medieval Concept of Order* (New York, 1956; 2nd ed. 1962), esp. 21–58 (pt. 1, chap. 2); see the critical discussion of von Simson's thesis by G. Binding, "Die neue Kathedrale: Rationalität und Illusion," in *Aufbruch–Wandel–Erneuerung: Beiträge zur "Renaissance" des 12. Jahrhunderts*, ed. G. Wieland (Stuttgart, 1995), 211–35. See also Panofsky, *Abbot Suger* (as in note 2), 18–26.

16. E. Panofsky, *Gothic Architecture and Scholasticism* (Latrobe, 1951), esp. 27–35.

17. See A. Speer, "Kunst und Schönheit: Kritische Überlegungen zur mittelalterlichen Ästhetik," in *Scientia und Ars im Hoch- und Spätmittelalter*, Miscellanea Mediaevalia 22, ed. I. Craemer-Ruegenberg and A. Speer (Berlin and New York, 1994), 945–66, esp. 945–48; for Hegel, see also W. Desmond, "Gothic Hegel," in *Owl of Minerva* 30, no. 2 (spring 1999), 237–52.

18. Panofsky, *Abbot Suger* (as in note 2), 85. In the absence of a revised translation based on a new critical text, I will generally follow Panofsky's standard translation in his *Abbot Suger* (as in note 2).

The Latin texts are quoted from a new critical edition: *Abt Suger von Saint-Denis, Ausgewählte Schriften: Ordinatio, De consecratione, De administratione*, ed. A. Speer and G. Binding in collaboration with G. Annas, S. Linscheid-Burdich, and M. Pickavé (Darmstadt, 2000); there one finds the following abbreviations, also used here, in connection with line and sentence numeration: *ord = Ordinatio, cons = De consecratione, adm = De administratione*.

cons 7:48–58: "in medium proferentes gloriosam et Deo

dignam sancte huius ecclesie consecrationem preciosissi-
morum martirum dominorum et apostolorum nostrorum
Dyonisii, Rustici et Eleutherii et aliorum sanctorum, quo-
rum prompto innitimur patrocinio, sacratissimam trans-
lationem ad successorum noticiam stilo assignare elabo-
rauimus, qua de causa, quo ordine, quam sollempniter,
quibus etiam personis ad ipsum actum sit, reponentes, ut
et diuine propitiacioni pro tanto munere condignas pro
posse nostro gratiarum acciones referamus et sanctorum
protectorum nostrorum tam pro impensa tanti operis cura
quam pro tante sollempnitatis adnotatione oportunam
apud Deum optineamus intercessionem."

19. von Simson, *The Gothic Cathedral* (as in note 15),
123–24.

20. Panofsky, *Abbot Suger* (as in note 2), 14–15.

21. Concerning those dates, see M. Pickavé, "Zur Über-
lieferung der drei Schriften des Suger von Saint-Denis," in
Abt Suger von Saint-Denis (as in note 18), 147–62, esp.
157–58.

22. A. Speer, "Abt Sugers Schriften zur fränkischen
Königsabtei Saint-Denis," in *Abt Suger von Saint-Denis*
(as in note 18), 13–66, esp. 18–31.

23. Panofsky, *Abbot Suger* (as in note 2), 87; *cons*
10:83–87: "ut sepius in sollempnibus uidelicet diebus ad-
modum plena per omnes ualuas turbarum sibi occuren-
tium superfluitatem refunderet et non solum intrantes
non intrare, uerum etiam qui iam intrauerant preceden-
tium expulsus exire compelleret."

24. For the analysis of the archaeological evidence, see
J. van der Meulen and A. Speer, *Die fränkische Königs-
abtei Saint-Denis: Ostanlage und Kultgeschichte* (Darm-
stadt, 1988), 95–106, 267–71.

25. Panofsky, *Abbot Suger* (as in note 2), 135; *ord*
36:199–204: "Huc accessit nostram rapiendo deuotionem,
quoniam infra sancti sanctorum locus ille diuinitati
idoneus, sanctorum frequentationi angelorum gratissimus
tanta sui angustia artabatur, ut nec hora sancti sacrificii
in solemnitatibus fratres sacratissime eucharistie commu-
nicantes ibidem demorari possent nec aduentantium pere-
grinorum molestam frequentiam multociens sine magno
periculo sustinere ualerent." See also *cons* 10:81–12:100
and *adm* 164:714–18.

26. William W. Clark speaks accurately of Suger's enter-
prise as a "religious pilgrimage through the history of the
abbey" and sees the category of continuity also expressed
in the "reuse and repositioning of actual architectonical
elements"; see W. W. Clark, " 'The Recollection of the
Past Is the Promise of the Future.' Continuity and Con-
textuality: Saint-Denis, Merovingians, Capetians, and
Paris," in *Artistic Integration in Gothic Buildings*, ed. V.
Chieffo Raguin et al. (Toronto, 1995), 92–107, esp. 94 and
98. See also van der Meulen and Speer, *Die fränkische
Königsabtei Saint-Denis* (as in note 24), 267–71 and
302–7.

27. A. W. Robertson, *The Service-Books of the Royal
Abbey of Saint-Denis: Images of Ritual and Music in the
Middle Ages* (Oxford, 1991).

28. E. B. Foley, *The First Ordinary of the Royal Abbey
of St.-Denis in France (Paris, Bibliothèque Mazarine 526),*
Spicilegium Friburgense 32 (Fribourg, 1990).

29. M. Andrieu, *Le Pontifical romain au Moyen-Âge,*

vol. 1, *Le Pontifical romain du XIIe siècle,* Studi e Testi 86
(Vatican City, 1938); the "Ordo ad benedicandam eccle-
siam" of the Pontificale Romanum of the twelfth century
can be found on pp. 176–95. Concerning the development
and transmission of this type of pontifical, see also An-
drieu's introduction and his remarks with regard to the
leading mansucripts Vat. lat. 7818 and Vat. Barb. 631 (see
pp. 92–97). Of special interest for reconstructing Suger's
model are remarks concerning the old *ordines romani,*
preserved in a manuscript from Cassino (Ms. Cassin. 451;
see note 67 below and Andrieu, *Le Pontifical romain,*
9–11). For a deeper analysis, see Speer, "Abt Sugers
Schriften zur fränkischen Königsabtei Saint-Denis" (as in
note 22), 38–53, esp. the scheme on 45–48; also Speer,
"Art as Liturgy: Abbot Suger of Saint-Denis and the Ques-
tion of Medieval Aesthetics," in *Roma, magistra mundi:
Itineraria culturae mediaevalis. Mélanges offerts au Père
L. E. Boyle à l'occasion de son 75e anniversaire,* Fédéra-
tion des Instituts d'Études Médiévales, Textes et Études
du Moyen Âge 10, no. 2, ed. J. Hamesse (Louvain-la-
Neuve, 1998), vol. 2, 855–75.

30. *cons* 87:537–95, 580.

31. *adm* 183:835–37: "reseruata tamen quantacumque
porcione de parietibus antiquis, quibus summus pontifex
Dominus Jesus Christus testimonio antiquorum scripto-
rum manum apposuerat." See also *cons* 47:283–86 and
cons 93:567–68. The treatise "De dedicatione ecclesie
beatissimi ariopagite Dyonisii sociorumque eius" is edited
by C. J. Liebman Jr., "La Consécration légendaire de la
basilique de Saint-Denis," *Le Moyen Age* 45 (1945),
252–64; on the historical and liturgical backgrounds, see
van der Meulen and Speer, *Die fränkische Königsabtei
Saint-Denis* (as in note 24), 147–72; and A. Lombard-Jour-
dan, "La Légende de la consécration par le Christ de la
basilique mérovingienne de Saint-Denis et de la guérison
du lépreux," *BullMon* 143 (1985), 237–69.

32. *cons* 8–9 and 88–90. See, with extensive references,
van der Meulen and Speer, *Die fränkische Königsabtei
Saint-Denis* (as in note 24), 141–47; also G. M. Spiegel,
"The Cult of Saint Denis and Capetian Kingship," *JMed-
Hist* 1 (1975), 43–69. In fact, Suger traces back the old
basilica to the times of Dagobert. This "primitiua eccle-
sia" (*cons* 9:77) becomes a determining motive for Suger's
undertaking.

33. *cons* 61:382–83.

34. *cons* 10–13 and 51; see Speer, "Abt Sugers Schriften
zur fränkischen Königsabtei Saint-Denis" (as in note 22),
41–43.

35. Panofsky, *Abbot Suger* (as in note 2), 121; *cons*
98:615–16: "materialia immaterialibus, corporalia spiritu-
alibus, humana diuinis uniformiter concopulas."

36. von Simson, *The Gothic Cathedral* (as in note 15),
123–24.

37. See, for example, my articles "*Luculento ordine*:
Zum Verhältnis von Kirchweihliturgie und Baubeschrei-
bung bei Abt Suger von Saint-Denis," in *Kunst und Litur-
gie im Mittelalter: Akten des internationalen Kongresses
der Bibliotheca Hertziana und des Nederlands Instituut
te Rome, Rom, 28.–30. September 1997, Römisches Jahr-
buch der Bibliotheca Hertziana* 33 (1999/2000), Beiheft,
ed. N. Bock et al. (Munich, 2000), 19–37, esp. 30–35; "Su-

gers Baustelle," in *Form und Stil: Festschrift für Günther Binding zum 65. Geburtstag,* ed. S. Lieb (Darmstadt, 2001), 181–93.

38. See G. Binding, "Beiträge zum Architektur-Verständnis bei Abt Suger von Saint-Denis," in *Mittelalterliches Kunsterleben nach Quellen des 11. bis 13. Jahrhunderts,* ed. G. Binding and A. Speer (Stuttgart, 1993; 2nd ed., 1994), 184–207.

39. cons 85; see Foley, *The First Ordinary* (as in note 28), 197–99; Robertson, *Service-Books of the Royal Abbey* (as in note 27), 86–87, 92, 315–16, 380.

40. cons 93–95.

41. cons 96. See H. P. Neuheuser, "'*Ne lapidum materia apparentium locus vilesceret*': Die Raumvorstellung des Abtes Suger in seiner Kirchweihbeschreibung von Saint-Denis," in *Raum und Raumvorstellungen im Mittelalter,* Miscellanea Mediaevalia 25, ed. J. A. Aertsen and A. Speer (Berlin and New York, 1998), 641–64, at 646–47.

42. cons 49:298–99. For the context, see *cons* 49:295–302 (note 69 below); for "in medio ecclesiae," see H. P. Neuheuser, "Die Kirchweihbeschreibungen von Saint-Denis und ihre Aussagefähigkeit für das Schönheitsempfinden des Abtes Suger," in *Mittelalterliches Kunsterleben* (as in note 38), 116–83, at 146–52; F. Oswald, "*In medio ecclesiae:* Die Deutung der literarischen Zeugnisse im Lichte archäologischer Funde," *FS* 3 (1969), 313–26.

43. adm 184–86, esp. *adm* 186:845–47: "Sed quia iam inceptum est, in alarum extensione aut per nos aut per quos dominus elegerit, ipso auxiliante perficietur." On the side aisles, see van der Meulen and Speer, *Die fränkische Königsabtei Saint-Denis* (as in note 24), 104–5; also S. McK. Crosby, *The Royal Abbey of Saint-Denis from Its Beginnings to the Death of Suger, 475–1151,* ed. and compl. by P. Z. Blum (New Haven and London, 1987), 267–77 and 339–60.

44. See van der Meulen and Speer, *Die fränkische Königsabtei Saint-Denis* (as in note 24), 299–301. All assumptions concerning the so-called Suger Choir, the surviving ambulatory and beyond—as, for example, in D. Kimpel and R. Suckale, *Die Gotische Architektur in Frankreich, 1130–1270* (Munich, 1985), 87—must remain speculative.

45. For details, see Speer, "*Luculento ordine:* Zum Verhältnis von Kirchweihliturgie und Baubeschreibung" (as in note 37), 32–34; and Speer, "L'Abbé Suger et le trésor de Saint-Denis" (as in note 13), 66–70.

46. adm 3–159; see Speer, "Abt Sugers Schriften zur fränkischen Königsabtei Saint-Denis" (as in note 22), 27–29 and 37.

47. adm 173–75.

48. adm 180–81.

49. adm 197–221.

50. adm 240–42.

51. adm 256 and 262.

52. adm 262–65. For the glass windows, note both volumes by L. Grodecki, *Études sur les vitraux de Suger à Saint-Denis (XIIe siècle),* Corpus Vitrearum, France, *Études* 1 (Paris, 1976) and *Études* 3 (Paris, 1995); see also M. H. Caviness, "Suger's Glass at Saint-Denis: The State of Research," in *Abbot Suger and Saint-Denis: A Symposium,* ed. P. L. Gerson (New York, 1986), 257–72.

53. adm 180:813–14 and 816–21.

54. Panofsky, *Abbot Suger* (as in note 2), 22.

55. See the highly sophisticated analysis of S. Linscheid-Burdich, "Beobachtungen zu Sugers Versinschriften in *De administratione,*" in *Abt Suger von Saint-Denis* (as in note 18), 112–46, concerning the poem cited on the epitaph, esp. 114–20.

56. adm 174:775–783:

> Portarum quisquis attollere queris honorem,
> Aurum nec sumptus operis mirare laborem.
> Nobile claret opus, sed opus, quod nobile claret,
> Clarificet mentes, ut eant per lumina uera
> Ad uerum lumen, ubi Christus ianua uera.
> Quale sit intus, in his determinat aurea porta.
> Mens hebes ad uerum per materialia surgit
> Et demersa prius hac uisa luce resurgit.

For various interpretations of these verses and recent bibliography, see Linscheid-Burdich, "Beobachtungen zu Sugers Versinschriften" (as in note 55), 112–46, esp. 120–25 (with a critical discussion of M. Büchsel, "Ecclesiae symbolorum cursus completus," *Städel-Jahrbuch* n.s. 9 [1983], 69–88, esp. 74; Büchsel, *Die Skulptur des Querhauses der Kathedrale von Chartres* [Berlin, 1995], 168–82; Büchsel, *Die Geburt der Gotik: Abt Sugers Konzept für die Abteikirche St.-Denis* [Freiburg im Breisgau, 1997], 125–34; and C. Markschies, *Gibt es eine "Theologie der gotischen Kathedrale"?: Nochmals, Suger von Saint-Denis und Sankt Dionys vom Areopag,* AbhHeid, Phil.-hist.Kl. [1995], 1. Abh. [Heidelberg, 1995], 66–67). In addition, see P. C. Claussen, "*Materia* und *opus:* Mittelalterliche Kunst auf der Goldwaage," in *Ars naturam adiuvans: Festschrift für Matthias Winner zum 11. März 1996,* ed. V. von Flemming and S. Schütze (Mainz, 1996), 40–49, esp. 43; and, recently, S. Linscheid-Burdich, *Suger von Saint-Denis: Untersuchungen zu seinen Schriften Ordinatio - De consecratione - De administratione,* Beiträge zur Altertumskunde 200 (Munich and Leipzig 2004), esp. 13–19 and 196–202.

57. Panofsky, *Abbot Suger* (as in note 2), 23.

58. See Linscheid-Burdich, "Beobachtungen zu Sugers Versinschriften" (as in note 55), 121.

59. D. Poirel has recently tried to give some new evidence for a certain Dionysian influence on Suger, especially through the Victorine school. In fact, Poirel's careful study confirms that any possible influence is more general than profound—it is at least not stronger than those to which I have called attention ("Abt Sugers Schriften zur fränkischen Königsabtei Saint-Denis" [as in note 22], 52–53). See D. Poirel, "*Symbolice et anagogice:* L'École de Saint-Victor et la naissance du style gothique," in *L'Abbé Suger, le manifeste gothique de Saint-Denis* (as in note 13).

60. The *Gesta Dagoberti* belong to the same part of the codex Reg. lat. 571 (Rome, Bibl. Vat.) that contains Suger's *De consecratione* as well as other pieces belonging to the Saint-Denis tradition, for example, the *Miracula Sancti Dionysii;* see Pickavé, "Zur Überlieferung der drei Schriften" (as in note 21), 147–49.

61. See, for example, the emphasis that Suger places on the "conuenientia et coherentia antiqui et noui operis" (cons 20:137). As I have already pointed out, for Suger, the

old basilica goes back to Dagobert (see note 32).

62. See J. A. Aertsen, "Beauty in the Middle Ages: A Forgotten Transcendental," *Medieval Philosophy and Theology* 1 (1991), 68–97; also *Historisches Wörterbuch der Philosophie*, vol. 8 (Basel, 1992), s.v. "Schöne (das), II. Mittelalter," cols. 1351–56, and *Lexikon des Mittelalters*, vol. 7 (Munich, 1995), s.v. "Schöne (das)," cols. 1531–34.

63. Panofsky, *Abbot Suger* (as in note 2), 87; *cons* 9:67–78, esp. 67–74: "Quam cum mirifica marmorearum columnarum uarietate componens copiosis purissimi auri argenti thesauris inestimabiliter locupectasset ipsiusque parietibus et columpnis et arcubus auro tectas uestes margaritarum uarietatibus multipliciter exornatas suspendi fecisset, quatinus aliarum ecclesiarum ornamentis precellere uideretur et omnimodis incomparabili nitore uernans et omni terrena pulcritudine compta inestimabili decore spendesceret."

64. Concerning the discussion between Suger and Bernard of Clairvaux about their allegedly common goal, the justification of personal visions—inspired by Cluny—of the mirroring of the heavenly splendor of Jerusalem through the wondrous inner rooms of the church by Suger in comparison to the Cistercian austerity of Bernard, see Speer, "Abt Sugers Schriften zur fränkischen Königsabtei Saint-Denis" (as in note 22), 33–34 and 63–65. This discussion is often overstated; see, for example, C. Rudolph, *The "Things of Greater Importance": Bernard of Clairvaux's Apologia and the Medieval Attitude towards Art* (Philadelphia, 1990), esp. 30–35 and 61–63 with respect to Suger-Bernard. H. L. Kessler supports Rudolph's argument "that Suger's artistic enterprise was a response to Bernard of Clairvaux's attack on art's materiality" based on the analysis of two medallions (the Chariot of Aminadab and the Brazen Serpent); he also tries to reintroduce Pseudo-Dionysius. See Kessler, "The Function of *Vitrum Vestitum* and the Use of *Materia Saphirorum* in Suger's St.-Denis," in *L'image: Fonctions et usages des images dans l'Occident médiéval*, ed. J. Baschet and J.-C. Schmitt (Paris, 1996), 179–203, reprinted in H. L. Kessler, *Spiritual Seeing: Picturing God's Invisibility in Medieval Art* (Philadelphia, 2000), 190–205. See, on the other hand, the careful philological analysis of Suger's verses by S. Linscheid-Burdich, who reveals very clearly Suger's "library" and the background of his poetry; with respect to the stained-glass windows, see esp. Linscheid-Burdich, "Beobachtungen zu Sugers Versinschriften" (as in note 55), 134–44.

65. Indeed, John of Salisbury, in his *Historia pontificalis* (ed. M. Chibnall [Oxford, 1986], 15–16), gives a very fine portrait of "Sigerius abbas Sancti Dionisii, uir litteratus et eloquens" during the proceedings against Gilbert of Poitiers and describes his role and place within the intellectual climate of the times.

66. *Narratio de consecratione ecclesiae Casinensis*, ed. T. Leccisotti, in *Le vicende della basilica di Montecassino attraverso la documentazione archeologica*, ed. A. Pantoni and T. Leccisotti, Miscellanea Cassinese 36 (Montecassino, 1973), 213–25 (=PL 173:997–1002); *Chronica Monasterii Casinensis*, ed. H. Hoffmann, MGH, SS 34 (Hannover, 1980). See Panofsky, *Abbot Suger* (as in note 2), 232–33. So, to a certain extent, one can speak of a Montecassino-*imitatio*. See in this context the remarks regarding the old *ordines romani* (note 29 above) preserved in a manuscript from Cassino (Cassin. 451); in particular, A. Speer and M. Pickavé, "Abt Sugers Schrift *De consecratione*: Überlieferung–Rezeption–Interpretation," *Filologia mediolatina* 3 (1996), 207–42, esp. 222–30.

67. This question has been discussed in a more general manner by C. Markschies, *Gibt es eine "Theologie der gotischen Kathedrale"? Nochmals, Suger von Saint-Denis und Sankt Dionys vom Areopag* (as in note 56). Markschies points in particular to the allegorical exegesis of texts and also, though it is more specific, to the topic of theological allegories in church buildings (23–39 and 54–55), earlier noted by H. de Lubac, *Exégèse médiévale: les quatre sens de l'écriture*, vol. 2 (Paris, 1959), 621–33; note also H. Brinkmann, *Mittelalterliche Hermeneutik* (Darmstadt, 1980), 243–59.

68. Panofsky, *Abbot Suger* (as in note 2), 101; *cons* 49:295–302: "Prouisum est etiam sagaciter, ut superioribus columpnis et arcubus mediis, qui inferioribus in cripta superponerentur, geometricis et arimeticis instrumentis medium antique testudinis ecclesie augmenti noui medio equaretur nec minus antiquarum quantitas alarum nouarum quantitati adaptaretur excepto illo urbano et approbato in circuitu oratoriorum incremento, quo tota clarissimarum uitrearum luce mirabili et continua interiorem perlustrante pulcritudinem eniteret." The understanding of this description is highly controversial, mainly because of the confusion of archaeological and philological arguments. If one respects the methodological borders, this passage can be seen as one of the most precise descriptions of what was going on during the building campaign in the eastern section of the abbey church. See Speer, "Sugers Baustelle" (as in note 37), 185–86.

69. Concerning the understanding of "medium," see note 42; see also G. Binding, "'Geometricis et arithmeticis instrumentis': Zur mittelalterlichen Bauvermessung," *Jahrbuch der rheinischen Denkmalpflege* 30/31 (1985), 9–24.

70. See Robertson, *Service-Books of the Royal Abbey* (as in note 27), 13–23, 37–38, 220, 224–25; van der Meulen and Speer, *Die fränkische Königsabtei Saint-Denis* (as in note 24), 137–38 and nn. 375–77.

71. A good example is an annotated breviary from the early twelfth century, Vendôme, Bibliothèque Municipale, Ms. 17C; see Robertson, *Service-Books of the Royal Abbey* (as in note 27), 435–36.

72. von Simson, *The Gothic Cathedral* (as in note 15), 100.

73. See Neuheuser, "Die Kirchweihbeschreibungen von Saint-Denis" (as in note 42), 153–62 and esp. 154–57. In addition, see A. Speer, "*Lux mirabilis et continua*: Anmerkungen zum Verhältnis von mittelalterlicher Lichtspekulation und gotischer Glaskunst," in *Himmelslicht: Mittelalterliche Glasmalerei zur Zeit der Grundsteinlegung des gotischen Kölner Domes, 1248–1349*, Katalog der Jubiläumsausstellung des Schnütgen-Museum zum Kölner Domjubiläum, ed. H. Westermann-Angerhausen (Cologne, 1998), 89–94, esp. 92–94.

74. See Speer, "Abt Sugers Schriften zur fränkischen Königsabtei Saint-Denis" (as in note 22), 34–35, 38, 62–65.

75. See Speer, "Sugers Baustelle" (as in note 37), esp. 184–87 and 190; as far as I can see, Jan van der Meulen was the first to raise this question and draw the methodological consequences: J van der Meulen, "Die Abteikirche von Saint-Denis und die Entwicklung der Frühgotik," *Kunstchronik* 30 (1977), 60–61.

76. See, for example, É. de Bruyne, *Études d'esthétique médiévale*, 3 vols. (Bruges, 1946), and U. Eco, *Arte e belleza nell'estetica medievale* (Milan, 1987), which was translated into many languages. In his preface Eco confesses that he and most authors working in this field of "medieval aesthetics" rely heavily on the sources to be found in de Bruyne's great study.

77. See J. Dufour, *Recueil des actes de Louis VI*, 4 vols. (Paris, 1992–94), vol. 2, 338, n. 163 and 465, n. 220; also *ord* 4:14.

78. Binding, "Die neue Kathedrale" (as in note 15), 227–35.

79. I first developed this hermeneutic approach in "Vom Verstehen mittelalterlicher Kunst," in *Mittelalterliches Kunsterleben* (as in note 38), 13–52; see also my article "Beyond Art and Beauty: In Search of the Object of Philosophical Aesthetics," *International Journal of Philosophical Studies* 8 (2000), 73–88.

Christ and the Vision of God: The Biblical Diagrams of the Codex Amiatinus

Celia Chazelle

Pictorial decoration in early medieval Bibles, John Williams has reminded us, was a highly conservative art form. Particularly when the subjects came from the New Testament, imagery could "in some sense . . . share the authenticity of the text, assuming the role of a sanctioned portrait of an event presented verbally in the Bible."[1] It is therefore understandable that during much of the twentieth century, one of the most prominent currents in art-historical scholarship on biblical manuscripts from the early medieval West was the search for their artistic sources. The artist was seen as a "passive agent of descent," Williams notes,[2] and the principal significance assigned to his production was its success in transmitting an identifiable model or models or its failure to do so; discernible departures from a source or the inclusion of features without confirmable precedent were treated as of secondary interest. When the exemplar was no longer extant or traceable, the goal of the scholar's inquiry often become its reconstruction. The lost archetype was culturally more meaningful and interesting than the object at hand.

In the last three decades a number of studies, among them the volume edited by Williams from whose introduction I quoted, have challenged this approach by examining how older iconographic subjects and artistic forms served as raw materials with which early medieval artists responded to their own cultures. The choices they made from available materials, it is now better understood, what they decided to copy or to omit, their deviations from and adaptations of their models, can reflect ways of thought and goals rooted in their own backgrounds and environments. By investigating the evidence of this decision-making in early medieval Bibles in light of contemporary social, political, religious, and intellectual conditions, we can gain valuable insight into how the art of those books was informed by the contexts in which their creators worked, and into how the decoration may itself add to our knowledge of the same circumstances.

Until the mid-1990s, a manuscript largely immune to this new historiography was the Codex Amiatinus (Florence, Biblioteca Medicea Laurenziana, Cod. Amiatino 1), one of three pandects (one-volume Bibles) produced at the Northumbrian monastery of Wearmouth-Jarrow under its abbot, Ceolfrid, probably between 689 and 716, and more likely toward the end than the beginning of this period.[3] Twelve folia and fragments of a thirteenth survive from one or both sister pandects of Amiatinus,[4] but this is the only Bible of the three still evidently in possession of all

its leaves, though it lacks the original binding. The anonymous *Vita Ceolfridi* and the *Historia abbatum* by Bede, a monk at Jarrow during Ceolfrid's abbacy, inform us that whereas the other two Bibles were placed in Wearmouth's church of St. Peter and Jarrow's church of St. Paul, in June 716 Amiatinus was sent with other gifts to the shrine of St. Peter in Rome. Ceolfrid joined the party traveling to the holy see, but he died on the way, just outside Langres, Burgundy, in September of that year. After his burial, the *Vita Ceolfridi* indicates, some of his fellow monks continued on to Rome, bringing the codex to Pope Gregory II.[5] By the eleventh century, the pandect was at the monastery of San Salvatore at Monte Amiata. It was sent back to Rome in the sixteenth century to be used for Pope Sixtus's revision of the Vulgate, and it then returned to Monte Amiata, remaining there until the abbey was dissolved and its library moved to the Biblioteca Laurenziana in Florence in the late eighteenth century.[6]

The *Historia abbatum* links Wearmouth-Jarrow's production of the three pandects to its possession of a now lost *uetusta translatio* of the Bible that Ceolfrid had acquired in Rome on his sole visit to the city about 677, with Benedict Biscop, Wearmouth's founder.[7] In 1883, Peter Corssen noted similarities between the texts of three diagrammatic lists of Scripture in Amiatinus's first quire (ff. 5/VIr, 8r, 6/VIIr; Figs. 1–3)[8] and the texts of the Scripture diagrams in Book 1 of the Italian scholar Cassiodorus's treatise, the *Institutiones*, written in the mid-sixth century. In the *Institutiones*, Cassiodorus states that he earlier placed the same charts in his Codex Grandior, a pandect made under him at his monastery of Vivarium in southern Italy.[9] While the Latin version of Grandior's New Testament is unknown, its Old Testament was an "old" translation, namely, Jerome's pre-Vulgate revision based on the Septuagint of Origen's *Hexapla*. In 1887, F. J. A. Hort suggested that Cassiodorus's Bible should be identified with Ceolfrid's *uetusta translatio*.[10] In general, this hypothesis has won widespread scholarly acceptance, but an article by Karen Corsano, published in 1987, argued that Grandior was not at Wearmouth-Jarrow and that Amiatinus's recognizably Cassiodorian features were based on other manuscripts. The biblical diagrams, she maintained, were inspired by the diagrams both of Scripture and of the liberal arts in a copy of the *Institutiones* in the English monastery's library.[11] Although Paul Meyvaert has presented evidence that it is unlikely Wearmouth-Jarrow owned the *Institutiones*, Corsano's theory that the *Institutiones* were there but Grandior was not has recently been reiterated by Michael Gorman.[12]

In my view, Corsano and Gorman have not succeeded in demonstrating that the *Institutiones* were at the English abbey; Meyvaert's arguments against this remain generally persuasive. Whatever the final resolution of this particular disagreement, however, we should not allow it to obscure the weight of evidence that the monastery did possess the Codex Grandior: the connection the *Historia abbatum* draws between Ceolfrid's *uetusta translatio* and the abbey's preparation of three pandects; Amiatinus's prologue, which uses Cassiodorian language and was probably written by Cassiodorus for a pandect which, like Grandior, contained seventy books of Scripture;[13] Amiatinus's picture of the Tabernacle, recalling Grandior's imagery of the Tabernacle and Temple; Bede's references to older illustrations of the Tabernacle and Temple he had seen, other than the painting in Amiatinus, which he assigns to Cassiodorus;[14] and the presence in Amiatinus of three Scripture diagrams comparable to those Cassiodorus placed in Grandior as well as in the *Institutiones*. Other explanations might be proposed for each individual circumstance, but overall the logical conclusion is that Grandior and Ceolfrid's copy of the *uetusta translatio* were one and the same volume, and that Grandior was one, quite possibly the only, source of Cassiodorus's influence on Amiatinus.[15]

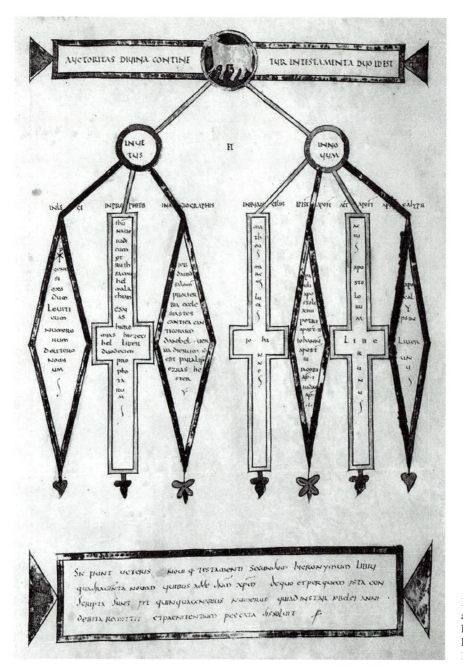

1. Division of scripture according to Jerome. Florence, Biblioteca Medicea Laurenziana, Ms. Amiatino 1, f. 5/VIr

Significant differences existed between Amiatinus's scriptural text and Grandior's, so far as the latter is known. The English pandect, unlike Grandior, is written *per cola et commata*, a system of line division that added significantly to its length, and whereas Grandior's Old Testament was a pre-Vulgate Latin edition, both Testaments in Amiatinus are versions of Jerome's Vulgate.[16] But the main script in Amiatinus is an imitation of sixth-century Italian uncial, which could reflect Grandior's influence,[17] and, with only a few divergences, Amiatinus follows the organization of biblical books that the *Institutiones* note was found in Grandior.[18] Twentieth-century art historians were typically also disposed to view some, or even all, of the illustrated folios in Amia-

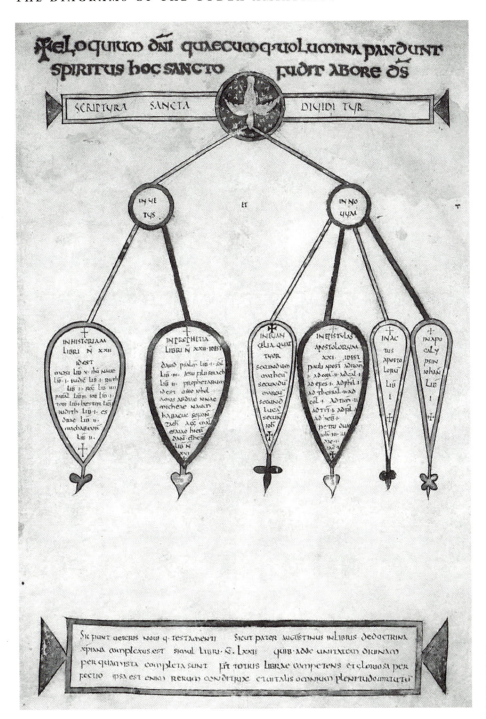

2. Division of scripture according to Augustine. Florence, Biblioteca Medicea Laurenziana, Ms. Amiatino 1, f. 8r

tinus, especially its first gathering, where most of the art occurs, as copied directly from a Cassiodorian manuscript, the preferred candidate being Grandior.[19] Supporting evidence was found in the *Institutiones* report of Grandior's three charts of Scripture and in the references by Bede and Cassiodorus to Grandior's depictions of the Tabernacle and Temple.[20] In addition, some art in Amiatinus lacking parallels in written sources concerning Grandior has been thought more in tune with a sixth-century Italian than an eighth-century Northumbrian aesthetic; the most ex-

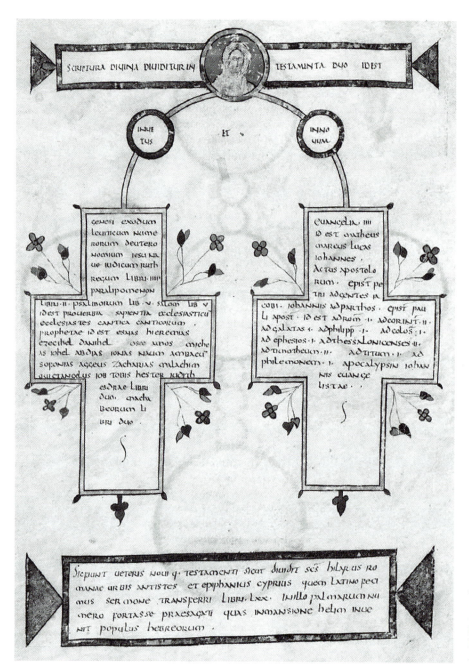

3. Division of scripture according to Pope Hilarus and Epiphanius. Florence, Biblioteca Medicea Laurenziana, Ms. Amiatino 1, f. 6/VIIr

traordinary example is the famous portrait of the prophet Ezra (f. 4/Vr; Fig. 4). Contrasting the style of this picture to that of the Majestas illumination prefacing Amiatinus's New Testament (f. 796v; Fig. 5), G. F. Browne proposed in 1887 that both the Ezra and Tabernacle images, and possibly other pages of Amiatinus's first quire, had been lifted directly from Grandior.[21] Browne's theory was not decisively refuted until the 1960s, but for the next three decades the thrust of art-historical research continued to be to look at Amiatinus for insight into Cassiodorus's Vivarium, and particularly into the contents of the Codex Grandior, more than Bede's Wearmouth-Jarrow.[22]

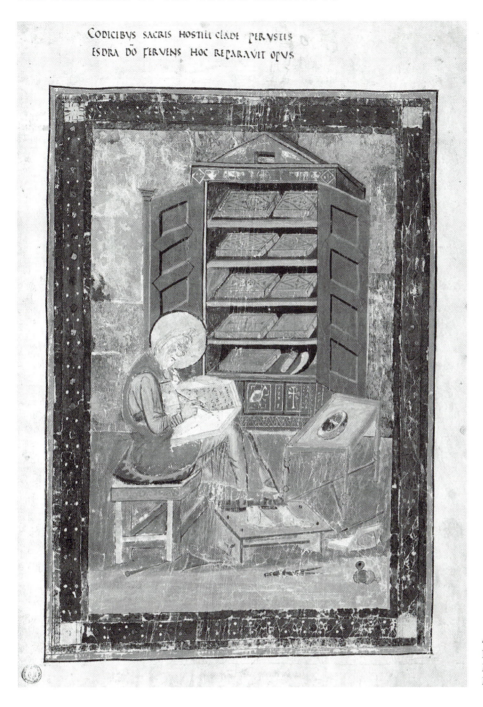

CODICIBVS SACRIS HOSTILI CLADE PERVSTIS
ESDRA DŌ FERVENS HOC REPARAVIT OPVS

4. Portrait of the prophet Ezra. Florence, Biblioteca Medicea Laurenziana, Ms. Amiatino 1, f. 4/Vr

Since 1995, though, several studies have contended that while Grandior provided inspiration for some elements of the first quire, Wearmouth-Jarrow's borrowing of its texts and ornament was selective. The surviving evidence concerning Grandior's non-biblical material is limited, but enough remains to show that, in preparing Amiatinus's first quire, the English scriptorium ignored some features of the sixth-century manuscript, made changes to what it did copy, probably drew on other sources as well, and added new texts of its own composition and probably new artistic

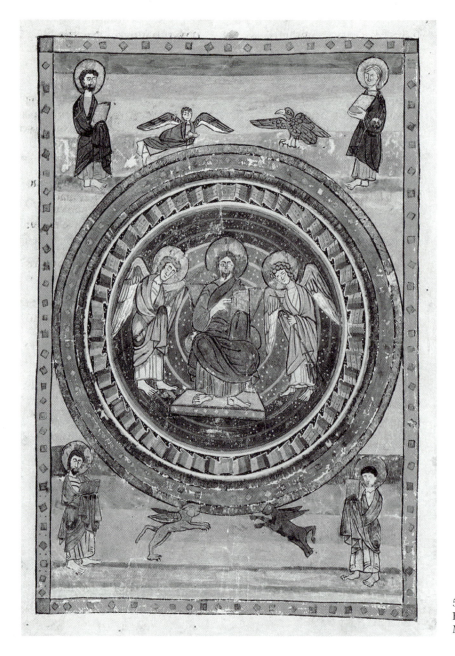

5. Majestas Domini. Florence,
Biblioteca Medicea Laurenziana,
Ms. Amiatino 1, f. 796v

forms.[23] These findings provide the starting point of my discussion here of the art of Amiatinus's three biblical diagrams, for which the chief models were most likely the diagrams in Grandior. Even if Wearmouth-Jarrow owned a copy of the *Institutiones*, I think the scriptorium would have looked primarily, if not exclusively, for guidance to the Scripture charts in its Italian pandect as it designed those of its own Bible. As I discuss below, certain elements of the decoration of Grandior's three diagrams can be reconstructed by comparing information provided by manuscripts of the *Institutiones* with the Amiatinus charts. Yet, although I will give some attention to the formal similarities and differences between Cassiodorus's and Wearmouth-Jarrow's diagrams, this is not the principal question I want to address. Rather, it is the rationale behind the ornament

of the English folia and the impact that contemporary events and thought may have exerted on the English artist's handling of his sources. As Lawrence Nees suggested in his study of Amiatinus in Williams's book, some artistic details of the three pages may reflect concerns at Wearmouth-Jarrow about political and theological developments in the Mediterranean and Northumbria.[24] Once the potential impact of such developments on the Amiatinus diagrams is appreciated, we can also understand better the intellectual motivations for the design of the rest of the first quire and the production of the three pandects.[25]

Each of Amiatinus's three diagrams of Scripture (ff. 5/VIr, 8r, and 6/VIIr; Figs. 1–3) presents a carefully executed, predominantly geometrical pattern of forms. Lists of biblical books are set out like genealogical trees within colored, regularly shaped frames that descend from a tablet with handle-like ends (*tabula ansata*) enclosing an inscription.[26] The center of each tablet is marked by a medallion-framed image painted in gold foil on a colored background: a lamb, a bird (probably a dove) flying downward with wings outspread, and a male bust. Beneath the lists of Scripture, another *tabula ansata* encloses an inscription that refers to the diagram above it and names the lists' purported inventor or inventors. The chart with the lamb is attributed to Jerome (f. 5/VIr) and that with the dove to Augustine (f. 8r). The diagram with the male bust, which sets out the organization of Scripture actually followed in Grandior and Amiatinus, is jointly ascribed to the fifth-century pope Hilarus and the fourth-century Greek theologian Epiphanius of Cyprus (f. 6/VIIr).[27] Epiphanius was included in Bede's martyrology, and Hilarus of Rome was known to Bede for his interest in the Easter table and defense of the Councils of Nicaea, Ephesus, and Chalcedon.[28] The symmetrically arranged tablets, one above and one below each diagram, the alternating shapes of the frames around the lists, and the centered roundels with descending straight or arched lines contribute to each page's orderly appearance.[29]

While some aspects of the three charts were inspired by the diagrams of Grandior, others seem to represent input from Wearmouth-Jarrow. The English scriptorium copied Cassiodorus's lists of biblical books with minor variations.[30] The rubrics in the tablets below the Amiatinus charts correspond closely with, but are not identical to, passages relating to the Scripture diagrams in Book 1 of the *Institutiones*. As Meyvaert has demonstrated, the Wearmouth-Jarrow texts are most likely emended versions of similar passages written near Grandior's charts. One probable change in Amiatinus, to which I will return, was to substitute references to the "lord Christ" (*dominus Christus*) and "divine unity" (*unitas diuina*), in the lower tablets of the Jerome and Augustine diagrams, for references Cassiodorus had made to the Trinity.[31]

Another change involved adapting Cassiodorus's text for the tablet below Amiatinus's third diagram in order to attribute it to Pope Hilarus and Epiphanius. Judging from Amiatinus and the evidence of the *Institutiones*, the passage by Cassiodorus mentioned the Septuagint, Hilary of Poitiers, Epiphanius, possibly the Synods of Nicaea and Chalcedon, a translation of Epiphanius's writings that Cassiodorus had commissioned, and Exodus 15:27. The rubric in the Amiatinus tablet reads: "Thus occur seventy books of the Old and the New Testament as divided by Saint Hilarus, bishop of the city of Rome, and Epiphanius of Cyprus, whom we had translated into Latin, [the books having been] perhaps presaged in the number of palm trees that the Hebrew people found during their stay at Elim" (Ex. 15:27).[32] As Ian Wood has observed, the Northumbrian pandect's organization of biblical books is thus presented as partly a papal invention.[33]

The English monastery likely also modeled the layout and decoration of the Amiatinus charts

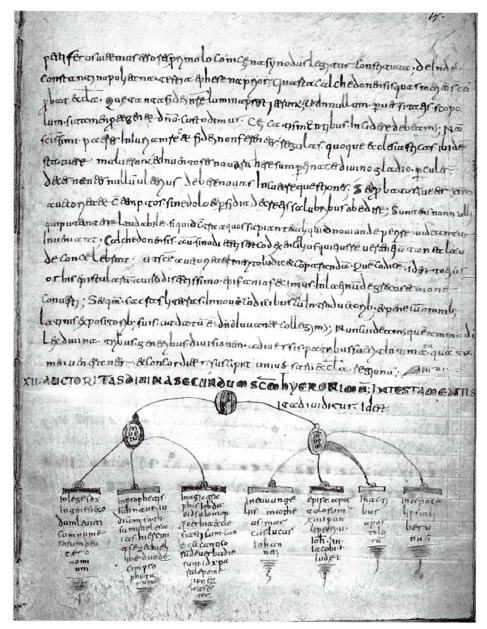

6. Division of scripture according to Jerome. Cassiodorus, *Institutiones*, second half of the eighth century. Bamberg, Staatsbibliothek, Ms. Patr. 61, f. 14r

on those in Grandior, but with significant alterations. I have examined microfilms of five manuscripts of the *Institutiones* that include versions of the diagrams of the liberal arts that Cassiodorus provided the treatise's second book; the manuscripts date from the eighth and ninth centuries.[34] The oldest codex, Bamberg, Ms. Patr. 61 of the second half of the eighth century, contains, along with the liberal arts diagrams, all three of Book 1's charts for Scripture (ff. 14r, 15r, and 15v; Figs. 6–8). An inscription at the end of the treatise (f. 67v) states this is the "the archetype codex to whose model others should be corrected" (*codex archetypus ad cuius exemplaria sunt reliqui*

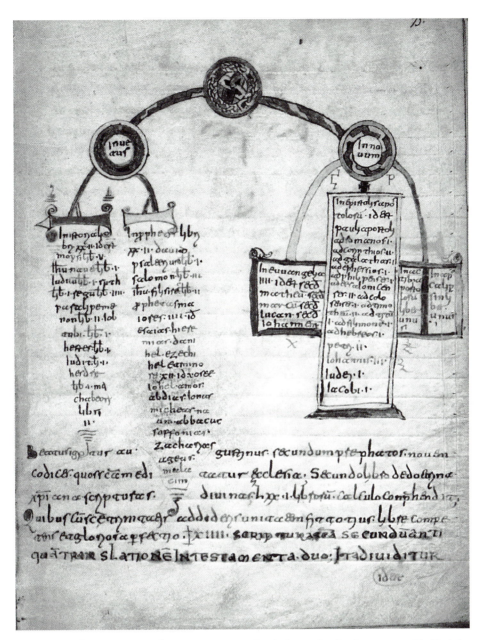

7. Division of scripture according to Augustine. Cassiodorus, *Institutiones*, second half of the eighth century. Bamberg, Staatsbibliothek, Ms. Patr. 61, f. 15r

corrigendi).[35] As in Amiatinus, the charts in the five codices generally have rows of lists hanging from supports that branch off a central fulcrum. None, however, matches the insistently orderly, geometric layout of the Northumbrian diagrams:[36] the spacing between lists is often irregular, rows are not always horizontal, the ornament from which the charts spring is not always centered, the lines connecting a motif to the lists curve in different directions and are sometimes of different lengths.[37] Sometimes lists are unframed, in which case they often taper downward to points, a common format for marginal notes in medieval texts and one Cassiodorus hints he favors.[38] Or

the lists are the only framed writing on the page, and, whereas a concern with pattern is apparent from the frames in Amiatinus, most of those for the diagrams of the *Institutiones* are "shaped" only by the texts they enclose. It is possible that Cassiodorus's original design for his charts was closer to what we see in Amiatinus, though I think this is more likely true of the diagrams in Grandior than those in the *Institutiones*; the Vivarium scriptorium may well have put special care into production of a Bible.[39] Nevertheless, it is important to note that the pronounced effect of visual order and harmony in the English charts is also a feature of every other folio in Amiatinus's first quire, including pages almost certainly not modeled on Grandior.[40] To a large measure, therefore, it should be considered representative of Wearmouth-Jarrow's own objectives in designing the pages, and thus it points to aesthetic concerns similar to those revealed by the geometric frontispiece design of the Utrecht Gospels, a possibly contemporary production of the same scriptorium (Utrecht, University Library, Ms. 32, f. 101v).[41]

Lawrence Nees has noted that the *tabulae ansatae* surmounted by medallions do not accord with a sixth-century Italian aesthetic and were likely, too, devised at Wearmouth-Jarrow.[42] The motifs within the Amiatinus roundels, however, were probably inspired by imagery placed at the fulcra of the Grandior diagrams. The Scripture charts of the Bamberg copy of the *Institutiones* lack similar pictures; there, the Jerome and Augustine lists (ff. 14r, 15r; Figs. 6, 7) descend from small medallions containing abstract ornament, and the Septuagint lists (f. 15v; Fig. 8) spring from an interlace-filled cross.[43] But in every codex of the *Institutiones* I have studied, various objects, animals, and human figures are represented above the liberal arts diagrams of Book 2, and four of the five manuscripts show a male bust, lamb, and bird flying downward, in this order, with the diagrams of Book 2 for rhetoric, the five parts of Porphyry's *Isagoge*, and Aristotle's categories. The only interruption to this sequence is a vase-like object above the chart for *philosophia*, between the charts for rhetoric and the *Isagoge*.[44] The presence of the same grouping of images in four of the earliest copies of the *Institutiones* suggests it was invented at Cassiodorus's Vivarium.

Conceivably, similar imagery decorated the original Scripture diagrams designed at Vivarium for the *Institutiones* but was removed by later copyists of the treatise; the evidence is insufficient to determine whether or not this occurred. The most reasonable explanation for the sequence of images above the biblical charts in Amiatinus, though, is that it was inspired by the Vivarium decoration of Grandior's biblical diagrams; there, too, the fulcra of the three charts must have shown a male bust, lamb, and bird or dove. In preparing its three diagrams, the English scriptorium adapted the art as well as the texts of the charts in the sixth-century pandect. One likely difference between the images in Amiatinus and in Grandior, however, was their order. We cannot be sure that each picture in Grandior accompanied the same diagram as in Amiatinus, but in light of the connection the *Institutiones* draw between the Trinity and the diagrams of Jerome and Augustine, probably echoed in the texts accompanying Grandior's charts, and in light of the theme of the Bible's relation to the Trinity developed in other sections of this treatise, it is reasonable to think that Cassiodorus set the imagery in Grandior in a recognizably Trinitarian order. Whatever the order of the charts themselves, either the bust—a "Father" symbol—came first, followed by the lamb (of the Son) and the dove (of the Holy Spirit); or, possibly, the bust was placed between the lamb and the dove.[45]

Amiatinus's first quire has been reorganized at least three times since 716, and scholars still debate its original arrangement. In a recent article, I argued that the order of leaves intended by Wearmouth-Jarrow was the following, and I presented evidence that this was not the result of haphazard decision making but was carefully planned at the English monastery with aesthetic and

doctrinal considerations in mind.[46] In contrast to Cassiodorus, it is probable the Wearmouth-Jarrow scriptorium placed its motifs in the order of lamb, dove, male bust:

Folio 1/I recto: blank
Folio 1/I verso: dedication poem
Folio 4/V recto: portrait of the prophet Ezra
Folio 4/V verso: blank
Folio 3/IV recto: purple-painted page; prologue
Folio 3/IV verso: purple-painted page; contents of Amiatinus; poem honoring Jerome
Folio 2/II recto: blank
Folio 2/II verso: Tabernacle (left side)
Folio 7/III recto: Tabernacle (right side)
Folio 7/III verso: blank
Folio 5/VI recto: division of Scripture according to Jerome (image of the lamb)
Folio 5/VI verso: blank
Folio 8 recto: division of Scripture according to Augustine (image of the dove)
Folio 8 verso: blank
Folio 6/VII recto: division of Scripture according to Pope Hilarus of Rome and Epiphanius of Cyprus (male bust)
Folio 6/VII verso: cross diagram of the Pentateuch with excerpted text from Jerome

That Wearmouth-Jarrow chose to locate the Hilarus/Epiphanius diagram with its male bust at the end of Amiatinus's series of biblical charts raises the problem of the disruption to the imagery's Trinitarian symbolism. Why did the monks put the Second Person's symbol first, the Third Person's second, and the First Person's last? Since there is little doubt that Amiatinus's first quire was designed from the outset (or nearly) of production to be part of a gift-pandect sent to the pope in Rome,[47] the pictures' theological import must have received serious attention.

The most plausible answer to the question just posed is that the Northumbrian scriptorium was indeed concerned about the doctrinal implications of Amiatinus's three miniatures, but it selected this arrangement to convey different ideas from those it associated with the imagery in Grandior. Although Bede and his fellow monks may have been somewhat unsure about the precise theological significance of the three pictures in the Italian Bible, in particular its male bust, they almost certainly identified the iconography as Trinitarian and the male bust as, in some sense, a symbol of the Godhead's First Person.[48] In Amiatinus, as I will explain further shortly, rather than using the three motifs to signify the Trinity's eternal reality, they sought to shift the focus more directly onto Christ and his unfolding revelation of divinity in the temporal realm. Two reasons for doing this were probably negative: to avoid implying that the Trinity could be portrayed with three separate artistic images, which might conflict with the doctrine of unified shared divinity; and second, to avoid implying a belief that God the Father possessed anthropomorphic features. If the rubrics below the Jerome and Augustine charts in Amiatinus are emended versions of those in Grandior, similar concerns probably underlay the changes made there—the replacement, that is, of references by Cassiodorus to the Trinity with the references on the Amiatinus pages to the "lord Christ" and "divine unity."[49]

Bede's writings suggest additional reasons why he and his brothers at Wearmouth-Jarrow would have wanted to distance Amiatinus's pictures from an overtly Trinitarian interpretation. We need to consider, first, the evidence for their, or especially Bede's, theoretical conception of artis-

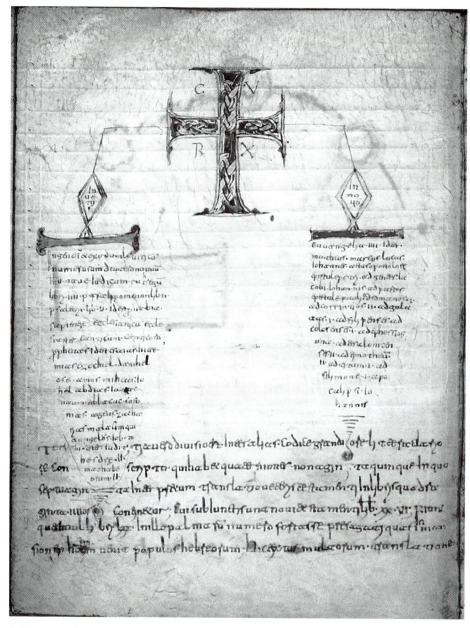

8. Division of scripture according to the Septuagint. Cassiodorus, *Institutiones*, second half of the eighth century. Bamberg, Staatsbibliothek, Ms. Patr. 61, f. 15v

tic images. The frequency of travel between England and Italy in the sixth to eighth century—Anglo-Saxon monks went south and Mediterranean ecclesiastics came to England—enabled English churchmen to gain considerable familiarity with artistic productions south of the Alps and with the region's devotional practices and beliefs concerning images.[50] An openness to Mediterranean attitudes is implied by the accounts of miracle-working pictures in Adomnán of Iona's *De locis sanctis*, a work known by about 703 to Bede.[51] It is also suggested by Bede's report in the *Historia ecclesiastica* of Augustine of Canterbury's arrival in England, with a group that carried a panel painting of Christ and a cross in procession and chanted litanies as it went to meet Ethel-

bert of Kent.[52] There is no record that worship was directed toward the paintings of Christ, saints, and scenes from the Old and New Testaments that Benedict Biscop collected in Rome and placed in Wearmouth-Jarrow's churches; but it is quite possible this occurred, particularly with the images of the Virgin and apostles displayed across the nave of St. Peter's at Wearmouth, *mediam eiusdem aecclesiae testudinem*.[53]

Two of Bede's reports of the paintings at Wearmouth-Jarrow, in his *Historia abbatum* and homily on Benedict Biscop, incorporate brief comments on the nature and function of images. A longer excursus on this theme occurs in his treatise *De Templo*, where he defends pictures by interpreting the second commandment in light of the Temple's decoration. These writings postdate completion of Amiatinus, and the passage in *De Templo* may have been influenced by Gregory I's correspondence with Serenus of Marseilles, which probably became familiar to Bede only after Amiatinus was on its way to Rome.[54] Nevertheless, all three sources probably give a basic idea of his thinking as the three pandects and Amiatinus's first quire were being prepared. The tone of his remarks is consistently positive: artistic representations are valuable insofar as they ornament churches, encourage meditation on the persons and events they depict, and stir emotional responses such as contrition, love, or anxiety about the Last Judgment. Above all, as in Gregory's letters, the emphasis is on the art's ability to induce memory of holy persons and sacred stories or history, and thus to serve, to a limited degree, as a substitute for the written word, especially for the illiterate.

Although, however, Bede probably accepted that miracles sometimes occurred through images, as Adomnán reported, he does not seem to have believed that they possessed the inherent sanctity he attributed to relics.[55] The *Historia abbatum* refers to "pictures of sacred images" (*picturas sanctarum imaginum*), but the sanctity evidently belongs to their subjects, not the works of art themselves.[56] Moreover, Bede's comments on Grandior's depictions of the Tabernacle and the Temple in his treatises *In Regum Librum XXX quaestiones*, *De Tabernaculo*, and *De Templo* imply that images assist viewers to comprehend spiritual truth only to the extent that the pictures conform to the teachings of sacred texts. Where the artwork does not strictly represent biblical or hagiographical truth, it might have a certain historical utility, but only for remembering things of the past without spiritual merit. It cannot assist the Christian to grasp the mysteries of the faith.[57]

A second theme of Bede's thought to consider is divine invisibility. Here we may turn to other of his writings, in particular, other homilies likely postdating Amiatinus's completion, which clarify how he reconciled the Bible's statements that mortal eyes cannot see God, its accounts of prophetic visions of the divine, and the doctrine of the vision of God at the end of time.[58] In general, Bede follows earlier patristic exegesis in accepting the limited character of the visions received in this life, Christ's status as the only Person of the Trinity to possess humanity, and the knowledge of God attained through Christ, who took on human nature for this purpose.[59] Through the Son, mortals may learn about the "unity of the sacred Trinity" and approach the vision of the divine majesty, to which Christ will lead them after the Last Judgment.[60] As the audience of one homily is reminded, it is necessary to embrace the truth about Christ's equality with the Father in order to be rewarded later with the one vision of both, "concerning which Philip requested, 'Lord, shew us the Father, and it is enough for us', and the Lord himself answered saying, 'He that seeth me seeth the Father also'" (John 14:8–9).[61] Because of the incorporeal nature of divinity and the imperfection of physical sight, no mortal in this life can truly behold the face of God; as God said to Moses, "Man shall not see me and live" (Ex. 33:20). Bede draws an emphatic contrast between the circumscribed "images" (*imagines*) mediated to the patriarchs, prophets, and saints

through fire, angels, clouds, and *electrum* or amber, which fragile flesh can comprehend, and the eternal, incircumscribable light of divinity.[62] Even the transfiguration showed the disciples only Christ's glorified humanity and is differentiated from the eternal contemplation of God, "face to face" (*facie ad faciem*; Gen. 32:30), reserved to heaven.[63]

The disparity between the visions that the prophets and saints enjoyed on earth, and the reward the blessed will receive at the end of time was doubtless on Bede's mind as he wrote his first exegetical treatise, a commentary on the Apocalypse that its recent editor has characterized as exceptionally faithful to Tyconius.[64] The abbreviated style of this work makes its doctrine more difficult to decipher than that of the homilies, but since it was written between 703 and 709, while Amiatinus's first quire was perhaps being planned or prepared, simply the choice of biblical book for exegesis seems significant for analyzing the pandect's roundel motifs. For Bede, John's visions, like those of other prophets, were mediated through words and figures accessible to human understanding and are open to different levels of exposition.[65] While he acknowledges the Book of Revelation's literal significance as a foreshadowing of the eschaton, he also develops its allegorical interpretation, following Primasius, as an account of the church moving through history and already triumphing in Christ's name.[66]

Bede perceived religious imagery that conformed to biblical and hagiographical truth as useful to Christian devotion and teaching; but the foregoing considerations suggest that he and his brothers may well have found the Trinitarian iconography of Grandior's biblical charts a source of puzzlement and concern. As Bede knew so well, Scripture announces that the divinity of the Trinity is unified and imperceptible to mortal eyes, and that although God has manifested himself to earth in different forms, his humanity belongs to Christ. Yet, as opposed to the Bible's clear doctrine, Grandior seemed to divide the Trinity's three Persons by depicting their symbols on separate pages with separate diagrams of Scripture, as though each Person taught something different. Furthermore, the pandect used a material image to signify, it appeared, the incorporeal divine nature of God the Father, as if the Trinity's First Person had a human form distinguished from that of the Son, symbolized by the lamb.[67]

As the Wearmouth-Jarrow scriptorium worked on Amiatinus, worries about the theological message of Grandior's biblical diagrams were probably fueled by news of the doctrinal strife threatening Rome at the time. During the second half of the seventh and the early eighth century, the regular flow of travelers between Italy and Wearmouth-Jarrow kept the monastery acquainted not only with Mediterranean art and devotional practices, but also with the tensions between Rome and Byzantium caused by the doctrines of Monophysitism, Monenergism, and Monotheletism. The latter two Christologies developed in the East as Byzantine ecclesiastics searched for a compromise between the Fourth Ecumenical Council of Chalcedon (451) and the Monophysites who rejected its decrees. Whereas Chalcedon had affirmed that Christ had two distinct, complete natures of divinity and humanity united in one Person, Monophysites put forth that the Incarnation united divine and human into a single divine nature.[68] Pope Honorius I (625–638) accepted the Monothelete solution to the quarrel, which upheld the doctrine of two natures yet claimed that Christ possessed only a single divine will; but aided by Maximus Confessor's strenuous defense of Chalcedon in North Africa, subsequent popes, beginning with John IV (640–642), led a Western resistance to Monotheletism that culminated in the condemnation of the doctrine at the Lateran Synod of 649, convened under Pope Martin I. Benedict Biscop must have directly witnessed some of the synod's chaotic aftermath on his first visit to Rome, in 653; shortly before or after his

arrival, Byzantine authorities arrested Martin for the Lateran defense of Chalcedonian orthodoxy. The new pope, Eugenius, was not elected until August 654, so Benedict's first experience of the city—no matter how brief his stay, the length of which is unknown—was of disruption to its ecclesiastical life.[69]

On one of Benedict's later visits to Rome, about 677, this time with Ceolfrid, Pope Agatho sent the archcantor John back to England with the two monks. John's responsibilities were to teach liturgical reading and Roman chant at Wearmouth, assist in the organization of the calendrical liturgy, and, because of a renewed attempt at reconciliation between the papacy and Constantinople, ascertain England's support for Rome. It is uncertain how well Northumbrian ecclesiastics understood the quarrels in the Mediterranean, but they clearly identified their loyalty to Rome with support of its theology and therefore Chalcedon. John brought a copy of the decrees of 649 with him, and the Wearmouth scriptorium prepared a copy for its archives. In 679, Archbishop Theodore of Canterbury convened a synod at Hatfield in Northumbria that composed a letter to Rome confirming the five ecumenical councils and the Lateran synod.[70] Similar councils were held in other Western churches and in Rome at Easter in 680; the latter meeting was attended by the Northumbrian bishop Wilfrid, who was in the apostolic city to gain papal support for his claim to the see of York, from which he had been dismissed in 678.[71] Monotheletism was condemned for both the East and the West at the Sixth Ecumenical Council in Constantinople, 680–681. Under Pope Leo II, elected in August 682, the decrees from Constantinople were translated into Latin and sent to other Western churches, among them, no doubt, those in England.[72]

Further contacts between Wearmouth-Jarrow and Rome occurred in the mid-680s, when Benedict was in the city on his final visit, and under Pope Sergius I (687–701). Ceolfrid's eventual successor, Hwaetbert, studied in Rome during Sergius's pontificate, and he perhaps brought back to Wearmouth-Jarrow the new papal charter mentioned in the *Historia abbatum* and the anonymous life of Ceolfrid.[73] Wilfrid was again in Rome about 703, to ask for another papal confirmation of his rights to the episcopacy and to his monasteries.[74] Either of these churchmen, or other English visitors, could have returned with the news that Sergius had rejected the decrees of the Quinisext Council *in Trullo*, held under Emperor Justinian II in 691–692 to confirm and extend the decisions of the Fifth and Sixth Ecumenical Synods.

Rome apparently disapproved of the Quinisext legislation both because it was thought to challenge papal authority in the West and because some devotional practices it imposed conflicted with Latin traditions.[75] One of the decrees Sergius probably disliked was canon 82, which ordered images of Christ to be substituted for those of his prefiguration in the lamb. It has been argued that Sergius's opposition to this decree lay behind his promotion of the singing of the *Agnus Dei* in the mass, and that for the same reason he commissioned the imagery of the lamb on the triumphal arch of SS. Cosma and Damiano and on the facade of Old St. Peter's.[76] Papal opinion on specific canons of Quinisext may have been unknown in Northumbria, yet to the degree that Wearmouth-Jarrow was informed about the council, the monastery likely identified the quarrel that this meeting, too, engendered with the Christological and Trinitarian issues previously addressed in Rome in 649 and 680, Hatfield in 679, and Constantinople in 681. Although the Byzantine court and Pope Constantine I evidently settled their disagreement about Justinian's council in 710–711, the peace was again broken under Emperor Philippikos (711–713), who tried to revive Monotheletism. Philippikos's successor, Anastasios II (713–715), reversed this imperial policy, but worries about Byzantine heterodoxy continued in the West. Even in the last years before Amiati-

nus's departure in 716, then, travelers from Italy to Northumbria might have brought reports of theological strife in the Mediterranean.[77]

Whenever the first quire of Amiatinus was made under Ceolfrid, these circumstances offer additional reasons to suspect that Wearmouth-Jarrow would have avoided emulating imagery that hinted of unorthodoxy, above all in regard to the Trinity. If we turn now, though, to doctrines that the scriptorium might have wanted the three pictures of its own Scripture diagrams to communicate—arranged in the order of lamb, dove, male bust—then we should recognize that the lines of thought this order most directly evokes are chronological and mystical. The imagery remains in a sense Trinitarian, but it less immediately recalls the eternal truth of the First, Second, and Third Persons than the temporal movement of divine revelation from the Old Testament, through the present time of the spirit in the church, to the eschaton: the stages of past, present, and future set forth in the Bible. In mystical terms, these stages parallel the ascent in knowledge of God from material symbols, epitomized by the lamb, to the faith in the unseen Christ brought with the grace of the Holy Spirit, to the fullness of the vision of God, through the heavenly Christ, awaiting the blessed.[78]

By setting the bust last in the series rather than first or second, Wearmouth-Jarrow tied it to the prophetic visions of the apocalypse, parousia, or eschaton, words I use interchangeably to refer to the apparitions connected with the prophecies of the end of time.[79] It is likely that the scriptorium thought the gold coloring supportive of an eschatological reading of the imagery. Nees has stressed the unusual nature of the gold foil technique used for Amiatinus's three miniatures, especially the male bust. Although all three motifs are similarly executed, the gold paint of the bust's entire figure, including the face, is particularly striking.[80] Whether or not the technique was copied from Grandior, there is little doubt that the English monks would have associated this coloring with the radiance of the theophanies described in the Old and New Testaments: Ezechiel's enthroned one shining like amber (electrum; Ez. 1:27); the "stream of fire" from the ancient of days in Daniel's vision (Dan. 7:10); the one like "a refining fire" in Malachias 3:2; the eyes "as a flame of fire," the Lord's face shining like the sun, the appearance "like the jasper and the sardine stone" in John's Apocalypse (Apoc. 1:14, 16; 4:3), discussed in Bede's commentary of 703–709;[81] the brilliance of the Son of man overcoming the sun and moon, according to Matthew 24:27–29; the Son of man's return like lightning according to Luke, to which Bede, about 717, devoted a commentary.[82]

In terms of artistic influences besides Grandior, those monks who had gone to Rome most likely remembered the mosaics of episodes from the Old Testament on the walls of Sta. Maria Maggiore, in which the Lord God appears as a Christ-like, half-length figure alone in the heavens.[83] More importantly, they would have recalled the full-length images of the glorified Son of God in the apses of other Italian churches, such as the sixth-century mosaic in SS. Cosma e Damiano, Rome, where he floats in the sky dressed in gold.[84] Probably a stronger influence on their thinking was Mediterranean imagery of the Pantocrator: the frontal bust or half-length portrait of Christ, bearded, robed, usually with shoulder-length hair, sometimes framed by a clipeus.[85] Early Mediterranean church mosaics and some other works of art combine images of the full- or half-length Son of God with depictions of the lamb, again at times in roundels.[86] Examples of these varied iconographies were probably seen among the panel paintings that Benedict Biscop hung in his churches, such as those with scenes from John's Apocalypse, or among the monastery's other rich holdings of manuscripts and artifacts from Italy.[87] It is important to remember that, besides

Grandior, Amiatinus's designers were familiar with many Mediterranean productions from which they could have sought inspiration in developing the art of their own Bible.

Since the Amiatinus bust lacks a cruciform halo or other attribute specific to Christ, a modern viewer might regard its identity as more ambiguous than that of the Majestas prefacing the volume's New Testament, where the nimbus is marked by a faint cross (f. 796v; Fig. 5). Yet in Late Antiquity and the early Middle Ages, the cruciform halo distinguishing Christ from other holy figures was not an invariable iconography,[88] and in some Mediterranean Pantocrator imagery, as in all three miniatures of the Amiatinus biblical charts, there is no halo except the medallion frame.[89] Simply the location of the Amiatinus bust at the end of the sequence was probably thought sufficient to identify it with the eschaton and Christ's return; for, as already remarked, Bede, like earlier commentators, well understood that the visions of divinity in human form recorded in the Bible, such as John's Apocalypse, were dependent on the Son's humanity that would again be visible at the parousia.[90] Placed last in the series and painted in gold, the image was a reminder of the longed-for revelation through the reappearance of Christ, the Son of man.

If this interpretation of Amiatinus's lamb, dove, and male bust is correct, then other intellectual considerations reflected in Bede's writings can be discerned that Wearmouth-Jarrow might have utilized in explaining its arrangement of the images. One is Scripture's multivalence. Bede's short treatise of uncertain date, *De schematibus et tropis*, offers a variant on the traditional levels of biblical interpretation: the Bible, he asserts, expresses truth both through its literal text and allegorically on three levels that correspond to the different moments of sacred time. Typologically, it can present the Christian reader with figures of past events in the life of Christ and the history of his church; tropologically, it can refer to the present state of the Christian soul; and anagogically, to higher, heavenly things. The example offered in *De schematibus et tropis* of a single scriptural passage that performs all three functions is 3 Kings 6, the description of Solomon's Temple, which allegorically denotes Christ's body and his church, tropologically the souls of the faithful, and anagogically the joys of heaven.[91] In other writings, Bede identifies and makes use of three levels of exegesis, the historical together with the allegorical and moral or the allegorical and anagogic.[92] At Wearmouth-Jarrow, the pictures of the lamb, dove, and male bust may have been thought to conform with any of these interpretations of the exegetical process and for this reason, too, to constitute fitting art for a set of Scripture diagrams. Signifying the chronology of sacred history and the stages in the inner ascent from the material world to the eschatological vision, and placed at the springs of charts listing the books of the Old and New Testaments, the motifs point to the different levels of meaning accessible to the exegete in the texts listed on the same pages.

A second but related focus of Bede's scholarly activity was the calculation of time, the discipline of *computus*. His major treatise on this subject, *De temporum ratione*, written about 725, is an expanded version of *De temporibus*, written in 703.[93] The conclusion of *De temporum ratione* responds to a charge of heresy against the earlier tract, an accusation made at the monastery of Hexham under the bishop and abbot Wilfrid, to which Bede previously reacted in a letter of 708 to Hexham's monk, Plegwine.[94] Together with Bede's commentary on the Apocalypse, also written near the beginning of the eighth century, the letter to Plegwine is revealing of how, in the years when the three Bibles and the first quire were likely under production, Bede's inquiries into chronology and the nature of the eschaton intersected. Against the claim at Hexham that he had "denied that the Lord Savior came in the flesh in the world's sixth age," the letter comments on the connection between the beginning of that age and Jesus' nativity, but toward its conclusion,

and at greater length in *De temporum ratione*, the main subjects become Christ's return, the world's end, and the impossibility of knowing when this will take place.[95] In its analysis of the issue of the eschaton's timing, the letter twice refers to Luke, perhaps an indication of Bede's developing interest in the exegesis of this gospel. The first reference, a paraphrase of Luke 12:35–36, occurs within a warning of the need always to be vigilant, since it is unknown when Christ will reappear. The second is a quotation of Luke 17:24, which describes the return's suddenness "like lightning" (*sicut fulgur coruscans*).[96]

While Bede's thought alone offers a sound platform for interpretation of the Amiatinus motifs, our grasp of the complex network of ideas that could have shaped Wearmouth-Jarrow's perception of these images can be broadened if we turn now to the Easter conflict and, once more, to the monastery's familiarity with developments in the Mediterranean. This is not to say that anyone in the monastery necessarily viewed the three pictures as direct references to precisely defined doctrine on these matters; yet the mental associations the imagery might have stirred or been expected to stir at Wearmouth-Jarrow and in Rome need to be recognized. One such association was possibly with orthodox dogma of Christ. In setting the miniatures in the order of lamb, dove, male bust, the Northumbrian scriptorium was perhaps not only mindful of the mystical ascent and the course of Christian history; it may also have recalled the Chalcedonian definition of faith that had been the cause of such conflict within the previous century.[97] To present the lamb and bust as two symbols of the same Person of the Trinity, with between them the symbol of the unifying power of the Holy Spirit, was perhaps believed to be a way of visually confirming the Son's union of two natures in one Person. The Incarnation foreshadowed in the lamb is joined to the final revelation of divinity made possible by his humanity. If, as is likely, Amiatinus's first quire was produced after Wearmouth-Jarrow had learned of the Quinisext Council of 691–692 and the papal reaction to it, and if the monastery knew of the papacy's opposition to canon 82 (less probable though conceivable), it may have also associated the sequence of motifs with its belief, like Rome's, in the validity of the lamb as a symbol of Christ and the legitimacy of images of both it and the incarnate son.

A geographically more immediate influence on the monastery's view of these images was probably the combined effect of the controversy over the proper method of dating Easter, and other arenas of tension that directly impinged on Wearmouth-Jarrow in the late seventh and early eighth centuries: disagreements revolving around the jurisdiction of the see of York, Wilfrid's claims to the episcopacy, and control of the bishopric of Hexham, to which Wearmouth-Jarrow belonged after the see's formation in 678;[98] criticisms of the monastery's rule and its application;[99] challenges to its autonomy from Benedict's kin and probably other outside powers;[100] and possibly disputes within its two houses, which may have increased in the period just before Amiatinus's departure.[101] The monastery's emphasis on loyalty to the Church of Rome and its efforts to strengthen those ties, for instance, through the papal charters acquired by Benedict and Ceolfrid, ought to be seen against the backdrop of these difficulties. Although the Synod of Whitby in 664 decided in favor of the Dionysiac (Rome's) system of timing the Easter feast, the Celtic method continued to attract adherents into the second decade of the eighth century.[102] By the late seventh century Wearmouth-Jarrow evidently had good relations with Iona, a monastic stronghold of the Celtic Easter, but in this controversy, too, Ceolfrid's abbey supported Rome.[103] A lengthy analysis of the Roman system occurs in a letter sent about 710 from Wearmouth-Jarrow to the Pictish king Nechtan, who had appealed to Ceolfrid for assistance in converting the Picts to Roman practices. The letter is recorded in the *Ecclesiastical History* as sent in Ceolfrid's name, but Bede was probably mainly responsible for the version found there and likely helped with the original com-

position.[104] In order to explain how Easter's date is determined, the letter provides a detailed examination of the laws governing the timing of Passover, beginning with the sacrifice of the lambs, Easter's relation to Passover, and the Christian feast's commemoration of the crucified and resurrected Christ as the new lamb who liberates God's chosen from eternal death.[105]

For Wearmouth-Jarrow, the dating system outlined to Nechtan was a fundamental measure of allegiance to Rome. The Northumbrian scriptorium may not have planned the miniatures of the Amiatinus schemata as an allusion to its position in the Easter controversy, but it is unlikely to have overlooked the thematic parallel between the three images and the doctrinal principles on which it knew Roman practice to be based, or the appropriateness of recalling these in a Bible sent to the pope in 716. As Barbara Beall has remarked, this was the year Iona converted to the Dionysiac system, a victory that conceivably led Wearmouth-Jarrow to decide the time was right to send the pandect, a work magnificently celebrating the monastery's special relationship with the holy see.[106] Indeed, the possibility of connecting the roundel motifs with the final stage in the Easter conflict, evidenced by the letter to Nechtan, with other aspects of Bede's thought in the first decade of the eighth century, and perhaps with the tensions surrounding the Quinisext decrees, lends support to the hypothesis that Amiatinus, or more specifically its first quire, was completed only shortly before the Bible left the abbey.[107]

That Wearmouth-Jarrow wanted to remind Amiatinus's papal recipient of the monastery's orthodoxy and attachment to Rome is also implied by two other characteristics of the three diagram pages: the numerical relationship between the charts and their purported inventors, and the final diagram's decoration and texts. While Cassiodorus attributed Grandior's three charts to three sources—Jerome, the Septuagint, and Augustine—those in Amiatinus are assigned to four: Jerome, Augustine, Hilarus, and Epiphanius. Four theologians are presented as the spokespersons of a narrative of divine revelation occurring in three stages, designated by the images of lamb, dove, and eschatological vision. Even though three theologians' names were probably found written on the diagram pages of Grandior, this was unlikely to have been the sole reason for their inclusion in Amiatinus. Both the numerology of three and four and the authors' identities should be recognized as significant: Jerome, the church father Wearmouth-Jarrow most closely connected with the Latin Bible; Augustine, the preeminent exponent of Christian dogma in the West; Epiphanius of Cyprus and Hilarus of Rome, a Greek together with a papal champion of Christological and Trinitarian orthodoxy.[108] Very possibly, it was hoped that the conjunction of the last two names with the same Scripture diagram, with priority assigned to Hilarus (his name comes first) and a notice that Epiphanius had been translated into Latin, would remind viewers that the East had once been in doctrinal harmony with Rome. But more notably, Wearmouth-Jarrow's reverence for the apostolic see is communicated by the page's decoration. The only pope named in the first quire except St. Peter, in the dedication poem,[109] is identified with the most beautifully ornamented diagram, the only one with lists framed in gold crosses and an anthropomorphic representation of divinity: Christ's humanity mediating knowledge of God to mortals, since he is both God and man, the essence of the orthodox faith that Hilarus and the papacy in Ceolfrid's own day defended.

Although the foregoing analysis helps clarify the intellectual stance from which Wearmouth-Jarrow designed Amiatinus's Scripture diagrams, it is clearly improbable that such wide-ranging concerns would have influenced only three pages of this manuscript. The monastery's desire to express its admiration for Rome has frequently been cited to explain Amiatinus's carefully prepared edition of Jerome's Vulgate, its imitation of sixth-century Italian uncial, and the classicizing features of

its art;[110] but the biblical diagrams offer a conceptual key to other ways in which this admiration was expressed, and to other intellectual factors at work as the scriptorium prepared the pandect and its sister volumes. Amiatinus conveyed Wearmouth-Jarrow's fidelity to the holy see by linking that loyalty decisively to the monks' knowledge of Scripture and the orthodox faith, and to their conviction that the Bible was the absolute foundation of orthodoxy. At the core of the knowledge gained from Scripture, Amiatinus demonstrated, was the doctrine of the unity of God, his recorded word, and the Church of Rome to which Wearmouth-Jarrow belonged.

Since I have elsewhere discussed in detail some artistic elements of Amiatinus that reveal these lines of thought,[111] I will conclude simply by pointing out briefly how they are reflected in a few characteristics besides the biblical diagrams. One striking aspect of this manuscript is the remarkable number of ways it announces the English scriptorium's belief in biblical, ecclesiastical, and doctrinal unity.[112] As should already be evident, the oneness of Scripture and God is a clear message of the three biblical diagrams, where lists of every book in the Bible descend from symbols of the divinity revealed through Christ, and the regularity of geometric forms underscores the harmony of the charts' contents.[113] More basically, the doctrine of Scripture's unity is proclaimed in the fact that Amiatinus and the other two Bibles were pandects, the entirety of Scripture written in a single volume, a type of book rare in the early medieval West.[114] Notice should be taken, too, of how most of the pages of the first quire, in addition to the biblical charts, evoke this idea: the Ezra miniature, in which the prophet sits before an armarium that contains multiple volumes, copying Scripture into a single book;[115] the prologue's announcement of the harmony among the different schemes for organizing Scripture attributed to Jerome, Augustine, and the Septuagint; the verso of the same page listing all the books in the Amiatinus pandect;[116] the Tabernacle miniature, with its allusions to the Tabernacle's prefiguration of the Temple, the church, and the heavenly sanctuary, and thus to the union of the Old with the New Testament;[117] and the Pentateuch diagram at the end of the first quire, where inscriptions describing the first five books of the Old Testament are joined together within a single cross-frame (f. 6/VIIv).[118] Preceding Amiatinus's New Testament, the canon tables (ff. 798r–801r) draw attention to the harmony of the Four Gospels, and in the Majestas illumination (f. 796v; Fig. 5), the Four Evangelists together present their books to the one enthroned Christ.

Other features of Amiatinus and its sister pandects more directly advertise the unity of the Church of Rome and Wearmouth-Jarrow with the holy see. Amiatinus's dedication poem directs the book on Ceolfrid's behalf to the "body of St. Peter."[119] The Tabernacle miniature, as already noted, depicts the edifice as a type of the church. The Ezra miniature, as I have more fully argued in my recent article, offered Gregory II, the pope who received Amiatinus, a mirror of papal virtue centered on biblical scholarship.[120] The production of three pandects, one for St. Peter's in Rome, the other two for Wearmouth-Jarrow's churches of St. Peter and St. Paul, I think, was partly undertaken to symbolize the union of the two Northumbrian houses with one another and both with the apostolic city, and to identify that unity with the Trinity.

Finally, Ceolfrid's timing of his departure with Amiatinus on the Thursday before Pentecost is likely significant.[121] By choosing this day (a day associated with penitence), he opened the way for Hwaetbert to be elected on the Sunday of Pentecost, the feast celebrating Christ's sending of the Holy Spirit to his apostles and the establishment of his church.[122] For the monks, both the ceremony that marked Ceolfrid's leave-taking and that of his successor's election must have further reinforced their belief in the Christian unity of the two houses over which Hwaetbert would now be sole abbot, and, again, the spiritual ties of both to Rome.[123] Like the Scripture diagrams of Ami-

atinus's first quire, these features of the same Bible, its sister pandects, and the circumstances under which Amiatinus was sent to the holy see were carefully conceived to attest Wearmouth-Jarrow's full membership in the one Church of Rome, by virtue of its adherence to Scripture and Christian orthodoxy.

Acknowledgments

My thanks to Anne-Marie Bouché and Jeffrey Hamburger for the opportunity to present my ideas about the biblical diagrams of the Codex Amiatinus at the conference *The Mind's Eye*. I am grateful to the Delaware Valley Medieval Association and the 20th International Conference of the Charles Homer Haskins Society, especially Paul Hyams, for opportunities to speak on this subject, and to Mildred Budny, Herbert L. Kessler, and Lawrence Nees for their comments and advice on earlier drafts of this article. The article was written during a membership at the School of Historical Studies, Institute for Advanced Study, Princeton, in the spring semester of 2002. I also wish to thank Giles Constable for providing me with an ideal setting for research and writing, and to The College of New Jersey for its continuing support of my research through its SOSA fund.

Notes

1. J. Williams, "Introduction," in *Imaging the Early Medieval Bible*, ed. J. Williams (University Park, Pa., 1999), 1–8, at 5.

2. Williams, "Introduction" (as in note 1), 5.

3. A complete reproduction of the Codex Amiatinus with scholarly apparatus is now available on CD-ROM: *La Bibbia Amiatina/The Codex Amiatinus, Complete Reproduction on CD-ROM of the Manuscript Firenze, Biblioteca Medicea Laurenziana, Amiatino 1* (Florence, 2000). On the dating, see R. Marsden, *The Text of the Old Testament in Anglo-Saxon England*, Cambridge Studies in Anglo-Saxon England 15 (Cambridge, 1995), 98–106, esp. 102, 106; D. Wright, "Some Notes on English Uncial," *Traditio* 17 (1961), 441–56 with plates at 442. A list of most of the bibliography on Amiatinus of the 1990s is found in *Bibliografia della Bibbia Amiata (1990–1999)*, ed. V. Longo et al. (Rome, 2000). Omissions include Marsden's book; P. Meyvaert, "Bede, Cassiodorus, and the Codex Amiatinus," *Speculum* 71 (1996), 827–83; B. A. Beall, "The Illuminated Pages of the Codex Amiatinus: Issues of Form, Function, and Production" (Ph.D. diss., Brown University, 1997); L. Nees, "Problems of Form and Function in Early Medieval Illustrated Bibles from Northwest Europe," in *Imaging the Early Medieval Bible* (as in note 1), 121–77, at 148–74.

4. London, B.L., Add. Ms. 37777 (one folio, "Greenwell leaf"), Add. Ms. 45025 (ten folios and fragments of eleventh, "Middletown leaves"), Loan Ms. 81 (one folio, "Bankes leaf"). See Beall, "Illuminated Pages" (as in note 3), 32–34, 225–27; Marsden, *Text* (as in note 3), 90–98; M. B. Parkes, "The Scriptorium of Wearmouth-Jarrow," Jarrow Lecture 1982, reprinted in *Bede and His World: The Jarrow Lectures*, 2 vols., preface by M. Lapidge (Aldershot, 1994), vol. 2, 555–86, at 557.

5. Vita Ceolfridi 20–21, 34–40, in *Venerabilis Baedae Historiam Ecclesiasticam Gentis Anglorum, Historiam Abbatum, Epistolam ad Ecgberctum, una cum Historia Abbatum Auctore Anonymo*, 2 vols., ed. C. Plummer (Oxford, 1896), vol. 1, 388–404, at 394–95, 401–4 (henceforth cited as *VC*, ed. Plummer); cf. Bede, *Historia abbatum* 15–16, 21–23, in *Venerabilis Baedae*, vol. 1, 364–404, at 379–81, 385–87 (henceforth cited as *HA*, ed. Plummer). I discuss the evidence that the codex reached its Roman destination in "Ceolfrid's Gift to St. Peter: The First Quire of the Codex Amiatinus and the Evidence of Its Roman Destination," *Early Medieval Europe* 12 (2003), 129–57, esp. 130–31. An additional, circumstantial piece of evidence supporting this hypothesis is the later recorded belief at Monte Amiata, which came to own the pandect, that Pope Gregory I had himself written the codex. This papal association, and moreover association with a pope Gregory, may well reflect a distorted memory that the book had come from Rome, where it had first been received by Pope Gregory II. The connection drawn at Monte Amiata between the Codex Amiatinus and Pope Gregory I is noted by Gorman (M. Gorman, "The Codex Amiatinus: A Guide to the Legends and Bibliography," *StMed* 44 [2003], 863–910, at 864).

For further discussion and evidence that Amiatinus reached Rome from Wearmouth-Jarrow, see Paul Meyvaert, "The Date of Bede's *In Ezram* and His Image of Ezra in Codex Amiatinus," *Speculum* 80 (2005), in press. I am very grateful to Dr. Meyvaert for providing me with a copy prior to publication. The article was completed too late for me to address its theories fully here. I should note, however, that I am not persuaded by the order of leaves that Meyvaert proposes for Amiatinus's first quire or by his assertion that the roundel motifs of the three biblical diagrams were invented at Wearmouth-Jarrow rather than derived from similar imagery in Grandior. I stand by the arguments presented in this essay and in my other work on the codex, and I return to these issues in the book I am currently writing on Amiatinus.

6. Gorman, "The Codex Amiatinus" (as in note 5),

863–64, 874–75; S. Magrini (with preface by F. Arduini), "'Per difetto del legature . . . ': Storia della relegature della Bibbia Amiatina in Laurenziana," *Quinio: International Journal on the History and Conservation of the Book* 3 (2001), 137–67, at 148–50. The date of the pandect's arrival at San Salvatore is unknown. The monastery's existence is documented from 762. The codex was still in Rome when Alcuin visited the last time in 781; see Meyvaert, "The Date of Bede's *In Ezram*" (as in note 5), at n. 128. At San Salvatore Amiatinus's dedication verses were altered to attribute the book to "Peter of the Lombards"; Peter was abbot ca. 900. When this emendation happened is unclear. The original poem, which directed the book to the "deservedly venerable body of the outstanding Peter" (*corpus ad eximii merito uenerabile Petri*), the altered version from Monte Amiata, and the other texts of Amiatinus's first quire are transcribed in *Biblia Sacra iuxta Latinam Vulgatam Versionem*, vol. 1, ed. H. Quentin (Rome, 1926), xxi–xxv, xxii–xxiii for the dedication verses. At the Laurenziana the manuscript was first studied by A. M. Bandini; see his *Bibliotheca Leopoldina Laurentiana seu Catalogus Manuscriptorum Qui Iussu Petri Leopoldi*, vol. 1 (Florence, 1791), 701–32.

7. *HA* 15, ed. Plummer, 379: "ita ut tres pandectes nouae translationis, ad unum uetustae translationis quem de Roma adtulerat, ipse super adiungeret."

8. In this article I indicate the pages in the first quire according to their eighteenth-century Arabic and nineteenth-century Roman numerations, which represent two different arrangements of the gathering. The quire has recently been rebound; the new arrangement, too, probably does not represent the original order: see Magrini, "Per difetto della legature" (as in note 6), 140–67; Chazelle, "Ceolfrid's Gift to St. Peter" (as in note 5), 133–35; and note 46 below.

9. P. Corssen, "Die Bibeln des Cassiodorus und der Codex Amiatinus," *Jahrbücher für protestantische Theologie* 9 (1883), 619–33, at 619–28; Marsden, *Text* (as in note 3), 116–17; *Cassiodori senatoris institutiones* 1.14.3, ed. R. A. B. Mynors (Oxford, 1937, repr. 1961), 40, lines 15–16 (henceforth cited as *Institutiones*, ed. Mynors).

10. F. J. A. Hort, letter to *The Academy*, no. 773 (26 February 1887), 148–49. On Grandior's text, see Marsden, *Text* (as in note 3), 117, 131, cf. 6–7; J. H. Halporn, "Pandectes, Pandecta, and the Cassiodorian Commentary on the Psalms," *RBén* 90 (1980), 290–300, at 297–98.

11. K. Corsano, "The First Quire of the Codex Amiatinus and the *Institutiones* of Cassiodorus," *Scriptorium* 41 (1987), 3–34, at 22–30.

12. Meyvaert, "Bede, Cassiodorus" (as in note 3), 827–31; Gorman, "The Codex Amiatinus" (as in note 5), 866–67, 869–72.

13. Meyvaert, "Bede, Cassiodorus" (as in note 3), 866–68.

14. The comments of Bede and Cassiodorus make it evident that Grandior had pictures of both the Tabernacle and the Temple; for analysis of their language, see Halporn, "Pandectes" (as in note 10), 299; Meyvaert, "Bede, Cassiodorus" (as in note 3), 833–34, 846 n. 91, discussing Cassiodorus, *Expositio psalmorum* 14 (ed. M. Adriaen, CCSL 97 [Turnhout, 1958], 133 lines 43–45); Cassiodorus, *Expositio psalmorum* 86 (ed. M. Adriaen, CCSL 98 [Turnhout, 1958], 189–90 lines 40–44); Cassiodorus, *Institu-*

tiones, 1.5.2, ed. Mynors, p. 23; Bede, *In Regum librum XXX quaestiones* (ed. D. Hurst, CCSL 119 [Turnhout, 1955], 312 lines 52–59); Bede, *De Tabernaculo* 2 (ed. D. Hurst, CCSL 119A [Turnhout, 1969], 81–82 lines 1563–70); Bede, *De Templo* 2 (CCSL 119A, 192–93 lines 28–30, 48–52). I discuss the Amiatinus image of the Tabernacle and its relation to Grandior's picture in a forthcoming article, "A Sense of Place: Wearmouth-Jarrow, Rome, and the Tabernacle Miniature of the Codex Amiatinus," in *The Transmission of the Bible in Word, Image and Song*, ed. M. Budny and P. G. Remley (volume in preparation).

15. Cf. Marsden, *Text* (as in note 3), 117–23.

16. Marsden, *Text* (as in note 3), 114–15, 131–32.

17. Marsden, *Text* (as in note 3), 111–13; Parkes, *Scriptorium of Wearmouth-Jarrow* (as in note 4), 3. See D. H. Wright, "Review of Lowe, *English Uncial*," *Speculum* 36 (1961), 493–96; E. A. Lowe, *English Uncial* (Oxford, 1960), 1, 8–9. The significance of this imitation of sixth-century Italian forms is discussed in I. Wood, *The Most Holy Abbot Ceolfrid*, Jarrow Lecture 1995 (Newcastle upon Tyne, 1995), 13–14.

18. *Institutiones*, 1.14, ed. Mynors, pp. 39–41.

19. The dominance of this scholarly view and the difficulties it poses are nicely outlined in Nees, "Problems of Form and Function" (as in note 3), 148–56; also see Beall, "Illuminated Pages" (as in note 3), 4–9.

20. See notes 9 and 14 above.

21. Letter to *The Academy*, no. 782 (April 1887), 309–10.

22. R. L. S. Bruce-Mitford, *The Art of the Codex Amiatinus*, Jarrow Lecture 1967, reprinted in *Bede and His World* (as in note 4), vol. 1, 185–234; Wright, "Some Notes" (as in note 3), 442–53, at 443. For an overview of the debate and its aftermath, see Beall, "Illuminated Pages" (as in note 3), 46–52. A recent exploration of the art of the Codex Amiatinus that sees it as simultaneously a window on Vivarium and Wearmouth-Jarrow is presented by J. O'Reilly, "The Library of Scripture: Views from Vivarium and Wearmouth-Jarrow," in *New Offerings, Ancient Treasures: Studies in Medieval Art for George Henderson*, ed. P. Binski and W. Noel (Stroud, 2000), 3–39. I disagree with O'Reilly that Amiatinus sheds significant light on Cassiodorus's monastery, but her analysis of the art of the Northumbrian manuscript is remarkably insightful.

23. Nees, "Problems of Form and Function" (as in note 3), 156–60, 164–65; Meyvaert, "Bede, Cassiodorus" (as in note 3), passim; J. O'Reilly, "Introduction," in *Bede: On the Temple*, trans. S. Connolly, Translated Texts for Historians 21 (Liverpool, 1995), lii–lv. Cf. Corsano, "First Quire" (as in note 11), esp. 8–34. Despite my disagreement with Corsano concerning the role of Grandior in the preparation of Amiatinus, her study remains very important for its analysis of the differences between the first quire of Amiatinus and what is known about the pandect of Cassiodorus.

24. Nees is the first scholar to propose this, so far as I am aware, in "Problems of Form and Function" (as in note 3), see esp. 167–72.

25. The first quire was made separately from the rest of the pandect. While the sister pandects may have had preliminary material, those pages are unlikely to have been

identical with the folios in Amiatinus's first quire, one reason being that the latter were designed for a papal audience. I discuss the evidence of the intention to send a Bible with this gathering to Rome in "Ceolfrid's Gift to St. Peter" (as in note 5), esp. 146–57. Other reasons to think the art of the three Bibles differed are indicated in Marsden, *Text* (as in note 3), 102–3, citing G. D. S. Henderson, *Losses and Lacunae in Early Insular Art*, University of York Medieval Monograph Series 3 (York, 1982), 12.

26. See *Institutiones*, ed. Mynors, xxiii; E. Teviotdale (discussing the liberal arts diagrams of the *Institutiones*), "The Filiation of the Music Illustrations in a Boethius in Milan and in the Piacenza '*Codice magno*'," *Imago Musicae* 5 (1988), ed. T. Seebass with the assistance of T. Russel, 7–22, at 18. My thanks to Dr. Teviotdale for sending me a copy of her article.

27. Jerome diagram (f. 5/VIr): "Sic fiunt ueteris nouique testamenti secundum hieronymum libri quadraginta nouem quibus adde dominum christum de quo et per quem ista conscripta sunt fit quinquagenarius numerus qui ad instar iobelei anni debita remittit et paenitentium peccata dissoluit."

Augustine diagram (f. 8r): "Sic fiunt ueteris noui que testamenti sicut pater augustinus in libris de doctrina christiana complexus est simul libri numero LXXI[I (erased?)] quibus adde unitatem diuinam per quam ista completa sunt. Fit totius librae competens et gloriosa perfectio ipsa est enim rerum conditrix et uitalis omnium plenitudo uirtutum."

The inscription of the Hilarus/Epiphanius diagram (f. 6/VIIr) is given below.

28. Meyvaert, "Bede, Cassiodorus" (as in note 3), 842–44, esp. 843, quoting from Hilarus's biography, *Liber pontificalis* 48, MGH, *GestPontRom* 1.1, 107–11, at 107 (henceforth cited as *LP*). The lives of the early popes are available in English translation based on the editions of Mommsen and Duchesne and the manuscript evidence, in *The Book of Pontiffs (Liber Pontificalis)*, trans. R. Davis, Translated Texts for Historians, Latin Series 5, 2nd rev. ed. (Liverpool, 2000); for Hilarus, see 40–42. Hilarus is sometimes referred to in English as Hillary, but the former appellation is more accurate; my thanks to Peter Brown for correcting me on this point. Epiphanius, bishop of Salamis in Cyprus (ca. 367–403), sided with Jerome in a controversy over Origen, and in 374–375 wrote a lengthy refutation of heresy, the *Panarion*: see *Dictionnaire de Spiritualité*, vol. 4 (Paris, 1960), s.v. "Epiphane (saint)," cols. 854–61, on the writings of Epiphanius, cols. 856–57 (R. Tandonnet); L. Nees, *The Gundohinus Gospels* (Cambridge, Mass., 1987), 15–16. On Epiphanius in Bede's martyrology, P. Meyvaert, "Bede the Scholar," in *Famulus Christi: Essays in Commemoration of the Thirteenth Centenary of the Birth of the Venerable Bede*, ed. G. Bonner (London, 1976), 40–69, at 60.

29. Carol Farr rightly stresses the formal harmony of the Amiatinus schemata, though she is mistaken about their order, in "The Shape of Learning at Wearmouth-Jarrow: The Diagram Pages in the Codex Amiatinus," in *Northumbria's Golden Age*, ed. J. Hawkes and S. Mills (Stroud, 1999), 336–44.

30. *Institutiones*, 1.12–14, ed. Mynors, pp. 36–41. See Marsden, *Text* (as in note 3), 119.

31. Meyvaert, "Bede, Cassiodorus" (as in note 3),

839–41. Compare the texts in note 27 above with the following passages from the *Institutiones* (boldface mine): "unde factum est ut omnes libros veteris Testamenti diligenti cura in Latinum sermonem de Hebreo fonte transfunderet. . . . huic etiam adiecti sunt novi Testamenti libri viginti septem; qui colliguntur simul quadraginta novem. **cui numero adde omnipotentem et indivisibilem Trinitatem**, per quam haec facta et propter quam ista praedicta sunt, et quinquagenarius numerus indubitanter efficitur, quia ad instar iubelei [iobelei] anni magna pietate beneficii debita relaxat et pure paenitentium peccata dissolvit" (Jerome's arrangement; *Institutiones*, 1.12.2, ed. Mynors, p. 37); "Beatus igitur Augustinus secundum praefatos novem codices, quos sancta meditatur Ecclesia, secundo libro de Doctrina Christiana Scripturas divinas LXXI librorum calculo comprehendit; **quibus cum sanctae Trinitatis addideris unitatem**, fit totius librae competens et gloriosa perfectio" (Augustine's arrangement; *Institutiones*, 1.13.2, ed. Mynors, p. 39).

32. "Sic fiunt ueteris nouique testamenti sicut diuidit sanctus hilarus romanae urbis antistes et epiphanius cyprius quem latino fecimus sermone transferri libri. LXX. In illo palmarum numero fortasse praesagati quas in mansione helim inuenit populus hebreorum." The allusion to Ex. 15:27 can be compared to *Institutiones* 1.14.2, p. 40; the reference to the translation of Epiphanius into Latin parallels *Institutiones*, 1.5.4, ed. Mynors, p. 24. See also *Institutiones* 1.14.3, ed. Mynors, p. 40; Meyvaert "Bede, Cassiodorus" (as in note 3), 841–44.

33. Wood, *Abbot Ceolfrid* (as in note 17), 13.

34. *Institutiones*, ed. Mynors, x–xxxix. I am very grateful to Dr. Teviotdale for generously loaning me her microfilms; see her article, "Filiation of the Music Illustrations" (as in note 26); F. Troncarelli, "Alpha e acciuga: Immagini simboliche nei codici di Cassiodoro," *Quaderni medievali* 41 (1996), 6–26.

35. *Institutiones*, ed. Mynors, x. The four other manuscripts I have studied are Paris, Bibliothèque Mazarine, Ms. 660; St. Gallen, Stiftsbibliothek, Ms. 855; London, B.L., Ms. Harley 2637; Karlsruhe, Badische Landesbibliothek, Ms. Augiensis CCXLI, ff. 1–71. I have not consulted Berlin, Phillipps 1737, ff. 38–43. See M. Gorman, "The Diagrams in the Oldest Manuscripts of Cassiodorus' Institutiones," *RBén* 110 (2000), 27–41; F. Troncarelli, *Vivarium: I libri, il destino* (Turnhout, 1998), esp. 29–33; Corsano, "First Quire" (as in note 11), 23–30, pls. 2–4. Mynors (*Institutiones*, ed. Mynors) discusses the *Institutiones* 2 decoration, without reproductions, at xxii–xxiv. My thanks to Roger Reynolds for his advice (oral communication, March 2002) concerning the Bamberg manuscript.

36. As Corsano and Nees have noted in relation to the Bamberg manuscript: Corsano, "First Quire" (as in note 11), 28–29; Nees, "Problems of Form and Function" (as in note 3), 163–64.

37. The most carefully executed of the five manuscripts is Paris, Bibliothèque Mazarine, Ms. 660, but even here the diagrams lack the geometry of those in Amiatinus. See Teviotdale, "Filiation of the Music Illustrations" (as in note 26), 20–21.

38. Corsano, "First Quire" (as in note 11), 28; see *Institutiones*, 1.3.1, ed. Mynors, p. 18. This is the format of all the Scripture diagrams of the Bamberg codex except the one set of four lists in the Augustine scheme, which is

grouped within the four arms of a cross-shaped frame (Corsano, "First Quire," 28–29).

39. See Nees, "Problems of Form and Function" (as in note 3), 164.

40. The list of Amiatinus's contents with the poem honoring Jerome and the dedication page with its poem directing Amiatinus to Rome were clearly not modeled on Grandior. See Meyvaert, "Bede, Cassiodorus" (as in note 3), 868–70.

41. Noted by Farr, "The Shape of Learning" (as in note 29), 338–39 and fig. 27.5. On the Utrecht Gospel, also see K. van der Horst, "The Utrecht Psalter: Picturing the Psalms of David," in *The Utrecht Psalter in Medieval Art: Picturing the Psalms of David*, ed. K. van der Horst et al. ('t Goy, The Netherlands, 1996), 23–84, at 30–32, fig. 7.

42. Nees, "Problems of Form and Function" (as in note 3), 164–65. The roundels mirror the liking for circular ornament also evident in other parts of Amiatinus, such as its Pentateuch diagram and Majestas illumination, ff. 6/VIIr, 796v.

43. The fulcrum of the Scripture diagram in Paris, Bibliothèque Mazarine, Ms. 660 (f. 92r, for Jerome), is also marked by abstract ornament.

44. The motifs occur at Bamberg Patr. 61, ff. 41v, 44r, 45r, vase-motif at 43v; Paris, Bibliothèque Mazarine, Ms. 660, ff. 114r, 117v, 118r, vase at f. 116v; St. Gallen, Stiftsbibliothek, Ms. 855, ff. 220r, 234r, 236r, vase at f. 230r; and London, B.L., Ms. Harley 2637, ff. 12r, 17r, 17v, vase at f. 15v. In the Bamberg codex, the bust is labeled *Domnus Donatus eximius grammaticus* (f. 41v), and the vase is labeled *calix domni Donati gramatici* (f. 43v). See Corsano, "First Quire" (as in note 11), 29–30. In Karlsruhe, Badische Landesbibliothek, Ms. Augiensis CCXLI, the male bust occurs at f. 10r, the vase at f. 13r, and the lamb at f. 14r, but the bird is replaced by an abstract ornament at f. 15r. In the Karlsruhe codex (f. 9r); Bamberg Patr. 61, f. 40v; London, B.L., Ms. Harley 2637, f. 11r; and St. Gallen, Stiftsbibliothek, Ms. 855, f. 216r, the sequence is preceded by a diagram that springs from a cross in a roundel, for the *partes orationis rethoricae* (*Institutiones*, 2.2.9, ed. Mynors, p. 103). The copyists of St. Gall 855 (f. 220r) and Paris, Bibliothèque Mazarine, Ms. 660 (f. 114r), seem to have interpreted the sequence as Trinitarian; both give the male figure a halo, and in the St. Gall codex this is inscribed with a cross.

45. The latter order may be implied in *Institutiones*, 1.14.2, ed. Mynors, p. 40 line 6, where Cassiodorus states that his Septuagint diagram was placed in Grandior *inter alias*, the reference being to the three diagrams. If the same motifs accompanied the same diagrams as in Amiatinus, this implies that the order was lamb, bust, dove.

46. "Ceolfrid's Gift to St. Peter" (as in note 5), passim. I am enormously grateful to Mildred Budny for her wise counsel as I wrestled with the quire's codicological problems. My solution to its order has only been possible because of the insights she generously provided.

47. See note 25 above.

48. I discuss this issue in an article in preparation: "Cassiodorus, the Three Chapters, and the Trinitarian Imagery of the Codex Grandior," in *The Crisis of the Oikoumene: The Three Chapters and the Failed Quest for Unity in the Sixth-Century Mediterranean*, ed. C. Chazelle and C. Cubitt (Turnhout, forthcoming, 2006).

49. See notes 27 and 31 above. On the rarity of images of the Trinity in antique and early medieval art, see Nees, "Problems of Form and Function" (as in note 3), 165–66. I may overstate this distinction, as Herbert Kessler has recently suggested. My main point is to stress the imporance of Christ as the human face of God. Only through Christ does one approach the Father, an experience only truly possible at his return. See Herbert L. Kessler, "Images of Christ and Communications with God," in *Communicare e significare nell'alto medioevo*, Settimane di Studio della Fondazione Centro Italiano di Studi sull'Alto Medioevo 52 (Spoleto, 2005), 1099–36, at 1119–20.

50. For example, the visits of Benedict Biscop and Ceolfrid to Rome. For visits of Mediterranean ecclesiastics to England, see Bede's *Ecclesiastical History of the English People*, 1.23–25, 4.1–2, 4.17(15)–18(16), ed. B. Colgrave and R. A. B. Mynors (Oxford, 1969; henceforth cited as *HE*, ed. Colgrave and Mynors), 68–76 (Augustine's mission and arrival), 328–36 (Theodore and Hadrian), 384–90 (John). Cf. H. Mayr-Harting, *The Coming of Christianity to Anglo-Saxon England*, 3rd ed. (University Park, Pa., 1991), esp. 61–62, 69–77, 120–22, 124–28.

51. Adomnán, *De locis sanctis*, 3.4–5, Scriptores Latini Hiberniae 3, ed. D. Meehan (Dublin, 1958), 110–18. On the significance of these stories, J.-M. Sansterre, "Entre deux mondes? La Vénération des images à Rome et en Italie d'après les textes des VIe–XIe siècles," in *Roma fra Oriente e Occidente*, Settimane di studio del Centro italiano di studi sull'alto medioevo 49, 2 vols. (Spoleto, 2002), vol. 2, 993–1050. My thanks to Professor Sansterre for providing me with a copy of his article. Bede's own *De locis sanctis*, written 702–703, was deeply influenced by Adomnán's work (W. T. Foley, "Introduction: On the Holy Places," in *Bede: A Biblical Miscellany*, trans. W. T. Foley and A. G. Holder, Translated Texts for Historians 28 [Liverpool, 1999], 1–2).

52. "At illi non daemonica sed diuina uirtute praediti ueniebant, crucem pro uexillo ferentes argenteam, et imaginem Domini Saluatoris in tabula depictam, laetaniasque canentes pro sua simul et eorum, propter quos et ad quos uenerant, salute aeterna Domino supplicabant" (*HE* 1.25, ed. Colgrave and Mynors, 74).

53. *HA* 6, ed. Plummer, 369.

54. See previous note; Bede, *Homilia* 1.13 (*S. Benedicti Biscopi*, Matthew 19.27–29) (ed. D. Hurst, CCSL 122 [Turnhout, 1955], 88–94, at 93 lines 180–85); Bede, *De Templo* 2 (CCSL 119A, 212–13). See P. Meyvaert, "Bede and the Church Paintings at Wearmouth-Jarrow," *Anglo-Saxon England* 8 (1979), 63–77, at 68–69. On the probable dating of the homilies to 730–735 (*De Templo* dates to ca. 729–731), see Hurst, *Praefatio*, CCSL 122, vii. The relative dates of *De Tabernaculo*, *De Templo*, and Bede's exegetical treatise *In Ezram et Neemiam* have recently been discussed by Scott DeGregorio, "Bede's *In Ezram et Neemiam* and the Reform of the Northumbrian Church," *Speculum* 79 (2004), 1–25, at 22–23. On the teachings of the letters of Gregory I to Serenus, see my article, "Pictures, Books, and the Illiterate: Pope Gregory I's Letters to Serenus of Marseilles," *Word & Image* 6 (1990), 138–53.

55. See C. Thomas, *Bede, Archaeology, and the Cult of Relics*, Jarrow Lecture 1973, reprinted in *Bede and His World* (as in note 4), vol. 1, 349–68, esp. 351–55.

56. *HA* 6, ed. Plummer, 369; cf. *VC* 9, ed. Plummer, 391:

"historiarum canonicarum picturam merito uenerandam."

57. I discuss this more fully in a forthcoming article, "A Sense of Place" (as in note 14).

58. Bede, *Hom.* 1.2 (*In Adventu*, John 1:15–18; CCSL 122, 7–13, esp. 11–13); *Hom.* 1.23 (*In Quadragesima*, John 5:1–18; CCSL 122, 161–69, esp. 167–69); *Hom.* 1.24 (CCSL 122, 170–77, esp. 175–77); *Hom.* 2.17 (*Dominica Pentecostes*, John 14:15–21; CCSL 122, 301–10, esp. 304–10).

59. Compare the discussions of heavenly visions and the eschaton in Jerome, *In Esaiam* 3.3, in *Commentaires de Jerome sur le prophète Isaie, Livres I–IV*, ed. R. Gryson and P.-A. Deproost, Vetus Latina: Die Reste der altlateinischen Bibel 23 (Freiburg, 1993), 309–11; Augustine, *De civitate Dei* 20.30; Gregory, *Hom.* 8.20–32, *Homélies sur Ézéchiel*, vol. 1, SC 327, ed. C. Morel (Paris, 1986), 302–26; Cassiodorus, *Institutiones*, 2, *Conclusio*, ed. Mynors, pp. 158–63. On Bede's emphasis on Christ as the visible God, see B. C. Raw, *Trinity and Incarnation in Anglo-Saxon Art and Thought* (Cambridge, 1997), 66–67.

60. Bede, *Hom.* 1.2 (CCSL 122, 12); *Hom.* 2.17 (CCSL 122, 304–5). See Raw, *Trinity and Incarnation* (as in note 59), 184.

61. "Credamus eum ueraciter se patri aequalem potestae gloria aeternitate et regno praedicasse et bene agendo satagamus ad unam utriusque uisionem peruenire de qua roganti Philippo ac dicenti, 'domine ostende nobis patrem, et sufficit nobis,' respondit ipse dominus dicens, 'qui me uidet uidet et patrem'" (Bede, *Hom.* 1.23; CCSL 122, 169). Cf. Bede, *Expositio Apocalypseos* 37 (ed. R. Gryson, CCSL 121A [Turnhout, 2001], 565–67). English translations of Vulgate quotations are taken from the Douay-Rheims version.

62. Bede, *Hom.* 1.2 (CCSL 122, 11–12).

63. Bede, *Hom.* 1.24 (CCSL 122, 171–72, 175–77). Cf. *Hom.* 1.9 (*Sancti Iohannis Evangelistae*, John 21:19–24; CCSL 122, 60–67, at 63–65); Raw, *Trinity and Incarnation* (as in note 59), 14–15.

64. Bede, *Expositio Apoc.* (CCSL 121A, 153–54). Also on this treatise, see T. W. Mackay, "Augustine and Gregory the Great in Bede's Commentary on the Apocalypse," in *Northumbria's Golden Age* (as in note 29), 396–405; E. A. Matter, "The Apocalypse in Early Medieval Exegesis," in *The Apocalypse in the Middle Ages*, ed. R. K. Emmerson and B. McGinn (Ithaca, 1992), 38–50, esp. 47; G. Bonner, *Saint Bede in the Tradition of Western Apocalypse Commentary*, Jarrow Lecture 1966, reprinted in *Bede and His World* (as in note 4), vol. 1, 155–83.

65. Bede, *Expositio Apoc., Praefatio*, CCSL 121A, 221 lines 1–2: "Apocalypsis sancti Iohannis, in qua bella et incendia intestina ecclesiae suae deus uerbis figurisque reuelare dignatus est."

66. See Bede, *Expositio Apoc., Praefatio*, CCSL 121A, 221–33. Cf. Bede, *De temporum ratione liber* 70–71 (ed. C. W. Jones, CCSL 123B [Turnhout, 1977], 539–44).

67. The dilemma that early medieval artists faced trying to reconcile corporeal vision with the incorporeal nature of divinity and the spiritual vision through which it was "beheld" is examined with great subtlety in the recent collection of essays by H. L. Kessler, *Spiritual Seeing: Picturing God's Invisibility in Medieval Art* (Philadelphia, 2000); see esp. chap. 1, "The Icon in the Narrative," 1–52.

68. See J. Herrin, *The Formation of Christendom* (Prince-

ton, 1987), 107–8, 119–27, 208–9, 250–59, 275–80; J. F. Haldon, *Byzantium in the Seventh Century: The Transformation of a Culture*, rev. ed. (Cambridge, 1997), 48–49, 56–59, 67–68, 286–323; Mayr-Harting, *Coming of Christianity* (as in note 50), 120–28.

69. Herrin, *Formation* (as in note 68), 217–19, 250–59; Haldon, *Byzantium* (as in note 68), 56–59, 285, 306–7, 309–12; see the lives of Martin and Eugenius, in *LP* 76–77, pp. 181–85; *Book of Pontiffs* (as in note 28), 70–73. On Benedict's first visit to Rome, *HA* 2, ed. Plummer, 365; É. Ó Carragáin, *The City of Rome and the World of Bede*, Jarrow Lecture 1994, 15–17; E. Fletcher, *Benedict Biscop*, Jarrow Lecture 1981, in *Bede and His World* (as in note 4), vol. 2, 539–54, at 542, on the uncertain length of the stay.

70. Bede, *HE* 4.17(15)–18(16), ed. Colgrave and Mynors, 384–90, quoting portions of the synodal book at 384–86. See, too, *HA* 6, ed. Plummer, 368–70; *VC* 9–10, ed. Plummer, 391; Bede, *Hom.* 1.13 (CCSL 122, 93 lines 178–80).

71. Bede, *HE* 5.19, ed. Colgrave and Mynors, 522–26; *The Life of Bishop Wilfrid by Eddius Stephanus: Text, Translation, and Notes*, ed. and trans. B. Colgrave (Cambridge, 1927), chaps. 24, 29–32, pp. 48–50, 56–66; Herrin, *Formation* (as in note 68), 276–77.

72. Herrin, *Formation* (as in note 68), 277–80, noting (280) that only the letters to Spain survive; Haldon, *Byzantium* (as in note 68), 313–16.

73. On Benedict's final trip, *HA* 9, ed. Plummer, 373; *VC* 12–13, ed. Plummer, 392. On Hwaetbert's stay in Rome, *HA* 18, ed. Plummer, 383. On the charter Ceolfrid obtained, *HA* 15, ed. Plummer, 380; *VC* 20, ed. Plummer, 395. Benedict earlier received a charter from Pope Agatho, during his visit with Ceolfrid ca. 677: *HA* 6, ed. Plummer, 369; *VC* 20, ed. Plummer, 395.

74. *Life of Bishop Wilfrid* (as in note 71), 50–55, pp. 102–20; D. H. Farmer, "Saint Wilfrid," in *Saint Wilfrid at Hexham*, ed. D. P. Kirby (Newcastle upon Tyne, 1974), 35–59, at 52–54.

75. Conciliar decrees in Greek, Latin, and English in *The Council in Trullo Revisited*, ed. G. Nedungatt and M. Featherstone (Rome, 1995), 45–186; cf. the life of Sergius in *LP* 86, pp. 210–16, esp. 211–13; *Book of Pontiffs* (as in note 28), 82–87, esp. 84–85. See Haldon, *Byzantium* (as in note 68), 73–74, 317–18, 332–37; Herrin, *Formation* (as in note 68), 284–88; T. F. X. Noble, *The Republic of St. Peter: The Birth of the Papal State, 680–825* (Philadelphia, 1984), 16–18; H. Ohme, *Das Concilium Quinisextum und seine Bischofsliste: Studien zum Konstantinopeler Konzil von 692* (Berlin, 1990), 55–61, 373–86.

76. The decree concerning the *Agnus Dei* is noted in *LP* 86, p. 215; *Book of Pontiffs* (as in note 28), 86–87. See Noble, *Republic of St. Peter* (as in note 75), 17; Nees, "Problems of Form and Function" (as in note 3), 169, n. 142. On the triumphal arch of SS. Cosma e Damiano, dating its mosaic after 692, and linking it to the decoration of St. Peter's, see V. Tiberia, *Il mosaico restaurato: l'arco della basilica dei Santi Cosma e Damiano* (Rome, 1998), 11–22, esp. 19. Herbert L. Kessler ("Real Absence: Early Medieval Art and the Metamorphosis of Vision," in *Morfologie sociali e culturali in Europa fra Tarda Antichità e Alto Medioevo, 3–9 aprile 1997*, Settimane di studio del Centro italiano di studi sull'alto medioevo 45 [Spoleto, 1998], 1157–1211, reprinted in Kessler, *Spiritual Seeing* [as in note 67], 108–10 and n. 16) implies doubt that the lamb

on the facade of St. Peter's responded to the Quinisext canon. My thanks to him for guidance on this issue and the reference to Tiberia's work.

77. J.-M. Sansterre, "Le Pape Constantin Ier (708–715) et la politique religieuse des empereurs Justinien II et Philippikos," *Archivum Historiae Pontificae* 22 (1984), 7–29; Sansterre, "Jean VII (705–707): Idéologie pontificale et réalisme politique," in *Rayonnement grec: Hommages à Charles Delvoye*, ed. L. Hadermann-Misguich and G. Raepsaet (Brussels, 1982), 377–88; Sansterre, "À propos de la signification politico-religieuse de certaines fresques de Jean VII à Sainte-Marie-Antique," *Byzantion* 57 (1987), 434–40. Also see Herrin, *Formation* (as in note 68), 288, 312, 318–19, 341; Ohme, *Concilium Quinisextum* (as in note 75), 61–75.

78. As far as I know, the only other scholar to have proposed an interpretation of the images in this order is L. Castaldi, "Quire Arrangement," in *La Bibbia Amiatina/ The Codex Amiatinus* (as in note 3). Castaldi sees the arrangement as symbolic of the route by which mortals arrive at knowledge of God, progressing from the Son to the Holy Spirit to the Father. My interpretation is essentially in agreement.

79. See J. Engemann, "Images parousiaques dans l'art paléochrétien," in *L'Apocalypse de Jean: Traditions exégétiques et iconographiques, IIIe–XIIIe siècles*, ed. R. Petraglio et al. (Geneva, 1979), 73–107, at 73–74; Y. Christe, *La Vision de Matthieu (Matth. XXIV–XXV): Origines et développement d'une image de la Seconde Parousie* (Paris, 1973), esp. 73–88.

80. Nees, "Problems of Form and Function" (as in note 3), 169, n. 145.

81. Bede, *Expositio Apoc.* 3 (CCSL 121A, 247–49 [to Apoc. 1.16]): "'Et facies eius sicut sol lucet in virtute sua'. Qualis in monte discipulis, talis post iudicium dominus omnibus sanctis apparebit; impii enim in iudicio uidebunt in quem pupunxerunt (John 19:37). Totus autem hic filii hominis habitus etiam ecclesiae conuenit, cum qua una natura ipse factus est Christus, honorem illi sacerdotalem et iudiciariam tribuens potestatem, et ut fulgeat sicut sol in regno patris sui."

82. Bede, *In Lucae euangelium expositio* 5 (ed. D. Hurst, CCSL 120 [Turnhout, 1960], 316–17). See M. Gorman, "Source Marks and Chapter Divisions in Bede's Commentary on Luke," *RBén* 112 (2002), 246–90.

83. J. Wilpert and W. N. Schumacher, *Die römischen Mosaiken der kirchlichen Bauten vom IV.–XIII. Jahrhundert* (Basel, 1916/1976), pls. 28, 34, 40, 41, 48.

84. Wilpert and Schumacher, *Die römischen Mosaiken* (as in note 83), pls. 101, 102; G. Matthiae, *Mosaici medioevali delle chiese di Roma*, 2 vols. (Rome, 1967), vol. 2, pl. 78.

85. See Nees, "Problems of Form and Function" (as in note 3), 167–68, 172; Kessler, "Real Absence" (as in note 76), 109 and figs. 6.6–6.8. I am grateful to Martin Büchsel for suggesting to me (oral communication, October 2001) that the Amiatinus bust follows an iconography of the Pantocrator first seen in Eastern imagery of the sixth to seventh century, distinguished by the portrayal of Christ's hair. Unfortunately, the Northumbrian miniature is too worn to be certain. Cf. M. Büchsel, "Das Christusporträt am Scheideweg des Ikonoklastenstreits im 8. und 9. Jahrhundert," *MarbJb* 25 (1998), 7–52, at 12–13. My thanks

to Dr. Büchsel for sending me a copy of this article.

86. See Tiberia, *Il mosaico restaurato* (as in note 76), on the triumphal arch of SS. Cosma e Damiano, where the lamb appears on the arch and Christ is depicted in the apse; Wilpert and Schumacher, *Die römischen Mosaiken* (as in note 83), pl. 20 (S. Pudenziana), pl. 101 (SS. Cosma e Damiano); J. Lowden, *Early Christian and Byzantine Art* (London, 1997), fig. 77 (S. Vitale, Ravenna).

87. Bede, *HA* 6, 9, 15, ed. Plummer, 369–70, 373, 379–80; *Hom.* 1.13 (CCSL 122, 93); *VC* 9, 20, ed. Plummer, 391, 394–95.

88. Cf. Matthiae, *Mosaici medioevali* (as in note 84), vol. 2, pls. 27–28 (S. Costanza), pl. 36 (S. Pudenziana), pl. 78 (SS. Cosma e Damiano); Wilpert and Schumacher, *Die römischen Mosaiken* (as in note 83), pls. 1, 2 (S. Costanza), pl. 19 (S. Pudenziana, detail), pl. 73 (Mausoleum of Galla Placidia), pls. 101, 102 (SS. Cosma e Damiano).

89. Examples include some of the earliest Mount Sinai icons: K. Weitzmann, *The Monastery of Saint Catherine at Mount Sinai, the Icons*, vol. 1, *From the Sixth to the Tenth Century* (Princeton, 1976), pls. 48, 50a, 52, 53, 57. See also Büchsel, "Das Christusporträt" (as in note 85), figs. 2, 4, 5, 9, cf. 11; Lowden, *Early Christian and Byzantine Art* (as in note 86), fig. 56; Kessler, *Spiritual Seeing* (as in note 67), figs. 2.6, 4.11, 5.4, pl. IVa; J. D. Breckenridge, *The Numismatic Iconography of Justinian II (685–695, 795–711 A.D.)* (New York, 1959), 22, 46, 90, pl. V.30; Nees, "Problems of Form and Function" (as in note 3), 168 and fig. 23.

90. See notes 58 and 59 above.

91. Bede, *Libri II de arte metrica et de schematibus et tropis/ The Art of Poetry and Rhetoric*, ed. and trans. C. B. Kendall (Saarbrücken, 1991), part 2, 192, 196–200. See Kendall's introduction, 25–28; on the treatise's uncertain date, 28–29.

92. G. H. Brown, *Bede the Venerable* (Boston, 1987), 42–61, esp. 47, with examples from the commentaries. See Meyvaert, "Bede the Scholar" (as in note 28), 44–47.

93. *De temporum ratione liber* (CCSL 123B [as in note 66]); *De temporibus liber* (ed. C. W. Jones, CCSL 123C [Turnhout, 1980], 580–611).

94. *Epistola ad Pleguinam* (CCSL 123C, 617–26).

95. *Epistola ad Pleguinam* (CCSL 123C, 617–18, 624–25, see 626); *De temporum ratione* 67–71 (CCSL 123B, 535–44).

96. *Epistola ad Pleguinam* (CCSL 123C, 624–25); cf. Bede, *In Lucam* 5 (CCSL 120 [as in note 82], 316–17).

97. See note 68 above.

98. T. M. Charles-Edwards, *Early Christian Ireland* (Cambridge, 2000), 416–17, 429–38; Wood, *Abbot Ceolfrid* (as in note 17), 7–8; C. Cubitt, "Wilfrid's 'Usurping Bishops': Episcopal Elections in Anglo-Saxon England, c. 600–c. 800," *Northern History* 25 (1989), 18–38; W. Goffart, *The Narrators of Barbarian History (A.D. 550–800): Jordanes, Gregory of Tours, Bede, and Paul the Deacon* (Princeton, 1988), 258–328; cf. D. P. Kirby, "Northumbria in the Time of Wilfrid," in *Saint Wilfrid at Hexham* (as in note 74), 1–34.

99. See Wood, *Abbot Ceolfrid* (as in note 17), 6–7, 9–10. P. Wormald, "Bede and Benedict Biscop," in *Famulus Christi* (as in note 28), 141–69, at 143–44, notes the differences between Benedict Biscop's and Wilfrid's versions of the Benedictine Rule.

100. On his deathbed, Benedict urged his monks to prevent the dispersal of the monastic library and warned them that his blood brother might seek kinship rights: *HA* 11–13, ed. Plummer, 374–77; see Wood, *Abbot Ceolfrid* (as in note 17), 10–11; Wormald, "Bede and Benedict Biscop" (as in note 99), 153–54. The papal charter that Ceolfrid obtained for the monastery was to protect it against the "incursion of the wicked" (*ab inproborum inruptione securiora*): *VC* 20, ed. Plummer, 394–95.

101. Wood, *Abbot Ceolfrid* (as in note 17), 11–12. Ceolfrid's departure speech stresses the need to avoid dissension between the two houses: *VC* 25, ed. Plummer, 397. I discuss the evidence of internal tensions in my forthcoming article, "A Sense of Place" (as in note 14).

102. Charles-Edwards, *Early Christian Ireland* (as in note 98), 317–21, 391–415; Mayr-Harting, *Coming of Christianity* (as in note 50), 103–13.

103. See Charles-Edwards, *Early Christian Ireland* (as in note 98), 326, 410, 436–37; Goffart, *Narrators* (as in note 98), 183, 309–13, 326–27, stressing Bede's admiration for the Irish in contrast to his hostility (Goffart argues) toward Wilfrid.

104. *HE* 5.21, ed. Colgrave and Mynors, 534, n. 1.

105. *HE* 5.21, ed. Colgrave and Mynors, 534–50, esp. 534–46.

106. Beall, "Illuminated Pages" (as in note 3), 129–30.

107. See note 3 above.

108. It is striking that Augustine, Jerome, and also Epiphanius were included in Bede's martyrology. Hilarus of Rome is placed here in very good company. See Meyvaert, "Bede the Scholar" (as in note 28), 60.

109. *Biblia Sacra* (as in note 6), vol. 1, xxii–xxiii.

110. Among recent discussions, e.g., Wood, *Abbot Ceolfrid* (as in note 17), 13–15; Nees, "Problems of Form and Function" (as in note 3), 148–74; Marsden, *Text* (as in note 3), 105–6; William J. Diebold, *Word and Image: An Introduction to Early Medieval Art* (Boulder, Col., 2000), 33–37.

111. "Ceolfrid's Gift to St. Peter" (as in note 5); "A Sense of Place" (as in note 14).

112. For another unified reading of the art of this codex, taking a somewhat different, also valuable perspective, see O'Reilly, "The Library of Scripture" (as in note 22).

113. On the formal harmony of the three pages and other folia in the first quire, see my article, "Ceolfrid's Gift to St. Peter" (as in note 5), 139–45; Farr, "The Shape of Learning" (as in note 29).

114. Nees, "Problems of Form and Function" (as in note 3), passim, esp. 121–24.

115. See Chazelle, "Ceolfrid's Gift to St. Peter" (as in note 5), 139–40.

116. For both texts, *Biblia Sacra* (as in note 6), vol. 1, xxi–xxii.

117. Chazelle, "A Sense of Place" (as in note 14), passim; also see O'Reilly, "The Library of Scripture" (as in note 22), 5, 30–34.

118. *Biblia Sacra* (as in note 6), vol. 1, xxv; O'Reilly, "The Library of Scripture" (as in note 22), 8–11.

119. *Biblia Sacra* (as in note 6), vol. 1, xxii–xxiii.

120. "Ceolfrid's Gift to St. Peter" (as in note 5), esp. 149–57.

121. *HA* 17, ed. Plummer, 381–82; *VC* 25–26, ed. Plummer, 396–97.

122. Wood, *Abbot Ceolfrid* (as in note 17), 16. See *HA* 18–19, ed. Plummer, 382–84; *VC* 29–30, ed. Plummer, 398–400.

123. See Ó Carragáin, *City of Rome and the World of Bede* (as in note 69),11–13.

Raban Maur, Bernard de Clairvaux, Bonaventure: expression de l'espace et topographie spirituelle dans les images médiévales

Christian Heck

La théologie médiévale ne peut échapper à la contradiction entre, d'un côté, une volonté de relier l'anagogie à l'au-delà du temps et de l'espace, à un monde dans lequel les notions terrestres de direction, de déplacement, de dimensions, de jour et de nuit n'ont plus de sens, et, de l'autre côté, la nécessité d'exprimer la quête spirituelle en termes d'espace: haut et bas, droite et gauche, verticale, courbure, horizontale, superposition des niveaux, etc. Le texte biblique utilise abondamment ces notions, du Psaume 109 ("Le Seigneur a dit à mon Seigneur: siège à ma droite") au jugement évoqué par Matthieu 25:33 ("Il placera les brebis à sa droite, et les boucs à sa gauche"), et le shéol est bien "en bas" (Prov. 15:24), comme Dieu est "au plus haut des cieux" (Job 22:12).[1]

Cette hiérarchie des notions spatiales, sans doute reliée à une expérience anthropologique,[2] est également largement fondée, dans le christianisme, sur la théologie de l'Incarnation: le Verbe s'est fait chair, le Christ a vécu dans le temps et l'espace des hommes. Et le vocabulaire même des valeurs théologiques utilise des notions propres à la définition de l'espace sensible: on parle de rectitude spirituelle, en la reliant à la rectitude physique qui en serait le signe, de la courbure comme signe et conséquence de la perte et du péché,[3] de montée vers le ciel et de descente aux enfers, en une théologie de l'espace, une géographie chrétienne du monde. La porte, le chemin, l'échelle, sont des thèmes évidents de la quête spirituelle.[4]

Dans le langage de la théologie, la solution de cette contradiction entre les images du monde des formes, et l'au-delà des formes, est permise à la fois par la théologie de l'Incarnation, qui justifie que l'on puisse, selon Saint Paul, atteindre l'invisible à partir des réalités sensibles (Rom. 1:20),[5] mais aussi par l'abstraction des textes, qui supportent la conciliation des contraires. Parler d'espace comme non-espace est plus facile que de le représenter dans des œuvres d'art.

La question se pose autrement pour les images médiévales,[6] nourries d'un vocabulaire symbolique fondé sur cette spatialisation des concepts du christianisme.[7] Car cette spatialisation des concepts doit s'accorder avec le nécessaire rappel du dépassement du monde des formes. Les

images s'appréhendent avec les sens, et existent dans l'espace même, qu'elles s'inscrivent dans deux ou dans trois dimensions. Comment l'œuvre d'art peut-elle utiliser ce vocabulaire spatial sans se laisser réduire à la seule évocation du monde sensible, sans perdre l'appel au ciel?

D'André Grabar[8] à Herbert Kessler,[9] de nombreux travaux ont tenté des réponses à cette question. Nous avons choisi un des aspects du problème, pour tenter de comprendre comment l'art médiéval a parfois tenté de résoudre cette contradiction entre la spatialisation des concepts et l'au-delà de l'espace, la "fin du lieu." Et ceci à travers trois exemples: (1) les enluminures du *De laudibus sanctae crucis* de Raban Maur, (2) l'enluminure du *De gradibus humilitatis* de Bernard de Clairvaux dans le manuscrit d'Anchin, et (3) l'*Itinerarium mentis in Deum* de Bonaventure, qui revient sans cesse à une intériorisation des notions spatiales, entre autres par la hiérarchisation de l'âme, définissant ainsi une cosmologie "en l'homme," que l'on peut mettre en parallèle avec sa théologie de l'histoire.

Ces exemples montrent à la fois une expression de l'espace symbolique d'une topographie spirituelle, d'une géographie du salut, mais aussi une volonté d'aller au-delà même des termes de la topographie, d'abandonner les notions et les repères spatiaux.

Le *De laudibus sanctae crucis* de Raban Maur

Le *De laudibus sanctae crucis*, composé par Raban Maur au début du IXe siècle (Fig. 1), est bien connu, et on a souvent relevé l'intégration extrême du texte et de l'image dans cette œuvre.[10] Nous voudrions montrer comment ce traité théologique associe le naturalisme et l'abstraction, et comment l'accord particulier du texte et de l'image se fait au service de l'expression de l'invisible dans le visible.

On doit rappeler brièvement la nature du *De laudibus*,[11] qui est un hommage à la croix. La forme choisie est celle du *carmen figuratum*, ou poème figuré (Fig. 2), genre littéraire qui remonte au moins à l'Antiquité classique,[12] et les *carmina figurata* de Porphyrius, composés en 325 à la gloire de l'empereur Constantin, font partie des modèles de Raban.[13] Les *carmina figurata* donnent à chaque lettre une place précise dans la structure formelle ou le jeu des lignes et des colonnes du poème, créant une image visuelle particulière.[14] Les vingt-huit chapitres qui forment le cœur de l'œuvre comprennent chacun deux folios se faisant face, le poème figuré à gauche, et une explication en prose (*declaratio*) sur le folio de droite. Le poème figuré se présente comme un rectangle ou un carré, les lettres étant disposées en lignes ou en colonnes parfaitement régulières. Une première lecture se fait en suivant toutes les lettres dans un sens normal. Puis une seconde lecture prend en compte les lettres différenciées par un fond de couleur ou une ligne qui entoure certaines d'entre elles.[15] La *declaratio* du folio de droite comprend un commentaire théologique et spirituel, mais aussi l'explication du sens des figures, et la transcription des mots ou des vers qu'elles forment. Le traité commence par cinq éléments introductifs: une dédicace au pape (Fig. 1), seule enluminure "normale" du livre, avec un court poème de quatre vers qui forme la bordure,[16] puis le texte de la dédicace; une dédicace à l'empereur (Fig. 2), poème figuré puis *declaratio*, parfois suivis d'autres dédicaces dans certains manuscrits[17]; un prologue, texte normal sans illustration; une préface-signature, qui se rapproche du principe du poème figuré, car certaines lettres ressortent et donnent le nom de l'auteur; une table des chapitres. Après les vingt-huit *carmina figurata*, chacun suivi de sa *declaratio*, une seconde partie comprend la transcription en prose, également par

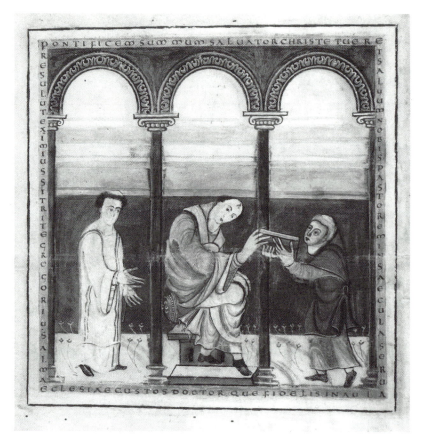

1. Raban Maur, *De laudibus sanctae crucis*, second quart du IXe siècle. Bibliothèques d'Amiens Métropole, Ms. 223, dédicace au pape

Raban, de ses vingt-huit poèmes. Chaque chapitre se présente donc sous trois aspects: le poème figuré, la *declaratio* en prose, la transcription en prose.

Les lettres différenciées à l'intérieur des poèmes figurés forment trois types d'images visuelles: d'une part des représentations figuratives, qui ne sont que cinq, pour la dédicace à César, puis pour quatre chapitres (I, IV, XV, XXVIII); d'autre part, et le plus souvent, pour dix-sept chapitres, des formes géométriques simples, en général purement abstraites (carrés, cercles, triangles, octogones, etc.), mais parfois ornementales, comme ce que Raban appelle la "croix de fleurs" du chapitre XVI[18]; et enfin, dans sept cas, des mots (*Crux salus, Adam*, etc.), des chiffres (50 en chiffres romains) ou des lettres grecques symbolisant des chiffres (aux chapitres XIV et XX).

Mais la séquence de ces différents types d'images n'est pas quelconque. Le *De laudibus* commence par une composition figurative normale, la dédicace au pape (Fig. 1), mais un poème l'entoure comme s'il s'apprêtait à entrer dans l'image. Vient ensuite le poème figuré le plus proche d'une composition peinte, la dédicace à César (Fig. 2), qui inclut la représentation de plis du vêtement, de gestes naturels. Puis le poème figuré du premier chapitre (Fig. 3) commence à s'éloigner d'une image naturaliste, avec le Christ les bras en croix, car l'absence de croix introduit un effet d'irréalité. Et le second poème figuré propose une forme abstraite (Fig. 4). Il s'agit donc d'une entrée progressive dans l'abstraction, les repères figuratifs étant peu à peu abandonnés. Ils reparaissent plus loin, aux chapitres IV et XV (Fig. 7), mais avec une figuration très éloignée de notre monde sensible: chérubins et séraphins, tétramorphe et agneau. L'élément figuratif revient au

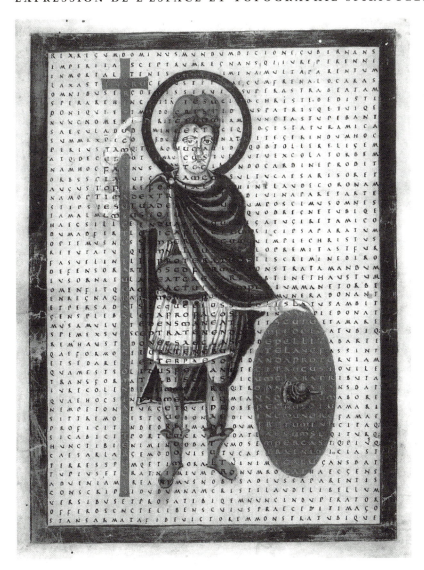

2. Raban Maur, *De laudibus sanctae crucis* (Amiens), dédicace à César

dernier chapitre, mais il ne s'agit pas d'un retour au naturalisme pour quitter le livre et revenir au monde des hommes. Les trois derniers chapitres marquent en effet l'aboutissement à l'abstraction la plus insistante et la plus austère. Les poèmes XXVI et XXVII (Fig. 8 et 9) proposent uniquement la représentation d'une croix, nue. Et le poème XXVIII (Fig. 10) représente Raban agenouillé sous la croix, mais hors de toute référence à un espace à trois dimensions. Raban semble s'effacer devant l'invisible, et s'apprêter à reculer vers l'angle inférieur droit pour disparaître. Il ne lève pas les yeux vers la croix, mais regarde vers la gauche un espace vide, sous cette forme géométrique qui n'est pas représentation de la croix, mais signe du mystère.[19]

La cohérence de cette séquence qui traverse tout le traité, et son importance pour la compréhension du *De laudibus*, est confirmée par le texte du prologue, dans lequel Raban demande au lecteur "qu'il suive l'ordre de la rédaction et ne néglige pas d'y observer chacune des figures tracées."[20]

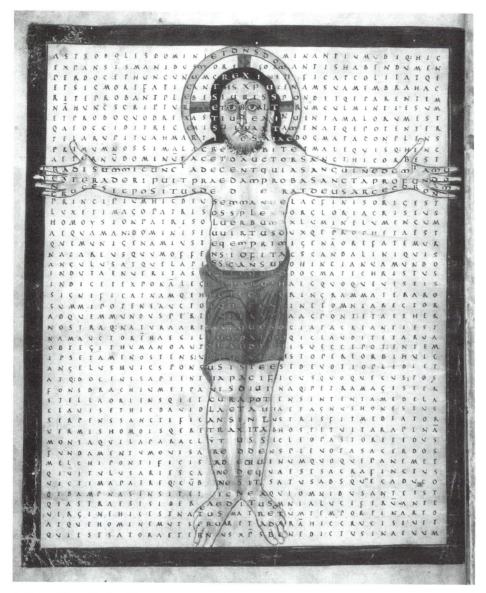

3. Raban Maur, *De laudibus sanctae crucis* (Amiens), chapitre 1, l'image du Christ étend ses bras en forme de croix

A cela s'ajoute une volonté d'effacement des notions spatiales dans les images. Le poème VI (Fig. 6) représente quatre figures en forme de triangles, symbolisant les quatre vertus cardinales, en une composition qui signifie une ascension spirituelle, car ces quatre vertus "progressent toutes ensemble."[21] Et Raban précise que chacun de ces triangles présente sept degrés sur ses deux côtés, pour relier l'échelle des vertus aux sept dons du Saint Esprit. Il s'agit donc de degrés à monter, comme il l'évoque à nouveau au poème XVI qui parle également des dons du Saint Esprit: "l'homme ... doit monter ainsi tous les autres degrés. ... Quand il sera monté au septième degré, c'est-à-dire à la sagesse, il se montrera alors un homme parfait."[22] Mais ces degrés à monter sont ordonnés non selon un espace sensible, mais selon un espace symbolique. Seul le triangle du bas

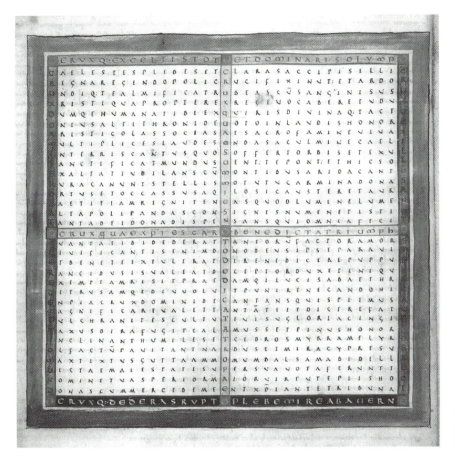

4. Raban Maur, *De laudibus sanctae crucis* (Amiens), chapitre 2, la forme de la croix

repose sur sa base, les deux latéraux sont basculés, et celui du haut est renversé. Car ils ne sont pas tournés vers ce qui serait le haut d'une image figurative, mais vers le cœur de la croix qu'ils forment.

Ailleurs, dans le premier poème, le Christ est présenté les bras en croix mais sans la croix, alors que le poème parle de "celui qui peine ainsi suivant l'usage sur la croix."[23] Mais si l'on observe les poèmes I puis II (Fig. 3 et 4), il paraît évident que l'image du Christ , puis celle de la croix seule, se superposent pour donner l'image du Christ sur la croix. Le rapport spatial n'est pas visuel, mais mental. C'est la pensée et non l'œil qui comprend l'œuvre.

La rédaction même du texte du *De laudibus* participe de cette expression de l'invisible. Le premier élément en est l'association étroite des effets du texte et des images. On peut être d'abord étonné par l'apparente opposition entre les métaphores visuelles maximales du texte, et les notions spatiales minimales des images. Dans le poème VI (Fig. 6), l'image tout à fait abstraite des quatre triangles est évoquée en une description poétique très concrète, pleine d'un naturalisme sensible et lyrique, faisant de la croix un arbre riche en fruits: "son fruit est éternel et sa racine perpétuelle, son odeur remplit le monde, sa saveur rassasie le fidèle, son éclat dépasse le soleil. . . . "[24]

Cette évocation d'une grande partie des cinq sens, cet intérêt direct pour le monde sensible se retrouve dans d'autres poèmes, et en particulier ceux qui n'offrent aucune image figurée. Le poème II ne représente qu'une croix, mais l'évoque avec lyrisme: "O croix . . . le monde, le vent,

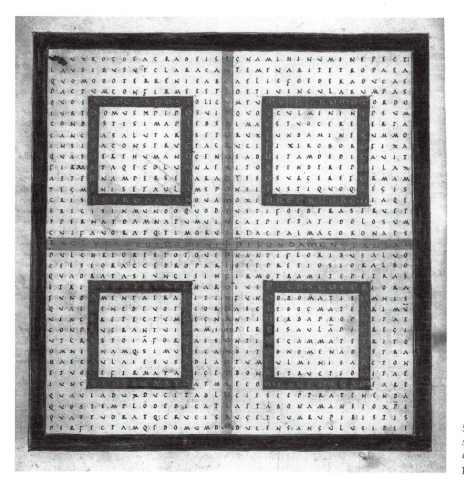

5. Raban Maur, *De laudibus
sanctae crucis* (Amiens),
chapitre 5, les quatre carrés
placés autour de la croix

la mer te proclament sainte; le soleil ici-bas comme les monts, t'honore en te jubilant . . . le cèdre,
la myrrhe, la résine s'effacent devant ton parfum; le nard, le cyprès merveilleux, la résine, l'en-
cens . . . t'exaltent plus qu'eux-mêmes."[25]

De tels effets poétiques sont repris pour deux images d'une abstraction extrême, aux chapitres
V (Fig. 5): "Croix illustre . . . tu es plus belle que la terre entière éclatante de fleurs, plus haute que
le cèdre, plus précieuse que le marbre blanc de Paros,"[26] et au chapitre XIII: "Arbre à l'odeur puis-
sante, aux larges et hautes frondaisons . . . jardin incomparable, opulent, par tes fleurs et tes
feuilles, riche de mille fruits . . . seul arbre pourvu par ta vertu de couleurs variées."[27]

La force de cet appel qui s'adresse aux sens, et se fonde sur les goûts, les saveurs, les odeurs,
pour enrichir les images visuelles, rapproche les textes des images du *De laudibus*. Il faut que les
lettres du texte, qui ne sont que des signes abstraits, fassent apparaître le visible. Il faut que les
formes de l'image, qui est représentation, s'effacent pour faire apparaître l'invisible. Raban fait
aller l'image vers l'invisible, et relie le texte au visible, car ce n'est que par la relation des deux
que le mystère se dessine. Si tout est fait pour que l'on puisse penser les images, il faut aussi que
l'on puisse voir le texte, le texte et l'image se rapprochant ainsi au service d'un but d'ensemble.

Mais d'autres moyens s'ajoutent à cela pour mettre le texte du *De laudibus* au service d'une
perte des repères sensibles. On observe en effet une volonté d'effacer les notions de parcours, de
droite et de gauche, dans la lecture des vers.

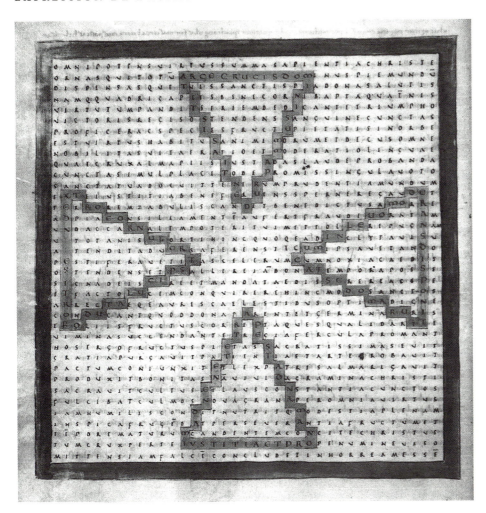

6. Raban Maur, *De laudibus sanctae crucis* (Amiens), chapitre 6, comment les quatre vertus principales sont en rapport avec la croix

C'est déjà le cas dans la nature même des *carmina figurata* choisis par Raban. Le lecteur ne peut pas s'arrêter sur un texte. Car il est mis en présence de l'au-delà du texte, sous la forme du texte dans le texte. Et lorsque la composition qui apparaît dans la page prend la forme de mots (*Adam, Crux salus*, etc.), il y a même texte dans le texte dans le texte. Le texte n'est plus un donné fixe, mais une surface qui se creuse et contient des niveaux plus profonds.

Cette volonté d'une perte des repères sensibles dans la présentation du texte se voit aussi dans la volonté de rupture avec le sens normal de la lecture. Dans tout le poème, la lecture suit bien sûr l'ordre normal de l'écriture en Occident: du haut vers le bas, et de la gauche vers la droite; ceci rappelant que l'écriture garde de façon conventionnelle une modalité d'inscription dans l'espace. C'est en respectant ces deux directions que se lisent les textes inscrits dans les figures abstraites. Mais les trois derniers poèmes, pour les compositions figurées desquels nous avons noté un aboutissement vers l'abstraction la plus grande, font un choix analogue pour la lecture des vers inscrits dans l'image. Dans le poème XXVI en effet (Fig. 8), une seule des deux dimensions (verticale ou horizontale) de la croix suffit, quelle qu'elle soit, pour lire le vers, car c'est le même vers qui y est inscrit deux fois. Dans le poème XXVII (Fig. 9), on reprend le même principe, mais encore accentué, en deux vers: le premier se lit dans la verticale, le second dans l'horizontale. Mais le second est l'inverse du premier, ce qui fait que le second se lit aussi quand on lit le premier de

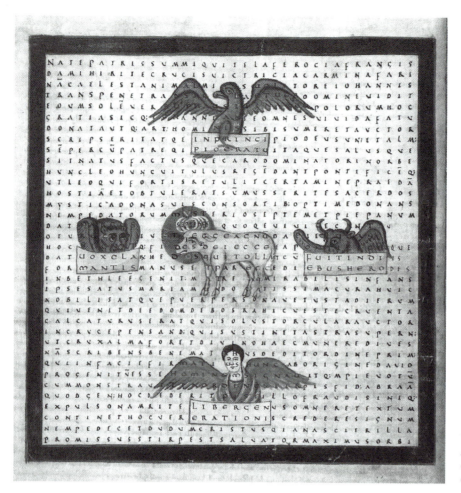

7. Raban Maur, *De laudibus sanctae crucis* (Amiens), chapitre 15, les quatre évangélistes et l'agneau

bas en haut, et le premier se lit aussi quand on lit le second de droite à gauche (Fig. 11). Dans la verticale, on lit le premier vers à l'aller, le second au retour, dans l'horizontale le second à l'aller, le premier au retour. Une seule des deux dimensions de la croix suffit, car les deux vers s'y trouvent. Enfin, dans le poème XXVIII (Fig. 10), le dernier du traité, un vers unique est présent dans les deux bras axes de la croix. Mais il se lit en palindrome, c'est-à-dire à l'endroit comme à l'envers: *Oro te ramus aram, ara sumar et oro* (O bois, je t'implore, toi qui es autel, et j'implore d'être emporté sur ton autel). Une seule des deux dimensions de la croix suffit pour lire le vers, mais en plus on perd même le sens de lecture, qui ne compte plus. Haut, bas, droite, gauche, aucune importance pour lire.

Cette perte des repères spatiaux pour exprimer l'invisible à travers le visible correspond à cette quête de l'au-delà qu'exprime Raban: citons la *declaratio* du poème II: "Cette figure montre la croix du Christ: par ses quatre branches, elle embrasse tout, aux cieux, sur terre et sous terre, c'est-à-dire le visible et l'invisible, l'animé et l'inanimé."[28] Et le poème XI: "A partir de l'invisible, la sainte gloire de la croix resplendit."[29]

Ce choix de Raban n'est peut-être pas sans rapport avec les *Libri carolini*, rédigés à la fin du VIIIe siècle, et qui insistent sur la distance immense qu'il y a entre les images faites de main

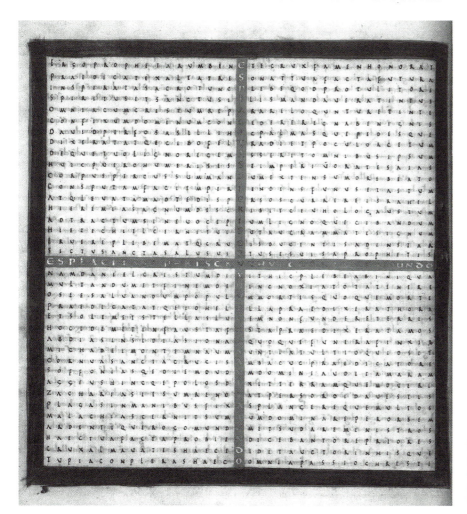

8. Raban Maur, *De laudibus sanctae crucis* (Amiens), chapitre 26, les paroles des prophètes à propos de la Passion du Christ

d'homme et le mystère de la Croix: "C'est par la croix, et non par des peintures que les prisons de l'enfer ont été vidées . . . ce n'est pas quelque image matérielle, mais le mystère de la croix du Seigneur qui est l'étendard que nous devons suivre."[30]

Cela est tout à fait en rapport avec la position de Raban sur la prééminence des mots sur les images: "The sign of writing is worth more than the form of an image and offers more beauty to the soul than the false picture with colours, which does not show the figure of things correctly."[31] Mais si le *De laudibus* occupe autant une place à part, pour l'expression de l'espace, dans le livre enluminé de l'époque carolingienne,[32] c'est sans doute aussi parce que le thème retenu—la croix—n'est pas une image comme une autre.[33]

Plus que rapprocher ce choix de Raban des positions de l'Occident carolingien face aux débats sur l'iconoclasme,[34] nous voudrions cependant le relier à la théologie négative, et à l'abandon des dimensions et des directions du monde sensible. A propos de la situation des quatre animaux cités par Jean autour du trône de l'Apocalypse, Raban précise: "Lorsque Jean dit qu'ils sont quatre animaux autour du trône, je pense que, par là, il ne veut rien signifier d'autre que" dans les quatre

9. Raban Maur, *De laudibus sanctae crucis* (Amiens), chapitre 27, les paroles des apôtres sur la Passion du Christ

parties "c'est-à-dire l'avant, l'arrière, la droite et la gauche, pour autant que son expression ait valeur de localisation, mais quelque chose de ce genre ne peut être défini sans référence à un lieu."[35]

C'est dans la théologie chrétienne de Clément d'Alexandrie, marquée fondamentalement par le platonisme, en particulier dans le cinquième livre des *Stromates*, que nous trouvons une des plus claires expressions de cet abandon des repères spatiaux du monde sensible: "Figure, mouvement, repos, trône, lieu, droite, gauche du Père de tous les êtres, il ne faut pas du tout en concevoir l'idée, même si cela est écrit. . . . Non, la cause première n'est pas dans un lieu, elle est au-dessus du lieu, temps. . . . Car l'objet de la recherche est sans forme et invisible."[36]

Cette volonté de Clément de partir des objets, puis de retrancher les qualités physiques des corps, d'enlever la profondeur, puis la largeur et la longueur, de dépasser la droite et la gauche, la figure, le lieu, le temps, le nom, développée dans le même chapitre des *Stromates*,[37] semble bien définir la méthode choisie par Raban. La séquence des images du *De laudibus* s'inscrit dans ce que Pierre Hadot préfère appeler plutôt apophatisme que théologie négative,[38] mode de connaissance qui remonte du complexe au simple, et de la réalité visible aux réalités invisibles qui la fondent.[39]

10. Raban Maur, *De laudibus sanctae crucis* (Amiens), chapitre 28, l'adoration de la croix

Le *De gradibus humilitatis* de Bernard de Clairvaux

Le second exemple que nous voulons présenter est l'illustration du *De gradibus humilitatis* de Bernard de Clairvaux, dans le manuscrit de l'abbaye bénédictine d'Anchin, réalisé vers 1165 (Fig. 12). Nous avons eu l'occasion de proposer une interprétation de cette enluminure majeure.[40] Nous voudrions reprendre ici l'étude de cette œuvre, et montrer qu'elle constitue une véritable exégèse visuelle, par la reprise des notions paradoxales de l'analogie de la voie et du but, du cheminement par la direction du regard, de la conversion comme retournement, et du contre-modèle comme élément cohérent d'une théorie du salut.

Dans le manuscrit de la bibliothèque de Douai, qui constitue la plus ancienne collection

11. Raban Maur, *De laudibus sanctae crucis* (Amiens), ordre de lecture des poèmes inscrits dans les chapitres 26, 27, 28 (schéma C. Heck, d'après les dessins de Migne, PL 107:251–62)

12. Saint Bernard, *De gradibus humilitatis*, Anchin, vers 1165. Douai, Bibliothèque Municipale, Ms. 372-I, f. 100, l'échelle de Jacob comme échelle d'humilité et d'orgueil

d'œuvres de Saint Bernard, notre enluminure se trouve au début du *De gradibus humilitatis*.[41] Ce traité de Bernard constitue un commentaire du chapitre sept de la *Règle* de Saint Benoît, dans lequel celui-ci fonde une présentation des degrés d'humilités, conçus comme une échelle, sur une exégèse du récit de l'échelle de Jacob de Genèse 28.[42] L'enluminure d'Anchin se fonde sur l'échelle de Jacob, mais ce thème ne suit pas sa forme habituelle. L'échelle possède douze échelons—ce qui renvoie aux douze degrés présentés par Saint Benoît—et elle se développe entre deux demi-cercles dans lesquels se trouve Jacob endormi en bas, avec dans le phylactère une paraphrase de Genèse 28:16 ("En vérité ce lieu est saint"), et le Christ au sommet, entre Saint Benoît à gauche et Saint Bernard à droite. Les échelons sont occupés par huit anges dont quatre montent et quatre descendent. Au bas de l'échelle, un diable brandit une hache de façon menaçante, et se saisit de la tête de l'ange descendant le plus proche du sol. Ce diable, le principal élément inhabituel de l'image, avait en général été interprété comme un ennemi des anges.

Il faut en fait situer cette enluminure à la fois dans le texte de Bernard,[43] et dans la totalité du folio. Bernard commente les degrés d'humilité, puis décrit les degrés d'orgueil. Et le chapitre neuf du traité, qui se trouve entre ces deux parties, précise l'articulation des deux séries de degrés. Il y a une voie qui monte, et une voie qui descend, une voie de la vérité et une voie du mensonge, mais elles ne forment qu'une voie: "la même route mène à la ville et en part; une seule porte forme l'entrée et la sortie de la maison; Jacob vit les anges monter et descendre par la même échelle."[44] Pour Bernard, si nous désirons retourner à la vérité, nous n'avons pas à chercher un nouveau chemin, mais le même que celui par lequel nous sommes descendus. En revenant sur nos pas, nous pouvons monter par humilité les mêmes échelons que ceux que nous avons descendus par orgueil, et ainsi ce qui était le douzième degré d'orgueil, descendant, est le premier d'humilité si l'on monte; le onzième devient le second, le dixième le troisième, énumération que le texte continue jusqu'au premier qui devient le douzième.[45]

Or cette double liste des degrés est exprimée graphiquement dans des manuscrits du XIIe siècle. La *capitulatio*, qui regroupe les sous-titres ou *capitula* du traité, est souvent disposée comme un texte normal. Mais les *capitula* présentent aussi parfois en deux colonnes parallèles les degrés d'orgueil et ceux d'humilité. C'est le cas dans le manuscrit d'Anchin, et nous voyons immédiatement à gauche de l'enluminure, sur le même folio, et sous la *retractatio*, la *capitulatio* sous forme de tableau en deux arcades. A gauche, sous le titre *gradus ascendenti*, sont les douze degrés d'humilité. A droite, sous les mots *gradus descendenti*, les degrés d'orgueil. Mais l'écriture ne suit pas l'ordre du traité, mais le contenu symbolique des chapitres. Les degrés d'orgueil sont présentés du haut vers le bas, comme on descend ces degrés. Mais les degrés d'humilité sont présentés du bas vers le haut, la disposition "calligraphique" étant ainsi en accord avec le sens théologique.[46] Mais surtout cette disposition visualise l'accord des degrés défini dans le texte de Bernard: le douzième degré d'orgueil, dans la descente, est en contact avec le premier degré d'humilité si l'on monte; le onzième d'orgueil correspond au second d'humilité, et ainsi de suite.

La *capitulatio* et l'enluminure, placées côte à côte, s'éclairent mutuellement. Les anges qui montent illustrent la colonne des degrés d'humilité, et les anges qui descendent celle des degrés d'orgueil. Trois éléments confirment cette interprétation. Le premier est l'inscription sur le phylactère de l'ange qui descend, et est placé en haut de l'échelle. Les mots "Ponam sedem meam ad aquilonem, et ero similis excelso" (J'installerai mon siège au nord, je serai semblable au Très Haut), sont une paraphrase d'Esaïe 14:12–15, que Bernard cite par ailleurs au chapitre dix du *De gradibus humilitatis*, et que les théologiens ont compris comme une évocation de la volonté

d'orgueil de Lucifer, qui sera jeté dans l'abîme, avec les anges rebelles, pour avoir voulu dépasser Dieu.[47] Le second élément est le fait que les anges qui montent ont une auréole, alors que ceux qui descendent n'en ont pas. Le troisième élément est une tradition exégétique. Dans son traité sur les psaumes, Saint Jérôme, à propos du Psaume 91, compare la croix du Christ à l'échelle de Jacob, et interprète les anges qui montent comme les Gentils, et ceux qui descendent comme les Juifs.[48] L'interprétation est reprise au IXe siècle par Gérard de Csanád.[49] Le commentaire du Psaume 119, par Jérôme, va plus loin. Il rappelle l'échelle de Jacob, et interprète les anges qui montent comme les saints qui vont de la terre au ciel, et les anges qui descendent comme les diables, les démons et leurs troupes, précipités depuis le ciel.[50]

L'enluminure du manuscrit d'Anchin ne représente donc pas l'échelle des degrés d'humilité, mais simultanément l'échelle d'humilité et l'échelle d'orgueil, qui forment une seule voie, selon le texte de Bernard. Et comme le Christ accueille les anges qui montent, le diable reçoit comme nouveaux compagnons les anges qui descendent. Mais cette enluminure exprime aussi avec clarté une topographie spirituelle, une géographie paradoxale du salut. Bien sûr, le haut et le bas sont pris comme symboles de morale et de spiritualité, avec des valeurs respectivement positive, pour le haut, et négative pour le bas. Mais cette image exprime la quête spirituelle plus comme direction que comme déplacement. Quel que soit le niveau où il se trouve, l'homme sera sur un degré d'humilité s'il est tourné vers la vertu, sur un degré d'orgueil s'il est orienté vers le mal. Passer d'un degré d'orgueil à un degré d'humilité ne se fait pas en allant ailleurs, mais en se tournant dans l'autre direction. Le sens profond de la conversion est parfaitement exprimé par cette image. Une conversion est un retournement, un changement complet de direction. Une logique intellectuelle mettrait ces deux échelles une au-dessus de l'autre. L'homme pourrait commencer à monter l'échelle d'humilité lorsqu'il a fini de remonter tous les degrés de l'échelle d'orgueil. Et c'est d'ailleurs ainsi que cette double série des degrés, du texte du *De gradibus humilitatis*, est représentée dans une image du XVIIe siècle qui se fonde, comme son titre l'indique, sur le texte de Bernard, mais qui ne comprend plus sa logique de spiritualité monastique.[51] Mais dans l'enluminure d'Anchin tout se passe dans le même endroit, il n'y a rien à quitter, et l'homme s'éloigne du mal en opérant un demi-tour complet, de 180 degrés.

On comprend mieux ainsi le sens des images, en particulier à l'époque romane, qui représentent le monde infernal comme l'envers du monde céleste. C'est le cas sur le dessin de Heilsbronn, du dernier quart du XIIe siècle, des *Deux voies de la vie humaine*, qui mènent l'une au ciel l'autre en enfer: la ville qui représente le monde infernal est l'image inversée de la cité céleste.[52] Le monde du mal n'est pas le désordre, mais le contraire de l'ordre. Si c'était un désordre aléatoire, retrouver la bonne direction serait particulièrement difficile. Mais ainsi, celui qui s'y trouve, s'il fait un retournement complet, à 180 degrés, se place aussitôt dans la bonne direction. Ce monde à l'envers est un contre-modèle, mais ce contre-modèle est, comme le modèle, un élément cohérent d'une théorie du salut.

L'autre élément important est que l'échelle, qui appelle une montée, un déplacement, est en même temps comprise comme le signe d'une direction. Ce n'est pas le niveau apparent qui compte. L'ange situé tout en bas, à gauche, et qui monte, est pourtant plus haut spirituellement que les anges situés plus haut sur l'enluminure, et qui descendent vers le diable. L'important n'est pas le déplacement, mais l'attitude intérieure. Car la montée de l'échelle est de toute façon impossible. Pour Bernard, dans le *De consideratione*, "Elève-toi, si tu peux, à un degré plus haut encore, et Dieu montera d'autant."[53] Car, encore pour Bernard, "Le fruit du savoir n'est pas dans

ce qui est connu, mais dans l'acte de comprendre."[54] Et il dit encore plus clairement, toujours dans le *De consideratione*, "Ce qui est au-dessus de nous n'exige pas une action de notre part, mais un regard."[55]

L'enluminure d'Anchin est ainsi en parfait accord avec la théologie de Bernard, et unit de façon paradoxale le thème de l'échelle, invitation apparente à se déplacer d'un niveau vers un autre, et celui de la montée par le regard. Comme chez Raban, l'espace sensible dans lequel nous vivons n'est pas le modèle de l'espace de la spiritualité. Grégoire le Grand avait clairement formulé que le "lieu" où se trouve un homme ne dépend pas de son déplacement dans l'espace: "Nous nous "tenons" là où nous fixons les yeux de l'âme."[56] L'espace de la spiritualité, ici aussi, a perdu les caractères de l'espace sensible.

L'*Itinerarium mentis in Deum* de Bonaventure

Nous voudrions enfin évoquer, plus rapidement et pour terminer, un troisième exemple, à partir de l'œuvre de Bonaventure, et d'images créées à une époque où l'art manifeste un intérêt nouveau pour le monde sensible, et pour la reproduction de l'apparence. Nous l'illustrerons par les enluminures du "trône de charité" réalisées au XIVe siècle à partir de textes de Bonaventure. Elles montrent comment la théologie bonaventurienne de la hiérarchisation de l'âme permet de donner à l'expression de l'espace sensible une signification intérieure.

La théorie de la hiérarchisation de l'âme est essentielle chez Bonaventure.[57] Elle s'inscrit dans un système de remontée, de degré en degré, vers Dieu, pour refaire en sens inverse le chemin que Adam a descendu. L'*Itinerarium mentis in Deum*, rédigé en 1259, contient l'une des plus belles formulations de cette pensée,[58] et propose "six degrés d'illumination qui partent des créatures et conduisent jusqu'à Dieu."[59] Bonaventure utilise ici les idées de montées, de s'élever, de rejoindre un "sommet,"[60] mais ces notions sont intériorisées. L'âme est appelée à retrouver les vertus qu'elle a perdues, et par là des degrés se forment en elle. Ces degrés d'élévation dans l'âme correspondent à six degrés de fonctions (les sens, l'imagination, la raison, l'intellect, l'intelligence, et la cîme de l'âme).[61] Mais cette opération donne à l'intérieur de l'âme un ordre analogue à celui des ordres angéliques qui organisent le cosmos: "Ainsi disposé, notre esprit est hiérarchisé dans ses degrés d'élévation et rendu conforme à la Jérusalem d'en haut. . . . Il ressemble alors aux neuf chœurs des anges, dont il assume intérieurement tour à tour les fonctions. . . . Ainsi pourvue, lorsqu'elle entre en elle-même, l'âme entre dans la Jérusalem céleste. . . . "[62] Cette hiérarchie rétablie dans l'âme est aussi en accord avec la suite des neuf degrés du retour vers Dieu définis dans le *In Hexaemeron*.[63] Le déplacement à l'intérieur de soi est assimilé à un déplacement dans le cosmos, et cette hiérarchisation de l'âme définit ainsi une cosmologie "en l'homme."

Les illustrations du "trône de charité," fondées sur un texte de Bonaventure, sont un bon exemple de cette intériorisation des notions spatiales. On sait que le thème iconographique du "trône de charité," selon l'expression utilisée dans les manuscrits enluminés, est présent dans le Psautier de Bonne de Luxembourg, vers 1345–1350,[64] et dans les Petites Heures du duc de Berry, vers 1385–1390.[65] Nous ne reprendrons pas ici l'étude de ce thème complexe, sinon pour rappeler qu'il est issu à la fois des images du trône de Salomon, et des enluminures créées vers 1300 dans des version du *Speculum theologie*.[66] Rappelons aussi que le texte qui accompagne ces deux images du trône de charité reprend un passage du *De triplici via*, de Bonaventure, écrit vers 1260–1270, texte dans lequel les six degrés du trône de Salomon signifient six degrés d'amour,

dont l'ascension progressive permet de se rapprocher de Dieu.[67] La montée de l'âme vers Dieu, qu'elle soit directement représentée comme dans le Psautier de Bonne de Luxembourg, ou qu'elle soit montrée indirectement à travers les six vertus successives qu'elle doit réaliser, comme dans les Petites Heures du duc de Berry, prend la forme d'une montée de l'âme dans les niveaux de l'espace cosmique. Mais la théologie de Bonaventure fait de cette ascension un voyage intérieur, un déplacement de l'âme à l'intérieur d'elle-même, dans les degrés qu'elle a rétablis en elle.

Nous n'avons pas le temps de montrer ici comment cette théologie d'une géographie chrétienne de l'âme et du monde, chez Bonaventure, est en parallèle avec la théologie bonaventurienne de l'histoire. De la même manière qu'elle est franchissement des espaces, la remontée est accomplissement dans le temps, *regressus*, retour, qui rachète l'*egressus*, la sortie. Joseph Ratzinger a bien montré comment Bonaventure, en ce sens, est le seul théologien majeur de la scolastique qui tente une synthèse entre la pensée "historico-symbolique" de l'âge monastique et la pensée conceptuelle et abstraite de la scolastique.[68]

Nous avons évoqué plus haut comment les notions de droite et de gauche, de mouvement, finissent par disparaître dans la topographie spirituelle de Raban Maur ou de Bernard. La manière dont Bonaventure évoque Ephésiens 3:18 rejoint ce dépassement des notions spatiales.[69] Dans ce verset, Paul annonce "vous recevrez la force de comprendre, avec tous les saints, ce qu'est la largeur, la longueur, la hauteur et la profondeur." Paul réutilise ici une énumération de quatre termes qui désignaient, dans la philosophie stoïcienne, la totalité de l'univers. Et il s'en sert pour présenter le rôle universel du Christ dans le salut du monde. Bonaventure, dans l'*Itinerarium*, cite les quatre notions de ce verset pour évoquer le mariage mystique de l'âme: "Soyons donc enracinés et fondés dans la charité. Nous pourrons alors comprendre avec tous les saints la longueur de l'éternité, la largeur de la libéralité, la hauteur de la majesté, et la profondeur de la sagesse du souverain juge."[70] C'est chez Bernard que nous avons trouvé la source de ce passage de Bonaventure. Bernard termine le *De consideratione* par un commentaire d'Ephésiens 3:18, et fait de ces quatre notions sur les dimensions de l'univers les symboles de quatre formes de contemplation: Dieu est longueur, largeur, hauteur, profondeur. Mais par longueur il faut comprendre éternité, par largeur la charité, par hauteur la puissance de Dieu, par profondeur sa sagesse.[71] Il s'agit bien d'une "longueur sans extension, largeur sans distension," car "il excède les étroites limites du temps et du lieu, mais par la liberté de sa nature, non par l'énormité de sa substance."[72]

La théologie de Bonaventure n'est pas celle de Bernard, et les images de ces manuscrits gothiques ne sont absolument plus celles du XIIe siècle. Mais dans les deux cas, et comme pour les choix de Raban Maur dans le *De laudibus sanctae crucis*, nous sommes en présence des conventions d'un système pictural qui fonctionne en parallèle avec un système théologique. La droite et la gauche, la montée et la descente, la verticale et l'horizontale, le déplacement vers un but apparent présents dans ces images ne peuvent être compris que dans une théologie qui veut remonter du fini vers l'infini, du visible vers l'invisible, et de la longueur, la largeur, la hauteur et la profondeur vers le dépassement de toutes dimensions.

Notes

1. Pour de très nombreux autres exemples, voir F. P. Dutripon, *Concordantiae Bibliorum Sacrorum, Vulgatae Editionis* (Paris, rééd. 1844) à *altus, ascendo, dexter, incurvo, sinister*, etc.

2. Nous partageons tout à fait, sur la conscience corporelle de l'espace, les observations essentielles de P. Zumthor, *La Mesure du monde: Représentation de l'espace au Moyen Age* (Paris, 1993), 18–21.

3. Voir Bernard de Clairvaux, *Sermons sur le Cantique des Cantiques*, sermon 24, dans *Sermons sur le Cantique*, éd. P. Verdeyen et R. Fassetta, t. 2, SC 431 (Paris, 1998), 246–57; et C. Heck, *L'Echelle céleste dans l'art du Moyen Age: Une image de la quête du ciel* (Paris, 1997), 249–51.

4. Voir, par exemple, *Vocabulaire de théologie biblique*, dir. X. Leon-Dufour (Paris, 1962), notices "Ascension," "Ciel," "droite," "porte," etc.

5. Voir Y. Christe, "L'Emergence d'une théorie de l'image dans le prolongement de Rm 1, 20 du IXe au XIIe siècle en Occident," dans *Nicée II, 787–1987: Douze siècles d'images religieuses, Actes du colloque de Paris 1986*, éd. F. Boespflug et N. Lossky (Paris, 1987), 303–11; et surtout, désormais, J. Hamburger, "Speculations on Speculation: Vision and Perception in the Theory and Practice of Mystical Devotion," dans *Deutsche Mystik im abendländlischen Zusammenhang: Neu erschlossene Texte, neue methodische Ansätze, neue theoretische Konzepte*, Kolloquium Kloster Fischingen 1998, éd. W. Haug et W. Schneider-Lastin (Tübingen, 2000), 353–408.

6. Nous utilisons dans ce travail le terme "image" dans le sens d'œuvre d'art, de représentation figurée.

7. Par exemple, sur le symbolisme de la porte et du seuil, voir R. Favreau, "Le Thème épigraphique de la porte," dans *La Façade romane: Actes du colloque de Poitiers, 1990*, CahCM 34 (1991), 267–79, et W. Sauerländer, "Façade ou façades romanes," dans *La Façade romane*, 398–400.

8. Voir entre autres A. Grabar, "Plotin et les origines de l'esthétique médiévale," CahArch 1 (1945), 15–34, repris dans *Les Origines de l'esthétique médiévale* (Paris, 1992), 29–87.

9. Sur ces questions de l'expression, dans l'art médiéval, de l'invisible à travers le visible, nous ne pouvons pas citer toute la bibliographie. Mais il faut rappeler le recueil récent et fondamental de H. L. Kessler, *Spiritual Seeing: Picturing God's Invisibility in Medieval Art* (Philadelphia, 2000).

10. Nous disposons désormais d'une excellente édition critique, *Rabani Mauri In honorem sanctae crucis*, éd. M. Perrin, CCCM 100 (Turnhout, 1997), qui contient également la traduction française des *carmina figurata*, et est accompagnée d'un volume annexe (CCCM 100A) contenant les reproductions en couleurs des *carmina figurata* du Ms. Vatican Reginensis 124. Une édition antérieure est également extrêmement utile: Raban Maur, *Louanges de la sainte croix*, éd. M. Perrin (Paris, 1988). Elle contient entre autres la reproduction en couleurs des *carmina figurata* du manuscrit Amiens 223, mais aussi le texte français de la totalité de l'ouvrage: soit la traduction des deux dédicaces principales, du prologue, de la préface, des *carmina figurata*, mais aussi des *declarationes*, et des transcriptions en prose du livre II. Les autres bases de l'étude du *De laudibus* se trouvent dans M. Perrin, "Le *De laudibus sanctis crucis* de Raban Maur et sa tradition manuscrite au IXe siècle," *Revue d'histoire des textes* 19 (1989), 191–251; K. Holter, *Hrabanus Maurus, Liber de laudibus sanctae crucis . . . Codex Vindobonensis 652 der Österreichischen Nationalbibliothek*, 2 vol. (Graz, 1972–1973); H. G. Müller, *Hrabanus Maurus, De laudibus sancta crucis: Studien zur Überlieferung und Geistes-*

geschichte mit dem Faksimile-Textabdruck aus Codex Reg. lat. 124 der vatikanischen Bibliothek (Ratingen, 1973); et dans M. C. Ferrari, *Il Liber sanctae crucis di Rabano Mauro: Testo, immagine, contesto*, Lateinische Sprache und Literatur des Mittelalters 30 (Berne, Berlin, Francfort, New York, Paris et Vienne, 1999). Pour une bibliographie, voir les éditions citées de Michel Perrin.

11. Selon l'édition critique, CCCM 100 (cité note 10), xxvi–xxix, le meilleur titre à retenir serait en fait *In honorem sanctae crucis*. Nous utilisons cependant ici le titre qui reste le plus employé.

12. Pour l'histoire du poème figuré, voir U. Ernst, *Carmen figuratum: Geschichte des Figurengedichts von den antiken Ursprüngen bis zum Ausgang des Mittelalters* (Cologne, Weimar et Vienne, 1991); et P. Zumthor, *Langue, texte, énigme* (Paris, 1975), 25–35.

13. Perrin, *Louanges* (cité note 10), 18. Pour les différentes formes prises par le thème de la croix dans le *De laudibus*, et leurs relations à des formes du Haut Moyen Âge, voir B. Reudenbach, "Das Verhältnis von Text und Bild in *De laudibus sanctae crucis* des Hrabanus Maurus," dans *Geistliche Denkformen in der Literatur des Mittelalters*, Münstersche Mittelalter-Schriften 51, éd. K. Grubmüller, R. Schmidt-Wiegand et K. Speckenbach (Munich, 1984), 282–320. Pour un nouvel intérêt pour la copie du poème de Raban au XVe siècle, voir R. Suckale, "Das geistliche Kompendium des Mettener Abtes Peter: Klosterreform und Schöner Stil um 1414/15," *Anzeiger des Germanischen Nationalmuseums* (1982), 7–22. Pour la reprise post-médiévale, surtout au XVIIe siècle, de poèmes dont la calligraphie ou la typographie suit le schéma de la croix, voir U. Ernst, "Die neuzeitliche Rezeption des mittelalterlichen Figurengedichts in Kreuzform: Präliminarien zur Geschichte eines textgraphischen Modells," dans *Mittelalter-Rezeption: Ein Symposium*, Germanistische Symposien Berichtsbände 6, éd. P. Wapnewski (Stuttgart, 1986), 177–233. Pour les miniatures allégoriques accompagnant d'autres œuvres de Raban, et d'un esprit bien différent, voir M. Reuter, *Text und Bild im Codex 132 der Bibliothek von Montecassino, "Liber Rabani de originibus rerum": Untersuchungen zur mittelalterlichen Illustrationspraxis*, Münchener Beiträge zur Mediävistik und Renaissance-Forschung 34 (Munich, 1984). Pour un autre exemple du rapport de Raban au temps, voir V. Frandon, "Les Saisons et leurs représentations dans les encyclopédies du Moyen Âge: L'Exemple du *De universo* de Raban Maur (1022–1023)," dans *L'Enciclopedismo medievale*, éd. M. Picone (Ravenne, 1994), 55–78.

14. Sur la technique de composition de Raban, voir Müller, *Hrabanus* (cité note 10), 113–21. Pour une courte présentation de l'illustration du poème, voir E. Sears, "Word and Image in Carolingian *Carmina Figurata*," dans *World Art: Themes of Unity in Diversity. Acts of the XXVIth International Congress of the History of Art*, éd. I. Lavin, t. 2 (University Park et Londres, 1989), 341–48.

15. Pour la transcription et l'ordre de lecture de ces "textes dans le texte," voir les schémas publiés par Migne, PL 107:141–262, et repris par Perrin, *Louanges* (cité note 10), 169–229.

16. Il s'agit d'une prière au Christ pour qu'il protège le

pape, "gardien de la sainte Eglise." Sur cette image, voir aussi E. Sears, "Louis the Pious as *Miles Christi:* The Dedicatory Image in Hrabanus Maurus's *De Laudibus Sanctae Crucis,*" dans *Charlemagne's Heir: New Perspectives on the Reign of Louis the Pious (814–840),* éd. P. Godman et R. Collins (Oxford, 1990), 605–28.

17. Voir la liste donnée par Perrin, *Louanges* (cité note 10), 26, et l'édition CCCM (cité note 10), xix–xxvi.

18. "florigeram crucem," *declaratio* XVI; Perrin, *Louanges* (cité note 10), 127; édition CCCM (cité note 10), 134.

19. Sur ce portrait de Raban devant la croix, voir aussi J.-C. Bonne, "L'Image de soi au Moyen Âge (IXe–XIIe siècles): Raban et Godefroy de Saint-Victor," dans *Il ritratto e la memoria: Materiali,* t. 2, éd. A. Gentili et P. Morel (Rome, 1993), 37–60. Pour le développement, à l'époque carolingienne, d'attitudes corporelles nouvelles pour la prière, ainsi chez Raban ou chez Eginhard, voir E. Palazzo, "Les Pratiques liturgiques et dévotionelles et le décor monumental dans les églises du Moyen Age," dans *L'Emplacement et la fonction des images dans la peinture murale du Moyen Age: Actes du 5ème séminaire international d'art mural, Saint-Savin, 16–18 septembre 1992,* éd. P. Klein (Saint-Savin, 1992), 45–56.

20. Edition Perrin, *Louanges* (cité note 10), 43.

21. *Carmen figuratum* VI; Perrin, *Louanges* (cité note 10), 59.

22. *Declaratio* XVI; Perrin, *Louanges* (cité note 10), 127.

23. *Carmen figuratum* I; Perrin, *Louanges* (cité note 10), 49.

24. *Declaratio* VI; Perrin, *Louanges* (cité note 10), 113.

25. *Carmen figuratum* II; Perrin, *Louanges* (cité note 10), 51.

26. *Carmen figuratum* V; Perrin, *Louanges* (cité note 10), 57.

27. *Carmen figuratum* XIII; Perrin, *Louanges* (cité note 10), 73.

28. *Declaratio* II; Perrin, *Louanges* (cité note 10), 107.

29. *Carmen figuratum* XI; Perrin, *Louanges* (cité note 10), 69.

30. *Libri carolini,* II, 28. MGH, *Leges* III, *Concilia,* t. 2, *Supplementum,* éd. H. Bastgen (Hanovre et Leipzig, 1924), 89; traduction dans D. Menozzi, *Les Images: L'Eglise et les arts visuels* (Paris, 1991), 106.

31. MGH, *Poetae latini aevi Carolini,* éd. E. Dümmler, t. 2 (Berlin, 1884), 196. Cité par H. L. Kessler, "*Facies bibliothecae revelata:* Carolingian Art as Spiritual Seeing," dans *Testo e immagine nell'alto medioevo* (Spolète, 1994), t. 2, 537, repris dans Kessler, *Spiritual Seeing* (cité note 9), 150, avec bibliographie.

32. Pour les choix majeurs de l'enluminure carolingienne en ce domaine, voir M. S. Bunim, *Space in Medieval Painting and the Forerunners of Perspective* (New York, 1940), 44–61.

33. Sur les raisons particulières qui facilitent, dès l'époque carolingienne, le refus de l'assimilation de la croix aux images (forme géométrique simple tendant à devenir symbole aniconique; lien à la fonction de reliquaire ou de custode; lien entre "signe de croix" et geste de bénédiction), voir J. Wirth, *L'Image à l'époque romane* (Paris, 1999), 50–52.

34. Voir entre autres C. Heitz, "L'Image du Christ entre 780 et 810, une éclipse?" dans *Nicée II* (cité note 5), 229–46.

35. *Declaratio* XV; Perrin, *Louanges* (cité note 10), 125.

36. *Stromate* V, chap. XI, 71.4–5; Clément d'Alexandrie, *Les Stromates, Stromate* V, éd. A. Le Boulluec et P. Voulet, SC 278–279, 2 vol. (Paris, 1981) t. 1, 145.

37. *Stromate* V, 71; édition citée note 36, t. 1, 143–45, et t. 2, 244–47.

38. P. Hadot, "Apophatisme et théologie négative," dans, du même, *Exercices spirituels et philosophie antique,* 2e éd. (Paris, 1987), en particulier 187 pour la tradition platonicienne de la méthode aphairétique chez Albinus et Clément d'Alexandrie.

39. Voir aussi *Dictionnaire de spiritualité ascétique et mystique,* éd. M. Viller, article "Néant," t. 11 (Paris, 1982), 64–80, et article "Théologie négative," t. 15 (Paris, 1991), 509–16.

40. Heck, *L'Echelle céleste* (cité note 3), 78–83.

41. Sur ce manuscrit, voir W. Cahn, *Romanesque Manuscripts: The Twelfth Century,* Survey of Manuscripts Illuminated in France (Londres, 1996), t. 2, 146–47, no. 122. Sur l'enluminure que nous analysons, voir aussi W. Cahn, "Bernard and Benedict: The Ladder Image in the Anchin Manuscript," *Arte medievale* 8, no. 2 (1994), 33–45.

42. Voir *La Règle de saint Benoît,* éd. A. de Vogüé et J. Neufville, t. 1, SC 181 (Paris, 1972), 472–91. Le *De gradibus humilitatis* figure dans l'édition critique, *Sancti Bernardi Opera,* éd. J. Leclercq et H. M. Rochais, t. 3 (Rome, 1963), 13–59.

43. Pour une excellente étude de la structure du traité, voir J. Leclercq, *Recueil d'études sur saint Bernard et ses écrits,* t. 2 (Rome, 1966), 116–23.

44. *De gradibus humilitatis,* IX, 27; *Sancti Bernardi Opera* (cité note 42), 37.

45. *De gradibus humilitatis,* IX, 27; *Sancti Bernardi Opera* (cité note 42), 37.

46. Une disposition analogue se retrouve dans l'échelle-table des matières de *L'Echelle sainte* de Jean Climaque; voir J. R. Martin, *The Illustration of the Heavenly Ladder of John Climacus* (Princeton, 1954), 10, fig. 6–11. Pour les significations de la représentation de l'écrit dans l'image médiévale, voir M. Schapiro, "L'Ecrit dans l'image: Sémiotique du langage visuel," dans *Les Mots et les images: Sémiotique du langage visuel* (Paris, 2000), 125–87. Sur le rapport entre vision et lecture, voir aussi O. Pächt, *L'Enluminure médiévale: Une introduction* (Paris, 1997), chap. 7.

47. Voir par exemple Bernard de Clairvaux, sermon 60 (113), PL 183:684.

48. Saint Jérôme, *Tractatus de Psalmo,* XCI, 187–91; *S. Hieronymi Presbyteri Opera,* pt. 2, *Opera homiletica,* éd. D. G. Morin, CCSL 78 (Turnhout, 1958), 139.

49. Gérard de Csanád, *Deliberatio super hymnum trium puerorum,* VIII, 356–58; *Gerardi Moresenae Aecclesiae seu Csanadiensis Episcopi Deliberatio supra Hymnum Trium Puerorum,* éd. G. Silagi, CCCM 49 (Turnhout, 1978), 144.

50. Saint Jérôme, *Tractatus de Psalmo,* CXIX, 76–79; CCSL 78 (cité note 48), 248.

51. Johann Bussenmacher, *Scala coeli et inferni ex divo Bernardo,* gravure sur cuivre, Cologne, vers 1606–1616;

Die Sammlung der Herzog August Bibliothek in Wolfen-büttel, t. 3, *Theologica, Quodlibetica*, Deutsche illustrierte Flugblätter des 16. und 17. Jahrhunderts 3, éd. W. Harms, M. Schilling, A. Juergens et W. Timmermann (Tübingen, 1989), 198–99, no. 102.

52. Erlangen, Universitätsbibliothek, Ms. 8 (*Lamentations de Jérémie*), f. 130v. Voir E. Lutze, *Die Bilderhandschriften der Universitätsbibliothek Erlangen* (Erlangen, 1936), 4; C. Nordenfalk, "Les Cinq sens dans l'art du Moyen Age," *Revue de l'art* 34 (1976), 19; Heck, *L'Echelle céleste* (cité note 3), 87–88.

53. *De consideratione*, V, 17; *Sancti Bernardi Opera* (cité note 42), t. 3, 481. En attendant la prochaine édition du *De consideratione* dans Sources Chrétiennes, on peut utiliser la traduction française de P. Dalloz (Paris, 1986). Une traduction particulièrement judicieuse et éclairante de passages isolés se trouve dans l'excellent article de B. Michel, "La Philosophie: Le Cas du *De Consideratione*," dans *Bernard de Clairvaux: Histoire, mentalités, spiritualité. Colloque de Lyon-Cîteaux-Dijon*, SC 380 (Paris, 1992), 579–603.

54. *De consideratione*, V, 27; *Sancti Bernardi Opera* (cité note 42), t. 3, 490.

55. *De consideratione*, V, 1; *Sancti Bernardi Opera* (cité note 42), t. 3, 467.

56. "Ibi enim stamus, ubi mentis oculos figimus"; Grégoire le Grand, *Homélies sur Ezéchiel*, II, I, 17, éd. C. Morel, SC 360 (Paris, 1990), 89.

57. E. Gilson, *La Philosophie de saint Bonaventure* (Paris, 1924), 426–34. Voir aussi *Dictionnaire de spiritualité*, article "Bonaventure," t. 1 (Paris, 1937), 1816–18.

58. L'*Itinerarium mentis in Deum* de Bonaventure se trouve dans les *Opera omnia*, t. 5 (Quaracchi, 1891), 295–313. Nous citons la traduction de Duméry, accompagnée du texte latin de l'édition de Quaracchi: Bonaventure, *Itinéraire de l'esprit vers Dieu*, éd. H. Duméry (Paris, rééd. 1990).

59. *Itinerarium*, Prologue, 3, éd. Duméry (cité note 58), 23.

60. *Itinerarium*, I, 8, éd. Duméry (cité note 58), 35.

61. *Itinerarium* I, 6, éd. Duméry (cité note 58), 33.

62. *Itinerarium* IV, 4, éd. Duméry (cité note 58), 77.

63. Voir le tableau des degrés dans Gilson (cité note 57), 435; voir aussi J. Ratzinger, *La Théologie de l'histoire selon saint Bonaventure* (Paris, 1988), en particulier 54.

64. New York, The Metropolitan Museum of Art, The Cloisters, inv. 69.86; le trône de charité est au folio 315. Sur ce manuscrit, voir K. Morand, *Jean Pucelle* (Oxford, 1962), 21–22 et 40; M. Meiss, *French Painting in the Time of Jean de Berry: The Late Fourteenth Century and the Patronage of the Duke* (Londres, 1967), 20, 31, 287, fig. 352–55 et 361; F. Deuchler, "Looking at Bonne de Luxembourg's Prayer Book," *The Metropolitan Museum of Art Bulletin* 29, no. 6 (février 1971), 267–78; F. Avril, *L'Enluminure à la cour de France au XIVe siècle* (Paris, 1978), 20, 35, et pl. 18; *Les Fastes du gothique: Le Siècle de Charles V*, catalogue d'exposition (Paris, Grand Palais, 1981), 315–16, notice 267 par F. Avril; C. Sterling, *La Peinture médiévale à Paris, 1300–1500*, t. 1 (Paris, 1987), 108–13, nr. 13.

65. Paris, B.N.F., Ms. lat. 18014; le trône de charité est au folio 278v. Sur ce manuscrit, voir Meiss, *French Painting* (cité note 64), 155–93, 334–37, et fig. 83–176; Avril, *L'Enluminure* (cité note 64), 20, 37, et pl. 39; *Les Fastes du gothique* (cité note 64), 343–44, notice 297 par F. Avril; Sterling, *La Peinture* (cité note 64), 122–28, nr. 16; et surtout le facsimilé (Lucerne, 1988) et son commentaire par F. Avril, L. Dunlop et Y. Brunsdon, *Les Petites Heures de Jean, duc de Berry: Introduction au manuscrit latin 18014 de la Bibliothèque Nationale* (Paris et Lucerne, 1989).

66. C. Heck, "L'Iconographie de l'ascension spirituelle et la dévotion des laïcs: Le Trône de charité dans le Psautier de Bonne de Luxembourg et les Petites Heures du duc de Berry," *Revue de l'art* 110, no. 4 (1995), 9–22.

67. Voir les *Opera* de Bonaventure, t. 8 (Quarrachi, 1898), 3–27 pour le *De triplici via*, et 10–11 pour le chapitre *De sex gradibus dilectionis Dei*. Sur ce traité, voir J.-F. Bonnefoy, *Une somme bonaventurienne de théologie mystique: le "De triplici via"* (Paris, 1934).

68. Ratzinger, *La Théologie* (cité note 63), 7, 105–7, 160–63.

69. Sur l'apophatisme de Bonaventure et la "claire-ténèbre," voir *Dictionnaire de spiritualité*, article "Bonaventure," t. 1 (Paris, 1936), 1835–38.

70. *Itinerarium*, IV, 8, éd. Duméry (cité note 58), 81.

71. *De consideratione*, V, 28; *Sancti Bernardi Opera* (cité note 42), 491.

72. Idem (*De consideratione*, V, 28); voir Michel, "La Philosophie" (cité note 53), 593–95, pour l'analyse de ces notions: les propriétés divines sont indépendantes de ce qu'elles mesurent dans l'espace ou dans le temps.

Typology and Its Uses in the Moralized Bible

Christopher Hughes

In memory of Harvey Stahl, 1941–2002

In the first half of the thirteenth century a series of manuscripts were produced which have since acquired the name of *Bibles moralisées*, or moralized Bibles.[1] This modern title has a medieval origin—it is derived from an explanatory note found at the beginning of a fifteenth-century, un-illustrated copy of the manuscript.[2] There, an anonymous introduction sets forth the work's guiding exegetical principles: the Bible is to be interpreted according to the four senses of Scripture—a practice that would have seemed conservative in the fifth, let alone the fifteenth, century. The introduction closes with a description of the book's contents: it "tells in a few words all the stories found in the Bible, each of which is accompanied by a short *moralitez*," hence the modern term *Bible moralisée*. It is true that the moral, or tropological, sense of Scripture figures largely in the four thirteenth-century copies of the manuscript—its glosses speak frankly about contemporary matters such as proper social behavior and religious comportment. However, the manuscript does not emphasize the moral sense at the expense of the other three, and the fifteenth-century redactor's choice of the word *moralitez* perhaps reveals a lazy allusion to the interpretive style of such other late medieval works as the *Ovide moralisé*.[3]

A glance at a folio from the book of Genesis (Fig. 1), which illustrates the Sacrifice of Isaac in the two bottom right roundels, gives a better sense of the original moralized Bible's exegetical caste of mind. A titulus to the left of the uppermost of the two paraphrases the biblical narrative of Abraham leading his son Isaac to be sacrificed according to God's command. In the roundel to the right of the titulus are depicted God sending Abraham along and Isaac carrying wood to the awaiting altar. Following the organizing principle of the moralized Bible, both biblical text and image are glossed below—which is to say the lower titulus and image seek to elucidate the upper ones. The titulus explains how God, like Abraham, willingly offered his son in sacrifice, and the image shows Christ carrying the cross, which is held in such a way as to mirror the bundles of wood carried by Isaac above. After studying the paired texts and images, it becomes clear that they relate to each other in a typological way, or to be more precise, the lower set performs a typological interpretation of the upper set.

By typology, I mean in a narrow sense the venerable mode of scriptural exegesis that discovers structural analogies among the events and personages of the Old and New Testaments, and in

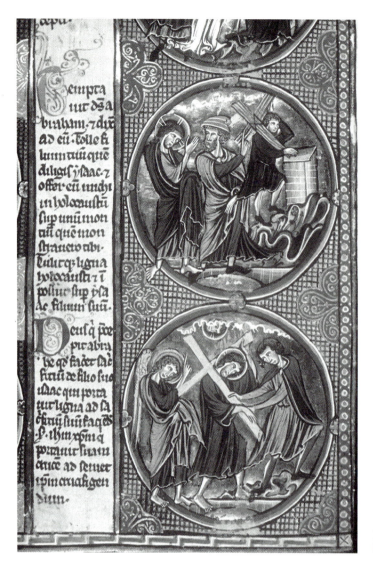

1. Moralized Bible, ca. 1240. Oxford, Bodleian Library, Ms. 270b, f. 15v

a broader sense a system of figurative or allegorical signification. A full presentation of the history and workings of biblical typology is not possible to give here,[4] but two modern definitions offer a conception of typology not only as a dynamic method for reading the prophetic or allegorical significance of historical events, but also as a figurative habit of mind or a metaphorical grammar of thought. The first of these passages appears in Erich Auerbach's seminal essay "Figura"; the second is by Amos Funkenstein:

> Figural interpretation establishes a connection between two events or persons, the first of which signifies not only itself but also the second, while the second encompasses or fulfills the first. The two poles of the figure are separate in time, but both, being real events or figures, are within time, within the stream of historical life.[5]

Ever since antiquity, Christian theologians had exposed the structure and meaning of history with the aid of immanent-historical symbols called "types" (typoi) or "figures"

(*figuræ*). *Figuræ* are symbolic speculative analogies. Events, persons and institutions of the old and new dispensations are matched to each other: one is seen as a "prefiguration" of the other.[6]

These two authors see typology as both a structure for the understanding of temporality and history, and, more broadly, as a system of figurative interpretation.

By saying typology lies at the heart of the moralized Bibles, I do not present myself as an innovator. All modern commentary on the books has acknowledged this, for the simple reason shown by these two images: typology's presence in the manuscript is clear for all to see. However, just as *The Mind's Eye* conference took as its call to order a re-examination of theology's relationship to medieval art, so I propose the use of typology in the moralized Bible as a test case for defamiliarizing the relationship of an exegetical practice to a work of art—in this case, one of the best-known French Gothic manuscripts. As we shall see, the moralized Bible engages biblical typology in ways that have not been completely understood in the previous literature on the subject.

In recent decades, the history of medieval art has turned away from what were perceived as the stifling discourses of high theology and iconography and has looked increasingly into the work of art's social and cultural context. Likewise, interest in the moralized Bibles has moved from questions of exegetical sources and Parisian workshop practice to the often startling bluntness with which the work addresses contemporary social concerns, many of which have a compelling resonance for modern scholars. Recently, for example, our attention has been turned to the manuscript's representations of such marginalized groups as Jews, women, heretics, and same-sex couples. Other studies have shown how institutional authority figures in the books, while others still have investigated the manuscript's contribution to social power and the formation of a royal ideology.[7] Generally speaking, these studies have treated the moralized Bible as a visual record of the social, religious, and political views of Gothic France. At the same time, there has been a tendency to treat the moralized Bible as a visual compendium of a semipopular ideology, and selected images from the books are often used to illustrate or reflect "what people believed" at the time. While the subject matter of these recent studies differs from previous ones, they are essentially concerned with iconography.[8] Furthermore, some of this type of work runs the risk of using what Michael Baxandall would call "artistic facts" to explain "social facts" (or vice versa)—a practice that suggests a simple relationship but never quite explains how the equivalency obtains.[9] This paper will revisit the meaning of typology in the moralized Bible, not as part of a reactionary return to a lost order, but rather to ask ourselves what happens when we think of typology not as a self-evident or threadbare notion and not as a kind of iconography, but instead as a manner of engagement or cognitive style. As we shall see, this approach has ramifications for the study of much more of medieval art than just the moralized Bibles.

By the early thirteenth century, the rough date of the moralized Bible's inception, typology had been around for a very long time—since Christ himself, in fact, and Christ's use of typology has roots in Jewish exegesis before him. In fact, most of the important typological commentary on the Bible had been completed by the time of Augustine. Similarly, Christians had decided at a very early time that they wanted to see typology, not just hear about it. Thus, much of the earliest Christian art represents or engages with typological thought.[10] And just as the truths laid out by the church fathers were repeated endlessly in medieval commentaries,[11] so typological subjects

appear regularly throughout centuries of medieval art.[12] Typology, both written and pictorial, was therefore of abiding interest to medieval Christians. And yet when art history has approached the topic, it has too often been content to treat the subject simply as subject matter or iconography and, beyond the valuable search for source texts and images, has not found typology worth much comment in and of itself.[13] Typology is seemingly not in need of explanation—we know it when we see it, and we know what it meant to the Middle Ages.

And yet, throughout the Middles Ages, and particularly between the years 1140 and 1240, some of the most ambitious and expensive works of art commissioned—including Nicholas of Verdun's Klosterneuburg Altar and stained-glass windows made for St.-Denis, Sens, Bourges, and Chartres—were typological. This suggests that patrons and viewers found typology far more compelling than it seems to us. St. Augustine offers an explanation for the period's interest in the subject. In the *City of God*, he calls typology a *forma intellegendi*—a way of knowing or a structure of knowledge.[14] Here, Augustine reminds us that for Late Antique and medieval Christians, typology was a dynamic process for understanding the world. It was an activity or a cognitive skill one used in an exploratory way, not a rigid system of established pairings. To put it another way, in the Middle Ages, typology was understood to be an epistemology, and not only an established body of knowledge.

In *De doctrina christiana*, Augustine writes about the pleasures inherent in typological and other figurative modes. Echoing the classical rhetoricians, Augustine asks, Why is it that we so much enjoy seeing difficult, riddling figures and allegories in Scripture?

> [N]o one doubts that things are perceived more readily through similitudes and that what is sought with difficulty is discovered with more pleasure. Those who do not find what they seek directly stated labor in hunger. Those who do not seek because they have what they wish at once frequently become indolent with disdain.[15]

The complexities of typological figuration spur our appetite for knowledge by challenging our mental powers. "The goal of these teachings by means of figures," Augustine wrote in a letter, "is to nourish and excite within us the fire of love so that we lift ourselves very high and seek for repose inside of us. Truths thus presented touch and reach the heart much more than those appearing to us stripped of those mysterious vestments." After explaining how typological and figurative exposition serves the soul, he pauses to make an aside: "It is difficult to say why, but every one knows that an allegory strikes us, charms us, sticks with us more than something said to us simply in its own sense."[16] This comment pits Augustine the bishop, who expounds the allegorical interpretation of Scripture and ritual because it strengthens the soul, against Augustine the former rhetor and stylist, still susceptible to the pleasures of figurative discourse. He argues for the spiritual necessity of figuration, while acknowledging a more worldly engagement with it. To put it in abstract terms, Augustine understands how allegorical figuration is at once instrumental (it leads the soul away from the world and on to better things) and aesthetic (strictly construed as a formal activity, it attracts our interest).[17] This insight into the tension between the instrumental and aesthetic aspects of figuration lies at the heart of the moralized Bible. Its creators must have seriously considered whether the attractions of figurative interpretation could be pressed into the service of dogma or whether they were too strong to contain.

If Augustine can be taken as an intellectual guide, typology was attractive to medieval viewers because it provided a form of cognitive stimulation that enabled them to think more deeply

and searchingly about their world. It is not surprising that they would wish to commission works of art that activated or facilitated this type of thought. A return to the moralized Bible shows quite clearly just how typology, pictorially conceived, could do this. A look at an early folio devoted to the Fall and its meaning from the Oxford moralized Bible (Fig. 2) also reveals the potential—and the potential pitfalls—inherent in the method. Reading the simple Latin of the first titulus and looking at the adjacent picture, we learn the basics of the story. Immediately below both we read and see the figurative significance of this incident. Just as in the biblical text Eve listened to the false serpent, in the gloss an idolator worships before a false god; this act is presented not only as a consequence of the Fall, but as a quasi-structuralist explication of the Fall's significance and of how different temporal periods in divine history mirror each other purposefully. And the typology does not end there: just as in the upper text and image Adam and Eve fall into lustfulness after they eat, so in the lower glossing text and image a modern couple engage in *concupiscentia*, their actions being (again) a fulfillment as well as a consequence of those shown above. The illuminator works carefully to bring out the connections underlying the two scenes. For example, in the second roundel the shrine containing the idol stands atop a pole; this form echoes the serpent appearing up in the tree in the upper roundel. Thus, belief in the serpent is likened to belief in a false god. Eve's *tête à tête* with the serpent is mirrored by the couple below who press their faces together, suggesting that Eve's conversation with the serpent had an erotic quality. The textual glosses state their exegetical points baldly enough, but the painter creates a more suggestive system of formal rhymes and responses meant to captivate the attention and stimulate the mind just as Augustine described. This system of rhymes, echoes, and imitations is the artist's[18]—and the viewer's—*forma intellegendi*.

We can see this at work on another folio from the Oxford manuscript (Fig. 3) given over to the story of Joseph and his brothers. A titulus tersely summarizes centuries of exegetical tradition: "Joseph pulled from the well signifies Christ resurrected from the tomb." Likewise, the painter imbues the corresponding images with a set of formal analogies that make this point visually: Pharaoh's henchmen on the right take Joseph by the hands and lift him out of the cistern on the left, while below God, standing to the right, lifts Christ, on the left, also by the hands, out of his tomb. Up until this point, writer and painter have performed similar tasks.

The painter, however, surpasses the writer (as is often the case in this manuscript) by using active, pictorial means to spur further typological thought. At the top of the left column, we see Pharaoh and his counselors, who cannot interpret his dream. He points to them, but two of them gesture downward, to Joseph, who will be able to assist Pharaoh. Joseph, however, appears not in the next roundel, but below in the next scene from the biblical narrative, which is in fact the third roundel down. Intervening between the two Genesis scenes is the gloss of the initial scene. This shows bad theologians who mistakenly look to astronomers for answers to spiritual questions. The astronomers point upward—partly because the text says "they respond that they understand nothing concerning the heavens besides vain fancies."[19] They also point to their Egyptian counterparts above. So these gestures in the first two roundels bind them together, while at the same time, in narrative terms, the counselors' gestures connect that roundel to the next biblical one. Here, the artist has moved beyond the basic unit of the paired roundels into new binary configurations.

In fact, if we return to the folio representing the Fall (Fig. 2), we can see figurative thinking exceeding the boundaries of the paired image there as well. Is it by accident that the two most

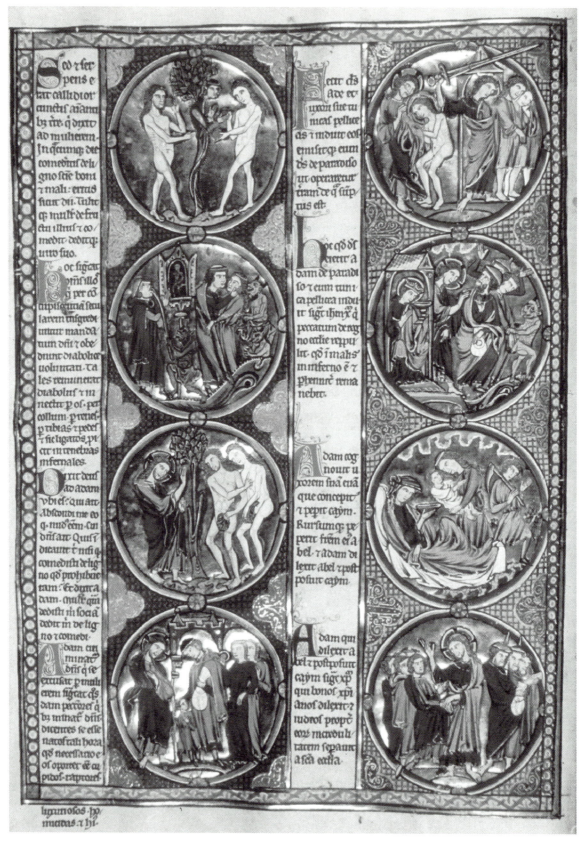

2. Moralized Bible, ca. 1240. Oxford, Bodleian Library, Ms. 270b, f. 7v

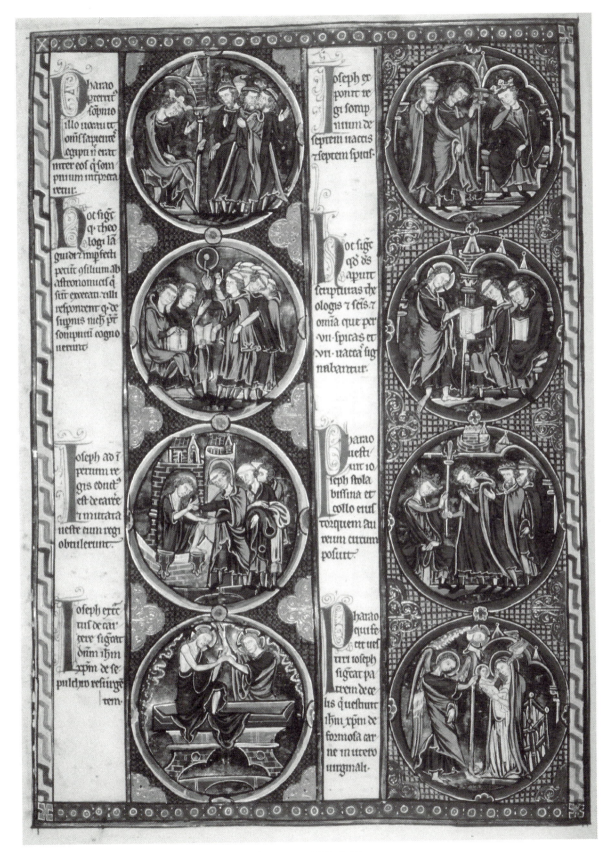

3. Moralized Bible, ca. 1240. Oxford, Bodleian Library, Ms. 270b, f. 27v

familiar scenes from the story—the Fall and the Expulsion from Paradise—appear at the top of the page like an easily read banner headline? What is implied by the proximity of the idol in its shrine to Ecclesia, at the right, seated under an ecclesiastical canopy? Every picture in the right-hand column contains figures moving out of the frame toward the right—to what effect? Does Adam's loving embrace of his son Abel (right, third from the top) contrast purposefully with the illicit embrace of the lustful lovers opposite left? These suggestions are not expressed by the usual pairing of roundels, yet they propose themselves by the same kind of visual correspondences found in those pairs. And these heterodox readings could lead to interesting visual and spiritual speculation. The artists of the book—which contains over 5,400 roundels—have provided its owner with a basis for an infinitely extendable, seductive activity, one that engages the wandering eye and keeps the mind searching for new configurations.

So the instrumental and aesthetic aspects of typology have made themselves apparent. The dynamism of typology could either promote spiritual growth or devolve into idle play, and, to be sure, my last comments on the Fall folio veered toward the latter. To rein in the potentially self-absorbed uses of figuration, the planners of the manuscripts—who were very concerned with doctrinal orthodoxy and not at all interested in spiritual free association—saw to it that structures designed to restrain an overzealous imagination were carefully built into the texts and images. These restraints should not be regarded as sinister—they are intended to harness typology's energies, which makes the moralized Bible intelligible to its users.

Because I am interested in how typology works as an intellectual system in the moralized Bible, I must pause to consider the subject of restraints in some detail. One could talk about the ways exegetical tradition and the linguistic conventions used to express that tradition shape the manuscript's tituli as a form of restraint or policing structure. By this I mean that the composers of the moralized Bible's textual portions wrote out of a typological tradition with its own specialized vocabulary and rhetorical parameters. This governed both how and what they could say, and rendered it intelligible to their readers. One could also think about how the artists used pre-existing visual structures like diagrams and roundel compositions to restrain within certain agreed-upon boundaries the navigation of the manuscript's imagery.[20] For example, twelfth-century typological metalwork such as the Alton Towers triptych (Fig. 4) often expresses itself through intricately linked roundels and connecting bars which suggest to the viewers suitable ways for making out the work's potentially obscure subject matter. The prefatory miniatures of the Psalter of Blanche de Castille (Fig. 5), an almost exact contemporary of the moralized Bible, uses roundels and half-roundels to express both narrative continuity and typological glossing. Surely the artists of the moralized Bible were informed by these types of compositions and expected their own viewers to be guided by a similar familiarity.

Here, I will limit my discussion to one kind of restraint that manifests itself both textually and pictorially that I suspect will be less self-evident than the others just mentioned: namely, rhetorical figures. Since Late Antiquity, biblical typology, allegoresis, and rhetorical figures have been understood to be mutually influencing on a deep level. We should note, however, that the church fathers reflect on this in their works and employed a common Latin vocabulary for the discussion of rhetorical figures and typological readings of Scripture.[21] This understanding extends into the thirteenth century as well: the textual component of the moralized Bible, rarely admired for its Latin style, reflects a practical knowledge of classical rhetoric perfectly in keeping with both the traditional medieval school curriculum and the thirteenth-century revival of the writings of rhetorical treatises, or *artes poetriae*. The following three examples show how both authors and

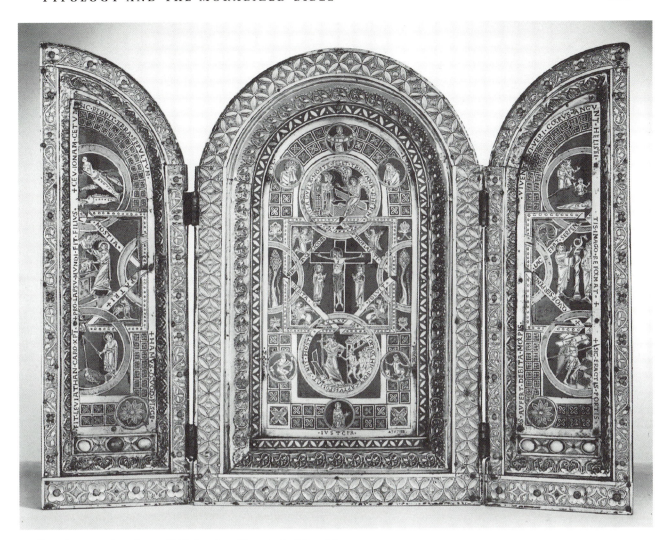

4. Alton Towers triptych, ca. 1160. London, Victoria & Albert Museum

artists used rhetorical figures and their pictorial analogy to endow the book with limits and recognized conventions, which were, in turn, designed to structure and facilitate the user's experience.[22] It should be stated here that nowhere in the moralized Bible do its writers or artists explicitly announce their rhetorical intentions or mention by name the figures I discuss below. Their reliance on rhetorical figures is more intuitive, understood, and playful than that. There are, however, many locutions and formulae used throughout the tituli that reveal a first-hand knowledge of basic rhetoric on the part of the writers.

The first rhetorical structure I will point out is called *complexio*. In the *Rhetorica ad Herennium*, complexio, or recapitulation, is defined as "a brief conclusion, drawing together the parts of the argument." Complexio is necessary when the argument has been long and the matter is important. It comes at the end of an argument. [23] In the moralized Bible, examples of written and visual complexio appear on the page presenting the Annunciation and its moralizations (Fig. 6). The manuscript's planners allow the episode to unfold slowly, illustrating four distinct moments from the first chapter of Luke. In the final exegetical titulus (bottom right), the author acknowledges

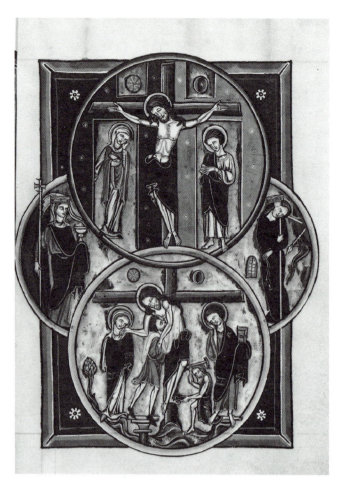

5. *Crucifixion and Deposition*, Psalter of Blanche de Castille, ca. 1215. Paris, Bibliothèque de l'Arsenal, Ms. 1186, f. 24r

the (relative) length of the textual exposition and the significance of the matter by the inclusion of a summary. He reminds us of "that which is stated above" (quod autem superius dicitur) by reiterating phrases from the gospel excerpts quoted above, each followed by an "et cetera." All of these elements, he concludes in his recapitulation, attest to the doctrine of the Trinity. Following the author's example, the artist effects a visual equivalent of *complexio*, which proves the same point. In the first exegetical roundel (left, second from top), Christ appears, crucified, above the figure of Ecclesia and a cleric. Below (bottom left), Christ prompts a cleric to do good works for the church, while God the father (with his tripartite globe) looks on above. In the next exegetical roundel (right, second from top), the Holy Spirit flies above Christ and two clerics. The fourth roundel (bottom right) recapitulates the elements found in the upper portions of the three previous roundels—Christ, God, the Holy Spirit—to form an image of the Trinity, before which a cleric prays. In both the cases of titulus and image, the recapitulation contained in the fourth moralization serves to underscore the main theological precept: the Annunciation heralds not only the birth of Christ, but the origin of the Trinity as well.

The use of the rhetorical recapitulation, on the one hand, gives the page coherence and intelligibility. Rather than allowing the reader to wander about the folio aimlessly, text and image work in tandem to shape the viewer's experience. On the other hand, because the use of *complexio* on

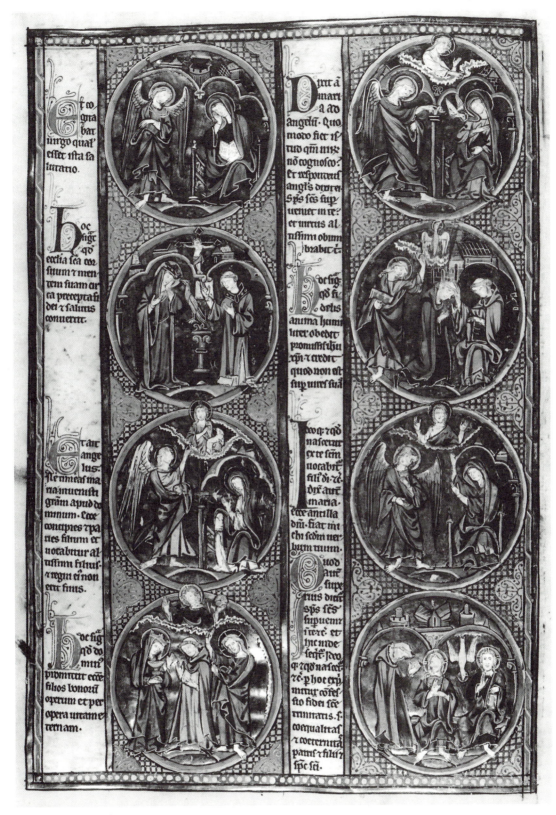

6. Moralized Bible, ca. 1240. London, British Library, Ms. Harley 1527, f. 6v

the folio is not explicitly announced, the reader or viewer is initially allowed a certain amount of freedom to make out the folio's logic. The sophistication of the *mise-en-page* stimulated thought in the Augustinian manner; the built-in restraints prevent the activity from lapsing into aesthetic idleness. Finally, it does not matter if the manuscript's reader would have the word *complexio* at hand to describe his experience—it is enough for him to have sensed its presence.

Another figurative restraint used, perhaps unexpectedly in the moralized Bible, is irony. Quintilian states that with irony "we understand something which is the opposite of what is actually said."[24] The moralization of a moment in the Good Samaritan parable uses irony as a kind of restraint (Fig. 7). The titulus (bottom right) for moralization of the priest and the Levite passing by the injured pilgrim without helping him reads: "This signifies that the ministers of the Law, no matter how great they may have been, could accuse sins but by no means could they confer compassion." The accompanying illustration shows Old Testament priests (one holds the tablets of the Law) who face a group of figures standing in a garishly painted Hell-mouth. The priests rest their heads on their hands—a gesture of despondency—while the sufferers glare at them. Both the text and this odd image are ironic in their own ways. When the writer says that the Jewish priests, "no matter how great [*magni*] they were," cannot confer compassion, he strongly implies the opposite about them—they were not so great after all. This is a simple, but neat, example of verbal irony— pointedly saying one thing when you mean another. The artist gives visual form to this figure by other means. His unusual image shows one thing but alludes to another. Elsewhere in the moralized Bible (and throughout contemporary art), one would have seen pictures of the Harrowing of Hell which show Christ triumphantly leading naked figures out of Hell-mouths. In this scene, the priests of the Old Law cannot harrow Hell—they stand aside ineffectually while resentful souls burn in Hell. In this case, visual irony depends on a prior knowledge of Harrowing of Hell imagery. The artist ironically presents a representation of one thing while inviting us to see another at the same time.

Other images rely on what might be called hyperbole as a structuring restraint. Augustine observes that Scripture often relies on hyperbole, "just as it uses other tropes," and defines hyperbole as a "figure of speech, [which] occurs when the words used are a much more sweeping assertion than the bare facts to which they refer." This squares with the definition found in the *Rhetorica ad Herennium:* "Hyperbole is a manner of speech exaggerating the truth, whether for the sake of magnifying or minifying something."[25] An example of hyperbole, according to Augustine, appears in Genesis 13:14–17: "I will make your seed like the sands of the earth," God tells Abraham. This, Augustine says, "is surely a figurative, not a literal expression," for "who could fail to see how incomparably greater the number of grains of sand is than that of all men from Adam himself to the end of the world can possibly be?" The biblical author has God deliberately exaggerate in order to add weight to his statement.[26]

The moralized Bible declines to treat this passage from Genesis. There are, however, other points in the narrative where God engages in a similar style of hyperbolic speech. Just after staying Abraham's hand and telling him not to sacrifice Isaac, the angel of the Lord delivers this promise from God: "I will shower blessings on you, I will make your descendants as many as the stars of heaven and the grains of sand on the seashore" (Gen. 22:16–17). The moment that directly precedes this one, the staying of Abraham's hand, is illustrated in the manuscript (Fig. 8). The titulus glossing this passage (left, second from top) reveals that the angel, who told Abraham to take the lamb (*agnus*) caught in the thorns, "signifies the Heavenly Father who said Christ is under-

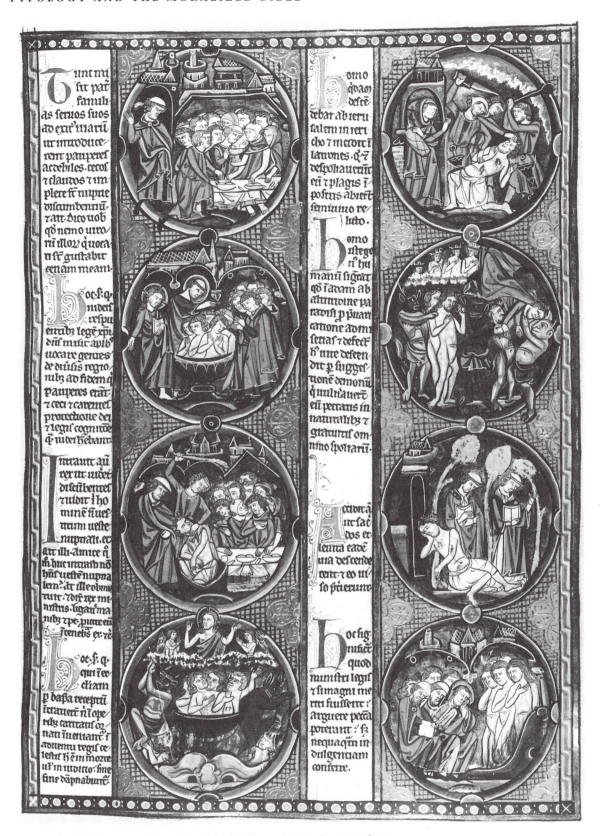

7. Moralized Bible, ca. 1240. London, British Library, Ms. Harley 1527, f. 43r

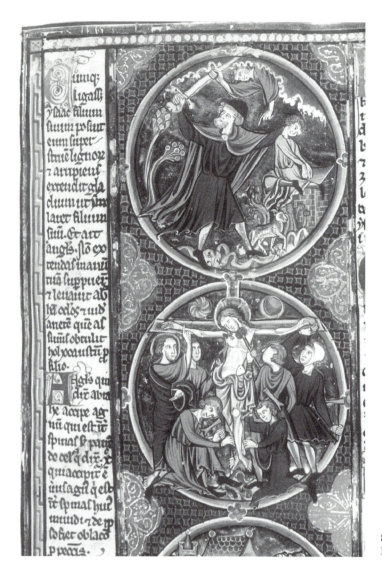

8. Moralized Bible, ca. 1240. Oxford, Bodleian
Library, Ms. 270b, f. 16r

stood as a lamb caught in the thorns of this world and thus is made a sacrifice for sinners." This
statement, predictable in its content, could be construed as hyperbole, at least by medieval stan-
dards: it consists of a string of dramatic similes which, taken together, form a hyperbole. The mor-
alized Bible's titulus proceeds by similar means: a series of analogies—Christ as lamb caught in
bush, Christ as sacrifice—build up into a hyperbolic whole stronger than its individual parts. The
metaphors dramatize the events, too: Christ was not actually caught among thorns nor was he a
lamb. Thus, the intent of this passage is to exaggerate the truth for the sake of magnifying the
significance of the event.

The image standing next to this titulus is more clearly hyperbolic. It ignores the lamb
metaphor and instead presents a hectic Crucifixion scene. Men nail Christ's feet and hands to the
cross; others pierce his side and offer him the vinegar sop; Christ hangs dead on the cross, with
the sun and moon above him. These three elements represent stages in the narrative, here con-
densed into one scene. Meanwhile, God stands to the left pointing upward, just as the angel in the

Abraham scene, his counterpart according to the titulus, points downward. Like the presence of the sun and moon, God's gesture reminds those present of the celestial significance of Christ's death. Therefore the artist tries to magnify the image so it lives up to the import of the event—it is the Crucifixion after all—by visual exaggeration. These events did not happen simultaneously, so the overly eventful contents of the image are hyperbolic. On a more purely pictorial level, the artist has crammed the roundel full of chaotic, visual incident. Compared to the relatively clear image of Abraham and Isaac above, this Crucifixion is exponentially more exaggerated in its compositional effects. The artist even appears to have let his hyperbole get away from him a bit—in his haste to represent a profusion of imagery, he forgot to paint in the face of the man with the sop. That hyperbole should appear in this picture, of course, is perfectly orthodox: the significance of the Sacrifice of Isaac is greatly magnified in its typological fulfillment, the sacrifice of Christ. Hyperbole is one appropriate way to express the meaning of the Crucifixion.

It could be argued that such an image as the Crucifixion I have just been describing could have been understood in simpler terms by its medieval viewers—they may have seen only a literal, or historical, representation of the event and not visual hyperbole. This would, of course, be permissible in the world of typological exegesis in that two historical moments, the Sacrifice of Abraham and the Crucifixion, were thought to be immanently or prophetically related to each other. Yet, as I have argued, the experience of the manuscript as a whole, that is, an engagement with its overall interpretive and figurative strategies, strongly indicates that the book's designers did their best to elicit a much more dynamic and complex response from the book's user than the mere comprehension of simple binary—and in this case, very obvious—typologies. This makes sense within the context of the book's production: it is hard to imagine why a patron would go to the tremendous expense of commissioning a manuscript of unprecedented lavishness only to have it prosaically depict clichés which create little interpretive excitement. I do not mean to say every reader/viewer of this folio found the paired roundels hyperbolic—but some did.[27] This is in keeping with my intuition that the moralized Bible permits a much wider range of creative responses, informed by many different areas of culture, than has previously been suggested.

The designers of the moralized Bible employed rhetorical restraints in order to make a new and potentially overwhelming genre of manuscript accessible to its user. As I mentioned earlier, other forms of restraint were employed as well. The various forms of pictorial and rhetorical restraint found throughout the manuscript also serve to reign in the inherently unruly energies of figurative interpretation of the kind Augustine worried about. The presence of these very palpable restraints suggests that the manuscript's producers and its audience shared a visual and textual interpretive culture. Furthermore, it seems unproductive to try to sort out too neatly the visual and textual strands of this activity. The evidence of the manuscript itself suggests an extraordinary degree of ease in moving from one activity to the other without entirely losing sight of the fact that these are analogous and not identical activities.

This brings me back to the point made by Michael Baxandall about confusing, or at least uncritically substituting for each other, artistic facts and social facts. Adapting his terms slightly, it could be said that by comparing the kinds of structures devised by the artists with the kinds wielded by the writers, I have meretriciously elided the difference between art and rhetoric, or have used one to "explain" or "displace" the other in an illegitimate way. Instead, I have tried to adhere to what Baxandall called "the Bouguer principle," which he summarizes as follows: "in

the event of difficulty in establishing a relation between two terms, modify one of the terms till it matches the other, but keeping note of what modification has been necessary, since this is a necessary part of one's information."[28] This is not slight of hand—it is an attempt to describe relationships within a culture that are at once distinct and mutually informing, without merely letting one stand in for the other.

Hence, I do not mean to suggest that the kinds of compositional arrangements seen in the moralized Bible's pictures are rhetorical figures *tout court*, or that all the artists read Quintilian in an effort to exactly re-create different tropes and figures (although in certain cases they might have). I do assume that the artists and writers were in contact with each other during the couple of years it took to make the books and that beyond any literal exchange of ideas that may have taken place *sur place*, there was a larger, intuitive tendency in early-thirteenth-century France to think figuratively across what we think of as boundaries. There are many other episodes in early Gothic art and literature where one sees this sort of thing happening: it has recently been argued quite convincingly that the narrative stained-glass programs of the Sainte-Chapelle were informed by, among others, the rhetorical figures *amplificatio* and *circumlocutio* as theorized by medieval rhetoricians; other manuscripts produced (probably) in the ambit of the Capetians, such as the Morgan Old Testament Picture Book, combine narrative and typological modes without explicitly shifting from one to the other; and the vernacular narrative literature of the period is plainly marked by an awareness of both rhetorical study and typological allegoresis.[29] We also know with certainty that rhetoric, or *ars poetriae*, was a basic element of any cathedral school or university education—meaning that both designers and users were well-equipped to think rhetorically. Given the extraordinary richness of this cultural moment, it should not seem unusual that the moralized Bible's planners, executors, and users were supple in their approaches to the figurative interpretation and judicious in their restraint of it.

Finally, to return to the question of iconography, some might feel that the picture I have been painting of the moralized Bible is marred by too much Bakhtinian *heteroglossia*—too freewheeling, too open-ended, too heterogeneous to agree with the book's unsubtle didactic tone. After all, the lessons imparted by the moralized Bible are orthodox and uncompromising, leaving no doubt or confusion in the mind of its reader as to how he or she should arrange his or her spiritual and temporal life. We must not confuse, however, the clear content of individual episodes in the manuscript with the much more unregulated ways in which these episodes would have been comprehended as part of the whole. To focus on isolated images or even recurrent iconographic themes tells us much about the socio-political world in which the books were produced; to focus on typological figuration, to my mind at least, gets at the manuscript's particular visual nature. Those responsible for compiling and transcribing the doctrinal and exegetical component of the moralized Bible may very well have had one clear idea they wanted to express, while the artists knew that the experience of viewing a page does not proceed in any one way. The artist's job, therefore, was to accommodate—and then control—the vagaries of the scanning eye.

Acknowledgments

I would like to thank Jeffrey Hamburger for his helpful suggestions and comments made for the published version of this paper.

Notes

1. The four thirteenth-century manuscripts, in probable order of production, are: Vienna, Österreichische Nationalbibliothek, Cod. Vind. 2554; Vienna, Österreichische Nationalbibliothek, Cod. Vind. 1179; a third version divided between Toledo, Tesoro del Catedral, and New York, Morgan Lib., Ms. M.240; and a final version divided among Oxford, Bodleian Library, Ms. 270b, Paris, B.N.F., Ms. lat. 11560, and London, B.L., Harley Mss. 1526 and 1527. This essay considers the Oxford-Paris-London version only.

2. London, B.L., Add. Ms. 15248, f. 1r.

3. R. Haussherr, "Sensus litteralis und Sensus spiritualis in der *Bible Moralisée*," *FS* 6 (1972), 360.

4. For useful surveys of how Early Christian and medieval writers articulated their understanding of biblical typology, see H. de Lubac, *Exégèse médiévale: Les Quatre Sens de l'écriture* (Paris, 1959–61), vol. 1, 305–67, and J. Daniélou, *From Shadows to Reality: Studies in Biblical Typology of the Fathers* (London, 1960), passim.

5. E. Auerbach, "Figura," in *Scenes from the Drama of European Literature* (New York, 1959), 11–76; this quotation, 53.

6. A. Funkenstein, *Perceptions of Jewish History* (Berkeley and Los Angeles, 1993), 99.

7. On the representation of Jews, see S. Lipton, *Images of Intolerance: The Representation of Jews and Judaism in the Bible Moralisée* (Berkeley, 1999), 82–111. The moralized Bible's stance against intellectual novelty and heresy is described in K. H. Tachau, "God's Compass and *Vana Curiositas*: Scientific Study in the Old French *Bible Moralisée*," *ArtB* 80 (1998), 7–33. On Jews and heretics, see R. M. Wright, *Art and Antichrist in Medieval Europe* (Manchester, 1995), 90–113. For the manuscript's relation to religious and social reform movements, see J. Heinlen, "The Ideology of Reform in the French Moralized Bible" (Ph.D. diss., Northwestern University, 1991), 12–101. For images of episcopal power in the manuscript, see C. Heck, "Représentation du pillori et justice épiscopale au croisillon sud de Nôtre-Dame de Paris," in *Iconographica: Mélanges offerts à Piotr Skubiszewski*, ed. R. Favreau and M.-H. Debiès (Poitiers, 1999), 115–22. For an appropriation of the manuscript's representation of same-sex couples, see M. Camille, *The Medieval Art of Love: Objects and Subjects of Desire* (New York, 1998), 138–39, and "For Our Devotion and Pleasure: The Sexual Objects of Jean, Duc de Berry," *Art History* 24 (2001), 169–94. On the manuscript's role in Capetian self-fashioning, refer to H. Stahl, "The King as Viewer," paper given at the session "Regarding the *Bibles Moralisées*: Capetian Connections" at the Thirty-second International Congress of Medieval Studies, Kalamazoo, Michigan, 9 May 1997, and D. Weiss, "The Three Solomon Portraits in the Arsenal Old Testament and the Construction of Meaning in Crusader Painting," *Arte medievale* 6, no. 2 (1992), 15–33. This is not to ignore the major, recent contribution to our knowledge of the manuscript's dating, production, and codicology found in J. Lowden, *The Making of the Bibles Moralisées* (University Park, Pa., 2000).

8. The clear exception to this generalization would be Harvey Stahl's paper (as in note 7).

9. M. Baxandall, "Art, Society, and the Bouguer Principle," *Representations* 12 (1985), 32–43.

10. For recent demonstrations of the early Christian engagement with typology in a variety of media, see W. Kemp, *Christliche Kunst: Ihre Anfänge, Ihre Strukturen* (Munich, 1994), 101–262, and C. Weyer-Davis, "Komposition und Szenenwahl im *Dittochaeum* des Prudentius," in *Studien zur Spätantiken und Byzantinischen Kunst: Friedrich Wilhelm Deichmann gewidmet*, ed. O. Feld and U. Peschlow, Monographien Römisch-Germanische Zentralmuseum, Forschungsinstitut für Vor- und Frühgeschichte 10 (Bonn, 1986), vol. 3, 20–29.

11. This is not to suggest that biblical typology, as it evolved over the centuries, was a discipline entirely devoid of creativity. See, for example, the studies of Friedrich Ohly collected as *Schriften zur mittelalterlichen Bedeutungsforschung* (Darmstadt, 1977), 338–400, and R. Suntrup, "Zur sprachlichen Form der Typologie," in *Geistliche Denkformen in der Literatur des Mittelalters*, ed. K. Grubmüller et al. (Munich, 1984), 23–68.

12. See, for example, C. Hughes, "Visual Typology: An Ottonian Example," *Word & Image* 17 (July–Sept. 2001), 185–98.

13. This has also been the case with even the most serious studies of the moralized Bibles. See, among others: A. de Laborde, *Étude sur la Bible moralisée illustrée* (Paris, 1927), 154–55; G. B. Guest, *Bible Moralisée: Codex Vindobonensis 2554, Vienna, Österreichische Nationalbibliothek* (London, 1995), 1–48; H.-W. Stork, *The Bible of St. Louis* (Gräz, 1996), 16–19. Surprisingly, the first volumes of Lowden's monumental study have virtually nothing to say about typology or exegesis. Several recent historians of medieval art, including Wolfgang Kemp and Martina Pippal, have shown an interest in typology. However, I would argue that in his work on Gothic stained glass, Kemp tends to view typology statically and too often only in opposition to narrative, which he sees as the progressive and dominant force of the early thirteenth century. See W. Kemp, *The Narratives of Gothic Stained Glass* (Cambridge, 1997), 42–88.

14. Augustine, *The City of God against the Pagans*, trans. G. McCracken et al. (Cambridge, Mass., 1957–72), vol. 4, 418–19. I have altered the translation somewhat. Augustine also wrote a more conventional commentary on Galatians 4:24, where Paul uses the term allegory but does not take up its epistemological significance. See *Expositio epistolae ad Galatas* (PL 35:2132–33).

15. Augustine, *De doctrina christiana* and *De vero religione*, ed. K.-D. Daur, CCSL 32 (Turnhout, 1962), 35–36. The translation used here is taken from Augustine, *On Christian Doctrine*, trans. D. W. Robertson Jr. (Upper Saddle River, N. J., 1958), 37–38.

16. Augustine, *Epistle* 55 (PL 33:214).

17. On Augustine and the tension between instrumentality and the aesthetic, see M.-D. Chenu, *La Théologie au douzième siècle* (Paris, 1957), 172–73.

18. As Lowden has shown, all of the moralized Bible manuscripts were executed by a team of artists, and individual roundels seem to have been worked on by more than one hand. Thus, when I speak of "the artist" in this paper, I use this as a kind of shorthand for the collaborative process involving designers and painters, who may or may not have been the same people. See Lowden, *The Making of the Bibles Moralisées* (as in note 7), vol. 1, 165–67.

19. The moralized Bible's stance against false astronomy and intellectual novelty is described in Tachau, "God's Compass and *Vana Curiositas*" (as in note 7), 7–33.

20. In a study on typology and early Gothic art currently being prepared, in the chapter on the moralized Bible, I describe at length the various restraints used in the manuscript.

21. This is the heart of Auerbach's argument in "Figura" (as in note 5).

22. It should be recalled that the Latin word *figura* also meant figure in the visual or plastic sense. Such classical authors as Quintilian deliberately used this overlapping vocabulary when relating rhetorical figures to works of art. See M. Baxandall, *Giotto and the Orators* (Oxford, 1971), 18.

23. *Rhetorica ad Herennium*, trans. H. Caplan (Cambridge, Mass., 1989), 107–13.

24. Quintilian, *Institutio oratoria* IX, 1.4–14, trans. H. E. Butler (Cambridge, Mass., 1953), vol. 3, 401.

25. Medieval authors discuss this figure as well. Far example, Geoffrey of Vinsauf gives an example of "yperbolicus" that accords with the two definitions mentioned above (Geoffrey of Vinsauf, *Poetria Nova*, trans. M. Nims [Toronto, 1967], 68–69). On the thirteenth-century *artes poetriae* and *artes dictandi*, see J. J. Murphy, *Rhetoric in the Middle Ages* (Berkeley, 1974), 135–93, and D. Kelly, *The Arts of Poetry and Prose*, Typologie des sources du Moyen Age occidental (Turnhout, 1991).

26. Augustine, *The City of God against the Pagans* (as in note 14), vol. 5, 101; *Rhetorica ad Herennium* (as in note 23), 339.

27. Given the other, closely related, manuscripts made at the same time as the moralized Bibles, such as the *Crucifixion* from the Psalter of Blanche de Castille (Fig. 5), we know that viewers could handle all sorts of multivalent typologically informed imagery.

28. Baxandall, "Art, Society, and the Bouguer Principle" (as in note 9), 41.

29. On the stained glass, see A. Jordan, *Visualizing Kingship in the Windows of the Sainte-Chapelle* (Turnhout, 2002), 10–14, 32–41. Jordan recognizes that the moralized Bible makes use of rhetorical figures, a quality she wisely argues it shares with the windows of the Sainte-Chapelle. However, her opposition of an "out-moded typological approach to biblical exegesis" and "avant-garde rhetorical devices" in the moralized Bible betrays a misunderstanding of the deep relation, perceived in the thirteenth century, shared by both disciplines: one did not supercede the other. It is also hard to describe typology as "out-moded" when it appears so prominently in metalwork, manuscripts, and stained glass of the period (see Jordan, 75–76). For the typological undercurrent in the Old Testament Picture Book, see the scene of Jacob blessing the sons of Joseph (f. 7r) and Samson carrying off the gates of Gaza (f. 15r), both of which employ compositional devices conspicuously derived from Mosan typological metalwork, and then see H. Stahl, "The Iconographic Sources of the Old Testament Miniatures, Pierpont Morgan Library, Ms. 638" (Ph.D. diss., New York University, 1974), 44–45; for the intersection of typology and vernacular literature, see E. Auerbach, "Typological Symbolism in Medieval Literature," *Yale French Studies* 9 (1951), 3–10; and for the influence of rhetoric on literary texts, see D. Kelly, "The Theory of Composition in Medieval Narrative Poetry and Geoffrey of Vinsauf's *Poetria Nova*," *MedSt* 31 (1969), 117–148, and S. Reynolds, *Medieval Reading: Grammar, Rhetoric, and the Classical Text* (Cambridge, 1996), 25–27, 61–87.

L'Exception corporelle: à propos de l'Assomption de Marie

Jean-Claude Schmitt

Le sous-titre de ce colloque—*Art and Theological Argument*—pourrait laisser entendre que la "pensée argumentative" était au Moyen Âge réservée à la théologie et absente de ce qu'il est convenu d'appeler "l'art." Et que "l'art," pour sa part, se contenterait d'illustrer les concepts élaborés par les théologiens et transmis par l'écrit. Les théologiens guideraient les artistes, leurs écrits influenceraient les images, sans contre partie. Nous savons qu'il n'en est rien: de même que la théologie elle-même fait usage de métaphores visuelles (par exemple, celle des "yeux de l'âme" qui a inspiré le titre de cette rencontre), les images "pensent" théologiquement, politiquement, socialement. Mais elles pensent à leur manière, que Pierre Francastel nommait la "pensée figurative." Que la "pensée figurative" des "artistes" médiévaux (acceptons par convention le mot "artiste," même s'il ne nous satisfait pas) se soit élaborée en étroite relation avec la pensée "argumentative" des auteurs ecclésiastiques—écrivains monastiques (comme Saint Bernard, par exemple) ou théologiens scolastiques (comme Saint Bonaventure)—cela est certain. Travaillant en étroite relation avec les commanditaires ecclésiastiques, les artistes, qui eux-mêmes, pendant longtemps, furent des hommes d'Eglise (ou des religieuses, comme ces "nonnes artistes" étudiées par Jeffrey Hamburger), partageaient largement la même culture que les clercs et les Ecritures étaient leur source d'inspiration commune.[1]

Cependant, la "pensée figurative" n'est pas seulement la pensée des artistes: c'est la pensée mise en œuvre par les images elles-mêmes, dans leur usage d'un espace bi- ou tridimensionnel, dans la confrontation des figures entre elles, dans la disposition des couleurs, la dynamique des gestes, le choix ou l'exclusion de tel ou tel motif, et plus tard le respect ou la subversion des règles de la perspective linéaire. La "pensée figurative" s'exprime d'abord par tous les procédés conscients auxquels recourt celui qui *fabrique* l'image. Elle réside aussi dans les effets de sens produits sur ceux qui *reçoivent* l'image, par la manière dont ils la regardent et y trouvent un objet de réflexion intellectuelle, d'identification personnelle ou collective, d'émotion, d'imagination, d'affection, d'oraison, de vision mystique, etc. L'image ne traduit pas seulement la croyance, elle contribue à la façonner, surtout quand celle-ci n'est pas fixée par une doctrine, mais—comme on va le voir sur un exemple précis—ne cesse de se chercher tout en se développant.

Telles sont, me semble-t-il, les questions que posent le titre et le sous-titre de notre rencontre.

Pour tenter d'en préciser les enjeux, je voudrais réfléchir ici sur les premiers développements des images de l'Assomption corporelle de Marie en Occident. Ces images renvoient à une tradition narrative et dans une certaine mesure, au XIe/XIIe siècle, à une argumentation théologique. D'autant mieux que l'Assomption de Marie n'a aucune base scripturaire. Elle ne fut donc pas l'objet d'une exégèse biblique, ce qui assura d'entrée de jeu une certaine liberté à son développement narratif, conceptuel et imaginaire. L'Assomption de Marie n'est pas non plus—avant 1950—un dogme officiel de l'Eglise,[2] comme c'est le cas, par exemple, dès le IVe siècle, de la croyance en la Trinité. Elle n'en constitue pas moins une croyance partagée qui s'est développée à partir des VIe/VIIe siècle dans la littérature apocryphe d'origine orientale.[3]

La formation d'une croyance

Durant le premier millénaire, la lettre apocryphe du Pseudo-Jean (connue dans ses versions grecque et syriaque de la fin du Ve siècle ou du début du VIe siècle),[4] la traduction latine du Pseudo-Meliton,[5] divers traités anonymes latins, intitulés *De transitu Mariae*, assurent la diffusion de la légende en Occident. Grégoire de Tours en donne l'une des premières versions latines élaborées.[6] Le bref chapitre qu'il consacre dans le *De gloria martyrum* aux "Apôtres et à Sainte Marie," fait suite à de plus longs développements consacrés aux miracles du Sauveur, à sa Passion, sa Résurrection et son Ascension. D'emblée est donc proposé le rapprochement entre l'*ascensio* du Christ (qui monte *par lui-même* au ciel) et l'*assumptio* de sa mère (qui est *transportée* au ciel par les anges, sur l'ordre de son fils). Le point de départ du récit est la mention, dans l'Ecriture (Actes 4), de la réunion des apôtres et de Marie après l'Ascension du Christ, en une maison où ils mettent tous leurs biens en commun, avant de se disperser pour aller évangéliser les diverses parties du monde. Mais—et c'est là que la tradition apocryphe prend le relais des Ecritures canoniques—à l'annonce que la Vierge allait mourir, tous les apôtres se réunissent à son chevet (leur retour immédiat est généralement donné pour miraculeux, mais pas par Grégoire de Tours). Les événements se déroulent en deux temps, marqués chacun par une apparition de Jésus: d'abord le Christ revient sur terre pour prendre l'âme de Marie et la confier à Saint Michel. La séparation par Jésus de l'âme et du corps de Marie constitue sa *Dormitio.* Les apôtres ensevelissent ensuite son corps dans un *monumentum*, un tombeau. Puis Jésus apparaît de nouveau et cette fois il ordonne que le corps soit porté (*deferri*) dans une nuée, jusqu'au paradis, où il est réuni à l'âme (*resumpta anima*). Ce deuxième moment est au sens propre l'*Assumptio.* Alors que le Pseudo-Jean compte trois jours entre ces deux moments, Grégoire ne donne pas d'indication précise sur le temps écoulé entre la Dormition et l'Assomption. Cela aura duré au moins le temps des funérailles de la Vierge, pendant lesquelles les juifs, sous la conduite du grand prêtre, auraient tenté, mais en vain, de s'emparer du corps de la Vierge pour le brûler. Mais de cela non plus Grégoire de Tours ne parle pas.

Dans la liturgie, la fête de l'*Assumptio* semble remonter à un usage ancien de l'église de Jérusalem, où elle était déjà fixée au 15 août. Elle s'impose dès le VIIIe siècle à Rome, et de là dans toute la chrétienté latine. Sa première mention occidentale apparaît vers 770 dans la sacramentaire *Hadrianum*, qui insère dans les prières du propre de la fête l'oraison *Veneranda*,[7] dont l'initiale historiée sera plus tard un lieu privilégié d'élaboration de l'iconographie de l'Assomption de la Vierge.

Au XIIe siècle, la nonne visionnaire Elisabeth de Schönau (1129–1162) entame une discussion

critique du plus haut intérêt sur la date et la signification de cette fête. Elisabeth se distingue des autres visionnaires contemporains (au premier rang desquels Hildegarde de Bingen), par l'organisation liturgique de ses extases, dont le récit suit, année après année, l'ordre des fêtes religieuses.[8] Lors d'une de ces extases, à l'octave de l'Assomption de l'année 1156, elle se voit dialoguer avec la Vierge Marie, à qui elle demande, "si elle fut portée aux cieux en esprit seulement, ou dans sa chair." Ce qu'elle en a lu dans les livres, dit-elle à la Vierge, lui a paru "douteux." La Vierge ne lui donnant pas de réponse, elle interroge tout au long de l'année suivante, mais en vain, son ange familier ou la Vierge elle-même, chaque fois que celle-ci lui apparaît. Le jour de l'Assomption 1157, elle bénéficie d'une vision de la Vierge s'élevant de son sépulcre jusqu'au ciel ou son Fils la reçoit. L'ange lui explique qu'elle voit la Vierge "assumée dans sa chair comme dans son esprit." Huit jours plus tard, l'ange précise à sa demande que la Vierge ressuscita et fut assumée au ciel quarante jours après sa mort, soit le 9 des calendes d'octobre (23 septembre). Deux ans plus tard, le jour de l'Assomption 1159, la Vierge lui apparaît pour la mettre en garde contre la divulgation de cette révélation hors des murs du couvent. Elle lui précise, à sa demande, qu'elle a vécu après l'ascension du Christ une année entière et autant de jours qu'on en compte entre la fête de l'Ascension et sa propre fête de l'Assomption. Cette réponse est étrange puisque la fête mobile de l'Ascension—quarante jours après Pâques—fait varier le décompte des jours d'une année sur l'autre. L'année 1159 est-elle prise pour base d'un tel calcul? L'essentiel était surtout, me semble-t-il, d'établir par une durée de quarante jours, un parallèle rigoureux entre la Résurrection et l'Ascension du Christ d'une part, la Dormition de la Vierge et son Assomption d'autre part.

Bien qu'Elisabeth ait reçu de la Vierge l'ordre de ne pas divulguer ses révélations, celles-ci, grâce à Eckbert, furent promptement connues. Du vivant de la moniale, Jean Beleth mentionne qu'une "femme religieuse du nom d'Elisabeth, qui vit encore en Saxe, dit qu'il lui fut révélé que le corps [de la Vierge] fut assumé quarante jours après l'assomption de l'âme; elle a composé à ce sujet un traité, mais celui-ci n'est pas autorisé par l'Eglise romaine."[9] Au XIIIe siècle, Guillaume Durand de Mende reproduit la même observation. A Schönau, la fête du 23 septembre fut effectivement célébrée sous le titre "Resuscitatio sancte Mariae, XL dies post Dormitionem ejus" et au XVe siècle encore les diocèses de Brandeburg, Freising, Mayence, Passau et Regensburg, fêtaient en ce jour l'"Assomption corporelle de Marie," la "Commémoration de l'Assomption de Marie," ou "la Quadragésime de l'Assomption corporelle" de Marie.[10]

Même si le témoignage d'Elisabeth de Schönau reste isolé, la manière dont elle rabat sur les derniers moments de la vie terrestre de Marie, le modèle des derniers moments de la vie du Christ, est révélatrice d'une tendance générale qui revêt, pour l'iconographie mariale, la plus grande importance. Le parallélisme des deux récits ne saurait pourtant être parfait, puisque le Christ a *vécu* sur terre pendant quarante jours entre sa résurrection (Pâques) et l'Ascension. Elisabeth de Schönau est obligée d'imaginer que le corps de la Vierge est resté quarante jours dans son tombeau (et non trois comme celui du Christ) entre sa mort (ou plutôt sa Dormition (le 15 août) et le jour de sa résurrection et de son assomption corporelle (le 23 septembre).

Parmi les nombreux autres textes qui traitent de l'Assomption corporelle de Marie, deux ont joui au cours du Moyen Âge d'un renom particulier en raison de leur attribution à Saint Jérôme et à Saint Augustin. La lettre *Cogitis me* était censée avoir été écrite par Saint Jérôme à ses émules Paula et Eustochia. On sait aujourd'hui qu'elle est due en fait au théologien carolingien Paschase Radbert de Corbie († ca. 860), bien connu pour ses prises de position en matière eucharistique, mais aussi pour sa contribution à la théologie mariale.[11] Cette lettre fut écrite pour des religieuses

de Soissons, qu'elle met en garde contre la diffusion d'écrits apocryphes *De transitu Virginis*. Ceux-ci présentent comme une certitude la résurrection corporelle de Marie, dont le tombeau vide peut toujours se voir près de Jérusalem dans la vallée de Josaphat. Pour Paschase Radbert, ces écrits sont "douteux" et "quant à savoir si la Vierge est ressuscitée, on ne le sait pas" (*utrum resurrexerit nescitur*). A priori, Paschase n'en écarte pas la possibilité, mais il se méfie de textes dont il connaît le caractère apocryphe. Sans doute la question de l'Assomption corporelle de Marie ne revêtelle pas non plus au IXe siècle l'importance qu'elle aura à partir du XIIe siècle. A la même époque, le sacramentaire d'Usuard, qui donne une interprétation symbolique de l'oraison *Veneranda*, se montre lui aussi réservé: pour Usuard, l'expression selon laquelle la Vierge a été "affranchie des liens de la mort"—*nec tamen mortis nexibus deprimi potuit*—ne signifierait pas qu'elle ressuscita corporellement, mais seulement qu'elle n'a pas connu le péché.[12]

Au XIe/XIIe siècle, le traité *De Assumptione Beatae Mariae Virginis* du Pseudo-Augustin (le véritable auteur reste inconnu), n'a au contraire plus aucune hésitation. Il use du raisonnement logique pour démontrer rationnellement la nécessité de l'Assomption corporelle de Marie.[13] Tout le raisonnement est fondé sur le constat de la proximité charnelle de Jésus et de sa mère: un corps qui a porté en lui le corps précieux du Christ (lequel par sa résurrection puis son ascension a échappé au sort commun), ne peut pas ne pas avoir été préservé comme lui de la putréfaction. Car le corps de la Vierge a acquis, au contact de celui du Christ, comme par contamination, une communauté de nature avec lui. Il ne saurait donc, sans scandale, pourrir dans la terre à l'instar de n'importe quel corps.[14]

Aux XIIe et XIIIe siècle, la croyance en l'Assomption corporelle de Marie ne rencontre plus de résistance.[15] La *Legenda aurea* de Jacques de Voragine compile toutes les traditions antérieures—dont les révélations d'Elisabeth de Schönau—dans un double chapitre relatif à cette fête.[16] La fête du 15 août est, aux côtés de Noël, de la Purification et de l'Annonciation, l'une des quatre grandes fêtes universelles à date fixe de la Vierge. La croyance parachève l'idée d'une pureté totale de Marie: non seulement elle fut conçue sans péché—il faudrait ici étudier en parallèle le développement du thème de l'Immaculée Conception[17]—et elle conserva sa virginité jusque dans la maternité, mais son corps, qui avait porté en son sein la chair glorieuse du Christ, a échappé à l'indignité de la putréfaction dans la tombe. Comme le Christ (bien que suivant une chronologie différente), elle est montée au ciel après sa mort, évitant la dissolution putride des chairs et anticipant sur la résurrection des morts à la fin des temps. Ainsi le thème de l'Assomption corporelle de Marie croise-t-il encore un autre thème de plus en plus important: celui de l'attente eschatologique de la résurrection des morts et du Jugement Dernier. Marie anticipe par sa résurrection et sa montée au ciel le sort qui attend les élus à la fin des temps, après que leurs corps, rendus à la poussière, se seront reformés comme des corps glorieux.[18]

L'Iconographie de l'Assomption

L'iconographie de l'Assomption de Marie a fait l'objet de plusieurs études particulières[19] et récemment de la synthèse remarquablement informée de Gertrud Schiller.[20] Toute étude du thème doit désormais partir de ce travail, d'autant mieux qu'il s'appuie sur une masse considérable de reproductions photographiques. On pourrait penser qu'il n'y a rien à ajouter à cette publication. Cela est vrai en ce qui concerne l'étude de l'évolution générale du thème dans la très longue durée, encore qu'il soit toujours possible de convoquer d'autres images, moins connues que celles que re-

produit ce corpus, mais aujourd'hui accessibles grâce aux nouvelles banques de données.[21] L'auteur étudie l'apparition et le développement dans le temps de chaque motif et de chaque attribut (le lit de la Vierge, le tombeau, les funérailles, la couronne, l'âme portée dans un linge ou enfermée dans un *clipeus*, etc.). La question centrale qu'elle se pose est de savoir quand l'image de l'*Assumptio corporis* s'est substituée à celle de la *Dormitio*. L'évolution générale ne fait en effet pas de doute: en Occident, jusqu'à l'époque romane au moins, et à Byzance (comme dans l'Eglise orthodoxe jusqu'à aujourd'hui), la seule image existante est celle de la Dormition, qui montre le Christ, debout derrière le lit de la Vierge, où elle gît morte, et tenant dans les bras la petite âme de sa mère.[22] Puis apparaît et s'impose de plus en plus fortement l'image de l'Assomption corporelle de Marie, ressuscitée et portée au ciel par les anges. Au XVe siècle, cette image est largement diffusée dans les livres d'Heures (Heures de la Vierge). A l'époque moderne, elle se distingue à peine de l'image de l'Immaculée Conception.

Mais l'évolution des images est beaucoup plus complexe que cela. Je souhaite le montrer en distinguant deux mises en scènes différentes des images de la Dormition ou de l'Assomption, que celles-ci se présentent isolément, ou au contraire dans une séquence narrative qui distingue les différents moments de la fin de la vie terrestre de la Vierge. Il me semble en effet que ces deux types de "mise en scène" ont fortement influé sur les formes iconiques et la chronologie de leur développement.

Les images isolées: Dormition ou Assomption?

Si l'on peut facilement identifier le point de départ de l'évolution des images isolées (la Dormition) et leur point d'arrivée (l'Assomption), il est plus difficile d'analyser tous les tâtonnements intermédiaires qui montrent comment la question du *corps* de Marie s'est très tôt posée dans les images de la Dormition. Alors que les images continuent de figurer ce type traditionnel, la croyance bien attestée en l'Assomption corporelle conduit à y introduire "des indices de corporéité," qui en modifient les caractères formels et la signification. Par exemple, dans une Dormition où le Christ est censé élever vers les cieux la petite âme de la Vierge, le fait que celle-ci soit emmaillotée comme un mort dans son linceul (avec des bandelettes qui se croisent sur tout le corps) ne fait-il pas allusion au corps mort et au tombeau d'où la Vierge a été enlevée?[23] L'image ne figurerait pas de manière univoque la séparation de l'âme, mais ferait simultanément allusion au destin du corps, bien qu'il ne s'agisse pas d'une Assomption. Autre exemple: montrant avec raison comment l'image de l'étreinte du Christ et de Marie comme figures des Epoux du Cantique des Cantiques participe aussi de l'iconographie de l'Assomption, Gertrud Schiller écrit que seule l'âme est en cause dans de telles images.[24] Mais, même si ces images renvoient aux commentaires monastiques sur les relations entre le Christ et l'âme du fidèle ou la Vierge-Eglise, elles donnent à *voir*, et pas seulement à lire, une relation amoureuse qui implique nécessairement le corps, même si le sens de l'image se veut d'abord spirituel ou allégorique.

Un point de départ: la Dormition

Toutes les images de la *Koimesis* byzantine ou, en latin, de la *Dormitio*, ne présentent pas cette ambiguïté. On peut en prendre, pour exemple, l'ivoire byzantin qui figure au centre de la reliure

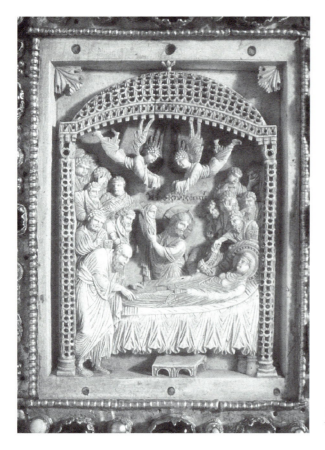

1. Evangéliaire d'Otton III. Munich, Bayerische Staats-
bibliothek, Ms. Clm 4453. Ivoire, Byzance, Xe siècle

d'or, sertie de pierres précieuses et de camées, de l'Evangéliaire d'Otton III, vers l'an mil (Fig. 1).[25]
Debout au centre de la scène et derrière le lit de la Vierge, distinct des apôtres qui se pressent à la
tête et aux pieds de celui-ci, le Christ élève l'âme de Marie que deux anges, les mains voilées, s'ap-
prêtent à recueillir et à introduire dans les cieux. A la même époque, le sacramentaire de l'évêque
Warmundus[26] montre le Christ se saisissant devant les apôtres (dont Pierre et Paul, seuls nimbés),
de la petite âme emmaillotée et nimbée de sa mère, et la tend vers l'étoile radieuse symbolisant
le ciel divin. L'inscription latine se lit en haut et en bas en caractères latins, *Christus in arce
poli*/*Prebet consorcia matri* (le Christ offre sa compagnie à sa mère dans la cité du ciel), et sur les
côtés en caractères grecs: *Dormicio*/*Virginis*. L'appellation retenue est donc bien celle, tradition-
nelle, de "Dormition."

 Un ivoire byzantin de la fin du Xe siècle[27] montre une *Koimesis*, mais avec plusieurs traits
singuliers: le Christ ne fait pas le geste de séparer l'âme du corps; il se tient droit et immobile, de
face, tenant l'âme dans ses bras tout en contemplant le corps mort de sa mère; l'âme de celle-ci n'est
pas une figure enfantine, elle présente l'allure d'une vieille femme; son vêtement comporte des ban-
delettes croisées qui évoquent le linceul; surtout, un ange emporte vers le ciel cette âme, qui appa-
raît ainsi deux fois, au début et à la fin de son assomption. Pourtant, même si l'image évoque le
parcours de l'âme vers les cieux, l'insistance sur la figure de Marie dans ses trois états successifs
suggère que c'est peut-être la totalité de sa personne, avec l'âme, mais aussi le corps, qui connaît à
cet instant un sort exceptionnel. Le même triplement de la figure de Marie se retrouve dans une

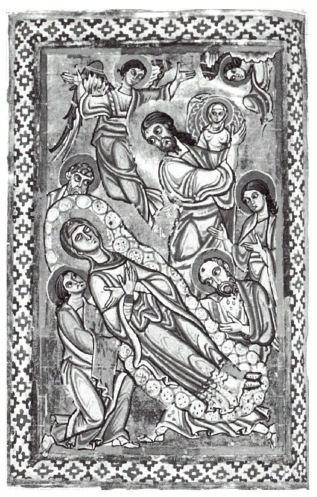

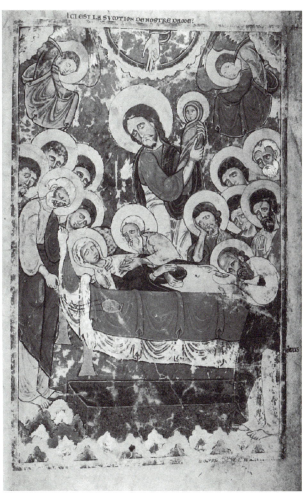

2. Livre des Péricopes de Saint-Ehrentrud de Salzburg. Munich, Bayerische Staatsbibliothek, Ms. Clm 15903, f. 81v, vers 1140

3. Psautier de Winchester. London, British Library, Cotton Ms. Nero C IV, f. 29r, vers 1170

miniature de l'Antiphonaire de Prüm entre 993 et 1001,[28] avec un détail supplémentaire: la main de Dieu couronne la petite figure de Marie au moment où l'ange l'introduit aux cieux.

Le livre des Péricopes du monastère de St. Erentrud du Nonnenberg de Salzburg,[29] vers 1140, présente une autre variation significative, qui n'affecte pas la figure de Marie, mais sa couche (Fig. 2). Le lit habituel est remplacé ici par une sorte de mandorle décorée à la manière d'un lit de fleurs et qu'un des apôtres, à genoux, paraît soutenir, sinon élever. Même si on peut admettre, une fois encore, que seule l'âme de Marie est en cause, l'attention de celui qui regarde l'image est dirigée vers l'élévation de ce corps mort, les main croisées, qui semble vouloir rejoindre l'âme que tient le Christ.

Un autre "indice de corporéité" apparaît dans la scène de la Dormition du Psautier de Winchester, vers 1170 (Fig. 3). Dans la série des pleines pages consacrées à la vie du Christ, une double page, appelée par les historiens de l'art le "diptyque byzantin," se distingue de toutes les autres. Sa partie droite (recto) présente l'icône trônante et frontale de la Mère de Dieu, figurée en orante et entourée de deux anges portant des bannières. La partie gauche (verso), qui lui fait face, présente

4. Chapiteau de Notre-Dame-du-Port,
Clermont-Ferrand, vers 1100

au premier regard une *Dormitio* dans la tradition byzantine.[30] Sous la main de Dieu bénissante, le Christ élève l'âme de sa mère qu'il s'apprête à remettre à deux anges aux mains voilées en signe de respect. Les apôtres entourent la Vierge qui vient de mourir et gît dans son lit. Mais plus bas dans l'image, la forme horizontale du lit est redoublée par celle du tombeau vide de la Vierge. Simultanément, et non dans la succession des phases d'un récit, l'artiste a su représenter le modèle byzantin de la *Koimesis* et suggérer que Marie est ressuscitée et montée corporellement au ciel puisque son tombeau est vide. La trouvaille formelle est remarquable: en usant du modèle de la *Dormitio*, l'image pose avant tout la question du devenir de l'âme de la Vierge. Mais en faisant figurer le tombeau vide sous le lit de la Vierge, elle attire l'attention sur le devenir simultané de son corps.

Le cas le plus étonnant de transformation de l'image traditionnelle de la Dormition en une image plus "corporelle," plus conforme à l'idée de l'Assomption, est présenté par un chapiteau du déambulatoire de Notre-Dame-du-Port à Clermont-Ferrand, œuvre du sculpteur Robert, vers 1100 (Fig. 4).[31] Ce chapiteau fait partie d'un ensemble de quatre chapiteaux, où Eve (avec le péché originel et l'expulsion du paradis) est opposée à Marie, la Nouvelle Eve (avec l'Annonciation puis l'Assomption). Le quatrième chapiteau comprend quatre faces: la principale (tournée vers le sud-ouest) montre la résurrection de la Vierge, suivant un schéma qui, à première vue, pourrait être confondu avec celui d'une Dormition. Mais ici, ce n'est pas l'âme de sa mère que tient le Christ, mais son corps, emmailloté dans le linceul, au-dessus du sarcophage ouvert. Une inscription énonce: *Maria hon(orata) in celum*. Les autres faces montrent successivement une personnification de la Jérusalem céleste, ailes déployées, l'oriflamme à la main, sonnant de la trompette; puis un ange, qui tient devant lui un grand livre sur lequel est écrit: *ecce l(ibro) v(i)te ecce Maria e(s)t nobis asscripta* (voici que sur le livre de vie Marie est inscrite pour nous); enfin, sous la forme d'une forteresse crénelée, le ciel qui s'ouvre, dévoilant l'arche d'alliance. Cet ensemble sculpté est fondamental à plus d'un titre: du point de vue formel, il témoigne de la nécessité, au XIIe siècle, de faire

évoluer le type ancien de la Dormition pour donner toute sa place au corps ressuscité et assumé au ciel de Marie. Du point de vue de sa signification, explicitée par les inscriptions, il souligne à quel point le sort exceptionnel de la Vierge anticipe sur celui des hommes: Marie les précède sur le "livre de vie" pour garantir qu'ils y seront inscrits à leur tour à la fin des temps.

Quelles sont les plus anciennes images de l'Assomption corporelle?

Un autre type d'image, plus précoce encore, suscite également de nombreuses questions, puisqu'il semble déjà présenter les traits caractéristiques de l'Assomption telle qu'elle sera représentée à la fin du Moyen Âge. Gertrud Schiller en donne pour exemple la miniature d'un missel d'Augsbourg de la première moitié du XIe siècle provenant de la Reichenau.[32] La Vierge, somptueusement vêtue, de face, faisant le geste de l'orante, est circonscrite dans une mandorle que quatre anges élèvent aux cieux. Jugeant que cette image est trop précoce pour pouvoir se référer à l'Assomption corporelle de Marie, Schiller y voit l'image de la glorification céleste de son *âme*, ce que confirmerait l'inscription "MARIS STELLA MARIA." Or, cette image peut être rapprochée de l'ivoire de Tuotila (895–912), utilisé vers 900 pour la reliure inférieure de *l'Evangelium longum* de Saint-Gall.[33] Il a souvent été présenté comme la première figuration de l'Assomption corporelle de Marie. Pour Schiller, qui consacre un long développement à cet ivoire,[34] il ne peut s'agir, une fois encore en raison de la date précoce, que de l'âme glorieuse de la Vierge au paradis. La Vierge est debout, dans la position de l'orante, flanquée de quatre anges qui l'honorent. Ses pieds reposent sur un sol, et un arbre symbolise le paradis. Une inscription identifie la scène comme étant l'"Ascensio s(an)c(t)e Marie." Celle-ci fait pendant à la Majestas Domini de la reliure supérieure. Le mot "ascensio" est ambigu, encore qu'il se réfère directement à l'ascension corporelle du Christ. On peut donc penser, contre Schiller, que l'inscription utilise cette référence christique pour défendre l'idée de l'assomption corporelle de Marie. Exactement à la même époque et au même endroit, le moine Notker de Saint-Gall, prenant ses distances par rapport aux doutes exprimés précédemment par Paschase Radbert, défend sans hésiter l'assomption corporelle de Marie et entend lui réserver le mot "assumptio (corporis)" afin de bien la distinguer du sort des autres saints, au sujet desquels il convient de parler de "depositio vel dormitio, aut certe natale."[35] On voit donc, pour revenir à l'ivoire de Tuotila, que la terminologie n'est pas encore tout à fait fixée vers 900, ce qui explique les efforts de clarification de Notker. L'interprétation de Schiller me semble limitée par son caractère univoque. Certes, Marie est figurée au paradis. Mais, l'inscription en fait foi, elle y "monte" ou y est "montée" (*ascensio*), sans même avoir besoin de l'aide des anges, exactement comme le Christ y est monté.

L'hypothèse d'une représentation précoce de l'assomption corporelle de Marie me semble devoir être d'autant mieux retenue que d'autres images lui font écho dès le XIe siècle. La première est une célèbre peinture murale dans la basilique inférieure de S. Clemente à Rome. Bien qu'elle soit endommagée, la signification de cette peinture ne paraît pas faire de doute. Marie, les bras ouverts dans le geste de l'orante, s'élève vers le ciel au dessus des apôtres, le regard tourné vers le Christ qui trône en majesté dans une mandorle soutenue par quatre anges. Un sacramentaire normand, daté lui aussi du XIe siècle, présente sur une double page, à gauche l'Assomption de Marie, à droite l'initiale ornée de la collecte *Veneranda*.[36] Marie, nimbée et couronnée, est debout, toute droite et de face, dans une mandorle que deux anges soulèvent vers le ciel; elle tient dans la main

droite la palme que l'ange lui a remise en lui annonçant sa mort prochaine. D'une nuée sort la main de Dieu qui la bénit. Il faut rapprocher cette image de celle, contemporaine et provenant également de Normandie, d'un manuscrit enluminé par le peintre Hugo à l'abbaye de Jumièges. Dans l'initiale historiée de la lettre *Cogitis me* attribuée à Saint Jérôme, Marie est figurée élevée au ciel par quatre anges et recevant de la colombe les flammes de l'Esprit Saint. Elle est couronnée et tient dans les mains la pomme de la Nouvelle Eve(?) et la palme que l'ange lui a remise.[37] Enfin, dans le Sacramentaire de Saint-Denis, à la même époque, Marie est figurée toute droite, sans couronne et sans mandorle, mais tenant la palme dans la main gauche. Elle est flanquée de deux anges, mais qui se tiennent écartés d'elle et ne la portent pas. Comme Philippe Verdier l'a noté, "le mouvement ascentionnel est complètement absent" de cette image;[38] celle-ci, "n'illustre pas une assomption, mais la prière." Pourtant, sans nier les différences entre cette image et les images contemporaines qui viennent d'être citées, on ne peut, me semble-t-il, exclure complètement l'idée que la croyance en l'Assomption corporelle de Marie sous-tend aussi cette miniature.

Les images ottoniennes

D'autres variations de l'image de la Dormition sont attestées dans la miniature ottonienne, dont on sait à quel point elle fut réceptive aux influences byzantines. Le livre des Péricopes de l'Empereur Henri II[39] a recours au procédé de l'*imago clipeata* pour figurer la réception de Marie à l'intérieur de la mandorle du Christ en majesté, à la verticale de la scène de la mort, ritualisée par la présence de croix et de cierges. Ce qui est figuré n'est pas le moment de la séparation de l'âme et du corps, puisque le Christ n'est plus présent au chevet de sa mère. Il s'agit plutôt d'une veillée funèbre, qui simultanément donne à voir l'apothéose de la Vierge dans le sein de son Fils. Le *clipeus* sert d'ordinaire à inscrire la figure du Christ dans la *Theotokos.* L'usage en est ici inversé: il sert à signifier la gloire céleste de la Vierge après sa mort. Cette image ne se comprend que dans sa confrontation avec d'autres images issues du même milieu.

Le Lectionnaire de la Reichenau,[40] vers 1018, présente sur une double pleine page, d'un côté la Dormition de Marie, dont l'âme est confiée par le Christ aux anges qui la reçoivent les mains voilées, et de l'autre côté, son *imago clipeata* portée par deux anges; plus bas, d'autres anges s'écartent violemment, comme saisis d'étonnement, en la voyant s'élever dans le ciel; au sommet de l'image, la main de Dieu, tenant trois rayons en forme de croix, sort des nuées célestes en direction de la Vierge.[41] Comment décider si seule l'âme est ici en cause? Certes, aucune assomption corporelle n'est figurée. Pourtant l'ampleur de la double page et l'introduction d'une iconographie nouvelle témoignent de la recherche de solutions formelles inédites, en réponse à la conception de plus en plus répandue de l'Assomption corporelle de Marie.

L'Assomption et l'Epouse du Cantique

A partir du XIIe siècle, l'identification de Marie, de *l'Ecclesia* et de la *Sponsa* du Cantique des Cantiques dans les commentaires de Bernard de Clairvaux, Rupert de Deutz, Pierre Damien et Honorius Augustodunensis, conduit à proposer une nouvelle iconographie de la Vierge de l'Assomption. Dans ces images, l'attention se porte moins sur le mouvement d'élévation au ciel de

5. Missel de Stammheim. Los Angeles, The J. Paul Getty Museum, Ms. 64, f. 145v, Hildesheim, vers 1160

l'âme ou du corps de Marie, que sur le résultat de ce mouvement: l'étreinte dans les cieux du *Sponsus* et de la *Sponsa*. L'image pourrait sembler n'avoir aucun lien direct avec l'Assomption si elle ne comprenait dans certains cas des inscriptions relatives à la glorification anticipée du corps de Marie. C'est ainsi que le Missel de Stammheim, écrit vers 1160 par le prêtre Henri, à St. Michel de Hildesheim, présente au centre d'une miniature à pleine page, le Christ qui attend dans le ciel Marie, identifiée comme "tota pulchra amica mea" (Cantique 4:7) (Fig. 5).[42] Il tient la couronne, symbole d'éternité, qu'il introduit dans la mandorle placée au dessous de lui. Dans cette mandorle, le fiancé conduit la fiancée, en passant la main droite derrière son épaule, et il tient un rouleau portant l'inscription: "Non veni solvere, sed adimplere" (Matt. 5:17), ce qui peut s'interpréter de la manière suivante: la loi de la mort n'est pas abolie, elle est accomplie par la résurrection. Deux anges, trois prophètes, Saint Jérôme et Saint Grégoire entourent la scène centrale, portant eux aussi des rouleaux avec des inscriptions. Le premier ange, en haut à gauche, désigne la

Fiancée tout en citant Sagesse 7:29: "Hec est speciosor sole." En face, le deuxième ange affirme: "Ista est speciosa inter filias Ierusalem" (Cantique 2:2). En dessous, Moïse, à gauche, regarde la fiancée en rappelant le quatrième commandement: "Honora patrem et matrem" qui fait référence aux relations du Christ et de sa mère. David désigne la Fiancée du doigt en citant le Psaume 45 (44):5: "Intende, prospere procede et regna." Plus bas, le roi Salomon lève le regard vers la Fiancée et la désigne du doigt avec une citation du Cantique: "Que est ista que ascendit per desertum" (Cantique 3:6) et Jérôme vêtu en moine (dont il faut rappeler qu'il est l'une des "autorités" toujours invoquée à propos de l'Assomption de Marie), déclare: "Gloriosa semper virgo Maria celos ascendens." Au-dessous de l'image, symétriquement opposé au Christ, le pape Grégoire le Grand, qui fut l'un des premiers à assimiler la *Sponsa* à l'Eglise, est représenté en buste, de face et levant la main droite pour déclarer: "Hec est quae nescivit thorum in delicto" (Marie est "celle qui n'a pas connu le lit dans le péché"). Plusieurs de ces citations font donc explicitement référence à la pureté de Marie et à son "ascension" au ciel. C'est du moins un des niveaux possibles de la lecture exégétique offerte par cette image, qui associe à la gloire de la Vierge celle de l'Eglise, la Fiancée du Christ.

Dépouillées de ces références scripturaires et patristiques, d'autres images reprennent la figure du couple du *Sponsus* et de la *Sponsa*, pour l'intégrer dans l'image de la Mort de la Vierge,[43] ou représenter une sorte de double assomption du Christ et de sa mère-épouse.[44] Cette dernière image est d'autant plus intéressante qu'on la trouve logée dans l'initiale C de la lettre *Cogitis me* de Paschase Radbert. La petite figure que le Christ tient dans ses bras est l'âme qui le désire ("die Christus minnende Seele," selon Schiller), mais aussi Marie couronnée et portant sur son vêtement les bandeaux croisés qui rappellent son linceul. Alors même que le texte orné par cette initiale exprime des réserves quant à l'Assomption corporelle de la Vierge, l'image a tout oublié de ces hésitations.

Les initiales de la collecte *Veneranda*

Il nous faut cependant revenir aux images qui se réfèrent le plus directement à la croyance en l'Assomption de Marie. Ce sont, dans les manuscrits liturgiques, les initiales historiées V de la collecte *Veneranda* propre à la fête de l'Assomption. Entendus en leur sens littéral, les termes de l'oraison imposent cette iconographie: la Vierge est vraiment figurée affranchie des "nœuds de la mort." Une solution a consisté à assimiler l'iconographie de l'Assomption de la Vierge à celle de l'Ascension du Christ, comme on le voit au début du XIIIe siècle dans un pontifical à l'usage de Chartres (Fig. 6).[45] Les apôtres pleurent devant le corps de la Vierge qui vient de mourir et dont les yeux sont fermés, mais dont le buste est relevé; simultanément, le corps de la Vierge est transporté au ciel par les anges dans une mandorle. Comme dans bien des images de l'Ascension du Christ, seuls les pieds de la Vierge sont encore visibles, le reste du corps ayant déjà atteint sa destination céleste.

Différent est le choix fait pour l'initiale *Veneranda* par le Sacramentaire de Saint-Martin de Tours, dans le dernier quart du XIIe siècle (Fig. 7).[46] Au-dessus du tombeau vide sur lequel se penchent les apôtres affligés, la Vierge couronnée est élevée par deux anges dans un linge qui épouse la forme de son corps et évoque une mandorle. Tout en haut de l'image, le Christ s'apprête à accueillir sa mère dans le cercle parfait du paradis céleste.

6. Pontifical à l'usage de Chartres, initiale V(eneranda).
Orléans, Bibliothèque Municipale, Ms. 144, f. 94r, debut du
XIIIe siècle

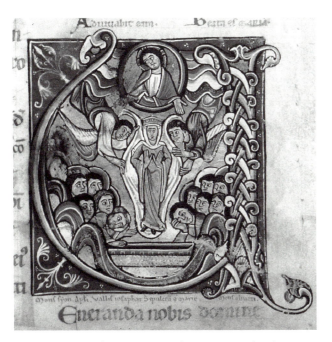

7. Sacramentaire de Saint-Martin de Tours, initiale V(ener-
anda). Tours, Bibliothèque Municipale, Ms. 193, f. 98r, vers
1175–1200

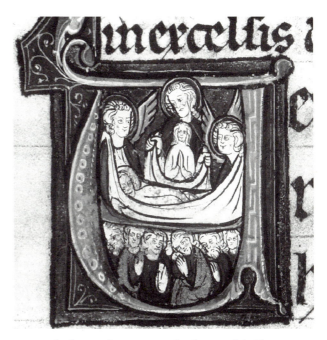

8. Missel à l'usage de Paris, initiale V(eneranda). Clermont-
Ferrand, Bibliothèque Municipale, Ms. 62, f. 24lv, vers
1250–1260

La mandorle finit par s'imposer en effet comme caractéristique de l'image de l'Assomption.[47] On la retrouve dans une initiale d'un graduel à l'usage de l'abbaye de Notre-Dame de Fontevrault du XIIIe/XIVe siècle.[48] Dans la mandorle de gloire se découpe, sur le fond bleu étoilé d'un ciel, la figure en pied de Marie tenant une croix en guise de sceptre. Les anges ne volent pas, ils sont debout et semblent moins transporter Marie qu'ils ne l'offrent au regard des fidèles invités à lui adresser leurs prières.

Cependant, l'ambiguïté entre l'assomption de l'âme et celle du corps persiste dans un type d'image où la figure de Marie n'est pas inscrite dans une mandorle, mais soutenue dans un linge porté par deux anges. Traditionnellement, ce linge emporte les âmes des saints.[49] On peut donc se demander, dans le cas de Marie, ce qui, de l'âme ou du corps, est figuré dans le linge. On peut avoir des doutes à propos du missel de Charleville-Mézières du XIIIe siècle[50] ou d'un antiphonaire du XIIIe/XIVe siècle conservé à Avignon,[51] encore que, dans les deux cas, la taille et le vêtement de Marie plaident pour une figuration de toute sa personne ressuscitée, son corps en même temps que son âme.[52] Mais le doute disparaît devant l'initiale *Veneranda* d'un missel parisien daté de 1250–1260, qui ne présente pas seulement un linge, mais également un drap, élevé par deux anges au dessus des apôtres (Fig. 8).[53] Les apôtres ne sont donc pas figurés en train d'ensevelir la Vierge. Ils sont les spectateurs de son Assomption corporelle. Au dessus du drap et plus petit que lui, on voit un linge que le Christ saisit et qui contient l'âme de la Vierge en position d'orante. C'est au ciel que l'âme et le corps doivent donc être réunis, après que le corps y aura été lui aussi transporté.

Les cycles narratifs

L'ambiguïté des images isolées (où le thème de l'Assomption s'impose progressivement sous le schéma traditionnel de la Dormition et finit par s'affranchir de celle-ci, tout en se découvrant d'autres modes d'expression) disparaît largement dans les séquences d'images qui dépeignent plusieurs ou la totalité des derniers moments de l'existence terrestre de la Vierge: l'apparition de l'ange à Marie, à qui il annonce sa mort prochaine; la réunion miraculeuse des apôtres puis la Dormition (quand le Christ vient prendre son âme) ou la mort (si le Christ est absent); les funérailles (avec le châtiment miraculeux des juifs); la résurrection (alors que l'âme est réunifiée au corps); l'Assomption corporelle et enfin le Couronnement de la Vierge (qui apparaît de plus en plus comme la suite directe de l'Assomption).[54] Cette séquence narrative, qui est rarement figurée tout entière, a permis au thème de l'Assomption de se développer sans faire disparaître dans tous les cas celui de la Dormition. On retrouverait ainsi dans les images la préoccupation exprimée par Elisabeth de Schönau, soucieuse de distinguer la Dormition de la Vierge (c'est-à-dire la séparation par le Christ de l'âme et du corps de sa mère), qu'elle entend commémorer le 15 août, et la Résurrection et/ou l'Assomption corporelle, qu'elle situe et veut fêter quarante jours plus tard, le 23 septembre. Les images narratives ne suggèrent pas l'écoulement du temps entre les épisodes qu'elles juxtaposent, mais cette juxtaposition même les rapproche du récit de la visionnaire.

Pour Schiller, c'est dans la sculpture que se rencontre pour commencer la figuration d'une telle séquence narrative. Un fragment du tympan de l'église de Cabestany (Pyrénées orientales, vers 1150),[55] figure de gauche à droite la résurrection de Marie, soutenue hors de tombeau par son Fils, le miracle de la ceinture de la Vierge, donnée par elle à Thomas, le Christ bénissant et Marie en orante, de face, et enfin l'Assomption de la Vierge, dans une mandorle soutenue par quatre

anges. Les deux anges du bas ont les mains couvertes d'un linge. Ceux du haut agitent des encen-
soirs. Bien droite, les bras le long du corps, la Vierge conserve encore la rigidité qu'elle avait dans
la tombe. Ses yeux sont fermés. Elle porte un voile, le *maphorium*, et par dessus la couronne.

Au tympan de Saint-Pierre-le-Pullier de Bourges (vers 1175),[56] sont figurées simultanément,
au registre inférieur, sous un édifice à arcatures, l'annonce par l'ange de sa mort à Marie, l'arrivée
simultanée des apôtres, la Dormition ou la mort de Marie (on ne peut en juger puisque cette
scène est entièrement détruite) et au registre supérieur, la mise au tombeau de la Vierge par les
apôtres et son Assomption. Dans cette dernière scène, la Vierge couronnée trône dans une man-
dorle que soutiennent des anges. Elle fait le geste de l'orante, tandis que des rayons se diffusent
à partir de son corps.

A Cabestany comme à Saint-Pierre-le-Pullier, on peut voir comment la mandorle contenant
la figure de la Vierge, qui était isolée dans certains manuscrits du XIe siècle, a été introduite dans
des cycles narratifs sculptés de la deuxième moitié du XIIe siècle. Quand elle traite des manu-
scrits, Schiller affirme, parce qu'ils datent du XIe siècle, que la mandorle contient l'âme de la
Vierge; mais quand elle traite de la sculpture, parce que celle-ci est plus tardive, elle n'hésite plus
à parler de l'Assomption corporelle de Marie. Faut-il admettre que l'image, sans avoir changé sur
le plan formel, aurait changé de signification? C'est possible, mais on peut aussi retenir l'idée
d'une ambivalence des premières images, qui aurait facilité l'infléchissement de leur signification
dans des séquences narratives ultérieures. Il faut en tout cas se garder d'imposer à l'histoire de ces
images une chronologie a priori, comme s'il était inconcevable que le thème de l'Assomption, par-
faitement admis dans la littérature ecclésiastique, impose précocement sa marque "corporelle"
aux images plus traditionnelles.

Le témoignage des psautiers enluminés

Si les cycles narratifs sculptés ont favorisé l'apparition d'une nouvelle iconographie de l'assomp-
tion corporelle de Marie, ou ont permis de préciser le sens des images anciennes,[57] les manuscrits
ont eux aussi joué un rôle dans cette évolution. Gertrud Schiller estime qu'un seul manuscrit
médiéval—le Hunterian Psalter (autrefois Psalter d'York), vers 1170[58]—a représenté le cycle des
légendes apocryphes relatives à l'Assomption de la Vierge. Il s'agit en effet d'une œuvre exception-
nelle. Six miniatures successives, disposées sur trois pages consécutives comportant chacune deux
registres superposés, illustrent les derniers moments de l'existence terrestre de la Vierge. Au folio
17v, la Vierge reçoit la palme de l'ange et, au registre inférieur, la transmet à Saint Jean (Fig. 9).
Au folio 18r, au registre supérieur, le Christ se tient derrière le lit de mort; cette image reproduit
le schème formel de la Dormition, mais elle se distingue en même temps de cette dernière (Fig.
10). En effet, le Christ ne prend pas l'âme de sa mère, il la bénit tandis qu'une cohorte d'anges des-
cend du ciel. Au registre inférieur est figurée la procession funéraire de la Vierge: les apôtres por-
tent la bière, que deux anges, les mains voilées, honorent en se glissant sous elle comme s'ils la
soutenaient; en tête du cortège, Saint Pierre tient la palme, que Saint Jean, selon la légende, lui a
remise. Au folio 19v enfin, le registre supérieur, plus petit qu'à l'accoutumée, montre les apôtres
ensevelissant le corps de la Vierge, qui est dissimulé dans un linceul et encensé par les anges. Beau-
coup plus grand, le registre inférieur a bénéficié de toute l'attention du peintre (Fig. 11). Cette
image est absolument unique. Tandis que deux anges encensent le tombeau vide, deux groupes de
sept anges élèvent au ciel le corps de la Vierge, qui est encore enfermé dans son linceul, l'emplace-

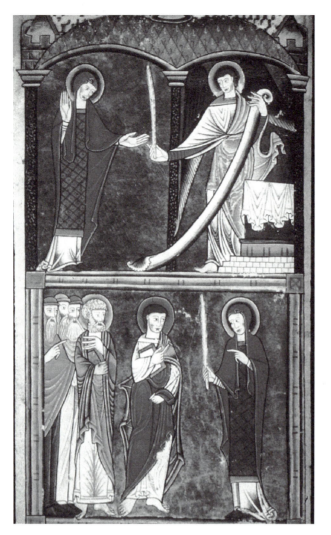

9. Hunterian Psalter. Glasgow, University Library, Ms. Hunter 229 (U.3.2), f. 17v, vers 1170

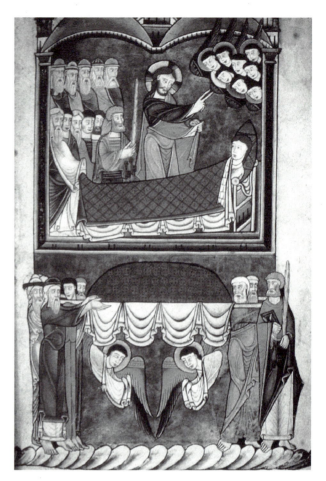

10. Hunterian Psalter. Glasgow, University Library, Ms. Hunter 229 (U.3.2), f. 18r, vers 1170

ment des yeux étant soigneusement bandé. Le corps est porté par les anges dans un grand drap dont les plis en forme d'arc témoignent à la fois du poids du corps et de la dignité éminente du précieux fardeau. L'image donne un instantané du début de l'Assomption de la Vierge, alors que celle-ci n'est pas encore ressuscitée. Elle se conforme ainsi au récit, entre autres, de Grégoire de Tours. D'ordinaire, les images suggèrent plutôt la résurrection de la Vierge sur terre, avant l'Assomption de toute sa personne au ciel.

Le moment de la résurrection de Marie

D'autres images tentent en effet de fixer le moment précis de la résurrection de la Vierge. C'est un instant difficile à saisir, qui se distingue difficilement de ce qui le précède immédiatement (la

11. Hunterian Psalter. Glasgow, University Library, Ms. Hunter 229 (U.3.2), f. 19v, vers 1170

Vierge morte dans le Hunterian Psalter), ou de ce qui le suit (l'Assomption de la Vierge déjà ressus-citée). La Bible de Pampelune, qui date du début du XIIIe siècle, obéit à la première formule. Elle développe le cycle de la mort de la Vierge sur deux pleines pages successives. La première (Fig.12)[59] représente une *Dormitio*, bien que la légende parle de son "ascension" au ciel: "hodie ha(ec) virgo Maria celos asce(n)dit. gaudete q(ui)a cum Chr(is)to regnat in et(er)nu(m). exaltata est gloriosa se(m)p(er) Maria v(ir)go sup(er) choros ang(e)lor(m)." La Vierge repose sur son lit de mort, contemplée par le groupe compact des apôtres, tandis que le Christ remet aux anges son âme, figurée comme un petit personnage emmailloté, pour qu'ils l'emportent au paradis. La même couleur mauve caractérise le drap funéraire, la robe du Christ et les langes de l'âme-enfant, soulignant peut-être tout ce qui les unit entre l'ici-bas et l'au-delà. Cette continuité chromatique est d'autant plus remarquable qu'elle outrepasse la limite du monde sensible, marquée dans cette image par la ligne oblique qui sépare la scène funèbre de la rencontre du Christ et des anges.

12. Bible de Pampelune. Amiens, Bibliothèque Municipale, Ms. 108, f. 201r, début du XIIIe siècle

13. Bible de Pampelune. Amiens, Bibliothèque Municipale, Ms. 108, f. 20lv, début du XIIIe siècle

La deuxième image complète la première et en explicite la signification (Fig. 13). La légende insiste sur le sépulcre de Marie et sur le fait que les pèlerins peuvent le voir dans la vallée de Josaphat, à proximité de Jérusalem: "Monstrat(ur) a(u)t(em) sepulcru(m) be(ate) Marie c(er)ne(n)tib(us) n(o)b(is) usq(ue) ad p(re)s(n)s in valle Iosaphat medio. qu(i)a vallis int(er) mon(em) Syon e(t) montem Oliveti posita e(st)." Pourtant, l'image ne montre pas le tombeau, mais le lit de mort de Marie, dont un ange désigne le corps aux douze apôtres tandis que cinq anges descendent du ciel pour l'emporter aux cieux. La miniature fixe ainsi l'instant qui précède immédiatement la résurrection de Marie.

L'instant même de la résurrection a peut-être été figuré sur le portail nord de la cathédrale d'Autun, dans la première moitié du XIIe siècle. Le trumeau, le linteau et le tympan présentaient un ensemble de sculptures qui ont pour la plupart disparu. Les vestiges du tympan suggèrent la présence d'un cycle marial, dont subsiste peut-être la scène de la résurrection de la Vierge. Si cette identification est la bonne, on verrait celle-ci à l'instant même où elle est tirée par deux anges de son sépulcre, nimbée, les bras levés dans le geste de l'orante et soutenus par deux anges.[60]

14. Bible. Paris, Bibliothèque Sainte-Geneviève, Ms. 10, f. 129r, France de l'Est, vers 1175–1200

Bien que cette sculpture soit singulière et qu'elle reste énigmatique, on peut, pour s'assurer de sa signification, la comparer à une double miniature ornant vers 1175–1200 les tables des canons d'une Bible provenant de la France de l'Est (Fig. 14).[61] A gauche, un groupe d'anges et trois apôtres en larmes entourent le corps de la Vierge déposé dans son sépulcre. Une croix est inscrite sur le fond de l'image, juste devant le visage de la Vierge, soulignant son lien privilégié avec le Christ. On attendrait ici une Dormition, mais ce n'est plus le cas. L'image montre la déploration d'un cadavre. A droite, deux anges tirent la Vierge ressuscitée hors de son tombeau. Ce n'est pas, comme dans le Hunterian Psalter, le cadavre enfermé dans son linceul qui est porté par les anges. La Vierge a les yeux ouverts, elle s'anime en s'inclinant légèrement sur sa droite. Elle est vêtue d'ornements sacerdotaux dont la magnificence illustre la gloire de son corps ressuscitée. Le vêtement fait deux plis sur les côtés, là où les anges portent la main pour la soutenir, rendant ainsi sensible la pesanteur du corps.

L'attention à la réalité physique du corps ressuscité et "assumé" au ciel s'est développée au cours du XIIIe siècle. Les tympans des cathédrales gothiques font une large place à la résurrection de la Vierge, à l'intérieur du cycle plus ou moins complet de la fin de sa vie et de sa glorification.[62] A Notre-Dame de Paris, le registre médian du tympan est occupé par la résurrection de la Vierge, dont le corps encore couché dans un drap est élevé au dessus du tombeau par les anges. Le registre supérieur du même tympan montre le Couronnement de la Vierge. A Senlis, à Chartres, à l'abbaye de Longpont, à Amiens, à Sens, le registre inférieur se dédouble latéralement pour montrer successivement, à gauche, la mise au tombeau de la Vierge par les apôtres (soit un mouvement de haut en bas), et à droite, sa résurrection, quand les anges la soulèvent encore couchée dans un drap

(soit un mouvement de bas en haut). La similarité formelle des deux scènes—toutes deux centrées sur le corps de la Vierge enveloppée dans un drap qui retombe sur les flancs du tombeau—accentue le caractère dramatique de l'inversion du mouvement, descendant dans la scène de la mort, ascendant dans celle de la résurrection.

Au XIVe siècle, d'autres formules sont proposées dans la peinture pour rendre compte de la résurrection de la Vierge. Ugolino di Prete Ilario peint, entre 1370 et 1384, dans l'abside de la cathédrale d'Orvieto, tout le cycle de la vie de la Vierge, en plaçant aux registres supérieurs l'ange annonçant sa mort prochaine à la Vierge, et, en face, la Dormition; au dessus, les funérailles de la Vierge, avec, en face, la résurrection de la Vierge, que le Christ tire hors de son tombeau; au sommet, l'Assomption, et, dans la voûte, le Couronnement de la Vierge. L'image de la résurrection est particulièrement remarquable puisqu'on y voit la Vierge, toute droite et les mains jointes, émergeant à mi-corps de son tombeau, comme animée du désir de rejoindre son fils qui lui apparaît dans une nuée angélique et qui l'attire à lui (Fig. 15).[63]

L'Assomption et le Couronnement de la Vierge

Dès la fin du XIIe siècle, l'Assomption de la Vierge est de plus en plus souvent associée à la scène de son Couronnement, qui clôt l'ensemble du cycle. Au début, la scène figure plutôt le Christ bénissant sa mère, laquelle est déjà couronnée. Ou bien tous deux siègent ensemble sur le même trône, comme c'est le cas dans la mosaïque de l'abside de Santa Maria di Trastevere. Cette scène est encadrée, sur les piliers qui ferment l'abside, par les images des funérailles et, d'autre part, de la Dormition.[64] Au portail occidental de Senlis, qui présente la première figuration achevée du Couronnement de la Vierge, comme sur la plupart des portails gothiques qui s'en sont inspirés ensuite, la scène du Couronnement de la Vierge, au centre du tympan, domine les scènes de la mort et de la résurrection de la Vierge, figurées sur le trumeau.[65] Voyons plus précisément comment s'articulent les scènes de la Dormition/Assomption et du Couronnement de la Vierge et quel rôle elle a joué dans la formation de l'image de l'Assomption corporelle de Marie.

Un psautier à l'usage de Troyes destiné à la comtesse Jeanne de Flandre (vers 1170)[66] montre une pleine page occupée pour l'essentiel par la scène du Couronnement de la Vierge, encadrée dans un losange d'or qui lui-même se détache sur un quadrilobe bleu contenant quatre figures angéliques (Fig. 16). Les deux anges du haut encensent rituellement le Christ et Marie. Les deux anges du bas élèvent dans un voile, en direction de l'espace divin, la petite âme nue de cette dernière. Quant au corps de Marie, les apôtres le mettent au tombeau dans la partie inférieure de l'image. Cette image extrêmement dynamique s'attache à montrer tout le processus par lequel la Vierge est parvenue au ciel où elle fut couronnée. Explicitement, c'est l'âme qui est ainsi transportée de la terre vers le ciel au moment même où le corps est déposé dans le tombeau. Mais l'image est distincte d'une Dormition, puisque le Christ n'y figure pas pour emporter lui-même l'âme de sa mère. Le même schéma s'observe ailleurs, par exemple dans un psautier franciscain daté de 1250–1265, où les deux registres superposés (Couronnement de la Vierge en haut, ensevelissement et assomption de l'âme en bas) figurent dans les deux panses de l'initiale *B* de *Beatus* du Psaume 1.[67]

Vers 1200, le Psautier d'Ingeburge de Danemark, épouse du roi de France Philippe Auguste,[68] consacre un très riche cycle de pleines pages à l'exaltation de la dignité royale de la Vierge. La Dor-

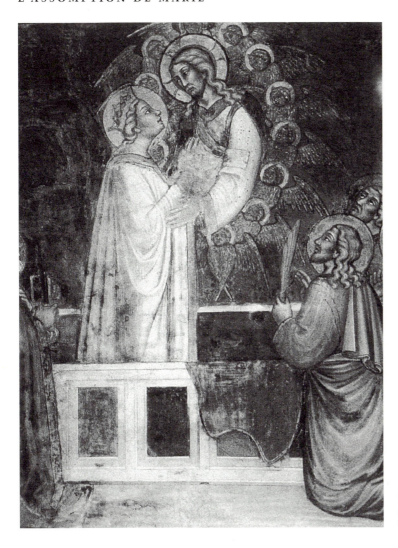

15. Ugolino di Prete Ilario (1370–1384).
Abside de la cathédrale d'Orvieto, fresque,
entre 1370 et 1384

mition apparaît au terme de ce cycle, dans une pleine page à deux registres superposés (Fig.17). La
légende en français du registre inférieur parle de l'ensevelissement de la Vierge: "Si come li apos-
tle ensevelissent nostre dame." De fait, deux apôtres déposent son corps dans le tombeau, devant
les autres apôtres qui pleurent. Mais en même temps, l'image dépeint une Dormition, puisque,
derrière le corps, le Christ debout tient l'âme de sa mère dans ses bras. Le paradoxe est que la Dor-
mition n'ait pas lieu dans la chambre mortuaire de la Vierge, comme c'est le cas traditionnelle-
ment, mais devant le tombeau. On peut à cet égard opposer à cette image celle, postérieure, mais
plus conforme à la tradition, du psautier dit de Sainte Elisabeth de Hongrie réalisé vers 1200–1217
à l'occasion du mariage de Sophie de Saxe et du landgrave Hermann de Thuringe. Sur une pleine
page, comportant deux registres superposés, figurent en bas une Dormition (la Vierge gisant sur
son lit, le Christ tenant son âme) et en haut le Couronnement de la Vierge.[69]

Le registre supérieur de la page du Psautier d'Ingeburge montre le Christ trônant et bénissant
sa mère couronnée. Tous deux sont entourés par deux anges tenant des cierges. La légende en

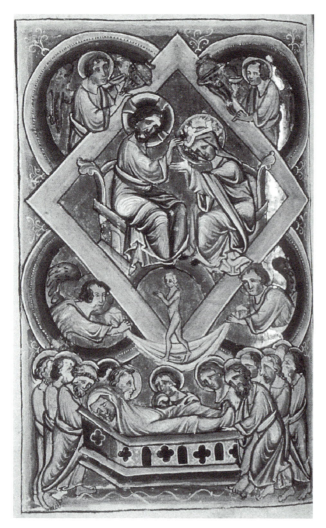

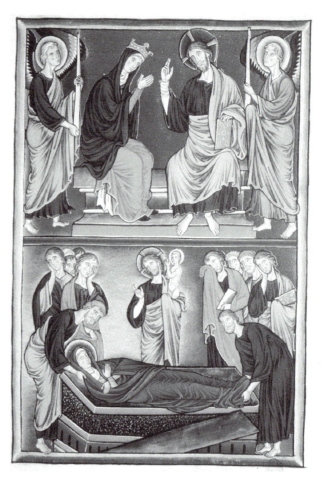

16. Psautier de la comtesse Jeanne de Flandre, à l'usage de Troyes. Paris, Bibliothèque Nationale de France, Ms. lat. 238, f. 62v

17. Psautier d'Ingeburge de Danemark. Chantilly, Musée Condé, Ms. 9, f. 34r, atelier du Vermandois(?), vers 1200

français énonce: *Si comme diex l'asiet de lez lui et il la corone*. La Vierge, après la Dormition et son ensevelissement, a donc accédé pour l'éternité à la gloire céleste. La présence de Marie en son corps glorieux aux côtés de son Fils suppose la résurrection et l'assomption corporelle, qui toutefois ne sont pas montrées explicitement. L'image n'exclut en rien la croyance en l'Assomption; elle témoigne seulement de la prégnance du modèle traditionnel de la Dormition.

Proche dans le temps (avant 1223) et lié au même milieu royal capétien, le psautier de la reine Blanche de Castille présente à peu près les mêmes scènes, mais disposées dans deux des médaillons de la longue chaîne narrative de l'histoire sainte qui rythme les pleines pages du manuscrit (Fig.18).[70] Dans le médaillon supérieur, la Vierge-Eglise portant la bannière cruciforme, est couronnée par le Christ. Dans le médaillon inférieur, la Vierge est mise au tombeau par deux apôtres sous les yeux de deux groupes de six apôtres, au premier plan desquels sont figurés une seconde fois

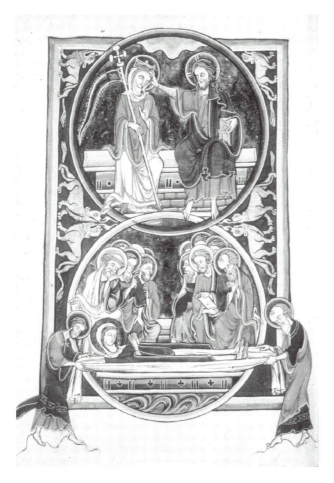

18. Psautier de Blanche de Castille. Paris, Bibliothèque
de l'Arsenal, Ms. 1186, f. 29v, vers 1215

Saint Pierre et Saint Paul. Un apôtre lève un doigt interrogateur, un autre se serre la barbe en signe
de douleur. Le plus remarquable est le vide ménagé entre ces deux groupes, exactement à l'em-
placement où l'on attendrait, dans la Dormition, la figure du Christ élevant l'âme de Marie. Le
rejet dans les marges des deux apôtres qui tiennent le drap mortuaire et dont les pieds reposent
sur un sol soigneusement souligné, exprime fortement l'ancrage terrestre de la scène. Cependant,
la Vierge morte semble relever la tête et le buste, comme si elle ressuscitait au moment même où
elle est portée en terre: alors que le corps de la Vierge rencontre le plus intensément le destin or-
dinaire des corps, où il est le plus prés de connaître l'indignité de la putréfaction commune, il se
redresse dans la manifestation du miracle qui lui est réservé.[71]

 Dans le Psautier de Blanche de Castille, cette scène ne montre pas la Dormition (comme dans
le Psautier de Sainte Elisabeth), ni une Dormition/ensevelissement (comme dans le Psautier
d'Ingeburge), ni un ensevelissement/assomption de l'âme (comme dans le Psautier de Jeanne de
Flandre et dans le psautier franciscain de Cambridge), mais tout au plus l'ensevelissement/résur-
rection du corps de la Vierge. On retrouve une disposition analogue, mais inversée, dans un
psautier anglais daté de 1253 environ: la scène du Couronnement de la Vierge occupe le registre
inférieur, tandis que le registre supérieur montre les apôtres éplorés contemplant le corps mort de
la Vierge, toute pâle dans son linceul blanc et étendue dans son tombeau.[72] Il n'est plus, ici non

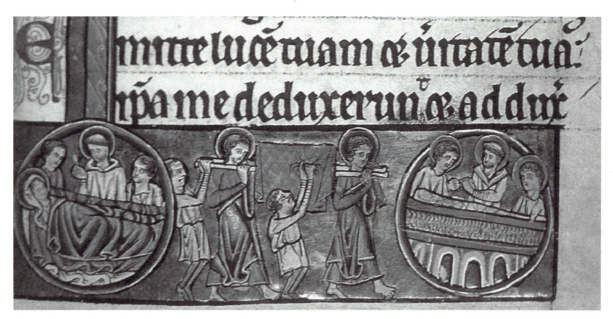

19. Livre d'Heures de William de Brailes. London, British Library, Ms. Add. 49999, f. 61r, Oxford, vers 1240

plus, question de Dormition, ni d'ailleurs non plus d'Assomption corporelle, et le corps de la Vierge ne montre aucun signe de résurrection: c'est le corps mort et le deuil des apôtres qui a exclusivement retenu l'attention du peintre.

En déclinant et en comparant entre elles toutes ces images contemporaines et analogues par leur structure et leur destination (elles appartiennent toutes à des psautiers), on peut constater l'intensité, dans la première moitié du XIIIe siècle, des recherches formelles visant à rendre compte le plus adéquatement possible de la fin de l'existence terrestre de la Vierge. On a l'impression que toutes les formules ont été tentées et combinées entre elles. Cependant, une ligne directrice se dessine, qui tend à substituer à l'image traditionnelle de la Dormition (qui avait trait à l'âme de la Vierge), les images qui évoquent le devenir du corps et de la personne tout entière de Marie: la mort, l'ensevelissement, l'Assomption corporelle et enfin le Couronnement.

Une page enluminée du livre d'Heures peint par William de Brailes (Angleterre, vers 1240) résume à elle seule le destin du corps et de la personne de la Vierge à la fin de son existence (Fig. 19).[73] L'image accompagne les Complies de la Vierge et fait écho au Psaume 42. Une légende en français—"ce est lasumption nr dame quant les apostles la porterent al val de iosefaz"—dit bien la double dimension de l'image: les funérailles d'une part, l'Assomption de l'autre. Et en effet, l'image se déploie suivant deux axes qui partent, horizontalement et verticalement du même médaillon, situé dans le coin inférieur gauche de la page. Ce médaillon figure la mort de la Vierge, qu'assiste Saint Jean l'Evangéliste. Curieusement, l'image reprend le schéma formel de la Dormition, mais en plaçant Jean, figuré sous les traits d'un saint moine, debout, derrière le lit mortuaire de la Vierge. Il se substitue au Christ, mais sans prendre dans ses bras l'âme de la Vierge. Le moment est celui de la mort de Marie, dont nous avons déjà dit l'importance croissante qu'il revêt dans les images de la fin du Moyen Âge.

L'axe horizontal qui part sur la droite du médaillon représente le destin du corps de la Vierge,

transporté sur une civière par deux apôtres (avec le miracle du juif puni de son sacrilège puis miraculeusement guéri), puis enseveli, en présence de Saint Jean, dans un linceul entièrement fermé (médaillon inférieur droit). Cet axe ne concerne donc en aucune façon l'âme de la Vierge.

L'axe vertical figure dans deux demi-médaillons superposés le transport au ciel, par un ange, de Marie ressuscitée, figurée en buste, vêtue et nimbée, puis son Couronnement par le Christ. Il ne s'agit pas de son âme seulement, mais bien de sa personne, tout entière ressuscitée et couronnée par son Fils. En opposant deux axes, l'un céleste, l'autre terrestre, qui divergent à partir de la scène-pivot de la mort de la Vierge, le Livre d'Heures de William de Brailes montre bien à quel point est centrale la question de la mort de la Vierge.

Le développement du cycle narratif n'est propre ni à la sculpture, ni à l'enluminure. Les vitraux lui ont aussi apporté une contribution décisive, par exemple, à la cathédrale d'Angers (où l'ordre des scènes a vraisemblablement été modifié). Le plus bel exemple est incontestablement le vitrail rond du chœur de la cathédrale de Sienne, œuvre de Duccio di Buoninsegna (vers 1255–vers 1319). Il daterait de 1287.[74] Au centre du vitrail est figurée l'Assomption, inscrite dans une mandorle. Cette image ne représente pas seulement une phase parmi d'autres du récit, mais le cœur du mystère à partir duquel s'organisent non seulement les autres scènes mariales, mais le Tétramorphe des Evangélistes (dans les écoinçons) et, sur les côtés, les figures de quatre saints. L'image de l'Assomption acquiert ainsi la dignité d'une Majestas Domini. A la base, le Christ assiste, au milieu des apôtres, à la mort de la Vierge. Au sommet, il couronne sa mère, assise à ses côtés sur un somptueux trône d'or dont le dossier est recouvert d'une précieuse étoffe. Six anges assistent le couple divin de la mère et du Fils.

Il se confirme ainsi que le déploiement narratif des images a amené à préciser la figuration de l'Assomption de Marie. Cependant, en distinguant les différentes phases de la fin de l'existence terrestre de Marie, il a permis aussi à la scène de la Dormition de résister, dans une certaine mesure, au succès croissant des images de l'Assomption corporelle.[75] Celle-ci n'a pas nécessairement refoulé celle-là. On peut en prendre pour exemple, au XIVe siècle, le *Légendier angevin*, un manuscrit italien destiné aux rois angevins de Hongrie; sur trois pleines pages se déroulent dix scènes successives de la fin de la vie de la Vierge. On y voit la Dormition, et après les funérailles, l'Assomption du corps, dans un voile porté au ciel par deux anges.[76] On peut citer aussi, vers 1413–1414 le somptueux bréviaire à l'usage de Paris de Louis de Guyenne (Fig. 20).[77] Tout l'espace de la pleine page est conçu comme un parcours ascendant et partiellement circulaire permettant de suivre la Vierge dans tous les événements qui marquent la fin de son destin terrestre et sa glorification après la mort: en bas à gauche, la *Dormitio* prend l'apparence d'une veillée funèbre où Saint Pierre asperge d'eau bénite le corps de la défunte. Le Christ bénit le corps, tout en tenant dans ses bras l'âme couronnée de sa mère. Les apôtres, debout, assis à même le sol, vaquent à leurs saintes lectures. De cet espace intérieur s'échappe sur la droite la Vierge ressuscitée. La frange de sa robe blanche, tenue par un ange, s'attarde sur la corniche de l'édifice. Les anges l'accueillent au ciel dans une nuée lumineuse. A gauche s'accomplit, depuis le ciel, le miracle de la ceinture, qui doit dissiper les doutes de Thomas. Tout en haut de la page, entouré des ordres angéliques bleus et rouges, le Christ couronne sa mère, qui partage son trône.

Le plus bel exemple de ce déploiement narratif est donné quelques décennies plus tard par les Heures d'Etienne Chevalier, peintes par Jean Fouquet vers 1452–1460.[78] Une série continue de six pleines pages représente successivement l'ange annonçant à Marie sa mort prochaine, la Dormition, l'attaque et le châtiment des juifs pendant les funérailles, l'Assomption, le Couronnement

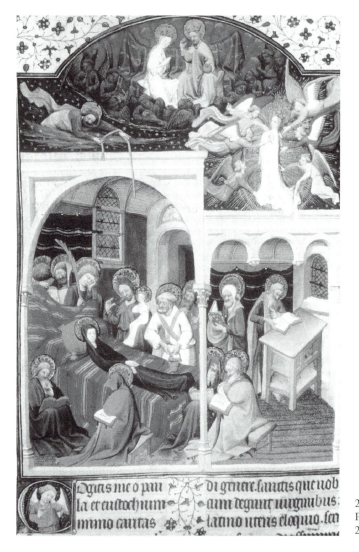

20. Bréviaire de Louis de Guyenne, à l'usage de
Paris. Châteauroux, Bibliothèque Municipale, Ms.
2, f. 282v, vers 1413–1414

de la Vierge par la Trinitié, l'adoration de la Trinité. Les apôtres miraculeusement réunis au chevet
de la Vierge mourante assistent, frappés d'émerveillement, à son Assomption au ciel (Fig. 21). Dans
une nuée lumineuse que circonscrit une double rangée d'anges, la Vierge, le corps bien droit, les
mains jointes, s'offre de face aux regards des apôtres (et à ceux du spectateur de l'image) dans toute
l'épaisseur physique de son corps ressuscité et glorifié. Sous elle et dans le même axe médian est
figuré le tombeau vide que son corps vient de délaisser.

On pourrait presque dire que la peinture de Jean Fouquet, en créant l'illusion d'un espace en
trois dimension, fait voir la Vierge s'élever dans le ciel, à peu près à l'époque des premières men-
tions du drame liturgique de l'Assomption. Il arrivait qu'une statue de la Vierge, la face tournée
vers le chœur, fût tirée par des cordes tout en haut de la voûte de l'église, tandis que le chœur en-
tonnait l'antienne *Assumpta est Maria in celum* et que la fumée de l'encens envahissait l'édifice.
Antienne et repons alternaient les versets du Cantique, *Quae est ista que progrediteur? Ista est
speciosa,* sans omettre la collecte *Veneranda.* Dans ce cas, ce n'est certainement pas le drame
liturgique qui a influencé l'iconographie, ce sont plutôt les images qui ont trouvé, tardivement,
leur traduction paraliturgique.[79]

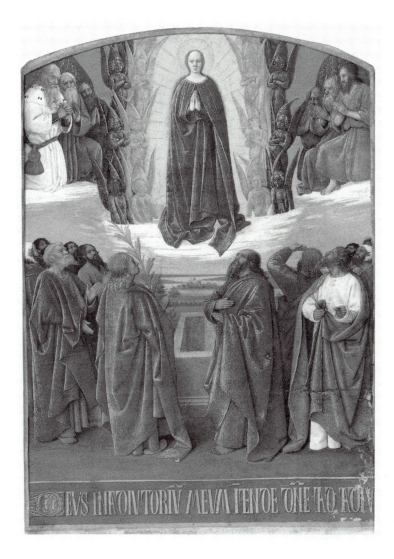

21. Jean Fouquet, Livre d'Heures d'Etienne Chevalier. Chantilly, Musée Condé, Ms. 12, vers 1452–1460

La Mort de la Vierge

Mais la Dormition n'a pas seulement été menacée par le succès grandissant de l'Assomption. Dans les séquences narratives, l'image du trépas de la Vierge tend de plus en plus à remplacer et l'une, et l'autre.[80] Dans le dernier quart du XIIIe siècle, un diptyque en ivoire conservé aujourd'hui au Musée du Louvre, dont chaque panneau est constitué de deux scènes superposées, montre d'un côté la mort de la Vierge et, au dessus, le Christ debout tenant l'âme de sa mère, comme si la Dormition avait éclaté en deux scènes distinctes, l'une terrestre (la mort), l'autre céleste (le transport de l'âme), comme si le céleste et le terrestre ne pouvaient plus occuper le même lieu de l'image. Dans la partie droite du diptyque, deux anges portent la Vierge debout dans une mandorle (Assomption), et au dessus le Couronnement de la Vierge clôt le cycle.[81]

La Mort de la Vierge s'impose de plus en plus comme un thème iconographique à part entière, qui retient toute l'attention des graveurs et les peintres. Elle est fréquemment associée au Couronnement de la Vierge,[82] ou bien elle est même traitée comme une scène singulière, qui synthétise

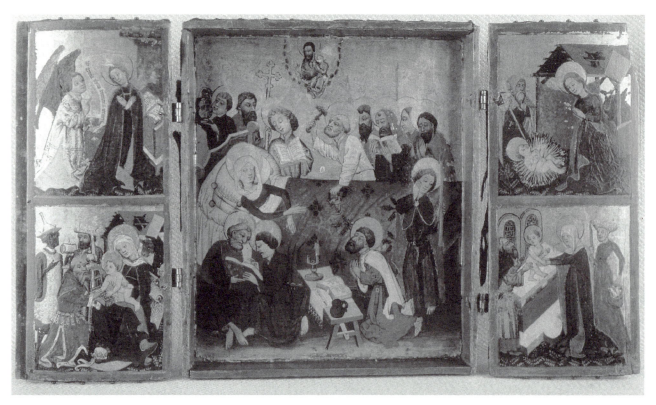

22. Autel portatif. Colmar, Musée d'Unterlinden, inv. 88.5.1, Vallée du Rhin, fin du XVe siècle

à elle seule l'ensemble du cycle. L'une de ses expressions les plus remarquables est une gravure de Martin Schongauer.[83] On peut citer aussi, au Musée de Colmar, un petit autel portatif rhénan de la fin du XVe siècle (Fig. 22);[84] bien que la scène centrale dépeigne en fait une Dormition (puisque le Christ est fort discrètement présent dans le ciel, emportant l'âme de Marie), c'est plutôt l'image de la Mort de la Vierge qui s'impose au premier regard, par l'importance du lit de la Vierge et la réunion des apôtres tout autour de lui. Les autres scènes de la Vie de la Vierge occupent les panneaux latéraux: l'Annonciation et l'Adoration des Mages d'un côté, la Nativité et la Présentation au temple de l'autre.

La voie sinueuse des images

La distinction de thèmes et de motifs iconographiques est toujours réductrice puisqu'il n'y a jamais, au Moyen Âge, deux images exactement semblables. Ce sont les variations, souvent infimes, qui s'observent d'une image à l'autre, qui témoignent le mieux du travail de la pensée propre aux images. Ce travail n'est peut-être jamais aussi intense que lorsqu'il s'agit, pour les images, de rechercher la meilleure adéquation possible à une croyance elle même mouvante et qui n'a cessé de s'affermir et de se diffuser. Dans le cas de l'Assomption de Marie, cette recherche n'est pas partie de rien, mais d'un premier modèle iconique, celui de la *Koimesis* ou *Dormitio*. Cependant,

cette image a vite montré ses limites, puisqu'elle n'illustrait pas la glorification du corps de la Vierge. Peintres et sculpteurs se sont donc efforcés d'en modifier certains détails ou d'en changer la signification en l'associant à d'autres images, comme le Couronnement de la Vierge. Des "indices de corporéité" (par exemple, les bandeaux croisés du linceul) trahissent l'adhésion implicite à la croyance en l'Assomption corporelle, même quand les images semblent suggérer plutôt une Dormition ou une assomption de l'âme. Les résonances "corporelles" de la figure de Marie-*Sponsa* âme et/ou Eglise, venue de l'illustration du Cantique et associée par les *tituli* à la question du sort de Marie après la mort, traduisent sans doute la même évolution. Simultanément s'impose la nécessité de créer un nouveau type iconographique, qui corresponde plus étroitement à la croyance en l'Assomption corporelle de Marie. Mais cette création passe par bien des tâtonnements, qui vont du recours à des moyens iconiques traditionnels, qu'il s'agisse de la mandorle ou du linge, ou plus rarement à l'image de la résurrection de la Vierge, tirée de son tombeau par les anges ou le Christ. La représentation de toute la séquence narrative de la fin de l'existence terrestre de la Vierge a d'autant mieux aidé à l'émergence de l'image de l'Assomption que celle-ci a dû se distinguer de la Dormition, qui, au début de la séquence, marque la montée de l'âme au ciel. Mais s'il est vrai qu'une image n'est jamais isolée et ne peut se comprendre que dans le rapport mouvant qu'elle entretient avec les images voisines, nous voyons la prééminence des images de l'Assomption et du Couronnement de la Vierge mise en cause à son tour à la fin du Moyen Âge par l'image de la Mort de la Vierge. Cette image témoigne au plus haut degré de la préoccupation pour le corps de Marie, qu'on a vu s'affirmer au cours des siècles. Il n'est pas impossible qu'elle fasse écho aux rituels funéraires qui acquièrent à cette époque une ampleur sans précédent et qui occupent, dans l'iconographie des Heures de la mort, une place de premier plan.

Quoi qu'il en soit, l'histoire complexe et sinueuse de l'image de l'Assomption de la Vierge, témoigne, une fois de plus, de l'extraordinaire faculté d'innovation des images dans l'Occident médiéval. Dès le XIIe siècle, certaines images, dans la sculpture ou les miniatures, parviennent à traduire au mieux la croyance en l'Assomption de Marie et à contribuer à sa diffusion. L'émergence de cette nouvelle iconographie ne se limite pas à un seul type d'image et plusieurs solutions sont, à chaque époque, proposées simultanément. Mais toutes, en accord avec le développement du culte marial, vont dans le même sens, déjà indiqué par le Pseudo-Augustin: celui de la glorification du corps de Marie—immaculé, virginal et imputrescible—qui à porté en lui le corps du Christ. C'est à ce titre que Marie connaît par anticipation la gloire corporelle promise à tous les élus à la fin des temps.

Le Christ, Marie, Saint Jean et les autres

Si la naissance de l'image ou des images de l'Assomption de Marie connaît un cheminement si complexe, c'est que la figure de la Vierge est elle-même tiraillée entre sa proximité du divin (elle a porté le Fils de Dieu dans son sein) et sa condition humaine (qui explique qu'elle ait dû mourir comme tous les hommes). Son corps est le lieu de cette tension et de la recherche d'un compromis entre ces deux tendances opposées. Mais pour finir, il échappe au destin commun du corps des autres hommes, en imitant celui du corps du Christ, qui est ressuscité et monté au ciel. Les durées qui séparent les événements ne sont pas les mêmes pour le Christ et la Vierge, mais leur parallélisme n'en est pas moins frappant, quand se succèdent la mort, la mise au tombeau (sur laque-

lle pèse dans les deux cas la menace des juifs), la résurrection, l'Ascension de l'un et l'Assomption de l'autre, et enfin le Couronnement, qui les voit réunis. Dans les deux cas, la disparition du corps laisse un sépulcre vide, celui du Christ—ce que constatent les saintes femmes—et celui de la Vierge, que les pèlerins continuent de visiter dans la vallée de Josaphat. Pour le Christ, quarante jours séparent sa Résurrection, à Pâques, de l'Ascension. Quarante jours, suivant Elisabeth de Schönau, séparent la mort de la Vierge (15 août) de sa Résurrection/Assomption (23 septembre).

Le préoccupation croissante pour le corps, qui me semble être une des raisons profondes du succès de l'image de l'Assomption de la Vierge, imprègne simultanément les images qui concernent le Christ: on ne peut qu'évoquer ici en passant les transformations des images de la Passion (avec l'insistance sur les souffrances du Christ), et de l'image du Crucifié, dont le relief du corps s'accentue sur la croix, le caractère moins symbolique et plus anecdotique de l'image de l'Ascension (avec, par exemple, la disparition dans le ciel des pieds du Christ, dont la marque reste inscrite dans le sol), et plus encore le changement fondamental qui affecte l'image de la résurrection de Jésus. A la fin du XIIe siècle, l'image "gothique" du Christ sortant physiquement du sépulcre remplace définitivement la scène "romane" de la visite des saintes femmes au tombeau, où l'ange les informe que le Christ est ressuscité.[85] Le corps ressuscité du Christ est ainsi rendu visible par l'image, ce qui est paradoxal puisque l'Evangile de Jean insiste au contraire sur la vacuité du tombeau. Le "croire" passe désormais par le "voir."[86] On peut même dire qu'il passe par le "toucher," car s'impose aussi le parallèle entre Thomas, qui doute de la résurrection du Christ (lequel lui fait toucher sa plaie au côté), et le même apôtre qui, n'ayant pu arriver à temps au chevet de la Vierge, reçoit du ciel la ceinture de Marie, preuve matérielle de son Assomption.[87]

Le modèle christique a donc puissamment pesé sur les représentations du destin de Marie après sa mort. Mais à son tour, l'exemple de Marie a fait école. Saint Jean l'Evangéliste, en raison de ses liens privilégiés avec Jésus et avec Marie (on l'a vu dans le Psautier de William de Brailes), a bénéficié de semblables représentations. Selon les paroles de Jésus sur la croix, Jean est le "fils" de Marie et celle-ci est sa "mère." La relation de Marie et de Jésus se reproduit symboliquement entre Marie et Jean. Le destin de Jean s'apparente d'autant mieux avec celui de Marie que l'évangile qui lui est attribué suggère lui-même que Jean n'est peut-être pas mort.[88] Selon les *Actes de Jean*, un apocryphe grec du IIe siècle,[89] et ses commentateurs médiévaux, le disciple préféré pourrait être entré vivant dans sa tombe,[90] où une lumière divine l'aurait enlevé. Jacques de Voragine précise qu'on ne retrouva dans la tombe qu'une manne céleste. Mais Dante rejette la croyance en une assomption corporelle de Jean: son corps ne se trouverait pas au paradis, mais dans la terre.[91] Pourtant, il arrive que les images, à la fin du Moyen Âge, représentent une véritable assomption corporelle de Saint Jean, en assimilant résolument celui-ci à la "mère" que Jésus lui avait donnée.[92] Car l'enjeu est le même pour ces trois personnes si intimement liées: en raison de leur caractère divin, ou de leur proximité du divin, il leur faut échapper à la corruption de la chair après la mort.

D'autres figures encore, dans la légende et l'iconographie chrétiennes, échappent à la mort commune et à la putréfaction des chairs. Marie l'Egyptienne[93] et parfois Marie Madeleine (premier témoin de la résurrection du Christ)[94] auraient elles aussi bénéficié d'un sort comparable. Suivant une tradition bien établie, les deux "témoins" Enoch et Elie, auraient disparu au ciel en attendant la venue de l'Antéchrist. Celui-ci ordonnera leur mise à mort, mais trois jours et demi plus tard, ils ressusciteront et monteront au ciel dans une nuée.[95] La légende du Juif errant, attestée à partir du XIIIe siècle, représente un autre cas encore, qui s'apparente à certains égards aux précédents. Comme Saint Jean, il a reçu de la bouche même du Christ l'assurance qu'il ne mourrait

pas, mais vivrait jusqu'au Jugement dernier. Comme Enoch et Elie, il est un "témoin" perpétuel, celui de la Passion du Christ à laquelle il a personnellement participé.[96]

L'idéal consistant à échapper, sinon à la mort, du moins à la putréfaction des chairs, concerne en fait l'ensemble des saints. L'odeur de sainteté qui émane de leur tombeau, la découverte, dans certains cas, que leurs chairs sont restées intactes, la préservation de leurs reliques, manifestent à grande échelle que, dans le Chrétienté médiévale, la résistance à la mort (que celle-ci soit différée, que le mort ressuscite ou que son corps soit préservé de la corruption), donne la mesure de la grâce divine.[97] Plus précisément, le bénéfice d'une assomption corporelle dès après la mort permet d'anticiper sur le sort des autres élus, qui devront attendre la fin des temps pour ressusciter et entrer avec un corps glorieux dans l'éternité.[98] Dans les textes et les images, nul, mieux que la Vierge, ne pouvait incarner ce principe de l'anthropologie chrétienne.

Notes

1. Voir à ce propos les études suggestives de Mary Carruthers, *The Craft of Thought: Meditation, Rhetoric, and the Making of Images, 400–1200* (New York, 1998).

2. Vues synthétiques dans M. Warner, *Seule entre toutes les femmes: Mythe et culte de la Vierge Marie* (1976; trad. fr., Paris et Marseille, 1989), 87–104, et K. Schreiner, *Maria: Jungfrau, Mutter, Herrscherin* (Munich et Vienne, 1994), 463–90.

3. M. Jugie, *La Mort et l'Assomption de la Sainte Vierge* (Cité du Vatican, 1944); S. C. Mimouni, *Dormition et Assomption de Marie: Histoire des traditions anciennes*, Théologie historique 98 (Paris, 1995). Pour la période médiévale, H. Barré, "La Croyance à l'Assomption corporelle en Occident de 750 à 1150 environ," *Etudes mariales (Bulletin de la Société française d'Etudes mariales)* 7 (1949 [1950]), 63–123; M.-D. Chenu, "La Croyance à l'Assomption corporelle, en Occident de 1150 à 1250 environ," *Etudes mariales (Bulletin de la Société française d'Etudes mariales)* 8 (1950 [1951]), 13–32; suivi de H. Barré, "Dossier complémentaire," 33–70. L'une des plus remarquables études est celle de Philippe Verdier, "La Dormition et l'assomption: La Collecte *Veneranda*," in *Le Couronnement de la Vierge: Les Origines et les premiers développements d'un thème iconographique* (Montréal et Paris, 1980), 59–79.

4. "Dormition de Marie du Pseudo-Jean," introduction de S. C. Mimouni, in *Ecrits apocryphes chrétiens*, sous la dir. de F. Bovon et P. Geoltrain, t. 1 (Paris, 1997), 163–204.

5. Pseudo-Meliton de Sardes (VIe/VIIe s.); cf. M. Geerard, *Clavis Apocryphum Novi Testamenti* (Turnhout, 1992), 111.

6. Gregoire de Tours († v. 594), *De gloria martyrum*, PL 71:708.

7. B. Capelle, "L'Oraison 'Veneranda' à la messe de l'Assomption," in *Travaux liturgiques*, t. 3 (Louvain, 1967), 387–407. Sur la fête romaine de l'Assomption et son rapport à l'icône de la Vierge de Santa Maria Maggiore, voir G. Wolf, *Salus Populi Romani: Die Geschichte römischer Kultbilder im Mittelalter* (Weinheim, 1990).

8. Elisabeth de Schönau, *Visio de resurrectione beate Virginis Mariae*, éd. F. W. E. Roth, *Die Visionen und Briefe der hl. Elisabeth sowie die Schriften der Äbte Eckbert und Emecho von Schönau* (Brünn, 1886), 53–55. (Cette vision n'est pas reprise, parce que d'attribution jugée douteuse, par J.-P. Migne, PL 195:177, n. 58). Cf. A. Clark, *Elisabeth of Schönau: A Twelfth-Century Visionary* (Philadelphia, 1992), 109, et R. Fulton, *From Judgment to Passion: Devotion to Christ and the Virgin Mary, 800–1200* (Chicago, 2002), 366. La moniale Elisabeth de Schönau confie à son frère Eckbert les expériences extatiques et visionnaires dont elle a bénéficié au cours de plusieurs années liturgiques à partir de 1152. La fête de l'Assomption, comme les autres fêtes mariales (Nativité, Purification, Annonciation) et les grandes fêtes de l'Eglise (Pâques, la Pentecôte) sont l'occasion de ces extases.

9. Jean Beleth, *Summa de ecclesiasticis officiis*, éd. H. Douteil, CCCM 41A (Turnhout, 1976), 282 (cap. 146, "De assumptione beatae Mariae").

10. H. Grotefend, *Zeitrechnung des deutschen Mittelalters und der Neuzeit*, t. 2 (Hanovre, 1984), 17, 48, 116, 150, 160. Dans ce dernier diocèse, on trouve aussi le 13 septembre, "Tricesimus Assumptionis Mariae."

11. R. Gregoire, "Paschase Radbert," dans *Dictionnaire de spiritualité* (1983). Voir les deux traités consacrés à la Vierge: *Paschasii Radbertii De partu Virginis, De Assumptione Sanctae Mariae Virginis*, éd. E. A. Matter et A. Ripberger, CCCM 56C (Turnhout, 1985), et *Der Pseudo-Hieronymus-Brief IX 'Cogitis me': Ein erster marianischer Traktat des Mittelalters von Paschasius Radbert*, Spicilegium Freiburgense 9, éd. A. Ripberger (Fribourg/Suisse, 1962), édition reprise dans CCCM 56C, p. 97 et suiv., sans l'introduction de l'édition de 1962. Cette édition remplace PL 30:126–47.

12. Capelle, "L'oraison 'Veneranda'" (cité note 7), 390.

13. La démarche est à certains égards parallèle à celle d'un Anselme voulant prouver rationnellement la nécessité logique de l'Incarnation du Christ.

14. Pseudo-Augustin, *De assumptione Beatae Mariae Virginis liber unus*, PL 40:1141–48.

15. Sur la tradition textuelle depuis l'époque carolingienne, voir, outre le dossier réuni par H. Barré et M.-D. Chenu (*supra*, note 3): Ambroise Autpert († 784), *Sermon*

208, PL 39:2129–34; Paul Diacre (VIIIe s.), *Homélie,* PL 95:1565–94; Abelard, Sermo 26, PL 178:539–46; Pierre Le Venerable, *Lettre* 94 ad Gregorium monachum (vers 1135), *The Letters of Peter the Venerable,* éd. G. Constable (Cambridge, Mass., 1967), t. 2, 234–55 (251); *Office de l'Assomption,* PL 189:923; Thomas De Chobham, *Sermones,* éd. F. Morenzoni, CCCM 82A (Turnhout, 1993), 422. Il faut faire aussi une place à la littérature vernaculaire: voir notamment, pour la fin du XIIe siècle, I. Spiele, *Li Romanz de Dieu et de sa Mère d'Hermann de Valenciennes* (Leyde, 1975).

16. Jacobus a Voragine, *Legenda Aurea,* éd. T. Graesse (reproduction anastatique, Osnabrück, 1969), 508–27 (cap. CXIX, "De assumptione sanctae Mariae virginis"), qui cite successivement la lettre du Pseudo-Jean, la lettre "Cogitis me" du Pseudo-Jérôme, l'évêque Gérard de Csnad († 1046), les révélations d'Elisabeth de Schönau, Saint Bernard, etc. Suit une deuxième section, "Mode de l'assomption de la sainte Vierge Marie," qui compile à son tour un grand nombre d'auteurs: Saint Germain de Constantinople, Jean Damascène, le Pseudo-Augustin, etc. Je remercie Pascal Collomb de m'avoir fourni la liste exhaustive des citations de Jacques de Voragine dans ce chapitre.

17. M. Lamy, *L'Immaculée Conception: Etapes et enjeux d'une controverse au Moyen Âge (XIIe–XVe siècle)* (Paris, 2000), 184, souligne le lien établi au XIIe siècle entre le privilège de Marie d'avoir été conçue sans péché et celui de n'avoir pas connu la putréfaction de la chair après la mort.

18. C. W. Bynum, *The Resurrection of the Body in Western Christianity, 200–1336* (New York, 1995). Mais l'auteur ne parle guère de l'Assomption de la Vierge comme anticipation de la résurrection générale des morts au moment du Jugement Dernier.

19. C. Schaffer, *Koimesis: Der Heimgang Mariens. Das Entschlafungsbild in seiner Abhängigkeit von Legende und Theologie* (Regensburg, 1985); O. Sinding, *Mariae Tod und Himmelfahrt: Ein Beitrag zur Kenntnis der frühmittelalterlichen Denkmäler* (Christina, 1903); J. Vanuxen, "Autour de quelques objets des Musées de Cologne: La Koimesis en France et en Allemagne du Xe au XVe siècle," dans *Mémorial d'un voyage d'études de la Société Nationale des Antiquaires de France en Rhénanie* (Paris, 1953), 249–58; E. G. Millar, *La Miniature anglaise du Xe au XIIIe siècle,* trad. fr. (Paris et Bruxelles, 1926) (Bénédictionnaires de Saint Aethelwold, v. 975–980, et de l'archevêque Robert de Rouen, fin du Xe siècle). Pour le thème dans la sculpture, on se reportera encore aux deux ouvrages d'Emile Mâle, *L'Art religieux du XIIe siècle en France,* 8e éd. (Paris, 1998), 435–37 (qui oppose judicieusement la recherche encore hésitante du tympan de Saint-Pierre-le-Puellier, à la solution achevée du portail de Senlis en 1185), et *L'Art religieux du XIIIe siècle en France,* 8e éd. (Paris, 1948), 248–59, qui analyse les grands tympans gothiques.

20. G. Schiller, *Ikonographie der christlichen Kunst,* t. 4, pt. 2, *Maria* (Gütersloh, 1980), 83 et suiv.

21. Ainsi ai-je pu bénéficier des ressources photographiques et informatiques de l'Institut de Recherches et d'Histoire des Textes (CNRS) à Orléans, de la base Mandragore de la B.N.F., de la base Images du GAHOM (EHESS, Paris), de l'Index of Christian Art de Princeton, des Photo Study Collections du Getty Research Institute de Los Angeles.

22. Voir, par exemple, à l'époque romane: Munich, Staatsbibliothek, Ms. Clm 23093, f. 66r (initiale historiée); cf. E. Klemm, *Die romanischen Handschriften der bayerischen Staatsbibliothek,* Teil 1, *Die Bistümer Regensburg, Passau und Salzburg* (Wiesbaden, 1980), 116–17, fig. 424. Un peu plus tard: A. Boecker, *Die regensburger Prüfenings Buchmalerei des XII. und XIII. Jahrhunderts* (Munich, 1924), fig. 46 (Munich, Graphische Sammlung, inv. nr. 39768). Au XIIIe siècle: Vie de Saint Denis en français (vers 1250), Paris, B.N.F., Ms. Nouv. acq. lat. 1098, f. 33v, ou encore le Psautier de Thérouanne, Marseille, Bibl. Mun., Ms. 111, f. 28r.

23. Lectionnaire du Custos Berthold, Salzburg, 1074–77, New York, Pierpont Morgan Library, Ms. M.780, f. 64v; Schiller, *Ikonographie* (cité note 20), fig. 601.

24. Schiller, *Ikonographie* (cité note 20), 103.

25. *Das Evangeliar Ottos III: Clm 4453 der Bayerischen Staatsbibliothek München,* éd. F. Mütherich et K. Dachs (Munich, Londres et New York, 2001), 25–26 et pl. 1.

26. Ivrea, Biblioteca Capitolare, Ms. 86, f. 101r.

27. Cologne, Schnütgen-Museum. Reproduit dans Schiller, *Ikonographie* (cité note 20), fig. 588.

28. Paris, B.N.F., Ms. lat. 9448, f. 52v; Schiller, *Ikonographie* (cité note 20), fig. 607 et p. 99. Cf. P. Lauer, *Les Enluminures romanes des manuscrits de la Bibliothèque Nationale* (Paris, 1927), pl. XLIV, 1.

29. Munich, Staatsbibliothek, Ms. Clm 15903, f. 81v; Schiller, *Ikonographie* (cité note 20), fig. 603.

30. Londres, B.L., Cotton Ms. Nero C IV, f. 29r. Cf. F. Wormald, *The Winchester Psalter* (Londres, 1973), pl. 4, fig. 32, p. 87; et K. E. Haney, *The Winchester Psalter: An Iconographic Study* (Leicester, 1986), 43, 125, fig. 28.

31. Cf. B. Craplet, *Auvergne romane* (La Pierre-Qui-Vire, 1972), 122.

32. Londres, B.L., Ms. Harley 2908, f. 123v; Schiller, *Ikonographie* (cité note 20), fig. 595.

33. Saint-Gall, Stiftsbibliothek, Cod. 53; Schiller, *Ikonographie* (cité note 20), fig. 594.

34. Schiller, *Ikonographie* (cité note 20), 97–98.

35. Verdier, "La Dormition et l'assomption" (cité note 3), 67, note 40, citant le Martyrologe de Notker (PL 131:141–42).

36. New York, Pierpont Morgan Library, Ms. M.641, f. 143r; Verdier, "La Dormition et l'assomption" (cité note 3), fig. 67.

37. Rouen, Bibl. Mun., Ms. Y 109, f. 4r (XIe siècle). Cf. R. Gameson, "Hugo Pictor, enlumineur normand," *CahCM* 44 (avril–juin 2001), 121–38, fig. 5.

38. Paris, B.N.F., Ms. lat. 9436, f. 129r. Cf. Verdier, "La Dormition et l'assomption" (cité note 3), 68, et M.-P. Laffitte, "Les plus beaux manuscrits à peintures du trésor de Saint-Denis," *Dossiers d'Archéologie* 261 (mars 2001), 96–107 (101).

39. Munich, Staatsbibliothek, Ms. Clm 4452, f. 161v; Schiller, *Ikonographie* (cité note 20), fig. 597. H. Fillitz, R. Kahsnitz et U. Kuder, *Zierde für ewige Zeit: Das Perikopenbuch Heinrichs II.* (Munich, 1994). Cette pleine page (f. 161v) fait face à l'image en pleine page de Jésus dans la maison de Marthe et Marie (f. 162r).

40. Hildesheim, Domkapitel, Ms. 688, ff. 83v et 84r.

41. Voir aussi, parmi les images contemporaines obéissant au même schéma, le Tropaire de la Reichenau, daté de 1001: Bamberg, Staatsbibliothek, Ms. Lit. 5, f. 121v (Fillitz, Kahsnitz et Kuder, *Das Perikopenbuch Heinrichs II* [cité note 39], fig. 21).

42. Los Angeles, The J. Paul Getty Museum, Ms. 64 (97.MG.21), f. 145v; Schiller, *Ikonographie* (cité note 20), fig. 610; E. C. Teviotdale, *The Stammheim Missal* (Los Angeles, 2001), fig. 51, p. 75.

43. Munich, Staatliche Graphische Sammlung, inv. nr. 40259 (recto), début du XIIIe siècle; Schiller, *Ikonographie* (cité note 20), fig. 609.

44. Hamburg, Staats- und Universitätsbibliothek, Cod. In Scrin. I, f. 3v (lectionnaire, vers 1250); Schiller, *Ikonographie* (cité note 20), fig. 613.

45. Orléans, Bibl. Mun., Ms. 144, f. 94r.

46. Tours, Bibl. Mun., Ms. 193, f. 98r.

47. Voir, par exemple, Boecker, *Die regensburger Prüfenings Buchmalerei* (cité note 22), fig. 46: la Vierge couronnée et richement vêtue dans une mandorle soutenue par le Christ qui contemple le corps couché de sa mère, est recueillie par deux anges venant de l'extérieur de la bordure de l'image. Autre exemple: Los Angeles, The J. Paul Getty Museum, Ms. 44 / Ludwig VI, 5 (92.MH.22), f. 115r (initiale *V*, antiphonaire franco-flamand, vers 1260–70), quatre anges portent la mandorle de la Vierge que la main de Dieu saisit par le haut.

48. Limoges, Bibl. Mun., Ms. 2, f. 172v. Cf. M.-F. Damongeot, "Les Manuscrits des Dames de Fontevrault," *303: Arts, Recherches et Créations. La Revue des pays de la Loire* 67 (2000), 94–107 (p. 99). Voir aussi Copenhague, Royal Library, Ms. Thott 517 4°, f. 1r: livre des prières avec Vies de Sainte Marie, Marguerite et Madeleine, Angleterre, vers 1340 (en français): le Christ aidé des anges semble tirer vers le haut, hors du tombeau, la mandorle dans laquelle la Vierge se tient debout.

49. Toulouse, Bibl. Mun., Ms. 815, f. 60v: Apocalypse (Angleterre? début du XIVe siècle): à gauche, Saint Paul agenouillé en prière devant un ange; à droite, l'âme de Paul portée au ciel dans un linge que tiennent quatre anges.

50. Charleville-Mézières, Bibl. Mun., Ms. 149, f. 111v.

51. Avignon, Bibl. Mun., Ms. 190, f. 186v.

52. Pour un exemple plus tardif, voir K. Gould, *The Psalter and Hours of Yolande of Soissons* (Cambridge, Mass., 1978), f. 305v.

53. Clermont-Ferrand, Bibl. Mun., Ms. 62, f. 241v.

54. Mâle, *L'Art religieux du XIIIe siècle* (cité note 19), 250, parle de "sept thèmes plastiques" différents. Je remercie Klaus Oschema de m'avoir fait bénéficier de ses remarques sur ce grand classique.

55. Schiller, *Ikonographie* (cité note 20), fig. 642 et p. 108–9.

56. Schiller, *Ikonographie* (cité note 20), fig. 625 et p. 109. Cf. Mâle, *L'Art religieux au XIIe siècle* (cité note 19), 435.

57. On peut en citer un autre exemple, inconnu de G. Schiller: l'autel sculpté de l'église Notre Dame d'Avenas (Rhône) (XIIe siècle), dont la face latérale nord illustre quatre scènes de la vie de la Vierge: l'Annonciation, la Nativité, la Présentation au Temple, la Dormition/Assomption, où la Vierge est figurée deux fois: couchée et assistée de Saint Jean et Saint Pierre, et au dessus, en buste, montant au ciel dans un linge ou une nuée semi-circulaire qu'accueillent les mains de Dieu. S'agit-il de son âme ou de son corps? Je remercie Pascal Collomb d'avoir attiré mon attention sur ce cas méconnu.

58. Glasgow, University Library, Ms. Hunter 229 (U.3.2).

59. Amiens, Bibl. Mun., Ms. 108, ff. 201r et 201v.

60. D. Grivot et G. Zarnecki, *Gislebertus, Sculptor of Autun*, introduction by T. S. R. Boase (Londres, 1961), 12.

61. Paris, Bibliothèque Sainte-Geneviève, Ms. 10, f. 129r.

62. Mâle, *L'Art religieux du XIIIe siècle* (cité note 19), 248–59, fig. 124–31.

63. Sur ce peintre, voir Z. A. Cox, "Ugolino di Prete Ilario, Painter and Mosaicist" (Ph.D. diss., New York University, 1977), fig. 25–30. Je remercie Dominique Donadieu Rigaut de m'avoir indiqué cette oeuvre.

64. M.-L. Therel, *Le Triomphe de la Vierge-Eglise: Sources historiques, littéraires et iconographiques* (Paris, 1984), fig. 2. Je remercie Mme Michèle Humbert d'avoir attiré mon attention sur ces deux mosaïques latérales.

65. Therel, *Le Triomphe de la Vierge-Eglise* (cité note 64), fig. 1.

66. Paris, B.N.F., Ms. lat. 238, f. 62v.

67. Cambridge, Fitzwilliam Museum, Ms. McClean 41, f. 1v.

68. Chantilly, Musée Condé, Ms. 9, f. 34r.

69. Cividale del Friuli, Museo Archeologico Nazionale, Ms. cxxxvii, f. 117r.

70. Paris, Bibliothèque de l'Arsenal, Ms. 1186, f. 29v.

71. Autre exemple dans un manuscrit flamand: M. Smeyers, *Flemish Miniatures from the 8th to the Mid-16th Century: The Medieval World on Parchment* (Turnhout, 1999).

72. Londres, B.L., Ms. Add. 21926, f. 24v.

73. Londres, B.L., Ms. Add. 49999, f. 61r, vers 1240; C. Donovan, *The de Brailes Hours: Shaping the Book of Hours in Thirteenth-Century Oxford* (Londres, 1991), pl. 5 et p. 96–98.

74. E. Carli, *Vetrata Duccesca* (Florence, 1946). Le vitrail mesure 7 m de diamètre.

75. Voir, par exemple, H. Martin, *Légende de Saint-Denis: Reproduction des miniatures du manuscrit original présenté en 1317 au roi Philippe le Long* (Paris, 1908), pl. xx.

76. Biblioteca Apostolica Vaticana, Ms. Lat. 8541, ff. 14r, 15v, 16r.

77. Châteauroux, Bibl. Mun., Ms. 2, f. 282v. On peut comparer à cette image pleine page l'image composite des Heures de Turin-Milan: Turin, Museo Civico d'Arte Antica, Ms. 47, f. 100v. Cf. A. H. Van Buren, J. H. Marrow et S. Pettenati, *Das Turin-Mailänder Stundenbuch/Les Heures de Turin-Milan*, edition facsimilée (Lucerne, 1994–96). Une pleine page montre en bas la Mort de la Vierge, dans l'initiale G(audeamus) la Vierge en bleu portée au ciel par deux anges, en haut le Couronnement de la Vierge.

78. Chantilly, Musée Condé. Cf. G. Bazin, *Jean Fouquet: Le Livre d'Heures d'Etienne Chevalier* (Paris, 1990), 47. Cf. C. Sterling, *Le Peinture médiévale à Paris, 1300–1500* (Paris, 1987), pour une comparaison avec d'autres manuscrits contemporains. Voir aussi J. Plummer, *The Hours of*

Catherine of Cleves (New York, 1964), fig. 15: la Vierge, droite dans une nuée en forme de mandorle, est portée dans le ciel par deux anges et accueillie par le Christ. Ou encore: Petites Heures d'Anne de Bretagne, vers 1503(?), Paris, B.N.F., Ms. Nouv. acq. lat. 3027, f. 38v.

79. K. Young, *The Drama of the Medieval Church* (Oxford, 1933), 236 (*ordo* de Halle, XVIe siècle). Pour l'Espagne au XVIe siècle, voir aussi R. W. Vince, *A Companion to the Medieval Theatre* (New York et Londres, 1989), 22.

80. Voir le manuscrit Londres, B.L., Ms. Add. 21926, f. 24v (supra, p. 173).

81. Paris, Musée du Louvre, inv. OA 11096: diptyque de la Mort du Couronnement de la Vierge, ivoire, Paris, dernier quart du XIIIe siècle.

82. Il est remarquable qu'un psautier anglais conservé à Cambridge, St. John's College, Ms K. 26 (vers 1270–80), présente successivement la Vierge attendant la mort dans son lit (f. 23r), la mort de la Vierge (f. 23v), les funérailles de la Vierge (f. 24r), l'ensevelissement de la Vierge (f. 24v), le Couronnement (f. 25r), mais pas l'Assomption. Cf. N. J. Morgan, *Early Gothic Manuscripts (II), 1250–1285* (Londres, 1988), 182, no. 179.

83. Colmar, Musée d'Unterlinden. La légende nomme la scène, de manière erronée puisque le Christ est absent, "Dormition de la Vierge." Il faudrait dire: "Mort de la Vierge."

84. Colmar, Musée d'Unterlinden, inv. 88.5.1. Sur la faveur du thème iconographique de la Mort de la Vierge, voir aussi les Heures de Madame Marie, Paris, B.N.F., Ms. Nouv. acq. fr. 1625, ff. 53v (Mort de la Vierge) et 54r (Couronnement de la Vierge), du début du XIVe siècle. Cf. A. Stones, *Le Livre d'Heures de Madame Marie* (Paris, 1997); les Heures de Catherine de Clèves, New York, Pierpont Morgan Library, Ms. M.917 (vers 1440), mais qui comporte aussi une Assomption; le Bréviaire romain de René II de Lorraine, Paris, Bibliothèque du Petit-Palais, Ms. 42, f. 287v (Mort de la Vierge); les Heures Spinola à l'usage de Rome, Los Angeles, The J. Paul Getty Museum, Ms. 83.ML.114 (Ms. Ludwig IX 18), vers 1515; etc.

85. Comme dans le cas de l'Assomption de Marie, on trouve déjà des images plus anciennes, à l'époque carolingienne (Psautier d'Utrecht, Utrecht, University Library, Ms. 484, f. 10v, illustration du Psaume 18:19) ou dans l'E-vangéliaire d'Henri II, vers 1020 (Munich, Staatsbibliothek, Ms. Clm 4454, l'évangéliste Matthieu contemple la résurrection du Christ). Otto Pächt, après H. Schrade et A. Grabar, souligne toutefois (1) que les premières images byzantines ou ottoniennes de la "résurrection dans la chair" sont la transcription littérale de versets des psaumes, mais pas de l'Evangile, comme c'est le cas à partir du XIIe siècle; (2) que c'est seulement à cette époque que la nouvelle image se répand massivement. Cf. O. Pächt, *The Rise of Pictorial Narrative in Twelfth-Century England* (Oxford, 1962), 56. Voir, par exemple: Klosterneuburg, retable de Nikolaus de Verdun, 1181, puis le Psautier de Bamberg, vers 1210. Cf. W. Braunfels, *Die Auferstehung* (Düsseldorf, 1951), fig. 4 et 5. Exemples pour la sculpture dans Mâle, *L'art religieux du XIIe siècle en France* (cité note 19), 127 et suiv. Vers 1210–1220, le Huntingfield Psalter présente simultanément, sur les deux registres de la même pleine page, l'iconographie ancienne

et la nouvelle, signe évident du tournant de l'iconographie (New York, Pierpont Morgan Library, Ms. M.43, f. 23r).

86. R. Recht, *Le Croire et le voir: L'Art des cathédrales, XIIe–XIVe siècle* (Paris, 1999).

87. Voir, par exemple, *supra*, Châteauroux, Bibl. Mun., Ms. 2, f. 282v.

88. Jn. 21:21–24: Jésus ayant dit à Pierre au sujet de Jean: "S'il me plaît qu'il demeure jusqu'à ce que je vienne, que t'importe?," l'évangile commente: "Le bruit se répandit alors parmi les frères que ce disciple ne mourrait pas." Pourtant, Jésus n'avait pas dit à Pierre: "Il ne mourra pas," mais: "S'il me plaît qu'il demeure jusqu'à ce que je vienne." La question est donc laissée ouverte.

89. *Ecrits apocryphes chrétiens* (Paris, 1997), 973–1037. Voir E. Junod et J.-D. Kaestli, *L'Histoire des Actes apocryphes des Apôtres du IIIe au IXe siècle: Le Cas des Actes de Saint Jean*, Cahiers de la Revue de Théologie et de Philosophie 7 (Genève, 1982), 9–12.

90. C'est pourquoi Jean Beleth, au XIIe siècle, parle à son propos de *depositio* et non d'*assumptio* comme pour Marie. Jean Beleth, *Summa de ecclesiasticis officiis* (cité note 9), 14.

91. Dante, *Divina Comedia*, Paradiso XXV, 122–129: c'est Jean lui-même qui déclare à Dante qu'il ne doit pas chercher son corps au ciel, qu'il a été enseveli dans la terre et qu'il y restera avec les autres corps tant que leur nombre ne sera pas égal au décret éternel: "Perché t'ab-bagli/per veder cosa che qui non a loco?/In terra è terra il mio corpo, et saragli / tanto con li altri, che 'l numero nos-tro/con l'etterno propositio s'agguagli."

92. M. Wehrli-Johns, "Das Selbstverständnis des Predi-gerordens im Graduale von Katharinenthal," in *Contem-plata aliis tradere: Studien zum Verhältnis von Literatur und Spiritualität*, éd. C. Brinker, U. Herzog, N. Largier et P. Michel (Bern, Berlin, Frankfurt a.M., New York, Paris et Wien, 1995), 241–71; J. F. Hamburger, "Brother, Bride and *Alter Christus:* The Virginal Body of John the Evangelist in Medieval Art, Theology and Literature," in *Text und Kultur: Mittelalterliche Literatur, 1150–1450*, éd. U. Peters (Stuttgart et Weimar, 2001), 291–327.

93. Voir, par exemple, la sculpture sur bois de l'assomp-tion corporelle de Marie l'Egyptienne à l'église Saint-Jean de Torun (Pologne), XVe siècle.

94. Par exemple: Paris, B.N.F., Ms. lat. 1156 B, f. 174r, Heures de Marguerite d'Orléans, deuxième quart du XVe siècle.

95. Les fondements scripturaires de cette légende sont Gen. 5:19–24 (Dieu a "pris" Enoch, qui n'est donc pas mort comme les autres patriarches); 2 Rois 2:11 (ascension d'Elie au ciel sur un char de feu); Zach. 4:14 (Enoch et Elie sont rapprochés en tant qu'ils sont les "deux oints"); Heb. 11:5–6 (selon Saint Paul, Enoch n'a pas connu la mort et fut "translatus" par Dieu); Apo. 11:1–13 (les deux "té-moins" Enoch et Elie mis à mort par l'Antéchrist qui au bout de trois jours et demi ressuscitent et montent au ciel dans une nuée). Toutefois, comme l'a montré Otto Pächt, *Rise of Pictorial Narrative in Twelfth-Century England* (cité note 85), p. 7 et fig. 1, l'iconographie s'est au moins autant inspirée de l'apocryphe *Livre des Secrets d'Enoch* que des Ecritures canoniques. Cf. M. M. Witte, *Elias und Henoch als Exempel, typologische Figuren und apokalyp-*

tische Zeugen: Zur Verbindungen von Literatur und Theologie im Mittelalter (Frankfurt a.M., 1987). L'iconographie d'Enoch et Elie est attestée depuis les manuscrits anglo-saxons de la *Genèse de Caedmon* et des *Paraphrases d'Aelfric* au XIe siècle, et déjà les manuscrits enluminés du commentaire de l'Apocalypse par Beatus de Liebana au Xe siècle, jusqu'aux manuscrits de l'Apocalypse du XIIIe siècle et au Psautier de Blanche de Castille.

96. J.-C. Schmitt, "La Genèse médiévale de la légende et de l'iconographie du Juif errant," in *Le Juif errant, un témoin du temps* (Paris, 2001), 54–75.

97. On pourrait, dans cette perspective (qui ici nous emmènerait trop loin), étudier la légende et les images des Sept Dormants d'Ephèse (mentionnés dans la *Légende Dorée*) et voir aussi dans la littérature vernaculaire le cas de Mordrain (dont la mort fut pendant plusieurs siècles différée), dans *La Queste du Saint Graal*, roman du XIIIe siècle. Il faut compter aussi avec la récupération, par la

culture chrétienne, de croyances de type folklorique. Giraud de Cambrie signale au début du XIIIe siècle, l'existence au large de l'Irlande de l'île d'Aran, visitée par Saint Brendan, où "les corps des morts ne sont pas mis en terre et ne se putréfient pas: placés et exposés en plein air, ils demeurent préservés de la corruption. Là, le mortel étonné peut voir et reconnaître ses aïeux, ses bisaïeux et ses trisaïeux, et la longue lignée de ses ancêtres en remontant dans le temps." Cf. J.-M. Boivin, *L'Irlande au Moyen Âge: Giraud de Barri et la Topographia Hibernica (1188)* (Paris, 1993), 202.

98. La question de la Vision béatifique, telle qu'elle se pose au début du XIVe siècle, n'est pas étrangère à cette problématique, vue du côté spirituel: les saints bénéficient-ils de la Vision directe de Dieu dès leur trépas, ou leur faut-il attendre le Jugement dernier? Voir C. Trottmann, *La Vision béatifique: Des disputes scolastiques à sa définition par Benoît XII*, BEFAR 289 (Rome, 1995).

Theologians as Trinitarian Iconographers

Bernard McGinn

At the beginning of his *De mystica theologia* the mysterious Dionysius intones a hymn to "Trinity, higher than any being, any divinity, any goodness!"[1] If the absolute transcendence of the Trinity puts into question all human language, according to Dionysius, this is *a fortiori* true of attempts to picture the Father, Son, and Holy Spirit. To be sure, insofar as the Second Person took on flesh in Jesus of Nazareth, and also because the Bible records manifestations of the Holy Spirit under the forms of fire and dove, there were scripturally sanctioned ways of portraying the Second and Third Persons. But the Father was totally invisible (see John 1:18 and 14:8–9), and the Trinity *precisely as Trinity* assuredly is beyond depiction.

Nevertheless, things have not been quite so simple in the history of the relation between Christian faith and artistic expression. From at least the fourth century, there have been attempts to depict the Trinity, either in geometric or in figural ways. One of the more unlikely became the canonical form in the Orthodox East, though it has also been popular at times in the West. This is the *Philoxenia*, or Hospitality of Abraham, the account in Genesis 18 of the patriarch's encounter with the three angels in his camp at Mamre. Justin Martyr and other early Christians saw this theophany as an Old Testament appearance of the Logos accompanied by two angels, but from the time of Origen, the three angels were also interpreted as a symbolic manifestation of the Trinity. Illustrations of the Mamre theophany begin in the fourth century and culminated in the fifteenth when the artist monk Andrei Rublev "wrote" his version, the most famous of all icons and one of the notable images in the history of Christian art.[2]

Rublev's icon, approved by a Moscow synod in 1551, would not have been welcome to those theologians who insisted that the Trinity is beyond all depiction. Augustine of Hippo, for example, forbade all attempts to picture the Trinity, symbolic or anthropomorphic. In his *Epistula* 120 he says that the Trinity is not "like three living masses, even though immense and beautiful, bounded by their proper limits, . . . whether with one in the middle, . . . or in the manner of a triangle with each touching the other." We must "shake out of our faith" all such figments, he goes on to say, because "the Trinity is invisible in such a way that it cannot be seen [even] by the mind."[3] But Augustine's powerful argument against representing the Trinity did not result in an absence of Trinitarian images in the West. Despite the bishop's strictures, Latin Christians continued to create images of the invisible *deus unitrinus* in the period from about 500 to 1100, though on a restricted scale.[4] What is more surprising is that from the twelfth century on, new

images of the invisible Trinity were produced not in opposition to theologians, but rather with their active encouragement, and sometimes even an eagerness on the part of theologians to become their own iconographers.

The rejection of images found in a few theologians has led some art historians to posit an unavoidable tension between theology and iconography. According to Hans Belting: "[W]hen theologians commented on some issue involving images, they invariably confirmed an already existing practice. Rather than introducing images, theologians were all too ready to ban them."[5] This claim is not correct even with regard to the ultimate test case—the impossible, but still apparently necessary, desire to picture the unknowable Trinity. A study of some of the late medieval theologians who became their own iconographers (and perhaps even artists) will show just how close the interaction of text and image became after the twelfth century.

Trinity and Iconography in Two Twelfth-Century Theologians

Hildegard of Bingen (1098–1179) and Joachim of Fiore (ca. 1135–1202) are among the most challenging theological figures of the twelfth century. They also provide important test cases of the paradoxical task of making the invisible Trinity visible. The German nun and the Calabrian abbot shared an intensely visual approach to Christian belief based on their visionary experiences. Many medieval seers, however, such as Hadewijch and Mechthild in the thirteenth century, and Julian of Norwich in the fourteenth, did not feel compelled to illustrate, or to commission others to illustrate, the visions that God had given them. Hildegard and Joachim did. A brief analysis of how each sought to give visual form to the Trinity reveals how intimate, even necessary, they conceived the relationship between theology and iconography to be.

Early medieval vision theory, following the lines laid down by Augustine in the twelfth book of his *De genesi ad litteram*, distinguished three kinds of seeing, which had both natural and supernatural registers, depending on whether they had as their object things in the world of common experience or those produced by special divine action. Augustine differentiated corporeal vision (the outward appearance of a form), spiritual vision (seeing an interior image), and intellectual vision (direct perception of unchanging truth). In the case of divinely given visions, God could supply special external and internal images for the first two kinds; with regard to the last, he could even grant immediate and infallible cognition of divine truth.[6] Both Hildegard and Joachim were primarily spiritual visionaries, although their showings often stretched or blurred Augustine's categories.[7] Hildegard occupies a special place among medieval visionaries for the way in which she reflected on how her visions came to her, descriptions that have fostered modern attempts to describe her as suffering from a form of migraine known as scintillating scotoma.[8] Joachim is more circumspect, though he does recount two formative visions in some detail.[9]

Hildegard says that the manifestations she had received from childhood involved both the seeing of images in her mind while she remained fully aware of ordinary forms of perception, as well as the hearing of messages and commands from God's voice.[10] Central to her theology was the way she integrated visionary experience and traditional monastic theology as exegetical practice. Monastic theology centered on the interpretation of the Bible. Without neglecting Scripture (indeed, the confidence and scope of her exegesis grew throughout her career), Hildegard used her divinely given *visiones/auditiones* as the base-text for the exposition of her theology. Her trilogy,

the *Scivias* (1141–51), the *Liber vitae meritorum* (1158–63), and the *Liber divinorum operum* (1163–73), employs the same format throughout—a description and illustration of the imaginative vision given by God, followed by an exegesis of its meaning.

Manuscripts of the *Scivias* and the *Liber divinorum operum* come equipped with illustrations of the visions, and, in recent decades, with a history of scholarly disagreement about how far these pictures can be attributed to Hildegard herself. In the present state of our knowledge it is not possible to be totally sure, but there are good reasons for agreeing with Madeline Caviness and others that the illustrations from the lost Rupertsberg codex of the *Scivias* (ca. 1165) were the direct product of the German visionary's directions, and that those found in the Lucca version of the *Liber*, although later in date (ca. 1227?), can also be said to be Hildegard's, iconographically, if not stylistically.[11] Thus, when God commands the seer, "Proclaim, explain, and write down (*scribe*) these mysteries of mine which you see and hear in mystical vision," we should take the "write down" in the broad sense of both write and paint.[12] Hildegard's theology is as much visual as it is verbal—neither side can be neglected in trying to gain an understanding of her teaching. In the case of Hildegard, as with the other figures to be discussed here, art does not so much illustrate theology in the sense of being a secondary adjunct to it; it is a necessary expression or manifestation of theological insight itself. Image is not just illustration, it is argument.

Although she paid deference to the ultimate unknowability of God, Hildegard was more concerned with God's appearance, both in cosmology and in history, than his/her hidden nature. The nun's use of feminine images for divinity has been well studied;[13] less attention has been given to her Trinitarian illustrations. Hildegard's interest in the doctrine of the Trinity is evident not only from the commentary she wrote on the Athanasian Creed, a key document of Trinitarian faith,[14] but also from the reputation she acquired as a divinely inspired authority on Trinitarian questions, as several letters sent to her indicate.[15] Christel Meier has even argued that the three-part structure of the *Scivias* should be seen as basically Trinitarian.[16] Be that as it may, at least four of the twenty-six *Scivias* visions and their illustrations refer to the Trinity, as do two of the ten showings of the *Liber divinorum operum*.

Hildegard's Trinitarian images are primarily didactic presentations of the mystery of the divine triunity. They are also fundamentally anthropomorphic. Even the one case that can be described as having a more geometric character expresses a visualizable object in the world of experience, a church pillar. Only one picture is rather traditional—*Visio* III.12 of the *Scivias*—where the Father is presented anthropomorphically as an old man, and the Son and the Spirit appear under the symbols of lamb and dove.[17] In her other images Hildegard creates new iconographic motifs, involving unusual human forms, even of the "monstrous" variety, and complex color-coding. A brief look at three of these will suggest the originality of her visual presentation of the Trinity.

Visio II.2 of the *Scivias* pictures the Trinity as a sapphire-colored, androgynous Christ-figure, standing within a mandorla of a band of "glowing fire" representing the Holy Spirit, and one of "bright light" signifying the Father (Fig. 1).[18] "That bright light," she tells us, "bathed the whole of the glowing fire, and the glowing fire bathed the bright light; and the bright light and the glowing fire poured over the whole human image, so that the three were one light in one power of potential."[19] The appearance of the shimmering human image of Christ within the two circles indicating the other Persons suggests a keystone of Hildegard's theology: her teaching about the absolute predestination of the Second Person of the Trinity.[20] The accompanying text explains

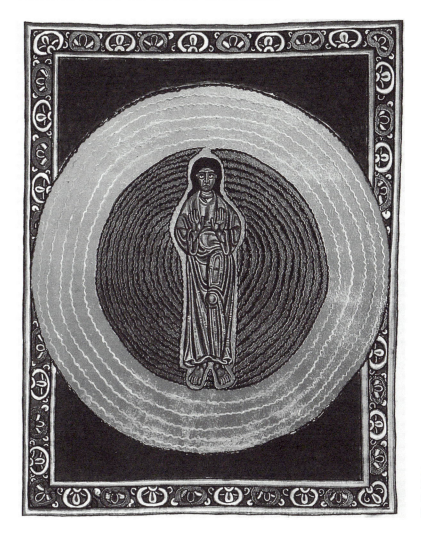

1. Hildegard of Bingen, *Scivias*, Vision II.2, Christ in the Trinity. Wiesbaden, Hessische Landesbibliothek, Cod. 1, f. 48 (lost)

how the Son gives access to the other two Persons and also explores a variety of Hildegard's distinctive Trinitarian analogies.[21]

Another visualization of the Trinity found in the *Scivias* is even more unusual. In Visio III.7, Hildegard, a noted builder herself, beholds the Trinity as "a wondrous, secret, and supremely strong pillar, purple-black in color, . . . so placed in the corner that it protruded both inside and outside the building" (Fig. 2).[22] The three metallic edges of the pillar, facing southwest, northwest, and west, signify the "holy and ineffable Trinity of the supreme Unity," hidden in the time of the Law but made manifest by Christ. These sharp edges cut off the errors of those who do not properly confess the mystery—the pieces of straw on the southwest are heretics; the little wings on the northwest figure the Jews; and the decaying branches on the west signify the pagans.[23] Later in her explanation Hildegard takes up additional topics of Trinitarian theology, expounding on the "Johannine inclusion" (1 John 5:7), and presenting another series of triadic analogies for the Trinity.[24]

The first vision of the *Liber divinorum operum* is not as explicitly Trinitarian as the two

aduerba hec anhelet: & ea in
nria animi sui conscribat.
licit sexta visio tertie par
tis. Capitula septime visi
onis tertie partis:
d ineffabilis trinitas is sine tepo.
declarata. simplici & humili
a fidelib' credenda & colenda
ene qs plus inuestigans qua
oportet. qa comphendi n potest.
in deteri cadat.
di sangne xpi mundus sal
uatus e. & cultus sce trinitatis
manifestissime declarat e. ipsa
tam nulli intellectui patet.
d ineffabilis trinitas omi creatu
re aptissime impio & potestate
apparet. exceptis icredulis cor
dib? cuncta tam uelut icidens
gladius penetrat. § succidit.
vt xpiano pplo catholice fidi
a indutare infidelitatis aduer
sant: hos diuinitas istitutione
d diuinitas iactantia iudaici
pplo deicit.
d diabolicu scisma gentilis ppli
a do abscisu uadit i pdicione.
arabola ad eande re.
erba iobis ad eande re.

2. Hildegard of Bingen, *Scivias*, Vision
III.7, the pillar of the Trinity. Wies-
baden, Hessische Landesbibliothek,
Cod. 1, f. 48 (lost)

from the *Scivias*, but it has significant Trinitarian aspects (Fig. 3).[25] In this showing Hildegard
sees a human figure with a shining face clothed in a tunic glowing like the sun and holding a
lamb bright as the light of day. From a golden chaplet on its head the face of an old man extends
upward, framed by one of the pairs of wings emerging from the *forma hominis*. The figure pro-
claims itself to be divine love (*caritas*), "the supreme fiery force" that enkindles all things, that
is, "the fiery life of the substance of divinity."[26] This power is identical with the divine *racional-
itas* that created humanity in its image and likeness as the microcosm of all things. It also rep-
resents God as Trinity. Exploring the connection between humanity and God in relation to the
vision, Hildegard states:

> The same life, moving and activating itself, is God, and nevertheless this one life exists
> in three powers. Eternity is the Father, the Son is the Word, the Holy Spirit is said to be

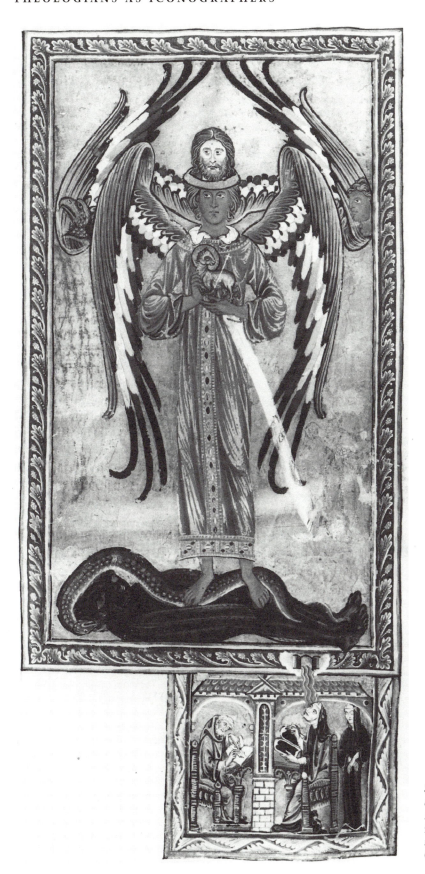

3. Hildegard of Bingen, *Liber divinorum operum*, Vision I.1. Above: Divine Love as supreme fiery force; below: Hildegard as visionary and writer. Lucca, Biblioteca Statale, Cod. lat. 1942, f. 1v

the breath connecting the two, just as God has signified in humanity in which there are body, soul, and rationality.[27]

In her rather diffuse explanation Hildegard says that the *forma hominis* signifies the "love of the highest Father" (*superni patris caritas est*),[28] and she identifies the glowing tunic and lamb figure with the Son's taking on of human flesh for our salvation.[29] The upper head is the *benignitas divinitatis*, which may be taken as a reference to the Holy Spirit,[30] though image and text do not clearly mesh in the exposition, and hence it is difficult to be sure. (This may be because the nun's basic concern in this vision is the general manifestation of divine *caritas* in history, not the three Persons as such.) In all, this image is a good example of the mixed, or what are often called "monstrous," illustrations of the Trinity. It underlines what seems to be the essential note of the nun's Trinitarian iconography: Hildegard's fascination with what theologians call the economic Trinity, that is, the Trinity revealed in history. She shows little interest in the inner life of the Trinity through visualizations based on the interplay of revealing and concealing the hidden mystery.

Joachim of Fiore's theology is more consistently Trinitarian than Hildegard's.[31] His understanding of how the divine triunity provides the structure of all history guarantees that the Trinity appears everywhere in his lengthy and often obscure works of biblical exegesis.[32] While Joachim, like Hildegard, insisted that the Trinity is ultimately beyond human knowing and representation,[33] his Trinitarian *figurae*, like her images, do not emphasize the hiddenness of the mystery, but rather serve as geometric, mandala-like diagrams designed to display the *trinitas in tempore*, the action of the Trinity in salvation history.[34] The Calabrian abbot's sense of the rationality of God's plan for history, what he called the *vivens ordo rationis*, is evident in his *figurae* as much as in his writings.[35]

For Joachim, the *figurae* were not mere human constructions but were based upon ideal forms rooted in the divine world. Natural knowledge of the rightness (*rectitudo*) of forms like the circle and the triangle, however, was not sufficient to reveal their transcendent significance. This was given to Joachim in his visions and the *intelligentia spiritualis* of the Bible that accompanied them. Joachim also claimed his divinely given insights could be more effectively communicated by picture than by word.[36] For example, in speaking of the psaltery figure to be discussed below, he says: "Concerning what has been said, it is necessary for us . . . , according to our custom, to fashion a *figura*, so that by bringing the image of ten-stringed psaltery before fleshly eyes . . . the mind's spiritual eyes may be opened to understanding by clay placed on the outside, so to speak."[37] In another place in the same treatise he describes how "when fitting figures have been set forth, we may direct the mind's eye (*mentis oculum*) to an understanding of the Three Persons."[38] Joachim, like Hildegard, felt that iconography was a necessity, not a luxury. Where the abbot's *figurae* differ from Hildegard's illuminations is in the way they fuse text and image into dynamic new syntheses, teaching tools employed among the circles of his original followers to be shown and studied over and over again.[39]

From the beginning of his writing career, Joachim had introduced diagrams and *figurae* into the margins of his works. These pictures were subsequently expanded and enriched, both by the abbot and by his close followers, into the famous *Liber figurarum*, which Fabio Troncarelli has termed "a sort of recapitulating appendix of his works."[40] Recent work has brought out the links between some of these symbolic images and earlier South Italian manuscript illumination,[41] but this does not lessen Joachim's iconographic creativity.

Almost all Joachim's *figurae* have Trinitarian implications. Here we can only give brief treatment to one of the most famous images and to mention two others to illustrate something of the power of the Calabrian's visual imagination. Joachim differs from Hildegard in avoiding representation of the human form in his images. Most of the *figurae* are geometrical creations designed to show history's unfolding order through richly glossed circles, spirals, triangles, and rectangular shapes (sometimes appearing as trumpets). Other *figurae* are vegetative, making use of trees and flowers to symbolize the progressive growth of the *intelligentia spiritualis*, the spiritual understanding of the Bible resting at the heart of history's progress toward deeper appropriation of the Trinity.[42] In a few cases animal forms appear, notably eagles representing progressive stages of contemplation,[43] and the seven-headed dragon of Apocalypse 12 picturing the historical embodiments of Antichrist.[44] While almost all the *figurae* manifest aspects of Joachim's Trinitarianism, this is particularly evident in the psaltery figure.

Joachim tells us that the image of the "ten-stringed psaltery" (*psalterium decem chordarum*) was given to him in a vision (Fig. 4). On Pentecost Sunday, while praying in the abbey church at Casamari, he was beset with doubts about the Trinity. Joachim continues:

> When that happened, I prayed with all my might. I was very frightened and called upon the Holy Spirit whose feast day it was to deign to show me the holy mystery of the Trinity. . . . I repeated this and began to pray the psalms. . . . At this moment, without delay, the shape of a ten-stringed psaltery appeared in my mind. The mystery of the Holy Trinity shone so brightly and clearly in it that I was at once impelled to cry out: "What God is as great as our God?" (Ps. 76:14)[45]

Joachim's desire to be *shown* the Trinity in a visible way, as well as his subsequent use of this *forma psalterii* in many of his writings, brings us to the heart of his theological iconography.[46]

The relation between the *psalterium* figure and the Trinity is discussed by the abbot in Book 1 of his *Psalterium decem chordarum*.[47] The *figura* appears in a more complex form in the *Liber figurarum*, one that not only expresses the three Persons and one God, but that also reveals how humanity, as *imago trinitatis*, is meant to progress to final realization of its destiny in the coming third *status* through the mediation of the *una sancta ecclesia catholica* as the instrument of salvation.[48] The relation between Trinitarian iconography and theological anthropology, also evident in Hildegard's images, resurfaces in the Calabrian's iconography in a distinctive way.[49] The truncated psaltery-triangle, or Alpha, with its color symbolism and an elaborate series of titles and biblical texts,[50] portrays the Father as unbegotten in its blunt top,[51] and manifests the relations of the Persons in the three sides—green on the left for the Father as begetter, red below for the Son as begotten, and blue on the right for the Holy Spirit as proceeding from both. In the Oxford manuscript (the most authentic), the three divine names found in Joachim's version of the Tetragrammaton (IE-EU-UE) appear at the angles and are also written out in full in the inner circle, or *rosa*, of the diagram, thus signifying the identity of the Trinity with the divine Unity.[52] The inscriptions on the sides of the triangle relate the three Persons to the three orders of humans connected to the ages of history: the *ordo coniugatorum* of the Old Testament on the left; the *ordo clericorum* of the New Testament beneath; and the *ordo monachorum* of the dawning third *status* of the Holy Spirit on the right. Finally, the horizontal ten strings across the interior of the triangle signify the connection between the nine orders of angels crowned by the tenth order, *homo* (on the left), and the progression (on the right) of the seven gifts of the Holy Spirit and three the-

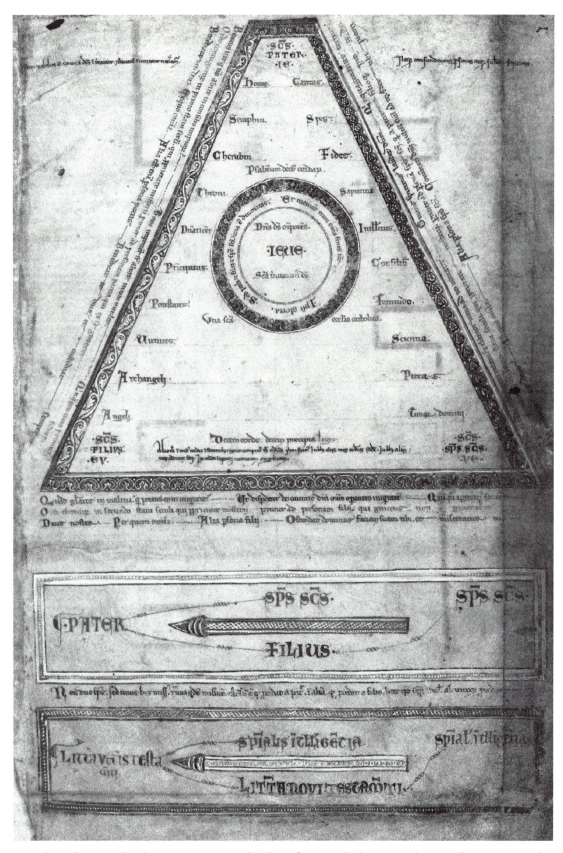

4. Joachim of Fiore, *Liber figurarum,* ten-stringed psaltery figure. Oxford, Corpus Christi College, Ms. 255a, f. 8r

ological virtues—the divine graces that lead to God. As Marjorie Reeves and Beatrice Hirsch-Reich put it: "This harmony of such different conceptions in one comparatively simple figure gives the Psaltery . . . a depth of perspective which no other figure reaches."[53]

Almost as complex an image, though apparently not one given to Joachim in a vision, is found in the *figura* of three interlocking rings representing the three *status* of Father, Son, and Holy Spirit (Fig. 5).[54] This figure, which incorporates a small version of the Alpha-Psaltery image in the upper left corner, expresses the role of the Trinity in history with great detail, but it does not bring out the anthropological dimensions as explicitly as the *Psalterium* figure. A third important Trinitarian image, more simple if more aesthetically compelling, is the *figura* known as the Trinitarian Tree Circles, where the Calabrian combines circles and trees to express the intertwined roles of Jews and Gentiles in the three Trinitarian states of salvation history (Fig. 6).[55] Further analysis of the significance of these *figurae* is not possible here, but it is worth noting that the abbot's images had more widespread influence than those of the German nun. They even achieved architectural expression in the windows in the apse of the abbey church at San Giovanni in Fiore erected in the first quarter of the thirteenth century, not long after Joachim's death (Fig. 7).[56]

Revealing and Concealing the Trinity in the Fourteenth Century

The theologies of Hildegard and Joachim have important mystical dimensions, but their Trinitarian iconography was more concerned with showing the action of the triune God in the history of salvation than in trying to manifest how humans during this life can share in the hidden inner life of the Father, Son, and Holy Spirit. In the later Middle Ages, however, there are some cases in which mystical theologians took up the challenging task of seeking to reveal through images not only the inner dynamism of the Trinity, but also how humans can come to participate in this deepest mystery of Christian faith. Such efforts can be thought of as both necessary and impossible—pictorial analogues of the late medieval efforts to "unsay" God through language itself.[57]

The last two centuries of the Middle Ages saw a proliferation of experiments in Trinitarian iconography. Only one example will be analyzed here, that of Henry Suso, in order to suggest something of the rich interaction between mystical Trinitarian theology and art during this time. Suso, like Hildegard and Joachim, was a theologian who felt impelled to become an iconographer, in his case despite considerable ambivalence about the role of images. In order to understand Suso's suspicion of images, we need to take a brief look at the mysticism of his teacher, Meister Eckhart.[58]

For Eckhart, everything we can know is an image (*imago/bild*), but images are divided into two categories: outer, created ones that only participate in a lower way in what they figure; and inner, spiritual images that represent the archetype in more perfect fashion. The production of every interior *imago* is what Eckhart called a pure formal emanation, modeled on the "emanation from the depths of silence," the inner "boiling" (*bullitio*) that is the heart of Eckhart's theology of the Trinity.[59] The role of the Word, the Second Person of the Trinity, as absolute *Imago*, is crucial to Eckhart's thought, especially his understanding of how human beings are both *imago Dei* insofar as they pre-exist in the Word, and *ad imaginem Dei* insofar as they are individual created realities.

Eckhart's theology of the Trinity, especially his understanding of the emanation of the Son from the Father, is rooted in his teaching about the *gruntlos grunt*, the "ground without ground." Eckhart speaks of the *grunt* as "the quiet desert into which distinction never gazed, not the Father,

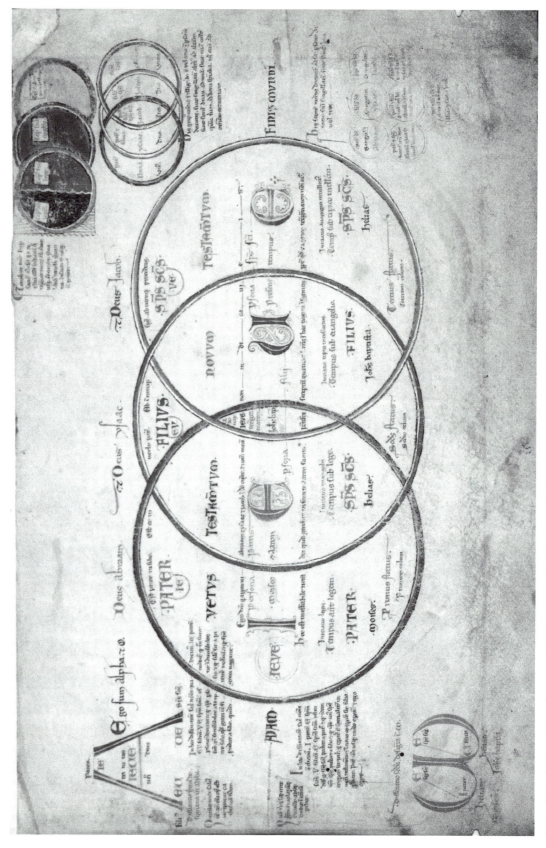

5. Joachim of Fiore, *Liber figurarum*, Trinitarian circles figure. Oxford, Corpus Christi College, Ms. 255a, f. 7v

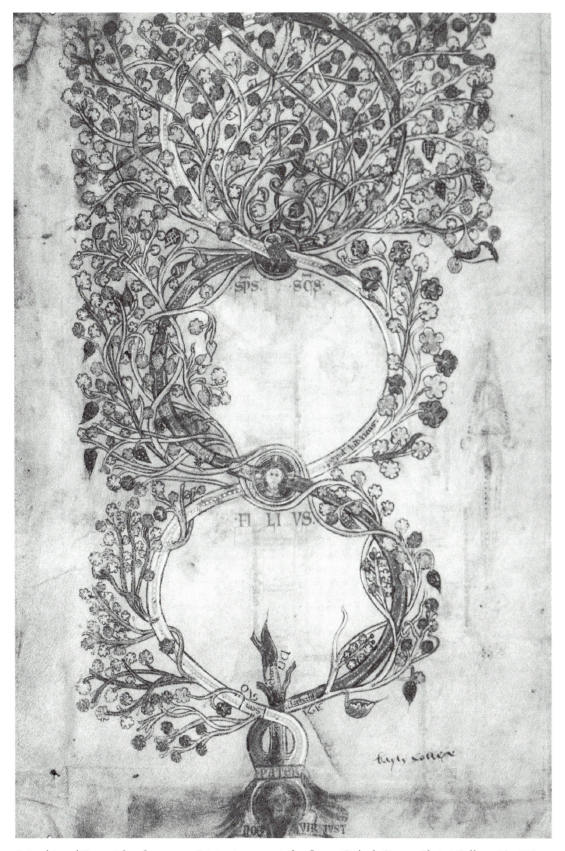

6. Joachim of Fiore, *Liber figurarum*, Trinitarian tree circles figure. Oxford, Corpus Christi College, Ms. 255a, f. 12v

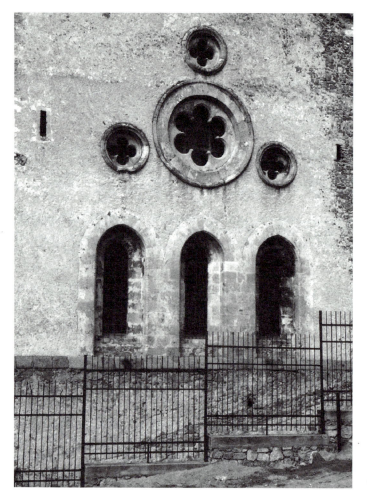

7. San Giovanni in Fiore, abbey church, apse windows, early thirteenth century

nor the Son, nor the Holy Spirit; . . . for this ground is a simple silence, in itself immovable, and by this immovability all things are moved."[60] The *grunt*, which Eckhart describes as the divine desert and sometimes as the abyss,[61] is the fused identity of what is deepest in God and in the human soul. As such, it challenges both traditional notions of the Trinity and inherited expressions of attaining union with God. This is why Eckhart, as a part of his mystical teaching, emphasizes that the path back into the *grunt* involves the unusual practices of "detaching/cutting off" (*abscheiden*), "letting go" (*gelassen*), and finally the deep self-annihilation that he describes as *durchbrechen* (breaking-through), *entbilden* (un-forming, or dis-imaging),[62] and even *entwerden* (un-becoming, or de-creating).[63]

Eckhart says that all created images have to be discarded to attain God: "If I am to know God, that must happen without images and without any medium."[64] This is why in speaking of the images found in Scripture, he insists on "breaking the shell." *Predigt* 51 says: "If you want to get at the kernel, you must break the shell; and also, if you want to find nature unveiled, all likenesses must be broken through [*so muessent die gleychnuss alle zerbrechenn*], and the further you penetrate, the nearer you will get to the essence."[65] Such a process is necessary in order to become totally one with "the Reflection that alone is the Image of God and the Godhead insofar as the

Godhead is the Father." This is "the Image in which all images have flowed forth and departed, and to the extent that we are re-imaged in the Image and equally brought into the Image of the Father, to the degree that he recognizes that in us, to that same degree we know him as he knows himself."[66]

Attaining union with the Second Person as the *Imago* that pre-contains all images, however, does not seem to be final, at least in some of Eckhart's sermons. His doctrine of the *grunt* that lies beyond the Trinity of Persons implies the possibility of a movement into a state of fusion where there is no image at all, not even the Absolute *Imago* that is the Word. A number of sermons (e.g., Prr. 42, 48, 52, 69, 83) appeal to this breaking-through beyond the Trinity. To give but one example: in a sermon on mystical death Eckhart says, "So the soul breaks through her eternal image in order to penetrate to where God is rich in unicity."[67] Eckhart's radical negation of images, not only created images, but even ultimately the *Imago* that is the Word in the Trinity, paradoxically coexists in his writings with an often striking use of unusual verbal images, *exempla*, and the like. This suggests that images, in word and perhaps even in picture, on some level at least, do have a function, though always within the framework of the drive to ultimate *durchbrechen*, or breaking-through. This is the issue that Eckhart's disciple, Henry Suso, took up.[68]

Suso attempted to fuse many of the disparate aspects of fourteenth-century mysticism into a new and highly influential teaching. In bringing together courtly motifs and language, emotional Passion devotion, and Eckhartian apophaticism, among other themes, the Dominican portrays himself as an exemplar of the mysticism of his era.[69] This representative character may also help account for his program of "using images to drive out images" [*daz man bild mit bilden us tribe*], as he put it in a phrase from *The Life of the Servant*.[70] Like Hildegard and Joachim, Suso was a visionary with a highly developed visual imagination.[71] Reflecting on his use of images, Jeffrey Hamburger notes, "The picture [in the text] reminds us that Seuse first saw and then read."[72] Again, like Hildegard and Joachim, he also explicitly discussed the role of visions and images. In the prologue to his Latin work, the *Horologium sapientiae*, he says that the visions in the work need not all be taken literally (*ad litteram*), though many were perceived by him as such. He insists that they should be considered as a form of *figurata locutio*, that is, "speaking through figures," as found in scriptural parables. "The attentive reader," he continues, "will easily note the hidden mysteries of this speaking through figures, if he makes a skillful effort."[73] Later in the same treatise, he defends the use of artistic images, noting that "weak human memory within is aided by exterior signs."[74]

Yet Suso was also a disciple of Eckhart, inheriting the Meister's apophatic drive to discard all images in order to attain the God beyond images and likenesses.[75] His Trinitarian theology is shot through with Eckhartian teaching. In putting together *The Exemplar*, the definitive edition of his writings (1362–63), Suso summarized his teaching on the use of pictorial images in conveying mystical teaching. In the prologue to the work he speaks of the necessity of employing *bildgebender wise*, i.e., "image-employing means," to draw the religiously minded person away from the falsity of the world.[76] More tellingly, at the end of the *Life of the Servant*, he responds to the request of his spiritual daughter, Elsbeth Stagel, for "image-employing likenesses" (*bildgebender glichnus*) with a comment on the dilemma of needing images to reach what is imageless. He asks:

How can one form images of what entails no images or state the mode of being of something that has no mode, that is beyond all thinking and the human intellect? . . . But still,

8. Henry Suso, *Exemplar*. Strasbourg, Bibliothèque Nationale et Universitaire, Cod. 2929, f. 82r

so that one may drive out one image with another, I shall now explain it to you with images and by making comparisons, as far as this is possible, for these same meanings beyond images.[77]

It is no accident that this defense comes in the chapter in which Suso presents the last of the eleven (or possibly twelve) pictures he commissioned and oversaw to illustrate *The Exemplar*.[78] Just as the earlier parts of the book had explored the motifs of courtly mysticism and Passion mysticism, at the end of the treatise Suso returned to the Eckhartian mysticism of the divine ground, especially as it relates to the Trinity, a topic that he had previously explored in his *Little Book of Truth*.[79] The details of this theology cannot be presented here, but a brief look at Suso's understanding of the Trinity's role in the *exitus* and *reditus* of all creation out of and back to God can suggest how word and image have a necessary mutual relation in the Dominican's mysticism.[80]

It is important to note that Suso intended the picture accompanying chapter 53 of the *Life* to precede the written text, thus interrupting, and in a sense negating, the narrative flow of his exposition. In the mystical path to God, both images and texts function to conceal as much as they do to reveal, which is one of the senses in which "images drive out images."[81] The illustration itself, which might be described as an *itinerarium oculi mentis in Deum*,[82] is a remarkable summa-

tion of Suso's mystical thought (Fig. 8). With its attendant captions it has a strong didactic element, but that is subordinate to the way in which the picture fixes into a single presentation, both revealing and concealing, the many pages in which the Dominican expressed his view of how all things come forth from the hidden Godhead and return to it. The mind's eye here beholds time and eternity in a single gaze. The introductory caption expresses this atemporal *regyratio* and temporal *itinerarium* in a nutshell:

> The following pictures show the presence of the naked Godhead in the Trinity of Persons and all creatures, flowing out and flowing back within; and they show the first principle of a person at the outset, and his well-ordered breakthrough of progressing, and the most sublime spilling over of perfection beyond being.[83]

For Suso, both word and image are equally important—and equally insufficient in the long run. The interaction of the two aspects of his presentation, and the fact that this picture tries to present in a single synoptic view the entire process of *exitus* and *reditus*, marks a new stage in the history of Trinitarian iconography.

A full analysis of the illustration to chapter 53 of the *Life* is not possible here.[84] A few remarks, however, will highlight some of its complexity. The picture incorporates the Passion motifs in Suso's mysticism but places them within a more universal theological context, beginning with the *grunt*, or divine abyss. At its starting point, in the upper left, we discern three mysterious rings figuring the Eckhartian ground-abyss-desert, but also hinting that the root of the revealed Trinity of Persons lies hidden in the unrevealed ground. The caption reads: "This is the modeless abyss of the eternal Godhead, which has neither beginning nor end."[85] The modeless abyss emanates outward through a tabernacle-like image,[86] representing the first moment of divine outflowing whose continuity throughout the whole process is expressed by the red string connecting the figures, as well as the presence of small "grounding" circles in the human figures. The first station of the process is a picture of the three divine Persons, with the Spirit as the bond between Father (left) and Son (right). "This is the Trinity of Persons in substantial Unity, which is what Christians believe."[87] The remaining figures present the stages of the mystical life, progressing downward in *exitus* on the right side, and then detailing the various moments or stations of the return (*ker*), up to, into, and even beyond the Trinity of Persons, in a way that enriches and sometimes qualifies Suso's discussion in the final chapters of the *Life*.[88]

Suso's drawing was not the first attempt at picturing a map of ascent to union with the Trinity. A luxurious version of such an itinerary dating from the early fourteenth century can be found in a tract in a manuscript written and illustrated about 1300 and now in the British Library.[89] Proceeding from left to right beginning with the top register, this picture shows a nun being confessed by a Dominican friar, praying to an image of the coronation of the Blessed Virgin, falling into ecstasy before a vision of Christ bleeding into a chalice on the altar, and finally being shown the Trinity in the standard Throne of Glory depiction. Although the cloudlike frames around the bleeding Christ and the image of the Trinity suggest the difference between the earthly realm and heaven, this mystical journey is fairly traditional, making no attempt to manifest the hidden ground of the Trinity and its relation to the ground of the soul, as we see in Suso's picture.

Suso's daring experiment at creating an illustration that sought to portray a basically Eckhartian Trinitarian mysticism had been anticipated in the Trinitarian images of the Rothschild Canticles.[90] I will not dwell on this fascinating program here, not only because it has been dealt with insightfully by Jeffrey Hamburger, but also because we cannot tie these images to a specific

theologian. These miniatures, however, certainly form an analogue to Suso's program of using images to drive out images, especially in the way in which they begin with anthropomorphic figures which more or less portray, or reveal, the three Persons of the Trinity, and then gradually subvert the revelation by complex techniques of veiling and unveiling, finally ending up with apophatic "explosions" of all images that still contain hints of the Three who are yet One.[91] While there can be no question of the artistic power of the portrayals of "mystical 'hide-and-seek'" (as Hamburger puts it)[92] in the Rothschild Canticles, none of these illustrations nor the texts that accompany them present a fully worked-out Trinitarian mysticism in the way that Suso's treatise and picture do.

Conclusion

André Grabar once wrote: "No satisfactory iconography of the dogmas of the Trinity has ever been achieved, and the best proof of this is that all the iconographies that have ever been proposed have been rapidly abandoned, to be followed by new attempts just as debatable and equally ephemeral."[93] It is true that no attempt to picture the Trinity can ever be fully satisfactory, but Grabar's generalization is wrong on at least two counts. First, the claim of ephemerality does not apply to some ancient depictions, such as the Old Testament Trinity icon, which has been in continuous use for more than sixteen centuries. Second, the constant experimentation in imaging the Trinity, as illustrated in the cases examined here, can be given a more positive evaluation than Grabar allowed. From the perspective of Christian faith, the Trinity is just as *ineffabilis* as it is *invisibilis*, but this has never prevented believers from attempting to speak the mystery, just as it has not blocked experiments in picturing it, if always in inadequate ways. Indeed, it can be argued that the ultimacy of the mystery of the Trinity is *precisely* what makes such experiments necessary. Augustine, no friend of attempts to picture the Trinity, is a good witness for the need to speak the inexpressible Trinity. In his *De doctrina christiana*, reflecting on the paradox of speaking about what is by definition ineffable, he says: "God should not even be said to be ineffable, because when this is said, something is said. There is a form of word-conflict here, since if that which is ineffable cannot be spoken, what can be called ineffable is not ineffable."[94] And yet Augustine, like other theologians, kept on talking. Dionysius the Areopagite agreed. Concerning the mystery of Jesus, God incarnate, his third letter says: "What is to be said of it remains unsayable; what is to be understood of it remains unknowable."[95] The same is true of the Trinity, with the addition, "what can be made visible of it remains invisible." In picturing the Trinity, theological iconographers were not really trying to depict what is by essence unimaginable and unportrayable. Rather, as themselves images of the Trinity (*imago Trinitatis*), they were trying to give fitting praise to the mystery that was the foundation of their faith.

Notes

1. Dionysius Areopagita, *De mystica theologia* 1.1, in *Corpus Dionysiacum*, ed. B. R. Suchla, 2 vols. (Berlin, 1990–91), vol. 2, 141: "Trias hyperousie, kai hyperthee, kai hyperagathe."

2. For a sketch of the history of the image and its possible theological meaning, see B. McGinn, " 'Trinity Higher than Any Being!' Imaging the Invisible Trinity," in *Die Ästhetik des Unsichtbaren*, ed. D. Ganz (Berlin, 2004), 30–47.

3. Augustine, *Ep.* 120.2.7 and 12 (PL 33:455 and 458):

"quasi tres quasdam viventes moles, licet maximas et pulcherrimas, suorum tamen spatiis propriis terminatas, . . . sive una earum sit in medio constituta, . . . sive in modum trigoni duas caeteras unaquaeque contingat. . . . Si autem in nullo istorum genere putanda est ista Trinitas, et sic est invisibilis, ut nec mente videatur."

4. For a general introduction to the history of representing the Trinity, see W. Braunfels, *Die heilige Dreifaltigkeit* (Düsseldorf, 1954). More detailed studies of early medieval Trinitarian images can be found in F. Boespflug and Y. Zaluska, "Le Dogme trinitaire et l'essor de son iconographie en Occident de l'époque carolingienne au IVe Concile du Latran (1215)," *CahCM* 37 (1994), 181–240; A. M. D'Achille, "Sull'iconografia trinitaria medievale: La Trinità del santuario sul Monte Autore presso Vallepietra," *Arte medievale*, ser. 2, 5 (1991), 49–73; and A. Patschovsky, "Die Trinitätsdiagramme Joachims von Fiore (d. 1202): Ihre Herkunft und semantische Struktur im Rahmen der Trinitätsikonographie, von deren Anfängen bis ca. 1200," in *Die Bildwelt der Diagramme Joachims von Fiore: Zur Medialität religiös-politischer Programme im Mittelalter*, ed. A. Patschovsky (Ostfildern, 2003), 56–87.

5. H. Belting, *Likeness and Presence: A History of the Image before the Era of Art* (Chicago, 1994), 1.

6. Augustine, *De Genesi ad litteram*, esp. 12.6.15–12.26 and 12.23.49–31.59 (PL 34:458–64 and 473–80).

7. On Hildegard's visions, see B. McGinn, "Hildegard of Bingen as Visionary and Exegete," in *Hildegard von Bingen in ihrem historischen Umfeld*, ed. A. Haverkamp (Mainz, 2000), 321–50. On the visual character of Joachim's thought, B. McGinn, "*Ratio* and *Visio*: Reflections on Joachim of Fiore's Place in Twelfth-Century Theology," in *Gioacchino da Fiore tra Bernardo di Clairvaux e Innocenzo III: V Congresso Internazionale di Studi Gioachimiti*, ed. R. Rusconi (Rome, 2001), 27–46.

8. On Hildegard's migraines and how they may help explain aspects of her illustrations, see M. Caviness, "Artist: 'To See, Hear, and Know All at Once'," in *Voice of the Living Light: Hildegard of Bingen and Her World*, ed. B. Newman (Berkeley and Los Angeles, 1998), 110–24, especially the discussion on 113–14.

9. Joachim describes two visions given to him while he was staying at the Cistercian monastery of Casamari ca. 1183–84. The first was an intellectual vision, the *intelligentia spiritualis* of the Apocalypse that occurred on Easter night and was connected with the Person of the Son. The second was a spiritual vision of the Trinity shown at Pentecost and related to the Holy Spirit. In addition, tradition credits Joachim with an earlier vision relating to the Father. On these visions, see B. McGinn, *The Calabrian Abbot: Joachim of Fiore in the History of Western Thought* (New York, 1985), 21–22; and R. E. Lerner, *The Feast of Saint Abraham: Medieval Millenarians and the Jews* (Philadelphia, 2000), 7–9.

10. The passages in which Hildegard comments on how she received her visions are discussed in McGinn, "Hildegard of Bingen as Visionary and Exegete" (as in note 7), 327–37.

11. Besides the recent summary article, "Artist" (as in note 8), see M. H. Caviness, "Hildegard of Bingen: German Author, Illustrator, and Musical Composer, 1098–1179," in *Dictionary of Woman Artists*, ed. D. Gaze (London, 1997), vol. 1, 685–87; and "Hildegard as Designer of the Illustrations to Her Works," in *Hildegard of Bingen: The Context of Her Thought and Work*, ed. C. Burnett and P. Dronke (London, 1998), 29–62. Other recent investigators argue for a greater distance between Hildegard and the surviving illustrations; see, e.g., K. Suzuki, "Zum Strukturproblem in den Visionsdarstellungen der Rupertsberger 'Scivias'-Handschrift," *Sacris Erudiri* 35 (1995), 221–91.

12. *Hildegardis, Scivias* II.1, ed. A. Führkötter and A. Carlevaris, CCCM 43 and 43A (Turnhout, 1978), vol. 1, 111–12: "clama et enarra et scribe haec mysteria mea quae vides et audis in mystica visione." For this understanding of *scribe*, see Caviness, "Hildegard as Designer" (as in note 11), 31–32.

13. B. Newman, *Sister of Wisdom: St. Hildegard's Theology of the Feminine* (Berkeley and Los Angeles, 1987), esp. chap. 2, "The Feminine Divine."

14. Hildegard, *Explanatio symboli Sancti Athanasii* (PL 197:1065B–82A).

15. Not long after 1148, the Paris Master, Odo of Soissons, asked Hildegard for an opinion on the controversial Trinitarian theology of Gilbert of Poitiers. His letter and Hildegard's response are Epp. 39 and 40 of her correspondence found in *Hildegardis Bingensis Epistolarium*, vols. 1–2, ed. L. van Acker, CCCM 91–91A, and vol. 3, ed. L. van Acker and M. Klaes-Hachmöller, CCCM 91B (Turnhout, 1991–2001), vol. 1, 100–103. About 1163, Eberhard of Bamberg wrote to Hildegard about the proper understanding of the triad *eternitas-equalitas-conexio* in relation to the three Persons (Ep. 31). Her response in Ep. 31r is an original rendition of this popular motif in twelfth-century theology (van Acker, vol. 1, 83–88). On Hildegard's Trinitarian theology, see C. J. Mews, "Hildegard and the Schools," in *Hildegard of Bingen*, ed. Burnett and Dronke (as in note 11), 101–7.

16. C. Meier, "Hildegard von Bingen," in *Die deutsche Literatur des Mittelalters: Verfasserlexikon*, ed. K. Ruh et al.(Berlin, 1981–), vol. 3, 1263–64.

17. On this image, which can be related to the development of the popular Throne of Grace (*Gnadenstuhl*) motif, see Boespflug and Zaluska, "Le Dogme trinitaire" (as in note 4), 195–96.

18. *Scivias* II.2 (as in note 12 [vol. 1, 124]). For a translation of this vision, see *Hildegard of Bingen: Scivias*, trans. C. Hart and J. Bishop (New York, 1990), 159–65.

19. *Scivias* II.2 (as in note 12 [vol. 1, 124]): "Et illa serena lux perfudit totum illum rutilantem ignem, et ille rutilans ignis totam illam serenam lucem, ac eadem serena lux et idem rutilans ignis totam speciem eiusdem hominis, ita lumen unum in una ui possibilitatis existentes." For a study of the interrelationships among this image, Joachim's Trinitarian circles (to be discussed below), and Dante's vision of the Trinity in *Paradiso* XXXIII, see P. Dronke, "Tradition and Innovation in Medieval Western Colour-Imagery," in *The Realms of Colour–Die Welt der Farben–Le Monde des couleurs, Eranos* 41 (1972), ed. A. Portmann and R. Ritsema (Leiden, 1974), 98–106.

20. Hildegard's teaching that the Second Person of the Trinity would have become incarnate even if Adam had not sinned is set forth in her lengthy commentaries on John's prologue and the Genesis Hexaemeron in the *Liber*

divinorum operum, I.4.105 and II.1.17–49; see *Hildegardis Bingenensis Liber divinorum operum*, ed. A. Derolez and P. Dronke, CCCM 92 (Turnhout, 1996), 248–64 and 285–344. In an unpublished text from her *Causae et curae* she summarizes: "Cum enim Deus mundum fecit, in antiquo consilio habuit quod homo fieri voluit"; see P. Dronke, *Women Writers of the Middle Ages* [Cambridge, 1983], 241).

21. For example, *Scivias* II.2.5–7 (as in note 12, [vol. 1, 127–30]) has a discussion of the qualities of stone, flame, and word as figuring the three Persons in one God.

22. *Scivias* III.7 (as in note 12 [vol. 2, 462]): "Deinde vidi in angulo occidentali demonstrati aedificii mirabilem et secretam atque fortissimam columnam colorem purpureae nigredinis habentem, eidemque angulo ita impositam ut et intra et extra ipsum aedificium appareret." For a translation, see *Hildegard of Bingen: Scivias* (as in note 18), 411–21. There is a study of this image in Caviness, "Hildegard of Bingen: German Illustrator" (as in note 11), 686–87.

23. *Scivias* III.7.4–6 (as in note 12 [vol. 2, 465–66]).

24. *Scivias* III.7.8 (as in note 12 [vol. 2, 470–72]) is a disquisition on the Johannine inclusion (a Trinitarian passage inserted after 1 John 5:7 about 800); III.7.10 (vol. 2, 473–74) presents brief Trinitarian analogies based on work (*operatio*), breath, and the eye. Finally, III.7.11 (vol. 2, 474–76) attacks contemporary Trinitarian errors of those who "presumed to know what is not to be known" in the case of the Trinity. This may be a reference to Gilbert of Poitiers, about whose views Hildegard had been queried; see note 15.

25. *Liber divinorum operum* (as in note 20), I.1.1–17 (46–59).

26. *Liber divinorum operum* (as in note 20), I.1.1 (47–48): "Et imago hec dicebat: Ego summa et ignea uis, que omnes uiuentes scintillas accendi et nulla mortalia efflaui, sed illa diiudico ut sunt; . . . sed et ego ignea uita substantie diuinitatis super pulchritudinem agrorum flammo et in aquis luceo atque in sole, luna et stellis ardeo."

27. *Liber divinorum operum* (as in note 20), I.1.2 (49): "eademque uita se mouens et operans deus est, et tamen hec uita una in tribus uiribus est. Eternitas itaque Pater, uerbum Filius, spiramen hec duo connectens Spiritus sanctus dicitur, sicut etiam Deus in homine, in quo corpus, anima et racionalitas sunt, signauit." Another reference to the Trinitarian significance of the illustration can be found in I.1.4 (51). Hildegard had also identified the Father with *eternitas* in Ep. 31r.

28. *Liber divinorum operum* (as in note 20), I.1.3 (50).

29. *Liber divinorum operum* (as in note 20), I.1.11 (55).

30. *Liber divinorum operum* (as in note 20), I.1.4 (51). *Benignitas* is a term traditionally associated with the Holy Spirit as divine love.

31. For an overview, see McGinn, *The Calabrian Abbot* (as in note 9), especially chap. 6, "The Trinity in History." A recent survey of the role of the Trinity in Joachim is A. Mehlmann, "Confessio trinitatis: Zur trinitätstheologischen Hermeneutik Joachims von Fiore," in *Von der Suche nach Gott: Helmut Riedlinger zum 75. Geburtstag*, ed. M. Schmidt and F. D. Reboiras (Stuttgart-Bad Cannstatt, 1998), 83–108.

32. Joachim's major exegetical works are: (1) the *Liber de concordia*, laying out the premises of his hermeneutics and providing an interpretation of a number of the historical books of the Old Testament; (2) the unfinished *Tractatus super quatuor evangelia*; (3) the *Psalterium decem chordarum*, commenting on the Psalms; and (4) his longest work, the *Expositio in Apocalypsim*, showing how the final book of the Bible is the key to its meaning. For the last two works we still depend on a flawed sixteenth-century edition: *Ioachim Abbas. Expositio in Apocalypsim . . .* (Venice, 1527).

33. In *Psalterium decem chordarum*, f. 233ra, when commenting on the Psaltery *figura*, Joachim distinguishes between speaking (and presumably illustrating) *similitudinarie* and speaking *causative*: "quomodo autem dixi similitudinarie, quid non causative, quia aliud est dare imaginem, aliud est exprimere causam." For other passages that stress the unknowability of the Trinity, see, e.g., *Psalterium*, f. 233va; and also f. 232va, where he says: "quia nulla corporalis imago potest summam illam exprimere unitatem in qua non est minus aliquid in singulis quam in tribus."

34. The geometrical and arithmetical character of Joachim's *figurae* has been studied by B. Obrist, "Le Figure géométrique dans l'oeuvre de Joachim de Flore," CahCM 31 (1988), 297–321. On the usefulness of the application of the notion of mandala (Sanskrit: circle) to some medieval religious images, see G. Zinn, "Mandala Symbolism and Use in the Mysticism of Hugh of Saint Victor," *History of Religions* 12 (1972–73), 317–41; and J. Hamburger, *The Rothschild Canticles: Art and Mysticism in Flanders and the Rhineland circa 1300* (New Haven, 1990), 128–29.

35. The phrase *vivens ordo rationis* is found in Joachim's *Dialogi de praescientia Dei et praedestinatione electorum*, ed. G. L. Potestà (Rome, 1995), 129. On this aspect of the abbot's thought, see McGinn, "Ratio and Visio" (as in note 7), 32–39.

36. On the relation between geometrical (figural) and grammatical demonstration in Joachim's thought, see Obrist, "La Figure géométrique" (as in note 34), 310–21.

37. Joachim, *Psalterium decem chordarum*, f. 269rb: "Sed oportet nos secundum ea que dicta sunt . . . pro more nostro coaptare figuram, ut adducta imagine ipsa psalterii coram oculis carnis, spirituales mentis oculi (extra posito, ut ita dixerim) luto aperiantur ad intellectum." Joachim is appealing to Jesus' cure of the blind man by spreading clay on his eyes (John 9:6–15). For other texts on the necessary role of *imagines*, see, e.g., *Psalterium*, ff. 230vb, 234va, and 237rab. See also *Liber de Concordia* 2.1.35, and 2.2.5 (*Abbot Joachim of Fiore: Liber de Concordia Noui ac Veteris Testamenti*, ed. E. R. Daniel [Philadelphia, 1983], 145–46, and 160); and *Expositio in Apocalypsim*, f. 38rb: "quod potius figuris ostendi quam lingua exprimi potest."

38. Joachim, *Psalterium decem chordarum*, f. 256rb: "praemissis competentibus figuris ad intellectum trium personarum mentis oculum dirigamus."

39. On the synthesis of word and image in Joachim, see Patschovsky, "Die Trinitätsdiagramme Joachims von Fiore" (as in note 4), 90 and 94.

40. F. Troncarelli, "A Terrible Beauty: Nascità ed evoluzione del *Liber Figurarum*," *Florensia* 11 (1997), 7–40 (quotation at 9). The *Liber figurarum* was edited by L.

Tondelli, M. Reeves, and B. Hirsch-Reich, *Il Libro delle figure*, 2 vols. (Turin, 1953; reprint 1990). Unfortunately, the edition reproduces the inferior Reggio-Emilia manuscript of the *Liber figurarum* rather than the earlier and more authentic one in Oxford (Corpus Christi College, Ms. 255a). The fundamental study remains M. Reeves and B. Hirsch-Reich, *The Figurae of Joachim of Fiore* (Oxford, 1972); for more recent insights, see Patschovsky, "Die Trinitätsdiagramme Joachims von Fiore" (as in note 4).

41. See Troncarelli, "A Terrible Beauty" (as in note 40), as well as the same author's "Il Liber figurarum: Osservazioni ed ipotesi," in *Roma, Magistra Mundi: itineraria culturae medievalis. Mélanges offerts au Pere L. E. Boyle*, ed. J. Hamesse, 3 vols. (Louvain-la-Neuve, 1998), vol. 2, 927–49.

42. Reeves and Hirsch-Reich, *The Figurae* (as in note 40), pt. 3, chaps. 5–9.

43. F. Troncarelli, "Le due aquile: il riscatto della storia in una immagine del 'Liber figurarum'," *Florensia* 7 (1993), 59–75, as well as Reeves and Hirsch-Reich, *The Figurae* (as in note 40), pt. 3, chap. 6.

44. On this *figura*, see Reeves and Hirsch-Reich, *The Figurae* (as in note 40), pt. 3, chap. 4; R. E. Lerner, "Frederick II, Alive, Aloft, and Allayed in Franciscan-Joachite Eschatology," in *The Use and Abuse of Eschatology in the Middle Ages*, ed. W. Verbeke, D. Verhelst, and A. Welkenhuysen (Leuven, 1988), 359–84; and A. Patschovsky, "The Holy Emperor Henry 'the First' as One of the Dragon's Heads of the Apocalypse: On the Image of the Roman Empire under German Rule in the Tradition of Joachim of Fiore," *Viator* 29 (1998), 292–322.

45. Joachim, *Psalterium decem chordarum*, f. 227rv: "Quod cum accideret oravi valde, et conterritus vehementer compulsus sum invocare Spiritum Sanctum cuius sacra solemnitas praesens erat ut ipse mihi dignaretur ostendere sacrum mysterium Trinitatis, . . . Hec dicens cepi psallere ut ad propositum numerum pervenirem. . . . Nec mora occurrit animo modo forma Psalterii decachordi et in ipsa tam lucidum et apertum sacre mysterium Trinitatis ut protinus compellerer clamare: Quis Deus magnus sicut Deus noster?"

46. On the psalterium figure and its prehistory, see Reeves and Hirsch-Reich, *The Figurae* (as in note 40), 52–61, 199–211; Obrist, "La Figure géométrique" (as in note 34), 302–4, 317–21; and Patschovsky, "Die Trinitätsdiagramme Joachims von Fiore" (as in note 4), 94–100. Also important is B. M. Hirsch-Reich, "The Symbolism of Musical Instruments in the *Psalterium X Chordarum* of Joachim of Fiore and Its Patristic Sources," in *Papers Presented to the Fourth International Conference on Patristic Studies*, *Studia Patristica* 9, ed. F. L. Cross, Texte und Untersuchungen zur Geschichte der altchristlichen Literatur 94 (Berlin, 1966), vol. 3, 540–51.

47. *Psalterium, Liber primus . . . De contemplatione Trinitatis* (ff. 228r–243r; the first folios of the Venice edition are confusingly reversed). In one of the earliest manuscripts (Padua, Biblioteca Antoniana, Ms. 322), the psaltery figure appears five times in the margins of book 1 (ff. 1r–14r).

48. Joachim's understanding of the *psalterium* as imaging both the Trinity and the perfected soul may have been suggested by the *Expositio in septem psalmos poeniten-*

tiales ascribed to Gregory the Great, but actually written by Heribert, bishop of Reggio-Calabria (elected 1085), where we read: "Psalterium quoque eandem animam spiritualibus exercitiis assuetam non inconvenienter nominamus. Sicut enim musicum illud instrumentum triangulum decem chordarum inferius quidem percutitur, superius vero sonare videtur, ita anima sanctae Trinitatis fide formata, decem Legis praeceptis instructa, inferius percutitur et superius auditur" (PL 79:551). On Heribert's authorship of the treatise, see A. Mercati, "L'autore della 'Expositio in septem psalmos poenitentiales' fra le opere di S. Gregorio magno," *RBén* 31 (1914–19), 250–57.

49. This has been noted by Reeves and Hirsch-Reich, *The Figurae* (as in note 40), 207–8.

50. How far the color symbolism in the surviving manuscripts of the *Liber figurarum* may go back to Joachim is an open question. As Alexander Patschovsky has reminded me, the best manuscript of book 1 of the *Psalterium decem chordarum* (Padua, Biblioteca Antoniana, Ms. 322, ff. 1r–14r) uses a variety of colors for the psaltery figure.

51. As explained in Joachim, *Psalterium decem chordarum*, f. 237va.

52. On the interior circle (i.e., the sounding hole) of the psaltery as expressing the unity of the Trinity (which is also manifested in the entire *figura*), see Joachim, *Psalterium decem chordarum*, f. 232vb. For discussions, see Obrist, "La Figure géométrique" (as in note 34), 317–21; Patschovsky, "Die Trinitätsdiagramme Joachims von Fiore" (as in note 4), 98–99.

53. Reeves and Hirsch-Reich, *The Figurae* (as in note 40), 208.

54. On the Trinitarian circles, see Reeves and Hirsch-Reich, *The Figurae* (as in note 40), pt. 3, chap. 11; and Patschovsky, "Die Trinitätsdiagramme Joachims von Fiore" (as in note 4), 90–94.

55. On this *figura*, see Reeves and Hirsch-Reich, *The Figurae* (as in note 40), pt. 3, chap. 7.

56. On the influence of Joachim's *figurae* in general, see Reeves and Hirsch-Reich, *The Figurae* (as in note 40), pt. 4. On the windows of the abbey church at San Giovanni in Fiore, see A. Cadei, "La chiesa, figura del mondo," in *Storia e messaggio in Gioacchino da Fiore: Atti del I Congresso internazionale di Studi Gioachimiti* (San Giovanni in Fiore, 1980), 301–65.

57. Much has been written on late medieval apophatic mystical attempts to unsay God. See, e.g., S. Köbele, *Bilder der unbegriffenen Wahrheit: Zur Struktur mystischer Rede im Spannungsfeld von Latein und Volkssprache* (Tübingen and Basel, 1993); M. A. Sells, *Mystical Languages of Unsaying* (Chicago, 1994); and D. Turner, *The Darkness of God: Negativity in Christian Mysticism* (Cambridge, 1995), and "The Art of Unknowing: Negative Theology in Late Medieval Mysticism," *Modern Theology* 14 (1998), 473–88.

58. For an introduction to Eckhart's views on *imago/bild*, see A. M. Haas, "Meister Eckhart: Mystische Bildlehre," in *Sermo Mysticus: Studien zu Theologie und Sprache der deutschen Mystik* (Fribourg, 1979), 209–37. A more detailed treatment can be found in M. Wilde, *Das neue Bild vom Gottesbild: Bild und Theologie bei Meister Eckhart* (Fribourg, 2000).

59. See B. McGinn, *Meister Eckhart's Mystical Thought:*

The Man from Whom God Hid Nothing (New York, 2001), 72–90, for a sketch of Eckhart's doctrine of the Trinity.

60. All citations from Eckhart are from *Meister Eckhart: Die deutschen und lateinischen Werke* (Stuttgart and Berlin, 1936–). The abbreviation *DW* will be used for the German works, and *LW* for the Latin writings, and the citations will be by volume, page, and line. The term *gruntlos grunt* can be found in a number of texts, e.g., *Predigt* (hereafter *Pr.*) 42 (*DW* vol. 2, 309 lines 3–7). The passage quoted is from *Pr.* 48 (*DW* vol. 2, 420 lines 9–421 line 2): "die stillen wüeste, dâ nie underscheit îngeluogete weder vater noch sun noch heiliger geist; . . . wan dirre grunt ist ein einvaltic stille, diu in ir selben unbewegelich ist, und von dirre unbewegelicheit werdent beweget alliu dinc." For Eckhart's teaching on the *grunt*, see McGinn, *Meister Eckhart's Mystical Thought* (as in note 59), chap. 3.

61. Eckhart's uses the desert metaphor more than a dozen times; see B. McGinn, "Ocean and Desert as Symbols of Mystical Absorption in the Christian Tradition," *Journal of Religion* 74 (1994), 167–72. "Abyss" (*abgrunt*) appears only four times in his writings.

62. The importance of this term for understanding Eckhart has been emphasized by W. Wackernagel, *Ymagine denudari: Éthique de l'image et métaphysique de l'abstraction chez Maître Eckhart* (Paris, 1991). Important passages on *entbilden* can be found in the *Liber Benedictus: Daz buoch der goetlîchen troestunge* 1 (*DW* vol. 5, 11 lines 12–14, 12 line 22, 21 line 8, 27 line 6, 112 line 19, and 116 line 16).

63. On the relation of these terms to the radical annihilation of the created self, see McGinn, *Meister Eckhart's Mystical Thought* (as in note 59), 131–47. See also Wackernagel, *Ymagine denudari* (as in note 62).

64. *Pr.* 70 (*DW* vol. 3, 195 lines 11–12): "Sol ich ouch got bekennen, daz muoz geschehen âne bilde und âne allez mittel." In an "Anhang" to this sermon, accepted as authentic by Josef Quint (*DW* vol. 3, 200 line 26–201 line 7), Eckhart specifically uses the example of an artistic image to illustrate the process of *entbilden*, saying that we must begin by removing an image painted on a wall, then remove the image of the painting in the imagination, in order finally to reach the unmediated direct seeing in the intellect.

65. *Pr.* 51 (*DW* vol. 2, 473 lines 6–9): "Wann, wiltu den kernen haben, so muostu die schalen brechen. Vnd also: wiltu die natur bloss finden, so muessent die gleychnuss alle zerbrechenn, vnnd ye das es me darin trittet, ye es dem wesen naeher ist." On this sermon, see S. Köbele, " 'Primo aspectu monstruosa': Schriftauslegung bei Meister Eckhart," *Zeitschrift für deutsches Altertum und deutsche Literatur* 122 (1993), 64–67.

66. *Pr.* 70 (*DW* vol. 3, 197 line 5–198 line 2): "in dem widerbilde, daz aleine bilde gotes ist und der gotheit, niht der gotheit dan als vil, als si der vater ist. Rehte als vil wir bilde glîch sîn, in dem bilde alliu bilde ûzgevlozzen und gelâzen sint, und in dem bilde widerbildet sîn und glîche îngetragen sîn in daz bilde des vaters, als verre als er daz in uns bekennet, als verre bekennen wir in, als er sich selben bekennet."

67. This sermon, Jostes no. 82, has not yet appeared in the critical edition but is accepted as authentic by many Eckhart scholars. It was edited by F. Jostes, *Meister Eckhart und seiner Jünger: Ungedruckte Texte zur Geschichte der deutschen Mystik* (Fribourg, 1895), 94 lines 13–14: "so durchbricht di sele ir ewigen bild, uf daz si kum, da got ist reich in einikeit."

68. On the importance of images for Suso, see E. Colledge and J. C. Marler, " 'Mystical' Pictures in Suso's 'Exemplar': Ms. Strasbourg 2929," *Archivum Fratrum Praedicatorum* 54 (1984), 293–354; J. Hamburger, "The Use of Images in the Pastoral Care of Nuns: The Case of Heinrich Suso and the Dominicans," *ArtB* 71 (1989), 19–45; and Hamburger, "Medieval Self-Fashioning: Authorship, Authority, and Autobiography in Seuse's Exemplar," in *Christ among the Medieval Dominicans*, ed. K. Emery Jr. and J. P. Wawrykow (Notre Dame, Ind., 1998), 430–61; N. Largier, "Der Körper der Schrift: Bild und Text am Beispiel einer Seuse-Handschrift des 15. Jahrhunderts," in *Mittelalter: Neue Wege durch einen alten Kontinent*, ed. J.-D. Müller and H. Wenzel (Stuttgart, 1999), 241–71; and S. Altrock and H.-J. Ziegeler, "Vom *diener der ewigen wisheit* zum Autor Heinrich Seuse: Autorschaft und Medienwandel in den illustrierten Handschriften und Drucken von Heinrich Seuses 'Exemplar'," in *Text und Kultur: Mittelalterliche Literatur 1150–1450*, ed. U. Peters (Stuttgart, 2001), 150–81.

69. For summaries of Suso's mysticism, see K. Ruh, *Geschichte der abendländische Mystik*, vol. 3, *Die Mystik des deutschen Predigerordens und ihre Grundlegung durch die Hochscholastik* (Munich, 1996), 417–75; and A. M. Haas, *Kunst rechter Gelassenheit* (Bern, 1995).

70. The standard edition of Suso's vernacular writings is Heinrich Seuse, *Deutsche Schriften*, ed. K. Bihlmeyer (Stuttgart, 1907; reprint 1961). This passage is from the *Leben Seuses*, chap. 53 (191 line 9).

71. For Suso's doctrine of visions, see Haas, "Seuses Visionen: Begriff der Vision," in *Kunst rechter Gelassenheit* (as in note 69), 179–220.

72. Hamburger, "Medieval Self-Fashioning" (as in note 68), 441.

73. *Heinrich Seuses Horologium Sapientiae*, ed. P. Künzle (Fribourg,, 1977), 366 line 20–367 line 14. The passage quoted (367 lines 12–14): "Porro huius figuratae locutionis occulta mysteria diligens lector faciliter poterit advertere, si tamen sollertem curam studuerit adhibere." On Suso's teaching on *figurata locutio*, see N. Largier, "Figurata locutio: Philosophie und Hermeneutik bei Meister Eckhart von Hochheim und Heinrich Seuse," in *Meister Eckhart: Lebensstationen—Redesituationen*, ed. K. Jacobi (Berlin, 1998), 303–32.

74. *Horologium Sapientiae* II.7 (597 lines 25–26): "ut per exteriora signa interior fragilis humana iuvaretur memoria."

75. For some remarks on the relation between Eckhart and Suso in this connection, see H. Stirnimann, "Mystik und Metaphorik," in *Das "einig Ein": Studien zu Theorie und Sprache der deutschen Mystik*, ed. A. M. Haas and H. Stirnimann (Fribourg, 1980), 245–49. Suso often speaks of the need to go beyond images; e.g., "Leben," chap. 49 (*Deutsche Schriften* [as in note 70], 164 lines 8–16): "Ein mensch sol in siner unbiltlicheit und in siner unenthaltlicheit stan, dar inne lit der maist lust. . . . Es ist neiswas von innen einvaltigs, und da minnet der mensch nút gegenwúrtikeit dez bildes, mer, da mensch und er

selbs und ellú ding eins sind, und daz ist got." For an English translation of Suso's writings, see *Henry Suso: The Exemplar, with Two German Sermons*, trans. and introduced by F. Tobin (New York, 1989).

76. *Deutsche Schriften* (as in note 70), prologus 2–3.

77. *Leben*, chap. 53 (*Deutsche Schriften* [as in note 70], 191 lines 6–12): "Er sprach: wie kan man bildlos gebilden unde wiselos bewisen, daz úber alle sine und úber menschlich vernunft ist? . . . Aber doch, daz man bild mit bilden us tribe, so wil ich dir hie biltlich zoegen mit glichnusgebender rede, als verr es denn múglich ist, von den selben bildlosen sinnen."

78. Modern scholars have agreed that Suso was the source, if not the actual artist, of the pictures found in the surviving manuscripts of *The Exemplar*; see Colledge and Marler, " 'Mystical' Pictures," 300; Hamburger, "The Use of Images," 25, and "Medieval Self-Fashioning," 432 (all in note 68).

79. *Leben*, chaps. 46–53 (*Deutsche Schriften* [as in note 70], 155–95). This final section of the work begins with a discussion of the difference between true and false reasoning regarding mysticism (chaps. 46–48, basically an attack on the "Free Spirit"), follows this with a chapter of mystical axioms (chap. 49), and concludes with a speculative treatment of the doctrine of God (chaps. 50–53) arranged under three headings: (1) *waz got ist*, the divine nature in itself (chap. 50); (2) *wa got ist*, divine omnipresence (the first part of chap. 51); and (3) *wie got ist*, how God can be both utterly simple and also three (the second part of chap. 51 through chap. 53). Chapter 53, the summation of this difficult teaching, is where Suso turns to illustration. For Suso's earlier Trinitarian teaching in the *Büchlein der Wahrheit* (Little Book of Truth), originally written ca. 1329, see chaps. 2 and 6 (*Deutsche Schriften*, 329–31, 352–57).

80. As Hamburger puts it: "In addition to authorizing images as vehicles of mystical ascent no less legitimate than the texts with which they are associated, the drawings identify the viewing and the reproduction of images as a model for the process of imitation central to the spiritual life itself" ("Medieval Self-Fashioning" [as in note 68], 432).

81. The full implications of the role of images in Suso's thought cannot be discussed here. Largier, for example, posits three functions for images in Suso: "Damit ist das Bild für Seuse gleichzeitig mnemotechnisches Konstrukt (*figura* als Hilfsmittel der Erinnerung), Grenze repräsentativer Positivität (*figura* als Allegorie) und erfahrungshaftes Stimulans im Sinne der Ekphrasis, die plötzlich eine neue Wahrnehmungstotalität eröffnet (*figura* als intensives Moment der Erfahrung)"; see "Der Körper der Schrift" (as in note 68), 268.

82. Suso uses the term "eye of the mind" and its equivalents several times in these last chapters of the *Life*. See, e.g., *daz vernunftig oge* (chap. 47, 158 lines 28–29); *oge unsers gemuetes* (chap. 51, 177 line 11); and *oge unser bekentnus* (chap. 51, 177 line 15).

83. *Leben*, chap. 53, fig. 11 (195; text 52*): "Disú nagendú bild bezeichnent der blossen gotheit iewesentheit in persönliche driheit vnd aller creaturen us vnd widerflossenheit vnd zögent denersten begin eins anuahenden

menschen vnd sinen ordenlichen durpruch dez zuonemens vnd den aller höhsten úberswank úberweselicher volkmomenheit" (using the translation of Tobin, *Henry Suso* [as in note 75], xv, with some modifications).

84. A more detailed account can be found in Colledge and Marler, " 'Mystical' Pictures" (as in note 68), 338–49, but their presentation is marred by some errors and a confusing arrangement of the captions.

85. *Leben*, chap. 53 (195; text 52*): "Diz ist der ewigen gotheit wisloses abgrunde daz weder annuang hat noch kein ende."

86. Colledge and Marler (" 'Mystical' Pictures" [as in note 68], 344) refer to the tabernacle of the Holy of Holies from Exodus 23 as a possible source. For a comparison of the abyss and tabernacle images with some of the miniatures in the Rothschild Canticles, see Hamburger, *The Rothschild Canticles* (as in note 34), 142.

87. *Leben*, chap. 53 (195; text 52*): "Diz ist der personen driheit in wesenlicher einicheit von dem cristianer gelob seit."

88. The final three captions (*Leben*, 53*–54*) of the process read: (1) "Hie ist der geist ingeswungen vnd wirt in der driheit der personen funden" [clearly Trinitarian]; (2) "Ich bin in got vergangen; nieman kan mich hie erlangen" [objective apophaticism?]; and (3) "In dem inschlag han ich aller ding vergessen wan es ist grundlos vnd vngemessen" [subjective apophaticism in the *grunt*].

89. The treatise, known as La Sainte Abbaye, is found in London, B.L., Ms. Add. 39843, with the illustration on f. 29r. For discussions, see J. Hamburger, "The Visual and the Visionary: The Image in Late Medieval Monastic Devotion," *Viator* 20 (1989), 174–75; and M. Camille, *Gothic Art: Glorious Visions* (New York, 1996), 120–23.

90. On the Trinitarian miniatures of the Rothschild Canticles, see Hamburger, *The Rothschild Canticles* (as in note 34), chap. 8. These miniatures originally consisted of twenty pictures, one of which is now missing but whose caption survives. Three are found on ff. 40r–44r of the manuscript, and the remaining seventeen on ff. 75r–106r.

91. If Eckhart's language of the *grunt* can be characterized as an "explosive metaphor" (*Sprengmetapher*) that uses language to subvert and destroy it (see McGinn, *Meister Eckhart's Mystical Thought* [as in note 59], chap. 3), then the striking images of the Rothschild Canticle are no less effective examples of a similar strategy in the pictorial realm.

92. Hamburger, *The Rothschild Canticles* (as in note 34), 141.

93. A. Grabar, *Christian Iconography: A Study of Its Origins* (Princeton, 1968), 112.

94. Augustine, *De doctrina christiana* 1.6.13–14 (CSEL 80:11, ed. G. M. Green): "Ac per hoc ne ineffabilis quidem dicendus est deus, quia et hoc cum dicitur, aliquid dicitur. Et fit nescio qua pugna verborum, quoniam si illud est ineffabile quod dici non potest, non est ineffabile quod vel ineffabile dici potest. . . . Et tamen deus, cum de illo nihil digne dici possit, admisit humanae vocis obsequium et verbis nostris in laude sua gaudere nos voluit."

95. Dionysius, *Ep.* 3, in *Corpus Dionysiacum* (as in note 1), 2:159: "alla kai legomenon arrêton menei kai nooumenon agnôston."

Seeing and Seeing Beyond: The Mass of St. Gregory in the Fifteenth Century

Caroline Walker Bynum

Is the Gregorymass a Depiction of Transubstantiation?

In the past two decades, historians of theology and art have stressed the importance of visuality, ocularity, "Schaufrömmigkeit," "Schaulust," "Schaubedürfnis" in the later Middle Ages.[1] Central to this enthusiasm for encounter through sight was the rising popularity of the feast of Corpus Christi, accompanied by frenzy to view the eucharistic host at the moment of elevation or in procession, although many scholars stress as well a new sense of spiritual communion—of encounter with Christ's sacrifice outside sacramental reception—that spilled far beyond the event of the Mass or the host as object.[2] Some have gone so far as to find in late medieval religion a piety of becoming by seeing, based in classical assumptions that "like" is known by "like" and an optical theory according to which the eye literally became the object viewed.[3] Others stress a disjunction between inner and outer, which freed response to image from simple mimesis but left encounter with the visual more central and complex than ever.[4]

In generalizations about "Augenkommunion" and the piety of seeing, no iconographical motif is more frequently invoked than the so-called Mass of St. Gregory, which enjoyed great popularity especially in Germany and the Low Countries but also in England and France (less so in Italy) between 1400 and 1550. Although scholars who treat it acknowledge that the image is one of great complexity and variety,[5] the short description given in much recent scholarship sees it as proof of the doctrine of transubstantiation, deployed by the church in eucharistic controversy in the century and a half between Wycliffe and the Reformers.[6] The image depicts, we are told, the Man of Sorrows appearing to Pope Gregory the Great at the moment of consecration or elevation, thus demonstrating the presence of Christ in the species on the altar as established at the Fourth Lateran Council of 1215. The Mass of St. Gregory seems then to be an ideal case for exploring the theme of this volume. Traditionally interpreted as illustration—even argument—for eucharistic theology, it also raises questions about the role and significance of visuality itself in fifteenth-century religious thought and practice.

The conventional description of the Gregorymass as a depiction of transubstantiation cannot be right, however, for several reasons. First, thanks to general theoretical arguments such as those

of David Freedberg and Hans Belting and detailed analysis of devotional objects by scholars such as Robert Suckale and Jeffrey Hamburger, our understanding of the function of images in the fifteenth century is now vastly more sophisticated than any notion that art illustrates doctrine.[7] As Paul Binski has reminded us, images not merely reflect but also constitute religious experience.[8] Moreover, there is no single religious experience they reflect and constitute, frame and are framed by. Appearing in many genres and contexts, the Gregorymass was commissioned by lay and clerical elites for use in private devotional as well as public liturgical settings. As indulgence tablet or epitaph, as prayer card or illuminated initial in a Book of Hours, it elicited and was intended to elicit a very different response from that signaled when it served as altar wing or central shrine.

Second, owing to the work of historians such as Hans Jorissen, James F. McCue, David Burr, and Gary Macy, we must now reject entirely the notion that the Fourth Lateran Council of 1215 defined transubstantiation or established it as dogma.[9] The real presence of Christ in the Eucharist had been required for orthodoxy since the eleventh century, but full understanding of "transubstantiation" as the going over of the substance of bread and wine into the substance of Christ's body and blood was defined only at the Council of Trent (if then), and much of what fourteenth- and fifteenth-century theologians meant when they employed the words "substance" and "accidents" was quite different from what was adopted by Trent. Insofar as the image relates—as it surely does—to real presence at Mass or in private quasi-eucharistic devotion, the exact nature of that presence was less an established formula than a living and demanding problem to Christians, ranging from ordinary layfolk, penitents, and pilgrims to ecclesiastical authorities and university theologians.

Third, close examination of the image itself suggests that it does not have anything to do with explicating doctrine or dispelling doubt.[10] There are many miracles and visions known from the Middle Ages in which the consecrated host turns into Christ or, in a far smaller number of cases, the eucharistic wine into blood. Such miracles fit into a number of different story lines; the appearance of a beautiful Christ or of bleeding flesh is reward for faith, proof to doubters, or accusation against those such as Jews, criminals, or low-status women whose disbelief or antagonism led them to supposed acts of host desecration.[11] These tales were often used by preachers and university theologians to demonstrate eucharistic doctrine.[12] There is indeed a story, which apparently originated in the Carolingian period, of a vision in which consecrated bread supposedly turned into a bloody finger, at Gregory's request, to dispel the doubt of a female communicant.[13] The story became quite popular in the later Middle Ages in *exempla* collections, most of which retain the specific characteristics of the original tale.[14] It had an iconographic tradition as well. Both a twelfth-century miniature and an early-sixteenth-century tapestry survive that depict it in clear detail.[15] There may even be a reference to a supposed relic of the finger in a fifteenth-century pilgrim account from Rome.[16]

The popular Gregorymass of the fifteenth century has, however, nothing to do with this story. No woman is shown, except an occasional female saint. Indeed, the Mass of St. Gregory does not depict the congregation at all; lay persons are rarely present, even as donors.[17] And nothing in the image suggests the presence of a doubter. In many versions, it is not clear that anyone *inside* the composition sees the figure on the altar. Moreover, in only a subset of these images is there any suggestion that the moment is that of consecration or elevation.[18] In a number of so-called Gregorymasses, Mass is apparently not being said. In some cases, the pope is wearing his tiara; in other cases, candles are not lit and the chalice lies on its side.[19] The earliest texts that

accompany the Gregorymass refer not to proof or doubt but to remission of time in purgatory and read: "This is the vision of Our Lord Jesus Christ which appeared to Gregory, and Gregory gave to all who kneel before this figure and pray . . . so many years of indulgence."[20] Traditions surrounding Gregory, and indeed his own writings, connected him with eucharistic devotion and eucharistic visions, to be sure; hence, some late medieval stories of wonderhosts are attached either to his name (as at Andechs) or to his feast day (as at Benningen).[21] But the theme of such stories is the proper revering of Christ's presence, not theological demonstration. Unless one conflates Gregory's vision with the story of the woman and the finger (for which conflation there is little specific literary or iconographic support), there is no reason to interpret the Gregorymass as having to do with doubt or proof.

Fourth, it is worth noting that there are few, if any, Gregorymasses that can be understood as, in a technical sense, transubstantiation—the replacement of bread and wine by Christ. In many of the varied iconographical combinations, there are *several* bodies of Christ, as, for example, in the well-known image from Nuremberg (1490) (Fig. 1), where we see Christ himself, the Veronica (often used as an emblem for the eucharistic host), and a host partly obscured by the pope's nimbus. To be sure, there are images from the second half of the fifteenth century in which the host bleeds (the Mass of Bolsena is one) or in which Christ's body is represented in place of the host as if in full "depiction" of transubstantiation (Fig. 2).[22] But these are usually not Gregorymasses. Moreover, some of the Gregory images in which Christ bleeds directly into the chalice—images often interpreted as stating that the wine is the blood of Christ—in fact evince a more general blood mysticism, which stresses the salvation of souls effected by Christ's sacrifice.[23] If we consider, for example, the so-called Gregorymass on the outer right wing of a St. Anne altar in the Wiesenkirche in Soest (Fig. 3), we note that it may not be a depiction of the moment of consecration.[24] Moreover, the entire energy of the picture is drawn away from the chalice toward the "poor souls" rising from the dead. Thus, this image is "about" the Eucharist only if we take Eucharist in an expanded sense as encounter with the eternally present sacrifice of Christ.[25]

A fifth argument against reading the Gregorymass as proof of transubstantiation lies in the theology. Because eucharistic presence was understood as involving substance, not accidents (regardless of how exactly the term "substance" was understood), transubstantiation as a technical notion was not depictable; however change was understood, what changed was what was *not* seen. Hence, if the presence evoked by the Gregorymass is theologically or devotionally correct, it must be a presence beyond; Gregory's vision, which the viewer sees, must itself be only a visual prod to encounter with an unseen.

For all the popularity of visions and the visual, theologians in the later Middle Ages expressed doubts about seeing. According to accepted theory, which went back to Augustine, there were three sorts of vision: corporeal (by which one saw the things of the exterior world), spiritual (which saw inwardly but used mental images that were like bodily ones), and intellectual (by which one saw the highest, imageless truth).[26] Hence, there was suspicion of both devotional images and visions among spiritual directors; theologians stressed that the highest form of encounter was without images, that devotional objects and church furnishings were *simulacra* that pointed beyond, that even relics were to be revered because of the saint whose worship they inspired (however much the pious simply conflated relic and saint).[27] We find indeed some hesitation before images and visions even among those visionaries, especially but not exclusively women, whose understanding of their own union with Christ was not only expressed in increas-

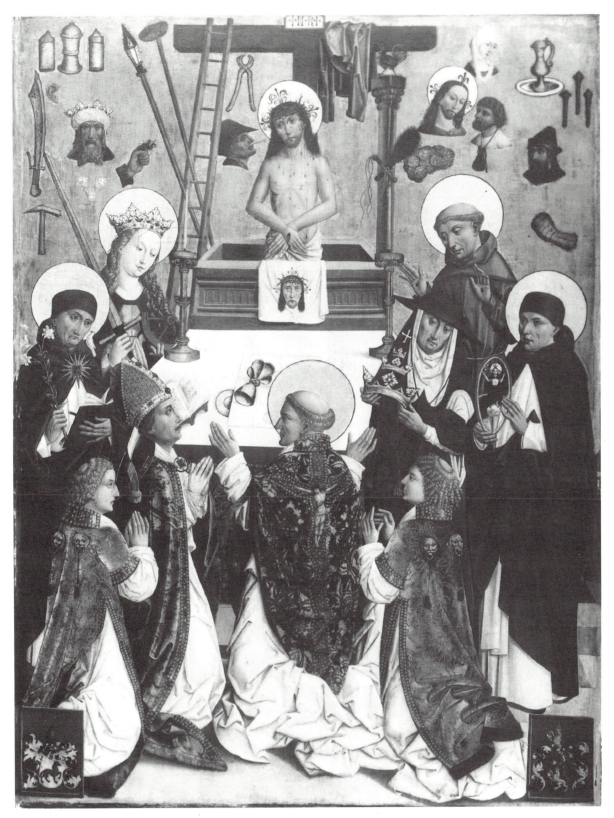

1. Workshop of the Master of the Augustine Altar, *Mass of St. Gregory with Saints Catherine, Thomas Aquinas, Francis, and Vincent Ferrer*, panel, ca. 1490. Nuremberg, Germanisches Nationalmuseum

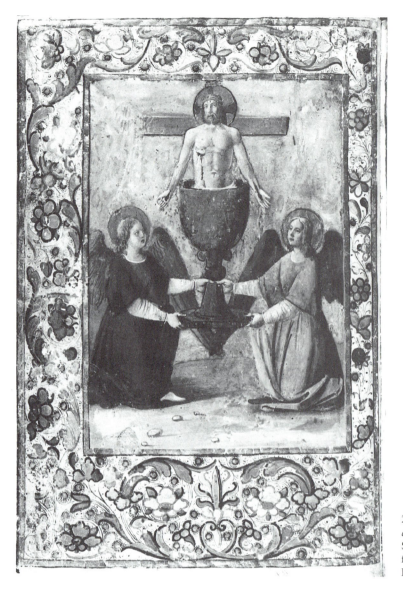

2. *Angels Present the Man of Sorrows in a Chalice*, manuscript, Register of the Scuola del Corpo di Cristo, Venice, fifteenth century. London, British Library, Add. Ms. 17047, f. 1v

ingly graphic and somatic language but also manifested in bodily phenomena such as levitation, stigmata, and mystical pregnancy.[28]

Moreover, there was a long theological tradition that treated the Eucharist explicitly as unseen. As far back as the controversies of the eleventh century, major figures such as Alger of Liège, Lanfranc, and Guitmond of Aversa argued that veiling of presence was necessary in order to support faith.[29] If one simply saw, belief would not be necessary; the New Testament sacrifice would then be in no way superior to the Old.[30] Veiling was also necessary in order to discourage obscure heresies such as stercoranism (which supposedly saw Christ as polluted by digestion and excretion) and to protect against *horror cruoris*. As Roger Bacon wrote, the sacrament "is veiled . . . [because] the human heart could not endure to masticate and devour raw and living flesh and to drink fresh blood."[31]

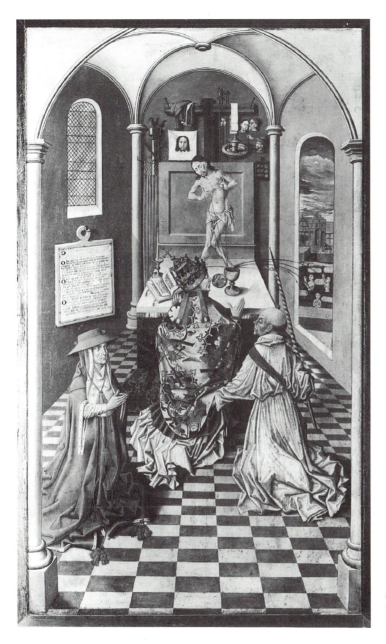

3. *Mass of St. Gregory*, Altar of St. Anne and the Holy Kinship, panel, 1473. Soest, St. Maria zur Wiese

According to a number of theorists, even a vision of Christ's body on the altar was not a seeing of Christ. Theologians from Thomas Aquinas to Nicolas of Cusa explained that when a pious individual saw the sacrament as "a small particle of flesh or at times . . . a small child," no change took place in the accidents of the sacrament. Rather, as Thomas put it, the change was in the beholder "whose eyes [were] . . . affected as if they outwardly saw flesh, or blood, or a child." The substance was Christ; the accidents were those of bread and wine, given the appearance of Christ by God in a special miracle. In other words, the viewer does not, in a eucharistic vision, see "what is really there" but sees something at two removes, so to speak, rather than one, because he sees

neither the unseeable substance nor the seeable accidents but an appearance substituted by God for the accidents in order to indicate the unseeable substance beneath. The same is true even when a number of the faithful claim to see such things simultaneously, and the flesh or blood or child appears to perdure. Because "done to represent the truth," such moments are not deceptions, but if preserved in pyxides or monstrances, such objects cannot be Christ; for it would be "wicked," says Aquinas, to think Christ's freedom could be abrogated by incarceration. The minority of theologians who, following Duns Scotus, thought that Christ's blood was really present, held this to be so only in cases of collective seeing and affirmed the truth of such presence more for devotional reasons ("lest faith be confirmed by phantasms or the community commit idolatry") than theological. Moreover, the majority even of later Franciscans agreed with Thomas.[32]

In general, theologians stressed presence as unseen. Jean Gerson (d. 1429) wrote: "It is not what our bodily eyes see but what the eyes of our heart see that is our God." Gabriel Biel (d. 1495), who refused to decide on the reality of miracle-hosts, used the distinction between substance and accidents to argue that communion with the eyes reached only the accidents of bread, whereas those who eat consume species and the *vere contentum* as well.[33]

Such arguments were drawn upon in the fifteenth century in numerous lengthy disputes over the host- and blood-miracles characteristic of the period. For example, when Heinrich Tocke, a university-trained theologian and member of the Council of Basel, attacked the bleeding hosts of Wilsnack in the 1440s, he first raised questions about the visual evidence in the monstrance but moved quickly to the deeper theological issues. Querying whether the surviving fragments showed any evidence of blood stain, Tocke then commented that even if blood had appeared, there was no reason to conclude that it was the blood of Christ.[34] In 1451, the papal legate Nicholas of Cusa went further:

> We have heard from many reliable men and also have ourselves seen how the faithful stream to many places in the area of our legation to worship the precious blood of the Lord that they believe is present in a transformed red host. . . . The clergy . . . permit this worship out of greed for revenue. . . . [But] it is pernicious . . . and we cannot permit it without damage to God. *For our catholic faith teaches us that the glorified body of Christ has glorified blood completely un-seeable in glorified veins [sanguinem glorificatum in venis glorificatis penitus invisibilem].* In order to remove every opportunity for the deception of simple folk, we therefore order that . . . the clergy . . . should no longer promulgate such miracles. . . . [emphasis added][35]

A year after Nicholas wrote, a provincial council in Cologne decreed that such relics should not be publicly venerated, a prohibition echoed at Magdeburg and elsewhere. In late-fifteenth-century Würzburg, a tractate on "the perils of the Eucharist" maintained: "It is a *periculum* to the host if the figure of flesh or a child or any other thing appears in it." Such an appearance is a miracle for the viewer, but for the sacrament, there is "no change." The priest should therefore consume such a host immediately if an individual claim is made; if, however, many people profess to see it, the priest should repeat the consecration with new hosts, and the miraculous one should be hidden from view so that every opportunity for a crowd to gather is avoided.[36]

Some theologians even argued that the *continuation* of the accidents of bread and wine was what signaled sacramental presence after consecration; hence, Christ was present only in the whole and undecayed accidents; he disappeared when they were altered. A stark repudiation of

the assumptions of popular practice, such argument made it logically impossible for Christ to be present in any completely altered host, any chalice filled entirely with blood. Ironically, in such formulation, unseeability guaranteed presence![37]

Although local churches orchestrated blood cult and pilgrimage—to the point that some were clearly frauds and were uncovered as such—historians have sometimes underestimated the ecclesiastical opposition to them.[38] Resistance was regularly voiced, especially by Dominicans.[39] Even when popes permitted blood devotion or specific instances of wonderhosts, the phenomena were hedged about: first, by a refusal to pronounce on their ontological status; second, by the requirement that freshly consecrated hosts be displayed alongside all wonderhosts to obviate any danger of idolatry; and third, by a tendency to keep the physical objects hidden, even their containers being only rarely available to the laity.[40] Those controversialists, usually Franciscans or Benedictines, who supported blood cult did so more because it stimulated popular devotion centered on appropriate sites than because they fully trusted the more extravagant claims of local propagandists. For example, Werner Rolevink, who supported the cult, wrote that errors in such things do not matter, since they are "not really articles of belief," as long as the people "come with pious intent." But it was exactly such pious intent that many Church leaders questioned. John of Dorsten, for example, on the occasion of the pilgrim enthusiasm of 1475, urged authorities to instruct the people with gentleness that grace and miraculous power do not lie "in images or in bleeding objects [cruoribus] or in any inanimate created thing"; God alone should be adored.[41] Hence, even in the exuberant pilgrim culture of the fifteenth century, we find a complex dynamic of promotion and containment of holy objects, of permitting and denying—both in theory and in fact—the seeing of Christ.

The Image

It thus seems wrong for many reasons to take the Gregorymass as illustration of, or propaganda for, the doctrine of transubstantiation. Nor, if the mode of presence of the "Schmerzensmann" is so problematic, can it be interpreted as, in any simple sense, an example of the "Schaulust" or ocularity of the later Middle Ages. Yet the Gregorymass is clearly in some sense about seeing and about the Eucharist.[42] For all the variety of the genres in which the image occurs (epitaphs, indulgence tablets, miniatures, altar wings, etc.), for all the variety of motifs, there appear to be three constant elements in the iconography. First, the figure that appears is the suffering Savior, the so-called Man of Sorrows (frequently but not always bleeding, frequently but not always accompanied by the arma Christi, the instruments of his torture). Second, the event is ritually located. The Christ figure is always on an altar, and there is always an ecclesiastic, a celebrant, although not always of Mass. Third, the image concerns itself with the framing of the located Christ figure. Whether or not the figure is "seen" by any viewer within the composition, however it is depicted in its setting (and the depictions range from extremely realistic to extremely illusionist), whatever exactly the combination in the image of what are sometimes called narrative and devotional elements, the Gregorymass deals with the question of the figure's presence—that is, with its presence and absence.

If we turn then to the image, stripping from our response any assumption that it should "demonstrate" or "illustrate," we find that the religious experience it "constitutes" is one in

which "seeing" is "seeing through." In order to understand this, we need to note two points about the image itself. First, its setting. Paul Binski, Eamon Duffy, Bruno Reudenbach, Flora Lewis, and others have recently pointed out in general terms that medieval iconography does not float free from the objects on which it is found; moreover, those objects must be understood in their ecclesiastical setting and liturgical function.[43] This point has, however, been neglected in the specific case of the Gregorymass. Too often, study has focused on the small number of examples (such as the now-destroyed Bernt Notke altarpiece) in which the image occupies a retable or forms the central shrine of a winged altar. Its status as proof or recapitulation of real presence has been extrapolated from the assumption that it itself formed the background against which a celebrant performed Mass, thus depicting behind the elevated host the presence of the suffering body of Christ.

Very few Gregorymasses, however, are central retables or shrines[44] (and the relatively few that are in central positions often occur on side altars, such as the altar of the Corpus Christi Brotherhood in Lübeck).[45] Indeed, the earliest version of the Gregorymass motif is probably penitential and soteriological rather than eucharistic in focus and found typically in engravings or small reliefs.[46] This group of Gregorymasses has to do with purgatory, either because the image itself accompanies or includes an indulgence (see, for example, Fig. 4), or because it depicts the salvation of poor souls in purgatory through Christ's sacrifice, whether or not Mass is being said.[47] In some cases, as in the Gregorymass from Soest (Fig. 3), we find both an indulgence plaque and the release from purgatory (souls are represented here as bodies rising from the dead).[48]

The indulgenced version of the Gregorymass is found in a variety of genres (reliefs and frescoes, engravings, manuscript illuminations for Books of Hours, altar wings), and the minimal form of the accompanying text reads: "Our Lord Jesus Christ appeared to Gregory, and Gregory gave to all who kneel before this figure and pray *Pater Nosters* and *Ave Marias* so many years of indulgence."[49] As both Carlo Bertelli and Flora Lewis have explained, the indulgence in these Gregorymasses attaches not to the Man of Sorrows but to the Man of Sorrows as an image of a vision seen by Gregory. Thus, the indulgenced object is an image in which Gregory frames the devotional center and mediates its power to us.[50] The image is neither a relic nor an *archeiropoieta* (although it has affinities to both); what is indulgenced is not an object but an image of an image of a vision.[51] There is something objective about the image, it is true; and from it, an objective indulgence is gained. Behind it, however, lies not an object but an epiphany, and that epiphany is of the sacrifice that undergirds the whole economy of salvation within which any indulgence is possible. Moreover, when the iconography combines depictions of poor souls with the plaque of an indulgence text (as at Soest), the Gregorymass itself is both an object that effects remission of purgatory and a depiction of that process of remission and of the sacrifice of Christ that is its basis. The viewer prays before the image, seeing what Gregory (perhaps) sees, and by thus receiving the indulgence becomes one of the poor souls toward which fall the arcs of bright red blood. The altar wing is both indulgenced object and image of the effect of indulgenced object; the viewer is both before and within the image.

Hence the status of the vision in early indulgenced versions of the Gregorymass is complicated. Nor is it less so in non-indulgenced versions, which are also found in a wide range of settings and genres: as engravings, as manuscript illuminations (both in Mass books in a clearly eucharistic context, and in Books of Hours), and as epitaphs, where the import is clearly more soteriological than eucharistic.[52] Even when it is found in altar painting, the Gregorymass seems to serve a wider range of liturgical and iconographical functions than is sometimes recognized. Typically it occurs on a side wing, usually an outer wing;[53] on feast days, when the inner altar was

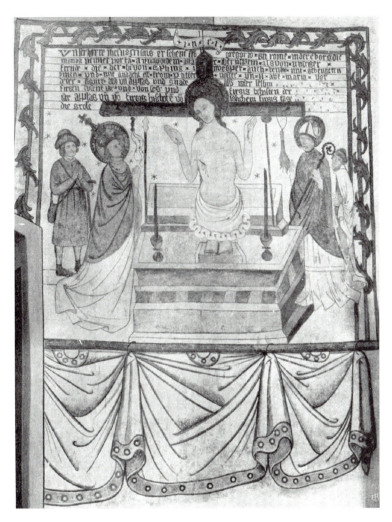

4. *Mass of St. Gregory*, wall painting, 1448. Karlstadt, parish church (after J. A. Endres, *Zeitschrift für christliche Kunst* 30 [1917], fig. 1)

displayed, it would have been folded away, so that the eucharistic sacrifice was performed not in front of the Gregorymass but in front of the Madonna and Child or the Crucifixion, which were far more frequently central. Often it is paired with and complementary to other images of revelation or ostentation, such as the manifestation to the Three Kings, Moses and the burning bush, Mary and Joseph adoring the infant Christ, the *Ecce homo*, or the *Noli me tangere*.[54] Sometimes the Gregorymass serves as a kind of attribute for St. Gregory, as in an altar from Lüneburg (1516), where the image is located in the upper left of the outer wing over the figure of Gregory on the inner side. Sometimes its protective function is stressed, as when it is placed on the outside of buildings along with the image of St. Christopher.[55] Sometimes it stands, in a narrative sequence, for the *Ecce homo* or the Crucifixion itself.[56] It is depicted on chests and eucharistic tabernacles; it also appears on altars and containers that house the controversial blood relics and wonderhosts of the fifteenth century, which many historians simply label eucharistic but which also, as authorities realized perfectly well, competed with eucharistic piety[57] (see, for example, Fig. 5, the blood-chest from Wilsnack). When displayed on the everyday (that is, outer) side of winged altars, on tabernacles or chests, and in prayer books, the Gregorymass was available to pious laypeople for meditation and spiritual communion outside the Mass or office.[58]

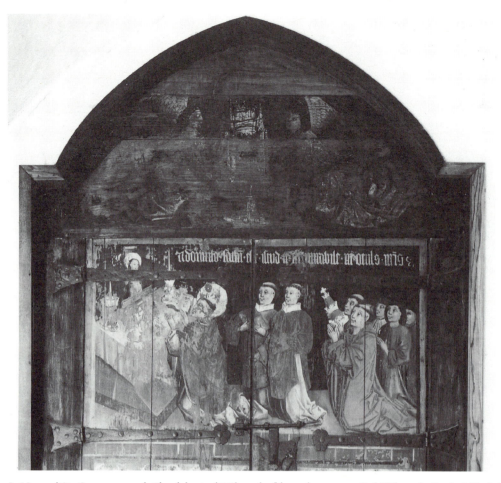

5. *Mass of St. Gregory*, panel, Bloodchest of Wilsnack, fifteenth century. Bad Wilsnack, Sankt Nikolai

Moreover, historians seem not to have noticed that a large number of Gregorymasses on side wings are split images—that is, double panels that quite explicitly summon the viewer to go within. Sometimes the split is between Gregory and his vision on one wing, and the panoply of attending ecclesiastics on the other—a setting that clearly draws our attention not so much to the "Schmerzensmann" as to the pomp of liturgy and the possibility that it opens into something beyond.[59] Sometimes the break comes between celebrant or recipient on one side and vision on the other—a depiction that divides painted seer from seen and centers us, the viewers.[60] Sometimes, as in an altarpiece from Aurich in East Frisia (Fig. 6), the image—with the pope off center and the crucified Christ obscured—is split on an axis that partially eclipses the vision. Such a staging makes present not the sacrifice but its un-representability.[61] Thus, just as the indulgence frequently accompanying the Gregorymass stresses the vision at its heart, so the physical positioning of the motif on the outer wings of chests or altars suggests that it is not so much a backdrop stating the significance of what occurs before it as a stimulus evoking absence as well as presence, an inducement and a trigger to go beyond.[62]

I would argue that the same focus on seeing *through* is present in iconography.[63] Historians have disagreed about how to sort out the strands. Gertrude Schiller's iconographical handbook sees two basic types (although it then proceeds to complicate the distinction): one in which Christ

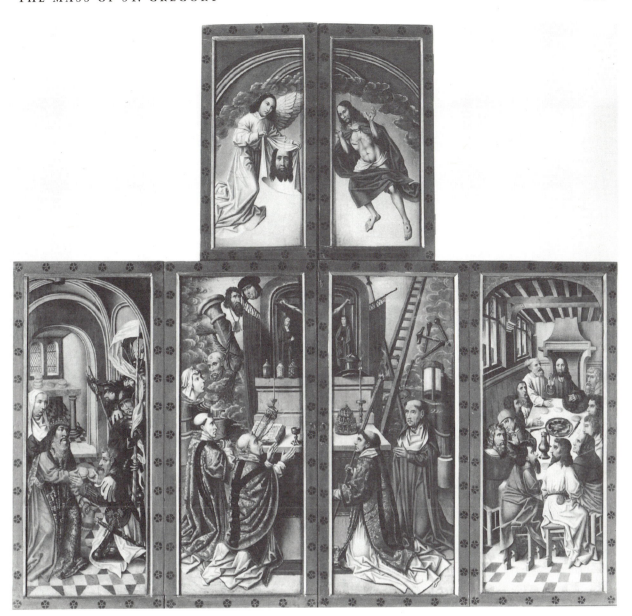

6. *Mass of St. Gregory*, exterior panel of the Passion Altar, ca. 1510–15. Flemish, from Antwerp. Aurich, Lambertikirche

presses a stream of blood into the chalice while Gregory celebrates Mass, and a separate tradition in which the pope prays before an altar on which the Man of Sorrows appears surrounded by the *arma Christi*. Uwe Westfehling, in the most recent full-length study, suggests (among other distinctions) that a French tradition includes angels displaying Christ at the moment of elevation, whereas German and Netherlandish depictions omit angels and multiply both the signs of Christ's torture and the accompanying ecclesiastical attendants.[64] Without attempting a full catalogue of types or regional traditions, I wish simply to point out some of the complexities of the three iconographic constants I mentioned earlier: the figure of the "Schmerzensmann," the ritual framing, and the image's self-consciousness about vision and visuality.

The Christ of the Gregorymass is always a suffering Christ with a visible side wound: sometimes the living-dead Man of Sorrows in his sarcophagus, sometimes a full-length Christ bleeding into the chalice, much more rarely a figure partly eclipsed behind an elevated host. The half-figure often occurs in depictions where Mass is not being said;[65] many of these images are indulgenced. The figure bleeding into the chalice becomes increasingly common, especially in Germany in the later fifteenth and sixteenth centuries, and does appear in many cases in the setting of a Mass: a host lies on the corporal, or over the chalice, or occasionally is elevated in the priest's hands.[66] The quite remarkable array of ecclesiastical pomp in some late German and Low Country versions emphasizes the might and power of the clergy, who perform the Mass or meditate before the altar. Yet in some images the celebrant is almost alone; there are even examples that may be Gregorymasses without Gregory, although the presence of an ecclesiastical figure to frame the vision and an altar on which it appears are constants of the iconography.[67] Clearly, then, the image often evokes eucharistic presence—but less the moment of consecration than the expanded sense of spiritual communion recently discussed by Caspers: an awareness of the sacrifice of the cross as the essential moment of human salvation.[68]

What is evoked is not, however, mere presence. The blood insists, the looming figure threatens (see, for example, Fig. 7).[69] Whether bleeding or not, Christ is set against a background of increasingly graphic and hostile *arma Christi*: isolated mocking or spitting heads with stylized Jewish features, large instruments of cutting and beating, etc. (see, for example, Fig. 1). Sometimes (as in a very early example from Räzüns) the Gregorymass is explicitly connected with another motif of guilt and reproach—the image known as either the *Feiertagschristus* or "Christ attacked by the sins of the world." Although many scholars have insisted that the *arma Christi* and the *Feiertagschristus* are independent traditions, they are clearly visually parallel and conceptually linked. In both, the implements that surround the wounded Christ accuse their wielders of attacking God (Fig. 8).[70] Thus, the blood that spills from Christ's side in the Gregorymass is not only (in those examples where it spills into the chalice) the sign of Christ's sacramental presence; it is also an accusation to those who mock with the mockers, a call to penitence before it is too late. It is worth remembering in this connection that fifteenth-century devotions to the side wound sometimes relate it not to Eucharist but to baptism and penance, and that the pressing out of Christ's blood (even in the image of the winepress) is often not associated with sacramental feeding at all but rather with the need to drain every drop in expiation for the sins of the world.[71] The reproaches of Good Friday—"Oh my people, what have you done unto me?"—reverberated in the fifteenth century around the looming figure of the "Schmerzensmann."

Moreover, the "encounter" is problematic. Often the participants in the Gregorymass do *not* see.[72] In some paintings or illuminations, the line of sight is hard to decipher, partly because of restoration work. Nonetheless, the fact that Gregory is sometimes in profile before the Mass book, oblique to the Man of Sorrows, involves more than (as one scholar has claimed) a need to show Gregory's face.[73] There are clearly cases in which Gregory and his attendants see the Christ figure; there are cases in which Gregory alone (or a lone attendant) sees, cases in which Gregory does not see, cases in which the ambiguity of who sees is part of the image (see, for example, Fig. 1). There are cases in which a donor (as a sort of second framing, a viewer of the viewer) sees Gregory seeing[74] and cases in which a donor sees a Gregory who does not see.[75] But we the viewers always see; there is always a "Schmerzensmann" on the altar. And for us the issue of seeing is always raised; what makes the image a Gregorymass rather than simply a Man of Sorrows or the

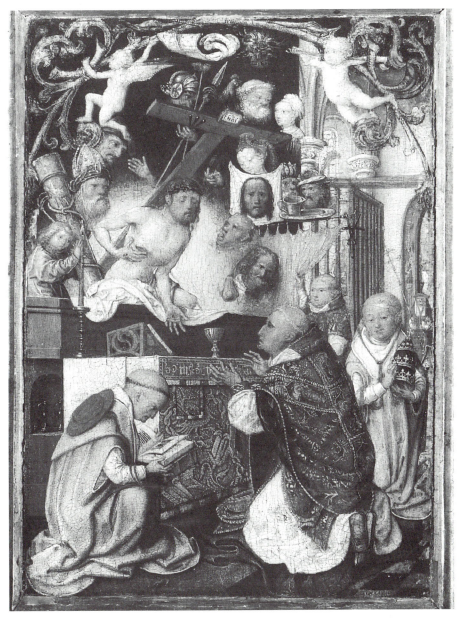

7. Master of the St. Bartholomew Altar, *Mass of St. Gregory*, 1480–95. Cologne, Wallraf-Richartz-Museum, on loan from the Bischöfliches Museum, Trier

panoply of the *arma Christi* is the fact of *potentially-seeing* attendants; the frame of those who do or who might see is always there.

Gregorymasses, then, are not just meditational objects in the sense so beautifully elucidated by Suckale and Ridderbos and long ago by Schrade. In such objects, the viewer moves freely around the field, choosing the order in which to focus.[76] There is a difference, however, between these devotional images and even early versions of the Gregorymass that have much in common with them (see, for example, Fig. 9, a woodcut from about 1400, now in Berlin).[77] In the Gregorymass

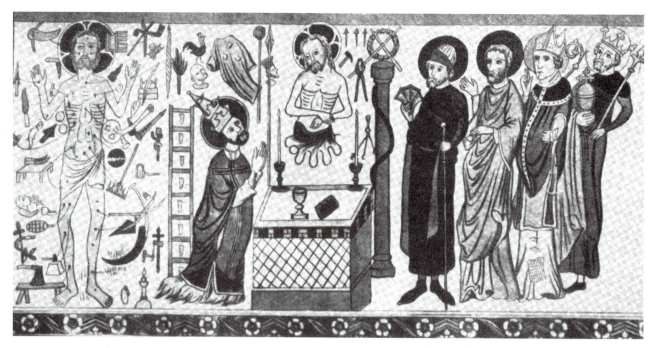

8. *Christ Suffering under the Sins of Mankind, Mass of Saint Gregory, and Saints,* wall painting, ca. 1400. St. Georg bei Räzüns (Graubünden), Switzerland (drawing by R. Berliner, *MünchJb*, ser. 3, 6 [1955], fig. 18)

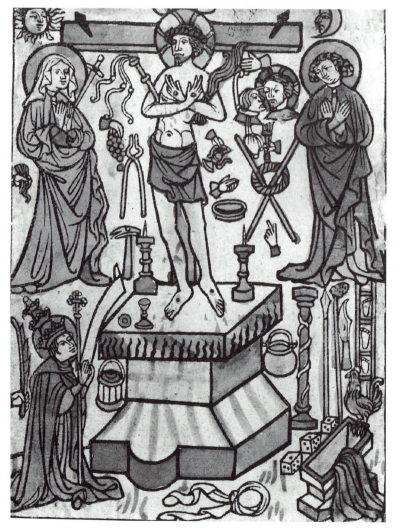

9. *Mass of Saint Gregory.* Woodcut, early fifteenth century. Berlin, Kupferstichkabinett

there is always a narrative element, a particular moment of relationship between two of the constituents of the image; the point is someone inside the image seeing or not seeing something. In other words, in a Gregorymass, the presence on the altar is always problematically or perspectivally present. What the viewer outside the image always sees is the possibility of seeing, but a seeing of considerable ambiguity.

The issue of who sees is intimately connected to the complex balance of realism and illusion.[78] In a number of images, not only is the perspective of the viewer within the image problematic; the status of the "Schmerzensmann" is problematic as well; church furnishings and vision overlap and become each other. For example, one of the famous Cologne images by the Master of the Holy Kinship (Fig. 10) manipulates the space of the altar so that the "Schmerzensmann" and *arma Christi* appear as a dramatically rendered retable, bracketed in architectural elements

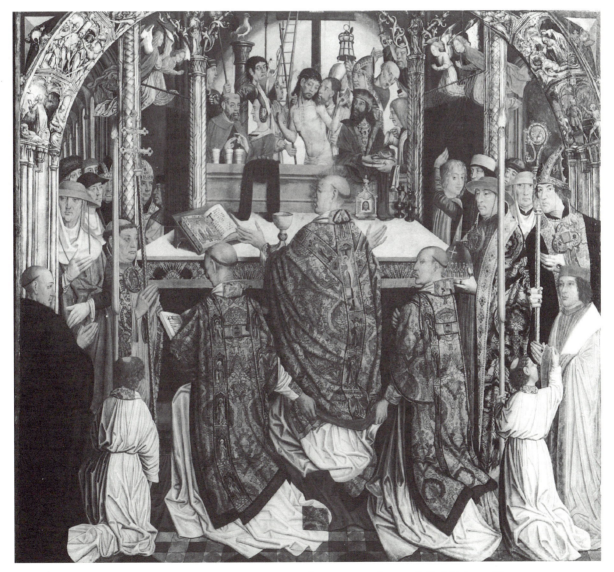

10. Master of the Holy Kinship, *Mass of Saint Gregory*, panel, ca. 1500. Cologne, Wallraf-Richartz-Museum

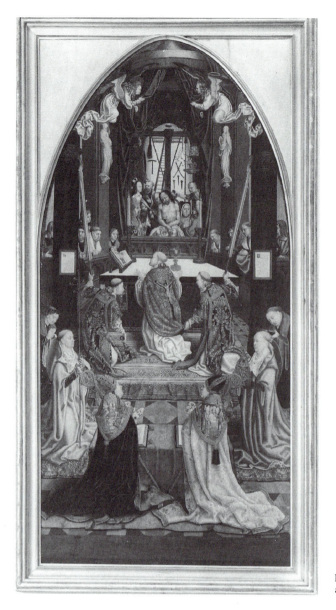

11. Master of the Aachen Altar, *Mass of Saint Gregory*, panel, ca. 1500. Utrecht, Rijksmuseum het Catharijneconvent

(columns and arches) with the sarcophagus forming a sort of predella and bottom frame. It seems that no one is looking at the retable-vision. The picture might be simply a picture of Mass before an elegantly appointed altar. Yet the status of the altarpiece as altarpiece is challenged not only by Christ's cloak which breaks across onto the altar table but also by the hand of the servant bearing the basin for Pilate.[79] In a parallel image now in the museum in Utrecht (Fig. 11), once again no one in the picture sees the Man of Sorrows. The artist locates what is clearly in one sense a painted retable behind frames within frames. Yet the lighting focuses the attention of the viewer on the vision as if a window behind the altar has opened into reality.[80]

The inclusion of the poor souls in purgatory adds another level to the ways in which Gregorymass iconography plays with presence and absence, realism and illusion. In a painting, attributed to Wilm Dedeke, on the outer wing of the altar of the Corpus Christi Brotherhood in Lübeck (Fig. 12), angels rescue the poor souls at the moment of elevation; the souls (depicted as bodies)

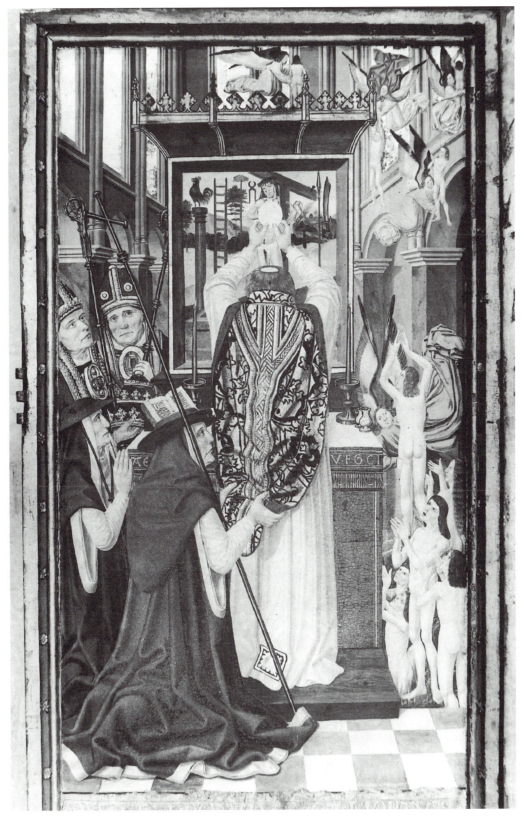

12. *Mass of Saint Gregory*, Altar of the Corpus Christi Fraternity. Panel attributed to Wilm Dedeke;
altar from workshop of Henning van der Heide, 1496. Lübeck, St.-Annen-Museum

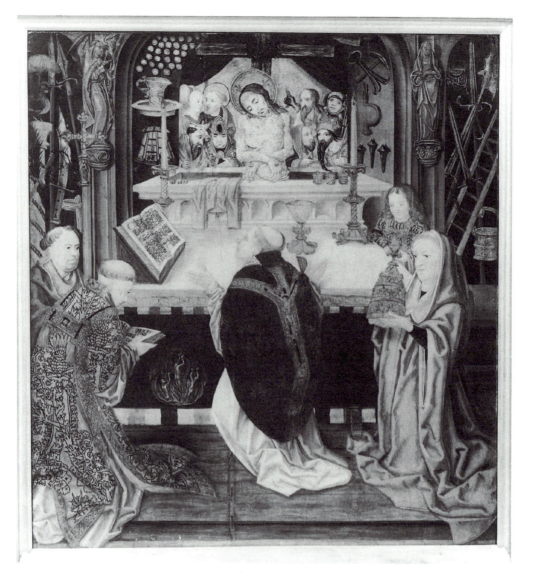

13. Master of the Aachen Altar, *Mass of Saint Gregory*, panel, early sixteenth century. Cologne, Erzbischöfliches Diözesanmuseum

are, at least to us, fully visible and located in the realm of the picture; but the Man of Sorrows surrounded by the *arma Christi* here appears to be a retable.[81] Christ does not step forward; nothing extrudes; the cross is cut off by a frame that runs entirely around what is clearly a panel; the sarcophagus from which the "Schmerzensmann" typically emerges is here neither predella nor altar but a painted object inside a border. Unusually, the focal point of this Gregorymass is the host, which visually recapitulates the roundness of the buttocks and shoulders of the poor souls, lifting them to heaven. It not so much reveals as eclipses and incorporates Christ. *It* is what is present. In contrast, in one of the Gregorymasses of the Master of the Aachen Altar (Fig. 13), where the *arma Christi* also seem a painted retable, the Man of Sorrows appears with solid physicality, rising from the altar-sarcophagus, his cloak breaking across the space onto the altar table. *He* is what is present. The poor souls in purgatory are a minor illusion, floating against the frontal like a delicate bit of embroidery.[82]

At heart, then, the Mass of St. Gregory—both in its physical positioning and structure and in its iconographical complexity—reflects not so much "Schaufrömmigkeit" as the problematic nature of seeing, not so much doubt about Christ's sacrificial presence on the altar as exploration of exactly how he was to be encountered there, not so much seeing as seeing beyond.

The Theological Setting

Neither folk art nor ecclesiastical propaganda, yet popular with both lay groups and clerical elites, the Gregorymass expressed the religious assumptions of a wide range of social statuses. Commissioned for epitaphs, altars of lay confraternities, and Books of Hours, the image was popular with the laity; hundreds of engravings, illuminations, reliefs, small panels, are known. The Gregorymass was common in books of private devotion as well as in public settings; burghers commissioned it for family epitaphs; we find it not only on eucharistic tabernacles but also on altars dedicated to the problematic blood relics that, despite widespread ecclesiastical opposition, drew hordes of pilgrims and led on occasion to mass outbursts and pogroms.[83] Indeed, the iconography even of altar retables was not controlled by clergy in the fifteenth century.[84] The high altar might be hidden from lay view by a screen, but the side altars on which we often find the Gregorymass were sometimes paid for by lay brotherhoods (as was the case at Lübeck).

Nonetheless, the Gregorymass is often an image of ecclesiastical pomp and power; its elements have complex theological content. One must be iconographically educated, for example, to recognize the large blade often included among the arma Christi as the knife of the circumcision or to understand how that first blood spilling foreshadows, and therefore becomes, one of the torments of Christ. In many of its venues (and not only when indulgenced), the iconography is clearly didactic and hortatory, intended both to inculcate correct belief and to channel penitent response. When used, as for example at Wilsnack, to frame (and substitute for) the viewing of a wonderhost, the image seems intended to induce the faithful to look beyond holy matter to spiritual significance. In its major elements, then—the bloody and often accusatory body of the "Schmerzensmann," the ritual framing, the privileging and questioning of seeing—the Gregorymass helped to constitute the piety of burghers, clerics, and religious from 1400 to 1550, during which period it emerged, proliferated with stunning intensity, and then quickly and almost completely disappeared.[85]

It stands to reason, then, that the iconography, piety, and theology of the period must echo and resonate with each other in ways I have not yet fully discussed. I have argued that a motif as popular as the Gregorymass can hardly have been an illustration of an abstruse theological doctrine that was formulated only after its rise. But if I am to deal with the topic of this volume—art and theology—I must consider again the doctrinal and devotional background against which Gregorymass iconography should be situated. In what follows, I devote a few paragraphs to sketching general trends in eucharistic piety in the fourteenth and fifteenth centuries and then turn again to learned theology.

The rise of devotion to the eucharistic host in the thirteenth and fourteenth centuries has been much discussed recently. Although it is not usually put this way, the development can be seen as making the host both more and less an object. On the one hand, there had been a tendency since the early Middle Ages to see the consecrated bread and wine themselves as holy matter—hence objects that could pollute or be polluted. Anything in improper contact with such holy matter had to

be burned or buried underneath the altar; fasting before communion was in order to keep sacred food from touching ordinary nourishment.[86] Over the course of the thirteenth and fourteenth centuries, the cup was entirely withdrawn from the laity for fear of spillage and other forms of profanation. Both lay people and members of religious orders felt increased reluctance about a sacramental reception that would, because it placed God objectively in their mouths, damn them if any element of their spiritual intention or preparation was flawed. Not only did many devout persons see visions, as devout persons had done for hundreds of years, in which Christ was physically present to the senses as well as to the inner eye; miracles also proliferated in which hosts or holy images such as crucifixes oozed Christ's blood, which the faithful clamored to keep as an eternal presence, parallel to the relics of the saints, with which it sometimes competed.[87] (Relics themselves saw no dwindling in popularity, although apparitions of the saints came increasingly to precede pilgrimages to them.[88]) As we know from commentaries on the Mass, the consecration came to be understood not only as sacrifice but also as the narrative of Christ's crucifixion and entombment.[89] Practices such as burying the host in the breast of a Christ-sculpture during the triduum came close to treating the eucharistic elements as dead body.[90]

On the other hand, the faithful were urged to encounter with eyes where encounter with lips was dangerous and rare, to "eat" by "seeing." Such seeing was stressed, moreover, as seeing with the inner rather than with the outer eye; "spiritual communion" was more than—sometimes contradictory to—ocular communion. Christ could be received outside Mass, outside church, even outside any stimulus except a whispering deep in the heart. Presence was both object and absence; it became profoundly inner—unencompassable, untouchable, unseeable.[91]

Theologians and devotional writers differed about how this presence was received. According to the doctrine of concomitance, Christ was whole in any eucharistic particle.[92] Some theologians argued that the pious Christian took in the *totus Christus* only in sacramental reception, not by mere seeing.[93] But the tendency to think in synecdoche—the assumption that part is whole—dominated late medieval piety[94] and could lead to a sense that the receiving Christian incorporated Christ (divinity and humanity, soul, body, and blood) no matter how inward the reception. Mystics in the high Middle Ages speak in stunningly physical images of union with Christ achieved through eyes as well as lips, in hearts and bowels as well as minds.[95]

Moreover, blood came increasingly to center stage in European piety. For all the assurances that seeing is eating and part is whole, a frenzied desire to receive the blood of Christ flooded across Europe, stimulated in part by the withdrawal of the cup from the laity.[96] Blood as access, as salvific washing, as expiation and ecstasy, joined an older sense of Christ's wounds as reproach and judgment. As early as Bede, the wounds had been said to be proof of Christ's martyrdom, intercession to the Father, demonstration of love, and graphic blaming of the evil and the damned; fourteenth-century texts regularly expanded the final category to target the Jews.[97]

Such currents clearly form the background to Gregorymass iconography. The Christ who rose from the sarcophagus or appeared on the altar, whether or not accompanied by instruments of torture, was a God who threatened as well as comforted, reproached as well as mediated. In sacrificial blood that streamed from heaven, the divine was immediate yet lofty, a cleansing bath and nourishing drink yet a murder indictment as well. Moreover, such eucharistic piety, like the iconography that manipulated viewers within and without the picture frame, underlined the questions "present how?" "present to whom?" Whether the sacred matter of relic and wonderhost or a whispering deep within the heart of the mystic, the holy was in the fifteenth century not simply palpable or visible. It was a presence that was behind, yet accessed through, the physical.

I have already explained that learned theology and ecclesiastical legislation were deeply resist-ant to the extreme physicality, the literalism, of some forms of presence. Ecclesiastical authori-ties in the fifteenth century sometimes opposed, and often attempted to tame and channel, the piety of pilgrimage and pogrom that grew up around the wonderhosts, blood relics, and images popular at sites such as Wilsnack, Walldürn, and Andechs.[98] I have also explained that many uni-versity theologians were suspicious of vision and argued for a presence on the altar that was by definition un-seeable. In closing, I suggest that there is an even deeper level at which we find in learned theological discourse a concern with presence and absence that may help us situate the complex dynamic of the Mass of St. Gregory. I thus return to the topic of eucharistic theology, not to see iconography as its illustration but to show how the concern that throbs beneath it may also be a context for art.

From early theorists such as Guitmond of Aversa and William of Champeaux down to the Council of Trent, theologians attempted to explain how Christ could be really—substantially—present on the altar without apparent change in the bread and wine. Into the fifteenth century, a number of those who struggled with the issue found some theory of two substances or of the sub-stitution of one substance (bread) by another (Christ) more compelling *philosophically* than Aquinas's formulation, according to which bread "went over into" body.[99] And, indeed, any real grappling with the Aristotelian concepts supposedly undergirding Thomistically defined "transub-stantiation" makes it clear that substance is what is replaced when one thing becomes another. (In change, a first substance must cease and a second take its place.) But in order for change to be possible, there must be something at least conceptually in common between before and after—which is what the Aristotelian idea of matter accounts for. Hence "transubstantiation," in which one substance becomes another rather than replaces another but without a common element, is very hard to grasp philosophically; this is perhaps why, even at Trent, it was not really philosoph-ically defined.[100]

But behind all the debates lurked a basic issue that goes to the heart of fourteenth- and fif-teenth-century ontological and religious anxieties: the issue of change.[101] In the early thirteenth century Innocent III had already stressed:

> Although that which was bread is the body of Christ, the body of Christ is not however something that was bread, since that which was bread is now totally other than it was; but the body of Christ is in every way that which it was. . . . [Hence the Eucharist is not parallel to the Incarnation.] For the Word remaining what it was is made flesh when it as-sumes flesh; it does not go over into flesh; but the bread ceases to be what it was and thus becomes flesh because it goes over into flesh rather than assumes flesh.[102]

In other words, the bread becomes the eternal "is" that is God. Fifty years later, Albertus Magnus struggled with how the immutable (God), which gives and receives nothing, can experience even the change of something into itself. "The whole substance of bread becomes the whole substance of Christ," writes Albert, so that body "necessarily remains the same but becomes present where transubstantiation occurs."[103] Later still, Scotus, Ockham, and Biel found themselves troubled to explain how conversion into Christ leaves God completely without *mutatio*.[104] The issue of change continued to plague.

Those at Trent who decided finally for "transubstantiation"—the awkward idea that the sub-stance of bread goes over into the substance of Christ rather than that the substance of Christ is added to bread or that bread is annihilated and Christ substituted for it—seem to have done so

exactly because of deep-seated fears of any theory that would suggest *mutatio* in God. If Christ were in some sense added to bread in a kind of consubstantiation or impanation, there was no real change (because change means something becoming something else). But there was no guarantee that Christ was *there* where bread was (after all, the bread was still there). If, however, the bread was annihilated and Christ substituted, not only had God annihilated a creature (and God never destroys creation), but Christ himself changed, for he came into the place where bread had been before. Thus it came to seem that only "transubstantiation" held a specific place for Christ on the altar (he came there *where* the bread was and replaced it) while guaranteeing that he suffered no change (bread went over into Christ; Christ did not go over into bread, nor did he come down onto the altar; he did not undergo even the change of changing places).

Over and over again, what theologians struggled to avoid in theorizing the Eucharist was *annihilatio*. Beneath *horror cruoris* lay *horror corruptionis*. From William of St. Thierry to Gabriel Biel, preachers and devotional writers urged that even in the union of spiritual reception, there is no change in God. We become Christ in the Eucharist, he does not become us.[105] Adelheid Langmann wrote: "We eat God not so that he changes into us but so that we change into him."[106] At the moment of consecration, it is the eucharistic elements that change place, ascending to join Christ where he resides with the angels in heaven. In answer to the riddle "Where is earth higher than heaven?" Christina Ebner of Engelthal replied: "Where God's body is transubstantiated."[107]

Therefore, I would suggest that behind the resistance to seeing found in so much theological writing of the period is a resistance to change itself, a sense that the fundamental difference between earthly and divine is that fact that we change, God does not. For becoming visible is *mutatio*. The objections of theologians and diocesan synods to seeing Christ in the host or revering his bodily relics—complex theoretical objections that made problematic what were clearly often devout and penitential experiences—were not merely fear of superstition or popular piety but efforts to maintain the changelessness and unseeability of God.

Indeed, although the theologians did not realize it, the blood miracles they struggled to control, or even suppress, mirrored their own concern for immutability. Some of these miracles expressed not so much eucharistic presence as resistance to decay or violation. To the people of the parish of Wilsnack, their miracle-hosts were wonders first and foremost because they survived intact through fire and flood.[108] Raoul Glaber, Conrad of Eberbach, and Salimbene told stories of eucharistic bread buried in altars that survived hundreds of years without decay; Rupert of Deutz and Rudolph Schlettstadt reported hosts that came unscathed through fire.[109] When Nicholas of Cusa found himself forced to approve the miracle-hosts of Andechs, he pronounced them incorruptible but said nothing about their blood-color or about any images seen in them.[110] In such cases, it is as if the miracle lies in changelessness, in resistance to the natural processes of decay and fragmentation, rather than in substantial presence, or as if what presence guarantees is immutability. The emphasis is on resistance to *mutatio*. It is, moreover, against *mutatio* that blood cries out. The miracle corporales of Bolsena and Walldürn were protests against spillage.[111] The hosts that betrayed supposed Jewish sacrilege were understood as manifesting not only the presence of Christ within but also the horror of violating him—a horror Christians were increasingly induced to think they perpetrated too and might, in some awful way, expiate by turning against his older enemies.[112] Thus, one cannot sort late medieval piety into, on the one hand, a learned concern for immutability and un-seeability and, on the other, a folk hysteria for holy matter. The same basic concerns run through it all. In the bleeding hosts of Wilsnack, said to perdure despite assault by

fire and water, there is a distant echo of the insistence by university theologians on the change-lessness of God.

Conclusion

The spiritual climate in which the Gregorymass arose was not one in which the primary devotional and theological problem was doubt about what occurs at Mass. Rather, to many theologians and ecclesiastical authorities, the real threat was the physicalization of religious experience in miraculous objects (wonderhosts and blood relics)—that is, a failure to understand that presence is somehow beyond, that God is truly immutable. But pious laypeople, who cried "Blood of Christ, save me" before reliquary chests, monstrances, or elevated hosts, understood that they cried for a power other than, although present in, what they saw. To them, the challenge was access to a God kept distant through clerical control or through their own unworthiness—that is, a way to find the presence in the absence. The Gregorymass, popular for side altars commissioned by lay confraternities, private prayer books, and bourgeois epitaphs, as well as for large altarpieces depicting clerical pomp and for chests devoted to bloodhosts and relics, seems less a doctrinal statement about the exact mode of Christ's presence than a major element in constituting, containing, and channeling an encounter that is a seeing beyond.

Set against the fifteenth-century theological and devotional background, it is not surprising that the Gregorymass should locate, frame, and explore the ultimately un-seen. Such an interpretation of the iconography is not a postmodern projection onto a more straightforward age, nor a theological imposition on simple piety, nor yet an injection of modern visual theory into the "age before art." I return in closing to an example, the Passion Altar of the church of St. Lambert in Aurich (Fig. 6). For now we can recognize quite clearly that the complexity of seeing and seeing beyond is in the image itself.[113]

This Gregorymass is, as I noted before, on the outer wings. It has been cut to accommodate the frame. The crucified Christ in the central altar niche may have once been more visible; the attendant has lost his hand. Nonetheless, these outer wings, taken together, clearly stress both seeing and seeing through. The Veronica and the bleeding "Schmerzensmann" hover above, emblems of the eucharistic body and blood. To the left, Abraham exchanges bread with Melchizedek, who carries a wine jug; to the right is the Last Supper, not the moment of consecration, but (as was typical of the period) Mark 14:18 ("One of you will betray me"). The accusing wounds of the "Schmerzensmann," who floats above, echo the statement of reproach below—a reproach seldom absent from fifteenth-century devotion. The Gregorymass itself is not the depiction of a vision, or at least not of the pope's vision. The pope does look toward the altar; he is, it seems, celebrating Mass. But the central Christ figure appears to be an altarpiece. If there is a vision in the picture, it is the *arma Christi*, which press down upon the un-seeing attendants and yet provide a ladder for mounting not toward the altarpiece but obliquely toward the Man of Sorrows. Hence, it is we the viewers who see the vision; Gregory sees the altar. Yet we the viewers are not so much to see as to penetrate through to the Crucifixion that lies beyond the central divide. And that Crucifixion is itself bracketed by two further images of manifestation—an *Ecce homo* and a *Noli me tangere*—both images which, while bidding the viewer to see, suggest distance as well (Fig. 14).

Images never illustrate theology. This is first and foremost because images (even highly didac-

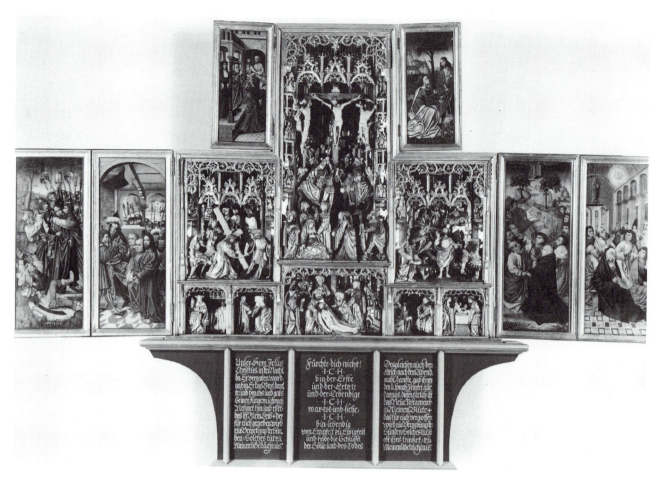

14. Passion Altar, interior, ca. 1510–15. Flemish, from Antwerp. Aurich, Lambertikirche

tic images) never merely illustrate. Moreover, unseeability and immutability—those basic themes of fifteenth-century theology—defy illustration by their very nature. Nor could the images of fifteenth-century art—not even those of manifestation, such as the *Noli me tangere*, the burning bush, the presentation to the Magi—simply depict the sort of seeing that was also a key theme. For the "Schaulust" of the period was a craving to see through as much as to see. The holy matter (relics, hosts, and wonderhosts) for which pilgrims clamored was encountered as a presence that was more than visual. It forced itself into the viewer with an almost physical power.[114] Yet the seeing it stimulated was a seeing of what was beyond. Pilgrims cried "Blood, Blood!" whether they saw crystalline vessels or closed chests, bits of ashes, particles of bread, or red spotted cloths. Furthermore, spiritual communion, which was sometimes (to the discomfort of some devotional writers and theologians) understood to be accessible almost anywhere, was only sometimes "Augenkommunion"; sometimes it was theorized as inner, imageless encounter. If I am correct in interpreting the Gregorymass as an exploration of seeing and seeing through, of presence as both certain and problematic, it reflects basic themes of popular religiosity and learned theology in the fifteenth century, which themselves (as should not surprise us) reflect and respond to each other.

Hence the Gregorymass challenges us to think more deeply about the theme of this volume: art and theology. But it gives no comfort to those who seek ways in which one causes or illustrates the other. Rather it suggests that each grappled, in the fifteenth century, with what could not be said or seen. Behind eucharistic theology, the practices of pious pilgrims, and the iconography of the Gregorymass lay yearning for an ultimately impossible seeing—for a presence forever beyond.

Acknowledgments

I am grateful to Patricia Decker and Jane Rosenthal for help with the plates, to Anne-Marie Bouché, Jeffrey Hamburger, Joel Kaye, Guenther Roth, and Dorothea von Mücke for critical readings.

Notes

1. On the importance of ocularity in later Middle Ages, see U. Westfehling, *Die Messe Gregors des Grossen: Vision, Kunst, Realität: Katalog und Führer zu einer Ausstellung im Schnütgen-Museum der Stadt Köln* (Cologne, 1982), esp. 37; R. Scribner, "Vom Sakralbild zur sinnlichen Schau," in *Gepeinigt, begehrt, vergessen: Symbolik und Sozialbezug des Körpers im späten Mittelalter und der frühen Neuzeit*, ed. K. Schreiner and N. Schnitzler (Munich, 1992), 309–36; J. Oliver, "Image et dévotion: Le Rôle de l'art dans l'institution de la Fête-Dieu," in *Fête-Dieu (1246–1996): Actes du Colloque de Liège, 12–14 septembre 1996*, ed. A. Haquin, Université Catholique de Louvain: Publications de l'Institut d'Études Médiévales (Louvain-la-Neuve, 1999), vol. 1, 153–72; B. Reudenbach, "Der Altar als Bildort: Das Flügelretabel und die liturgische Inszenierung des Kirchenjahres," in *Goldgrund und Himmelslicht: Die Kunst des Mittelalters in Hamburg* (Hamburg, 1999), 26–33. Basic is still A. Mayer, "Die heilbringende Schau in Sitte und Kult," in *Heilige Überlieferung: Ausschnitte aus der Geschichte des Mönchtums und des heiligen Kultes. Festschrift für Ildefons Herwegen* (Münster, 1938), 234–62. For intelligent caveats about this recent emphasis, see P. Binski, "The English Parish Church and Its Art in the Later Middle Ages: A Review of the Problem," *Studies in Iconography* 20 (1999), 1–25, esp. 13–14. In his paper for this volume (" 'As far as I can see' . . . Rituals of Gazing in the Late Middle Ages"), Thomas Lentes provides historiographical background to the concept of "Schaufrömmigkeit," and thus gives a rather different interpretation of it from the one that has been used recently in English-language scholarship.

2. M. Rubin, *Corpus Christi: The Eucharist in Late Medieval Culture* (Cambridge, 1991); Oliver, "Image et dévotion" (as in note 1). The point is supported by the analysis of P.-A. Sigal, who argues that the later Middle Ages saw a shift from miracles accomplished by touching holy objects at shrines to miracles and visions that occurred at a distance from the tombs of saints (*L'Homme et le miracle dans la France médiévale [XIe–XIIe siècle]* [Paris,

1985]). And see P. M. Soergel, *Wondrous in His Saints: Counter-Reformation Propaganda in Bavaria* (Berkeley, 1993), 20–30. But note the argument of Peter Dinzelbacher that Eucharist and relic were two different forms of "real presence" in the later Middle Ages ("Die 'Realpräsenz' der Heiligen in ihren Reliquiaren und Gräbern nach mittelalterlichen Quellen," in *Heiligenverehrung in Geschichte und Gegenwart*, ed. P. Dinzelbacher and D. Bauer [Ostfildern, 1990], 115–74).

3. Scribner, "Vom Sakralbild zur sinnlichen Schau" (as in note 1). Jeffrey Hamburger partly disagrees ("Seeing and Believing: The Suspicion of Sight and the Authentication of Vision in Late Medieval Art," in *Imagination und Wirklichkeit: Zum Verhältnis von mentalen und realen Bildern in der Kunst der frühen Neuzeit*, ed. A. Nova and K. Krüger [Mainz, 2000], 47–70). On medieval theories of vision, see D. C. Lindberg, "The Science of Optics," in *Science in the Middle Ages*, ed. D. Lindberg (Chicago, 1978), 338–68.

4. See M. Carruthers, *The Craft of Thought: Meditation, Rhetoric, and the Making of Images, 400–1200* (Cambridge, 1998); T. Lentes, " 'Andacht' und 'Gebärde': Das religiöse Ausdrucksverhalten," in *Kulturelle Reformation: Sinnformation im Umbruch, 1400–1600*, ed. B. Jussen and C. Koslofsky (Göttingen, 1999), 29–67; R. Suckale, "*Arma Christi*: Überlegungen zur Zeichenhaftigkeit mittelalterlicher Andachtsbilder," *Städel-Jahrbuch* n.s. 6 (1977), 177–208; and S. Kramer and C. Bynum, "Revisiting the Twelfth-Century Individual: The Inner Self and the Christian Community," in *Das Eigene und das Ganze: Zum Individuellen im mittelalterlichen Religiosentum*, ed. G. Melville and M. Schürer (Münster, 2002), 57-85.

5. Fundamental works on the Gregorymass are H. Thurston, "The Mass of St. Gregory," *The Month* 112 (1908), 303–19; J. A. Endres, "Die Darstellung der Gregoriusmesse im Mittelalter," *ZChrK* 30, nos. 11–12 (1917), 146–56; R. Berliner, "Arma Christi," *MünchJb*, ser.3, 6 (1955), 35–152; M. Lorenz, "Die Gregoriusmesse: Entstehung und Ikonographie" (Ph.D. diss., Innsbruck, 1956); C.

Bertelli, "The *Image of Pity* in Santa Croce in Gerusalemme," in *Essays in the History of Art Presented to Rudolf Wittkower,* ed. D. Fraser, H. Hibbard, and M. J. Lewine (London, 1967), 40–55; Comte J. de Borchgrave d'Altena, "La Messe de saint Grégoire: Étude iconographique," *Musées royaux des beaux-arts: Bulletin; Bulletin Koninklijke Musea voor Schone Kunsten* 8 (1959), 3–34; Westfehling, *Die Messe Gregors des Grossen* (as in note 1); B. d'Hainaut-Zveny, "Les Messes de saint Grégoire dans les retables des Pays-Bas: Mise en perspective historique d'une image polémique, dogmatique et utilitariste," *Bulletin des Musées royaux des beaux-arts de Belgique* 41–42 (1992–93), 35–61; and F. Lewis, "Rewarding Devotion: Indulgences and the Promotion of Images," in *The Church and the Arts,* ed. D. Wood, Ecclesiastical History Society (Oxford, 1992), 179–94. A good overview is still L. Réau, *Iconographie de l'art chrétien,* vol. 3, pt. 2 (Paris, 1958), 609–15. Crucial on the related issue of the Man of Sorrows are H. Schrade, "Beiträge zur Erklärung des Schmerzensmannbildes," in *Deutschkundliches: Friedrich Panzer zum 60. Geburtstage überreicht von heidelberger Fachgenossen,* ed. H. Teske (Heidelberg, 1930), 164–82; R. Bauerreiss, OSB, "Der 'gregorianische' Schmerzensmann und das 'Sacramentum S. Gregorii' in Andechs," *Studien und Mitteilungen zur Geschichte des Benediktiner-Ordens und seiner Zweige* n.s. 13 (44) (1926), 57–78; C. Eisler, "The Golden Christ of Cortona and the Man of Sorrows in Italy," *ArtB* 51, no. 2 (June, 1969), 107–18, 233–46; H. Belting, *The Image and Its Public in the Middle Ages: Form and Function of Early Paintings of the Passion,* trans. M. Bartusis and R. Meyer (New Rochelle, N. Y., 1990); and B. Ridderbos, "The Man of Sorrows: Pictorial Images and Metaphorical Statements," in *The Broken Body: Passion Devotion in Late Medieval Culture,* ed. A. A. MacDonald, H. N. B. Ridderbos, and R. M. Schlusemann (Groningen, 1998), 145–81. A collaborative project on the Gregorsmesse is now underway at the University of Münster; for information, see www.uni-muenster .de/kultbild. The term "Gregorsmesse" for the iconography I consider here is not a medieval term but rather a coinage of the nineteenth century.

6. See, for example, Y. Hirn, *The Sacred Shrine: A Study of the Poetry and Art of the Catholic Church* (Boston, 1912, trans. from the Swedish of 1909), 127; Westfehling, *Die Messe Gregors des Grossen* (as in note 1), 21–24; Rubin, *Corpus Christi* (as in note 2), 116–21; A. N. Nemilov, "Gedanken zur geschichtswissenschaftlichen Befragung von Bildern am Beispiel der sog. Gregorsmesse in der Ermitage," in *Historische Bildkunde: Probleme-Wege-Beispiele,* ed. B. Tolkemitt and R. Wohlfeil (Berlin, 1991), 123–33; P. Deleeuw, "Unde et Memores, Domine: Memory and the Mass of St. Gregory," in *Memory and the Middle Ages,* ed. N. Netzer and V. Reinburg (Chestnut Hill, Mass., 1995), 33–43; and d'Hainaut-Zveny, "Les Messes de saint Grégoire" (as in note 5), 39–42. For a standard catalogue description, see K. Kösters, *Verborgene Schätze: Mittelalterliche Kunst in Westfalen* (Münster, 2000), 55 and 191; for a standard textbook account, see R. N. Swanson, *Religion and Devotion in Europe, c. 1215–c. 1515,* Cambridge Medieval Textbooks (Cambridge, 1995), 137–38. Some of these accounts include other interpretations and functions for the image, but all assume that the story

of the woman and the finger is fundamental to the image and that both the extirpation of doubt and the inculcation of eucharistic doctrine are key functions.

7. Suckale, "*Arma Christi*" (as in note 4), 177–208; D. Freedberg, *The Power of Images: Studies in the History and Theory of Response* (Chicago, 1989); H. Belting, *Likeness and Presence: A History of the Image before the Era of Art,* trans. E. Jephcott (Chicago, 1994); J. F. Hamburger, *The Visual and the Visionary: Art and Female Spirituality in Late Medieval Germany* (New York, 1998).

8. Binski, "The English Parish Church" (as in note 1), 1–25, esp. 1–2 and 6.

9. H. Jorissen, *Die Entfaltung der Transsubstantiationslehre* (Münster, 1965); J. F. McCue, "The Doctrine of Transubstantiation from Berengar through the Council of Trent," *HTR* 61 (1968), 385–430; E. D. Sylla, "Autonomous and Handmaiden Science: St. Thomas Aquinas and William of Ockham on the Physics of the Eucharist," in *The Cultural Context of Medieval Learning: Proceedings of the First International Colloquium on Philosophy, Science and Theology in the Middle Ages, September 1973,* ed. J. E. Murdoch and E. D. Sylla, Boston Studies in the Philosophy of Science 36 (Dordrecht and Boston, 1974), 349–91; B. Stock, *The Implications of Literacy: Written Language and Models of Interpretation in the Eleventh and Twelfth Centuries* (Princeton, 1983), 241–325; D. Burr, *Eucharistic Presence and Conversion in Late Thirteenth-Century Franciscan Thought, TAPA* 74, no. 3 (Philadelphia, 1984); G. Macy, "The Dogma of Transubstantiation in the Middle Ages," *JEH* 45, no. 1 (1994), 11–41, reprinted in G. Macy, *Treasures from the Storeroom: Medieval Religion and the Eucharist* (Collegeville, Minn., 1999), 81–120. See also "Reception of the Eucharist According to the Theologians: A Case of Diversity in the Thirteenth and Fourteenth Centuries," in *Theology and the University,* ed. J. Apczynski, Proceedings of the Annual Convention of the College Theology Society, 1987 (Lanham, Md., 1990), 15–36, reprinted in *Treasures from the Storeroom* , 36–58.

10. Both Westfehling, *Die Messe Gregors des Grossen* (as in note 1), and Thurston, "The Mass of St. Gregory" (as in note 5), comment on the fact that there are versions in which no one sees the Man of Sorrows and versions in which Mass is not being said.

11. J. Heuser, " 'Heilig-Blut' in Kult und Brauchtum des deutschen Kulturraumes. Ein Beitrag zur religiösen Volkskunde" (Ph.D. diss., University of Bonn, 1948), 59–85 and passim; C. W. Bynum, *Holy Feast and Holy Fast: The Religious Significance of Food to Medieval Women* (Berkeley, 1987), 76–78 and passim; Rubin, *Corpus Christi* (as in note 2), 129–42 and passim; M. Rubin, *Gentile Tales: The Narrative Assault on Late Medieval Jews* (New Haven, Conn., 1999). Fundamental to all work in the area is P. Browe, *Die eucharistischen Wunder des Mittelalters,* Breslauer Studien zur historischen Theologie n.s. 4 (Breslau, 1938); see also P. Browe, "Die eucharistischen Verwandlungswunder des Mittelalters," *RQ* 37 (1929), 137–69.

12. It is important to note that miracles of the bleeding host are not always used as proof of real presence even when they are used didactically. For examples of the miracle used by Bonaventure and William of Mellitona to prove concomitance, see J. J. Megivern, *Concomitance*

and *Communion: A Study in Eucharistic Doctrine and Practice* (Fribourg and New York, 1963), 195 and 213.

13. *AASS* March, vol. 2, pp. 133–34 and 152–53.

14. See, for example, Gerald of Wales, *Gemma ecclesiastica*, in Gerald, *Opera*, vol. 2, ed. J. S. Brewer, in Rerum Britannicarum Medii Aevi Scriptores 21 (London, 1861–91), chap. 11, p. 39 (note that in *The Jewel of the Church: A Translation of Gemma Ecclesiastica by Giraldus Cambrensis*, trans. J. J. Hagen [Leiden, 1979], 32, the translator has mistakenly interpreted the Latin as saying that a lamb appeared between Gregory's fingers); Jacobus de Voragine, *The Golden Legend: Readings on the Saints*, trans. W. G. Ryan, 2 vols. (Princeton, 1993), vol. 1, 179–80; *Speculum laicorum*, ed. J. T. Welter (Paris, 1914), chap. 32, no. 258, p. 52 (compiled at the end of the thirteenth century and very popular in the fourteenth and fifteenth centuries); *An Alphabet of Tales*, ed. M. M. Banks, EETS 126, 127 (London, 1904–5), 211; J. Mirk, *Liber festivalis* and *Quatuor sermones* (1519), ed. T. Erbe, EETS 95 (London, 1905), 53. Egbert of Schönau, in his Sermon 9, "Contra octavam haeresim de corpore et sanguine Domini" (PL 195:94A), departs from the pattern of the above *exempla* collections, all of which retain the woman, to tell a more general story of Gregory praying to dispel the doubts of a group to whom "caro Dominica" appeared; see Heuser, " 'Heilig-Blut' in Kult und Brauchtum" (as in note 11), 68–69, who also connects the story to the Andechs hosts. Egbert's sermon is the only direct evidence I have found of a version intermediate between the woman-and-the-finger legend and the later iconography of the vision of a bleeding Man of Sorrows.

15. G. de Tervarent, "Les Tapisseries du Ronceray et leurs sources d'inspiration," *GBA* 6th period, vol. 10, 75th year (1933), 80–83; and M. Heinlen, "An Early Image of a Mass of St. Gregory and Devotion to the Holy Blood at Weingarten Abbey," *Gesta* 37 (1998), 55–62. A late-fifteenth-century chronicle from Andechs gives another miracle story concerning a Mass of Gregory and a woman, in this case Queen Elvira of Spain, who doubted the real presence; during the celebration a divine light and the *arma Christi* appeared. See Soergel, *Wondrous in His Saints* (as in note 2), 39–40. It is of course quite possible that this late story derives from the iconography.

16. Thurston, "The Mass of St. Gregory" (as in note 5), 316.

17. See Thurston, "Mass of St. Gregory" (as in note 5), 305. M. Meiss (with K. Morand and E. W. Kirsch, *French Painting in the Time of Jean de Berry: The Boucicaut Master* [London, 1968], pl. 43) gives an example where the donor clearly sees Gregory (although it is not completely clear whether Gregory sees the vision or only the host). See note 14 above.

18. Westfehling (*Die Messe Gregors des Grossen* [as in note 1], 38–43), drawing on M. Lorenz, points out that only in the French type do we have the moment of elevation. D'Hainaut-Zveny ("Les Messes de saint Grégoire" [as in note 5], 42) says that the moment of consecration becomes more common, and my own study suggests that this is so, at least for Germany. But, as I point out below, the bleeding Man of Sorrows is a representation of sacrifice and sometimes occurs in what is not specifically the moment of consecration; in the piety of the period, the "Schmerzensmann" is sometimes understood as a trigger of penitence and guilt; it is not necessarily eucharistic in the narrow sense of real presence.

19. Thurston, "Mass of St. Gregory" (as in note 5), 305; Westfehling, *Die Messe Gregors des Grossen* (as in note 1), 42–43; Nemilov, "Gedanken zur geschichtswissenschaftlichen Befragung" (as in note 6); G. Schiller, *Iconography of Christian Art*, trans. J. Seligman, 2 vols. (Greenwich, Conn., 1972), vol. 2, 226–28. It seems that, from at least the twelfth century on, the pope would have removed his tiara (as bishops today remove the mitre) during the canon of the Mass. See J. Braun, *Die liturgische Gewandung im Occident und Orient: nach Ursprung und Entwicklung, Verwendung und Symbolik* (Freiburg im Breisgau, 1907, reprinted Darmstadt, 1964), 485–87; and on the tiara as a form of mitre, see G. B. Ladner, "Der Ursprung und die mittelalterliche Entwicklung der päpstlichen Tiara," in *Roland Hampe zum 70. Geburtstag am 2. Dezember 1978 dargebracht von Mitarbeitern, Schülern und Freunden*, 2 vols., ed. H. A. Cahn and E. Simon (Mainz, 1980), vol. 1, 449–81, and vol. 2, pls. 86–93.

20. See below note 49.

21. On Benningen, see Heuser, " 'Heilig-Blut' in Kult und Brauchtum" (as in note 11), 71, 81–82; on Andechs, ibid., 68–69; Browe, "Die eucharistischen Verwandlungswunder" (as in note 11), 138 n. 4; and note 57 below. For the connection to Gregory's eucharistic devotion, see the work of Schrade, "Beiträge zur Erklärung des Schmerzensmannbildes" (as in note 5).

22. On the Veronica as representing the host, see Hamburger, "Seeing and Believing" (as in note 3), 54. On the Nuremberg Gregorymass, see Schiller, *Iconography* (as in note 19), vol. 2, 227 and pl. 80. For the Mass of Bolsena, see W. Brückner, "Liturgie und Legende: Zur theologischen Theorienbildung und zum historischen Verständnis von Eucharistie-Mirakeln," *Jahrbuch für Volkskunde* 19 (1996), 139–66; and Hirn, *Sacred Shrine* (as in note 6), 126. The fresco reproduced in P. Camporesi, "The Consecrated Host: A Wondrous Excess," in *Fragments for a History of the Human Body*, ed. M. Feher with R. Naddaff and N. Tazi, 3 vols. (New York, 1989), vol. 1, 220, is a related miracle. Plate 2 is London, B.L., Ms. Add. 17047, f. 1v, a Venetian miniature; see Schiller, *Iconography* (as in note 19), vol. 2, pl. 760. Thurston ("Mass of St. Gregory" [as in note 5], 305) gives an example of a depiction of a eucharistic miracle that is not a Gregorymass and makes the point I make here.

23. For sensitive interpretation of several images with the Man of Sorrows bleeding into the chalice, see d'Hainaut-Zveny, "Les Messes de saint Grégoire" (as in note 5), 42, who takes the image as "militant confirmation of the contested doctrine of transubstantiation."

24. See F. von Dreden and H.-G. Scholten, *St. Maria zur Wiese in Soest: Ein Führer durch die Kirche* (Soest, 1996), 26–29. The pope's gesture and the fact that an acolyte holds his chasuble suggest the moment of consecration; the fact that he wears his tiara suggests, however, that the image may conflate several moments and motifs. See note 19 above. The companion image on the left outer wing is Mary cradling the dead Christ in her lap at the foot of the cross; the predella, which is of an earlier date, depicts three revelations of Christ: his appearance to the Magda-

lene as a gardener, his appearance to Doubting Thomas, and his manifestation to the Three Kings.

25. For an interpretation that takes all encounters with Christ as a kind of spiritual communion, see C. M. A. Caspers, "*Meum summum desiderium est te habere:* L'Eucharistie comme sacrement de la rencontre avec Dieu pour tous les croyants (ca. 1200–ca. 1500)," in *Fête-Dieu*, ed. Haquin (as in note 1), 127–51; C. M. A. Caspers, "The Western Church during the Late Middle Ages: *Augenkommunion* or Popular Mysticism," in *Bread of Heaven: Customs and Practices Surrounding Holy Communion. Essays in the History of Liturgy and Culture*, ed. C. Caspers, G. Lukken, and G. Rouwhorst (Kampen, The Netherlands, 1995), 83–97; and Oliver, "Image et dévotion" (as in note 1). See also Schrade, "Beiträge zur Erklärung des Schmerzensmannbildes"; Eisler, "The Golden Christ of Cortona"; and Belting, *The Image and Its Public* (all as in note 5), especially 75–80, who see the Man of Sorrows as basically a eucharistic image. I am not completely convinced by such interpretation. In my opinion, little is gained simply by declaring everything in fifteenth-century piety to be eucharistic, as Caspers and Oliver tend to do, much as I admire their reaction against previous knee-jerk condemnations of late medieval piety as mechanistic. I do not think, for example, that all of the emphasis on suffering and blame in the prayers and iconography is preparation for spiritual communion. As Douglas Gray pointed out long ago, the theme of reproach takes on a life of its own. See D. Gray, "The Five Wounds of Our Lord," *Notes and Queries* (1963), 50–51, 82–89, 127–34, 163–68. See also notes 97 and 98 below.

26. J. Baschet, "Âme et corps dans l'Occident médiéval: Une dualité dynamique, entre pluralité et dualisme," *Archives de sciences sociales des religions* 112 (2000), 5–30, esp. 7; J.-C. Schmitt, *Ghosts in the Middle Ages: The Living and the Dead in Medieval Society*, trans. T. L. Fagan (Chicago, 1998), 22–24.

27. Hamburger, "Seeing and Believing" (as in note 3), 48–52. Also see Thomas Aquinas, *Summa theologiae* 2–2, q. 103, arts. 2–3.

28. For example, Christina Ebner of Engelthal, whose visions were often to her moments of glory, responded with terror, not welcome, when she saw Christ hanging on the cross at the elevation. See L. P. Hindsley, *The Mystics of Engelthal: Writings from a Medieval Monastery* (New York, 1998), 160.

29. On the veiling of presence, see M. Dutton, "Eat, Drink, and Be Merry: The Eucharistic Spirituality of the Cistercian Fathers," in *Erudition at God's Service*, ed. J. R. Sommerfeldt, Studies in Medieval Cistercian History 11 (Kalamazoo, Mich., 1987), 9–10; G. Macy, *The Theologies of the Eucharist in the Early Scholastic Period: A Study of the Salvific Function of the Sacrament According to the Theologians, 1080–1220* (Oxford, 1984), 28–51, 72, and 108 (Macy tends to underestimate the element of sacrifice in twelfth-century eucharistic theology); J. Pelikan, *The Growth of Medieval Theology (600–1300)*, vol. 3 of *The Christian Tradition: A History of the Development of Doctrine* (Chicago, 1978), 199; Rubin, *Corpus Christi* (as in note 2), 91 n. 56; Stock, *Implications of Literacy* (as in note 9), 290–91; and K. Berg, "Der Traktat des Gerhard

von Köln über das kostbarste Blut Christi aus dem Jahre 1280," in *900 Jahre Heilig-Blut-Verehrung in Weingarten, 1094–1994: Festschrift zum Heilig-Blut-Jubiläum am 12. März 1994*, ed. N. Kruse and H. U. Rudolf, 3 vols. (Sigmaringen, 1994), vol. 1, 442, 449–50. Also see Thomas Aquinas, *Sentence* Commentary bk. 4, d. 10, q. 1, art. 1.

30. Alger of Liège, *De sacramentis*, bk. 2, chap. 3 (PL 180:815). A similar point about Christian and Hindu food rituals as veiled (and hence, to their adherents, superior) cannibalism is made by the modern scholar Wendy Doniger, *Other People's Myths: The Cave of Echoes* (New York, 1988), 116–18.

31. Roger Bacon, *The Opus Maius of Roger Bacon*, trans. R. B. Burke, 2 vols. (Philadelphia, 1928), vol. 2, 822. P. J. Fitzpatrick ("On Eucharistic Sacrifice in the Middle Ages," in *Sacrifice and Redemption: Durham Essays in Theology*, ed. S. W. Sykes [Cambridge, 1991], 129–56, esp. 134) thus sees the elements as a kind of "camouflage."

32. Aquinas, *Sentence* Commentary bk. 4, d. 10, q. 1, art. 4; *Summa theologiae* 3, q. 77, art. 1, and q. 80, art. 4 ad 4. See also Hirn, *Sacred Shrine* (as in note 6), 124–25, 135–36; and P. Browe, "Die scholastische Theorie der eucharistischen Verwandlungswunder," *ThQ* 110 (1929), 305–32. For Scotus, see ibid., 309–10 n. 2; for Cusanus, ibid., 313–14 n. 2. For resistance to miracles of lasting transformation, see Browe, "Die eucharistischen Verwandlungswunder" (as in note 11).

33. For Gerson, see G. J. C. Snoek, *Medieval Piety from Relics to the Eucharist: A Process of Mutual Interaction*, Studies in the History of Christian Thought 63 (Leiden, 1995), 373. For Biel, see A. Goossens, "Résonances eucharistiques à la fin du moyen âge," in *Fête-Dieu*, ed. Haquin (as in note 1), 173–91, esp. 177; and Browe, "Die scholastische Theorie" (as in note 32), 311 n. 2.

34. H. Kühne, " 'Ich ging durch Feuer und Wasser . . . ' Bemerkungen zur Wilsnacker Heilig-Blut-Legende," in *Theologie und Kultur: Geschichten einer Wechselbeziehung. Festschrift zum einhundertfünfzigjährigen Bestehen des Lehrstuhls für Christliche Archäologie und kirchliche Kunst an der Humboldt-Universität zu Berlin*, ed. G. Strohmaier-Wiederanders (Halle, 1999), 51–84, esp. 54. On Wilsnack, see also Heuser, " 'Heilig-Blut' in Kult und Brauchtum" (as in note 11), 26–27, 77–79; H. Boockmann, "Der Streit um das Wilsnacker Blut: Zur Situation des deutschen Klerus in der Mitte des 15. Jahrhunderts," *Zeitschrift für historische Forschung* 9, no. 4 (1982), 385–408; C. Zika, "Hosts, Processions and Pilgrimages: Controlling the Sacred in Fifteenth-Century Germany," *Past and Present* 118 (1988), 25–64; and notes 62 and 108 below.

35. Browe, "Die eucharistischen Verwandlungswunder" (as in note 11), 156–57 nn. 60 and 61.

36. Brückner, "Liturgie und Legende" (as in note 22), 139–66, esp. 151; Browe, "Die scholastische Theorie" (as in note 32), 324–32; Browe, "Die eucharistischen Verwandlungswunder" (as in note 11), 157; N. Vincent, *The Holy Blood: King Henry III and the Westminster Blood Relic* (Cambridge, 2001), 122. In reading such discussion, it is hard not to be reminded that the story of Gregory and the doubting woman, as circulated in fifteenth-century manuals for preachers, stressed the *re-transformation* of

finger into bread, which was consumed by the female doubter.

37. Browe, "Die scholastische Theorie" (as in note 32), 319–20. This was a minority opinion.

38. Browe, "Die scholastische Theorie" (as in note 32), 319–20; Kühne, "'Ich ging durch Feuer und Wasser'" (as in note 34); Boockmann, "Der Streit" (as in note 34); and *Lexikon für Theologie und Kirche*, ed. J. Höfer and K. Rahner, 2nd ed., vol. 2 (Freiburg, 1958), s.v. "Blut Christi" (R. Haubst), "Bluthostien" (R. Bauerreiss), and "Blutwunder" (A. Winklhofer), cols. 544–49.

39. Browe, *Die eucharistischen Wunder* (as in note 11), 151, 162–66, 185–87; *Dictionnaire de théologie catholique*, ed. A. Vacant, E. Mangenot, and E. Amann, vol. 14 (Paris, 1939), s.v. "Sang du Christ" (M.-D. Chenu), cols. 1094–97; Heuser, "'Heilig-Blut' in Kult und Brauchtum" (as in note 11), esp. 77–79; *Theologische Realenzyklopädie*, ed. G. Krauss, G. Müller, et al., vol. 6 (Berlin, 1980), s.v. "Blut und Blutglaube im Mittelalter" (W. Michel), 737–38; H. U. Rudolf, "Die Heilig-Blut-Verehrung im Überblick: Von den Anfängen bis zum Ende der Klosterzeit (1094–1803)," in *900 Jahre* (as in note 29), vol. 1, 3–51, esp. 13–16; W. Kasper, "Der bleibende Gehalt der Heilig-Blut-Verehrung aus theologischer Sicht," in *900 Jahre*, 377–86; P. Dinzelbacher, "Das Blut Christi in der Religiosität des Mittelalters," in *900 Jahre*, 415–34; Snoek, *Medieval Piety* (as in note 33), 290, 356–57, and 376–79; Vincent, *Holy Blood* (as in note 36), 82–136; C. Bynum, "Das Blut und die Körper Christi im späten Mittelalter: Eine Asymmetrie," *Vorträge aus dem Warburg-Haus* 5 (2001), 75–119; and C. Bynum, "The Blood of Christ in the Later Middle Ages," *ChHist* 71 (2002), 685–715.

40. Browe, "Die scholastische Theorie" (as in note 32), 325–32; Boockmann, "Der Streit" (as in note 34), 391–92; Brückner, "Liturgie und Legende" (as in note 22); Vincent, *Holy Blood* (as in note 36), 82–117. Authorities sometimes even *replaced* wonderhosts with freshly consecrated ones; see Snoek, *Medieval Piety* (as in note 33), 290 and 378.

41. See Heuser, "'Heilig-Blut' in Kult und Brauchtum" (as in note 11), 78 and 107. I return to these points below. I should add here that I have not forgotten that the fifteenth century is the period of Lollardy in England and the Hussite revolution in Bohemia, in which movements access to and interpretation of the Eucharist were at issue. Nonetheless, the geographical distribution of Gregorymass iconography does not suggest that it should be seen as propaganda for a eucharistic theology counter to theirs.

42. Bertelli ("The *Image of Pity* in Santa Croce" [as in note 5]) emphasizes the ways in which the image is about seeing. On "ocularity," see note 1 above.

43. E. Duffy, *The Stripping of the Altars: Traditional Religion in England, c. 1400–c. 1580* (New Haven, Conn., 1992); Binski, "The English Parish Church" (as in note 1); Reudenbach, "Der Altar als Bildort" (as in note 1); Lewis, "Rewarding Devotion" (as in note 5).

44. Westfehling, *Die Messe Gregors des Grossen* (as in note 1), 32–34; d'Hainaut-Zveny, "Les Messes de saint Grégoire" (as in note 5), 50–51.

45. This altar has a carved Gregorymass in the central shrine and a very different version attributed to Wilm Dedeke on an outer wing; see B. Heise and H. Vogeler, *Die Altäre des St. Annen-Museums: Erläuterung der Bildprogramme* (Lübeck, 1993), 67–73, and below at note 81. Even when an image is a retable or central shrine, it is not necessarily a backdrop or frame for the liturgy. As Binski and Duffy remark (Duffy, *Stripping* [as in note 43], 96; Binski, "The English Parish Church" [as in note 1], 5), retables were sometimes covered to prevent them from interfering with what was seen.

46. I shall not here discuss the related and much debated question of the origin of the Gregorymass motif (often and quite plausibly said to reside in Carthusian propaganda for a Byzantine icon in the church of Santa Croce in Gerusalemme in Rome). See Bertelli, "The *Image of Pity* in Santa Croce" (as in note 5).

47. The motif of the poor souls is connected to the major themes of the Gregorymass by the fact, first, that Mass (if Mass is being said) can be offered for the souls of the dead; second, by the presence in some versions of indulgence tables detailing what can be won through the image; and third, by ancient traditions concerning Gregory's advocacy for souls in purgatory. (These went back to the story of Gregory praying Trajan out of hell.)

48. See above note 24.

49. Bauerreiss, "Der 'gregorianische' Schmerzensmann" (as in note 5), 59–61. Sometimes the text says in which "species" or "effigies" Christ appeared. (These early references are confusing; one says "specie ignis.") Sometimes the texts identify the church of the apparition; this is often, but not always, Sta. Croce in Gerusalemme in Rome. Frequently, but not in the oldest versions, the text locates the vision in another way: "while Gregory was celebrating Mass" or "while he was contemplating the Sacrament." Sometimes we are told explicitly that Gregory had the image made to depict his vision. See also Endres, "Die Darstellung der Gregoriusmesse"; Bertelli, "The *Image of Pity* in Santa Croce"; and Lewis, "Rewarding Devotion" (all as in note 5). The number of *Pater Nosters* and *Ave Marias* and of years of indulgence on the plaques vary; the prayers are typically five, the indulgence for 14,000 years. Sometimes in books of hours, additional prayers to be said are given, especially the so-called Seven O's of St. Gregory; see Thurston, "The Mass of St. Gregory" (as in note 5), 312.

50. In a number of these the pope on the left with tiara is balanced by a mitred bishop on the right. The presence of the bishop has not been explained, but it seems likely that it is a reflection of the indulgence text, which often reads that a pope (usually Gregory) gave so many years of indulgence, to which a local bishop added another so many.

51. In Lewis's interpretation ("Rewarding Devotion" [as in note 5]), what the object depicts is almost a relic, parallel to indulgenced images of the Veronica. To Bertelli ("The *Image of Pity* in Santa Croce" [as in note 5]), it represents an *archeiropoieta*, an exact copy (under Gregory's direction) of Christ as he appeared. The point is, however, that it is not quite either. Even if an exact copy, it is an exact copy of a vision, not of a portrait of Christ handed down from heaven or of a relic (or contact relic) of Christ's body.

52. For the large number of engravings, see Thurston,

"The Mass of St. Gregory," and for use of the image in manuscripts, Lewis, "Rewarding Devotion" (both as in note 5); for the Man of Sorrows as cemetery art, see R. Bauerreiss, *Pie Jesu: Das Schmerzensmann-Bild und sein Einfluss auf die mittelalterliche Frömmigkeit* (Munich, 1931). An early epitaph from Nuremberg combines a Gregorymass with the Nativity; see *Kataloge des Germanischen Nationalmuseums zu Nürnberg: Die Gemälde des 13. bis 16. Jahrhunderts*, ed. E. Lutze and E. Wiegand (Leipzig, 1937), *Bilderband*, pl. 20.

53. See notes 44 and 45 above. In the area of Braunschweig, it is popular for the predella; see H. G. Gmelin, *Spätgotische Tafelmalerei in Niedersachsen und Bremen* (Munich and Berlin, 1974), passim.

54. See, for example, note 24 above (Soest) and note 113 below (Lambertikirche, Aurich).

55. For the Lüneburg altar, see Gmelin, *Spätgotische Tafelmalerei* (as in note 53), 156–64. For the association with Christopher and protection, see D. Rigaux, "Autour de la dispute *De sanguine Christi*," in *Le Sang au Moyen Age: Actes du quatrième colloque international de Montpellier, Université Paul-Valéry (27–29 novembre 1997)*, ed. M. Faure (Montpellier, 1999), 400.

56. See, for example, *Kataloge des Germanischen Nationalmuseums zu Nürnberg* (as in note 52), pl. 117.

57. For examples, see Bauerreiss, "Der 'gregorianische' Schmerzensmann" (as in note 5) (on Andechs); Brückner, "Liturgie und Legende" (as in note 22) (on Walldürn); *Ev. Kirche St. Nicolai Bad Wilsnack: Ein Führer* (Regensburg, 1994), 12–18 (for the Wilsnack bloodchest); and (for the Mary altar at Wienhausen, which apparently housed a blood relic and had a Gregorymass on the outer wing), see H. Appuhn, *Kloster Wienhausen* (Wienhausen, 1986), pls. 27–28, and Gmelin, *Spätgotische Tafelmalerei* (as in note 53), 457–66. See also Bynum, "Das Blut und die Körper Christi" (as in note 39).

58. D'Hainaut-Zveny, "Les Messes de saint Grégoire" (as in note 5), 61. She notes the large number of such images on outer wings or predellas but does not comment on the split image (56–58).

59. Westfehling (*Die Messe Gregors des Grossen* [as in note 1], 27–32) points out the display of ecclesiastical power. For examples, see Borchgrave d'Altena, "La Messe de saint Grégoire" (as in note 5), 13, and pls. 16, 24, and 26; and (from Lübeck) Heise and Vogeler, *Die Altäre des St. Annen-Museums* (as in note 45), 26.

60. For examples, see Borchgrave d'Altena, "La Messe de saint Grégoire" (as in note 6), 17–19 and pls. 20–23; and d'Hainaut-Zveny, "Les Messes de saint Grégoire" (as in note 5), pls. 5 and 6.

61. Gmelin, *Spätgotische Tafelmalerei* (as in note 53), 638; and see note 113.

62. In the case of the holy blood cabinet at Wilsnack, a split Gregorymass on the outer doors (Fig. 5) opened to reveal a monstrance holding both the supposed wonderhosts (objects of an enormously popular pilgrimage) and a freshly consecrated host; the inner doors flanked the monstrance with, on the left, a Throne of Grace (an image of the Trinity in which the Father holds the crucified Son), and on the right, a Mocking of Christ in which Christ's body

bears stark red clots of blood, and the scoffing soldiers, with heavily Jewish faces, hold lances. Thus the body and blood of Christ are here displayed between a Trinitarian image, often explicitly understood to be eucharistic (it is, for example, frequently the *Te igitur* image in Mass books; see Oliver, "Image et dévotion" [as in note 1], 161–64) and an image associated with reproach (against Jews and against all Christians as sinners). The Gregorymass itself (with its little Christ figure positioned far to the left) emphasizes less the appearance of Christ to Gregory than, appropriate to a pilgrimage spot, the long row of those attending. The inscription above—"adoratio salutis est istud . . . mirabile in oculis meis"—suggests that what is important is the wonder that lies behind the doors.

63. It is important to note that there is no clear correlation between function and iconography.

64. Schiller, *Iconography* (as in note 19), vol. 2, 226–28, drawing on Berliner, "Arma Christi" (as in note 5), and Westfehling, *Die Messe Gregors des Grossen* (as in note 1).

65. For an example, see Nemilov, "Gedanken zur geschichtswissenschaftlichen Befragung" (as in note 6).

66. Westfehling, *Die Messe Gregors des Grossen* (as in note 1), 37–46. The angels found in French and many English examples may reflect John 1:51, or a passage from the *Dialogues* of Gregory the Great (bk. 4, chap. 58); see the discussion in Schrade, "Beiträge zur Erklärung des Schmerzensmannbildes" (as in note 5), 177.

67. See, for example, the Crucifixion altar from Wienhausen; Gmelin, *Spätgotische Tafelmalerei* (as in note 53), 468. It is interesting to note that this altar, made for a house of women, opens to a Crucifixion in which all of the mourning figures (except John) are women.

68. Caspers, "*Meum summum desiderium*" and "The Western Church during the Late Middle Ages" (both as in note 25); and see note 25 above.

69. Master of the Bartholomew Altar, 1480–95; Westfehling, *Die Messe Gregors des Grossen* (as in note 1), 52–53, pl. 20.

70. Berliner, "Arma Christi" (as in note 5), 68; see also Schiller, *Iconography* (as in note 19), vol. 2, pl. 690.

71. See notes 25 and 38 above, note 94 below, and *Ancient Devotions to the Sacred Heart of Jesus by Carthusian Monks of the XIV–XVII Centuries* (London, 1895; 2nd ed., 1920), esp. 1–4, 17–28, 47–48, 61–62, and 185.

72. Berliner and Westfehling make the point; a number of scholars neglect it.

73. Westfehling, *Die Messe Gregors des Grossen* (as in note 1), 34 and 42.

74. Altar painting of 1489/90 from Augsburg, now in Munich, Bayer. Staatsgemäldesammlung, inv. 4633; Schiller Archives, Warburg Haus, Hamburg, inv. H-512/ 35-37.

75. Meiss, *French Painting* (as in note 17), pl. 43, and see note 17 above.

76. On medieval methods of meditation before devotional objects, see Suckale, "*Arma Christi*" (as in note 4). On devotional images as loci of paradox, see Schrade, "Beiträge zur Erklärung des Schmerzensmannbildes," and Ridderbos, "The Man of Sorrows" (both as in note 5). For an example, from 1443, see Schiller, *Iconography* (as in note 19), vol. 2, pl. 747.

77. Borchgrave d'Altena, "La Messe de saint Grégoire" (as in note 5), 7, pl. 6. This is not to say that there are not composite types.

78. Another way of putting this is to speak, as d'Hainaut-Zveny does, using the ideas of Philippot and Białostocki, of the "levels of reality" in the paintings. See her "Les Messes de saint Grégoire" (as in note 5), 36.

79. From about 1500; Westfehling, *Die Messe Gregors des Grossen* (as in note 1), 51, pl. 19.

80. Master of the Aachen Altar, about 1500, Utrecht, Rijksmuseum at the Catherine Convent; Westfehling, *Die Messe Gregors des Grossen* (as in note 1), 54, pl. 21.

81. See Heise and Vogeler, *Die Altäre des St. Annen-Museums* (as in note 45), 67–73.

82. Westfehling, *Die Messe Gregors des Grossen* (as in note 1), pl. 22; for another example of a gesture toward the purgatory theme, which puts it on another level of reality, see Borchgrave d'Altena, "La Messe de saint Grégoire" (as in note 5), 23, pl. 27.

83. See note 57 above and note 98 below.

84. Binski, "The English Parish Church" (as in note 1).

85. Although it is beyond the scope of this paper to explore why the motif disappeared so rapidly in the late sixteenth century, the fact that it did so just at the moment when transubstantiation was finally defined gives further support to my contention that it is not an illustration of that doctrine. I would suggest that the disappearance of Gregorymass iconography is clearly related to the Tridentine stress on sacramental rather than spiritual reception, to the de-emphasis on indulgences consequent upon Protestant attack, and to the post-Tridentine opposition to host- and blood-miracles. (On the latter point, see Browe, "Die scholastische Theorie" [as in note 32], 313, and see above on the large number of indulgenced Gregorymasses.) If this is correct, it lends further support to my argument that the Gregorymass is about a seeing and seeing beyond that is characteristic of fifteenth-century spirituality.

86. H. Lutterbach, "The Mass and Holy Communion in the Medieval Penitentials (600–1200): Liturgical and Religio-Historical Perspectives," in *Bread of Heaven*, ed. Caspers et al. (as in note 25), 61–81; Snoek, *Medieval Piety* (as in note 33); and Brückner, "Liturgie und Legende" (as in note 22), 139–66.

87. Bauerreiss, *Pie Jesu* (as in note 52); Browe, *Die Eucharistischen Wunder* (as in note 11); Snoek, *Medieval Piety* (as in note 33), esp. 196, 282, 290, 311–19; Soergel, *Wondrous in His Saints* (as in note 2), 22–25; Dinzelbacher, "Die 'Realpräsenz' der Heiligen" (as in note 2); and see note 25 above and note 98 below.

88. Sigal, *L'Homme et le miracle* (as in note 2); W. A. Christian, *Apparitions in Late Medieval and Renaissance Spain* (Princeton, 1981); and see note 2 above. On the competition between Eucharist and relics, see Hirn, *Sacred Shrine* (as in note 6), 135–36, and Pelikan, *Growth of Medieval Theology* (as in note 29), 180ff. Snoek (*Medieval Piety* [as in note 33]) treats them as parallel.

89. Hirn, *Sacred Shrine* (as in note 6), 79–80, 136, and 162–66, citing evidence from Durandus and Honorius Augustodunensis.

90. Eisler, "The Golden Christ of Cortona" (as in note 5), 238. Although Eisler may go too far in his interpretation, which the theological discussion of the period would clearly refute, the implication is there.

91. On the absence in eucharistic presence, see B. Pranger, "Le Sacrement de l'eucharistie et la prolifération de l'imaginaire aux XIe et XIIe siècles," in *Fête-Dieu*, ed. Haquin (as in note 1), vol. 1, 97–116. On the inwardness of spiritual communion, see Caspers, "*Meum summum desiderium*," and "The Western Church during the Late Middle Ages" (both as in note 25). See also N. Mitchell, OSB, *Cult and Controversy: The Worship of the Eucharist outside Mass* (New York, 1982), 163–86.

92. Megivern, *Concomitance and Communion* (as in note 12).

93. See note 33 above.

94. On this point, see C. W. Bynum, "Violent Imagery in Late Medieval Piety," *Bulletin of the German Historical Institute* 30 (Spring 2002), 3–36, esp. 22–23.

95. A reminder of this is the example from Gertrude of Helfta discussed by Jeffrey Hamburger in "Seeing and Believing" (as in note 3), 59–60.

96. Dinzelbacher, "Das Blut Christi" (as in note 39). As Megivern (*Concomitance and Communion* [as in note 12]) points out, the old argument that the doctrine of concomitance was developed to justify the withdrawal of the cup is untenable. The roots of the idea are in early medieval efforts to refute the notion that receiving communion divides Christ into pieces.

97. Schrade, "Beiträge zur Erklärung des Schmerzensmannbildes" (as in note 5), 168–70; L. Gougaud, *Dévotions et pratiques ascétiques du Moyen Age*, Collection Pax 21 (Paris, 1925), 74–128; Gray, "Five Wounds" (as in note 25); J. A. W. Bennett, *Poetry of the Passion: Studies in Twelve Centuries of English Verse* (Oxford, 1982), 43–45; N. Morgan, "Longinus and the Wounded Heart," *Wiener Jahrbuch für Kunstgeschichte* 46–47: *Beiträge zur mittelalterlichen Kunst* pt. 2 (1993–94), 507–18; Schiller, *Iconography* (as in note 19), vol. 2, 184–98. On the early medieval background to this sense of blood as blame and guilt, see now R. Fulton, *From Judgment to Passion: An Intellectual History of Devotion to Christ and the Virgin Mary* (New York, 2002). I elaborate upon this theme in "Violent Imagery" (as in note 94). Blaming Christians as the "new Jews" is a theme in the treatise edited in Berg, "Der Traktat des Gerhard von Köln" (as in note 29).

98. See note 38 above. For the suggestion that the "Schmerzensmann" image itself triggered pilgrimage and pogrom, see Bauerreiss's unjustly neglected study, *Pie Jesu* (as in note 52). See also Browe, *Die Eucharistischen Wunder* (as in note 11). Mitchell Merback of Depauw University is at work on a major study of sites of pilgrimage and pogrom in southern Germany.

99. Macy, "The Dogma of Transubstantiation" (as in note 9).

100. McCue, "The Doctrine of Transubstantiation from Berengar through the Council of Trent"; Sylla, "Autonomous and Handmaiden Science"; Macy, "The Dogma of Transubstantiation"; and Burr, *Eucharistic Presence and Conversion* (all as in note 9).

101. Burr, *Eucharistic Presence and Conversion* (as in note 9), esp. 100–107.

102. Innocent III, *Mysteriorum evangelicae legis et sacramenti eucharisticae libri sex*, IV, 20 (PL 217:871B–D); and see Jorissen, *Die Entfaltung der Transsubstantiationslehre* (as in note 9), 95–97.

103. Burr, *Eucharistic Presence and Conversion* (as in note 9), 17–18, citing Albert's *Sentence* Commentary of 1249.

104. Burr, *Eucharistic Presence and Conversion* (as in note 9).

105. Macy, "The Dogma of Transubstantiation" (as in note 9); Dutton, "Eat, Drink, and Be Merry" (as in note 29); Schrade, "Beiträge zur Erklärung des Schmerzensmannbildes" (as in note 5); and Goossens, "Résonances eucharistiques" (as in note 33), esp. 175–78. For technical questions about whether the body of Christ can bilocate, see Browe, "Die scholastische Theorie" (as in note 32), 312.

106. See Hindsley, *The Mystics of Engeltha* (as in note 28), 127–28. For another example, see the passage from William of St. Thierry cited in Caspers, "*Meum summum desiderium*" (as in note 25), 137.

107. Hindsley, *The Mystics of Engelthal* (as in note 28), 80. Schrade ("Beiträge zur Erklärung des Schmerzensmannbildes" [as in note 5]) discusses passages and images in which the eucharistic elements are lifted up rather than Christ descending.

108. A recent study by Hartmut Kühne of the Wilsnack Legend, our only early account of the wonderhosts that is not directly part of the huge amount of polemical literature concerning their authenticity, suggests that the original miracle was understood as one of holy matter surviving through fire and water rather than as a revelation of Christ's presence. The original story was of hosts found undamaged and spotted with red after the church burned to the ground and was subsequently flooded by rain. Into this account, there appears to have been interpolated another story that concerns the bishop of Havelberg. Arriving shortly after the original events, he was apparently prepared to reconsecrate the miracle-hosts, fearing that they were unconsecrated wafers now adored by the faithful in idolatrous circumstances. But when he saw, in a vision, the blood of Christ run from the middle host over the edge of the corporal, his doubts disappeared and he abstained from the *iniuria* of double consecration. See Kühne, " 'Ich ging durch Feuer und Wasser' "; see also Boockmann, "Der Streit" (both as in note 34). Kühne interprets the legend as folk material, in opposition to the eucharistic interpolation. Soergel (*Wondrous in His Saints* [as in note 2], 172–73) also sees a split between clerical and lay attitudes in Bleeding Host cults, although of a different sort. I see parallels between the folk concern and the theological emphasis on immutability.

109. Snoek, *Medieval Piety* (as in note 33), 189–90, 222, 319–22, and 328–34. For an account (ca. 1300) of holy blood surviving unscathed through fire, see appendix 4 in Vincent, *Holy Blood* (as in note 36), 209–10.

110. Browe, "Die eucharistischen Verwandlungswunder" (as in note 11), 148. The parallel to the increasing concern for incorruptibility of holy cadavers is obvious, although I cannot explore it here. See C. W. Bynum, *The Resurrection of the Body in Western Christianity, 200–1336* (New York, 1995), 200–25, 320–29.

111. Brückner, "Liturgie und Legende" (as in note 22), 139–66. And see Browe, "Die eucharistischen Verwandlungswunder" (as in note 11), 161–64, for other examples.

112. See notes 97 and 98 above. And see Snoek, *Medieval Piety* (as in note 33), 311–19, for examples of bleeding as testimony both to violation and to sacred presence. I should point out that Heuser (" 'Heilig-Blut' in Kult und Brauchtum" [as in note 11], 69), who does not consider iconography, interprets the evolution of the Gregory legend as moving away from vision, in the earliest version by John the Deacon, and toward a stress on holy matter in the story of the hosts of Andechs.

113. Gmelin, *Spätgotische Tafelmalerei* (as in note 53), 636–40.

115. See note 95 above.

Porous Subject Matter and Christ's Haunted Infancy

Alfred Acres

Lurkings of evil in several famous Renaissance paintings were not much noted in modern writing about them before the middle of the twentieth century. In 1945, Meyer Schapiro published an article explaining the mousetrap in the right wing of the Mérode triptych as a symbol of God's plan to ensnare the devil with the incarnation of Christ (Fig. 1).[1] Eight years later in the same journal, the *Art Bulletin*, Lotte Brand Philip published an article on the *Epiphany* triptych of Hieronymus Bosch, the central claim of which was that an unsavory character in the doorway of the shed is the Antichrist himself, standing ready as the Messiah is revealed to the powers of the world.[2] And a few years after that, in 1960, Robert Walker published a short notice calling attention to the nearly invisible demon in Hugo van der Goes's Portinari Altarpiece, a creature buried in shadows behind the ox in the center panel (Fig. 2).[3] Taken together, these detections of supernatural menace or its prospect at the margins of a scene suggest that a previously inconspicuous theme was coming into view in these years. We can assume that such elements were more apparent—at least to some observers—when the paintings were made, since it is hard to imagine an artist's decision to include something that was meant to be overlooked. But how, exactly, were they supposed to be seen? Their modern elusiveness—in terms of interpretation, visibility, or both—prompts reflection on the ways in they were initially intended and perceived.

In some ways, new recognition of such hauntings of Christ's infancy in Renaissance images during the 1940s and the decades following is not surprising.[4] The booming art-historical scholarship of the period was marked by an especially strong taste for iconographic research, which demanded a widening scope of scrutiny within images. Although none of the intimations is prominent in the scene it occupies, these were years in which unassuming objects, marginal figures, and obscure spaces in Renaissance pictures, especially Netherlandish ones, were inviting curiosity of a sort that had not surfaced much in earlier writing about them. Elements previously regarded as naturalistic context were being explored as untapped reservoirs of meaning.

Still, while this may help explain such renewed recognitions, there remain basic questions about the specters of evil in these and other Infancy images. Why, for example, did the painters introduce such a presence, which is not mentioned in gospel accounts of the Infancy? Various patristic and later medieval texts recount dimensions of a struggle between Satan and God over

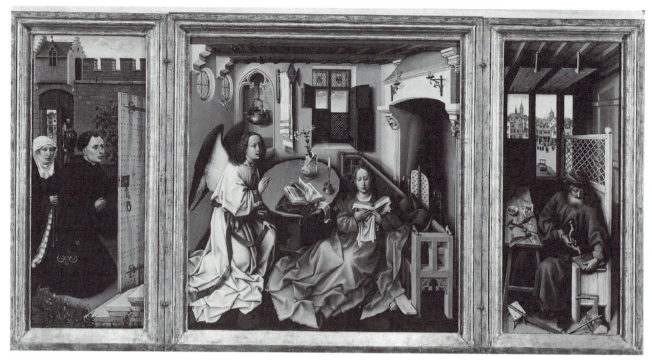

1. Robert Campin, Mérode Altarpiece, *Annunciation*, ca. 1427. Oil on wood, 64.1 × 117.8 cm. New York, The Metropolitan Museum of Art, The Cloisters Collection, 1956 (56.70)

Christ's incarnation, some of which have been adduced to explain what occurs in individual images. In most cases, however, these texts cannot be firmly linked to the image in question, and it seems clear that no single text can account for the range of such imagery that emerged during the fifteenth century. It must also be wondered why the painters persistently made this presence so oblique—in some cases to the point of virtual or actual invisibility. Demonic interference in the plan of salvation surely would have qualified as more than a theological footnote. If it is proposed that artists underplayed the presence so as to deny evil a starring role, it should be asked why they gave it any role at all. And if it is proposed that its low profile conveys the retreat or defeat of evil, it should be asked why the conquest is whispered rather than trumpeted within the images. Another question is more historiographic: Why have these elements drawn scholarly attention mainly as isolated cases rather than collectively? I am aware of no major study that addresses allusions to evil in Infancy scenes, despite the fact that they have been recognized in several of the most famous paintings of the period. Beyond the works already noted, some will think, for example, of the devils scurrying for cover in the foreground of Botticelli's *Mystic Nativity* (London, National Gallery).[5] Others will recall the green-feathered musician in the angel concert at the heart of the Isenheim Altarpiece (Colmar, Musée Unterlinden), whom Ruth Mellinkoff identifies as a benighted Lucifer, accompanying but not yet comprehending the Madonna and Child in the adjacent scene.[6]

Such questions can be answered only in tentative ways, and in order to do so it will be especially important to recognize that these hauntings seek unusual kinds of attention and reflection from an observer. With maneuverings of attention in mind, it will be possible to reconsider a major

work in which no such presence has been pursued before now and to suggest that in this painting, too, demonic presence was in play for the artist and the first generation of viewers. It will also become clear that inklings of evil at Christ's infancy are almost invariably—and significantly—accompanied by a premonition of his sacrifice.

Before proceeding, it should be asked how such a variety of images can constitute a group. Each mentioned thus far is an extraordinarily sophisticated work with strands of meaning tied closely to the circumstances of its patronage or artist. They were made in different generations and different cities, and they depict distinct events: the Annunciation, the Nativity, and the Adoration of the Magi. Even beyond these basic differences, their figurings of evil work in different ways. The Portinari Altarpiece and the *Mystic Nativity* are occupied by manifestly demonic figures—hiding in the one and fleeing in the other. The sinister figure in Bosch's Prado *Epiphany*, if he is the Antichrist, is not a demon or even the devil, strictly speaking.[7] If the creature in the Isenheim Altarpiece is Lucifer, he is more the devil than a demon—though these and related names blur widely in medieval thought.[8] And the painter of the Mérode triptych seems to have pictured no demonic presence at all, but instead an implement that calls metaphoric attention to his threat.[9]

In associating these and several other examples, I do not claim to frame a single subject that has been missed or underplayed in the scholarship, because they do not define a subject in any familiar sense of the term. Attention to the aims and means of several images that haunt Christ's infancy can, in fact, usefully test the modern idea of subject matter—which is more constricting than it is typically assumed to be. Because we recognize and categorize these works as being first and mainly about something else (an Annunciation, a Nativity, or a Madonna, etc.), our accounts of each handle references to evil as a detail, an isolatable part of something larger. It is, however, too often overlooked that details as they are generally conceived are in large measure a modern phenomenon.[10] They are the work of photographers, writers, editors, and lecturers who isolate something from the whole to make a point. Because fifteenth-century European painters were

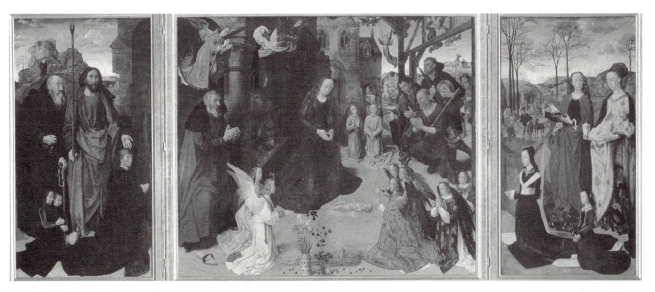

2. Hugo van der Goes, Portinari Altarpiece, ca. 1476–79. Oil on wood, 253 × 586 cm. Florence, Galleria degli Uffizi

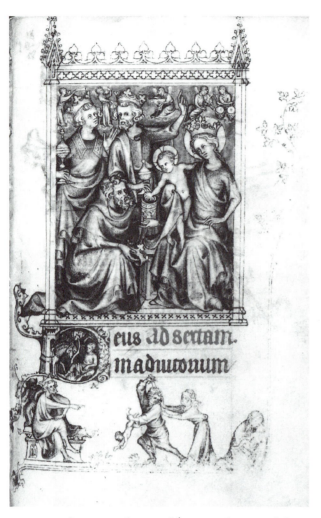

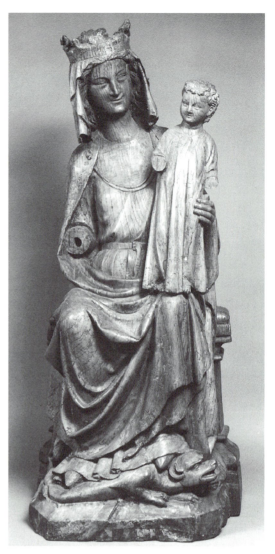

3. Jean Pucelle, Hours of Jeanne d'Évreux, *Adoration of the Magi with Herod and Massacre of the Innocents on the bas-de-page*, ca. 1324–28. New York, The Metropolitan Museum of Art, The Cloisters Collection

4. Madonna and Child with serpent beneath her feet. Wood, German, ca. 1270. Cologne, Museum Schnütgen

committed as never before to comprehensive integrations of spaces, figures, and other things, they would have been baffled by the tidy extraction—both visual and conceptual—of pictorial fragments of the sort today employed reflexively in lectures and publications (see, e.g., Figs. 6 and 7). While they funnel attention effectively to a given passage, such detail illustrations also allow one to think of the isolated areas as adjuncts to the scenes they occupy rather than as fully integrated elements.

Recent scholarship has repeatedly demonstrated the extent to which the structures of a medieval image could contribute at least as much to its meaning as did the selection of figures or things within.[11] Although this interpretive principle has seemed less pertinent for readings of fifteenth-century Christian images than for earlier ones, it becomes clear among the examples to

come that matters of location and relationship, which do not register among conventional categories or systematic indices of subject matter, were uniquely instrumental to articulations of evil close to the infant Christ. Considered together, they reveal a distinct pictorial dynamic of meaning in the fifteenth and early sixteenth centuries, with painters finding ways to draw thought toward uncharted implications of familiar kinds of scenes. They do so in terms that are neither narrative, symbolic, typological, nor allegorical. It will emerge instead that many, if not all, of these hauntings were devised to be as much the work of a viewer as of an artist, and that they moved in undefined spaces between the texts in which Christian images had their roots and the names subsequently given to those images.

It is useful to begin by noting some of the seeds of the idea in Scripture. The infancy narratives of Matthew and Luke make no mention of this threat to the newborn Christ, unless one assumes demonic inspiration behind the massacre of innocents dictated by Herod (Matt. 2:13–16). There is certainly precedent for doing so, as in numerous images that show the king advised by a demon as he issues the order or oversees the slaughter. This occurs, for example, in the Hours of Jeanne d'Évreux, where Herod receives foul council from behind as the children are massacred across the *bas-de-page* of the Adoration of the Magi scene (Fig. 3).[12] Such images of the Massacre of the Innocents are, however, unlike the imagery to be considered here, in that they account for the evil done by one mortal, rather than the less mediated, more ambient menace in the paintings to come.

A passage more closely associable with these paintings is the description of the woman clothed in the sun at the opening of Revelation 12:

> And a great sign appeared in Heaven: a woman clothed with the sun, and the moon under her feet, and on her head a crown of twelve stars. And being with child, she cried travailing in birth, and was in pain to be delivered. And there was seen another sign in Heaven: and behold a great red dragon, having seven heads, and ten horns: and on his head were seven diadems . . . and the dragon stood before the woman who was ready to be delivered; that, when she should be delivered, he might devour her son.

Theologians have generally interpreted these verses as referring not to the Nativity, but rather to messianic fulfillment in Christ's death and Resurrection.[13] Yet the tableau of a monstrous predator awaiting the birth of a divine child found its way into Marian imagery of the later Middle Ages, most frequently in the depiction of a serpent or dragon beneath her. Although that conjunction occurs often, for example, in German sculpture of the thirteenth and fourteenth centuries (Fig. 4),[14] it is perhaps less familiar to many today than the one that was advancing by the end of the fifteenth century, in which it is the moon rather than—or in addition to—a dragon beneath her feet. The image of the moon below the Virgin hews more closely to the Revelation text; although these verses do describe the dragon threatening before the child's birth, the subsequent ones report his defeat by Michael and the angels rather than by the woman herself, which is what is implied by the images in which she alone stands on him.

A text closer to the image of the trodden dragon is Genesis 3:15, a passage often associated with Revelation 12, especially for its Mariological resonance. After Adam blames Eve and she the serpent during their interrogation, God curses the serpent and says: "I will put enmities between thee and the woman, and thy seed and her seed: she shall crush thy head, and thou shalt lie in wait for her heel" [Inimicitias ponam inter te et mulierem, et semen tuum et semen illius: Ipsa

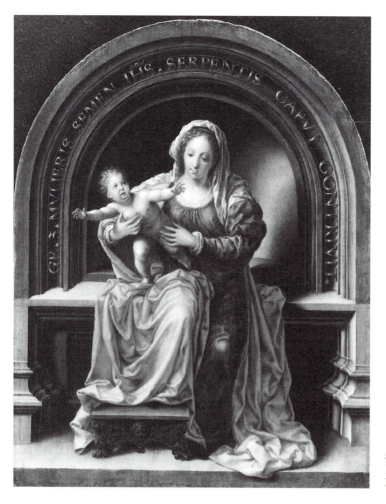

5. Jan Gossaert, Madonna and Child, ca. 1527. Oil on wood, 30.7 × 24.3 cm. London, National Gallery

conteret caput tuum, et tu insidiaberis calcaneo eius]. There may be no more explicit Mariological reading of this passage than a Jan Gossaert composition from the later 1520s known in several copies, the autograph version of which was recently revealed to be a panel in London (Fig. 5).[15] An upright Christ child lunges from atop the bench on which the Virgin is seated beside him. No additional figures or attributes are present, but gold letters in the arch surrounding them begin by citing Genesis 3, followed by: MVLIERIS SEMEN IHS. SERPENTIS CAPVT CONTRIVIT [Jesus, the seed of the woman, has bruised the head of the serpent].[16] These words paraphrase those of the Vulgate, which are written in the first person as God's promise to put enmity between the serpent and the woman, and between its seed and hers. In contrast, the panel's inscription is written in the third person and declares that the woman's seed, Jesus Christ, crushes the head of the serpent.[17] The shift thus makes the mentioned woman Mary rather than Eve, and reports the crushing of the serpent as an act accomplished rather than anticipated, as it is in Genesis 3:15. Because we began with images harboring diabolical menace, it must be asked whether the serpent of Genesis belongs in the same category. Modern biblical scholarship tends to reject identification of the tempter in Eden as Satan himself, but the serpent and the devil were often equated in apocalyptic and later literature.[18] The connection sounds explicit in Revelation 12:9, where, after the struggle

with Michael and his angels, it is related that "that great dragon was cast out, that old serpent, who is called the devil and Satan, who seduceth the whole world."

Whether or not Gossaert had in mind any textual evidence of the serpent-Satan connection, there can be no question that he transplanted the serpent of Genesis far beyond Eden to fulfill its defeat at the hands of the Messiah. Extracted from the narrative of the Fall, and named rather than shown, the creature assumes a more general character of evil to which the Christ child responds in a singular way: his otherwise inexplicably outstretched arms foretell the sacrifice by which he will vanquish the threat. The image thus makes a point that is not literally present in the New Testament, and does so with an unusual coordination of body language and text editing. Most striking of all is the painter's decision to cast a bridge between those modes in the gaze of Christ himself, who looks over his shoulder to target the word *serpentis* as his arms open outward. The ancient enemy and the child's mortal future are pulled together with a look and a reach.

One more biblical locus worth bearing in mind in this connection is the verse immediately following Isaiah's prophecy (7:14) of the Virgin birth. Isaiah 7:15 is less familiar to most than 7:14; together they read as follows: "Therefore the Lord himself shall give you a sign. Behold a virgin shall conceive, and bear a son, and his name shall be called Emmanuel. He shall eat butter and honey, that he may know to refuse the evil, and to choose the good" (Isaiah 7:14–15). That passage, in which the awaited messiah is forecast to refuse evil, can return us to the *Annunciation* triptych with which we began. Amid the vast array of interpretive thought and debate about the Mérode triptych, few writers have resisted Schapiro's recognition, via Saint Augustine, that Joseph's mousetrap is meant for the devil.[19] Schapiro cites a sermon that explains it this way: "The cross of the Lord was the devil's mousetrap; the bait by which he was caught was the Lord's death."[20] Questions remain for some about whether the Mérode trap refers mainly to Christ himself or perhaps more to Joseph (who was seen as helping to disguise the arrival of the messiah), but in either case the trap is set for the devil.

Although the operative metaphor is clear enough, the means by which the painter develops it deserve further thought. If the trap refers to the defeat of the devil, it is important to remark that no such defeat is actually pictured—and that no devil is pictured, either. His presence and his fate are both a matter entirely of inference: because a trap is set for him, he is assumed to be here, or somewhere within striking distance. And because Christ is arriving in the room next door, visible as a tiny figure proceeding from the window above Gabriel, the trap will work (Fig. 6).[21] It is equally important that the trapping, which is to be accomplished with Christ's death, lies in the future of the moment now unfolding. There is, in other words, a double absence: one of a devil that cannot be seen, and one of a death that has not happened. Of course, the painter and his contemporaries knew perfectly well what the climax of this incipient life would be, and he telegraphed it by having the child haul the cross toward the moment of his incarnation in the center panel. In this always approaching figure, birth and death travel together, equally imminent, so that what implicitly haunts the situation from the right side of the work is answered by what advances from the left. As it is pictured, neither Christ nor the devil yet fully occupies the world in which they will collide.

"Haunt" is intended here and elsewhere among these pages as more than a vaguely evocative term. It is an old word of uncertain derivation, present in English by the thirteenth century and in French by the twelfth.[22] One of its two prime senses is that of doing something habitually, and the other is of frequenting a place habitually, often with a disruptive effect. It is this aspect of

6. Mérode Altarpiece (detail of Fig. 1) 7. Portinari Altarpiece (detail of Fig. 2)

tenacity, an habitual effort to do or to be, that helps isolate the unusual impulses of these images. In each it becomes clear, but usually not immediately, that something or someone is there that had been present before the pictured moment and will remain or act after this moment has passed. In modern representations of haunting, mainly in literature and film, the habitual being is typically elusive or invisible—so much so, in fact, that those who are haunted may or may not be imagining things. Haunting happens on the edges of perception, slipping back and forth between the mind and the physical world.

The demon of the Portinari Altarpiece straddles just such a border (Fig. 7). Most people who know the creature is there do so only because they have been told that it is. An unapprised visitor to the painting will miss it, and most who have seen it at all will have done so only through the not entirely revealing black-and-white close-up published in Walker's article. Few if any colorplate details have shown it any better in the forty years since this image was published.[23] There is no reason to think that the situation would have been much different in late-fifteenth-century Florence, where the altarpiece stood in a chapel without museum lighting, and where no photography was available.[24] Some observers might have been told the demon is there, and word of mouth might have made it common knowledge, but however many people might have known about it, most would never have seen it.

Why would an artist do this? Given that scholars of early Netherlandish painting now generally agree that these painters would have had little reason to disguise symbols, we should consider motives for hiding such a consequential being.[25] Why not cast the bound or broken enemy into the open, where his defeat would be manifest? The first answer is that he is not yet defeated, at

least partly because the Passion has yet to occur—something of which we are reminded by the eucharistic still life in the foreground. If this was the thinking, then why not expose him as a more potent threat than this small, outnumbered creature? The devil is feared and reviled, after all, not because he is a pest, but because he is the body of evil itself. An answer to this might be that he has begun to shrink away because his fate has just been sealed. If this was the intention, though, it should be remarked that nothing in the position or aspect of the creature specifically conveys retreat; he faces out, claw forward, in a way that bespeaks lingering interest in the proceedings before the shed.

Robert Walker, who first published the existence of the demon in the scene, pointed to a passage in the account of the Nativity in the *Golden Legend*, which enumerates the ways in which Christ's birth was useful.[26] First among these, Jacobus de Voragine notes that "it served to confound the demons, for they could no longer overpower us as they had before."[27] This idea might indeed have been in play when the demon of the Portinari Altarpiece was conceived, but it seems likely that more were, as well. For example, in one of the few subsequent efforts to interpret this presence, Elisabeth Dhanens turns to the same painter's depiction of the serpent in a diptych now at Vienna (Kunsthistorisches Museum), which juxtaposes the *Fall of Man* and the *Lamentation*.[28] Noting that the Portinari demon's clawed leg is comparable to that of the tempter in the Vienna *Fall*, she proposes that the serpent of Genesis was at least a part of what Hugo had in mind when he pictured the creature at the Adoration. She suggests that it might also embody the vanquished dragon of Revelation (12:3–9), citing an indirect precedent for this allusion in the dragon slain by Saint Michael on the lectern of the musical angels in the upper tier of the Ghent altarpiece.[29]

More generally, Dhanens sees the Portinari demon in terms of a clash of darkness and light across the picture: "Par l'opposition entre le côté droit du tableau, vivement éclairé, et le côté gauche plongé dans l'obscurité, le peintre indique de façon symbolique que la venue du Christ marque la victoire de la lumière sur les ténèbres."[30] This conflict is indeed striking and appears, in fact, to play a more than general role in the image. As illumination pouring forth from the right encounters the dark structure fully closing the left side of the composition, Christ lies just to the right of the central axis, which passes through the praying hands of Mary. That this broad pictorial opposition was designed rather than merely allowed seems to be confirmed in a strongly defined shadow on the building in the middle ground (Fig. 8). The grand yet decaying structure is generally identified as the house of David because of the harp that adorns its tympanum, and the tiny letters *MV* and *PNSC* that inscribe it have been seen as possible allusions to the Virgin Mary and the birth of the child.[31] It is understandable that no such focal attention has been paid to the shadow looming across the tympanum and right side of the facade, since individual shadows in a painting are rarely accorded much interpretive gravity. But this one invites a closer look, not least because its highly specific, gabled contour must be cast by a structure that is not otherwise visible in the painting, or not entirely so. Since shadows in the foreground scene announce a light source to the viewer's left and somewhat in front of the picture plane, the shadow on the middleground building must be cast either by unseen upper stories of the Nativity building before us or by those of an adjacent structure that is entirely out of the picture. The decision to throw such a bold shadow from a structure invisible to the viewer was an unusual and presumably cogitated one.[32] While it is difficult to know whether a specific typological or dialectical charge was intended for this shadow, which bisects the harp and portal immediately beyond the face of the Virgin, it neatly answers the division of light and shadow staged across the scene as a whole.

8. Portinari Altarpiece (detail of Fig. 2) 9. Portinari Altarpiece (detail of Fig. 2)

The large shadow also prompts attention to the most riveting moment of illumination in the triptych, which occurs on the angel over Mary's right shoulder (Fig. 9). Like no other figure here, this one occupies—embodies, in fact—a stark intersection of light and dark.[33] Radiance from Christ reveals the otherwise obscured face from below, while a sharp shaft of sun catches the lower half of his robe from above. This abruptly divided angel is as close as the painter comes to training a spotlight on the lair of the demon, which is in the tightly framed gloom just below the glowing, flapping hem. It may or may not be coincidence that the same mutually opposed elements converge in the origins of the devil himself, an angel whose name, Lucifer, means bearer of light, and whose fall made him prince of darkness. This angel is not the devil, but he is cast in a way that can draw eyes and thoughts in his direction. Whether the creature steeped in the shadows below was meant to refer to the confusion of the demons through the Incarnation, the serpent of Eden, the apocalyptic dragon, or some other incarnation of evil, his teetering on the brink of invisibility must itself be regarded as a part of the artist's intention.[34]

Could the devil occupy deep shadows in other Infancy scenes? The question arises pointedly in the foreground of Rogier van der Weyden's triptych of the Nativity in Berlin (Fig. 10). Painted probably during the second half of the 1440s for one Pieter Bladelin, perhaps for a church in Middelburg, it flanks the Nativity with the Emperor Augustus's vision of the Tiburtine Sibyl on the left and the Magi having a vision of the child in the sun on the right.[35] The two deep openings at the threshold of the Nativity, one grated and one completely open, have drawn less comment than one might expect (Fig. 11). They have been explained mainly in two ways. One explanation looks to the *Speculum humanae salvationis*, which might well have been a source for other aspects of the triptych.[36] That text's presentation of the Annunciation to the Magi, the relatively

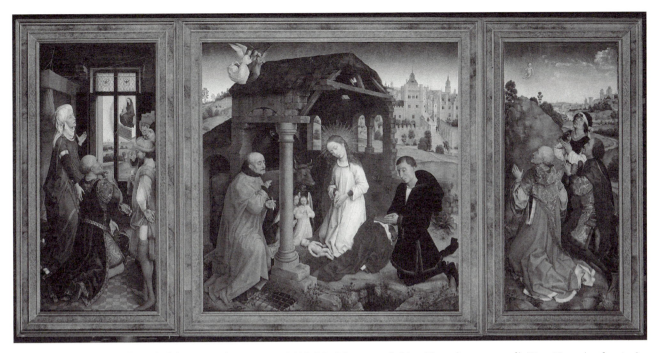

10. Rogier van der Weyden, Bladelin triptych, *Nativity*, 1445–50. Oil on wood, 91 × 89 cm (center panel), 91 × 40 cm (each wing). Berlin, Gemäldegalerie, Staatliche Museen zu Berlin

11. Bladelin triptych (detail of Fig. 10)

uncommon scene depicted on the right wing, cites an Old Testament parallel in the story of three men sent by King David to fetch water from a cistern at Bethlehem. The *Speculum* aligns the missions of the two trios, with David's men seeking an earthly water and the Magi seeking a heavenly one, in the grace that would flow from Christ.[37] With this linkage in mind, Shirley Blum has proposed that the holes of the Bladelin *Nativity* open onto a well alluding typologically to the visit of the kings.[38]

A second suggestion sees the openings referring to the cave in which the Nativity and Adoration were sometimes reported to have occurred, as they are, for example, in the *Meditations on the Life of Christ*.[39] Gert von der Osten proposed this to account for an assortment of several dozen Netherlandish and German images of Adoration (usually by the Magi) with comparable openings in the ground.[40] In response to von der Osten's essay, Günther Bandmann posited a distinction between the two holes in the Berlin triptych, suggesting that the open one before the donor represents the grotto of the Nativity, and that the grated one next to it portends the incarceration of Christ.[41] Recent scholarship on the Bladelin triptych acknowledges the proposed readings of the openings as either well or cave but does not clearly favor one or the other.[42]

A more oblique view of the Bladelin holes was taken by Charles de Tolnay, who referred to them in a discussion of Leonardo's *Madonna and Child with Saint Anne* that focuses on a shadowy recess at the foremost edge of that scene, below the figures of Christ and the lamb (Fig. 12).[43] Gathering a handful of Italian and northern images (including works by Benozzo Gozzoli, Botticelli, Giovanni Bellini, and others) with suggestive foreground darknesses, Tolnay chose not to identify such pits and shadows in precise terms, but instead to see in them a more elemental expression of instability and anxiety. The one in the foreground of Leonardo's canvas is said to "révèle soudainement au spectateur la précarité de toute existence humaine, menacée pas les dangers permanents."[44] While Tolnay's instinct about a symbolic dimension of these cavities is intriguing, questions remain about whether they were meant to represent or harbor more specific things.

The holes of the Bladelin *Nativity* are defined, and in one case barred, in a way that rules them out as topographical features. They are roughly rectangular penetrations of ground and masonry, one extending from the foundation of the shed and one standing just apart from it. While it seems likely that both open onto a single substructure or space below, their different relationships to the foundation of the shed and the impenetrability of their shadows ultimately leave this an open matter. In the absence of earlier images of the Nativity that place such pronounced openings in the foreground, it is difficult to know what Rogier meant them to represent. I do, however, hesitate to see them as specifically depicting either a well or a cave. The suggestion of a well is based mainly on an iconographic motif, the story of David's water bearers, which would have been an oddly arcane reference in so prominent a place. The reason for including it (a story typologically bound to the scene in the right wing and not to the Nativity in the center) would not be evident, nor would the need for two holes rather than one to represent a well. Allusion to the cave of the Nativity might seem a more logical explanation, but the narrowness of the openings and their masonry framing are distinctly not cavelike—or at least unlike any cave in which one might imagine the Nativity occurring.[45] It may be that we should not try hard to associate the holes with a specific kind of structure. We can see, after all, that the shed itself is an implausible composite, an invention in paint crafted to integrate the figures and setting rather than an approximation of any specific building known to the artist. Moreover, it is worth emphasizing that these openings are articulated in two different ways, and that neither is a structure, per se: both are defined above all by a framed absence of ground or building.[46]

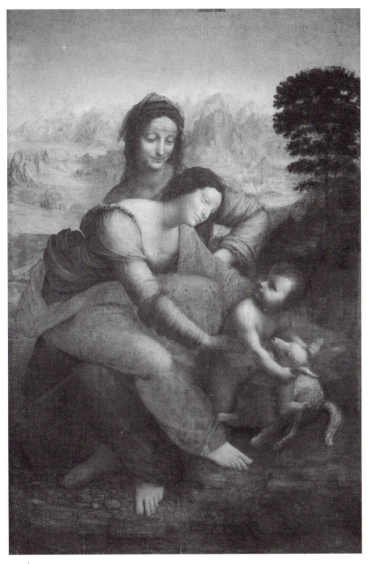

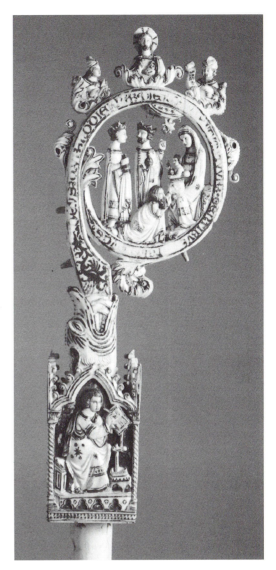

12. Leonardo, *Madonna and Child with Saint Anne*, ca. 1508. Oil on wood. Paris, Musée du Louvre

13. Head of a pastoral staff, fourteenth century. Ivory. London, Victoria and Albert Museum

Another way to approach these openings leads through the *Golden Legend* account of the Nativity, which is widely believed to have been a source for other aspects of the triptych.[47] As Walker noted in connection with the Portinari Altarpiece, the first reason cited there for the Nativity of the Lord is the confusion of demons. The text goes on to recount the story of Saint Hugh, abbot of Cluny, who on the night of the Nativity had a vision in which the newborn Christ asked the Virgin, "Where now is the power of the devil? What can he do now? What can he say?"[48] In response, the devil himself rose from the ground and replied, "Even if I cannot enter the church where your praises are chanted, I shall get into the chapter house, the dormitory, the refectory!" The text goes on to explain that the devil's efforts were still thwarted, because "he found the chapter house door too narrow for his gross girth, the door of the dormitory too low for his height, and the door of the refectory fastened with bars and bolts, these being the charity of those who served there,

their eagerness to hear the readings, and the sparseness of the food and drink consumed there. So, confounded, he vanished."[49]

If the Bladelin holes mainly signify a dark space below rather than a well or cave, they offer a parallel for the *Golden Legend*'s account of two ways in which the devil's intrusive efforts were rebuffed on the night of the Nativity: first, by the life of the church, which would correspond to the structurally secured hole; and then, by the piety of those outside its walls, which would correspond to the one that remains open, but perhaps impassable from below thanks to prayer offered directly above.

Whether or not the painter had this portion of the legend in mind when he designed them, it seems clear that he located the openings to draw curiosity—which they still do today, judging from the leaning and peering of a fair proportion of those who observe the triptych at the Gemälde-galerie in Berlin. The individuality of reception becomes especially pointed in such a situation, because the curiosity sparked is not rewarded from within the image. While there can be no doubt that different observers would have responded in various ways, it is very likely that fifteenth-century observers looking into these depths, which are all the more absorbing for the nearness and blackness of their shadows, would have been looking for signs of trouble in them. Some might have had in mind familiar images, especially in sculpture, of the dragon trodden by the Madonna (Fig. 4). Others could have recalled different formulations of a threat from below, as on the heads of certain pastoral staffs upon which a volute bearing the Christ child springs from the mouth of a serpentlike hybrid. This occurs, for example, on several fourteenth-century staffs in which either a Madonna and Child or a scene from the Infancy stands immediately above the upward-gaping creature (Fig. 13).[50] Granted that such configurations serve Gothic and earlier tastes for the animation of peripheries, it remains the case that these and similar carvings also build a fraught relationship between the infant Christ and an open, snarling maw below.

Shirley Blum has pointed out that the Bladelin triptych is uniquely threaded by a theme of annunciation: to Mary herself on the closed exterior (where an Annunciation attributed to Rogier's shop appears), to Emperor Augustus in the left wing, to the Magi on the right wing, and to the shepherds in depth, where they receive the news in the distance of the upper left corner of the central panel.[51] If one imagines the devil in the darkness, the message radiating through the world above comes full circle to be delivered below as well. The crucial term here is "imagine," because there is no devil there. The question then becomes whether this sort of speculation is valid. Can we reasonably impute to an artist an intention to make viewers seek or conjure something that is not there? To do so, one might first look for support in writings of the period that point at least generally in this direction, such as the description of painting in the introduction to Cennino Cennini's *Libro dell'arte* (ca. 1400) as something that "calls for imagination, and skill of hand, in order to discover things not seen, hiding themselves under the shadow of natural objects, and to fix them with the hand, presenting to plain sight that which does not actually exist."[52]

More immediately revealing in this context is a look toward another of Rogier's major works from the same years, the polyptych of the Last Judgment for the Hôtel-Dieu at Beaune (Fig. 14). It has long been noted that the stricken souls pictured along the lower right margin are unlike most in that they stumble toward their fate unprodded and even unaccompanied by devils.[53] An effort has been made to identify one of the figures in the abyss as Satan, but whether or not he is present, this is also a hell strangely devoid of demons.[54] Panofsky observed that the doomed, who are far more individualized and individually reactive than their counterparts in earlier images of the

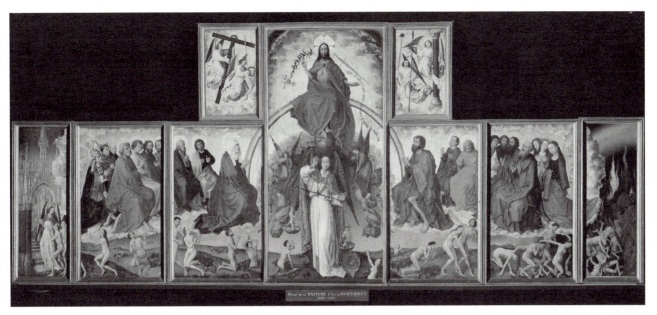

14. Rogier van der Weyden, *Last Judgment* polyptych, ca. 1445–51. Oil on wood, 215 × 560 cm. Beaune, Musée de l'Hôtel Dieu

Last Judgment, are impelled by their own understanding of what led them to this: "The fate of each human being . . . inevitably follows from his own past, and the absence of any outside instigator of evil makes us realize that the chief torture of the Damned is not so much physical pain as a perpetual and intolerably sharpened consciousness of their state."[55] An artist who pictured souls walking themselves to hell because they know they have sinned might also have made dark openings, one of which touches the viewer's space, that draw thoughts of the dangers below. Not only was a devil not needed, but his absence anywhere but in the mind of a wary observer could make his proximity all the more pressing.

Rogier painted another such hole at the threshold of the Columba *Adoration of the Magi* (Fig. 15). Here its relation to a larger structure is more legible, in that a stairway descending just to the left, from the corner of the shed, establishes the presence of a cellar below. Both depths exceed the lower edge of the panel, as if opening into the space of observers before the work. If one is invited to imagine or wonder about a demonic presence in those shadows, it certainly would *not* follow that Joseph, who is moving from the top step, has some untoward association with the darkness. He would instead be understood in his role as a guardian, here positioned close to the opening much as he had been near the grated opening in the Bladelin *Nativity*.[56] His protective or obstructive aspect is reinforced by the donor, whose prayer beads dangle brightly, and perhaps apotropaically, over the darkness, much as do Bladelin's praying hands in his *Nativity*. Within the broader vista of the Columba triptych, the donor and the staircase suggestively abut the figure of the Annunciate, and even more closely, the Fall of Man carved onto the bench at which she kneels (Fig. 16). Together these corners compose a profound footnote that gathers the origin of sin in the world, the shadows in which it survives, and the prayers by which it can be suppressed. While such prayers are essential in Christian thought, even more crucial in this role is the sacrifice made

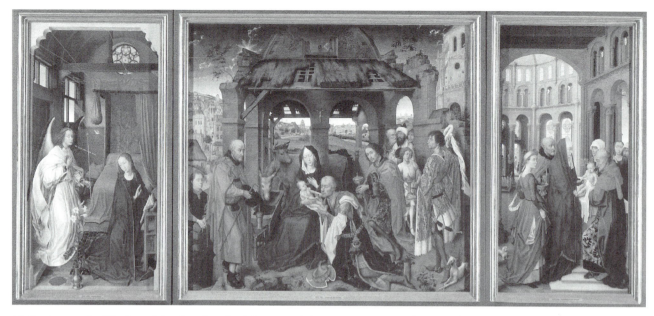

15. Rogier van der Weyden, Columba triptych, *Adoration of the Magi*, ca. 1455. Oil on wood, 138 × 153 cm (center panel), 138 × 70 cm (each wing). Munich, Alte Pinakothek

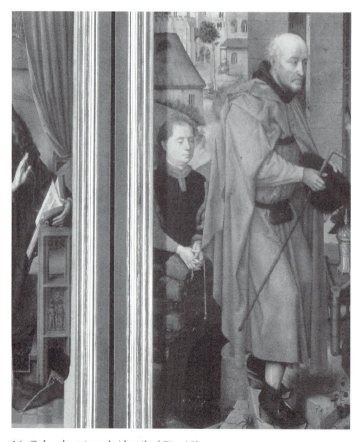

16. Columba triptych (detail of Fig. 15)

visible on the pier at center, a small image of Christ on the cross quietly presiding over everything one sees in the triptych.[57]

Even among these few examples, it becomes clear that intimations of evil at Christ's infancy are often accompanied by imagery or inklings of his death. In the Mérode triptych, the arriving child carries his future over his shoulder. In the Portinari triptych, a still life embodying the Eucharist stands in the foreground. In the Gossaert *Madonna*, the child's arms anticipate the cross. And in the Columba triptych, the body already occupies the cross above his infant self. These can be regarded as double hauntings of the child, at once by evil and by sacrifice. Their pairing is not surprising, since it is the latter by which the former is to be defeated. Like the proximity of evil at the Infancy, a premonition of his Passion is an idea without a single prime locus in Scripture. And even more than the shadow of evil, that of the sacrifice found an enormous variety of shapes in art of the fifteenth and early sixteenth centuries; in countless images of the Infancy, artists foreshadowed the Passion with symbols, visions, body language, contextual cues, and more.[58] Both hauntings involve efforts to convey things that are, at the same time, absent or suppressed in the moment pictured: a death not yet present for the infant and a threat forestalled by his coming.[59]

The Passion may be present as well in the Bladelin triptych, which foregrounds a column that would have seemed no less conspicuous or unusual than the openings in the ground before a Nativity.[60] It has been suggested that the column, an eccentric element in this compact stone building, might refer to one that Mary was sometimes reported to have leaned against at the moment of Christ's birth.[61] This could have been intended, but would not have ruled out its simultaneous evocation of—or identity as—the column of his flagellation. Panofsky and others have noted Mary's vision of that instrument of the Passion during her labor at Bethlehem, as recounted in the *Revelationes* of Saint Bridget.[62] This potential Brigittine source is appealing, but not necessary to make the case for a plausible allusion to the column of the flagellation, which by this time had wide visual currency as one of the *arma Christi*.[63] From among countless fifteenth-century images of the column freestanding or floating as an instrument of the Passion, one need look no further for a good comparison than to the one held by an angel to the right of Christ in the same painter's *Last Judgment* altarpiece at Beaune (Fig. 14).[64]

The Bladelin column would thus be a single object able to support thoughts equally of events from the Infancy and from the Passion. It does so, moreover, without actually depicting either her leaning or his scourging. Just as can occur among the provocative shadows below, such thoughts are triggered neither by depiction nor by symbols (for the column is the thing itself rather than a reference to it), but instead by an observer's recollection, conscious or not, of more explicit texts or images of these scenes. At the same time, it draws further thought toward the evil held at bay from both ends of Christ's life, because this piece of his future bears down on the subterranean opening that is physically secured against unwanted passage.[65] Seeing their conjunction in this way may cast additional light on the situation of the demon in the Portinari *Nativity* (Fig. 2), the shed of which has sometimes been seen as indirectly derived from the Bladelin one. The shadows only half hide the demon; the rest of his obscurity is ensured by a column that intervenes between him, the holy figures, and the viewer. Could Hugo have suspected and later pictured a suppressed demon that Rogier had left to an observer's imagination? [66]

Whether or not the screened Bladelin cavity was designed to recall the *Golden Legend* vision in which the devil's first attempt to rise was thwarted by the life of the church, its grate gains special strength when we link it, as the artist did, with the evocative column rising over the same

stones. The other opening, which is outside the structure and more fully in the world, is covered neither by a grate nor by an instrument of the Passion. The resulting contrast—and it is important to underscore the calculated role of contrast in pondering these two openings—places all the more weight on the thoughts of the donor, who might be praying *not* to see something that the painter was, at the same time, baiting individuals who stand before the image to look for.

The devil was perfectly real in the fifteenth century, not an abstraction of evil in the way many think of him today. He lived a rich life not only as the great enemy in theology and devotions, but also as an omnipresent, tireless, and resourceful character in literature, drama, folklore, and the anxieties of life.[67] If we were to seek echoes elsewhere in the culture of the hauntings described here, one good avenue would be through religious plays. In the Nativity portion of Arnoul Gréban's *Mystère de la Passion* (ca. 1450), for example, canonical episodes of the Infancy are interrupted by a series of "diableries," conversations among scheming demons. The first follows the scene of Mary's Visitation with Elizabeth, which is celebrated by the Heavenly Host but then darkened immediately by Lucifer's call for devils to "leap out of the black abysses."[68] The audience hears him inquire about a strong king predicted by the Scriptures and then promise that "Satan will go strike a blow on earth. At least, if perchance there were born a man of virtue so perfect that by him the transgressions of humanity ought to be redeemed, Satan will tempt him to do evil."[69]

Despite vivid parallels between demonic incursions in drama and the sorts of things we have been considering in painting, there is little reason to think that any one text or even group of them provided a discrete source for such expressions. Because the devil worked in so many ways in so many stories and minds, it is impossible to draw a single contour around him and his projects in the period. It is understandable that few can easily distinguish among characters or implications behind a wide variety of names associated with him, or that he often seems indistinguishable from demons doing his work, or indeed from the quantity of evil itself; to a unique degree, he is a being made of what he does—or might still do. Unlike Christ's earthly biography, which was essentially fixed and familiar, that of the devil was still in progress and unpredictable. He and his swarm have been likened to "the way we imagine microbes today—always potentially present and malign."[70]

This helps to explain the familial resemblance emerging among the hauntings considered here, all of which are at once allusive and elusive. Each allows something troubling to come to mind, but in most cases it stops there, before entering the picture. Evil at the Infancy has not been treated as a theme unto itself because it can live only in seams or edges of familiar stories, none of which can fully contain it. A viewer knows that the Annunciation concludes and is succeeded by the Nativity, and that this is to be followed by Adorations, and that all such scenes are understood as single events that came and went in time. But evil has no plot. Artists who insinuated this presence were doing more than annotating the Incarnation. They were also opening channels between Christ's infancy and some of the most pointed concerns of daily life, and doing so with subtle bids for curiosity, conversation, and even fear.[71] Although Christ's Passion is promised in most of the images, the devil is not shown defeated at least in part because he still lived and worked among the painters and their communities.

In the end, what may be most intriguing about this dimension of the Bladelin *Nativity* is not the likelihood of a haunting front and center that has not appeared in the literature, but rather the necessary uncertainty of that idea. There is really nothing there. Its openings seem to have made it an early instance of a growing number of images to recognize that the devil moves more effec-

tively in the mind than in the visible world. Among the works addressed most closely here, he appears only in one, the Portinari Altarpiece, and there so inconspicuously that one must be told of his presence. To late medieval observers, what may have mattered most was not that the hole on the right side of the Bladelin foreground is empty, but that it will always remain open.

Acknowledgments

My sincere thanks to Anne-Marie Bouché and Jeffrey Hamburger, as well as to other friends and colleagues who responded to versions of this material presented in Princeton, Washington, D.C., and Seattle. Much within this essay was developed during a deeply appreciated year at the Center for Advanced Study in the Visual Arts, where I wrote most of a larger study of Infancy imagery in the Renaissance.

Notes

1. M. Schapiro, "'Muscipula Diaboli': The Symbolism of the Mérode Altarpiece," *ArtB* 27 (1945), 182–87.

2. L. Brand Philip, "The Prado Epiphany by Jerome Bosch," *ArtB* 35 (1953), 267–93.

3. R. M. Walker, "The Demon of the Portinari Altarpiece," *ArtB* 42 (1960), 218–19.

4. Two more recent examples are the identification of sinister associations in a wasp nest at the base of the Nativity shed (by C. I. Minott, "Notes on the Iconography of Robert Campin's 'Nativity' in Dijon," in *Tribute to Lotte Brand Philip, Art Historian and Detective*, ed. W. Clark, C. Eisler, W. S. Heckscher, and B. G. Lane [New York, 1985], 112–16); and an identification, by D. Heffner, of the insect in Dürer's engraving of the "Madonna and the Dragonfly" (B 44) as a damselfly, which was known in the sixteenth century as a *Teufelspferd* ("A Memento Diaboli in Dürer's 'The Virgin with the Dragonfly,' " *Print Collector's Newsletter* 18, no. 2 [May–June 1987], 55–56).

5. R. Lightbown, *Sandro Botticelli*, vol. 2, *Complete Catalogue* (Berkeley and Los Angeles), 1978), 99–101, and colorpl. IX in vol. 1. A study of the painting that pays particular attention to the presence of demons is R. Hatfield, "Botticelli's *Mystic Nativity*, Savonarola, and the Millennium," *JWarb* 58 (1995), 89–114.

6. R. Mellinkoff, *The Devil at Isenheim: Reflections of Popular Belief in Grünewald's Altarpiece* (Berkeley, 1988).

7. See H. D. Rauh, *Das Bild des Antichrist im Mittelalter: von Tyconius zum deutschen Symbolismus*, 2nd ed. (Munich, 1979); R. K. Emmerson, *Antichrist in the Middle Ages: A Study of Medieval Apocalypticism, Art, and Literature* (Seattle, 1981).

8. See, for example, J. B. Russell, *Lucifer: The Devil in the Middle Ages* (Ithaca and London, 1984).

9. The traditional attribution of the Mérode triptych to Robert Campin has come under significant pressure, as has the entire structure of attribution to this painter. See L. Campbell, "Robert Campin, the Master of Flémalle, and the Master of Merode," *Burlington Magazine* 116 (1974), 634–46; S. Kemperdick, *Der Meister von Flémalle: Die Werkstatt Robert Campins und Rogier van der Wey-*

den (Turnhout, 1997), 77–99; S. Foister, "The History of Campin Scholarship," in *Robert Campin: New Directions in Scholarship*, ed. S. Foister and S. Nash (Turnhout, 1996), 1–9.

10. For a range of reflections along these lines, see, e.g., D. Arasse, *Le Détail: Pour une histoire rapprochée de la peinture* (Paris, 1992); A. Acres, "Small Physical History: The Trickling Past of Early Netherlandish Painting," in *Symbols of Time in the History of Art*, ed. C. Heck and K. Lippincott (Turnhout, 2002), 7–25. Each of the three articles cited at the opening of this article includes a detail illustration of the presence in question.

11. A point demonstrated repeatedly among the other papers published in this volume.

12. Another Parisian example can be found on the tympanum of Notre Dame, where a demon whispers in the king's ear.

13. R. E. Brown, *An Introduction to the New Testament* (New York, 1997), 791.

14. See *Schnütgen-Museum, Die Holzskulpturen des Mittelalters (1000–1400)* (Cologne, 1989), 194–203 (cat. nos. A766, A46). For a later (ca. 1520) example, see A. Legner, *Rheinische Kunst und das Kölner Schnütgen-Museum* (Cologne, 1991), 270.

15. L. Campbell and J. Dunkerton, "A Famous Gossaert Rediscovered," *Burlington Magazine* 138 (March 1996), 164–73. Other major versions of the composition are in Munich (Alte Pinakothek) and Vienna (Kunsthistorisches Museum).

16. Campbell and Dunkerton, "Gossaert" (as in note 15), 164. *Contrivit*, translated by the authors as "bruised," can also be rendered as "crushed."

17. Campbell and Dunkerton ("Gossaert" [as in note 15], 164) note that the Vulgate text has *ipsa* rather than *ipsum*, which would be more accurate. By making Christ the crusher, Gossaert has in a sense corrected the Vulgate.

18. J. B. Russell, *The Devil: Perceptions of Evil from Antiquity to Primitive Christianity* (Ithaca, 1977), 182, n. 6; 217–18, n. 95.

19. Edwin Hall singles this out as one of the few sym-

bolic interpretations of a common object that has not been widely challenged (E. Hall, *The Arnolfini Betrothal: Medieval Marriage and the Enigma of Van Eyck's Double Portrait* [Berkeley, 1994], 114). Two recent, synthetic discussions of the triptych (with earlier bibliography) are A. Châtelet, *Robert Campin: Le Maître de Flémalle: La Fascination du quotidien* (Antwerp, 1996), 97–113; and M. W. Ainsworth, "The Annunciation Triptych (Mérode Triptych)," in *From van Eyck to Bruegel: Early Netherlandish Painting in the Metropolitan Museum of Art*, ed. M. W. Ainsworth and K. Christiansen (New York, 1998), 89–96.

20. "Muscipula diaboli, crux Domini: esca qua caperetur, mors Domini," from Sermo CCLXIII, "De ascensione Domini," PL 38:1210, as cited by Schapiro, "Muscipula Diaboli" (as in note 1), 182, n. 4.

21. Regarding a relationship between the mousetrap and the cross-bearing Christ child, it should be noted that the center and right panels of the triptych seem to have been painted at different times, and perhaps by different hands. See, inter al., Kemperdick, *Der Meister von Flémalle* (as in note 9), 84–88; Ainsworth, *From van Eyck to Bruegel* (as in note 19), 92. While this might seem to weaken an intended iconographic linkage between the two elements, it is entirely possible that a symbolic mousetrap in the right wing would have been conceived in relation to—and perhaps even inspired by—a pre-existing depiction of the Passion-bound Christ child in the center. For thoughts about programmatic readings of the triptych in light of its piecemeal evolution, see R. Falkenburg, "The Household of the Soul: Conformity in the Mérode Triptych," in *Early Netherlandish Painting at the Crossroads: A Critical Look at Current Methodologies*," ed. M. W. Ainsworth and K. Christiansen (New York, 2001), 2–17.

22. *Oxford English Dictionary*.

23. Walker, "Demon" (as in note 3), fig. 2.

24. The altarpiece was installed in Florence 1483 at the hospital church of Sant' Egidio. Three major recent discussions of the triptych (with earlier bibliography) are E. Dhanens, *Hugo van der Goes*, trans. C. Warnant and M. Vincent (Antwerp, 1998), 250–301; M. Koster, "Hugo van der Goes's Portinari Altarpiece: Northern Invention and Florentine Reception" (Ph.D. dissertation, Columbia University, 2000); and M. Koster, "New Documentation for the Portinari Altarpiece," *Burlington Magazine* 145 (2003), 164–79. The demon is not mentioned in the scant early notices of the work that survive.

25. Disguised symbolism and its afterlife are discussed within a broader account of iconological interpretation of early Netherlandish painting in C. Harbison, "De iconologische benadering," in *'Om iets te weten van de oude meesters': De Vlaamse Primitieven—herontdekking, waardering en onderzoek*, ed. B. Ridderbos and H. van Veen (Nijmegen,1995), 394–432. An earlier, more pointed critique of the concept is by L. Benjamin, in "Disguised Symbolism Exposed and the History of Early Netherlandish Painting," *Studies in Iconography* 2 (1976), 11–24.

26. Walker, "Demon" (as in note 3), 218–19.

27. Jacobus de Voragine, *The Golden Legend: Readings on the Saints*, trans. W. G. Ryan (Princeton, 1993), vol. 1, 42.

28. Dhanens, *Hugo van der Goes* (as in note 24), 287.

29. Dhanens, *Hugo van der Goes* (as in note 24), 287.

30. Dhanens,*Hugo van der Goes* (as in note 24), 287.

31. Panofsky's assertion (*Early Netherlandish Painting: Its Origins and Character* [Cambridge, 1971], vol. 1, 334) that *MV* stands for "Maria Virgo" and *PNSC* for "Puer Nascetur Salvator Christus" has been generally accepted. See, e.g., H. Belting and C. Kruse, *Die Erfindung des Gemäldes: Das erste Jahrhundert der niederländischen Malerei* (Munich, 1994), 232. An inscription on a panel to the right of the portal is illegible.

32. Considering the portal in a different way, Dhanens (*Hugo van der Goes* [as in note 24], 273) wonders whether this doorway, which occupies the vanishing point of major orthogonals and is "éclairé d'une lumière vive," might be a hidden allusion to the Portinari name, since a depiction of the family arms would have been proscribed by the hospital.

33. The distinctiveness of the half-illuminated angel has been noted by Belting and Kruse, *Die Erfindung* (as in note 31), 232; and by B. Ridderbos, *De melancholie van de kunstenaar: Hugo van der Goes en de oudnederlandse schilderkunst* (The Hague, 1991) , 32.

34. Koster reports that infrared reflectography examinations of the altarpiece reveal that the demon was not included in the underdrawing on the panel. See Koster, "New Documentation" (as in note 24), 171.

35. For a recent survey of opinion on the Bladelin triptych, see D. de Vos, *Rogier van der Weyden: The Complete Works* (Antwerp, 1999), 242–48. The assumed patronage of Pieter Bladelin, an official in the service of Philip the Good, hinges on two close associations between the triptych and Middelburg, which he founded: a seventeenth-century copy of the work in the church of Sts. Peter and Paul at Middelburg; and an engraved copy of the castle in the painting that was included in Sanderus's *Flandria Illustrata* (1641), where it is captioned *Castellum de Middelburch Domini Comitis de Isengien*.

36. The triptych's possible dependence on the *Speculum humanae salvationis* was noted early by E. Mâle, "L'Art symbolique à la fin du moyen âge, II," *Revue de l'art ancien et moderne* 18 (1905), 196–97; and F. Winkler, *Der Meister von Flémalle und Rogier van der Weyden* (Strasbourg, 1913), 159–60. This connection was pursued further and with more specific reference to the foreground openings by S. N. Blum, *Early Netherlandish Triptychs: A Study in Patronage* (Berkeley, 1969), 19–22.

37. J. Lutz and P. Perdrizet, *Speculum humanae salvationis*, trans. J. Miélot (Leipzig, 1907–9), 129 (chap. IX). The corresponding text reads: "Ces trois robustes alerent en Bethleem, pour avoir de l'eaue de la cisterne, et les trois roys vindrent en Bethleem, pour avoir de l'eaue de la grace eternele. Les trois robustes tirerent de la cistern terrienne, et les trois roys recurent l'eaue de grace du bouteillier du ciel. Celle cisterne de Bethleem figuroit doncques que le bouteillier du ciel devoit naistre en Bethleem, lequel administreroit eaue de grace a tout homme qui auroit soif, et puis donneroit pour neant eaue a ceulx qui n'auroient pour quoy. Le roy David offroit a Dieu l'eaue qu'on lui apporte, pour lui rendre graces."

38. Blum, *Early Netherlandish Triptychs* (as in note 36), 20. Working from this proposed identification of the open-

ings, Heike Schlie has recently considered how they might have related the donor and the rest of the image to the sacrament on the altar below the triptych (H. Schlie, *Bilder des Corpus Christi: Sakramentaler Realismus von Jan van Eyck bis Hieronymus Bosch* [Berlin, 1999], 273–74).

39. *Meditations on the Life of Christ: An Illustrated Manuscript of the Fourteenth Century. Paris, Bibliothèque Nationale, Ms. Ital. 115*, trans. I. Ragusa, ed. I. Ragusa and R. B. Green (Princeton, 1977), 32.

40. G. Von der Osten, "Der Blick in die Geburtshöhle," *Kölner Domblatt* 23–24 (1964), 341–58, esp. 345.

41. Bandmann first made the suggestion in discussion with von der Osten, as noted by the latter in G. von der Osten, "Der Blick in die Geburtshöhle: ein Nachtrag," *Kölner Domblatt* 26–27 (1967), 112. Bandmann published and elaborated the idea in G. Bandmann, "Höhle und Säule auf Darstellungen Mariens mit dem Kinde," in *Festschrift für Gert von der Osten* (Cologne, 1970), 130–48, esp. 134–35. Regarding what would seem a redundancy in depicting cave *and* stable, Bandmann ("Höhle und Säule," 130) notes that these appear alternately in the visions of the Nativity recounted by St. Bridget; and that both are occupied consecutively in the apocryphal infancy narrative of the Pseudo-Matthew, in which Mary gives birth in "an underground cave, in which there never was light," and three days later "went out of the cave and, entering a stable, placed the Child in a manger." (J. K. Elliott, *The Apocryphal New Testament* [Oxford, 1999], 93–94).

42. Belting and Kruse (*Die Erfindung* [as in note 31], 114) accept the association with the grotto at Bethlehem. De Vos (*Rogier van der Weyden* [as in note 35], 243) writes that "No truly satisfactory explanation has been found for the cellar openings at the front, but the prominence they are afforded suggests that they are significant." Allowing for both possibilities, Bret Rothstein refers to "the well and grotto in the extreme foreground" (B. Rothstein, "Vision, Cognition, and Self-Reflection in Rogier van der Weyden's Bladelin Triptych," *ZKunstg* 64 [2001], 37–55, quotation at 38). One interpretation accepts their association with the cave at Bethlehem and seeks a parallel in Isaiah 51:1, which enjoins seekers of the Lord to "look unto the rock whence you are hewn, and to the hole of the pit from which you are dug out" (O. Delenda, *Rogier van der Weyden—Rogier de le Pasture* [Paris, 1987], 49).

43. C. de Tolnay, "Remarques sur la Sainte Anne de Léonard," *Revue des Arts* 6, no. 3 (1956), 161–66. Von der Osten ("Nachtrag" [as in note 41], 111) acknowledged de Tolnay's earlier attention to the Bladelin openings in the 1967 sequel to his 1964 article.

44. de Tolnay, "Remarques" (as in note 43], 161. This archetypal reading is resisted by Bandmann, "Höhle und Säule" (as in note 41], 130.

45. While pilgrims' accounts of the grotto in the Church of the Nativity at Bethlehem were known, it seems unlikely that the place of birth would have been depicted with such small openings in the ground.

46. It can be argued that this is not quite the case for the opening on the left, the masonry surrounding and grating of which might qualify it as a structural element. The left opening gains considerable identity as a hole, though, through its pairing—for aligned as they are, they cannot

be seen apart—with the less mediated interruption of the ground on the right.

47. In addition to de Vos, *Rogier van der Weyden* (as in note 35], 242–44, see Panofsky, *Early Netherlandish Painting* (as in note 31], vol. 1, 277; Blum, *Early Netherlandish Triptychs* (as in note 36], 19–22; M. Davies, *Rogier van der Weyden* (London, 1972), 201–2.

48. *Golden Legend* (as in note 27], vol. 1, 42.

49. *Golden Legend* (as in note 27], vol. 1, 42.

50. See M. H. Longhurst, *Catalogue of Carvings in Ivory* (Victoria & Albert Museum), part 2 (London, 1929), 34, 59–60 (cat. no. 297-1867, pl. XXXIII; cat. no. 604-1902, pl. LII; cat. no. A547-1910, pl. LII).

51. Blum, *Early Netherlandish Triptychs* (as in note 36], 18–19. For an illustration of the Annunciation on the closed wings, see de Vos, *Rogier van der Weyden* (as in note 35], 243.

52. C. Cennini, *The Craftsman's Handbook, 'Il Libro dell'art*e,' trans. D. V. Thompson Jr. (New York, 1960), 1.

53. Panofsky, *Early Netherlandish Painting* (as in note 31], 270.

54. A. Eörsi, "From the Expulsion to the Enchaining of the Devil: The Iconography of the Last Judgement Altar of Rogier van der Weyden in Beaune," *Acta Historiae Artium* 30 (1984), 123–59.

55. Panofsky, *Early Netherlandish Painting* (as in note 31], 270.

56. Saint Joseph's protective aspect has been considered in the context of the Mérode triptych, e.g., by M. Schapiro, "Muscipula Diaboli" (as in note 1] and W. Heckscher, "The Annunciation of the Mérode Altarpiece: An Iconographic Study," in *Miscellanea Jozef Duverger: Bijdragen tot de kunstgeschiedenis der Nederlanden* (Ghent, 1965), 37–65. More generally on this and other aspects of Joseph, whose character shifted substantially during the fifteenth century, see C. Hahn, " 'Joseph Will Perfect, Mary Enlighten and Jesus Save Thee': The Holy Family as Marriage Model in the Mérode Triptych," *ArtB* 68 (1986), 54–66; and B. Heublein, *Der 'verkannte' Joseph: Zur mittelalterlichen Ikonographie des Heiligen im deutschen und niederländischen Kulturraum* (Weimar, 1998) (with earlier bibliography).

57. A. Acres, "The Columba Altarpiece and the Time of the World," *ArtB* 80 (1998), 422–51.

58. There has been no comprehensive study of the Passion in the infancy, sometimes termed the proleptic Passion. Among studies of specific articulations of the theme, see, for example, F. Zoepfl, "Das schlafende Jesuskind mit Totenkopf und Leidenswerkzeugen: Ein volkstümliches Bildmotiv und seine Herkunft," *Volk und Volkstum: Jahrbuch für Volkskunde* 1 (1936), 147–64; G. Firestone, "The Sleeping Christ Child in Italian Renaissance Representations of the Madonna," *Marsyas* (1942), 43–62; A. A. Barb, "Krippe, Tisch und Grab: Ein Versuch zur Form-Symbolik von Altar und Patene," in *Mullus: Festschrift für Theodor Klauser*, ed. A. Stuiber und A. Hermann (Münster, 1964), 17–27; U. Davitt-Asmus, "Zur Deutung von Parmigianinos 'Madonna dal collo lungo,'" *ZKunstg* 31 (1968), 305–13; D. J. Janson, "Omega in Alpha: The Christ Child's Foreknowledge of His Fate," *Jahrbuch der Hamburger Kunstsammlungen* 18 (1973), 33–42.

59. A common symbolic element that seamlessly combines intimations of evil and the Passion is the coral frequently worn by the Christ child, especially in Italian painting. The coral was a traditional shield against the evil eye, a force often associated with the devil. Its redness associated it with Christ's blood; see M. A. Lavin and M. I. Redleaf, "Heart and Soul and the Pulmonary Tree in Two Paintings by Piero della Francesca," *Artibus et Historiae* 31 (1995), 9–17, esp. 13; and F. T. Elworthy, *The Evil Eye: An Account of This Ancient and Widespread Superstition* (London, 1895). An observer aware of both basic dimensions of the coral's meaning would thus have recognized not only the saving power of the sacrifice, but also the omnipresent threat to which it responds.

60. The novelty of the column in this triptych and its considerable afterlife in later Nativities are remarked by Panofsky, *Early Netherlandish Painting* (as in note 31), 277.

61. For example, in the *Meditations on the Life of Christ* (as in note 39), 32; this connection was noted by E. Mâle, *L'Art religieux de la fin de la Moyen Âge en France: Étude sur l'iconographie du Moyen Âge et sur ses sources d'inspiration*, 2nd ed. (Paris, 1922), 47.

62. "Ductus ad columnam personaliter se vestibus exuit. . . . personaliter ad columnam manus applicuit" (*Revelationes* I, 10, as cited by Panofsky, *Early Netherlandish Painting* [as in note 31], 470, n. 277/3).

63. See R. Berliner, "Arma Christi," *MünchJb* 6 (1955, 35–152.

64. Blum, who sees a singular consistency of reference to the circumstances of Christ's birth in the Bladelin triptych, considers it unlikely that the column was meant to refer to the Passion (Blum, *Early Netherlandish Triptychs* [as in note 36], 21). Although Bandmann develops an important study of a devotionally intensive relationship between imagery of grotto and column, with the latter acquiring strong associations as the column of the flagellation, he believes the Bladelin column—an early example—to have been intended more as the one described by Bridget against which Mary leaned during the birth (Bandmann, "Höhle und Säule" [as in note 41], 140).

65. The architectural imprudence of locating a load-bearing member directly atop a subterranean opening may underscore the thematic rather than naturalistic thrust of the conjunction.

66. The notion of a prompt to imagine menace can invite another look at the Mérode *Annunciation*, and especially at the carved face staring out from the towel rack on the back wall (see Fig. 6). The face was most carefully addressed by Charles de Tolnay, "L'Autel Mérode du Maître de Flémalle," *GBA* 53 (1959); 65–78, esp. 72, who tentatively identified it as the visage of God the Father. He notes that the face—which is near a vanishing point of several orthogonals, close to the top of the picture and turned toward the Virgin—must have had a special impor-

tance for the artist. Associating its bright red surface with fire, de Tolnay notes metaphorical imagery of flame and sun for the Divine. The author makes the identification with a justly cautious tone, for this would be a most unusual (though perhaps not inconceivable) image of God the Father. Could the bright red face have been meant also or instead to evoke God's fiery opposite in the minds of fifteenth-century observers? Its exact alignment with the most centrally projected ceiling beam, which implies its position precisely on axis with a viewer of the picture, can compare with Rogier's decision to open a black hole into the viewer's space at the threshold of a picture. The gaze of the face toward Mary might also be directed through the flame-blackened fireplace toward the shop of Joseph, whose work evidently entails protection against the devil. Viewed in this negative light, the face would give new focus to the gaze of the incoming Christ child, who seems to look more toward it than toward the Annunciate.

67. Among the vast bibliography devoted to the history of the devil, see, for example G. Roskoff, *Geschichte des Teufels* (Leipzig, 1869); J. B. Russell, *Lucifer: The Devil in the Middle Ages* (Ithaca, 1984); P. Dinzelbacher, "Die Realität des Teufels im Mittelalter," in *Der Hexenhammer: Entstehung und Umfeld des Malleus Maleficarum von 1487*, ed. P. Segl (Cologne and Vienna, 1988), 151–75; *Diable, diables et diableries au temps de la Renaissance*, ed. M. T. Jones-Davies (Paris, 1988); *Duivels en demonen: De duivel in de Nederlandse beeldcultuur*, ed. P. van Boheemen and P. P. W. M Dirske (Utrecht, 1994); L. Link, *The Devil: The Archfiend in Art from the Sixth to the Sixteenth Century* (New York, 1995); P. Dinzelbacher, *Angst im Mittelalter: Teufels-, Todes- und Gotteserfahrung. Mentalitätsgeschichte und Ikonographie* (Paderborn, 1996).

68. Arnoul Gréban, *The Nativity*, trans. S. Sewall (Carbondale, Ill., 1991), 29.

69. Gréban, *Nativity* (as in note 68), 33. Given the present discussion of the Bladelin Nativity, it is suggestive that illustrations of the Nativity and Adoration of the Magi in an Arras manuscript (Bibliothèque d'Arras, Ms. 625) of Gréban's play include prominent indications of a shadowy, structurally framed underground area in the lower left corner of each miniature (Gréban, *Nativity*, 52, 61).

70. Link, *Devil* (as in note 67), 40.

71. In a study of apotropaic imagery in the margins of Flemish manuscripts and paintings around 1500, Reindert Falkenburg illuminates another way in which the devil was a living concern for artists and their audience (R. L. Falkenburg, "De duivel buiten beeld: Over duivelafwerende krachten en motieven in de beeldende kunst rond 1500," in *Duivelsbeelden: Een cultuurhistorische speurtocht door de Lage Landen*, ed. G. Rooijakkers, L. Dresen-Coenders, and M. Geerdes (Baarn, 1994), 107–22. Such efforts, many based in folk belief, constitute a physically conceived border control that reveals a perception of evil's easy mobility far beyond the pages of Scripture and theology.

Love's Arrows: Christ as Cupid in Late Medieval Art and Devotion

Barbara Newman

Love is swift of foot;
Love's a man of war,
 And can shoot,
And can hit from far.

Who can 'scape his bow?
That which wrought on thee,
 Brought thee low,
Needs must work on me.
—George Herbert, "Discipline"

The Bible frequently depicts God as both lover and warrior. But these images stand in tension rather than harmony, so when George Herbert chose to portray divine Love as a "man of war," his source was not biblical but Ovidian. It is Cupid—or his medieval avatar, the *dieu d'Amors*—who shoots from afar with his unerring aim and irresistible darts.[1] In Herbert's deceptively simple stanzas, this warlike god of love has become Jesus Christ, but he is also the vanquisher of Christ, who was himself "brought low" by Love's arrows before presuming to launch them from his own almighty bow. This double rapprochement between Christ and Cupid was not original with the Anglican poet, but derives from a current of medieval piety that originated in the twelfth century and flourished well into the seventeenth.

The Phenomenon of Crossover

In this essay I will revisit the trope of Love's arrows and its corollary, the depiction of Christ in the guise of Cupid, as a superb illustration of the medieval practice of "crossover"—the intentional borrowing and adaptation of courtly themes in devotional art and vice versa.[2] This phenomenon was once a familiar problem in literary history, and the same kind of exchange is no less

prominent in visual art. But since the 1970s, prevailing theoretical trends have encouraged scholars to maximize the ironic and self-serving aspects of medieval erotic culture, while minimizing its sublime and "ennobling" aspects.[3] This critical tendency has obscured the close relationship that older critics used to perceive between the idioms of devotion and *fin' amors*.[4] In a recent revisionist essay, however, Simon Gaunt acknowledges that "the strategy behind these critical moves was deliberate and largely political": in seeking to demystify medieval love poetry in order to expose its misogyny and homophobia, he and other scholars felt they could ill afford the luxuries of aesthetic pleasure and affective power these texts had afforded to less resistant readers in the past.[5] Having achieved that goal, Gaunt now questions whether there is any such thing as "purely secular" art to be found in the Middle Ages, and undertakes once again to discover why medieval poets took the theme of erotic love with such intense moral seriousness that they could readily assimilate it to religious devotion.

In response to this question, he proposes that "it is less the worship of the lady . . . that gives the courtly lyric its quasi-religious flavor, than the importance of sacrifice, or what one might call . . . sacrificial desire."[6] While I will not echo Gaunt's Lacanian interpretation of such desire, I believe his insight is true and goes a long way toward explaining the medieval predilection for Christ as Cupid. The god of love, in most medieval representations, is not the least bit "cute": he is neither the naked winged boy of Classical art nor the putto of the Italian Renaissance.[7] Dante in the *Vita nuova* called him a "lord of terrible aspect," and so he is—mature, imperious, and with grave power to harm.[8] The troubadours and their heirs, despite their many moments of self-dramatizing hyperbole and irony, often took the motif of "Love's wounds" with deep seriousness, and it was primarily their obsession with erotic torment, self-surrender, and even death for love that enabled devotional writers, mystics, and artists to translate the fictive god of love so easily into the biblical God who is Love (1 John 4:8). Conventionally defined as a *passio*, a form of suffering, amorous desire was treated by medical writers as a legitimate disease (*amor hereos*),[9] while religious writers linked it with the *passio* of the Crucified who died to win the heart of his beloved, the human soul—*quia amore langueo* (Cant. 2.5).

Like so many elements in the medieval discourse of love, the motif of divine archery turns out to have a dual provenance: Ovid and the Song of Songs. In Canticle 4:9 the bridegroom laments, or perhaps exults, "You have wounded my heart, my sister, my bride; you have wounded my heart with one [glance] of your eyes" (*vulnerasti cor meum in uno oculorum tuorum*). Here the gaze of the beloved requires no intermediary god but exercises direct agency, smiting the lover's heart with those delicious wounds on which twelfth-century commentators loved to dwell. Ovid, an author savored almost as widely as Solomon, first introduced the Greek motif of Cupid's arrows into Latin literature in a classic passage of his *Metamorphoses*. The poet there described the mischievous god taking aim at Apollo's heart with a sharp golden arrow to arouse love, while striking Daphne's with a blunt leaden shaft to quench it.[10] Through this favorite school-text, the theme made its ubiquitous way into medieval poetry and mythography.[11] From the mid-thirteenth century onward, transfixed lovers might be found languishing for the love of God as often as for a lady, and the divine archer was as likely to be the celestial Caritas as the carnal Amor.[12]

In contrast to Cupid, who was always the agent but never the subject or object of erotic love, Jesus as *dieu d'Amors* is all three. Just as in Herbert's lyric, he is both heavenly bowman and lovesick victim, and in his role as victim he inspires that tender-hearted *pitee* which, in courtly lyric and romance, is often the first sign of a woman's love. It required no great stretch of the medieval imagination to interpret Christ's bleeding wounds as *vulnera amoris* and to discern Love's

arrow in the centurion's lance that pierced his heart, opening the salvific fount of blood and water. In a famous pair of miniatures from the Rothschild Canticles, it is the Bride of Christ (a figure interchangeable with Caritas) who actually launches the weapon, aiming it like a javelin at the wound in her lover's side.[13] Closely linked with the arrow and the sacred lance is a less bloody weapon, the pen of the celestial scribe. As Eric Jager has recently shown, the inscribed heart and the pierced heart are close kin in the poetics of love. Indeed, the same Latin word, *calamus*, designates both the feathered quill and the feathered arrow.[14] In one manuscript of the *Roman de la Rose*, the character Genius, who plays bawdy bishop to the god of love, is represented with a quill pen (or arrow) in lieu of an episcopal crosier.[15]

Even more remarkably, the symbolic act of love that concludes the great French poem—the illicit plucking of a rosebud from a virgin's well-protected garden—is ascribed to Christ himself in a devotional text contemporary with the *Rose*. Meditating on the Crucifixion, the Anglo-Latin poet Walter of Wimborne asks what theft Jesus could have committed to deserve a thief's punishment, since he was already the rightful owner of heaven and earth:

Dumtaxat unum est furtum quod fecerat	Yet Jesus did commit one theft
Jhesus, dum clanculo carnem assumpserat	when he secretly put on our flesh
et furtim uirginis claustrum intrauerat,	and stole into the Virgin's bedroom,
quod ipsum etiam sponsum latuerat.	concealed from even her bridegroom.
* * * * *	* * * * *
Unam de uirginis rosam rosario	The harmless thief plucked one bud
fur insons accipit, et de florario	from the virgin's flower bed,
decerpsit flosculum, Joseph non concio;	took from her garden a single rose:
an tale facinus est dignum crucio?[16]	did such a crime deserve the cross?

Innumerable texts could be cited to illustrate the bold erotic theology that emerged in such crossover poems. One of the least familiar and most accomplished of them is the *Philomena*, a Latin devotional epic in some 1,131 ornate rhyming quatrains, penned by the prolific English poet and canon, John of Howden (d. ca. 1272).[17] The *Philomena* is a versified *vita Christi*, recounting the mysteries of Christ's Nativity, Passion, and Resurrection. But the poem's epic hero is predominantly a victim: *Christus patiens* meekly suffers all that is done to him by the agency of a more powerful personage, Amor. The Latin noun has an ambiguity that would be difficult to replicate in a modern vernacular, since Amor can be read as a personified virtue but also as the ancient god of love, in direct continuity with Ovid. This divinity is the motivating force behind all that Christ does and suffers in the poem: Amor humbles the King of kings in the Incarnation, pierces his heart in the garden of Gethsemane, binds him to the pillar with chains, imposes the crown of thorns on his head, and eventually nails him to the cross. All these actions manifest the unchallenged dominion Love holds over the heart of God (*Philomena*, strophe 22):

Tuum, Amor, dulce dominium	Your sweet dominion, Love, has made
Sic, sic domat Regem regnantium!	The King of kings so meek, so tame!
A te vinci vult Rex vincentium,	The King of conquerors wills to be conquered by you,
Ut sic victus vim vincat hostium.	That, vanquished, he may vanquish the violent foe.

After lamenting the death of Christ, John of Howden invokes Amor once again, asking the love-god in more than two hundred strophes to inscribe every detail of the Passion on his willing heart (strophes 491–92):

Fortis Amor, forti conamine	Mighty Love, with a mighty effort
Cordis mei scribas volumine	Inscribe on the volume of my heart
Carnem natam virenti virgine,	The flesh born of the verdant Virgin,
Roris nantem in nati flumine.	Moistened in the dewy stream of her Son.
Amor scriba, scribe velocius	Like a scribe, Love, swiftly inscribe
Cor petrinum et sis notarius;	My stony heart, and be my secretary;
Scribas ibi ferro profundius,	Deeply inscribe with your iron pen
Agnum ferro confossum fortius.	The Lamb pierced deeply with iron nails.

In a Middle English adaptation of this passage, the speaker asks Love to write Christ's sufferings on his stony heart "with nailes and with spere kene." He goes on to equate the pen of the divine scribe with the arrow of the god of love:

Let now loue his bowe bende,	Let Love now bend his bow
An arwe to myn herte sende,	and send an arrow to my heart
That it may perce to the rote;	that it may pierce it to the core—
ffor such a wounde were my bote.[18]	For such a wound would be my cure.

At the end of his lengthy invocation to Amor as scribe, John inquires more closely into the god's identity (strophes 802–4):

Ipsum Deum fulgentem superis,	You conquered the radiant God himself,
Vinctum, Amor, misisti miseris;	Love, and sent him in chains to wretches.
Et, cum implet quodcunque iusseris,	Since he fulfills whatever you command,
Nonne Deus deorum diceris?	Should you not be called the God of gods?
Sed quis horum maior apparuit?	But which of these appeared the greater—
Deus, an is, qui Deum domuit?	God, or the one who conquered God?
Diffinire liber hic noluit,	This book has no wish to decide the question;
Disputare potest qui voluit.	Let anyone who will debate it.
Istud sciat certa scientia,	Yet let them know with certain knowledge
Quod ambobus una substantia	That the two have but one substance;
Est et concors utrique gloria,	God and Love are united in glory,
Honor unus, par excellentia.[19]	In one sole honor, equal excellence.

In other words, God *is* Amor: the divine archer is his own victim, now begged to puncture his lover's heart with his quill (or arrow) just as his own was pierced by the centurion's spear.

In view of such comprehensive literary treatments, it is no surprise to find that visual artists also took up the theme of Christ as Cupid—and its complement, Cupid as Christ. Some late medieval authors even personally supervised the illustration of their works,[20] and given such active exchange between writers and painters, the crossover movement worked in both directions. Markers of divine glory normally reserved for Christ and the saints, such as the crown, the nimbus, the

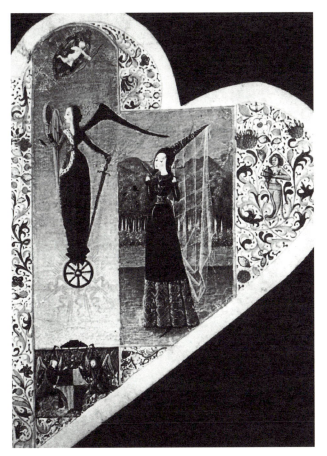

1. Love and Fortune; Cupid shoots a lady from a celestial mandorla. Songbook (*chansonnier*) of Jean de Montchenu, Paris, Bibliothèque Nationale de France, Ms. Rothschild 2973, f. 4. Savoy, ca. 1475

2. Christ child with firebrand enthroned in the heart. Hours of Anne of Mattefelon, Bourges, Musée du Berry, Ms. Bibl. 2160, D. 327, f. C verso. England, ca. 1440

mandorla, and the presence of kneeling worshipers, might be bestowed on the god or goddess of love.[21] One late but compelling example occurs in a heart-shaped songbook commissioned by a prominent Savoyard churchman, the *Chansonnier de Jean de Montchenu* (Fig. 1). In this rarity from circa 1475, the god has already returned to his Classical form as a winged infant, yet he takes aim at a court lady from a very unclassical mandorla in the sky.[22] Venus, too, might be glorified in a celestial mandorla, as if in mildly sacrilegious homage to the Virgin's Assumption. A Florentine salver or *desco da parto* from about 1400, probably intended as a maternity gift from husband to wife, features the nude goddess in a mandorla adored by six celebrated lovers, just as devout saints might adore the Queen of Heaven.[23]

One of the most ambiguous motifs in Love's iconography is the *arbor amoris*, a figure whose precise origins have not been established. Sacred and secular versions both abound. Depictions of the god of love, especially in the *Roman de la Rose* tradition, often show him perched as a sniper in a tree, presumably so he could shoot unseen from a lofty vantage point.[24] But the symbol of the *arbor amoris* also had far-reaching Christian connotations, ranging from the genealogical Tree of Jesse to mythological conceptions of the cross as world-tree to allegorical accounts of the virtues

rooted in charity.[25] Such iconographic motifs could be subjected to parody. For example, an illustration of the late-thirteenth-century poem *L'Arbre d'Amours* co-opts the familiar Tree of Jesse image, representing the lineage of Jesus, to glorify the conquests of Amor. In a painting from this text, the god of love stands in a treetop with his bow, in the commanding position usually occupied by Christ, while the lower branches support three couples, in lieu of patriarchs or prophets, illustrating the successive stages of a love affair.[26] Conversely, however, the arboreal perch customary for the *dieu d'Amors* may have contributed to the puzzling late medieval image of Christ as a naked child in a treetop.[27] Initially portrayed only in Nativity scenes, the naked Christ child became a popular subject in a variety of contexts by the fifteenth century. For example, he could be depicted with the classical attributes of Cupid (Fig. 2) or even placed with his amorous weapon in the branches of an *arbor amoris* (Fig. 5).

Christian iconographers borrowed not only Love's bow and arrows, but also such attributes as the firebrand, the pierced heart, and the flaming heart. The burgeoning and closely linked cults of the Holy Name and the Sacred Heart were both implicated in this development. After the Second Council of Lyon in 1274 decreed that the faithful should bow their heads whenever the name of Jesus was uttered at Mass, the pope charged the mendicant orders with promulgating this decree.[28] Enthusiastically carrying out the papal will, friars fostered devotion to the Holy Name by disseminating exempla in which various saints were discovered, upon autopsy, to have the name of Jesus or the *arma Christi* literally inscribed upon their hearts. This tale was recounted of Saint Ignatius in the influential *Legenda aurea*, and in "modern" times it was told of the Franciscan Chiara of Montefalco (d. 1308).[29] These invisible stigmata of the heart testified to God's power to inscribe his love on the inner self, just as Saint Francis's visible stigmata inscribed Christ's Passion on his flesh for all to see. The devotion to the Holy Name was further inflamed by Henry Suso, who carved the monogram of Jesus on his chest in his own blood and then wrote about it in his autohagiography.[30] In this way, the courtly motif of the heart inscribed with the name or image of the beloved was sacralized and assimilated to the "valentine" emblem of the pierced heart, which is still part of our commercial culture. A book of hours from the mid-fifteenth century demonstrates the final stage in this fusion of Christ with Cupid. In the Hours of Anne of Mattefelon, circa 1440 (Fig. 2), a naked Christ child with what appears to be a firebrand is ensconced in an enormous crucified heart, framed by drawings of Christ's wounded hands and feet.[31] This sacred valentine restores the old pagan iconography of the son of Venus, now firmly identified with the son of Mary.

In the following sections I will examine two special cases of this sacred eroticism: the frequent portrayal of Saint Augustine as a model *fin amant* and (for that reason) a model contemplative, his heart pierced by Love's arrows, and the much rarer representation of the god of love as a six-winged seraph—a motif borrowed from the iconography of Saint Francis receiving Love's wounds. In conclusion, I will speculate on how the motif of Love's arrow came to function by the late Middle Ages as a meta-trope for the sacred image itself.

Saint Augustine as Model *fin amant*

Alfred North Whitehead once characterized the whole of Western philosophy as a series of footnotes to Plato. It has been observed just as plausibly that the history of Christian theology is a series of footnotes to Augustine. Theologians as diverse as Hugh of St.-Victor, Thomas Aquinas,

Martin Luther, and John Calvin can all be claimed as Augustinians, for the sheer mass of the bishop's oeuvre—not to mention its richness, variety, and penchant for self-contradiction—makes his influence both inescapable and impossible to restrict to any one theological stance.

When we turn to the subject of love, the very core of Augustine's thought, we can with equal justice trace two diametrically opposed currents in late medieval piety back to the same master. The stern ascetic, Augustine of the moralists, set an unbreachable chasm between the erotic love represented by Cupid (*cupiditas*) and the sacred love portrayed in the Song of Songs (*caritas*). In *De doctrina christiana* he supplied authoritative definitions of these opposing loves: *caritas* is the love of God, self, and neighbor only for God's sake, and *cupiditas* the love of anything at all without regard for God.[32] The same contrast recurs in *De civitate Dei*, where the bishop remarks that the ephemeral earthly city is built on "self-love even to the point of contempt for God" (*cupiditas*), and the eternal heavenly city on "love of God even to the point of contempt for self" (*caritas*).[33] D. W. Robertson Jr., an influential translator of *De doctrina*, famously exaggerated the ubiquity of this "two loves" topos in courtly literature, but it is true that one cannot read very far in medieval monastic or pastoral writing without coming across some form of it.[34]

Yet there was a second medieval Augustine, the Augustine of the mystics—a contemplative theologian beloved especially for his *Confessions* and *De Trinitate*. This Augustine, far from eschewing the secular idiom of love, seems ironically to have been the first Latin writer to assimilate Christ to Cupid.[35] In a purple passage from the *Confessions*, just as familiar in the late Middle Ages as his dichotomizing texts, Augustine gave the God of his conversion the signature attribute of the pagan love-deity, confessing that "you had shot through my heart with the arrow of your charity, and I bore your words deeply fixed in my entrails."[36] This sentence was paraphrased in a responsory for the saint's feast day on August 28, inspiring monastics to take Love's arrow as a subject for their own meditations and prayers; and it was cited by Jacobus de Voragine in the *Legenda aurea*, guaranteeing a diffusion far beyond the readership of the *Confessions*.[37] The passage was so frequently illustrated that it came to supply the saint with his defining emblem, the pierced heart.[38] In a German life of Saint Augustine, copied and illustrated by a nun of Strasbourg in 1480 (Fig. 3), the heart-piercing arrow of love doubles as the letter I in the sacred monogram of Jesus, IHS. In the lower left corner a praying nun, perhaps the scribe herself, utters the responsory based on the *Confessions*: "Vulneraverat caritas Christi cor eius, Et gestabat verba eius in visceribus quasi sagittas acutas" (The charity of Christ had wounded his heart, and he bore [Christ's] words in his entrails like sharp arrows).[39] Two additional symbols of this piercing love embellish the lower margin: a barefoot Christ child with a cruciform staff, and a unicorn with an enormous horn.

Augustine's arrow-of-charity metaphor was so often echoed that, as the centuries passed, many of the numerous prayers and meditations inspired by it came to be associated with the bishop himself. One of the earliest of these texts was a *Liber meditationum* now ascribed to John of Fécamp (d. 1078). In it "Augustine" prays:

> by those saving wounds of yours, which you suffered on the cross for our salvation, from which flowed that precious blood by which we have been redeemed: wound this sinful soul for which you deigned even to die. Wound her with the fiery and potent dart of your exceeding great charity. . . . You, the chosen arrow and the keenest sword, can penetrate the tough shield of the human heart with your power. Transfix my heart with the spear of your love so that my soul may say to you, "I am wounded by your charity," and let abundant tears flow day and night from that wound of your love.[40]

3. Love's arrow as the letter *I* in the monogram of Jesus. Life of St. Augustine, Berlin, Staatsbibliothek, Preussischer Kulturbesitz, Ms. germ. qu. 1877, f. 2v. Strasbourg, 1480

In the first half of the twelfth century an Augustinian canon, Hugh of St.-Victor, penned the brief but magnificent treatise known as *De laude caritatis*, which influenced John of Howden and many others. This rhetorical tour de force, deeply Ovidian in its imagery, rewrites Caritas as a kind of celestial Venus who brought Christ low with her arrows, just as Cupid had once triumphed over Jove and Apollo:

> O Charity, great is your power! You alone were able to draw God down from heaven to earth. How mighty is your chain by which even God could be bound, and man who had been bound broke the chains of iniquity! . . . We were still rebels when you compelled him, who obeyed you, to descend from the throne of his Father's majesty and take on the weakness of our mortality. You led him bound in your chains, you led him wounded by your arrows, so that man should be all the more ashamed to resist you when he sees that you have triumphed even over God. You have wounded the Impassible, bound the Invincible, dragged the Changeless One down, made the Eternal One mortal.[41]

Hugh in this passage carries Augustine's metaphor to extremes but at the same time reverses it, making Christ himself the first and paradigmatic victim of Love's archery. Given the high medieval fascination with this theme, it is understandable that another of Hugh's widely copied treatises on love, the *Soliloquium de arrha animae* (*Soliloquy on the soul's bridal gift*), should have been ascribed to Augustine in at least ten manuscripts, a sign of his growing reputation as the patron saint of passionate lovers.[42]

Another of the twelfth-century pseudo-Augustines was Gilbert of Hoyland, a Cistercian continuator of Saint Bernard's *Sermons on the Song of Songs*. Like many devotional writers, Gilbert conflated the Ovidian image of Love's arrows with the notion, found in both the Song of Songs and chivalric romances, that Love pierces the heart through the gaze of the eyes. "Would that he might multiply such wounds in me, from the sole of my foot to the crown of my head, that there might be no health in me! For health is evil without the wounds that Christ's gracious gaze inflicts."[43] These metaphorical wounds of love might in turn be identified with Christ's bleeding wounds, especially the side-wound produced by the "arrow" of the centurion's (or Charity's) spear. Another Cistercian of the mid-thirteenth century, Gérard of Liège, used these passionate writings by Gilbert—which he took to be Augustine's—to characterize the saint as a kind of romance hero, *li anguisseus damours*, who could serve as an exemplar for monks and beguines. "Augustine, the man driven to anguish by love, was keenly aware of [its power] when he said, 'Mighty and almighty is the passion of love! It is indeed powerful, because it renders the spirit possessed by it powerless over itself.'"[44]

Augustine's own writings, together with the medieval texts ascribed to him and the many hagiographic accounts, stimulated a fervent cult of this saint as model of all devout lovers. This devotion first became prominent in Gérard's own milieu, as one element of the monastic and beguinal piety that flourished in the Low Countries throughout the thirteenth century. Juliana of Mont-Cornillon (1193–1258), said to have been a fine Latin scholar in her youth, loved the works of Augustine and Bernard, another celebrated *fin amant*, above all other saints.[45] Bernard's copious writings, like Augustine's, had been augmented with numerous pseudonymous works, many of which treated the theme of love. In a mystical *cursus honorum*, aspiring contemplatives were encouraged to begin their spiritual lives by meditating on the humanity of Christ, especially his infancy and Passion, before moving onward and upward to his divinity, with the mystery of the Blessed Trinity as a *ne plus ultra* of divine insight. If Bernard furnished the prime model of devotion to Christ's humanity, Augustine was the unquestioned teacher of Trinitarian contemplation. Thus when the nun Ida of Léau (or Goorsleeuw) immersed herself in Augustinian readings from the lectionary one Christmas, she became so jubilant as she pondered the life of the Trinity that "her soul was steeped in joy, her spirit kindled with joys so great that she almost feared she would lose her mind."[46] Hadewijch of Brabant, also at Christmas, experienced a vision of herself and her beloved Augustine as two great eagles devoured by a phoenix, representing "the Unity in which the Trinity dwells, wherein both of us are lost."[47] More than a century later, Henry Suso held an exalted colloquy with his spiritual daughter, Elsbeth Stagel, on the same themes of the Trinity, the Unity, and the soul's joyous annihilation in the abyss of God. Although his discourse owes much to Meister Eckhart, it is Augustine whom he cites as his authority on such matters.[48] At a more popular level, exemplum collections include a legend that Augustine's heart, preserved in a precious reliquary, leapt for joy whenever the Trinity was mentioned or the Sanctus chanted.[49]

Given their roles as model lovers of God, it is fitting that Augustine and Bernard should ap-

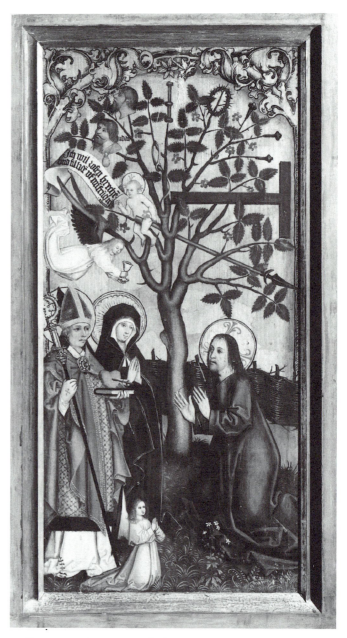

4. Man of Sorrows with Saints Augustine and Bernard pierced by Love's arrows. Devotional compendium, Paris, Bibliothèque Nationale de France, Ms. fr. 17115, f. 156r. Metz, early fourteenth century

5. Christ in Gethsemane with the Virgin and Saint Augustine, the Christ child with a lance, and Saint Augustine with Love's arrow. Workshop of Daniel Mauch, Buxheim Retable, Ulmer Museum, inv. 1922.5109. Ulm, early sixteenth century

pear together, flanking Christ as the Man of Sorrows, in a French historiated initial of the early fourteenth century (Fig. 4).[50] Each saint appears with an arrow from the *dieu d'Amors* aimed at an opening in his habit, cut to display a mystical side-wound resembling Christ's. A more complex rendering of the motif appears in a retable from Ulm (Fig. 5), commissioned for the Cistercian nunnery of Heggbach. This panel offers an allegorical vision of Christ in Gethsemane attended by his mother and Saint Augustine, who is identified by a crosier, a book, and his distinctive attribute

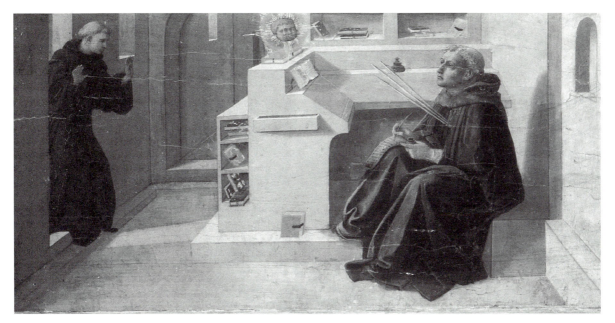

6. Saint Augustine's vision of the Trinity. Fra Filippo Lippi, predella panel from Madonna di S. Spirito (Barbadori Altarpiece), 1437. Florence, Uffizi

of the pierced heart. Between the praying Christ and the attending saints is an idiosyncratic version of the *arbor amoris*, bedecked with instruments of the Passion including an oddly horizontal *tau* cross. In its branches is perched a naked child, identifiable as Christ by his cruciform nimbus, with a scroll paraphrasing Suso: "I will pluck roses and bestow many sorrows on my friends."[51] It is as if the immortal infant Christ waits to shower blessings—which is to say, sufferings—on the two saints even as they commiserate with the historical adult Christ. Between the innocent Child's legs, however, is a huge phallic lance pointed backwards—the same lance of divine love that wounded Christ's heart on the cross and now runs parallel to the arrow in Augustine's heart. This weapon marks the infant God as still an avatar of the god of love, that dangerous arboreal sniper, however chaste and chastened he may now appear. Though Gothic in iconography and style, this early-sixteenth-century work looks forward to the Baroque eroticism of Bernini's *Ecstasy of Saint Teresa*, a simpler and more dramatic statement of the same idea.

As we have seen, Augustine's reputation as a passionate lover of God was enhanced by his sublime contemplations of the Trinity. In a unique predella panel from Fra Filippo Lippi's Barbadori Altarpiece, commissioned about 1437, the saint's erotic passion is inspired precisely by his Trinitarian vision (Fig. 6).[52] A handsome, tonsured Augustine, wearing a friar's habit, is seated at an elaborate writing desk surrounded by books, but he is not reading them. Instead, with his gaze fixed on an apparition of the Trinity in the form of three cherubic faces surrounded by an aureole, he records his vision on a scroll as if scarcely aware that he is writing. Three long arrow shafts, one for each divine Person, stick firmly in his heart. Another friar enters the study from the left, his hands raised in astonishment at the saint's condition. In this painting divine Love visibly pierces Augustine's heart through the gaze of his eyes, but what the diagrammatic vision actually represents is the sight of his mind's eye. Since the theologian never in fact characterized the Trinity in pictorial terms, the radiant emblem before his face must be meant to evoke the imageless *visio intellectualis*, the saint's highest category of vision, which by definition eludes the painter's

7. Saint Augustine's conversion: an angel brandishes three arrows. Zanobi Strozzi, antiphonary, Florence, Museum of San Marco, f. 1r. Mid-fifteenth century

art. It is the spectator, not the saint, who has need of this imaginary form.[53] But for the viewer of the painting, the Trinitarian emblem represents Augustine's intellectual contemplation as surely as the arrows represent his love. The panel thus links his stature as the greatest of the Church's doctors with his unequaled capacity for amorous vision.

The triple arrows recur in a slightly later miniature by the Florentine painter Zanobi Strozzi, a follower of Fra Angelico (Fig. 7).[54] This illumination from an antiphonary decorates the *L* initial (*Letare, Jerusalem*) for the first vespers of Augustine's feast day. In it we see the young Augustine reading in a garden just prior to his conversion, his face upturned to listen to the unseen children's voices chanting "tolle, lege" (take and read). In the upper left corner an angel—or Amor—brandishes three arrows aimed at the young man's heart. While the angel's presence is traditional in this narrative scene, ordinarily he either holds a book or himself recites the words "tolle, lege."[55] Strozzi's substitution of Love's arrows for Love's words appears to be unique. He has thereby conflated the famous garden scene from *Confessions* VIII.12 with Augustine's arrow metaphor and his fame as an expositor of the Trinity. Within its liturgical context, the meaning of this image is clear enough, yet so too is a certain crossover sensibility. The youthful saint, represented in secular

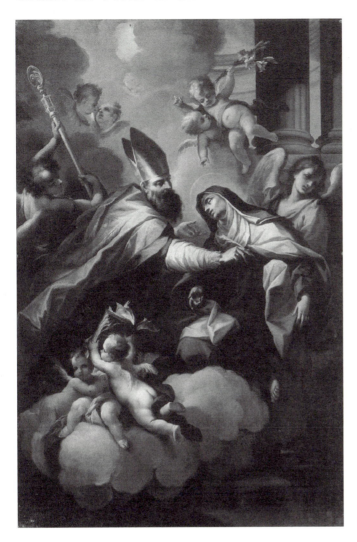

8. Giovanni Sagrestani, *Saint Augustine Writing on the Heart of Santa Maria Maddalena de' Pazzi*, Florence, San Frediano in Cestello. Circa 1702

garb, could just as well be a melancholy poet-lover brooding in a *locus amenus*; and the angelic marksman, though he lacks the telltale bow, stalks his amorous prey from the same position as the insouciant Cupid in a contemporary *chansonnier* (Fig. 1).

In a late Baroque painting by Giovanni Sagrestani (1702), the same Augustine whose heart was once pierced by Charity's arrows becomes a scribe impressing Christ's love on a female heart (Fig. 8). Sagrestani's painting glorifies Maria Maddalena de' Pazzi (1566–1607), a Counter-Reformation mystic who twice experienced visions in which Augustine wrote the words "Verbum caro factum est" on her heart—first in letters of blood and then in gold.[56] In continuity with medieval nuns, the Italian Carmelite thought of Saint Augustine as the ultimate contemplative lover. Not only did she regard him as her spiritual father, but she declared that he had penetrated even deeper into divine love than Saint John, because the evangelist merely wrote the sacred gospel of the Incarnation whereas Augustine had expounded its meaning.[57] In this scene of mystical inscription, the bishop becomes a chosen instrument of the god of love, while the quill that opens Maria Maddalena's heart again recalls the traditional arrow as well as the lance that pierced Christ's heart.

The artist's winged putti, paired off in amorous couples, offer a semipagan commentary on the scene of sacred eroticism.[58]

The God of Love and the Seraphic Christ

One of the most curious instances of crossover can be seen in two manuscripts, related iconographically but not textually, in which the god of love is depicted as a six-winged seraph. In a troubadour *chansonnier* from northern Italy, written during Dante's lifetime, songs by seven Provençal poets are illustrated with a set of unusual marginal drawings.[59] The first and most amply represented of these poets is Folc of Marseille (d. 1231), whose own life is a remarkable case study in crossover.[60] Although prolific and successful as a troubadour, Folc (also called Folco or Folquet) stopped composing songs around 1195, after the death of his patrons and his lady. Around 1200 he became a Cistercian monk at Le Thoronet; in 1205 he was named bishop of Toulouse and in that capacity played a role in the Albigensian Crusade which so effectively crushed the culture of southern France. It seems fitting then that the poetry of Folc, who served first *Amors* and then Christ as his god of love, should have inspired one of the most ambivalent of all images of this deity. His *canso* "Ben an mort mi e lor" laments the speaker's fate of being compelled to flee what pursues him (*Amors*) while pursuing what flees him (his lady). The marginal sequence (Fig. 9) reads from left to right, beginning with the sorrowful poet and ending with the reluctant lady. *Amors* appears twice in the form of a seraph with three faces and a crown: at left he is quiescent, but in the center he flaps his wings vigorously, "creating psychic disturbance."[61]

While the god of love is often depicted with a crown and a single pair of wings, he has six wings only in this *chansonnier* and one other manuscript, to be discussed below, while the three faces are unique to the Italian songbook. They inevitably suggest the Trinity (cf. Fig. 6), just as the six wings recall the cherubim and seraphim of sacred iconography (see, e.g., Mary Carruthers, "Moving Images in the Mind's Eye," in this volume). A few folios later, the seraphic *Amors* strikes

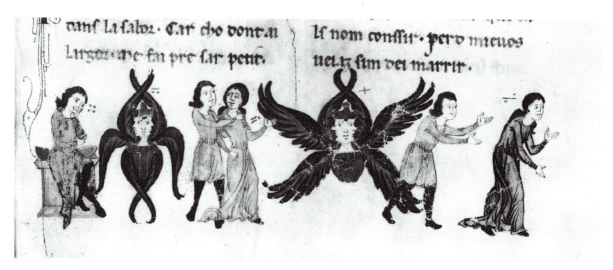

9. *Amors* in the form of a six-winged seraph. Troubadour *chansonnier*, New York, Pierpont Morgan Library, Ms. M.819, f. 56r. Padua, late thirteenth century

the poet's heart not with an Ovidian arrow, but with a lance, the same weapon we have seen linked with the amorous wounding of Christ. In such a case it is virtually impossible to determine whether the artist meant to confer an aura of genuine sacredness on *Amors* or to unmask him as a blasphemous parody of the true God. Sylvia Huot's description seems apt: "The portrayal of Love as an angelic figure, seraphic or otherwise, is undoubtedly a means of representing its power as an abstract entity, an overwhelming spiritual force that can work for either good or evil."[62]

Neither Folc nor any other troubadour in this manuscript provides a visual description of the god of love, let alone one that matches the painter's unique creation. Angelica Rieger has proposed that his model was a didactic figure of the six-winged cherub which, in Alan of Lille's treatise *De sex alis cherubim*, symbolizes an array of virtues.[63] But such cherub diagrams, widely used as mnemonic devices, themselves helped to shape an iconographic motif much closer in spirit to the troubadours' god of love. In late-thirteenth-century Italy, the likeliest model for the *chansonnier* painter would have been Saint Francis receiving the stigmata from Christ, who appeared to him in the form of a crucified seraph. The saint's vision on Mount Alverno quickly became a topos in Franciscan art, but his experience could be depicted in a variety of ways.[64] Sometimes, as in Giotto's celebrated frescoes, rays of light proceed from each of Christ's five wounds to impress stigmata on the corresponding parts of Francis's body. In other representations, however, the rays travel directly from Christ's gaze to his servant's (Fig. 10). Since the stigmata are nothing more nor less than *vulnera amoris* borne by Christ's lover, this version accords with the old idea that Love wounds by way of the beloved's eyes: "vulnerasti cor meum in uno oculorum tuorum." Jacobus de Voragine explained the miracle by speculating that, through the power of the imagination—the *vis imaginativa* of medieval psychology—the image of the wounded Christ impressed itself so forcefully on the mind's eye that it was subsequently able to imprint itself on the saint's very flesh.[65] In any case, the six-winged, seraphic Christ whose gaze had such power to wound his lover already bears a resemblance to the six-winged *Amors* of the *chansonnier*, who pursues and eventually pierces the hapless poet.

The other image of seraphic Love occurs in a French romance of the mid-thirteenth century, the *Roman de la Poire*, written by an obscure poet who revealed his name, Tibaut, in a rebus. The *Poire* is indebted to a more celebrated romance, Guillaume de Lorris's *Roman de la Rose*, for its allegorical treatment of the psychology of love. In this case, it is the text itself that describes *Amors*, in the god's own words, as a deity with six wings:

Por ce que des amanz sui li soverains diex,	Because I am the sovereign god of lovers,
sui ge assis si plesans devant Fortune tiex,	I am seated thus pleasantly before Fortune,
en .VI. eles volanz com ange esperitiex.	Flying with six wings—spiritual, like an angel.
Plus faz de mes talenz que ne fet hom mortiex.[66]	I do just as I please, more than any mortal man.

In contrast to the *Rose*, the god of love in the *Poire* does not shoot the poet. Instead, much later in the text, he shoots the lady. But the Parisian illustrator, combining the datum of a six-winged *Amors* with the god's traditional archery, represents a seraphic figure shooting from on high at two lovers, impaling each with an arrow through the heart (Fig. 11).

Tibaut has not yet finished with the god of love. His allegorical narrative continues with an evocative scene in which the lady plucks a pear from a tree, bites it with her "teeth whiter than

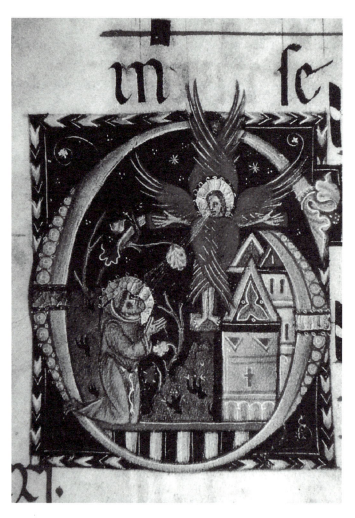

10. Saint Francis receiving the stigmata from Christ in the form of a seraph. Gradual, Montalcino, Archivio Comunale, Ms. 5, f. 181v. Italy, second half of the thirteenth century

ivory," and gives it to the poet, who also eats. "Never since Adam bit the apple," says Tibaut, has there been such a fruit, for the pear is at once "poisonous and wholesome," causing effects both good and evil.[67] This fruit, because of its shape, was an obvious symbol of female sexuality and pregnancy. It may also have been intended to recall the episode of stolen pears in Augustine's *Confessions*, which many readers have taken to symbolize the youthful scholar's illicit sexual indulgence.[68] At any rate, as soon as he tastes the fruit the poet begins to suffer all the pains, along with the sweetness, of love. Like his precursor in the *Rose*, he falls completely beneath the sway of *Amors*. Given Tibaut's erotic rewriting of the Fall in this scene, the six-winged deity is once again profoundly ambiguous. Since the poet-lover is tempted into his misery by a fruit, *Amors* cannot help but recall the biblical serpent. Yet his winged form suggests a different personage—the cherub with the flaming sword who "guards the way to the Tree of Life" (Gen. 3:24). Tibaut describes the god as having six wings because he is "a spiritual being, like an angel" (*com ange esperitiex*)—but whether fallen or unfallen, we do not know. Such images may well represent what Alcuin Blamires called "a creative encounter between Platonising lyricism, and the Catholic proclivity for relishing blasphemy without any concomitant alarm lest faith be diminished."[69] As in the troubadour *chansonnier* from Padua, the god of love's appropriation of sacred attributes makes him both more numinous and more dangerous.

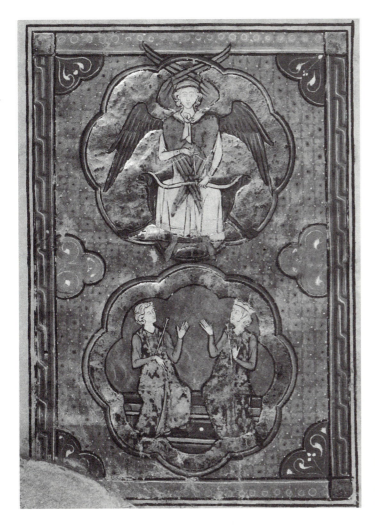

11. *Amors* as a six-winged seraph shoots two lovers. *Roman de la Poire*, Paris, Bibliothèque Nationale de France, Ms. fr. 2186, f. 1v. Paris, ca. 1260–70

Finally, with an image from the *Exemplar* of Henry Suso, we return full circle to the seraphic Christ of Saint Francis. In open homage to the Poverello, Suso's *Life* describes a spiritual vision in which he beheld "the likeness of the crucified Christ in the form of a seraph."[70] An illustration from the well-known Strasbourg manuscript (Fig. 12) depicts the friar kneeling in prayer before this vision. He had been asking Christ to teach him how to suffer, so the inscriptions on the seraph's wings exhort him to receive suffering willingly, bear it patiently, and learn to suffer as Christ did. Suso's head is crowned with a lover's chaplet of roses, signifying torments freely accepted, while in lieu of an arrow his heart bears the inscription of the Holy Name, a token of his self-imposed martyrdom.[71] These courtly elements testify to a crossover mentality that is not yet present in the iconography of Saint Francis. Like the medieval Augustine, Suso gladly adopts the posture of the *fin amant* (or *minnende Seele*) and accepts suffering for his Beloved as a gift, offered and received in the loving mutual gaze he exchanges with the seraph. Needless to say, Suso's Christ crucified on the Tree of Life is hardly equivalent to the *dieu d'Amors* perched in the tree of knowledge of love, with its sweetly poisonous fruit. Yet neither is their relationship a simple binary opposition, a moralistic typology of Good and Evil, such as we might find in pedagogical diagrams of the *arbores virtutum et vitiorum*. Rather, a set of shared presuppositions about love

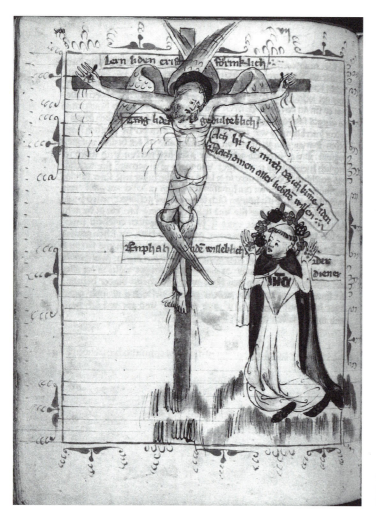

12. Henry Suso prays to Christ in the form of a seraph. *Exemplar*, Strasbourg, Bibliothèque nationale et universitaire, Ms. 2929, f. 65v. Strasbourg, ca. 1370

subtend the exchange of iconographic motifs: Love is a bitter sweetness, a mighty supernatural force, and above all, a source of anguish and suffering, which pierces the lover's heart and inscribes it indelibly with the name and image of the beloved. Most often, as we shall see in the final section, it is through the eyes that Love's fateful arrow enters the heart.

Piercing the Heart through the Eye

> Wine comes in at the mouth
> And love comes in at the eye;
> That's all we shall know for truth
> Before we grow old and die.
> —W. B. Yeats, "A Drinking Song"

Love's entrance through the eye—for Yeats, a truth as timeless as death and taxes—was an axiom of the medieval art of *fin' amors*. Whether launched by Cupid, Venus, Frau Minne, or the gaze of the beloved, Love's arrows passed figuratively through the lover's eyes to lodge themselves in the

heart. Ruth Cline, in an erudite source study, traced this refinement on the motif of Love's archery to the Arabic poets of al-Andalus.[72] But it was popularized in twelfth-century France through the *Roman d'Enéas* and the works of Chrétien de Troyes. In Chrétien's *Yvain*, the hero is smitten by *Amors* as soon as his eyes light on the lady of the fountain:

[Amors] si dolcemant le requiert	Love's pursuit's a gentle art:
que par les ialz el cuer le fiert.[73]	through the knight's eyes she strikes his heart.

In *Cligès*, similarly, the knight Alexander marvels at Love's strange archery:

Par l'uel? Et si nel t'a crevé?	How through the eye the arrow rushed
An l'uel ne m'a il rien grevé;	and left the eye unhurt, uncrushed.
Mes au cuer me grieve formant.	If through the eye the arrow pressed,
Or me di donc reison, comant . . . ?	why is there heart pain in the chest . . . ?
De ce sai je bien reison randre:	I can explain: the eye won't try
Li iauz n'a soing de rien antandre	to understand the reason why
Ne rien n'i puet feire a nul fuer;	and could not do so from the start
Mes c'est li mireors au cuer.[74]	but is the mirror of the heart.

Influential as Chrétien's romances were, the *locus classicus* for this iconography is the *Roman de la Rose*. The first of the two *Rose* poets, Guillaume de Lorris, describes the archery of the *dieu d'Amors* taking aim at the hapless Amant:

Li diex d'Amors, qui l'arc tendu	The god of Love, who never ceased
Avoit touz jors mout entendu	To spy and stalk me as he pleased, . . .
A moi porsivre et espier . . .	Took up and bent his mighty bow,
Il a tantost pris une floiche	From his quiver chose an arrow,
Et quant la corde fu en coche	Drew the bow straight back to his ear,
Il entesa jusqu'à l'oreille	And fired with taut string, vision clear
L'arc qui estoit fort a merveille,	And flawless aim. His potent dart
E trait a moi par tel devise	Sailed through my eye to pierce my heart.
Que parmi l'oel m'a ou cors mise	
La saiete par grant roidor.[75]	

This passage was *de rigueur* for the numerous illustrators of the *Rose*. Some painters cut to the chase and lodged the arrow in the heart, while others depicted the scene literally, with the shaft piercing the lover's eye.[76]

Unlike manuscripts of the *Rose*, sacred art never represents a divine arrow directly striking the beholder's eye, for God is not a visible object like the beloved lady. Nevertheless, even this erotic motif finds its echo in the greatest of all crossover works. Dante's *Paradiso*, which is at once an ascent to the beatific vision and the apotheosis of *fin' amors*, plays continually on the theme of Beatrice's gaze. The light of her eyes fills the poet with amorous joy, even as it did during her earthly life, but at the same time her regard is literally a divine force that propels him through the celestial spheres toward the throne of God. A particularly telling instance of the gaze occurs at the end of canto IV. Dante has just addressed Beatrice as the "beloved of the First Lover" (O amanza del primo amante), and she is about to enlighten him on the mystery of free will and destiny. But first she subjects him to the full radiance of her divine gaze, which he cannot yet endure:

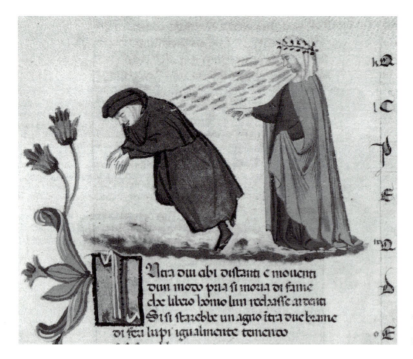

13. Dante staggers beneath the radiant gaze of Beatrice (*Paradiso* IV). Padua, Seminario, Ms. 67, f. 208r. Padua, early fifteenth century

Beatrice mi guardò con li occhi pieni
di faville d'amor così divini,
che, vinta, mia virtute diè le reni,
e quasi mi perdei con li occhi chini.[77]

Beatrice gazed at me with eyes so full
of the sparks of love, and so divine,
that, vanquished, my strength gave way,
and with eyes cast down, I was nearly lost.

The poet here might be any lover abashed by the sight of his lady's beauty—yet in this case, the two are discussing theology in heaven, and the *faville d'amor* really *are* divine. An early-fifteenth-century manuscript from Padua presents this scene (Fig. 13) with the same literalism that French illuminators of the *Rose* sometimes lavished on the arrow in Amant's eye. The laurel-crowned Beatrice launches a whole volley of sparks from her sacred gaze, overpowering her lover as surely as the intellectual vision of the Trinity pierces Augustine's heart (Fig. 6), or the gaze of the seraphic Christ imprints the stigmata on Francis (Fig. 10). Although Dante does not actually say that he turned away from Beatrice, he uses the idiom that his strength "gave way" (*diè le reni*, or "turned its back"), and the artist has literalized this expression to show the poet staggering as if about to fall, as he seeks to flee from the unbearable gaze of Love. At this early point in the *Paradiso*, the image might recall God's solemn warning that no one can behold his face and live; so, as a special favor, he permits Moses to see his back (Exod. 33:18–23). Similarly, the poet's vision at this point in his pilgrimage is not strong enough to gaze on *l'ultima salute* face to face. Yet the radiance of Beatrice's eyes looks forward typologically to the beatific vision: Dante will not be ready to approach the face of God until he can bear the force of his lady's gaze without flinching.

In the literature of *fin' amors*, Love's arrow is a metaphor for the physical beauty of the beloved, which afflicts the lover with painful yearning. This point is made explicit in the *Roman de la Rose*, where the barb of beauty—the first of the god's five arrows—remains fixed in the lover's heart even after he removes its feathered shaft. In the case of divine love, the metaphor may

seem less appropriate, since the beauty in question is invisible. Yet one of the most frequently cited functions of religious art was to set the unseen object of worship before the mind's eye in order to arouse affection in the heart. Like a metaphorical arrow fired by the hand of God, the devotional image itself was meant to pierce the beholder's heart through the eye, setting it afire with love for invisible beauty by means of the beauty and pathos that could be seen. Pathos was at least as important as beauty, for late medieval artists often strove to represent the Crucified in his death pangs with "no form or comeliness, . . . no beauty that we should desire him" (Isa. 53:2). Yet pity could awaken love just as effectively, and visual images might serve as well as actual visions to puncture a heart with what Julian of Norwich called the "three wounds" of contrition, compassion, and longing for God. Her own experience provides a case in point, proceeding from the physical sight of a crucifix to a spiritual vision of the dying Christ to the final, triumphant knowledge that "love was his meaning."[78]

Despite a long-standing theological bias in favor of imageless contemplation, not to mention the periodic outbreaks of iconoclasm among reformists, the ever-growing popularity of devotional images testified to an axiomatic truth about love that everyone simply "knew." Andreas Capellanus, as good an authority as any, had in the late twelfth century defined love as "a certain inborn suffering derived from the sight of and excessive meditation upon the beauty of" the beloved.[79] So self-evident was this truth that Andreas had even raised as a *quaestio* whether blind persons were capable of loving. Faith might come through the hearing of the ear, as Saint Paul had asserted (Rom. 10:17), but love arose from the eye's attraction to beauty. In consequence, the more Christianity came to define itself as a religion centered on the arousing and ordering of love, the more indispensable it found images.[80] Nor is it a coincidence that the iconoclastic fervor of the Reformation accompanied a spiritual reorientation toward faith—"the conviction of things not seen" (Heb. 11:1)—rather than love, the adoration of things seen. It is no wonder, then, that the late Middle Ages, the most iconographically fertile and creative period in all of Christian history, cherished such a predilection for the trope of Love's arrows.

Acknowledgments

I would like to thank John Fleming, Jeffrey Hamburger, Richard Kieckhefer, Marit MacArthur, William Paden, Katharine Park, and Nicholas Watson for their helpful comments and references.

Notes

1. In medieval exegesis of one biblical passage, Isa. 49:2, Christ himself is figured as a "chosen arrow" in the Father's quiver. See B. McGinn, "Tropics of Desire: Mystical Interpretation of the Song of Songs," in *That Others May Know and Love: Essays in Honor of Zachary Hayes*, ed. M. Cusato and F. E. Coughlin (St. Bonaventure, N.Y., 1997), 133–58. The motif of divine archery also occurs elsewhere in the Bible, e.g., in Psalm 38:2, Lamentations 3:12–13, and Job 6:4 ("the arrows of the Almighty are in me"). But these passages deal with divine wrath and punishment rather than love, and are independent of the traditions investigated here. Their iconographic echoes are rather to be found in such subjects as the Last Judgment and the martyrdom of Saint Sebastian.

2. In chapter 4 of my book *God and the Goddesses: Vision, Poetry, and Belief in the Middle Ages* (Philadelphia, 2002), I discuss the motivations of crossover art and some feminine counterparts of Christ as Cupid: the medieval representations of Caritas, Frau Minne, and Dame Amour as mystical Venus-figures.

3. But see now C. S. Jaeger, *Ennobling Love: In Search of a Lost Sensibility* (Philadelphia, 1999). The tendency to-

ward irony is well represented by S. Kay, *Subjectivity in Troubadour Poetry* (Cambridge, 1990), and M. Camille, *The Medieval Art of Love: Objects and Subjects of Desire* (New York, 1998).

4. See, for example, C. S. Lewis, *The Allegory of Love: A Study in Medieval Tradition* (Oxford, 1936); P. Dronke, *Medieval Latin and the Rise of European Love-Lyric*, 2 vols. (Oxford, 1965–66); N. Perella, *The Kiss Sacred and Profane: An Interpretative History of Kiss Symbolism and Related Religio-Erotic Themes* (Berkeley, 1969).

5. S. Gaunt, "A Martyr to Love: Sacrificial Desire in the Poetry of Bernart de Ventadorn," *Journal of Medieval and Early Modern Studies* 31 (2001), 477–506, at 480.

6. Gaunt, "Martyr to Love" (as in note 5), 482.

7. E. Panofsky, "Blind Cupid," in *Studies in Iconology: Humanistic Themes in the Art of the Renaissance* (New York, 1939), 95–128 and figs. 69–106; C. Dempsey, *Inventing the Renaissance Putto* (Chapel Hill, 2001). See esp. chap. 2, "*Spiritelli d'Amore.*"

8. Dante, *Vita nuova*, 3 ("uno segnore di pauroso aspetto"), ed. V. Cozzoli (Milan, 1995), 26.

9. M. F. Wack, *Lovesickness in the Middle Ages: The Viaticum and Its Commentaries* (Philadelphia, 1990).

10. "[Amor] sagittifera prompsit duo tela pharetra/diversorum operum: fugat hoc, facit illud amorem;/quod facit, auratum est et cuspide fulget acuta,/quod fugat, obtusum est et habet sub harundine plumbum" (Ovid, *Metamorphoses*, I.468–71, ed. W. S. Anderson [Leipzig, 1977], 16).

11. For Cupid/Amor in mythography, see J. Chance, *Medieval Mythography: From Roman North Africa to the School of Chartres, A.D. 433–1177*, 2 vols. (Gainesville, Fla., 1994); T. Tinkle, *Medieval Venuses and Cupids: Sexuality, Hermeneutics, and English Poetry* (Stanford, 1996); R. Blumenfeld-Kosinski, *Reading Myth: Classical Mythology and Its Interpretations in Medieval French Literature* (Stanford, 1997).

12. Conflation of the two was still possible as late as 1893, when the sculptor Sir Albert Gilbert designed his memorial for the seventh Earl of Shaftesbury, meant as an allegory of Christian charity, in the form of a naked winged boy with a bow. Gilbert miscalculated, however, for his statue—in London's Piccadilly Circus—is universally known as Eros (Dempsey, *Inventing* [as in note 7], 4–5).

13. J. F. Hamburger, *The Rothschild Canticles: Art and Mysticism in Flanders and the Rhineland circa 1300* (New Haven, 1990), 72–77, pl. 5.

14. E. Jager, *The Book of the Heart* (Chicago, 2000), 78.

15. S. Huot, *The* Roman de la Rose *and Its Medieval Readers: Interpretation, Reception, Manuscript Transmission* (Cambridge, 1993), 298–99.

16. Walter of Wimborne, *Marie carmina*, stanzas 586, 590, in A. G. Rigg, ed., *The Poems of Walter of Wimborne* (Toronto, 1978), 270–71.

17. John of Howden, *Philomena*, ed. C. Blume, *John Hovedens Nachtigallenlied über die Liebe unseres Erlösers und Königs Christus* (Leipzig, 1930). See also Jager, *Book of the Heart* (as in note 14), 108–11; A. G. Rigg, *A History of Anglo-Latin Literature, 1066–1422* (Cambridge, 1992), 208–15.

18. *Meditations on the Life and Passion of Christ*, lines 1629–32, ed. C. d'Evelyn, EETS, O.S. 158 (Oxford, 1921),

43. Abridged from this text is the lyric "Ihesu that hast me dere I-boght," no. 91 in *Religious Lyrics of the XIVth Century*, ed. C. Brown, rev. G. V. Smithers (Oxford, 1952), 114–19. Cf. *Philomena*, strophe 620: "Telum arcus Amoris iaciat/Et saxosum cor sancte feriat."

19. This passage is indebted to Hugh of St.-Victor's *De laude caritatis*, discussed below: "O caritas . . . Nescio enim si forte maius sit te Deum dicere, an Deum te superasse. Quod si maius est, etiam hoc libenter et fiducialiter de te dicam: 'Deus caritas est, et qui manet in caritate, in Deo manet et Deus in eo'" (1 John 4:8). *L'Oeuvre de Hugues de Saint-Victor* I, ed. H. B. Feiss and P. Sicard (Turnhout, 1997), 196 (also in PL 176:975A–B). The German poet Lamprecht of Regensburg (ca. 1250) similarly identifies God with Lady Love: "Diu minne ist got, got ist diu minne,/einz ist in dem andern inne" (*Tochter Syon*, lines 3192–93, in *Sanct Francisken Leben und Tochter Syon*, ed. K. Weinhold [Paderborn, 1880], 445).

20. These included Guillaume de Machaut, Christine de Pizan, and Francesco Barberino (*Documenti d'Amore*). See M. Müller, *Minnebilder: Französische Minnedarstellungen des 13. und 14. Jahrhunderts* (Cologne, 1996), 191–92.

21. Müller, *Minnebilder* (as in note 20), 172–94.

22. *Chansonnier de Jean de Montchenu*, ed. G. Thibault and D. Fallows (Paris, 1991); D. D. R. Owen, *Noble Lovers* (New York, 1975), 129; Jager, *Book of the Heart* (as in note 14), 84–85.

23. For competing interpretations, see Camille, *Art of Love* (as in note 3), 32–33, and A. Blamires, "The 'Religion of Love' in Chaucer's *Troilus and Criseyde* and Medieval Visual Art," in *Word and Visual Imagination: Studies in the Interaction of English Literature and the Visual Arts*, ed. K. J. Höltgen et al. (Erlangen, 1988), 11–31, fig. 4. On maternity salvers generally, see J. M. Musacchio, *The Art and Ritual of Childbirth in Renaissance Italy* (New Haven, 1999).

24. Müller, *Minnebilder* (as in note 20), 185–88 and figs. 29, 64, 115, 117; Panofsky, "Blind Cupid" (as in note 7), fig. 75; Camille, *Art of Love* (as in note 3), 40, fig. 29.

25. E. S. Greenhill, "The Child in the Tree: A Study of the Cosmological Tree in Christian Tradition," *Traditio* 10 (1954), 323–71; U. Kamber, ed., *Arbor amoris, der Minnebaum: Ein Pseudo-Bonaventura-Traktat herausgegeben nach lateinischen und deutschen Handschriften des XIV. und XV. Jahrhunderts* (Berlin, 1964).

26. Müller, *Minnebilder* (as in note 20), fig. 34; Camille, *Art of Love* (as in note 3), 122, fig. 108.

27. Suggestions of this motif first appear in two Grail romances: Wauchier's continuation of Chrétien de Troyes's *Perceval* (ca. 1190–1200) and the prose *Didot Perceval* (before 1227). In his quest Perceval comes upon a mysterious child in a tree, who offers him guidance and then suddenly disappears. While the child is never clearly identified, he is allied with the mysteries of the Grail and may represent the infant Christ. See Greenhill, "Child in the Tree" (as in note 25), 324–26.

28. M.-A. Polo de Beaulieu, "La Légende du coeur inscrit dans la littérature religieuse et didactique," in *Le "Cuer" au Moyen Âge: Réalité et sénéfiance* (Aix-en-Provence, 1991), 299–312, at 310.

29. For Ignatius, see Jacobus de Voragine, *The Golden Legend: Readings on the Saints*, trans. W. G. Ryan (Princeton, 1993), vol. 1, 140–43; for Chiara of Montefalco, see A. M. Kleinberg, *Prophets in Their Own Country: Living Saints and the Making of Sainthood in the Later Middle Ages* (Chicago, 1992), 155–56, and K. Park, "The Criminal and the Saintly Body: Autopsy and Dissection in Renaissance Italy," *Renaissance Quarterly* 47 (1994), 1–33.

30. H. Suso, *Life of the Servant*, chap. 4, in *The Exemplar*, trans. F. Tobin (New York, 1989), 70–71.

31. The Christ child in this woodcut holds a knotted scourge in his right hand and what seems to be a torch in his left, although a later colorist has painted it green, perhaps taking it for another kind of flagellum. On the wounded heart, see C. Raynaud, "La mise-en-scène du coeur dans les livres religieux de la fin du Moyen Âge," in *Le "Cuer" au Moyen Âge* (as in note 28), 313–43.

32. "Caritatem uoco motum animi ad fruendum deo propter ipsum et se atque proximo propter deum; cupiditatem autem motum animi ad fruendum se et proximo et quolibet corpore non propter deum" (Augustine, *De doctrina christiana* III.16 [CCSL 32 (Turnhout, 1962), 87]).

33. "Fecerunt itaque ciuitates duas amores duo, terrenam scilicet amor sui usque ad contemptum Dei, caelestem uero amor Dei usque ad contemptum sui" (Augustine, *De civitate Dei* XIV.28 [CCSL 48 (Turnhout, 1955), 451]).

34. D. W. Robertson Jr., *A Preface to Chaucer: Studies in Medieval Perspectives* (Princeton, 1962). For a nuanced review of this problem, see Tinkle, *Medieval Venuses* (as in note 11), 9–41.

35. Origen had already characterized Christ as Eros in the Greek tradition. See F. J. Dölger, "Christus als himmlischer Eros und Seelenbräutigam bei Origenes," in *Antike und Christentum: Kultur- und religionsgeschichtliche Studien*, vol. 6 (Münster, 1950), 273–75.

36. "Sagittaueras tu cor nostrum caritate tua, et gestabamus uerba tua transfixa uisceribus" (Augustine, *Confessiones* 9.3 [CCSL 27 (Turnhout, 1981), 134]).

37. Hamburger, *Rothschild Canticles* (as in note 13), 76; P. Courcelle, *Les Confessions de Saint Augustin dans la tradition littéraire: Antécédents et postérité* (Paris, 1963), 322; Jacobus de Voragine, *Golden Legend* (as in note 29), vol. 2, 117. Jacobus's biography of Augustine is one of his longest and quotes liberally from the *Confessions*.

38. L. Réau, *Iconographie de l'art chrétien*, vol. 3 (Paris, 1958), 150–51.

39. J. F. Hamburger, *Nuns as Artists: The Visual Culture of a Medieval Convent* (Berkeley, 1997), 118–19. For a later example of the pierced-heart monogram, see J. F. Hamburger, "La Bibliothèque d'Unterlinden et l'art de la formation spirituelle," in *Les Dominicaines d'Unterlinden*, vol. 1 (Colmar, 2000), 158.

40. "Rogo te per illa salutifera vulnera tua, quae passus es in cruce pro salute nostra, ex quibus emanavit ille pretiosus sanguis quo sumus redempti, vulnera hanc animam peccatricem, pro qua etiam mori dignatus es; vulnera eam igneo et potentissimo telo tuae nimiae charitatis. . . . Tu sagitta electa, et gladius acutissimus, qui durum scutum humani cordis penetrare tua potentia vales, confige cor meum jaculo tui amoris: ut dicat tibi anima mea, Chari-

tate tua vulnerata sum; ita ut ex ipso vulnere amoris tui uberrimae fluant lacrymae nocte ac die" (John of Fécamp, *Liber meditationum*, chap. 37 [PL 40:935]). For the attribution, see A. Wilmart, "Deux préfaces spirituelles de Jean de Fécamp," *Revue d'ascétique et de mystique* 18 (1937), 3–44; J. Leclercq and J.-P. Bonnes, *Un maître de la vie spirituelle au XIe siècle: Jean de Fécamp* (Paris, 1946), 39–41.

41. "Magnam ergo uim habes, caritas. Tu sola Deum trahere potuisti de celo ad terras. O quam forte est uinculum tuum, quo et Deus ligari potuit et homo ligatus uincula iniquitatis dirupit. . . . Adhuc nos rebelles habuisti, quando illum tibi obedientem de sede paterne maiestatis usque ad infirma nostre mortalitatis suscipienda descendere coegisti. Adduxisti illum uinculis tuis alligatum, adduxisti illum sagittis tuis uulneratum, ut amplius puderet hominem tibi resistere, cum te uideret etiam in Deum triumphasse. Vulnerasti impassibilem, ligasti insuperabilem, traxisti incommutabilem, eternum fecisti mortalem" (Hugh of St.-Victor, *De laude caritatis* 10–11, ed. Feiss and Sicard [as in note 19], 194).

42. R. Goy, *Die Überlieferung der Werke Hugos von St. Viktor* (Stuttgart, 1976), 277–329.

43. "Talia in me utinam multiplicet vulnera a planta pedis usque ad verticem, ut non sit in me sanitas. Mala enim sanitas, ubi vulnera vacant quae Christi pius infligit aspectus" (Gilbert of Hoyland, *Sermones in Canticum Salomonis* 30.2 [PL 184:156B]).

44. "Hoc enim bene senserat et cognouerat Augustinus, *li anguisseus damours*, qui dicebat: O potens et prepotens passio caritatis. Iure enim potens, quia animum quem possederit sui ipsius efficit impotentem" (Gérard of Liège, *Quinque incitamenta ad deum amandum ardenter*, III.3.1, in "Les Traités de Gérard de Liège sur l'amour illicite et sur l'amour de Dieu," ed. A. Wilmart, *Analecta reginensia: Extraits des manuscrits latins de la reine Christine conservés au Vatican* [Rome, 1933, repr. 1966], 223).

45. *Life of Juliana of Mont-Cornillon* I.6, trans. B. Newman (Toronto, 1988), 33.

46. *Ida the Gentle of Léau: Cistercian Nun of La Ramée*, 52b, trans. M. Cawley (Lafayette, Ore., 1998), 55–56. The translator of this anonymous vita suggests that the "Augustinian" reading which most captivated Ida was in fact pseudo-Augustine.

47. Hadewijch, Vision 11, in *Complete Works*, trans. C. Hart (New York, 1980), 289–90.

48. Suso, *Life of the Servant*, chap. 52 (as in note 30), 197.

49. F. C. Tubach, *Index Exemplorum: A Handbook of Medieval Religious Tales* (Helsinki, 1969), no. 415; Jean Gobi, *Scala coeli*, ed. M.-A. Polo de Beaulieu (Paris, 1991), 392, no. 524; Polo de Beaulieu, "La Légende" (as in note 28), 299.

50. J. F. Hamburger, *The Visual and the Visionary: Art and Female Spirituality in Late Medieval Germany* (New York, 1998), 134–38.

51. "Ich wil rosen brechen und fil liden uf min frund trechen" (Hamburger, *Visual and the Visionary* [as in note 50], 252).

52. The predella panels are at the Uffizi; the altarpiece itself has been at the Louvre since 1814. See J. Ruda, *Fra*

Filippo Lippi: Life and Work with a Complete Catalogue (London, 1993), 112–14, 392–96, and pl. 64.

53. This point is made even more subtly in an altarpiece from the Augustinian monastery of Neustift (ca. 1460–70). One panel depicts two closely linked scenes: at left, Augustine sits at his writing desk, so absorbed in contemplation that he fails to notice a widow who has come up from behind to speak with him. At right, as Augustine celebrates Mass, it is the widow herself who sees a three-faced apparition of the Trinity, similar to that in the Lippi panel, and thus comes to understand the object of the saint's meditation (J. Courcelle and P. Courcelle, *Iconographie de Saint Augustin*, vol. 2, *Les Cycles du XVe siècle* [Paris, 1969], 115, pl. 72).

54. Courcelle, *Les Confessions* (as in note 37), 651–52, pl. 10.

55. J. Courcelle and P. Courcelle, *Iconographie de Saint Augustin*, vol. 1, *Les Cycles du XIVe siècle* (Paris, 1965), pls. 57, 72, 89; vol. 2 (as in note 53), pls. 70, 81.

56. V. Puccini, *The Life of St. Mary Magdalene of Pazzi, a Carmelite Nun* (London, 1687), 58–59; Jager, *Book of the Heart* (as in note 14), 94–97.

57. "Selected Revelations," in *Maria Maddalena de' Pazzi*, trans. A. Maggi (New York, 2000), 129, 67.

58. For Giovan Paolo Roffi's 1669 portrait of Maria Maddalena herself as a painter, ecstatic and blindfolded, see K. Barzman, "Cultural Production, Religious Devotion, and Subjectivity in Early Modern Italy: The Case Study of Maria Maddalena de' Pazzi," *Annali d'Italianistica* 13 (1995), 295, fig. 1.

59. S. Huot, "Visualization and Memory: The Illustration of Troubadour Lyric in a Thirteenth-Century Manuscript," *Gesta* 31 (1992), 3–14. The manuscript is New York, Pierpont Morgan Library, Ms. M.819. See also A. Rieger, "'Ins e.l cor port, dona, vostra faisso': Image et imaginaire de la femme à travers l'enluminure dans les chansonniers de troubadours," *CahCM* 28 (1985), 385–415.

60. See N. M. Schulman, *Where Troubadours Were Bishops: The Occitania of Folc of Marseille (1150–1231)* (New York, 2001).

61. Huot, "Visualization" (as in note 59), 8. The six-winged *Amors* appears nine times in this manucsript. Five of the illustrations accompany the poems of Folc; the other four illustrate songs by another monk-troubadour, Gausbert de Poicibot.

62. Huot, "Visualization" (as in note 59), 8.

63. Rieger, "'Ins e.l cor port'" (as in note 59), 402–3. For the cherub diagrams, see U. Ernst, *Carmen figuratum: Geschichte des Figurengedichts von den antiken Ursprüngen bis zum Ausgang des Mittelalters* (Cologne, 1991), 656–59; C. Frugoni, *Francesco e l'invenzione delle stimmate: Una storia per parole e immagini fino a Bona-*

ventura e Giotto (Turin, 1993), figs. 8, 61.

64. Frugoni, *Francesco* (as in note 63), offers a comprehensive study.

65. Jacobus de Voragine, *Sermo* 264 (third sermon on St. Francis), from *Opus sermonum de sanctis per anni circulum* (Augsburg, 1484). I thank Katharine Park for this reference.

66. Tibaut, *Le Roman de la Poire*, lines 25–28, ed. C. Marchello-Nizia (Paris, 1984), 4.

67. Tibaut, *Roman de la Poire*, ed. Marchello-Nizia (as in note 66), 20–24.

68. Augustine, *Confessiones* 2.9–18, CCSL 27 (as in note 36), 21–26; M. O'Rourke Boyle, *Divine Domesticity: Augustine of Thagaste to Teresa of Avila* (Leiden, 1997), 3–26. In Chaucer's "Merchant's Tale," the young wife May and her lover consummate their adultery in a pear tree in the presence of May's blind husband.

69. Blamires, "'Religion of Love'" (as in note 23), 23–24.

70. Suso, *Life of the Servant*, chap. 43 (as in note 30), 168–69.

71. Hamburger, *Visual and the Visionary* (as in note 50), 257–61.

72. R. Cline, "Heart and Eyes," *Romance Philology* 25 (1972), 263–97.

73. Chrétien de Troyes, *Yvain, ou, Le Chevalier au lion*, lines 1369–70, ed. J. Nelson and C. W. Carroll (New York, 1968), 80–81; *Yvain, or The Knight with the Lion*, trans. R. H. Cline (Athens, Georgia, 1984), 38.

74. Chrétien de Troyes, *Cligès*, lines 699–712, ed. W. Förster, 4th ed. (Halle, 1921), 20; *Cligès*, trans. R. H. Cline (Athens, Georgia, 2000), 21.

75. Guillaume de Lorris, *Le Roman de la Rose*, lines 1681–95, ed. D. Poirion (Paris, 1974), 83; my translation.

76. S. Lewis, "Images of Opening, Penetration and Closure in the *Roman de la Rose*," *Word & Image* 8 (1992), 215–42; H. Arden, "The Slings and Arrows of Outrageous Love in the *Roman de la Rose*," in *The Medieval City Under Siege*, ed. I. Corfis and M. Wolfe (Woodbridge, Suffolk, 1995), 191–206.

77. Dante, *Paradiso* IV.139–42, ed. J. Sinclair (Oxford, 1961), 66.

78. Julian of Norwich, *Shewings*, ed. G. R. Crampton (Kalamazoo, 1993): chap. 2 (the three wounds) and chap. 86 ("love was his meaning").

79. Andreas Capellanus, *De amore* I.1; *The Art of Courtly Love*, trans. J. J. Parry (New York, 1941), 28.

80. See now K. Kamerick, *Popular Piety and Art in the Late Middle Ages: Image Worship and Idolatry in England, 1350–1500* (New York, 2002), and S. Biernoff, *Sight and Embodiment in the Middle Ages* (New York, 2002). These volumes appeared after the present essay was substantially completed.

Moving Images in the Mind's Eye

Mary Carruthers

Since at least the eighteenth century, it has become commonplace to define verbal and visual arts as two separate "realms of representation" (or epistemology), based upon wholly different sorts of apprehension and comprehension. With some notable exceptions, contemporary analysis of the classical art of rhetoric, following this view, has confined its application to wholly verbal artifacts, such as orations and disputations, while art history has developed a differently-based analytic vocabulary appropriate to this assumed incompatibility between language and picture.[1] Yet in antiquity itself, and through the later Middle Ages, this assumed incompatibility is not at all evident in much of the writing on rhetoric and its various aspects, especially those of Invention, Disposition, Style, and Memory (and even Delivery had its visual element in the importance accorded to the postures, gestures, and even the costume of the orator). This was not due simply to philosophical carelessness on the part of rhetoricians.

For many purposes, including the matters discussed in this essay, it is useful to keep the *aporiai* of rhetoric and epistemology separate, understanding that "representation" is not the major objective of rhetoric but rather persuasion—a different goal with a different problematic and scope of work. Many contemporary discussions of "word" and "image" focus on their epistemological claims. Though this is a legitimate focus—and one that has been highly productive in the theory both of art and of literature—it is not the only possible one. Deliberately or not, art historians do make use of concepts and qualities that are rhetorical in their origin and nature. For example, the historian's concern with how an artist "communicated" to various audiences is fundamentally a rhetorical concern, even when the artistic medium is not words. Thus, when Michael Baxandall, discussing Fra Angelico's Annunciation paintings, notes that the artist "had different exegetical moods or emphases . . . depending on context or occasion," he is making a point about the rhetoric of the painter.[2] As I have argued elsewhere, it is not correct simply to elide the concept "words" with "rhetoric," even though the teaching of rhetoric (in ancient and medieval schools and, therefore, in the handbooks that have survived) focused on verbal crafts.[3] The ancients separated rhetoric from philosophy, regarding training in the one as useful for the conduct of the other, but not attempting to make the one into a "part" of the other. The best orator was indeed "a good man speaking eloquently," but he learned how to be a good man from philosophy, not from rhetorical training per se.[4] Another way to consider this distinction would be in the context of the function of a rhetorical picture. It is less important whether or in what way any of the pictures of the ser-

aphs discussed later may be "truly representative" (either of seraphs or of the divisions of penance), for their value lies in their usefulness *to a person, whether acting as author or as audience, during a procedure of thought.* In this essay, I want to examine briefly one fundamental concept of medieval rhetoric that invokes the phenomenon of picture-making for distinctly rhetorical purposes.

My first set of examples consists of three instances when a preacher asks his audience to paint a picture in their minds. Although there are many such moments, these seem representative of a universally used trope of medieval homiletic rhetoric and meditational invention, one which is not catalogued in the fourth book of the *Rhetorica ad Herennium* or by Donatus or Priscian, and thus remained unnamed in medieval academic rhetorical theory. The preachers called it *pictura*, or "a picture," *painture* in medieval French, and they regarded it as a highly useful tool.[5] They thought of such "pictures" in terms of rhetorical *dispositio*, as an *arrangement* of images in a structure. Rhetorically, *pictura* functioned as a means for securing the *divisio* essential to rhetorical *memoria*, supplying to a listening audience the essential visual schematic within which to organize and thus retain what they were about to hear (it is a common observation of very long standing that most people find it more difficult to comprehend matters from listening than from seeing). While one certainly can retain matters from listening alone, it requires great concentration, and even so, it is always made easier and more secure when supported by a visual image. This observation underlies the ancient philosophical idea that memory is stored (and retrieved) in images for the mind's eye, *phantasmata*, and thus that recording "by heart" is always a form of mental inscription or writing, as recollection is a sort of mental seeing and reading. Cicero commented in *De oratore* (II.87.357) that those matters are most completely pictured (*effingi*) in our minds which come to us through our senses, especially that of sight. "Consequently perceptions received by the ears or by thought alone can be most easily retained if they are also conveyed by the mediation of the eyes, with the result that things not seen and not lying in the field of visual discernment are earmarked by a sort of outline and image and shape so that we may keep hold by an act of sight, as it were, of things that we can scarcely embrace by an act of thought."[6]

The first example comes at the start of Saint Bonaventure's meditation, *Lignum vitae*, "The Tree of Life" (ca. 1260). The life of Christ is mapped upon a tree diagram, which constitutes the divisions of the meditation to come. Bonaventure tells his auditors: "Picture in your mind a tree [*describe igitur in spiritu mentis tuae arborem quandam*] whose roots are watered with an everflowing fountain that becomes a great and living river with four channels to water the garden. . . . From the trunk of this tree, imagine that there are growing twelve branches that are adorned with leaves, flowers and fruit. Imagine that the leaves are a most effective medicine to prevent and cure every kind of sickness, because the word of the cross is the power of God for salvation to everyone who believes (Rom. 1:16). . . . Imagine that there are twelve fruits, *having every delight and the sweetness of every taste* (Sir. 16:20)." After this relatively detailed verbal picture, Bonaventure summarizes: "This fruit of the tree of life, therefore, is pictured and is offered to our taste under twelve flavours on twelve branches."[7]

The diagram is a summary of the topics to come, a "table of contents" for the audience to hold in their minds in order to comprehend the work (a task understood literally as "to take hold of all at once"). Bonaventure's motive is entirely practical. He says: "I have bound [the narrative] together with a few ordered and parallel words to aid the memory. . . . Since visualization [*imaginatio*] aids understanding, I have arranged in the form of an imaginary tree the few items I have collected from among many, and have ordered and disposed them" among the branches of the

tree-picture.[8] And, indeed, the treatise is divided not into chapters but into "fruits," which organize the themes of Christ's life that Bonaventure uses as the basic structure of his meditations. (I stress the literalness of his introduction because we are much too quick to assume some allegorized doctrine is at work in such moments.) Very soon after this treatise began circulating, the "tree of life" was realized in paint on physical surfaces, such as manuscript pages and walls.[9] But in his prologue, Bonaventure insists his motive is to aid understanding and to further thought. His mental picture is not presented as an allegory or as an illustration but as a useful device for comprehension and a tool of further meditation.

At another synthesizing moment expressed in a picture—this time in a vernacular English sermon of the late fourteenth century—the preacher (almost certainly a friar) has used as his sermon theme the single word, "Ambulate," found in the fifth chapter of Ephesians. After expounding a collation of biblical texts using various forms both of this word and of *gradus* [steps], he addresses his audience with the following curious rhetorical figure. "Concerning how and in what manner," he says, "we shall do and go in this world, we have as an exemplar a manner of monster called Cenopede [Scinopodes or Sciopod]. . . . This monster has but one foot . . . of such a nature that with his foot he can shelter himself from the burning of the sun and from all other storms, and in the shadow of his foot he sleeps and rests himself."[10]

Having established the striking visual image of the one-footed creature who shades himself with his foot, the preacher proceeds to moralize the image, or as he refers to it, "goosteliche to speke by þis beste þat haþ but on fote" [to speak in a spiritual way concerning this beast that has but one foot]. But his explanation of this foot serves primarily as a device to organize his thoughts and to orient his audience to his next topics. "With art and reason," he says, "may love be likened to a foot."[11] On this foot we should proceed toward God—and he quotes from Ephesians 5:2: "ambulate in dilectione" [walk in love]. He proceeds with his sermon. On the big foot there are five toes. Each toe is then linked to an attribute of loving God: the first "toe" is to think often on God, the second toe to speak often of God, the third toe to desire to hear others speak of God, the fourth toe is to flee those things that displease God, the fifth toe is to do those things that please God.

These links remain arbitrary in the sermon, for the preacher does not in fact develop any iconography or "allegory" rationalizing *why* these particular numbered toes should be linked to these attributes. The five digits serve simply as place markers for him—his chapters—as he elaborates certain themes, digresses freely from his main topics to tell stories, and finally returns to the Pauline source. Nothing further is said about the Sciopod, which in fact he confuses, as did his sources, with the Cyclops. In other words, this preacher uses the one-footed monster solely as a compositional device, both to enable his *ad libitem* talk and for his audience's memories as they listen to his words.

The use of such inventory *picturae* was a conscious rhetorical decision, in keeping with well-established conventions of oratory.[12] Evidence for this comes from the end of one of Saint Bernard of Clairvaux's sermon-meditations on the Song of Songs (works addressed to a far different, and more elite, audience than the popular friar had). At the end of his twenty-third sermon (when he had reached only chapter 1:3 of the biblical text, with much more ahead, as he and his audience were becoming aware), he actually apologizes for lengthiness and makes a suggestion to his auditors.[13] For their memories' sake, he says, they should imagine a basic architectural structure of storeroom, garden, and bedchamber, all locations that figure in the Song of Songs. These three imagined "rooms" should be connected to the subjects he is developing during his sermons: three

divisions of historical time (before the Law, under the Law, under Grace), three types of merit (of discipline, nature, and grace), and three rewards of contemplation. The subject matter of "times" should be connected to the garden, of "merits" to the storeroom, of "rewards" to the bedchamber. He has said enough about the storeroom, but he has more to say about both the garden and the bedchamber, so he has paused, he tells them, to make for them this summary so that if and when he has new things to say on these various topics, they will have a place to put them—in the storeroom or the garden or the bedchamber.

Bernard's summary *pictura* is a very simple one, to be sure, but it performs the requisite cognitive function of disposing matters in an easily maintained and recalled order, that thus makes it simple to connect and reconnect them, and that can be "entered" at any point without losing track of the whole and without losing one's way. The architectural frame, by its very simplicity, is an effective instrument for this. Thus, the obscure pleasures of rhetorical allegory are not Bernard's stated motive for introducing this building plan into his sermon cycle, but rather the practical demand of making sense out of a lengthy auditory presentation. Meditating further upon the contents of the summary picture can (and should) direct an auditor (as it has already directed Bernard) to engage in the invention procedures associated with meditation. The basic exemplar of the building plan or "picture" makes possible the tasks of storage/retrieval and of composition/invention.

But where did this medieval trope of *pictura* come from? It bears most likeness to the ornament called *ekphrasis* (or *descriptio* in Latin) in the specific system of rhetoric defined and taught in the schools of the Roman imperial period, and known to the Middle Ages primarily through the work of Priscian.[14] The modern definition of *ekphrasis* restricts it to the description of a painting or building, and often of an actual rather than a fictional object. In ancient rhetoric, however, the term *ekphrasis* was more loosely understood to mean a description of just about any sort, including imaginary things, often buildings. More important than worrying about its theoretical definition, however, is recognizing fully what the trope was used for. Rhetoric is a craft, and like all crafts it has its tools and instruments. The importance of *ekphrasis* lies in its role as one of the *progymnasmata*, or composition exercises, of the imperial schools. Knowledge of these passed to the Middle Ages partly through written texts, yet even more through practice: of the two, the latter is far more significant.

Typical of the ancient pedagogy of composition is the teaching of Theon of Alexandria, a schoolmaster of the mid-first century A.D. Indeed, similar advice, but less neatly summarized, can be found in Quintilian's *Institutio oratoria*, also of the first century. A passage from an *auctor* was read aloud to the students, who were then to work with it in a series of exercises. They paraphrased it, amplified it, sought to develop and to refute it. These basic compositional processes could involve any one or several of a number of specific exercises, including *chria* (expanding the pithy saying of a famous person), fable, *prosopopeia* (an imaginary speech), encomium, anathema—and *ekphrasis*.[15] Thus, imaginative description was learned in school *primarily* as a device of composition, of what we now (vaguely) call "creative thinking." It was not, as it is now, something merely to be passively identified, catalogued and classified, in some very old writer's text.

I stress the emphasis on *imaginative description*. For *ekphrasis* works only as description of a fictive object—or the reconstructed recollection of an object—but not as a modern-style "objective" description. I always set the *progymnasmata* for my own graduate students in my course on the history of rhetoric, and I can always tell when, for *ekphrasis*, one of them has decided to

describe an object set before her rather than to "make it up" in imagination and memory, because such a description, while it usually has a kind of mensural coherence concerning the dimensions, colors, and so on, lacks narrative qualities or "plot." Mental descriptions, by contrast, often leave gaps and inconsistencies in the "object," but their narrative articulates an experiential whole. They have rhetorical "arrangement" or *dispositio*, which is what I mean in this context by "plot."

Another source of medieval *pictura* seems to derive from practices of philosophy and meditation, both Greek and Jewish. What Pierre Hadot (in *Philosophy as a Way of Life*) calls "the view from above," *kataskopos*,[16] the traditional meditation of the soul in flight looking down upon the earth at human affairs, is found not only in Plato, but also in several other ancient philosophical writings. Democritas is said by Proclus to have collected such stories; and in the sixth book of his treatise *De republica*, Cicero, most famously among pagan authors for the Middle Ages, has his narrator, the younger Scipio, tell his guests the story of his flight above the earth guided by his grandfather, the great general Scipio Africanus the Elder. He looks down upon the cities of men and up to the stars, terrified and awestruck the while—but not so much as to be incapable of edifying reflection upon human governance, fame, and the rushing if harmonious movement of the spheres. Jewish mysticism had its traditions involving meditative visions upon the Divine Chariot, and the Temple and its furniture—Enoch III is an example, and it has been suggested that Paul himself had been schooled in such traditions, when he describes an experience of being caught into the third heaven (2 Cor. 12:1–4).[17]

The kataskopic visions of philosophers are a major type of spiritual exercise, a part of the way of life of ancient philosophers, the "soul-directing" way of monasticism and related movements in Late Antiquity.[18] These exercises, as Hadot has most recently emphasized, were thought to be essential to the composition of the philosopher's life as well as to the content of his thought. This same focus on spiritual exercise is found in earliest monasticism. And these several traditions in antiquity—philosophical, mystical, and rhetorical—all emphasized the compositional efficacy of picture-making. Again, it is not only the mimetic value of *pictura* that is at issue (often the kataskopic view is presented in a sketchy manner, the verbal equivalent of a crude architectural drawing) but its instrumental value in making sustained thought even possible.

The examples of medieval *picturae* discussed so far—the tree of life, the storeroom/garden/bedroom structure, and the Sciopod with its five big toes—are schematic. One draws them mentally as the speaker describes them, but they are planar structures, static in themselves, like a two-dimensional diagram. Indeed, hierarchical stasis like this has been said for over a century to be "typical" of the medieval aesthetic as a whole. Modernity introduced movement, and put the viewer into the picture. Frances Yates wrote of the medieval art of memory as static and lifeless, even as killing thought. By way of contrast, she associated Ramon Llull (1232–1316) with the "new" energy of the Renaissance on the basis of the moving parts and diverse motions he attributed to the mnemotechnical figures in his *Great Art*.[19]

But movement in the mind's eye is nothing new. It involves more than the implied movement in *kataskopos* of the visionary flying over the land, or the implied motion in the arts of memory of the viewer walking through an edifice or looking from close-up or afar at images in an imagined scene, or even "raising up" images in the mind. These are all movements invited and described in traditional *ekphrases* that remind us that *ekphrasis* was commonly said to be an activity of mental painting, with the visionary as an artist painting the images in his mind as the words of the description are read. By contrast, there are moments in the verbal *pictura* when the

picture itself is said to move or is required to be mentally manipulated by the viewer in the same way that an instrument or engine, a machine, is manipulated for a particular task. This task models the author not just as painter (as in the Horatian commonplace *ut pictura poesis*) or as meditative philosopher, but makes of the author a kind of engineer and builder, engaging in mental previsualization exercises as a deliberate instrument of invention.

One of the more extraordinary works by Hugh of St.-Victor is an extended *pictura* of the Ark of Noah, whose measurements are given briefly in Genesis 6:14–16. This is the "De arca Noe mystica," now better renamed as "Libellus de formatione Arche." Several manuscript rubrics identify it as "De pictura Arche" or "De pictione Arche," indicating that at least some scribes recognized its genre as the kind of *pictura* I have been discussing.[20]

From the few words in Genesis, Hugh constructs a remarkable encyclopedic timeline and map for the complete history of the terrestrial, cosmic, and human world from the beginning of history, with empty space to be filled in by the future. He fits all this into a basic structure of a triple-tiered, quadrangular wooden boat, with a central mast and ship's ladders, and even a row of outer cabins. Scholars have been intrigued by the ingenuity of Hugh's apparent allegorizing of the basic Ark (which Christian exegesis had always seen as a figure for the Church), but to my mind the more intriguing aspect of this work is the way in which Hugh presents it to his readers: he shows himself constructing a model, not describing a work already complete. He calls what he is doing *descriptio mystica*. "Mystica" means "spiritual," and in this context I would identify it with the activity of spiritual exercise rather than with the so-called four levels of exegesis. For this work is not one of interpretation, that is, of reading, but of invention, specifically of mental drawing and painting. (Recall that in rhetoric, *descriptio* is the Latin translation of *ekphrasis*.) This work, then, is a type of the compositional exercise called *ekphrasis*, or "imaginary description." And, as Hugh makes clear through his presentation, it is also a meditational exercise, an exercise for making thoughts about God:

> First I find the center of the plane on which I intend to draw the Ark, and there I fix a point. Around this point I make a small square, which is like one cubit, [the measure] with which the Ark was constructed. And around this square also I make another, a bit bigger than the first, so that the space between the two squares looks like a band around the [central] cubit. Next, I draw a cross in the innermost square so that the four limbs of the Cross meet each of its sides, and I go over the Cross in gold. Then I color in the spaces between the four angles of the Cross and those of the square, the two above with red, the two lower ones with blue. . . . Next in the band above the cubit above the Cross I make [the letter] *alpha*, which is the beginning. Opposite it under the Cross I make *omega*, which is the end.[21]

Notice the active, present tense of Hugh's verbs in these instructions, clearly addressed to a reader whom he expects to be making the figure to his exemplar as he reads the description.

The verbs I have translated above as "make" and "draw" are various forms of *pingere, depingere*, and *scribere*, in addition to the more general *facere*. These are typical medieval usages, and are, I think, significantly different from the verbs used in ancient rhetoric (for example, in the *Rhetorica ad Herennium*) for a similar task, that of making the colorful, exaggerated *imagines agentes* of artificial memory. There the usual verbs are *constituere* and *fingere* (both used in the *Ad Herennium* and by Cicero in *De oratore*, for example). These are certainly verbs meaning to

construct and fashion, but without connoting the definite craft activities referenced by the medieval usages. Evidence suggests that mental image-making was described as a kind of painting and building in Late Antiquity and onward. The fifth-century African monk Arnobius, invoking the Heavenly City in a sermon, exhorts his audience to "Paint [*Pinge*], paint before your eyes the various structures. . . . Of what sort? Those which were seen with wonder by the apostles; paint the temples, paint the baths, paint the forums and the ramparts rising on the high summit."[22] To use a verb like *pingere*, it seems to me, emphasizes the process and procedure involved, the *craft* in image-making, even of a mental sort. And it is addressed to the audience as an exercise for their minds' eyes, to be engaged in *while the preacher continues to speak*—for *pinge* is the imperative form of the verb.

The emphasis on continuing process is certainly that of Hugh of St.-Victor's *pictura* of Noah's Ark, which comes into being as it is described and is clearly not a pre-existing object, even though some modern scholars, misled perhaps by their own assumptions, have attempted to draw parts of it as an actual painting or plan. It cannot be an actual painting because at a certain point in the *descriptio*, the plan becomes an elevation, and the whole *pictura* must be seen three-dimensionally.

Hugh continues his picture by drawing two parallel lines horizontally across the length of the whole rectangle, spaced apart by the width of the central cubit, under which they pass. He then does the same thing across the width of the entire rectangle. He also, by trisecting the outer dimensions of the large rectangle, draws two additional rectangles, one inside the other, so that one ends up with three nested rectangles of proportional dimensions, all centered about the square cubit. Then, he writes:

> If you are curious how this drawing represents the shape of the Ark, understand that an equilateral column is raised up within the Ark by means of the band that transverses its width. The height of this column is in a 3:5 ratio to the width of the Ark, since its height was thirty cubits and its width fifty cubits. If you wonder what I mean when I say we should make a column, think of it like this: raise up the cubit that lies in the middle of this band so that it drags the band up with itself, as though the band were folded over the center. And thus both halves of the band hang downwards towards the floor of the Ark, forming surfaces themselves, and they are joined to the floor of the Ark at the edges, so that it looks like an upright column. At the summit of that column stands the cubit that was in the middle of the plan initially. This cubit is exactly the cross-section of the column seen from above. And its border is like a little rim on the top of the column for receiving the timbers that rise up from all sides of the Ark. They are fixed under that rim at the top of the roof, like an imbrex, designed to hold together the highest points of the roof.[23]

This is not only mental painting of the sort Arnobius called for but also previsualization of forms of the sort that builders and similar craftsmen were taught to perform. Some modern scholars have insisted that such a sophisticated, complex plan could not be achieved only in the imagination. But, in fact, it is far easier to achieve mentally than physically, because producing such a plan requires a degree of manipulation and changing of its forms (to say nothing of the crowding of its spaces when all the information that Hugh requires is placed within it), greater than would be possible with a single, two-dimensional drawing no matter how large the parchment on which it was made. It is surely significant that, in all the fifty-eight manuscripts of this work still extant, *none* has even a partial drawing of this figure. Some of those manuscripts were made and held

at St. Victor shortly after Hugh composed the work (ca. 1130), and the work continued to be copied into the fifteenth century. Today it is impossible for us to even considering visualizing so complex a figure without considerable physical support. Yet no one seems to have required that it be fully realized in a physical medium—until the late twentieth century.

Hugh says that he offers his work as an "exemplar," that is, as a template for others to copy and use. Its form is to be "imprinted in your heart"—in memory—as a device for learning and further meditation.[24] These are exactly the motives that Bernard of Clairvaux adduced in urging his auditors to construct for their memories the summary structure of storeroom/garden/bedroom while listening to his meditations on the Song of Songs. But how much more complex this Ark is. As a spiritual exercise, it is cosmographic and kataskopic in its range, containing entire libraries of material all collected and disposed within its spaces. It provides an inventory for future thought that could last even a Victorine for a lifetime. And it has a great many moving parts.

Three-dimensional moving diagrams of a far humbler sort, however, are common cognitive devices; indeed, almost every medieval diagram implies some degree of mental manipulation on the part of the student using it. A fairly typical example of a common academic device, the *rota*, occurs in a treatise on rhetoric written in 1235 by the Bolognese master Boncompagno da Signa.[25] In his discussion of rhetorical image-making or metaphor (*transumtio*), which is long and eclectic and sums up a career's worth of teaching notes, is a curious *descriptio* with the rubric "Visio Boncompagni," always translated as "Vision of Boncompagno." Though Boncompagno has a reasonably well-deserved reputation as a windbag with an outsized ego (he is not alone among professors of rhetoric in this regard), I think we interpret him wrongly if we write off this episode as mere posturing. *Visio* should here be translated not as "vision" but as "visualization," for he describes a visualized device to relate the subjects of human knowledge.

He writes: "I saw [*Vidi*] eleven major wheels and five minor wheels turning in orbits within a *machina mundialis*," a machine or mill of worldly knowledge.[26] The eleven major orbiting wheels contain memory-images for the Seven Liberal Arts, plus Medicine, Civil Law, Canon Law, and Theology—in other words, the faculties of a medieval university such as Bologna. The five minor wheels are all the vain [*futiles*] arts of divination: necromancy, geomancy, pyromancy, "spatomancy" [=spatulamancy?], and alchemy. Each major wheel turns with a movement iconic for that subject. Thus, the first (Grammar) revolves in laborious motion, but from it proceeds that milk which is given to those whose teeth are yet soft. The eleventh (Theology) is turned about that ladder which Jacob saw rising upward. Boncompagno's mental machine, his mill of learning, has many moving parts, and viewers are intended to see them in motion in their mind's eye.

In his discussion of rhetorical *memoria*, Boncompagno describes another sort of moving figure (which he admits is obscure) that involves a rectangle projected into the middle of a sphere. A continuous line is then zigzagged across the figure.[27] The particular *divisiones* of a subject, each having been linked to an especially distinctive image, are attached to the points of the zigzagging line, and the whole contraption can then be moved around by the sphere which contains it. In this way, apparently, one can recombine and shuffle about the matters of memory to invent new composition. The Latin of this description is so difficult that I suspect some text has been dropped during copying, but the general purport of the figure is clear enough. It is for making new work, and it involves a difficult act of previsualization and manipulation of a complex three-dimensional mental form. In fact, just after this passage, Boncompagno compares the task of the rhetorician to that of a master carpenter, who goes into the forest and, by previsualizing the finished product in the living tree, is able to select the proper timber for his task.[28]

But does all this mental work within the mind's eye ever affect physical images in ways we can demonstrate? Here the evidence is indirect, as I think it must be. After all, except for the ubiquitous *rotae* in later medieval manuscripts, that are made of cut-out parchment disks tied onto the page, it would be difficult to see how the technology of the day could have permitted a full graphic realization of most of the images I have been discussing. There is a group of manuscript paintings, however, that may demonstrate efforts to deal with the problems created by the need for an image to be movable. These are all various redactions of a well-known late medieval meditational diagram, the "Cherub."

This figure was initially the summary *pictura* of a well-used homiletic text called "A *Tractatus* upon the Six Wings" (*De sex alis*) which was widely, if wrongly, attributed to Alan of Lille. An alternative, and more likely, attribution is to a twelfth-century prior named Clement, of the Augustinian house of Llanthony in Gloucestershire.[29] The textual history of *De sex alis* strongly supports the conjecture that the Cherub is part of a putative "set" of meditational/pedagogical images emanating from St. Victor, and including, in addition to the "Seraph/Cherub" figure, a *pictura* of the Ark/Tabernacle, used as the summary of a longer work by both Richard of St. Victor (for his "The Mystical Ark" or "Benjamin Major") and by the Premonstratensian canon Adam of Dryburgh (in his "On the Triple Tabernacle").[30] There were close ties among the Victorines, the Premonstratentians, and the Augustinians (all reform orders of canons), all concerned with developing both spiritual devotion and education in a broad setting that included some ministry to "the world."[31]

At work in the development of such *picturae* as Hugh's Ark and Clement of Llanthony's Seraph/Cherub is the long-standing exegetical linkage of the Ark of Noah, the Ark of the Tabernacle, the Cherubim which guard the Ark, and the Throne-chariot visions in both Isaiah and Ezekiel, which include seraphim and the rotating wheels of the Divine Chariot, accompanied by living creatures (*animalia*). The text of "On the Six Wings" begins with a meditation on the divine throne vision from Isaiah 6, copied from book I, chapter 2 of Hugh of St.-Victor's moral commentary on Noah's Ark (formerly *De arca Noe morali*, now *De archa Noe*). Isaiah is identified as the textual source for the figure to follow, but the quoted commentary focuses on the Divine Throne, or Majesty, as a whole scene. It thus sets the stage, as it were, for the detail to come, but it does so by implicating for the reader a different, if related, *pictura*, that known as the "Majestas Domini" or "Majesty," evidently assuming that a reader would be familiar enough with the *imagines* of this general *pictura* to be able to envision them mentally from Hugh's words alone. The second half of the treatise concerns the accompanying seraph drawing itself. It gives a terse, at times almost notational, exposition of the legends on the various wings and feathers of the angelic creature, and was clearly written in conjunction with the drawing.

It is often assumed that such a picture was made primarily for a preacher to "help" in expounding hard doctrine to lay audiences, and was devised after the initial composing process was completed, essentially as a pedagogical diagram made by a teacher and intended for students. But this explanation does not account for why the picture continued to be made in monastic contexts and valued for its usefulness by clergy who were not engaged directly in preaching but in meditation and contemplation, tasks of inwardly directed invention and composition. The Seraph/Cherubs of Figures 1 and 4, the earliest and the latest of the four redactions on which I am focusing, were each made for monasteries.

Indeed, when one reads the treatise "On the Six Wings," it is clear that as a whole this text could be of little use except to someone who already knew enough about the subject to be able to

amplify its meagerness. In other words, it is useful not to a beginner but to one already adept—not to a student but to a teacher, specifically a confessor, a chaplain, a preacher, people whose offices required being able to speak ex tempore and flexibly to various audiences on the large topic of penitence. "On the Six Wings" is not truly a sermon (as it is now commonly classified) but an *ars inveniendi*. I would go a step further and characterize the Seraph/Cherub device itself as the basic *ars inveniendi*, and the accompanying words as only its brief *aide-memoire*. As a painting, it came often to stand alone.[32]

To use such a compositional device as the Seraph/Cherub, a person would need to internalize the picture, remembering the *divisiones* of the subject in order, as major headings of "wings" and subheadings of "feathers." With this figure in mind (literally), one could readily have the gist of as many as thirty sermon-meditations, nearly a whole Lent's worth, on the general topic of penitence. Each preacher would readily be able to adapt the scheme to the specific occasions of his own speaking. Adapting and amplifying an exemplary scheme, after all, is the way most medieval sermonizing was done.

It will be useful to compare four adaptations of the seraph image with respect to how they solve a basic perceptual problem presented by this figure. Each one is quite different from the others, though each has six wings and the main heading on each wing remains constant (but the order of the wings does not): the headings are *confessio* on wing 1, *satisfactio* on wing 2, *munditia carnis* on wing 3, *munditia* (or *puritas*) *mentis* on wing 4, *dilectio proximi* on wing 5, and *dilectio Dei* on wing 6. The order of the wings from left to right is not constant either, though the pairings of main topics (1 with 2, 3 with 4, 5 with 6) are in each redaction of the scheme. The wording of the legends on the "feathers" also varies in the extant copies. These variations are best understood as evidence of how each was adapted to the desires of a particular user. As an example, consider the legends on the feathers of wing 6 (*dilectio dei*) presented in each of four manuscripts:

Cambridge, Corpus Christi College, Ms. 66, p. 100 (Fig. 1): (1) *in his perseuerare*; (2) [illegible]; (3) *omnia relinquere*; (4) [illegible]; (5) *aliena non concupiscere* (the painter of this manuscript figure used a blue ink, which has now seriously faded, for the legends no longer readable).

London, British Library, Ms. Arundel 83-II, the De Lisle Psalter, f. 130r (Fig. 2): (1) *omnia propter deum relinquere*; (2) *proprie voluntati renunciare*; (3) *aliena nullo non concupiscere*; (4) *sua distribuere*; (5) *hiis perseuerare*.

Florence, Biblioteca Medicea Laurenziana, cod. Pluteo 30.24, f. 3r (Fig. 3): (1) *omnia propter deum relinquere*; (2) *proprie voluntati renunciare*; (3) *aliena non concupiscere*; (4) *sua distribuere*; (5) *in hiis perseuerare*.

New Haven, Conn., Beinecke Library, Yale University, Ms. 416, f. 8 (Fig. 4): (1) *aliena non concupiscere*; (2) *sua distribuere*; (3) *omnia relinquere*; (4) *abnegare se ipsum*; (5) *in hiis perseuerare*.

These variations are small but significant. More significant still is that in a number of the redactions of the figure, the legends of wings 1–4 are completely shifted about, especially among those that were made as part of the set of figures called the *Speculum theologie*. In this group, legends for *confessio* (wing 1) can be found among those for *munditia mentis* (wing 4), while the legends under *satisfactio* (wing 2) are reversed with those of *munditia carnis* (wing 3). The outline of headings and subheadings is clear in the treatise, so evidently confusion arose initially in the visual image itself. But the users of the Seraph/Cherub figure evidently were able to make sense of the

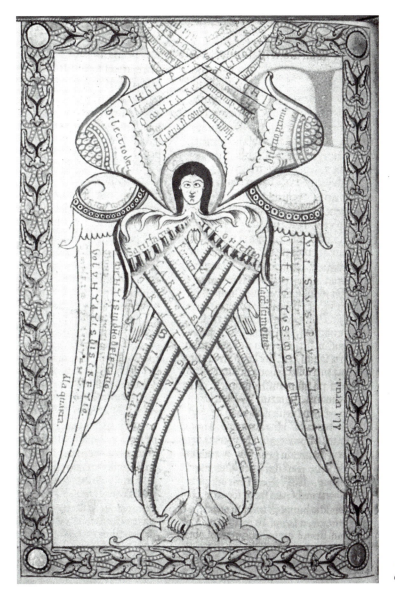

1. Cambridge, Corpus Christi College, Ms. 66, p. 100. English, Sawley Abbey, ca. 1200

outline anyway, undoubtedly by adapting it for their own purposes. In other words, it would be naive to assume that what we now find incoherent with reference to the modern edited text would have been thought to be so by the adept users of these manuscripts.

The anatomy of the Seraph/Cherub picture is complicated by the fact that all six wings spring from one location on the back. There is thus no easy way to place them distinctly from one another on the seraph's body, for they tend to get in the way of one another as they are raised or lowered (as in Isaiah's text) to cover the feet or the face or to fly. Actually in no case is the medial pair of wings shown covering the face, for that would badly crowd the legends and make the figure impossibly confusing to read. That there is such a large discrepancy from the source text in this respect demonstrates that this figure is not primarily a textual illustration but a device in its own right, whose ability to function as an instrument of thought is paramount.

Figure 1 shows the earliest adaptation, from about 1200 in a manuscript from Sawley Abbey;

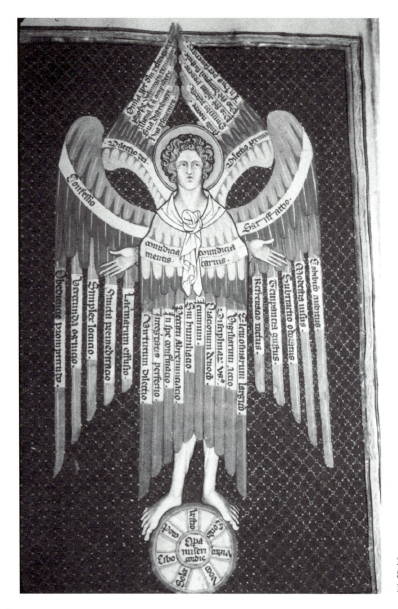

2. London, British Library, Ms. Arundel 83-II, f. 130r. The De Lisle Psalter, English, before 1339

in this manuscript it prefaces a complete text of the tractatus. The whole work is identified by its titulus as *descriptio*, that is, rhetorical *ekphrasis* (and in the context of compositional invention, a word of particular significance as a choice to name this figure).[33] The Sawley redaction predates the incorporation of the seraph picture into the series compiled and redesigned by John of Metz, the Franciscan friar, in the late thirteenth century, and known now as the *Speculum theologie*. The second version of the figure (Fig. 2) is from the De Lisle Psalter, made in the early fourteenth century and left by Robert De Lisle to his daughters in 1339 when he entered the Franciscan order; it was intended eventually for the library of a priory of Gilbertine nuns.[34] The next one chronologically is Italian (Fig. 3), from a late-fourteenth-century manuscript containing, among several computational materials, the *Speculum theologie*.[35] And the latest (Fig. 4) is the picture made for

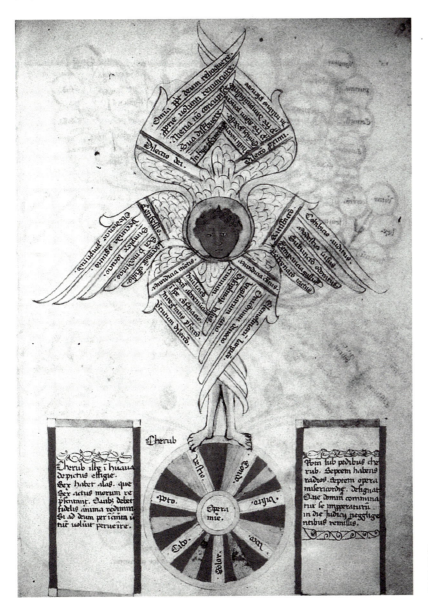

3. Florence, Biblioteca Medicea Laurenziana, cod. Pluteo 30.24, f. 3r. Italian (possibly Dominican), late fourteenth century

Clement's treatise in a late-fourteenth- or early-fifteenth-century manuscript from the Cistercian monastery of Kempen in the Rhineland.[36]

Each of the painters has attempted in his own way to solve the problem of depicting a six-winged figure. One would think that this would not be difficult and perhaps it should not be, but what complicates the task is the necessity to be able to read clearly the legends on each of the feathers of the two wings folded over the seraph's feet, and to see all the pairs of wings clearly, to keep their topics and subtopics distinct from one another. Why do these legends need to be kept clear? Because anyone using the figure for composing, especially if he or she has it "in mind," has to be able to read the figure distinctly and readily in order to use it. Confusion owing to a failure in just this aspect has most likely led to the transpositions of the feather-legends I have already

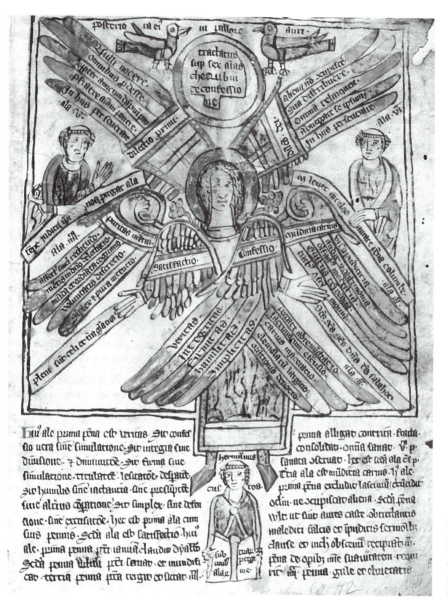

4. New Haven, Conn.,
Beinecke Library, Yale
University, Ms. 416, f. 8r.
German (Rhineland), mona-
stery of Kempen, early
fifteenth century

pointed out. Furthermore, in my comparison of these four seraphic summaries of Penance, I hope to demonstrate that in using this device, people expected to move its parts about mentally, by bending the wings back and forth, for example, or moving one pair up out of another's way. This is shown by the quite radically different ways that the wings in these four redactions are situated. I also hope to show that the problem these four different manipulations of the device sought to resolve was not a representational one but a cognitive one.

The painter of the Sawley Abbey manuscript has laced the feathers of wings one and two together; these are the wings that cover the legs (Fig. 1). However, this solution immediately has produced a problem of visual "crowding" and thus lack of clarity, because it is difficult to tell which feather belongs to which wing (that is, which subtopic goes with which main heading). Mnemotechnical "crowding" is a vice because it creates confusion. To alleviate the crowding prob-

lem, this scribe wrote the subheadings on the feathers in alternating red and blue ink, but the blue is now so faded that these legends are nearly unreadable. He also folded the pair of medial wings (3 and 4) back from the torso, because if they were drawn to cover the face one could not read what was written on them, nor could one distinctly see the lower pair over the feet. The enduring problem of placing these two pairs of wings (1 and 2, 3 and 4) within the dimensions of the page so that they can be read distinctly is confirmed by the confusion of their legends from one redaction to another. Wings 5 and 6, which are raised above and away from the angelic head, remained separate, and their legends on their feathers have not been transposed with others.

The De Lisle Psalter painter has a different solution to the anatomical problem but one that still produces some confusion (Fig. 2). Instead of the two folded wings over the legs, he has given the seraph a sort of feathered cloak. This makes for an artistically more pleasing picture, perhaps, but mnemotechnically it is confusing because the locational "backgrounds" (the wings, that is) have been run together. In trying to resolve one crowding problem, a new one has been created. If one compares the De Lisle figure to the Sawley Abbey seraph, one can see that if one were, mentally, to unlace and straighten up wings 1 and 2 ("confession" and "satisfaction") of the Sawley figure so that all their subheadings were distinct, one would then have to somehow move wings 3 and 4 ("purity of body" and "purity of mind") out of the way of 1 and 2, so that they also could be clearly read. The De Lisle redactor solved this problem by lifting wings 1 and 2 up and outward, and folding wings 3 and 4 down side-by-side over the body in a dresslike manner. But now wings 1 and 2 appear to occupy the medial position and wings 3 and 4 the lower one, covering the legs—a chief reason why, I suspect, the legends of these wings became transposed and confused. And, in fact, in the De Lisle figure, the legends of the feathers of wing 2 in the original work ("satisfaction") have been transposed with those for wing 3 ("purity of body"). Moreover, by folding down wings 3 and 4 adjacent over the torso, the already-confused headings on the feathers of wings 3 and 4 are insufficiently distinguished from one another, and a major source of confusion still remains.

The painter of the Laurenziana seraph has simply dispensed with a body (except for the lower legs and feet) and painted a cherub's face in a roundel, thus conflating the seraph with the wheeled, four-faced "living creatures" of Ezekiel's vision of the Throne-Chariot (Fig. 3). Now the seraph's six wings can be painted around the circle, each distinctly set off from the others, and each set of five feathers rendered readable as well, though the texts on them are very compressed. And the scribe worked from an exemplar that had already been confused. The wings of this Seraph/Cherub follow the same order as those in the De Lisle Psalter figure, as wings 3 and 4 fold over the legs, and wings 1 and 2 occupy the medial position. There is also the same erroneous transposition of the legends on the feathers of wings 1 through 4.

The most ingenious solution to the mnemotechnical problem, though the one least understandable by modern canons of representational art, was that made for the Kempen manuscript (Fig. 4). The painter has rotated the second wing on its pinions by 180 degrees. Every student to whom I have shown this picture has had the same response: the painter made an incompetent error that needs to be corrected. But if one were to "correct" the supposed error and rotate the pinions of this wing back to a normal position, one could no longer read its feathers. One would have exactly the problem faced (and not solved) by the Sawley Abbey manuscript painter. So the Kempen manuscript painter has violated "realism" in order to meet the *cognitive* requirements of rhetorical *memoria* for subject matter disposed in sets of distinct backgrounds, each with clearly

visible "images" (in this case, the abbreviated words of the legends) to organize the topics placed therein. Moreover, the painter has gone back and read the original text and corrected the mis-ordered wings, putting wings 1 and 2 where one would expect them, in "front" of the other pairs with wings 3 and 4 just above them, and recomposing the legends on their feathers. This painter was clearly less of a draftsman than the master who painted the De Lisle Psalter Seraph/Cherub, but in some ways he understood better the craft of rhetorical *memoria* and the requirements of *ars inveniendi*.

His method also underscores how personal an artifact he has made. For he has not only corrected the image with the text, and made it more useful to himself by redrawing it, but he has also placed his own portrait directly under the framed seraph picture, as though the image were indeed springing from his mind. "Hermannus custos" displays a book bearing the (modified) text of Psalm 16:8, "sub umbra alarum tuarum protege me" [Protect me under the shadow of your wings]. He also added material to the Seraph/Cherub trope that allies it specifically with monastic devotional literature, the meditation "on the dove and the hawk"(part 1 of *De avibus*) by the Augustinian canon Hugh of Fouilloy (d. 1172). Above the angel are two golden-backed doves, and a quote from Psalm 67:14, "posteriora eius in pallore auri," a text strongly associated since at least the time of Hugh with monastic withdrawal and silence. Above wings 3 and 4 are banderoles with the words "tempore judicii Christi nos protegat ala/leuet in celos aurate penna columbe" [in the time of judgment Christ's wing protects us/the feather of the golden dove raises [us] to the heavens]. Together with the other rhetorical adaptations I have mentioned, both of design and of content, these texts serve to "domesticate" and familiarize the seraph picture to the circumstances and occasions of the community of Kempen.[37] The final two banderoles in the picture, above wings 1 and 2, quote the text that is the first theme of *De sex alis* (and before it, of the section of Hugh of St.-Victor's *De archa Noe* copied in *De sex alis*), "Sanctus sanctus sanctus dominus deus sabahot" above wing 1, and "pleni sunt celi et terra gloria tua" above wing 2 (Isa. 6:3).

To summarize: there are three main strands of influence converging in this familiar medieval device for the craft of composition of a "picture" painted in and for the mind's eye. These are *ekphrasis* or *descriptio*, a composition exercise taught as part of the craft of ancient rhetorical composition; the kataskopic view from above, taught as a spiritual exercise in ancient philosophical and mystical disciplines; and the exercise of previsualization that was practiced in many crafts, including—notably—architecture and carpentry, two crafts to which the composition of text was frequently likened in medieval rhetoric. What they have in common is the characteristic of being exercises, all of which make use of visualized exemplars, and it is their practical application that is basic to understanding the cognitive work of the summary picture when we encounter it in medieval compositions.

Notes

1. Some exceptions in art-historical work include that of M. Baxandall, *Giotto and the Orators: Humanist Observers of Painting in Italy and the Discovery of Pictorial Composition, 1350–1450* (Oxford, 1971), and *Patterns of Intention: On the Historical Explanation of Pictures* (New Haven, 1985); S. Alpers, *The Art of Describing: Dutch Art in the Seventeenth Century* (Chicago, 1983); and M. Camille, "The Book of Signs: Writing and Visual Differ-ence in Gothic Manuscript Illumination," *Word & Image* 1 (1985), 133–48, and "Seeing and Reading: Some Visual Implications of Medieval Literacy and Illiteracy," *Art History* 8 (1985), 26–49. On the rhetoric side, efforts from scholars trained in literary history include R. A. Lanham, *The Electronic Word: Democracy, Technology, and the Arts* (Chicago, 1993); W. J. T. Mitchell, *Iconology: Image, Text, Ideology* (Chicago, 1986), and *Picture Theory: Essays*

on *Verbal and Visual Representation* (Chicago, 1994); M. Carruthers, *The Book of Memory: A Study of Memory in Medieval Culture* (Cambridge, 1990), and *The Craft of Thought: Meditation, Rhetoric, and the Making of Images, 400–1200* (Cambridge, 1998); and L. Bolzoni, *The Gallery of Memory: Literary and Iconographic Models in the Age of the Printing Press* (Toronto, 2002), and *La rete delle immagini: Predicazione in volgere dalle origini a Bernardino da Siena* (Turin, 2002; English translation, *The Web of Images: Vernacular Preaching from Its Origins to St. Bernardino da Siena* [Aldershot, 2004]). This work collectively has been influential in giving a "rhetoric turn" at least to medieval and early modern art history, and a less evident "design turn" to some literary scholarship, while in the contemporary pedagogy of rhetoric some attention is at last being paid to the specifically rhetorical aspects of visual organization and design. On the problems of the epistemological relationships of word and image, see also J. F. Hamburger, *The Visual and the Visionary: Art and Female Spirituality in Late Medieval Germany* (New York, 1998), esp. 28–29, 111–48.

2. M. Baxandall, "Pictorially Enforced Signification: St. Antonius, Fra Angelico and the Annunciation," in *Hülle und Fülle: Festschrift für Tilmann Buddensieg*, ed. A. Beyer, V. Lampugnani, and G. Schweikhart (Alfter, 1993), 35. My thanks to Jeffrey Hamburger for initiating this discussion with me as he edited this essay, and for bringing Baxandall's article to my attention. It is a particularly concentrated instance of how "rhetoric" (as distinct from philosophy or theology) can fruitfully resolve some apparent dilemmas in "word and image" discussions, and help us all to ask better questions of our materials, whether written or painted.

3. See especially the discussion of "picture" in *The Medieval Craft of Memory: An Anthology of Texts and Pictures*, ed. M. Carruthers and J. Ziolkowski (Philadelphia, 2002), 1–17, and my comments about the rhetoric of architecture in *Craft of Thought* (as in note 1), 222–24, 251–66.

4. A wry and engaging analysis of the ancient mistrust of rhetoric as fundamentally amoral, and the (mostly unsuccessful) efforts to defend it, is Lanham's essay on "The 'Q' Question," in *Electronic Word* (as in note 1), 155–94.

5. J. V. Fleming discussed the importance of verbal and painted pictures in later medieval preaching in *An Introduction to the Franciscan Literature of the Middle Ages* (Chicago, 1977), esp. 127–29, though he does not identify "picture" as a rhetorical figure. I discussed the nature of rhetorical pictures in *Book of Memory* (as in note 1), 229–42 and especially in *Craft of Thought* (as in note 1), 116–70. Using actual pictures in churches as tools for preaching has a long tradition. In an important essay, C. M. Chazelle argued that Gregory the Great's justification for having pictures in churches rested in large measure on their value in pastoral care, especially preaching: "Pictures, Books, and the Illiterate: Pope Gregory I's Letters to Serenus of Marseilles," *Word & Image* 6 (1990), 138–53. See also H. L. Kessler, "Pictorial Narrative and Church Mission in Sixth-Century Gaul," in *Pictorial Narrative in Antiquity and the Middle Ages*, Studies in the History of Art 16, ed. H. L. Kessler and M. S. Simpson (Washington, D.C., 1985), 75–91.

6. With slight modifications, I have cited the translation by E. W. Sutton and H. Rackham, Loeb Classical Library (Cambridge, Mass., 1940). Repeating this same Ciceronian observation some sixteen hundred years later, in 1562, the Englishman William Fulwood translated as follows similar memory advice from Guglielmo Gratarolo (1553), a Protestant physician from Bergamo: "Such things as you wil remember, are not only to be heard, but also to be sene: for they that do but once behold a thing do remember it [better], then they that heare the same verye often and beholde it not" (*The Castel of Memorie* [London, 1562], Fii). On Gratarolo, see P. Rossi, *Logic and the Art of Memory*, trans. S. Clucas, 2nd ed. (1983; Chicago, 2000), 71–73; on Fulwood, see F. Yates, *The Art of Memory* (Chicago, 1966), 255.

7. Bonaventure, "Lignum vitae," prol. 3–4, in *Opera omnia*, Quaracchi edition (1891), vol. 8, 68–87. I quote from the English translation by E. Cousins, *Bonaventure* (New York, 1978), 117–75. This treatise is the source of the common Franciscan picture called "the Tree of Life," which was often depicted both in manuscripts and in murals. J. V. Fleming has well described the work as "an image surrounded by a text"; see his "Obscure Images by Illustrious Hands," in *Text and Image*, ed. D. W. Burchmore (Binghamton, N.Y., 1986), 1–26, at 6 (though Fleming insists that a painting existed with the text from the beginning, a hypothesis I do not accept). The use of the image called "the Cherub" in sermons by a later Franciscan preacher, San Bernardino da Siena, is demonstrated by L. Bolzoni, "Predicazione e arte della memoria: un quaresimale di Bernardino da Siena e l'immagine del Serafino," in *Musagetes: Festschrift für Wolfram Prinz*, ed. R. G. Kecks (Berlin, 1991), 179–95; see as well her *La rete delle immagine* (as in note 1), chap. 4. A valuable compilation of murals found in English churches that may have mutually affected preachers and sermon materials is M. Gill, "Preaching and image in Late Medieval England," in *Preacher, Sermon and Audience*, ed. C. Muessig (Leiden, 2002), 155–80 and pls. 1–8. Mural painting has been discussed in connection with specific images in *Piers Plowman* by C. D. Benson, "Piers Plowman and Parish Wall Paintings," *Yearbook of Langland Studies* 11 (1997), 1–38, and L. Iseppi, "*Memoria agens:* Verbal and Visual Rhetoric in Late Medieval English Lay Culture, c. 1300–c.1500" (Ph.D. diss., New York University, 2004). Thomas Bradwardine recommended using familiar painted images for various kinds of memory work in his advice "On acquiring an artificial memory," which is translated in *Medieval Craft of Memory* (as in note 3), 205–14.

8. Bonaventure, "Lignum vitae," trans. Cousins (as in note 7), 121. *Imaginatio* or *vis imaginativa* was simply the ability of the mind to form mental images and "likenesses" of sensually derived experiences (*phantasiai*). It had not acquired the rapturous powers given to it by the early Romantics; on this point, see Carruthers, *Book of Memory* (as in note 1), 47–60.

9. The tree diagram has a long history before its use by Bonaventure. It is important both in pedagogy and in meditational practice from an early time (tree-form stemmata are found in early manuscripts of Cassiodorus's *Institutiones*), and the scholarly literature on its use in these domains is extensive. On Cassiodorus, see F. Troncarelli,

"Alpha e acciuga: immagini simboliche nei codici di Cassiodoro," *Quaderni medievali* 41 (1996), 6–26, and J. W. Halporn, "After the Schools: Grammar and Rhetoric in Cassiodorus," in *Latin Grammar and Rhetoric: From Classical Theory to Medieval Practice*, ed. C. D. Lanham (London, 2002), 48–62. On the pedagogical use of tree stemmata in the Middle Ages, see K.-A. Wirth, "Von mittelalterlichen Bildern und Lehrfiguren im Dienste der Schule und des Unterrichts," in *Studien zum städtischen Bildungswesen des späten Mittelalters und der frühen Neuzeit*, ed. B. Moeller et al. (Göttingen, 1983), esp. 278–310. On the history of the trope in more meditative and contemplative situations, see A. Katzenellenbogen, *Allegories of the Vices and Virtues in Medieval Art* (London, 1939), and W. Fleischer, *Untersuchungen zur Palmbaumallegorie im Mittelalter* (Munich, 1976). Jeffrey Hamburger discussed one example of the meditational trope, "palma contemplationis," in *The Rothschild Canticles: Art and Mysticism in Flanders and the Rhineland circa 1300* (New Haven, 1990), 35–44. Of particular interest to Bonaventure's use of it are two poems by Jacopone da Todi (*Laude* 69 and 89), his contemporary in the Franciscan life; these visualize a tree as the compositional structure for the meditations.

10. Sermon 14, in *Middle English Sermons Edited from British Museum Ms. Royal 18 B.XXIII*, ed. W. O. Ross, EETS, O.S. 209 (Oxford, 1940), 77: "How and in what maner we shall do and goye in þis werlde haue we ensaumple of a manere of a beeste þat is called ciclopes, of wiche beeste telleþ a grett clerke; et est Hillarius [for Honorius Augustodunensis], De Ymagine Mundi. He telleþ þat þer is a beeste þat hythes cenopedes, uel cyclopes. Þis beeste haþ not but oon fote. Neuer-þe-lesse he is so swifte a beeste þat vondur is. He is of suche a keende, þat with is foote he kepeþ hym fro þe brennynge of þe sonne and fro alle oþur tempestes; and in þe shadowe of is fote he slepeþ and resteþ hym." The whole text is in 72–83. Scinopodae is the name in Honorius Augustodunensis for what others identified as the Sciopod or the Scinopede or Monocolos (*De imagine mundi* I.xii). The latter name explains the common confusion of this creature with the Cyclops or "monoculi": see J. B. Friedman, *The Monstrous Races in Medieval Art and Thought* (Cambridge, Mass., 1981), 18, 23, and S. D. Westrem, *The Hereford Map* (Turnhout, 2001), 376. We do not know the conditions in which this sermon was preached, but the preacher and his audience may possibly have had before them a large wall map showing a sciopod, such as that in Hereford Cathedral.

11. "And skillefulliche may loue be likened to a fote, for þus seiþ Seynt Austyn, "Pes meus, amor meus—my fote is my loue. In þis fote ben v toes" (Ross, *Middle English Sermons* [as in note 10], 77; the preacher alludes to Augustine, *Enarratio in Psalmum 9*, PL 36:124).

12. The history of this trope is treated at length in Carruthers, *Craft of Thought* (as in note 1), 171–220.

13. See Bernard of Clairvaux, *On the Song of Songs*, Sermon 23, especially sections 3 and 17 (trans. K. Walsh, vol. 2 [Kalamazoo, 1983], 24–25).

14. Around 500 A.D., Priscian translated and summarized the teaching on composition attributed to Hermogenes of Tarsus, a second-century rhetorician, which incorporated the exercises of *progymnasmata*, and which Priscian called *prae-exercitamina*. This became the standard text on this matter thenceforth for the Western Middle Ages. (More influential for centuries in Byzantine education and then in the early modern period was the late-fourth-century treatise on the *progymnasmata* by Aphthonius, which was unknown in the West until translated in the fifteenth century by the Dutch scholar and humanist Rudolphus Agricola. A translation of Aphthonius's work is in *Readings from Classical Rhetoric*, ed. P. P. Matson et al. [Carbondale, Ill.,1990], 266–88.) Priscian translated *ekphrasis* as *descriptio*, and defined it as "oratio colligens et praesentans oculis quod demonstrat" [speech assembling and presenting to the eyes that of which it gives an account]. Priscian's text is available as selection 17 in C. Halm, *Rhetores latini minores* (Leipzig, 1863); a translation can be found in *Readings in Medieval Rhetoric*, ed. J. M. Miller et al. (Bloomington, Ind., 1973), 52–68.

15. An account of the development of *progymnasmata* in the late imperial period known as the Second Sophistic is given in G. A. Kennedy, *A New History of Classical Rhetoric* (Princeton, 1994), 202–17, 280–81 (on Priscian). Kennedy points out (202) that composition was taught by exercises far earlier, however, for mention of such pedagogy can be found in the Hellenistic *Rhetoric for Alexander* and, in the Latin tradition, in Cicero and Quintilian. See also J. J. Murphy, *A Short History of Writing Instruction from Ancient Greece to Twentieth-Century America* (Davis, 1990), and G. A. Kennedy, *Classical Rhetoric and Its Christian and Secular Tradition*, 2nd edition (Chapel Hill, 1999), 26–28.

16. P. Hadot, *Philosophy as a Way of Life*, trans. A. I. Davidson (Oxford, 1995), 238–50.

17. I discussed several such instances of *kataskopos* in *Craft of Thought* (as in note 1), 77–81, 231–37. On Jewish practice, see M. D. Swartz, *Scholastic Magic: Ritual and Revelation in Early Jewish Mysticism* (Princeton, 1996).

18. On early monastic spiritual exercise, see P. Rabbow, *Seelenführung: Methodik der Exerzitien in der Antike* (Munich, 1954), and I. Hausherr, *The Name of Jesus*, trans. C. Cummings (Kalamazoo, 1978).

19. See F. A. Yates, "Architecture and the Art of Memory," *Architectural Association Quarterly* 12 (1980), 4–13, and Yates, *The Art of Memory* (as in note 5), 178.

20. The old title, "De arca Noe mystica," used in the Patrologia Latina edition, has now been corrected by Patrice Sicard, who, in his recent critical edition of Hugh's work on Noah's Ark, calls this work "Libellus de formatione arche," a title found in many manuscripts. See Hugo de St.-Victor, *De archa Noe*, ed. P. Sicard, CCCM 176, 176A (Turnhout, 2001), and P. Sicard, *Diagrammes médiévaux et exégèse visuelle: Le Libellus de formatione arche de Hugues de Saint-Victor* (Turnhout, 1993). The manuscripts of Hugh's works are described in R. Goy, *Die Überlieferung der Werke Hugos von St. Viktor* (Stuttgart, 1976). Sicard has argued forcefully that the works on Noah's Ark are actually a single work *De archa Noe*, to which the "libellus" stands as an appendix or summary.

21. The translation is that of Jessica Weiss, in *Medieval Craft of Memory* (as in note 3), 45; the complete translation is 41–70.

22. Arnobius Iunior, *Commentarii in Psalmos*, ed. K.-D. Daur, CCSL 25 (Turnhout, 1990), 199. See Carruthers, *Craft of Thought* (as in note 1), 135.

23. Translated by Weiss in *Medieval Craft of Memory* (as in note 3), 47.

24. Cited from the preface to the long version: "Now I will offer you an exemplar for our own ark, as I have promised. I depict it as an object, so that you can learn outwardly what you ought to do inwardly, and so that, once you imprint the form of this example in your heart, you will be glad that the house of God has been built inside of you" (trans. Weiss in *Medieval Craft of Memory* [as in note 3], 45). This prologue does not appear in the Patrologia Latina, but the text is included Sicard's edition of *De archa Noe*, and also in his *Diagrammes médiévaux* (as in note 20), 34. Sicard discusses this use of "exemplar" and the textual evolution of Hugh's two works (or perhaps one work) on Noah's Ark in *Diagrammes médiévaux*, 34–69, 101–18. Sicard (40–45) insists that a real drawing must have existed, largely on the grounds that such a complex figure could not have been merely a mental game ("le jeu mental," 45), as though that somehow demeaned its importance. I remain unconvinced that an Ark exemplar had to have existed for Hugh to have been able to describe it, given the established medieval conventions of invented *picturae*. Michael Evans has also argued against this being a physical image, in an essay of much value for the general subject of mental images: "Fictive Painting in Twelfth-Century Paris," in *Sight and Insight: Essays on Art and Culture in Honour of E. H. Gombrich at 85*, ed. J. Onians (London, 1994), 73–87.

25. Boncompagno da Signa, *Rhetorica novissima*, ed. A. Gaudenzi, *Scripta anecdota glossatorum*, Bibliotheca Iuridica Medii Aevi (1892; repr. Turin, 1962), vol. 2, 249–97.

26. Boncompagno, *Rhetorica novissima* IX.iii (ed. Gaudenzi [as in note 25], 285). The object envisioned in this structure of turning wheels is evidently some sort of mill, one meaning of Latin *machina*: see Carruthers, *Craft of Thought* (as in note 1), 88–94. Thanks for helping me realize just what Boncompagno was visualizing go to the participants at a symposium to honor Michael Camille, given by the Department of Art History of the University of Chicago (March 1, 2002).

27. Boncompagno, *Rhetorica novissima* VIII (ed. Gaudenzi [as in note 25], 278).

28. I discussed this figure in the context of Boncompagno's general teachings on *memoria* in M. Carruthers, "Boncompagno at the Cutting-Edge of Rhetoric: Rhetorical *Memoria* and the Craft of Memory," *Journal of Medieval Latin* 6 (1996), 44–64.

29. See M.-T. D'Alverny, "Alain de Lille: Problèmes d'attribution," in *Alain de Lille, Gautier de Châtillon, Jakemart de Giélée et leur temps*, ed. H. Roussel and F. Suard (Lille, 1978), 27–46. On the Victorine use of figural designs for meditation and pedagogy, see Sicard, *Diagrammes médiévaux* (as in note 20), 141–54, and Carruthers, *Craft of Thought* (as in note 1), 246–50. Sicard further argues for a connection between the map-like quality of Hugh's Ark *pictura* and the architecture of the cloister (*Diagrammes médiévaux*, 54–69; cf. Carruthers,

Craft of Thought, 257–76). Given Hugh's likely connection to Suger and the program at St.-Denis, one might profitably consider St.-Denis itself also as an architectural realization of the *pictura* device, perhaps with specific connections to the complex figure(s) within Hugh's Ark of Noah. Considering its programs as *picturae*, in the rhetorical sense that I have been developing, might profitably help one to understand its civic role as a monumental, memorial architecture for procession and preaching. See G. A. Zinn, "Suger, Theology, and the Pseudo-Dionysian Tradition," in *Abbot Suger and Saint-Denis: A Symposium*, ed. P. L. Gerson (New York, 1986), 33–40.

30. "The Mystical Ark" has been translated by G. A. Zinn in *Richard of St. Victor* (New York, 1979), 149–370. Adam of Dryburgh's *De tripartitio tabernaculo* is in PL 198:609–796. See the discussion in Carruthers, *Craft of Thought* (as in note 1), 246–50.

31. On the lives of canons and their indebtedness to and divergences from monastic rule, see C. W. Bynum, '*Docere verbo et exemplo': An Aspect of Twelfth-Century Spirituality* (Missoula, 1979), and G. Constable, *The Reformation of the Twelfth Century* (Cambridge, 1996).

32. Though identified in Isaiah as a seraph, the six-winged figure came also to be commonly identified as a cherub, as by Idung of Prüfening in his *Dialogus duorum monachorum* (a Cluniac and a Cistercian), III.46–47: see the translation by J. F. O'Sullivan in *Cistercians and Cluniacs: The Case for Cîteaux* (Kalamazoo, 1977), 135.

33. M. R. James, *A Descriptive Catalogue of the Manuscripts in the Library of Corpus Christi College, Cambridge* (Cambridge, 1912), vol. 1, 137–45.

34. L. F. Sandler, *The Psalter of Robert de Lisle in the British Library* (London, 1983), 80. Sandler's discussion of the *Speculum theologiae* pictures as a group is fundamental.

35. On this manuscript, see Bolzoni, *La rete delle immagini* (as in note 1), 72–83; Bolzoni later discusses (155–66) San Bernardino da Siena's use of the "cherub" in his preaching. See also Bolzoni, "Predicazione e arte della memoria" (as in note 7).

36. Described in W. Cahn and J. Marrow, "Medieval and Renaissance Manuscripts at Yale: A Selection," *Yale University Library Gazette* 52, no. 4 (1978), 195–96, and B. Shailor, *Catalogue of Medieval and Renaissance Manuscripts in the Beinecke Rare Book and Manuscript Library, Yale University*, vol. 2 (Binghamton, N.Y., 1987), 329–30.

37. Hugh of Fouilloy's *Aviarum* has been edited and translated by W. B. Clark, *The Medieval Book of Birds* (Binghamton, N.Y., 1992), which also thoroughly discusses the various manuscript groups of the Aviary. The treatise was especially popular among Cistercians and Benedictines as well as Augustinians, as indeed was much of Hugh of Fouilloy's other work (Clark, 24–26, and Carruthers, *Book of Memory* [as in note 1], 239–42). Jeffrey Hamburger remarks on the picture of "Hermannus custos" in *The Visual and the Visionary* (as in note 1), 262; and see also the catalogue descriptions of Cahn and Marrow, "Manuscripts at Yale," and Shailor, *Catalogue* (both as in note 36).

Vox Imaginis: Anomaly and Enigma
in Romanesque Art

Anne-Marie Bouché

One of the great charms of medieval art is its fondness for diagrammatic clarity, the symptom of a hierarchical worldview in which the dark forces of chaos and unreason are firmly confined to the margins, and order rules the center. Yet occasionally one finds irrational episodes in the most unlikely places, those very works of art where order and system are so important they might almost be considered part of the thematic content. This paper will examine two well-known Romanesque examples in which unexpectedly "irrational" details occur in otherwise orderly and rigidly structured hieratic compositions. The comparison reveals that in these two works anomaly is used deliberately, as a mechanism for engaging and guiding viewers as they explore the deepest recesses of these particularly dense iconographic programs. A technique known from rhetorical sources thus became a powerful tool for constructing complex works of visual exegesis.

The two-page frontispiece of the second volume of the Floreffe Bible in London (Figs. 1, 2) and the Last Judgment tympanum of Sainte-Foy, Conques (Fig. 3), seem in most respects to be more different than they are alike. The first, a book illumination, was made for the use of an elite, cloistered community of highly educated clerics. The second, a work of monumental sculpture, was intended for a mixed and transient population of pilgrims at a major pilgrimage site on the road to Santiago de Compostela. The frontispiece program is erudite and obscure, with no parallels, antecedents, or successors, while the tympanum's Last Judgment program belongs to an established pictorial tradition and has often been described as a work intended for a "popular" audience because of its moralizing content and the many genre details it includes.

Both, however, have complex iconographic programs in which text plays a prominent role, and both introduce anomalies[1]—elements that are out of place, incomplete, or seem to violate an expected pattern—into otherwise tightly controlled, regular compositions. These deliberate disturbances, I shall argue, are a mode of communication, a "voice" through which the works speak to their viewers and guide them through the interpretative process. The unique psychological and cognitive effects of anomaly enabled these programs' designers to communicate more material than would otherwise have been the case, and to offer their audiences an experience that was a valued end in itself, quite apart from the information conveyed. By encountering these anomalies ourselves and seeing where they lead us, we may hope to learn more about how such complex iconographic programs were conceived and what purposes they were intended to serve.

The Floreffe Bible was made around the middle of the twelfth century for the Premonstratensian canons of Floreffe, near Namur in what is now eastern Belgium.[2] It contains a number of visual and textual anomalies, all concentrated in the large two-page frontispiece that opens the Bible's second volume (Fig. 1).[3] This composition confronts us at the very outset with a clash between what the imagery actually depicts and what, according to its tituli, it is supposed to mean.[4] Verses framing the frontispiece on three sides state that the imagery is a "sign" (signum) of the Active and Contemplative Lives, yet only some of the heterogenous subjects jostling for space on its two pages have any obvious bearing on that theme. Conspicuously absent are the two emblematic pairs of figures most often associated with the Active and Contemplative Lives, Mary and Martha (the sisters of Lazarus), and Jacob's wives Leah and Rachel.

This strange discordance between text and image is not the only anomalous feature in the frontispiece, for the Transfiguration scene alone has three irregularities, all of which violate conventions or expectations in some way (Fig. 4). For example, hieratic Transfigurations of this two-tiered compositional type are normally rigidly symmetrical, yet here the rays of light extending from Christ do not radiate evenly, but emerge in clumps, at odd angles, as if at random. Peter appears in the center, directly under Christ, whereas in other similar Transfigurations the central apostle is usually John.[5] The third anomaly is textual: the quotation in the banderole appearing in the luminous cloud above Christ's head, while scriptural, is not, as we might expect, to be found in any of the gospel accounts describing the Transfiguration, but is from a different source altogether.

The tympanum of the abbey church of Sainte-Foy, Conques, also contains a number of unexplained or enigmatic details that seem to be deliberate anomalies. Jean-Claude Bonne has drawn attention to the strange lacunae and distortions in the inscriptions on the horizontal bar of the cross, as well as in the titulus of the banderole held by the angels to Christ's right. The cross inscription (Fig. 5) is disposed in two lines, as follows:

SOL	LANCEA	CLAVI	LUNA
OCSIGNM	CRUCIS	ERITIN	CELOCUM

While the first line consists of four labels for immediately adjacent elements of the composition (sun, lance, nails, moon), the second line is a continuous, though incomplete, sentence that breaks off oddly after the temporal conjunction, "cum," so that it reads: "this sign of the Cross will be in heaven when—" (HOC SIGNUM CRUCIS ERIT IN CAELO CUM). This line has also suffered some odd transformations: certain letters are missing and words are run together, so that the inscription appears as four arbitrary blocks of text.

Bonne was apparently the first to observe that these orthographic eccentricities produce patterns in the numbers of letters, i.e., the 7-6-6-7 palindrome of the second line.[6] There is also a regular, if unsymmetrical sequence in the four blocks of letters in the second line (3 / 6 / 5 / 4). The letters on each side of the axis even add up to the same totals, like equations:

$$\frac{\text{SOL} \quad \text{LANCEA}}{\underbrace{3+6}_{9}} \quad = \quad \frac{\text{CLAVI} \quad \text{LUNA}}{\underbrace{5+4}_{9}}$$

$$\frac{\text{OCSIGNM} \quad \text{CRUCIS}}{\underbrace{7+6}_{13}} \quad = \quad \frac{\text{ERITIN} \quad \text{CELOCUM}}{\underbrace{6+7}_{13}}$$

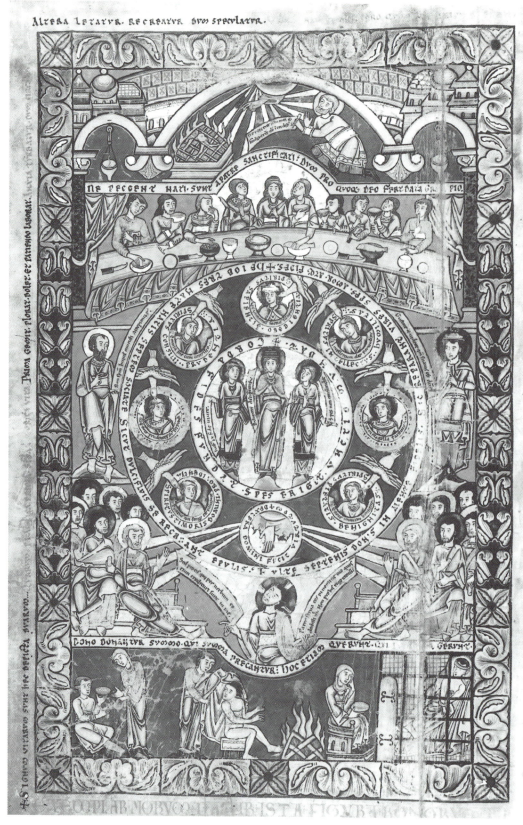

1. Floreffe Bible, frontispiece to volume 2. London, British Library, Ms. 17737, ff. 3v–4r

QVEM MOYSES VELAT. VOX ECCE PATERNA REVELAT. QVEMQ PROPHETIA TEGIT. ET FVLTA MARIA

hic est filius meus dilectus

in quo michi complacui

Noli tangere

LEX VETVS IMPLETVR. VT VERVM PASCHA PARET. AC VIVVM FIT SANGVIS. CARO QVI SVBERIT ACVIS

HEC DIVINORVM DOCE T ABOITA MYSTERIORVM

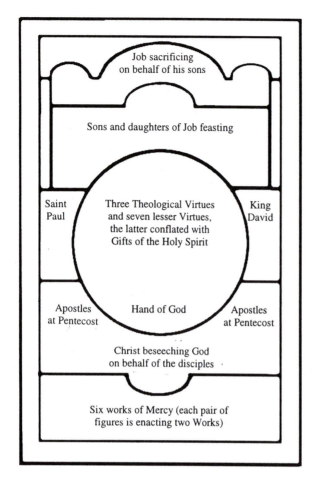

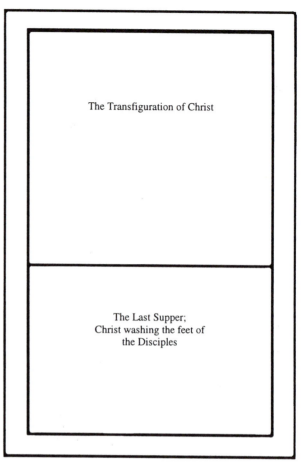

2. Floreffe Bible, diagram showing distribution of subjects (drawing: author)

Bonne also noted a strangely mutilated titulus on the banderole held by the angel to Christ's right (Fig. 6).[7] Christ's raised hand overlaps and obscures its center so that all that is visible are two groups of letters, "IPATRISMEIP" and "IDETEVO." While the phrase is in fact identifiable from the context, it could not be reconstructed from these letters alone, for the only recognizable part is PAT-RIS MEI ("of my father"), too common a phrase to be useful, and the rest is not only fragmented, but departs from all known conventions of medieval epigraphic contraction or abbreviation.[8]

In isolation, or in less-structured contexts, "aberrations" such as those just described might be dismissed as accidents. But in works as carefully planned, as regular, and as erudite as the Floreffe frontispiece and the Conques tympanum, so many anomalies, especially clustered together as these are, must surely be purposeful. But what function might they have served?

One way to answer this question is to consider what happens when we encounter an anomaly. We all know, from experience, that anomalies are often jarring, not only intellectually but emotionally. Running into one can be painful and infuriating, like entering our own familiar bedroom in the dark and falling over an obstacle that is not supposed to be there and that we did not anticipate. They perturb our sense of the order of things, challenge our assumptions, infect us with self-doubt and even anger. These discomforts provoke responses; our attention is drawn to them,

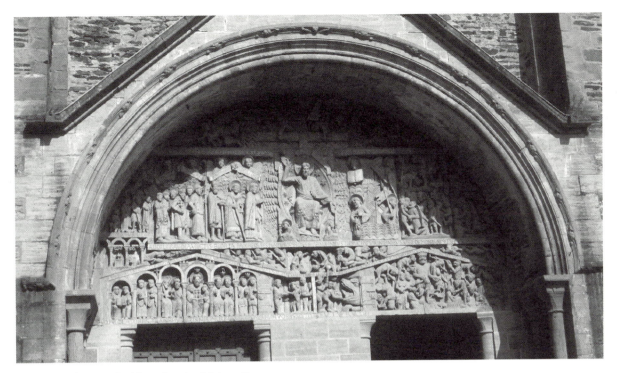

3. Conques (Aveyron), abbey church of Sainte-Foy, tympanum

our interest is engaged, and we often react by seeking explanations that will resolve the anomaly and relieve the discomfort.[9]

Such responses are no doubt why enigmas appear in these works of art: anomaly is provocative, an effective way of eliciting engagement and an interpretive effort from an audience. Mary Carruthers has discussed how Prudentius, in the preamble to his *Psychomachia*, used a "mystical figure," a kind of visual pun based on letter-forms, in order to engage his readers in speculation. Such enigmas, she writes, "make us anxious, but they are also stimulating. . . . Thus, the specific content of an interpretation . . . is less the point of finding out its secret than is the richly networked memory of the Bible which the clue finds out in one's mind—if one has done one's homework."[10] Carruthers's evocation of how Prudentius's enigma targets the reader's "richly networked memory" of a wider textual context also describes how the anomalies of our Romanesque examples work. They do more than merely attract attention and stimulate curiosity; by remaining open-ended and allusive, they call up chains of associations that greatly expand the field within which these works may be interpreted. A closer look will reveal some of the remarkably sophisticated and ingenious ways these works use anomaly to communicate complex, extended structures of meaning.

The Floreffe Bible Frontispiece

The Floreffe Bible frontispiece is a rarity in medieval art: a well-preserved and legible iconographic program, its component parts all clearly labeled, that belongs to no recognizable category and has

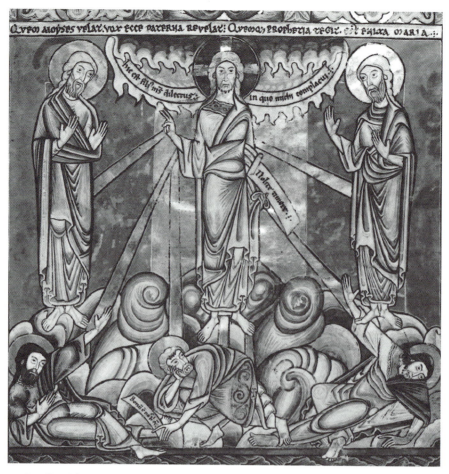

4. Floreffe Bible, frontispiece, detail of folio 4r, the Transfiguration

no immediately identifiable overall subject, the way that the Conques tympanum can be identified as a "Last Judgment." It represents itself in its tituli as a "figure" and a "sign" (*figura*, *signum*), indicating that interpretation will be required, and indeed there is no way to approach this work except by systematic investigation, since there is no superficial level at which it may be understood. Since a full explanation of this unusually difficult program is beyond the scope of this paper, I shall focus on just those anomalies already described in the Transfiguration scene, sketching in enough of the rest of the program to give a general idea of its subject matter and structure.[11]

This second volume contains the biblical books from Job to Revelation. From these texts the frontispiece designer selected a limited number of persons, episodes, and themes. Some he represented as narrative scenes; some he alluded to via personifications or the depiction of individual figures; the rest, in quotation or paraphrase, he included as actual text. The scenes are distributed such that the pages can be read in two complimentary ways (Fig. 2): separately, as freestanding compositions, each with its own coherent meaning, or together, as a continuous sequence describing a U-shaped itinerary, beginning at the top of the left-hand page with Job and ending at the top of the right-hand page with the Transfiguration.

The scenes and texts do not "narrate" the thematic content directly. Instead, each viewer

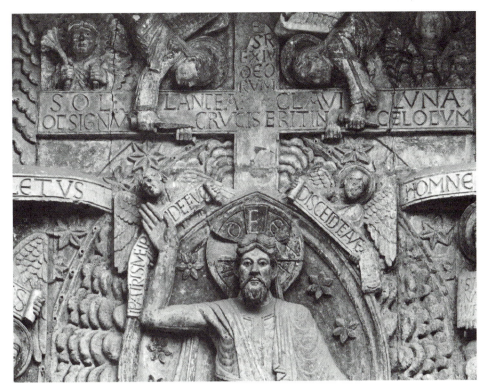

5. Conques (Aveyron), abbey church of Sainte-Foy, tympanum, cross inscriptions

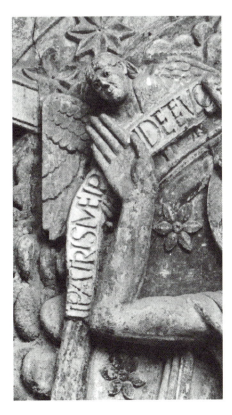

6. Conques (Aveyron), abbey church of Sainte-Foy, tympanum, banderole titulus

must reconstruct the meaning anew through a process of interpretation that is initiated and guided by formal and textual cues. Independently, as the inscriptions indicate, the left-hand page can be read as an allegory of the Active Life, and the right-hand page as an allegory of the Contemplative Life. Read as a continuous itinerary across the two pages, however, the sequence of subjects provides the basis for three superimposed exegetical interpretations of the text of this second volume of the Bible. The first is roughly chronological, reading the biblical text as an outline of world history, both what has happened in the past and (via prefiguration) what is yet to come. The second and third evoke the activity of the Holy Spirit in the world, respectively on the macrocosmic scale of the Church as a whole, and on the microcosmic scale of the individual soul. These three readings correspond to the three "senses," or ways of interpreting Scripture, described by Gregory the Great in his *Moralia in Job:* the "historical" (or "literal"), the "allegorical," and the "moral" interpretations. All are constructed from standard exegetical material derived primarily from patristic sources. The three superimposed itineraries of interpretation are outlined for clarity in Table 1.

	SEQUENCE OF SUBJECTS (CORRESPONDING TO THE "HISTORICAL" OR "LITERAL" *SENSUS* OF SCRIPTURE)	ALLEGORICAL *SENSUS:* THE HOLY SPIRIT IN HISTORY / THE CHURCH	MORAL *SENSUS:* THE HOLY SPIRIT IN THE INDIVIDUAL / THE SPIRITUAL ASCENT OF THE SOUL
PAST	Job scenes	Old Testament / Pre-Incarnation (Christ and the Apostles prefigured in Job and his children)	Pre-conversion or pre-baptism
PAST	Seven Gifts of the Spirit / Virtues	Incarnation: the Holy Spirit, and with it the Virtues, enter the world with Christ (=Isaiah 11)	Conversion / Baptism
PAST	Pentecost	Transmission of Spirit to the Apostles at Pentecost	Unction / gift of Grace
PRESENT	Works of Mercy	The Spirit (*Caritas,* or God's love) acts in the world as love of neighbor	In the individual, love of neighbor inspires the acquisition and practice of the virtues in emulation of Christ and the apostles (=the Active Life)
PRESENT	The Last Supper	*Caritas* in its other temporal manifestation, Love of God (expressed in corporate prayer and the liturgy)	Prepared through the rigors of the Active Life, the purified soul is drawn by the love of God to seek him in the Contemplative Life
FUTURE	Transfiguration	Radiance of Tabor prefigures Christ's Resurrection glory at the Second Coming / the Beatific Vision at the end of time	Transfiguration reveals Christ's true nature and that of God (the Trinity) / goal of the individual journey of the soul / Contemplation

Table 1. Superimposed interpretations of the frontispiece of the Floreffe Bible according to the three "senses" of Scripture

These interpretations highlight the larger themes of the volume II frontispiece, the part played by the Holy Spirit in the economy of salvation, both for the Church as a whole and for the individual, with a certain emphasis on the role of the apostles in transmitting the Spirit to the world.[12] They are based on the identification of the Holy Spirit with God's love, in its dual manifestations of love of neighbor and love of God. The Active and Contemplative Lives are thus revealed to be the visible manifestation of the Holy Spirit, acting in the world to power the process of salvation.

While it is unusual to encounter such a complex edifice of exegesis in visual form, the interpretations outlined here are quite conventional by medieval standards, as is their formal expression as three parallel "senses." But the anomalies noted in the Transfiguration do not relate to any of the three "senses" already described.[13] Instead, they are cues revealing the presence of an *additional* layer of meaning in that scene, one that is more local and contemporary, in that it speaks to the particular situation of the Bible's patrons, the Premonstratensian canons of Floreffe, and creates a link between that specific community and the broad historical process that is the subject of the rest of the program.[14]

By reversing the positions of Peter and John in the Tranfiguration, the designer ensured that each apostle would appear once on the page in the privileged axial position, Peter in the Transfiguration and John in the Last Supper. Peter and John are thus highlighted as a dyad, the two disciples who are closest to Christ. But we, the audience, are expecting a different dyad, Mary/Martha or Leah/Rachel, for these pairs are powerfully evoked by the language of the long poem that frames the frontispiece. This describes the two Lives in terms of polar opposition derived from the traditional exegeses of these female pairs; it contrasts the "groaning," "weeping," "sorrowing," and "toiling" of the Active Life with the "rejoicing," "resting," and "expectant waiting" of Contemplation, the "many things" that preoccupied Martha with the "one thing" that absorbed Mary's attention.[15]

The canons of Floreffe would have had no trouble in recognizing that the apostolic dyad had been substituted for the female exemplars, for Peter and John had been interpreted as an allegory of Action and Contemplation by Saint Augustine in his *Tractatus in Joannis*,[16] and this had become a standard exegetical topos in homilies for the feast of John the Evangelist.[17] They would also have known why the substitution was made: the exegeses concerning Mary and Martha and Leah and Rachel, taking their cue from the original stories, leave no doubt that the Active partner in each case is inferior to the Contemplative one.[18] But since the apostles are equal in honor, exegeses of the Peter/John dyad offer a model of Action and Contemplation that considers both Lives as equal in merit, and describe the ideal life as one that unites both Action and Contemplation in a single person.

The distinction was an important one for regular canons, because there was by this time such a strong tendency to associate monasticism with the Contemplative Life and the priesthood with the Active Life. Regular canons, however, felt that their vocation should be considered equally Active and Contemplative, since they were ordained priests living in monastic communities. Peter and John were much better exemplars of their ideal than Mary and Martha or Leah and Rachel.

Augustine had made an important distinction between Peter and John as *symbols*, respectively, of Action and Contemplation, and their function as *exemplars*, models to be emulated. John might symbolize speculative Contemplation, and Peter pastoral Action, but in actual fact they were both equally Active and Contemplative: both preached and taught, exercised an active pastoral role in their communities, and died as martyrs, but each also experienced unique moments

of authentically contemplative insight into Christ's (and therefore God's) true nature, a degree of understanding not accorded to the other disciples. John, resting his head on Christ's breast at the Last Supper, was the image of the speculative theologian penetrating the secrets of God's inner nature, but Peter was the first of the disciples to recognize Jesus as divine (Matt. 16:16).

In leading his audience to expect one thing, and then delivering another, the frontispiece designer ensured that *both* would be noticed and remembered; the omission of the women was made as explicit a part of the thematic content as the inclusion of Peter and John. Similar rhetorical strategies may be observed in contemporary polemical exchanges between regular canons and their monastic critics. In the late eleventh and twelfth centuries, communities of canons were proliferating rapidly, attracting secular patronage and talented recruits away from Benedictine monasteries,[19] which led to conflict, and even on occasion to violence.[20] Premonstratensians, as the largest and fastest-growing organization of regular canons, frequently found themselves in competition with monastic orders, especially Cistercians, who were also expanding rapidly in some of the same geographical zones.[21] Floreffe must often have encountered such difficulties, since, as one of four Premonstratensian "mother houses," it was responsible for founding and staffing new abbeys.[22]

While the roots of these quarrels were complex, the debates themselves tended to be framed rather simplistically in terms of the relative merits of monasticism versus the priesthood. The bone of contention was not how regular canons or monks actually lived—especially when reformed orders were being compared, their mode of life was almost indistinguishable—but rather which obligations and qualities were considered primary or intrinsic to their vocations.[23] For those desiring to demonstrate the superiority of one order over another, the exegetical traditions concerning the Active and Contemplative Lives were a fertile source of arguments;[24] monastic polemicists found much profit in the Mary/Martha and Leah/Rachel exegeses, while canons, for obvious reasons, preferred to argue from those exegetical traditions that associated the two Lives with Christ and the apostles, especially Peter and John. The Premonstratensian Anselm of Havelburg, for example, maintained that while Mary was undoubtedly to be preferred over Martha, Christ, the true model of regular canons, was to be set above both the sisters, for in Christ the two Lives were not opposed but united.[25] Arno of Reichersberg, in his *Scutum canonicorum* (A Shield for Canons), adopted a similar strategy when he used an exegesis of the race of John and Peter to the tomb of Christ (John 20:2–8) to argue that monks and priests were in reality equal in the hierarchy of vocations.[26] John, racing ahead with youthful vigor, arrived first at the tomb, but it was Peter who first entered the sepulcher and fully undersood the miracle.[27]

The John/Peter dyad had an additional attraction for canons because Peter was not merely an abstract symbol, but the founder of their order and the true exemplar of their ideal. The remaining two anomalies noted in the frontispiece's Transfiguration single out Peter as the central figure and stress his credentials as an authentic contemplative. The irregular distribution of rays of light coming from Christ's body, for example, results in Peter receiving three rays, while each of the other participants gets only one. Their number alludes to the Trinitarian implications of the Transfiguration; it was Peter who first recognized Christ's divinity, when he answered Christ's question, "Who am I?" with the words, "Thou art the Christ (the annointed one), son of the Living God" (Matt. 16:16). This episode, which in Matthew's text occurs immediately before the Transfiguration, led to Peter's receiving the power of binding and loosing, a prerogative that was naturally of great importance to regular canons, who had inherited it.

The final and most subtle anomaly is the inscription on the banderole that appears in the lu-

minous cloud over Christ's head. It is, first of all, rare to find God's words explicitly recorded as a titulus in Transfiguration scenes.[28] The precise quotation, "Hic est Filius meus dilectus in quo mihi conplacui," is not found in any of the gospel accounts of the Transfiguration, but comes instead from the second canonical epistle of Peter, in which Peter recounts his *experience* at the Transfiguration: "But we were eyewitnesses of his greatness, for he received from God the Father honour and glory, this voice coming down to him from the magnificent glory: *This is my beloved Son, in whom I am well pleased. Hear ye him.* And this voice, we heard brought from heaven, when we were with him in the holy mount." (2 Peter 1:16–18).

Thus, at the culmination of the frontispiece's itinerary—when Christ appears resplendent with Resurrection glory and his inner nature is revealed—at this apex of contemplative experience, it is Peter, exemplar of the Active Life, of the priesthood and of regular canons in particular, who is the privileged spectator. It is, indeed, the Transfiguration, but the Transfiguration *as mediated through Peter's experience*, that is unveiled in this final scene of the frontispiece, for the edification of Peter's spiritual progeny, the canons of Floreffe.

The complexity of this iconographic program—surely one of the most ambitious in all of Western art—no doubt reflects the sophistication of its intended audience. The earliest Premonstratensians seem to have been highly educated, mature adults, with strong ties to the Victorines (who were also regular canons) and their intellectual traditions.[29] Many had studied in the schools of Laon and Paris before entering the cloister,[30] and seven of the first twelve canons of Prémontré were recruited by the order's founder, Norbert of Xanten, from among the pupils of Radulphus of Laon, brother and successor of the renowned theologian and teacher Anselm of Laon.[31] Since Floreffe was founded barely a year after Prémontré, it is probable that some of these former students were among the canons sent to establish the new community. Thus, while the frontispiece is challenging, it would not have been encountered "cold" by an unprepared audience, but rather in the context of organized biblical studies that would have involved the whole community. Its designer could predict what his audience would have read and no doubt expected that guidance would be available for its interpretation.[32]

The Last Judgment Tympanum of Conques

In the case of the Conques tympanum, however, the situation must have been very different. Its anomalies occur in the context of a public program addressed to an indeterminate population, itinerant pilgrims and possibly also the resident monks.[33] The more esoteric, textually based elements of the tympanum could only have been intended for a select subset of that audience, but the program also had to be broadly appealing and informative to the whole range of visitors. No doubt many pilgrims gazed on the tympanum without noticing the banderole and cross inscriptions or analyzing their peculiarities. Assuming, however, that some of the more literate and educated pilgrims did notice them, what might they have concluded?

Of the anomalies already discussed, the one that would probably have caused the least trouble to an educated viewer is the truncated second line of the inscription on the horizontal bar of the cross, "[H]oc signum crucis erit in celo cum. . . ." No reasonably competent medieval cleric would have failed to recognize the quotation or had difficulty completing it, for it is a well-known

liturgical text[34] from the liturgies of two feast days devoted to the Holy Cross, the Finding of the True Cross (*Inventio*, May 3) and its Exaltation *(Exaltatio*, September 14):[35]

> (Respond) Hoc signum crucis erit in caelo, cum Dominus ad judicandum venerit. Tunc manifesta erunt abscondita cordis nostri. (Verse) Cum sederit filius hominis in sede maiestatis suae et ceperit iudicare seculum per ignem.[36]

> This sign of the cross will be in Heaven, when the Lord comes in judgment. Then the things hidden in our hearts will be revealed, when the Son of man shall sit on his glorious throne, and shall begin to judge the world with fire.

In the full version quoted here, the text serves as a "great" or prolix responsory, one of the long and musically demanding pieces sung after each of the substantial readings in the night office of matins. "Great" responsories—so called to distinguish them from the shorter, simpler responsories of other offices—are, second only to hymns, the most characteristic and elaborate melodic chants of the Divine Office.[37]

Hoc signum crucis is among the most widely distributed of Holy Cross great responsories in the manuscript sources. Its text permeates other parts of the Divine Office for these feasts as well, since its first line is used separately as a short response/versicle chant in some of the day offices on those feast days, and often also as the verse, or second part, of one or more of the other great responsories for Holy Cross feasts.[38] Between all these different liturgical appearances, the words engraved on the tympanum might be repeated six or more times in various offices over the course of a single day, albeit only twice a year.[39] According to Robert Favreau and Jean Michaud, *Hoc signum crucis* also occurs as the verse of an antiphon sung in the special liturgy used for would-be pilgrims during which the candidate would be marked with the sign of the cross. Thus, every pilgrim to Conques who had inaugurated his journey with this formal ceremony would also have heard the words of the inscription.[40]

But if recognizing the source of the inscription is not difficult, it does not explain what purpose was served by engraving this liturgical fragment on the cross, in this oddly manipulated form. Is it supposed to function, at least in part, as a label, like *sol* or *lancea*? Why was it truncated after the conjunction, rather than before, and disposed so oddly in conflated blocks containing balanced numbers of letters? And what was achieved by quoting a liturgical text instead of, for example, "Then shall appear in heaven the Sign that heralds the coming of the Son of man" (Matt. 24:27), the gospel passage that clearly inspired it?

Jean-Claude Bonne related the truncation of *Hoc signum* to the fragmented banderole inscription, "IPATRISMEIP IDETEVO," noting that the incomplete inscriptions all refer to future events. For Bonne, the interruptions are openings, not necessarily meant to be completed in any particular way, but signifiers of things yet to come.[41] But the use of *Hoc signum* in this abbreviated form has other interesting implications. The responsory is neither a scriptural quotation, nor a paraphrase of one, but rather a digest, a synthetic statement distilling the theological point of the feast being celebrated, while at the same time evoking, in its choice of language, the much larger body of scriptural texts that provide context and justification for the theology. In a very condensed form, it not only conjures up these source texts, but it also provides a commentary on them. It is, in other words, a work of exegesis that connects the liturgical celebration with its underlying meaning, by pointing to and connecting the relevant passages in Scripture.

Hoc signum crucis derives from a series of gospel passages in which Christ describes events of the last day, when the Son of man will come to judge the world.[42] How economically it does so can be seen when the words evoked in the responsory are underlined in the original texts:

1. Sicut enim fulgur exit ab oriente et paret usque in occidente ita erit et adventus <u>Filii hominis</u>. . . . Statim autem post tribulationem dierum illorum sol obscurabitur et luna non dabidt lumen suum et stellae cadent de caelo et virtutes caelorum commovebuntur; et <u>tunc parebit signum Filii hominis in caelo</u>; et <u>tunc</u> plangent omnes tribus terrae et videbunt <u>Filium hominis</u> venientem in nubibus caeli cum virtute multa et <u>maiestate</u>; et mittet angelos suos cum tuba et voce magna et congregabunt electos eius a quattuor ventis a summis caelorum usque ad terminos eorum. Ab arbore autem fici discite parabolam cum iam ramus eius tener fuerit et folia nata scitis quia prope est aestas; ita et vos cum videritis haec omnia scitote quia prope est in ianuis.

For as lightning comes out of the east and appears in the west: so shall also the coming of the Son of man be. . . . And immediately after the tribulation of those days, the sun shall be darkened and the moon shall not give her light and the stars shall fall from heaven and the powers of heaven (*virtutes caelorum*) shall be moved. And then shall appear in heaven the sign of the Son of man. All tribes of the earth mourn: and they shall see the Son of man coming in the clouds of heaven with much power and majesty. And he shall send his angels with a trumpet and a great voice: and they shall gather together his elect from the four winds, from the farthest parts of the heavens to the utmost bounds of them. And from the fig tree learn a parable: When the branch thereof is now tender and the leaves come forth, you know that summer is nigh. So you also, when you shall see all these things, know ye that it is nigh, even at the doors" (Matt. 24:27–33).

2. <u>Cum</u> autem <u>venerit filius hominis</u> in maiestate sua et omnes angeli cum eo, <u>tunc sedebit super sedem maiestatis suae</u>, et congregabuntur ante eum omnes gentes, et separabit eos ab invicem sicut pastor segregat, oves quidem a dextris suis, hedos autem a sinistris. Tunc dicet rex his qui a dextris eius erunt "venite benedicti Patris mei possidete paratum vobis regnum a constitutione mundi." . . . <u>tunc</u> dicet et his qui a sinistris erunt "discedite a me maledicti in ignem aeternum qui paratus diabolo et angelis eius . . . et ibunt hii in supplicium aeternum, iusti autem in vitam aeternam."

When the Son of man comes in his majesty, and all the angels with him, he will sit upon his glorious throne, and all the nations will be assembled before him. And he will separate them one from another, as a shepherd separates the sheep from the goats. He will place the sheep on his right hand, and the goats on his left. Then the king will say to those on his right, "Come, you who are blessed by my Father. Inherit the kingdom prepared for you from the foundation of the world." . . . Then he will say to those on his left, "Depart from me, you accursed, into the eternal *fire* prepared for the devil and his angels. . . . And these will go off to eternal punishment, but the righteous to eternal life." (Matt. 25:31–34, 41, 46).

3. <u>Cum</u> autem videritis circumdari ab exercitu Hierusalem; tunc scitote quia adpropinquavit desolatio eius. . . . et <u>erunt signa</u> in sole et luna et stellis et in terris pressura gen-

tium prae confusione sonitus maris et fluctuum arescentibus hominibus prae timore et expectatione quae supervenient; universo orbi nam virtutes caelorum movebuntur, et tunc videbunt Filium hominis venientem in nube cum potestate magna et maiestate.

And when you shall see Jerusalem compassed about with an army, then know that the desolation thereof is at hand. . . . And there shall be signs in the sun and in the moon and in the stars; and upon the earth distress of nations, by reason of the confusion of the roaring of the sea, and of the waves: men withering away for fear and expectation of what shall come upon the whole world. For the powers of heaven shall be moved. And then they shall see the Son of man coming in a cloud, with great power and majesty (Luke 21:20, 25–26).

The responsory's allusion to hidden things made manifest (*abscondita, manifesta*) comes from Christ's discourses on the kingdom of God.

4. Non enim est aliquid absconditum quod non manifestetur, nec factum est occultum sed ut in palam veniat.

For there is nothing hid, which shall not be made manifest: neither was it made secret, but that it may come abroad (Mark 4:21–23; cf. also Luke 8).

And in another, even more dramatic passage:

5. Nihil autem opertum est quod non reveletur neque absconditum quod non sciatur, quoniam quae in tenebris dixistis in lumine dicentur et quod in aurem locuti estis in cubiculis praedicabitur in tectis.

For there is nothing covered that shall not be revealed: nor hidden that shall not be known. For whatsoever things you have spoken in darkness shall be published in the light: and that which you have spoken in the ear in the chambers shall be preached on the housetops (Luke 12:2–3).

Although the general idea of judgment by fire appears in the gospel passages cited above, the source of the responsory's last phrase, "et ceperit iudicare saeculum per ignem," seems to be liturgical rather than scriptural; it is the formula of absolution from the liturgy of the dead: "Libera me domine de morte aeterna in die illa tremenda, quando caeli movendi sunt, et terra: dum veneris iudicare saeculem per ignem." With this citation, *Hoc signum crucis* links the scriptural account of future judgment to the much more imminent and terrifying prospect of one's own death.

The responsory does not attempt to be comprehensive, but rather picks out a few key terms and concepts: the "signs" in heaven; the coming of the Son of man, described as enthroned in majesty; the notion of concealed things being revealed, the future judgment. Even in this highly elliptical form, it is able to provide mnemonic links to the content of the original passages with surprising effectiveness. One way it does this is by using the conjunctions, *tunc* and *cum* ("then" and "when") to mark the separation points between the modular phrase-units out of which the responsory is constructed. *Cum* and *tunc* are particularly characteristic of the language Christ uses in describing the Second Coming, and have an important structural role in *Hoc signum crucis* as well, especially in performance.

Great responsories have two basic parts, a "respond" (R. *Hoc signum . . . nostri*) followed by a "verse" (V. *cum sederit . . . per ignem*), to which are added a short doxology (Glory be to the Father . . .) and, for festive occasions, an alleluia. In performance, the second half of the respond (*cum Dominus ad iudicandum venerit*) is repeated after the verse, and again after the doxology:[43]

respond—alleluia—verse—½ respond—Gloria—½ respond

When *Hoc signum crucis* is sung with all the repeats, "cums" and "tuncs" proliferate:

> (R.) This sign of the cross shall be in Heaven *when* the Lord comes in judgment. *Then* shall be revealed the things hidden in our hearts. *Alleluia, alleluia, alleluia.* (V.) *When* the Son of man shall sit on his glorious throne, and shall begin to judge the world with fire, *then* shall be revealed the things hidden in our hearts.—Glory to the Father and the Son and to the Holy Spirit.—*Then* shall be revealed the things hidden in our hearts.

Cum and *tunc* are rather flexible conjunctions; they allow this responsory to break apart and link up in new permutations with itself or with other texts, while preserving grammatical and logical coherence. Thus, fragments of *Hoc signum crucis* (here in italics) are sometimes found in the verses of other great responsories:

> (R.) O Lord, our King, when you shall come to judge the world, then shall appear the holy Cross, shining like gold in its virtue. (V.) *When the Son of man shall sit in his majesty, and shall begin to judge the world with fire*, then shall appear the holy cross, shining like gold in its virtue.[44]

> (R.) You who have followed me, you shall sit upon thrones, judging the twelve tribes of Israel, alleluia, alleluia. (V.) At the Resurrection, *when the Son of man shall sit on the throne of his majesty*, you too shall sit judging the twelve tribes of Israel [great responsory for the feast of Saint Paul].[45]

But the same facility means that the "cums" and "tuncs" of *Hoc signum crucis* lead back readily to the many phrases beginning with the same conjunctions in the original gospel texts describing the Second Coming. The *cum* of the truncated titulus implies the *tunc* that is to follow, and by extension, all the "cums" and "tuncs" in the body of source texts from which the responsory was derived. The dangling *cum*, like a key that fits many different locks, thus provides access, in memory, to most of the scriptural and liturgical contexts of the iconographic program, doorways where one can pass easily from the responsory text to various parts of the gospel texts, or to another liturgical text, hardly noticing the transition.

By choosing a liturgical text over a scriptural one, and then truncating it in this way, the designer of the tympanum found an economical and effective way to "package" a vast body of material and ensure that it would be retrievable in memory. He was also able to take advantage of one of the most powerful mnemonic aids ever discovered, music.

Everyone has experienced music's ability to assist memorization, enhance long-term retention of texts, and facilitate associations and intuitions.[46] A few moments spent contemplating the phrase "Silent night, holy night. All is. . . . " will more than likely bring the tune to mind, and with it, the rest of the words. This is particularly true when the sentence is truncated in a way that implies a continuation; we might read the words "Silent night" as simply a title, without the

melody, but not this fragmentary phrase. This, no doubt, is why the liturgy was originally sung: it had to be committed to memory, and words memorized as prose, no matter how weighty, are infinitely more forgettable than the most trivial advertizing slogan set to music.

The truncation of the cross titulus after the word *cum* is even more jarring when the words are associated with the music, because of the way the melody is structured:

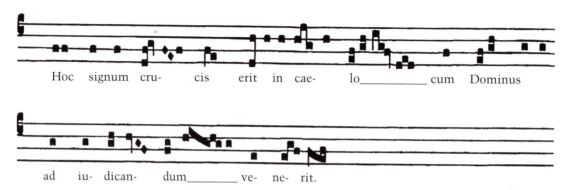

Hoc signum cru- cis erit in cae- lo_____ cum Dominus

ad iu- dican- dum_____ ve- ne- rit.

After the florid melismatic emphasis on *crucis* and *caelo*, *cum* gets only one note, a brief, unstressed upbeat leading to the stressed first syllable of *Dominus*. Anyone reading the titulus who knew the great responsory *as music* would have found it all but impossible to stop on the word *cum*.

For many people, the first few words of "Silent Night" will evoke, along with the words and music, the emotions associated with the occasion and the season. Music, memory, and emotion are intimately linked, in occult ways that are not yet fully understood, but that have long been exploited for the purpose of preserving vital cultural knowledge from generation to generation. Because it was originally set to music, the cross titulus would probably have had emotional connotations as well for that part of its audience with the right cultural background. This aspect would only have been accentuated by its appearance in the unfamiliar context of a pictorial program, much as a familiar melody has a peculiar power to move us when it is encountered unexpectedly in a foreign land.

No other text, scriptural or liturgical, could have substituted for Hoc signum crucis in the tympanum, and produced the same effect. It is the only great responsory for the Holy Cross feasts whose text is based directly on the Gospels, on Christ's own descriptions of the events surrounding the end of time,[47] and the only one that so explicitly situates the cross in the eschatological context of the Second Coming, by identifying it with the mysterious "sign" in heaven of Matthew 24.[48]

Hoc signum crucis is not the only clue directing the viewer's memory to the underlying sources of the program, for the tympanum is full of other details, textual and visual, that also refer back to the same set of passages. In discovering these, the beholder who had taken the trouble to think about it would be rewarded with confirmation that he was on the right associative track. The sun and moon, for example, are typically found in the context of Crucifixion scenes, but are here as literal reminders of the heavenly "signs" in Matthew 24. The "powers of heaven," that, according to Matthew 24 and Luke 21, "shall be moved" (*virtutes caelorum commovebuntur/ movebuntur*) are represented literally too, as angel-personifications of Virtues—the English distinction between "virtue" and "power" being nonexistent in Latin—their "movement" being represented as well, in the rising and falling diagonals of their banderoles (Fig. 7).

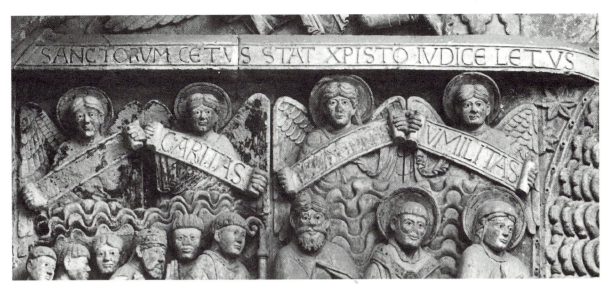

7. Conques (Aveyron), abbey church of Sainte-Foy, tympanum, the Virtues

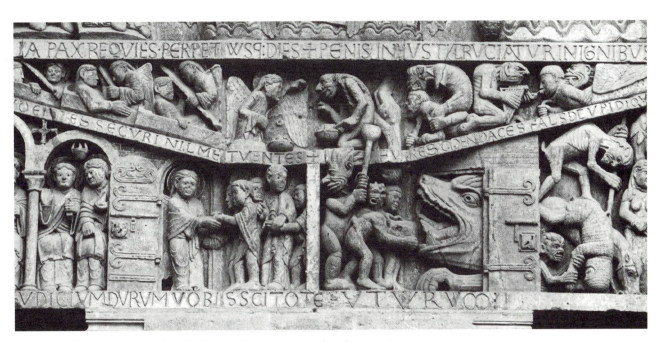

8. Conques (Aveyron), abbey church of Sainte-Foy, tympanum, lintel inscription

Even the ominous threat directed at the audience of pilgrims that concludes the tympanum's long poetic inscription, "O sinners, unless you change your ways, know *(scitote)* that this hard judgment awaits you," may have been meant to resonate with a specific scriptural passage. The couplet, inscribed as a single line on the lower edge of the lintel (Fig. 8), is severely compressed at the beginning and stretched out at its end, so that the word "scitote" appears between the doors, recalling Matthew 24:33: "when you shall see all these things, know *(scitote)* ye that it is nigh, even at the doors"—*scitote quia prope est in ianuis.*

The fragmented titulus on the first of Christ's two banderoles (Fig. 6) is another case in point, though a more complex one. Its identification poses no real problem since the unmutilated text of the pendent banderole (Fig. 5), *Discedite a me* (depart from me), makes it possible to locate the source, in Christ's description of the coming Judgment (Matt. 25:31–34):

> Cum autem venerit filius hominis in maiestate sua. . . . congregabuntur ante eum omnes gentes, et separabit eos ab invicem sicut pastor segregat oves quidem a dextris suis, hedos autem a sinistris. Tunc dicet rex his qui a dextris eius erunt "Venite benedicti <u>Patris mei</u> <u>possidete</u> paratum <u>vobis</u> regnum a constitutione mundi." . . . Tunc dicet et his qui a sinistris erunt "<u>discedite a me</u> maledicti in ignem aeternum qui paratus diabolo et angelis eius" . . . et ibunt hii in supplicium aeternum, iusti autem in vitam aeternam.

Once the constituent letters of the first inscription have been identified, it becomes apparent that the legibility of the titulus has been deliberately obscured. Instead of beginning at the logical place, with the first words of Christ's invitation, *Venite benedicti*, it begins bizarrely *in medias res*, with the last letter (*I*) of the second word, *benedicti*. The next phrase, *Patris mei*, though written out in full, is a common one, and the fourth word, the verb *possidete*, is interrupted by Christ's hand so that only its first letter, *P*, and the imperative ending *IDETE* are visible. Of the last three words, *vobis paratum regnum*, just two letters, the first two of the penultimate word (*VO*), are provided. The original statement, *Venite benedicti <u>Patris mei possidete</u> paratum <u>vobis</u> regnum* (a sentence of only eight words to begin with!), has thus been disrupted no fewer than four times—at the beginning, twice in the middle, and again at the end. To get the full flavor of the confusing impression this must have made on its original audience, one has only to render it as it might appear in English (omitting, as in the Latin, the direct object, "the kingdom prepared"):

<div align="center">

DOFMYFATHERI . . . ITYO

</div>

<div align="center">

[Come blesse]d of my Father i[nher]it [the kingdom prepared for] yo[u]

</div>

Bonne, it will be recalled, linked this fragmented titulus to the truncation of *Hoc signum crucis* above, describing their "open-ended" quality as a reference to "things yet to come."[49] The banderole texts, however, do little more than confirm that Matthew 24 is the source behind the imagery, and this would have been accomplished as effectively by an unmutilated titulus. More to the point, the anomalies in these tituli express two themes central to the larger tympanum program.

The deliberate concealment of the banderole text on Christ's right and the perfect legibility of the one on his left, recognized as a "hiding" and "revealing" motif by Bonne, is surely related to the passages in Mark 4 and Luke 21 (nos. 4 and 5 above), with their allusions to hidden things that shall be revealed.[50] The same idea, in a slightly different guise, occurs in the Last Judgment tympanum program of Moissac, in which angels to Christ's right and left hold scrolls, one open and one closed.[51]

The anomalous treatment of the banderoles and of the cross tituli also has the effect of altering the normal relationships of symmetry and dissymmetry. in the tympanum. Paradoxically, the designer went to some trouble to undermine the natural parallelism of the two banderole statements, yet he imposed a highly artificial numerical symmetry on the (inherently nonsymmetrical) cross inscriptions. Since symmetry and balance are one of the most salient formal features of

the composition as a whole, this violation of the expected order must be seen as another, equally deliberate, anomaly.

The most important place in any bilaterally symmetrical system is the axis, and the axis in this case is crossed by only three elements: the cross, Christ, and the scales used to weigh souls. The role of the cross at this critical moment in human history, when everything literally hangs in the balance, would seem to be a major preoccupation of the tympanum program, if not its entire raison d'être. This might account for the bizarre numerical symmetries in the cross inscriptions, which Bonne noted without really explaining. In addition to exciting curiosity, they express a thematic idea of even balance, echoing the scales held by the archangel Michael, below. The artificial, equation-like arrangement of letters on the two sides of the axis could be seen as a symbol, if not an actual artifact, of the power of the cross, its capacity to even things out at the end, to restore the balance lost with the sin of Adam. If this is correct, then the numerical patterns of the inscriptions would be like the patterns a magnet creates in iron filings scattered at random, the visible symptom of this otherwise invisible force. The expressive medium for the idea is certainly unusual, but the theology behind it is not.

It has been suggested, most recently by Emmanuel Garland, that the prominent role given to the cross in the tympanum program should be related to Pope Paschal II's gift of True Cross relics to the abbey in 1100.[52] The presence of these relics would certainly have increased the importance of both Holy Cross feasts at Conques. But the web of liturgical allusion in the tympanum extends well beyond the simple allusion to relics.

In many liturgical sources, the offices for the Finding of the Cross (*Inventio crucis*) also include chants appropriate to the feast of a martyr, such as the responsories *Tristitia vestra convertetur*, *Pretiosa in conspectu Domini*, and *Filiae Jerusalem, venite et videte martyres*.[53] According to David Knowles, the martyrs in question are Saint Alexander and his companions, whose feast was celebrated on the same day.[54] Besides this specific commemoration, however, there is also a natural thematic association between martyrdom and the salvific power of the cross, an association made explicit by the offertory of the Mass for the *Inventio crucis*: "The right hand of the Lord does great things (or, does mightily); the right hand of the Lord shall exalt me; I shall not die, but live, and I shall tell of the works of the Lord" (Dextera Domini fecit virtutem, dextera Domini exaltavit me; non moriar, sed vivam, et narrabo opera Domini). The offertory comes originally from the solemn Mass on Holy Thursday—the Crucifixion being one of the "great works" (*virtutem*) of Christ—yet its text is equally appropriate to a martyr.

One of the most unusual scenes in the tympanum program is also an almost literal visualization of this offertory from the *Inventio crucis* mass. On the left-hand side, the upper border of the lintel suddenly jumps upward a few inches, to a higher level. Under it, in the little bit of extra space so created, is a diorama-like representation of an architectural interior, a miniature arcade of tiny columns, complete with capitals and bases (Fig. 9). Unlocked shackles hang from beams overhead, the votive offerings of freed prisoners.[55] Underneath the shackles is an altar with a chalice. We are in the abbey church of Conques, for there behind the altar, facing the ambulatory where throngs of pilgrims would be circulating, is the throne of the golden reliquary statue of Saint Foy, its four large spheres clearly recognizable.[56] But the throne is empty, for the saint has risen from her seat, taken a few steps to the right, and is now prostrating herself before the outstretched right hand of the Lord (*Dextera Domini*).

This sudden coming-to-life of the sculpted reliquary statue can only be an anticipation of the

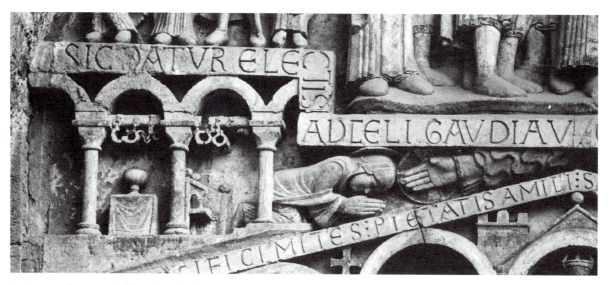

9. Conques (Aveyron), abbey church of Sainte-Foy, tympanum, Saint Foy and hand of God

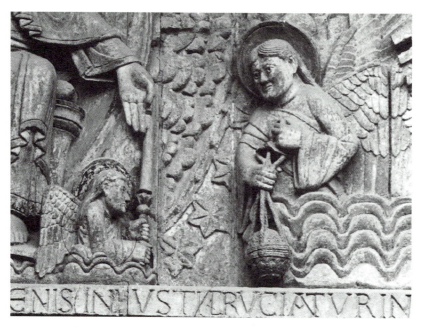

10. Conques (Aveyron), abbey church of Sainte-Foy, tympanum, angel with censer

events expected on the last day, when at the sound of the trumpet Saint Foy will rise from her golden tomb. The offertory *Dextera Domini*, expressed in the first person, could be the voice of the martyred virgin, raised from the dead at that instant by the power of the right hand of God: "The right hand of the Lord shall exalt me; I shall not die, but live, and I shall tell of the works of the Lord."

The "right hand of the Lord" that "does great works" is Christ, "through whom the power of the Father operates in the exaltation of the saints,"[57] an identification confirmed by the sculpted hand's cruciform nimbus. The offertory text, evoked by the sculpted *Dextera Domini*, thus cre-

ates an explicit link between the martyred local saint and her relics, the newly acquired Holy Cross relics and their cult, and the eschatological theme of the tympanum. As in the Floreffe frontispiece, the program has found a way to locate that particular place and community within the larger historical *processus*, showing exactly how the particular relates to the universal, and where the connection lies.

Other details in the tympanum, that have up to now seemed hard to explain, may also have been inspired by local liturgical practices. Among the program's more mysterious figures are the six angels immediately adjacent to Christ: two with candles kneeling at his feet, and a group of four to his left, two facing Christ carrying respectively a censer and a book, and two armed angels facing Hell.[58] The censer, in particular (Fig. 10), is extraordinarily vivid, as if it were an isolated object of special interest, a goldsmith's model, rather than a minor part of a larger composition. Censing angels typically occur in pairs, the angels actively swinging their censers on either side of a privileged person or object. This angel has no pendant; he stands quietly, his censer held ready, but apparently motionless, recalling the solitary "other angel" described in a passage from the Book of Revelation, who "stood next to the altar of the Temple, having a thurible in his hand . . . and the smoke rose from the hand of the angel before the Lord's presence" (Rev. 8:3–4).[59] This passage, paraphrased for liturgical use, was used as a great responsory text and, in shortened form, as an antiphon and versicle/in liturgies honoring angels, most conspicuously the archangel Michael.[60]

Michael, of course, is a key actor in the drama of the Last Judgment, its virtual patron saint. His role is not only to weigh souls, but also, at least in popular imagination, to engage in single combat with the devil on behalf of each individual. The archangel, moreover, had long been the object of a cult at Conques, for the tenth-century abbey church had a chapel dedicated to him in its western block, above the main entrance. Bernard of Angers recounts that one of Saint Foy's most important miracles occurred in that chapel; Foy had instructed an injured man to accompany the monastic procession going to the altar of Saint Michael for the vigil service of the archangel's feast day, where, she promised, a miraculous healing would occur.[61]

Saint Foy, Saint Michael, and the True Cross were not just neighbors in the relics and altars of the abbey church and on the tympanum, but in the ecclesiastical calendar as well, with the Exaltation of the Cross on September 14. followed by the feast day of Saint Michael on September 29 and Saint Foy's own feast on October 6. After the acquisition of the True Cross relics in 1100, the Exaltation, which falls exactly twenty days before the feast day of the local patron, would thus have inaugurated a particularly festive sequence of three important celebrations, all highlights of the local ecclesiastical calendar, during which, one imagines, pilgrims would be gathering and excitement building in anticipation of Foy's anniversary, the major event of that pilgrimage site.

For a viewer whose habits of mind were formed by the daily performance of the liturgy and scriptural study based on exegetical analysis, encountering the tympanum for the first time must have been an extraordinary experience. Complex, synthetic monumental programs were a relative rarity at the beginning of the twelfth century, as indeed were pictures of all kinds. We are probably right to imagine, therefore, that most viewers would have examined the tympanum closely, inventorying and identifying every detail. For the general audience of pilgrims, it would have told what was in broad terms a familiar story: the resurrection of the dead, the separation of the saved and the damned. For the educated clerics in its audience, however, the tympanum would have brought familiar *texts* to life, not dispersed, as they are in Scripture and in the liturgy, but in a single unified moment, as if Christ were "speaking" the imagery aloud.

The choice of *Hoc signum crucis* for the cross titulus reveals the designer's profound under-

standing of how the liturgy creates meaning by associating events, texts, and ideas. Via the responsory, he was able, with only seven words, to conjure up much of the context for the events depicted in the tympanum. Without the titulus, the cross is merely one object among many in a visually crowded field. With the titulus, however, it becomes the literal and thematic fulcrum of the program. When the ramifications of *Hoc signum crucis* are fully explored, the program is reoriented, becoming broader in its scope, richer in nuance and detail, and more explicitly liturgical.

The Tympanum and Frontispiece Compared

Though necessarily incomplete, these analyses reveal a number of parallels in the way the Conques tympanum and the Floreffe Bible frontispiece deploy their materials and communicate with their audiences. At the most basic level, they have the same constituents: pictures together with large amounts of text, and the same sort of tightly structured and symmetrical compositions. Both target specific audiences equipped with specialized knowledge, though the Conques tympanum addresses a general audience as well. Both are steeped in a text-based literary culture that is highly conversant with and interested in hermeneutics. They expect their educated viewers not only to read text, but to question it, to play with it, to subject it to the kind of probing investigation that one might expect in the classroom. Both use textual and visual citations to lead the viewer to specific textual sources, including liturgical ones.[62] And both rely on anomalies to violate expectations of regularity and logic, elicit curiosity and problem-solving behavior, and stir up memories of texts and ideas that, though located outside the pictorial fields, are as much a part of the works in question as paint or stone. In both cases, moreover, anomalies are used in the context of more general programs to refine the message and convey a more specialized subset of its content.

The enigmas of the Conques and Floreffe programs, albeit serious in intent, have many of the qualities of recreational puzzles. They appear in the context of tightly controlled systems as distinct "problems" requiring precise answers: something missing must be supplied, or something strange must be explained. They engage the intellect, the emotions, and the sense of play of their audiences; they intrigue, irritate, frustrate, and ultimately reward their viewers, providing us with opportunities to feel victorious and proud of our cleverness or knowledge; they are entertaining.

Anomaly, paradox, and enigma were well known in the Middle Ages as literary devices. Yet, barring new discoveries, their deliberate use in complex works of pictorial exegesis seems to be extremely rare, at least in Romanesque art. It may be asked, therefore, whether there is not some material connection between our two examples. The suggestion may seem far-fetched, but there is a certain amount of evidence in its favor, enough to present here by way of a conclusion and invitation to further research.

There is an underlying similitude in the thematic content of the two works, both being based on the notion of polar opposition. This theme is expressed not only in the formal composition of the images but also textually, in the long poems that in both works are disposed within or around the entire pictorial field. These two poems are identical in format: each consists of twelve lines of Leonine verse, of which the first ten expand on their respective binary subjects (the Active and Contemplative Lives, the Saved and the Damned), and the last two refer to the future fates of their respective audiences.[63] The parallels may be most easily seen when they are printed side by side:

FLOREFFE

Signum vitarum / sunt haec depicta duarum
Quarum practica prima / secunda theorica vita
Prima gemit, plorat / dolet, et patiendo laborat
Anxia turbatur / dum circa multa vagatur
Altera laetatur / recreatur, dum speculatur
Unum nam cernit / pro quo iam plurima spernit.
Servat utramque deus / famulis quia servit egenus
Ut forma tali / sibi discant assimilari
Se quoque transformat / et eorum corda reformat
Ut bona mansura / cernant spernant peritura

 * * *

Partem de caelis / hanc speret quisque fidelis
Si sua sit vita / factis fidei redimita.[64]

CONQUES

Sanctorum cetus / stat xpisto iudice letus
Homines perversi / sic sunt in tartara mersi
Sic datur electis / ad celi gaudia vectis
Gloria pax requies / perpetuusque dies
Penis iniusti / cruciantur in ignibus usti
Demonas atque tremunt / perpetuoque gemunt
Casti pacifici / mites pietatis amici
Sic stant gaudentes / securi nil metuentes
Fures mendaces / falsi cupidique rapaces
Sic sunt dampnati / cuncti simul et scelerati

 * * *

O peccatores / transmutetis nisi mores
Iudicium durum / vobis scitote futurum.[65]

Both poems express the theme of contrast and opposition visually as well as textually. In the Floreffe frontispiece, the verses are written in alternating lines of red and black, the only such use of color patterns in the frontispiece's many lines of text. At Conques, on the other hand, the lines of writing that respectively evoke the fates of the Blessed and the Damned are physically located on opposite sides of the tympanum. Only the final couplet, addressed to the viewers—those whose fates have not yet been determined—crosses over the axis of the composition. Finally, there is a curious reticence or disingenuousness about both poems; they present themselves formally as if they were summarizing the general thematic content of the whole, yet both tacitly ignore most of what is going on in the imagery they purport to describe,[66] and pointedly *avoid* shedding light on the more obscure aspects of their respective programs.

The formal and thematic resemblance between the poems is striking because there is no obvious reason for it. While there are certainly conventions in titulus subject matter, polar opposition is not a particularly common theme. Nor is the form standardized: Leonine poetry is extremely varied, lines have no fixed length, even within the same poem, and only the most general structural conventions are observed. Certain Leonine *couplets* seem to be common topoi, widely distributed in tituli, and there are cases of direct copying from one monument to another, but among longer poetic tituli it is extremely difficult if not impossible to find two *unrelated* examples that are as much alike, formally and thematically, as are the Conques and Floreffe poems.[67]

Whether these works were created independently or not, it is clear that both designers had a similar set of concepts and tools at their disposal, and used them in much the same way. It seems likely that they articulated a good deal of this theoretical infrastructure consciously. These program designers seem to have had a sophisticated understanding of cognitive psychology, for they knew how information is stored and retrieved in the mind; how perception, emotion, memory, and imagination interact; and how to tap into these processes via the work of art.

Indeed, cognitive and emotional processes—interpretation, analysis, emotional responses like annoyance and curiosity—seem to have been an important, if not the most important, point of these programs. They are not purveyors of finished statements of dogma, but devices for stimulating intellectual and spiritual experience. They offer their beholders an opportunity to test their knowledge, exercise their imaginations, and experience the delights of searching out hidden things, solving problems, and recognizing connections. But these are not mere entertainments, for the subject matter is serious, and the discoveries and associations made in this way are infinitely

more powerful, memorable, and emotionally charged than the same information would be if it were supplied ready-made.

There are circumstances when unreason is better than reason, when falling over a stool in the dark is better than turning on the light before entering the room. The experience of anomaly seems to have been valued not only as a powerful motivator, but also for the special quality of the insights so conveyed. At the end of the twelfth century, the poet and theologian Alan of Lille addressed this aspect when he considered the problem of communicating theological truths. In the preface to his *Rules of Sacred Theology*, Alan wrote that every discipline expresses its fundamental principles in characteristic forms or "rules," each of which has its proper name. Dialectic has "maxims"; geometry, "theorems"; physics, "aphorisms"; and music, "musical axioms." Theology, as befits the elevated object of its regard, has the most exacting requirements, and must be able to describe the most profound and glorious concepts. This greatest of all intellectual endeavors therefore expresses its key concepts in terms that are superior in dignity to all others—*supercaelestis vero scientia, id est theologia, suis non fraudatur; habet enim regulas digniores, sui obscuritate et subtilitate caeteris praeeminentes*—and they are not for beginners, but only for those who, suitably prepared and separated from the material world, are able to perceive hidden things with the pure eye of philosophy. Theology's special terms, Alan reveals, are called "paradoxes" and "enigmas," for their inherent subtlety and obscurity makes them the most natural, and the most accurate, language in which to express the unfathomable truth of God.[68]

Notes

1. I am using "anomaly" in its modern sense, as distinct from its medieval use as a technical grammatical term. Isidore of Seville defines "anomaly" as a grammatical irregularity *strictu sensu*; cf. Isidore of Seville, *Sancti Isidori Hispalensis Episcopi Etymologiarum libri XX*, bk. 1, chap 28.2, PL 82:105a. For Isidore, "paradox" is something unexpected ("Paradoxon est, cum dicimus inopinatum aliquid accidisse," bk. 2, chap. 21.31, PL 82:138), while "aenigmas" are deliberately obscure statements (bk. 1, chap. 37.26, PL 82:116a.)

2. The order takes its name from its first abbey, Prémontré, founded in 1121 near Laon in northern France by the itinerant preacher and later bishop of Magdeburg, Norbert of Xanten.

3. London, B.L., Ms. Add. 17738, ff. 3v–4r. In addition to the volume 2 frontispiece, the Bible contains individual frontispiece miniatures to each of the four Gospels. Originally it also had a general frontispiece to volume 1, now lost; see H. Köllner, "Zur Datierung der Bibel von Floreffe: Bibelhandschriften als Geschichtsbücher?" in *Rhein und Maas: Kunst und Kultur, 800–1400*, exh. cat., Schnütgen-Museum, 2 vols. (Cologne, 1972), vol. 2, 361–76. The rest of the Bible's decoration, though extensive, is purely ornamental.

4. This was recognized as a deliberate anomaly by Arwed Arnulf in *Versus ad Picturas: Studien zur Titulusdichtung als Quellengattung der Kunstgeschichte von der Antike bis zum Hochmittelater* (Munich, 1997), 245–48.

5. The typical arrangement, with John in the center and Peter to Christ's right, can be seen in the twelfth-century Byzantine mosaic icon of the Transfiguration, now in the Louvre, and in the ivory plaque of the Afflighem Gospels (Paris, Bibliothèque de l'Arsenal, Ms. 1184 res.; see *Trésors de la Bibliothèque Nationale de France*, vol. 1, *Mémoires et merveilles, VIIIe–XVIIIe siècle* [Paris, 1996], no.15). One of the rare Transfigurations that has Peter in the middle is the well-known sixth-century apse mosaic of St. Catherine's, Mount Sinai. The only other Romanesque example with Peter in the center known to me is a full-page miniature illustrating Peter the Venerable's liturgy for the Transfiguration, from a Cluniac liturgical miscellany (Paris, B.N.F., Ms. lat. 17716, f. 7v; see *Trésors de la Bibliothèque Nationale* [as above], no.14). Here, the variation is no doubt to be explained by the fact that Cluny was dedicated to St. Peter.

6. J.-C. Bonne, *L'Art roman de face et de profil: Le Tympan de Conques* (Paris, 1984), 42.

7. Bonne, *L'Art roman de face et de profil* (as in note 6), 44–45.

8. One would have expected the phrase to be contracted, as in the late-twelfth-century enamel plaque in Aachen, cited by Bayer: VENITE BENEDICTI P[ATRIS] M[ei] POSIDETE (sic) REGN[um] QUOD VOB[is] P[aratum]. Here, and in an Anglo-Saxon ivory in the Victoria & Albert Museum, it is "Patris mei," an easily recognizable phrase, that is contracted; in the Conques tympanum this is the *only* fully written-out phrase. Cf. C. M. M. Bayer, "Essai sur la disposition des inscriptions par rapport à l'image: Proposition d'une typologie basée sur des pièces de l'Orfèverie Rhéno-Mosane," in *Épigraphie et iconographie: Actes du Col-*

loque tenu à Poitiers les 5–8 octobre 1995 (Poitiers, 1996), 13 and nn. 59–61.

9. The effects of paradoxes and anomalies on human cognition have been the subject of considerable discussion from many disciplinary points of view, including psychology, literature, linguistics, aesthetics, and philosophy. See, for example, A. J. Weir, "Notes for a Prehistory of Cognitive Balance Theory," *British Journal of Social Psychology* 22 (1983), 351–62; D. B. Leake, *Evaluating Explanations: A Content Theory* (Hillsdale, N.J., 1992); D. S. Miall, "Metaphor and Affect: The Problem of Creative Thought," *Metaphor and Symbolic Activity* 2 (1987), 81–96.

10. M. Carruthers, *The Craft of Memory: Meditation, Rhetoric, and the Making of Images, 400–1200* (Cambridge, 1998), 165–66.

11. For a more detailed account, see A.-M. Bouché, "The Spirit in the World: The Virtues of the Floreffe Bible Frontispiece: British Library, Add. Ms. 17738, ff. 3v–4r," in *Virtue and Vice: The Personifications in the Index of Christian Art*, ed. C. Hourihane (Princeton, 2000), 42–65; A.-M. Bouché, "The Floreffe Bible Frontispiece (London, B.L. Add. Ms. 17738, Fol. 3v–4r) and Twelfth-Century Contemplative Theory" (Ph.D. diss., Columbia University, 1997); U. Kuder, "Die dem Hiobbuch vorangestellten Bildseiten zu Beginn des 2. Bandes der Bibel von Floreffe," in *Per assiduum studium scientiae adipisci margaritam: Festgabe für Ursula Nilgen zum 65. Geburtstag*, ed. A. Amberger et al. (St. Ottilien, 1997), 109–36.

12. The allegorical reading is based on a typological relationship between the sons of Job and the apostles (an interpretation inspired by Gregory the Great's *Moralia in Job*). Herbert Köllner ("Zur Datierung" [as in note 3]) was the first to suspect that the core theme of the frontispiece must be the Holy Spirit, based on his discovery of a Trinitarian structure in the Bible's program of frontispieces. He reasoned that if the lost Genesis/Creation frontispiece to volume 1 epitomized the work of God the Father and the four gospel frontispieces with the cardinal Works of Christ the work of God the Son, then the volume 2 frontispiece, by a process of elimination, must refer to work of the Holy Spirit, a hypothesis supported by the presence of the Works of the Spirit and Pentecost among the frontispiece's subjects.

13. The Transfiguration alludes proleptically to the end point of the historical journey of the Church, since Christ's radiant body on Tabor prefigures the Resurrection glory with which he will return at the Second Coming (Jerome, *Commentariorum in Mattheum libri IV*, ed. D. Hurst and M. Adriaen, CCSL 77 [Turnhout, 1969], bk. 3, chap. 17.2, 147ff.). The episode also epitomizes the apostles' role in the history of the Church: Peter, James, and John ascend Mount Tabor in Christ's footsteps, where they are granted a glimpse of the Savior's true nature, his humanity and divinity both revealed at once, just as the apostles, following Christ, lead the Church through history, in the end sharing in the beatific vision. The Transfiguration was traditionally seen as representing the apex of contemplative experience for the individual soul, since it granted insight into the inner nature of God, i.e., the Trinity.

14. The Floreffe frontispiece is not the only document to situate the vocation of regular canons within the escha-

tological context of salvation history; for another example and discussion, see S. Weinfurter, "*Vita canonica* und Eschatologie: Eine neue Quelle zum Selbstverständnis der Reformkanoniker des 12. Jahrhunderts aus dem Salzburger Reformkreis, mit Textedition," in *Secundum regulam vivere: Festschrift für P. Norbert Backmund, O. Praem.*, ed. G. Melville (Windberg, 1979), 139–67.

15. Genesis 29–30; Luke 10:38.

16. Augustine, bishop of Hippo, *In Joannis Evangelium tractatus CXXIV* (PL 35:1970–76, tract. CXXIV).

17. These homilies were based on John 21:19–24, the pericope for the feast of John the Evangelist. One of the most influential was that of Bede, *Homilia VIII. In die natali sancti Joannis evangelistae* (PL 94:44–49). For the twelfth century, see, for example, Godefrid of Admont (*Homilia XII. In festum s. Joannis evangelistae prima* [PL 174:671–73]). The pericope appears to have been associated with the feast of St. John from an early date, since it is the same in all four of the cycles repertoried by Klauser for the early Roman lectionary; see T. Klauser, *Das Römische Capitulare Evangeliorum: Texte und Untersuchungen zu seiner ältesten Geschichte* (Münster-Westfalen, 1972), 13, 58, 102, and 140.

18. The exegetical traditions concerning the Active and Contemplative Lives are detailed in G. Constable, "The Interpretation of Mary and Martha," in *Three Studies in Medieval Religious and Social Thought* (Cambridge, 1995), 3–141.

19. C. W. Bynum ("The Spirituality of Regular Canons in the Twelfth Century," in *Jesus as Mother* [Berkeley and Los Angeles, 1982], 22–58) has discussed the often-overlapping ideals and claims of monks and canons to be followers of the apostles, preachers, and contemplatives.

20. The regular canons of Reichersberg, for example, were forcibly invaded and their abbey was taken over by monks; see P. Classen, *Gerhoch von Reichersberg: Eine Biographie* (Weisbaden, 1960), 445–46.

21. The two orders even found it necessary to settle such issues as the problem of individuals leaving one order for the other, or the establishment of new foundations in proximity to abbeys belonging to the competiton, with formal legislation. See G. Melville, "Zur Abgrenzung zwischen *Vita canonica* und *Vita monastica*: Das Übertrittsproblem in kanonistischer Behandlung von Gratian bis Hostiensis," in *Secundum regulam vivere* (as in note 14), 205–43; T. J. Gerits, "Les Actes de confraternité de 1142 et de 1153 entre Cîteaux et Prémontré," *Analecta praemonstratensia* 40 (1964), 193–205; *Les Statuts de Prémontré au milieu du XIIe siècle*, ed. P. Lefèvre and W. M. Grauwen (Averbode, 1978), xxv.

22. The standard history of Floreffe, now quite old, is Victor Barbier, *Histoire de l'abbaye de Floreffe de l'Ordre de Prémontré* (Namur, 1892); see also B. Ardura, *Prémontrés: Histoire et spiritualité*, Publications de l'Université de Saint-Etienne (Saint-Etienne, 1995). For the foundation of Floreffe, see W. M. Grauwen, "Norbert en de stichting van Floreffe, 1121," *Analecta praemonstratensia* 71 (1995), 25–36.

23. The institutional organization of the Premonstratensian order was in fact modelled on the Cistercian system, and the statutes regulating the details of daily life for all Premonstratensian houses were, with a few significant ex-

ceptions, adopted verbatim from the Cistercian code; see *Les Statuts de Prémontré* (as in note 21); R. van Waefleghem, *Les Premiers statuts de l'Ordre de Prémontré: Le Clm. 17,174 (XIIe siècle)*, Analectes de l'Ordre de Prémontré 9, nos. 3–4 (Louvain, 1913).

24. The importance of the Active/Contemplative theme in conceptualizing the distinction between monks and canons is disucussed by Melville, "Zur Abgrenzung" (as in note 21), 212.

25. Anselm (PL 188:1119ff.) makes this argument in response to a letter from Ecbert of Huysburg, occasioned by the defection of the provost of the Premonstratensian abbey of Hamersleben to the Benedictine monastery of Huysburg in or ca. 1150; cf. Classen, *Gerhoch von Reichersberg* (as in note 20), 446. I have been unable to consult the recent publication by Werner Bomm, "Anselm von Havelberg, 'Epistola apologetica': Über den Platz der Prämonstratenser in der Kirche des 12. Jahrhunderts. Vom Selbstverständnis eines frühen Anhängers Norberts von Xanten," in *Studien zum Prämonstratenserorden*, ed. I. Crusius and H. Flachenecker (Göttingen, 2003), 107–83.

26. Arno of Reichersberg, *Scutum canonicorum*, PL 194:1489–1528. For a discussion of this text, which also circulated (with some modifications) in Premonstratensian circles under the name of Anselm of Havelberg, see O. Capitani, "Nota per il testo dello *Scutum canonicorum*," in *La vita comune del clero nei secoli XI e XII* (Milan, 1962), vol. 2, 40–47; Classen, *Gerhoch von Reichersberg* (as in note 20), 445–46. Arno, provost of the important reformed canonical foundation of Reichersberg and brother of its learned abbot, Gerhoch (1092 or 1093–1169), appears to have derived his John-Peter comparison and exegesis of the race to the tomb from John Scot Eriugena: Johannes Scotus Eriugena, *Homélie sur le Prologue de Jean*, ed. É. Jeauneau, Sources Chrétiennes (Paris, 1969), chaps. 2–3, 209–18.

27. The origins of these interpretations are discussed by Édouard Jeauneau in Johannes Scotus Eriugena, *Homélie* (as in note 26), 210–11 nn. 3–4; 212–13 nn. 1 and 3; 217 n. 3.

28. Another example is the Transfiguration of the Ingeborg Psalter (Chantilly, Musée Condé, Ms. 9, f. 20v), in which, however, God's words are written vertically on the axis between Christ and John, so that they appear to be directed to John in particular.

29. The twelfth-century library of Bonne-Espérance, now mostly in Mons, included a number of standard school texts, possibly the gift of the abbey's scholar-abbot, Philip of Harvengt. Later in the twelfth century (ca. 1185) a note in a copy of Hrabanus Maurus from Arnstein-an-der-Lahn recorded the acquisition of no fewer than fifty-eight schoolbooks given to the abbey by its abbot "when he renounced the world" (London, B.L., Ms. Harley 3045, f. 47v: "Isti sunt libri scolarum, quos contulit Richolfus abbas ecclesie nostre cum seculo renuntiaret"); B. Krings, *Das Prämonstratenserstift Arnstein a. d. Lahn im Mittelalter (1139–1527)* (Wiesbaden, 1990), 240–43.

30. The benefits of a Parisian education were extolled by Philip of Harvengt in letters to two young clerics: Philip of Harvengt, *Epistola III, ad Heroaldum* (PL 203:26–31); *Epistola XVIII, ad Richerum* (PL 203:157–60). Philip was himself a product of the Parisan schools.

31. F. Petit, "L'Ordre de Prémontré de Saint Norbert à Anselme de Havelberg," in *La vita comune del clero* (as in note 26), vol. 1, 465, citing the testimony of Herman of Laon, a familiar of Hugh of Fosses, who was Norbert's successor as abbot of Prémontré. Anselm of Havelberg was apparently among the seven canons recruited at Laon: N. Backmund, *Geschichte des Prämonstratenserordens* (Grafenau, 1986), 27.

32. Hugh of St.-Victor describes the use of images (whether actual or imagined continues to be disputed) as a teaching tool in his treatise on the Ark, for which see P. Sicard, *Diagrammes médiévaux et exégèse visuelle: Le Libellus de formatione arche de Hugues de Saint-Victor* (Turnhout, 1993). The "bookish" quality of the frontispiece's program suggests that it may have been used in some similar teaching environment. The Premonstratensian abbot of Dryburgh, Adam Scot (1140–1212), who later entered the Carthusian abbey of Witham, wrote a treatise on the Tabernacle that was clearly inspired by Hugh. According to its text, it was accompanied by a visual diagram that, as described in the treatise, must have been extraordinarily complex (*De tripartito tabernaculo* [PL 98:609–792]). For a description of this treatise, see F. Petit, *Ad viros religiosos: Quatorze sermons d'Adam Scot* (Tongerloo, 1934), 41–44. Adam's views on the uses of visual imagery as an aid to contemplation are discussed by J. F. Hamburger, "A *Liber Precum* in Sélestat and the Development of the Illustrated Prayer Book in Germany," *ArtB* 73 (1991), 232–33.

33. For the iconography of the tympanum and its inscriptions, see Bonne, *L'Art roman de face et de profil* (as in note 6); C. Altman, "Conques and Romanesque Narrative," *Olifant* 5 (1977), 5–28; E. Garland, "Le Conditionnement des pèlerins au Moyen Age: L'Exemple de Conques. Corps saints, récits et iconographie au service de l'édification des fidèles et de la puissance de l'abbaye," in *Le Culte des saints à l'époque préromane et romane: Actes des XXXe Journées romanes de Cuixà, 7–16 juillet 1997* (=*Cahiers de Saint-Michel de Cuxa*, 29 [1998]), 155–76; C. B. Kendall, "The Voice in the Stone: The Verse Inscriptions of Ste.-Foy of Conques and the Date of the Tympanum," in *Hermeneutics and Medieval Culture*, ed. P. J. Gallacher and H. Damico (Albany, N.Y., 1989), 163–82; W. Sauerländer, "*Omnes perversi sic sunt in tartara mersi*: Skulptur als Bildpredikt. Das Weltgerichtstympanon von Sainte-Foy in Conques," *Jahrbuch der Akademie der Wissenschaften in Göttingen*, 1979, 33–47.

34. The liturgical origin of this text is signaled in R. Favreau et al., *Corpus des inscriptions de la France médiévale* (Paris, 1974–), vol. 9, 24.

35. To judge by the medieval liturgical sources repertoried in Hesbert and the CANTUS database, there is no clear distinction in the assignment of responsory texts, versicles, etc. to one or the other day, and there is a good deal of overlap in both the Mass and the office. One consistent difference is found in the Mass: the Communion chant for the *Inventio* is *Dextera Domini*; for the *Exaltatio*, it is *Deus enim firmavit*. R.-J. Hesbert, *Corpus Antiphonalium Officii* (Rome, 1963–79); R.-J. Hesbert, *Antiphonale missarum sextuplex*, édité par René-Jean Hesbert d'après le graduel de Monza et les antiphonaires de Rheinau, du Mont-Blandin, de Compiègne, de Corbie et

de Senlis (Rome, 1967); T. Bailey, project director, *CAN-TUS: A Database for Latin Ecclesiastical Chant. Indices of Chants in Selected Manuscripts and Early Printed Sources of the Liturgical Office;* content: Debra Lacoste, Andrew Mitchell, CANTUS staff and contributors, Faculty of Music, University of Western Ontario (London, Ontario, 2003): http://publish.uwo.ca/~cantus/.

36. Hesbert, *Corpus Antiphonalium Officii* (as in note 35), CAO no. 6845.

37. D. Hiley, *Western Plainchant: A Sourcebook* (Oxford, 1993), 22.

38. Although, as Hiley notes, the relationship between responds and their verses is often unstable, *Hoc signum crucis* always seems to have the same verse, *cum sederit filius hominis in sede maiestatis suae et ceperit iudicare seculum per ignem;* cf. Hiley, *Western Plainchant* (as in note 37), 70. The only exception I have discovered is in an early (tenth-century) source, Paris, B.N.F., Ms. lat. 1085, from St. Martial of Limoges, where in the feast of the Invention *Hoc signum* is used twice as a great responsory, once in its full form as the second responsory in the first nocturn, with *cum sederit* as the verse, and again, in a shortened form, as the fourth responsory in the third nocturn, with *cum dominus ad iudicandum veniet* as the verse; cited as chant number 626 in *CANTUS* (as in note 35).

39. Hesbert, *Corpus Antiphonalium Officii* (as in note 35), CAO no. 8088.

40. Favreau et al., *Corpus des inscriptions* (as in note 34), vol. 9, 24.

41. Bonne, *L'Art roman de face et de profil* (as in note 6), 45–48. Bonne also discusses other examples of truncation and fragmentation in the tympanum inscriptions.

42. Emmanuel Garland cites a somewhat different selection of source texts, though the general principle remains the same; see "Le Conditionnement des pèlerins" (as in note 33), 155–76.

43. This abbreviated method for performing great responsories seems to have originated in the Frankish kingdoms, as attested by Amalarius of Metz in the ninth century; cf. Hiley, *Western Plainchant* (as in note 37), 70. *Hoc signum crucis* appears to have been composed with the expectation that only the second half of the response would be repeated, which may mean that it originated north of the Alps. See the observations of A. Wilmart, "Chants en l'honneur de Sainte Anne," in *Auteurs spirituels et textes devots du Moyen Âge latin* (Paris, 1932), 55.

44. Hesbert, *Corpus Antiphonalium Officii* (as in note 35), CAO no. 6510: "Domine, Rex noster, quando veneris judicare terram, tunc apparebit crux sancta, fulgens ut aurum in virtute sua. V. Cum sederit Filius hominis in majestate sua et coeperit judicare saeculum per ignem.— Tunc."

45. Hesbert, *Corpus Antiphonalium Officii* (as in note 35), CAO no. 7915: "Vos qui secuti estis me, sedebitis super sedes, judicantes duodecim tribus Israel, alleluia alleluia. V. In regeneratione, cum sederit Filius hominis in sede majestatis suae, sedebitis et vos judicantes" (cf. Matt. 19:28).

46. The occult way music makes connections in memory was demonstrated when, in the course of writing this section, I found a short phrase from the "Libera me Domine" movement of the Verdi *Requiem* beginning to repeat itself in my mind. Eventually I realized that the words *Dum veneris iudicare saeculum per ignem* were nearly identical to a phrase in the responsory *Hoc signum crucis:* my unconscious had unearthed a relationship I had not previously noticed between the Holy Cross responsory and the formula of absolution from the funeral liturgy.

47. The only exception repertoried by Hesbert (*Corpus Antiphonalium Officii* [as in note 35], CAO no. 6510), *Domine, Rex noster,* is clearly a later derivative of *Hoc signum crucis.* Hesbert notes only one, twelfth-century source for it, whereas *Hoc signum crucis* is in almost all the major sources, including the oldest, the ninth-century antiphonary of Compiègne (Paris, B.N.F., Ms. lat. 17436). Most Holy Cross responsories praise the cross in language derived, directly or indirectly, from the hymns written in honor of the cross by the sixth-century poet Venantius Fortunatus, especially *Pange lingua gloriosa proelium certaminis.*

48. This identification, which had important theological implications, was already current in the fourth century; e.g., Jerome, *Commentariorum in Mattheum* (as in note 13), chap. XXIV.30.

49. See note 41.

50. Bonne, *L'Art roman de face et de profil* (as in note 6), 46 and n. 35.

51. N. Mezoughi, "Le Tympan de Moissac: Études d'iconographie," *Cahiers de Saint Michel de Cuxa* 9 (1978), 171–200.

52. E. Garland, "L'Art des orfèvres à Conques," *Mémoires de la société archéologique du Midi de la France* 60 (2000), 99–100, and, for additional bibliography, 83 n. 5; Garland, "Le Conditionnement des pèlerins" (as in note 33), 165–67. The relics were soon enshrined by Conques goldsmiths in three important reliquaries, the "Pope Paschal" reliquary, the " 'A' of Charlemagne," and the portable porphyry altar of Abbot Begon III, all still in the treasury at Conques.

53. Hesbert, *Corpus Antiphonalium Officii* (as in note 35), CAO nos. 7782, 7429, 7111, and 6735. The incorporation of martyr-feast chants into the liturgy of the *Inventio crucis* is attested in numerous manuscript sources as well as in the *Monastic Constitutions* of Lanfranc, archbishop of Canterbury under William the Conqueror; cf. D. Knowles, *The Monastic Constitutions of Lanfranc* (London, 1951), 66–67.

54. Knowles, *Monastic Constitutions* (as in note 53), 66 n. 2.

55. Bernard of Angers mentions the great quantity of shackles and chains left by prisoners at Conques; the iron, he says, was used to make the grilles of the choir enclosure. These are apparently the very grilles that are still to be seen separating the choir proper from the ambulatory; according to new research, these date from the end of the tenth century and were re-used when the present church was built; see M.-A. Sire, "Les Grilles du sanctuaire de Conques: Les Secrets d'un écrin," in *Utilis est lapis in structura: Mélanges offerts à Léon Pressouyre* (Paris, 2000), 403–12.

56. As Garland notes, the presence of spheres on the throne in the sculpture proves that even if the present spheres are replacements, they re-create a much earlier disposition; see Garland, "L'Art des orfèvres" (as in note

52), 104 n. 97.

57. Cassiodorus, *Expositio psalmorum*, pt. 2, *Pss. LXXI–CL*, ed. M. Adriaen, CCSL 98 (Turnhout, 1958), Ps. 117:15–17: "dextera Domini fecit virtutem, id est Christus, per quem Pater virtutem operatus est in exaltatione sanctorum."

58. The two angels holding candles at Christ's feet probably also have a liturgical prototype in an antiphon/responsory text: "Isti sunt duae olivae et duo candelabra lucentia ante Dominum; habent potestatem claudere caelum nubibus et aperire portas eius, quia linguae eorum claves caeli factae sunt" (These are two olive-trees and two candlesticks shining before the Lord, having the power to close heaven with clouds, and open the doors thereof, for their tongues are made the keys of heaven); cf. Hesbert, *Corpus Antiphonalium Officii* (as in note 35), CAO no. 3438 (as an antiphon), and CAO no. 7014 (as a responsory). The antiphon and responsory are used for feasts devoted to pairs of apostles, such as Peter and Paul or Philip and Jacob. The feast of Philip and James falls on May 1, immediately before the Invention of the Cross on May 3.

59. Rev. 8:3–4: "Et alius angelus venit et stetit ante altare habens turibulum aureum et data sunt illi incensa multa ut daret orationibus sanctorum omnium super altare aureum quod est ante thronum et ascendit fumus incensorum de orationibus sanctorum de manu angeli coram Deo."

60. Hesbert, *Corpus Antiphonalium Officii* (as in note 35), CAO no. 7707: "Stetit angelus juxta aram templi, habens thuribulum aureum in manu sua, et data sunt ei incensa multa; et ascendit fumus aromatum de manu angeli in conspectu Domini. V. In conspectu angelorum psallam tibi, et adorabo ad templum sanctum tuum et confitebor nomini tuo."

61. *The Book of Sainte Foy*, ed. P. Sheingorn (Philadelphia, 1995), bk. II.1. The miracle involves restoring for the third time the sight of the same hapless character, Guibert or Gerbert, whose first miracle (book I.1) was decisive in persuading Bernard that Saint Foy's miracles were authentic and her reliquary statue justified.

62. In the case of the Floreffe frontispiece the most important allusion is to the famous Pentecost hymn, *Veni creator spiritus*. Many of the names applied to the Holy Spirit by the hymn are represented visually or verbally in the zone surrounding the frontispiece's depiction of Pentecost, i.e., the "Gift of the Most High" of the adjacent inscription, the names *unctio* and *amor* applied to the personification of charity, the unprecedented fire in the scene of the Works of Mercy, the Gifts of the Spirit represented as doves in the central roundel, etc. By evoking the hymn through these specific citations, the designer of the frontispiece was able to communicate more precisely the significance of the Pentecost scene for the program as a whole.

63. On the Conques poem, see also Kendall, "The Voice in the Stone" (as in note 33), 163–82. I have followed his reading of *vectis* for *vinctis* in the third line.

64. These things pictured here are a sign representing two lives

Of which the first is practical and the second theoretical
The first groans, weeps, sorrows and, suffering, struggles
It is agitated by anxiety, vacillating among many cares.
The other rejoices, rests, while it expectantly watches
For it sees the one thing for whose sake in the present it spurns many things.
God keeps both these lives for His servants, because he serves as [=in the person of] a pauper,
So that they [the servants] may learn to be assimilated to him in such a form [i.e., human]
He also transforms himself and reforms their hearts
In order that they may perceive that which is to endure and despise that which is perishable

Anyone of the faithful may hope for this share of heaven.
If his life be redeemed by deeds of faith.

65. The company of saints stands rejoicing before Christ, the Judge,
Perverse men are thus plunged into hell
Thus to the elect, who have been born to the joys of heaven, are given
Glory, peace, rest, and perpetual light.
The unjust are tortured with torments, burned in the flames
The demons shake, and groan without ceasing
The chaste, the peaceful, the gentle, and the friends of piety
Stand thus, rejoicing, in safety, fearing nothing
Thieves, liars, deceivers, the greedy, and the despoilers
Are thus damned, together with all the wicked

O sinners, unless you change your ways
Know that this hard judgment awaits you.

66. The formulaic and strangely uninformative content of these verses led Altman to characterize the poetry as qualitatively inferior, even though he found its formal interrelationship with the pictorial field to be surprisingly complex and sophisticated (Altman, "Conques and Romanesque Narrative" [as in note 33], 12–16).

67. Approximate parallels for the Conques and Floreffe poems may be found in the verses from the Tours *Florilegium* and among the tituli written by Udalscalc, abbot of SS. Ursus and Affra in Augsburg (1124–50). Compare, for example, the rhythmic, insistent alliteration in this titulus once associated with a cross, possibly a True Cross reliquary, as transmitted by the Tours manuscript, edited in Arnulf, *Versus ad Picturas* (as in note 4), 278: "Morsus Adam mortem/duram sub iudice sortem//Impressit natis/et totius posteritatis//Sed protoplastorum/mortem miserando suorum//Mortem gustavit,/mortem Deus evacuavit//Et nos morte crucis/transvexit ad atria lucis.//Hoc praefert lignum/crucis admirabile signum//per quam vita datur,/per quam mors evacuatur" (The bite of Adam, when judged, imposed a hard sentence on his children and

his whole posterity. Yet moved by pity for his first creation, God tasted death, God drove death out, and by his death on the cross transported us to the threshhold of light. This sign of the cross admirably displays the wood by which life is given, and death driven out). Udalscalc's verses are published in O. Lehmann-Brockhaus, *Schriftquellen zur Kunstgeschichte des 11. und 12. Jahrhunderts für Deutschland, Lothringen und Italien* (Berlin, 1938), [text volume] 579–607, nos. 2575–2602. See also U.

Kuder, "Das Fastentuch des Abtes Udalscalc mit Ulrichs- und Afraszenen," in *Pinxit, Sculpsit, Fecit: Kunsthistorische Studien. Festschrift für Bruno Bushart* (Munich, 1994), 9–23. A catalogue of portal inscriptions in verse may be found in C. B. Kendall, *The Allegory of the Church: Romanesque Portals and Their Verse Inscriptions* (Toronto, 1998).

68. Alan of Lille, *Regula de sacra theologia* (PL 210:621A–623A).

Seeing as Action and Passion in the Thirteenth and Fourteenth Centuries

Katherine H. Tachau

When we open our eyes and look out at the world, what happens? At least since the ancient Greeks posed this question directly, it has been clear that a good, complete answer should explain how the outside world affects our eyes, thereby our brains, and consequently our consciousness; but we also want an answer that explains how each individual's unique personal experiential history affects—or even effects—what happens on each occasion when s/he opens his or her eyes. Thus, we can describe the answer we are looking for as bifurcated, and how anyone answers each part will both depend upon and dictate an answer to the great enveloping metaphysical question that gave rise to Greek philosophy: what is the nature of reality? What is the world really like, and how are things really? This larger question remains at the core of Western philosophical inquiry today, yoking metaphysics, vision, and epistemology. Quite recently, for instance, the philosopher Barry Stroud put the connection simply; in his words, finding out "what the world is really like . . . involves distinguishing what is really so from what only appears to be so, or separating reality as it is independently of us from what is in one way or another dependent on us and so misleads us as to what is really there."[1] When we open our eyes, visual perception begins. The connection, then, between this bigger project and our starting point, namely the question "when we open our eyes and look out at the world, what happens?" is ineluctable:

> We want to understand not only what gives rise to our perceivings and [consequent] believings but also whether *what* we perceive or come to think about the world represents it as it really is. In which respects does the world correspond to the ways we think it is, and in which not? . . . [This] is a question not only about the world, and not only about our perceptions, thoughts, and beliefs about it, but also about the relation between them.[2]

A great deal hangs, therefore, on any explanation of perception (which should but usually does not account also for auditory and tactile perception, taste, and smell, as well as vision). Our contemporaries remain far from being able to give a *complete* answer to the question of what happens in sight and how. But like ancient and medieval scholars, scientists and philosophers recognize that both *activity* and *receptivity* are involved in the processes of seeing the world, retaining something from what is seen, and recalling or understanding what we have seen.[3]

Action, Potential, and Passion

Employed as a technical term, the English word "activity" with its derivatives principally trans-
lates the Latin words *actio* and *agens* (or agent), from *agere*, "to do" or "to act upon." For activ-
ity's contrary, "receptivity," there is no similarly straightforward and etymologically obvious way
to convey the complex of words derived from the Latin verb *patior*, "to allow," "to suffer," or "to
undergo." These include *patiens*, "what is acted upon," from which comes *patientia*, "patience";
passive, "passively" (as opposed to "actively"); and, most multivalent of all, *passio*: "the under-
going," "the suffering," "the martyrdom," "the status of being acted upon," or even "emotion."
Medieval philosophers needed, however, to express the opposite of "acting" and "actuality" with
a further complex of Latin words expressing what is *able* to act or be actualized, which derived
from the verb *posse*, "to be able" (or, by A.D. 1115, well attested as "to have the power")[4]: these
include *potens*, "able" or "potent"; *potestas*, "power" or "faculty" (synonymous with *facultas*);
potentia or *potentialitas*, "potential" or "potency"; and *possibilia, possibilitas, possibile*, "possi-
ble" and "possibility."

For Latin intellectuals from the twelfth century on, the denotative domains of these words
shaded into each other, and they were used by philosophers (many of whom were theologians) to
convey a dichotomy fundamental to Aristotle's theory of change: that of actuality and potential.
Nested inside this dichotomy was a second, that of action and passion, and a third, that of actual
and possible. For Aristotle, every motion, every change, every event is a continuous process by
which a receptive potentiality is actualized by an agent.[5] So, for instance, the light (*lux*) of the sun
actualizes the potential of the receiving air; as a result, the air becomes actually warm, the sky is
actually colored blue and is actually visible. When the potential of the eye to sense that color and
light has been actualized by the air touching the eye, the eye actually sees.[6] Thus, the contrary of
actuality (Aristotle's ἐνέργεια, the root of "energy") is potential (δύναμις, whence our "dynam-
ics"); the contrary of action is passion.

Activity and passivity on the part of the observer and on the part of the universe remained
the ontological and epistemological Scylla and Charybdis between which accounts of vision have
been and must be navigated. The greater the activity of the world upon the observer, the more rea-
son we have to worry that the universe is a deterministic one; the greater the activity of the ob-
server's eye and brain in representing the world to the mind, the more reason we have to worry
that these representations are sufficiently arbitrary and unique to misrepresent the world or rep-
resent it incompletely. Worse, these may diverge so much from person to person that we can never
actually have the "same" perceptions or images in mind—or even ones sufficiently similar—to
be talking about the same thing when we speak what's on (or in) our minds. This conclusion
would land us right back with Gorgias.[7]

Beginning with the Atomists, ancient Greek treatments of optical phenomena all posited that,
for corporeal sight to occur, either the eye actively reaches out to the world by emitting something
(a process historians of science call "extramission"), or the eye is the passive recipient of some-
thing from a somehow active object (a process termed "intromission").[8] Greek and Hellenistic pro-
ponents of intromission and extramission alike mostly treated the principal sensible features of
the world as discrete items, of which we gain discrete images in the mind and to which nouns (Lat.
nomina, i.e., names) correspond. For Augustine, even more than for other scholars, these images

in the mind are signs (*signa*) that, as likenesses of objects in the world, represent them; mental images are also the very words (*verba*) with which we think. Thus, Augustine's account of vision, more explicitly than those of his sources, grounded an understanding of thought as at one-and-the-same time "essentially linguistic and essentially visual."[9] Although it may seem obvious that discrete items do constitute what there is in the world to be perceived—indeed, modern and contemporary representative realists usually remain inclined to treat this as a given—an alternative would be to treat what is to be perceived as fluid processes. If, for instance, one were to take hearing as our paradigmatic sense, and music as the kind of object that hearing perceives, then the theory of perception—and of language's relation to the objects of perception—would be quite different, where dynamic flow would be the primary unit or "sensible."[10]

The competing theoretical approaches of the ancient Greek and Hellenistic philosophers, mathematicians, and physicians became the basis for renewed theorizing in the ninth through twelfth centuries as polymaths writing in Arabic in the Islamic world absorbed and then surpassed their ancient sources. The most notable of these scholars were al-Kindi,[11] working in ninth-century Baghdad, and al-Haytham,[12] a late-tenth- to early-eleventh-century Egyptian whom generations of Europeans would know as Alhacen. Numerous other savants in the Islamic world augmented a growing literature on light and vision, most influentially Ibn Sina, known as Avicenna[13] to those who would read his works in Latin, and Ibn Rushd, or Averroes.[14] The Arabic works of these four scholars, their contemporaries, and their ancient Greek and Hellenistic sources became available to Latin readers beginning in the twelfth century. In Salerno, as at Hereford and then Oxford, scholars responded with intense interest to Graeco-Arabic mathematical, medical, philosophical, and other scientific works as these arrived in Latin translation. The response at Paris was not as welcoming, but by the middle of the thirteenth century the initial hostility to the writings of "pagans and infidels" among a significant portion of the teachers of the Sacred Page had yielded to assiduous study,[15] a transition encouraged by influential theologians' deployment of these new resources for explaining light and vision.

Theorizing Vision at Paris in the Early Thirteenth Century

Although historians once attributed the development of medieval optics to Oxford,[16] the evidence now points to Paris: it was there that the future bishops Robert Grosseteste (ca. 1169–1253) and William of Auvergne (ca. 1180–1249) first explored and then introduced scientific accounts of light and vision into their theological teaching and writing during the 1220s.[17] Friends with often congruent approaches, these two innovators may have assisted each other's efforts to assimilate the newly available accounts of Avicenna, al-Kindi, Euclid, and Averroes (in that order) to those of Augustine and the Pseudo-Dionysius.[18] Both Grosseteste and William of Auvergne promoted an understanding of the workings of light and vision in the world that Dominican and Franciscan theologians elaborated into a scholarly paradigm over the course of the thirteenth century. Like all such paradigms, this one diffused at varying rates in different scholarly communities and remained subject to debate, misunderstanding, refinement, correction, and popularization in many literary and artistic media; but its broad outlines were widely shared among persons with some university-level education or the equivalent from a monastic school or mendicant seminary (or *studium*).

Whatever the importance of William of Auvergne for Parisian scholars' embrace of Graeco-

Arabic learning as it became available at Paris, where he was bishop from 1228 to 1249, Roger Bacon would later laud Robert Grosseteste as the scholar in whose mind the perspectivist paradigm had really begun to take shape. Grosseteste's early scientific and medical education was acquired at the schools of Hereford at a time when Neoplatonism framed the philosophical thinking of its scholarly community, who constituted an intellectual avant-garde, attracted by the ready access to newly translated Arabic scientific works.[19] After spending some time studying theology in Paris, where he first gained access to Averroes's commentaries on Aristotle's *Metaphysics* and *De anima* in the mid-1220s,[20] Grosseteste taught theology at Oxford for at least a decade to the early Franciscans, whose religious vocation he admired and supported (but to which he did not convert). By then his contemporaries recognized him as exceptionally erudite, and his erudition eventually earned him the episcopal mitre. As bishop of Lincoln, Grosseteste exercised some oversight of the new University of Oxford, and gained the honorific name *Lincolniensis*, by which he was known to generations of readers. He continued to write and to influence scholarship after becoming a bishop. Throughout his career, Grosseteste was ever endeavoring to integrate an ongoing and extensive reading of patristic literature (including the Pseudo-Dionysius, whose work he retranslated from Greek into Latin) with Aristotle (whose *Nicomachean Ethics* he also translated) and nearly the entire corpus of works so far translated from Arabic. Much ink has been devoted to arguing whether Grosseteste's views were essentially Neoplatonic (or Augustinian) or Aristotelian, or evolved from the former to the latter;[21] my own view is that Grosseteste would have found the very question wrong-headed, for I think that he implicitly believed as his enthusiastic reader, Roger Bacon, explicitly did, that what was required was synthesis. Synthesis, at any rate, was what Grosseteste achieved.

Artistic images from Roger Bacon's lifetime (if not also William of Auvergne's and Grosseteste's) in relatively luxurious but still scholarly copies of Aristotle are emblematic of this effort at synthesis. Thus, for instance, in a manuscript produced in Paris near the end of the thirteenth century, the opening folio of Aristotle's major psychological treatise, the *De anima*, shows the synthesis of Aristotle's notion of the *psyche* with the Christian notion of the soul, here depicted according to convention as a tiny naked person on the left who leaves the body of a man who has just died (Fig. 1). With the guardian angel's assistance, the soul has just evaded the horned devil standing on the dead man's bed. Reaching out with a hook, this demon clearly intends, in the words of the medieval peasants' right to glean dead limbs from the lord's forest, to grab that soul "by hook or by crook." A second image in the same manuscript, marking the first words of Aristotle's *On Sense and Sensibilia* (*De sensu et sensato*), reminds the reader of a dictum that circulated widely as Aristotle's own, "the senses are the gateway to the soul" (Fig. 2). Here, wearing a magisterial biretta, a scholar stands facing the gate to his soul's citadel; holding a rose to his nose and eyes, he engages the three exterior senses of touch, smell, and vision.[22]

Of the senses, vision chiefly interested Grosseteste, who found in the workings of light the most intimate interaction of our bodies and souls with the rest of the created biological, physical, and soteriological order.[23] His Neoplatonic sources, notably the Pseudo-Dionysius and Augustine, confirmed for Grosseteste that an original point of light had, by "multiplying itself," generated the entire universe of concentric spheres.[24] Almost certainly, he had read the treatise by al-Kindi translated as *On Rays* (*De radiis*), for Grosseteste's doctrine of the universal agency of the "multiplication" of light restates the Persian scholar's doctrine of the universal radiation of force.[25] Like al-Kindi, Grosseteste argued that every object in the universe innately—that is, by its nature—acts

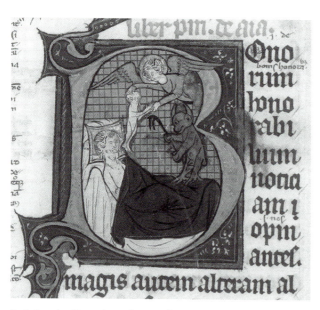

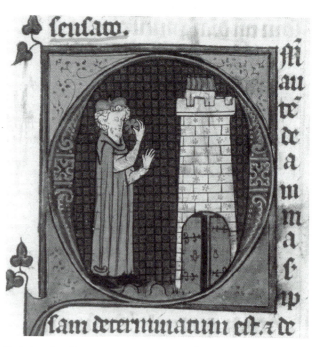

1. Aristotle, *De anima,* thirteenth-century manuscript. Vatican City, Biblioteca Apostolica Vaticana, Ms. Barberini lat. 165, f. 299r, detail

2. Aristotle, *De sensu.* Vatican City, Biblioteca Apostolica Vaticana, Ms. Barberini lat. 165, f. 330r, detail

on its surroundings through the emanation[26] of its likeness (*species*) in all directions. Although Grosseteste also termed what radiates "power" or "force" (*vis* or *virtus*),[27] he preferred the term *species,* the etymon of which conveyed the notion of "what is visible," as Grosseteste the translator surely appreciated.[28] In the case of the sun or other light source, its light was, strictly speaking, *lux,* while the illumination that emanated from that *lux* as its multiplying *species* was *lumen.*[29] The study of light reinforced Grosseteste's belief in the importance of applying geometry to the understanding of nature, and he found the tools to delineate the "multiplication of *species*" in Euclid's *On Mirrors* (*De speculis,* a translation of the *Catoptrica*) and probably Euclid's *On Sight* (*De visu*) as well as al-Kindi's *Perspectives* (*De aspectibus*). Evidently Ptolemy's *Optica* and Alhacen's *De aspectibus,* which would take Roger Bacon much further along this path of research, were not yet available.

Grosseteste was nonetheless able to sketch an answer to our question, "what happens when we open our eyes?" According to Grosseteste, what we see with our eyes when we look at a visible object are light and colors—colors being the original light of the universe as incorporated into transparent material bodies (thus literally "embodied"). These colors on the object's surface are its visible aspects, form, or *species;* and when they are suffused with rays of light, they generate rays in turn, multiplying themselves from every point on the surface rectilinearly in all directions. This *pointillistic* radiation was al-Kindi's theoretical discovery. Sight, however, also requires that this radiation from the visible object of its visible *species* interact with a visual spirit made, Grosseteste says, "of the same nature as the sun's light" that emanates from the eye.[30] This is ultimately a synthesis of the views of both Plato and Galen, and it means that, for al-Kindi and Grosseteste, the eye, like all other objects in the universe, is active in this process: it sends forth its

visual spirit. Yet the eye is also the recipient, a fact that guarantees the existence of an objective core to what we perceive: because this extramental radiation would exist even if we did not, the outside world and its arrangement produce what reaches the eye's visible spirit. When, as a result, the eye has received this form, the act of vision is complete, according to Grosseteste.

The eye, however, is not conscious, and therefore cannot be *aware* that it sees. Hence, there must be more to the story. If what we see is to be of any use to us, we must be able to "make sense" of it. If we are to learn from what we see, we must retain the received *species*. To dream of what we have seen or may see, and to hallucinate visually, we require access to stored mental images. Moreover, because some animals appear to be able to retain and use what they have seen or perceived in at least some of these ways, these cannot be the work of the intellect which, by definition, scholars understood to be possessed by humans, angels, and God, but not animals.[31] Ancient authors therefore posited the existence of interior sense faculties, for which the five exterior senses—touch, taste, hearing, smell, and vision—were the instruments. The number, location, and functioning of the internal senses had been debated since the time of Aristotle. A developing consensus that these faculties were lodged in the brain (rather than the heart) was due largely to the evidence provided by the physician Galen (d. after A.D. 210), who correctly thought that the completion of vision and other sensory perception—and thereby consciousness, as well as subsequent sensory evaluation or "judgment" of what the eyes have seen, and such other functions as the storage of sensed images and memory—all occurred in the substance of the brain itself, and required its use of the body's nerves. The next step, the explicit localization of the internal senses in the four *ventricles* of the brain, rather than in the brain's substance, was promoted by Nemesius of Emessa, whose *On the Nature of Man*, a treatise synthesizing the views of Platonist, Aristotelian, Stoic, and other authors with those of Galen, was the major vehicle for transmitting theories about the interior senses to both the early medieval Latin West and the Muslim East. In that work, Nemesius assigned the coming together of the various external senses' impressions or images in the *imagination* to the frontal (or anterior) ventricles, while allocating sensory cogitation and reason to the middle ventricle, and to the posterior ventricle, memory.[32] A somewhat different schema was offered in the opthalmological treatise of the influential ninth-century physician and translator, Hunayn ibn Ishaq, who reported (in Arabic):

> In the brain are four cavities known as the ventricles of the brain, two cavities in the anterior, one in the posterior part, and one in the intervening space between the two anterior cavities and the posterior cavity. In these cavities is a psychic pneuma by which those functions are performed which we have mentioned and which cannot be performed without it. . . . Through the pneuma which is in the posterior cavity, *movement* and the act of *recollection* are accomplished; through the pneuma which is in the anterior part of the brain, *observation* and *imagination*; and through the pneuma which is in the middle part of the brain, *reflection*.[33]

Hunayn's opthalmological oeuvre in turn transmitted the Nemesian doctrine of the ventricles as the locus of the interior senses to the Muslim physician-philosophers Avicenna and Averroes, who both developed extensive accounts of the interior faculties of the soul that Grosseteste and William of Auvergne were among the earliest medieval Christian authors to bring together with Augustine's descriptions of the powers of the human soul.[34]

It is important to appreciate that these ventricles in fact exist. Located deep within the brain,

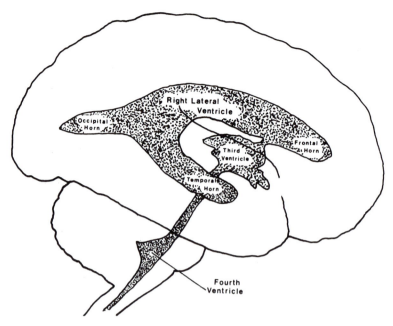

3. The ventricular system of the human brain, lateral view

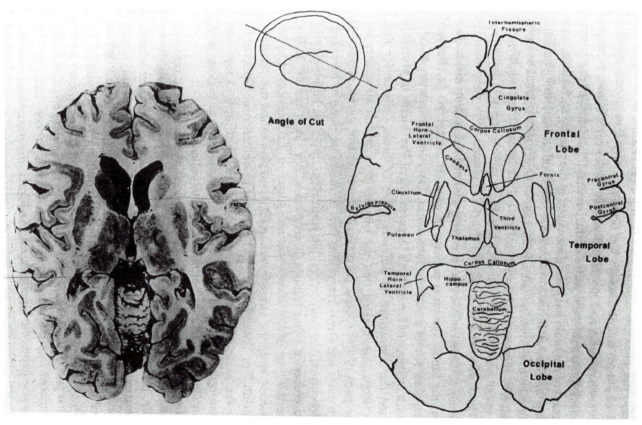

4. The ventricular system of the human brain seen from above, photograph and diagrams

the ventricles—which medieval authors also termed "cells" (*cellulae*)—are cavities filled with the cerebrospinal fluid that Galenic physicians considered to be or to convey the psychic *pneuma*. If one slices vertically through the brain along the interhemispheric fissure, severing the two hemispheres, three ventricles are among the observable structures of the brain, as shown in Figure 3 (where they appear as darkened areas). The right lateral ventricle, a three-horned cavity projecting into the frontal, occipital, and temporal lobes, is one of the two "anterior" ventricles (the other, the left lateral ventricle, is omitted from this diagram, as the left hemisphere of the brain has been sliced away). The fact that the ventricles are connected may not be obvious when one examines the brain from above, as in Figure 4, a photograph and drawing of the brain sliced at a diagonal from the forehead (above) back to the base of the skull. There were, however, no ancient or medieval conventions for precisely depicting the verbal anatomical descriptions in Galen's medical works. Consequently, medieval and early-modern readers had difficulty establishing exactly which anatomical features of the brain were the "ventricles" to which Galen (and subsequent physicians) referred. Such images in manuscripts as do exist have seemed to twentieth-century scholars to show a division of the brain into frontal, temporal, and occipital lobes, and there were medieval philosophers who evidently conflated the ventricles with these lobes, thus reducing the four ventricles that Galen had identified to three.[35]

Grosseteste was among those who understood the brain to possess (or comprise?) three "cells." In the first, he asserts, the forms of an object sensed by the different external senses are brought together by the common sense and are preserved by the imagination (both of which Aristotle had mentioned); nearby, in the middle cell, resides the estimative sense, which Avicenna had defined as the faculty by which animals and people notice "intentions"—not impressed sensible forms per se, but such properties as pleasantness, friendship, painfulness, or hostility exuded by the perceived object. Put another way: for an Avicennian, these properties do not require an intellect to be perceived. Moreover, use of this estimative faculty also enables us to make perceptual distinctions before we think about them. The brain stores these intentions in the sense-memory, located within the brain's rearmost cavity.[36]

Intellectual or Spiritual Vision

The senses, both external and interior, are still only part of the story. For Grosseteste, the Pseudo-Dionysius and Augustine had thoroughly established that the human mind experiences intellectual insights and understanding regarding intelligible objects (such as mathematical objects, Forms, universals, or truths) by real processes that are precisely like those by which corporeal vision of visible objects are brought about. Grosseteste states explicitly and more than once that this is the case. He does so in influential works, including his commentary on Aristotle's *Posterior Analytics*—the commentary that would introduce several generations of students to Aristotle's theory of scientific method. There, Grosseteste stresses:

> I [Grosseteste] therefore say that there is a spiritual light (*lux spiritualis*) that floods over intelligible objects (*res intelligibiles*) and over the mind's eye (*oculus mentis*)—[this is a light] that is related to the interior eye and to intelligible objects just as the corporeal sun relates to the bodily eye and to corporeal visible objects. Therefore, the intelligible objects that are more receptive of this spiritual light are more visible to the interior eye. . . . And

so things that are more receptive of this light are more perfectly penetrated by the mind's gaze (acies mentis) that is likewise a spiritual irradiation, and this more perfect penetration is greater certitude.[37]

If we take together what Grosseteste tells us elsewhere about vision with what he asserts here, we arrive at the following as his account. When suffused with light, a corporeal visible object can multiply its species to be received by the corporeal eye; the latter must also send forth a visual spirit for there to be corporeal sight. Similarly, to be seen, the intelligible object must be irradiated, but by a "spiritual" light. Moreover, the object must also be irradiated by the mind's analogue to the visual spirit "extramitted" by the bodily eye. This analogue is the acies mentis.[38] Grosseteste was neither novel nor unusual in his conviction that such a spiritual light exists; among thirteenth-century theologians, William of Auvergne, Bonaventure, and Henry of Ghent were among the most influential who relied upon it to explain intellectual knowledge of divine truth.[39] The crucial point here is that spiritual light irradiating intelligible objects and the mind's eye so that they can be seen is not, for Grosseteste and others who posit it, a metaphor.[40] Just as, for the philosophical dualist (and heir to this tradition) Descartes, res cogitans is absolutely as real as res extensa, so for Grosseteste and his successors, what has spiritual or intellectual being really exists. Yet, unlike Descartes, these heirs to Augustine and Plato treated spiritual light as having dimension or extension, and so exerting its agency along geometrical rays precisely as did corporeal light.[41]

Moreover, the irradiation of spiritual light is, I think, frequently depicted in late medieval art. One may take as an example a depiction of Aquinas designed to show that his teachings convey God's truth: The Triumph of Aquinas, in the church of the Dominican house at Pisa, Sta. Caterina, a large panel painted about 1340 and long attributed to Francesco Traini, but more recently ascribed to Lippo Memmi (Fig. 5).[42] At the summit of the Traini/Memmi Aquinas, Christ—who is, in Christian theology, God as "the Light" and "the Word"—enunciates his Truth, which issues from his lips as rays of golden light. Three of these rays reach and are received by the head (and, therefore, the mind) of Aquinas seated below; others travel to the minds of the sages and prophets who have known some of the Truth and who are ranged in the heavens between Christ and the Dominican saint. The divine light that the prophets receive is further reflected, reaching Aquinas's mind as radiation from the words written in the books that they have authored and hold above his head. A more general irradiation of divine light from Christ's entire body is received by the philosophers Aristotle and Plato standing to the right and left of Aquinas, from whose books he receives yet more reflected rays of light. Thus, while Aquinas actively gazes at none of these sources of his knowledge, he impassively receives what, in the terminology of thirteenth- and fourteenth-century theologians, was a personal, direct, unmediated, and unbroken divine illumination as well as reflected, and therefore indirect, illumination.[43]

Resting open upon Aquinas's lap in the middle of the panel are books bearing the incipits of his works. Here shines the central message of the entire image: from Aquinas's teaching, the spiritual light of Truth continues to be reflected. Radiating outward, it travels rectilinearly along rays diffusing themselves spherically in just the way that perspectivists' diagrams depict the multiplication of species from many spots on a circular surface to suggest their rectilinear multiplication from every point. The light rays from Aquinas's oeuvre fall upon the theologians, clergy, religious, and laity standing below him—and, insofar as the light is emitted spherically from these tomes, the implicit geometry of illumination requires that it reach outward, to fall also upon anyone who

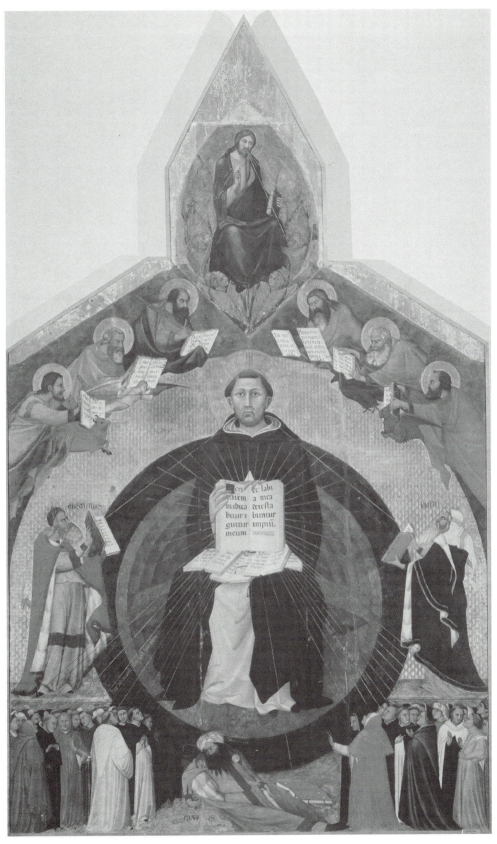

5. Francesco Traini/Lippo Memmi, *Il trionfo di Tommaso d'Aquino*. Pisa, Chiesa di Sta. Caterina, ca. 1340, oil and gold on wood

6. The St. Louis Psalter, mid-thirteenth century, Paris, Bibliothèque Nationale de France, Ms. lat. 10525, f. 85v, detail, "Beatus vir" at opening of Psalm 1

stands and looks at this painting. Unless we are to assume that the rays issuing from Christ's mouth or from the books of inspired authors are to be understood as corporeal light—that is, the light that issues from the sun or a lit candle—then the light working its way through this depiction of Aquinas's triumph must be understood instead as spiritual light.

Artists also found ways to manifest the difference between spiritual and corporeal vision. An example from the Psalter of King Louis IX of France, a manuscript produced at Paris within a decade of Grosseteste's death, is the historiated initial *B* of "Beatus vir" (or Blessed man), the incipit of the Psalms (Fig. 6). Michael Camille correctly saw the artist as having juxtaposed and thereby contrasted spiritual or intellectual sight and corporeal vision.[44] In the upper lobe of the *B*, the illuminator has conjured up the moment when King David, looking out one of his palace win-

dows on the left, first sees Bathsheba. She is shown naked, seated in an outdoor pool under the trees, being bathed by one attendant while the other holds up the dress to be worn after the bath. David sees her with his bodily eyes, and we know from the biblical account that this sight of her beautiful body stimulated his bodily lust, with sin and history as results. The lower lobe offers a parallel: precisely beneath the figure of King David in his castle kneels his likeness, the modern (to a medieval viewer) David for whom the psalter was made, as the diamond-patterned background of fleur-de-lys indicates. For a medieval Catholic theologian, the term *beatus* was a technical one, denoting a person who has been saved by God's grace, and who, therefore, in the afterlife, will be in his presence for the rest of eternity, blissfully enjoying the Beatific Vision, the most spiritual of visions. Here the Capetian ruler sees God as the *Beati* see him, according to the convention for depicting the Beatific Vision: on the right, in a mandorla rimmed by the wavy blue and white clouds of the heavens and filled with a golden light, sits Christ, a cross-nimbus framing his head; his left hand holds the orb, and with his right he offers the sign of his blessing.[45]

For the *beatus*, Augustine had argued, the Beatific Vision provides perfect happiness in part because it is secure: it is perpetual and, thus, the happy recipient need not fear that, like earthly happiness, it may end. In this life, the closest one can come to the unalloyed happiness of the Beatific Vision is the temporary spiritual sight of God achieved by intellectual contemplation.[46] A century after the completion of the St. Louis Psalter, an illuminator at Paris depicted the happiness that such spiritual vision bestows in this life for the Valois king, Charles V. Opening the tenth book of Aristotle's *Nicomachaean Ethics* in the presentation manuscript of the French translation that the king had commissioned from the eminent theologian Nicole Oresme (d. 1382), an image labeled twice "Contemplative Happiness" (*félicité contemplative*) introduces the transition from corporeal to intellectual pleasure that, Oresme states, Aristotle considers in the concluding chapters of his treatise (Fig. 7).[47] Above are the heavens, identified as such not only by the deep lapis-lazuli blue, but also by the moon on the left and the sun on the right. In the center, reaching over the labels "félicité contemplative"[48] and surrounded by his angels, a gray-bearded, haloed God the Father stretches forth his right hand in blessing. He looks downward but does not engage the eyes of the woman sitting on a stone bench beneath him, the hem of whose dress interrupts another label "félicité contemplative." Her haloed head bent back as far as it will go, she gazes directly up at his face. Her posture tells us that she rather than God is the active contemplator. Moreover, she cannot be the personification of "contemplative happiness," since both she and the object of her vision are so labeled. So we must conclude that she represents instead the "intellective soul" (*l'âme intellective*) who experiences such happiness, as indicated just under the image by the opening words of Oresme's introduction to Aristotle's text.[49]

Spanning a century and produced in two distinct artistic milieux, these three images (Figs. 5–7) must stand for the many in which scholarly theories comparing spiritual and corporeal vision entered artistic vocabulary. The one hundred years in which they were created were the ones in which the science that Grosseteste had advocated took shape, gained explanatory force, became an accepted scholarly paradigm, and finally entered the university curriculum. When Parisian illuminators were completing their *Beatus vir* initial in the Psalter of Louis IX, other producers of books a few streets away were already providing copies to scholars of the most recently translated works of Graeco-Arabic learning, as well as the works of William of Auvergne and Robert Grosseteste.[50] As a result, scholars at Paris (and at Oxford) were in the early stages of assimilating the newly available sources on light and vision. The Franciscans and Dominicans,

7. Aristotle, *Ethica Nico-
machea,* translated by Nicole
Oresme, manuscript dated
1376. The Hague, Rijks-
museum Meermanno-
Westreenianum, Ms. 10.D.1, f.
193r, *Félicité contemplative*

new religious orders still setting up their educational systems, were particularly important in the process of absorbing and disseminating these texts. The development of a science of light and vision within those orders was rooted in the writings of Albert the Great (ca. 1200–1280) and especially Roger Bacon (ca. 1210?–ca. 1292), who were also the first scholars to teach the entire Latin corpus of works by Aristotle or those circulating under his name. Without Roger Bacon's treatises and relentless propaganda on its behalf, the science that he called *perspectiva* might never have gained a place in university studies, much less come to dominate thought on optical questions for at least 350 years.

Roger Bacon's Theory of Vision

Roger Bacon was, like Grosseteste, an Englishman whose career brought him to both Oxford and Paris. At Paris, Bacon taught in the Faculty of Liberal Arts for at least two decades, beginning

within a few years of the marriage and coronation of King Louis IX in 1234. They were exact contemporaries, living within the same city walls. As did many others in the Arts Faculty, Bacon was probably studying theology during some of the period of his Arts teaching, and this may have played a role in his decision to enter the Franciscan order about 1256. Bacon's writings on *perspectiva* were all composed after that date, although for some years he had been delving deeply into the subject. Having been convinced by his study of al-Kindi's and Grosseteste's writings that the study of light was fundamental to understanding *all* of natural philosophy (including human perception of the universe), Bacon found with Grosseteste that al-Kindi's *On Rays* provided a model of the universe as a vast network of radiating forces. In al-Kindi's *Optics*, Bacon recognized a demonstration that the radiation of these forces—especially when perceptible as light—could be mapped by "lines, angles, and figures," in the words of Grosseteste. Adopting wholeheartedly Grosseteste's doctrine and vocabulary of the "multiplication of species," Bacon became the first Christian intellectual to exploit the entire body of works translated into Latin that treated light and vision, including the hitherto unused optical *magna opera* of Ptolemy and Alhacen. Through Bacon, several friars who resided with him at the Franciscan convent in Paris became sufficiently acquainted with *perspectiva* to incorporate its tenets into their theological lectures, or even, in the case of John Pecham, to compose their own perspectivist textbooks.[51]

Among the most significant ideas demonstrated by al-Kindi and Alhacen that both Grosseteste and Bacon elaborated was that images that are received in the interior senses from the eyes are the coherent effects of an incoherent radiation of *species*. This is the technical way of saying that each "point" of an object's surface multiplies only an image (or *species*) of that point, not an image of the whole. Only when this point-by-point radiation has reached the eyes, has continued multiplying through them and the optic nerves to their juncture at the optic chiasma, is the potential for a visual image of the whole seen object actualized from the array of *species*. According to Bacon (who is following Alhacen), not all rays of light and color that reach the eyes are vision producing. Those rays of multiplying visible *species* that fall perpendicularly on the eye and enter it without refraction are primarily involved in the production of visual images; these rays form a cone (or, in medieval Latin, a "pyramid") originating from the visual object as base and proceeding toward an apex (which they never reach) in the eye of the observer.[52] The eye itself is made up of tunics and humors (cornea, crystalline lens, aqueous and vitreous humors, retina, and so forth) that are defined or enclosed by spherical surfaces, the centers of which are situated on the eye's axis, a straight line running through the center of the pupil at the front to the opening into the optic nerve at the back. A geometrical diagram from a fourteenth-century manuscript of Bacon's *Perspectiva* (the fifth book of the seven constituting his *Opus maius*) purports to explicate this arrangement (Fig. 8).[53] Difficult both to construct and to decipher, this diagram locates the eye's lens (labeled "the aperture of the uvea") at the top. We should construe it as siting the lens above the glacial humors, as we would look through it from above, peering downward through the layers of the eye into the tapering channel of the optic nerve leading to its half-moon base. The *Perspectiva communis*, a textbook written by Bacon's follower, John Pecham, also shows from the side what Bacon is describing (Fig. 9).[54] Here we see the visual cone to the right, as it reaches into the vitreous humor within the spheres of the eye at the center, beyond which lie the parallel lines of the optic nerve's lining to the left. In this diagram, the axis of sight in the center of the visual cone is labeled "[the] axis under which the thing is apprehended." On Bacon's and Pecham's account, after the rays of the visual cone have reached and passed without refraction through the cornea, the aqueous humor, and the front surface of the crystalline lens, they are refracted at its

8. Roger Bacon, *Perspectiva*, fourteenth-century manuscript. Oxford, Bodleian Library, Ms. Digby 77, f. 7r, image of the structure of the eye

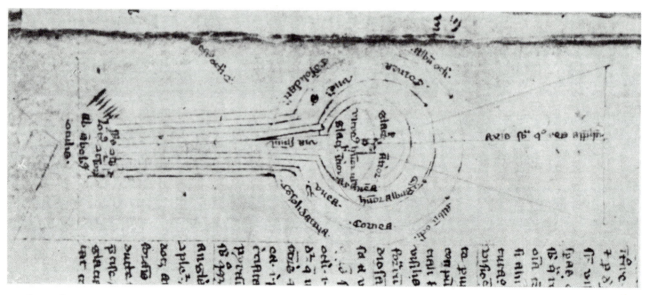

9. John Pecham, *Perspectiva communis*. Erfurt, Wissenschaftliche Bibliothek, Ms. Amplonianus Q. 387, f. 32v, details showing the external organs of sight according to Pecham

rear surface into the vitreous humor. Still multiplying the species of light and color, the rays continue through the opening into the optic nerve (also filled with vitreous humor), which conducts them to its juncture with the other optic nerve (our *optic chiasma*), so labeled in Figure 9 at the left.[55] For Bacon, once an actual image (or *similitudo*) has been produced there, it in turn continues to multiply into the three chambers of the brain housing the inner senses. Evidently unaware of the smaller ventricles, Bacon followed Grosseteste in thinking that these three chambers constitute the entire substance of the brain, but departed from his enumeration of four interior senses to adopt instead the five that Avicenna had expounded in his *On the Soul*.[56]

These processes in Bacon's theory were "intromissionist," allying him with Aristotle, Avicenna, and Alhacen, whom, he believed, he joined in positing "intromitted" species as necessary for vision and its principal cause; the senses (as Aristotle pointed out in a passage quoted by Bacon) are initially passive participants, while the agent is the *species* of the visible object.[57] Yet, Bacon was convinced that our senses are not only passive but also active. At least the "ultimate sensor" at the optic chiasma, as well as the common, estimative, and discriminative senses, play an active part in making the world appear to us as it does, by combining, discriminating, or otherwise sorting and filtering (thus "evaluating") what has been received from it through the sense organs. More remarkably, Bacon was not inclined to dismiss the theories of the "extramissionists." Their position could be supported, he thought, by persuasive arguments and ample empirical evidence. Bacon therefore interpreted Alhacen, Avicenna, and Averroes not (as we read them) as having demonstrated the nonexistence of extramitted rays, but merely as having proved the necessity, and therefore the existence, of intromitted radiation. This allowed Bacon (and subsequently Pecham) to accept that intromitted rays are the immediate cause of vision, while acknowledging that extramitted rays exist—after all, they must exist if his fundamental thesis is true, that "*every natural thing,*" such as the physical eye itself, "completes its action solely through [multiplying] its power, or species."[58]

Most important for Bacon—even if superfluous for an explanation that our culture would recognize as "scientific"—"extramission" was crucial for his claim that, in a universe in which all objects multiply *species*, not only do "celestial things influence the terrestrial realm," but also creatures on this earth "act reciprocally on the heavens," not least in sight. Prayers must reach the heavens, after all.[59] For us to see objects as distant as the stars, Bacon asserts, there must be this bi-directional action and reception:

> It should be understood that a species is produced in celestial bodies not only by other celestial bodies, but also by terrestrial things. . . . And since the species of our sight is required for the act of sight . . . when we see the stars, the species of our sight must be generated in the heaven, just as in the elemental spheres [below the sphere of the moon]. . . . That alteration is quite appropriate which consists in the generation of a species by which celestial nature is assimilated to [the] terrestrial, for the sake of well-being and greater unity of the universe and to meet the needs of sense, especially sight, the species of which comes to the stars and to which the species of the stars come in order to produce sight.[60]

An echo of this idea—central to notions of scholarly magic as well—can be found in educated circles well into the sixteenth century, and the interaction of the solar light and reciprocal *virtus visiva* appears in an engraving from Cesare Cesariano's translation of and commentary on Vitru-

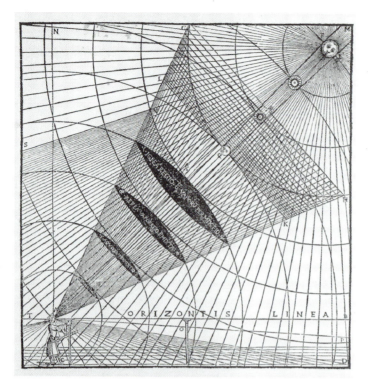

10. Cesare Cesariano, *Vitruuio Pollione de Architectura Libri Dece[m] Traducti de Latino in Vulgare Affigurati* (Como, 1521), f. 11v

vius, published in Como in 1521 (Fig. 10). Cesariano's figure presents a visual cone that stretches indeed from man, the microcosm, to the cosmic orbits of the stars, even as the sun's light radiates through the spheres below it to the earth.[61]

Perspectiva after Roger Bacon

The foregoing has sketched only a part of Roger Bacon's extensive, complex, and detailed analysis of light and vision, which he elaborated in a series of treatises that he wrote in Paris from about 1267 until the end of his life. These works, then, were precisely coeval with the earliest artistic images considered here (Figs. 1, 2, 6). Attempting to set *perspectiva* on as sound a footing as possible, Bacon lobbied his contemporaries, including Pope Clement IV, to reorient university education around *perspectiva* and allied disciplines. He clearly persuaded a number of theologians, including some of his Franciscan confrères at Paris, of the importance of *perspectiva*. Moreover, Bacon's conversion to the Franciscan life evidently did not prevent him from continuing to cultivate like-minded scholars outside the religious orders at Paris. Most notable among these was Pierre of Limoges, who inherited Bacon's library, and whose *Moral Treatise on the Eye*, a book for preachers, was undoubtedly influenced by Roger Bacon's insistence on the utility for Christendom of *perspectiva*.[62] Yet, Bacon's most significant early convert was his compatriot John Pecham, who rose to the archiepiscopal see at Canterbury and used his authority to influence Oxford's curriculum. Pecham's little textbook on *perspectiva*, based largely on Alhacen and Bacon, was so widely

used for the teaching of the subject that it came to be known as the "usual" *Perspectiva* (*Perspectiva communis*). At the papal court in Viterbo, the Silesian cleric Witelo (d. after 1281), who had been educated at the universities of Paris and Padua, evidently learned of Bacon's work, which led him to compose an enormous and systematic *Perspectiva* during the 1270s. Of these early perspectivists, Witelo was unusual in rejecting Bacon's theory of extramitted rays; this sometimes enables us to tell when a scholar or artist is following Witelo rather than some other perspectivist authority.[63]

If one path of the influence of optical theories extends through Franciscans' treatises and lectures, another can be traced connecting the Dominicans from Albert the Great to the encyclopedist Vincent of Beauvais and to Thomas Aquinas, who was both Albert's student and Witelo's friend. It is important to appreciate that Albert and Aquinas probably played a much smaller role in creating the perspectivist paradigm than did Roger Bacon, and that, while they did not concur on all details, they shared many tenets of this account of vision and resulting psychological processes.[64] This means that, if we wish to figure out what aspects of the general paradigm a particular scholar, artist, or community of religious understood, the works of Albert the Great and Thomas Aquinas are not the first or always the best places to look.

Thanks to the involvement of theologians from the outset in the creation of the Latin science of *perspectiva*, by the end of the thirteenth century, theologians' lectures on Peter Lombard's *Sentences* routinely offered opportunities to spell out how we come to know the world, and many drew partly upon the "multiplication of species" to do so. Among theologians well known to historians of science, both Nicole Oresme at Paris and Henry of Langenstein (ca. 1325–1397) at Paris and Vienna would head the list of those whose lectures treated perspectivist topics extensively. From the fourteenth century, if not earlier, students could as readily learn the fundamentals of the discipline of *perspectiva* in faculties of arts and medicine, not only at Oxford and Paris, but in universities all over Europe.[65] Broadly speaking, scholars at universities debated the number and precise anatomical location of the internal senses; they sometimes rejected the view (promoted by Bacon) that the images received in the brain from vision were our very mental concepts or words themselves, or rather the proximate cause of these; some scholars rejected the necessity for a special divine act of intellectual illumination for the apprehension of ordinary truths; but most accepted *grosso modo* the theoretical chain of light's operations in the universe, upon our eyes, and through our brains.

Among the small minority who did not do so was the Franciscan Pierre Auriol (d. 1322). A friar from Languedoc who was to become the bishop of Aix-en-Provence, Auriol taught at Bologna, Toulouse, and eventually at Paris. His lectures on Lombard's *Sentences* were the only ones to sail dangerously close to Charybdis, for Auriol departed from the general readiness to treat extramental objects in the world as the origin of images received or impressed upon the visual powers (sensory and intellectual), and then transmitted to, stored, and used by other interior faculties.[66] He recognized that, to this extent, reality would produce the mind's contents and structure their arrangement. By the time of his writing, scholars had reached consensus that such transient appearances as rainbows, shifting colors, and virtual images, or optical illusions, are exceptional, being partly the product of the observer's position and gaze, partly independent realities. Auriol became famous to generations of theologians for arguing instead that such appearances have no extramental existence. Denying that they are visible species that have multiplied from the object,

Auriol insists that sensitive and intellectual vision (stimulated, perhaps, by such species) form these appearances. More important, Auriol asserts, the production of such phenomena shows what also occurs in normal, veridical perception. In other words, what Bacon and other perspectivists had thought the observer's perceptual powers *sometimes* do, Auriol realizes, they *always* do in the act of vision (in his terminology, "ocular cognition" or "intuition"): they actively form purely subjective conceptions that appear like, and thereby represent, that object.[67] Many scholars knew and rejected Auriol's views, disagreeing with his conviction that our visual powers inevitably structure reality, fearing that to accept this claim was to embrace an unappealing skepticism as to whether the world is as one's faculties depict.

There were, to be sure, optical puzzles that perspectivists and their late-medieval readers could not solve within their theoretical framework, such as how to determine what independent ontological reality optical images and colors possess, with what epistemological implications—questions that remain live ones for philosophers today.[68] In the perspectivists' own era, their successes were culturally more obvious: their treatises helped to encourage the development of magnifying lenses, eyeglasses, and telescopes. Moreover, as historians of art have increasingly appreciated, once Giotto and subsequent fourteenth-century artists began to apply geometry to the task of depicting spaces, buildings, and living beings more naturalistically, medieval *perspectiva* provided necessary tools.[69]

Precisely where and how the crucial encounters occurred between artists and the scholars who studied light, color, and vision, has not been discovered, but given the practices of artisanal training, we should assume that initial exchanges were probably informal and personal, not conveyed directly through the medium of books. Clearly, some scholars interested themselves in the relationship of contemporary artistic practice to their own optical theories;[70] suggestively, Roger Bacon, at least, actively urged the application of geometrical precision to the figural arts for the benefit of the faith. In the *Opus maius* he explained how such carefully constructed images could assist one to visualize biblical passages:

> Now I wish to impart the fifth [way in which it is necessary to use mathematics], which concerns geometrically depicted figures (*figurationes*), both bodily [i.e., sculpted] and on surfaces [i.e., painted], according to lines, angles and figures. For it is impossible that the spiritual sense [of Scripture] be known without already knowing the literal sense; but the literal sense cannot be known unless a person knows what things the terms [of the biblical passage] signify, and what the properties of these signified things are. . . . Therefore, since the works of [human] artifice, such as Noah's Ark, the Tabernacle with its lamps and all, the Temple of Solomon . . . and countless other such works are set out in Scripture, it is not possible for the literal sense of these to be known unless a person has their figures depicted or even made bodily [present] to the senses. And so the holy fathers and ancient wise men used paintings and various depictions, so that the literal sense—and consequently the spiritual sense—would be obvious to the eye. . . . But no one can think up or arrange (*ordinare*) such bodily figures unless he knows well Euclid's *Elements*, Theodosius's [*On spheres*], and . . . [the works] of the other geometers. . . . Oh how ineffably would the beauty of divine wisdom shine forth and how much would its infinite utility abound, if these geometrical things that Scripture contains could be placed in bodily figures before our eyes! . . . And so I deem nothing more worthy to be set before the eyes of one who studies divine wisdom than such geometrical figures. May the Lord order

that these be made! There are [only] three or four men who would be sufficiently able [to do so], but they are the most expert of the Latins. . . . Let us recall to our memories that nothing can be known about the things in this world without the power of geometry, as has already been proved . . . [and that] nothing is completely intelligible to us unless it is displayed in figures before our eyes.[71]

Notes

1. B. Stroud, *The Quest for Reality: Subjectivism and the Metaphysics of Colour* (Oxford, 2000), 3–4. In the present article, when discussing the views of Grosseteste, Roger Bacon, Pierre Auriol, and their sources, I draw upon or elaborate what I have written elsewhere, not always without some repetition.

2. Stroud, *Quest for Reality* (as in note 1), 6.

3. John Duns Scotus's dual, concurrent modes of cognition—abstractive and intuitive—provided a widely influential account on which perception is both passive initially (in abstraction) and active initially (in intuition); see K. H. Tachau, *Vision and Certitude in the Age of Ockham: Optics, Epistemology, and the Foundations of Semantics, 1250–1345* (Leiden, 1988), 55–81.

4. R. E. Latham, *Revised Medieval Latin Word-List from British and Irish Sources* (London, 1965), 361.

5. See Aristotle, *Physics*, 3.1–3; *On Generation and Corruption*, 1.5.

6. Aristotle, *De anima*, 2.7.

7. Gorgias of Leontini, ca. 480–399 B.C., was alleged to have maintained: (1) that nothing is; (2) that even if it be, it cannot be comprehended; and (3) even if someone could comprehend it, it could not be communicated to another. See G. B. Kerferd, "Gorgias of Leontini," in *The Encyclopedia of Philosophy* (New York, 1967), vol. 3–4, 374–75.

8. The best introduction to ancient theories is D. C. Lindberg, *Theories of Vision from al-Kindi to Kepler* (Chicago, 1976), 1–17. See also S. Berryman, "Euclid and the Sceptic: A Paper on Vision, Doubt, Geometry, Light and Drunkenness," *Phronesis: A Journal of Ancient Philosophy* 43 (1998), 176–96; G. Romeyer-Dherbey, "Voir et toucher: Le Problème de la prééminence d'un sens chez Aristote," *Revue de métaphysique et de morale* 96 (1991), 437–54.

9. M. Sirridge, "*Quam videndo intus dicimus*: Seeing and Saying in *De Trinitate* XV," in *Medieval Analyses in Language and Cognition*, ed. S. Ebbesen and R. Friedman, Historisk-filosofiske Meddelelser 77, Det Kongelige Danske Videnskabernes Selskab (Copenhagen, 1999), 317–30, at 317.

10. See, for example, the opening statement of the philosopher Frank Jackson who, despite the title of his important *Perception: A Representative Theory* (Cambridge, 1977), explicitly treats only visual perception, as he admits at the outset, p. 1, incipit: "In this book I argue that the correct philosophical theory of perception is a representative one. By such a theory, I mean one which holds . . . that there are objects, variously called external, material or physical, which are independent of the existence of sentient creatures. . . . (The restriction to visual perception—seeing—is to be understood throughout.)"

11. Abu Yusuf Ya'qub ibn Ishaq al-Kindi (fl. 850, d. 873); see Lindberg, *Theories of Vision* (as in note 8), 18–32. For his optical treatises, see *Oeuvres philosophiques et scientifiques d'al-Kindi*, vol. 1, *L'Optique et la catoptrique*, ed. R. Rashed (Leiden, 1997).

12. Abu 'Ali al-Hasan ibn al-Hasan ibn al-Haytham (965–ca. 1039); see Lindberg, *Theories of Vision* (as in note 8), 58–86; *The Optics of Ibn al-Haytham, Books I–III on Direct Vision*, 2 vols., ed. and trans. A. I. Sabra (London, 1989). On the spelling of "Alhacen" (correcting his and my earlier "Alhazen"), see D. C. Lindberg, *Roger Bacon and the Origins of Perspectiva in the Middle Ages: A Critical Edition and English Translation of Bacon's Perspectiva with Introduction and Notes* (Oxford, 1996), xxxiii, n. 75.

13. Abu 'Ali al-Husain ibn 'Abdullah Ibn Sina (980–1037); see Lindberg, *Theories of Vision* (as in note 8), 43–52, for further detail; also *Avicenna Latinus: Liber de anima sive Sextus de naturalibus*, ed. S. Van Riet and G. Verbeke, 2 vols. (Leiden, 1968, 1972), vol. 1, pp. 63*–86*.

14. Abu-l-Walid Muhammad Ibn Rushd (1126–98); see Lindberg, *Theories of Vision* (as in note 8), 52–57.

15. See K. H. Tachau, "God's Compass and *Vana Curiositas*: Scientific Study in the Old French *Bible moralisée*," *ArtB* 80 (1998), 7–33. The roles of Salerno, Hereford, and Oxford in the initial stages of Latin scholars' reception of Graeco-Arabic learning have long been the subject of historians' study; see recently M.-T. d'Alverny, "Translations and Translators," in *Renaissance and Renewal in the Twelfth Century*, ed. R. L. Benson and G. Constable (Cambridge, Mass., 1982), 421–62; C. Burnett, "The Introduction of Aristotle's Natural Philosophy into Great Britain: A Preliminary Survey of the Manuscript Evidence," in *Aristotle in Britain during the Middle Ages*, ed. J. Marenbon (Turnhout, 1996), 21–50.

16. H. Rashdall, *The Universities of Europe in the Middle Ages*, ed. F. M. Powicke and A. B. Emden (Oxford, 1936), vol. 3, 239–50; and, with considerable overstatement, A. C. Crombie, *Robert Grosseteste and the Origins of Experimental Science, 1100–1700* (Oxford, 1953, 1971).

17. It now seems unlikely that Grosseteste was chancellor of Oxford as early as 1214, as historians have previously thought. Like Rashdall, *Universities* (as in note 16), vol. 3, 239, R. Southern preferred to see Grosseteste as a scholar formed entirely in England, in his *Robert Grosseteste: The Growth of an English Mind in Medieval Europe* (Oxford, 1986); see now, however, J. Goering, "When

and Where Did Grosseteste Study Theology?" in *Robert Grosseteste: New Perspectives on His Thought and Scholarship*, ed. J. McEvoy (Turnhout, 1995), 17–52; N. M. Schulman, "Husband, Father, Bishop? Grosseteste in Paris," *Speculum* 72 (1997), 330–46; and C. Panti, *Moti, virtù e motori celesti nella cosmologia di Roberto Grossatesta, studio ed edizione dei trattati De Sphera, De Cometis, De Motu Supercelestium* (Florence, 2001), 24–34.

18. E. A. Moody's discussion of William of Auvergne's theories of light and vision remains valuable; see Moody, "William of Auvergne and His Treatise *De Anima*," in his *Studies in Medieval Philosophy, Science, and Logic* (Berkeley, 1975), 46–54.

19. On the importance of this period for Grosseteste, see E. S. Laird, "Robert Grosseteste, Albumasar, and Medieval Tidal Theory," *Isis* 81 (1990), 684–94, at 685; Goering, "When and Where" (as in note 17), 18–19, analyzing Gerard of Wales's description of Grosseteste as skilled in medicine, ca. 1195. On Grosseteste's reconciliation of Avicenna's interior senses with Augustine's psychology, see J. McEvoy, *The Philosophy of Robert Grosseteste* (Oxford, 1982), 267–68, 295–96, 341–42.

20. Panti, *Moti, virtù* (as in note 17), 24–25.

21. S. Marrone, *William of Auvergne and Robert Grosseteste: New Ideas of Truth in the Early Thirteenth Century* (Princeton, 1983), and, more recently, his *The Light of Thy Countenance: Science and Knowledge of God in the Thirteenth Century*, vol. 1, *A Doctrine of Divine Illumination* (Leiden, 2001).

22. On peasants' right to glean, see B. A. Hanawalt, *The Ties that Bound: Peasant Families in Medieval England* (Oxford, 1986), 50. For imagery related to Figure 2 in a probably coeval manuscript, Paris, B.N.F., Ms. fr. 412, produced in Paris for the scholar Richard de Fournival in 1285; see E. Sears, "Sense Perception and Its Metaphors in the Time of Richard of Fournival," in *Medicine and the Five Senses*, ed. W. F. Bynum and R. Porter (Cambridge, 1993), 17–39, 276–83.

23. A sensitive introduction to Grosseteste's thinking on light is A. Speer, "Physics or Metaphysics? Some Remarks on the Theory of Science and Light in Robert Grosseteste," in *Aristotle in Britain* (as in note 15), 73–90.

24. This is, in origin, indisputably a Plotinian thesis that goes back to Plato's *Republic*, a connection some scholars have missed thanks to Grosseteste's frequent references to Aristotle for specific supporting arguments. See D. C. Lindberg, "The Genesis of Kepler's Theory of Light: Light Metaphysics from Plotinus to Kepler," *Osiris*, ser. 2, 2 (1986), 4–42, at 15–16; see also K. Hedwig, *Sphaera Lucis: Studien zur Intelligibilität des Seienden im Kontext der mittelalterlichen Lichtspekulation*, Beiträge zur Geschichte der Philosophie und Theologie des Mittelalters, n.s. 18 (Münster, 1980).

25. Al-Kindi's *De radiis* (or *Theorica artium magicarum*) has been critically edited in M.-T. d'Alverny and F. Hudry, "Al-Kindi *De radiis*," *Archives d'histoire doctrinale et littéraire du Moyen Âge* 41 (1974), 139–259. In addition to Lindberg, *Theories of Vision* (as in note 8), 19, 96–99, and "Genesis of Kepler's Theory" (as in note 24), 13, see P. Travaglia, *Magic, Causality, and Intentionality: The Doctrine of Rays in al-Kindi* (Florence, 1999); and

R. C. Dales, "Robert Grosseteste's Views on Astrology," *Mediaeval Studies* 29 (1967), 357–63.

26. "Emanation" is, for Neoplatonists beginning with Plotinus, a technical term, one difficult to explain; see P. Merlan, "Emanationism," in *Encyclopedia of Philosophy* (as in note 7), vol. 1–2, 473–74. The use of the vocabulary of emanation by a medieval scholar is, therefore, prima facie evidence of his indirect or direct familiarity with Neoplatonic theory.

27. As, e.g., Grosseteste, *De lineis, angulis, et figuris seu de fractionibus et reflexionibus radiorum*, in *Die philosophischen Werke des Robert Grosseteste, Bischofs von Lincoln*, ed. L. Baur, Beiträge zur Geschichte der Philosophie des Mittelalters 9 (Münster, 1912), 59–65, at 60, lines 17–18; trans. D. C. Lindberg, in *A Source Book in Medieval Science*, ed. E. Grant (Cambridge, Mass., 1974), 385.

28. An "etymon" is a modern label for an original, root (or true) meaning of a term; at least as early as the twelfth century, scholars referred to such a semantic core as the *vis* or *virtus sermonis*. On the notion of the *virtus sermonis*, see W. J. Courtenay, "Force of Words and Figures of Speech: The Crisis over *Virtus sermonis* in the Fourteenth Century," *Franciscan Studies* 44 (1984), 107–28.

29. There were theological overtones for this distinction in the language of the Bible. Thus, the original light of the universe that God created on the first day was *lux*: see Genesis 1:3: "dixitque Deus fiat lux et facta est lux." John 1:1–9 not only provides the basis for identifying Christ as God's Word and the Light of the World (*lux mundi*), but explicitly distinguishes John the Baptist as the *lumen* from the true light (*vera lux*) coming into the world which he announces. On the distinction between *lux* and *lumen*, see Lindberg, "Genesis of Kepler's Theory" (as in note 24), 18–20, 23–29.

30. Grosseteste, *De operationibus solis*, par. 7, in J. McEvoy, "The Sun as *Res* and *Signum*: Grosseteste's Commentary on Ecclesiasticus ch. 43, vv. 1–5," *Recherches de théologie ancienne et médiévale* 41 (1974), 38–91, at 69–71; *De iride*, ed. Baur (as in note 27), 72–73; *In posteriorum analyticorum libros*, 2.4, ed. P. Rossi (Florence, 1981), 386; *Hexaëmeron* 10.1–2, in Robert Grosseteste, *Hexaëmeron*, ed. R. C. Dales and S. Gieben, Auctores Britannici Medii Aevi 6 (London, 1982), 97–99. Grosseteste is not drawing directly on Plato, but on Augustine, as McEvoy and Lindberg document, in the articles cited here and in note 24.

31. K. Tachau, "What Senses and Intellect Do: Argument and Judgment in Late Medieval Theories of Knowledge," in *Argumentationstheorie: Scholastische Forschungen zu den logischen und semantischen Regeln korrekten Folgerns*, ed. K. Jacobi (Leiden, 1993), 651–66; R. Sorabji, *Animal Minds and Human Morals: The Origins of the Western Debate* (Ithaca, N.Y., 1993).

32. Nemesius was a late-fourth-century Christian physician and follower of Plotinus, founder of Neoplatonism; see *Némésius d'Émèse, De natura Hominis: Traduction de Burgundio de Pise*, ed. G. Verbeke and J. R. Moncho (Leiden, 1975), 71, 81, 86, 89. See also W. Pagel, "Medieval and Renaissance Contributions to Knowledge of the Brain and Its Function," in *The History and Philosophy of Knowledge of the Brain and Its Functions*, ed. F. N. L.

Poynter (Oxford, 1958), 95–114, at 98–99 (although Pagel thinks Nemesius mentioned only three ventricles).

33. Translation from B. S. Eastwood, *The Elements of Vision: The Micro-Cosmology of Galenic Visual Theory According to Hunayn Ibn Ishāq,* TAPS 72, pt. 5 (Philadelphia, 1982), 19. Hunayn's views would become known to readers of Latin under the name of Constantine the African, the eleventh-century translator of his *De oculis* and *Introduction (Isagoge)* to Galen's *Tegni.*

34. For William of Auvergne (who enumerates the common sense, imagination, memory, estimative sense, and *vis ratiocinativa*), see Moody, "William of Auvergne (as in note 18)," 46–48.

35. See A. Mark Smith, "Getting the Big Picture in Perspectivist Optics," *Isis* 72 (1981), 568–89; K. Tachau, "'Et maxime visus, cuius species venit ad stellas et ad quem species stellarum veniunt': *Perspectiva* and *Astrologia* in Late Medieval Thought," in *La Visione e lo sguardo nel Medio Evo,* vol. 1, Micrologus 5 (Florence, 1998), 201–24. I have been conducting a study of such imagery and descriptions which I hope to publish elsewhere; the best collection of such imagery remains E. Clark and K. Dewhurst, *An Illustrated History of Brain Function* (Oxford, 1972).

36. Grosseteste, *In posteriorum analyticorum,* 2.6 (as in note 30), 404; see also his sermon "Deus est," in S. Wenzel, "Robert Grosseteste's Treatise on Confession, *Deus est,*" *Franciscan Studies* 30 (1970), 218–93, at 262. For Avicenna, see his *De anima,* 1.5, 4.1–2, 5.8 (as in note 13), and Verbeke's introduction to that work, *Avicenna Latinus* (as in note 13), vol. 2, pp. 49*–50*, for the different schemas of internal senses in Avicenna's other works.

37. Grosseteste, *In posteriorum analyticorum,* 1.17 (as in note 30), 240–41; see also *Hexaëmeron* 2.9.1–2 (as in note 30), 96–97.

38. See text at note 30 above.

39. Moody, "William of Auvergne" (as in note 18), 59–60; for Bonaventure, see Lindberg, "Genesis of Kepler's Theory" (as in note 24), 17–19; for Henry of Ghent, see Tachau, *Vision and Certitude* (as in note 3), 28–39; S. D. Dumont, "The Scientific Character of Theology and the Origin of Duns Scotus's Distinction between Intuitive and Abstractive Cognition," *Speculum* 64 (1989), 579–99.

40. *Pace* Marrone, *Auvergne and Grosseteste,* 185–86, 195–200, and *Light of Thy Countenance* (both as in note 21), vol. 1, 31–32, 43–50. In both studies, when reading Grosseteste's explicit statements, Marrone evidently does not believe that the bishop means what he says; instead, Marrone states that Grosseteste was only making "use of the *image* of light" or "the *image* of intelligible light," and was merely being "adamant about preserving a role for *the language of vision,* with all it implied about the function of light"; but "it is *impossible* to turn up *any* role for illuminationism *or Augustinian patterns* of thought. For the nuts and bolts of an epistemology sustaining the Aristotelian schema of science to which both scholastics swore allegiance, *the image of light was beside the point*" [emphases mine] (*Light of Thy Countenance,* vol. 1, 46–47, 56–57). Marrone, however, does not provide any method for distinguishing between when we may and when we should not take seriously Grosseteste's "image"

or "language" of vision; thus, see rather, Lindberg, "Genesis of Kepler's Theory" (as in note 24), and Hedwig, *Sphaera Lucis* (as in note 24). Of course, for our contemporaries "spiritual" light may be a metaphor, but if so, we differ on this point from the medieval scholars and artists whom we study; for that reason, it is misleading to characterize corporeal sight as in any way functioning as a "metaphor for more purely spiritual operations," as does B. Rothstein in his otherwise valuable "Vision, Cognition, and Self-Reflection in Rogier van der Weyden's Bladelin Tryptich," *ZKunstg* 64 (2001), 37–55, at 40.

41. See, for example, Roger Bacon, below, note 58.

42. See J. Polzer, "The 'Triumph of Thomas' Panel in Santa Caterina, Pisa: Meaning and Date," *Mitteilungen des Kunsthistorischen Institutes in Florenz* 37 (1993), 29–70. This panel is also discussed in M. Camille, *Gothic Art: Glorious Visions* (New York, 1996), 24–25. There is a closely related, smaller panel painting of the same name, a similar but not exact copy painted by Benozzo Gozzoli while he was in Pisa about 1470–71, now in the Louvre, for which see D. C. Ahl, *Benozzo Gozzoli* (New Haven, 1996), 239–40, her cat. no. 50.

43. Such a distinction is often discussed in commentaries on Peter Lombard's *Sentences,* at book 2, distinction 13, which concerns the nature of light; see E. McCarthy, "Medieval Light Theory and Optics and Duns Scotus' Treatment of Light in D. 13 of Book II of His Commentary on the Sentences" (Ph.D. dissertation, City University of New York, 1976).

44. The Psalter of St. Louis, Paris, B.N.F., Ms. lat. 10525, f. 85v, detail, discussed in Camille, *Gothic Art* (as in note 42), 8–9, 16.

45. There are elements of such depictions in, for instance, the Toledo *Bible moralisée,* from ca. 1226–34: Toledo, Tesoro del Cabildo de la Catedral, Ms. III, ff. 175, 189.

46. For a sample of the passages in which Augustine makes this point, see C. Trottmann, *La Vision Béatifique des disputes scolastiques à sa définition par Benoît XII* (Rome, 1995), 54–59. While Trottmann's is an important study, and one that is especially useful for gaining an initial familiarity with the chief actors and issues in Scholastic debates concerning the Beatific Vision, it is, in my judgment, neither definitive nor entirely unpolemical. See also Marrone, *Light of Thy Countenance* (as in note 21), vol. 1, chap. 4.

47. "Apres il sensuit que par aventure il convient briefment traictier de delectacion. Oresme: Il fu traictie ou VIIe livre de delectacion en tant comme elle est matiere de continence et principalment de delectacion corporele. Et ici il en parle plus pour delectacion de lame intellective" (my transcription), *Les Éthiques d'Aristote,* Nicole Oresme, trans. and commentator, in The Hague, Rijksmuseum Meermanno-Westreenianum, Ms. 10.D.1, f. 193r, as shown in plate 6 of C. R. Sherman, *Imaging Aristotle: Verbal and Visual Representation in Fourteenth-Century France* (Berkeley, 1995). I have benefited greatly from Sherman's important studies of the manuscripts of Oresme's translations for Charles V. Oresme incorporated the perspectivist paradigm (with modifications) into his own theories, as I remarked in Tachau, *Vision and Certi-*

tude (as in note 3), 381–82; see also note 65 below.

48. As is usual in fourteenth-century French, there are no accents or apostrophes in the actual manuscript text.

49. Thus, I do not concur with Sherman's identification of the seated woman as herself the personification of *felicité* either in this image or in the quite different depiction provided the same incipit in a different manuscript, Brussels, Bibliothèque Royale Albert Ier, Ms. 9505–06, f. 198vb. Sherman's further claim, that "[t]he size and beauty of Félicité contemplative, as well as the power of God's head and gesture, mark them as '*imagines agentes*' or '*corporeal similitudes*'," seems to me to reflect an inexact understanding of medieval theories of vision, which I hope the present essay clarifies. See Sherman, *Imaging Aristotle* (as in note 47), 163, 167.

50. See R. H. Rouse and M. A. Rouse, *Manuscripts and Their Makers: Commercial Book Producers in Medieval Paris, 1200–1500*, 2 vols. (Turnhout, 2000), chap. 1.

51. Among the Franciscans who knew Bacon and/or his writings while they were studying at Paris, the most significant were Guillaume de la Mare, Roger Marston, Mattheus de Aquasparta, John Pecham, and Peter of John Olivi (Bacon's first major critic); see Tachau, *Vision and Certitude* (as in note 3), 27, 39–54; K. Tachau, "Some Aspects of the Notion of Intentional Existence at Paris, 1250–1320," in *Medieval Analyses* (as in note 9), 331–53. For Pecham, who, despite his independent study of the sources known to Bacon, closely follows the latter's synthesis, see D. C. Lindberg, *John Pecham and the Science of Optics* (Madison, 1970), 14–29, 34–39.

52. With Alhacen, Bacon recognized that some refracted rays are also efficacious, and offered an experiment to show this; see Lindberg, *Roger Bacon and the Origins of Perspectiva* (as in note 12), lxiv.

53. Oxford, Bodl., Ms. Digby 77, f. 7r, as reproduced in J. E. Murdoch, *Album of Science: Antiquity and the Middle Ages* (New York, 1984), 237; see the redrawn and labeled diagram in Lindberg, *Roger Bacon and the Origins of Perspectiva* (as in note 12), 46–47.

54. Pecham, *Perspectiva communis*, Erfurt, Wissenschaftliche Bibliothek, Ms. Amplonianus Q. 387, f. 32v, from Lindberg, *John Pecham* (as in note 51), pl. 3b (in which see propositions I.32–I.39). See also text at note 63 below.

55. Lindberg, *Roger Bacon and the Origins of Perspectiva* (as in note 12), xlvi–xlviii, discussing Bacon, *Opus maius*, 5: *Perspectiva*, 1.3.3. Pecham's diagram labels the optic nerve as leading to the "locus concursorum ab ambobus oculis."

56. Bacon, *Perspectiva*, I.1.2, in Lindberg, *Roger Bacon and the Origins of Perspectiva* (as in note 12), 6; again I.2.1, p. 22. On Bacon's account of the inner senses, see Smith, "Big Picture" (as in note 35); Tachau, "What Senses and Intellect Do" (as in note 31), 651–66; Lindberg, *Roger Bacon and the Origins of Perspectiva* (as in note 12), xlix–lxxi.

57. Bacon, *Perspectiva*, I.5.1, in Lindberg, *Roger Bacon and the Origins of Perspectiva* (as in note 12), 60, "visus indiget specie rei visibilis . . . secundum quod dicit Aristoteles secundo *De anima* quod universaliter sensus suscipit species sensibilium ad hoc ut fiat operatio sentiendi.

Item oportet patiens assimilari per agens; sed visus est virtus passiva, ut ostendit Aristoteles."

58. Bacon explicitly provided a list of what multiply species that should be (meta)physically exhaustive: substance and accidents; body and spirit; sense and intellect; "indeed, all matter in the universe," *Opus maius*, 4.1.1, in *The Opus Majus of Roger Bacon*, ed. J. H. Bridges, 2 vols. (London, 1897), vol. 1, 111; also Bacon, *On Multiplication of Species*, 1.1–2, and 1.5, ed. in D. C. Lindberg, *Roger Bacon's Philosophy of Nature: A Critical Edition, with English Translation, Introduction, and Notes, of De multiplicatione specierum and De speculis comburentibus* (Oxford, 1983), 2–36, 72–74, lines 61–79. For Pecham, see Lindberg, *John Pecham* (as in note 51), 34–39.

59. Here I cover material discussed at greater length in Tachau, " '*Et maxime visus*' " (as in note 35). For the further importance to Bacon of this reciprocity, see I. Rosier, *La Parole comme acte: Sur la grammaire et la sémantique au XIIIe siècle* (Paris, 1994), chap. 6, 207–31; for al-Kindi, *De radiis* (as in note 25), 224, 230, 233–50; Lindberg, "Genesis of Kepler's Theory" (as in note 24), 13.

60. Bacon, *De multiplicatione specierum*, 1.5, lines 61–79 in Lindberg, *Bacon's Philosophy of Nature* (as in note 58), 72–75; the translation is Lindberg's, with my bracketed insertions.

61. In discussing man's own irradiation of the cosmos, al-Kindi reminds us that man is a microcosm ("unde minor mundus est et dicitur"), al-Kindi, *De radiis* (as in note 25), 230.

62. R. Newhauser, "Der *Tractatus moralis de oculo* des Petrus von Limoges und seine 'exempla,'" in *Exempel und Exempelsammlungen*, ed. W. Haug and B. Wachinger (Tübingen, 1991), 95–136; J. Hackett, "The Hand of Roger Bacon, the Writing of the *Perspectiva*, and MS Paris BN Lat. 7434," in *Roma, Magistra mundi: Itineraria culturae medievalis. Mélanges offerts au Père L. E. Boyle à l'occasion de son 75e anniversaire*, ed. J. Hamesse (Louvain-la-Neuve, 1998), 323–36.

63. C. H. Lawrence, "The University in State and Church," in *History of the University of Oxford*, vol. 1, *The Early Oxford Schools*, ed. J. I. Catto (Oxford, 1984), 102, 107, 113, 115–18; On Pecham and Witelo, see Lindberg, *Theories of Vision* (as in note 8), 116–20; A. Bagliani-Paravicini, "Witelo et la science optique à la cour pontificale de Viterbe, 1277," *Mélanges de l'École Française de Rome: Moyen-Âge, temps modernes* 87 (1975), 425–53.

64. See E. Mahoney, "Sense, Intellect, and Imagination in Albert, Thomas, and Siger," in *The Cambridge History of Later Medieval Philosophy*, ed. N. Kretzmann, A. Kenny, and J. Pinborg (Cambridge, 1982), 602–22; Lindberg, *Theories of Vision* (as in note 8), 104–7.

65. Lindberg, *Theories of Vision* (as in note 8), 120–46.

66. This general readiness extended even to authors who, like Giles of Rome, accepted the Platonist view that the intellectual faculties possess innate Ideas.

67. I have explicated Auriol's views at length in Tachau, *Vision and Certitude* (as in note 3), 85–112. Auriol taught at Paris from 1316 to 1319, if not longer; his *Sentences* lectures reveal considerable familiarity with the work of Alhacen (as well as Bacon and many of the latter's ancient, patristic, and Arabic sources).

68. See Stroud, *Quest for Reality* (as in note 1). While present-day debates are generally grounded in the writings of Descartes, Locke, Berkeley, or Hume, few philosophers appreciate that these authors inherited the framing of the issues from the medieval theologians who developed or drew upon the science of *perspectiva*.

69. In addition to Lindberg, *Theories of Vision* (as in note 8), 147–68, see, e.g., S. Y. Edgerton, *The Heritage of Giotto's Geometry: Art and Science on the Eve of the Scientific Revolution* (Ithaca, N.Y., 1991).

70. For instance, Grosseteste, Bacon, and Albertus Magnus commented regarding light passing through colored-glass windows, painters' inability to depict the shifting colors of the rainbow, and which colors painters cannot obtain by mixing when discussing Aristotle, *De sensu et sensato*, 4, 442a19–29; *Meteorologica*, 3.2, 371b34–372a11; also 3.5, 375a1–11; see also Nicole Oresme's treatment of relief and shading in P. Marshall, "Two Scholastic Discussions of the Perception of Depth by Shading," *JWarb* 44 (1981), 170–75; Tachau, *Vision and Certitude* (as in note 3), passim.

71. My translation, from Bacon, *Opus maius*, 4 (as in note 58), vol. 1, 210–12. Bacon's references here to the terms' significates and their properties (*significata terminorum et rerum significatarum proprietates*) tie this passage to his semantics, for which see Rosier, *Parole comme acte* (as in note 59). This passage has also led C. Parkhurst to suggest links between Giotto and Bacon in his "A Viewpoint for Giotto's *Life of Mary* in the Arena Chapel," in *Shop Talk: Studies in Honor of Seymour Slive Presented on His Seventy-Fifth Birthday* (Cambridge, Mass., 1995), 194–97; see also Edgerton, *Heritage of Giotto's Geometry* (as in note 69), 48.

"As far as the eye can see . . .": Rituals of Gazing in the Late Middle Ages

Thomas Lentes

Therefore, thou must look neither at the sin in the sinners nor in your own conscience . . . thou must rather turn thy back on sin and look at a holy image and form that same picture in thyself with all thy strength and with all thy might and be always mindful of it. The holy image is none other than Christ himself upon the cross and all his beloved saints. . . . Through mercy and grace, Christ on the cross removes thy sins from thee, carries them, and strangles them; keep this always in mind and doubt it not—this means, look at this holy image and make it thy own.[1]

Although these words might very well have been uttered by a late medieval iconolater, they come, in fact, from the mouth of none other than Martin Luther. Undoubtedly, Luther had material images in mind only as a negative and wanted to encourage his readers and listeners to turn from outer to inner images.

Nevertheless, the logic as well as the great confidence of late medieval piety in images as well as in gazing can best be explained with the help of Luther's dictum. As was later echoed in his own words, images were places of prayer, forming a link between this world and the next, just as much as they were intended to release inner images that served to transform, expiate, and purify man of his guilt. By means of the eye and sight, it became possible for the pious to come into contact with the people from the hereafter in pictures, a contact that we can hardly imagine realistically.[2]

These foundations of the late medieval use of images have still not been studied in great detail, let alone made fruitful for a history of vision.[3] This report is less concerned with the use of images in liturgy than it is with the area of so-called private prayer. First, in order to name several categories for a history of the gaze within religion, the still floating concept of *Schaufröm-migkeit* (hereafter, "visual piety") needs clarification. Next, the extent to which the personal and individual picture-prayer was fed by liturgical ritual concepts will be examined.

What Is "Visual Piety"?

"Gothic piety" is distinguished essentially by a "devotional gaze," a "curiosity," a "visual piety," indeed, even a "visual addiction"—or so, at least, researchers in German-speaking countries have

repeatedly claimed since the time of Ildefons Herwegen and his student Anton L. Mayer.[4] In this scheme, the pious of the late Middle Ages would have tried to secure their salvation simply through eye contact with whatever objects of salvation might be available—for instance, the host being elevated, the relics in the *ostentatio*, or icons. According to Herwegen and Mayer, the aim and crucial point of all vision would have been the "salvatory gaze." The history of the effectiveness of this assessment has yet to be written. But just how influential this thesis has been and how this description has been able to become a tag of the late Middle Ages can be seen in the question posed by Reformation historian Peter Blickle : "Why did people in 1515 want to 'see' the Host, and why in 1525, did they want to 'hear' the plain Word of God?"[5] The importance of the gaze for piety in the late Middle Ages can hardly be stressed enough, yet it has been the primary aim of scholars to place a general level of importance upon the gaze with respect to piety. Furthermore, the differences in the relationship between gaze and piety need to be better explained for earlier and later epochs. Still, one cannot help but assign a high level of importance to the gaze during the Catholic Baroque period as well as to the medieval, with respect to the eucharistic apparatus and, especially, to the viewing of the Host.[6]

The deficiencies of the thesis of visual piety, as presented by Mayer and Herwegen, are clear from their completely magical conception of sight. Gazing would not have meant communication between the (sacred) object and the seeing subject; rather, it would have been an automatism of salvation. Whichever sacred object the eye met, it would have come into contact with holy material: "Strictly physical vision concerns the simplest, most primitive type of sensual connection with the object and with the belief in the effect, the blessing, and the power of the sensual-human contact alone."[7] In this interpretation, however, the eucharistic and reliquary cults did not necessarily concern themselves with the sacred or godly object; instead, the aim of piety was "(through) the act of 'viewing,' an execution of the sensual act itself, in the plain reality of the primitive-sensual connection."[8] However much this applied to parts of the practice of piety, modern research has absorbed this concept to such an extent that differentiated representations of visual expectations, as well as of visual rituals, have not been forthcoming.[9] This "magical" gaze could come into question even by the raising of the Host during Mass. Still, the raising of the Host was part of a ritual and was to be accompanied by prayers and the like.[10] The second, more questionable thesis constantly repeated by Mayer goes much further. To him, visual piety was the example par excellence of the decadence of late medieval piety. The objective aspect of the liturgy would thus have been completely transported into the private-subjective area and would eventually have "corroded" all liturgical-sacramental action.[11] Although research of the past twenty years has increasingly emphasized the push to subjectify during the late Middle Ages—and hence bequeathed the period noticeably more positive connotations—another tendency has been ignored: namely, that of the strengthening of the objective-liturgical moment in private prayer.[12]

Opposed to the thesis of visual piety is the representation of the meaning of gazing and sight in a more differentiated manner. In this way, the connection of vision to medieval anthropology, as well as its relationship to the other senses and to the practice of seeing, can be independently described.

Tentatively, the following questions may be formulated:

1. If there is a basic anthropological thesis in the literature of piety as well as in the moral didactics and literature of the late Middle Ages, then this is similar to Luther's quotation "You become what you see."[13] Again and again, late medieval preachers emphasized that the eye and sight had to be guarded because the inner person would always adapt to what he saw. And, inversely,

they assumed that the inner state of a person could be deciphered from the manner in which he gazed. A person's manner of gazing, his eye, and his sight were all indicators of the salvatory state of a person as, inversely, the inner person was to be trained by means of his eye and the manner in which he gazed. In this context, a completely coherent theory of image was been elaborated for the practice of piety. The inner person, the *imago Dei*, was an area where good and bad images were projected. By means of contemplating images, this *imago* was to be purified. The images penetrated the eye and were, so to speak, engraved upon the interior person. Thus, from the point of view of many forms of meditation of the Passion, the individual person was again to become a picture, the spitting image of what he gazed on in his meditation, an example, indeed, for other people. This practical theory of image and gaze has not yet been examined in detail as a driving force behind the manner in which pictures were used. However much images may have been magically used, the fact that the eye and the gaze were so decisive with regard to the salvatory state of a person meant that the use of images was beyond questioning and was the order of the day.

2. The proponents of the concept of visual piety have failed to recognize that the gaze and the use of pictures were based upon contemporary anthropological theses. In addition, the whole area of the interrelationship of all the senses was ignored and gaze was isolated. For example: self-descriptions of the viewing of images are generally descriptions of synesthetic experiences. Above all, it is a question of taste, or even, still better, of sweetness.[14] Whether it is Rupert of Deutz in the twelfth century, Mechthild of Magdeburg or Henry Suso in the thirteenth and fourteenth centuries, or anonymous nuns in the fourteenth and fifteenth centuries, the people who contemplated images reported that seeing was a gustatory experience, indeed, one of sweetness. The outer view had, by no means, only a visual effect; what was seen was intended to be tasted as well, at least by means of inner senses. The instructions for viewing found in prayer books have this kind of logic, too, and they run as follows: "Look and linger there where you experience the most pleasure."[15]

We are still far removed from a typology, not to mention an understanding of such "synesthetic" moments or a correlation between vision and the other senses.

3. Because of their magical concept of the gaze, the proponents of the concept of visual piety completely misunderstood that both gazing at and meditating on a picture *meant* communicating with *it*. Moreover, the act of seeing was by no means the only thing that occurred in front of the picture. An example taken from a late medieval prayer book demonstrates this: "If you are saddened, go and stand before a crucifix or kneel before it and repeat the Psalm *Ad te levavi* (I raise my eyes to you). Then say: "Lord and my Savior, see my sadness . . . and cleanse me of my sins . . . through your most noble suffering and countenance upon the cross."[16] This can apply as the standard formula of the picture-prayer for prayer books. The exchange of gazes with the picture and the person in the picture, however, was striven after: "Look at the picture and then pray: Look at me." This exchange of looks was accompanied by a practical choreography, which was often described in the minutest detail in prayer books. Just as synesthesia was an issue when concerning sight, movements of the entire body were a factor in the repertoire of gestures. So, for instance, an exact chronology of bodily poses is prescribed for the recitation of the Lord's Prayer seventy-seven times before the picture of the Mount of Olives;[17] only those who used the right gestures in front of the picture could be sure that the person in it would look at them with merciful eyes and would likewise hear their prayer. Alas, however, we are still far removed from a detailed description of such rituals of gazing and of the entire behavior in front of images.

4. Finally, it is important to review the scope of the thesis of visual piety: Who could actually

see? When could he see? And what could he see? The basic condition of sight, the very physical ability to see, has yet to be examined for its cultural importance in relation to the perception of images and the esteem in which they were held. When one considers that Huldreich Zwingli, himself one of the leading theorists of iconoclasm in the sixteenth century, stated that images had no effect upon him—due to his nearsightedness, he was hardly able to see[18]—it can be construed just how much the physical sense of sight was connected to the interpretation of images. The role that perception, not to mention the expectations that people had of perception, played in a society that hardly knew how to correct nearsightedness ought to be described in far greater detail.[19] Similarly, research into questions regarding the accessibility of images, the covering and uncovering of images, the lighting within church interiors, etc., has only recently begun. As long as no detailed research in the area of the visibility of images, the accessibility within hierarchically segregated church rooms, and the evolution of altar paintings exists, we can assume only that the paintings and their visibility or invisibility were part of a staging strategy, which, in turn, constituted the foundational theological ritual. Where altarpieces were opened for particular feast days during the year, changes in the images portrayed the progression of the holy year and salvation; the covering and uncovering of images resemble a ritual staging of the Christian story of salvation. When the altar of the Petrikirche in Dortmund was opened, the revelations of Christianity could be viewed in their entirety—the embodiment, the life and sufferings of Christ, as well as his eternal presence in the Sacrament. This networking of staging strategies, visual practice, and religious experience is only in the preliminary stages of research.[20] It is also important to keep the lighting strategies in mind, since they affected the altarpieces and the subsequent experiences induced. It is not only that the *Goldene Wunder* ("The Golden Miracle," the altarpiece in the Petrikirche) works differently in different lighting situations, but that its legibility was completely dependent upon proper lighting. Just as the glittering gold of the altar often produced only a full view of the altar in the eye of the beholder, individual parts of the altar could be recognized only in particular lighting situations.

The Multiplicity of Gaze, or Forms of Seeing

Pictures were looked at in different ways and with different intentions. This may sound banal at first, but it merits a more precise description. From looking at the image, people expected consolation—as in the *Ars moriendi*—just as much as they expected that the image with its *occuli misericordiae* or *indulgentiae* would give indulgence and mercy. People paused in front of it to purify themselves internally, to collect themselves, and to become united with it in contemplation.

Here we can discern different key forms of the gaze with regard to images and their viewing. Three elements may have been essential for iconography in the late Middle Ages:

1. First of all, there is the "heilbringende Schau" or "salvatory gaze." Hardly any other picture provides a better example than Ostendorfer's print of the Fair Virgin of Regensburg (Fig. 1). Regardless of how one interprets the gestures in Ostendorfer's print, whether as a caricature or as the presentation of hysteria during a pilgrimage, it is true—especially with respect to the more famous icons—that they were probably never simply *seen*; rather, prayer would have been conducted in a bodily manner in front of the altarpiece in order to gain Mary's mercy. Neither the act of looking at the picture nor the act of gazing should be isolated; the complete choreography during the prayer in front of the picture must be considered.

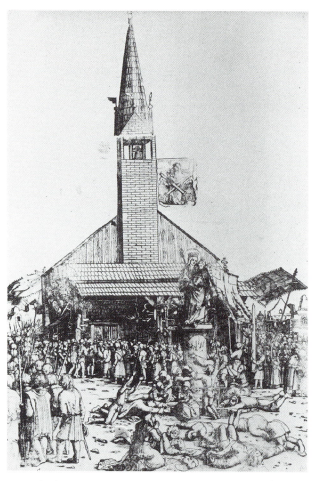

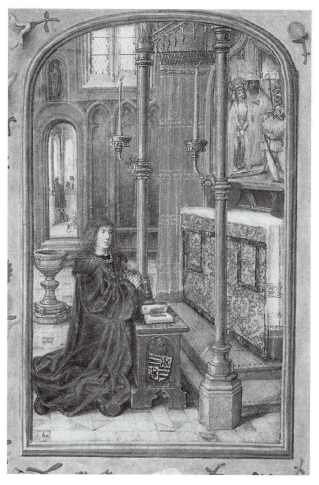

1. Michael Ostendorfer, pilgrimage to the Fair Virgin of Regensburg, woodcut, about 1519

2. A lone worshipper on the prie-Dieu in a Book of Hours, Ghent, 1510–1520. Vatican, Biblioteca Apostolica Vaticana, Ms. Vat. Lat. 3769, f. 66v

Furthermore, the excessive emotional gestures of the pilgrims in the picture may be traced back to the rituals from which they originate: the kneeling, the praying posture, the prostration, and the praying in cruciform. In every way, liturgical gestures in front of pictures take priority over private prayer. Here, a process that may be typical of the fifteenth century can be examined: the liturgization of the private realm. Through the confrontation with images of mercy, liturgical gestures were carried over into the private realm of piety, as practitioners hoped to achieve a greater chance of their prayers being heard.

2. Alongside the use of gesticulation in front of images, a new kind of behavior evolved in the late Middle Ages, namely, the gaze of devotion. A typical example of this is the lone worshipper on the prie-Dieu (Fig. 2), who, in inner contemplation, holds a devotional pose with folded hands and prayer book in front of an icon. In this picture it is no longer a question of the body being contorted in an attempt to convince the image by means of gestures and gesticulation. The body before the icon is presented as almost immobilized, thus creating an impression of greater inner contemplation.

Nevertheless, we should be careful in our interpretation of this devotional gesture and should

3. Fra Angelico's *Annunciation* at the entrance to the dormitory of San Marco

not speak too rashly of contemplation, nor should we understand the word "devotion" in its modern, subjective, and emotionally charged sense. By the fourteenth and fifteenth centuries *devotio* (devotion) had long been a fashionable concept.[21] Whoever wanted to be seen as pious had to be "devoted." Devotion also meant indulgence. It is not necessary, therefore, to record, as Hans Belting has done for the *imago pietatis*, that the same artistic form was capable of fulfilling various functions of piety.[22] The very same pious gesture, that of devotion, was used to illustrate that quite different intentions could be pursued with it, whether attaining indulgence or contemplation. Those studying devotion to images must examine each individual case carefully.

In addition, the person praying on the prie-Dieu is the ideal and the product of an increasing discipline of gesture and gaze. High and late medieval attempts to hold the body still and thereby create an inner sphere of devotion would have created a new formula of gestures, which probably became a standard form of icon prayer in the late Middle Ages.[23]

Pictures such as Ostendorfer's print show, however, that this attempt at standardization only partially succeeded. In cases where one hoped to receive a pardon or to benefit from a miracle or healing from the image, bodily prostration was still common before the icons. Furthermore, lingering before certain pictures was not intended; rather, they were to be glanced at in passing. The best-known example of this "passing glance" is probably Fra Angelico's *Annunciation* at the entrance to the dormitory of San Marco (Fig. 3).[24] It is a typical processional picture which the fri-

ars passed in procession when entering and leaving the dormitory. The inscription upon the picture even instructs the viewer: "VIRGINIS INTACTE CVM VENERIS ANTE FIGVRAM PRETEREVNDO CAVE NE SILEATUR AVE" (When you pass by the image of the eternal Virgin, be sure not to forget to say the Ave). The picture did not invite one to linger, but rather provided the function of a processional way marker, a glance like a prayer in passing.

In the case of the Fra Angelico, the "passing glance" is still liturgically and ritually connected to Dominican liturgy; it is also found repeatedly in private prayer. How often did the *imago pietatis* bear inscriptions such as this: "O Vos omnes qui transitis per viam . . . " (O you all who pass by . . .).[25] The image of Saint Christopher would certainly be the most famous example of such a glance in passing. Pictures were, therefore, not only intended to be lingered in front of, but also to function as memorial stones in everyday life.

3. A final type of gazing specific to the late Middle Ages portrays the inner gaze, or the *imaginatio*.[26] Image devotion and prayer were directed, above all, toward the creation of interior spaces of vision as well as the change from one world to the next. The outer gaze at a material picture was often only an occasion for creating inner images. Images of the Passion, for example, visualized whatever aspects of the contemplation of the Passion were to be created by the inner eye: the memory of Christ's suffering and death. External and internal gazes were complementary. The inner person was perceived as a place into which images that penetrated the external eye could be projected. Through the worship of images, the internal space for vision was intended to be filled with images of salvation and of the saints.

Image, Gaze, and Liturgy:
Between Objective–Subjective and Liturgical–Private

The proponents of the thesis of visual piety have restricted their discussion to the subjectivization of the liturgical, claiming that this had obscured the very essence of ritual. Conversely, it is important to work out more clearly to what considerable extent the way images were looked at meandered between the objective and the subjective, from liturgy to private piety. Regarding an ideal type, two strains with many nuances can be distinguished in the late Middle Ages.

One strain was the privatization of the liturgy by pictorial and visual means, as has been one-sidedly emphasized by the proponents of visual piety. According to their thesis, private gaze had dissolved liturgy. And in fact this can hardly be disputed with regard to the practice of elevation of the Host during the Mass. The mystics of the fourteenth century indicate tendencies to reconstruct the liturgy in subjective and visionary terms.[27] Official sacramental action, by contrast, faded out completely. If we bear in mind the many visions recounted in connection with the liturgy, it seems that mystics assumed that the (objective) liturgy could be implemented only through private experience.

The other strain was a counter-movement specific to the fifteenth century: the "liturgization" of privacy. The liturgy was the force behind the private image cult; whoever prayed in front of an icon in the late Middle Ages was seeking not isolation but connection—with the liturgical, the ecclesiastical, indeed, the official-sacramental. It was not for nothing that Martin Luther claimed in his "Admonishment of the Clergy in 1530" that, by means of boards and pictures, the pope gained access to "chambers and parlors."

The fusion of liturgy and private prayer can be described on at least five different levels.

1. To date, not enough research has been conducted on the extent to which public space could also be used for private image devotion. Richard Marks is currently concluding initial research on the use of images in parish churches in England.[28] The very use of images of Saint Christopher as well as the indulgences for individual images, or, indeed, even for the veneration of stained-glass windows in town churches, lead us to believe that public sacred space was used not only for official-sacramental purposes, but also—and indeed probably primarily—for private prayer. This is likely to have been the case because, among other reasons, sacred space, hallowed as it was by consecration and liturgy, promised the greater guarantee of a person's prayers being heard.

2. The extent to which iconography was fed from liturgy is not yet clear. The share of liturgy in iconographic invention and the standardization of representation for the life of Christ and the Passion can hardly be overestimated. The liturgical interpretation of both the Mass and hourly prayers was always connected with the individual stages of the Passion. This is a classic case of the meandering between the liturgical and the private. In the course of the late Middle Ages, exact instructions were given as to which stage of the Passion belonged to which hour or to the corresponding psalms. This type of gazing during the liturgy had an influence on the production of images that cannot be overestimated. After all, it led to a specific type of image, the so-called Table of Hours (Horentafel), a subject that has not been investigated before now. Such a Table of Hours is preserved in the Cathedral of Lübeck (Fig. 4), where seven tables present an image to contemplate for each hour of the Stations of the Cross. The meditations on the Passion for the hourly prayers were thus visualized by those pictorial panels. The Passion was thus placed as a subtext, an underlying text of liturgical prayer, intended to serve the private devotions during the official liturgy. The same use of images one must also be assumed for other settings, especially in choir altarpieces in cloisters. In places such as the high altar in the Blaubeuren cloister[29] or in the Petrikirche in Dortmund, we can assume that the divisions of the panels with scenes from the life of Christ or of the Passion were intended for just such a use during the liturgy. Obviously—at least to state the thesis—it was the liturgy that fed the whole imaginative paraphernalia of the iconography of the Passion.

It is still unclear today how much this practice of viewing the life of Christ or the Passion during the liturgy formed and molded the actual sphere of private devotion. It is, however, clear that the successful books about the meditation of the Passion, such as the *Meditationes vitae Christi* or Ludolph of Saxony's *Vita Christi* were exactly oriented toward this liturgical scheme. It is true that they offer a complete contemplation of the life and sufferings of Christ, but this is always exactly subdivided into the liturgical hours of the Office.

3. If private pictures were used in public spaces during the liturgy, they could just as well have taken on a virtual liturgical function in private places, where they could have been used analogously to church fixtures to create a holy space. Thus, a picture could serve as an altar in a private home, just as many pictures embellished private altars in private homes. As in the liturgical offertory, the pictures were brought offerings in the form of prayers, flowers, or candles. How many small-format altar paintings were in existence in private use and how they were used remain unknown factors, still to be studied. It is incontestable that the liturgical formula—and even more particularly the triptych—entered the private sphere in this way.

4. If the picture could become an extra-liturgical place of worship, it could even better fulfill another basic function of the liturgy: the *Memoria Passionis,* in the sense of placing the historical time of salvation on a par with the present time of the viewers. If we follow an interpretation often presented, we can best illustrate this by the very well-known example from the Book of

4. Table of Hours preserved in the Cathedral of Lübeck

Hours of Marie de Bourgogne (Fig. 5). In the second full-page miniature, the worshiper has disap-
peared, having stepped from the frame into the picture; the worshiper is thus placed in the same
setting in time as the Crucifixion. Similarities can be found in many old Flemish paintings.

Thus, imagination and the contemplation of images were fed by the liturgy, which preached
"Now is the time," "Now is the hour," allowing the act of salvation, which was historically past,
to repeat itself in ritual. This was exactly what happened in private image devotion: the praying
persons changed from the here-and-now into the space and time of Jerusalem and the Passion.

Many a picture demanded corresponding gazing gestures from the viewer. This is most evi-
dent in the example of the panorama pictures of the Passion or on the altar in Amelsbüren (Fig.
6). The simultaneous presentation of the individual Stations of the Passion allows the inquisitive
eye to reconstruct time and to recall it anew every time. Looking at these pictures was by no

5. Book of Hours of Marie de Bourgogne, Vienna, Österreichische Nationalbibliothek, Cod. 1857, fol. 43r

means a changing of place, but rather a recapitulation of time, thereby placing the time viewed on a par with the viewer's time.

5. The Mass of St. Gregory[30] clearly illustrates the way in which private devotion was transformed into something liturgical, consequently with a specific gesture for a specific picture. Whether in private space or in the private pictorial genres, such as the epitaph and the engraving, predominantly lay people used the liturgy for their private pious practices. The Mass of St. Gregory by the Master of the St. Bartholomew Altar (Fig. 7) can serve as an illustration of how the presentation of the Mass gained access to the area of private devotion. Though we know little of the historical background of this picture, it is clear from its measurements alone, barely 28 cm × 19.5 cm, that it can only have been a picture intended for the private sphere.

In terms of its contents, the Mass of St. Gregory is no different; it shows private devotion bound to both the liturgy and the pope. Viewers could view the picture only over the shoulder of

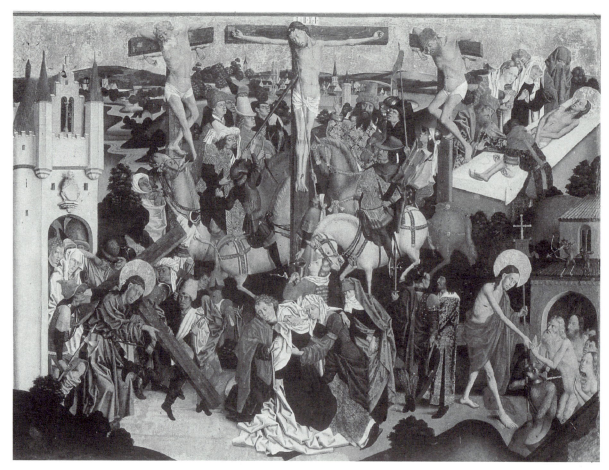

6. Panorama pictures of the Passion or on the altar in Amelsbüren, Münster, Westfälisches Landesmuseum für Kunst- und Kulturgeschichte

the pope. The official sacramental connection to the private viewing of pictures can hardly be expressed more clearly. In particular, the liturgy was imitated by the gesture of the gaze demanded by the picture. In many representations of the Mass of St. Gregory, as in the print of Israhel van Meckenhem (Fig. 8), there is a calculated change between the view from above and the view from below; these challenge the viewer into a particular type of gesture to comprehend the picture. The viewer views the altar from above, and, inversely, the *corpus Christi* from below. This change of view takes place with the sacramental chalice. The gaze of the viewer is also transformed by looking at the picture, and it carries out the actions of the priest at the altar, namely, the consecration and the transubstantiation.

The Prospects

This report is merely a thesis and therefore it is also a plea for further research. The aim is clear: to better situate the liturgical and sacramental connections among image, eye, and gaze. This is all dependent upon a specific understanding of images which identifies the image as being a place

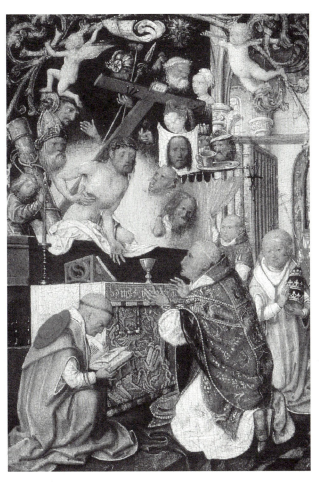

7. Master of Saint Bartholomew's Altar, *Mass of St. Gregory*, 1500–1505. Trier, Bischöfliches Diözesanmuseum

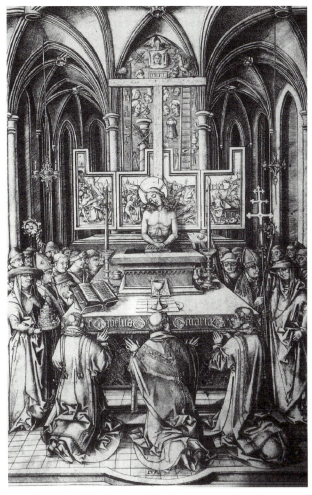

8. Israhel van Meckenhem, *Mass of St. Gregory*, engraving, 1490/1495

of holy presence. This admittedly has much less to do with magic than with an understanding of the sacraments of the Middle Ages. According to the sacramental theology of the Mass, the creation of holiness upon the altar was equally dependent upon both pictures and picture worship. An investigation into rituals of gazing effectively brings the thesis of visual piety out of the realm of magic and into the center of Christian sacramental doctrine. If the sacramental performance was based upon the interplay of three factors—the material (bread and wine), the *verba et signa* (or word and gesture), and the intention—image devotion was based upon these same elements. The material picture was not only venerated through word, gaze, and gesture, but also was actually sanctified and could, accordingly, be used for different purposes. Succinctly put: images were the very sacrament of the pious—and the gaze and picture worship were their liturgy.

Notes

This article simply outlines the work being done by the research group "Cultural History and Theology of Images in Christianity," which I am heading at Westfälische Wilhelms-Universität, whereby until the end of 2005 the re-

lationship between religion and visuality is being studied. Based upon that, the following theses are still of a largely preliminary nature and contain only the most necessary notes. For further information, see http://www.uni-muenster.de/kultbild.

1. Martin Luther, *Ein Sermon von der Bereitung zum Sterben* 1519, *Martin Luthers Werke: Kritische Gesamtausgabe,* vol. 2 (Weimar, 1884), 685–97, at 689; translated according to Martin Luther, *Ein Sermon von der Bereitung zum Sterben,* trans. K. Bornkamm, in Martin Luther, *Erneuerung von Frömmigkeit und Theologie* (Martin Luther, *Ausgewählte Schriften,* vol. 2, ed. K. Bornkamm and G. Ebeling [Frankfurt a.M., 1990], 22).

2. For further information, see T. Lentes, "Inneres Auge, äußerer Blick und heilige Schau," in *Frömmigkeit im Mittelalter: Politisch-soziale Kontexte, visuelle Praxis, körperliche Ausdrucksformen,* ed. K. Schreiner (Munich, 2002), 179–220.

3. The best overview of budding information can be found in K. Schreiner, "Soziale, visuelle und körperliche Dimensionen mittelalterlicher Frömmigkeit," in *Frömmigkeit im Mittealter* (as in note 2), 10–38, esp. 21–30.

4. A. L. Mayer, "Die heilbringende Schau in Sitte und Kult," in *Heilige Überlieferung: Ausschnitte aus der Geschichte des Mönchtums und des heiligen Kultes,* Festschrift Ildefons Herwegen, ed. O. Casel (Münster, 1938), 234–62; I. Herwegen, *Kirche und Seele: Die Seelenhaltung des Mysterienkultes und ihr Wandel im Mittelalter* (Münster, 1936); I. Herwegen, "Liturgie und Volksandacht," *Hochland* 16, no. 2 (1919), 618–25. For criticism on this topic, compare A. Angenendt, *Liturgik und Historik: Gab es eine organische Liturgie-Entwicklung?* Quaestiones Disputatae 189 (Freiburg, 2001), 60–65; and N. Schnitzler, "Illusion, Täuschung und schöner Schein: Probleme der Bilderverehrung im späten Mittelalter," in *Frömmigkeit im Mittelalter* (as in note 2), 221–42.

5. P. Blickle, "Reformation und kommunaler Geist," in *Kommunalisierung und Christianisierung: Voraussetzungen und Folgen der Reformation, 1400–1600* (*Zeitschrift für Historische Forschung,* suppl. 9), ed. P. Blickle and J. Kunisch (Berlin, 1989), 9–28, at 25.

6. Concerning Baroque strategies of staging and perception, compare J. Imorde, *Präsenz und Repräsentanz oder: Die Kunst den Leib Christi auszustellen* (Emsdetten, 1997); G. Henkel, "Rhetorik und Inszenierung des Heiligen: Eine kulturgeschichtliche Untersuchung zu barocken Gnadenbildern in Predigt und Festkultur des 18. Jahrhunderts" (dissertation, Münster, 2003).

7. Mayer, "Die heilbringende Schau" (as in note 4), 236.

8. Mayer, "Die heilbringende Schau" (as in note 4), 236.

9. In recent years, many attempts have been made to deal productively with the topic of *Schaufrömmigkeit* (visual piety). From the perspective of Church history, compare H. Kühne, *Ostensio Reliquiarum: Untersuchungen über Entstehung, Ausbreitung, Gestalt und Funktion der Heiltumsweisungen im römisch-deutschen Regnum,* Arbeiten zur Kirchengeschichte 75 (Berlin and New York, 2000), 814–32. From a cultural perspective, C. L. Diedrichs, *Vom Glauben zum Sehen: Die Sichtbarkeit im Reliquiar. Ein Beitrag zur Geschichte des Sehens* (Berlin, 2001), 23–55.

10. P. Browe, "Die Elevation in der Messe," in *Die Eucharistie im Mittelalter: Liturgiehistorische Forschungen in kulturwissenschaftlicher Absicht,* Vergessene Theologen , ed. H. Lutterbach, and T. Flammer (Münster, 2003), 475–508.

11. The disintegration (*Zersetzung*) theory is expounded upon by A. L. Mayer, "Die Liturgie in der europäischen Geistesgeschichte," in A. L. Mayer, *Gesammelte Aufsätze,* ed. E. von Severus (Darmstadt, 1971), where he explicitly speaks of "Gothic disintegration" and the "victory of individual principle," notably, that the "individual disintegrated the holy order." The "antisocial, egocentric individualism" as well as a "mystical and lyrical subjectivity" led to the "dissolution of the eucharistic sacrificial community" (citations 1ff., 19ff., 34ff., 42).

12. See also the section "Image, Gaze, and Liturgy" below. Very different is the view that two different paths were formed in the late Middle Ages, namely, the path to the interior and the path to the exterior: B. Hamm, *Frömmigkeitstheologie am Anfang des 16. Jahrhunderts: Studien zu Johannes von Paltz und seinem Umkreis,* Beiträge zur historischen Theologie 65 (Tübingen, 1982), 222–47.

13. For further infomation, see Lentes, "Inneres Auge, äußerer Blick und heilige Schau" (as in note 2); T. Lentes, "Bild, Reform und Cura Monalium: Bildverständnis und Bildgebrauch im *Buch der Reformacio Predigerordens* des Johannes Meyer († 1485)," in *Dominicains et dominicaines en Alsace XIIIe–XXe siècle: Actes du colloque de Guebwiller, 8–9 avril 1994,* ed. J.-L. Eichenlaub (Colmar, 1996), 177–95; T. Lentes, "*Vita Perfecta* zwischen *Vita Communis* und *Vita Privata:* Eine Skizze zur klösterlichen Einzelzelle," in *Das Öffentliche und das Private in der Vormoderne,* Norm und Struktur 10, ed. G. Melville and P. von Moos (Cologne et al., 1998), 125–64; T. Lentes, "Gebetbuch und Gebärde: Religiöses Ausdrucksverhalten in Gebetbüchern aus dem Dominikanerinnen-Kloster St. Nikolaus in undis zu Straßburg (1350–1550)" (dissertation, Münster, 1996).

14. Joseph Imorde is currently preparing a larger study, concerned with the connection between the experience of pictures and emotions, under the heading of sweetness. Compare J. Imorde, "Die Entdeckung der Empfindsamkeit—Ignatianische Spiritualität und barocke Kunst," in *Die Jesuiten in Wien: zur Kunst- und Kulturgeschichte der österreichischen Ordensprovinz der "Gesellschaft Jesu" im 17. und 18. Jahrhundert,* ed. H. Karner and W. Telesko (Vienna, 2003), 179–91, esp. 182–85.

15. Staatsbibliothek Berlin, Preußischer Kulturbesitz, Ms. germ. oct. 31, f. 162v: "vnd óbe dem mónschen an einem stúcke [. . .] nit gnode zúflússet, so sol (es) dz selbe stúcke úberlóssen vnd sol gon zú dem nehsten stúcke dor noch vnd in wellem stúcke er gnode vnd andaht vindet, vff dem sol er dester lenger bliben vnd wolust haben in got."

16. Staatsbibliothek Berlin, Preußischer Kulturbesitz, Ms. germ. oct. 17, f. 16v: "Wen du bist jn betrúbnis, so gan fúr j crucifixus stonde oder knuwe nider vnd sprich den psalm Ad te leuaui v dage. Gott erloeset dich. Ad te leuaui oculos meos qui habitas in celis . . . vnd spirch dise vermanung darnoch. Herre vnd myn erloeser, sich an myne betrúbnis vnd erbeit . . . vnd loese mich von allen minen sunden vnd von allem úbel vnd betrúbnis durch din aller wúrdigestes versertes antlit an dem krucze."

17. Staatsbibliothek Berlin, Preußischer Kulturbesitz, Ms. germ. oct. 17,, f. 18v: "die ersten v pater noster bett knúwende mit geneigtem hauebt vnd zúsammen geleitten henden. Die ij v pater noster an j sletten vemigen. Vnd v pater noster krucz wisz. Vnd v pater noster stond krucz wisz. . . . "

18. Huldreich Zwingli, "Eine Antwort. Valentin Compar gegeben," in *Huldreich Zwinglis Sämtliche Werke*, Corpus Reformatorum 91 (Leipzig, 1927; repr. Zürich, 1982), 84: "Ich gedar ouch mich wol für einen unpartiigen leerer in der sach dargeben, uß vi ursachen: Die erst, das mich die bilder wenig verletzend mögend, dass ich sy übel sehen mag." Here compared to G. Finsler, "Zwinglis Kurzsichtigkeit," in *Zwingliana: Mitteilungen zur Geschichte Zwinglis der Reformation* 3 (1913–20), 87–89.

19. Although it is generally assumed that concave lenses existed during the second half of the fifteenth century, it is unclear whether glasses for the nearsighted were known and how widespread they were. See W. Pfeiffer, "Brille," in *Lexikon des Mittelalters*, vol. 2 (1999), 689–92, esp. 691.

20. Allusions to this topic can be found in numerous essays in the following collections: *Bildproduktion und Bildpraxis: Das Goldene Wunder in der Dortmunder Petrikirche*, ed. T. Lentes et al. (Dortmund, 2003); *Kunst und Liturgie: Choranlagen des Spätmittelalaters. Ihre Architektur, Ausstattung und Nutzung*, ed. A. Moraht-Fromm (Ostfildern, 2003).

21. On terminology of the late Middle Ages, compare Hamm, "Frömmigkeitstheologie am Anfang des 16. Jahrhunderts" (as in note 12), 156–63.

22. H. Belting, *Das Bild und sein Publikum im Mittelalter: Form und Funktion früher Bildtafeln der Passion* (Berlin, 2000), esp. 35ff.

23. On the history of prayer in kneeling posture and with folded hands, see J.-C. Schmitt, *Die Logik der Gesten im europäischen Mittelalter* (Stuttgart, 1992), 280–85.

24. W. Hood, *Fra Angelico at San Marco* (New Haven and London, 1992), 260–72.

25. Belting, *Das Bild und sein Publikum* (as in note 22), 289ff.

26. For more detail, see Lentes, *Inneres Auge, äußerer Blick und heilige Schau* (as in note 13), 185–96.

27. O. Langer, *Mystische Erfahrungen und spirituelle Theologie: Zu Meister Eckharts Auseinandersetzung mit der Frauenfrömmigkeit seiner Zeit*, Münchener Texte und Untersuchungen zur deutschen Literatur des Mittelalters 91 (Munich, 1987), 109–15.

28. R. Marks, *Image and Devotion in Late Medieval England* (Stroud, Gloucestershire, 2004).

29. Compare *Kloster Blaubeuren: Der Chor und sein Hochaltar*, ed. A. Moraht-Fromm and W. Schürle (Stuttgart, 2002); *Kunst und Liturgie: Choranlagen des Spätmittelalters* (as in note 20).

30. More details about the Mass of St. Gregory will appear in *Das Bild der Erscheinung: Die Gregorsmesse im späten Mittelalter*, ed. A. Gormans and T. Lentes (forthcoming, Berlin, 2005); for information about the individual examples in the index of the Databank for the Mass of St. Gregory, see http://gregorsmesse.uni-muenster.de. See also C. W. Bynum, "Seeing and Seeing Beyond: The Mass of St. Gregory in the Fifteenth Century," in this volume.

The Medieval Work of Art:
Wherein the "Work"? Wherein the "Art"?

Jeffrey F. Hamburger

"The work of art"—the phrase comes trippingly off the tongue. What could be more inoffensive? Many historians of medieval art, however, now hesitate before speaking of "art." Instead, they speak of "images." In 1995, a session of the College Art Association posed the question "The history of medieval art without 'Art'?" and elicited half a dozen essays, most of which failed to notice the question mark.[1] It has become even more risky to speak of medieval aesthetics, once a burgeoning field of study.[2] Reticence about any viable notion of art in the Middle Ages can be traced, in large measure, to the anthropological turn in medieval art history, which has been defined, above all, by David Freedberg's *The Power of Images* and Hans Belting's *Likeness and Presence: A History of the Image before the Era of Art.* These studies, each in its own way, have productively directed attention away from style, aesthetics, and production toward function and reception (an extreme example is recent interest in graffiti as records of devotion).[3] Neither Belting nor Freedberg, however, should be regarded as telling the whole story.

In considering those objects that today are conventionally considered works of art, I am hardly the first to ask, "Wherein the work? Wherein the art?" Seeking to defend liturgical display against Cistercian criticism, Abbot Suger of St. Denis praised the antependium of Charles the Bald, which is known only from its representation within a fifteenth-century painting by the Master of St. Gilles (Fig. 1): "The rear panel, of marvelous workmanship and lavish sumptuousness (for the barbarian artists were even more lavish than ours), we ennobled with chased relief work equally admirable for its form as for its material, so that certain people might be able to say [and here he quotes Ovid]: the workmanship surpassed the material" [*materiam superabat opus*].[4] Similar sentiments mark the jewel-encrusted mount of Suger's eagle vase (Fig. 2). The inscription reads: "This stone deserves to be enclosed in gems and gold. It was marble, but in these [settings] it is more precious than marble."[5] And then there are the famous, if notoriously difficult, verses on the doors of St. Denis, in Panofsky's translation: "Whoever thou art, if thou seekest to extol the glory of these doors, marvel not at the gold and the expense, but at the craftsmanship of the work."[6] Panofsky's translation, however, has been contested and may even be tendentious; a more literal rendition might be: "Admire the gold and laboriousness of the work, but not the expense."[7] This is more than just quibbling: as Martin Büchsel has suggested, the labor [*labor operas*] to which the

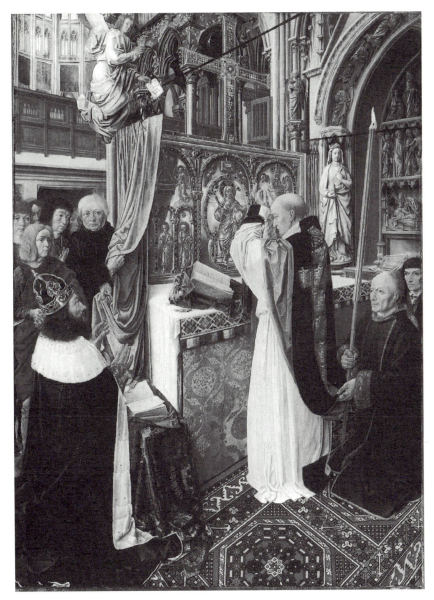

1. Master of St. Gilles, *Miraculous Mass of St. Gilles*, ca. 1500. London, National Gallery of Art, NG 4681

inscription refers could be construed not principally as the craftsman's skiii (what Panofsky translated as "craftsmanship"), but rather as Christ's struggle and toil in the salvation of mankind, the subject matter of the lost figural reliefs on the door that depicted the Passion, Resurrection, and Ascension.[8] Read this way, Suger's inscription does not praise the doors as a work of art, at least not directly. Instead, it identifies the work of the craftsman and, still more, of the patron, as a form of *imitatio Christi* and asks all who enter the church to overlook its cost and instead admire the work of salvation.

Craft as opposed to artistry, in the modern sense; the manual versus the liberal arts; the image

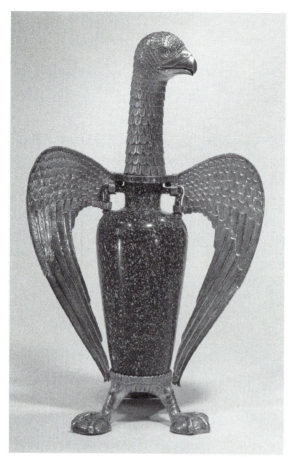

2. Eagle vase. Egypt or Imperial Rome and St.-Denis (mount),
before 1147. Paris, Louvre, MR 422

versus art: these are just a few of the oppositions under which medievalists themselves labor in
attempting to come to terms with the medieval "work of art."[9] My argument will be that, con-
fronted by such alternatives, there is no need to choose.[10] Rather than reading reception against
production, I want to look at some of the ways in which medieval images structure, or at least at-
tempt to structure, what they themselves frame as the viewer's experience. Indeed, frames can be
viewed as one of the principal means by which all images, not only medieval images, qualify and
comment on their status as representations.[11]

Inscriptions are one way of manipulating response. Inscriptions often occur on frames or
mounts: Suger's commissions offer numerous examples.[12] The Hitda Codex (Fig. 3), an early-
eleventh-century Gospel Book made for Abbess Hitda of Meschede, offers another alternative: the
verses inscribed opposite the Majestas extoll the visible as a token of the invisible, not just in
praise of the image's powers, but also by way of warding off aspersions of idolatry: "Hoc visibile
imaginatum/figurat illud invisibile veru(m). / cuius splendor penetrat mundu(m)./cum bis binis
candelabris./ipsius novi sermonis."[13] For all their recourse to the word, however, medieval images
have something to say over and against the texts that claim to speak for them. Some objects are
more eloquent than others. Therefore, it is to a select group, representations of the Ark and the
Tabernacle—and particularly the ways in which they address issues of authorship, authority, and
artistic invention—that I would now like to turn.

In the Middle Ages, the Ark of the Covenant and the Tabernacle that housed it were considered

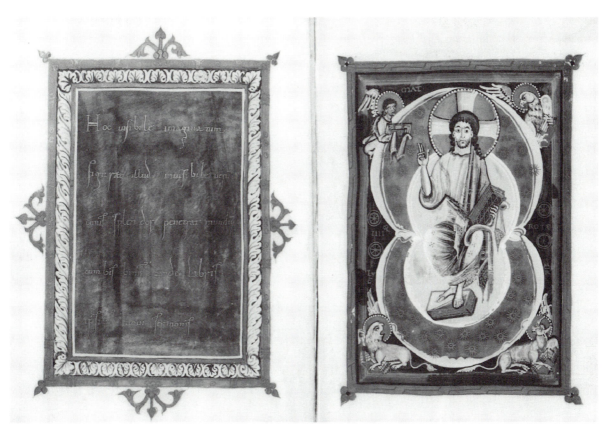

3. Text page (left) and Christ in Majesty (right). Gospels of Abbess Hitda of Meschede, Cologne, ca. 1000. Darmstadt, Hessische Landes- und Hochschulbibliothek, Cod. 1640, ff. 6v–7r

the archetypal works of art and architecture.[14] To this day, the ark remains, to some, an object of intense desire. Representations of the ark and the ark itself, however, are two very different things. To begin with, the ark is lost, or at least hidden—and that is precisely the point. In the Hitda Codex, as in all sacred art, the visible is related to the invisible. One way of reading medieval representations of the Jewish Holy of Holies would be to assume that, in the spirit of initiation, they help the viewer bridge this gap. At St.-Denis, the stained-glass panel depicting the Chariot of Aminadab (Fig. 4), which carried the Ark of the Covenant, supplies just such a vehicle: the uplifting chariot, mounted on four wheels standing for the Four Evangelists, identifies itself with the Tabernacle, whose content manifests itself as the crucified Christ, as in the words of the inscription: "On the ark of the covenant is established the altar with the cross of Christ; Here Life wishes to die under a greater covenant."[15] The Crucifixion—an image within the image—identifies the panel of which it is a part as a justification of images in specifically Christian terms.

Representations of the Tabernacle lent themselves to the rhetoric of revelation, which invariably implies concealment. The mosaic in the apse at Germigny-des-Prés (Fig. 5), erected around 800 by Theodulf of Orléans immediately above the altar of his private chapel, offers a famous example.[16] A fierce critic of the visual arts, if not an outright iconoclast, Theodulf wrote the *Opus Caroli regis* (previously known as the *Libri Carolini*) in opposition to what he took to be Greek teaching on images.[17] The mosaic mirrors Theodulf's text in enshrining the ark as a vessel of the Word and emphasizes the ultimate invisibility of the Godhead.

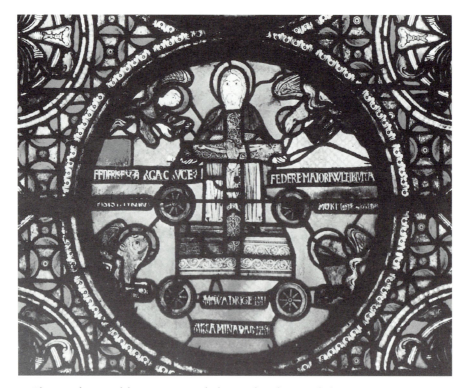

4. Chariot of Aminadab. St.-Denis, ambulatory chapel, stained glass, ca. 1140

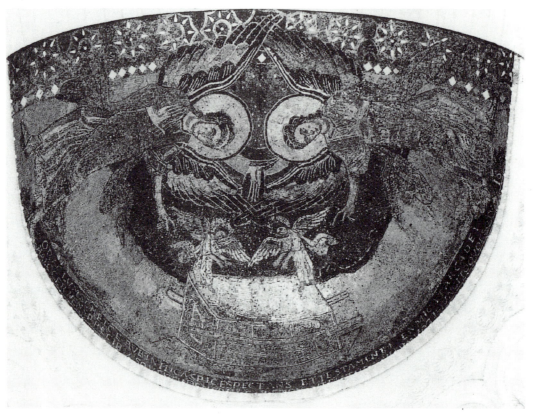

5. Tabernacle of the Ark. Germigny-des-Près, mosaic, ca. 800

The two poles—the visible and the invisible—come together in the Rothschild Canticles (Fig. 6), a mystical miscellany illuminated about 1300, which concludes with a refulgent representation of the Tabernacle reminiscent of the conclusion of Dante's *Paradiso*.[18] The image, however, is not only about access and revelation. It is no less about concealment. The facing page paraphrases God's warning to John: "No man can see God and live" (John 1:18). The miniature, moreover, does not require the text to make this point. The contortions of the seer on the text page speak volumes in themselves: turning away, he nonetheless looks back, directing the viewer from the text to the image. Within the miniature itself, the illuminator might have drawn a simple equation between veils and concealment, and light and revelation. The rhetoric of the image, however, is more complex and paradoxical. Light conceals as much as it exposes, and veils uncover as well as protect. Whereas the knotted cloth of the Tabernacle veil obscures vision in most of the miniatures, at the end it takes the form of curtains that have been pulled aside. The border of the miniature acts as a frame to which the curtains are attached in a series of loops. Even here, the illuminator introduces an element of the unexpected: the curtains are not suspended from the top of the frame but instead "fall" from the sides, held back by two asymmetrical arcs of clouds, whose parallel curves contradict the otherwise consistently concentric system of three circles representing the Trinity. Up and down lose their directional meaning; the viewer enters a space in which no place is privileged except the center.

The Rothschild Canticles embodies and conveys the paradoxes of vision by framing the viewer's experience in terms of its own oxymoronic pictorial rhetoric. In this instance, the Tabernacle is no mere symbol or figure of initiation. It provides a place to which the worshiper actively seeks access. The traditional point of access, however, was not an image, but Holy Writ, enshrined within the Tabernacle. In Late Antique Gospel books, the architecture of the canon tables defines the manuscript itself, in part, as a holy precinct. In the venerable Codex Amiatinus, an eighth-century Northumbrian Bible adapted from a Late Antique original, this opening of the Temple precinct identifies the volume as a vessel of Holy Wisdom.[19] In the twelfth century, Hugh and Richard of St.-Victor reconstructed the Temple and its Tabernacle in diagrams such as this, all part of their effort to map out a coherent reading of the whole of Christian history.[20]

My focus is the late Middle Ages, specifically several fourteenth-century copies of the *Bible historiale*, a compendium of sacred history written in the late 1290s by Guyart des Moulins, a canon at the collegiate church of St.-Père d'Aire in the diocese of Thérouanne.[21] Manuscripts of the *Bible historiale*, a work which has never received systematic study, despite (or perhaps because of) its enormous popularity, offer an expanded—some might say bloated—translation of Petrus Comestor's *Historia scholastica*, itself a combination of Scripture and world chronicle.[22] Of this compendium, a magnificent copy, now in St. Petersburg, was illuminated in Paris about 1350–55 by a team of artists who, working in the tradition of Jean Pucelle, also executed the *Bible moralisée* of Jean le Bon.[23] The opening image presents a grand cosmological scheme embracing the entire hierarchy of Creation (Figs. 7, 8). At first glance, it asks to be read as issuing from the Hell Mouth in the lower margin, where a man hanging from a gibbet represents the nadir of being (Fig. 9). The contrast with Jan Breughel's *Magpie on the Gallows* could not be starker; there, the instrument of execution assumes center stage, yet is submerged in the landscape (Fig. 10). In the manuscript, the natural world is represented by a series of schematic rings of earth, sky, and sea, where, as if on a fluid wheel of fortune, sailors symbolizing worldly pursuits make their way from one castle to the next, oblivious to the Leviathan that lurks below, waiting to swallow them up.

6. Text page with seer (left) and Trinity (right). Rothschild Canticles, Diocese of Thérouanne(?), ca. 1300. Beinecke Rare Book and Manuscript Library, Yale University, New Haven, Ms. 404, ff. 105v–106r

In the larger scheme of things presented by the *Bible historiale*, Nature seems of little significance in its own right. Radiating out from Hell, which, like Lucifer, occupies a point displaced from the center, the miniature plots an ascent that begins with the nine spheres of the visible universe, including the fiery vault of the sky, the *primum mobile*, and the signs of the zodiac. It then rises through the central block of text, where three initials introducing the three prologues enclose a trio of tiny author portraits: Guyart des Moulins, Petrus Comestor, and Saint Jerome (Fig. 11). Although in the transmission of Scripture, Guyart comes last, having translated the Comestor's Latin adaption of Jerome's Vulgate, the layout presents him first, on the left, where he is shown praying to an image of the Virgin and Child on an altar. The ninefold scheme in the lower margin is then quite literally taken up and recapitulated in the miniature proper at the top of the folio by the nine orders of angels, each identified by a golden letter (Fig. 12).[24]

In medieval art, as in medieval theology, angels serve as figures of mediation between heaven and earth, between the invisible and the visible.[25] In the *Bible historiale*, they map out a path for the reader to follow. The letters identifying the various orders form the visual equivalent of a ladder extending the realm of the text up toward the Logos in the Trinity, where the three persons seated on the altarlike throne appear identical in every respect except poses and attributes.[26] The

decoration provides a diagrammatic vision of the cosmos structured in neo-Platonic terms as a series of emanations descending from the Godhead, to which, thanks to the Incarnation, mankind can return if he is wise enough to escape Satan's clutches. From the "Book of Nature," at the bottom, the miniature ascends through the "Book of Scripture" before culminating in the Tabernacle of heaven, which here extends to embrace the entire page, structuring the relationship of text to image and of both to the viewer's experience.

The frontispiece to the St. Petersburg *Bible historiale* was not cut from whole cloth. In its general outlines, the miniature harks back to one of the earliest illustrated copies of the text, illuminated by the Papeleu Master in Paris in 1317, which opens with a miniature of Christ in Majesty within an architectural frame flanked by orders of angels (Fig. 13).[27] In both structure and content, however, the *Bible historiale* in St. Petersburg bears a still more striking resemblance to the opening illustration of the Roda Bible, a Catalonian manuscript of the mid- to late eleventh century, in which the angelic orders, the seraphim chief among them, flank the Mercy Seat from which Christ presides over Creation (Fig. 14).[28] The opening words of Genesis—"In principio creavit Deus"—can still be read at the upper left and right, to either side of the quatrefoil that represents celestial space. The lower portion of the page—the equivalent of the lower margin in the *Bible historiale*—could be read as a literal illustration of the latter part of the verse, *et terram*—the word *celum* or "heaven" having been excised, along with two of the four wind personifications that occupied the corners. As opposed to the invisible world of eternity, identified with the abstract geometry of the upper portion of the page, the visible world of Nature is illustrated by the animals that occupy a verdant, flowering arbor. To the plants and "living creatures that move upon the earth," the illuminator adds "the fowl of the air," a few of which float above the arcade. Three of their number appear to have breached the divide and hover beneath the seraph to the right of Christ, just below a square object, either a codex or the *orbis quadratus*.[29]

An image such as the Genesis frontispiece in the Roda Bible served, in turn, as the model for the opening miniature of the Lothian Bible, illuminated at Oxford or St. Albans about 1220 (Fig. 15).[30] As in the St. Petersburg *Bible historiale*, the Trinity now takes the place of Christ in Majesty, a motif inspired by the plural of Genesis 1:26, where God states, "We made mankind according to our image and likeness." Christian commentators did not read this as a royal "We," but took it instead to refer to the triune deity. In the Lothian Bible, Father and Son appear rather awkwardly as two torsos attached to a single lower body, connected by the outspread wings of the Holy Spirit, an expression of the *filioque*, the joint and double procession of the Holy Ghost so vehemently disputed by the Eastern Church. As in the Roda Bible, the quatrefoil frame still separates heaven and earth, but now, in the spirit of emanation, the Trinity is connected with what lies beyond: Father and Son extend their outward arms toward the frame and grasp it securely. The temporal sphere assumes greater importance: the lower half of the miniature is given over to all but one of the seven days of Creation. The first, exceptional day, placed in the lower left quadrant of the upper section, shows the spirit hovering over the waters, surrounded by a circle of angels. Its pendant contains the four rivers of Paradise. The rebel angels, who fall from beneath the feet of the Creator, tumble toward the natural realm in the lower half of the miniature. Only one element disrupts the otherwise strict symmetry: the inchoate band to the left of the Trinity representing the tenth choir once occupied by Lucifer and his cohorts. To this empty space mankind shall be elevated at the end of time, a motif that points to the ultimate reconciliation of God and his creation.[31]

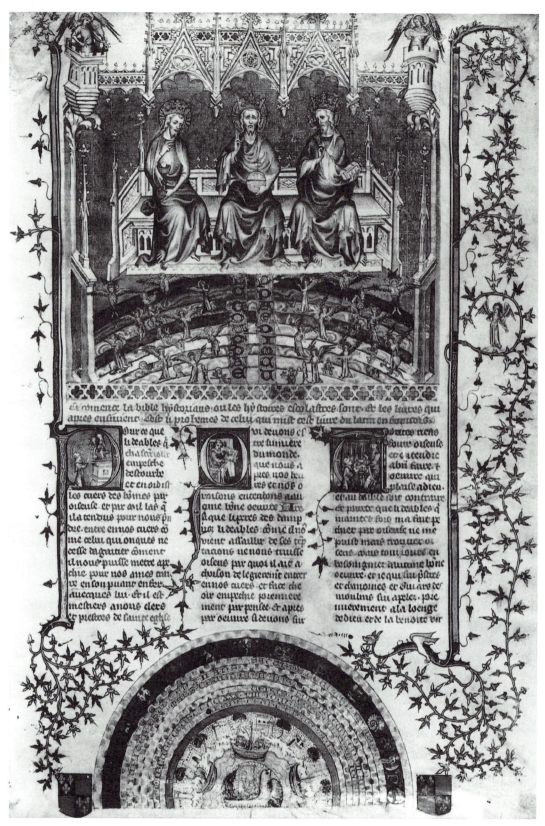

7. Cosmological hierarchy of Creation. Frontispiece to Old Testament, *Bible historiale*, ca. 1350–55. St. Petersburg, State Library, Ms. Fr. F. v. I, 1/1-2, vol. 1, f. 1r

8. Crucifixion and scenes from the life of Christ. Frontispiece to New Testament, *Bible historiale*, ca. 1350–55. St. Petersburg, State Library, Ms. Fr. F. v. I, 1/1-2, vol. 2, f. 1r

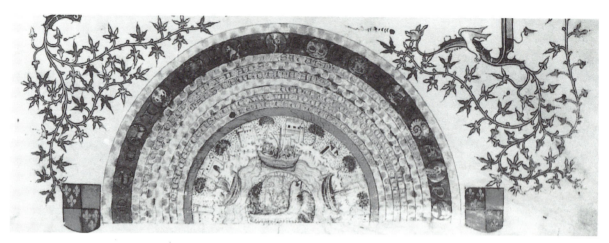

9. The sublunary world (detail of Fig. 7)

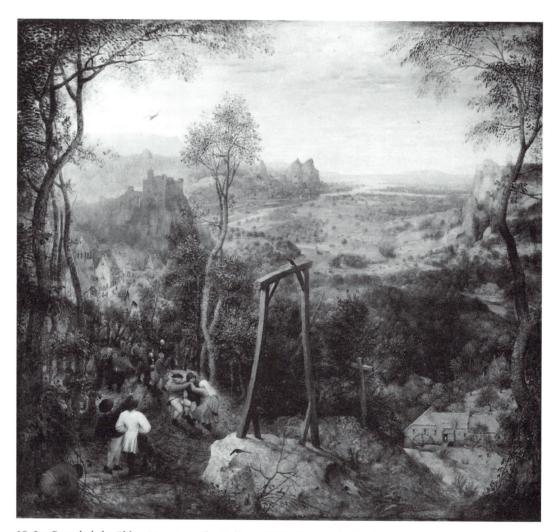

10. Jan Breughel the Elder, *Magpie on the Gallows*, 1568. Darmstadt, Landesmuseum

11. Guyart des Moulins, Petrus Comestor, and Saint Jerome (detail of Fig. 7)

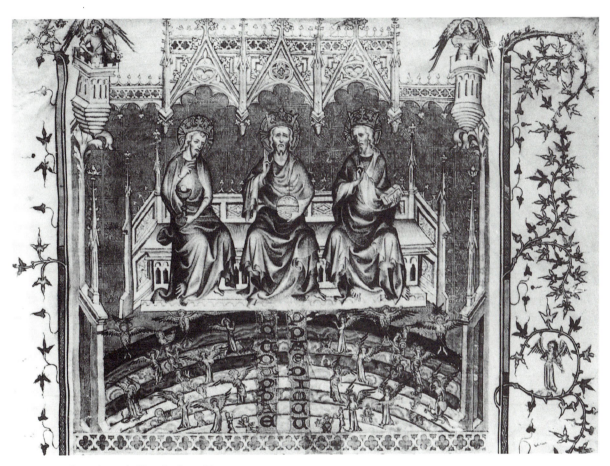

12. Nine orders of angels (detail of Fig. 7)

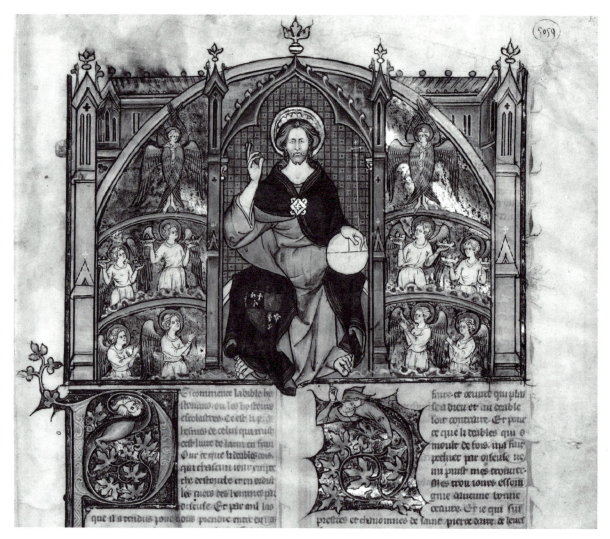

13. Papeleu Master, Christ in Majesty with angels. Frontispiece, *Bible historiale*, Paris, 1317. Paris, Bibliothèque de l'Arsenal, Ms. 5059, f. 1r

The frontispiece to the vernacular Bible in St. Petersburg (see Fig. 7) also offers a vision of history and the cosmos. Unlike the shimmering image that prefaces the Lothian Bible and presents a conceptual diagram that relies on size, shape, and position to lay out the "order of things," the French frontispiece appears within an elaborate architectural framework. Three bays, capped by crenellated towers and surmounted by a Gothic canopy, correspond to the three persons of the Trinity supported by flanking buttresses shaded to suggest outward protrusion, even though they extend inward toward the center atop a dado ornamented with quatrefoils. This elaborate frame and the cosmic panorama it contains ostensibly take as their point of departure a passage in the prologue in which Guyart des Moulins compares the structure of Scripture to the three chambers of an emperor's palace: the audience chamber ("auditoire ou concitoire ouquel il fait ses Iuge-

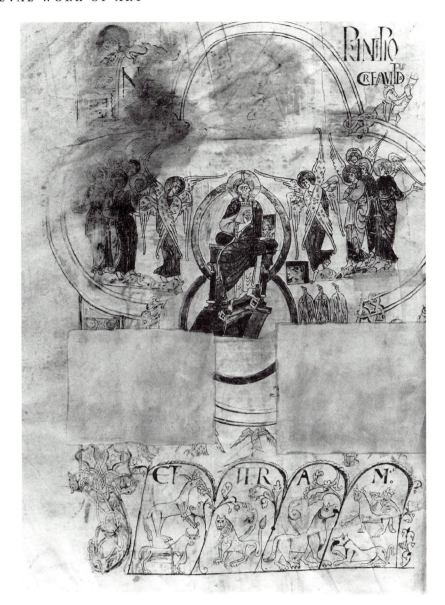

14. Christ, flanked by angelic hosts, presiding over Creation. Frontispiece to Genesis, Roda Bible, Catalonia, mid- to late eleventh century. Paris, Bibliothèque Nationale de France, Ms. lat. 6 (1), f. 6v

mens et donne a chascun son droit"), the bedchamber ("chambre en laquele il repose"), and the banqueting hall ("et chenaille ou salle en laquele il donne des mengiers").[32] Guyart identifies God's creation with the audience chamber, the soul with the bedchamber, and Scripture with the banqueting hall in which the emperor (i.e., God) feasts his followers. The banqueting hall in turn has three parts (foundations, walls, and roof) that correspond to the three senses of Scripture: history, allegory, and tropology.[33] In a manuscript in Berlin, this passage is preceded by a small miniature, distinct from the frontispiece of the St. Petersburg *Bible historiale*: it depicts a woman

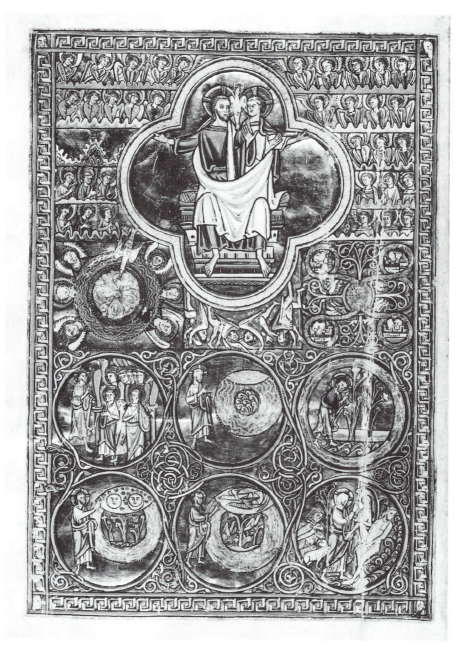

15. Trinity with heavenly hosts and the Seven Days of Creation. Lothian Bible, Oxford or
St. Albans, ca. 1220. New York, Pierpont Morgan Library, Ms. M.791, f. 4v

pointing to a fortified structure—a formulaic image used elsewhere in the manuscript to represent the city of Jerusalem; for example, in the miniature prefacing the Song of Songs, the bridegroom, shown as the Christ-Logos, beckons to the bride and the daughters of Jerusalem, seen within the walls (Figs. 16, 17).[34]

The sea- and landscape that fill the lower margin of the frontispiece of the *Bible historiale* appear to respond to Guyart's characterization of the audience hall of creation resonating with God's command: "Celum et terram impleo. Iou emplis le ciel et la terre."[35] Images, however, need not

16. The palace of the king. *Bible historiale*, Paris, third quarter of the fourteenth century. Staatsbibliothek zu Berlin, Preussischer Kulturbesitz, Handschriftenabteilung, Ms. Phillips 1906, f. 9v

17. The palace of the king representing Jerusalem in scene from the Song of Songs: Christ as bridegroom beckoning to the bride and the daughters of Jerusalem. *Bible historiale*, Paris, third quarter of the fourteenth century. Berlin, Staatsbibliothek zu Berlin, Preussischer Kulturbesitz, Handschriftenabteilung, Ms. Phillips 1906, f. 266v

illustrate texts, at least not directly. No less remarkable than the landscape in the *bas-de-page* is the extent to which the rest of the *mise-en-page*—be it the Trinity at the top, the hierarchy of angels immediately below, or, not least, the way in which the architecture in the margins mediates between text and image—remains unaccounted for by Guyart's prologue. Despite its ties to the text, the illusionistic architecture of the frontispiece makes larger claims, both on us as viewers and on behalf of artist and author. It does this by quite literally framing and shaping our experience of the image. To the Lothian Bible's diagrammatic representation of Nature, the *Bible historiale* adds a schematic structuring of perception (inspired by, but independent of, Guyart's own scheme) that lays out the principal means by which it is enacted: words (in this instance, the words of the Bible); images (not just its own illustrations, but the architecture itself, within which the Word is situated); and, to a lesser extent, music (made present in the form of the accompanying angelic consort). The image implies that man's handiwork, be it translations and adaptations of Scripture or the liturgical arts (both metalwork and music), is worthy and admirable in the same sense as God's own creation. It is, moreover, the image itself, and not any text, that makes this argument.

As commonplace decorative elements in Gothic manuscript illumination of the late thirteenth and fourteenth centuries, architectural frames and canopies are too ubiquitous to be considered specific bearers of meaning, let alone representations of specific architectural settings.[36] Nonetheless, translated to Jewish Scripture, the claims represented by the willful imposition of an ecclesiastical framework are anything but innocent. For example, in the Gradual of Johann von

18. Johann von Valkenburg
kneeling before the Majestas.
Gradual of Johann von Valken-
burg, Cologne, 1299. Cologne,
Diözesanbibliothek, Ms. 1b, f. 1v

Valkenburg, illuminated in Cologne in 1299 and named for the Franciscan patron who kneels in reverence at the feet of the central Christ in Majesty, the elaborate frame—so ample that it threatens to overwhelm the miniature—is no mere decoration (Fig. 18). The framework carries an ideological charge, identifying its content, most specifically, the space around the altar, as a sacred, ecclesiastical precinct: simultaneously the sanctuary of a Gothic church, the *sancta sanctorum* of the Old Testament Temple, and the Heavenly Jerusalem.[37] In the *Bible historiale* in St. Petersburg, the text may identify the structure crowning the cosmos as a palace; yet the presence of the Trinity at the center beneath a triple gable suggests a chapel or a metalwork shrine rather than a secular structure.[38]

Ecclesiastical architecture and fixtures come to the fore in a *Bible historiale* now in Geneva but painted in Paris by Jean le Noir shortly after the death of his presumed master, Jean Pucelle, in 1334; its pages make still bolder claims on behalf of artist as well as author (Fig. 19).[39] As in the St. Petersburg *Bible historiale*, architecture forms only part of a larger argument encompassing all of Creation. Here, however, Nature is reduced to a scene of stag hunting in the *bas-de-page*,

19. Jean le Noir, Christ in Majesty with the Four Evangelists. *Bible historiale*, Paris, ca. 1335. Geneva, Bibliothèque Publique et Universitaire, Ms. 2, f. 1r

perhaps an allusion to the Passion of Christ, but more likely an evocation of necessity and violence in the postlapsarian world. In accord with an exegetical tradition extending as far back as Bede, Le Noir portrays the Ark as a church or, better put, the church as a Tabernacle shrine, not unlike the Sainte-Chapelle or the mid-thirteenth-century Shrine of Saint Taurin from Évreux (Fig. 20).[40] His resplendent shrine simply does not admit the possibility of being mistaken for the palace referred to in the text. In the *Bible historiale* in Berlin, the initial that prefaces the Book of Samuel depicts the ark as a similar shrine being transported through the wilderness on the Chariot of Aminadab—a literal rendering of the same subject that was chosen by Suger for the allegorical window at St.-Denis (Fig. 21).[41] The initial recasts the Jewish rite in terms familiar to a medieval Christian audience: the transportation of the ark resembles nothing so much as a translation of relics.[42] Le Noir's ark is unmistakably Christian in character, identifying Jewish Scripture as part of a larger, more comprehensive Christian dispensation.

In crafting his ark, Le Noir follows Exodus closely, making it, according to the scriptural prescription, a "propitiatory of the purest gold." To reinforce the "real presence" of his Tabernacle, Le Noir allows it to float free of the frame, much like the church of St.-Denis in Pucelle's Hours of Jeanne d'Évreux, the obvious source for his image. As James Marrow has observed, Pucelle's

20. Shrine of Saint Taurin, Évreux, Paris, ca. 1260

elimination of the frame or any other kind of decorative armature represented a self-conscious departure from the Gothic tradition, one that was still perpetuated in the manuscript in St. Petersburg: witness the figures who, Atlas-like, either support the structure or who, like the woman on the right, use it as a prop and allow someone else to take the weight (Fig. 22).[43] Le Noir's golden shrine can also be compared to the shrine housing the miniature for All Saints in a Book of Hours dated about 1300 and now in Cambrai (Fig. 23).[44] In contrast to Le Noir's Tabernacle, this edifice rests securely on small supports anchored to the outer frame. The miniature depicts the Heavenly Jerusalem, but that is too generic a description: the angels and six-winged seraphim guarding the gates identify the structure with the Old Testament Tabernacle whose true content and meaning are now revealed, at the end of days, as the body of the faithful.[45] The image redefines the presence in the Tabernacle shrine as the *corpus Christi* in keeping with the opposition between the figures of *Synagoga* and *Ecclesia*, who flank the miniature. More particularly, it identifies the Church with the collective body of the saints, their bloody wounds transformed into jewel-like roses. In the tradition of the commentaries on Psalm 25:8 ("Lord, I loved the beauty of thy house"), the bodies of the blessed represent the decor of God's house, a topos in texts seeking to justify liturgical display.

21. Ark of Aminadab transported through the wilderness. *Bible historiale*, Paris, third quarter of the fourteenth century. Berlin, Staatsbibliothek zu Berlin, Preussischer Kulturbesitz, Handschriftenabteilung, Ms. Phillips 1906, f. 120v

22. Jean Pucelle, Jeanne d'Évreux praying at St.-Denis. Hours of Jeanne d'Évreux, Paris, 1325–27. New York, The Cloisters, The Metropolitan Museum of Art, acc. no. 1954 (54.1.2), f. 102v

The Geneva *Bible historiale* contains well over a hundred miniatures. Le Noir, however, executed only the frontispiece. This miniature, which puts his mark on the manuscript, could be read as a gesture—though not a humble one—toward his recently deceased master: Le Noir implicitly compares himself with Bezaleel, the maker of the ark, whom Exodus describes as filled "with the spirit of God, with wisdom and understanding and knowledge in all manner of work" (Exodus 31:3). Le Noir was not the first medieval artisan to hazard such a comparison.[46] Writing in the early twelfth century, Theophilus Presbyter, perhaps identifiable as Roger of Helmarshausen, introduces Book II of his handbook on monastic craftsmanship, *De diversis artibus*, by justifying his craft in comparable terms.[47] Theophilus states: "Desiring to follow this man [Solomon], I have approached the temple of holy wisdom, and beheld the sanctuary filled with a variety of all kinds of diverse colors. . . . Entering forthwith unobserved, I have filled the storehouse of my heart with a sufficiency of all those things and, without envy, have clearly set them forth for your study."[48] Theophilus departs from tradition, which, with a disdain for manual labor inherited from antiquity, had either ignored Bezaleel altogether or read his work metaphorically, as a prefiguration of the exegetical activity of the church fathers. Instead, Theophilus takes the biblical account quite literally, identifying himself with the craftsman of Exodus. Theophilus returns to the topic in the prologue to Book III, where, after quoting Psalm 25—"Lord, I loved the

23. Christ and the Virgin with the Elect. Book of Hours, ca. 1300. Cambrai, Médiathèque Municipale, Ms. 87, f. 17v

beauty of thy house"—he argues that David furnished Solomon with all the materials required to build the Temple, "for he had read in Exodus that the Lord had given instructions to Moses to build a Tabernacle . . . and had filled the masters of the work (*operum magistros*) with the spirit of wisdom and understanding and of knowledge in all learning for contriving and making works in gold and in silver . . . and in art of every kind."[49]

A written apology for images is one thing, an image that seeks to justify itself quite another. For example, in speaking of painting in the heart, Theophilus employs a metaphor of ancient ancestry. Yet it did not appear in pictorial form until the early modern period: witness Antoine Wierix's engraving showing the Christ child decorating the heart's interior with pious paintings.[50] Le Noir's image translates Theophilus's argument into pictorial terms. The miniature introduces Jewish Scripture with an image of Christ the Word surrounded by the Four Evangelists, filling the shrine. An image of the wilderness Tabernacle prefacing Exodus in an Alsatian *Weltchronik*, or world chronicle, dated 1459, now in Colmar, underscores the necessity of usurping the interior of the Tabernacle (Fig. 24).[51] The tent of the Tabernacle is pulled aside to reveal the interior, where the various Temple implements, including the ark itself, are displayed. Close inspection of the gilt-edged book reveals a paraphrase of Genesis: "In the beginning of creation God created heaven and earth." Immediately above, however, Christ—not just God, but Christ, identified by his cross-halo—appears in a cloud formation as the *Salvator mundi*. Another *Weltchronik*, this one for-

24. The wilderness Tabernacle. Rudolf von Ems, *Weltchronik*, Alsace, 1459. Colmar, Bibliothèque Municipale, Ms. 305, f. 131r

merly at Donaueschingen (Fig. 25), offers a programmatic frontispiece analogous to the miniature in Geneva.[52] The angels carrying the Gospels to either side of the golden Tabernacle correspond to the Four Evangelists at work within the shrine (cf. Fig. 19), whereas the ploughman who tills the soil in the sublunary sphere, suspended above the fires of Hell, corresponds to the scene in the lower margin of the *Bible historiale* in St. Petersburg (cf. Fig. 9).

In the St. Petersburg *Bible historiale*, the frontispiece for the Old Testament (see Fig. 7) finds its true counterpart and pendant in the miniature prefacing the New Testament (Fig. 8). In lieu of the *opus conditionis*, the contingent work of Nature, which occupies the lower margin on the page prefacing Genesis, the reader now confronts a scene that exemplifies the *opus gratiae*, the work of grace: the Last Supper, or, to be precise, the much rarer Institution of the Eucharist (this is one of its earliest appearances in Northern painting).[53] The enactment of Mass encapsulates the meaning of sacred history acted out in the miniature above. An analogous rhetoric of ritual repetition marks the page preceding the Old Testament text, where the three human authors in the initials echo the activity of the triune Creator.[54] The parallelism suggests that the French text of

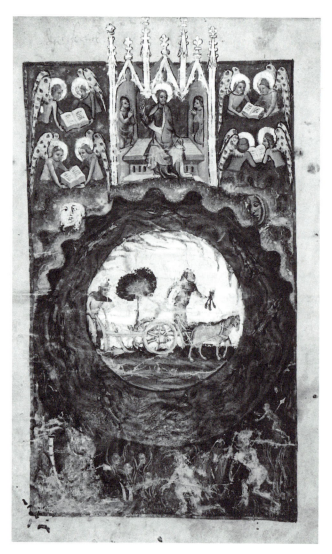

25. Heaven, Earth, and Hell. Frontispiece to Genesis, Rudolf von Ems, *Weltchronik*, late fourteenth century. Formerly Donaueschingen, Fürstlich Fürstenbergische Hofbibliothek, Cod. 79; now Karlsruhe, Badische Landesbibliothek, Ms. Donaueschingen 79, f. 1v

Guyart des Moulins participates in the authority of the Word enshrined within the ark no less than the Eucharist participates in the reality of Christ's sacrifice, a truth here adumbrated by the figure of Christ in the Trinity, who holds a large host and chalice. Guyart was keenly aware of the challenges posed by translating Scripture into the vernacular, as he writes in his preface on this very page: "For by my soul, I have not changed anything or added anything, but only the pure truth, as I found it in the Latin of the Bible and in the *Historia scholastica*. . . . I took it all from the Latin word by word."[55] At an earlier point in the preface, Guyart refers to the "thousand snares" (*mil las*) with which the devil "hampers and disturbs and sullies the hearts of men by indolence"—a reference which in the copy in St. Petersburg links the diabolical imagery at the foot of the page to the author portraits above and lends the diabolical imagery an unexpected autobiographical immediacy.[56] Whereas in the manuscript in Geneva, Guyart's text appears to translate the words transcribed by the Four Evangelists, in the St. Petersburg version, Guyart prays before an image of the Virgin and Child, thereby providing the viewer with a model for his own attention to the image. The illuminator's conceit (in both senses of the word) is that his image usurps the authority of the text, which here is derived directly from the word of God. In

theory, the reader who opens the Bible confronts the ultimate author of history, God as the divine *artifex*, and it is God's authority that, according to the program of decoration, guarantees the authenticity of Guyart's translation. In practice, the architectural framework identifies Guyart's text with the "testimony" that God gave to Moses before instructing him to house it in the ark. Even as the image champions the primacy of the word, it also serves to authorize the text and determine its interpretation.

The programmatic frontispieces to the *Bible historiale* appropriate a long tradition of interpreting the Old Testament Tabernacle as a structured model of reading and perception.[57] Bonaventure, for example, identified its three chambers as a model for a tripartite process of contemplative ascent, which he figured as a threefold journey toward the seat of God within the depths of the soul. In the St. Petersburg Bible, the entire *mise-en-page*, text and image together, supplies the reader with an interpretive vehicle that identifies itself with the proverbial "Book of Nature." In his *Breviloquium*, Bonaventure takes up this metaphor in terms that could be taken to underwrite the miniature:

> The Creation of the world is a kind of book in which the Trinity, the world's maker, shines forth, is represented and read in three modes of expression, namely in the modes of vestige, image, and likeness: thus the meaning of vestige is found in all creatures, of image in intellectual or rational spirits only, of likeness in those alone who are godlike; and from these, human understanding is destined to ascend step by step to the highest principle, God, as if up a kind of ladder. [58]

In the *Bible historiale*, as in Bonaventure's treatise, the experience of Nature, which here extends to include the viewing of the image, supplies but the first step along this itinerary, but it is nonetheless an essential foundation. The miniature declares, along with Hugh of St.-Victor's commentary on the *Celestial Hierarchy* of the Pseudo-Dionysius: "Our soul could not ascend to the truth of these invisible things, if not through the learned consideration of visible things. Thus it is seen that visible forms should be considered to be representations [or similitudes] of invisible beauty."[59] The frontispiece to the *Bible historiale* aspires to a similar conjoining of Nature and art, arguing, in visual terms, for the capacity of the cosmos, not just the *corpus Christi*, to direct the observer back to the Creator.

The *Bible historiale* could never be mistaken for a theological commentary. Like a commentary, however, its illustrations constitute frames that preface, construct, and mediate our experience as readers and interpreters. In so doing, the image itself is empowered, but in ways altogether different from those envisaged by Freedberg.[60] In this case, the "visible forms" experienced by the viewer are not simply those of Nature, they are the beauties of the manuscripts themselves. To sanction and legitimize this significant shift from Nature to art (and from text to image), the manuscript shows the triune Creator, painted in grisaille, seated within an elaborate architectural framework, much like a piece of sculpture in a Gothic Tabernacle (see Fig. 12). The imagery of art is taken up in the initials, where Christ Incarnate appears, not in person but rather in the form of a living image: the statue of Virgin and Child that sways in response to Guyart's prayer, which begins by speaking of the need for redemption (see Fig. 11). Next to Christ holding the chalice, Nature is reduced to the tiny orb held in the hands of God the Father, who, together with the Son and the Holy Spirit, presides over the whole of Creation. Despite its own daring, the miniature asserts that divine artistry, represented, or at least intimated, by *ars sacra*, transcends Nature, which occupies the secondary sphere in the lower margin.[61] The unruly rinceaux inhabited by winged

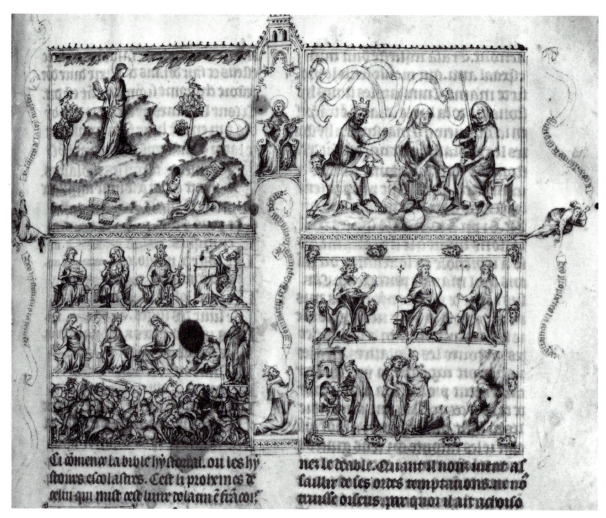

26. Jean le Noir, Charles V before the Throne of Mercy and biblical scenes. *Bible historiale* of Charles V, Paris, ca. 1370. Paris, Bibliothèque de l'Arsenal, Ms. 5212, f. 1r

dragons filling the remaining margins are not merely decorative; they confirm, by comparison, the importance of the Word at the center.

More could be said about the illustrations to these exceptional manuscripts. Instead, I would like to consider how later copies of the same text respond to their visual rhetoric, which harnesses the discourse of visibility to a larger argument about the opposition and unity of the two Testaments. Many of the copies in question owe their origin to Le Noir, a fact that is significant, as it points to a heightened self-consciousness of place within a pictorial tradition.[62] Le Noir and other illuminators not only recognized that the frontispieces identified themselves with the edifice of the Tabernacle; they elaborated this content, making the images more polemical in the process.

In about 1370, Le Noir illuminated a second *Bible historiale*, this one for King Charles V of France (Fig. 26).[63] Its iconography is exceptionally complex. I can dwell only on a single element: the contrast between Moses, who, at the upper left, cowers in what Exodus describes as "a hole in the rock" and looks at Jehovah's "back parts," and Charles V, who, playing the part of David at

the center, looks up at the Trinitarian Throne of Mercy in the canopied niche above him.[64] The king's prayer scroll reads, "Teach me discipline and goodness and knowledge," a quotation from Psalm 118 that identifies the monarch, not just with David, but also with Solomon, who presides in the scenes to left and right. The niche housing the Throne of Mercy is nothing other than the propitiatory that God instructs Moses "to set upon the ark of testimony in the holy of holies." In looking at this miniature, Charles joins David and Solomon in peering into the innermost recesses of the sanctuary. What he sees is the content of the covenant revealing itself: in accord with the polemics of the rest of the program, the Trinity takes the place of the solitary Messiah.

Toward the end of his life, around 1375, Jean le Noir revisited and revised his earlier invention. The Christ of the Geneva *Bible historiale* reappears in the *Petites Heures* of Jean, duc de Berry (Fig. 27).[65] The miniature prefaces the penitential appearance of David in the initial, not only as author, but also as a type of Christ. Once again, both images ultimately depend on inventions by Pucelle: the miniature of Christ in Majesty in the Hours of Jeanne d'Évreux (Fig. 28) and the small miniature of David praying before the Majestas in an illustration for Advent in the Belleville Breviary (Fig. 29). As always, however, Le Noir reinterprets his sources. To begin with, he places a chalice and tablets on small altars to either side of Christ. On Christ's left (or *sinister*) side, the tablets are juxtaposed with the open book in his left hand. The altar, significantly, is uncovered. In contrast, the eucharistic elements that receive Christ's blessing rest atop a cloth-covered altar. To use the Pauline language of interiority, Christ, the living Word, written in the heart, takes the place of the tablets written in stone.

This innovative iconography seems to have originated in France during the course of the thirteenth century.[66] It appears prominently on the front cover of the third lectionary of the Sainte-Chapelle, dated about 1255–60, the work that may have lent the imagery its currency and prestige (Fig. 30).[67] It recurs soon thereafter in several two missals, where it illustrates the canon, or prayer of consecration, for the Mass, one made for the church of Ste.-Geneviève, the other for the canons of Mont-St.-Eloi in northeastern France (Fig. 31).[68] In Parisian illumination, much of it with royal associations, the iconography persisted into the fourteenth century, for example, in the canon pages from a missal painted by Jean le Noir himself, now in the Bodleian Library, Oxford (Figs. 32, 33).[69] Similar imagery marks the *Bible historiale* in Berlin, also part of the library of Charles V, where it provides a perfect programmatic frontispiece to this comprehensive account of salvation history (Fig. 34).[70] The logic of Christian supercession comes full circle in a late-fourteenth-century copy of the *Bible historiale* in the Fitzwilliam Museum, Cambridge, in which the Four Evangelists transcribe the testimony within the Tabernacle (Fig. 35).[71] Christ, seated in front of the curtain, blesses the eucharistic elements that make his presence visible. To his left, however, the tablets have vanished from view. The rhetoric of visibility and invisibility here takes on a sharper ideological edge.[72]

Le Noir's elaborate tropes on the image of Christ in Majesty placed between symbols of the Old and New Covenants are more than a means of paying tribute to a tradition or of inscribing himself within it. His reworking and refinement of the subject underscore a larger act of appropriation: Christianity's arrogation of the Jewish covenant. Above all, in Mass books, such as a fifteenth-century missal from Autun in which the iconography recurs yet again, the altars flanking the enthroned Christ frame and figure the altar supporting the missal itself (Fig. 36, right). The miniatures consummate a transfer of meaning similar to what can be observed in the Cambrai Hours: from book, specifically, the Mosaic Law, to image, to body—in this instance, the *corpus Christi* made present in the Eucharist. With the rending of the Tabernacle veil at the moment of

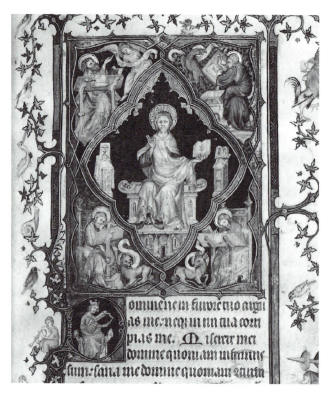

27. Jean le Noir, Christ in Majesty. *Petites Heures* of Jean, duc de Berry, Paris, ca. 1370–90. Paris, Bibliothèque Nationale de France, Ms. lat. 18014, f. 53r

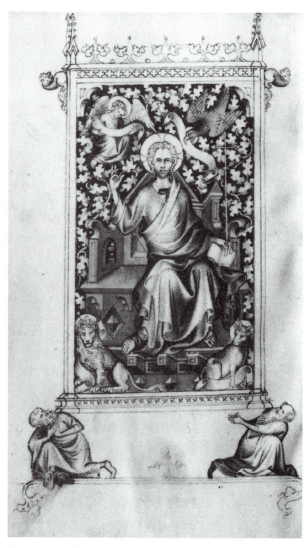

28. Jean Pucelle, Christ in Majesty. Hours of Jeanne d'Évreux, Paris, 1325–27. New York, The Cloisters, The Metropolitan Museum of Art, acc. no. 1954 (54.1.2), f. 182v

29. David praying before the Majestas. Belleville Breviary, Paris, mid-1320s. Paris, Bibliothèque Nationale de France, Ms. lat. 10483, f. 213r

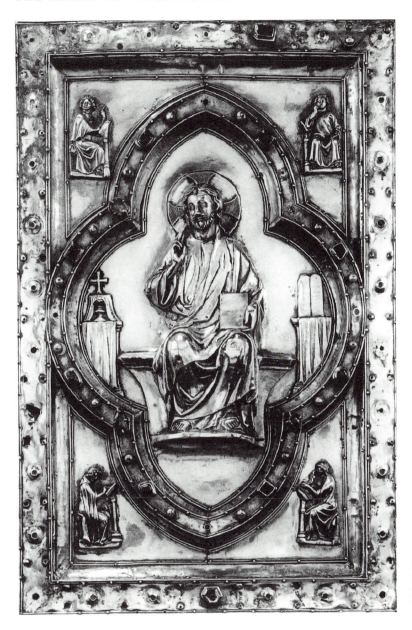

30. Christ in Majesty. Third lectionary of the Sainte-Chapelle, ca. 1260–70. Paris, Bibliothèque Nationale de France, Ms. lat. 17326, front cover

the Crucifixion, visible on the facing folio (Fig. 36, left), the inner sanctum, like Christ's body, is opened, laid bare for all to see. In lieu of the *deus absconditus*, the hidden God, the viewer, in this case, the celebrant himself, sees Christ, visible, in the flesh, just as in a panel attributed to Robert Campin, the tent of the wilderness Tabernacle opens to reveal the *Gnadenstuhl*—Luther's term for the propitiatory of the ark (Fig. 37).[73]

Allusions to the Ark of the Covenant emerge more explicitly in a mural on the east wall of the Chapel of the Virgin at Karlštejn part of an elaborate Apocalypse cycle (Fig. 38).[74] The accompanying inscription speaks of "the ark of his testament . . . seen in his Temple" (Rev. 11:19: *et apertum est templum Dei in caelo et visa est arca testamenti eius in templo eius*). The image leaves no doubt as to whose Temple and testament are meant. Consonant with the eschatological context of

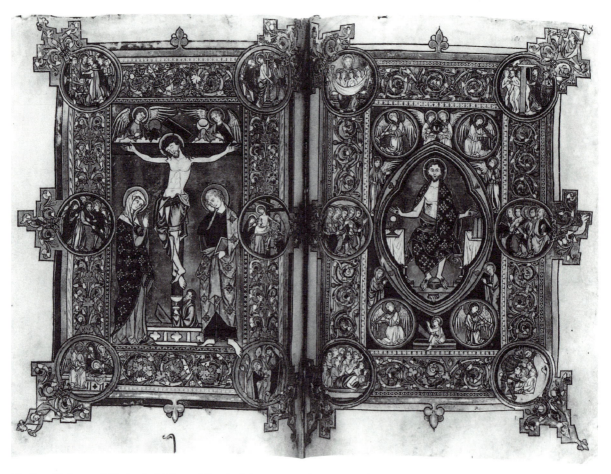

31. Crucifixion and Christ in Majesty. Missal of the canons of Mont-St.-Eloi, ca. 1250. Arras, Bibliothèque Municipale, Ms. 38(58), ff. 105v–106r

the chapel's entire pictorial program, Christ emerges from the golden shrine in the guise of the *Salvator mundi*, much like the Risen Christ emerging from his tomb, but with his gesture of blessing pointedly directed, not outward, but at his own temple (from the Latin, *tempus*, or forehead). In keeping with Paul's polemical reading of the opening of the Holy of Holies in Hebrews 10:19–24, the revelation to which we are made witness underscores the newfound visibility of the ark's interior in the person of Christ himself.[75] Presence replaces absence; visibility supercedes invisibility.

At the outset of this essay, I promised that I would return to David Freedberg's *Power of Images*. One would think that all medievalists, especially those interested in the history and character of devotional art and experience, would welcome Freedberg's book, in part because he insists on characterizing the Middle Ages not as an exception, but as the norm, for the whole of humankind, not simply the whole of Western art history.[76] The medieval response to images, he argues, represents a basic human instinct, the inescapable urge to identify an image with what it represents. A miniature from a fifteenth-century Spanish manuscript apparently exemplifies this kind of emotive, corporeal response, which involved visions so intense they left physical marks on the body (Fig. 39).[77]

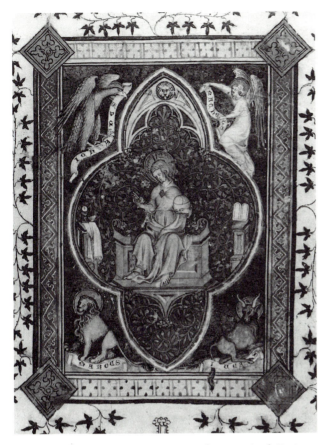

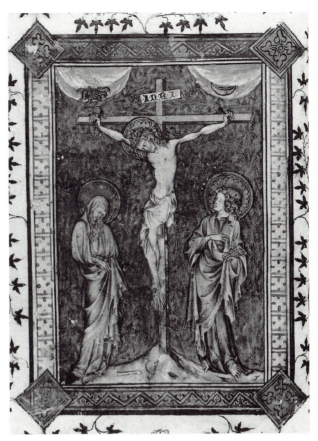

32. Jean le Noir, Majestas. Canon page from a missal, Paris, ca. 1370, inserted into a printed Eusebius (Ketelaer & Leempt, Nijmegen, 1473). Oxford, Bodleian Library, Ms. Auct. 7Q 2.13, first illustration

33. Jean le Noir, Crucifixion. Canon page from a missal, Paris, ca. 1370, inserted into a printed Eusebius (Ketelaer & Leempt, Nijmegen, 1473) Oxford, Bodleian Library, Ms. Auct. 7Q 2.13, second illustratio

The story behind the image involves not one, but two holy images. The first, a statue of the Virgin and Child, calls out to an errant nun as she flees the convent with her lover, asking why she is giving herself over to the devil. At this, the second image, a life-sized statue of the crucified Christ, detaches itself from the cross, pursues the nun, then slaps her, driving the nail from his hand through her cheek. Convinced of the error of her ways, the nun repents.

There are many other ways of reading this particular image, all of which would involve contextualization of the kind Freedberg so vehemently rejects and also the forthright recognition that, like all images, it is a representation, not just a record, of experience. All I want to point out here, however, is that Freedberg's history of medieval art omits a broad spectrum of visual experience, including what Richard of St. Victor called "the simple perception of matter."[78] Also lost from view are all those elements, visual as well as textual, that reminded viewers of what Herbert Kessler has aptly called "real absence," the inability of the human eye, and hence of art, to circumscribe and capture the invisible and unseen.[79] In response to ever-present concerns about idolatry, medieval artists had at their disposal any number of means to indicate the limits of representation.

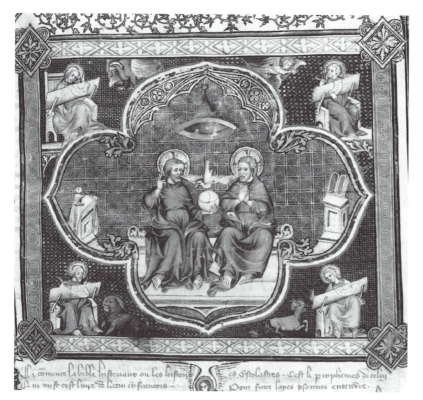

34. Trinity with the Four Evangelists. Frontispiece, *Bible historiale*, Paris, third quarter of the fourteenth century. Berlin, Staatsbibliothek zu Berlin, Preussischer Kulturbesitz, Handschriftenabteilung, Ms. Phillips 1906, f. 8r

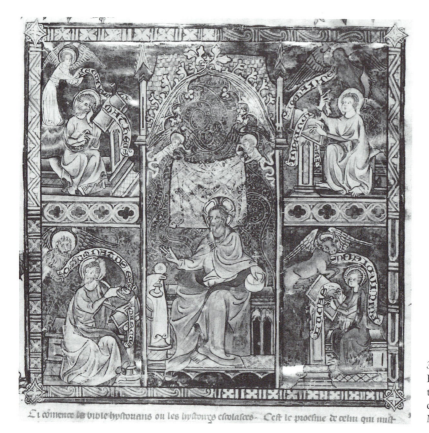

35. The Four Evangelists. Frontispiece, *Bible historiale*, Paris, third quarter of the fourteenth century. Cambridge, Fitzwilliam Museum, Ms. 9, f. 1r

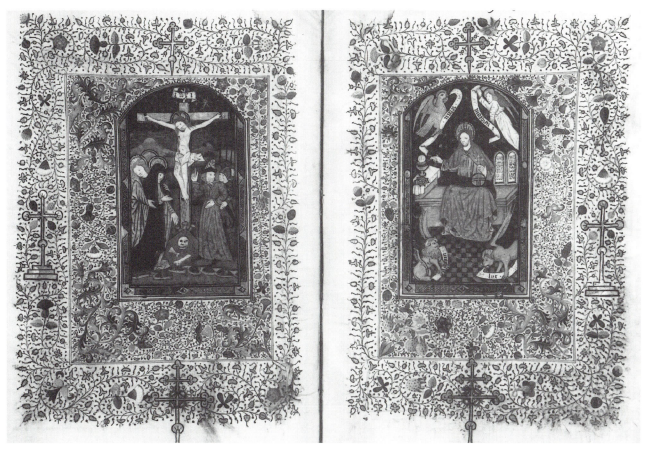

36. Crucifixion and Majestas. Missal, before 1476. Autun, Bibliothèque Municipale, Ms. 118 bis (S141), ff. 97v–98r

Representations of the Tabernacle provide implicit, yet sophisticated meditations on the ability of images to question and delimit their own power and potentiality. At the same time, they offered exceptional artists, like Jean le Noir, opportunities to reflect on the place of representation per se in negotiating the divide between the visible and the invisible, between presence and absence, between the image and art. The work of art, artifice itself, comes to stand for what cannot be seen. A thirteenth-century Flemish psalter provides a closing example (Fig. 40).[80] In effect, the image offers a model of vision. The miniature places us before the Tabernacle, its curtain pulled aside, where we come face to face with Christ. The miniature is modeled on a Majestas. If one looks carefully, however, one notices that a displacement has occurred: King David and his musicians have taken the place of the Evangelists. We see an image both of prophecy and promise. In looking at this image, we join the angelic choir in triumphant jubilation and bear witness to the Pauline promise, "We see through a glass darkly, but then face to face." Like Paul, the image declares: "Brethren, [we have] confidence in the entering into the holies by the blood of Christ; a new and living way which he hath dedicated for us through the veil, that is to say, his flesh." The veil comes to stand, paradoxically, for the body, the visible, for vision itself.

Representations of the Tabernacle rely on, yet collapse, the various distinctions around which

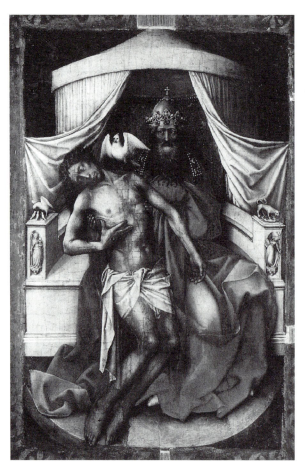

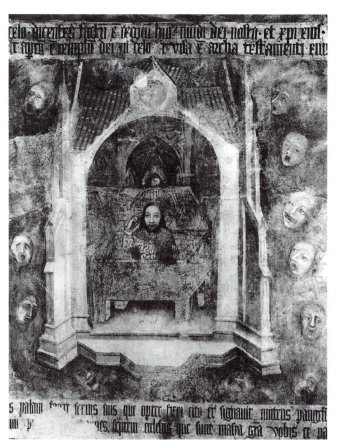

37. Robert Campin(?), Trinity in the Tabernacle, left wing of diptych, ca. 1425–30. St. Petersburg, The Hermitage

38. Christ in the Ark of the Tabernacle. Mural on east wall of the Chapel of Our Lady, Karlštejn, 1358–63

I have structured this paper: the visible versus the invisible, the image versus art, and, not least, craft versus artistry, which here takes the form of liturgical celebration, as in the *opus Dei*, the work of God. The *work* of art, to return to that enigmatic phrase, is not just to make present, but to mediate between image and text, visible and invisible, presence and absence. Art's work, if I may put it that way, is to provide an implicit theory of the image where medieval texts provide none. The work of art itself shapes, structures, and defines our experience in essential ways. The frontispieces to the *Bible historiale* serve as only one type of example; I have singled them out because they provide unusually detailed maps of reading, but also of vision, framed in Christian terms. In fact, they define reading, not just as insight, but as a form of vision itself.

Protestant reformers, imagining themselves like Moses before the *Deus absconditus*, insisted that God had turned his back on this entire discourse of veiled vision. With it, they rejected, not only much of the subject matter, but also the subtle visual rhetoric of many medieval works of art. To see these images as Luther and Calvin would have seen them, we have to imagine the curtains of the Tabernacle forever closed. Yet we need not be blinded by the rhetoric of the reformers. The Reformation may have ushered in the "era of art." Medievalists, however, have no obligation to overlook the artistry of medieval images.

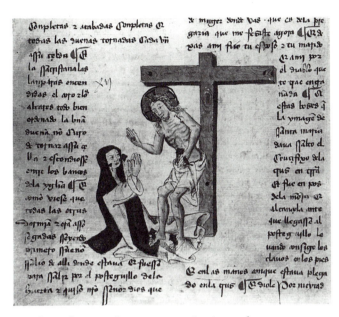

39. Christ chastises the errant nun. *Castigos e documentos*, fifteenth century. Madrid, Biblioteca Nacional, Ms. 3995 (olim Ms. 23), f. 74v

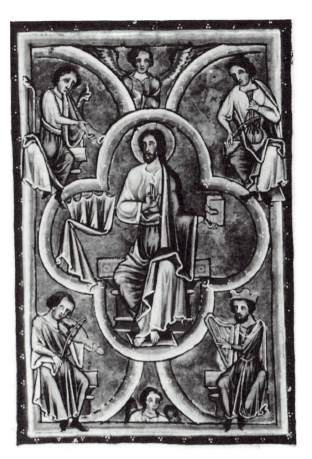

40. Christ in Majesty inside the Tabernacle, with King David and heavenly musicians. Psalter, Flanders, mid-thirteenth century. Paris, Bibliothèque Nationale de France, Ms. lat. 238, f. 114v

Notes

1. See the special issue of *Gesta* 34, no. 1 (1995), ed. H. Maguire.

2. Consider E. de Bruyne's *Études d'esthétique médiévale*, 3 vols. (Bruges, 1946; reprint Geneva, 1975), and U. Eco's *Art and Beauty in the Middle Ages*, trans. H. Bredin (New Haven and London, 1986).

3. D. Freedberg, *The Power of Images: Studies in the History and Theory of Response* (Chicago, 1989), and H. Belting, *Likeness and Presence: A History of the Image before the Era of Art*, trans. E. Jephcott (Chicago, 1994), originally published as *Bild und Kult: Eine Geschichte des Bildes vor dem Zeitalter der Kunst* (Munich, 1990). No less important is M. Camille, *The Gothic Idol: Ideology and Image-Making in Medieval Art* (Cambridge, 1989). On graffiti, see, e.g., C. Jäggi, "Graffiti as a Medium for Memoria in the Early and High Middle Ages," in *Memory and Oblivion: Proceedings of the Twenty-ninth International Congress of the History of Art*, ed. W. Reinink and J. Stumpel (Amsterdam, 1996), 745–51; and P. Schmidt, "Beschriebene Bilder: Benutzernotizen als Zeugnisse frommer Bildpraxis im späten Mittelalter," in *Frömmigkeit im Mittelalter: Politisch-soziale Kontext, visuelle Praxis, körperliche Ausdrucksformen*, ed. K. Schreiner with M. Müntz (Munich, 2002), 347–84, esp. 348–51.

4. *Abbot Suger on the Abbey Church of St.-Denis and Its Art Treasures*, ed. and trans. E. Panofsky, 2nd ed. by G. Panofsky-Soergel (Princeton, 1979), 61–63. Panofsky's conclusions have been challenged by A. Speer and G. Binding, ed., *Abt Suger von Saint-Denis, Ausgewählte Schriften: Ordinatio, De consecratione, De administratione* (Darmstadt, 2000). See also R. Haussherr, "*Arte nulli secundus:* Eine Notiz zum Künstlerlob im Mittelalter," in *Ars auro prior: Studia Ioanni Białostocki sexagenario dicata*, ed. J. A. Chrościcki et al. (Warsaw, 1981), 43–47.

5. Panofsky, *Abbot Suger* (as in note 4), 79.

6. Panofsky, *Abbot Suger* (as in note 4), 47–49. The original reads: "Portarum quisquis attollere quaeris honorem,/ Aurum nec sumptus, operis mirare laborem." Also see note 8 below.

7. A reading first proposed by K. Hoffmann, "Zur Entstehung der Königsportale in Saint-Denis," *ZKunstg* 48 (1985), 29–38, esp. 36.

8. See M. Büchsel, "Ecclesiae symbolorum cursus completus," *Städel-Jahrbuch* n.s. 9 (1983), 69–88, esp. 74: "Wer immer du seist, der du die Schönheit der Tore zu rühmen suchst,/bestaune nicht das Gold und die Kosten, sondern die Mühsal des Werks"; Büchsel, *Die Skulptur des Querhauses der Kathedrale von Chartres* (Berlin, 1995), 168–82; and Büchsel, *Die Geburt der Gotik: Abt Sugers Konzept für die Abteikirche St.-Denis* (Freiburg im Breisgau, 1997), 125–34. On the same verses, see also S. Linscheid-Burdich, "Beobachtungen zu Sugers Versinschriften in *De administratione*," in Speer and Binding, *Abt Suger* (as in note 4), 112–46, esp. 120–25. C. Markshies (*Gibt es eine "Theologie der gotischen Kathedrale"?: Nochmals, Suger von Saint-Denis und Sankt Dionys vom Areopag, AbhHeid, Phil.-hist.Kl.* [1995], 1. Abh. [Heidelberg, 1995], 66–67) offers yet another translation: "bewundere das Gold und nicht die Kosten, die Mühe des Werkes." For previous suggestions and disagreements concerning the translation of this passage and the connotations of the term *opus*, see P. C. Claussen, "*Materia* und *opus*: Mittelalterliche Kunst auf der Goldwaage," in *Ars naturam adiuvans: Festschrift für Matthias Winner zum 11. März 1996*, ed. V. von Flemming and S. Schütze (Mainz, 1996), 40–49, esp. 43.

9. For medieval representations of craft or artistry, see H. Huth, *Künstler und Werkstatt der Spätgotik* (Augsburg, 1923), and the papers collected in *Artistes, artisans et production artistique au Moyen Âge: Colloque international, Centre national de la recherche scientifique, Université de Rennes II, Haute-Bretagne, 2–6 mai 1983*, 3 vols., ed. X. Barral i Altet (Paris, 1986). Among the many other publications on aspects of this topic is P. C. Claussen, "Nachrichten von den Antipoden oder der mittelalterlichen Künstler über sich selbst," in *Der Künstler über sich in seinem Werk: internationales Symposium der Bibliotheca Hertziana, Rom, 1989*, ed. M. Winner (Weinheim, 1992), 19–54.

10. For another recent attempt to reconcile a similar set of oppositions, see M. V. Schwarz, *Visuelle Medien im christlichen Kult: Fallstudien aus dem 13. bis 16. Jahrhundert* (Vienna, Cologne, and Weimar, 2002), 110–14 ("Kunst vs. Frömmigkeit?").

11. See H. Holländer, "Bild, Vision und Rahmen," in *Zusammenhänge, Einflüsse, Wirkungen: Kongressakten zum ersten Symposium des Mediävistenverbandes in Tübingen, 1984*, ed. J. O. Fichte, K. H. Göller, and B. Schimmelpfennig (Berlin, 1986), 71–94, esp. 81: "Es gab keine besondere Bildästhetik [im Mittelalter]. Das Bild definiert sich selbst. Es leistet dabei anderes, oft mehr als der Text. Eines der Mittel der Selbstdefinition ist der Rahmen." See also K. Krüger, "Mimesis als Bildlichkeit des Scheins: Zur Fiktionalität religiöser Bildkunst im Trecento," in *Künstlerische Austausch/Artistic Exchange: Akten des XXVIII. Internationalen Kongresses für Kunstgeschichte, Berlin, 15.–20. Juli 1992*, vol. 2, ed. T. W. Gaeht-

gens (Berlin, 1993), 423–36; W. Tronzo, "On the Role of Antiquity in Medieval Art: Frames and Framing Devices," in *Ideologie e pratiche del reimpiego nell'alto medioevo*, Settimane di Studio del Centro Italiano di Studi sull'Alto Medioevo 46, 2 vols. (Spoleto, 1999), vol. 2, 1085–14; and, more generally, *The Rhetoric of the Frame: Essays on the Boundaries of the Artwork*, ed. P. Duro (Cambridge, 1996), 79–95, 258–73.

12. See S. Linscheid-Burdich, "Sugers Versinschriften" (as in note 8).

13. Darmstadt, Hessischen Landes- und Hochschulbibliothek, Cod. 1640, f. 6v. See P. Bloch and H. Schnitzler, *Die Ottonische Kölner Malerschule*, 2 vols. (Düsseldorf, 1967), vol. 1, 44–53, and vol. 2, pls. 113–70.

14. See P. von Naredi-Rainer, *Salomos Tempel und das Abendland: Monumentale Folgen historischer Irrtümer* (Cologne, 1994); and G. Binding, *Der früh- und hochmittelalterliche Bauherr als sapiens architectus*, 2nd rev. ed. (Darmstadt, 1998), 381–417.

15. See, most recently, J. A. Frank, "The Moses Window from the Abbey Church of Saint-Denis: Text and Image in Twelfth-Century Art," *GBA* 133 (1996), 179–94, and, for a somewhat different interpretation, H. L. Kessler, "The Function of *Vitrum Vestitum* and the Use of *Materia Saphirorum* in Suger's St.-Denis," in *L'image: Fonctions et usages des images dans l'Occident médiéval*, ed. J. Baschet and J.-C. Schmitt (Paris, 1996), 179–203, reprinted in H. L. Kessler, *Spiritual Seeing: Picturing God's Invisibility in Medieval Art* (Philadelphia, 2000), 190–205, 253–58.

16. See, most recently, P. Meyvaert, "Maximilien Théodore Chrétin and the Apse Mosaic at Germigny-des-Près," *GBA* 137 (2001), 203–20.

17. See K. Morrison's contribution to this volume and *Opus Caroli regis contra synodum (Libri Carolini)*, ed. A. Freeman, MGH, Conc 2, suppl. 1 (Hanover, 1998).

18. For a fuller discussion, see J. F. Hamburger, *The Rothschild Canticles: Art and Mysticism in Flanders and the Rhineland, ca. 1300* (New Haven, 1990). For the latest scholarship on the manuscript's date and localization, see W. Scheepsma, "Filling the Blanks: A Middle Dutch Dionysius-Quotation and the Origins of the *Rothschild Canticles*," *Medium Aevum* 70 (2001), 278–303.

19. See the discussion of this manuscript in C. Chazelle's essay in this volume; also L. Nees, "Problems of Form and Function in Early Medieval Illustrated Bibles from Northwest Europe," in *Imaging the Early Medieval Bible*, ed. J. Williams (University Park, Pa., 1999), 121–77, esp. 148–74; and C. Farr, *The Book of Kells: Its Function and Audience* (London and Toronto, 1997), 52–61.

20. See W. Cahn, "Architecture and Exegesis: Richard of St.-Victor's Ezechiel Commentary and Its Illustrations," *ArtB* 76 (1994), 53–68.

21. For Guyart, see S. Berger, *La Bible française au Moyen Âge: Étude sur les plus anciennes version de la Bible écrites en prose de langue d'oïl* (Paris, 1884; reprint Geneva, 1967), 157–86; R. Potz McGerr, "Guyart Desmoulins, the Vernacular Master of Histories, and His *Bible Historiale*," *Viator* 14 (1983), 211–44; and P.-M. Bogaert, "Adaptations et versions de la Bible en prose (langue d'oïl)," in *Les genres littéraires dans le sources théolo-*

giques et philosophiques médiévales: Définition critique et exploitation. Actes du Colloque internationale de Louvain-la-Neuve, 25–27 mai 1981 (Louvain-le-Neuve, 1982), 259–77, the last kindly brought to my attention by A. Kumler.

22. See P. Burckhart, "Eine wiederentdeckte 'Bible historiale' aus der königlichen Bibliothek im Louvre: Stuttgart, WCB Cod. bibl. 2° 6," Scriptorium 53 (1999), 187–99; and A. Komada, "Les Illustrations de la Bible historiale: Les Manuscrits réalisés dans le nord" (thèse de Doctorat Nouveau Régime, 2000, Université de Paris IV), kindly brought to my attention by P. Stirnemann.

23. Reproduced in color in T. Voronova and A. Sterligov, Les Manuscrits enluminés occidentaux du VIIe au XVIe siècle: à la Bibliothèque nationale de Russie de Saint-Pétersbourg: France, Espagne, Angleterre, Allemagne, Italie, Pays-Bas (Bournemouth and St. Petersburg, 1996), 82–87, with previous bibliography. The manuscript is no. 104 in Komada's catalogue (as in note 22), 1064–68.

24. Similar imagery occurs in the earlier Vie de St. Denis, Paris, Bibliothèque Nationale de France, Ms. fr. 2090, f. 107v; see C. Lacaze, The "Vie de St. Denis" Manuscript (Paris, Bibliothèque Nationale, Ms. fr. 2090–2092) (New York, 1979), 123–24, fig. 19.

25. See G. Peers, Subtle Bodies: Representing Angels in Byzantium (Berkeley, 2001), and B. Bruderer Eichberg, Les Neufs Chœurs angéliques: Origine et évolution du thème dans l'art du Moyen Âge, Civilization Médiévale 6 (Poitiers, 1998).

26. For ladder imagery in medieval art, see C. Heck, L'Échelle celeste dans l'art du Moyen Âge: Une image de la quête du ciel (Paris, 1997). For a later frontispiece providing a "fantasia on the theme of the mind's ascent to heaven," see the Bible historiale, London, B.L., Ms. Harley 4381–82, vol. 1, f. 3r, painted in Paris circa 1400 and part of the library of Jean, duc de Berry, discussed by M. W. Evans, "Boethius and an Illustration to the Bible historiale," JWarb 30 (1967), 394–98, and reproduced in color in E. L. Sandgren, The Book of Hours of Johannete Ravenelle and Parisian Book Illumination around 1400, Acta Universitatis Upsaliensis, Figura, n.s. 28 (Uppsala, 2002), 103–7, fig. 84.

27. See J. Diamond Udovitch, "The Papeleu Master: A Parisian Illuminator of the Early Fourteenth Century," 2 vols. (Ph.D. diss., New York University, 1979), vol. 1, 112–35 and 218–25; and, for the likelihood that this artist could be identified as Richard de Verdun, R. H. Rouse and M. A. Rouse, Manuscripts and Their Makers: Commercial Book Producers in Medieval Paris, 1200–1500, 2 vols. (Turnhout, 2000), vol. 1, 140–43.

28. See F. Avril, J.-P. Aniel, M. Mentré, A. Saulnier, and Y. Zauska, Manuscrits enluminés de la peninsule ibérique (Paris, 1982), 31–43; the entry by P. K. Klein in The Art of Medieval Spain, A.D. 500–1200, exh. cat. (New York, 1993), 307–9, no. 158; and M. A. Castiñeiras González, "From Chaos to Cosmos: The Creation Iconography in the Catalan Romanesque Bibles," Arte medievale n.s. 1 (2002), 35–50, esp. 43–44.

29. In addition to the latter possibility, H. R. Broderick also kindly suggested that it might represent Christ as the cornerstone rejected by the builders (Matt. 21:42).

30. N. Morgan, Early Gothic Manuscripts [I], 1190–1250, A Survey of Manuscripts Illuminated in the British Isles 4 (London, 1982), no. 32, 106–10. See also Bruderer Eichberg, Les Neuf Choeurs (as in note 25), 105–6; H. R. Broderick, "The Influence of Anglo-Saxon Genesis Iconography on Later English Medieval Manuscript Art," in The Preservation and Transmission of Anglo-Saxon Culture, ed. P. Szarmach and J. Rosenthal (Kalamazoo, Mich., 1997), 211–39; and J. F. Hamburger, "Speculations on Speculation: Vision and Perception in the Theory and Practice of Mystical Devotions," in Deutsche Mystik im abendländischen Zusammenhang: Neue erschlossene Texte, neue methodische Ansätze, neue theoretische Konzepte, Kolloquium Kloster Fischingen, ed. W. Haug and W. Schneider-Lastin (Tübingen, 2000), 353–408, esp. 373–74.

31. For the tenth choir, see P. Salmon, "Der zehnte Engelschor in deutschen Dichtungen und Predigten des Mittelalters," Euphorion 57 (1963), 321–30; E. C. Lutz, " 'In niun schar insuder geordent gar': Gregorianische Angeologie, Dionysius-Rezeption und volkssprachliche Dichtungen des Mittelalters," Zeitschrift für deutsche Philologie 102 (1983), 335–76; and W. Babilas, Untersuchungen zu den Sermoni subalpini: Mit einem Exkurs über die Zehn-Engelchor-Lehre, Münchner romanistische Arbeiten 24 (Munich, 1968), 79–82 and 173–213.

32. I use the edition of the text provided by Potz McGerr, "Guyart Desmoulins" (as in note 21), 229, lines 1–5, which is based primarily on Yale University Ms. 129 (New Haven, Beinicke Rare Book and Manuscript Library). There are significant variants in other manuscripts. For example, the copy in Berlin (Staatsbiblithek zu Berlin, Preussischer Kulturbesitz, Ms. Phillips 1906, f. 9r) speaks of four chambers, although in keeping with other copies, it identifies only three.

33. See the edition in Potz McGerr, "Guyart Desmoulins" (as in note 21), 229–30, lines 5–25.

34. For the manuscript Staatsbibliothek zu Berlin, Preussischer Kulturbesitz, Ms. Phillips 1906, see J. Kirchner, Beschreibende Verzeichnisse der Miniaturen-Handschriften der Preussischen Staatsbibliothek zu Berlin, vol. 1 (Leipzig, 1926), 77–86.

35. Potz McGerr, "Guyart Desmoulins" (as in note 21), 229, line 8.

36. For microarchitecture, see P. Kurmann, "Gigantomanie und Miniatur: Möglichkeiten gotischer Architektur zwischen Grossbau und Kleinkunst," Kölner Domblatt: Jahrbuch des Zentral-Dombau-Vereins 61 (1996), 123–46; and Kurmann, "Miniaturkathedrale oder monumentales Reliquiar? Zur Architektur des Gertrudenschreins," in Schatz aus dem Trümmern: Der Silberschrein von Nivelles und die europäische Hochgotik, exh. cat., ed. H. Westermann-Angerhausen (Cologne, 1995), 135–53.

37. Reproduced in color in Glaube und Wissen im Mittelalter: Die Kölner Dombibliothek (Cologne and Munich, 1998), 423–33.

38. For the imitation of metalwork in fourteenth-century French illumination, see Lacaze, The "Vie de St. Denis" Manuscript (as in note 24), 144–53.

39. Bibliothèque Publique et Universitaire, Ms. fr. 3; see L'Enluminure de Charlemagne à François Ier: Manuscrits de la Bibliothèque publique et universitaire de Genève,

exh. cat. (Geneva, 1976), 67–70. For Jean le Noir, see most recently B. Carqué, *Stil und Erinnerung: Französische Hofkunst im Jahrhundert Karl V. und im Zeitalter ihrer Deutung*, Veröffentlichungen des Max-Planck-Instituts für Geschichte 192 (Göttingen, 2004), 263–82.

40. For a reevaluation of the traditional dating of the shrine of Saint Romain, see R. Suckale, "Réflexions sur la sculpture parisienne à l'époque de Saint Louis et de Philippe le Bel," *Revue de l'Art* 128 (2000), 33–48, revised and reprinted in Suckale, *Das mittelalterliche Bild als Zeitseuge: Sechs Studien* (Berlin, 2002), 123–71. A far more elaborate rendering of the Temple and Tabernacle can be found in the *Bible historiale*, Paris, Bibliothèque de l'Arsenal, Ms. 5057, f. 77r, reproduced in H. Martin, *Les Miniaturistes français* (Paris, 1906), fig. 34, brought to my attention by A. Kumler. An initial in an early-fourteenth-century Westphalian Bible that portrays Moses praying in front of an ark resembling a locked chest indicates that portraying the ark as a reliquary shrine was hardly obligatory, but rather, represented a conscious choice; see *Der "Codex Henrici": Lateinische Bibelhandschrift, Westfalen, 1. Viertel des 14. Jahrhunderts*, Kulturstiftung der Länder: Patrimonia 144 (Munster, 1998), pl. 15.

41. See Kirchner, *Beschreibende Verzeichnisse* (as in note 34).

42. Cf. the representation of the ark in the thirteenth-century French psalter, New York, Morgan Lib., Ms. M.730, f. 109r, where it appears in a scene of David's entry into Jerusalem; reproduced in E. J. Beer, "Die Buchkunst der Handschrift 302 der Vadiana," in *Rudolf von Ems, Weltchronik: Der Stricker Karl der Grosse. Kommentar zu Ms 302 Vad.*, ed. E. J. Beer et al. (Lucerne, 1987), 100, fig. 29. P. Springer ("Der Schrein der hl. Walpurgis als 'persona mixta'," in *Der Welfenschatz und sein Umkreis*, ed. J. Ehlers and D. Kötzsche [Mainz, 1998], 287–308) reproduces a medieval reliquary that mimics the form of both a portable altar and the Ark of the Covenant, including the rings through which the reliquary was attached to the staves that supported it.

43. J. H. Marrow, "Symbol and Meaning in Northern European Art of the Late Middle Ages and the Early Renaissance," *Simiolus* 16 (1986), 150–69.

44. H. Stahl, "Heaven in View: The Place of the Elect in an Illuminated Book of Hours," in *Last Things: Death and the Apocalypse in the Middle Ages*, ed. C. W. Bynum and P. Freedman (Philadelphia, 2000), 205–32, 344–50.

45. The Crucifixion flanked by seraphim in the Bible of William of Devon (London, B.L., Ms. Royal 1 D.I, f. 4v; reproduced in J. Higgitt, *The Murthly Hours: Devotion, Literacy, and Luxury in Paris, England, and the Gaelic West* [London, 2000], 122, fig. 84) could be interpreted in the same vein.

46. See Camille, *Gothic Idol* (as in note 3), 26–27 and 167; J.-D. Müller, "The Body of the Book: The Media Transition from Manuscript to Print," in *Materialities of Communication*, ed. H. U. Gumbrecht and K. L. Pfeiffer, trans. W. Whorby (Stanford, 1994), 32–44, esp. 35; and W. J. Diebold,, *Word and Image: An Introduction to Early Medieval Art* (Boulder, Colo., 2000), 103.

47. See J. van Engen, "Theophilus Presbyter and Rupert of Deutz: The Manual Arts and Benedictine Theology in the Early Twelfth Century," *Viator* 11 (1980), 147–63; and B. Reudenbach, " 'Ornatus materialis domus Dei': Die theologische Legitimation handwerklicher Künste bei Theophilus," in *Studien zur Geschichte der europäischen Skulptur im 12./13. Jahrhundert*, 2 vols., ed. H. Beck and K. Hengevoss-Dürkop (Frankfurt, 1994), vol. 1, 1–16.

48. *Theophilus: The Various Arts, De Diversis Artibus*, ed. and trans. C. R. Dodwell (Oxford, 1986), 36–37.

49. *Theophilus* (as in note 48), 61–62.

50. See J. F. Hamburger, " 'On the Little Bed of Jesus: Pictorial Piety and Monastic Reform," in Hamburger, *The Visual and the Visionary: Art and Female Spirituality in Late Medieval Germany* (New York, 1998), 383–426, fig. 8.3.

51. See J.-U. Günther, *Die illustrierten mittelhochdeutschen Weltchronikhandschriften in Versen: Katalog der Handschriften und Einordnung der Illustrationen in die Bildüberlieferung*, Tuduv-Studien: Reihe Kunstgeschichte 48 (Munich, 1993), 112–24.

52. Günther, *Weltchronikhandschriften* (as in note 51), 133–40; and U. von Bloh, *Die illustrierten Historienbibeln: Text und Bild in Prolog und Schöpfungsgeschichte der deutschsprachigen Historienbibeln des Spätmittelalters*, Vestigia Bibliae 13–14 (Bern, 1991–92), 191–93.

53. For an all too brief discussion of the iconography of the Institution of the Eucharist, see B. Welzel, *Abendmahlsaltäre vor der Reformation* (Berlin, 1991), 43–44.

54. For the iconography of authorship in French manuscripts, both in Latin and in the vernacular, of the thirteenth and fourteenth centuries, see U. Peters, "Autorbilder in volksprachigen Handschriften des Mittelalters: Eine Problemskizze," *Zeitschrift für deutsche Philologie* 119 (2000), 321–68; and C. Meier, "Bilder der Wissenschaft: Die Illustration des 'Speculum maius' von Vinzenz von Beauvais im enzyklopädischen Kontext," *FS* 33 (1999), 252–86.

55. Berger, *Bible française* (as in note 21), 160: "Car, seur l'ame de moi, je n'i ai riens ne mis ne ajousté, fors tant seulement pure verité, si com je l'ai el latin de la Bible trouvé, et des Histoires les escolastres . . . Je ai tret dou latin tout mot a mot."

56. Berger, *Bible française* (as in note 21), 159: "Pour ce que li deables, qui chacun jour empeeche et destourbe et enordit les cuers des hommes par oiseuse."

57. See, e.g., M. Carruthers, *The Craft of Thought: Meditation, Rhetoric, and the Making of Images, 400–1200* (Cambridge, 1998), chap. 5 ("The Place of the Tabernacle"). See also H.-J. Spitz, *Die Metaphorik des geistigen Schriftsinss: Ein Beitrag zur allegorischen Bibelauslegung des ersten christlichen Jahrtausends*, Münstersche Mittelalter-Schriften 12 (Munich, 1972), 205–18.

58. S. Bonaventure, *Opera theologica selecta*, vol. 5, ed. A. Sépinski (Florence, 1964), 55 (part II, chap. 12): "Ex praedictis autem colligi potest, quod creatura mundi est quasi liber, in quo relucet, repraesentatur et legitur Trinitas fabricatrix secundum triplicem gradum expressionis, scilicet per modum vestigii, imaginis et similitudinis: ita quod ratio vestigii reperitur in omnibus creaturis, ratio imaginis in solis intellectualibus seu spiritibus rationalibus, ratio similitudinis in solis deiformibus; ex quibus

quasi per quosdam scalares gradus intellectus humanus natus est gradatim ascendere in summum principium, quod est Deus."

59. Hugh of St.-Victor, *Commentariorum in Hierarchiam coelestem S. Dionysii Areopagitae secundum interpretationem Johannis Scoti*, PL 175, col. 949B: "Quas vero visibilium similitudines ad invisibilia ipse noster animus arbitrari debeat et existimare, quaedam distincta subjiciens exempla ostendit, ac si diceret: Ideo per visibilia invisibilium veritas demonstrata est; quia non potest noster animus ad invisibilium ipsorum veritatem ascendere, nisi per visibilium considerationem eruditus, ita videlicet, ut arbitretur visibiles formas esse imaginationes invisibilis pulchritudinis. Quia enim in formis rerum visibilium pulchritudo earumdem consistit, congrue ex formis visibilibus invisibilem pulchritudinem demonstrari dicit, quoniam visibilis pulchritudo invisibilis pulchritudinis imago est."

60. See note 3 above.

61. For the representational role of *ars sacra* in late medieval images, see J. F. Hamburger, "Seeing and Believing: The Suspicion of Sight and the Authentication of Vision in Late Medieval Art," in *Imagination und Wirklichkeit: Zum Verhältnis von mentalen und realen Bilder in der Kunst der frühen Neuzeit*, ed. A. Nova and K. Krüger (Mainz, 2000), 47–70.

62. One could easily point out that terms such as "master" and "workshop" are in many respects anachronistic and belie the complexity of the collaborations that produced these manuscripts. Yet it was precisely during this period that craftsmen began to fashion images that can be interpreted as statements on their own standing and status.

63. Paris, Bibliothèque de l'Arsenal, Ms. 5212; reproduced in color in F. Avril, *Painting at the Court of France in the Fourteenth Century* (New York, 1978), 114–15.

64. For another extraordinary representation of the face of God seen, remarkably, from the rear, see the miniature depicting the vision of Moses according to Exodus 33:12–23 in *Weltchronik* of Rudolf von Ems (Los Angeles, J. Paul Getty Museum, Ms. 33, f. 89v), reproduced in Springer, "Schrein der hl. Walpurgis" (as in note 42), 307, fig. 19.

65. F. Avril, L. Dunlop, and B. Yapp, *Les Petites Heures du duc de Berry*, 2 vols. (Lucerne, 1988–89).

66. The earliest example, kindly brought to my attention by A. Kumler, appears on the exterior of the ivory Shrine Madonna from Bourbon, usually dated ca. 1200, for which see G. Radler, *Die Schreinmadonna "Vierge Ouvrante" von den bernhardinischen Anfängen bis zur Frauenmystik im Deutschordensland, mit beschreibendem Katalog*, Frankfurter Fundamente der Kunstgeschichte 6 (Frankfurt, 1990), 51–55 and 203–9. The authenticity of the Shrine Madonna has often been questioned; see the entry by R. H. Randall in *Images in Ivory: Precious Objects of the Gothic Age*, exh. cat., ed. P. Barnet (Detroit and Princeton, 1997), 285–89, challenged in turn by K. Holbert, "The Vindication of a Controversial Early-Thirteenth-Century *Vierge Ouvrante* in the Walters Art Gallery," *Journal of the Walters Art Gallery* 55–56 (1997–98), 101–21.

67. There is unfortunately no consensus on the date of the binding. In *Schatz aus den Trümmern* (as in note 36), 306, E. Antoine argues for a date of ca. 1260. In *Le trésor de la Sainte-Chapelle* (Paris, 2001), no. 37, 159–60, M.-P. L. (unidentified) suggests ca. 1260–70. Suckale (*Das mittelalterliche Bild* [as in note 40]) offers an earlier date, ca. 1255. For further discussion of the binding's iconography and its implications, see J. F. Hamburger, "Body vs. Book: The Trope of Visibility in Images of Christian-Jewish Polemic," in *Die Ästhetik des Unsichtbaren: Zum Verhältnis von Sichtbarkeit und Unsichtbarkeit in Kunst und Bildtheorie des Mittelalters und der Frühen Neuzeit*, ed. D. Ganz and T. Lentes, KultBild: Visualität und Religion in der Vormoderne, vol. 1 (Berlin, 2004), 113–46.

68. R. Branner, in *Manuscript Painting in Paris during the Reign of Saint Louis: A Study of Styles* (Berkeley, 1977), dates the missal in Paris (Bibliothèque Sainte-Geneviève, Ms. 90, f. 168) to shortly after 1253. The missal of Mont-St.-Eloi is reproduced in color in M. Smeyers, *Flemish Miniatures from the 8th to the Mid-16th Century: The Medieval World on Parchment*, trans. K. Bowen and D. Imhof (Turnhout, 1999), 117.

69. See O. Pächt and J. J. G. Alexander, *Illuminated Manuscripts in the Bodleian Library, Oxford*, 3 vols., vol. 1, *German, Dutch, Flemish, French and Spanish Schools* (Oxford, 1966), 47. As noted by Pächt and Alexander, the leaves are inserted into an Eusebius, *Historia Ecclesiastica* printed by Nicholas Ketelaer and Gerardus Leempt of Nijmegen in 1473. The iconography recurs in the early-fifteenth-century missal for Châlons-sur-Marne (New York, Morgan Lib., Ms. M.331, ff. 186v–187r), and still later in the missal of Etienne de Longwy, Maçon(?), ca. 1490, f. 135r, sold at Sotheby's, *Western Manuscripts and Miniatures*, London, 18 June 2002, lot 43, 57–63, esp. 63.

70. See Kirchner, *Beschreibende Verzeichnisse* (as in note 34). The same imagery marks the Majestas prefacing the *Bible historiale* of Jean le Bon (London, B.L., Ms. Royal 19 D.II, f. 1r); reproduced in C. Ferguson O'Meara, *Monarchy and Consent: The Coronation Book of Charles V of France, British Library MS Cotton Tiberius B. VIII* (London, 2001), 188, fig. 60.

71. M. R. James, *A Descriptive Catalogue of the Manuscripts in the Fitzwilliam Museum* (Cambridge, 1895), 14–18.

72. In the late fourteenth and the early fifteenth century, the iconography eventually finds its way into Parisian Books of Hours; see, e.g., Sotheby's, 3 December 1968, lot 23C (reproduced in color); Frankfurt, Ms. lat. oct. 129 (reproduced in color in J. Sander, *Die Entdeckung der Kunst: Niederlandische Kunst des 15. und 16. Jahrhunderts in Frankfurt* [Mainz, 1995], 194 and pl. 13); Oxford, Bodleian Library, Ms. Buchanan e.2 (reproduced in P. Kidd, *Medieval Manuscripts from the Collection of T. R. Buchanan in the Bodleian Library, Oxford* [Oxford, 2001], 14); New York, Morgan Lib., Ms. M.515, f. 95r (reproduced in A. S. Farber, "Considering a Marginal Master: The Work of an Early Fifteenth-Century Parisian Manuscript Decorator," *Gesta* 32 (1993), 21–39, fig. 12; and several Parisian Hours whose current location remains unknown: *Speculum Manuscriptorum: A Mirror of Manuscripts* (Southport,

Conn., n.d.), no. 15, 28–30; and *Livres rares et précieux: Manuscrits à miniatures, reliures anciennes, lettres autographes*, Bulletin de la Librairie Jacques Rosenthal, Catalogue 36 (Munich, n.d.), no. 236, in which the tablets of the law are placed on a column in the manner of an idol.

73. See W. Braunfels, *Die Heilige Dreifaltigkeit* (Düsseldorf, 1954), 35.

74. Reproduced in color in *Magister Theodoricus, Court Painter to Emperor Charles IV: The Pictorial Decoration of the Shrines at Karlštejn Castle*, exh. cat., ed. J. Fajt (Prague, 1998), 76.

75. For related symbolism, see A. Krüger and G. Runge, "Lifting the Veil: Two Typological Diagrams in the *Hortus deliciarum*," *JWarb* 60 (1997), 1–22.

76. A point Freedberg makes still more emphatically in his essay "Holy Images and Other Images," in *The Art of Interpreting*, ed. S. C. Scott, Papers in Art History from the Pennsylvania State University 9 (University Park, 1995), 69–87.

77. J. E. Keller and R. P. Kinkade, *Iconography in Medieval Spanish Literature* (Lexington, Ky., 1984), 105.

78. See M. H. Caviness, " 'The Simple Perception of Matter' and the Representation of Narrative, ca. 1180–1280," *Gesta* 30 (1991), 41–47.

79. See H. L. Kessler, "Real Absence: Early Medieval Art and the Metamorphosis of Vision," in *Morfologie sociali e culturali in Europa fra Tarda Antichità e Alto Medioevo, 3–9 aprile 1997*, Settimane di studio del Centro italiano di studi sull'Alto Medioevo 45 (Spoleto, 1998), 1157–1211, reprinted in Kessler, *Spiritual Seeing* (as in note 15), 104–48.

80. See Hamburger, *Rothschild Canticles* (as in note 18), 141.

Turning a Blind Eye: Medieval Art and the Dynamics of Contemplation

Herbert L. Kessler

Medieval art theory distinguished pictures seen by means of physical sight from the mental images they were intended to evoke. The eleventh-century customary of the monastery of Fruttuaria, for example, maintained that the faithful looking at the statue of Christ astride his donkey paraded to the church on Good Friday believed that God was actually present before them, but then added:

> because, were it permitted to us to contemplate with bodily eyes, it would seem that we ourselves have gone to meet the Son of God, which we must without any doubt believe we have done. Although He may not indeed be seen physically, yet the person whose inner eyes He will have opened has the power to see that we have gone forth to meet our Lord Jesus Christ.[1]

A little later, Alan of Lille explained that material pictures "depict the image of Christ so that people can be led through those things seen to the invisible."[2] Modern writing on medieval art, often based on photographs or digital forms which reduce all depictions to "images," frequently fails to make this essential distinction, thereby eliding the difference between substance and appearance and hence neglecting the play between material and mental images that was so important to the medieval experience. The theory was frequently introduced in connection with real works. As early as A.D. 1000, a caption facing the Christ in Majesty in the Hitda Codex (ff. 6v–7r; see Fig. 3 in J. F. Hamburger, "The Medieval Work of Art," in this volume) proclaimed: "This visible image represents the invisible truth/Whose splendor penetrates the world through the four lights (Gospels) of his new doctrine."[3] And an inscription around the depiction of the celestial Christ on a mid-twelfth-century Mosan phylactery in St. Petersburg (Fig. 1) asserts: "Revere the image of Christ by bowing before it when you pass by it; but in doing this make sure you do not worship the image but rather Him whom it represents."[4]

The basic tenet could not be simpler. Trapped in a world of sensual experience, humans need (or at least benefit from) material props; but, to avoid confusing what they see with God's invisible divinity, they must transform the sensual impressions derived from looking at artistic representations into mental contemplations. Just how such a conversion might be effected is anything but clear-cut, however; and it was the subject of much discussion and artistic experimentation.

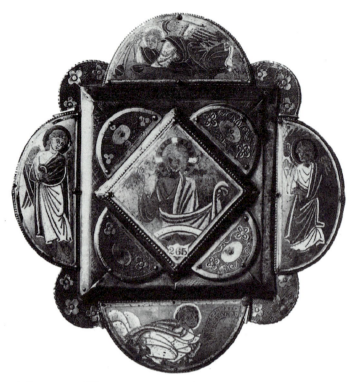

1. Phylactery, twelfth century. St. Petersburg, Hermitage, Φ 171 (cf. Fig. 8)

Isidore of Seville, for example, began his discussion *De pictura* with a commonsense notion: "A painting expresses the appearance of a thing which, when seen, recalls that thing to the mind."[5] But, punning on *pictura/fictura*, he immediately added the subversive counterclaim that a painting is only a manufactured thing, devoid of truth and fully capable of conjuring up monsters. Six hundred years later, another Spanish theologian who had read Isidore, Bishop Lucas of Tuy, criticized (heretical) pictures because they "deceive the simple and wean their minds and thoughts from devotion to our most glorious Lady, Mary Ever-Virgin."[6]

By focusing on the mechanisms through which "those things seen" in material images were believed capable of leading viewers to the invisible deity (or were deemed insufficient for the task), the essays in *The Mind's Eye: Art and Theological Argument in the Medieval West* attend to a central problem of medieval art. And, while acknowledging the importance of such other issues as memory, materiality, and the relationship between images and texts, they advance an original and fundamental principle of interpretation,[7] namely, that medieval pictures not only represented religious figures and themes but also instigated dynamic progressions that, themselves, generated theological content. Examining the processes rather than the products, the book opens lines of inquiry that promise to be fruitful for a very long time.

One of those lines involves systems for staging the transformation of physical seeing into contemplation of the divine. In essence, these reversed the sacred narrative according to which the direct vision of the divine enjoyed by Adam and Eve in paradise had undergone successive transformations after the first couple sinned and was expelled from Eden. Replaced by carnal sight, it was reinstated through several epiphanies reported in the Jewish Scripture and restored for a short

time when God assumed flesh and lived on earth. Suspended again when Christ returned to his Father's side in heaven, the direct vision of God was promised to those among the blessed at the end of time who would see him "face to face."[8] Augustine explained it this way:

> Because the inner eye had already had the dust of sin thrown in it, blinding it and disabling it from grasping and enjoying that, there was no longer any means by which the Word could be understood; and so the Word agreed to be flesh, to purify the organ by which he could later be seen, which he can't be just yet.[9]

As a first step, by engaging physical sight, art might at least attract attention away from the mundane world and call attention to more elevated things. As early as the early fifth century, Paulinus had expressed the hope that pilgrims in Nola "feed[ing] their eyes with this attractive and charming fast, [would] turn more slowly to thoughts of food"[10] and seven centuries later, Bruno of Segni speculated that art had been allowed in churches in the first place because "gentiles and unbelievers used to take the greatest delight in seeing [ornament] and were drawn to a love of Christ through it."[11] Writing around 1200, the anonymous author of the *Pictor in carmine* elaborated the argument,

> For since the eyes of our contemporaries are apt to be caught by a pleasure that is not only vain, but even profane, and since I did not think it would be easy to do away altogether with the meaningless paintings in churches, . . . I think it an excusable concession that they should enjoy at least that class of pictures which, being the books of the laity, can suggest divine things to the unlearned, and stir up the learned to the love of Scriptures.[12]

Paintings in Sta. Maria Immacolata (San Felice II) at Ceri north of Rome, which are contemporary with Bruno of Segni and perhaps influenced by his thinking, exemplify the process.[13] Even while it delights the senses with an otherworldly spectacle, the colorful, highly ornamented interior provides a controlled experience imbued with sacred appearances that contrasts with the disordered natural world outside (Figs. 2, 3). How art regulated the transition from the unruly urban and rural environs into the sacred space it helped to create and out again needs further scholarly attention; but at Ceri, the procedure is clear. Depictions of demons and carnal temptations lead to portraits of saints and pictured episodes from Scripture inscribed with words; at the same time, embedded warnings against the temptation of physical ornament engage the viewer in a reciprocal process of accepting and rejecting the pictures themselves. Thus, directly below the scene of Adam and Eve eating the forbidden fruit "pleasing to the eye and tempting to contemplate," the paintings at Ceri picture Joseph fleeing Potiphar's wife (Fig. 4), rendered as an allegory of the seductiveness of church decoration. Bedecked by curtains, the palace building resembles a basilica with side aisles;[14] and garbed in a richly embroidered dress that conjures up the serpent's scales in the scene above, the temptress represents art's carnal appeal from which virtuous Christians, of which Joseph was a type, must escape. For Bruno of Segni, Potiphar's wife symbolized idolatry;[15] thus, even while elevating the viewers' spirits, the decorations offer a warning against their own capacity to satisfy rather than to recall absent things. As Augustine pointed out, only those with mental vision are able to resist the attraction of physical objects and see the invisible,[16] an argument reiterated throughout the Middle Ages—in the fourteenth century, for instance, by Opicino de Canistris.[17]

Another way that art effected a transfer from object to thought was to subject the figures rep-

2. Ceri, Sta. Maria Immacolata, north wall, ca. 1100

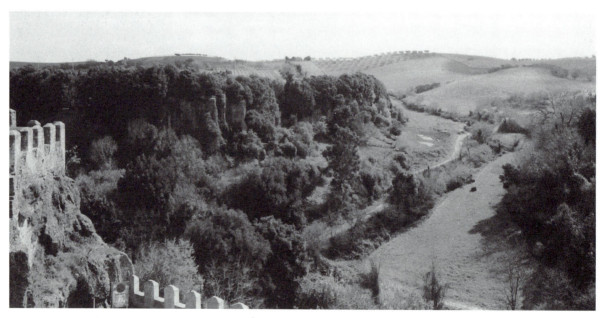

3. Ceri, landscape

4. Joseph and Potiphar's wife. Ceri, Sta. Maria Immacolata, north wall

resented through it to an exegetical process that destabilized any notion that they replaced a single thing; just as "carnal" texts and the real world were interpreted for what they revealed of God's plan, so too, pictures were scrutinized for all possible archetypes behind their overt appearance. In a letter Peter Damian wrote to Desiderius of Montecassino in 1069, he provided an example of how such a process worked.[18] Attempting to explain why ancient representations of the *traditio legis*, such as the one on a late-fourth-century sarcophagus in Arles (Fig. 5),[19] pictured Paul rather than Peter on Christ's right, he introduced as many scriptural justifications as he could discover, arguing among other things that Paul, who had never seen the Lord in the flesh, enjoyed pride of place because he had comprehended his divinity when he ascended to the third heaven. Another example is the *Pictor in carmine*, which structures subjects from Hebrew Scripture as prophecies of Christ's life story; it understands the epiphanies to Moses on Mt. Horeb as allegories of his virgin birth because the flaming bush was not consumed by the fire and the staff changed into a serpent when Moses threw it on the ground in God's presence.[20]

According to such texts, a picture need not represent a single thing or a particular event, but rather, by suggesting as many references as are consistent with accepted belief, can initiate processes of linking and replacing. The depiction at Ceri of Moses on Mt. Horeb (Fig. 6) illustrates the way the mechanism actually worked.[21] Alluding to the Incarnation, it focuses on Christ

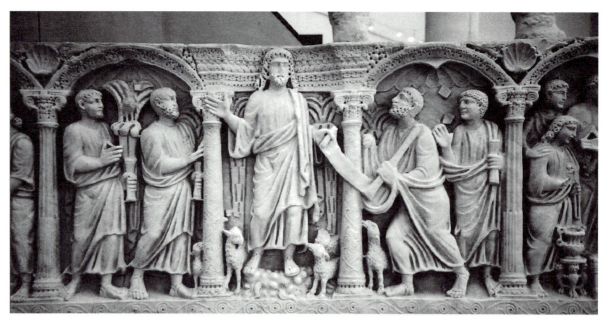

5. Christ flanked by Saints Peter and Paul. Sarcophagus, fourth century. Arles, Musée de l'Arles Antique

6. Moses on Mt. Horeb, ca. 1100. Ceri, Sta. Maria Immacolata

within the flaming tree and, in so doing, engages the very theory of vision. Inspired by the reading of the event as evidence that Moses "saw one thing with his [bodily] eyes and imagined its significance [in his mind],"[22] it pictures the prophet at the left looking into the void while he removes his sandals. Made of animal flesh, the sandals symbolize the carnal seeing that Moses had to shed in the presence of God, connecting the scene to the expulsion pictured directly above, which pictures animal hides covering Adam and Eve's nudity from prurient looking as the first couple is expelled from the vision of the Lord. Similarly, Moses grabbing the rod as it changes into a serpent and then back again bears on the transformative capacity of pictures, as well as on the Incarnation. Moreover, the entire composition recalls the *traditio legis* as pictured in many Roman church apses, asserting visually that as the prophet and leader summoned by God to take his people into the holy land, Moses was a predecessor of Peter and Paul, the founders of the Church established by Christ;[23] and it suggests that the histories reported in Hebrew Scripture are but preparations for the realizations in the Christian Church.

The references in the paintings at Ceri would have appealed variously to the diverse audience that looked at them and would have been understood according to individual abilities; the *Pictor in carmine* acknowledged just that when it pointed out that a picture "can suggest divine things to the unlearned, and stir up the learned to the love of scriptures." Attracted by the rich physical effects and animated histories, for example, children and simple people could have read the paintings simply as narrative accounts, perhaps deriving moral lessons also from the scenes of temptation and sin. More sophisticated viewers and those who, over a lifetime, meditated on the details and discovered meaning in the juxtapositions, would have discovered elevated messages in the depiction of Christ within the burning bush. Still others, acquainted with art and text, would have pondered the meaning of the "quoted" apse composition and the relationship to the Old Testament theophany of the accompanying titulus, "sed Deus est et homo quem sacra figurat imago."

At Ceri and in many other works of medieval art, the tension between art's basic attraction and its higher aspirations was part of a fundamental spiritual battle, countered by various strategic responses, of which many are examined in this volume and others still await further study.[24] The struggle between carnality and spirituality is often made an explicit theme; at Ceri, for instance, Saint George slaying the dragon and Saint Sylvester subduing the demon in the Roman forum frame the Old Testament cycle and provide a transition between the holy space inside and the real world beyond. Jousting knights represented at the start of the richly illustrated twelfth-century St. Alban's Psalter (Fig. 7)[25] provide a particularly instructive example of how such pictures of battle worked because they are accompanied by an explanatory gloss; the lively depiction was intended to capture the *oculis corporis* but only as a way of producing in the *oculis cordis* a vision of the victory of faith and love over pride and malice: "Whoever wishes to be a son of God and a worthy heir of the heavens . . . let him watch in eye and heart that war and [fight for] justice which he observes drawn out [in the fighters]." The text, or rather the oscillation between text and image, thus transforms any "vain pleasure" the viewer might derive from looking at the pictured encounter drawn from the contemporary world into a higher vision and spiritual picture of "divine things."[26] In this way art was, itself, a weapon in the contest. Even the generally hostile Bernard of Clairvaux understood art's usefulness to "stimulate the devotion of a carnal people with material ornaments because they cannot do so with spiritual ones";[27] and, following him, the author of the *Pictor in carmine* maintained that good images were useful because they could super-

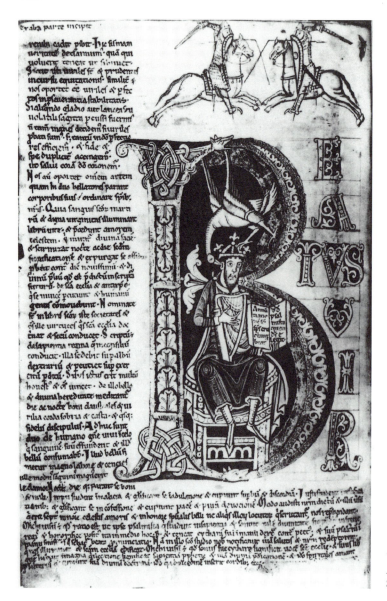

7. Jousting knights, twelfth century. St. Alban's Psalter, Hildesheim, Dombibliothek St. Godehard, Ms. 1, p. 72

sede bad ones. The risk, of course, was that they might do the very opposite. What troubled Desiderius and Lucas of Tuy was the prospect that pictures containing features contrary to Church doctrine might actually taint the minds of those seeking God in them and lead them astray.[28] Throughout the Middle Ages, art itself remained part of the spiritual fray.

As the very structure of the *Pictor in carmine* reveals and the caption beneath the Horeb narrative in Ceri indicates, the spiritual struggle embodied in art centered on Christ's own person, another topic considered by many essays in this book. The Ceri inscription—the second line of a widely circulated distich inscribed in its entirety on the back of the St. Petersburg phylactery (Fig. 8)—reads in full: "Nec Deus est nec homo, praesens quam cernis imago,/sed Deus est et homo quem sacra figurat imago."[29] A "sacra imago," it asserts, must not picture either Christ's human

8. Phylactery, twelfth century. St. Petersburg, Hermitage, Φ 171. The inscription reads: Nec Deus est nec homo, praesens quam cernis imago, /sed Deus est et homo quem sacra figurat imago

nature alone or his divinity alone; it must convey the mysterious amalgam of the two natures.[30] To do that, it had to conceive of the representation of Christ's human person as a stimulus to contemplation of his divinity. Although the Savior had been portrayed from the very beginning of Christian art, even in stone as on the Arles sarcophagus, this became a critical problem only in response to Byzantine iconoclasm during the eighth and ninth centuries.[31] Even while reinforcing the legitimacy of depictions of the human Christ, image texts and works of art from that time betray the need also to assert that looking at them was but the first step in an anagogical process.[32] Thus, the forger of the eighth-century interpolation into Gregory I's letter to Secundinus argued that a picture of Christ rendered the Lord visible to corporeal sight and, in so doing, showed his invisible reality;[33] and, a short time later, Pope Hadrian I maintained that material images are honored so that "by a spiritual force our mind is carried up through the visible face to the invisible majesty of divinity, through the contemplation of the image depicted in human form, which the son of God deigned to assume for our salvation."[34] Christ's dual nature also underlies the mosaic that Hadrian's successor, Leo III, introduced in the church of SS. Nereo e Achilleo (Fig. 9); flanked by depictions of the Annunciation and Virgin and Child in which Christ's divinity is still hidden within the flesh, the Transfiguration is depicted at the apex of the apsidal arch, the epiphanic demonstration par excellence of the Lord's two inseparable aspects.[35] Clothed as on the Arles sarcophagus and standing in much the same pose, Christ is transformed in the apse by a mandorla and by the saintly witnesses who simultaneously point to his human appearance and fall down before his divinity. Later in the century, the illuminator of the Codex Aureus of St. Em-

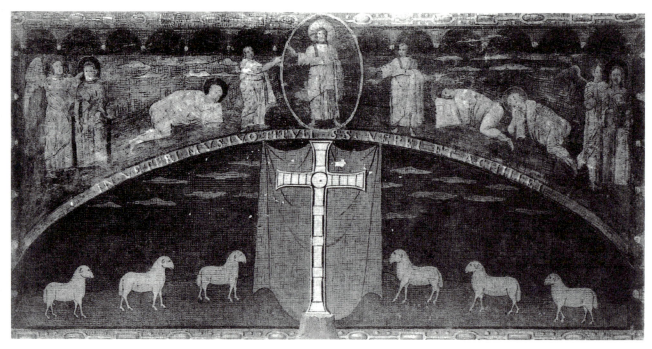

9. Transfiguration. Mosaic, ca. 814. Rome, SS. Nereo ed Achilleo, apse

meram (Figs.10, 11) solved the problem of rendering the two natures by replacing Christ with a lamb; what Charles the Bald prays to with "wide open eyes"[36] and what the whole earth and twenty-four elders adore is only a symbol of Christ—a symbol that is distanced further from reality by being presented by means of a quotation of a recognizable work of art. Like the reference to the apse in Ceri, the domelike composition in the manuscript refers to the mosaic in the Cappella Palatina at Aachen; here, too, the image's overt artificiality is a mechanism for channeling attention away from the appearance and to the archetype beyond.[37]

The desire to suggest Christ's divinity in representations of his incarnate person persisted long after the immediate threat of iconoclasm ended. The apse of S. Pietro at Tuscania offers a particularly telling witness to the way this was done (Fig. 12). Largely lost in an earthquake in 1971 but well recorded in a watercolor by Johann Anton Ramboux (Fig.13),[38] the painting reconfigured the Early Christian *traditio legis* as a depiction of the moment when the Lord "was lifted up and a cloud removed him from their sight" at the Ascension (Acts 1:9). Perhaps as a direct response to Augustine's interpretation of the event, it conceives of Christ's departure from the earth as a demonstration of the apostles' need to detach themselves from his human form so that they could redirect their thoughts to his divinity:

> They were fixated on the man, and unable to think of him as God. The time they would think of him as God would be if the man were removed from their sight; this would cut short the familiarity they had acquired with him in the flesh, and so they would learn at least through his absence in the flesh to think about his divinity.[39]

At the bottom of the composition, the disciples are shown discussing Christ's disappearance while struggling to keep him in view even as his head penetrates the clouds; and, following Augustine's

description, it represents the belief that "the flesh, that is the head, went before us into heaven [and] the other members will follow"; [40] it pictures Christ's feet still planted firmly on the earth and his face above the clouds. Angels silhouetted against the landscape bear banderoles with texts that help effect the transition, the *Gloria* and a passage from the Book of Acts: "Why stand there looking at the sky?" (1:10). The painting also extends the vector established by Christ's body both upward and downward. Between Peter and Paul portrayed beneath Christ's feet and the actual episcopal throne below them, a portrait of the pope identifies the Church of Rome with the apostolic church founded after the Ascension and specifically with this church of S. Pietro. [41] The apparently seamless transition from Christ's feet to his head thus effects a transition from contemplation of his human nature to contemplation of his divine nature, and hence from the earthly appearance to the celestial. Indeed, mimicking the Early Christian source composition, Peter and Paul directly under Savior's feet appear already to be comprehending Christ's divinity in their "mind's eye."

As Augustine pointed out, to move from the physical contemplation of Christ's human form to mental devotion of his divinity demanded an interruption of carnal seeing: "It is better that you should not see this flesh, and should turn your thoughts to my divinity. I am removing myself from you outwardly and filling you with myself inwardly." Reflecting that belief, the Tuscania apse deploys mechanisms to interrupt or at least complicate the movement from material representation to the ineffable archetype. Thus, heaven is depicted on the apsidal arch, separated from the Ascension by a band of angels symbolizing the firmament. As in the Codex Aureus of St. Emmeram, the celestial vision is pictured by means of the twenty-four elders adoring God, here represented by Christ within a medallion.

Reflecting the same development of image theory, successive interventions also transformed Rome's most important icon, the Lateran *Acheropita* (Fig. 14). Painted around 700, the panel originally pictured the enthroned figure of Christ Emmanuel; and, conceived as an actual presence, it was carried through Rome and venerated as Christ himself. By the millennium, it had been fitted with the painted velum that still covers its face and was referred to simply as the *vultus*; about the middle of the twelfth century it was inserted into the story of Christ's Ascension when Nicholas Maniacutius reported that the icon had been painted by Saint Luke because, like other mourners, the apostles had wanted to have a likeness of the deceased to comfort them. [42] And, incorporating an ancient distinction between under-drawing and painting to signal Christ's dual nature, [43] Maniacutius maintained that Luke was able to fashion only the preliminary sketch; the *Acheropita* was completed in full color strictly by divine intervention, "ineffabili virtute peracta," causing the face to radiate "gloriosa Salvatoris imago stupendo admodum decore praefulgens." At the beginning of the thirteenth century, Innocent III provided the venerable image with a silver casing fitted with little doors for the papal ceremonial foot washing; while the doors reinforced the reality of the material image, at least of the lower torso, they also further distinguished the face, veiled and separated from the feet by a "body" covered with cosmological designs, the firmament beyond which the Divinity resides. [44] Finally, toward the end of the century, the transformations were consolidated when the encased icon was installed behind an altar in the Sancta Sanctorum, with its feet on relics from the Holy Land (including Mt. Olivet), where Christ had lived, and with its head refigured above in mosaic, borne heavenward by angels. [45]

The sequential modifications of the Lateran *Acheropita* incorporate the widespread identification of Christ's face with his divinity and his torso with his humanity. [46] In the contemporary

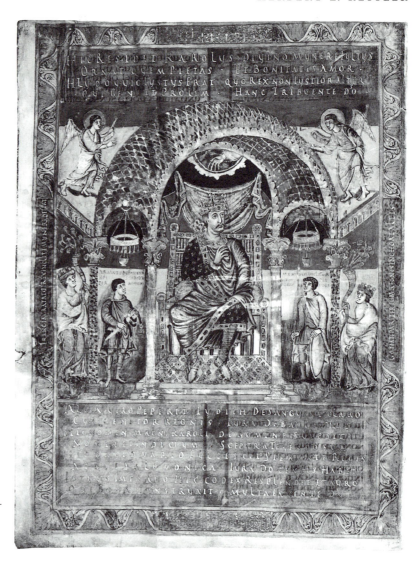

10. Charles the Bald, 870. Codex Aureus of St. Emmeram, Munich, Bayerische Staatsbibliothek, Clm 14000, f. 5v

allegorical interpretation of a depiction of the desert Tabernacle, for instance, Adam Scotus likened the former to the inner sanctum (symbolic of heaven) and the latter—"a ventre usque ad pedes"—to the outer courtyard (symbolizing earth).[47] Implicit in this allegory is the notion that Christ's body proper was like the curtain that closed off the outer courtyard of the Temple from the place of expiation itself, an allegory referred to in the cosmological sheathing of the icon. Identified with Christ's flesh in the Epistle to the Hebrews and, in turn, with the firmament dividing the earthly world from heaven, the veil had entered image theory during the iconoclastic period and was figured in numerous works of art.[48] The mosaic in SS. Nereo ed Achilleo, for example, includes a depiction of Mary weaving the Temple curtain at the moment of the Annunciation and (originally) featured an enormous cross before a suspended red curtain, symbolic of Christ's sacrifice, the "way of all flesh." Like the Transfiguration pictured directly above, therefore, the curtain stands for Christ's dual nature, the visible human character colored blood red covering his divinity, which is merely suggested by the clouds. Moreover, the entire mosaic is

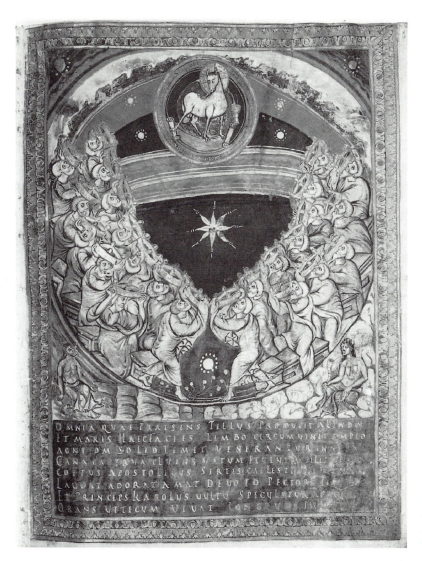

11. Adoration of the Lamb, 870.
Codex Aureus of St. Emmeram,
Munich, Bayerische Staatsbibliothek,
Clm 1400, f. 6r

fashioned as a tapestry suspended from the gemmed border, likening art itself to the veil and, in turn, to Christ's two aspects.[49]

In the Jewish Tabernacle/Temple, God did not reveal himself directly but only manifested himself on the mercy seat behind the curtain; and Adam Scotus built on this essential invisibility in his allegory. He introduced a verse from Luke on the altar under Christ's feet: "If anyone wishes to be a follower of mine, he must leave self behind; he must take up his cross, and come with me" (9:23); and he had another text inscribed on three steps at the entrance of the Tabernacle, "through which Jesus exposes to the view of the human soul the image of the true Trinity." But by means of an inscription above Christ's head, he reminded his readers that they could not glimpse the Lord's face directly: "Things beyond our seeing, things beyond our hearing, things beyond our imagining, all prepared by God for those who love him" (1 Cor. 2:9). The firmament-curtain and velum of the Lateran *Acheropita* create the same effect; God can be approached through art, but he can never be seen directly in it.

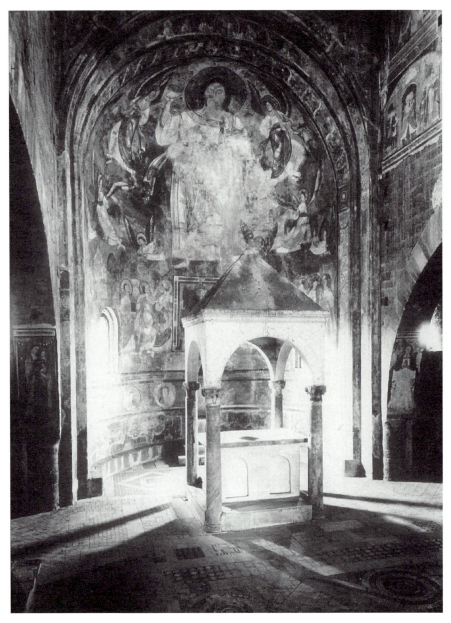

12. Tuscania, San Pietro, apse

Many works make this same point by actually separating the human lower torso from the celestial upper body. In one part of his *Chronica majora*, for instance, Matthew Paris included a depiction of the stone from Mt. Olivet impressed with Christ's footprint when the Lord ascended into heaven (Fig. 15) and the Veronica, the image made from his face, in another (Fig. 16).[50] The *vestigium*, Paris tells his readers, was made "in order that this sign might perpetuate to his disciples the memory of him at whom they gazed for the last time and whom they would not see until he would come again to judge the world,"[51] while the *effigies* evoked the future when the blessed "on the good side of the judge" will see him "face to face."[52] The contrast between upper and

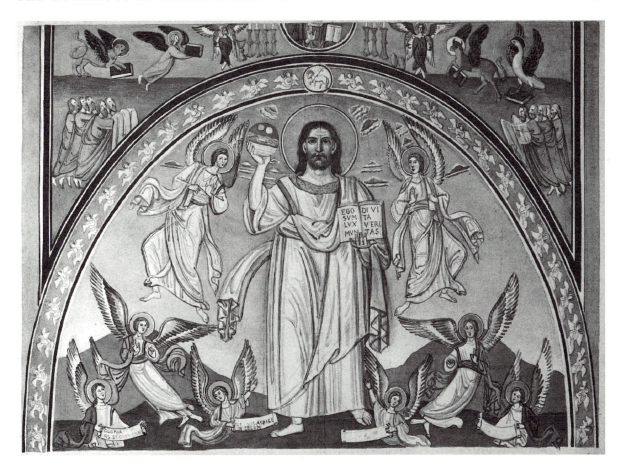

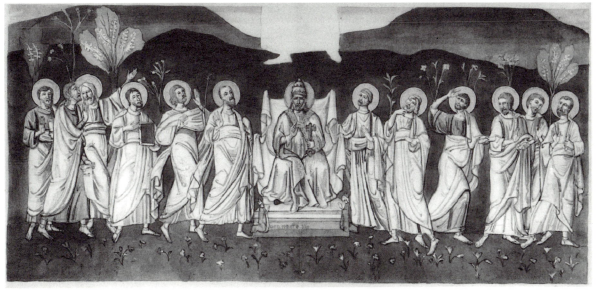

13. Ascension. Tuscania, San Pietro, apse, watercolor copy by Johann Anton Ramboux

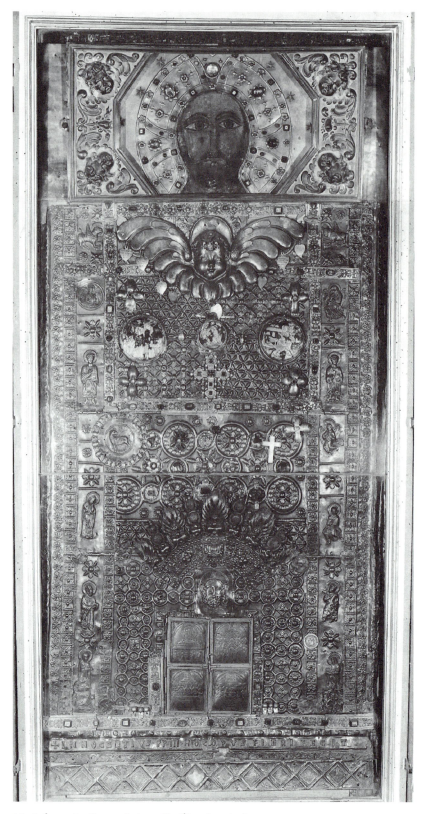

14. *Acheropita*. Rome, Lateran Basilica, Sancta Sanctorum

15. Ascension. London, British Library, Royal Ms. 14 C. VII, f. 146

lower body is deployed to make a similar point in the St. Alban's Psalter, albeit within a different context. Drawing on the well-established Ascension iconography, pictured in the St. Alban's Psalter itself (p. 54), Christ is depicted at Emmaus on facing pages of one opening (pp. 70–71; Figs. 17–18), opposing the moment when the disciples saw his person to the moment of his disappearance when they recognized his divinity.[53] Tellingly, an excerpt of Pope Gregory's defense of images is inserted before the paired illustrations, signaling the proper way to read the pictures that precede and follow it; and, inspired by the dove of the Holy Spirit at his ear, David is portrayed in the guise of Gregory, suggesting that not only the Psalms but also the myriad pictures that adorn them are meant to "teach what should be adored,"[54] an idea articulated as well in the gloss on the jousting knights with its discourse on spiritual seeing.[55]

After they watched Christ vanish from sight, the disciples at Emmaus realized that they had recognized him because he had lighted their "hearts on fire" (Luke 24:32); similarly, in his discussion of the Ascension, Augustine maintained that Christ's withdrawal from the apostles allowed spiritual love to replace their grief over his death.[56] The emotional response to material images of the Savior was understood to function in the same way; and it is yet another important topic considered in this volume.[57]

Toward the end of his influential letter to Serenus of Marseilles, Gregory the Great had already cited affect's role as a conduit to God's divinity, albeit only incidentally: "from the sight of the event portrayed should catch the ardor of compunction, and bow themselves down in adoration of the One Almighty Holy Trinity."[58] The importance of this passage grew gradually during the course of the Middle Ages, reflecting a steady increase in the importance attached to art's compunctive role. Thus, the forger of the eighth-century interpolation into Gregory's I's letter to Secundinus underscored emotions, applying the Augustinian principle of desire to an icon allegedly sought by the holy hermit: "You seek in your heart him whose image you desire to have before your eyes, so that, every day, what your eyes see brings back to you the person depicted, so that while you gaze at the picture your soul burns for him whose image you carefully contemplate."[59]

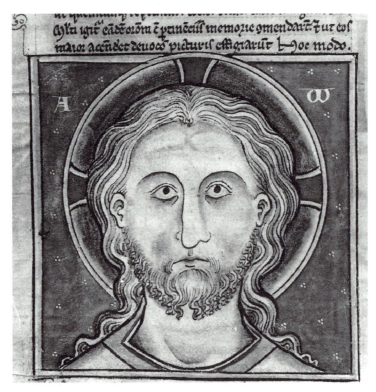

16. The Veronica. Cambridge, Corpus Christi College, Ms. 16, f. 49v

A short time later, Pope Hadrian I introduced affect as the major fuel to drive the ascent from material images to God's celestial glory.[60]

For Walafrid Strabo, "tears" proved that "the visible figures [of Christ's Passion in a picture] are impressed like daubs on their hearts";[61] and two centuries later, Gerard of Cambrai enunciated the claim more fully at the Council of Arras, arguing that the faithful do not adore "visible images" of the Crucifixion but through them "their interior minds are excited and Christ's Passion and death on behalf of humankind are inscribed on the membrane of their hearts."[62] Recalling the Epistle to the Colossians, "For though absent in body, I am with you in spirit" (2:5), Peter Damian also introduced love into his interpretation of the *traditio legis*:

> See, when the apostolic heart is melted by the fire of fraternal love, when it is excited to the point of sweat by the desire for the salvation of the people. Here, it is visible to the body, there it is led to the spirit, and it lays out in the present the feeling of love of the Father, and extends to the absent.[63]

The anagogical power of emotions ultimately secured them a place in the *ratio triplex*, Thomas Aquinas reducing the argument to the claim that images "excite devotional feeling, which is stimulated more effectively by things seen than those heard."[64]

How compunction was intended actually to work still needs investigation. For Jonas of Orleans, art was dangerous because it could generate "excessive and indiscreet love";[65] while Lucas of Tuy worried that the need continuously to activate emotional responses generated unorthodox creations:

17. Christ at Emmaus. St. Alban's Psalter, Hildesheim, Dombibliothek St. Godehard, Ms. 1, p. 70

18. Christ at Emmaus. St. Alban's Psalter, Hildesheim, Dombibliothek St. Godehard, Ms. 1, p. 71

Since the aim of religious art is to arouse the emotions of the spectator, the artist must have liberty to compose his works, so as to assure to them the greatest effectiveness. The representation should not always be forced into traditional patterns. In order to avoid the dullness of accustomed formulas, the artist needs to devise unusual motifs and to invent new ideas as they seem appropriate to him with respect to the location of the work of art and to his period, even if they contradict the literal truth and only serve to deepen the love for Christ through the emotion they arouse.[66]

Adherents to Gregory's *via media*, however, accepted the emotional reaction generated by material images as part of the staging of devotion.[67] For one thing, it could clear of the mind of negative images, as Jacques Panteléon (later Pope Urban IV) attested in 1249 when he sent a copy of the Mandylion to his sister at Montreuil-les-Dames near Laon so that by contemplating an image of God's earthly appearance, the nuns' pious affections "might be more inflamed so that their minds might be made purer."[68] It could also elicit and fix memory.[69]

Most important, if the reaction to an image was sufficiently intense, and if the viewer recognized that the material representation was incapable of satisfying the desire evoked, then the affect generated could be transferred to the spiritual archetype. Thus, the Gregorian forger likened the experience to that of a lover who, seeing a portrait of his beloved, is led to seek her out in person;[70] and the *Pictor in carmine* expressed the hope that religious art would "stir up the love of Scriptures" in the educated.[71] This required that the insufficiency of the immediate object be demonstrated in some way. That is why Charles (and we) see only a "quoted" vision of heaven in the Codex Aureus and why the Veronica in the *Chronica majora* is painted on a separate piece of vellum pasted onto the page, reminding the viewer engaged in prayer before it that the face of God is only a material image.

Understandably, the most potent sources of *spiritalis affectus* were depictions of Christ's relationship to his mother and his suffering or, conversely, of his glorious removal to heaven above.[72] The Crucifixion was specifically cited in the defense of images at the Council of Arras, and during the thirteenth century the crucifixion and Majestas Domini—which had often been pictured side by side (cf. Hamburger, "The Medieval Work of Art," Fig. 31)[73]—were yoked together to realize the idea that Christ's human nature could evoke sufficient emotional energy to spark the mental leap to his divinity.[74] One of the earliest surviving witnesses, Suger's roundel of the Chariot of Aminadab at St.-Denis (Hamburger, "The Medieval Work of Art," Fig. 4), inserts the new Throne of Mercy into the Tabernacle allegory; the Crucifixion (in the explicit form of a crucifix) rises from the Ark of the Covenant and is separated by a curtain from the Father within the Sancta Sanctorum. The normal form of the subject, depicted on a late-twelfth-century cutting from a Sacramentary in Vienna (Fig. 19), includes the altar/throne but no other reference to the Tabernacle; there, the Son's eternal sacrifice leads through the dove of the Holy Spirit to the Father alive in heaven who, in turn, proffers the Crucified to the viewer. Constructed on the internal dynamic relationship of the three Persons of Trinity, which was itself understood, in part, in terms of images,[75] the Throne of Mercy could only work for the faithful. Thus, before he converted, Herman-Judah was unable to connect the crucified Christ to the majestic God in such an image as he encountered in the Münster cathedral. Not only did he consider the one to be a degraded idol, but like all Jews refusing accept the possibility that God could be seen, he declared that the other was "exalted" only by means of artistic deception; and, most important, he did not perceive the relationship of the one to the other.[76] To this, Rupert of Deutz responded as would be expected:

> We do this so that while we externally image forth his death through the likeness of the cross, we may also be kindled inwardly to love of him and that we, who continually remember that entirely untainted by any sin, he endured so ignominious a death for us, may always consider with pious reflection (wrapped up in many and great sins as we are) what a great obligation we owe for his love.[77]

To work even for believers, however, the Throne of Mercy required a change of perceptual register triggered by sentiment. Describing a picture that must have resembled the one in the Vienna leaf, Sicard of Cremona explained: "in certain books, the majesty of the Father and the cross of the crucifix are portrayed so that it is almost as if we see present the one we are calling to, and the Passion which is depicted imprints itself on the eyes of the heart."[78]

Still, because the iconography pictured the divine Person, conservative Church figures criticized it. Citing Augustine, Lucas of Tuy, for instance, railed against it as a presumptuous attempt to "form an image of an uncircumscribable thing," repeating the claim that the faithful can see

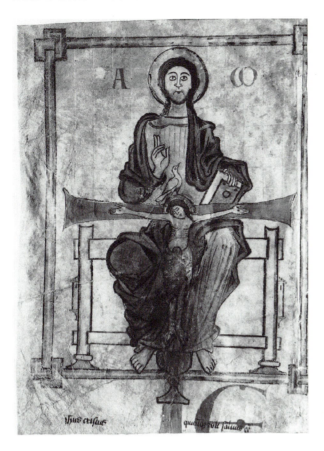

19. Throne of Mercy. Vienna, Albertina, Ms. Cod. Vind. 775, f. 1v

God's divinity only in their hearts;[79] and, in much the same vein, Durand Saint-Pouçain maintained that images could represent only Christ's human nature, dismissing as silly any attempt to represent the Father or the Holy Spirit.[80] The same reservations about the Throne of Mercy were actually pictured in a Psalter from about 1220 (Fig. 20), which conceives the initial *D* of Psalm 109, the very foundation of spiritual topography,[81] as the Tabernacle occupied by the Trinity.[82] Although other initials in the manuscript depict Christ's face directly, betraying the same hesitation Adam Scotus had expressed a little earlier, God's face in the Throne of Mercy is covered with a gold quatrefoil, symbolic of the Lord's pure *doxa*.[83] On the other hand, at the end of the century, the Throne of Mercy was deployed to represent the ultimate mental vision in the "La Sainte Abbaye" (London, B.L., Ms. Yates Thomson 11 [formerly Add. 39843], f. 29r; see Fig. 9 in B. McGinn, "Theologians as Trinitarian Iconographers," in this volume).

The conversion of carnal seeing into mental contemplation was often stimulated and controlled by formal rituals involving gestures and touching, ceremonial veiling and revealing, and auditory animation.[84] Although much attention has recently been paid to the role of art in the liturgy,[85] *The Mind's Eye* advances the study of art's role in religious performances by attending to the function that pictures served in the system of communication with God that lies at the very foundation of the Mass and other church rites. Seen in this way, the figure of Christ looming over the altar in Tuscania, for instance, is not simply a backdrop to the Mass but a visual channel between the mysteries enacted there and the eternal liturgy performed in heaven, as pictured above, where the depiction of the Adoration of the Elders includes bread and a chalice. Likewise, the full

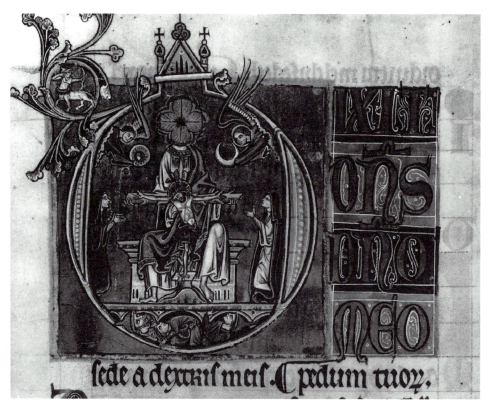

20. Throne of Mercy. Cambridge, Trinity College, Ms. B.11.4, f. 119r

experience of the St. Petersburg phylactery included unlatching the little door inscribed with the *Nec Deus* caveat and then introducing or withdrawing the eucharistic species—not an image but the true body of Christ.[86] Singing "Hosanna to the Son of David" surely helped to convince the boys and monks at Fruttuaria of Christ's presence in the wood sculpture before them; and the image of the Throne of Mercy that, in Sicardus's account, imprints itself on the "eyes of the heart" did so as part of a ritual, when the priest looks up to God in heaven as he consecrates the body and blood of Christ at the beginning of the canon of the mass and recites the *Te igitur*.[87] It is note-worthy that the Vienna fragment includes a chalice beneath the crucifix; and the phylactery pic-tures an angel censing the image of Christ.

One consequence of the use of art in ceremony was a reinforcement of the image's seeming reality. Thus, in the very passage in which Sicardus referred to depictions such as the (Vienna) Throne of Mercy, he described how the priest and canons celebrating Mass first bowed before a crucifix and kissed it and then kissed the feet of a Christ in Majesty "because the Father is reached through the Son." However abstract the rendering itself might be, when a corpus with movable arms was removed from the cross on Good Friday and lowered into a tomb, it suggested that Christ was truly present;[88] and during the annual procession to Sta. Maria Maggiore, the Lateran *Acheropita*—already largely abraded by wear—was washed and censed as if it were Christ him-self. In the ninth century, Eriugena had in fact worried that mental images would not be sufficient to overcome this sense of physical reality;[89] and repeating some of the same arguments centuries later, Opicino de Canistris was still concerned that viewers would therefore lapse into idolatry.[90]

Like the knights in the St.Alban's Psalter, viewers of art had to master a set of moves and countermoves if they were to win their spiritual battle. Sometimes, as in thirteenth-century Hildesheim, these involved theater. To arouse devotion in the citizens on the feast of the Ascension in the church of St. Moritz there, a *representacio ascensionis domini* and accompanying figures of angels were actually pulled up by ropes until they vanished into the ceiling;[91] in the presence of the bishop and canons, who would have been reciting the *Viri Galilaei* and other antiphons, the congregation thus re-experienced Christ's very presence and then the feeling of longing evoked by his disappearance. More commonly, the conversion of the emotional responses into interior vision involved not the movement of the material image, but the viewer's somatic reaction before it. Gregory the Great hoped that the "ardor of compunction" would cause viewers to bow down before the Holy Trinity; and, although the *Libri carolini* had criticized prostration before pictures to be an act of the half blind,[92] the pope's view prevailed. Thus, the three apostles who saw Christ's divinity on Mt. Tabor are pictured at SS. Nereo ed Achilleo prostrate and with their eyes averted; and a little later, the author of the *Life of Saint Hariolf of Ellwangen* presented bowing as a means for opening up the eyes of the mind, reporting that Hariolf had prayed in church on Christmas eve with his eyes fixed for a long time on the pavement and when he looked up, he had seen the Virgin and Child on the altar and for the first time had understood the Gregorian antiphon "Quem vidistis pastores."[93] Gerard of Cambrai proclaimed at the Council of Arras that "we bow down physically before the Crucifixion and mentally before God";[94] and to open their "inner eyes," the participants in the Good Friday processions at Fruttuaria repeatedly prostrated themselves before the wooden image of Christ. The inscription around Christ on the St. Petersburg phylactery expresses the hope that, once the image has caught their attention, passersby would kneel down before it; emulating John the Evangelist who is shown crouching beneath the Majestas, they would then see Christ with a spiritual vision.[95]

The "La Sainte Abbaye" suggests the same devotional progress. Kneeling before a statue of the Coronation, the nun first assumes a position of prayer identical to that of Mary before Christ himself. She then looks downward as the Man of Sorrows descends from heaven. Finally, having internalized the experience initiated by prayer before a material image, she is able to see in her mind's eye the unseeable Trinity, here appropriately in the form of the Throne of Mercy. The theological content is thus generated internally by the nun's serial experiences. By the thirteenth century, the church systematized the devotional process. A treatise recently attributed to Peter the Chanter, for instance, distinguishes seven gestures of prayer, each justified by the Bible or a church father, designed to express the humility and emotional response of a devout lay person;[96] and a similar handbook, written by a Dominican brother between 1280 and 1288, describes, documents, and illustrates nine positions.[97]

Pictures could thus help to reverse the devolution of spiritual vision Augustine had described, initiated when Adam and Eve sinned and partially restored by Christ, "the visible image of the invisible God."[98] They provided a representation of the lost paradise for those who were otherwise familiar only with the real world to which they had been exiled. And for those like Charles the Bald who were privileged to gaze with "eyes wide open" while praying before an image of Christ in heaven, they offered a preparation for the final seeing "face to face." As Augustine pointed out, however, the final seeing is "not yet." The essays in this book reveal in many ways that for pictures to succeed in opening the mind's eye to the true vision, they had to subvert not only their own substance but also their very appearance. Mimicking the process Augustine attributed to

Christ at the Ascension, material images had to demonstrate God's essential unseeability by disabling carnal vision. When viewers turned a blind eye to art, therefore, the turning—whether real or figurative—was as important as the seeing.

Notes

1. *Consuetudines Fructuarienses-Sanblasianae,* ed. L. G. Spätling and P. Dinter (Siegburg, 1985), vol. 1, 149–51; E. Lipsmeyer, "Devotion and Decorum: Intention and Quality in Medieval German Sculpture," *Gesta* 34 (1995), 20–27.

2. *De fide catholica contra haereticos,* IV, chap. 12; PL 210:427.

3. W. Diebold, *Word and Image: An Introduction to Early Medieval Art* (Boulder, Colo., 2000), 124–26.

4. H. van Os, *The Way to Heaven: Relic Veneration in the Middle Ages* (Utrecht, 2000), 119–22.

5. *Etymologiarum sive originum libri XX,* chap. 16; PL 82:676; the passage was quoted at the Council of Paris in 824. Cf. P. Weitmann, *Sukzession und Gegenwart: Zu theoretischen Äusserungen über bildende Künste und Musik von Basileios bis Hrabanus Maurus* (Wiesbaden, 1997); M. Carruthers, *The Craft of Thought: Meditation, Rhetoric, and the Making of Images, 400–1200* (Cambridge, 1998), 200 and passim.

6. Cf. R. Berliner, "The Freedom of Medieval Art," *GBA* 28 (1945), 263–88; C. Gilbert, "A Statement of the Aesthetic Attitude around 1230," *Hebrew University Studies in Literature and the Arts* 13 (1985), 125–52; S. Moralejo, "D. Lucas de Tuy y la 'actitud estética' en el arte mèdieval," *Euphrosyne: Revista de filologia clássica,* n.s., 22 (1994), 341–46.

7. Of course, the idea is not completely new; cf. C. Meier, "Malerei des Unsichtbaren: Über den Zusammenhang von Erkenntnistheorie und Bildstruktur im Mittelalter," in *Text und Bild, Bild und Text,* ed. W. Harms (Stuttgart, 1990), 35–65; J.-C. Bonne, "Entre l'image et la matière: La choséité en Occident," in *Les Images dans les sociétés médiévale: Pour une histoire comparé (Bulletin de l'institut historique Belge de Rome 69* [1999]), 77–111; T. Lentes, "Inneres Auge, Äusserer Blick und heilige Schau," in *Frömmigkeit im Mittelalter: Politisch-soziale Kontexte, visuelle Praxis, körperliche Ausdrucksformen,* ed. K. Schreiner (Munich, 2002), 179–220. Moreover, they continued to be explored even in the Counter-Reformation; cf. W. Melion, "Introduction," in J. Nadal, *Annotations and Meditations on the Gospels,* trans. F. Homann (Philadelphia, 2003).

8. For instance, Adam Scotus: "Sed postquam ad concupiscendum interdictae arboris fructum exteriores oculos suos homo incautus aperuit, illos interiores, quibus Conditorem suum videre debuit, damnabiliter" (PL 198:700).

9. "Sed quia ad illud tenendum et fruendum excaecatus erat oculus interior pulvere peccatorum, jam non erat unde intelligeretur Verbum; quod dignatus est caro fieri, ut mandaretur quo possit postea videri, quod modo non potest" (PL 38:1217; trans. E. Hill [New Rochelle, N.Y., 1993], part 3, vol. 7, p. 231).

10. "Dum grata oculis ieiunia pascunt, atque ita se melior stupefactis inserat usus, dum fallit pictura famem" (Carmen 27.587–89; trans. R. Goldschmidt, *Paulinus' Churches at Nola* [Amsterdam, 1940], 65).

11. "Hoc autem fidei ornamento post Christi passionem longo tempore Ecclesiae filii usi sunt, quoniam gentiles et infideles maxime hoc videre delectabantur, hoc ad Christia amorem trahebantur" (*Sententiae,* Bk. 2, chap. 12; PL 165:941).

12. M. R. James, "Pictor in Carmine," *Archaeologia* 94 (1951), 141–66; A. Arnulf, *Versus ad picturas: Studien zur Titulusdichtung als Quellengattung der Kunstgeschichte von der Antike bis zum Hochmittelalter* (Munich and Berlin, 1997), 293–95. A little later, an anonymous preacher contemporary with Bonaventure deployed a similar argument, namely, that the paintings help to "steady" the heart and direct it to inward things (see J. F. Hamburger, "The Place of Theology in Medieval Art History," in this volume).

13. N. Zchomelidse, *Santa Maria Immacolata in Ceri: Pittura sacra al tempo della riforma Gregoriana* (Rome, 1996).

14. Cf. the representation of S. Clemente in the lower church of S. Clemente; C. Filippini, "La chiesa e il suo santo: gli affreschi dell'undicesimo secolo nella chiesa di S. Clemente a Roma," in *Art, cérémonial et liturgie au Moyen Âge,* ed. N. Bock, P. Kurmann, S. Romano, and J.-M. Spieser (Rome, 2002), 107–24.

15. "Sed quid per uxorem Putiphar, nisi idololatriam intelligimus?" (*Expositio in Pentateuchum,* chap. 39; PL 164:221). The overt content is reinforced by the titulus which, though mostly lost, includes the fragmentary word STRVPV . . . , either "struprum" or "stuprum," a reference to illicit sex.

16. "Sed multis finis est humana delectatio, nec volunt tendere ad superiora, ut judicent cur ista visibilia placeant. At ego virum intrinsecus oculatum, et invisibiliter videntem non desinam commonere cur ista placeant, ut judex esse audeat ipsius delectationis humanae" (*De vera religione,* 32, 59; PL 34:148).

17. Cf. V. Morse, "Seeing and Believing: The Problem of Idolatry in the Thought of Opicino de Canistris," in *Orthodoxie, christianisme, histoire,* ed. S. Elm, E. Rebillard, and A. Romano (Rome, 2000), 163–76.

18. *Die Briefe des Petrus Damiani,* ed. K. Reindel (Munich, 1998), 90–99.

19. M. B. Rasmussen, "Traditio legis?" *CahArch* 47 (1999), 5–37.

20. James, *"Pictor in Carmine"* (as in note 12), 151.

21. H. Kessler, "Corporeal Texts, Spiritual Paintings, and the Mind's Eye," in *Old St. Peter's and Church Decoration in Medieval Italy* (Spoleto, 2002), 159–78; N.

Zchomelidse, "Das Bild im Busch: Zu Theorie und Ikonographie der alttestamentlichen Gottesvision im Mittelalter," in *Die Sichtbarkeit des Unsichtbaren: Zur Korrelation von Text und Bild im Wirkungskreis der Bibel*, ed. B. Janowski and N. Zchomelidse (Tübingen, 2003), 165–89.

22. For example, in the preface to the Apocalypse; D. de Bruyne, *Préfaces de la Bible latine* (Namur, 1920), 263.

23. Zchomelidse, "Bild im Busch" (as in note 21).

24. Cf. K. M. Openshaw, "The Battle between Christ and Satan in the Tiberius Psalter," *JWarb* 52 (1989), 14–33; J. J. G. Alexander, "Ideological Representation of Military Combat in Anglo-Norman Art," *Anglo-Norman Studies* 15 (1992), 1–24; T. Dale, *Relics, Prayer, and Politics in Medieval Venetia: Romanesque Painting in the Crypt of Aquileia Cathedral* (Princeton, 1997); C. Rudolph, *Violence and Daily Life: Reading, Art, and Polemics in the Cîteaux* Moralia in Job (Princeton, 1997); M. Angheben, *Les Chapiteaux romans de Bourgogne: Thèmes et programmes* (Turnhout, 2003).

25. *Buch und Bild im Mittelalter*, ed. U. Knapp (Hildesheim, 1999), 91–115; www.abdn.ac.uk/stalbanspaslter. Cf. M. Camille, "Philological Iconoclasm: Edition and Image in the *Vie de Saint Alexis*," in *Medievalism and the Modernist Temper*, ed. R. H. Bloch and S. Nichols (Baltimore, 1996), 371–401.

26. The principle that earthly deeds communicate spiritual truths extends to the Psalmist; David is portrayed within the opening initial *B* as the channel of divine prophecy "and for that reason spiritual people love the psalter."

27. C. Rudolph, *The "Things of Greater Importance": Bernard of Clairvaux's* Apologia *and the Medieval Attitude toward Art* (Philadelphia, 1990), 278–79.

28. Cf. Morse, "Seeing and Believing" (as in note 17).

29. Arnulf, *Versus ad picturas* (as in note 12), 276–78; C. Kendall, *The Allegory of the Church: Romanesque Portals and Their Verse Inscriptions* (Toronto, 1998), 81.

30. The distich is inscribed on an early-eleventh-century leaf in Verdun (Bibl. Mun., Ms. 95, f. 57r), for instance, which pictures the dead Christ being lowered from the cross and the resurrected Savior in the harrowing of Hell and appearance to the Maries; cf. J. F. Hamburger, *The Visual and the Visionary: Art and Female Spirituality in Late Medieval Germany* (New York, 1998), 185.

31. Cf. D. Appleby, "Instruction and Inspiration through Images in the Carolingian Period," in *Word, Image, Number: Communication in the Middle Ages*, ed. J. J. Contreni and S. Casciani (Turnhout, 2002), 85–111; E. Thunø, "Decus suus splendet ceu Phoebus in orbe: Zum Verhältnis von Text und Bild in der Apsis von Santa Maria in Domnica in Rom," in *Sichtbarkeit des Unsichtbaren* (as in note 21), 147–64.

32. J. Hamburger, "Idol Curiosity," in *Curiositas: Welterfahrung und ästhetische Neugierde in Mittelalter und früher Neuzeit*, ed. K. Krüger (Göttingen, 2002), 21–58.

33. *S. Gregorii Magni Registrum Epistularum*, vol. 1, ed. D. Norberg, CCSL 140 (Turnhout, 1982), pp. 1110f.; H. Kessler, "Real Absence: Early Medieval Art and the Metamorphosis of Vision," in *Morfologie sociali e culturali in Europa fra Tarda Antichità e Alto Medioevo, 3–9 aprile 1997* (Spoleto, 1998), 1157–1211, reprinted in H. L. Kessler, *Spiritual Seeing: Picturing God's Invisibility in Me-*

dieval Art (Philadelphia, 2000), 104–48.

34. "Per visibilem vultum ad invisibilem divinitatis maiestatem mens nostra rapiatur spiritali affectu per contemplationem figurate imaginis secundum carnem, quam filius Dei pro nostra salute suscipere dignatus est" (*Hadrianum* 25; MGH, EpKarA 3, ed. K. Hampe [Berlin, 1898–99], 56; Appleby, "Instruction and Inspiration" [as in note 31], 91).

35. G. Curzi, "La decorazione musiva della basilica dei SS. Nereo e Achilleo in Roma: Materiali ed ipotesi," *Arte medievale* 2 (1993), 21–45; E. Thunø, *Image and Relic: Mediating the Sacred in Early Medieval Rome* (Rome, 2002), 129–31 and passim.

36. "Et princeps Karolus uultu speculatur aperto, Orans, ut tecum uiuat longeuus aeuum"; P. Dutton and E. Jeauneau, "The Verses of the *Codex Aureus* of Saint Emmeram," *Studi medievali*, ser. 3, 24 (1983), 75–120; E. Jeauneau, "De l'art mystagogie (Le Jugement dernier vu par Érigène)," in *De l'art comme mystagogie: Iconographie du Jugement dernier et des fins dernières à l'époque gothique*, ed. Y. Christe (Poitiers, 1996), 1–8; *Iohannis Scotti Eriugenae Carmina*, ed. M. Herren (Dublin, 1993), 129.

37. For other examples, cf. Kessler, "Real Absence" (as in note 33).

38. E. Parlato and S. Romano, *Roma e Lazio: Il romanico*, 2nd ed. (Milan, 2001), 179–94.

39. "Fixi enim erant in homine, et Deum cogitare non poterant. Tunc enim cogitarent Deum, si ab illis et eorum oculis homo auferretur, ut amputata familiaritate quae cum carne erat facta, discerent vel absente carne divinitatem cogitare" (Sermon 264; PL 38:1214; trans. E. Hill, *The Works of Augustine: Sermons* [New Rochelle, N.Y., 1993], 226–35). Cf. Kessler, "Real Absence" (as in note 33), 135–36.

40. "Modo iam credo, quia adscendit in caelum caput meum; quo captu praecessit, et membra secutura . . . Longe est super omnes caelos, sed pedes habet in terra; caput in caelo est, corpus in terra" (*Ennarationes in Psalmos*, ed. E. Dekkers and J. Fraipont, CCSL 39 [Turnhout, 1956], pp. 1274 and 1287); cf. R. Deshman, "Another Look at the Disappearing Christ: Corporeal and Spiritual Vision in Early Medieval Images," *ArtB* 79 (1997), 518–46.

41. Probably representing Urban V, but perhaps replacing an earlier portrait.

42. G. Wolf, *Salus populi romani: Die Geschichte römischer Kultbilder im Mittelalter* (Weinheim, 1990); M. Bacci, *Il pennello dell'Evangelista: Storia delle immagini sacre attribuite a san Luca* (Pisa, 1998), 253–54; S. Romano, "L'acheropita lateranense: Storia e funzione," in *Il volto di Cristo*, ed. G. Morello and W. Wolf (Rome, 2000), 39–41.

43. Isidore, *Etymologiarum*, 19.16.1; PL 82:676. The *Glossa ordinaria* likened Hebrew Scripture to a preliminary sketch that required completion in painting to represent the truth: "Non ipsam imaginem. Id est veritatem, ut in pictura usquequo ponat quis colores, quedem est substratio. Vel substratio est umbra quedam, et non imago; cum vero flores ipsos quis colores intinxerit, tunc image efficitur" (PL 114: 660). Cf. Dale, *Relics, Prayer, and Politics* (as in note 24).

44. Wolf, *Salus populi romani* (as in note 42), 39–40 and passim; V. Pace, "La committenza artistica de Innocenzo

III: Dall'urbe all'orbe," in *Innocenzo III: Urbs et Orbis*, ed. A. Sommerlechner (Rome, 2003), vol. 2, 1226–44.

45. A copy made a short time later (Palombara Sabina, San Biagio Vescovo e Martire) suggests how it was perceived at the end of the Middle Ages. Christ's body is covered by a cosmological skin rendered in gilt stucco embossed with stars and divided at the waist by a broad band of circles; access to the feet is suggested by a false door at the bottom while the celestial character of the upper torso is indexed by the sun and moon. The Archetype is then shown beyond the materialized body, portrayed from the neck up against a black sky; cf. *Volto di Cristo* (as in note 42), p. 61.

46. Deshman, "Another Look" (as in note 40), 534–35.

47. This ancient trope was visualized at the end of the Middle Ages in the Virgin Chapel at Karlštejn (see J. F. Hamburger, "The Medieval Work of Art," Fig. 38, in this volume), where Christ is pictured from the waist up in the Ark of the Covenant.

48. Cf. K. Krüger, *Das Bild als Schleier des Unsichtbaren: Ästhetische Illusion in der Kunst der frühen Neuzeit in Italien* (Munich, 2001); G. Wolf, *Schleier und Spiegel: Traditionen des Christusbildes und die Bildkonzepte der Renaissance* (Munich, 2002).

49. Sicard of Cremona likened Christ's dual nature to woven curtains; cf. K. Faupel-Drevs, *Von rechten Gebrauch der Bilder im liturgischen Raum* (Leiden, 2000), 356–60.

50. Wolf, *Schleier und Spiegel* (as in note 48).

51. Cf. Hamburger's discussion of *vestigium* in "The Place of Theology" (as in note 12).

52. H. Belting, *Likeness and Presence: A History of the Image before the Era of Art*, trans. E. Jephcott (Chicago, 1994), 543.

53. Deshman, "Another Look" (as in note 40), 544–45.

54. K. Haney, *The St. Albans Psalter: An Anglo-Norman Song of Faith* (New York, 2002).

55. Deshman, "Another Look" (as in note 40), 544–45.

56. "Si quid erat in cordibus eorum tractum de desiderio carnali, quasi contristatum est in ipsis. . . . Ille autem missurus erat post istum decem diebus interpositis Spiritum sanctum, ut Spiritus sanctus impleret eos amore spirituali, auferens eis desideria carnalia" (Sermon 264, 4; PL 38:1215).

57. See, e.g., B. Newman, "Love's Arrows: Christ as Cupid in Late Medieval Art and Devotion," in this volume.

58. "ut ex uisione rei gestae ardorem compunctionis percipiant et in adoratione solius omnipotentis sanctae trinitatis humiliter prosternantur" (*Sancti Gregorii Magni Registrum Epistolarum* XI.10, 11, ed. D. Norberg, CCSL 140A [Turnhout, 1982], p. 875]).

59. Appleby, "Instruction and Inspiration" (as in note 31), 89–90.

60. For the text, see note 34 above. Appleby, "Instruction and Inspiration" (as in note 31), 90; Hincmar of Rheims reduced Gregory's dicta largely to this claim: "Sicut et de sanctorum imaginibus decreverunt, reprehendentes eos, veluti et beatus Gregorius in epistolis ad Secundinum et ad Serenum Massiliensem demonstrat episcopum, qui sub hac quasi occasione ne adorari debuissent, confringenda easdem imagines dixerunt, et laudantes eos, qui illas non adorandas, sicut neque confringendas, sed ad instruendas

solummodo mentes fuisse nescientium collocandas constituerunt: quoniam in adoratione solius omnipotentis sanctae Trinitatis humiliter prosterni debet" (*Opusculum LV capitulorum adversus Hincmarum Laudunensem*; PL 126:389).

61. Cf. A. L. Harting-Correa, *Walahfrid Strabo's Libellus de Exordiis et Incrementis Quarundam in Observationibus Ecclesiasticis Rerum* (Leiden, 1996), 74–75; D. Appleby, "Sight and Church Reform in the Thought of Jonas of Orleans," *Viator* 27 (1996), 11–33.

62. "Per illam visibilem imaginem mens interior hominis exitatur, in qua Christi passio et mors pro nobis suscepta tanquam in membrana cordis inscribitur" (PL 142:1306).

63. "Ecce cor apostolicum quanto fraterni amoris igne decoquitur, quanto ad desudandum pro salute gentium desiderio concitatur. Hic corpore tenetur, illuc spiritu ducitur, et paterni amoris affectum praesentibus impendit, absentibus porrigit" (*Briefe* [as in note 18], 95).

64. *Commentum in IV libros Sententiarum*, III.9; cf. C. Gilbert, *The Saints' Three Reasons for Paintings in Churches* (Ithaca, N.Y., 2001), 7.

65. "Nam et illi qui nimio et indiscreto amore ob honorem sanctorum eorum imaginibus supplicant, nescio an temere idolatrae sint vocandi. Videntur sane potius ab hac superstitione, adhibito rationis moderamine, revocandi, quam idolatrae, cum utique sanctae Trinitatis fidem veraciter credant et praedicent, nuncupandi" (*De cultu imaginum*; PL 106:326); cf. Appleby, "Instruction and Inspiration" (as in note 31), 103.

66. Berliner, "Freedom of Medieval Art" (as in note 6), 278.

67. J. Peterson, *The "Dialogues" of Gregory the Great in Their Late Antique Cultural Background* (Toronto, 1984), 160–65.

68. "Cum qua visus est in terris et versatus cum hominibus speciosus prae filiis hominum: quoque ex ejus contemplatione devoti affectus vestri magis accenderentur, et intellectus vestri puriores redderentur"; A. Grabar, *La Sainte Face de Laon: Le Mandylion dans l'art orthodoxe* (Prague, 1931); P. Klein, "From the Heavenly to the Trivial: Vision and Visual Perception in Early and High Medieval Apocalypse Illustration," in *The Holy Face and the Paradox of Representation*, ed. H. L. Kessler and G. Wolf (Bologna, 1998), 247–78; G. Wolf, "From Mandylion to Veronica: Picturing the 'Disembodied' Face and Disseminating the True Image of Christ in the Latin West," in *Holy Face*, 153–79.

69. M. Carruthers, *The Book of Memory: A Study of Memory in Medieval Culture* (Cambridge, 1990), and *Craft of Thought* (as in note 5); Appleby, "Sight and Church Reform" (as in note 61).

70. Kessler, "Real Absence" (as in note 33), 124.

71. J.-P. Antoine, "*Ad perpetuam memoriam*: Les Nouvelles Fonctions de l'image peinte en Italie, 1250–1400," *MEFR* 100 (1988), 541–615. Cf. C. Hughes, "Typology and Its Uses in the Moralized Bible," in this volume.

72. J.-C. Schmitt, "Rituels de l'images et récits de vision," in *Testo e immagine nell'alto medioevo* (Spoleto, 1994), 419–59.

73. F. Boespflug and Y. Załuska, "Le Dogme trinitaire et l'essor de son iconographie en Occident de l'époque car-

olingienne au IVe Concile du Latran (1215)," *CahCM* 37 (1994), 181–240; P. Skubiszewski, "L'Iconographie de la patène et du calice du frère Hugo," in *Autour de Hugo d'Oignies*, ed. R. Didier and J. Toussaint (Namur, 2003), 99–131.

74. On a fifteenth-century leaf inserted into the Hours of Jeanne de Navarre (Paris, B.N.F., Ms. nouv. acq. lat. 3145, f. 3v), a woman is pictured directing prayers toward an imagined Virgin and Child and a Throne of Mercy, beginning with the crucified Christ which extends into her space; cf. J. Baschet, "Pourquoi élaborer des bases de données d'image? Propositions pour une iconographie sérielle," in *History and Images: Towards a New Iconology*, ed. A. Bolvig and P. Lindley (Turnhout, 2003), 59–106.

75. B. Raw, *Trinity and Incarnation in Anglo-Saxon Art and Thought* (Cambridge, 1997); Bonne, "Entre l'image et la matière" and Lentes, "Inneres Auge" (both as in note 7).

76. K. F. Morrison, *Conversion and Text: The Cases of Augustine of Hippo, Herman-Judah, and Constantine Tsatsos* (Charlottesville, Va., 1992), 82–83; J.-C. Schmitt, "La Question des images dans les débats entre juifs et chrétiens au XIIe siècle," in *Spannungen und Widersprüche: Gedankschrift für František Graus*, ed. S. Burghartz et al. (Sigmaringen, 1992), 245–54.

77. Morrison, *Conversion and Text* (as in note 76), 83.

78. "In quibusdam codicibus majestas Patris, et crux depingitur Crucifixi, ut quasi praesentem videamus quem invocamus, et passio quae repraesentatur, cordis oculis ingeratur" (*Mitrale*; PL 213:124).

79. "Audiant pictores proterva praesumptione seducti qui in comprehensibilem Dei sanctissimam Trinitatem profanis picturis esse comprehensibilem loco, et intellectu nituntur probare. Cum igitur incircumscriptibilis imaginem rei nullus possit formare" (Gilbert, "Statement of the Aesthetic Attitude" [as in note 6], 150–51).

80. Cf. J. Wirth, "La Critique scolastique de la théorie thomiste de l'image," in *Crises de l'image religieuse: De Nicée II à Vatican II*, ed. O. Christin and D. Gamboni (Paris, 1999), 93–109.

81. Cf. C. Heck, "Raban Maur, Bernard de Clairvaux, Bonaventure: Expression de l'espace et topographie spirituelle dans les images médiévales," in this volume.

82. N. Morgan, *Early Gothic Manuscripts*, vol. 1, *1190–1250* (London, 1982), 82–83; J. F. Hamburger, *The Rothschild Canticles: Art and Mysticism in Flanders and the Rhineland circa 1300* (New Haven, 1990), 134, 136.

83. The contemporary psalter in Munich (Bayerische Staatsbibliothek, Ms. Clm 835) pictures a similar halo with petals which has been left behind on the cross when Christ is deposed (f. 26v), even though the previous scene depicts the Savior with a cross nimbus (Morgan, *Early Gothic Manuscripts* [as in note 83], figs. 81–82). Morgan does not elaborate his claim that it is a "Jewish-derived motif"; while the covering does evoke Herman-Judah's reaction, it also is consonant with the Christian critics of the iconography.

84. R. Trexler, "Habiller et déshabiller les images: Esquisse d'une analyse," in *L'Image et la production du sacré*, ed. F. Durand, J.-M. Spieser, and J. Wirth (Paris, 1991), 195–231; D. Wilkins, "Opening the Doors to Devotion: Trecento Triptychs and Suggestions Concerning Images and Domestic Practice in Florence," in *Italian Panel Painting of the Duecento and Trecento*, ed. V. Schmidt (Washington, D.C., 2002), 371–93.

85. Cf. E. Palazzo, *Liturgie et société au Moyen Age* (Paris, 2000).

86. The Fourth Lateran Council, which in many ways affected art positively, contrasted the inner reality of the Eucharist to the empty outward appearance of paintings and sculpture; cf. M. Collareta, "Le immagini e l'arte: Riflessioni sulla scultura dipinta nelle fonti letterarie," in *Scultura lignea: Lucca, 1220–1425*, ed. C. Baracchini (Florence, 1995), 1–7.

87. "Sacerdos osculatur pedes majestatis, et se signat in fronte, et se inclinans, dicit: Te igitur, innuens quod reverenter ad mysterium crucis accedant . . . et sacerdotium quidam prius osculantur pedes majestatis, et postea crucifixi secundum seriem canonis: quidam prius curcifixi, et postea majestas; quia per Filium pervenitur ad Patrem" (*Mitrale*; PL 213:124).

88. P. Jezler, "Bildwerke im Dienste der dramatischen Ausgestaltung der Osterliturgie: Befürworter und Gegner," in *Von der Macht der Bilder*, ed. E. Ullman (Leipzig, 1983), 236–49.

89. Jeauneau, "De l'art mystagogie" (as in note 36).

90. Morse, "Seeing and Believing" (as in note 17).

91. H.-J. Krause, "'Imago ascensionis' und 'Himmelloch': Zum 'Bild'-Gebrauch in der spätmittelalterlichen Liturgie," in *Skulptur des Mittelalters: Funktion und Gestalt*, ed. F. Möbius and E. Schubert (Weimar, 1987), 280–353.

92. *Opus Caroli Regis contra synodum (Libri Carolini)*, ed. A. Freeman (Hannover, 1998), p. 535; see K. F. Morrison, "Anthropology and the Use of Religious Images in the *Opus Caroli Regis (Libri Carolini)*," in this volume.

93. J.-M. Sansterre, "Attitudes occidentales à l'égard des miracles d'images dans le haut Moyen Age," *Annales HSS* (1998), 1219–41.

94. "Prosternimur corpore ante crucem, mente [ante] Deum" (PL 142:1306).

95. Even though he proffers a scroll attesting to his privileged seeing, "Ecce ego Ioh[an]n[es] vidi ostium a[pertum]" (Rev. 4:1), like Moses at Ceri, John averts his eyes. On John as seer, cf. J. F. Hamburger, *St. John the Divine: The Deified Evangelist in Medieval Art and Theology* (Berkeley and Los Angeles, 2002); see also A.-M. Bouché, "*Vox Imaginis*: Anomaly and Enigma in Romanesque Art," in this volume.

96. R. C. Trexler, *The Christian at Prayer: An Illustrated Prayer Manual Attributed to Peter the Chanter*, Medieval and Renaissance Texts and Studies 44 (Binghamton, N.Y., 1987); J.-C. Schmitt, *La Raison des gestes dans l'Occident médiéval* (Paris, 1990), 289–320.

97. S. Tugwell, "The Nine Ways of Prayer of St. Dominic: A Textual Study and Critical Edition," *Medieval Studies* 47 (1985), 1–124; Schmitt, *Raison des gestes* (as in note 96), 311–13.

98. Cf. Council of Arras; PL 142:305; also Morrison, "Anthropology and the Use of Religious Images" (as in note 92).

Index

Note: Pages with illustrations are indicated in *italics*.

Java for Programmers

by

Douglas Lyon, Ph.D.

Upper Saddle River, NJ 07458

Library of Congress Cataloging-in-Publication Data

Lyon, Douglas A.
 Java for programmers / by Douglas Lyon.
 p. cm.
 Includes bibliographical references and index.
 ISBN 0-13-047869-5
 1. Java (Computer program language) I. Title.

QA76.73.J38L98 2004
005.13'3 -- dc22

2003065628

Vice President and Editorial Director, ECS: *Marcia J. Horton*
Publisher: *Alan R. Apt*
Associate Editor: *Toni Dianne Holm*
Editorial Assistant: *Patrick Lindner*
Vice President and Director of Production and Manufacturing, ESM: *David W. Riccardi*
Executive Managing Editor: *Vince O'Brien*
Managing Editor: *Camille Trentacoste*
Production Editor: *John Keegan*
Director of Creative Services: *Paul Belfanti*
Art Director: *Jayne Conte*
Cover Designer: *Bruce Kenselaar*
Managing Editor, AV Management and Production: *Patricia Burns*
Art Editor: *Gregory Dulles*
Manufacturing Manager: *Trudy Pisciotti*
Manufacturing Buyer: *Lisa McDowell*
Marketing Manager: *Pamela Hersperger*

© 2004 Pearson Education, Inc.
Pearson Prentice Hall
Pearson Education, Inc.
Upper Saddle River, NJ 07458

The author and publisher of this book have used their best efforts in preparing this book. These efforts include the development, research, and testing of the theories and programs to determine their effectiveness. The author and publisher make no warranty of any kind, expressed or implied, with regard to these programs or the documentation contained in this book. The author and publisher shall not be liable in any event for incidental or consequential damages in connection with, or arising out of, the furnishing, performance, or use of these programs.

Printed in the United States of America

10 9 8 7 6 5 4 3 2 1

ISBN: 0-13-047869-5

Pearson Education Ltd., *London*
Pearson Education Australia Pty. Ltd., *Sydney*
Pearson Education Singapore, Pte. Ltd.
Pearson Education North Asia Ltd., *Hong Kong*
Pearson Education Canada, Inc., *Toronto*
Pearson Educación de Mexico, S.A. de C.V.
Pearson Education—Japan, *Tokyo*
Pearson Education Malaysia, Pte. Ltd.
Pearson Education, Inc., *Upper Saddle River, New Jersey*

*This book is dedicated to Martin and Rheva Lyon
for their love and support.*

Foreword

The fish rots from the head.

–Proverb

The best thing about this book is, of course, that it is about Java. Java is becoming the *lingua franca* of the Internet, as well as the favorite vehicle for a first course in programming. Dr. Lyon has set out to do for Java what Strunk and White did for English: He shows how to write pithy, effective Java code. Like English, Java continues to evolve. Lyon occasionally bemoans "deprecated" features, which are like obsolete orthography or gender-prejudicial pronouns in English, but he also exults in the expressiveness and power of new releases.

Note that this book is not a translation, because Lyon thinks, and perhaps even dreams, in Java. He may have been born object oriented, but his relationship with computers, always intense, reached new heights when Java came along. His prose waxes elegant, lyrical, and whimsical in turn, but it is always lucid and economical. The size of the book is only a reflection of the size of Java, whose current APIs include some 2,000 classes with 20,000 members (the book *does* bristle with acronyms).

I read the book from the perspective of its intended audience, as a survivor of a dozen programming languages, a former teacher of several, and a neophyte in Java. The text abounds in sound pedagogic devices. An entertaining Socratic dialog sheds light on controversial design decisions in successive Java specifications. Provocative examples and counterexamples illustrate recondite Java features. Throughout, exercises of graded difficulty emphasize best professional practice.

The early chapters succinctly present the core of the language and also offer the clearest and most convincing cases that I have seen for object-oriented thinking and design. Lyon also stresses the importance of internal and external documentation, and the book includes excellent chapters on software design tools and on JavaDoc for automating the generation of HTML pages from comments in the source code.

A programmer's programmer, Lyon is at his best when he discusses design choices with respect to typing, inheritance, nested classes and interfaces, reflection, and static and dynamic proxy delegation. The breadth of his practical experience is evident as he guides the reader through the Java microcosms of operating systems (threads), graphics (icons, fonts, and diagrams with *Swing* and *AWT* libraries), links to databases (*JDBC* for *SQL*), network

aspects (browsers, *XML*, and e-mail), and Web services (*servlets*). In most other Java books, these topics are treated only superficially, and coverage of server-side services and Java Server Pages (*JSP*) is virtually absent.

A weighty book calls for a short foreword. Read on, enjoy, and program!

Professor George Nagy
ECSE Department, RPI
Columbus Day 2002
Rensselaer, Troy, NY

Preface

**Do not remove a fly from your friend's
forehead with a hatchet.**

–Chinese Proverb

Welcome to *Java for Programmers*! This book is designed for people who already know how to program and who are interested in Java. As such, the book takes on an executive-summary approach to the teaching of Java, thus assuming that the reader is already knowledgeable about non-object-oriented programming topics.

The Java world consists of a slowly growing Java language, a quickly growing collection of libraries, and a mass of support tools. As the libraries grow, new elements are added while old elements are changed. These changes impact existing code in ways that are hard to measure. As a result, programmers have had to learn to program defensively. Defensive programming has come to mean creating custom, stable libraries that call upon features in the ever-changing libraries.

The number of tools and libraries has created a virtual supermarket of software-engineering solutions. Excited managers and newbies alike have run down the store aisles and filled their shopping carts with wondrous Java technologies only to find later that they have no idea what these technologies do (or how to use them!).

Introductory programmers tend to want it all—they want a vast bounty of knowledge, but they don't want to wade through the details! As a result, this book provides introductions to many Java technologies, but only to give a taste of their use. Several of these technologies require a whole book for proper coverage. The goal of this book is to break down the topics into small chunks that are easily presentable and understandable.

Features in *Java for Programmers*

This book contains the following unique features that differentiate it from other books on Java:

- Targets those with previous programming experience. Many books waste a lot of time in introductory sections that address issues like "What is a computer?" and "What is a program?" This book assumes the reader understands basic concepts.

- Provides full coverage of client- and server-side Java. This book takes the programmer from the basics of Java programming to state-of-the-art server-side programming.

- Requires no previous experience in Java Programming! This book does not assume that the reader knows Java.

- Offers totally modular coverage. Language coverage is clearly separate from coverage of the libraries.

- Boasts a GST/AFA rating (Graduate Student Tested/Adjunct Faculty Approved).

- Addresses a dual market—academe and industry.

- Introduces learning goals and new reserved words at the start of each chapter.

It is common enough for books to regurgitate the Sun API for all to see. *Java for Programmers*, however, is different. *Java for Programmers* has an open-source DocJava API, which makes this book innovative. In the DocJava API, for example, you can get a file dialog using either the Swing API or the AWT API. We even can set the API to get a file using the Wireless (i.e., cell phone) API, called *MIDP*.

Sun deprecates its public interfaces regularly, thus quickly making books obsolete. By creating an API that isolates the programmer from these changes, we can be sure to:

1. Keep the book's API stable.
2. Keep the book in print.
3. Focus on sound software-engineering principles rather than the the Sun API itself.
4. Show programmers how to build their own toolkits, thus freeing them from total dependence on others.

Who Should Read This Book?

**If I have seen farther than others, it is because
I have stood on the shoulders of giants.**

*–Isaac Newton, philosopher and mathematician
(1642–1727)*

This book is intended for people who have previous programming experience. I generally have found that the first language is the hardest to learn and that the second language is much easier. Thus, this book assumes that Java will be at least the second computer language for the reader.

This book's treatment of Java is suitable for use as a classroom textbook or as a quick how-to guide for the busy programming professional. It presently is used in a three-course graduate sequence covering 135 lecture contact hours in 45 weeks. Literally hundreds of graduate students have reviewed the material contained in this book. The book contains ample material to fill hundreds of hours of lectures.

Teaching Approach

Java for Programmers contains a rich collection of examples, frameworks, exercises, and projects. The book discusses design patterns, but only uses them when they are needed. This just-in-time teaching of design-pattern theory allows students to learn design patterns with less pain than they might have in a course dedicated exclusively to design patterns.

Deferred API Coverage

Java for Programmers is a well-structured text that introduces concepts that build logically upon each other. As such, discussion of the Java language and object-oriented design comes first, and API coverage is deferred until it is needed. This modular style offers the instructor increased flexibility in ordering the material. In addition, this book does not make the mistake of covering applets first (as some books do).

The book provides a clear and concise look at all of the programming aspects of Java, (e.g., class design, threads, and event handling). Each chapter covers what you need to know about each topic and gives many examples.

As its generic title implies, this book doesn't really focus on a single Java topic. Instead, it covers many topics, most of which are relatively advanced. The book is loaded with useful tips and tricks.

Many titles focus on a single topic, and they often are packed full of material that is marginally useful at best. In contrast, this book tackles a large number of topics that many Java programmers will need to know. For the most part, the book manages to cover these topics in more than enough depth to allow the reader to understand and use the Java technologies covered. It includes lots of examples and useful code. In some cases, the code is appropriate for direct use in an application, while in other cases utility programs are included that help the reader to understand or use the technology better.

Finally, this book gives a taste of a variety of APIs that enable a programmer to explore the high-tech Java frontier further.

About the Icons

Throughout the book, we have used several icons to highlight important parts of the prose.

 The Language Reference Summary icon is used when we provide a syntax summary of how to use the language.

 The Warning icon is used to indicate a situation that could harm a project or make a system insecure.

 The Note icon is used to indicate a special point.

 The Design Pattern icon is used to indicate that a design pattern is being introduced.

 The Style Point icon is used to indicate what would be considered good practice in the format and usage of Java code.

Acknowledgments

Nothing endures but change.

–Heraclitus (540 BC–480 BC)

So many people help during the process of writing a book that it is impossible to keep track of them all. To all whom I have neglected to list, please don't hold my forgetfulness against me!

Thanks goes to Hak Kywn Roh for his *ReplaceString* class and to James Linn for his excellent efforts in making the *AtomicClock* class happen. Thanks to Job Shen for his notable contributions on the automatic bridge pattern code. Thanks to Naoki Chigai for his permission to make use of *HtmlGenerator* and to Glenn Seseske for his permission to reproduce *ComponentEditor*. Thanks also go to my many students, who put up with my beta code and manuscript efforts. I hope that this did not hurt my student evaluations too much!

Thanks go to Allison McHenry for her comments and ideas for Chapter 6. I also would like to thank those who helped with copyediting, particularly Mary Ellen Buschman, Vipul Jagadevsinh Chavda, Maynard Marquis, and Carl Weiman.

Finally, I would like to thank the anonymous reviewers of this book who contributed to its present form.

This book has been such a long ordeal. What I need right now is a good psychotic break.

Contents

He who asks is a fool for five minutes,
but he who does not ask remains a fool forever.

–Chinese proverb

Illustrations

About the Contributors

Douglas Lyon, Ph.D., is Chair of the Computer Engineering Department at Fairfield University and President of DocJava, Inc. He has authored three books on Java and has worked at the Jet Propulsion Laboratory's Artificial Intelligence Research and Development department and at AT&T Bell Laboratories. He also was Chief Scientist for RAY-TEL, Inc. He has been an object-oriented programmer since 1984. Dr. Lyon may be reached at the Computer Engineering Department, Fairfield University, North Benson Road, Fairfield, CT 06430-5195 USA. His e-mail address is *lyon@docjava.com*, and his web address is *<http://www.docjava.com>*.

Diane Asmus has worked at Executone and NOTARA as a Software Engineer in Visual Basic and Java since 1994. She can be reached at Fairfield University, North Benson Road, Fairfield, CT 06430-5195 USA. Her e-mail address is *DianeJava@Yahoo.com*.

Dr. Frances Grodzinsky is a Professor of Computer Science and Information Technology at Sacred Heart University in Fairfield, CT. She is the co-author of *The Anatomy of Programming Languages*, the editor of *The Networking and Data Communications Laboratory Manual*, and the author of several articles on computer ethics. Her e-mail address is *grodzinskyf@sacredheart.edu*.

James Linn, M.S., has worked at Executone, IPC Inc., Neu Vis, and Hartford Technology Service Company. He has been an object-oriented architect and developer in C++ and Java since 1997. He can be reached at the Computer Engineering Department, Fairfield University, North Benson Road, Fairfield, CT 06430-5195 USA. His e-mail address is *jim@raptureart.com*.

Maynard L. Marquis, M.S., teaches graduate courses in Java in the School of Engineering at Fairfield University and provides training to commercial companies for DocJava, Inc. He has many years of engineering experience in the aerospace industry. He may be reached at the Computer Engineering Department, Fairfield University, North Benson Road, Fairfield, CT 06430-5195 USA. His e-mail address is *maynard_marquis@juno.com*.

Allison McHenry has an M.S. in Software Engineering from Fairfield University. She is also a developer at INT Media Group and has been working with Internet-related technologies since 1996. She may be reached at the Computer Engineering Department, Fairfield University, North Benson Road, Fairfield, CT 06430-5195 USA. Her e-mail address is *amchenry_fagan@techie.com*.

Rodrigo A. Obando, Ph.D., is an Assistant Professor in the Information Systems and Operations Management Department at the Charles F. Dolan School of Business at Fairfield University. He has worked for the NASA Langley Research Center and the Jet Propulsion Laboratory, as well as for several consulting companies and corporations. He currently works in the areas of information visualization and data mining. He started in object-oriented programming in 1988. He can be reached at: Assistant Professor of Information Systems and Operations

Management, Charles F. Dolan School of Business, Fairfield University, North Benson Road, Fairfield, CT 06430 USA. His telephone number is (203)254-4000, Ext. 2830, and his e-mail address is *RObando@fair1.fairfield.edu.*

 Thomas F. Rowland has an M.S. in Software Engineering from Fairfield University and holds a B.S. in Electrical Engineering. He has been involved in both hardware and software development since 1987 and has been developing object-oriented software for the past 5 years. He works for DocJava, Inc., as a member of the technical staff. He may be reached at the Computer Engineering Department, Fairfield University, North Benson Road, Fairfield, CT 06430-5195, USA. His e-mail address is *tomrowland@yahoo.com.*

Java for Programmers

C H A P T E R 1

Java, the Basic Idea

In the midst of great joy, do not promise anyone anything. In the midst of great anger, do not answer anyone's letter.

–Chinese proverb

In this chapter, you will learn about:

- The origins of Java
- Plug-in-based decoders
- Helper applications
- The Java model versus the HTML model
- Program download on demand

Section 1.1 provides a brief history of Java, starting with the 1966 language *Simula*. Section 1.2 summarizes various Java technologies. Section 1.3 shows the Java model and compares it with the HTML model. We shall see that Java is the product of many decades of experimentation with languages; that the remarkable thing about Java is that it was built for one goal, but was then used for another; and that a great deal of work (and luck!) contributed to Java's success as a language and a technology.

1.1 The History of Java

In 1966, a popular simulation language called *Simula* was in use. Simula was created by Ole-Johan Dahl and Kristen Nygaard at the Norwegian Computing Centre (NCC) in Oslo. The language had many new and interesting features. For example, you could group a set of things into a single *classification* called a *class*, and you could group subsets of elements that belonged to a class (called a *subclass*). One user of Simula was *Bjarne Stroustrup*, a Cambridge Ph.D. student who, in the late 1970s, needed to obtain some results for his thesis

work. Stroustrup liked Simula except that it was too slow. In order to make his simulator run faster, he rewrote the project in Martin Richards's Basic Combined Programming Language (**BCPL**). He found the experience very difficult, but he graduated and went to work at a Murray Hill, New Jersey-based phone company laboratory called *Bell Telephone Laboratories* (today the facility is called *Lucent*).

In 1970 Ken Thompson, a Bell Labs staff member, was experimenting with a new language based on *BCPL*, called *B*. Thompson had the idea to add data types to the *B* language, and by 1971 he had a new language that he called *C*. The *C* language became very popular, and by 1983 it was being considered by the *American National Standards Institute* (ANSI) as an ANSI standard (called *ANSI C*).

In May of 1979, Stroustrup started to work on a project called *C with classes*. His goal was to incorporate the speed of *C* with the *Simula* classes to which he was accustomed. At the time, he was also at Bell Labs, and he knew that speed was very important to the people who worked there. By 1983, C++ had its first implementation in use. Later, C++ became very popular and was adopted by many different companies, including one Mountainview, California-based firm called *Sun Microsystems*.

In early 1991, a group of Sun engineers started to explore opportunities in the embedded systems market. Called *Project Green*, the project involved the use of cheap microprocessors in a variety of consumer electronic devices, including personal digital assistants (PDAs), interactive TV boxes, and household appliances. One of the staff members at Sun, James Gosling, started to extend the C++ compiler. By mid-1991, a new language, called Oak, had evolved. Later, the name did not survive a trademark search and was dropped in favor of Java. Even though Java was meant for embedded systems, by 1994 use of the Web was on the rise. Java appeared well suited to Web-based applications. In particular, it had the multi platform, secure, simple, and robust features needed on the Web.

Thus, Java has features that can be traced directly to C++ classes, which came from the 1966 Simula language. Also, Java has features that it borrowed from C. In fact, if we examine the Java language in detail, we find very little in the language that is really new!

1.2 What Is Java?

The term *Java* has come to be used for a wide range of *Java technologies*. Java technologies include the Java programming language, supporting class libraries, and the *Java Virtual Machine* (*JVM*).

Java technology enables the running of Java programs using the *Java model*. The Java model typically makes use of several layers (also called *substrates*). A Java program is isolated from the hardware by virtue of a substrate called the JVM. Figure 1.2-1 shows a diagram of the Java model.

Java is popular for several reasons. One reason for Java's popularity is that it is a multiplatform language. The key elements of Java's multiplatform ability are the *peer methods*, as shown in Figure 1.2-1. Peer methods provide an application program interface (API) whose goal is to provide a mapping from the high-level Java API to the low-level operating system subroutines. Peer methods provide the key to a portable operating system interface.

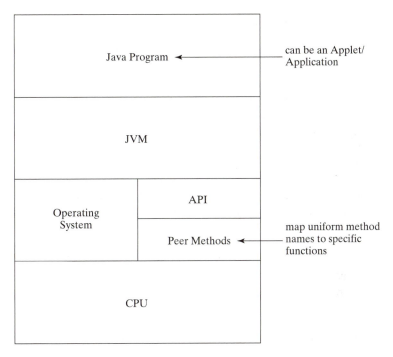

FIGURE 1.2-1
The Java Model

An operating system software interface library provides a programming environ-
ment not found in ANSI C, C++, or FORTRAN. The environment is what gives a pro-
gram its look and feel. For example, if you are a C++ programmer and you program
under Windows, the environment will feel like a Windows programming environment
(i.e., you will probably invoke Microsoft Foundation Classes). If you program under
UNIX, the environment will feel like UNIX (i.e., you will invoke X-Window library
subroutines).

Java is different in that it attempts to provide a portable operating system software
interface. For example, the code to display a dialog box in Java is the same no matter what
operating system you are using. Sometimes Java's ability to be portable is limited by the
cross-platform support for a library. When this situation occurs, Java programs that use the
non-portable library are no longer portable. For example, some people have created links
to C-library subroutines from within Java. For Java to be portable, these subroutines must
be made available on other platforms.

It is an error to assume that Java is a compile-once run-anywhere type of language.
Java needs to be tested (and sometimes debugged) on each platform. It is com-
mon to write code that runs well on one platform, but fails on another.

In addition, languages other than Java may exploit Java technology. For example, it is pos-
sible to implement a non-Java compiler that creates Java bytecodes that are suitable for
running on a JVM.

1.3 The HTML Model Versus the Java Model

We have seen that Java was intended to be a language for embedded systems. However, Java was not widely adopted for such use at the time. Instead, it was thought that Java could be used to supplement or even to displace the HTML model. This section describes the HTML model and how Java might have displaced it.

On the Internet, we find a variety of files. Data structures are saved in files and require decoding. The number of different data files that can be created is unbound. At any time, the number of file formats, though countable, generally remains uncounted and increase at an unknown rate. Few tools are available to count the number of different file formats, and even fewer can decode many of these formats.

Figure 1.3-1 depicts the Web model of data distribution. A Web server uses Hyper Text Transfer Protocol (HTTP) to transfer Web pages to a client.

A browser uses *plug-ins* that contain format-specific code to perform decoding. Different file formats require the respective plug-ins (or *helper applications*) for display. Thus, plug-ins extend a browser's capability.

A browser, with Java, is able to perform decoding using dynamically downloaded algorithms. This process requires a means of running a program on demand. To provide for security, Java provides feature limitations for the programs that are downloaded on demand. A *security manager* enables precise control over the features available to such Java programs downloaded on demand.

The basic assumption behind the Java model displacing the HTML model is that a program can be run on demand in a variety of platforms. Lack of uniform support for Java, however, kept such a displacement from happening. Some of the forces at work included disputes about the Java technology and about intellectual property.

FIGURE 1.3-1
The Internet

1.4 Summary

Unlike C or C++, when you program in Java the environment feels like Java. C++, on the other hand, has no portable, API like Java does. If you program in C++ under Windows, the environment feels like Windows, and you will have to learn the Windows API. If you program in C++ on a Macintosh, the environment will have the look and feel of a Macintosh interface.

Some people say that client-side Java is dead and that the revolution of the HTML model never took place because of the aforementioned disputes. However, more than six million Java-enabled phones were sold between March and August 2001 in Japan. The wireless providers (NTT DoCoMo, J-Phone, and KDDI) have deployed interactive services. Between 2001 and 2005, it is estimated that more than 700 million JVMs will be deployed on these new devices. Perhaps these new JVM-enabled platforms will keep client-side Java alive and well.

1.5 Exercises

1.1 Name 5 plug-ins used by your browser.

1.2 Name 10 helper applications that help you decode data.

1.3 Name 20 file formats available on the Web.

1.4 What is an example of a Java technology?

1.5 Why provide an environment for programming. After all C++ is successful and offers no built-in API.

1.6 What is a peer method?

1.7 What does HTTP stand for?

1.8 Do you need Java to program a JVM?

1.9 What is a browser plug-in?

1.10 What features does Java have that enable a program to be run on demand?

1.11 What are bytecodes?

Primitive Data Types

It takes all types of people to make a world.

–Miguel de Cervantes, Don Quixote (1605–15)

In this chapter, you will learn about:

- Primitive data types
- Built-in computation methods
- Built-in constants
- Variable declarations
- Type casting

Figure 2-1 shows the Primitive Data Types that you will learn in this chapter.

Java has two kinds of data types: *reference data types* and *primitive data types*. Reference data types are passed (or transferred) by name, whereas primitive data types are passed by value.

To show how a reference data type is transferred by name, we might look at the following example. Suppose you ask for the contents of a post office box by referring to that box. You say, "I want the contents of P.O. Box 320." The box number serves to represent or refer to the contents of the box. It would be much more difficult to ask for each item in the box by name; in other words, the box name is smaller than the names of all of the items in the box. Additionally, the number of items in the box is variable.

A primitive data type, on the other hand, is of a size that is a function of the type itself. Thus, when a primitive data type is passed, the number of bits required to be copied is a function of the type.

2.1 The Eight Primitive Data Types in Java

Java has eight primitive data types. Five are integer data types, and two are floating-point data types. The eighth data type is the *boolean* type, which is valued as either *true* or *false*.

Figure 2.1-1 shows the two types of data in Java, reference data types and primitive data types. Reference data types are covered in Chapter 6. There are two types of primitive

boolean
char
byte
short
int
long
float
double

FIGURE 2-1

data types: *signed* and *unsigned*. There are two types of *signed* data types: *floating point* and *fixed point*. There are two floating-point data types: *float* and *double*. There also are four types of fixed-point data types, *byte, short, int*, and *long*. Fixed point data types are 8-, 16-, 32-, and 64-bits in length, respectively, and are all signed. In addition, there are two types of unsigned data types: *boolean* and *char*. The *boolean* data type may have the value of *true* or *false*, and the *char* data type is an unsigned 16-bit quantity. The eight primitive data types in Java are all represented by *reserved* words (*char, boolean, float, double, byte, short, int,* and *long*). A *reserved* word is a word that cannot be used as a *variable*, which is a programmer-selected identifier that is used to hold some value.

Thus, the taxonomy represents an AKO (a kind of) relationship for all of the primitive data types. A summary of the different primitive data types is shown in Figure 2.1-2.

Unlike some other languages, Java has no facility for defining new primitive data types.

To embed a literal in Java code and give it a type, you can append a suffix. For example,

```
long l=1l;
float f=1f;
double d=1d;
```

In Java, the equal sign is used as an assignment operator. Thus, "set *x* to the value of *1*" is written as

```
x = 1;
```

Variables may be any length and may consist of any combination of characters except that they may not use reserved words.

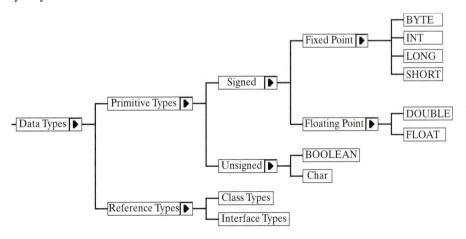

FIGURE 2.1-1
The Taxonomy of Data Types

Type Name	Value	Value	
boolean	1 bit	true, false	
char	16 bit	unicode	character
byte	8 bit	signed	$-2^{8-1}\ldots 2^{8-1}-1$
short	16 bit	signed	$-2^{16-1}\ldots 2^{16-1}-1$
int	32 bit	signed	$-2^{32-1}\ldots 2^{32-1}-1$
long	64 bit	signed	$-2^{64-1}\ldots 2^{64-1}-1$
float	32 bit	IEEE-754-1985	6–7 sig. figs.
double	64 bit		14–15 sig. figs.

FIGURE 2.1-2
Primitive Data Type Summary

2.2 Signed Fixed-Point Data Types

There are four signed fixed-point data types of different sizes and ranges. These data types are signed integers (i.e., they can be negative), as shown in Figure 2.2-1. Let n represent the number of bits needed to make up the integer data type. The most significant bit is used to store the sign of the number, and the remaining $n-1$ bits are used to represent the value. The minimum value is $-2^{(n-1)}$, and the maximum value is $2^{(n-1)}-1$. The range of data types in Java is machine independent, which is different from many other programming languages.

The values used to set an *integer* data type are expressed as a sequence of decimal, octal, or hexadecimal digits. Figure 2.2-2 shows how to formulate constants in Java using the base of 10, 8, and 16 and using varying *radix*. The radix is the base of a number. For example, radix 10 is decimal. If you are unfamiliar with the term radix, don't worry since it will be described in Chapter 4.

A leading *0* (numerial zero) is used to denote an octal number. The *0x* or *0X* (numerial zero followed by a letter *x*) is used to denote a hexadecimal number. Symbols corresponding to the decimal value of 10–15 are written as A–F. Integer literals are assumed to be of type *int* unless they end in the letter *L* or *l*.

Integer Type	Number of Bits	Minimum Value	Maximum Value
byte	8	-128	127
short	16	-32768	32767
int	32	-2147483648	"2147483647"
long	64	"-9223372036854775808"	"-9223372036854775807"

FIGURE 2.2-1
Signed Integer Data Types

Decimal	Octal	Hexidecimal
42	077	0x2a

FIGURE 2.2-2
Constants in Varying Radix

2.3 Simple Arithmetic Expressions

LANGUAGE REFERENCE SUMMARY
A simple variable declaration can be written by an optional modifier followed by the type, then by a variable declarator, and then by a ';'. A variable declarator can be written by an identifier optionally followed by an = sign with a variable initializer. A variable initializer can be written as an expression.

Java evaluates expressions in an order that is explicitly given by parentheses and implicitly given by the order of precedence for the operators. Given an equation that involves addition ($+$) and multiplication ($*$),

```
int i = 2 + 3*4;
```

Java will first multiply *3* by *4* and then add the result to *2*, yielding an answer of *14*. Java performs these mathematical operations in this particular order since multiplication has a higher order of precedence than addition. In order to add *2* and *3* before multiplying by *4* to yield *20*, parentheses can be used to explicitly alter the order of evaluation:

```
int j = (2+3)*4;
```

as a result, $(2 + 3)$ would have a higher order of precedence.

2.4 Elementary Examples of Primitive Data Types

Primitive types must be initialized before being used in Java. For example, in the following code

```
public class TrivialApplication {
    public static void main(String args[]) {
        int x; // this is a bug!
        System.out.println( x );
    }
}
```

a variable *x* was declared, but not initialized before being accessed.

It is a compile-time error to use a variable before it is set.

The compiler emits

```
Error    : Variable x may not have been initialized.
TrivialApplication.java line 7
        System.out.println( x );
```

and the correct code follows:

```
public class TrivialApplication {
    public static void main(String args[]) {
        int x = 10; // this is ok now, x must be defined!
        System.out.println( x );
    }
}
```

The data types of *byte, short, int, long, float*, and *double* are signed. The data types of *boolean* and *char* are unsigned. The *char* data type in Java is represented by an international

standard for character representation called Unicode [Unicode]. For example:

```
char c = 'a';
```

It is possible to assign a numeric literal to a character variable and a character literal to an integer variable:

```
char theChar = 48;
int theValue = 'a';
```

All real numbers in Java are stored either as *single* or *double* precision variables called *float* and *double*. The Java reals use the IEEE 754-1985 format [IEEE]. *Exponential notation* is used to help define the very large and very small numbers. For example,

$$1E2 = 100$$
$$1E - 2 = 0.01.$$

The smallest and largest positive non-zero values for floats range from 1.40239846e–45 to 3.40282347e + 38 (Float.MIN_VALUE and Float.MAX_VALUE). The smallest and largest positive non-zero values for doubles range from 4.94065645841246544e–324 to 1.79769313 486231570e + 308 (Double.MIN_VALUE and Double.MAX_VALUE).

For example,

```
public class FpError {
       public static void main(String argv[]) {
         float fmin = Float.MIN_VALUE;
         float fmax = Float.MAX_VALUE;
         double dmin = Double.MIN_VALUE;
         double dmax = Double.MAX_VALUE;
         String b = " ";
         System.out.println(fmin + b + fmax +
           b + dmin + b + dmax);
       }
}
```

The above outputs

```
1.4E-45 3.4028235E38 4.9E-324 1.7976931348623157E308
```

The following program shows how to code the escape sequences into Java:

```
public class Char {
       char backspace = '\b';
       char horizontalTab = '\t';
       char newLine = '\n';
       char formFeed = '\f';
       char carrageReturn = '\r';
       char doubleQuote ='\"';
       char singleQuote ='\'';
       char backSlash = '\\';
       char maxOctal = '\377';
       char minOctal = '\000';
       char maxUnicode = '\uFFFF';
       char minUnicode = '\u0000';
}
```

Note how the backslash '\' is used as an escape character. Thus, to print a backslash, you must insert two backslashes, '\\'. Also, note that the unsigned 16-bit characters use '*uxxxx*' to indicate the hexadecimal representation of the character.

2.5 Casting Primitive Data Types

It is possible to *cast* from one primitive data type to another. When we cast a primitive data type, we alter the type of the container of the primitive data. For example, to cast from a *short* to an *int* you can write

```
short s = 8;
int i = s;
```

Now *i* has the value stored in *s*. The type conversion is *automatic*. Automatic type conversion is an *implicit* casting done by the compiler. The compiler will not complain when you transfer a value held in a small container to one that is larger (in terms of the number of bits). However, if you try to go the other way:

```
s = i;
```

WARNING

It is a compile-time error to implicitly cast a variable to a type of smaller size. You may cast an *int* to a *long*, but you may not cast a *long* to an *int* without an explicit cast directive. The compiler will flag this as a syntax error.

To force the type conversion, a casting operation is required by the compiler. This operation, in effect, is the equivalent of the programmer saying to the compiler: "Trust me, I know what I am doing."

```
s = (short) i;
```

The floating-point data types are subject to the same rule: if data can be lost, an explicit type conversion must be issued. For example,

```
double d = 10.0;
int i = (int) d;
```

Care must be exercised or data will be lost. For example,

```
float f = 8.5;
int j = (int)f;
```

results in the value of *8* in the variable *j*.

2.6 Some Mathematical Methods

Java has some built-in methods for performing computations. The following will print the value of *PI*:

```
double pi = Math.PI;
System.out.println(pi);
```

The following will compute the sine and the cosine (the angles are input in radians):

```
Math.sin(d), Math.cos(d)
```

To compute *d* raised to the *d1* power, use

```
double d2 = Math.pow(d,d1);
```

Which means that the area of a circle is given by

```
area = Math.PI * Math.pow(r,2);
```

where *r* is the radius of the circle.

2.7 Summary

This chapter introduced the idea of a primitive data type. The eight basic data types of Java (*byte, short, char, int, long, float, double*, and *boolean*) can be remembered with the mnemonic *Bad Smells Can Infest Lazy, Fat Dog Beds*.

This chapter also showed how to make use of some methods (e.g., *Math.sin*, and *Math.cos*). We also saw how to access constants, like *Math.PI*. Finally, the idea of *type casting* was introduced, along with the concept of explicit versus automatic type casting.

2.8 Exercises

2.1 Math.random() is a method in Java that returns a non-negative random number that is less than one and of *double* type. The line

```
int i = (int)(10*Math.random()+1);
```

should yield a number between 1 and 10. Write a program that prints out 10 random integers that range from 1 to 10. The line

```
System.out.println(i);
```

should be able to print out the number.

2.2 Write a program that adds all of the integers from 1 to 10 and computes the average.

2.3 Try the following expressions in Java. Print out the results.

```
System.out.println(5 + 4 + 3);
System.out.println(5 * 4 * 3);
System.out.println(5 - 4 - 3);
System.out.println(5 / 4 / 3);
System.out.println(5 % 4);
System.out.println((5 / 4) / 3);
System.out.println(5 / (4 / 3));
```

2.4 A sequence of operations often generates a round-off error. For example, 1/3.0 + 1/3.0 + 1/3.0 = 1 when we use exact fractions. But if we use Java to do the computation, will it equal 1 or 0.99999 ? Why?

 WARNING
A sequence of operations often generates a round-off error.

2.5 We can use the following equation to approximate the value of *arctan(x)*:

$$\arctan(x) = x - \frac{x^3}{3} + \frac{x^5}{5} - \frac{x^7}{7} + \cdots$$

Use the first four terms of the expression to approximate *arctan (1)* in a Java program. Compare your result to the one you get using *Math.atan(x)*.

2.6 Take some familiar problem, such as computing gas milage or the future value of an investment, and compute a solution to this problem using Java.

C H A P T E R 3

Operators

by Douglas Lyon and Maynard Marquis

He who sacrifices his conscience to ambition burns a picture to obtain the ashes.

–Chinese Proverb

In this chapter, you will learn about:

- Orders of precedence
- Binary operators
- Unary operators

Java operators are language tokens that can manipulate Java data types. There are several kinds of operators, and they may be broadly classified as *increment, decrement, arithmetic, assignment, relational, equality, logical, conditional, bitwise*, and *shift*. An operator also is classified as unary or binary depending on the number of operands or arguments associated with it, and operators have associativity and an order of precedence. Some operators perform more than one operation, which is called operator overloading, much like method overloading.

Bitwise operators perform functions on binary numbers rather than on decimal numbers. Bitwise operators are discussed in Appendix J.

3.1 Precedence, Associativity, and Unary/Binary Classification

Java evaluates expressions in an order that is given explicitly by parentheses and given implicitly by the order of precedence for the operators. Given an equation that involves addition (+) and multiplication (*),

$$2 + 3*4 = 14$$

Java will first multiply *3* by *4* and then add the result to *2*, yielding an answer of *14*. Java performs these mathematical operations in this particular order since multiplication has a higher order of precedence than addition. In order to add *2* and *3* before multiplying by *4* to yield *20*, parentheses can be used to explicitly alter the order of evaluation:

```
(2+3)*4 = 20
```

as a result, *(2 + 3)* would have the highest order of precedence.

Associativity comes into play when several operators having the same order of precedence appear in a given expression. For example, multiplication (*) and modulus (%) have the same order of precedence. Modulus is the remainder after one number is divided by another. When multiplication and modulus appear in the same equation, associativity tells Java which operation to perform first. The order of evaluation is from left to right, so the left-most operation is performed first. In the next example, the multiplication of *3* by *20* is performed first, yielding *60*, before the modulus operator performs its function. For example,

```
3*20%3 = 60%3 = 0
```

In the example above, the remainder is zero.

Unfortunately, orders of precedence are not easily memorized because they contain many levels, and associativity sometimes involves a left-to-right order of evaluation and sometimes involves a right-to-left order of evaluation, depending on the set of operators under consideration. The author encourages liberal use of parentheses in statements with multiple operations to clarify the manner in which Java will perform the operations.

Unary operators work on only one parameter, whereas binary operators work on two. The expression

```
x++;
```

adds *1* to the current value of *x* and operates on *x* alone. The operator ++ is unary. On the other hand, the operator + in the expression

```
z = x + y;
```

operates on both *x* and *y*, so the operator, '+' is a binary operator.

Java operators, their unary/binary classifications, their orders of precedence, and their associativity are listed in Figure 3.1-1. This information is discussed further in the following sections.

The following code tests some of the more important operations. To test your understanding, record the output, then check it with the program's actual results:

```java
package examples;
public class Operations {
  public static void main(String args[]) {
    parenthesesDemo();
    memberSelectionDemo();
    separationDemo();
    postIncrementDemo();
    postDecrementDemo();
    preIncrementDemo();
    preDecrementDemo();
    plusDemo();
    minusDemo();
    multiplicationDemo();
```

Operator	Operation	Unary/ Binary	Order	Associativity
() [] . ,	(parentheses) (array subscript) (member selection) (comma)		1	left to right
++ --	(postincrement) (postdecrement)	unary	2	right to left
++ -- + - ! ~ (type)	(preincrement) (predecrement) (plus) (minus) (negation) (complement) (cast)	unary	3	right to left
*/ %	(multiplication) (division) (modulus)	binary	4	left to right
+ -	(addition) (subtraction)	binary	5	left to right
<<>> >>>	(left shift) (right shift, sign extension) (right shift, zero extension)	binary	6	left to right
<<=>>= instanceof	(greater than) (less than or equal to) (greater than or equal to) (type comparison)	binary	7	left to right
== !=	(is equal to) (is not equal to)	binary	8	left to right
&	boolean and bitwise AND	binary	9	left to right
^	bitwise or boolean exclusive OR	binary	10	left to right
\|	inclusive OR, boolean, and bitwise	binary	11	left to right
&&	logical AND	binary	12	left to right
\|\|	logical OR	binary	13	left to right
? :	ternary conditional	binary	14	right to left
= += -= /= %= &= ^= = <<= >>= >>>=	assignment operators	binary	15	right to left

FIGURE 3.1-1
Precedence Hierarchy for Java Operators

```
        divisionDemo();
        modulusDemo();
        additionDemo();
        subtractionDemo();
        equalsDemo();
        plusEqualsDemo();
        minusEqualsDemo();
        multiplyEqualsDemo();
        divideEqualsDemo();
        modulusEqualsDemo();
    }

    public static void parenthesesDemo() {
        int x = 4, y = 2, z = 1;
        hr();
        print("x = 4, y = 2, and z = 1"
            + "\nso when you calculate "
            + "x * (y + z)"
            + "the result is "
            + (x * (y + z)));
        print("x = 4, y = 2, and z = 1"
            + "\nso when you calculate"
            + " (x * y) + z the result is "
            + ((x * y) + z));
    }
```

```
public static void memberSelectionDemo() {
  int x = 0;
  hr();
  print("if we call Math.cos(x) when x = 0 "
        + "using the member"
        + "selection\nwe can "
        + "invoke method "
        + "cos of the Math class, "
        + "the result is "
        + Math.cos(x));
}

public static void separationDemo() {
  int x = 4, y = 2;
  hr();
  print("if we call Math.pow(x,y) "
        + "when x = 4 "
        + "and y = 2 using the "
        + "separation"
        + "\nwe can invoke method "
        + "pow of the Math class,"
        + "the result is " + Math.pow(x, y));
}

public static void plusDemo() {
  int x = 4;
  hr();
  print("x = 4 but +x = "
        + (+x));
}

public static void minusDemo() {
  int x = 4;
  hr();
  print("x = 4 but -x = "
        + (-x));
}

public static void postIncrementDemo() {
  int x = 0;
  hr();
  print("x = 0 but x++ = "
        + x++);
  print("after x++, x = "
        + x);
}

public static void postDecrementDemo() {
  int x = 0;
  hr();
  print("x = 0 but x-- = "
        + x--);
  print("after x--, x = "
        + x);
}
```

```
public static void preIncrementDemo() {
  int x = 0;
  hr();
  print("x = 0 but ++x = "
        + ++x);
  print("after ++x, x = "
        + x);
}

public static void preDecrementDemo() {
  int x = 0;
  hr();
  print("x = 0 but --x = "
        + --x);
  print("after --x, x = "
        + x);
}

public static void additionDemo() {
  int x = 4, y = 2;
  hr();
  print("x = 4 and y = 2"
        + "\nso x + y = "
        + (x + y));
}

public static void subtractionDemo() {
  int x = 4, y = 2;
  hr();
  print("x = 4 and y = 2"
        + "\nso x - y = "
        + (x - y));
}

public static void multiplicationDemo() {
  int x = 4, y = 2;
  hr();
  print("x = 4 and y = 2\nso x * y = "
        + (x * y));
}

public static void divisionDemo() {
  int x = 4, y = 2;
  hr();
  print("x = 4 and y = 2\nso x / y = "
        + (x / y));
}

public static void modulusDemo() {
  int x = 4, y = 2;
  hr();
  print("x = 4 and y = 2"
        + "\nso x % y = " + (x % y));
}
```

```java
public static void equalsDemo() {
  int x = 4, y = 2;
  hr();
  print("x = 4, y = 2\nso x = y "
        + "makes x equal to "
        + (x = y));
}

public static void plusEqualsDemo() {
  int x = 4, y = 2;
  hr();
  print("x = 4 and y = 2\nso x += y makes"
        + "x equal to " + (x += y));
}

public static void minusEqualsDemo() {
  int x = 4, y = 2;
  hr();
  print("x = 4 and y = 2"
        + "\nso x -= y "
        + "makes x equal to "
        + (x -= y));
}

public static void multiplyEqualsDemo() {
  int x = 4, y = 2;
  hr();
  print("x = 4 and y = 2"
        + "\nso x *= y makes "
        + "x equal to "
        + (x *= y));
}

public static void divideEqualsDemo() {
  int x = 4, y = 2;
  hr();
  print("x = 4 and y = 2"
        + "\nso x /= y makes x equal to "
        + (x /= y));
}

public static void modulusEqualsDemo() {
  int x = 4, y = 2;
  hr();
  print("x = 4 and y = 2\n"
        + "so x %= y makes x equal to "
        + (x %= y));
}

public static void hr() {
  print("_____");
}

public static void print(Object o) {
  System.out.println(o);
}
}
```

The output follows:

```
x = 4, y = 2, and z = 1
so when you calculate x * (y + z)the result is 12
x = 4, y = 2, and z = 1
so when you calculate (x * y) + z the result is 9
```

```
if we call Math.cos(x) when x = 0 using the memberselection
we can invoke method cos of the Math class, the result is 1.0
```

```
if we call Math.pow(x,y) when x = 4 and y = 2 using the separation
we can invoke method pow of the Math class,the result is 16.0
```

```
x = 0 but x++ = 0
after x++, x = 1
```

```
x = 0 but x-- = 0
after x--, x = -1
```

```
x = 0 but ++x = 1
after ++x, x = 1
```

```
x = 0 but --x = -1
after --x, x = -1
```

```
x = 4 but +x = 4
```

```
x = 4 but -x = -4
```

```
x = 4 and y = 2
so x * y = 8
```

```
x = 4 and y = 2
so x / y = 2
```

```
x = 4 and y = 2
so x % y = 0
```

```
x = 4 and y = 2
so x + y = 6
```

```
x = 4 and y = 2
so x - y = 2
```

```
x = 4, y = 2
so x = y makes x equal to 2
```

```
x = 4 and y = 2
so x += y makes x equal to 6
```

```
x = 4 and y = 2
so x -= y makes x equal to 2
```

```
x = 4 and y = 2
so x *= y makes x equal to 8
```

```
x = 4 and y = 2
so x /= y makes x equal to 2
```

```
x = 4 and y = 2
so x %= y makes x equal to 0
```

3.2 Highest Order-of-Precedence Operators

There are four operators in Java for which no particular category is normally assigned. The four are: 1) parentheses, '()', 2) the array subscript, '[]', 3) the member selection or period and 4) the variable separator or comma. Using the period for member selection is often called the *dot notation*. These operators have the highest order of precedence and associate from left to right.

Parentheses are an overloaded operator. They are used to give precedence to other operators, as discussed above. When an equation contains nested sets of parentheses operations within the inner set of parentheses are performed first. For example,

$$((2 + 3)*(4 + 1)) = 25.$$

STYLE POINT

It is generally a good idea to use parentheses to make the order of operation explicit.

Parentheses also are used to contain the objects or variables passed as arguments to a method. This use of parentheses holds true both when invoking methods and when defining them as in the following example:

```
public void methodA( int a, int b) {}
```

In addition, parentheses are used in the casting process, whereby Java changes a variable or object from one data type to another. For example, if it is desired to cast the double, *d*, to an integer, parentheses would contain the desired data type, as shown below.

```
int r = (int) d;
```

Operator	Operation	Java Expression	Meaning
()	parentheses	(x*(a + b))	add a to b, then multiply by x
[]	array subscript	int[] a;	declare an array, a, of integers
.	member selection	Math.cos();	invoke method cos of Math class
,	variable separator	m(a, b);	pass variables a and b into method m

FIGURE 3.2-1
Highest Order-of-Precedence Operators

The array subscript operator, '*[]*', is used in Java to declare an array. The placement of the '*[]*' in the declaration is arbitrary. The following declarations are all equally valid in Java:

```
String oneDArray [];
String [] oneDArray ;
String twoDArray [][];
String [][] twoDArray ;
String [] twoDArray [];
```

The member selection operator (a period or a dot) is used to separate the names of hierarchical elements in a path. A typical example is

```
s = javax.swing.JOptionPane.showInputDialog("Enter a Value");
```

which shows the method *showInputDialog* of the class *JOptionPane* in the *swing* package of the *javax* package. Dot notation also is used to separate the name of a method or a variable from its class, such as

```
Math.sin()
```

The comma is used to separate the arguments in a method definition and a method invocation:

```
myMethod(String a, String b, String c){}
myMethod(x, y, z);
```

The comma also is used to separate variables when declaring more than one object or variable for a given data type:

```
public int x, y, z;
```

Finally, a comma is used to separate indices in a *for* loop

```
for ( int i = 0, j = 1; i < 10; i++, j+=2)
```

3.3 Increment and Decrement Operators

The next level of precedence contains the post-increment operator, '++', and the post-decrement operator, '− −'. These operators are followed immediately by their pre-increment and pre-decrement counterparts.

Operator	Operation	Category	Java Expression	Meaning
++	postincrement	increment	x++	execute statement then add 1 to x
-	postdecrement	decrement	x--	execute statement then subtract 1 from x
++	preincrement	increment	++x	add 1 to x then execute statement
-	predecrement	decrement	--x	subtract 1 from x then execute statement

FIGURE 3.3-1
Increment and Decrement Operators

The statement

```
x++;
```

tells Java to add *1* to the current value of *x*. If this expression appears in a more complex statement, then the statement is executed before the value of *x* is incremented by *1*. For example, if *x* is equal to *5* when the statement:

```
System.out.println ("X = " + x++);
```

is reached, Java will print *5* and then change *x* to *6*. The same applies to the post-decrement operator, '−−'. Both of these operators are unary operators and operate on integers.

The pre increment, '++', and pre decrement, '−−', operators are overloaded in the sense that they will operate on a variety of types (byte, char, short, int, long, float or type) and they will return their input data types as their result. This is also true for the post increment and post decrement operators.

For example:

```
byte b = 2;
++b;
short s = 32;
s++;
```

WARNING

The pre fix and post fix operators do not promote their arguments to new data types automatically, so that in the case of:

```
byte b = 127;
b++;
```

An overflow will occur.

The pre increment operators add or subtract *1* from the current value of an numeric quantity. The post increment operators are just like the pre increment operators except that they perform the operation indifferent order. In the post increment case, the integer is changed by one one after the value of the variable is used. In comparison, in the pre increment case the variable is altered before the value is used.

For example, if *x* = 5 when the statement

```
System.out.println("X = " + ++x);
```

is reached, Java will add *1* to the value of *x* and then print its value, *6*.

3.4 Arithmetic Operators

Arithmetic operators are multiplication (*), division (/), modulus (%), addition (+), and subtraction (−). These are binary operators since they operate on more than one argument (e.g., *x***y*). The + and − operators are overloaded in that they also operate in the unary category as plus and minus signs. This unary operation allows us to write.

```
x = -5;
Y = +2;
```

The associativity of the unary arithmetic operators is from right to left, whereas the binary operators associate from left to right.

Operator	Operation	Java Expression	Meaning
+	plus	+x	make x positive
-	minus	-x	make x negative
*	multiplication	x*y	multiply x by y
/	division	x/y	divide x by y
%	modulus	x%y	determine the remainder of x/y
+	addition	x+y	add x to y
-	subtraction	x-y	subtract y from x

FIGURE 3.4-1
Arithmetic Operators

The modulus operator yields the remainder in a division. Thus,

```
10%3 = 1;
```

produces the remainder, *1*, from the division of *10* by *3*.

3.5 Assignment Operators

Assignment operators are listed in Figure 3.5-1.

The assignment operator = makes one variable equal to another. The statement *a = b* says that the value of *b* is assigned to the value of *a*.

WARNING

It is an error to use assignment in *if* statements instead of using the relational operator ==.

The remaining operators are combinations or augmentations of the assignment operator with other operators. For example, += means to add and assign; thus, *x += 2* says to add *2* to the latest value of *x* and assign the value *x*. If *x = 10* for all the following, then

```
x += 2;   // same as x = x + 2   = 10 + 2 = 12
x -= 2;   // same as x = x - 2   = 10 - 2 = 8
x *= 2;   // same as x = x * 2   = 10 * 2 = 20
x /= 2;   // same as x = x / 2   = 10 / 2 = 5;
```

Operator	Operation	Java Expression	Meaning
=	make equal	x = y	assign y to x
+=	add then assign	x += 2	add 2 to x, assign to x
-=	subtract then assign	x -= 5	subtract 5 from x, assign to x
*=	multiply then assign	x *= 2	multiply x by 2, assign to x
/=	divide then assign	x /= 3	divide x by 3, assign to x
%=	modulus then assign	x %= y	assign x%y to x

FIGURE 3.5-1
Assignment Operators

```
x %= 3;    // same as x = x % 3   = 10 % 3 = 1;
x >>= 3;   // same as x = x >> 3  = 10 / 8 = 0;
x <<= 3;   // same as x = x << 3  = 10 * 8 = 80;
x >>>= 3;  // same as x = x >>> 3 = 10 / 8 = 0;
```

3.6 The Syntax of Operators

Java operators can be written as one of the following character combinations:
'=', or '>', or '<', or '!' or '~' or '?' or, ':' or '==' or, '<=' or, '>=' or, '!=' or, '&&'
or '||' or '++' or '−−' or '+', or,'−' or '*' or, '/' or, '&' or, '*or*', or, '^' or, '%' or, '<<' or,
'>>' or, '>>>' or, '+=' or, '−=' or, '*=' or '/=' or '& =' or, '=' or, '^ =' or, '%=' or '<<='.
Unary operators work just like their C counterparts. The order of precedence is listed
below.

LANGUAGE REFERENCE SUMMARY
Postfix operators can be written as '[],' '.,' '(<parameters>)', '++' or, '−−'.
Unary operators can be written as '+', '−', '++', '−−', '~', or '!'.
Creation operators can be written as '*new*' or '(<type>)'.
Multiplicative operators can be written as '*', '/', or '%'.
Additive operators can be written as '+' or '−'.
Assignment operators can be written as '=', '+=', '−=', '*=', '/=', '%=', '>>=', '<<=',
'>>>=', '&=', '^ =', or '|='.
Relational operators can be written as '<', '>', '>=', '<=', or '*instanceof*'.
Equality operators can be written as '==' or '!='.
The logical AND is written as '&&'.
The logical OR is written as '||'.
The conditional operator is written as '?:.'

3.7 Self-Test

In this section of what you have learned thus far you can check your understanding. Read
through the following program, record the output, and then check your answers with the
answers provided. To get the full benefit of this exercise, try not to look at the answers until
you are done. Notice how elements like *public, package, static,* and *void* are left unex-
plained. These elements will be explained later in the book, as will ideas about building
methods (as we have done below). For this example, just focus on the operations. Without
the individual methods, you get a very large block of code, which is hard to read and un-
derstand. As an example of what **not** to do, see the *Chapter3Ops.java* source code in the
examples package.

```java
package examples;

public class Operations {
    public static void main(String args[]) {
        parenthesesDemo();
        memberSelectionDemo();
        separationDemo();
```

```
        postIncrementDemo();
        postDecrementDemo();
        preIncrementDemo();
        preDecrementDemo();
        plusDemo();
        minusDemo();
        multiplicationDemo();
        divisionDemo();
        modulusDemo();
        additionDemo();
        subtractionDemo();
        equalsDemo();
        plusEqualsDemo();
        minusEqualsDemo();
        multiplyEqualsDemo();
        divideEqualsDemo();
        modulusEqualsDemo();
    }

    public static void parenthesesDemo() {
        int x = 4, y = 2, z = 1;
        hr();
        print("x = 4, y = 2, and z = 1"
            + "\nso when you calculate "
            + "x * (y + z)"
            + "the result is "
            + (x * (y + z)));
        print("x = 4, y = 2, and z = 1"
            + "\nso when you calculate"
            + " (x * y) + z the result is "
            + ((x * y) + z));
    }

    public static void memberSelectionDemo() {

        int x = 0;
        hr();
        print("if we call Math.cos(x) when x = 0 "
            + "using the member"
            + "selection\nwe can "
            + "invoke method "
            + "cos of the Math class, "
            + "the result is "
            + Math.cos(x));
    }

    public static void separationDemo() {
        int x = 4, y = 2;
        hr();
        print("if we call Math.pow(x,y) "
            + "when x = 4 "
            + "and y = 2 using the "
            + "separation"
            + "\nwe can invoke method "
```

```
                           + "pow of the Math class,"
                           + "the result is " + Math.pow(x, y));
        }

        public static void plusDemo() {
          int x = 4;
          hr();
          print("x = 4 but +x = "
                + (+x));
        }

        public static void minusDemo() {
          int x = 4;
          hr();
          print("x = 4 but -x = "
                + (-x));
        }

        public static void postIncrementDemo() {
          int x = 0;
          hr();
          print("x = 0 but x++ = "
                + x++);
          print("after x++, x = "
                + x);
        }

        public static void postDecrementDemo() {
          int x = 0;
          hr();
          print("x = 0 but x-- = "
                + x--);
          print("after x--, x = "
                + x);
        }

        public static void preIncrementDemo() {
          int x = 0;
          hr();
          print("x = 0 but ++x = "
                + ++x);
          print("after ++x, x = "
                + x);
        }

        public static void preDecrementDemo() {
          int x = 0;
          hr();
          print("x = 0 but --x = "
                + --x);
          print("after --x, x = "
                + x);
        }
```

```
public static void additionDemo() {
  int x = 4, y = 2;
  hr();
  print("x = 4 and y = 2"
        + "\nso x + y = "
        + (x + y));
}

public static void subtractionDemo() {
  int x = 4, y = 2;
  hr();
  print("x = 4 and y = 2"
        + "\nso x - y = "
        + (x - y));
}

public static void multiplicationDemo() {
  int x = 4, y = 2;
  hr();
  print("x = 4 and y = 2\nso x * y = "
        + (x * y));
}

public static void divisionDemo() {
  int x = 4, y = 2;
  hr();
  print("x = 4 and y = 2\nso x / y = "
        + (x / y));
}

public static void modulusDemo() {
  int x = 4, y = 2;
  hr();
  print("x = 4 and y = 2"
        + "\nso x % y = " + (x % y));
}

public static void equalsDemo() {
  int x = 4, y = 2;
  hr();
  print("x = 4, y = 2\nso x = y "
        + "makes x equal to "
        + (x = y));
}

public static void plusEqualsDemo() {
  int x = 4, y = 2;
  hr();
  print("x = 4 and y = 2\nso x += y makes"
        + "x equal to " + (x += y));
}

public static void minusEqualsDemo() {
  int x = 4, y = 2;
  hr();
```

```
        print("x = 4 and y = 2"
                + "\nso x -= y "
                + "makes x equal to "
                + (x -= y));
    }

  public static void multiplyEqualsDemo() {
      int x = 4, y = 2;
      hr();
      print("x = 4 and y = 2"
                + "\nso x *= y makes "
                + "x equal to "
                + (x *= y));
  }

  public static void divideEqualsDemo() {
      int x = 4, y = 2;
      hr();
      print("x = 4 and y = 2"
                + "\nso x /= y makes x equal to "
                + (x /= y));
  }

  public static void modulusEqualsDemo() {
      int x = 4, y = 2;
      hr();
      print("x = 4 and y = 2\n"
                + "so x %= y makes x equal to "
                + (x %= y));
  }

  public static void hr() {
      print("_____");
  }

  public static void print(Object o) {
      System.out.println(o);
  }
}
```

The output follows:

```
x = 4, y = 2, and z = 1
so when you calculate x * (y + z)the result is 12
x = 4, y = 2, and z = 1
so when you calculate (x * y) + z the result is 9
_____
if we call Math.cos(x) when x = 0 using the memberselection
we can invoke method cos of the Math class, the result is 1.0
_____
if we call Math.pow(x,y) when x = 4 and y = 2 using the separation
we can invoke method pow of the Math class,the result is 16.0
_____
x = 0 but x++ = 0
after x++, x = 1
_____
```

```
x = 0 but x-- = 0
after x--, x = -1
```

```
x = 0 but ++x = 1
after ++x, x = 1
```

```
x = 0 but --x = -1
after --x, x = -1
```

```
x = 4 but +x = 4
```

```
x = 4 but -x = -4
```

```
x = 4 and y = 2
so x * y = 8
```

```
x = 4 and y = 2
so x / y = 2
```

```
x = 4 and y = 2
so x % y = 0
```

```
x = 4 and y = 2
so x + y = 6
```

```
x = 4 and y = 2
so x - y = 2
```

```
x = 4, y = 2
so x = y makes x equal to 2
```

```
x = 4 and y = 2
so x += y makes x equal to 6
```

```
x = 4 and y = 2
so x -= y makes x equal to 2
```

```
x = 4 and y = 2
so x *= y makes x equal to 8
```

```
x = 4 and y = 2
so x /= y makes x equal to 2
```

```
x = 4 and y = 2
so x %= y makes x equal to 0
```

3.8 Exercises

3.1 A truth table is a List of all possible inputs along side of all possible outputs. Write a program to compute a truth table for the following function:

$$F(A,B,C,D) = A + ABD + AC'D + A'CD' \qquad (3.8\text{-}1)$$

A	B	C	D	F
0	0	0	0	
0	0	0	1	
0	0	1	0	
0	0	1	1	
0	1	0	0	
0	1	0	1	
0	1	1	0	
0	1	1	1	
1	0	0	0	
1	0	0	1	
1	0	1	0	
1	0	1	1	
1	1	0	0	
1	1	0	1	
1	1	1	0	
1	1	1	1	

FIGURE 3.8-1
A Truth Table

For example, for the first term, *F (0,0,0,0) = 0*. We can represent equation (3.8-1) using the boolean expression

```
f = A || A && B && D || A && !C && D || !A && C && !D.
```

3.2 Repeat exercise 1 using bitwise operations. We can represent equation (3.8-1) using the bitwise expression

```
f = A | A & B & D | A & ~C & D | ~A & C & ~D.
```

3.3 Write a computer program that proves the following:

```
XY + XY'= X.
```

3.4 Write a computer program that proves the following:

```
X + XY=X.
```

CHAPTER 4

Base Conversion

by Douglas Lyon and Maynard Marquis

Books are good enough in their own way, but they are a mighty bloodless substitute for life.

–Robert Louis Stevenson 1850–1894

In this chapter, you will learn:

- How to convert from one base to another
- How to input numbers in various bases into Java source code.

Humans have devised several numbering systems that have evolved over time. The ancient Egyptians had a numbering system, as did the ancient Romans and many other civilizations. The current or modern numbering system comes from many sources, but it is particularly derived from the Hindus and Arabians. The system was further developed in Europe and has become almost universal in its use. This system (called *decimal*) uses the following 10 Arabic numerals or digits in a dual role of number and position 0, 1, 2, 3, 4, 5, 6, 7, 8, and 9. For example, the number 2 is associated with a particular unit or quantity, but that quantity depends on its position within the three numbers 275, 325, and 572.

4.1 Numbering Systems

The form or structure of the modern numbering system is given by its dual role. The number 2 means 2 units in 572, 20 units in 325, and 200 units in 275. Its value depends on its position within the total number. In 572, its value is 2 times 1; in 325, 2 times 10; and in 275, 2 times 100. The numeral 2 is multiplied by 10^0, in the first position, by 10^1, in the second position, and by 10^2 in the third position. So, the number consists of a summation

of numerals that have been multiplied by 10 taken to the power specified by the position of the numeral. Equation (4.1-1) expresses the decimal positional notation:

$$number = \sum_{i=0}^{N} a_{N-i}(10)^{N-i}$$

(4.1-1)

where

$$number = \text{base 10 or decimal value,}$$

$$N = \text{number of digits} - 1,$$

and

$$a_i = \text{the symbol at position } i.$$

Expanding positional notation, we can represent the number 572 base 10 as

$$5(10)^2 + 7(10)^1 + 2(10)^0 = 5(100) + 7(10) + 2(1).$$

Decimal is also called the *base 10 numbering system*. *Radix* is another term used for the base, which refers to the quantity that is raised to the exponent and is equal to the number of *symbols* in the system. The decimal system consists of these *symbols* (0, 1, 2, 3, 4, 5, 6, 7, 8, 9). For an arbitrary radix, *R*, we write

$$number = \sum_{i=0}^{N} a_{N-i}(R)^{N-i}.$$

For systems with a radix greater than 10, letters are used as symbols. The minimum value for the radix is 2. The radix is always an integer, and it has no maximum value.

4.2 Common Computer Numbering Systems

Several numbering systems are common in computing. Typically the radix is increased by a power of two, as a result, base 2, 8, 10, and 16 are the most common. However, larger bases (like 64) are used for transmitting textual codes on channels that cannot handle binary data. For example, Multi-purpose Internet Mail Extension (MIME) attachments are often base-64 encoded.

The hexadecimal system, is called base 16, and uses 16 symbols (0, 1, 2, 3, 4, 5, 6, 7, 8, 9, A, B, C, D, E, and F); the binary system (called base 2) uses only two symbols (0 and 1); and the octal system, called base 8, uses 8 symbols (0, 1, 2, 3, 4, 5, 6, 7). The higher the base, the more bits that are represented by each symbol. For example, binary symbols represent 1 bit of information; octal symbols represent 3 bits of information; and hexadecimal symbols represent 4 bits of information. Consequently, the octal and hexadecimal systems are used to write numbers with significantly fewer digits than the binary system. The symbols used in the various numbering systems are shown in Figure 4.2-1.

For example, the decimal number $(427)_{10}$ converts to the 9-digit binary number $(110101011)_2$, which also can be written as the 3-digit octal number $(653)_8$ or the 3-digit hexadecimal number $(1AB)_{16}$.

To write octal numbers into source code, the character zero (not a letter o, but the number zero 0) precedes the number. So, *0653* would appear in the code. For hexadecimal

Number System	Base or Radix	Numerals
Binary	2	0 1
Octal	8	0 1 2 3 4 5 6 7
Decimal	10	0 1 2 3 4 5 6 7 8 9
Hexadecimal	16	0 1 2 3 4 5 6 7 8 9 A B C D E F

FIGURE 4.2-1
Symbols in Various Numbering Systems

numbers, the character zero followed by an x precedes the number. So *0x1AB* signifies a hexadecimal number. Octal and hexadecimal numbers can be operated upon just like decimal numbers. The code statements shown below all yield the decimal value $x = $ *1281*.

```
x = 3*427;
x = 3*0653;
x = 3*0x1AB;
```

4.3 Converting to Decimal from Binary, Octal, and Hexadecimal

Positional notation can be converted directly from binary, octal, and hexadecimal numbers to decimal numbers. For example, the nine-digit binary number $(110101011)_2$ is equal to the decimal number $(427)_{10}$:

$$1(2)^8 + 1(2)^7 + 0(2)^6 + 1(2)^5 + 0(2)^4 + 1(2)^3 + 0(2)^2 + 1(2)^1 + 1(2)^0$$

$$= 256 + 128 + 0 + 32 + 0 + 8 + 0 + 2 + 1 = (427)_{10}.$$

The three-digit octal number $(653)_8$ is equal to the decimal number $(427)_{10}$:

$$6(8)^2 + 5(8)^1 + 3(8)^0 = 384 + 40 + 3 = (427)_{10}.$$

As another example, $(1AB)_{16}$ is equal to $(427)_{10}$:

$$1(16)^2 + 10(16)^1 + 11(16)^0 = 256 + 160 + 11 = (427)_{10}.$$

4.4 Converting from Binary to Octal and Hexadecimal

To convert binary numbers to octal, put the binary numbers in groups of three. The grouping starts from the right, and then each group is converted to octal. For example,

Binary: $(110\ 101\ 011)_2$

$110 = 4 + 2 + 0 = 6$

$101 = 4 + 0 + 1 = 5$

$011 = 0 + 2 + 1 = 3$

Octal: $(653)_8$.

To convert binary to hexadecimal, form groups of four bits, starting from the right. For example,

$$\text{Binary: } (1\ 1010\ 1011)_2$$
$$1 = 1$$
$$1010 = 1(8) + 0(4) + 1(2) + 0(1) = 10 = A$$
$$1011 = 1(8) + 0(4) + 1(2) + 1(1) = 11 = B$$
$$\text{Hexadecimal: } (1AB)_{16}.$$

4.5 Converting from Decimal to Binary, Octal, and Hexadecimal

Converting decimal numbers to binary, octal, and hexadecimal numbers can be done using a number of methods, each of which requires successive operations. The first method is called successive division. With successive division, we take a base 10 number and divide by R. The remainder is used to form the symbol of the new base R number, which is written from least to most significant (generally from right to left). The quotient is used for the next division, and this process continues until the quotient is zero. An example of successive division is shown in Figure 4.5-1.

Since many of the base conversion operations are easy to perform using a spreadsheet program (like Excel), we make reference to the Excel formula for implementing them. In this way, you can try some base conversions without having to program or make excessive use of a calculator. In Java, the quotient formula is $i/2$ in Excel we write $= TRUNC(i/2)$. The remainder formula is written in Java as $i\%\ 2$ in Excel we write $= MOD(i,2)$.

The same technique works for converting a decimal number to its octal equivalent, which is shown in Figure 4.5-2.

In Java, the quotient formula is $i/8$; in Excel we write $= TRUNC(i/8)$. The remainder formula is written in Java as $i\ \%\ 8$; in Excel we write $= MOD(i,8)$.

For small numbers, this process is easy to perform by hand. The octal number is written from the bottom up as $(653)_8$.

Repeating the same technique for the hexadecimal number produces $(1AB)_{16}$ as the equivalent decimal number $(427)_{10}$, which is shown in Figure 4.5-3.

In Java, the quotient formula is $i/16$; in Excel we write $= TRUNC(i/16)$. The remainder formula is written in Java as $i\ \%\ 16$; in Excel we write $= MOD(i,16)$.

Radix	Quotient	Remainder
2	427	1
2	213	1
2	106	0
2	53	1
2	26	0
2	13	1
2	6	0
2	3	1
2	1	1

FIGURE 4.5-1
Successive Division Converts Decimal to Binary

Radix	Quotient	Remainder
8	427	3
8	53	5
8	6	6

FIGURE 4.5-2
Successive Division Converts Decimal to Octal

Radix	Quotient	Remainder	Symbol
16	427	11	b
16	26	10	a
16	1	1	1

FIGURE 4.5-3
Successive Division Converts Decimal to Hexadecimal

Using repeated division, we can convert from decimal into any base. Because we are able to do binary division with ease, it is sometimes simpler to perform a decimal-to-binary conversion using successive division and then convert to the target base using a grouping of the binary symbols. Either process can yield a correct result. Repeated Division is shown in Figure 4.5-4. An Example of Figure 4.5-5 shows several operations that can be used to convert from one base to another.

Radix	Quotient	Remainder	Symbol
2	427	1	
2	213	1	b
2	106	0	
2	53	1	
2	26	0	
2	13	1	
2	6	0	a
2	3	1	
2	1	1	1

FIGURE 4.5-4
A Demonstration of Repeated Division for Radix 2

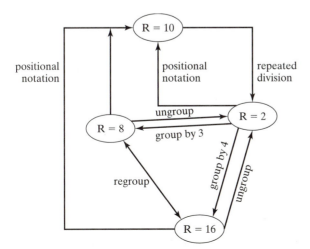

FIGURE 4.5-5
Operations That Allow Conversion from One Base to Another

4.6 Summary

In this chapter, we learned how to convert from base 10 to base 2 using repeated division. We also learned how to convert from bases 2, 8, and 16 back to base 10 using positional notation. Grouping was used to convert between bases 2, 8, and 16.

WARNING

It is possible to convert directly from base 10 to any other base using repeated division; however, dividing by a high base (like 16) can be an error-prone process.

When writing programs to perform this conversion, however, the source of the error is removed, and the conversion is more efficient.

4.7 Exercises

4.1 Convert the following numbers to base 10:

 a. $(DEAD)_{16}$

 b. $(757)_8$

 c. $(FED)_{16}$

 d. $(FEED)_{16}$

 e. $(1000)_{16}$

 f. $(1000)_8$

 g. $(1000)_2$

4.2 Convert the following numbers to the indicated base:

 a. $(DEAD)_{16}$ to base 2

 b. $(757)_8$ to base 16

 c. $(FED)_{16}$ to base 2

 d. $(1000)_{16}$ to base 8

 e. $(1000)_8$ to base 7

4.3 What will the following code output?

```
class Radix {
    public static void main(String args[]) {
        int x = 255;
        int y = 1;
        x = x | y;
        print(Integer.toString(x,2));
        print(Integer.toString(x,8));
        print(Integer.toString(x,16));
        print(Integer.toString(x,32));
    }
    static void print(Object o) {
        System.out.println(o);
    }
}
```

C H A P T E R 5

Control Structures

by Doug Lyon and Maynard Marquis

> **Reading makes a full man, meditation a profound man, discourse a clear man.**
>
> *–Benjamin Franklin*

In this chapter, you will learn about:

- Control structures
- Relational operators
- Equality operators
- Boolean operators
- Conditional operators
- Programmatic decisions

A *control structure* alters the flow of control in a program. Sometimes it is used to make decisions (e.g., if some condition exists, then take some action). Other times it performs tasks repeatedly (e.g., print all of the numbers from 1 to 10). This section describes Java's features for using repetition and shows when to use various control loops. The following control loops use boolean expressions: *while, for*, and *do*. The following control statements that affect the flow of control without looping: *if, conditional*, and *switch*. The control statements *if* and *conditional* take a boolean expression. The *switch* statement takes a scalar in the form of a fixed-point expression.

The keywords you will learn in this chapter are shown in Figure 5-1.

5.1 Relational Operators

Relational operators are binary, and their associativity is from left to right. Figure 5.1-1 shows relational operators.

| if |
| else |
| do |
| while |
| continue |
| break |
| switch |
| case |
| return |
| for |

FIGURE 5-1
Keywords

Operator	Operation	Java Expression	Meaning
<	less than	x < y	x less than y
<=	less than or equal to	x <= y	x less than or equal to y
>	greater than	x > y	x greater than y
>=	greater than or equal to	x >= y	x greater than or equal to y
instanceof	compare object or variable to data type	x instanceof class	x is an instance of type class

FIGURE 5.1-1
Relational Operators

The operators '<', '<=', '>', and '>=' are found in *if* statements. For example,

```
if ( a >= b ) c = a;
```

Also included in the relational group is the type comparison *instanceof*:

```
if ( x instanceof Integer) y = x;
```

The operator *instanceof* is used to compare reference data types, which is discussed in Chapter 6.

5.2 Equality Operators

Equality operators, '==' and '!=', are a special case of relational operators that also are used in *if* statements. These operators test the equality of two variables. They do not assign the value of one variable to another. For example,

```
if ( x == y ) z = x;
```

Figure 5.2-1 shows equality operators.

The operator '==' is used for primitive data types. It returns *true* if the arguments are equal.

Operator	Operation	Java Expression	Meaning
==	is equal to	x == y	x is equal to y
!=	is not equal to	x != y	x is not equal to y

FIGURE 5.2-1
Equality Operators

The logical negation operator, !, reverses the boolean value of the operand. For example,

```
if ( ! (age == 50)) System.out.println( "Age =" + age);
```

will print age for all values except 50. Quite often this unary operator can be avoided by using the binary relational operator, '!='. The operator '!=' means not equal to; it tests if two variables are unequal. For example,

```
if ( x != y ) z = y;
```

5.3 Logical Operators

Logical operators are binary operators, and their associativity is from left to right. Logical operators are used in Boolean Expressions. Boolean Expressions return "true" or "false".

Figure 5.3-1 shows logical operators.

Perhaps the most commonly used operators in this category are the logical AND, '&&', and the logical OR, '‖'. These are binary operators, and their associativity is left to right. These operators permit the testing of more than one condition before executing the statement when all the conditions are satisfied. For example,

```
if ( x < = y && x > = z)  a = x;
if ( x <= y || x < z)  b = x;
```

For the logical AND, if any one of the conditions is found to be false, then the remainder of the statement is not executed. In other words, the statement is false if any part of it is false. The same holds true for the logical OR except that it short-circuits when any of the conditions are found to be true. That is, the statement is considered to be true if any part of the statement is true.

The bitwise AND, '&', and inclusive OR, '|', operators work identically to the logical AND and OR described above with one exception. These operators require the evaluation of all conditions, which is useful if the right-most condition in an expression has a needed side effect, such as a change in the variable's value. The statement

```
if (register2 == closed) | ++line >=1{}
```

will increment *line* by one regardless of whether the first condition is true or false.

Operator	Operation	Java Expression	Meaning
!	boolean negation	!(x == 2)	reverses x is equal to 2 (i.e.,not = 2)
&&	boolean AND	x == y & a == b	x is equal to y AND a is equal to b
‖	OR	x == y‖a == b	x is equal to y OR a is equal to b

FIGURE 5.3-1
Logical Operators

The '&', '|', and '^' operators are overloaded. They are boolean operators, as discussed above, and they are also bitwise operators. To learn more about bitwise operations see Appendix J.

5.4 Conditional Operator

The combination question mark and colon '?:' called a ternary conditional operator. It operates like a shortcut *if* statement. If the expression before the '?' is true, then the expression immediately following the '?' is executed. If the expression before the '?' is false, then the expression following the colon is executed.

For example,

```
if (theCowsComeHome) {System.out.println("moo");}
    else System.out.println("no milk for you!");
```

has the same output as

```
System.out.println(
    theCowsComeHome ? "moo" : "no milk for you!");
```

The conditional operator requires a boolean expression followed by an expression to return if true, as well as a ':' and an expression to return if false.

5.5 The *if* Statement

LANGUAGE REFERENCE SUMMARY
The *if* statement in Java requires a boolean type expression. The *if* statement can be written as the reserved word 'if' followed by a '(' followed by a boolean expression, followed by a ')', followed by a Java statement optionally followed by the reserved word 'else' followed by another statement.

The typical form for the *if* statement is

```
if ( expr )
    statement
  else if ( expr )
    statement
  else
    statement
if (type.compareTo("ConstantValue") == 0)
if (i >= out.length)
```

The *then* part of the *if* statement may consist of any valid statement or block of statements surrounded by braces '{ }'. The braces are optional. For example,

```
if (Math.abs(return_val) < 0.99)
    return return_val;
else return 0;
```

An extended clause is often indented to indicate when the clause has ended.

It is often a good idea to indicate the end of the clause with a comment.

STYLE POINT

For example,

```
if (interfaces == null) dos.writeShort(0);
 else {
    dos.writeShort(interfaces.length);
    for (int i = 0; i < interfaces.length; i++)
        dos.writeShort(
            ConstantPoolInfo.indexOf(
                interfaces[i], constantPool));
 } // end else
```

Poor use of indentation and a lack of comments can make code hard to read.

For example,

```
if (x1 < datarect.x) x1 = datarect.x;
 else
if (x1 > datarect.x + datarect.width )
    x1 = datarect.x + datarect.width;

if (y1 < datarect.y) y1 = datarect.y;
 else

if (y1 > datarect.y + datarect.height )
    y1 = datarect.y + datarect.height;
```

Now, compare the code above with the code below:

```
if (x1 < datarect.x) x1 = datarect.x;
  else if (x1 > datarect.x + datarect.width )
        x1 = datarect.x + datarect.width;

if (y1 < datarect.y) y1 = datarect.y;
  else if (y1 > datarect.y + datarect.height )
        y1 = datarect.y + datarect.height;
```

An *Else-if* statement can be used as a word pair, which can clean up and shorten the code significantly.

Below is another example of a long if-else chain:

```
if (xminText.equals(e.target)) {
    xmaxText.requestFocus();
    return true;
 } else
if (xmaxText.equals(e.target)) {
    yminText.requestFocus();
    return true;
 } else
if (yminText.equals(e.target)) {
    ymaxText.requestFocus();
    return true;
 } else
if (ymaxText.equals(e.target)) {
    xminText.requestFocus();
    return true;
 }
```

Now, compare the code above with the code below:

```
if (xminText.equals(e.target)) {
        xmaxText.requestFocus();
        return true;
} else if (xmaxText.equals(e.target)) {
        yminText.requestFocus();
        return true;
} else if (yminText.equals(e.target)) {
        ymaxText.requestFocus();
        return true;
} else if (ymaxText.equals(e.target)) {
        xminText.requestFocus();
        return true;
}
```

Such long dispatches are common in Java.

The conditional expression

```
 bexpr ? expr1 : expr2
```

is exactly the same as writing

```
if (bexpr) expr1;
else expr2;
```

STYLE POINT

Such short-hand forms should be restricted to the few situations where the readability of the code is improved.

For example,

```
y = (x < 0) ? f(-x) : f(x);
```

should probably be rewritten as

```
y = f(Math.abs(x));
```

Modern compilers typically expand the method invocation in-line so that there is no difference in speed. The second form is also clearer. Forms like

```
i = ( i>b ) ? b : k;
```

are probably just as clear as

```
if (i > b) i = b;
else i = k;
```

In such a case, the selection of form is mostly a matter of taste.

5.6 The *while* and *do* Statements

The *while* and *do* statements are repetition structures.

NOTE

A *repetition structure* allows for a set of statements to be repeated or looped. This process is sometimes called *iteration*.

LANGUAGE REFERENCE SUMMARY

A typical form for the *while* statement follows:

```
while( expr )
```

The *while* statement must have a logical expression, just like the *if* statement. Also, the expression and following statement will be evaluated as long as the boolean expression returns *true*. If the expression returns *false*, the statement will not be executed.

The *while* statement always evaluates the expression before evaluating the statement.

To change this order use the *do* statement.

LANGUAGE REFERENCE SUMMARY

The *do* statement can be written as 'do' followed by a Java statement, followed by the reserved word 'while', followed by '(' followed by a boolean expression, followed by a ')' followed by a ';'.

A typical form for the *do* statement follows:

```
do
   statement
while( expr );
```

The *do* loop will always evaluates the statement at least once before evaluating the while statement.

It is a compile-time error to pass a non-boolean expression to the *do-while* statement.

To make an infinite loop, just make the boolean expression a constant *true*, as in

```
while (true) {
      System.out.println("Help I am stuck in a loop");
   }
```

It is common to embed assignments in the boolean expression given as an argument to the while statement.

For example,

```
while ((i = i + 1) < 10 ) {
```

Note the required use of parentheses. A compilation error would result if

```
while (i = i + 1 < 10 ) { //BUG!
```

were written instead.

This process occurs because the assignment operator takes lowest precedence. A while loop can be used for iteration. For example,

```
int i = 0;
while (i < 10)
      System.out.println(i++);
```

Compare the code above with the *do* statement below:

```
int i = 0;
do
        System.out.println(i++);
while (i < 10);
```

Both forms are identical except that the main body of the while statement will run only if the conditional remains true (i.e., i < 10), whereas the do loops will always execute at least once.

5.7 The *for* Statement

LANGUAGE REFERENCE SUMMARY
A *for statement* can be written as the keyword *for* followed by a '(' followed by one or more variable initializations, followed by a ';', followed by an optional boolean test, followed by another ';', followed by an expression that is evaluated at the bottom of the iteration block (called the update), followed by a ')', followed by a *statement*.

Typically, the *for* statement takes the form

```
for (initialization; test; update) statement.
```

The scope of all variables declared in the body of the for loop is local to the loop.

It is a syntax error to refer to the variables local to the loop from outside of the loop.

A single statement or a compound statement may follow a for loop. A compound statement is grouped by braces '{}'.

The test must be a logical expression or a compile-time error will result.

If the test is not satisfied, the statement will not execute. In fact, the statement does not have to execute even once. Some examples of the *for* statement include

```
for (int i=1; i < 99; i++) {
        }; // null statement
for (;;) { // an infinite loop
        if (expression) { break}
        // more junk here
}
for (int i = 99; i < 50; i++)
        System.out.println("I never printed");
```

When implementing an infinite loop, it is more clear to use

```
while (true) { ... }
```

rather than

```
for (;;) { ... }
```

To stop an infinite loop, it is typical to use the *break* statement, as described in Section 5.9.
 A comma, ';', is permitted in the initialization and increment section of the *for* loop to separate multiple operations. For example,

```
for (int i=0, j=10; i < 100; i++, j +=2) {
        ...
}
```

Also, the *for* loop can use non-integral index values. For example,

```
for (double x=0;f(x)>0; x=x+0.1) {
    . . .
}
```

If the initializations or update parts of the *for* loop throw an exception, then the *for* loop will throw an exception. The *for* loop is the only iteration form that uses the comma as a separator.

The body of a *for* loop should be indented in order to identify the repeated statements.

5.8 The *continue* Statement

The *continue* statement aborts out of an iteration. A continue statement without a label identifier proceeds to the next enclosing iteration. A *continue* statement with a label identifier proceeds to the next enclosing *labeled* statement.

LANGUAGE REFERENCE SUMMARY
The *continue* statement can be written as '*continue*' followed by an optional identifier followed by ';'.

WARNING

It is a compile-time error for a *continue* statement to appear in a statement other than a *while, do,* or *for* statement.

The *continue* statement is used with a *continue* target like *while, do*, or *for*. The *continue* statement causes the next iteration of the loop to execute immediately. The optional *identifier* permits a label to be used to transfer the flow of control. In the following example, the *continue* statement causes the termination of the inner *for* loop and a continuation of the next element in the labeled (or, in this case, the outermost) *for* loop:

```
foo: for (int i = 1; i < 5; i ++) {
        for (int j=1; j < 5; j++) {
          if ( i % j == 2) {
          System.out.println("continue");
          continue foo;
        }
        System.out.print(i*j + " ");
    }
        System.out.println();
}
```

The above code will output

```
1 2 3 4
2 4 continue
3 6 9 12
4 8 12 16
```

An unlabeled *continue* statement will cause the enclosing iteration statement to continue with the next iteration, thus skipping any statements that follow the *continue*.

```
for (int i = 1; i < constantPool.length; i++) {
        if (constantPool[i] == null)
            continue;
```

```
                   // more stuff follows
               }
```

Here, the continue statement will proceed to the next *i* without finishing the rest of the current iteration. The labeled *continue* statement is less popular than the unlabeled *continue* statement.

5.9 The *break* Statement

The *break* statement skips to the end of the current loop. An optional identifier permits the *break* to perform a non-local change of control.

LANGUAGE REFERENCE SUMMARY
The *break* statement can be written as 'break' followed by an optional identifier followed by a ';'.

For example,

```
break toHere;
break;
```

It is a compile-time error not to enclose a break statement within a break target.

Valid break targets are *switch*, *while*, *do*, and *for* statements. The *break* may be used with or without an identifier label. The *break* statement causes control to pass to the innermost enclosing *break* target and the *break* target completes normally. Compare this process to a *continue* statement in a loop. The *continue* statement will continue with the loop, whereas the *break* statement will break out of the loop.

The following example permits the for loop to terminate normally for two reasons. The first is the for-loop expression n < 2*Math.PI, which is only tested at the top of the loop. The second is the ((x*i) < 10) expression, that is tested at the bottom of the loop.

```
        doneWithFor:
          for (double n = 0; n < 2*Math.PI; n = n + step) {
               out[i] =  in[i]* Math.sin(n);
               i++;
               while (x<50) {
                     if ( (x*i) < 10) break doneWithFor;
                     ....
                     }
             }
```

In the following example, the *break* is removed by adding a more complex test in the for statement:

```
        for (double n = 0;
              (n < 2*Math.PI) && (i < out.length);
              n += step, i++) {
              out[i] =  in[i]* Math.sin(n);
          }
```

As a matter of style, it is more clear to write

```
while (true) {
    char ch = getC();
    if (ch == EOF) break;
    //... more stuff here
}
```

than to write

```
while ((char ch = getc()) != EOF) {
}
```

5.10 The *switch* Statement

The *switch* statement transfers control to one of several statements, depending on the value of an expression. This action is called a dispatch.

It is a compile-time error if the expression is not *char*, *byte*, *short*, or *int*. *Long* cannot be used in a *switch* statement.

LANGUAGE REFERENCE SUMMARY
The *switch* statement can be written as 'switch' followed by '(' followed by a boolean expression followed by ')' followed by '{' followed by 'case' followed by a constant expression followed by ':' followed by a statement.

LANGUAGE REFERENCE SUMMARY
The typical form for a *switch* statement is

```
switch ( expr ) {
  case const1: statement
                break;
  case const2: statement
                break;
  case const3: statement
                break;
  default    : statement
}
```

The *break* statement causes an exit from the *switch*. The *case* is really just a label. Once the condition of the *case* is satisfied, the execution continues with all of the other case statements unless a *break* or *return* is present.

In general, it is a good idea to end a *case* statement in a *switch* with a *break* or to use a comment like

```
// fall through.
```

For example,

```
public class Break {
    public static void main(String args[]) {
        int i=3;
```

```
        switch (i) {
        case 3:
            System.out.println("i=3");
            // fall through
        case 4:
            System.out.println("i=4");
            break;
        }
    }
}
```

will output

```
i=3
i=4
```

Your code will be more clear if you always use a *break* to prevent the flow of control continuing to the next statement. For example,

```
switch (expression) {
        case const_1:
          statement1;
          break;
        case const_2:
          statement2;
          break;
        default:
          statement3;
          break;
}
```

There can be, at most, one default branch in the *switch* statement. It is typical to have long switch statements when dispatching keyboard events. For example,

```
public boolean charSelect(char c) {
        switch (c) {
        case 'o':
          openAFile();
          return true;
        case 's':
          saveAs();
          return true;
        }
```

Keyboard shortcuts are popular as users gain experience with an interface. It is unfortunate that the switch statement can only take scalar values, since it would be helpful to be able to use it with strings. As a final example, consider the labeled break as a means to terminate an iteration:

```
public class Break {
    public static void main(String args[]) {
        done: for (int i=0; i < 9;i++)
            switch (i) {
            case 3:
                System.out.println("i=3");
                break done;
```

```
            case 4:
                System.out.println("i=4");
                break;
            }
         System.out.println("I am done!");
        }
    }
```

The output of the code above is

```
    i=3
    I am done!
```

The labeled break may prove useful if you are searching for a solution and you want to break out of the search when the solution is found.

5.11 The *return* Statement

LANGUAGE REFERENCE SUMMARY
The *return* statement consists of the keyword *return* followed by an optional expression followed by a ';'.

The return statement transfers the flow of control to the invoking method, returning the value of the optional expression, if present. When the expression is omitted, *void* is returned. For example,

```
    public static void main(String args[]) {
            return; // note, nothing is returned.
    }
```

As another example, consider the method *addOne*:

```
    public int addOne(int x) {
            return x + 1;
    }
```

It should be clear that

```
    int i = addOne(10);
    System.out.println(i);
```

will output

```
    11
```

The *return* statement can return any data type. As we shall see in the following chapters, data types can be primitive data types or reference data types. Using the *return* keyword, it is possible to perform a kind of functional programming. In the following example, we create a class called *Functions*. This class contains a series of static methods that can take arguments, pass them to an expression, and then return the value to the invoking method. In the example, the invoking method is the *main* method.

```
    public class Functions {
    // fv = future value of an investment.
    // see exercise 5.
     public static double fv(
```

```
              double p, double r, double y) {
                  return p * Math.pow(1+r,y);
        }

    // f2c converts Fahrenheit to Celsius.
    // see exercise 4.
     public static int f2c(double f) {
          return (int)( (5.0/9.0) * (f - 32));
      }
      public static void main(String args[]) {
          System.out.println(
            100 + " degrees f = "
            +f2c(100)+" centigrade");
          System.out.println(
            100 + " dollar for 30 years at 0.07% give you   "
            +fv(100,0.07,100)+" dollars");
      }
    }
```

5.12 Exercises

5.1 In order to convert from an angle in degrees to an angle in radians, multiply by *Math.PI* and divide
by 180.0:

```
    double radians = degrees * Math.PI / 180.0;
```

Write a loop that prints out a table of angles in radians and degrees from 0 to 360 degrees using
10-degree intervals.

5.2 Write a program that adds all of the integers between any two integral start points. Use your
program to compute the sum of all of the integers from 1 to 100.

5.3 Generate a table of conversions from dollars to Francs (Fr) and Deutsche Marks (DM). Assume
that there are 5.3 Fr per dollar and 1.57 DM per dollar. Generate the table in $5 increments
from 5 to 100 using a *for* statement.

5.4 Generate a table of conversions from degrees Fahrenheit (F) to degrees Celsius (C) in increments
of 5 degrees Fahrenheit from 5 to 100. Use a *while* statement and equation (5.12-1):

$$C = \frac{5}{9}(F - 32). \tag{5.12-1}$$

5.5 Generate a table that shows the value of an investment using (5.12-2):

$$v = p(1 + r)^n$$

$$v = \text{value}$$

$$p = \text{principle}$$

$$r = \text{interest rate per year}$$

$$n = \text{number of years.} \tag{5.12-2}$$

Use *a* for loop to compute the value $100 at an interest rate of 7% from 5 to 30 years

5.6 A weather balloon has a flight profile given by equation (5.12-3):

$$v(t) = -0.48t^3 + 36t^2 - 760t + 4100$$

$$a(t) = -0.12t^4 + 12t^3 - 380t^2 + 4100t + 220 \tag{5.12-3}$$

In the above equation, *a(t)* and *v(t)* are the altitude in meters and the velocity in meters per sec-
ond, respectively. Tabulate the time, altitude, and velocity as a function of time for the first 5
hours of flight. Show your result in 1-hour increments. What happens after 3 days? [Etter].

C H A P T E R 6

Reference Data Types

When it is dark enough, you can see the stars.

–Ralph Waldo Emerson,
writer and philosopher (1803–1882).

In this chapter, you will learn about:

- Instances of a class
- Class variables
- Methods, including overloaded, getter, and setter methods
- Subclassing and Superclassing
- Type conversion, or casting
- Interfaces
- The keywords *null* and *instanceof*
- AKO hierarchies
- Fragile base class problems

Figure 6-1 shows the keywords you will learn in this chapter.

6.1 Class Concepts

Algorithm–
A step-by-step problem-solving procedure.
A detailed sequence of actions to perform in
order to accomplish some task. Named after an
Iranian mathematician.

Al-Khawarizmi.

class
interface
null
new
instanceof
extends
super
this
void
implements

FIGURE 6-1
Keywords

An object-oriented program is like a cookbook located in a kitchen full of food. You have all the items you need to make something, all in one place.

 Object oriented means having both algorithms and data structures in a single entity.

Object-oriented programs are characterized by elements that contain data and the algorithms needed to manipulate that data. We obtain these elements in Java by making instances of a *class*.

 A class is like a cookie cutter. Different cookie cutters shape cookies differently. In other words, each cookie can have different properties.

Along these same lines each instance of a class can differ from another instance in some small way. For example, two instances of a *Customer* may have different names, yet all *Customer* instances have a name. The data in a class is sometimes called a *property* of the class. A class property is an attribute that is stored in a variable. An instance of a class is stored in a *reference* variable. A reference is a symbolic link to a location. A reference variable is used to hold a reference. It is a place holder for a reference type instance. For example, *classes* are reference data types (i.e., not primitive data types). Every class name is a new reference data type.

Figure 6.1-1 Sketches the relationship between variables and methods in classes.

FIGURE 6.1-1

Variables and Methods in a Class Class

The class name is an identifier (that may be of any length), and the class may extend another class. In Java, classes are able to form an AKO taxonomy. For example, if a *mammal* has hair, then we can write

```
public class Mammal {
    boolean hasHair = true;
}
```

Methods in the *Mammal* class can alter the properties in an instance of a mammal. For example,

```
public class Mammal {
    boolean hasHair = true;
    public void makeBald() {
     hasHair = false;
    }
    public static void main(String args[]) {
     Mammal m = new Mammal();
     m.makeBald();
     System.out.println(m.hasHair); // prints false
    }
}
```

In Java, we define classes as if they are sets, and subclasses as if they are subsets. Thus, the classification system is used to create the *AKO* association between elements. The term *class* is short for *classification*. The *classification* idea was used in the *Simula* language, borrowed by C++ and later used by Java [Stroustrup]. The data structures in a class have primitive or reference data types (i.e., instances of other classes). Classes can communicate with one another, which can cause interdependence between classes.

The *new* operator makes an instance of a class. For example,

```
class Point {
    public double x,y;

    public static void main(String args[]) {
     // assign a new value to the point instance
     Point p1 = new Point();

     p1.x = 10;
     p1.y = 11;
    }
}
```

Point is a *class* name, *new* is a keyword, and *p1* is a variable. Object-oriented programs have a complexity that is represented in part by the associations between classes. One type of association that is commonly used in object-oriented programs is *inheritance*.

 Inheritance enables subclasses to obtain properties and methods from superclasses.

This association permits subclasses to build on the methods and data structures of the parent class. To build on the methods and data structures of a parent class, a subclass is constructed that *extends* the parent class. For example,

```
public class Human extends Mammal {
```

In this case, the *Human* class extends the *Mammal* class, which means that the human is a kind of mammal. As a result, the *Human* class is a subclass of the *Mammal* class and inherits properties (like *hasHair*).

All classes descend from the *Object* class. As a result, the *Object* class is called the *primordial* class. Since the *Object* class has a *toString* method, all instances of its subclasses are able to support this method. The *toString* method creates a string representation of an instance, which is used in printing.

To define classes in Java:

1. Define the class type
2. Instance the class and store it in a variable name
3. Invoke methods and access member variables with the dot operator

For example define the new type:

```
class Circle { // define class
      int radius;
}
```

Then instance the class and store it in a variable name:

```
public static void main(String args[]) {
      Circle c = new Circle(); // map to variable name
}
```

Finally invoke methods and access member variables with the dot operator:

```
public static void main(String args[]) {
      Circle c = new Circle(); // access member
      System.out.println("radius=" +c.radius);
}
```

6.2 Constructors

A constructor is a method in a class that:

1. Shares the name of a class
2. Returns nothing, not even void
3. Is invoked by the *new* operator
4. Initializes variables
5. Takes parameters (optionally)

For example,

```
public class Customer {
      String name = "";
      Customer(String _name) {
        name = _name;
```

```
                     //initialize the class during construction
                     }

                     public static void main(String args[]) {
                       Customer c = new Customer("sam");
                       System.out.println(c.name); // outputs "sam"
                     }
              }
```

The following *Payroll* class has a corporate customer, *docjava.com*:

```
       public class Payroll {
              Customer c = new Customer("DocJava.com");
       }
```

A class's methods enable manipulation of class member variables. A method called the *constructor* enables the creation of new class instances. The constructor must have the same name as the class. The constructor returns nothing, not even void. If no constructor is specified, then a default constructor is assumed during compilation.

The default constructor takes *null* as an argument. The default constructor is overridden when another constructor is specified.

For example,

```
       class Lamp {
              boolean on;
              int Wattage;
              Lamp (int w) {
                Wattage = w;
              }
              Lamp ( ) {
                Wattage = 100;
              }
       }
```

The *Lamp* constructor has been overloaded with two versions. The first version will support

```
       Lamp dim = new Lamp(40);
```

while the second version will support the constructor invocation

```
       Lamp bright = new Lamp();
```

It is a syntax error to have two methods in the same class with the same signatures.

The signature of the method is determined by the name of the method, the number of arguments, the argument order, and the compile-time types.

Two kinds of variables can appear in a class: *static* variables and *dynamic* variables.

Static variables exist at compile time.

The dynamic variables are instance variables and only exist upon class instantiation.

 It is common for static and dynamic variables to be a source of confusion for beginning Java programmers.

We shall revisit the concepts of static versus dynamic variables in detail in Chapter 9.

6.3 The *getter* and *setter* Methods

It is generally a good idea to use *getter and setter* methods when trying to read or write a class variable from outside of a class.

 Do not use the *get* and *set* method prefixes unless you want to set or get something. Using these prefixes will confuse the *introspection* framework (a topic discussed in Chapter 35).

The getter and setter methods enable the programmer to insert error checking and pre-computation code that can ensure data consistency and control improper access to internal variables. In order to force the usage of the *getter* and *setter* methods, it is typical to declare the instance variables *private*. For example,

```
public class GetterSetter {
    private float salary = 40000;

    public float getSalary() {
      return salary;
    }

    public void setSalary(float _salary) {
      salary = _salary;
    }
}
```

The *GetterSetter* example shows that the salary cannot be accessed directly. A *public* method, *getSalary*, enables the reading of the salary. To set the salary, only the setSalary method can be used for external classes. The following example improperly accesses the *salary* property:

```
public class Broken {
    GetterSetter gs = new GetterSetter();
    void test() {
      gs.salary = 10;
    }
}
```

The above code produces a compile-time error:

```
Error    : Variable salary in class GetterSetter not
           accessible from class Broken.
GetterSetter.java line 15     gs.salary = 10;
```

 It is a syntax error to access private member variables from outside of the containing class.

Getter and setter methods have become important in the area of *Java beans*. Java beans are discussed in Chapter 34.

In some books, the getter method is called the *accessor* and the setter method is called the *mutator*.

6.4 The *null* Keyword

One of the literals of Java is *null*. The *null* is what you get when nothing has been created. It can be used in place of any reference data type. Uninitialized references are *null*. For example,

```
if (some_object != null) {
      System.out.println("Object Exists!");
}
```

 The keyword *null* has a *null* type and is the default value for any type that has not been created.

For example,

```
class Test {
      Lamp l;
}
Test t = new Test();
```

At this point, *t.l* is equal to *null*. To make an instance of the *Lamp* instance variable, *l*, you must first create an instance of *Test* and then instance *l*. Before this time, the *l* instance variable will be *null*. For example,

```
Test t = new Test();
t.l = new Lamp();
```

The keyword *null* can be used to indicate if a reference variable as been set. For example,

```
public void someMethodName(Object o) {
      if (o == null) return;
// If the reference has not been set,
// return otherwise, keep processing
      .... // more stuff here.
}
```

If a variable is explicitly set to *null*, it can signal the JVM that you are done with the variable, which may release the storage for reuse. This action, however, generally is not necessary.

6.5 Subclassing and Superclassing

 LANGUAGE REFERENCE SUMMARY
A class declaration expression can be written using an optional modifier followed by the keyword *class*, an *identifier*, the optional extends expression, and/or the optional implements expression.

The extends expression is written as the keyword *extends* followed by a class name. The implements expression is written by the keyword *implements* followed by a series of one or more interface names. There may be an unlimited number of interface names. Interfaces are discussed in the following section.

One feature of the Java class is that it represents a taxonomic structure. A *taxonomy* is a way to arrange related elements in sets and subsets. For example, the set of all mammals is

a superset of the set of all humans. The set of all students is a subset of the set of all humans. The AKO association is used to describe the relationship between the elements of a taxonomy. For example, a human is *a-kind-of mammal*.

 Subclassing enables code reuse by inheritance.

Taxonomic structures are formed by Java classes when a subclass *extends* a superclass. This type of extension is called *direct inheritance*. Thus, in terms of knowledge representation, Java classes can represent the AKO relationship. In addition, Java classes can represent the has-a relationship using the class member variables. For example, we can represent the statement "A student is a-kind-of human" by creating a student class that extends the human class. We can also represent the statement "The student has-a pencil" by placing a class member variable of pencil-class type into the student-class construct. In the following section, we present the syntax of Java and its relationship to the semantics of Java.

 Subclassing permits the incorporation of superclass properties.

A class may be used to provide a container for an instance variable of any primitive type. For example,

```
class Lamp {
     boolean on = false;
}
 . . .
Lamp l = new Lamp ( );
l.on = true;
```

A Java class may be used to store a reference to named constants:

```
class Constants {
     static final double PIon2 = Math.PI / 2;
}
```

Notice that these class examples have no methods. When one class extends another, we are subclassing a superclass. The subclass will inherit the member variables and methods of the superclass. In the case of a name conflict, the subclass implementation always overrides the superclass implementation. For example,

```
class Lamp extends Constants {
     double power = 100 / PIon2; // watts
     boolean on = true;
}
```

 Super is invoked before other statements in an overriding construction.

The power in the *Lamp* class is set using a *PIon2* constant that is inherited from the *Constants* class. In this case, it is not strictly correct to say that the *Lamp* is AKO *Constants* and thus the *extends* is being used as a programming convenience, not as a means for knowledge representation. To see how subclasses obtain properties from their superclasses, consider the *SpotLight* class:

```
class SpotLight extends Lamp {
    boolean spotPower = power * 2;
    // use the super-classes power to compute spotPower.
}
```

On the other hand,

```
class Student extends Human {
    Pencil p;
}
class Human {
    boolean bald = false;
}
```

Now we represent the statement that "Doug is a bald student with a pencil":

```
Student doug = new Student();
doug.p = new Pencil();
doug.bald = true;
```

Super is a keyword that permits a subclass to call upon the instance variable or method of the superclass. For example,

```
public class SuperDemo {
    public void print() {
      System.out.println("Oh, super man!");
    }
}
public class SubclassDemo extends SuperDemo{
    public void print() {
      System.out.println("We are going down, uh huh!");
      super.print();
    }
    public static void main(String args[]) {
      SubclassDemo scd = new SubclassDemo();
      scd.print();
    }
}
```

outputs

```
We are going down, uh huh!
Oh, super man!
```

Note that the *print* method has a different side effect when invoked from the *SubclassDemo* rather than from the *SuperDemo*. We say that the *SubclassDemo* overrode the *print()* method in *SuperDemo*. In order to invoke the superclasses print statement, a *super.print()* was needed. The shadow method is the method that was overridden a subclass.

Consider the following example:

```
/**
    An example of storing the AKO hierarchy
    using classes.
*/
public class Mammal {
    private boolean hasHair = true;
```

```
      }
public class Human extends Mammal {
      public static void main(String args[]) {
        System.out.println( "Hello World!" );
      }
}
public class Dog extends Mammal {
}
public class Student extends Human {
}
public class Professor extends Human {
}
```

Figure 6.5-1 shows the hierarchy in the *Mammal* class and also shows that a *Dog* is a kind of *Mammal*, a *Student* is a kind of *Human*, and a *Human* is a kind of *Mammal*.

 A subclass creates an AKO hierarchy.

The *super* invocation is required whenever the superclass's constructor is overridden in a subclass. For example,

```
1. class Customer {
2.   String name;
3.   Customer(String _name) {
4.     name = _name;
5.   }
6. }
```

In other words, to make a new instance of a *Customer*, you must supply a name due to the constructor of line 3. The default constructor (i.e., when no constructor is given) does not require parameters. For example,

```
Customer c = new Customer("Al K. Holic");
// c is an instance of the Customer class
```

In some businesses (like forensics) customers are given default names, such as *J. Doe*, to indicate that those customers are not identified. Such customers are Dead on Arrival (DOA). For example,

```
class Doa extends Customer {
    Doa() {
      super("J. Doe");
    }
}
```

You also can make a new instance of the *Doa* class. For example,

```
Doa d = new Doa(); // No name is supplied here.
```

FIGURE 6.5-1

The Hierarchy in the Mammal Class

The first thing that occurs in the *Doa* constructor is the invocation of the *super* class constructor. Failure to provide this invocation is a syntax error because the dynamic elements (i.e., methods and instance variables) do not exist until the superclass has been instanced.

If a superclass has a constructor, it is a syntax error to subclass without an invocation of the superclasses' constructor from within the subclasses' constructor.

In summary:

1. Subclassing enables code reuse by inheritance
2. Subclassing permits the incorporation of superclass properties
3. A subclass creates an AKO hierarchy
4. Super is invoked before other statements in an overridding construction

6.6 Casting

Type conversion in Java is called *casting*. Casting is able to convert only between compatible types.

Sometimes the only way to know for sure when types are compatible is to run the program. If a conversion fails, a *run-time error* occurs.

Class cast conversion at run time should be contained within a try-catch block if casting may fail.

It is always correct to cast an instance from a subclass to its superclass. For example,

```
class Mammal {
}
class Human extends Mammal {
}
class Test {
    Human h = new Human();
    Mammal m = h;
// note the automatic type change
}
```

In the assignment of the *Human* instance, *h,* to the *Mammal* variable, *m,* there is an *implicit* type change from *Human* to *Mammal*. This type change is permitted because the *Human* class subclasses the *Mammal* class.

Casting also is permitted for primitive data types. For example,

```
int i = (int) 1.0; // 1.0 is a double by default
byte i = (byte) 2f; // 2f is a float
```

In general, casting is not needed when no information is lost. For example,

```
// the int, 1, is automatically promoted to double
double d = 1;

// the float is automatically promoted to double.
double dd = 2f;
```

Casting is a syntactic operation that tells the compiler that you know what you are doing. In essence, you are telling the compiler that this reference is of a specific type. For example,

```
class Hello {
    public class hi() {
```

```
                    System.out.println("hello world");
                    }
              }
       class Test{
              public static void main(String args[]) {
              Hello h = new Hello();
              h.hi(); // this works fine
              Object o = h; // this alters the type
              o.hi(); // this will NOT compile!!
       // To fix the above, broken statement, try:
       // Cast o to the Hello type
              Hello j = (Hello)o;
              j.hi(); // this works OK!
              }
       }
```

Thus, casting is an operation that alters the reference data type so that the compiler will allow you to invoke methods in that type. Because the compiler does not know if casting can work, a run-time error (called a *ClassCastException*) can be generated.

WARNING

Be careful with casting operations. If they fail, they will throw a *ClassCastException* at run time.

6.7 The Keyword

The *instanceof* reserved word is used to tell the type of an instance.

LANGUAGE REFERENCE SUMMARY
The *instanceof* expression returns a boolean type. It can be written as an instance followed by the *instanceof* keyword and another instance.

For example,

```
       public static void dispatchType(Object o) {
              if (o instanceof String)
               process((String) o);
              if (o instanceof Integer)
               process((Integer) o);

       }
```

where the method *process* is overloaded to take different types of instances (i.e., *String* and *Integer*). If the *instanceof* keyword had not been used, then the casting operation may have failed. Such failures occur at run time and are described in more detail in Chapter 13.

6.8 Interfaces

An interface is defined just like a class except that it uses the keyword *interface* rather than *class*. Recall the language reference summary for a *class*:

LANGUAGE REFERENCE SUMMARY
A class declaration expression can be written using an optional modifier followed by the keyword *class*, an *identifier*, the optional extends expression, and/or the optional implements expression.

The extends expression is written as the keyword *extends* followed by a class name. The implements expression is written by the keyword *implements* followed by a series of one or more interface names. There may be an unlimited number of interface names.

An interface is a collection of constants and method *specifications*. The methods have no implementation. An interface is like an abstract class with only abstract methods and constant fields. For example,

```
public interface InterfaceName {
    public static final String hi = "I cant change";
    public void addName(String s); //no body here
}
```

LANGUAGE REFERENCE SUMMARY
An interface declaration can be written as an optional visibility modifier followed by interface and an identifier. Right after the identifier, the interface can extend another interface using extends followed by another interface name.

In fact, an interface can extend an unlimited number of other interfaces. For example,

```
interface IDontExtendAnything {
}
interface IExtendLotsOfStuff extends IDontExtendAnything,
        AndSomeOtherThing, AndThis, AndThat, YadaYadaYada {
}
```

An interface can extend multiple interfaces. The interface is a reference type, but it can never be instanced. Thus, classes that implement an interface can always be cast back to the interface type. For example,

```
public void foo(IExtendLotsOfStuff ielos) {
    AndThis at = ielos;
    YadaYadaYada yyy = ielos; // no casting required!
}
```

As another example, consider the *Runnable* interface (defined in the Java environment):

```
public interface Runnable {
    public void run();
}
```

Now, suppose we define a class that implements *Runnable*:

```
public class RunnableMammal extends Mammal implements
        Runnable {
    public void run() {
      System.out.println("I am running");
    }
// It is now an easy matter to run the RunnableMammal
// using the run method from the Runnable interface:
    public static void main(String args[]) {
```

```
        Runnable r = new RunnableMammal();
        r.run();
// as an alternative we can use the RunnableMammal ref:
        RunnableMammal rm = new RunnableMammal();
        rm.run();
        }
    }
```

Interfaces can contain fields. The field declarations can have methods, constructors, variables, and static initializers. In the following example, we define interfaces as *RealDumb*, *Dumb*, and *MixedUp*. The *MixedUp* interface has tried to disambiguate the usage of the constant, which results in a *syntax error*:

```
public interface RealDumb {
        double PI = 4;

}
public interface Dumb {
        double PI = 3;
}

public interface MixedUp extends Dumb, RealDumb
        {double foo=PI;}
Error   : Reference to PI is ambiguous. It is defined in
        interface Real_Dumb and interface Dumb.
constants.java line 17    {double foo=PI;}
```

It is a syntax error to have multiple inheritance of ambiguous constants.

The text below includes some correct uses of interfaces. For the first example, we show how interfaces may be used to group constants:

```
public interface constants {
        double Pi_on_180 = Math.PI / 180;
        double PI = Math.PI;
        double Pi_on_2 = Math.PI/2;
        double Pi_on_4 = Math.PI/4;
    }
```

Interfaces can extend multiple interfaces.

This process leads to inheritance of constants and methods from the interfaces extended. For example,

```
interface X {
        double PI = Math.PI;
        double PiOn2 = PI/2;
}
interface Y {
        double E = Math.E;
}
interface Z extends X,Y{
}
public class
        GetsConstantsFromZ
```

```
         implements Z {
         public static void main(
          String args[]) {
          System.out.println(
            "PI="+PI);
          System.out.println(
            "E="+E);
         }
      }
```

The *GetsConstantsFromZ* actually inherits constants from both the *X* and the *Y* interfaces.

It is a compile-time error to have a name conflict in inherited interfaces.

Below is an example of the interface extending multiple interfaces:

```
public interface Drawable {
     public void draw();
}
public interface Movable {
     public void move(double x, double y);
}
public interface GraphicsObject extends Movable, Drawable {
}
public class Mammal implements GraphicsObject {
     private boolean hasHair = true;
     private double x = 0;
     private double y = 0;

     public void move(double _x, double _y) {
      x = _x;
      y = _y;
}
     public void draw() {}; // does nothing right now.
}
public class Human extends Mammal {
     public static void main(String args[]) {
      System.out.println( "Hello World!" );
      }
}
public class Doggy extends Mammal {
}
public class Student extends Human {
}
public class Professor extends Human {
}
```

It is a syntax error to define an implementation for the *draw* method that has a more restrictive visibility than the specification in the *interface*.

In other words,

```
public class BUG extends Human {
     private void draw() {}; // does nothing right now.
}
```

FIGURE 6.8-1

Interface Example Showing an AKO Hierarchy

generates the syntax error

```
Error    : The method void draw()  declared in class BUG cannot
override the method of the same signature declared in interface
GraphicsObject.  The access modifier is made more restrictive.
```

To fix the bug in *BUG*, you must make the access modifier less or equally restrictive.
Figure 6.8-1 shows the class hierarchy of the relationships described above.
Casting may be applied to instances of classes that implement interfaces. For example,

```
public interface Drawable {
    public void draw();
}
public interface Movable {
    public void move(double x, double y);
}
public interface GraphicsObject extends Movable, Drawable {
}
// implicit type conversion can work for interfaces:
public void draw(GraphicsObject go) {
    Movable m = go;
    Drawable d = go;
    d.draw();
    go.draw(); // both draw methods work.
}
// to guard against run-time errors, it is wise to check
// the reference type before casting, unless you are sure:
public void process(Object o) {
    if (o instanceOf Drawable) {
     Drawable d = (Drawable) o;
     d.draw();
    }
}
```

Interface names can use simple identifiers, or they can use package names followed by an identifier. For example,

```
public interface java.lang.Runnable {
    public void run();
}
```

In summary:

1. An interface is a specification for a set of well-defined behaviors.
2. Interface visibility is either default or public. (private and protected are illegal).

3. An access modifier for a method in an implementing class cannot be made more restrictive.

4. Methods in interfaces are implicitly public, but may be declared public explicitly.

5. Interfaces and their methods are implicitly abstract, but may be declared explicitly abstract (this practice is discouraged).

6. Constants are implicitly final, but may be declared explicitly final.

7. Constants are implicitly static, but may be declared explicitly static (i.e., they are allocated with storage at compile time).

8. Constants must be initialized.

9. Constants may not shadow one another in interfaces (i.e., they must be unambiguous). It is a syntax error if the field names in an interface are not unique.

10. Interfaces can be declared as abstract, but such a declaration is not necessary.

11. Interfaces may extend multiple interfaces.

12. Interfaces may not implement interfaces.

13. Classes may implement multiple interfaces.

14. Interfaces have multiple inheritance of specification without implementation.

15. Class and interface names should be unique to prevent name-space conflicts (unless you use packages, as described in Chapter 14).

16. Interfaces have no common ancestor, such as *Object*.

17. An interface is a reference data type [Campione and Walwalrath].

18. An instance of a class can be cast to an interface if the class implements it.

6.9 Data-centered Object-Oriented Design

Suppose you are given some data that needs to be processed. This is a very common occurrence in programming called Electronic Data Processing (EDP).

When data is an object (i.e., an instance of a class), then we can either make the data process itself or provide a series of other methods in other classes that can process it. Here are some options:

1. Deepen the subclass for processing data, which is the strategy used in *Image Processing in Java* [Lyon 1999]. Each chapter built another subclass on the *Frame* until the classes were nine levels deep. However, subclassing is not always the best way to improve the functionality of a class. Another approach is called delegation, which we will discuss at length in the next paragraph. While subclassing is an object-oriented design, lack of multiple inheritance keeps Java from scaling this approach to large programs. For example, for a Professor to inherit attributes from a Human we might write

```
public class Professor extends Human {
}
public class Human extends Mammal {
}
public class Mammal extends Animal {
}
```

Since the professor does not belong in the AKO hierarchy, it is inappropriate to obtain attributes from the *Human* class by subclassing. The better approach is to use delegation.

2. Use *delegation* to keep adding references to *helper* classes that can process the data, then delegate to the other classes for the implementation. Imagine that you are the president of a country. All requests from the citizens go directly to you. Then you must make a phone call and delegate each the request to the right person. What a mess! In Java, this means that every class that is added for processing data will require that the data class be configured to pass the current execution context to the delegate. In other words, multiple programmers on a team all will have to communicate with the programmer responsible for the data set. This is the solution I took in *Java Digital Signal Processing*.

WARNING

Delegation can require code reorganization.

3. Use strong variables. A data set can be treated as a strong variable. For example, to graph all the data for drawing a graph, an interface called *GraphData* is created. Classes that implement the *GraphData* interface provide ways to obtain the data for graphing methods in another class. Thus, to graph data, call the right-draw method in the *BarGraph* class and the *GraphData* implementor will be used to draw a bar graph.

STYLE POINT

Strong variables provide for large-scale development, incremental deployment, and modular (i.e., contained) elements for processing. They also improve code reuse. Thus, develop your data set class, use instances of this class as a parameter to the processing methods, and group the processing methods by their role in the system.

Of course, no general rule will substitute for good object-oriented design. The key element is the assignment of responsibility to the various types of instances. If we can learn how to assign responsibility and create reusable code, then we will have made a major in-road toward improving the design. The goal is to balance reusability of code against code robustness.

Without multiple inheritance, we can only rely upon single inheritance or delegation as a means toward reuse. A means of automating the synthesis of delegation code is presented in Chapter 25.

6.10 The Fragile Base Class Problem

When a compiler makes references to instances of classes, the references are associated with symbolic names. Some compilers perform a process called *static linking*. This process typically is performed by C++ implementations and requires that actual addresses be used rather than names (addresses are substituted for names in the executable code). This process is called *resolution*. The Java implementation typically requires that the names be passed to the Java interpreter.

When encountering a name for the first time, a Java interpreter *dynamically resolves* the name to an address and then substitutes the address for the name in the output codes. After this first encounter, the Java interpreter does not need to resolve the name again. This process is called dynamic resolution and dynamic linking.

If an instance variable is added to a C++ class, the address of the class typically changes. As a result all dependent classes must be recompiled. This constant recompilation has been termed the *fragile base class problem*. Java is supposed to solve the fragile base class problem through dynamic resolution. In theory, such a resolution sounds great. However, in practice, when I recompile a class called the *ShortCutFrame*, 47 files need to be recompiled according to *Metrowerks*. But only 1 file gets recompiled in *IDEAJ* (another popular IDE). This means that not all classes are being recompiled when they should be.

Look out for tools that do not re-compile dependent classes.

Ideaj does not recognize the importance of recompiling subclasses. As a result, it misses important compilation errors and gives "incompatible class changed" errors at run time. It is possible to separate subclasses from their superclasses, but it is hard work and an error-prone process.

Extensive subclassing can lead to brittle code that is hard to maintain. Perhaps inheritance should be considered harmful.

6.11 Summary

This chapter covered some of the basic concepts regarding data types. The two basic types covered were the reference data types and the basic data types. The primary reference data type of interest is the *class* data type. Other data types are covered in the following chapter. The coverage of the class data type included a discussion of the *getter* and *setter* methods. The chapter also briefly covered *casting* and the *null* operator.

Casting is a rather challenging topic that deserves much larger coverage. We shall learn more about casting in Chapter 8.

6.12 Exercises

6.1 Primitive data types in Java can form an AKO hierarchy. Draw the relationships between the following classes in order to see the relationships between the various primitive data types:

```
class DataTypes {}
class ReferenceTypes extends DataTypes {}
class PrimitiveTypes extends DataTypes {}
class ClassTypes extends ReferenceTypes{}
class InterfaceTypes extends ReferenceTypes{}
class Signed extends PrimitiveTypes{}
class Unsigned extends PrimitiveTypes{}
class BOOLEAN extends Unsigned{}
class Char extends Unsigned{}
class FixedPoint extends Signed{}
class FloatingPoint extends Signed{}
class DOUBLE extends FloatingPoint{}
class FLOAT extends FloatingPoint{}
class BYTE extends FixedPoint{}
class SHORT extends FixedPoint {}
class INT extends FixedPoint {}
class LONG extends FixedPoint {}
```

6.2 Select a taxonomy with which you are familiar (e.g., kinds of books, kinds of people). Write the class hierarchy that depicts the relationships between the elements in the taxonomy.

6.3 Write a *Shape2DInfo* interface for 2D geometric shapes that permits the computation of perimeter, area, center, width, and height. Implement this interface for a rectangle, a circle, and a square. The constructors for these shapes will be used to specify their parameters. Below is a sample interface to get you started:

```
public interface Shape2DInfo {
        public double getHeight();
        public double getWidth();
        public double getPerimeter();
        public double getArea();
        public Point getCenter();
}
```

Define your *Point* class as

```
public class Point {
        private double x = 0;
        private double y = 0;

        Point(double _x, double _y) {
          x = _x;
          y = _y;
        }
}
```

6.4 Using the answer to exercise 3, add a *move* method that will alter the location of the shapes. Notice how the *move* method is the same for each shape. Suggest a way to eliminate the redundant code.

6.5 Write a *Dynamic2DInfo* class that computes the distance between the centers of any two instances of classes that implement *Shape2DInfo*. The distance between two points is given by

$$distance = \sqrt{(x_1 - x_2)^2 + (y_1 - y_2)^2}$$

In Java we write

```
distance = Math.sqrt((x1 - x2) * (x1 - x2) + (y1 - y2) *
        (y1 - y2));
```

What class should be responsible for computing the distance between the points?

6.6 How does Java avoid the fragile base class problem? How can you introduce fragile base classes into the Java environment? Why might doing so be advantageous?

6.7 What will the following code printout?

```
interface A {
        public static final double i=10;
        void help();
}
interface B {
        public static final int ii = 10;
        void help();
}
interface C extends A,B {};
public class Wild implements C {
        public static void main(String args[]) {
```

```
        System.out.println(i);
    }
    public void help(){}
}
```

6.8 What will the following code print?

```
public class Foo {
int i = 17;
}
public class Fee {
public static void main(String args[]) {
    Foo f1 = new Foo();
    Foo f2 = new Foo();
    f1.i = 100;
    System.out.println(f1.i);
    System.out.println(f2.i);
    }
}
```

6.9 Consider the following code:

```
interface Drawable {
    void draw();
}

abstract class Erasable
    implements Drawable {
    public void hi() {
     System.out.println("Hello");
    }
}
class Line extends Erasable {
    public void draw(){}
}
```

a. If the *Line* class did not implement the *draw* method, would it compile?

b. Why is the *Erasable* class declared *abstract?*

c. Why isn't the *Erasable* class declared as an interface?

d. Can the *hi* method be moved into the *Drawable* interface?

6.10 Name three reasons why a casting operation might fail.

CHAPTER 7

Static, Abstract, and Final Modifiers

Certainty is a weakness, I think.

–Douglas Lyon

In this chapter, you will learn about:

- Static methods
- Static variables
- Semantic rules regarding invocation of static items from dynamic code
- Dynamic calls from static code
- Abstract classes and methods
- Final and named constants

DESIGN PATTERN
The Singleton Design Pattern

Figure 7-1 shows the keywords that you will learn in this chapter.

7.1 Static Methods

LANGUAGE REFERENCE SUMMARY
A static method can be written as the keyword *static* followed by a method declaration.

A static method in Java is defined inside of a class with the prefix keyword *static*. Static methods can be invoked without having to make an instance of the class. For example,

```
public class Out {
    public static void println() {
      System.out.println();
    }
}
```

FIGURE 7-1
Keywords

static
abstract
final

```
public class Test {
    public static void main(String args[]) {
        Out.println(); // prints a new line
// no new class was needed.
// methods can be directly invoked.
    }
}
```

Here we see a class called *Out* that has a static method called *println*, which delegates the printing of a new line by invoking

```
System.out.println();
```

STYLE POINT

This type of programming is often called *defensive* programming. Such programming defends our code against sudden deprecations by the API supplier.

The implementation of the *Out.println* method could be changed so that it prints to a file rather than the console; however, the methods that make use of it are not affected by such a change in implementation. Further, the *Output* class may be expanded to include even more printing methods.

7.2 Static Variables

LANGUAGE REFERENCE SUMMARY
A static variable can be written as the keyword *static* followed by a type and a variable name. An optional assignment expression can follow.

A variable is either *static* or *dynamic*. A dynamic variable is called an *instance* variable because it is unique to each instance of a class. Static variables (also called class variables) are declared so that they are global to all methods and instances in a class.

NOTE

Static members are global to all instances of a class.

Classes that contain *static* fields allocate space for one instance of the member variable at compile time.

WARNING

Since static member variables are global to all class instances, it is a compile-time error to declare local variables as static because local variables cannot be global.

A static variable is often called a *class* variable. For example,

```
class Student {
    static int numberOfStudents = 0;
    Student() { numberOfStudents++ ;}
}
```

Every time a new *Student* instance is made, the *numberOfStudents* member will be incremented. Further, all instances of the Student class will be able to access the same *numberOfStudents* field. Thus, the *numberOfStudents int* is stored in only a single place in memory.

Static members are instantiated when the class is initialized.

 Static members may not throw an exception without creating a compile-time error. Also, they may only refer to variables that have been defined.

For example,

```
class Lamp {
      static int wattage = voltage*current;
      static int voltage = 80;
      static int current = 1;
}
```

results in a compile-time error:

```
Error  : Can't make forward reference to voltage in class
         Lamp.
Lamp.java line 2   static int wattage = voltage*current;
```

 It is a compile-time error to make a forward reference to a static variable.

Just as we can have static variables, we can also have *static methods*. Static methods are sometimes called *class methods*.

 Static methods are allocated at compile time and may be invoked without making an instance of a class. Dynamic methods are allocated at run time, so they require the making of an instance of a class.

For example, power may be computed using a static method:

```
public class Lamp {
      static int wattage = power();
      static int voltage = 110;
      static int current = 1;

      static int power() {
        return voltage * current;
      }
      public static void main(String args[]) {
        Lamp i = new Lamp();
        System.out.println("The power is "+ i.wattage);
      }
}
```

The code above will output

```
The power is 0
```

The power is zero because the power method is invoked first, before the class is instanced. The values for voltage and current are unset (and default to zero). Thus, power is set to the proper 110-watt answer only if both current and voltage are defined first. For example,

```
public class Lamp {
      static int voltage = 110;
      static int current = 1;
      static int wattage = power();

      static int power() {
        return voltage * current;
      }
```

```
        public static void main(String args[]) {
          Lamp i = new Lamp();
          System.out.println("The power is "+ i.wattage);
        }
      }
```

The code above will output

```
The power is 110
```

STYLE POINT Static methods often are used to make large collections of methods into function libraries. Use of static methods can lead to reusable code and well-documented libraries of methods.

For example,

```
y = Math.sin(x);
```

gives the programmer access to the sine function without having to make an instance of the *Math* class. This is possible because the method is static.

NOTE With the exception of the *inner* class, the *this* operation cannot be used in a *static method*. The *this* operation and *inner* classes are described in Chapter 12.

Dynamic variables can be used to take a *snapshot* of a static variable in order to store the state of an object. When a variable is dynamic, you must instance the containing class to gain access to the dynamic members. For example,

```
class Professor {
      static int n = 0;
      int professorNumber =0;
      Professor() {
        professorNumber = n;
        n++;
      }
      void print() {
        System.out.println(
        "There are "+n +" professors\n"
        +"I am prof#"+professorNumber);
      }
      public static void main(String args[]) {
        Professor p1 = new Professor();
// new instances are needed
        p1.print();
        Professor p2 = new Professor();
        Professor p3 = new Professor();
        p1.print();
        p2.print();
        p3.print();

      }
}
There are 1 professors
I am prof#0
There are 3 professors
I am prof#0
```

```
There are 3 professors
I am prof#1
There are 3 professors
I am prof#2
```

Thus, *professorNumber* is used to capture the total number of *Professor* instances at the time of construction.

WARNING

It is a syntax error for a dynamic method or dynamic instance variable to make direct reference to a static method or static instance variable.

The reason this error occurs is because the static method or instance variable exists at compile time. The dynamic method or instance variable does not exist until the class is instanced. For example, if we make the *print* method of the *Professor* class static,

```
static void print() {
  System.out.println(
  "There are "+n +" professors\n"
  +"I am prof#"+professorNumber);
}
```

we get the following compile-time error:

```
Error  : Can't make a static reference to nonstatic variable
         professorNumber in class Professor.
```

Figure 7.2-1 shows that static methods and variables cannot make direct reference to dynamic methods and variables. Also, static elements take up no new memory when their containing classes are instanced. Static members all share the same memory.

In summary:

1. Static variables must be defined in the order of independent first, dependent second.
2. Static methods cannot be used to avoid constraint 1.
3. Static members are global to all instances of a class.
4. Static methods can be invoked without making an instance of a class.
5. Dynamic methods can invoke static methods directly.
6. Dynamic variables can reference static variables directly.
7. Static methods cannot invoke dynamic methods directly.

FIGURE 7.2-1
Static Cannot Make Direct Reference to Dynamic

8. Static variables cannot reference dynamic variables directly.

9. It is a compile-time error to declare a static variable in a method block.

7.3 Abstract Classes and Methods

LANGUAGE REFERENCE SUMMARY
An abstract class is written as the keyword *abstract* followed by a class declaration. An abstract method is written as the keyword *abstract* followed by a return type, a method name, a parameter list, and a semicolon.

WARNING
It is a syntax error to instance an abstract class or to provide an implementation for an abstract method.

The golden rule of abstract methods: If the class contains an abstract method, then that class *must* be declared abstract. Subclasses of abstract classes are non-abstract if and only if they provide implementations for the abstract methods.

WARNING
It is a syntax error to attempt to instantiate an *abstract* class.

Classes that implement interfaces without providing implementations for the required methods are abstract. Subclasses of abstract classes are abstract if they do not implement the abstract methods.

Abstract methods must be implemented by a subclass before the subclass may be instanced. A subclass that does not implement the abstract methods is abstract. Java supports polymorphism by casting instances into their common superclasses and interfaces. The superclasses will typically have abstract methods that are implemented by the subclasses. For example, in drawing programs it is common to have an interface called *Drawable* that requires a *draw* method:

```
interface Drawable {
  void draw();
}
```

Classes that contain *abstract*-method declarations must be declared abstract.

NOTE
The term *polymorphism* comes from the Greek roots *poly* (many) and *morph* (shape) and means *many shapes*.

There are many different shapes in a draw program. Typically, shapes are stored in an instance of a data structure called a *container class*. One common container class is called the *Vector* class. If all of the instances of the shapes in a draw program support the *draw* method, then it is possible to *cast* the shape instances to *Drawable*. Then the instances can be targeted with the *draw* method, which is an example of *polymorphism*. For example,

```
void draw() {
  for (int i = 0; i < shapeList.size(); i++) {
    Drawable d = (Drawable)shapeList.elementAt(i);
    d.draw();
  }
}
```

WARNING It is a compile-time error to cast an *Object* instance to a non-*Object* without an explicit casting operation.

If the (*Drawable*) casting were removed, it would be a compilation error because the instance returned by the *shapeList.elementAt* invocation does not normally contain a *draw* method. Sometimes it is best to use the abstract class declaration to reuse methods. For example, we may want a class called *Shape* that has a name, but that does not yet have an implementation for the computation of the *area*. Thus,

```
abstract class Shape {
  public static final String name = "Shape";
      abstract double area();
}
class Circle extends Shape {
      double r = 1.0;
      Circle c = new Circle();
      double area(){
       Math.PI*r*r;
      }
}
```

If there were no implementation for the *area method* in the *Circle* class, then it too would have to have been declared *abstract*. Otherwise, a compilation error would occur.

WARNING It is a compile-time error to provide an implementation for an abstract method.

Suppose you want an array of customers so that each customer can be printed. As a result, you define a *Printable* interface:

```
public interface Printable {
      public void print();
}
```

To implement it, use

```
public class NamedCustomer implements Printable {
        private String name;
        private double netWorth;
        public NamedCustomer(
          String _name,
          double _netWorth) {
          name = _name;
          netWorth = _netWorth;
        }
        public void print() {
          System.out.println("Name:"
        +name+"\tNetworth:"+netWorth);
        }
}
```

Then you can make up your database and print it:

```
public class CustomerArray implements Printable {
        NamedCustomer list[] = {
        new NamedCustomer("Frank",100000),
```

```
        new NamedCustomer("Rob",50000),
        new NamedCustomer("Velma",999999)
    };
    public static void main(String args[]){
        CustomerArray ca = new CustomerArray();
        ca.print();
    }
    public void print() {
      for (int x=0; x < list.length; x++)
         list[x].print();
    }
}
```

The most compelling reason for using an abstract class is to implement some methods and leave others unimplemented. Doing so creates a base sequence of interfaces, abstract classes, and non-abstract classes. For example,

```
public interface Movable {
    public void move(int x, int y);
}
public interface Paintable {
    public void paint();
}
public interface Erasable {
    public void erase();
}

public abstract class GraphicsObject
    implements Movable, Paintable, Erasable {

    int x;
    int y;

    public void move(int _x, int _y) {
     erase();
     x = _x;
     y = _y;
     paint();
    }
}
```

In summary:

1. Abstract methods have no implementation.
2. Classes containing abstract methods must be abstract.
3. Abstract classes cannot be instanced; instead, they must be extended first.
4. Implementations for abstract methods are required of the subclasses of the abstract class, or it too is abstract.

7.4 The final Modifier and Named Constants

LANGUAGE REFERENCE SUMMARY
The *final* keyword is a modifier. It always can be used in front of a member variable.

Constants are values that remain unchanged. For example,

```
static final double PI = 3.14159265358979323846;
```

The *static* is a modifier that indicates that there is to be only one incarnation of the field; PI. *Final* indicates that PI cannot change during the life of the PI variable. You may perform computations with constants. For example,

```
private final double pi2 = Math.PI * 2;
```

Here we see that the field, *pi2*, has a *private* visibility.

LANGUAGE REFERENCE SUMMARY
A type specifier can be written as boolean, byte, char, short, int, float, long, double, a *className*, or an *interfaceName*.

The following are examples of the final modifier:

```
static final int HORIZONTAL = 0;
static final String version = "1.0";
public static final int ACC_PUBLIC = 0x1;
static final float twoPI = (float) (2*Math.PI);
public static final char NOT_CODE = (char)12;
private static final long UNIT = 1000;
```

A class may contain instance variables, which are available to all methods in a class. For example,

```
class Cup{
      boolean full = true;
}
```

A variable is local to a method if it is declared inside the body of the method. The *full* variable is available to all methods in the *Cup* class.

7.5 Final Classes and Methods

LANGUAGE REFERENCE SUMMARY
The *final* keyword is an optional modifier. It can precede a class or a method.

A final class may not be extended. To prevent a final class from being instanced, declare a single private constructor and never attempt to instance the class internally. For example,

```
public final class Math {

      // Prevent instantiation
      private Math() {}
```

Final also may be used as a method modifier, which prevents the method from being overridden. For example,

```
public final void foo() {
      . . .
```

A subclass is unable to override the *foo* method.

Some people have asked, "Why not make all final instance variables static?" Final instance variables must be dynamic if they are to be instantiated from dynamic elements, such as dynamic methods or dynamic instance variables. Otherwise, making final instance variables static is probably a good idea.

In summary:

1. Final methods cannot be overridden.
2. Final methods can be optimized by the compiler (using in-line expansion).
3. Final classes cannot be subclassed.
4. Final instance variables cannot be overridden.
5. Final instance variables cannot be set at run time.

7.6 The Singleton Pattern

> **Singleton is the one pattern to have when you're only having one.**
>
> *–Douglas Lyon*

When you begin to *think* like an object-oriented designer, you will begin to make use of object-oriented *design patterns*.

DESIGN PATTERN

Design patterns have a *pattern name*, a *problem*, a *solution*, and some *consequences*.

A design pattern describes a recurring problem, along with a solution [Gamma et al.]. For example, consider that the singleton pattern has the following:

- A pattern name: the singleton pattern
- A problem: to make sure that there is exactly one instance of a class
- A solution to the problem: creation of a final class, with a private instance of itself, held as static and provision of a getter for this instance
- Consequences: control over the number of instances.

In order to keep other classes from making instances of the *CachedDatabase* class, we declare the constructor *private*:

```
final class CachedDatabase {
    private static CachedDatabase
      cdb = new CachedDatabase();

    public static CachedDatabase getCachedDatabase() {
      return cdb;
    }
    private CachedDatabase() {
    }
      . . .
```

In order to get access to the *CachedDatabase* instance, use

```
CachedDatabase cdb = CachedDatabase.getCachedDatabase();
```

By declaring the class *final*, we prevent others from subclassing the *CachedDatabase*. By making the constructor *private*, we prevent other instances from instancing the *CachedDatabase*. By making the accessor public, we allow other instances to get a reference to a *CachedDatabase* database instance. It is possible to modify the singleton pattern to make a new pattern that regulates the number of instances of a class. There are many design patterns, and the singleton pattern is probably one of the simplest. For a more complete discussion, see [Gamma].

DESIGN PATTERN
The singleton pattern is the pattern to have when you are only having one.

7.7 Summary

In this section, we addressed:

- Static methods
- Static variables
- Semantic rules regarding invocation of static items from dynamic code
- Dynamic calls from static code
- Abstract classes and methods
- Final and named constants

With regard to *static*, we learned that:

1. Static variables must be defined in the order of independent first, dependent second.
2. Static methods cannot be used to avoid constraint 1.
3. Static members are global to all instances of a class.
4. Static methods can be invoked without making an instance of a class.
5. Dynamic methods can invoke static methods directly.
6. Dynamic variables can reference static variables directly.
7. Static methods cannot invoke dynamic methods directly.
8. Static variables cannot reference dynamic variables directly.

With regard to *abstract*, we learned that:

1. Abstract methods have no implementation.
2. Classes containing abstract methods must be abstract.
3. Abstract classes cannot be instanced; instead, they must be extended first.
4. Implementations for abstract methods are required of the subclasses of the abstract class, or it too is abstract.

With regard to *final*, we learned that:

1. Final methods cannot be overridden.
2. Final methods can be optimized by the compiler (using in-line expansion).

3. Final classes cannot be subclassed.

4. Final instance variables cannot be overridden.

5. Final instance variables cannot be set at run time.

7.8 Exercises

7.1 Find the error in the following code:

```
public abstract class Customer {
        public abstract print() {};

}
```

a. **public abstract class** Customer

b. **public abstract** print()

c. The constructor is missing.

d. The class cannot be abstract.

7.2 You can never instance a final class with a single private constructor. T F

7.3 You can subclass a final class. T F

7.4 You can initialize a final member variable. T F

7.5 It is an error to instance a final class. T F

7.6 It is an error to have an abstract method in a non-abstract class. T F

7.7 Abstract methods can have no implementations. T F

7.8 Abstract classes can be instanced. T F

7.9 Make use of the singleton pattern to make sure that there is exactly one instance of a payroll class.

C H A P T E R 8

Arrays and Vectors

Clay is moulded to make a vessel, but the utility of the vessel lies in the space where there is nothing. Thus, taking advantage of what is, we recognize the utility of what is not.

–Lao Tzu
philosopher (circa 600 BCE)

In this chapter, you will learn about:

- Arrays
- Vectors
- Container classes
- Abstract Data Types
- Stacks
- Queues

A *container class* is a class designed to hold references (i.e., instances of classes). Two basic container classes are *arrays* and *vectors*.

8.1 Arrays

LANGUAGE REFERENCE SUMMARY
A simple array declaration can be written as an optional modifier followed by a type followed by an identifier followed by one or more '[]' followed by an optional array initializer. An array initializer can be written as an '=' followed by an expression or a '{', followed by optional comma delimited variable initializers followed by '};'.

An array is a reference data type whose elements are indexed by a *short, byte, char*, or *int* type value. When values such as *short, byte*, and *char* are used, they are subjected to unary numeric promotion to the *int* type.

 It is a compile-time error to use a *long* type variable to index an array.

You may make an array of any type you like, including an array of *char*.

 An array index begins at location zero.

To declare an array, you use the *new* statement along with a data type and a number of elements to create.

 Arrays have the following default values: zero for numerics, *false* for boolean, and *null* for reference.

For example,

```
int aNewArrayOfInt[] = new int[10];
double da[] = new double[20];
// the types on both sides of the equal sign must match.
byte ba[] = new int[100]; //BUG, types don't match!
```

 Once you allocate storage to an array, you cannot increase its size.

If the number of elements in the array is likely to change, then alternative data types should be explored. Such data types are mentioned later in the chapter.

 An index into an array must be non-negative.

An instance of an array has a member variable called *length*. The *length* member is read-only and yields the number of elements in the array. Arrays are numbered starting at zero and end at element number *length* - 1. Access beyond the end of the array throws an *ArrayIndexOutOfBoundsException*. The *arraycopy* method will copy values between arrays of the same type.

An array may hold any data type, including arbitrary class instance, as long as every element is of the same data type. Arrays have fixed length and cannot be dynamically extended. It is possible to make deep arrays. For example,

```
int deepArray;[] [] [] [] [] [] [] [] [] [] = new int
[2] [2] [2] [2] [2] [2] [2] [2] [2] [2] ;
int sum = 0;
for (int i=0; i<2; i++) {
    deepArray[i] [i] [i] [i] [i]
        [i] [i] [i] [i] [i] = 1;
    sum += deepArray[i] [i] [i] [i] [i] [i] [i] [i]
[i] [i];
    System.out.println("sum =" + sum);
}
sum =1
sum =2
```

 The length of an array is obtained using the *length* member.

A simple example follows:

```
int a[] = new [100];
for (int i = 0; i < a.length; i++)
   a[i] = i;
```

You cannot set the *length* member.

An array may be filled with constants at compile time. A one-dimensional array looks like this:

```
int b[] = {1, 2, 3, 4};
```

A two-dimensional array may be initialized like this:

```
double mask[][] = {
                     {0.25, 0.25},
                     {0.25, 0.25}};
```

To pass the *mask* array shown above, we invoke a method called *convolve* using the reference to the *mask* array:

```
convolve(mask);
```

You can get the length of any dimension of an array.

Below is an example of how to use a 10 × 10 array with a doubly nested for-loop. Note how the length of each dimension is obtained.

```
public class Array {
      int i[][] = new int[10][10];

      public static void main(String args[]){
        Array a = new Array();
        a.setMainDiagonal(1);
        a.print();
      }
      public void setMainDiagonal(int s) {
        for (int x=0; x < i.length; x++)
          for (int y=0; y < i[0].length; y++)
              if (x == y)
                   i[x][y]=s;
      }
      public void print() {
        for (int x=0; x < i.length; x++) {
// Starting printing from the highest y value
// and work your way down to 0, when printing
// on the console.
            for (int y=i[0].length-1; y >=0 ; y--)
                System.out.print(i[x][y]+" ");
            System.out.println();
        }
      }
```

The output follows:

```
0 0 0 0 0 0 0 0 0 1
0 0 0 0 0 0 0 0 1 0
0 0 0 0 0 0 0 1 0 0
0 0 0 0 0 0 1 0 0 0
0 0 0 0 0 1 0 0 0 0
0 0 0 0 1 0 0 0 0 0
0 0 0 1 0 0 0 0 0 0
0 0 1 0 0 0 0 0 0 0
0 1 0 0 0 0 0 0 0 0
1 0 0 0 0 0 0 0 0 0
```

You cannot get the number of dimensions in an array.

It is possible to use an array to store a series of customer records. For example,

```java
public interface Printable {
        public void print();
}
```

You can implement it as follows:

```java
public class NamedCustomer implements Printable {
        private String name;
        private double netWorth;
        public NamedCustomer(
        String _name,
        double _netWorth) {
        name = _name;
        netWorth = _netWorth;
        }
        public void print() {
        System.out.println(
            "Name:"+name+"\tNetworth:"+netWorth);
        }

}
```

Then you can make up your database, and print it:

```java
public class CustomerArray implements Printable {
        NamedCustomer list[] = {
          new NamedCustomer("Frank",100000),
          new NamedCustomer("Rob",50000),
          new NamedCustomer("Velma",999999)
        };

        public static void main(String args[]){
          CustomerArray ca = new CustomerArray();
          ca.print();
        }
        public void print() {
          for (int x=0; x < list.length; x++)
             list[x].print();
        }

}
```

Multi-dimensional arrays can have dimensions of different size. To make a 2 × 3 × 4 array (i.e., a three-dimensional array) of type *int,* use

```
int C[][][] = new int[2][3][4];
System.out.println(C.length+", "
 + C[0].length+", "+C[0][0].length);
```

which outputs

```
2, 3, 4
```

 All of the elements in the array are of the same type.

To print all of the elements in a two-dimensional array,

```
public static void print(double a[][]) {
    for (int i = 0; i < a.length; i++) {
        for (int j = 0; j < a[0].length; j++)
            System.out.print(a[i][j]+" ");
        System.out.println();
    }
}
```

The number of elements in each dimension of the array may be found with the *length* member. For example,

```
int k[] = new int[100];
// k.length is 100
int j[][] = new int[1][2];
// j.length is 1
// j[0].length is 2
int l[][][] = new int[10][20][30];
// l.length is 10
// l[0].length is 20
// l[0][0].length is 30
// etc....
```

The number of dimensions, however, cannot be found so easily. Typically, a method is overloaded to take arrays with different numbers of dimensions.

Consider the following code:

```
public static double[][] shear(double x, double y) {
    double m[][] = new double[3][3];
    m[0][0] = 1;
    m[1][1] = 1;
    m[2][2] = 1;
    m[0][1] = x;
    m[1][0] = y;
    return m;
}
```

The *m* array is a two-dimensional array that has three rows and three values in each row. The initial value for each of the elements in an array is defined as zero.

Unlike with C, there is no way to know if Java stores arrays in *row-major order* or *column-major order.* This is a major problem for image-processing programmers. For a

two-dimensional array, this means that we cannot know which index to vary more quickly. If arrays are column major, then increment the column more quickly:

```
public void print() {
        for (int i = 0; i < 3; i++) {
            for (int j = 0; j < 3; j++)
                System.out.print(a[i][j]+" ");
            System.out.println();
        }
}
```

If arrays are row major, then increment the row more quickly:

```
public void print(); {
        for (int j = 0; j < 3; j++) {
            for (int i = 0; i < 3; i++)
                System.out.print(a[i][j]+" ");
            System.out.println();
        }
}
```

Memory in the computer is arranged in a linear, one-dimensional array. If we access the memory using a two-dimensional array and if we are not efficient, we will jump around in memory, as shown in Figure 8.1-1.

If an array is stored in row-major order but accessed in column-major order, the memory is being accessed out of order. If the array is stored completely in RAM, speed generally will not be degraded. However, a large data structure, such as an image, may not fit in main memory. When a data structure does not fit in main memory, it must be stored in a mixture of main memory and *virtual memory*.

Virtual memory maps a single processor's address space into two parts: main memory and auxiliary memory. If data is stored in auxiliary memory, then it must be swapped into main memory before it is accessed by the processor. When an array is stored in virtual memory, it is possible that indexing from pixel to pixel will cause the auxiliary memory to be accessed.

Modern computers typically use RAM for main memory and disk for auxiliary memory. If virtual memory is accessed using non-sequential addresses, then different parts of RAM can be swapped continually into and out of the disk. This swapping of RAM is called *thrashing* and leads to a performance degradation. RAM is roughly a million times faster than disk storage, so the degradation can hamper a program's performance. Thus, optimal virtual memory operations occur when algorithms access data using closely clustered addresses [Ralston].

As a result, it is typical in Java to simulate a two-dimensional array with a one-dimensional array. Suppose that pixel elements (*pels*) are stored in an *int* array of dimension

0,0	0,1	0,2
1,0	1,1	1,2
2,0	2,1	2,2

| 0,0 | 0,1 | 0,2 | 1,0 | 1,1 | 1,2 | 2,0 | 2,1 | 2,2 | Row Major |
| 0,0 | 1,0 | 2,0 | 0,1 | 1,1 | 2,1 | 0,2 | 1,2 | 2,2 | Column Major |

FIGURE 8.1-1
Row Major versus Column Major Order

width × *height*. A method to access a pixel by its location might look like

```java
public int getPixel(int x, int y) {
    return pels[y*width + x] ;
}
```

The *getPixel* method seems to solve the problem. We now know that the *x*-coordinate should be indexed more rapidly than the *y*-coordinate. But upon closer examination, we see that the cost is that of extra multiplication and addition every time a pixel is accessed.

An image can have millions of pixels. To access their colors will now require millions of unpacks, packs, multiplications and additions.

Below is an example where a large array of strings is being stored in an *interface*:

```java
public interface CplusplusText {
        public static String cplusplusReservedWords[] = {
            "asm",
            "auto",
            "break",
            "case",
            "catch",
            "char",
            "class",
            "const",
            "continue",
            "default",
            "delete",
            "do",
            "double",
            "else",
            "enum",
            "extern",
            "float",
            "friend",
            "for",
            "goto",
            "if",
            "inline",
            "int",
            "long",
            "new",
            "operator",
            "private",
            "protected",
            "public",
            "register",
            "return",
            "short",
            "signed",
            "sizeof",
            "static",
            "struct",
            "switch",
            "this",
```

```
          "throw",
          "try",
          "typedef",
          "union",
          "unsigned",
          "virtual",
          "void",
          "volatile",
          "while"
      };
```

Using arrays, it is possible to perform many computations on numbers. For example, the average and variance of a sequence of numbers can be computed using equation 8.1-1:

$$\sigma^2 = \text{variance} = \frac{1}{n}\sum_{k=0}^{n-1}(x_k - \mu)^2$$

$$\mu = \text{mean} = \frac{1}{n}\sum_{k=0}^{n-1}x_k$$

$$n = \text{number of elements in the array}$$

$$x_k = k\text{th sample in the array.}$$

(8.1)

```java
package examples;

public class Statistics {
  public static double average(double da[]) {
    double n = da.length;
    return sum(da) / n;
  }

  public static double sum(double da[]) {
    double s = 0;
    for (int i = 0; i < da.length; i++)
      s = s + da[i];
    return s;
  }
}
```

Naturally, adding up all of the numbers in a two-dimensional array is slightly different than adding up all of the numbers in a one-dimensional array:

```java
public static double mean (short a[] []) {
  double sum = 0;
  for (int x = 0; x < a.length; x++)
    for (int y = 0; y < a[0].length; y++)
      sum += a[x] [y];
  }
  return sum / (a length * a[0].length);
}
```

To compute and test the variance on a one-dimensional array, use

```java
public static double variance(int a[]) {
  double xBar = mean(a);
```

```
      double sum = 0;
      double dx = 0;
      for (int i = 0; i < a.length; i++) {
         dx = a[i] - xBar;
         sum += dx * dx;
      }
      return sum / a.length;
   }
   public static void testVariance() {
      int a[] = {1, 2, 3, 5, 4, 3, 2, 5, 6, 7};
      System.out.println("The variance =" + variance(a));
   }
```

Arrays have other applications as well. The following example shows how to create simple character-based graphics for drawing a circle and a simple line:

```
package examples;

public class CharacterGraphics {
   char screen[][] = new char[20][20];

   public void dot(int x, int y) {
      if (x < 0) return;
      if (y < 0) return;
      if (x >= screen.length) return;
      if (y >= screen[0].length) return;
      screen[y][x] = '*';
   }

   public void circle(int xc, int yc,int r) {
      for (double t = 0; t < 1; t = t + .01) {
         int ix = (int) (t * 20);
         double x = t * 2 * Math.PI;
         ix = (int) (r * Math.sin(x) + xc);
         int iy = (int) (r * Math.cos(x) + yc);
         dot(ix, iy);
      }
   }

   public void diag() {
      for (int i = 0; i < screen.length; i++)
         for (int j = 0; j < screen[i].length; j++)
            if (i == j)
               screen[i][j] = '*';
   }

   public void fillScreen(char fillChar) {
      for (int i = 0; i < screen.length; i++)
         for (int j = 0; j < screen[i].length; j++)
            screen[i][j] = fillChar;
   }

   public void printScreen() {
      for (int i = screen.length - 1; i > 0; i--) {
         for (int j = 0; j < screen[i].length; j++)
            System.out.print(screen[i][j]);
```

```java
        System.out.println();
      }
    }
  public void axis() {
    for (int i = 0; i < screen.length; i++)
      for (int j = 0; j < screen[i].length; j++) {
        if (i == 1)
          screen[i][j] = '-';
        if (j == 0)
          screen[i][j] = '|';

      }
    screen[1][screen[1].length - 2] = '>';
    screen[1][screen[1].length - 1] = 'x';

    screen[screen[0].length - 2][0] = '^';
    screen[screen[0].length - 1][0] = 'y';
  }
  public void print(Object a[]) {
    for (int i = 0; i < a.length; i++)
      System.out.println(a[i]);
  }

  public static void main(String args[]) {
    CharacterGraphics at = new CharacterGraphics();
    at.fillScreen('.');
    at.axis();
    at.circle(5,5,10);
    at.diag();
    at.printScreen();
  }
}
```

The output follows:

```
y.................*
^.................*.
|................*..
|..............*...
|.............*....
|...........*......
|..........*......
|.........*.......
|........*.......
|....*....*........
|.*****.*.........
|*......*.........
*......*.*.........
*.....*..*.........
*....*...*.........
*...*....**.........
*..*.....*.........
*.*......*.........
|*------*-◆------->x
```

Using the character-based graphics technique, a simple graphics package can be created to produce a wide variety of outputs. Before the widespread use of graphics packages, it was common for people to write their own. Even today, people continue to write their own specialized applications (such as character graphics).

In summary,

1. Once you allocate storage to an array, you cannot increase its size.
2. The length of an array is obtained using the *length* member.
3. You cannot set the *length* member.
4. You can get the length of any dimension.
5. You cannot get the number of dimensions.
6. All of the elements in the array are of the same type.
7. An array index begins at location zero.
8. Arrays have the following default values: zero for numerics, *false* for boolean, and *null* for reference.
9. An index into an array must be non-negative.

8.2 Vectors

The *Vector* is a container class that resides in the *java.util package*. An instance of the *Vector* class may be expanded dynamically. A container class is designed to store reference data types. Vectors are an excellent choice for implementing data structures of variable length. Vectors can hold any combination of objects. For example,

```
Vector v = new Vector();
Rectangle a = new Rectangle(10,20);
v.addElement(a);
```

Vectors cannot hold *int*, *float*, *char*, *byte*, or any of the primitive non-reference data types. Vectors are only one dimensional. The following example shows a series of different data types all being added to a *Vector* instance:

```
static public void addElements(Vector v) {
   for (int i=0; i < numberOfRays.getValue(); i++) {
        v.addElement(gratingTargetLine[i]);
      v.addElement(cameraGratingLine[i]);
   }
   v.addElement(employee);
   v.addElement(person);
   v.addElement(professor);
}
```

Some of the more useful elements in the *Vector* class are:

```
Vector v = new Vector();
// to get the number of elements in the vector, use:
int n = v.size();
// to add an element to a vector use:
Object o = someInstance;
v.addElement(o);
// to get an element from a location in a vector use:
int i = someIndex;
```

```
Object o = v.elementAt(i);
// to copy the internally held array in a vector into an external
     array, use:
Object o[] = new Object[v.size()];
v.copyInto(o); // o may be an array of any reference data type.
```

Recall the *casting* operation from chapter 6. This operation can be performed with a collection of instances whose types are unknown. Such a collection may be stored in a *Vector* instance. Once the elements are retrieved (as instances of type *Object*), they can be cast to the correct reference data type (provided it is permitted). For example,

```
1.      for (int i=0; i < v.size(); i++) {
2.          s = (Shape) v.elementAt(i);
3.          s.print();
4.      }
```

where *Shape* is an interface that all the elements in the vector implement. In line 1, an instance of a Vector, *v*, is accessed for size. The elements in the vector are accessed using line 2. Note that each element in the vector is a class that extends the Shape class. It is always correct to cast the subclass of the *Shape* class back into the superclass. Doing so enables the *print()* method invocation on each shape in the vector instance.

If we modified line 2 to read

```
2.      s = (Shape) (v.elementAt(i).print()); // BUG!
```

WARNING

it would not work because *v.elementAt(i)* always returns a reference of type *Object*. The *Object* class does not have a *print* method, hence the syntax error.

Having a collection of different instances in a *Vector* instance is a good way to implement polymorphism. With polymorphism, you can cast all the instances stored in the *Vector* instance into a common reference data type that supports a common method. In the example below, *drawnShapes* is a *Vector* that contains several different instances. All are subclasses of the *Shape* class. Thus, all can be cast into the *Shape* type. Also, the *Shape* class has an abstract *draw* method. Thus, the *draw* method may be invoked on any subclass of the *Shape* class, provided it has been cast properly. For example,

```
for (int i = 0; i < drawnShapes.size(); i++) {
    s = (Shape)drawnShapes.elementAt(i);
    s.draw(g);
}
```

The previous example was borrowed from geometry. The following example is more applicable to business applications. Suppose you want an unlimited number of customers. Each customer can be printed. So, you use a vector:

```
import java.util.Vector;

public class NamedCustomer
    implements Printable {
            private String name;
            private double netWorth;
            public NamedCustomer(
                    String _name,
                    double _netWorth) {
                name = _name;
```

```
                              netWorth = _netWorth;
                       }
                       public void print() {

                          System.out.println(
                              "Name:"
                              +name+"\tNetworth:"+netWorth);
                       }
          }

          public class CustomerVector
              implements Printable {
                private Vector v = new Vector();
              public void init() {
                       v.addElement(
                          new NamedCustomer(
                              "Frank",100000));
                       v.addElement(
                          new NamedCustomer(
                              "Rob",50000));
                       v.addElement(
                          new NamedCustomer(
                              "Velma",999999));
              }

              public static void main(String args[]){
                       CustomerVector cv =
                          new CustomerVector();
                       cv.init();
                       cv.print();
              }
              public void print() {
                       for (int x=0; x < v.size(); x++)
                          ((Printable)v.elementAt(x)).print();
                          // cast to an interface to let
                          // the compiler know the print method
                          // is available in the instance.
              }
          }

          public interface Printable {
              public void print();
          }
```

Vectors have a way to copy their internal arrays into given arrays using the *copyInto* method. For example, if *goodies* is a vector filled with shopping cart items, then

```
public String[] getItems() {
    String[] s = new String[goodies.size()];
    goodies.copyInto(s);
    return s;
}
```

In order to insert an element by shifting all the elements up one index position (toward the end of the vector), use *insertElementAt (int index)*. As a result, the size is increased by one. If the *index* is the same as the *size()*, then the method is the same as *addElement*. This is a handy way to implement a stack or a queue.

8.3 Building a Shopping Cart

This section covers an e-commerce application of container classes that can be of direct use to us when building a *shopping cart*. A shopping cart is an abstract data type that allows us to treat an instance of a class like a shopping cart in a store. There are a few operations that we perform on a cart as we push it around the store. For example:

- *addProduct*–puts a goodie into the cart
- *removeProduct*–takes a goodie out of the cart
- *getTotal*–computes the total cost of all of the goodies in the cart
- *toString*–provides a string listing of the cart goodies, along with a total.

The first step is to define how we want our product to be inventoried by the store database. We take care to define all of the member variables in the *Product* class as private. Providing *getter* methods that are public makes the values of the variables read only. Doing so protects a product instance from programs that use poor software engineering practice:

```
package net;
public class Product {
        private String name;
        private float price;
        private int productCode;

        public Product(String _name,
          float _price,
          int _productCode) {
          name = _name;
          price = _price;
          productCode = _productCode;
        }

        public String toString() {
          return "name:"+name
            +"\tprice:$"+price
            +"\tproductCode:"+productCode;
        }
        public float getPrice() {
          return price;
        }
        public String getName() {
          return name;
        }
        public int getProductCode() {
          return productCode;
        }
```

Two products are said to be the same if the *productCode*s match. Thus, the assumption is that all products have a unique product code and that if the price changes or the name

changes a new *productCode* will be assigned. Should this assumption prove without foundation, then the *equals* method would need to be revised:

```
public boolean equals(Product p) {
  return
     p.getProductCode() == productCode ;
}
}
```

Once a *Product* instance is made, we only can read values, not set them. As a result, we assert that the *Product* instance is immutable. In the *Product* class, we have no idea how many products there are, where they come from, or what the products are. As a result, the *Product* class can be used to generally represent any product. If more fields are needed (for example, a *Universal Product Code*), these fields can be added later.

To design the *Cart* class, we make use of a *Vector* called *goodies*. The *goodies Vector* has a collection of *Product* in it. As a result, the *Cart* requires that elements be added only through the *addProduct* method. This process protects the *goodies* from containing improperly typed classes. For example,

```
package net;

import java.util.Vector;

public class Cart {
    private Vector goodies = new Vector();

    public void addProduct(Product p) {
      if (p == null) return;
         goodies.addElement(p);
    }
```

The *removeElement* method in the *Vector* class removes the first element in the *Vector* that matches using the *equals* method. This removal decrements the size of the *Vector* and shifts the elements forward. This process is well suited for a shopping cart, where a user might want to put an item back on the shelf:

```
public void removeProduct(Product p) {
    goodies.removeElement(p);
}
```

What follows is another example of the *copyInto* method in the *Vector* class:

```
public Product[] getProducts() {
    Product[] pa = new Product[goodies.size()];
    goodies.copyInto(pa);
    return pa;
}
```

The *toString* method is automatically invoked when the *System.out.println* method is called. This method enables us to get a listing of all the goodies in the shopping cart:

```
public String toString() {
  Product p[] = getProducts();
  String s = "cart:\n";
```

```
    for (int i=0; i < p.length; i++)
      s = s + p[i].toString()+'\n';
    s = s + "total:"+getTotal();
    return s;
}
```

The *getTotal* class runs through the cart and arrives at a tally. After the sticker shock, the user might want to *removeProduct*:

```
public float getTotal() {
   Product p[] = getProducts();
   float t = 0;
     for (int i=0; i < p.length; i++)
       t = t + p[i].getPrice();
     return t;
}
```

What follows is an example of the shopping cart in action:

```
public static void main(String args[]) {
   Product p = new Product(
     "Image Processing in Java", 25f, 12);
   Product p2 = new Product(
     "Java for Programmers", 35f, 11);
   Cart c = new Cart();
   c.addProduct(p);
   c.addProduct(p);
   c.addProduct(p2);
   System.out.println(c);
   // Oh, I don't need two books
   // on image processing... lets get rid of one.
   c.removeProduct(p);
   System.out.println(c);
}
```

The output of the *main* method above follows:

```
cart:
name:Image Processing in Java    price:$25.0 productCode:12
name:Image Processing in Java    price:$25.0 productCode:12
name:Java for Programmers  price:$35.0 productCode:11
total:85.0
cart:
name:Image Processing in Java    price:$25.0 productCode:12
name:Java for Programmers  price:$35.0 productCode:11
total:60.0
```

The addition of a new field to the *Product* should not alter our implementation of the *Cart* class. Thus, the system is more robust in the face of a changing product requirement. In Chapter 31, we use the *Cart* class to build a shopping cart for on-line purchases using Java Server Pages.

8.4 A Stack

A *stack* is a data structure that is similar to a stack of items (such as a pile of plates). The first plate placed on the pile is the last plate taken off the pile. The operations that you perform on

the pile of plates are *push* and *pop*. You *push* a plate onto the stack and then you *pop* a plate off the stack. A stack's user does not care about the way in which elements are stored; instead, it is only important that the operations defined on the stack model work as specified. This process creates an abstract data type (ADT) that implements the storage of data types and operators using Java. For the ADT, we use the *Object* instance as the basic building block of the data structure. Using ADTs and procedures, we can encapsulate the details of operations into entities and create tools that will have a variety of uses. A stack is one such tool. For example,

```java
import java.util.*;
public class Stack {
        private Vector v = new Vector();

/**

        push inserts an element at the top of the stack.
*/
        public void push(Object o) {
          v.addElement(o);
        }

/**

        pop deletes the top element of the static and returns it.
        if the stack is empty, then pop returns null.
        This assumes that null is NOT being pushed into the stack.
*/
        public Object pop() {
          if (v.size() == 0) return null;
          Object o = v.elementAt(v.size()-1);
          v.removeElement(o);
          return o;
        }

        public static void main(String args[]) {
          Stack s = new Stack();
          s.push("Hello");
          s.push("world");
          for (Object o=s.pop(); o!=null;
                  o=s.pop())
            System.out.println(o);
        }
}
```

8.5 A List

A *list* is a sequence of elements. The type of the elements is generally unrestricted, but we shall assume that they are all of type *Object*. The number of elements must be a non-negative integer (e.g., 0, 1, 2, . . .).

The number of elements is the *size* of the list. The first element is element zero, and the last element is *size() -1*. Here are some list methods:

```java
// Insert o at position x
void insert(Object o, int x);
```

```
// return true if o is in the list
boolean contains(Object o);

// return true if the list is empty
boolean isEmpty();

// Convert the list to an array of object
Object[] toArray();

// append a non-null element to the list:
boolean add(Object o);

// delete the element at position x
Object remove(int x);

// delete all the elements in the list
void clear();

// Get the element at location x
Object get(int x);

// set the element at location x
 Object set(int x, Object element);

// insert the element at location x
void add(int x, Object element);

// return -1 if the element is not in the list, otherwise
// return the location
int indexOf(Object o);
```

The *Vector* class implements all of the methods mentioned above. As a result, you need only make an instance of a *Vector* to obtain a list.

8.6 A Queue

A queue is an abstract data type that is similar to a stack. The difference, however, is that in a stack, the last in is the first out (LIFO), but with a queue, the first in is the first out (FIFO). Queues are typical in places like banks. In a bank, customers form a line and each person who enters joins the back of the line. Tellers provide service to those at the front of the line who have been waiting longest. It is not polite to cut in front of another customer, so most people wait their turn. The rule is first come, first served. We can implement the queue using a *Vector* instance, as follows:

```
package examples;
import java.util.Vector;

public class Queues {
      Vector v = new Vector();

// new arrivals go to the back of the line
      public void enqueue(Object o) {
        v.addElement(o);
      }

// the next to obtain service from from the front
// of the line.
```

```
public Object dequeue() {
  try {
    return v.remove(0); // throws an exception when empty.
  } catch (java.lang.ArrayIndexOutOfBoundsException e) {
    return null;
  }
}
public static void main(String args[]) {
  Queues q = new Queues();
  q.enqueue("first");
  q.enqueue("second");
  q.enqueue("third");
  for (Object o = q.dequeue(); o !=null;o = q.dequeue())
  System.out.println(o);
}
}
```

The output is

```
first
second
third
```

8.7 Summary

This chapter presented arrays. Arrays are immutable objects that are homogeneous in nature (i.e., all of the elements are of the same type). Their length is always obtained from the *length* member. You can get the length of any dimension, but not the number of dimensions. The index is a non-negative integer that starts at zero and ends at *length - 1*.

This chapter also presented vectors. Vectors are changeable objects that are not homogeneous in nature. Their length is always obtained from the *size()* method and there is only one dimension. The *elementAt* index is a non-negative integer that begins with zero and ends with *size - 1*. The *addElement* method will only take a reference type, and the *elementAt* method only returns a reference type of *Object*. As a result, any strong typing must be added by the programmer.

The array and vector are two of the simplest container classes. To learn more about container classes, see Appendix K.

8.8 Exercises

8.1 Use the *copyInto* method to copy a vector of customers into an array of customers. Write another method that does the same thing, but that does not use the *copyInto* method (i.e., using a for loop and casting). How many more lines of code are required?

8.2 Create a *Vector* of Customers in a class called *Payroll*. Print out all of the customers in the *Vector* using *printCustomers()*.

8.3 Create a *ProductInterface* that allows for a wide variety of product fields. Use the *ProductInterface* to make a new class called the *ProductCart* and create a new line of products that implement the *ProductInterface* and call it the *BookProduct*. The *BookProduct* requires an author, an ISBN number, and a page count. Make sure the member variables are private in your classes.

Try a sample by adding three books and subtracting one of them. Print out your results, along with all of the code listings.

8.4 Create an array of 100 random numbers between 1 and 100. Recall that

```
int i = (int) (Math.random() * 100 + 1);
```

will yield a number r that ranges from 1 to 100. Compute the average of the numbers in the array and print your result.

8.5 In exercise 4, you computed the average value. Also, compute and print the *variance* using equation (8.8-1):

$$\sigma^2 = \text{variance} = \frac{1}{n}\sum_{k=0}^{n-1}(x_k - \mu)^2$$

$$\mu = \text{mean} = \frac{1}{n}\sum_{k=0}^{n-1}x_k$$

n = number of elements in the array

x_k = kth sample in the array. (8.8-1)

8.6 Using the idea of a stack from section 8.4, write a program that provides an array implementation. What happens if the number of elements pushed onto the stack exceeds the number of elements in the array?

8.7 A *queue* is an ADT that supports several methods. For example,

```
public void enqueue(Object o)
// adds x to the bottom of the stack

public Object dequeue()
// deletes and object from the top of the stack (like Pop)
// and returns null if we are at the end of the stack
```

Implement the queue using arrays. What happens if the number of elements included in the queue exceeds the number of elements in the array?

8.8 Implement the list in Section 8.5 using an array.

8.9 The number of available symbols limits the base that we can use. A sample of 36 symbols are 0123456789ABCDEFGHIJKLMONPQRSTUVWXY and Z. Suppose you want to express numbers in a higher base. An alternative symbol set might be 0123456789ABCDEFGHIJKLMONPQRSTUVWXYZ!@#$%^&*()`~;:<>,./?[]{}|= and _. This gives us 64 symbols, which enables base 64 numbers. Base-64 encoding is used for mail attachments because mail processing software (called *agents*) tend to alter binary data and treat all data as if it were text. Write a base-64 *encoder* that will read a base-10 integer and write it out in base 64. Use the algorithm of repeated division to obtain an index into a character array. One algorithm is to divide by 64 and take the modulus by 64. Thus, the least significant digit is

```
d0 = n % 64;
```

the next digits are

```
d1 = (n / 64 ) % 64;
d2 =( (n / 64) / 64 ) % 64;
```

and ith digit is

```
di = (( n / (64 * i)) % 64;
```

The following shows an example that takes *shift* bits at a time and uses them to index into an array:

```java
package io;
import java.util.*;
import java.awt.*;

public class Encoder {
        private static final char digits[] = {
            '0' , '1' , '2' , '3' , '4' , '5' ,
            '6' , '7' , '8' , '9' , 'a' , 'b' ,
            'c' , 'd' , 'e' , 'f' , 'g' , 'h' ,
            'i' , 'j' , 'k' , 'l' , 'm' , 'n' ,
            'o' , 'p' , 'q' , 'r' , 's' , 't' ,
            'u' , 'v' , 'w' , 'x' , 'y' , 'z' ,
            '!' , '@' , '#' , '$' , '%' , '^' ,
            '&' , '*' , '(' , ')' , ''' , '~' ,
            ';' , ':' , '<' , '>' , ',' , '.' ,
            '/' , '?' , '[' , ']' , '{' , '}' ,
            '\\' , '|' , '=' , '_'
        };

        public static String toBaseR (int i, int shift){
          char[] buf = new char[64];
          int charPos = 64;
          int radix = 1 << shift;
          int mask = radix - 1;
          do {
                  buf[--charPos] = digits[i & mask];
                  i >>>= shift;
          } while (i != 0);
          return new String(buf);
          }
          public static void main(String args[]) {
           int num = 0xffff;
           System.out.println(Encoder.toBaseR(num,4));
// outputs "ffff"
          }
        }
```

8.10 Write a base-64 *decoder* that is able to return integers given the base 64 numbers generated by the answer to exercise 2.

C H A P T E R 9

Wrapper Classes and Strings

A book is a garden carried in the pocket.

–Chinese proverb

In this chapter, you will learn about:

- Wrapper classes
- Strings
- Formatting
- Parsing
- String tokenizers
- CSV parsers

9.1 Wrapper Classes

Wrapper classes promote primitive data types to reference data types.

Some things can only be done with an instance, such as adding an element to a vector. All wrapper types support a method invocation that converts them to a string representation, and all may be constructed from a string and support the method:

```
public boolean equals(Object obj)
```

to check an object for equality of value.

When comparing two strings, use equals. Never use '=='.

For example,

```
if (arg.equals("this is right") {...
```

will check the value of the string in *arg* against the value of "this is right." The following example checks the value of the *arg* reference with the compile-time constant string reference. The following is probably not what the programmer wants:

```
if (arg == "this is wrong") {...
```

Always use the *equals* method to check values when comparing instances.

For readability, it is considered good practice to put one instance variable on a single line by itself. It is also good practice to declare the variables at the beginning of a block of code.

9.1.1 Boolean

The *Boolean* class promotes the primitive *boolean* type to a reference type. Construction is overloaded to handle both the primitive *boolean* type and a *String*. The *String* must be equal to the word true, ignoring case, before the *Boolean* instance will be true. For example,

```
Boolean b = new Boolean("true");
Boolean b = new Boolean("True");
Boolean b = new Boolean("TRuE");
```

will all lead to *b* representing true. Two static conversion methods are available for use in the *Boolean* class. The first is

```
public static Boolean valueOf(String s)
      - returns a Boolean instance.
Boolean b = Boolean.valueOf("true"); // sets b to true
Boolean b = Boolean.valueOf("yes");  // sets b to false
```

The second method is *getBoolean*, which has a primitive *boolean* type as its return:

```
public static boolean getBoolean(String name)
boolean b = Boolean.getBoolean("yes"); // sets b to false
```

9.1.2 Character

The *Character* class is a wrapper class for the primitive Java *char* data type. When embedded in the Java code, the a character is surrounded by single quotes, whereas strings use double quotes. Any Unicode character is permitted as an argument for the construction of a *Character* instance. In addition, there are methods for converting between *Character* and *char*. For example,

```
Character aCharacter = new Character('π');
char aChar = '©';
a = new Character(aChar);
aCharf = aCharacter.charValue();
```

Neither an array of *char* nor an array of *Character* constitutes a *String*. It is an error to treat an array of *Character* like a string.

The *Character* class supports several public static methods that are useful for testing and processing characters. All characters are Unicode so all comparisons are written for Unicode. For example,

```
public static boolean isDigit(char ch)
```

returns true if ch is a Unicode digit.

Java supports ISO-LATIN-1 (0 through 9), Arabic-Indic, ExtendedArabic-Indic, Devanagari, Bengali, Gurmukhi, Gujarati, Oriya, Tamil, Telugu, Kannada, Malayalam, Thai, and Lao digits.

The *Character* has a series of public static *char* test facilities that return a *boolean*. For example,

```
boolean aBoolean;
char aChar = 'a';

aBoolean =  Character.isDefined(aChar);
aBoolean =  Character.isLowerCase(aChar);
aBoolean =  Character.isUpperCase(aChar);
aBoolean =  Character.isTitleCase(aChar);
aBoolean =  Character.isDigit(aChar);
aBoolean =  Character.isLetter(aChar);
aBoolean =  Character.isLetterOrDigit(aChar);
aBoolean =  Character.isJavaLetter(aChar);
aBoolean =  Character.isJavaLetterOrDigit(aChar);)
aBoolean =  Character.isSpace(aChar);
```

The *Character* class also supports a series of *char* conversions that are public and static. These conversions may be accessed without ever making a *Character* instance. For example,

```
aChar =  Character.toLowerCase(aChar);
aChar =  Character.toUpperCase(aChar);
aChar =  Character.toTitleCase(aChar);

// returns an 'A', hex representation of 10.
aChar =  Character.forDigit(10, 16);

// returns 10, the hex value of 'A'
int digit = Character.digit(aChar, 16);
int i =  Character.MIN_RADIX // i = 2;
int i =  Character.MAX_RADIX // i = 36;
char aChar =  Character.MIN_VALUE // aChar = '\u0000';
char aChar =  Character.MAX_VALUE // aChar = '\uffff';
```

About the only thing you can do with a *Character* instance is

```
Character aCharacter = new Character('π');
String aString = aCharacter.toString();
aBoolean = aCharacter.equals(aCharacter);
int anInt = aCharacter.hashCode();
```

9.1.3 Numeric Wrapper Classes

Each numeric primitive type has an associated wrapper class. In the following examples, let

```
int i = 0;
long l = 0;
```

```
float f = 0;
double d = 0;
```

The name of the primitive numeric type, followed by its constructor wrapper class, is given below:

```
Byte B =            new Byte(b);
Short S =           new Short(s);
Integer I =         new Integer(i);
Long L =            new Long(l);
Float F =           new Float(f);
Double D =          new Double(d);
```

Each of the numeric wrapper classes supports a conversion to a string:

```
String SI = I.toString();
String SL = L.toString();
String SF = F.toString();
String SD = D.toString();
```

Each of the numeric wrapper classes also supports a conversion from a string to a reference type:

```
Integer I =  new Integer(SI);
Long L =     new Long(SL);
Float F =    new Float(SF);
Double D =   new Double(SD);
```

A string to number conversion can throw a *NumberFormatException*.

In addition, each of the numeric wrapper classes supports a conversion from a string to a primitive type using a static method invocation:

```
I =         Integer.valueOf(SI);
L =         Long.valueOf(SL);
F =         Float.valueOf(SF);
D =         Double.valueOf(SD);
```

An example of the use of the static *valueOf* method follows:

```
try {value = Float.valueOf(getText()).floatValue();}
catch(NumberFormatException e) {
  value = 0;
}
```

The scalar numeric wrappers (*Integer* and *Long*) support an overloaded *valueOf* and *toString* method. The *toString* method will yield a string in any radix from 2 to 36, For example,

```
SI = Integer.toString(i, 2); // yields a binary string
SL = Long.toString(l, 16); // yields a hex string
I = Integer.valueOf(SI,2); // converts from binary string
L = Long.valueOf(SL,16); // converts from hex string
```

To perform string conversions to primitive types, there are static methods called *parseInt, parseLong*, and *parseDouble*:

```
i = Integer.parseInt(SI); // converts from decimal string
i = Integer.parseInt(SI,2); // converts from binary string
l = Long.parseLong(SL,16); // converts from hex string
d = Double.parseDouble("1.0"); // converts a string to double
```

9.2 Strings

Verbosity leads to unclear, inarticulate things.

–Dan Quayle, 11/30/88

Java's *java.lang* package includes a class known as *String*. *String* instances in Java cannot be changed once they are created because, once created, a string instance is added to an internal string pool. The pool is a private *HashTable* instance that speeds string look-up operations. There is no public or private method (that we could find) for removal of a *String* instance from the internal hash table. Thus, once created, strings remain unchanged for the life of the virtual machine.

The *String* class supports a series of public static methods that may be accessed without ever making an instance of the string class. Suppose the following variables are pre-defined:

```
boolean aBoolean;
char achar;
int anInt;
long aLong;
float aFloat;
double aDouble;
Object anObject;
String aString;
char[] aCharArray;
int arrayOffset, numberOfElementsToConvert;
int endIndex; // last position in array - 1;
StringBuffer aStringBuffer = new StringBuffer(100);
Byte [] ASCIIByteArray;
int hiByte;
```

The following examples show how to use the *String* class given the pre-defined variables above:

```
aString = String.valueOf(anObject);
aString = String.valueOf(aCharArray);
aString = String.valueOf(aCharArray, arrayOffset,
             numberOfElementsToConvert);
```

```
aString = String.valueOf(aBoolean);
aString = String.valueOf(aChar);
aString = String.valueOf(anInt);
aString = String.valueOf(aLong);
aString = String.valueOf(aFloat);
aString = String.valueOf(aDouble);
```

The *String* class constructor is overloaded so that

```
aString = new String();
aString = new String(anotherString);
aString = new String(aStringBuffer);
aString = new String(aCharArray);
aString = new String(aCharArray, arrayOffset,
          numberOfElementsToConvert);
```

The following examples show how to build a *String* with *hiByte* in the most significant eight bits, and *ASCIIByteArray* elements in the least significant eight bits (*hiByte* is typically 0):

```
aString = new String(ASCIIByteArray, hiByte);
aString = new String(ASCIIByteArray, hiByte,
          arrayOffset,numberOfElementsToConvert);
```

The *String* class has a series of methods that use a string instance as a target. These methods typically involve extraction or conversion. For example,

```
aString = aString.toString();
aString = aString.substring(arrayOffset);
aString = aString.substring(arrayOffset, endIndex);
aString = aString.concat(anotherString)
//replace oldChar with aChar in aString
      aString = aString.replace(oldChar, aChar);
aString = aString.toLowerCase();
aString = aString.toUpperCase();
// Trims leading and trailing whitespace
      aString = aString.trim();
// intern returns a string from the private internal
      // hash table set that will pass the
      // aString == anotherString test
      aString = anotherString.intern();

aBoolean = aString.equals(anObject);
anInt = aString.hashCode();
anInt = aString.length();
aChar = aString.charAt(anInt);
// get charArray from aString
      aString.getChars(beginIndex,endIndex,
          charArray, arrayOffset);
aString.getBytes(beginIndex,endIndex,
      byteArray, arrayOffset)
charArray = aString.toCharArray();
aBoolean = aString.equalsIgnoreCase(anotherString);
```

The *CompareTo* method returns −1, +1 or, 0. The string comparison is performed using the underlying Unicode characters:

```
anInt = aString.compareTo(anotherString)
aBoolean = aString.regionMatches(beginIndex,anotherString,
        arrayOffset, numberOfElementsToConvert)
aBoolean = aString.regionMatches(
        boolean ignoreCase, arrayOffset,
        anotherString, arrayOffset,
     numberOfElementsToConvert)
aBoolean = aString.startsWith(aString)
aBoolean = aString.startsWith(aString, arrayOffset)
aBoolean = aString.endsWith(aString)
```

The *String* class has some string search functions. When they fail, they return −1. For example,

```
// first location of aChar in aString
        anInt = aString.indexOf(aChar);
// first location of aChar in aString starting from anInt
        anInt = aString.indexOf(aChar, anInt);
// first location of aString in anotherString
        anInt = anotherString.indexOf(aString);
// first location of aString in
        // anotherString starting from anInt
        anInt = anotherString.indexOf(aString, anInt);
// Find the last occurrence of a string or char in a string
        // starting from anInt
anInt = aString.lastIndexOf(aChar);
anInt = aString.lastIndexOf(aChar, anInt);
anInt = aString.lastIndexOf(aString)
anInt = aString.lastIndexOf(aString, anInt);
```

In order to determine if one string is contained in another, use

```
public static boolean    contains(String s1, String s2) {
        return s1.lastIndexOf(s2) != -1;
}
```

In order to format a number into a string, use the *DecimalFormat* class. This class can take a variety of *format strings*. For example,

```
import java.text.*;

public class FormatTest {
        public static void main(String args[]) {
          DecimalFormat df =
            new DecimalFormat("$000.00");
          System.out.println(df.format(1));
          System.out.println(df.format(100));
          System.out.println(df.format(0.8));
        }
}
```

will output:

```
$001.00
$100.00
$000.80
```

9.3 *ReplaceString*

The following program shows how to replace the first occurrence of a substring with another. Such a program could be extended to work with any number of occurrences (see the examples in Chapter 12).

```java
import java.util.*;
import java.io.*;

public class ReplaceString {
        public static String sub(
            String line, String ss, String rs){
          int lineSize=line.length();
          int ssSize=ss.length();

          for (int i=0;i<(lineSize-ssSize);i++) {
            if (line.startsWith(ss,i)) {
                String part1=line.substring(0,i);
                String part2=line.substring(i+ssSize);
                return part1+rs+part2;
            }
          }
          return line;
          }

        public static void main(String args[]) {
          String s = "public public public";
          s = sub(s, "public", "private");
          System.out.println(s);
        }

}
```

The above program outputs

```
private public public
```

To replace all instances of a string, use

```java
        public static String replaceAll(
            String s,
            String searchString,
            String replaceString) {
          int i = s.indexOf(searchString);
          if (i == -1) return s;
          int ssSize = searchString.length();
          while (i != -1) {
            String part1 = s.substring(0, i);
            String part2 = s.substring(i + ssSize);
```

```
            s = part1 + replaceString + part2;
            i = s.indexOf(searchString,
                            i+replaceString.length());
        }
        return s;
    }

    public static void main(String args[]) {
        System.out.println(
            replaceString(
                "This is a test test"
                + "test of replace string",
                "test", "example")));
    }
```

The above program outputs

```
This is a example exampleexample of replace string
```

The full code example is available in the *utils* package in the class *ReplaceString*.

9.4 *StringTokenizer*

A *StringTokenizer* is used to break up or parse a string into a series of substrings, called *tokens*. The *StringTokenizer* class resides in the *java.util* package. One constructor takes a string to parse. Another constructor takes a string to parse and a string that lists the *delimiters* that are used for parsing. The following example from *ReaderUtils* shows how a *StringTokenizer* can be used to obtain an array of strings from a single string:

```
public static String[]
            getTokens(String p) {
        String s =
            getString(p);
        StringTokenizer
            st = new StringTokenizer(
                s,", \t\n\r\f\\");
        int n = st.countTokens();
        String t[]= new String[n];
        for (int i=0;i<n;i++)
            t[i]= st.nextToken();
        return t;
    }
```

Here we see that the String Tokenizer constructor is being used with a delimiter list that includes a tab, new line, carriage return, form feed, comma, space, and backslash.
The default delimiters are '\n', '\t', '\r', and space.

9.5 *CsvParser*

It is typical for programs to output files that have comma-separated values (CSV) in them. These files are sometimes called *CSV* type files. Popular spreadsheet programs like Excel output such data.

CsvParser takes a string of CSVs and returns an array of strings. Each string contains a copy of what was contained in the original without the comma, leading spaces, or trailing spaces.

For example,

```
public static void main(String args[]) {
  CsvParser cp = new CsvParser("these, are,  43 345 &*()
   comma, + separated, :values");
  String s[] = cp.getTokens();
  for (int i=0; i < s.length; i++)
    System.out.println(s[i]);
}
```

will output

```
these
are
43 345 &*() comma
+ separated
:values
```

The code for *CsvParser* resides in the *futils* package, which will be discussed in Chapter 14 for example,

```
package futils;

import java.util.*;

/**
 * CsvParser Class
 */
public class CsvParser {

    StringBuffer sb ;
    Vector list = new Vector();

  /**
   * CsvParser Constructor
   */
  public CsvParser(String s) {
    sb = new StringBuffer(s);
  }
  /**
   * getTokens Method
   *
   * @return    String[]    tokens
   */
  public String[] getTokens() {
    int tc = 0;
    int start =0 ;

    for(int i=0; i < sb.length(); i++) {
      if(sb.charAt(i) == ',') {
        addElement(
               sb.toString().substring(start,i));
```

```
                            start = i+1;
                            tc++;
                    }
                }
            addElement(
              sb.toString().substring(start,sb.length()));

            String strObj[] = new String[list.size()];

            for (int i = 0; i < list.size(); i++) {
                strObj[i] = (String) list.elementAt(i);
            }
            return strObj;
        }
```

The private method, *addElement*, trims the leading and trailing white space from each token added:

```
        private void addElement(String s) {
                    list.addElement(s.trim());
        }
        public static void main(String args[]) {
            CsvParser cp = CsvParser("these, are,   43 345 &*()
             comma, + separated, :values");
            String s[] = cp.getTokens();
            for (int i=0; i < s.length; i++)
             System.out.println(s[i]);
        }

    }
```

The ability to read CSV type data from a file or a user is very important, but it requires that we know about *readers*. This topic is discussed in Chapter 14.

We also have an example, with the book code, that shows how to create an address book in Java. When we read a record from a CSV file, we are never quite sure if the correct number of elements will be present on a line. What follows is an example showing how to create a record that has a fixed number of fields from an input that has an unknown number:

```
    public static AddressBookRecord getRecord(String line) {

    AddressBookRecord abr =
        new AddressBookRecord();

        StringTokenizer st = new StringTokenizer(
         line, ",");
        try {
        abr.name = st.nextToken();
        abr.address = st.nextToken();
        abr.notes = st.nextToken();
        abr.dial_1 = st.nextToken();
        abr.dial_2 = st.nextToken();
        abr.dial_3 = st.nextToken();
    }
```

```
        catch (Exception e) {};
         return(abr);
    }
```

9.6 The Maze Solver

A classic example of an intelligent system is one that engages in a search. The following example shows how to solve a given maze using an exhaustive search technique. The example is important because it shows how to convert a one-dimensional array of *String* into a two-dimensional array of *char*. This conversion enables efficient indexing into the two-dimensional array and creates an important example of how arrays can be used.

```java
public class Amazed {
    public static void main(String args[]) {

        String mazeString[] = {
          "################",
          "#..............#",
          "#.....#..#####..#",
          "#.....#......#..#",
          "#.....#.#....#..#",
          "#.....#..#####..#",
          "#E....#......#..#",
          "#.....#.#....#..#",
          "#.....#..#####..#",
          "#.....#......#..#",
          "#.....#.#....#..#",
          "#.....#..#####..#",
          "#.....#......#..#",
          "#.....#.#....#..#",
          "##.##########.##",
          "#.......#....S..#",
          "################"
        };
        MazeUtility.setMazeString(mazeString);

        MazeUtility.print();
        System.out.println("---------- Solution ----");
          MazeUtility.solve();
        MazeUtility.print();

    }

}

import java.awt.Point;

public class MazeUtility {

    final static int right=1, left = 3, up = 2, down = 0;
        static int w = 0;
    static int h = 0;
```

```
static String mazeString[] = null;
public static void setMazeString(String ms[]) {
        mazeString = ms;
 maze = getChars(mazeString);
}
static char maze[][]= null;

public static char[][] getChars(String s[]) {
    char c[][] = new char[s.length][s[0].length()];
        for (int r=0; r < s.length; r++)
    s[r].getChars(0,s[0].length(),c[r],0);

return c;
}
public static void print() {
 char c[][] = maze;
 for (int r=0; r < c.length; r++) {
   for (int col=0; col < c[r].length; col++)
              System.out.print(c[r][col]);
   System.out.println();
 }
}
public static Point getStart() {
 for (int r =0; r < maze.length; r++)
   for (int c =0; c < maze[0].length; c++)
              if (maze[r][c]=='S')
              return new Point(r,c);
 return new Point(0, 0);
}
public static Point getExit() {
 return new Point(6, 16);
}
public static void markExit(Point p) {
    maze[p.x][p.y] = 'E';
}
public static boolean isDone(
    char maze[][],
    Point p) {
    return maze[p.x][p.y] == 'E';
}
public static void markStart(
    Point p) {
    maze[p.x][p.y] = 'S';
}
public static void mark(Point p) {
    maze[p.x][p.y] = 'X';
}
public static void solve() {
 Point start = getStart();
 //System.out.println("Start="+start);
 //Point exit = getExit();
 //System.out.println("Exit="+exit);
 //markStart( start);
```

```java
        //markExit(exit);
      mazeTraverse( start, left);
      }
      public static void mazeTraverse( Point loc, int
       direction){
       if (isDone(maze, loc)) {
          System.out.println("I am done!");
          return ;
      }
     w = maze.length;
     h = maze[0].length;
     int x = loc.x;
     int y = loc.y;
      mark(loc);
     for (int move = direction, count = 0; count < 4;
        ++count, ++move, move %= 4) {
        switch(move) {
            case down:
                  if (validMove(x+1, y)) {
                        mazeTraverse( new
Point(x+1,y),left);
                        return ;
                  }
                  break;
            case right:
                  if (validMove(x, y+1)) {
                        mazeTraverse( new
Point(x,y+1),down);
                        return ;
                  }
                  break;
            case up:
                  if (validMove(x-1, y)) {
                        mazeTraverse(
                              new Point(x-1,y),right);
                        return ;
                  }
                  break;
        case left:
                  if (validMove(x, y-1)) {
                        mazeTraverse( new Point(x,y-1),up);
                        return ;
                  }
                  break;
        }
    }
   }
   public static boolean validMove(int r, int c) {
          return ( r >=0 && r <= w && c >=0 && c < h
                && maze[r][c] != '#');
   }
}
```

9.7 Summary

In this chapter, we saw an overview of the wrapper classes. These classes were designed to promote primitive data types to reference data types. This promotion has a computational cost, but the cost is worth it if the features are needed. Commonly used wrapper methods are:

- String s = Integer.valueOf(i, b); // i is an int, b is the base
- **int** i = Integer.parseInt(s); // converts a string to an int
- **double** d = Double.parseDouble(s); // converts a string to a double

We saw how a new *String* can be created from an array of *char*. If *s* is a *String* instance, then the commonly used methods are:

- s = s.substring(arrayOffset, endIndex);
- i = s.length();
- c[] = s.toCharArray();

We also saw how to create our own API to extend the *String* API, and we learned about the *ReplaceString* class.

Finally, we looked into the details of the *StringTokenizer* and built a *CsvParser* to read spreadsheets into a Java program.

9.8 Exercises

9.1 What is a *StringTokenizer*?

9.2 Where does the *StringTokenizer* reside?

9.3 How do you make a *StringTokenizer*?

9.4 How do you find out how many tokens there are?

9.5 How do you use a *StringTokenizer*?

9.6 Write the method

```
String s = replaceString(s, "public", "private");
```

This method will take a string like "public static void main" and return a string like "private static void main". In other words, *replaceString* replaces all occurrences of *public* with *private*.

9.7 Write the method

```
String s = replaceString(s, "public", "private", 2);
```

This method will take a string like "public static void main" and return a string like "private static void main". With this method, *replaceString* replaces the first two instances of *public* with *private*, if two instances exist.

9.8 Write a static method that inputs a seven-digit phone number and tabulates all of the possible letter combinations using the number-letter table shown in Figure 9.8-1.
For example, 1-800-DOCJAVA is 1-800-362-5282.

9.9 In English, a sentence can be written as a noun phrase followed by a verb phrase. Using → (the translate factor is read "can be written as"), we can use the Modified Backas Naur Form (MBNF) (see Appendix A) to define a simple syntax:

```
s → nounPhrase, verbPhrase.
nounPhrase → determiner, noun.
verbPhrase → verb, nounPhrase.
determiner → [the].
determiner → [a].
verb → [hates].
```

Number	Letters
0	
1	
2	abc
3	def
4	ghi
5	jkl
6	mno
7	pqrs
8	tuv
9	wxyz

FIGURE 9.8-1
A Number-Letter Map

```
verb  →  [likes].
noun  →  [computer].
noun  →  [girl].
noun  →  [boy].
```

Using these three simple rules, suggest a few more nouns, verbs, and determiners. Write a program that generates sentences using your grammar. Example output might be:

```
the boy hates the computer.
the boy likes the girl.
the girl hates the boy.
etc...
```

9.10 Write a program that computes the travel time between two points given the start time and the end time. The input is embedded as a string. For example, "Mon 6:55 AM" is the start time, and "Tue 1:30 PM" is the end time. Let the days be represented by Mon, Tue, Wed, Thu, Fri, Sat, and Sun.

9.11 In the *Amazed* example in section 9.6, the program will run until a solution is found. If no solution exists, the program will run in an infinite loop and will not terminate. Modify the program so that it detects that no solution exists and terminates normally.

9.12 Write a program that generates a rectangular maze of any given size. Make sure that the maze has a solution. Allow the programmer to specify the start- and end- point locations.

9.13 Select your favorite application that is able to be exported as a text file (e.g., an address book program or file-tracking utilities). Write a Java program that uses a *StringTokenizer* to read this format.

C H A P T E R 1 0

Exceptions

Quidquid latine dictum sit, altum videtur.
That which is said in Latin, seems profound.

–Proverb

In this chapter, you will learn about:

- The *try-catch* statement
- The *finally* statement
- Checked and unchecked exceptions
- Defining your own exceptions
- The difference between *throw* and *throws*

Figure 10.1 shows the keywords that you will learn in this chapter. Exceptions are errors that are generated while a computer program is running and that disrupt the normal flow of control. Such errors, called *run-time* errors, are different from the compile-time errors that the compiler generates. An instance of an exception that is created and handed to the run-time system is called *throwing* an exception.

Run-time errors are much harder to debug than run-time errors.

Compile-time errors are generated in response to erroneous syntax in the source code. Run-time errors are generated in response to erroneous semantics. For example, it is not a compile-time error to divide by zero, but it is a run-time error to do so.

throw
throws
try
catch
finally

FIGURE 10.1
Keywords

10.1 Generating Your First Exception

Suppose you want to divide two numbers. If you cause the computer to divide by zero, an exception will be thrown at run time:

```
public class ExceptionExample {
    public static void main(String args[]) {
      System.out.println( "f(0)=" + f(0));
    }
    public static int f(int x) {
      return 1/x;
    }
}
```

The code above generates the following *run-time* error:

```
Exception in thread "main" java.lang.ArithmeticException:
        / by zero
        at ExceptionExample.f(ExceptionExample.java)
        at ExceptionExample.main(ExceptionExample.java)
```

Thus, when we generate a divide-by-zero exception, we are throwing a runtime exception.

It is tempting to handle all exceptions globally. Be sure to log them so that eventually they get fixed. Also, it is important to note that exceptions can slow down your code.

As a programmer, how would you stop the possibility of a division by zero? In languages like FORTRAN and Pascal you would guard the input so that something would happen if the argument to the division had a zero in the demoninator. But what? Here are some possibilities:

- Terminate the program with an error message.
- Ask the user for better input.
- Take an alternative computational path.

It is difficult to know which of the three alternatives to select. Can you think of other options? The primary contribution of the exception framework in Java is to enable the programmer to defer the handling of the exception to another layer in the code. In this way, the business logic does not become cluttered with error-handling code, which is considered good software engineering practice.

10.2 Guard the Input or Catch the Error

In the previous section, we mentioned the idea of intercepting bad input to prevent an error, which is called *guarding* the input. For example, we could say

```
public static int f(int x) {
  if (x == 0) return 0;
  return 1/x;
}
```

The code above would return an invalid answer, which is worse than the program stopping and informing the user. To intercept an exception after it has been thrown, use a *try-catch* block:

```java
public class ExceptionExample {
    public static void main(String args[]) {
     try {
          System.out.println( "f(0)=" + f(0));
     }
     catch (ArithmeticException e) {
          System.out.println("Bad input for f!");
     }
     System.out.println("program continues...");
    }
    public static int f(int x) {
     return 1/x;
    }
}
```

The code above outputs

```
Bad input for f!
program continues...
```

Guarding the input is often faster than catching exceptions. However, the solution to select is application dependent.

We see that the program does not stop suddenly when it divides by zero. According to the Java Language Specification [Gosling], the Java machine will throw an exception when a run-time error occurs. When an exception is thrown, a non-local transfer of control occurs from the area that generated the exception to a place that can catch the exception. In our case, we caught the exception, sent an error message, and then allowed the program to continue. The interesting part about this approach is that we can select where the error handling occurs and protect the program from crashing during a mission-critical area of the code.

10.3 Defining Your Own Exception

Suppose you are interested in building a credit card processing routine. You want the routine to perform an elementary check on the credit card number and to throw an exception if a problem the routine finds. When the credit check finds a problem, a new exception is thrown called a *CreditCardException*. Here is how we define it:

```java
public class CreditCardException extends Exception {
    public CreditCardException(String s) {
     super(s);
    }
    public static void check(int i) throws
     CreditCardException {
     if (i < 0) {
       throw new CreditCardException(
            "credit card ="+i);
     }
    }
}
```

The *Exception* class is defined in the *java.lang* package. A new exception may be defined by subclassing the *Exception* class. The class that performs the credit card check only makes sure that the credit card is positive. However, the checking process is an implementation detail, and a more complete credit card check could easily be performed. Here is a class that checks the credit card:

```
public class CheckCreditCard {
    public static void main(String args[]) {
      try {
        CreditCardException.check(-9);
      }
      catch (CreditCardException e) {
        e.printStackTrace();
        System.out.println("Here is the cc exception");
        return;
      }
      System.out.println("done.");
    }
}
```

10.4 Checked and Unchecked Exceptions

There are two kinds of exceptions: *checked* and *unchecked*. When a method is invoked that throws a checked exception, then the invoking method must place the invocation in a *try-catch* block or declare it in the *throws* clause. This process is not required for an unchecked exception. For example,

```
public static void check(int i) {
    CreditCardException.check(-9);
}
```

causes a *compile-time* error:

```
Error    : Exception CreditCardException must be caught, or
           it must be declared in the throws clause of this
              method.
ExceptionExample.java line 41
          CreditCardException.check(-9);
```

As a result, we can declare the *CreditCardException* in the throws clause:

```
public static void check(int i)
     throws CreditCardException {
   CreditCardException.check(-9);

}
```

Alternatively, we can place the invocation inside a try-catch block:

```
public static void check(int i) {
   try {
     CreditCardException.check(-9);
   }
   catch(CreditCardException e) {
     e.printStackTrace();
   }
}
```

FIGURE 10.4-1
An Overview of the *java.lang. Exception* Classes

FIGURE 10.4-2
An Overview of the *java.lang.RuntimeException* Classes

The checked exception is defined by subclassing the *Exception* class; the unchecked exception is defined by subclassing the *RuntimeException* class. With an unchecked exception, a *try-catch* construct is not needed to invoke methods or statements that throw *RuntimeExceptions*. For example, dividing by zero can throw a *RuntimeException*.
Figure 10.4-1 shows the java.lang. Exception subclass hierarchy.
Figure 10.4-2 shows the java.lang.RuntimeException class hierarchy.

10.5 The Syntax of the `try` Statement

LANGUAGE REFERENCE SUMMARY
The *try-catch* block has a syntax that can be written as the keyword *try* followed by a statement and by one or more *catch* statements.

After the last *catch* statement, there can be an optional *finally* statement.
It is typical to format the try-catch as follows:

```
try {
        statement1;
        statement2;
```

```
        ...
    }
catch (SomeException se) {
        se.printStackTrace();
    }
catch (SomeOtherException soe) {
        System.out.println("SomeOtherException in ..."+soe);
    }
finally {
        houseKeepingStatementsHere;
    }
```

Generally, it is better to throw exceptions to the invoking method so that large try-catch blocks do not clutter your code. Doing so improves readability and modularity. A consistent formatting style will help to prevent syntax errors from appearing in the try-catch block.

It is typical to use the *try-catch* block with any code that might fail. As we saw with the division-by-zero example, there was no requirement for the try-catch block. In other words, there was no requirement that the code be able to handle run-time errors locally.

WARNING

A *return* in a catch generally does not get executed right away if there is a finally statement. A finally statement is always executed first.

The *finally* statement is optional and is always executed at the end of a try-catch block. It is typically used to perform housekeeping operations, such as closing files. If an exception is thrown, the *catch* block is executed first, then the *finally*. For example,

```
try {
        // stuff that might throw an exception goes here
    }
catch (Exception e) {
        // stuff goes here in case of an exception
    }
finally {
        // always executed code goes here
    }
```

When an exception is caught, a message is obtained using

```
e.getMessage()
```

A sophisticated program can log the messages from the exceptions (called *error logging*) so that proper steps can be taken to correct any errors.

At the other extreme, we could catch the exceptions and then ignore them and continue running he program. For example,

```
    try {
      out.write(buffer);
      } catch(Exception e) { }
```

A new exception is defined by extending the *Exception* class. For example,

```
class FileFormatException extends Exception {
    public FileFormatException(String s) {
        super(s);
    }
```

Try-catch blocks can slow down the execution of code slightly by creating locally scoped variables. It is therefore important to place exceptions at the right level of granularity. For example, it would not be appropriate to place every division inside of a *try-catch* block. It would be better practice to guard the input at a higher level (e.g., by making the problem well-conditioned).

The checked exception decends from the *Exception* class. Such exceptions do require a *try-catch* statement or are required to be in methods that throw a checked exception. For example,

```java
public class ThrowsExample {
    public static void main(String args[]) {
      Float value = Float.valueOf("1.0");
      System.out.println(value);
      value = Float.valueOf("blah blah blah");
      System.out.println(value);
    }
}
```

will output

```
1.0
_exceptionOccurred: java.lang.NumberFormatException (blah
      blah blah)
java.lang.NumberFormatException: blah blah blah
        at java.lang.Float.valueOf(Float.java)
        at ThrowsExample.main(TrivialApplication.java)
        at
          com.apple.mrj.JManager.JMStaticMethodDispatcher.run
          (JMAWTContextImpl.java)
        at java.lang.Thread.run(Thread.java)
```

The *java.lang.NumberFormatException* is an unchecked or *RuntimeException* since the *NumberFormatException* subclasses the *IllegalArgumentException*, which in turn subclasses the *RuntimeException*.

With checked exceptions, the *try-catch* block is required. For example,

```java
public class FileExample {
    public static File openFile() {
     return new File("foo.txt");
    }
    public static FileReader openFileReader() {
     return new FileReader(openFile());
    }
    public static void main(String args[]) {
        System.out.println(openFileReader());
    }
}
```

will not compile. The syntax error is

```
Error    : Exception java.io.FileNotFoundException must be
          caught, or it must be declared in the throws clause
          of this method.
TrivialApplication.java line 23         return new
          FileReader(openFile());
```

The following shows a way to fix the code:

```
public class FileExample {
    public static File openFile() {
     return new File("foo.txt");
    }
    public static FileReader openFileReader()
        throws FileNotFoundException {
     return new FileReader(openFile());
    }
    public static void main(String args[]) {
        try {
         System.out.println(openFileReader());
        }
        catch(FileNotFoundException e) {
         e.printStackTrace();
        }
    }
}
```

10.6 The `throw` Statement

The *throw* statement uses a reserved word called *throw*. It creates a non-local transfer of the flow of control to the nearest enclosing catch statement. For example,

```
if (outOfBounds(x))
        throw new ArithmeticException();
```

In a business, we may want to create a new kind of exception for handling business transactions. For example,

```
class CreditCardException extends Exception {
    CreditCardException(String s) {
     super(s);
    }
}
```

Then, if we want to check a credit transaction, we write

```
public void buyGoodies(int i) throws
        CreditCardException {
    if (checkCard(i))
        throw new CreditCardException(i+ " is invalid");
    // buy goodies code here...
}
```

This defers the error handling to the person who invokes the *buyGoodies* method. The decision to defer the handling of the error to the caller enables the customer to be informed with an appropriate interface [e.g., e-mail, Web-based message, or interactive graphical user interface (GUI)], which is very important as a verification step in the transaction.

As another example, suppose a mission-critical function (*mcf*) requires software to recover from all exceptions. For example, a Web server might have code in it that is created by a programmer who submits server-side code with bugs in it. The Web server is required to report the bugs, but then it keeps running. For example,

```
    public static void main(String args[]) {
      while (true) {
        try {
         mcf();
        }
        catch (Exception e) {
         System.out.println(e);
        }
      }
    }
```

10.7 The `throws` Modifier

In this section, we elaborate on the use of the *throws* modifier. The throws modifier appears after a method's parameters but before the beginning of the statement block. The *throws* modifier is used quite a bit in Java. In fact, in the *java.io* package, the *throws* modifier appears 783 times.

Anytime an error is to be associated with an action, it is good policy to declare the exception in the *throws* section of the method declaration. For example,

```
public void close() throws IOException {...
```

We may not know what *close* does, but we do know that we either must handle the error in the invoking method or defer the handling of that error to the the next layer up.

A basic question for any programmer, then, is: "Where should the error handling performed?" This question has an easy answer. In general, if you are not sure what to do or if there exists a lot of surrounding business logic, it is probably a good idea to defer the error handling by declaring a throws modifier.

For example, suppose you write a function that guards the input, but defers the error handling until later. You write

```
public void someFunction(x) throws
         IllegalArgumentException {...
```

After some thought, you think that you may have forgotten an exception that needs to be caught. You can always add more exceptions to the list:

```
public void someFunction(x) throws
         IllegalArgumentException,
         NumberFormatException,
         ArithmeticException {...
```

In the case where a new exception is appropriate, you should define it (as we did with the *CreditCardException*).

In the core j2sdk1.4.0 API there are 280,159 lines of code in which the *throws* modifier appears for a total of 3,405 times. Thus, the *throws* modifier represents about 1.2% of the code. To put this in perspective, the reserved word *void* appears 3,283 times, which is only 1.1% of the code. Thus, the use of the *throws* modifier is common for professional Java code.

10.8 `System.err`

Invoking *System.out.println* prints to the standard output (i.e., the console window). However, when errors appear, it is often better to print them somewhere other than the console. *System.err* was created to address this need.

When *System.err.println* is invoked, the output goes to a special area called the *Error Output Stream*. Discussions of streams are beyond the scope of this chapter, but suffice it to say that *System.err* appears only 50 times in the 280,159 lines of code in the core j2sdk1.4.0 API.

10.9 Public Safety and Exceptions

Public safety can depend on the ability to handle errors. For example, a Boeing 777 is said to be 1 million lines of code flying in formation. This fly-by-wire aircraft may contain code with bugs. These bugs could create exceptions. By creating exception handlers, we can trap all of the exceptions and allow the program to continue.

The European Space Agency (ESA) has an Ariane 5 solid rocket booster. During a launch on June 4, 1996, the nozzles directing thrust caused the rocket to begin turning in the wrong direction. The rocket exploded seconds later at an altitude of 4,000 meters, which resulted in the destruction of the launch vehicle and a half-billion dollar package of four Cluster satellites to be used for studying the Earth's relationship with the Sun. The rocket's main cryogenic motor used liquid hydrogen and liquid oxygen, as a result, flaming debris filled the sky over the South American jungle.

The specification of the exception-handling mechanism contributed to the failure. According to the system specification, the guidance computer should shut down in the event of any kind of exception. Since a systematic software design error was not anticipated, and two healthy critical units of equipment were shut down.

The exception was due to a floating-point error: a conversion from a 64-bit integer to a 16-bit signed integer, which only should have been applied to a number less than $2^{15.}$ This exception was not the result of a design error, since the software was designed for an Ariane 4 booster, not an Ariane 5 booster (a much larger rocket).

Critical code should guard against failure by being embedded in a try-catch block.

Testing can only reveal some, not all, errors. Design reviews of complex systems may never be 100% effective.

If we operate under the assumption that a bug may have been left in a program, then we must assume that the unknown bug will create an unknown exception.

The proper design of exception handling software can prevent catastrophic mission failure. If, for example, the software in the Boeing 777 system were to fail, a lot of people might have a bad day.

10.10 Summary

In this chapter, we saw that:

1. An exception is a run-time condition.
2. A *try-catch* block can be used to process exceptions.
3. Exceptions can be thrown by any instance of a class that subclasses *java.lang.Throwable*. Thus, variables in a *catch* clause are descended from the *Throwable* class.

4. There are two kinds of exceptions: checked and unchecked.

5. Checked exceptions subclass the *Exception* class.

6. Unchecked exceptions subclass the *RuntimeException* class.

7. Exceptions must be caught in order to be intercepted and processed.

8. At least one catch is needed in a *try* statement.

9. The *finally* clause is executed at the end of the *catch* block unless the JVM is exited. A return in a try or a catch statement does not prevent the *finally* clause from being executed.

10. More specific exceptions should be caught before their superclasses.

11. A try block must be followed by a catch block.

12. A catch statement may be followed by a *catch* statement or a *finally* statement.

13. Exceptions separate error handling from the core business logic.

14. Exception hierarchies enable the grouping of different error types.

15. Exceptions move error handling code.

The astute reader may well ask, "When should I guard the input, and when should I use an exception?" There is probably no best answer to this question, since the programmer will want to balance the risk of unguarded input against the cost of slowing the coding process. As a result, the initial choice probably will be to use exceptions. As error handling becomes more refined, programmers will devise their own exceptions and expand catch statements to catch multiple exceptions.

The only time the *finally* statement is not executed is when the thread that contains the *finally* statement dies. For more information on threads, see Chapter 13.

These properties enabled us to define our own checked and unchecked exceptions. We used checked exceptions when we wanted to make the programmer think about how to handle the exception in the code. We used unchecked exceptions when exceptions generally were not expected or when the program was able to terminate with an error message.

10.11 Exercises

10.1 A MasterCard number is a positive integer that has 16 digits. Design a credit card checking routine that throws a *CreditCardException* when the number of digits in the credit card is invalid. Hint: A user may type in a combination of letters, spaces, and numbers. Just count the number of valid numbers in a *String*. It might help you to use

```
char c[] = s.toCharArray();
Character.isDigit(c[i]); // a for-loop might help here.
```

10.2 Write a program that computes how much it costs to leave a computer on 24 hours a day, 365 days a year. Assume that the computer uses 0.2 KWh and that power costs 10 cents per KWh. Tabulate the costs of operating a computer as a function of the cost of power. Increase the cost of power by 5 cents per KWh until you get to 50 cents per KWh. Use a function to perform the computation. Make the cost of power and the total amount of power consumed parameters and, if the parameters are negative, throw an *InvalidPowerException*. Make this a *RuntimeException* so that try-catch blocks are not required.

10.3 If you have a *return* in both a *try* statement and the *finally* statement is the value of the finally statement returned?

10.4 The *ArrayIndexOutOfBoundsException* and the *StringIndexOutOfBoundsException* both subclass the *IndexOutOfBoundsException*. If you catch the *ArrayIndexOutOfBoundsException*,

will you also catch the *StringIndexOutOfBoundsException*? What about the *IndexOutOf-BoundsException*? Why?

10.5 Why should exception handling be deferred to an invoking method?

10.6 If a *finally* statement is in a try-catch block, will it be executed if no exceptions are thrown?

10.7 How would you write a *catch* statement that intercepts all exceptions?

10.8 Can a try-catch block be placed inside of a catch statement?

10.9 If there is no exception and a return is encountered in the center of the try-catch block, will the *finally* statement be executed?

10.10 Suppose that

```
public void someFunction(Object o) {...
```

throws a *NullPointerException*. What could be wrong?

C H A P T E R 1 1

Packages, Imports, and Visibility

"That's a great deal to make one word mean," Alice said in a thoughtful tone. "When I make a word do a lot of work like that," said Humpty Dumpty, "I always pay it extra."

–Lewis Carroll, mathematician and writer
(1832–1898)

In this chapter, you will learn about:

- Packages
- Import statements
- Visibility modifiers

Figure 11.1 shows the keywords you will learn in this chapter. Several of the modifiers shown in Figure 11.1 also are mentioned in this chapter.

A class hierarchy is an AKO hierarchy that controls access to the instance variable and method name-space. A package hierarchy is a file system hierarchy that creates isolated name-spaces that contain class and interface names. The package hierarchy is like the class hierarchy, in that it is a directed-acyclic graph. However, it is unlike the class hierarchy in that there is neither a package inheritance nor any reference types created as a result. Additionally, there are no limits to the number of packages that may be imported, other than computational ones (e.g., linking tends to take longer).

The import statement enables access to elements in other packages. Classes and interfaces control access to instances and methods, whereas packages group access to classes and interfaces.

Packages are important because they allow programmers to collaborate on large systems without interfering with one another. In fact, it is common to have programmer ownership of a package. When this ownership occurs, public elements often are held as very important for their stated specification since other programmers will grow to depend upon them. When public elements are changed, class interdependency will also be affected, thus becoming a source of fragility.

import
package
private
protected
public

FIGURE 11.1
Keywords

11.1 Packages

Reference data types (classes and interfaces) are grouped into *packages*. A package typically is organized in a hierarchy, like a file system. One programmer can have many packages.

When two or more programmers work on the same package at the same time, that package can become a source of errors.

It is better software engineering practice to give each programmer his or her own package and to allow the interface to the package to act like a specification.

A package should have a stable interface so that other programmers do not have to alter the code that depends on it. When an interface in a package is updated, the old interface is said to be *deprecated*. Once an interface becomes deprecated, those maintaining packages that depend on the interface are obligated to alter their code. Thus, the deprecation of code interfaces creates a burden for other programmers: The more widely the API is distributed, the greater the burden. Before deprecating an interface, it is wise to compute the costs to others of deprecation for example, it appears that no one has estimated the cost of deprecating the 1.0 Abstract Window Toolkit (AWT) on the Java programming community. One impact on Sun has been a general distrust by the Java programming community of Sun's commitment to API stability, which is a basic API design issue. Through its actions, Sun has decided to consider speed to be more important than reliability, a design goal that runs contrary to the stated design goals of Java.

The package statement groups reference data types so that those classes with default visibility are accessible only to package programmers. Some things to remember about packages include:

LANGUAGE REFERENCE SUMMARY
- A package statement can be written as the word *package* followed by a package name followed by a ';'.

- Package statements must appear before *import* statements (i.e., package statements are optional, but if they do appear, they must appear before all other statements).
- There may be only one package statement to a file.

For example,

```
package somePackageName;
```

The only thing that can appear before a package statement is a comment. When a package statement is omitted, then the *class* or *interface* that follows is written into the default package.

FIGURE 11.1-1
Strict Java Filenames Settings

A package name takes the form of a standard Java language identifier followed by an optional period. If the period is present, then another identifier must follow. For example,

```
package thisIsAPackageName;
```

or

```
package thisIsAPackageName.withAnotherPackageName;
```

or

```
package thisIsAPackageName.withAnotherPackageName.andAnother;
```

When classes are written into a source file with no package declaration, they become a part of the default package. Packaging helps large programs to be written by hiding complexity and making code more modular.

The Java Development Kit (JDK) *javac* compiler requires packages to be stored in a subdirectory that matches the full package name for the class. While not a requirement of the language, such a procedure is good practice. For example,

```
java.awt.Frame
```

indicates that a *Frame* class is in the *awt* package. It also indicates that the *awt* package is in the java package. To enforce these constraints, select the *Edit:Target Settings* item in the CodeWarrior IDE (Integrated Development Environment) menu.

Then select the *Strict Java Filenames* settings, checking both *Use Strict Java File-names* and *Use Strict Source/Package Hierarchy* (See Figure 11.1-1). Doing so will flag inconsistent package name storage as a compile-time error.

WARNING

A public reference data type in a file that has a different name than the data type can be a syntax error.

It is generally easier to maintain many small packages with well-defined interfaces than to maintain large packages. One programmer should be working in a package at a time. Package collaborations force programmers to address the visibility of the reference data types.

11.2 The import Statement

The *import* statement enables access to the classes and interfaces in a package. For example,

```
import packageName.*;
```

or

```
import packageName.className;
```

or

```
import packageName.interfaceName;
```

LANGUAGE REFERENCE SUMMARY

An import statement can be written as the keyword **import** followed by a package name and '.*;' a '.className;' or an '.interfaceName;'.

A large number of unneeded imports can lengthen the time required for compilation.

WARNING

In summary,

1. You should package small and package often.
2. Every programmer should create stable interfaces to packages.
3. Default visibility enables all classes and interfaces to have access to each other.
4. The package statement is the first statement in a file.
5. Classes and interfaces must be public to be visible outside of the package.
6. Files in a package should be in a subdirectory that matches the package name.

As an example, consider the *class Foo* in the *fred* and *wilma* packages:

```
package fred;
public class Foo {
    public void print() {
        System.out.println("hi Fred");
    }
}

package wilma;
public class Foo {
    public void print() {
        System.out.println("hi Wilma");
    }

}
```

In order to use the *Foo* class, the programmer imports *fred*. However, the *wilma* package also has a class named *Foo*. Thus, the full class name (which includes the package name as a part of the prefix) is used to prevent a class-name conflict:

```
import fred.*;
public class Main {
    public static void main(String args[]){
      Foo f = new Foo();
      wilma.Foo w = new wilma.Foo();
      f.print();
      w.print();
      }
}
```

The above example shows how to use the full package name in the prefix to disambiguate the *Foo* classes in the *fred* and *wilma* packages. The output is "Hi Fred" and "Hi Wilma".

11.3 Visibility Modifiers

The visibility modifier enables access control to a member variable, a class, or an interface. Name-space contention occurs if two identifiers in the same name-space are the same. Packages can be used to help isolate an identifier's name-space, along with visibility modifiers.

Visibility is important because it keeps programmers from breaking important code. By restricting visibility, the programmer has said, "I won't tell anybody about this method, because they should never need it or because it is not ready for release." Thus, if a method is not visible, it may not be invoked.

A *private* method and *private* data may not be accessed from a subclass, which prevents a name-space conflict between subclass and superclass.

LANGUAGE REFERENCE SUMMARY

A visibility modifier can be written as the keyword **public**, **private**, or **protected**.

For example,

```
public class Foo {
     private static int i = 0;
     public static int j = i + 10;
     protected static int z = i + j;
     public static void main(String args[]) {...
     }
     private static void foo() {...
     }
     protected static void wow() {...
     }

}
```

The following list ranks visibility modifiers from most permissive to least permissive:

1. public–gives world access.
2. protected–gives class, subclass, and package access. It is applied to methods and variables.
3. default–gives package access. Classes that import the package will not be able to access types that have default access.
4. private–gives access only within the class. Only methods and variables may be private.

Protected members, however, can be shared across packages by subclassing. Also, the instinct, justifiably, is to believe that package access is less restrictive than protected access, which is not true. In fact, default package access is more restrictive than protected access.

Private members are useful when you want to make sure that only a class programmer can alter or invoke an item that can change the state of a class. Thus, if a variable is held as private, a *get* method is available to make the variable read-only. For example,

```
public class InterestRate {
     private double interest = 0.05;
     public double getInterest() {
```

```
      return interest;
   }

   public void greenspanManeuver() {
      interest = interest + 0.0025;
   }
}
```

The *InterestRate* class allows other instances to read the *interest* though they cannot set the *interest*. The only way to raise interest rates (known as adversarial monetary policy) is to perform the *greenspanManeuver*, which raises the interest rate by 25 basis points. Thus, the *interest* is a read-only variable that can be increased, but only by 25 basis points.

It is typical to have a collection of public static methods contained in a public final class with a private constructor that is never invoked. One example is the *Math* package in the *java.lang* package. For example,

```
public final class Math{
   /**
    * Don't let anyone instantiate this class.
    */
   private Math() {}
```

Figure 11.3-1 shows the visibility matrix for Java. A *1* in the visibility matrix indicates a *true* condition, and a 0 indicates a *false* condition. Each row is summed to obtain a *weight* for the visibility vector. For example, private gives no access outside of the class, so the weight is zero, whereas public gives complete access, so the weight is 6. An example of both the use and abuse of visibility modifiers follows:

```
public class Visible {
   public String publicString = "publicString";
   String defaultString ="defaultString";
   protected String protectedString = "protectedString";
   private String privateString = "privateString";
}

public class Invisible extends Visible {
   String iGetPublicStrings = publicString;
   String iGetDefaultStrings = defaultString;
   String iGetProtectedStrings = protectedString;
    // String iDontGetPrivateStrings = privateString;
}
```

	Access by Non-Subclass from Same Package	Access to Subclass from Same Package	Access to Non-Subclass from Different Package	Access to Subclass from Different Package	Inherited by Subclass in Same Package	Inherited by Subclass in Different Package	Weight
private	0	0	0	0	0	0	0
default	1	1	0	0	1	0	3
protected	1	1	0	0	1	1	4
public	1	1	1	1	1	1	6

FIGURE 11.3-1
Visibility Matrix

The rule of thumb for class/interface declarations is: first *public*, then *protected*, then default, and then *private*. Instance variables typically appear at the top of the class/interface declaration. The methods should be grouped by function rather than accessibility, thus improving readability.

11.4 Summary

This chapter covered packages as a means of organizing interfaces and classes. Import statement can be used to import all of the classes at a specific level of the package hierarchy. Using the current formulation of the Java language, there is no way to import an entire leg of the hierarchy (i.e., there are no recursive imports). Also, if you want to make use of a class in another package, either declare it public or protected. The protected class must be subclassed for it to be visible in another package (i.e., you must be a class author, but not a package author).

For default visibility, you can only use a class if it is in your package (i.e., you must be a package author). The package system is not an object-oriented way to organize references (unlike the nested reference system). In fact, this system is dependent on a file system organization scheme. This design issue is hotly debated in the Java community and is beyond the scope of this text to address.

11.5 Exercises

11.1 Write a method that makes an instance of a class in another package. Describe what happens if the class has default visibility.

11.2 Do you have to import a package in order to use classes in the package? Why?

11.3 Why might I not be able to find the classes I want, even though I imported their packages? Name at least two possible reasons.

11.4 Every class resides in a compilation unit called a package. T F

11.5 You cannot have a protected class. T F

11.6 Subclasses always can access the superclass's private strings. T F

11.7 You should organize you code with packages. T F

11.8 What is reference organization?

11.9 What is an isolated name-space?

11.10 Why isolate identifier groups?

11.11 The book suggested that one programmer should take ownership of a package. Will doing so alter the design of a software system? Why or why not? What are the good and bad aspects of such an allocation? Can you think of a better way to organize the team?

11.12 Give an example of an ambiguous class-name conflict.

11.13 Why not use unique identifiers to resolve ambiguous class names?

11.14 Why are packages always public?

CHAPTER 12

Nested Classes and Interfaces

Judge not the horse by his saddle.

–Chinese Proverb

In this chapter, you will learn about:

- Nested classes
- Nested interfaces
- The five inner-reference data types

This chapter covers two nested reference data types: *nested classes* and *nested interfaces*. Nested classes and nested interfaces are also called *inner classes* and *inner interfaces*.

Before Java 1.1, all of Java's classes and interfaces were top-level reference data types. Top-level reference data types occupy the package name-space. Two reference data types, however, cannot have the same name in the same package. Nested classes can improve object-oriented design and reduce *class* name-space clutter in a package. They also help to hide complexity. Inner classes have access to private members in their outer class and can extend classes and implement interfaces. A nested class can add functions to the outer class without altering the inheritance hierarchy.

There are five kinds of nested reference data types:

1. The *member inner class* also called a dynamic inner class, a nested class defined at the top level of an outer class

2. The *local inner class*, a dynamic inner class defined within a method

3. the *anonymous inner class*, an unnamed dynamic inner class defined within an expression

4. The *nested static class* (a static inner class)

5. The *nested interface*

FIGURE 12.1
The Taxonomy of Nested
Reference Data Types

The five kinds of reference data types have different applications. The member inner class is a nested class defined at the top level of an outer class.

Nested classes are new to the Java 1.0 language and cause a change in the language's grammar statement. The increment from JDK 1.0 to JDK 1.1 indicates a minor release. Considering the impact on the grammar, however, the introduction of inner classes in a minor release may have been unfounded. Figure 12.1 shows the different kinds of nested reference data types.

Figure 12.1 shows that there are two reference data types: *classes* and *interfaces*. There are two kinds of nested classes: *dynamic* and *static*. Further, there are two kinds of dynamic nested classes: *named* and *anonymous*. Finally, there are two kinds of named dynamic nested classes: *member* and *local*. We will see that interfaces and static nested classes always are named. Further, we will show that anonymous inner classes are always local in their scope. The named dynamic inner classes can be instanced only within the scope of the outer class. In comparison, we will show that the static nested class commonly is instanced outside of the outer class.

12.1 The Member Inner Class

A *member inner class* is a nested class that is defined at the top level of an outer class. It is also known as an *inner class member*. The class is named and may be one of several other classes; as such, the name must be different from the enclosing class. Member inner classes may have a variety of visibility modifiers, including *default, private, public*, and *protected*. These modifiers can be *final* or *abstract*. Infact, they can even be *static*. If a member inner class is static, then it only can access static variables and methods. Section 12.4 provides a more extensive discussion of the *inner static class*.

An example of a *dynamic inner class* follows:

```
class OuterClass  {
    InnerClass ic =
        new InnerClass();. . .
    class InnerClass {
        InnerClass() {...
        }
    }
}
```

The *InnerClass* typically is used to provide a class that can only be constructed by the *OuterClass*. However, references to instances of the *InnerClass* may be passed to classes outside of the *OuterClass*.

The non-static inner class can be used only within the containing classes. For example,

```
/*
        This example shows
        how to create a nested class.
        The Outer class is class called "Outer".
        The Inner class is class called "Inner".
        The Outer class contains the Inner class.
        Inner classes are useful for defining temporary
        reference data types.
*/
class Outer {
        Inner i = new Inner();
        public static void main(String args[]) {
          Outer o = new Outer();
          o.i.print();
        }
        class Inner {
          void print() {
             System.out.println("hello from Inner class!");
          }
        }
}
```

The output follows:

```
hello from Inner class!
```

Inner classes are temporary and locally scoped. As a result, classes that do not contain the *Outer* class are unable to make instances of the *Inner* class directly.

 It is an error for a class outside of an outer class to make direct reference to an *Inner* class unless the inner class is static.

WARNING

For example,

```
class DontWork {
        Inner i = new Inner();
}
```

creates the syntax error

```
Error    : Class Inner not found.
Outer.java line 23    Inner i = new Inner();
```

Thus, the *DontWork* class cannot compile.

For a real-world modeling example, consider the business process of writing a purchase order. An entity known as the purchasing department can create documents called purchase orders POs, which is shown in Figure 12.1-1.

The notation 0..N shows that they can be 0 or many items.

FIGURE 12.1-1
Purchase Order Process

Using some means (e.g., a phone call or *purchase requisition*), the purchasing department creates POs. No other entity is permitted to create a PO. Thus, to keep the rest of the system from creating POs, we make a dynamic inner class:

```
public class PurchasingDepartment {
    public class PurchaseOrder {
    }
    public PurchaseOrder getPurchaseOrder() {
      return new PurchaseOrder();
    }
}
```

In order to gain access to the dynamic method *getPurchaseOrder*, the programmer must make an instance of a *PurchasingDepartment*. The visibility of the *PurchaseOrder* constructor is limited in scope to the *PurchasingDepartment* outer class; thus, only *PurchasingDepartment* instances can make new instances of a *PurchaseOrder*. For example,

```
PurchasingDepartment pd = new PurchasingDepartment();
PurchasingDepartment.PurchaseOrder po = pd.getPurchaseOrder();
```

In comparison, code like

```
PurchasingDepartment.PurchaseOrder po = new
        PurchasingDepartment.PurchaseOrder(); // bug!
```

is not permitted because only the purchasing department can generate a PO.

12.2 The LocalInnerClass

LocalInnerClass is a nested class that is defined within an Outer-class method. It also is called an *inner class local*. It has access to local method variables if they are declared as *final*. The class may not be accessed outside of the code block.

For example,

```
public class LocalInnerClass {
    public static Runnable getRunnable() {
      class Hello implements Runnable {
        public void run() {
            System.out.println("Hello from run!");
        }
```

```
      }
      return new Hello();
   }

   public static void main(String args[]) {
      Runnable r = getRunnable();
      r.run();

   }
}
```

The *Hello* class is not available outside of the scope of the outer *LocalInnerClass* class, which is good since the *Hello* class is not very useful. It is the policy, therefore, of the *LocalInnerClass* author not to give access to the *Hello* class. The intent of this policy is to make the `Hello` class a local inner class.

The use of the *Runnable* interface enables the *Hello* class to be treated like any other `Runnable` class, which provides an example of a *LocalInnerClass*, an example of *polymorphism*, and an example of the *factory design pattern*. These object-oriented design concepts are beyond the scope of this subsection.

LocalInnerClass cannot be public, private, protected, or static. Its scope is limited to the life of the enclosing block of code. For example,

```
public class Outer {
   public static class StaticMember {
      public void print() {
         System.out.println( "Hello from inner" );
      }
   }

   public void print() {
         System.out.println( "Hello from Outer");
   }
}
public class StaticMemberTest {
   public static void main( String[] args ) {
      Outer.StaticMember a = new Outer.StaticMember();
   }
}
```

Thus, *StaticMember* class can act just like a regular class, except that its name is nested inside of the name of the containing class. In other words, static classes can be instanced without instancing the *Outer* classes. It also means that static classes populate the package name-space with names like *topLevelClass.StaticInnerClass*, which can be important for the creation of specialty classes designed to support an application. For example,

```
public class Chain {

      public static class Code {
         int direction;
         ChainCode nextChain = null;
         ChainCode previous = null;
      }
}
```

We now can make a new instance of the *ChainCode* class from any package in the system. However, a private, non-static member class would be a better alternative if we wanted to prevent non-*Chain* authors from directly accessing *ChainCode* links (e.g., such authors might break a link in the chain).

12.3 The Anonymous Inner Class

The *anonymous inner class* is a nested class defined within a single expression. These classes are called anonymous because they have no name and no constructor. They can only access *final* method variables and parameters.

These classes are frequently small and locally defined (like inner classes), though they require an internal method to be overridden. The anonymous inner class is the class to have when you are only having one! For example, suppose that an *abstract* class requires a method that returns a customer name. We could create an anonymous instance of the abstract class, if we provide implementations for the abstract methods that the abstract class contains. For example,

```
class Inner {
      public static void main(String args[]) {
        Bank b = new Bank();
        System.out.println(b.getCustomer().getName());
      }
}
class Bank {
      Customer getCustomer() {
        return new Customer() {
           String getName() {
                return "Frank";
           }
        };
      }
}
abstract class Customer {
      abstract String getName();
}
```

When the *Inner* class is run, it prints the customer name, *Frank*.

Thus, methods may be overridden in an anonymous inner implementation of a non-inner class, which enables a design pattern (as of JDK 1.1) called an *adapter*. The adapter pattern has seen increased use in the GUI class libraries, but it can lead to confusing code. It is probably better software engineering practice to limit the use of adapters to small classes. An example adapter follows:

```
public interface Accountable {
      public double getBalance();
      public void setBalance(double d);
}

public class AccountableAdapter implements Accountable {
      public double getBalance(){return 0;};
      public void setBalance(double d){};
}
```

```
public class Customer {
    AccountableAdapter aa
      = new AccountableAdapter() {
        public void setBalance(double d) {
            System.out.println("balance ="+d);
            super.setBalance(d);
        }
    };
}
```

As another example of the anonymous inner class, consider the *MetricFcn* interface:

```
interface MetricFcn {
    double metric2English(double d);
    double english2Metric(double d);
}
```

Normally, we never can make an instance of an interface. However, we can implement the interface using anonymous inner classes, as shown in *Meters2Yards*:

```
public class Meters2Yards {
    static MetricFcn meters2Yards = new MetricFcn() {
        public double metric2English(double d) {
            return d / 1.1;
        }
        public double english2Metric(double d) {
            return d * 1.1;
        }
    };
    public static void main(String args[]) {
        System.out.println("10 meters ="+
            meters2Yards.metric2English(10) + " yards");
    }
}
10 meters =9.09090909090909 yards
```

As another example, consider the *Commando* class, which contains an implementation of the *Command* interface:

```
interface Command {
    public void run();
}
class Commando {
    Command getCommand() {
        return new Command() {
            public void run() {
                System.out.println("hello world!");
            }
        };
    }
    public void doit() {
        getCommand().run();
```

```
        }
      public static void main(String args[]) {
        Commando c = new Commando();
        c.doit();
      }
    }
```

This class outputs

```
    hello world!
```

The *Commando* class provides an example of the *Command pattern*. The Command pattern generally is implemented in several different ways and can address the undo/redo problem (i.e., how do you undo a series of commands, each of which may have been different?). This type of problem is described in more detail in [Gamma et al].

As another example, recall the *LocalInnerClass* of the previous section:

```
    public class LocalInnerClass {
        public static Runnable getRunnable() {
          class Hello implements Runnable {
            public void run() {
                System.out.println("Hello from run!");
            }
          }
          return new Hello();
        }

        public static void main(String args[]) {
          Runnable r = getRunnable();
          r.run();

        }
    }
```

This code can be rewritten to make use of the anonymous inner class:

```
    public class LocalInnerClass {
        public static Runnable getRunnable() {
          class Hello implements Runnable {
            public void run() {
                System.out.println("Hello from run!");
            }
          }
          return new Hello();
        }
        public static Runnable getRunnable2() {
          return new Runnable() {
            public void run() {
                System.out.println("Hello from run!");
            }
          };
        }
```

```
public static void main(String args[]) {
  Runnable r = getRunnable2();
  r.run();

}
}
```

The *getRunnable2* statement works by creating an anonymous inner class, which is not needed anywhere else in the method. If multiple instances of the *Runnable* class had been needed, then *LocalInnerClass* would have been the better approach. The anonymous inner class always can be converted to a *LocalInnerClass*. Converting the *LocalInnerClass* to an anonymous inner class, however, can cause needless code duplication and can make code less readable. The general rule is that anonymous inner classes should be made only when the classes are small.

There is an isomorphic mapping between the anonymous inner class and the instance you make. Thus, there is really a new class that shall remain unnamed (hence anonymous) and whose implementation and member variables are unique.

In summary, the anonymous class is the class to have when your only having one; the member inner class is the class to have when your having more than one.

12.4 The Nested Static Class

A *nested static class* is a named class that is declared as static. It is sometimes also called a *static member class*. This class is the only class that you can declare as static. When you declare a dynamic member class, access is limited to an instance of the outer class. However, static member classes remove this limitation.

A static member class is a nested top-level class. The static inner class only can access static variables and methods unless it is passed a reference to an instance of the enclosing class as a parameter. For example,

```
public class Outer {
    static int x = 2;
    public static class Inner {
        private int x = 5;

        public void setX (int x) {
            this.x = x;
        } // end of method setX

        public void print () {
            System.out.println (" Inner x = " + x);
        } // end of method print|
    } // end of class Inner

    Inner in = new Inner();
    public static void main ( String args[] ) {
        Outer o = new Outer ();
        System.out.println (" Outer x = " + o.x );
        o.in.setX (10 );
        o.in.print ();
    } // end of method main
} // end of class Outer
```

FIGURE 12.4-1

Accessing an *Outer* Class
from an *Inner* Class

```
Outer x = 2
Inner x = 10
```

 The *This* keyword is used by the static inner class to disambiguate references to outer classes members.

As another example, recall the purchasing department and the PO. The business rule said that only the purchasing department could create a PO. As a result, we make the *PurchaseOrder* a named dynamic inner class. If we relax the rule so that anyone can create a *PurchaseOrder*, we make the *PurchaseOrder* class *static*. A modified example follows:

```
public class PurchasingDepartment {
     public static class PurchaseOrder {
     }
}
```

Thus, we have removed the dynamic method *getPurchaseOrder* because the programmer no longer must make an instance of a *PurchasingDepartment*. The visibility of the *PurchaseOrder* constructor is public in scope; in other words, anyone now can make new instances of a *PurchaseOrder*. For example,

```
PurchasingDepartment.PurchaseOrder po = new
        PurchasingDepartment.PurchaseOrder(); // now it works!
```

An interesting variant of the nested static inner class occurs when it appears inside an interface, which allows the interface to contain a reference data type that has an implementation in it. For example,

```
public interface Command {
     public void execute(String s) ;
     public static class Dos implements Command {
      public void execute(String s) {
         // write code to execute a dos command
      }
     }
     public static class Unix implements Command {
      public void execute(String s)  {
         // write code to execute a Unix command
      }
     }
}
```

Now we can get an implementation of a command execution method that is a function of the platform that we are using. For example, if we are on a UNIX platform, then

```
Command c = new Command.Unix();
c.execute("dir");
```

12.5 The Nested Interface

A *nested interface* is a named interface. It is also called an *inner interface*. An inner interface may be declared in a class or another interface. For example,

```java
public class ShapeFactory {
    interface Drawable  {
      public void draw();
    }
    class Circle implements Drawable {
      public void draw() {
      }
    }
    class Square implements Drawable {
      public void draw() {
      }
    }
}
```

In fact, if we want to defer the implementation of the *draw* method (implied by the null bodies in the previous examples), the interfaces can be nested inside interfaces. For example,

```java
public interface ShapeInterface {
    interface Drawable  {
      public void draw();
    }
    interface Circle extends Drawable {
    }
    interface Square extends Drawable {
    }
}
```

We now can implement the interfaces contained in the *ShapeInterface* interface:

```java
public class newSquare implements ShapeInterface.Square {
    public void draw() {
    }
}
```

Top-level interfaces cannot be made private because a private top-level interface would not be visible to other reference data types and therefore could not be implemented. However, *inner* interfaces can be private. For example,

```java
public class InterfaceProtector {
    private interface YouDontGetThisFromOutSideTheClass {
    }
    static class VisibleInPackage
      implements YouDontGetThisFromOutSideTheClass {
    }
}
public class Client {
    InterfaceProtector.VisibleInPackage vip
      = new InterfaceProtector.VisibleInPackage();
}
```

From the *Client* class, we have access to reference data types that have default visibility, but not to data types that have *private* visibility.

12.6 The *This* Keyword

The *This* reference can be used when a reference is required as an argument to a method. For example, the following class supports a print method that enables it to print itself:

```
public class ThisTest {
    public static void main(String args[]) {
      ThisTest tt = new ThisTest();
      tt.print();
    }
    public void print() {
      System.out.println(this);
    }
    public String toString() {
      return "Hello from ThisTest!!";
    }

}
```

The code above will output

```
Hello from ThisTest!!
```

 The *This* reference permits disambiguation between the arguments to a method and the class-member variables.

For example,

```
class Constructor {
    int x,y;
    Constructor(int x, int y) {
      this.x = x; // disambiguate between x and this.x
      this.y = y; // which y is y?
    }
    Constructor() {
      this(10,20); // default values being set with this!
    }
    void print() {
      System.out.println("x,y="+x+","+y);
    }
    public static void main(String args[]) {
      Constructor c = new Constructor();
      c.print();
    }
}
```

In the above example we see that the constructor that takes no arguments, *Constructor()*, invokes the constructor that takes arguments, *Constructor(int x, int y)*, permits a default value to be set for the variables.

The *this* reference permits a class to make a reference to an instance of itself, which can be very useful, particularly when working with the *Inner* class. For example,

```
class Outer {
    int x=10;
```

```
          Inner i = new Inner();
          public static void main(String args[]) {
            Outer o = new Outer();
            o.i.print();
          }
          class Inner {
            int x=20;
            void print() {
              System.out.println("inner x= "+x);
              System.out.println("outer x= "+Outer.this.x);
            }
          }
      }
```

will print

```
    inner x= 20
    outer x= 10
```

Thus, the usage of the *This* reference in *Outer.this* permits a reference to the instance variable in the *Outer* class from within the *Inner* class.

12.7 Summary

In this chapter we saw five kinds of nested reference data types:

1. the *member inner class*, (a nested class defined at the top-level of an outer class)
2. the *local inner class,* (a nested class defined within a method)
3. the *anonymous inner class*, (a nested class defined within an expression)
4. the *nested static class* (a static member inner class) and
5. the *nested interface*.

We also learned several rules that govern the use of these data types:

1. Non-static inner classes are always allocated dynamically.
2. Instances of inner classes are available externally.
3. You cannot make a new instance of a dynamic inner class externally.
4. Static inner classes can have their static methods directly invoked.
5. Dynamic inner class duration is temporary.
6. Dynamic inner classes are scoped locally.
7. Static inner classes are scoped at the top level.
8. Inner classes may not have static members.
9. An anonymous inner class is the class to have when you only have one.
10. An member inner class is the class to have when you have more than one.
11. Inner reference data types can be private.

We have seen alternative names used for these *Inner* classes. Sometimes they are called *nested* classes: for example, *nested member*, *nested local*, *nested anonymous*, *nested static*, and *nested interface*. Indeed there are too many naming conventions in common usage.

To make it explicit (where it is unclear from the context), the term *non-static* or *dynamic* is suggested as a prefix for the member class that is dynamic. There is no general agreement surrounding inner-class jargon. Some books use the term *nested*, while others use the term *inner*, thus complicating an already complex topic.

With version 1.1 of Java and the introduction of inner classes, Java became more complex. The justification for calling this a minor revision to the language is unclear.

12.8 Exercises

12.1 Write a program that shows an example of each of the five types of inner references.

12.2 Write a program that makes instances of an anonymous inner class and returns it. Where will you define the interface for this class? Can the interface be located inside the containing class, or must it be at the top level? Why?

12.3 Define a member inner class. Why would you want such a class?

12.4 Why would you want a top-level static inner class?

12.5 Why can you not make a new instance of a dynamic inner class externally?

12.6 Why are dynamic inner classes locally scoped?

12.7 Discuss tradeoffs between various inner classes.

12.8 Give a simple example of each inner class.

Threads

Many a false step is made by standing still.

–Chinese Proverb

In this chapter, you will learn about:

- Concurrency
- Multitasking
- Multithreading
- Mutex
- Atomic operations
- Synchronized operations
- Thread groups
- Thread managers

In addition, you will learn how to:

- Make a new thread
- Define the thread lifecycle
- Run multi-threaded queues
- Run thousands of threads
- Use the AWT damage control manager to do multithreading

13.1 Concurrency, Multitasking, and Multithreading

 In operating systems, *concurrency* is equivalent to *parallelism*, which means having more than one thing occur at the same time. True concurrency occurs when you do two or more things at the same time, for example on a network of workstations or on a multi-processor system.

FIGURE 13.1-1
A Multitasking Operating System

Compare true concurrency with *multitasking. Multitasking* (also called *multiprocessing*) means having more than one job (also called a task) to run in order to simulate parallelism. The term *multithreading* means having more than one thread in a single task. Figure 13.1-1 shows a diagram of the various tasks in a multitasking operating system. Each task can have many threads, which all share resources of the parent task. The n used to represent the number of tasks or threads can take on any nonnegative integral value, provided there are enough resources (e.g., memory) to go around.

True concurrency is made possible by making use of more than one CPU. For example, a dual Pentium or a network of workstations can execute instructions in parallel, which is known as true parallelism. While the Java language specification claims that "Threads may be supported by having many hardware processors," few, if any, implementations exist.

- In an operating system, a task is a job.
- A job has its own memory address space, which is called protected memory.
- If one job dies, the other jobs can continue.
- Each job receives some resources according to a program called a scheduler.

Figure 13.1-2 shows an image of a system that uses true concurrency. In the world of computer science, a task is sometimes called a process and sometimes called a job. Sometimes the nomenclature employed is a function of the operating system. For example, MacOS 9 has a *task switcher*. MacOS X adopted, BSD (Berkeley Software Distribution) UNIX nomenclature (favoring the term *process* over the term *task*). Since MacOS X operates MacOS 9 as a process, the MacOS 9 task switcher is still available as a process under UNIX. On Windows NT, the user brings up the task manager by typing <ctrl>-<alt>-.

Such confusion is common in a field with quickly changing technology. As a result, the terms *process, job*, and *task* will all be treated as synonyms. Sometimes a *job* is associated with a batch system, whereas a *task* is associated with a time-share system.

There is no general agreement about the use of the terms *process, task*, and *job*. It is common for these terms to be used interchangeably.

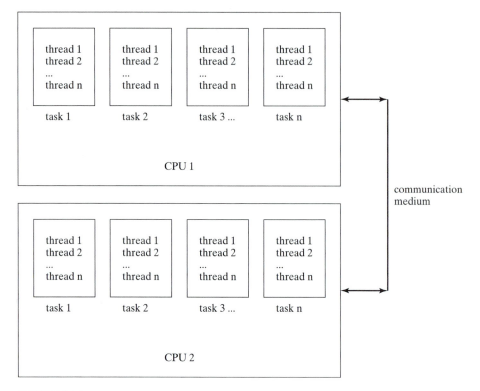

FIGURE 13.1-2
True Concurrency

The communication medium between two computers can be a low-speed serial network or a high-performance bus. Often, specialized architectures make use of shared memory for inter-CPU communications. In fact, computing history is filled with various architectures that enable true concurrency. See <*http://ei.cs.vt.edu/~history/Parallel.html*> for more information about the history of parallel architectures.

 An operating system provides a multitasking service that enables the scheduling of several tasks. Each task is given a priority. A task is run for a *time slice,* stopped, and placed back in a queue, after which times another task is run. Multitasking simulates concurrency on a single CPU, but it is not true concurrency. Each task has its own *protected memory* space; as a result, when a task is started, its memory space must be swapped into the CPU's memory space. Additionally, the memory for the task that was running must be swapped out, which is called *switching the context.* Thus, with multitasking there may be a high-overhead context switch if the amount of memory to be exchanged is large.

 Threads are similar to tasks, though their memory differs. Tasks have protected memory, but threads have *shared memory.* Threads run inside of tasks and share the protected memory in those tasks.

 Shared memory is a good feature because it provides the threads with a low-overhead context switch, relative to tasks. The lower overhead comes from the shared rather than the protected memory in the thread environment.

Shared memory makes the architecture of a multiprocessor implementation of threading more difficult, since CPUs have to share physical memory. When CPUs share physical memory, the speed of the memory and bandwidth of the bus used to transfer the data to and from the CPU must increase as the number of CPUs increases.

WARNING

The shared memory paradigm of parallelism does not scale well in hardware.

Threads also can communicate using message passing. For example, threads communicate via the file system, sockets, or Remote Method Invocation (RMI), which is discussed in Chapter 43. It is generally faster to communicate via shared memory.

Threads and tasks are *abstractions*. One CPU can run only one thing at a time. Multitasking is an operating system service. Multithreading, on the other hand, is either an operating system or a JVM service. Both tasks and threads can be managed with abstract data types called *priority queues*, which are used by programs called *schedulers*.

When multithreading is supported in the operating system, it is called a *kernel* thread. The JVM can use these kernel threads. In such a case, the JVM is supporting *native* threads. The JVM also can simulate the threads using *green* threads, which are generally slower than native threads. To see which version of threading the JVM has, type

```
java -version
```

For example:

```
www.docjava.com{lyon}1: java -version
java version "1.2.2"
Classic VM (build 1.2.2_006, green threads, nojit)
```

WARNING

Green threads typically are slower than native threads.

True concurrency is a topic of current research, particularly when it is applied to creating speedups for a single sequential application.

Figure 13.1-3 shows that the ideal speedup for a sequential program with 10 CPUs is 10. It is rare to see ideal speedups, however, which is due in part to communication overhead between processors.

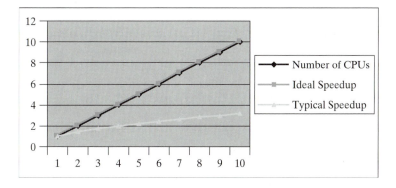

FIGURE 13.1-3

Typical Speedup versus Ideal Speedup

13.2 Making a New Thread

There are two ways to make a new thread: subclass the *Thread* class or pass an instance of a class that implements the *Runnable* interface as a parameter to the constructor.

 Invoking the *start()* method causes a thread to move into the *ready* state. Threads in the *ready* state are queued for execution, but are not yet running.

A new instance of a thread can be made by constructing a thread and passing to it an instance of a class that implements the *Runnable* interface. For example, the *TestThread* class extends the *Thread* class.

```
1.      class TestThread extends Thread {
2.          public void run() {
3.          while (true) {
4.              System.out.println("Priority=\t" +
        getPriority());
5.              System.out.println("toString=\t"+toString());
6.              System.out.println("getName=\t"+ getName());
7.              System.out.println("isDaemon=\t"+isDaemon());
8.              System.out.println("isAlive=\t"+isAlive());
9.              try {Thread.sleep(10000);}
10.             catch (InterruptedException e) {}
11.             }
12.         }
13.     }
```

To run an instance of *TestThread*, you must make an instance of *TestThread* and use this instance as the target of a *start* invocation.

```
TestThread tt = new TestThread();
        tt.start();
```

The following will be printed every 10 seconds at the console:

```
Priority=       5
toString=       Thread[Thread-2,5,main]
getName=        Thread-2
isDaemon=       false
isAlive=    true
```

Line 9 puts the thread to sleep for 10,000 milliseconds (10 seconds). *Thread.sleep* takes a long integer because 32 bits does not have enough range to represent long time periods. For example, there are

$$2^{\log_2(1000*60*60*24t)} = 2^{26}$$

milliseconds in a day. A signed 32-bit integer overflows in

$$2^{31} - 1$$

milliseconds, or 3.5 weeks. A long, 64-bit integer will overflow in 292.4 billion years. The Suns' corona will have engulfed the Earth in only 10 billion years (by which time, this book will be out of print).

The *sleep* method does not need to be invoked within a *run* method. The *Thread.sleep* method throws an *InterruptedException*.

Daemon (the Old English spelling of *demon*) is a term in the operating systems field. Some believe the term stands for "Disk and Execution MONitor." A daemon is a task or a thread that remains idle until an event occurs. Daemon tasks often are left idle on an operating system. For example, MacOS X typically can run with 41 daemon tasks sitting idle. In comparison, it is not uncommon for RedHat Linux to have more than 100 idle tasks.

Java can start daemon threads or tasks. To start tasks, it is typical to use platform-dependent (i.e., non-portable) code. In Java, a daemon thread has a special meaning that comes from the Sun API. In Java, the daemon thread dies when all non-daemon threads die. Before it dies, a daemon is said to be *lurking*. For example, a print spool daemon will wake when it sees a file in its spool directory, print the file, and go back to sleep after all of the files in its spool directory are printed. Typically, UNIX systems run daemon tasks in order to handle requests for services. These tasks typically are started by a single task (called *inetd*). Examples of elements started by *inetd* (or *etc/xinetd.d*) include on RedHat Linux echo daemon that responds to a *ping*. Some examples of daemons are day daemons, time daemons, login daemons, and printing daemons.

The *garbage collector* is a daemon thread, which is a thread that will enable the JVM to exit if only daemon threads are left. If even one non-daemon thread (e.g., a user thread) is active, then exiting out of the main thread will not cause the JVM to exit. To put it another way, when only daemon threads remain in a program, the program exits. Any thread may be set to be a daemon thread by using the *setDaemon(true)* invocation.

13.3 Thread States

Threads are born, threads live, and threads die. This process is called the lifecycle of a thread. The lifecycle of a thread may be described by a finite state machine table, which is shown in Figure 13.3-1. The *Thread* constructor takes an optional argument, which is an instance of a class that implements the *Runnable* interface. The *run* method of the *Runnable* interface provides the *scheduler* with a call-back method so that the thread can be restarted.

Figure 13.3-2 shows a simplified version of the finite state machine that describes thread operations.

 Finite state machines are discussed in Appendix F.

A blocked thread can be restarted by invoking the *notify* method, which is defined in the *Object* class. The *notify* method is used to notify an object of a change in condition. The

Present State	Next State	Input
new		Thread t = new Thread(runnableInstance);
new	ready	t.start()
ready	running	t.run() // invoked by thread scheduler
running	blocked	Thread.sleep()
running	blocked	Thread.wait()
running	blocked	waiting for IO
blocked	ready	t.notify()
running	dead	end of the run method reached

FIGURE 13.3-1
The Finite State Machine Table for Threads

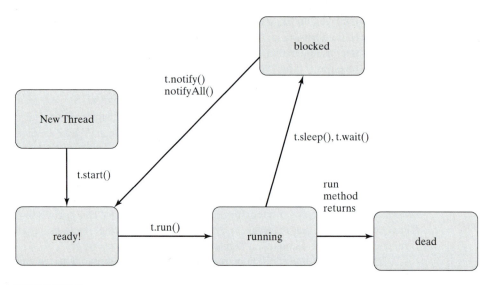

FIGURE 13.3-2

The Lifecycle of a Thread

methods *wait*, *notify*, and *notifyAll* are methods defined in the *Object* class. The *wait* method causes the thread of execution to block execution until its *notify* method is invoked by another thread. The *wait* method can take three forms:

```
wait();
wait(long milliseconds);
wait(long milliseconds, int nanoseconds);
```

For example, suppose you are writing a program that is waiting for a computation to finish. You invoke the *wait* method and give yourself a reference to the instance of the class that is to perform the computation. When the computation is complete, the caller's *notify* method is invoked, which creates a wake up condition that enables the caller to continue. The *notifyAll* method notifies all of the waiting threads to wake up.

As another example, consider a server in a doughnut shop. You walk in and notice a line. A list of numbers is posted. You want to order, but instead you take a number (thus placing a reference to yourself on a list of people waiting for service). While you *wait* for your number to be called (i.e., you wait for a *notify*), you start the process of browsing for pastry items. Finally, your number is called (you receive the *notify*). Now you restart the service request, communicate with the notifier, and continue the process of placing your order. Thus, the wait-notify pattern is excellent when you need to put a computation on hold while performing another task.

The input to an instance of a thread can come from a static method invocation that implicitly controls a state transition in the current thread. For example,

```
Thread.sleep(long ms) throws InterruptedException
```

will place the current thread to sleep for at least *ms* milliseconds. If the current thread dominates the CPU, the multithreaded system may not be able to permit other threads to run (i.e., their execution may become blocked). Sometimes a thread can consume too much

CPU time, causing *thread starvation* (i.e., threads that never have a chance to execute). To solve this thread starvation problem, it is good practice to invoke

```
Thread.yield();
```

It is typical to invoke *Thread.yield* inside of the *run* method of a class that implements *Runnable*. Doing so allows other threads a chance to execute.

13.4 The Synchronized Methods and Too Much Beer

Consider the math major who comes home to study. The student finds that there is no beer, though he requires beer in order to study. After going to the store and buying beer, he returns to find that his roommate has already bought more beer. Now there is too much beer (oh, no!) and they party rather than study. Moral of the story: never drink and derive.

Key to the goal of having just the right amount of beer is a mechanism for communication. We would like only one roommate at a time to be able to be engaged in the beer-buying process. Accordingly a mechanism called *mutual exclusion* is used to prevent two roommates from shopping for beer at the same time. In operating systems, such a feature is called a mutual exclusion (*mutex*).

LANGUAGE REFERENCE SUMMARY
A synchronized statement can be written as the term *synchronized* followed by a '(' an expression a 'j' and a statement. Synchronized methods can be written by the term *synchronized* followed by a method declaration.

In Java, the mutex feature can be implemented using the language feature *synchronized*, which also can be used to make sure that a method contained within a thread is executed *atomically*. Atomic operations appear to happen all at once as such, *synchronized* methods cannot be interrupted by other threads. To put it another way, *synchronized* methods prevent other threads from running. Threading is a part of the *java.lang* package. Thus, threads are available without having to perform an import. The thread class hierarchy is shown in Figure 13.4-1.

The *synchronized* methods allow only one thread to access data at a time, which can prevent data corruption.

The *synchronized* methods can prevent race conditions. However, deadlock still can occur.

The synchronized accessor methods can assure us of atomic access. Additionally, we can wrapper reference variables with the *synchronized* keyword so that they can be accessed atomically. Without atomic behavior, we can get unpredictable results that arise from a *race condition*.

FIGURE 13.4-1

The *Thread* Class Hierarchy

Race conditions occur when two or more threads try to access the same memory at the same time.

The *synchronized* keyword may be applied to any reference data type. For example, suppose several threads are trying to perform an output operation to the *PrintStream* instance contained in the *System* class (i.e., *System.out*). If the threads all output to *System.out* asynchronously, with respect to one another, then they will tend to overwrite one another, thus intermixing each others' output. The solution is to place a *lock* on the *System.out* resource using *synchronized*. The code will have the form

```
synchronized(System.out) {
        System.out.println(...);
...
}
```

As another example, suppose that we are programming a banking system. When someone adds money to the bank, we execute

```
public void addMoney(BankAccount ba, double dollars) {
        System.out.println("this is going to lock the account");
        synchronized(ba) {
          ba.addMoney(dollars);
        }
        System.out.println("the lock is released");
}
```

The lock implements a form of mutex. Should the resource that is locked become unavailable (or blocked), it then becomes a single point of failure. Imagine if such a single point of failure existed in a mission-critical subsystem (like the communications port between the tail-section and cockpit of an air frame). All threads that depend on the correct operation of the port would become *deadlocked*. The deadlock condition occurs when two or more threads are unable to make progress due to a dependency on an unavailable resource.

To implement atomic execution on a block of code, consider making the entire method *synchronized*.

For example,

```
1.      class Animation implements Runnable {
2.      public void synchronized run() {
3.      ....
4.        try {
5.              Thread.wait();
6.        }
7.        catch (InterruptedException e) {
8.              ....
9.        }
10.     }
11.     }
```

Line number 5 is used to give other threads a chance to run. During the execution of the *run* method, no other threads may be run. It is important that other threads be given a chance to run so that the system still can have some response to user input.

It is also possible to synchronize on the current instance. For example,

```
synchronized(this) {
        . . . . .
}
```

Synchronizing on the current instance is considered less clear than synchronizing at the method level [Campione and Walrath].

13.5 Thread Groups

Threads belong to *thread groups,* which are arranged in a thread group hierarchy. The root of the hierarchy is the *SystemThreadGroup. SystemThreadGroup* is thus the primordial thread and has five subthreads:

- Main group (where your *main* runs)
- Garbage collector (daemon thread)
- Clock handler (daemon thread)
- Idle thread (daemon thread)
- Finalizer thread (daemon thread)

As windows are started, new threads are added to the *Main* group. The *Main* group is a child of the *SystemThreadGroup* and has a default thread that starts at the *main ()* method. Main group threads include the *AWT-Input* thread, *AWT-Toolkit* thread, and *ScreenUpdater* thread.

The relationship between the *SystemThreadGroup* and the default threads and groups is shown in Figure 13.5-1. The *clock handler* thread manages timer events. The *idle* thread lets the garbage collector know when it is time to take out the trash. It is run when the other threads are blocked. The *garbage collector* thread scans for unused instances. The finalizer thread invokes *finalize* on objects freed by garbage collection [Oaks].

People interested in deterministic performance from an embedded system will be tempted to stop the garbage collector. However stopping the garbage collector can lead to the death of the JVM.

FIGURE 13.5-1
Default Threads and Groups

13.6 The Thread Manager

This section shows how to write a program that will enable the display of the various
threads running on a system. One procedure is to list the children of the
SystemThreadGroup. Another is to obtain a reference to the current thread and then traverse
the thread hierarchy until the parent has a *null* reference. To obtain a reference to the current
thread, use

```
Thread t = Thread.currentThread();
```

To obtain a reference to the current thread group, use

```
ThreadGroup tg = Thread.currentThread().getThreadGroup();
```

The following method returns the *SystemThreadGroup* :

```
public ThreadGroup getSystemThreadGroup() {

        ThreadGroup systemThreadGroup;
        ThreadGroup parentThreadGroup;

        systemThreadGroup =
          Thread.currentThread().getThreadGroup();

        while ( ( parentThreadGroup =
        systemThreadGroup.getParent()) != null)
          systemThreadGroup = parentThreadGroup;

        return systemThreadGroup;
}
```

The following code returns an array of all of the groups in the system. The number of
groups is increased by one so that the root group may be added onto the end of the array:

```
1.      public ThreadGroup[] getThreadGroupsArray() {
2.        ThreadGroup systemThreadGroup = getSystemThreadGroup();
3.        int numberOfGroups =
             systemThreadGroup.activeGroupCount() +1;
4.        ThreadGroup threadGroupsArray[] =
5.          new ThreadGroup[numberOfGroups];
6.        systemThreadGroup.enumerate(threadGroupsArray);
7.        threadGroupsArray[numberOfGroups] = systemThreadGroup;
8.        return threadGroupsArray;
9.      }
```

When *group_instance.enumerate(ThreadGroup list[])* is called, all of the thread group
instances and their descendants are placed into the list. It does not include the
group_instance itself, however, which is why it is added to the end of the array on line 7.

Another form of enumerate, *group_instance.enumerate(Thread list[])*, is associated
with a thread instance. This form returns an array of threads in this thread group and all de-
scendant thread groups. For example,

```
java.lang.ThreadGroup[name=system,maxpri=10]
    Thread[Finalizer thread,1,system]
    Thread[Idle thread,1,system]
    java.lang.ThreadGroup[name=main,maxpri=10]
```

```
                    Thread[main,5,main]
                    Thread[Thread-2,5,main]
                    Thread[AWT-macos,5,main]
                    Thread[Thread-3,5,main]
                    Thread[Image Fetcher 0,8,main]
                    Thread[Image Fetcher 1,8,main]
                    Thread[Image Fetcher 2,8,main]
                    Thread[Image Fetcher 3,8,main]
                    Thread[Screen Updater,4,main]
                    Thread[Audio Player,10,main]
```

The entire thread, called RaceThread, appears below:

```
class RaceThread extends Thread {

        public void run() {
        while (true) {
                printThreadGroups();
                try {Thread.sleep(10000);}
                catch (InterruptedException e) {}

                }
        }
```

13.7 ThreadUtil

ThreadUtil simplifies the API by making it less general and thus a little easier for the novice thread programmer. The source code for *ThreadUtil* follows:

```
public class ThreadUtil {
        public static ThreadGroup
          getSystemThreadGroup() {
          ThreadGroup systemThreadGroup;
          ThreadGroup parentThreadGroup;
          systemThreadGroup =
            Thread.currentThread().getThreadGroup();
          while (
            (parentThreadGroup
                    =systemThreadGroup.getParent()) != null)
                systemThreadGroup =
                    parentThreadGroup;
            return systemThreadGroup;
        }
        public static void
          printSystemThreadGroup() {
            System.out.println(
                getSystemThreadGroup()
            );
        }
        public static Thread getThread() {
         return new Thread(new Job());
        // the Job class is defined in section 13.7.
        }
```

```java
public static Thread[] getThreads(int n) {
  Thread ta [] = new Thread[n];
  for (int i=0; i < ta.length; i++) {
    ta[i] =  getThread();
    ta[i].start();
  }
  return ta;
}
public static ThreadGroup[]
  getThreadGroups() {
  ThreadGroup
    stg =
        getSystemThreadGroup();
  int nog =
    stg.activeGroupCount()+1;
  ThreadGroup tga[]
    = new ThreadGroup[nog];
  stg.enumerate(tga);
  tga[tga.length - 1]=
    stg;
  return tga;
}
public static void
  print(Object o[]) {
  for (int i=0; i <o.length;i++)
    System.out.println(o[i]);
}
public static void
  print(Thread o[]) {
  for (int i=0; i <o.length;i++)
    System.out.println(o[i]+
        " isAlive="+
        o[i].isAlive()+
        " name="+
        o[i].getName()+
        " isDaemon="+
        o[i].isDaemon());
}
public static Thread[]
  getThreads() {
  ThreadGroup
    stg =
        getSystemThreadGroup();
  Thread ta[] =
    new Thread[stg.activeCount()];
  stg.enumerate(ta,true);
  return ta;

}
public static void
  setPriority(Thread ta[],int p) {
```

```
        for (int i=0; i < ta.length; i++)
            ta[i].setPriority(p);
    }
    public static void
    setName(Thread ta[],
            String n) {
        for (int i=0; i < ta.length; i++)
            ta[i].setName(n);
    }

    public static void main(String args[]) {
        System.out.println(
            "Hello Thread!!!" );
        Thread ta[]
            = getThreads();
        print(ta);
        setPriority(ta,10);
        print(ta);
        setName(ta,"J Doe");
        print(ta);
    }
}
```

Figure 13.7-1 shows the output from creating the array, *ta*, of threads using *getThreads()*.
These are default threads in the system, since *getThreads()* does not create any threads.
These threads are persistent, and their purpose is not well documented. In addition, these
threads are not present in all versions of the JVM.

FIGURE 13.7-1

Threads Found on the Windows Version of JDK 1.2.2

From the names, we can guess how some of the threads are used. The six threads are Signal dispatcher, Reference Handler, Finalizer, main, SymcJIT-Lazy *Compilation-()*, and SymcJIT-Lazy *Compilation*.

Signal dispatcher might be a clock thread, an idle thread, both, or neither. Little documentation is available on this topic so its use is not clear. *Reference Handler* might be the garbage collector thread. *Finalizer* is clearly the finalizer thread, and the *main* thread probably is associated with the *Main group*. In addition all except main are daemon threads. The first three are identified as system threads, while the last three are identified as main threads; however, the meaning of this identification is not clear. One theory is that the Just-in-Time (JIT) compiler is being run as a thread in the main thread group.

Figure 13.7-2 shows the output when the priority of 10 is set for the threads. The same six threads are printed, first with default priorities and a second time with all their priorities changed to 10.

Figure 13.7-3 shows the output when the *setName* method is used. The printout resulting from *setName* augments the printout from Figure 13.7-2. Now the six threads have the names and priorities supplied by the program.

Figure 13.7-4 replaces *getThreads()* with *getThreads(3)* to create *Job* threads. The infinite loop was stopped to show the output at a particular time. In this case, the system threads were not obtained; and the three threads are instead main threads with default names: *Thread-0*, *Thread-1*, and *Thread-2*. It is not clear why the main threads print before the threads start, however all three start before their priorities can be changed to 10. In addition, their names are changed before they can be run again. The times shown say that they are all sleeping for a different amount of time.

FIGURE 13.7-2
Changing Thread Priorities

FIGURE 13.7-3

Setting Thread Names and Priorities

FIGURE 13.7-4

Launching Several Threads from the Main Group

Figure 13.7-5 shows the output with all of the print statements removed from the program. The threads are running with their random sleeping periods, and the printing is done in the *Job* class.

The code for the *Job* class follows:

```java
public class Job implements Runnable {
    static int  totalNumberOfJobs = 0;
    int jobNumber = 0;
    Job() {
      jobNumber = totalNumberOfJobs;
      totalNumberOfJobs++;
    }
    public void run() {
      while (true) {
        System.out.println(
            "t#="+jobNumber+" "+
            new java.util.Date());
        try {
            Thread.sleep(
            (int)(Math.random()*10000));
        }
        catch(InterruptedException e) {}
      }
    }
}
```

FIGURE 13.7-5

Job Thread Output

13.8 ThreadQueue

In the following example, we create a producer-consumer who uses a queue that provides asynchronous notification of the consumer thread when data becomes available:

```java
public class ThreadQueue {
        private static final int queue_size = 10;
        private Object[] queue =
          new Object [queue_size];

        private int head = 0;
        private int tail = 0;

        synchronized public void
          enqueue(Object item) {
          ++head;
          int i =  head % queue_size;
          queue[i]=item;
          this.notify();
        }

        synchronized public Object  dequeue() {
          try {
            while (head == tail) {
                  this.wait();
            }
          }
          catch (InterruptedException e) {
            return null;
          }
          return queue[+++tail % queue_size];
        }

        public static void main(String args[]) {
          ThreadQueue tq
            = new ThreadQueue ();
          tq.enqueue(tq);
          tq.enqueue(tq);
          System.out.println(tq);
          System.out.println(tq.dequeue());

        }
}
public class Consumer implements Runnable {
        ThreadQueue tq;
        Consumer(ThreadQueue _tq) {
          tq = _tq;
        }
        public void run() {
          while (true) {
            System.out.println(
                  (String)tq.dequeue());
          }
        }
}
```

```
public class Producer {
    public static void main(String args[]) {
    ThreadQueue tq =
      new ThreadQueue ();
      Thread ct = new Thread(new Consumer(tq));
      Producer p = new Producer();
      ct.start();
      tq.enqueue("This is my first entry");
      tq.enqueue("This is my second entry");
      tq.enqueue("This is my third entry");
    }
}
```

13.9 Running Thousands of Threads

The following example runs thousands of threads:

```
public class ThreadTest
        implements Runnable {
  Thread t = new Thread(this);
  int threadTestNumber = 0;
  public static int n=1000;

  ThreadTest() {
      t.start();
      threadTestNumber = n;
      n++;
}
  public void sleep(long time) {
      try {
        Thread.sleep(time);
      }
      catch(InterruptedException e) {
        System.out.println(e);
      }
}
  public void run() {
    while (true) {
      synchronized(System.out) {
      System.out.println(
              (
        threadTestNumber+":"+
          new java.util.Date()).toString());
        }
       sleep((int)(Math.random()*1000));
      }
  }
  public static void main(String args[]) {
      for (int i=0; i < 9000; i++)
        new ThreadTest();
  }
}
```

```
// And here is another example...
public class Count implements Runnable {
    public static int n = 0;
    int tn = n;
    Count() {
      tn = n;
      n++;
    }
      public void run(){
        for (int i=0; i < 10; i++)
          System.out.print(i);
        System.out.println("thread#="+tn+" is am done");
        }
    }
}
public class MCP {
        Thread ta[] = new Thread[10000];
        public static void main(String args[]) {
          new MCP();
        }
        MCP() {
          try {
          for (int i=0 ; i < ta.length; i++) {
            ta[i]=new Thread(new Count());
            ta[i].start();
          }
          }
          catch(Exception e) {}
        }
}
public class Hello implements Runnable {
        Thread t = new Thread(this);
        Hello() {
          t.start();
        }
        public static void main(String args[]) {
          new Hello();
        }
        public void run() {
          System.out.println("hello world");
        }
}
```

13.10 The Job Thread

This section shows how a detached *Job* can be launched to run a method every few seconds. The *Hello* class illustrates a usage of the *Job* class. Every two seconds, the phrase "Hello World!" is printed. The creation of the new *Job* instance requires definition of a *doProcess* method, which is an anonymous inner class that makes reference to an outer class method *print*. For example,

```
class Hello {
     private void print() {
       System.out.println("Hello World!");
     }
     Job j = new Job(2) {
       public void doProcess() {
         print();
       }
     };
     public static void main(String args[]) {
       new Hello();
     }
}
```

The *Job* class takes care of the details of keeping a reference to the thread. For example,

```
public abstract class Job
        implements Runnable {
        long st = 1000;
        Thread t = new Thread(this);
        public Job (double i) {
          st = (long)(i * 1000);
          t.start();
        }

        public abstract void doProcess();

        public void run() {
          while (true) {
            try {
                doProcess();
                Thread.sleep(st);
            }
            catch(InterruptedException e) {
            }
          }
        }
}
```

DESIGN PATTERN
Building jobs that know how to run themselves is an example of the *Command pattern*. In the Command pattern, you encapsulate a request within an instance.

13.11 Summary

This section gave a brief introduction to multithreading. Generally speaking, a course in operating systems is needed in order to provide a more thorough introduction. As such, many of the problems with threads have not been addressed.

For example, *deadlocks* occur when two or more threads are waiting for each other and thus are stalled. Sometimes it is important for a supervisor thread to run on a system that monitors the progress of other threads. When no progress is being made, a policy can be used to help break the deadlock. For example, when the user brings up the Task Manager in Windows NT, deadlocked tasks can be killed by explicit user invocation.

In addition, subclasses can override synchronized methods with unsynchronized methods. To prevent such an override, you should declare the method as *final*.

Synchronized methods have a cost, both in CPU time and in memory. One thread can have many locks, and the JVM does not track the order in which threads attempt to access a locked object. You may want to write your own thread scheduler to perform such tracking.

Finally, the expiration of a sleep time guarantees that a thread will be ready to run, not that it actually will run.

1. Deadlocks occur when two or more threads are waiting for each other and thus are stalled.
2. Subclasses can override synchronized methods with unsynchronized methods.
3. Synchronized methods have a cost in CPU time and memory.
4. Nonlocal synchronized references can provide a lock.
5. One thread can have many locks.
6. The *suspend* and *resume* methods do not release locks.
7. The *stop* method is now deprecated (setting instances to null is used instead).
8. The *resume* method is now deprecated.
9. A flag in the *run* method is used to stop a thread.
10. Default priority for a thread is inherited by the creator.

13.12 Exercises

13.1 Explain why deadlock occurs even if you use a *synchronized* block of code.

13.2 Draw a flowchart to show the finite state machine of Figure 13.3-2.

13.3 Draw a finite state machine diagram to show the states and transitions in Figure 13.3-2. See Appendix F for a description of finite state machine diagrams.

13.4 What are the three reasons for entering a blocked state? Under what conditions can the flow of control normally leave the blocked state?

13.5 What is the difference between multitasking and multithreading?

13.6 What is the reason for invoking *yield*?

13.7 Give an example of how deadlock might occur in a Java thread.

13.8 Threads have a minimum priority and a maximum priority, which are stored in *Thread.MAXIMUM_PRIORITY* and *Thread.MINIMUM_PRIORITY*. A higher priority number tends to permit a thread to obtain more CPU resources than threads with lower priority. Priority is set using *setPriority* and is obtained using *getPriority*. Write a GUI that permits you to set and get the daemon and priority attributes for all of the threads in the JVM. The *ThreadUtil* class may provide some help.

13.9 Replace the *Object[] queue* of the *ThreadQueue* in Section 13.8 with a *java.util.Vector*. What are the advantages of using a *vector*?

13.10 Define *signal dispatcher*. Why do you need one?

13.11 What is a reference handler? When is it used?

13.12 What is a daemon thread? When do daemon threads die in Java?

13.13 Given the following code,
```
Thread t = new Thread();
```
a) Is *t* in a runnable state?

b) Is *t* of known priority?

13.14 Modify the *Job* class in Section 13.10 so that the thread runs as a daemon with a default low priority. Write the accessor methods needed to set and get the priority of the internally held thread.

13.15 What is thrashing, and why don't threads thrash?

CHAPTER 14

Files

In this chapter, you will learn about:

- The definition of a file
- The *File* API
- Getting a file
- Batch file processing

In the first section, we will learn about files and the *File* class. The *File* class is used when doing anything with files in Java. We also will learn how to use an elementary GUI in order to prompt the user for a file name. We then will learn how to create a *FileNameFilter* interface. Finally, we will learn how to list all of the files in a directory.

14.1 What are Files?

A computer file consists of a series of data bits that are stored in some media. Files can be stored on disk, in temporary memory (called a RAM disk), on magnetic tape, on a CD-ROM, on paper tape, on punch cards, and so forth. In short, any media that can store data can be used to store a file. Files typically retain data after a program terminates.

Files can be used both for input and output data. In fact, many data processing programs serve only to input and output data from and to files. A *file system* generally is used to organize a variety of files around a tree structure. Often this structure is expressed as a hierarchy of file folders or directories. A *fully qualified file name* generally can take the form of a list of containing directories that terminated in a file name. For example,

```
/home/lyon/.cshrc
```

Thus the *home* directory contains a *lyon* directory that, in turn, contains a file called *.cshrc*. The '/' is called the path name separator. It is often operating system specific. For example, on Windows a backslash (i.e., '\') is used as a path separator, as in

```
c:\lyon\HelloWorld.java
```

An *absolute path name* that starts from the root directory (e.g., c: or */home*) and uniquely locates a file. A *relative path name* starts from some given present directory and then proceeds through subdirectories. DOS programmers must be careful with path names because '\' is treated as an escape character in a string. Thus, a file name like

```
String s1 = "c:\autoexec.bat";
```

must be written as

```
String s1 = "c:\\autoexec.bat";
```

In Java, files are manipulated using the *File* class. The following section shows how to prompt the user for a file name.

14.2 Getting a File from the User

It is bad practice to embed a file name in a Java program. Such references often need to be updated when the program moves. As a result, programs with embedded file names tend to be fragile (e.g., simple relocations can break the program).

One way to deal with this issue is to build a GUI that prompts the user for a file name. In order to do this, we must learn about how to build GUIs (a topic discussed in Chapter 18). Thus, in this section, we show how to use an API that was built for the book in the file utilities (*futils*) package, which contains the file utilities that are needed to prompt the user for a file name. You can use the *futils* package without understanding how to build GUI code. To learn how *futils* was implemented, see Chapter 18.

14.2.1 Futil.getDirFile

This section describes several helper methods in the *futils* package. This package contains a *Futil* class and is used as a primary means of providing file utilities.

The *Futil* class contains a series of static methods that prompt a user for a file. Typically, these methods can be used from any place in a program and provide a central point for getting a file.

The *File* instance that is returned can be used for several types of data processing applications. For example,

```
File f = Futil.getDirFile("select a file");
```

Having all of the GUI code in a single place simplifies maintenance.

14.2.2 Futil.getReadFile

Futil.getReadFile is a static method that creates a file open dialog box, which is used by the user to select a file. Once the file is selected, the *Futil.getReadFile* returns an instance of a *File*. Typically, a programmer would prompt the user to select a file by using

```
File inputFile =
        Futil.getReadFile("select the employee database");
```

STYLE POINT It is generally a good idea to wrapper API-specific code in order to simplify your program and make it more portable.

14.2.3 Futil.getWriteFile

To get a file, use

```
File f = Futil.getWriteFile("please select a file");
```

An image of the Swing file dialog appears in Figure 14.2.3-1.

FIGURE 14.2.3-1
The Swing Dialog

14.3 The File Class

The *File* class resides in the *java.io* package. An instance of the *File* class keeps track of several file-related properties including a path to the file, information on whether the path is relative or absolute, and a series of static constants that indicate the path separator. Unfortunately, on some systems (e.g., DOS and Windows,) the path-name separator is represented by a backslash, '\', whereas on other systems (e.g., Macintosh and UNIX variants) the path-name separator is represented by a forward slash, '/'.

Never assume that you know the path separator on your system. Such assumptions may make your code non-portable.

The *File* class makes use of the *FilenameFilter* instance, which is introduced in the following section on *FilenameFilter*.

14.3.1 File Class Summary

```
public class File {
    public static final String separator
    public static final char separatorChar
    public static final String pathSeparator
    public static final char pathSeparatorChar
    public File(String path)  public File(String path, String name)
    public File(File dir, String name)
    public String getName()
    public String getPath()
    public String getAbsolutePath()
    public String getParent()
    public boolean exists()
    public boolean canWrite()
    public boolean canRead()
    public boolean isFile()
    public boolean isDirectory()
    public native boolean isAbsolute();
    public long lastModified()
    public long length()
    public boolean mkdir()
    public boolean renameTo(File dest)
    public boolean mkdirs()
    public String[] list()
    public String[] list(FilenameFilter filter)
    public boolean delete()
    public int hashCode()
    public boolean equals(Object obj)
    public String toString()
}
```

14.3.2 File Class Usage

Suppose the following variables are predefined:

```
String absPath = Futil.getReadFileName();
// The fileName is relative and
```

```
                 // does not include absPath
                 String fileName;
                 String dirName; // absolute path to directory
                 File dirFile; // dir File instance
                 File destFile; // a destination file
                 boolean aboolean, successful;
                 int i;
                 long timeInMilliseconds; // relative time.
                 long bytes; // size of the file
                 String path; // relative or absolute
                 String fileNames[];
                 FileNameFilter filter;
```

To make an instance of the File class, type

```
                 file = new File(absPath);
                 file = new File(dirName,fileName);
                 file = new File(dirFile,fileName);
                 fileName = file.getName();
                 file = new File("mickey mouse is my hero");
                 //file instances are not the same things as files.
```

To get the path to the file, use

```
                 path = file.getPath();
```

To get the absolute path to the file, use

```
                 absPath = file.getAbsolutePath();
```

To get the name of the parent directory, use

```
                 dirName = file.getParent();
```

To see if a file exists, use

```
                 aboolean = file.exists();
```

To see if a file is writable, use

```
                 aboolean = file.canWrite();
```

To see if a file is readable, use

```
                 aboolean = file.canRead();
```

To see if a *File* instance is a file or a directory, use

```
                 aboolean = file.isFile();
                 aboolean = file.isDirectory();
```

To see if *getPath* is relative, use

```
                 aboolean = file.isAbsolute();
```

To get the relative time since modification, use

```
timeInMilliseconds = file.lastModified();
```

To get the size of the file in bytes, use

```
bytes = file.length();
```

To invoke mkdir and return true if successful, use

```
successful = file.mkdir();
```

To rename to a destination file, use

```
successful = file.renameTo(destFile);
```

To make all directories in this path, use

```
successful = file.mkdirs();
```

To list the files in a directory, use

```
fileNames = file.list();
```

To use a filter to list the files in a directory, use

```
fileNames = file.list(filter);
```

To delete a file, use

```
success = file.delete();
```

To compute a hash code, use

```
i = file.hashCode();
```

To see if two files are equal, use

```
aboolean = file.equals(destFile);
```

To get the path string, use

```
path = file.toString();
```

14.4 The *java.io.FilenameFilter* Interface

FilenameFilter is an interface that resides in the *java.io* package and requires an *accept* method to be implemented. Once the *FilenameFilter* instance is created, it may be

passed to utilities that use the accept method to determine if a file name should be allowed on a list.

14.4.1 FilenameFilter Interface Summary

```
public interface FilenameFilter
    boolean accept(File dir, String name);
}
```

14.4.2 FilenameFilter Interface Usage

The best way to illustrate the usage of the *FilenameFilter* interface is to show some examples taken from the *futils* package.

Keeping file names in *File* instances is very efficient. However, there are reasons for maintaining lists of files in an array of string. Such maintenance is particularly efficient when attempting to trade space for time. For example, the storage of a string instance is based on a dictionary that assumes the string is immutable, which permits the reuse of strings. Therefore, redundancy in absolute path name storage should not be too memory inefficient, since the string storage facility has been highly optimized. By emphasizing the storage of absolute path names in string instances, we have gained a space efficiency.

14.4.3 DirFilter

DirFilter resides in the *futils* package. It takes a file name and returns true if the file is a directory. It does this by first making an instance of the *File* class, using the file name, and then targeting the instance with an *isDirectory()* invocation.

The *FilenameFilter* interface resides in the *java.io* package and requires an *accept* method. The filter is used to control the formulation of a file subset. The following example, *getDirFiles*, lists all of the directories that are co-located with that start file and returns these directories as an array of *File* types:

```
package futils;

import java.io.File;
import java.io.FilenameFilter;

public class DirFilter implements FilenameFilter {
        public boolean accept(File dir, String name) {
        return new File(dir, name).isDirectory();
   }
   public static File[] getDirFiles() {
        File f = Futil.getReadDirFile("select a file");
        return f.listFiles(new DirFilter());
   }
   // Test the DirFilter:
   public static void main(String args[]) {
        File dirs [] = getDirFiles();
        System.out.println("These are just dirs:");
        for (int i=0; i < dirs.length; i++)
          System.out.println(dirs[i]);
   }
}
```

14.4.4 The FileFilter Class

There is a *FileFilter* interface in the *java.io* package. The *FileFilter* class accepts any element that is a file. On the other hand, if you implement the *FileFilter* interface, then you must provide an implement for the *accept* method:

```
public interface FileFilter {

    boolean accept(File pathname);

}
```

The *FileFilter* class, just like the *DirFilter* class, is used to determine if the dir + name constitutes a valid file by creating a temporary *File* instance. The *FileFilter* code follows:

```
package futils;
import java.io.*;
import java.util.*;

public class FileFilter implements FilenameFilter {
        public boolean accept(File dir, String name) {
          return new File(dir, name).isFile();
        }
}
```

Recursive code can be easier to read and write, but can also be less efficient than iterative code.

The *FileFilter* class only accepts a *file* instance if it corresponds to file. In the following code, we list all of the files in a given directory using recursion:

```
package futils;

import java.io.File;
import java.util.Vector;

// futils.FileList

public class FileList {

  // This vector will hold all the file names.
  private static Vector v = new Vector();

  public static File[] getFiles() {
    File f[] = new File[v.size()];
    v.copyInto(f);
    return f;
  }

  // Recurse through all subdirectories and store
  // all the file names in a vector.
  public static void list(File f) {

    add(f.listFiles(new FileFilter()));
    String dirs[] = f.list(new DirFilter());

    if (dirs == null) return;

    for (int i = 0; i < dirs.length; i++) {
      list(new File(f, dirs[i]));
```

```
      }
    }
    private static void add(File f[]) {
      if (f != null) {
        for (int i = 0; i < f.length; i++)
          v.addElement(f[i]);
      }
    }
    public static void print() {
      int VectorSize = v.size();
      for (int i = 0; i < VectorSize; i++)
        System.out.println(v.elementAt(i));
    }
    public static void main(String args[]) {
        File f =
            Futil.getReadDirFile(
                "select a start file");
                list(f);
                print();
                System.out.println(
                    "-----------------------");
                System.out.println(
                    "Total number of files = "
                    + v.size());
    }
}
```

14.4.5 The WildFilter Class

The *WildFilter* class accepts a file only if its name ends with a given suffix, which is defined via the constructor. For example,

```
package futils;
import java.io.*;
import java.util.*;
public class WildFilter implements FilenameFilter {
    private String suffix;
    public WildFilter (String suffix_) {
      suffix = suffix_;
    }
    public boolean accept(File dir, String name) {

      return name.endsWith(suffix);
    }
}
```

14.5 The *Ls* Class

The *Ls* class is designed to process lists of files, such as the *ls* command in UNIX. This class is able to get lists of files based on *wild cards*. For example, in UNIX, if you type

```
ls *.zip
```

all of the files that end with *.zip* will be listed. The *Ls* class returns the list of file instances as an array. Another feature is that we can traverse the file system into all of the subdirectories, thus making Java a full-featured, object-oriented batch file processing tool.

14.5.1 Ls.getWildNames

Ls.getWildNames is a static method that requires the user to select a file via a dialog box. It returns a list of all of the files that meet the *wild card* criteria. All of the names are returned in an array.

The related *getWildFiles* method returns an array of *File* instances rather than an array of strings. It uses *Futil.getReadFile* to get the start point. For example,

```
static public File[] getWildFiles( String wild) {
      return getWildFiles(
         Futil.getReadFile(),
         wild);
}
// The getWildFiles method is overloaded so that the programmer
      // can specify the starting point for a search for files:
  static public File[] getWildFiles(File dir, String wild) {
      return dir.listFiles(new WildFilter(wild));
  }
/*
As an alternative to getting the instances as File instance, we
      can get String instances. For example; getWildNames makes
      use of the WildFilter in order to get the files to match
      with the wild card string:
*/
   static public String[] getWildNames(File dir, String wild) {
         String absPath = dir.getAbsolutePath();
         String[] fileNames = dir.list(new WildFilter(wild));
         System.out.println("getWildNames:"+absPath);
         for (int i=0; i < fileNames.length; i++) {
            fileNames[i] = absPath+"\\"+fileNames[i] ;
         }
         return fileNames;
   }
/*
The getWildNames method is overloaded so that the programmer can
      prompt the user for a start-point for the search:
*
   static public String[] getWildNames(String wild) {
         File dir = Futil.getDirFile();
         return getWildNames(dir, wild);
   }
```

The *FileNameFilter* interface can be used with many implementations of the *accept* method, which is an example of polymorphism.

STYLE POINT

Writing interfaces and using polymorphism are excellent ways to achieve code reuse in a project.

14.5.2 Ls.wildToConsole

Ls.wildToConsole lists all the files to the standard output device which is equivalent to the
UNIX ls *.*wild* command or the DOS *dir *.*wild* command.

STYLE POINT

```
static public void wildToConsole(String wild) {
       String[] files = getWildNames(wild);
       System.out.println(files.length + " file(s):");
       for (int i=0; i < files.length; i++)
            System.out.println("\t" + files[i]);
}
```

Typically, the programmer would use some variant of `wildToConsole` to process all of
the files in a directory that end with a given suffix.

14.5.3 Ls.getDirNames

UNIX-type operating systems include a command called *ls*. We have modeled the ls com-
mand in the futils package using a class called *Ls*. The *Ls* class has static methods in it and
is declared as public and final. *Ls.getDirNames* will open a standard file dialog box and
ask the user to select a file (there is no way to select a directory as far as we know). Once
the file is selected, an array of directory names is returned. The following code comes from
the *Ls* class:

```
public static String [] getDirNames() {
       return getDirNames(Futil.getDirFile());
 }
  static public String [] getDirNames(File dir) {
    String absPath = dir.getAbsolutePath();
    String dirNames[] = dir.list(new DirFilter());
       for (int i = 0 ; i < dirNames.length; i++) {
           dirNames[i] = absPath + dirNames[i];
       }
    return dirNames;
}
```

We note that *getDirNames* only returns the name of a directory, not the file that was selected.

14.5.4 Ls.deleteWildFiles

Now for the really dangerous stuff.

WARNING

The following method deletes all of the files in a directory without requesting confir-
mation! Use this method with extreme caution.

```
static public void deleteWildFiles(String wild) {
       String[] files = getWildNames(wild);
       System.out.println(files.length + " file(s):");
       for (int i=0; i < files.length; i++)
        deleteFile(files[i]);
}
```

The *deleteWildFiles* method is about the same as

```
delete *.suffix
```

The *deleteWildFiles* method relies upon the helper method *deleteFile*. For example,

```
static public void deleteFile(String absPath) {
  File fileToDelete = new File(absPath);
  System.out.print("deleting file " + absPath);
  if (fileToDelete.exists()) {
    System.out.println(" deleted!");
    fileToDelete.delete();
  }
  else
    System.out.println(" does not exist");
}
```

Informational messages are printed to the console, which is a reasonable default action since most users want to be aware of the deletion of data.

14.5.5 Ls.WordPrintMerge

The *PICT* format is an object-based graphics format that is used by several draw programs. The *Ls.WordPrintMerge* method gets all of the files that end with a PICT suffix and creates Microsoft Word print merge commands that will incorporate the files into a single Word document. For example,

```
static public void WordPrintMerge() {
    String wild = "PICT";
    String[] files = getWildNames(wild);
    System.out.println(files.length + " file(s):");
    int fileNumber;
    for (int i=0; i < files.length; i++) {
      fileNumber = i + 1;
      System.out.print("Figure *."+
            fileNumber +
            ".    «INCLUDE hd:current:Java book:chapter
    I:batch 1 revl:picts:"
            System.out.println(files[i]+"»");
      }
}
```

The *include* command is used by Word during the print merge operation. Such programs can be used to generate Word input automatically.

14.6 DirList

The following program recursively traverses the file system, returning all files from a user-selected starting point. It automatically keeps track of how many bytes are used by the files and the number of files, which is particularly handy for batch file processing. It can also be easy to write code that can modify or delete mass quantities of files. For example,

```
package futils;

import utils.Complex;

import java.io.File;
import java.util.Collections;
import java.util.Vector;

/**
 * DirList, w/o recursion.
 */
public class DirList {
  private File startDir;
  private Vector history = new Vector();
  private int totalBytes = 0;
  private String suffix = null;
  private boolean verbose = false;

  public static void main(String args[]) {
    DirList dl = new DirList(".java");
    dl.printFiles();
    dl.sort();
    dl.printFiles();
    dl.printStats();
  }
// The collections classes are described in
// Appendix K.
  public void sort() {
    Collections.sort(history);
  }
/*
Prompt the user for a file, then list
all the files in the director that have the
_suffix at the end of their names.
*/

  public DirList(String _suffix) {
    suffix = _suffix;
    startDir = Futil.getReadDirFile(
        "select a *." + suffix + " file");
    startAtThisDir(startDir);
  }
// starting from _startDir, list all files
// whose names end with _suffix.
  public DirList(File _startDir, String _suffix) {
    startDir = _startDir;
    startAtThisDir(startDir);
  }

  public void printStats() {
    System.out.println(
      "Saw " +
      getTotalFiles() +
      " *" +
      suffix +
```

```
        " files with a total size of " +
        totalBytes +
        " bytes");
    }

    public void printFiles() {
      File f[] = getFiles();
      for (int i = 0; i < f.length; i++)
        System.out.println(f[i]);
    }

    public final void printVerbose(Object o) {
      if (verbose)
        System.out.println(o);
    }

    //-------------------------------------------------------
    // Recursive function that given an anchor directory
    // will walk directory gui.tree
    //
    //-------------------------------------------------------
    public void startAtThisDir(File f1) {
      printVerbose("Selected -> " + f1);
      printVerbose("Files in this Directory: ");
      addFilesInThisDirectory(f1);
      processAllDirectoriesInThisDirectory(f1);
    }

    private Vector vecDir = new Vector();

    private File nextDir() {
      return (File) vecDir.remove(vecDir.size() - 1);
    }
// The vecDir has a list of all the directories
// seen by addDirs.
    private void addDirs(File dirList[]) {
      if (dirList == null) return;
      for (int i = 0; i < dirList.length; i++)
        vecDir.addElement(dirList[i]);
    }

    private void processAllDirectoriesInThisDirectory(File f1) {
      addDirs(f1.listFiles(new DirFilter()));
      while (vecDir.size() > 0) {
      File f = nextDir();
      printVerbose("Selected -> " + f);
      printVerbose("Files in this Directory: ");
      addFilesInThisDirectory(f);
      addDirs(f.listFiles(new DirFilter()));
      }
    }

    //-------------------------------------------------------
    // Loop through all the filenames in the current directory
    // and store them in history:
    //-------------------------------------------------------
```

```
      private void addFilesInThisDirectory(File f1) {
        File ls[] = f1.listFiles(new WildFilter(suffix));
        if (ls == null) return;
        for (int i = 0; i < ls.length; i++)
          addFile(ls[i]);
      }

  // use the history vector to store all the files that have
  // been seen.
      private void addFile(File f2) {
        int bytes = Futil.available(f2);
        totalBytes += bytes;
        printVerbose(f2 +
                     " has " +
                     bytes + " bytes");
        history.addElement(f2);
      }

      public File getStartDir() {
        return startDir;
      }

      public File[] getFiles() {
        File f[] = new File[history.size()];
        history.copyInto(f);
        return f;
      }

      public int getTotalBytes() {
        return totalBytes;
      }

      public int getTotalFiles() {
        return history.size();
      }

      public String getSuffix() {
        return suffix;
      }

  }
```

14.7 Summary

STYLE POINT

This chapter showed how to open file dialog boxes using the *futils* package. Such portable tool boxes are typically used by seasoned programmers. They help to isolate code from deprecations and provide a level of API independence that enables programmers to switch quickly from Swing to AWT. In fact, several APIs all do just about the same thing, though they have different looks, availability, portability, and performance characteristics.

This chapter introduced a number of new classes that are unique to this book. The *Ls* class has the ability to list batches of files using *ls *.<suffix>* and place the results into internal data structures. The *Ls* class provides the ability to recursively traverse the directory tree

structure using a form that is similar to the UNIX *1s -al */* command. Doing so enables the listing of all the files in a directory for the purpose of batch file processing. Such processing is quite common, particularly when using Java in a typical data processing role. For example, listing all of the files in a Web page, moving files from one directory to another, and converting files to new formats or naming conventions.

14.8 Exercises

14.1 Write a program that prompts the user for a file name using the command line.

14.2 Write a program that checks for the existence of a *preferences* file (called *preferences.xml*) in a default location. If the file exits, then type, "found the preferences file!" If the file is missing, prompt the user for it.

14.3 Write a program that computes the size of a directory and all of its contents.

14.4 Write a program that lists all of the unreadable files in a directory and its subdirectories.

14.5 Write a program that lists all of the unwritable files in a directory and its subdirectories.

14.6 Identify the elements that questions 4 and 5 have in common. Devise an interface-based polymorphic mechanism for processing all of the files in a directory and its subdirectories. Now reimplement your solution to questions 4 and 5.

14.7 Write a program that lists all of the possible locations for the JDK home directory.

14.8 Write a program that locates all of the jars on your system.

C H A P T E R 1 5

Streams

**Nice thing about the Java API:
If you don't like it, just wait two minutes.**

–Douglas Lyon

In this chapter, you will learn about:

- Input and output streams
- File input and file output streams
- Data input and data output streams
- Reading and writing a data file
- Serialization
- Compression

A stream in Java is an uninterpreted sequence of bytes. There are two kinds of streams in Java: *input streams* and *output streams*. These streams are represented by instances of the *InputStream* and *OutputStream* classes. This chapter shows how to use some of the subclasses of the *InputStream* and *OutputStream* classes to read and write stream data. Streams use a wide variety of data sources and data sinks (e.g., a file, the console, and the WWW).

 InputStream and *OutputStream* are abstract classes. Examples of classes that subclass these classes include *FileInputStream* and *FileOutputStream*.

Figure 15.1 shows a characterization of the relationship between typical input and output streams.

FIGURE 15.1
Sketch Depicting the Relationship
Between the Streams

FIGURE 15.2
Application for a
Buffered Stream

Figure 15.1 shows an input stream with an unknown amount of data to be processed, which is typical of input streams. If the input stream comes from a human and is output to a human, as shown in Figure 15.1, then the introduction of storage (called a *buffer*) can add to the latency in the system. In fact, people expect *trivial-response* time to be low for a particular action or command. The trivial-response time is the time it takes to get an indication back from the computer. For example, when a user is typing on the keyboard, the user expects to see characters echoed on the screen quickly. Response times of less than a second lead to higher productivity [*Shneiderman*]. This productivity would suggest that when human feedback is involved, unbuffered streams are needed. However, buffered streams may greatly improve a program's throughput. Thus, there is a basic difference between optimizing for throughput and optimizing for latency. Often this is the difference between a responsive program and an efficient one.

 Interactive programs must have a small trivial response time or users will have a negative GUI experience.

In the case when I/O is between files, it is much more efficient to use buffered I/O. Figure 15.2 depicts a typical buffered I/O scenario.

Figure 15.2 shows a file input stream and a file output stream that are being used to read and write files. Such batch-style data processing is typical and can be accelerated greatly by buffering.

To further complicate the question of I/O with streams, a task can be I/O bound (that is, bottlenecked by I/O). The most common way to avoid such a bottleneck is to create a thread to manage the I/O task [Lea] and [Oaks].

15.1 The FileInputStream Class

The *FileInputStream* class is a subclass of the *InputStream* class and, as such, represents a source for an uninterpreted sequence of bytes from a file. It resides in the *java.io* package and can be created from a file name or *File* instance.

 The read methods always block the thread of execution if there are no more bytes to read. When a read method blocks, it will stop execution of the thread, which indicates that I/O-bound tasks probably should be placed into their own threads. If, on the other hand, a file will open quickly, then placing the file I/O in its own thread may complicate the program needlessly. Thus, the decision to use threaded I/O depends upon the application.

15.1.1 FileInputStream Class Summary

```
public class FileInputStream extends InputStream {
public FileInputStream(String name) throws
        FileNotFoundException
```

```
public FileInputStream(File file) throws
        FileNotFoundException
public FileInputStream(FileDescriptor fdObj)
public int read() throws IOException
public int read(byte b[]) throws IOException
public int read(byte b[], int off, int len) throws
        IOException
public long skip(long n) throws IOException
public int available() throws IOException
public void close() throws IOException
public final FileDescriptor getFD() throws IOException
}
```

15.1.2 FileInputStream Class Usage

Suppose the following variables are predefined:

```
String fileName;
FileInputStream fis;
File file;
byte b bytes[];
int length, offset;
int amountRead;
int n, numberSkipped;
```

To make an instance of the *FileInputStream* class from a file name, *File* instance, or *FileDescriptor* instance, type

```
fis = new FileInputStream(fileName);
fis = new FileInputStream(file);
fis = new FileInputStream(fd);
```

To read a byte of data (−1 returned at end of stream), use

```
b = fis.read();
```

To read an array of bytes (−1 returned at end of stream), use

```
amountRead = fis.read(bytes);
// amountRead < bytes.length when the number of bytes actually
// read is smaller than the length of the byte array.
```

To read a subarray of bytes, use

```
amountRead = fis.read(bytes, offset, length);
// offset is the number of bytes that we offset the
// read into the byte array.
```

To skip *n* bytes, use

```
numberSkipped = fis.skip(n);
```

To find out how many bytes can be read (used to test the length of the file), use

```
n = fis.available();
```

To close the stream, type, use

```
fis.close();
```

As a short example, consider the following code in the *futils.Futil* class for reading all of the bytes in a file and returning them in an array:

```
/**
 * Futil.readBytes inputs a File, f and
 * returns an array of bytes read from the file.
 * Any failures cause readBytes to return null.
 * A message is printed to the console.
 */
public static byte[] readBytes(File f) {
    FileInputStream fis = null;
    int sizeInBytes = -1;
    byte buffer[] = null;
    try {
        fis = new FileInputStream(f);
        sizeInBytes = fis.available();
        buffer = new byte[sizeInBytes];
        fis.read(buffer);
        fis.close();
    } catch (IOException e) {
        System.out.println(
            "Futil:readBytes, Could not open file");
    }
    return buffer;
}
```

The *Futil* class also contains a test program that you can run to test *readBytes*:

```
public static void testReadBytes() {
    byte b[] = readBytes(getReadFile("select a file"));
    System.out.println(
      "you read: " + b.length + " bytes");
    print(b);
 }

public static void print(byte b[]) {
    for (int i = 0; i < b.length; i++) {
        if ((i % 10) == 0)
            System.out.println();
        System.out.print(b[i] + " ");
    }
}
```

The *print* method prints out rows of bytes in decimal format with 10 numbers per row.

15.1.3 Futil.getFileInputStream

In order to localize exception handling within the *Futil* class, a static public method has been devised called *Futil.getFileInputStream*. As seen below, *getFileInputStream* takes a prompt. When no argument is passed, a standard file dialog box is presented to the user for file selection. After a valid file is selected, *getFileInputStream* calls the overloaded version of itself that takes a string. If the user cancels out of the dialog box selection, an exception causes an error message to be printed and program execution continues.

The policy of handling exceptions locally helps to make code look cleaner.

What follows is an example of how to implement the local exception handling when getting a *FileInputStream*:

```
public static FileInputStream getFileInputStream(
        String prompt) {
try {
     return new FileInputStream(getReadFile(prompt));
    }
    catch (Exception e) {
     System.out.println("Er: FileOutputStream in
     Futil.java");
    }
    return null;
}
```

Handling an exception locally simplifies the invoking code. This approach is not suitable for some applications, but it does seem to work most of the time.

15.1.4 Futil.available

The *Futil.available* method is a static public method that permits a fast file check to see how many bytes are in a file. The *available* method opens a file and returns −1 if a file cannot be opened; otherwise, it returns the size in bytes. For example,

```
public static int available(File file) {
FileInputStream fis = null;
int sizeInBytes = -1;
    try {
       fis =  new FileInputStream(file);
         sizeInBytes = fis.available();
       fis.close();
   }
     catch (IOException e) {
       System.out.println("Futil:Could not open file");
     }
     return sizeInBytes;
}
```

Finding out the size of a file in advance of its processing can affect how your program creates buffers. In a recent case, images were stored in files that were one to five GB each. Knowing the file size in advance allows a program to alter its approach to processing the images.

15.2 The FileOutputStream Class

The *FileOutputStream* class resides in the *java.io* package. Instances of the *FileOutputStream* class are used as targets of the close method [i.e., *fis.close ()*]. When an instance of a *FileOutputStream* is made, the file is opened for *write*.

15.2.1 FileOutputStream Class Summary

```
public class FileOutputStream extends OutputStream {
     public FileOutputStream(
        String name) throws IOException
     public FileOutputStream(File file) throws IOException
     public FileOutputStream(FileDescriptor fdObj)
     public native void write(int b) throws IOException;
     public void write(
             byte b[]) throws IOException
     public void write(
        byte b[], int off, int len) throws IOException
     public native void close() throws IOException
     public final FileDescriptor getFD()  throws
       IOException
}
```

15.2.2 FileOutputStream Class Usage

To open a file using a standard file save dialog box, define a *FileOutputStream* instance by using *Futil.getWriteFileName()*. For example,

```
FileOutputStream output_stream = new
          FileOutputStream(Futil.getWriteFileName());
```

Suppose the following variables are predefined:

```
String fileName;
File file;
FileDescriptor fd;
byte b, bytes[];
int offset, length;
```

Then, to open a file for write (remember to use *try-catch* or a *throws* clause), use

```
try {
      fos = new FileOutputStream(name);
} catch (IOException e) {
      e.printStackTrace();
}
```

To open a file using a *File* instance, use

```
fos = new FileOutputStream(file);
```

To open a file using a *FileDescriptor* instance, use

```
fos = new FileOutputStream(fd);
```

To write a byte of data, use

```
fos.write(b);
```

To write an array of bytes, use

```
fos.write(bytes);
```

To write a subarray of bytes, use

```
fos.write(bytes, offset, length);
```

To close the *FileOutputStream*, use

```
fos.close();
```

To get the file descriptor, use

```
fd = fos.getFD();
```

Since the creation and closing of a *FileOutputStream* instance can throw an *IOException*, operations involving the use of *FileOutputStream* are surrounded by a *try-catch* clause. The following example inputs an array of bytes and a *File* instance. It then writes the array of bytes to a file and returns either *true* or *false*. Using this example, you can write any array of bytes out to a file.

```
/**
 * Futil.writeBytes inputs a File, f and byte array.
 *
 * Any failures cause writeBytes to return false and
 * a message is printed to the console.
 * Otherwise, writeBytes returns true.
 */
public static boolean writeBytes(File f, byte b[]) {
    FileOutputStream fos = null;
    try {
        fos = new FileOutputStream(f);
        fos.write(b);
        fos.close();
         return true;
    } catch (IOException e) {
        System.out.println(
            "Futil.writeBytes,Could not open"+f);
        return false;
    }
}
```

Writing out all of the bytes at once is not always possible. As an example, consider the problem of copying a file in binary from one place to another. Our technique reads the entire file into a byte array, and then writes the entire byte array out to memory. This process is very fast, but will fail for large files (i.e., those that exceed the memory available to the computer). To solve this problem, check the size of the file using *avail* before attempting to execute this type of program. File size can be checked using the *Exec* class, as described in exercise 6 at the end of this chapter.

```
public static void binaryCopyFile() {
    byte b[] = readBytes(getReadFile("select a file"));
    writeBytes(
       getWriteFile("select a file to copy to"), b);
// if selected file exists, then the user is prompted
// to see if overwriting is OK.
    System.out.println("copy done!");
}
```

The use of a functional style is the primary reason for the brevity and elegance of the *binaryCopyFile* method.

Another approach, one that works for large files, is to use an internal buffer and copy only a few bytes at a time. For example,

```
    /**
     *  copy the file input stream into the file output
     * stream. Another fine Futil example...
     */
    public static void binaryCopyFile(FileInputStream fis,
                                      FileOutputStream fos)
    throws IOException {
        byte buffer[] = new byte[512];
// to be general, the size of the internal buffer should
// be a parameter.
        int count;
// if count == 0 or -1 then we are done.
        while((count = fis.read(buffer)) > 0)
            fos.write(buffer,0,count);
    }
    public static void testBinaryCopyFile() {
        try {
            binaryCopyFile(
                    new FileInputStream(
                            getReadFile("select input file")),
                    new FileOutputStream(
                            getWriteFile(
                        "select output file")));
            System.out.println("binaryCopyFile done.");
        } catch (IOException e) {
        }
    }
```

In the case of the *testBinaryCopyFile* method, we use *FileInputStream* and *FileOutputStream* with a small byte buffer, which enables us to trade CPU RAM (i.e., space) for a slower program (i.e., time). Such a program can handle very large files, but with performance costs.

15.2.3 Futil.getFileOutputStream

A simple way to get a file output stream involves prompting the user with a file dialog box and intercepting the possible resulting exceptions. The *Futil.getFileOutputStream* method will return *null* if the output file is unable to be made. An example of using a functional style for IO follows:

```
    public static FileOutputStream
        getFileOutputStream(String prompt) {
        return getFileOutputStream(getWriteFile(prompt));
    }
```

The *getFileOutputStream* method also can wrapper the exception handler if a *File* instance is already available. For example,

```
    public static FileOutputStream
        getFileOutputStream(File f) {
    try {
```

```
            return new FileOutputStream(f);
          }
          catch (Exception e) {
           System.out.println(
             "Er: FileOutputStream in Futil.java");
         }
            return null;
         }
```

As another example,

```
        FileOutputStream fos =
          new FileOutputStream(outputName);
```

15.2.4 Futil.close(OutputStream)

As with *getFileOutputStream*, there is a *closeOutputStream* method.

Any class that subclasses *OutputStream* (i.e., *FileOutputStream*) will be cast automatically to the *OutputStream* type during the call.

The *Futil* class has a *close* method that works generally on classes that implement the *OutputStream* interface. For example,

```
        public static void close(OutputStream os) {
          try {
            os.close();
          }
          catch (IOException exe) {
            System.out.println(
               "futil: could not close output stream");
          }
        }
```

Oftentimes, a novice using the *java.io* package will erroneously try to make a new instance of an *OutputStream* or an *InputStream*. In fact, these interfaces are implemented by classes like *FileOutputStream* and *FileInputStream*. Casting to the interface that these classes implement is automatic.

15.3 The DataInputStream Class

The *DataInputStream* class resides in the *java.io* package. The *DataInputStream* class is a byte stream reader that provides high-level methods, which supply reading and casting services from a stream of bytes into various primitive data types. These services are useful when reading non-text streams.

The use of *DataInputStream* and *DataOutputStream* on text-based streams is deprecated. The preferred way to perform text IO is with *Readers* and *Writers*, which are described in Chapters 16 and 17.

The *DataInputStream* is a subclass of the *FilterInputStream* and implements the *DataInput* interface. The *DataInput* interface requires methods for reading data values and returning primitive data types.

WARNING

When a read is performed and no bytes are available, the thread will block.

15.3.1 DataInputStream Class Summary

```
public class DataInputStream extends FilterInputStream
      implements DataInput {
   public DataInputStream(InputStream in)
   public final int read(byte b[]) throws IOException
   public final int read(byte b[], int off, int len)
     throws IOException
   public final void readFully(byte b[]) throws
     IOException
   public final void readFully(byte b[], int off, int
     len) throws IOException
   public final int skipBytes(int n) throws IOException
   public final boolean readBoolean() throws
     IOException
   public final byte readByte() throws IOException
   public final int readUnsignedByte() throws
     IOException
   public final short readShort() throws IOException
   public final int readUnsignedShort() throws
     IOException
   public final char readChar() throws IOException
   public final int readInt() throws IOException
   public final long readLong() throws IOException
   public final float readFloat() throws IOException
   public final double readDouble() throws IOException
   public final String readLine() throws IOException
   public final String readUTF() throws IOException
   public final static String readUTF(DataInput in)
     throws IOException
}
```

15.3.2 DataInputStream Class Usage

Suppose that the following variables are predefined:

```
InputStream is;
DataInputStream dis;
int numberRead;
byte b, bytes[];
int length, offset;
char c;
int i;
long l;
float f;
double d;
String string;
```

To create an instance of the *DataInputStream* class, use

```
dis = new DataInputStream(is);
```

To read data into a byte array or subarray, use

```
numberRead = dis.read(bytes);
numberRead = dis.read(bytes, offset, length);
```

To read *bytes.length* into *bytes* from *bytes[0]*, use

```
dis.readFully(bytes);
```

To read bytes into a subarray, use

```
dis.readFully(bytes, offset, length);
```

To skip bytes, use

```
numberSkipped = dis.skip(numberToSkip);
```

To read a boolean (a single byte that is non-zero for true to be returned), use

```
aboolean = dis.readBoolean();
```

To read a byte, use

```
b = dis.readByte();
```

To read the byte into an *int*, use

```
i = dis.readUnsignedByte();
```

To read a 16-bit signed or unsigned *short*, use

```
s = dis.readShort();
i = dis.readUnsignedShort();
```

To read a two-dimensional array of *short*, you need to write a loop. For example,

```
public void readArray(short a[][], DataInputStream dis)
    throws IOException {
  for (int x = 0; x < width; x++)
    for (int y = 0; y < height; y++)
      a[x][y] = dis.readShort();
}
```

To read a 16-bit char, use

```
c = dis.readChar();
```

To read 32 bits into an *int*, use

```
i = dis.readInt();
```

To read 64 bits into a *long*, use

```
l = dis.readLong();
```

To read 32 bits into a *float*, use

```
f = dis.readFloat();
```

To read 64 bits into a *double*, use

```
d = dis.readDouble();
```

To read a line, stopping at the end of the stream '\n', '\r' or '\r\n', use

```
string = dis.readLine();
```

To read a Unicode Transformation Format (UTF) string, use

```
string = dis.readUTF();
```

To read UTF from an InputStream, use

```
string = DataInputStream.readUTF(is);
```

15.4 The DataOutputStream Class

Like the DataInputStream class, the *DataOutputStream* class resides in the *java.io* package. The *DataOutputStream* class is a byte stream writer. The *DataOutputStream* provides high-level methods that supply writing services from various primitive data types into a stream of bytes. These services are useful when attempting to encode binary files.

The *DataOutputStream* is a subclass of *FilterOutputStream* and implements the *DataOutput* interface. The *DataOutput* interface requires implementation of methods for writing primitive data types. A *DataOutputStream* instance keeps track of the number of bytes that it has written.

15.4.1 DataOutputStream Class Summary

```
public class DataOutputStream extends FilterOutputStream
    implements DataOutput
  public DataOutputStream(OutputStream out)
  public synchronized void write(int b) throws
    IOException
  public synchronized void write(byte b[], int off,
    int len)
  public void flush() throws IOException
  public final void writeBoolean(boolean v) throws
    IOException
  public final void writeByte(int v) throws
    IOException
  public final void writeShort(int v) throws
    IOException
  public final void writeChar(int v) throws
    IOException
  public final void writeInt(int v) throws IOException
  public final void writeLong(long v) throws
    IOException
  public final void writeFloat(float v) throws
    IOException
  public final void writeDouble(double v) throws
    IOException
  public final void writeBytes(String s) throws
    IOException
  public final void writeChars(String s) throws
    IOException
```

```
    public final void writeUTF(String str) throws
        IOException
    public final int size()
}
```

The *writeUTF* method writes out strings using UTF-8, which is a byte encoding that outputs 1 to 6 bytes for each character. The UTF-8 format enables the writing of strings in a machine-independent manner. Characters from 1–127 are written as a single byte. Characters from 128–2047 and 0 are written by a pair of bytes. Characters from 2048–65535 are written by 3 bytes. The actual bit format is given in [Gosling et al.].

15.4.2 DataOutputStream Class Usage

Suppose that the following variables are predefined:

```
char c;
String string;
OutputStream os;
short s;
int i, offset, length;
long l;
float f;
double d;
byte b;
byte bytes[];
boolean aBoolean;
```

To construct a new *DataOutputStream* instance, use

```
DataOutputStream dos =
        new DataOutputStream(is);
```

To write a byte, use

```
dos.write(b);
```

To write a subarray of bytes, use

```
dos.write(bytes, offset, length);
```

STYLE POINT

If you are going to write out some bytes to a file, it is generally a good idea to place the number of bytes you intend to write inside the file itself. Generally, the bytes will exist with other data elements.

For example,

```
    public void write(DataOutputStream dos, byte data[]) throws
        IOException {
      dos.writeInt(data.length);

      dos.write(data, 0, data.length);
    } // later we can do a readInt
    // to discover how many bytes to read.
```

To flush the output stream, use

```
dos.flush();
```

To write a boolean (as a 0 or a 1 byte), use

```
dos.writeBoolean(aboolean);
```

To write a byte to an underlying 8-bit representation, use

```
dos.writeByte(b);
```

To write a short to an underlying 16-bit representation with the high byte first, use

```
dos.writeShort(s);
```

STYLE POINT

To write a two-dimensional array of short to a *DataOutputStream*, it is typical to use a nested `for` loop.

For example,

```
public void writeArray(short a[][], DataOutputStream dos)
    throws IOException {
  for (int x = 0; x < width; x++)
    for (int y = 0; y < height; y++)
      dos.writeShort(a[x][y]);
}
```

To write a *char* to an underlying 16-bit representation with the high byte first, use

```
dos.writeChar(c);
```

To write an *int* to an underlying 32-bit representation with the high byte first, use

```
dos.writeInt(i);
```

To write a *long* to an underlying 64-bit representation with the high byte first, use

```
dos.writeLong(l);
```

To write a *float* to an underlying 32-bit representation with the high byte first, use

```
dos.writeFloat(f);
```

To write a *double* to an underlying 64-bit representation with the high byte first, use

```
dos.writeDouble(d);
```

To write a *String* as a sequence of bytes (this casts each char as a byte, and then writes the byte, type the following, which will write *s.length* bytes, use

```
dos.writeBytes(s);
```

To write a *String* as a sequence of 16-bit characters, which will output *2 * s.len* bytes, use

```
dos.writeChars(s);
```

To write a string in a machine-independent UTF-8 format, use

```
dos.writeUTF(s);
```

To get the number of bytes written, use

```
i = dos.size();
```

15.5 The StreamSniffer Class

When faced with the WWW's wide variety of data formats, it is wise to develop a tech-
nique for testing an input stream. One technique is to "sniff" the stream to see if it is
known. The *StreamSniffer* class resides in the *futils* package and "sniffs" the bytes from the
java.io.InputStream instance, returning an integer that corresponds to one of several
known streams. The bytes are then pushed back into the *java.io.InputStream* instance so
that decoders will find the bytes they are seeking. In other words, the *StreamSniffer* is a
non-destructive reader that inspects the stream.

The *java.io.InputStream* instance is used to create a *java.io.BufferedInputStream*.
StreamSniffer requires a *java.io.BufferedInputStream* instance in order to read a few bytes
and then *reset java.io.BufferedInputStream* to the beginning of the stream. This task is
completely CPU bound, and no additional I/O is performed during the act of a sniff. The
methods of the *java.io.BufferedInputStream* require that we *mark* how many bytes we intend
to read, and then *reset* to the next point in the *Stream*.

StreamSniffer reads the first two bytes of a file to see what kind of file it is (e.g.,
image, audio, video, or *text*). Within the broad category of any single type of file, there are
generally an unbound number of subtypes. Examples of image formats include PPM, GIF,
PGM, FBM, QuickTime, Pict, pic, and TIFF. The same holds true for audio and video formats.
Writing a program that can read multiple formats is not easy, though Java provides some
tools that will ease our pain.

A code snippet from *StreamSniffer* follows:

```
1. package futils;
2. import java.io.*;
3. import java.util.*;
4. class StreamSniffer {
5.   private BufferedInputStream bis;
6.   private byte header[] = new byte[6];
7.   private int numberActuallyRead = 0;
8.   StreamSniffer(InputStream is) {
9.       bis = new BufferedInputStream(is);
10.      init();
11.      sniff();
12.  }
/*
Lines 1-12 show the creation of a BufferedInputStream instance as
well as the allocation of the space required for a header. After we
sniff the buffered stream, we cover our tracks by resetting the
internal stream pointer to the beginning of the stream. This
enables the passing of the unmodified buffered input stream to a
CODEC (COder-DECoder) without having to re-open the stream.
*/
private void sniff() {
    if (! bis.markSupported()) {
        System.out.println(
            "StreamSniffer needs"+
```

```
                    " a markable stream");
            return;
        }
        bis.mark(header.length);
// mark sets the current position in the input stream
// the argument to mark is the number of bytes that
// can be read or skipped before the mark becomes invalid.

        try {
            numberActuallyRead
                = bis.read(header);
            bis.reset();
        }
        catch (IOException e) {
            System.out.println(e);
            numberActuallyRead = -1;
        }

    }
```

In order to use the *StreamSniffer* class, we must first make an instance of an *InputStream*. We let *StreamSniffer* do the rest:

```
// To be general, this should take a File instance:
 public StreamSniffer openAndSniffFile() {
   String fn = getReadFileName();
   InputStream is;
   if (fn == null) return null;
   try {
           is = new FileInputStream(fn);
   }
   catch (FileNotFoundException e) {
           return null;
   }
   StreamSniffer ss = new StreamSniffer(is);
   System.out.println("Hmm, this smells like a "+ss);
   return ss;
 }
```

When an instance of *StreamSniffer* is passed to *System.out.println*, the *toString* method is invoked. *StreamSniffer* overrides the default *toString* method to print a string representation of what is found in the beginning of the file. For example, when *openAndSniffFile* is invoked on one file, it prints

```
Hmm, this smells like a GIF89a
```

To top off our sniffer, we need a database of file types. Though no comprehensive database is available, some pretty good ones can serve as a starting point (e.g., the UNIX *file* command uses a pretty good database). It is typical to be able to tell what kind of stream you are dealing with by looking at the first few bytes. In addition, the UNIX *file* command can use the *file name suffix* to help determine the file type (Windows calls the file name suffix an *extension*). Streams on the Web, though, do not inform a program of a file name suffix. Moreover, the file name suffix often is assigned by humans and may not be reliable as a source of information.

The sniffer uses only the bytes found in the stream, instead of file name suffixes, to identify file types. So far, we have expanded this technique to identify 40 common image and compression streams. Of course, this is only the tip of the iceberg! There are so many stream data types that no single program (that we know of) can read them all. However, *StreamSniffer* can help you to extend the database of known streams by giving you information about the stream. Thus, if you know the stream, but *StreamSniffer* does not, it is a straightforward matter to insert the stream into StreamSniffer's database.

An analysis of *StreamSniffer* can be very educational. It involves manipulation of bits and assumes a passing knowledge of the material in Appendix J. First, let's review how Java stores numeric constants. In Java, an *octal* number (that is, one expressed in base 8) is written with a leading zero. For example,

```
0377
```

is the octal for the *int* 255. Consider that any octal digit passed as an argument is promoted automatically to an *int*! Thus, the invocation of a method for matching a series of octal constants must take ints in its parameter list. For example, to tell if a stream is a JPG stream, we write

```
if (match(0377,0330,0377,0356))
        return JPG;
// Where JPG is a global constant defined as:
public static final int JPG=40;
```

The *match* method is invoked with four ints, each of which is denoted in its octal numeric equivalent. Octal is used primarily because the stream specification is written in octal. It is therefore a matter of consistency relative to the specification. As an alternative, we could transform octal numbers into their decimal equivalent.

Sometimes a specification is written using *hexadecimal* numbers (radix 16). In Java, hexadecimal numbers are written with a leading 0x or 0X. A hexadecimal digit may be uppercase or lowercase, i.e., one of {0, 1, 2, 3, 4, 5, 6, 7, 8, 9, a, b, c, d, e, f, A, B, C, D, E, F}. For example,

```
if (match(0xFF, 0xD8, 0xFF, 0xE0))
    return JPEG;
```

Hexadecimal numbers also are promoted to full ints. Thus, this use of the match method also requires a series of *int* parameters. In fact, *int* is the default numeric promotion for all integer-type constants.

The match method for the four ints follows:

```
public boolean match(
    int c0, int c1,
    int c2, int c3) {
    byte b[] = header;
    return
        ((b[0]&0xFF) == (c0&0xFF)) &&
        ((b[1]&0xFF) == (c1&0xFF)) &&
        ((b[2]&0xFF) == (c2&0xFF)) &&
        ((b[3]&0xFF) == (c3&0xFF));
}
```

The match method shows that each of the *int* values is truncated to its least significant eight bits before a comparison is performed. Sometimes a stream specification will

describe a string as being part of the header. The following snippet for the *classifyStream* method shows the header being converted into a string instance and then being compared to a prefix string:

```
public int classifyStream() {
    byte b[] = header;
    String s = new String(b);
    if (s.startsWith(".snd"))
        return SUN_NEXT_AUDIO;
    .....
```

Now you may be asking, "Where are these integer values stored?" They are stored as a series of public static final constants inside of the *StreamSniffer* class. For example,

```
public static final int TYPENOTFOUND = 0;
public static final int UUENCODED = 1;
public static final int BTOAD =2;
public static final int PBM =3;
public static final int PGM =4;
public static final int PPM =5;
    .....
public static final int GZIP=34;
public static final int HUFFMAN=35;
public static final int PNG_IMAGE=38;
public static final int JPEG=39;
public static final int JPG=40;
```

One of the interesting problems with Java is that it lacks an unsigned byte. This truly perplexing problem strikes at the heart of low-level stream programming.

Programmers who attempt to print bytes with various radices must address Java's lack of an unsigned byte. For example,

```
byte b = (byte)128;
System.out.println(b);
```

will print

```
-128
```

because the *byte* data type uses its most significant bit to represent the sign of the value. To address this problem, we created a *Ubyte* class, which is a missing class from the *java.lang* package because there is no corresponding scalar data type. The *java.lang* package contains a series of *wrapper* classes that enable the promotion from scalar data types to reference. For example, *int*, *char*, *double*, and *float* are all scalar data types that are passed by value. They correspond to class types with the following names: *Integer*, *Double*, *Character*, and *Float*. These class types, inturn, form the *wrapper* classes. One missing scalar data type is the unsigned byte and its corresponding wrapper, the *Ubyte* class. As non-language developers, we are unable to add scalar data types to Java; therefore, we cannot add an unsigned *byte*. However, we still can add the unsigned *byte* class.

The *Ubyte* class resides in the *utils* package and provides a series of methods for handling bytes in an unsigned manner. An example of the use of the *Ubyte* class follows:

```
byte b = (byte)128;
Ubyte.printToOctal(b);
Ubyte.printToHex(b);
```

```
                     Ubyte.printToDecimal(b);
                     System.out.println(Ubyte.toString(b,8));
```

see the book source code for full listings of *UByte*.

The output follows:

```
0200 0x80 128
200
```

All of the *Ubyte* class methods are public and static. The *toString* method takes a *byte* and an *int* which, is used to denote the radix in which the string should appear. The radix range is from *Character.MIN_RADIX (=2)* to *Character.MAX_RADIX (=36)*. The value of the radix is always given in base 10.

The *printToOctal* method works by shifting and performing a bitwise AND, three bits at a time. These bits are used to index into a character table, as shown in the following *printToOctal* example:

```
// Ubyte has a way to convert the byte to octal,
// assuming the byte is unsigned.
public static void printToOctal(byte b) {
        char oct[] = {
                '0','1','2','3','4',
                '5','6','7'};
        System.out.print("0"+
                oct[(b>>6) & 03] +
                oct[(b>>3) & 07] +
                oct[ b & 07]+" ");
}
```

Recall from Chapter 10 that we can use positional notation to obtain a decimal quantity from a byte. We isolate the most significant four bits, multiply by 16, and then add the least significant four bits, which yields an unsigned integer representation of the byte quantity:

```
// UByte can convert an unsigned byte to Int
1.    public static int byteToInt(byte b) {
2.        return
3.                ((b >> 4) & 0xF)*16 +
4.                (b & 0xF);
5.}
```

Line 3 shows a shift to the right by four bits, $(b \gg 4)$. Line 4 shows a bitwise AND. The bitwise AND is different from the boolean AND. The boolean AND is denoted by && and returns a *boolean* type, whereas the bitwise AND is denoted by an '&' and returns an *int* type. Once we have an unsigned integer, we can convert it to a string that represents the integer in a radix between 2 and 36 using

```
// UByte has its own unsigned byte conversion to String
public static String toString(byte b,int radix) {
        return
                Integer.toString(byteToInt(b), radix);
}
```

Note that the *toString* method returns something different from the print methods because the *toString* method is designed to be consistent with the *toString* methods of the wrapper

classes. The goal of the print method is to allow the *StreamSniffer* class to print out a header dump that can be used as an argument to the match method, thereby extending *StreamSniffer*'s database of known streams. Now when we sniff an unknown stream, we get a program fragment that can be used to help identify the stream later:

```
In hex...
0x01 0x3B 0x61 0x00 0x11 0x00
in base 8...
0001 0073 0141 0000 0021 0000
 in ASCII
 _;a___
if (match(1,59,97,0))
Hmm, this smells like a TYPENOTFOUND
The id is :0
```

If we sniff a known stream, we get

```
Hmm, this smells like a PPM_RAWBITS
The id is :8
```

15.5.1 StreamSniffer Class Summary

```java
package futils;
import java.io.*;
import java.util.*;
public class StreamSniffer {
    public boolean match(char c0, char c1)
    public boolean match(char c0, char c1, char c2, char c3)
    public boolean match(int c0, int c1)
    public boolean match(int c0, int c1, int c2, int c3)
    public BufferedInputStream getStream()
    public int classifyStream()
    public StreamSniffer(InputStream is)
    public String getStringForId(int id)
    public String toString()
    public void printHeader()
    public static final int TYPENOTFOUND = 0;
    public static final int UUENCODED = 1;
    public static final int BTOAD =2;
    public static final int PBM =3;
    public static final int PGM =4;
    public static final int PPM =5;
    public static final int PBM_RAWBITS=6;
    public static final int PGM_RAWBITS = 7;
    public static final int PPM_RAWBITS = 8;
    public static final int MGR_BITMAP =9;
    public static final int GIF87a =10;
    public static final int GIF89a =11;
    public static final int IFF_ILBM =12;
    public static final int SUNRASTER =13;
    public static final int SGI_IMAGE =14;
    public static final int CMU_WINDOW_MANAGER_BITMAP =15;
    public static final int SUN =16;
```

```
        public static final int TIFF_BIG_ENDIAN =17;
        public static final int TIFF_LITTLE_ENDIAN =18;
        public static final int FLI =19;
        public static final int MPEG =20;
        public static final int SUN_NEXT_AUDIO=21;
        public static final int STANDARD_MIDI=22;
        public static final int MICROSOFT_RIFF=23;
        public static final int BZIP=24;
        public static final int IFF_DATA=25;
        public static final int NIFF_IMAGE=26;
        public static final int PC_BITMAP=27;
        public static final int PDF_DOCUMENT=28;
        public static final int POSTSCRIPT_DOCUMENT=29;
        public static final int SILICON_GRAPHICS_MOVIE;=30;
        public static final int APPLE_QUICKTIME_MOVIE=31;
        public static final int ZIP_ARCHIVE=32;
        public static final int UNIX_COMPRESS=33;
        public static final int GZIP=34;
        public static final int HUFFMAN=35;
        public static final int PNG_IMAGE=38;
        public static final int JPEG=39;
        public static final int JPG=40;
    }
```

15.5.2 StreamSniffer Class Usage

The *StreamSniffer* class resides in the *gui* package. It is used to read and classify the header of a file. Typically, a stream decoder will use the classification to dispatch the stream to the correct decoder.

An instance of *StreamSniffer* is constructed using an *InputStream* instance. *StreamSniffer* internally constructs an instance of a *BufferedInput* stream, which is used to scan the header in the stream for identification. Scanning and classification are performed once automatically at the construction of *StreamSniffer*.

Suppose that the following variables are declared:

```
    StreamSniffer ss;
    InputStream is;
    String fn;
```

To see if the stream begins with two unsigned bytes whose character representation is known, use

```
        public boolean match(char c0, char c1);
```

To see if the stream begins with four unsigned bytes whose character representation is known, use

```
        public boolean match(char c0, char c1, char c2, char c3)
```

To see if the stream begins with two unsigned byte quantities whose integer representation is known, use

```
        public boolean match(int c0, int c1)
```

To see if the stream begins with four unsigned byte quantities whose integer representation is known, use

```
public boolean match(int c0, int c1, int c2, int c3)
```

To get an *untainted* instance of the buffered input stream, use

```
public BufferedInputStream getStream()
```

To get an identifier that corresponds to one of the static final constants in the *StreamSniffer* class, use

```
public int classifyStream()
```

To create an instance of the StreamSniffer from a file name, *fn*, use

```
    InputStream is;
if (fn == null) return null;
try {
     is = new FileInputStream(fn);
}
catch (FileNotFoundException e) {
    return null;
}
StreamSniffer ss = new StreamSniffer(is);
```

To map the identifier returned by *classifyStream* into a string, use

```
public String getStringForId(int id)
```

To return a minimal string representation of the stream and invoke the *printHeader* method if the header is known, use

```
public String toString()
```

To print the head of the stream in three radices and create a prototype *if*-statement that can check this stream type, use

```
public void printHeader()
```

15.6 Serialization

Java serialization technologies enable an instance of an object to be written and read to and from a stream. This means that instances can be saved to a file or passed across a network. In order to serialize a class, the *Serializable* interface must be implemented. Members that are not to be saved must be declared as *transient*.

What follows is a *Customer* class. The *name* member was declared as *transient* in order to show the effect of printing a member that was not serialized. For example,

```
package io;

import java.io.*;
import java.util.zip.*;

public class Customer implements
```

```
Serializable,
Runnable {

String s[] ={
        "Hello World",
        "This is a test of",
        "My serializer"
  };
transient String name = "J. Doe";
 boolean hasCallerID = false;
public void setName(String _s) {
 name = _s;
}
public void run() {
 System.out.println("Hello world");
}

public void print() {
 System.out.println(name);
 System.out.println(hasCallerID);
 for (int i=0; i < s.length;i++)
   System.out.println(s[i]);
}
}
```

Figure 15.6-1 shows how a file is read by a *FileInputStream* instance. Bytes, then, are supplied to a *GzipInputStream* instance, which decompresses the bytes so that an *ObjectInputStream* can decode them and render an instance of an object. An instance of a class is not the same as the bytecodes that are needed to define the reference data type. When operating on another JVM, the bytecodes for the class must be loadable before the class can be instanced. Thus, the class path, or some other means, must be made available in order for the reference data type to be known to the remote JVM. In the case of master-slave computing, this cumbersome setup and configuration step must be integrated into the deployment of a distributed application. I call this the *distributed computing configuration problem.*

FIGURE 15.6-1
Compressed Serialization

To show the instance being saved and read, we use the *SerializeTest* class:

```
package io;
import java.io.*;
import java.util.zip.*;
import futils.*;

public class SerializeTest {
    public static Object readObject()
        throws
            IOException,
            FileNotFoundException,
            ClassNotFoundException {
    FileInputStream fis
      = new FileInputStream(Futil.getReadFile());
    GZIPInputStream gis
      = new GZIPInputStream(fis);
    ObjectInputStream ois
      = new ObjectInputStream(gis);
    return ois.readObject();

    }
    public static void saveObject(Object o)
     throws IOException {
     FileOutputStream fos
       = new FileOutputStream(Futil.getWriteFile());
/*
We use a GZIPOutputStream in order to compress the instance
    before writing it to the disk. For small classes (like
    this one) the file can actually take more space
    compressed. However, for non-trivial instances,
    compression often makes sense. The gzip compression is
    a standard one, and tools like gunzip and winzip will
    be able to uncompress it.
*/
    GZIPOutputStream gos
      = new GZIPOutputStream(fos);
    ObjectOutputStream oos
      = new ObjectOutputStream(gos);
    oos.writeObject(o);
    oos.close();
    gos.finish();
    }
    public static void main(String args[]) {
    try {
       Customer c1 =
            new Customer();
    c1.setName("J. Shmoe");
    System.out.println("Object out=");
    c1.print();
    saveObject(c1);
    System.out.println("Object in=");
```

WARNING

Instances read from an *ObjectInputStream* always are returned as being of type *Object*. It is up to the programmer to test the instance and cast it properly.

```
        Object o =
                readObject();
        if (o instanceof Customer) {
         Customer c =
                (Customer) o;
         c.print();
        }
       }
       catch (Exception e) {
         e.printStackTrace();
       }
      }
     }
```

The output follows:

```
Object out=
J. Shmoe
false
Hello World
This is a test of
My serializer
Object in=
null
false
Hello World
This is a test of
My serializer
```

We see in the output that the *J. Shmoe* name was reduced to *null* during the save process because it was declared *transient*.

NOTE

Transient instances never are saved during the serialization process.

15.7 Reading and Writing GZIPed Files of Floats

This section shows how to read and write a file using an array of floating-point numbers. The *java.util.zip* package is used in order to create a kind of compression called *GZIP compression*. The *MatFloat* class is a matrix of floating-point numbers.

```
package gui;
import java.io.*;
import java.awt.*;
import java.util.zip.*;

public class MatFloat {
        float f[][];

MatFloat (float flt[][]) {
        f = flt;
}
```

```java
public String getSaveFileName(String prompt) {
        FileDialog fd = new
                FileDialog(
                        new Frame(),
                        prompt,
                        FileDialog.SAVE);
        fd.setVisible(true);
        fd.setVisible(false);
        String fn=fd.getDirectory()+fd.getFile();
        if (fd.getFile() == null) return null; //usr canceled
        return fn;
}

public static void main(String args[]) {
        System.out.println("Test");
        float flt[][] =
                {
                        {1.0f,3.0f,4.0f},
                        {1.0f,3.0f,4.0f},
                        {1.0f,3.0f,4.0f}
                };
        MatFloat mf = new MatFloat(flt);
        print(flt);
        String fn = mf.getSaveFileName("flt.gz file");
        mf.saveAsgz(fn);
        mf.readAsgz(fn);
        print(mf.f);
}
public void saveAsgz() {
        saveAsgz(
                getSaveFileName("flt.gz file"));
}
public void saveAsgz(String fn) {
    try {
        FileOutputStream fos = new FileOutputStream(fn);
        GZIPOutputStream gos = new GZIPOutputStream(fos);
        ObjectOutputStream oos = new ObjectOutputStream(gos);
         oos.writeInt(f.length);
         oos.writeInt(f[0].length);
         for (int x=0; x < f.length; x++)
          for (int y=0; y < f.length; y++)
                        oos.writeFloat(f[x][y]);
         oos.close();
         gos.finish();

        } catch(Exception e) {
         System.out.println("Save saveAsFloatgz:"+e);
        }
}
private  void readAsgz(String fn) {
    try {
        FileInputStream fis = new FileInputStream(fn);
        GZIPInputStream gis = new GZIPInputStream(fis);
```

```
        ObjectInputStream ois = new ObjectInputStream(gis);
         int w = ois.readInt();
         int h = ois.readInt();
         f = new float[w][h];
         for (int x=0; x < w; x++)
           for (int y=0; y < h; y++)
             f[x][y] = ois.readFloat();
          ois.close();
        } catch(Exception e) {
         System.out.println("readAsgz:"+e);
        }
        }
    }
```

15.8 Summary

Streams are the basic means by which the I/O libraries communicate with the outside
world. The unformatted sequence of bytes is used as the basis for transmitting all types
of data (binary, character, image, audio, etc.). An understanding of streams is therefore
important for understanding file I/O, network programming and server-side programming
(all topics that will be covered later in the book).

15.9 Exercises

15.1 Identify a file that the *StreamSniffer* does not know. Train the *StreamSniffer* to learn the new
file type, describe the steps you took to perform this training, and suggest ways to make it eas-
ier for *StreamSniffer* to learn new file types.

15.2 Add a constructor to the *futils.DirList* class that takes a string instance for a suffix. *DirList*
should construct a *WildFilter* instance to form a list of only those files that have an ending that
matches the suffix string.

15.3 Create a command-line interface to Java. Support commands like ls *.java > foo.

15.4 Modify the *Customer* example in Section 15.6 to use uncompressed objects during a save. Try
saving 100 customers. Now try again using compressed objects. What is the difference in size
between the compressed and uncompressed files?

15.5 Write a program that saves a *vector* of serializable objects as a single GZIPed file. As an ex-
ample, consider the following code, which saves three *short* arrays:

```
public void saveAsShortgz(String fn) {
    try {
        FileOutputStream fos = new FileOutputStream(fn);
        GZIPOutputStream gos = new GZIPOutputStream(fos);
        ObjectOutputStream oos = new ObjectOutputStream(gos);
        oos.writeObject(r);
        oos.writeObject(g);
        oos.writeObject(b);
        oos.close();
        gos.finish();
    } catch(Exception e) {
        System.out.println("Save saveAsShortgz:"+e);
    }
}
```

```
        private void readShortsGz(String fn){
            GZIPInputStream in = null;
            try {
             in = new GZIPInputStream(
                     new FileInputStream(fn));
            } catch(Exception e)
               {e.printStackTrace();}
          getShortImageGz(in);
        }
```

C H

Rea

15.6 Write a program that will copy a file using all available RAM. The following class (in *futils.Exec*) will help you to determine how much RAM is available on your computer for your program:

```
package futils;

import java.io.IOException;

public class Exec {
  Runtime rt = Runtime.getRuntime();

  public static void main(String args[]) {
    Exec e =
        new Exec();
    e.printRam();
  }

  public void setMethodTrace(boolean t) {
    rt.traceMethodCalls(t);
  }

  public void setInstructionTrace(boolean t) {
    rt.traceInstructions(t);
  }

  public void run(String s) {
    try {
      rt.exec(s);
    } catch (IOException e) {
      System.err.println("Exec error:" + e);
    }
  }

  public String getPrintRamString() {
    return "free " + getFreeRam()
        + " bytes out of "
        + getTotalRam() + " bytes\n" +
        getFreeRatioPercent() + " percent free";
  }

  public void printRam() {
    System.out.println(getPrintRamString());
  }

  public long getFreeRam() {
    return rt.freeMemory();
  }
```

In this c

- Fil
- De
- Us
- To

WARNING

Using *BufferedReader*, it is possible to read an entire file into memory for processing. The *futils.Futil* class, for example, has

```java
public static String getFile(File file) {
   try {
     char[] chars = new char[(int) file.length()];
// BufferedReader resides in java.io
       BufferedReader in = new BufferedReader(new
         FileReader(file));
       in.read(chars);
       in.close();
       return new String(chars);
     } catch (IOException e) {
       System.out.println("failed reading " + file.getName() + ":
         " + e);
       return null;
     }
   }
public static void testGetFile() {
       String s = Futil.getFile(Futil.getReadFile("select a
         file"));
       System.out.println(s);
   }
public static void main(String args[]) {
       testGetFile();
   }
```

 It is very important to close your readers when you are done to free up resources and reset the underlying streams.

Thus, *getFile* reads the entire file as a string. The rest of this chapter is just a variation on the theme of reading characters or strings from a *BufferedReader*. You can read one character at a time, a line at a time, or an entire buffer at a time. If the goal is to create the fastest program, and if plenty of memory is available, the *getFile* method should provide excellent performance.

 Buffered IO is almost always more efficient than character IO. Use buffered IO if at all possible.

16.1 ReaderUtils

In order to read data, we need to be able to open an *input stream*. An input stream is defined as an unformatted sequence of bytes. These bytes are not the primitive data bytes in Java (i.e., those quantities that range from -128 to 127) but rather are unsigned data bytes. In the past, languages like C and C++ made use of a byte as if it were a *char*. However, Java characters are 16-bit unsigned Unicode quantities. To convert an unformatted sequence of bytes into Unicode characters, we use classes in the *java.io* and the *java.util* packages. As a result, we include

```java
import java.io.*;
import java.util.*;
/*
```

The *ReaderUtils* class contains a private instance of a
BufferedReader and makes use of this for all of its input
utilities. The *BufferedReader* may be read using a getter
method and it may be set using a setter method. As a
result, it is externally directed to read from any source
(i.e., a socket, URL, console, or file).

```java
*/
private static BufferedReader br =
      new BufferedReader(
       new InputStreamReader(
         System.in));

      public static void setReader(BufferedReader _br) {
       br = _br;
      }
      public static BufferedReader getReader() {
       return br;
      }

// To obtain a string from the user, use:
public static String getString(String prompt){
      if (prompt != null)
        System.out.print(prompt);
      try {
        return br.readLine();
      }
      catch(IOException e) {}
      return null;
}
/*
To transform the string into an integer, and perform an internal
      error check, use:
*/
public static int getInt(String prompt) {
      String s = getString(prompt);
      int i=0;
      try {
            i = Integer.parseInt(s);
       }
        catch (NumberFormatException e) {
            System.out.println(
                  s+" is not a valid int, try again");
            return getInt(prompt);
       }
        return i;
}
```

An example of how to use *getInt* use follows:

```java
      public static void main(String args[]) {
         int i= getInt("please enter an int:");
         System.out.println("you typed "+i);
      }
```

StringTokenizer can be used to obtain an array of strings from a file. For example,

```
public static String[] getTokens(String p) {
        String s =
          getString(p);
        StringTokenizer
          st = new StringTokenizer(
                s,", \t\n\r\f\\");
        int n = st.countTokens();
        String t[]=new String[n];
        for (int i=0;i<n;i++)
          t[i]= st.nextToken();
        return t;
}
```

StringTokenizer is not as general as a search through the characters using methods like *String.charAt(int i)*.

16.2 Reading in a CSV File

It is typical for data to start in one application and then end up in Java. For this to occur, it is best to export the data in CSV format so that it can be parsed. Before we can parse CSV data, we must create it. Figure 16.2-1 shows the Excel dialog box that is used to export data in CSV format.

It is generally a bad idea to expect data to appear in a particular sequence. A better idea would be to use XML, as described in Chapter 32.

What follows is a sample of some of the data that was stored in the address book file:

```
Last Name,First Name,Address 1,Address 2,Address 3,Address
        4,Address 5,Home Phone,Bus. Phone,Fax
3C503-16tp,,,,,,,,,,
3Com,,Palm Computing, Inc.,5400 Bayfront Plaza,Box 58007,Santa
        Clara, CA 95052-8007,,
1956 psychologist george miller,,discovered that typical humans
        simultaneously,comprehend 7 chunks of information +-
        2.,,,,,,,
```

FIGURE 16.2-1
CSV Dialog in Excel

Using the following coding sequence permits the reading and decoding of the first four records:

```
CsvReader cr = new CsvReader(
  Futil.getBufferedReader(
    Futil.getReadFile("Select a CSV file")
  )
);
System.out.println(
    cr.getRecord(0)
  + cr.getRecord(1)
  + cr.getRecord(2)
  + cr.getRecord(3));
```

The output is

```
read 2194 lines
number of bad records=98

---
First Name Last Name
Address 1
Address 2
Address 3
Address 4
Address 5
Home Phone
Bus. Phone
Fax
---
 3C503-16tp
---
 3Com
Palm Computing
Inc.
5400 Bayfront Plaza
Box 58007
Santa Clara
CA 95052-8007
---
 1956 psychologist george miller
discovered that typical humans simultaneously
comprehend 7 chunks of information +- 2.
```

The *CsvReader* source code follows:

```
package futils;

import java.util.*;
import java.io.*;
import java.awt.*;

/*
```

The *CsvReader* is made to read *CSV* type files and, assuming that
 they are address records, store the records in its
 internally held *Vector*.

```java
*/
public class CsvReader {
      BufferedReader br;
      Vector v = new Vector();
// A BufferedReader is required by the constructor:
      public CsvReader(BufferedReader _br) {
        br = _br;
        getLines();
        System.out.println("read "+v.size()+" lines");
        System.out.println("number of bad
        records="+numberOfBadRecords);
      }
   int numberOfBadRecords = 0;
      class Address {
        String lastName = "";
        String firstName= "";
        String address1= "";
        String address2= "";
        String address3= "";
        String address4= "";
        String address5= "";
        String homePhone= "";
        String businessPhone= "";
        String faxPhone= "";
/*
```

Exception handling is built into the constructor of an address, in
 case there are too few records on the input:

```java
*/
      Address(String s[]) {
        try {
          lastName=s[0];
          firstName=s[1];
          address1=s[2];
          address2=s[3];
          address3=s[4];
          address4=s[5];
          address5=s[6];
          homePhone=s[7];
          businessPhone=s[8];
          faxPhone=s[9];
          } catch(ArrayIndexOutOfBoundsException e) {
              numberOfBadRecords++;
          }
      }
      private String outLine(String s) {
        if (s.equals("")) return s;
        return "\n"+s;
      }
```

```
            public String toString() {
              return outLine("----")
              +outLine(firstName+ " "+lastName)
              +outLine(address1)
              +outLine(address2)
              +outLine(address3)
              +outLine(address4)
              +outLine(address5)
              +outLine(homePhone)
              +outLine(businessPhone)
              +outLine(faxPhone);
            }
        }
/*
The toString method is used to fetch a record. In the future,
        another presentation may be required (like a GUI). In
        addition, a search feature may be needed.
*/
        public String getRecord(int i) {
          return v.elementAt(i).toString();
        }
        private void processLine(String l) {
          v.addElement(new Address(
                    new CsvParser(l).getTokens()
            ));
        }
        private void getLines() {
          try {
            for (String l=br.readLine();
                 l != null; l = br.readLine())
                 processLine(l);
          }
          catch (IOException e) {
            e.printStackTrace();
          }
        }

        public static void main(String args[]) {
          CsvReader cr = new CsvReader(
            Futil.getBufferedReader(
                    Futil.getReadFile("Select a CSV file")
            )
          );
          System.out.println(
            cr.getRecord(0)
            + cr.getRecord(1)
            + cr.getRecord(2)
            + cr.getRecord(3));
        }
}
```

16.3 The *Cat.toConsole* Method

This section shows how to list a file to the console. The *Futil* class contains a series of helper methods that keep the console listing code free of *try-catch* blocks and any direct dependencies on the built-in IO API:

```
public static void toConsole() {
    toConsole(Futil.getBufferedReader(
    Futil.getReadFile(
            "select a file to Cat.toConsole()")));
}
```

The *getReadFile* method opens a dialog box and prompts the user for an input file. The *getBufferedReader* treats the input file as a series of characters and supports the reading of a line of text. If the end of the file is reached, *Futil.readline* will return *null* For example,

```
static public void toConsole(BufferedReader br) {
                String line;
                while ((
                    line = Futil.readLine(br)) != null)
                System.out.println(line);
// the CR is stripped off by the buffered reader.
                Futil.close(br);
}
```

WARNING

Futil.close intercepts any errors and handles them silently. Depending on your application, you might want to consider alternatives to this approach.

Based on this simple model of reading in one line at a time, we are able to perform a series of text-based data processing tasks.

16.4 The Dos Class

As a final example of the use of a reader, consider the *Dos* class. The *Dos* class executes a *bat* file called *d:\foo.bat*. During the execution, it prints everything the batch file outputs. Thus, Java can be used as a kind of systems programming language. The following listing shows how *Dos.command* can be used to invoke a batch file and return results to an invoking Java program:

```
package utils;
import java.io.*;
public class Dos {
    public static void main(String args[]) {
      System.out.println("Hello Dos!");
      Dos d = new Dos();
      try {
        d.command("d:\\foo.bat");
      }catch (Exception e) {
        e.printStackTrace();
      }

    }

    public void command(String com)
        throws IOException {
```

```
Runtime rt = Runtime.getRuntime();
Process p =
  rt.exec(com);
System.out.println("process="+p);
BufferedReader br
  = new BufferedReader(
        new InputStreamReader(
          p.getInputStream()));
String s = null;
while ((s = br.readLine()) != null)
  System.out.println("dos:"+s);
}
```
}

WARNING
Invoking operating system-dependent scripts probably will make your code non-portable.

The *java.lang* package contains the *Runtime* class, which enables access to the run-time environment. This topic is beyond the scope of the current chapter, as is the *Process* class, which is described briefly below. Suffice it to say that the *Process* class starts a task outside of the JVM. The *RunTime.exec* method executes the command on the native operating system. The *Process* instance outputs to a stream that, from the Java client's point of view, is an *InputStream*. Thus, *Process.getInputStream* gives the Java client access to the output of the process.

DESIGN PATTERN
The *Runtime* class only keeps one copy of the *Runtime* instance internally, which is an example of the *singleton pattern*. See Chapter 9 and the Glossary for more information about the singleton pattern.

The *Runtime.exec* method is overloaded. There are two commonly used forms of the method:

```
Runtime.exec(String prog)
Runtime.exec(String progArray[])
```

To run a batch file without arguments, use

```
String prog = "c:\foo.bat";
```

To run a batch file with arguments, use

```
String progArray[] = {"c:\foo.bat", "arg1", "arg2"};
```

Running operating system commands from Java can be very handy. For example, a Java program can invoke a compiler from within the Java environment. The implication is that a Java program can write Java programs at run time and then compile them. In the following section we show how Java can be used to dial the phone with simple *DOS* commands.

16.5 Dial D for *Dos*

Using the batch files of *Dos*, it is possible to write a nonportable Java program that can dial a modem. The first step is to make sure that the modem is a *Hayes-compatible* modem that uses the *AT* command set. Type

```
ECHO ATDT > COM1
```

If the modem is on a different port, then you may have to use

```
ECHO ATDT > COMn
```

where *n* is the port number. If the modem is working, you should hear a dial tone. To hang up, type

```
ECHO ATH > COM1
```

To dial a long-distance 800 number, use

```
ECHO ATDT18005551212 > COM1
```

If you need to wait two seconds, use a comma:

```
ECHO ATDT1,8005551212 > COM1
```

Inserting commands into a batch file can enable Java to dial a modem with ease as long as *Dos* is available.

16.6 The StreamTokenizer Class

The *StreamTokenizer* class resides in the *java.io package*. It converts an *InputStream* instance into a stream of tokens. Bytes are read from the *InputStream* instance and are treated as unsigned shorts that range from 0–255. We refer the reader to [Gosling et al.] for a more complete description of the *StreamTokenizer*.

A *StreamTokenizer* instance is an instance of a parser. The parser settings may be altered to recognize C-style comments, C++-style comments, and line terminators, as well as to convert tokens to lowercase.

StreamTokenizer is a higher-level *Stream* than the *DataInputStream*. Thus, we wrap the latter in the former.

16.6.1 *StreamTokenizer* Class Summary

```
public class StreamTokenizer {
     public int ttype
     public static final int TT_EOF
     public static final int TT_EOL
     public static final int TT_NUMBER
     public static final int TT_WORD
     public String sval
     public double nval
     public StreamTokenizer (InputStream I)
     public void resetSyntax()
     public void wordChars(int low, int hi)
     public void whitespaceChars(int low, int hi)
     public void ordinaryChars(int low, int hi)
     public void ordinaryChar(int ch)
     public void commentChar(int ch)
     public void quoteChar(int ch)
     public void parseNumbers()
     public void eolIsSignificant(boolean flag)
     public void slashStarComments(boolean flag)
     public void slashSlashComments(boolean flag)
```

```
                        public void lowerCaseMode(boolean fl)
                        public int nextToken() throws IOException
                        public void pushBack()
                        public int lineno()
                        public String toString()
            }
```

16.6.2 *StreamTokenizer* Class Usage

Suppose the following variables are predefined:

```
            String sval;
            double nval;
            InputStream is;
            int low, hi, ch, token, lineNumber;
            String s;
            StreamTokenizer st;
```

To make an instance of a *StreamTokenizer*, use

```
            st = new StreamTokenizer(is);
```

StreamTokenizer has several constants held as public constants. These constants are used by case statements to determine the token type. [i.e., end-of-file (EOF) or end-of-line (EOL)]:

```
            StreamTokenizer.TT_EOF
            StreamTokenizer.TT_EOL
```

To determine if the token is a number (value in nval), use

```
            StreamTokenizer.TT_NUMBER
```

To determine if the token is a word (value in *sval*), use

```
            StreamTokenizer.TT_WORD
```

To return to the default settings, use

```
            st.resetSyntax();
```

To specify the cumulative range of Unicode characters to be used for words, use

```
            st.wordChars(low, hi);
```

To specify the range of Unicode characters to be used as white space, use

```
            st.whitespaceChars(low,hi);
```

To specify the range of Unicode characters to be treated as ordinary characters, use

```
            st.ordinaryChars(low, hi);
```

To add an *ordinaryChar*, use

```
            st.ordinaryChar(ch);
```

To add a single-line commentCharacter (all characters to the end of the line are *comment* characters, and the *StreamTokenizer* skips them), use

```
            st.commentChar(ch);
```

To specify the quote character to delimit a string, use

```
st.quoteChar(ch);
```

To specify that numbers should be parsed, use

```
st.parseNumbers();
```

To make *nextToken* return *TT_EOL*, use

```
flag = true;
st.eolIsSignificant(flag);
```

To select '/*' comments, use

```
st.slashStarComments(flag);
```

To select '//' comments, use

```
st.slashSlashComments(flag);
```

To determines whether or not *TT_WORD* tokens are automatically lowercased, use:

```
st.lowerCaseMode(fl);
```

To parse a token, returning *ttype*, use

```
ttype = st.nextToken();
```

To push a token back into the stream, use

```
st.pushBack();
```

To get the current line number, use

```
i = st.lineno();
```

To convert the token to a string, use

```
s = st.toString();
```

If an input stream is buffered, the thread reading the *StreamTokenizer* will be blocked if the buffer is empty. The thread will be ready to execute once the buffer starts to fill up again.

16.6.3 Futil.readDataFile

In order to save the state of our program, we write several key parameters into a file. These parameters are stored with keywords and values so that a human with a text editor (perhaps a non-programmer) is able to alter the data. A sample data file follows:

```
Data format is order dependent
lyon.Laser
Rotation= 34.4198            6.47311       -36.7812
lyon.Camera    rho=  18.4931        pc=          125.3
-102.35   A=   4.8    F=    3.6
lyon.Wedge     p1 =  -403.685     591.244
lyon.Grating   P1=   6651   P2=   2261   L=    81
```

The *readDataFile* method is in the *futils* package. It is used to take a file name and read data into an array of doubles. To perform this task, we use a *StreamTokenizer* instance

called *tokens*. Note that *tokens.nextToken()* must be nested in a *try-catch* block. Since the words are intended for humans, they are ignored. Only numbers matter, and since people are warned not to change the order of the parameters, future versions of the data file may only add numbers to the end of the file. For example,

```
public static  void readDataFile(File file,
    double data[]) {
System.out.println("processing:\t" + file);
FileReader fr = getFileReader(file);
StreamTokenizer tokens = new
  StreamTokenizer(fr);
int next = 0;
int num = 0;
try {
    while (
      (next = tokens.nextToken()) !=
        tokens.TT_EOF) {
        switch (next) {
            case StreamTokenizer.TT_WORD:
                break;
            case StreamTokenizer.TT_NUMBER:
                data[num] = (double) tokens.nval;
                System.out.println(num+": "+
          data[num]);
                num = num + 1;
                break;
            case StreamTokenizer.TT_EOL:
                break;
        }
    }
}
catch (Exception e) {
  System.out.println("Read Data File:er!");}
  Futil.close(fr);
}
```

Creation of the file is a simple matter of creating a *FileWriter*, as described in Chapter 17.

16.6.4 Futil.writeFilteredHrefFile

WARNING

A bug-filled Web authoring tool (such as Netscape 3.01 Gold) will produce HTML that includes hyper-text references (*hrefs*) with embedded spaces.

A space in an *href* is a bug since browsers stop reading the href name after the first space. To get browsers to recognize the space, we must replace spaces with their hexadecimal equivalent, %20.

```
1. <html>
2.     <head>
3.     <title>
4. API User's Guide
5.     </title>
```

```
6.        </head>
7.        <body>
8.        <a href= "API Documentation/packages.html" > Java API</a>
```

The corrected version of line 8 follows:

```
<a href= "API%20Documentation/packages.html" > Java API</a>
```

To perform this transformation, we build a custom tokenizer that looks for quoted strings and replaces all spaces with *%20*.

The *resetSyntax* method is used to make all characters ordinary:

```
public static  void writeFilteredHrefFile() throws IOException {
        FileReader fr = Futil.getFileReader();
        StreamTokenizer st =
          new StreamTokenizer(fr);

        FileWriter fw = Futil.getFileWriter(
          "select an HTML file for output");
        PrintWriter pw = new PrintWriter(fw);
        int i;
        int next = 0;
        st.resetSyntax();
/* The following line says that all characters are word
        characters.
*/
        st.wordChars(0,255);
/*
The only character of interest is the quote character:
*/
        st.quoteChar('"');
/* The nextToken method will read until the quoteCharacter,
        setting sval to the value of the body of the string
        contained in quotes
*/
        while ((next = st.nextToken()) != st.TT_EOF) {
            switch (next) {
                case '"':
                    pw.print('"');
/* We now output a quote, then we scan the string for a space.
        If a space is found, output a "%20" otherwise output the
        character.
*/
                    for (i=0;i<st.sval.length();i++)
                        if (st.sval.charAt(i) == ' ')
                            pw.print("%20");
                        else
                            pw.print(st.sval.charAt(i));
                    pw.print('"');
                    break;
/*
In all other cases we simply output the string read. This is
        really nice because we only read upto the point at which
        a delimiting character occurs.
*/
```

```
                              case StreamTokenizer.TT_WORD:
                                   pw.print(st.sval+" ");
                                   break;
                              case StreamTokenizer.TT_NUMBER:
                                   pw.print(st.nval+" ");
                                   break;
                              case StreamTokenizer.TT_EOL:
                                   pw.println();
                                   break;
                         } // end switch
                  } // end while
           Futil.close(fw);
           Futil.close(fr);
     }
```

WARNING

Closing writers is very important. Corrupt files can result if you do not close writers after you are done. Also, if there is a buffer, it will be flushed during the close.

16.7 The futils.PolymorphicProcessor

In this section, we show how to obtain code reuse by introducing a simple interface into the core of the *read-process* loop. The goal is to build a *read-process* loop that prompts the user for a file and then processes all of the lines of text in that file with an unknown algorithm. The interface follows:

```
interface LineProcessor {
    public void process(String l);
}
```

We may now build a framework for processing instances of classes that implement the *LineProcessor* interface. Since we are making use of polymorphism in our line processing, we call this the *PolymorphicProcessor*. The implementation follows:

```
public class PolymorphicProcessor {
    LineProcessor lp = null;

    PolymorphicProcessor(LineProcessor _lp) {
        lp = _lp;
        process();
    }

    public void process() {
        BufferedReader br =
                ReaderUtil.getBufferedReader(
                  "select text file");
        String s = null;
        while ((s = ReaderUtil.readLine(br)) != null) {
            lp.process(s);
        }
        ReaderUtil.close(br);

    }
}
```

No exceptions are being thrown or caught by the *PolymorphicProcessor* since our policy is to handle all such exceptions locally in the *ReadUtil*.

If the programmer is unhappy with the style of catching IO exceptions locally, it would be a simple matter to declare exceptions in a throws clause in the *process* method. Doing so can make code look cleaner.

The following example shows how to use the *LineProcessor* to print the lines in a file:

```java
class TestPolymorphicProcessor {
    public static void main(String args[]) {
        new PolymorphicProcessor(
                new LineProcessor() {
                    public void process(String s) {
                        System.out.println(s);
                    }
                }
        );
    }
}
```

LineProcessor uses an anonymous inner class to implement polymorphism and reuse the code in the processor. Since the *process* implementation can be complex, a named class might be more appropriate in some applications. In the following example, we show how to read all of the data into a local data store and return the lines as an array of *String*:

```java
class Reader implements LineProcessor {
    Vector v = new Vector();
    PolymorphicProcessor pp = new
            PolymorphicProcessor(this);

    public String[] getLines() {
        String s[] = new String[v.size()];
        v.copyInto(s);

        return s;
    }

    public static void main(String args[]) {
        System.out.println(new Reader());
    }

    public void process(String s) {
        v.addElement(s);
    }

    public String toString() {
        String s[] = getLines();
        StringBuffer sb = new StringBuffer();
        for (int i = 0; i < s.length; i++)
            sb.append(s[i] + '\n');
        return sb.toString();
    }
}
```

Now we see how the *Read* associates with the *PolymorphicProcessor* in order to make use of its read-process implementation. We need only instance a reader to make it swing into action, prompting the user for a text file and printing out the string representation of the file.

16.8 Summary

In this chapter, we covered the *Dialog* and *FileDialog* classes, which are the widgets to use to get file names from the user. *Futils.getReadFile* and *Futils.getWriteFile* both have embedded calls to the *FileDialog* constructor. As a result, there is no reason to embed a file name in a file in the Java source code. The *futils* package contains a list of classes that are used daily and that save several lines of source code each time that they are used.

STYLE POINT

From a style viewpoint, the programmer might object to handling exceptions locally, as the *futils* classes attempt to do. However, we have found the local handling of exceptions to be an acceptable approach in most cases that we have encountered thus far.

16.9 Exercises

16.1 Write a program that reads a set of true-false questions, along with their answers, from a text file. A sample format might be

```
true  Java is a cool language.
false Linux was designed to take over the OS market.
```

Thus, the first token is used to indicate the answer; the question follows. Use your reader to formulate a true-false exam, let the user complete the exam, and then show the exam score, along with the correct answers.

16.2 Write a program that reads Java source code from a file and prints out Javadoc comments. For example, if the input is

```
public class Hello {
      public int draw(Graphics g, Color c) {
        ...
      }
}
```

then the output would be

```
/**
      The <code> draw </code> method
      @author J. Doe
      @version       1.1
      @since       JDK1.0
      @param g is a Graphics instance
      @param c is a Color instance
      @return <code>int</code>
*/
```

16.3 Write a program that reads in a series of numbers from a file and prints out the number of integers. For example, if the input is

```
1 2.5 3 3.5
```

the output would print

```
There are two integers in the file.
```

16.4 Write a program that reads in the date from a file in the form *mm/dd/yy* and then prints it out in the form *yymmdd*. For example, if the input file contains
```
2/10/01
```

the output would read
```
The date is: 010210
```

16.5 The International Standard Book Number (ISBN) is used to identify books. ISBNs contain four sets of digits: (1) digits that represent the language in which the book is written, (2) digits that represent the book's publisher, (3) digits that are assigned by that publisher, and digits that provide an error-detecting code. For example, 0-13-974577-7 shows that the book's language is English because the first digit, 0, represents English. The first digit for a book in German is 3. The publisher is Prentice Hall because the second group of digits, 13, represents Prentice Hall. Another publisher is W.W. Norton, whose digits are 393. The number 974577 is assigned by the publisher, and −7 represents an error-detecting code. Write a program that reads the ISBN numbers from a file and breaks them down. For example,
```
0-13-974577-7
```

becomes

```
Language: 0
Publisher: 13
Book number: 974577
Check digit: 7
```

16.6 Universal Price Codes (UPCs) are used on products sold by most manufacturers. UPCs have the format

```
7 9  3  8  8  7  4  8  4  6  0  4
d i1 i2 i3 i4 i5 j1 j2 j3 j4 j5 k
```

The last digit is computed as a check digit. Adding the 1st, 3rd, 5th, 7th, 9th, and 11th digits yields S1:
```
26 = 7 + 3 + 8 + 4 + 4 + 0 = d+i2+i4+j1+j3+j5.
```

Adding the 2nd, 4th, 6th, 8th, and 10th digits yields S2:
```
38 = 9 + 8 + 7 + 8 + 6 = i1 + i3 + i5 + j2 + j4
```

The check digit is computed as k = 9–[((S1 times 3 plus S2) −1) mod 10]. For example,

```
k = 9- ((((S1 * 3) + S2)-1) mod 10 ) =9- ((115) mod 10 )
  = 9 - 5 = 4
```

Write a program that inputs a series of UPCs from a file and prints out if the check code, k, is correct or not. Codes are often in the format
```
7 93887 48460 4
```

though this is not always true.

16.7 Write a program that reads in a series of numbers from a file and computes the average.

16.8 Write a version of the *ReaderUtil* that can use either *Swing* or *AWT*. Using
```
private static boolean isSwing = false;
```

write private versions of *JGetReadFile* and *AwtGetReadFile*. Dispatch to the correct version from the *getReadFile* method based on the value of *isSwing*. By centralizing the usage of the GUI, you enable your program to make use of either Swing or AWT.

16.9 Write a program that dials the modem using

```
class Modem {
        public static void dial(String s) { ...
```

Where *String s* is a valid telephone number. For example,
```
Modem.dial("18005551212");
```

16.10 Write a version of a recursive file lister that takes a file name filter as a parameter based on the below program:

```
public static void listFilesRecursive(
        Vector v, File f, String suffix) {
 if (f.isFile() && f.getName().endsWith(suffix)) {
  v.addElement(f);
  return;
 }
 File[] files = f.listFiles();
 for (int i=0; i < files.length; i++)
   listFilesRecursive(v,files[i],suffix);
}
```

16.11 The astute reader will note that we did not perform local handling of exceptions for the *StreamTokenizer*. Develop a *StreamTokenizer* with local handling of exceptions.

C H A P T E R 1 7

Writers

Easy reading is damned hard writing.

–Nathaniel Hawthorne writer
(1804–1864)

In this chapter, you will learn how to:

- Get a file name for output
- Create your own writer
- Output text to a file
- Write out a list of HTML links from an HTML input file
- List a file into another file
- Write a table of contents to a file in HTML

This chapter describes several helper methods that are used to process a class of output streams called *Writers*.

 A *Writer* is an abstract class that provides a method for writing characters to an output stream.

Just like the *getFile* method discussed in Chapter 16, *futils.Futil* provides a record-oriented means of writing an entire string to a file in a single pass. This process is very fast, provided that all of the data is ready for output to a file in a single string:

```
public static void saveFile(File file, String newText) {
  try {
    char[] chars = newText.toCharArray();
    BufferedWriter out = new BufferedWriter(
        new FileWriter(file));
    out.write(chars);
    out.close();
  } catch (IOException e) {
    System.out.println(
        "failed reading "
        + file.getName()
```

```
                    + ": " + e);
        }
    }
```

Writers often have buffers, which are not flushed until the writers are closed. Always close your writers when you are done with them.

The rest of this chapter provides variations and support on the theme of writing out characters (or strings) to a *Writer* instance. Sometimes a file cannot be written in a single pass. More often than not, however, text files are short and can be read very quickly all at once.

17.1 Getting a File Name for Output

A *Writer* can be created from any output stream. The *WriterUtil* class has methods that enable the selection of an output file for example,

```
package futils;
import java.util.*;
import java.awt.*;
import java.io.*;
```

By declaring the class as *final*, we prevent anyone from subclassing the *WriterUtil* class.

```
public final class WriterUtil {
    /**
     * Don't let anyone instantiate this class.
     * It only contains static methods.
     */
```

By declaring the constructor as *private*, we prevent anyone from instancing the *WriterUtil* class. This is a typical way to handle classes that are intended to hold *static* methods.

```
    private WriterUtil() {}

    public static String getWriteFileName() {
            FileDialog dialog = new FileDialog(
                    new Frame(),
                    "Enter file name",
                    FileDialog.SAVE);
        dialog.setVisible(true);
        String fs = dialog.getDirectory() + dialog.getFile();
        System.out.println("Opening file: "+fs);
        dialog.dispose();
        return FilterFileNameBug(fs);
    }
     // Some versions of windows will
    // create a .* suffix on a file name
    // The following code will strip it:
    public static String FilterFileNameBug(String fname) {
            if (fname.endsWith(".*.*")) {
```

FIGURE 17.1-1
An Image of the Output File Dialog Box

```
            fname=fname.substring(0, fname.length() - 4);
        }
    return fname;
}
```

In order to test the class, a *main* method is added, which prints out the file name selected:

```
public static void main(String[] args) {
    System.out.println(getWriteFileName());

}
```

When *main* is run, Figure 17.1-1 results.
 The selection of *out.txt* results in

```
Opening file: /system/Desktop Folder/out.txt
/system/Desktop Folder/out.txt
```

This chapter presents a number of useful utilities for writing and processing text files.

One of the primary input classes for reading characters is called *BufferedWriter.* *BufferedWriter* resides in the *java.io* package and generally is used for all text input. *BufferedWriter* writes a character-output stream using a buffer. The default size of the buffer can be specified by the programmer (in order to trade space for time). The buffer increases the speed of a write operation. Any type of writer can be used in the construction of *BufferedWriter* (e.g., *FileWriter* or *OutputStreamWriter*). The following code example from *futils.Futil* is used to copy a text file:

```
/** copy an input file to an output file.
 */
public static void copyFile(BufferedReader br,
                            BufferedWriter bw)
        throws IOException {
    String line = null;
    while ((line =
            br.readLine()) != null)
        bw.write(line + "\n");
```

```
        br.close();
        bw.close();
    }

public static void testCopyFile() {
    try {
        copyFile(
                new BufferedReader(
                    new FileReader(
                        getReadFile("select .txt file"))),
                new BufferedWriter(
                    new FileWriter(
                        getWriteFile("output .txt file")))));
    } catch (IOException e) {
        e.printStackTrace();
    }
    System.out.println("Copy done");
}
```

The *testCopyFile* method makes use of the buffer (typically an array of some default size) contained internally by *BufferedReader* to read the text file one line at a time. Such programs easily can be modified to include one-line-at-a-time text processing (rather than a simple copy).

17.2 SimpleWriter

This section shows how to create a custom *Writer* called *PrintWriter*.

PrintWriter resides in the *java.io* package and prints a character-output stream.

You cannot write bytes using a print writer since it is intended for characters only. When automatic flushing is enabled, output will be forced when the println() method is invoked.

In the following example, *futils.SimpleWriter* outputs to a user-selected file. *SimpleWriter* takes a different approach from the *Futil* class in that it can open its own files. The assumption is that writers will output to files (an assumption that is only sometimes true). For example,

```
1.      import java.awt.*;
2.      import java.io.*;
3.
4.      public class SimpleWriter extends PrintWriter {
5.
6.          public static File getWriteFile() {
7.              return getWriteFile(
8.                  "Select a file for output");
9.          }
10.        public static File getWriteFile(
11.            String prompt) {
12.                FileDialog fd =
13.                    new FileDialog(
14.                    new Frame(),
15.                    prompt,
16.                    FileDialog.SAVE);
```

```
17.                        fd.setVisible(true);
18.
19.                    return new File(
20.                            fd.getDirectory()
21.                            + fd.getFile());
22.            }
```

Here we see that *SimpleWriter* has its own GUI. The GUI is used to get a file name for output, after which time the GUI uses this output to construct *FileWriter*.

```
23.            public SimpleWriter() throws IOException {
24.                super(new FileWriter(getWriteFile()));
25.            }
26.            public static void main(String args[]) {
27.                try {
28.                    SimpleWriter sw = new SimpleWriter();
29.                    sw.println(
                          "This is a writer that"+
                          " lets the user output to"+
                          " a GUI based file");
30.                    sw.close();
31.                }
32.                catch (IOException e) {
33.                    e.printStackTrace();
34.                }
35.            }
36.        }
```

It is typically a poor decision to mix GUI code and IO code in the same class because the code does not reuse the file-selection segment of the program. However, having all of the support methods in the same class sometimes can make the code clearer (as we have done here).

17.3 HTML2Links

The following example shows how to open an HTML file, read in all of the HTML links, and then use the links to create new HTML that just lists out the links. The text associated with the links is stripped out, and the hyper-text references are used for the links. Figure 17.3-1 shows a view of the HTML links used for inputs (obtained by exporting the *Favorites* from Explorer).

Figure 17.3-2 shows an image of the hyperlinks that were output by the program. Such programs are useful utilities when writing a web robot. A web robot searches the web, performing a kind of data processing that results in a larger database for a search engine.

```
package futils;

import java.util.StringTokenizer;
import java.io.*;

/**
@author D. Lyon
@version 1.1
@see HtmlUtil
```

FIGURE 17.3-1
HTML Links used for Inputs

FIGURE 17.3-2
Hyperlinks Output by the Program

```
  */
public class HtmlUtil {

        private static void makeLinks() {
/*
We make heavy use of the Futil class to provide a simple GUI for
        selecting files:
*/
        File f = Futil.getReadFile("select a bookmarks file");
/* We also use the Futil class to help to wrapper any exception
        handling at a local level:
*/
        BufferedReader br = Futil.getBufferedReader(f);
        FileWriter fw = Futil.getFileWriter("Enter file.html");
/* The basic idea behind wrappering the exceptions at a local
        level is to handle the exceptions locally, rather than
        defer the exception handling to the calling method.
*/
int i = getInt("please enter an int:");
/*
```

We use a *PrintWriter* so that we can do *println* invocations:
```
*/
        PrintWriter pw = new PrintWriter(fw);
        String link;
        String line = null;
        // creating html header for the output file
        String head =
                "<HTML> \n <BODY>\n <B><I>"
                +" Following HyperLinks are extracted from "
                +f+" <B><I><P>";
        // write the html header
        pw.println(head);

        while( ((line = Futil.readLine(br)) != null){
          link=getHyperLink(line);
          // extract the hyperlink
          // from the line read from the input file
          if (link != null)
        pw.println( "<LI><A HREF =\""+link+"\">"+link+"</A><P>");

        }
        pw.println("</BODY> \n </HTML>");
        Futil.close(fw);
        }
```

Here is an example of the use of *StringTokenizer*, which scans for quoted strings that start with *http*. Typically, a hyper-text reference will take on the form of a relative link, such as

```
<A HREF="book/ipij.htm">
```

or an absolute URL, such as

```
=<a href="http://www.docjava.com/anlgform.html">
```

Though other variations exist, *getHyperLink* specifically looks for the *http:* at the front of the quoted string. For example,

```
/**
* getHyperLink() - extract the hyperlinks from the line
*
*@param String - line from  the input file
*
*@return String - return the extracted hyperlink from the line
*/
        public static String getHyperLink(String l){
          String link;
/*
We want  the StringTokenizer  to look for a quote (") character.
        However, this is embedded in a string and so we must
        escape the quote with a back-slash ('\'):
*/
        StringTokenizer st = new StringTokenizer(l,"\"");
        int tc = st.countTokens();
```

```
        for (int i=0; i < tc; i++){
            String s=st.nextToken();
/* If the substring starts with a http string, then we must have
        a URL. Thus, we succeed if the index of the string is
        location zero. If http is not found, the index will be -1.
*/
            if(s.indexOf("http") == 0)
                return s;
        }
            return null;
        }
        public static void main(String args[]) {
          HtmlUtil.makeLinks();
          System.out.println("done");
        }
}
// The Futil.close and File.getBufferedWriter follow:
        public static void close(
          BufferedWriter bw) {
          try {
            bw.close();
          }
          catch(IOException e) {
            e.printStackTrace();
          }
        }
/* The Futil class policy is to wrapper all invocations to the
        low-level IO API. That way, when low-level routines are
        deprecated, the client classes can remain unchanged.
        Also, exceptions are handled locally. This creates a
        cleaner look and feel in the client code:
*/
        public static BufferedWriter
          getBufferedWriter(String prompt) {
          File f = getWriteFile(prompt);
          return getBufferedWriter(f);
        }
        public static BufferedWriter
          getBufferedWriter(File f) {
          BufferedWriter bw = null;
          try {
            bw = new BufferedWriter(
                new FileWriter(f));
          }
          catch(IOException e) {
          }
          return bw;
        }
```

WARNING

It is very important to close *BufferedWriter* when writing has completed. A *BufferedWriter* instance only *flushes* the last of its buffer upon a close. The act of flushing ensures that no buffered data is waiting to be written to the file.

17.4 The Cat Class

In UNIX, the *cat* command is used to list a file. Sometimes *cat*, which stands for *concatenate*, is used to take a list of file names and incorporate them into a single file. Thus, we can use the cat class to concatenate the contents of a list of files into a single file. For example,

```
show.docjava.com{lyon}20: ls *.h
dlist.h  f2j.h  f2jparse.tab.h  initialize.h  symtab.h
show.docjava.com{lyon}21: cat *.h >foo
```

The file called *foo* now contains the contents of all the files from

```
dlist.h  f2j.h  f2jparse.tab.h  initialize.h  symtab.h
```

The *Cat* class shows how such a program can be written in Java. Figure 17.4-1 shows the standard file dialog input used to select a Java file.

Figure 17.4-2 shows the standard file dialog used to select the output file.

Invocation of the *Cat* class can be done via its main method:

```
public static void main(String args[]) {
    System.out.println("javasToFile");
    Cat.toFile(".java");
    System.out.println("done!");
}
```

All of the methods in the *Cat* class are static. The *toFile* method takes a suffix for the file names that it is supposed to search. In UNIX, we would write

```
cat *.java >outputFile
```

FIGURE 17.4-1
Standard File Dialog for Input

FIGURE 17.4-2
Standard File Dialog for Output

The code for the *toFile* method is

```
static public void toFile(String suffix) {
      String[] files = Ls.getWildNames(suffix);
      BufferedWriter bw =
        Futil.getBufferedWriter(
          "select an output for the *"+suffix+" files");
        for (int i=0; i < files.length; i++)
          fileToWriter(files[i], bw);
      Futil.close(bw);
}
```

The *toFile* method has several dependencies. One example is *Ls.getWildNames*, which facilitates this type of batch-file processing by listing all of the files with a given suffix.

 Do not close writers before you are done with them! Never close the stream upon which the writer is based; instead, only close the writer.

```
static public void fileToWriter(
      String fileName, BufferedWriter bw) {
      System.out.println("cat: "+fileName);
      BufferedReader br =
        Futil.getBufferedReader(new File(fileName));
      for (String line = Futil.getLine(br);
        line != null; line = Futil.getLine(br)) {
            Futil.println(bw, line);
        }
      Futil.close(br);
    }
    /*
```

The *fileToWriter* method takes an input file name and opens up the file for read. Then it writes it to the already opened *BufferedWriter*. When the reading is finished, we close the reader when we are done. It would be an error to close the writer, since we are not done writing. To keep the code clean and protected from Sun's possible deprecation of the *BufferedWriter* (as they did with *PrintStreams*) we layer all the IO invocations in the *Futil* class:
```
*/
    public static void println(
      BufferedWriter bw, Object o){
      try{
        bw.write(o+"\n");
      }
      catch(IOException e) {
        e.printStackTrace();
      }
    }
/*
```
A *BufferedWriter* has no *println* method. This does not prevent us from adding one in the *Futil* class. While we are at it, we also wrapper the *IOException*.
```
*/
    public static void close(
      BufferedWriter bw) {
      try {
        bw.close();
      }
      catch(IOException e) {
        e.printStackTrace();
      }
    }
```

17.5 Futil.makeTocHtml

This section shows a method in the *Futil* class called *makeTocHtml*. This method reads the documents in a directory and creates a table of contents in HTML. The user is prompted for the input directory and for the location of the output file. After being run on the futils package the browser output of *makeTocHtml* appears, as shown below:

<u>Cat.java</u>
<u>DirFilter.java</u>
<u>FileFilter.java</u>
<u>Find.java</u>
<u>Futil.java</u>
<u>Ls.java</u>
<u>WildFilter.java</u>

When clicking on any of the underlined links, a plain-text file of the source code appears:
```
    public static void makeTocHtml() {
        File dir = getDirFile();
```

```
            String[] files = dir.list(new FileFilter());
              System.out.println(files.length +
                " file(s):");
    /*
    Here we make use of the getFileWriter method in the Futil class.
            A FileWriter implements an OutputStreamWriter interface.
            It is used to output characters by converting them to a
            byte encoding before writing them to a file.
    */
            FileWriter fw=Futil.getFileWriter("Select List.html");
    /*
    The PrintWriter accepts primitive data-types as arguments to its
            print and println methods. These enable it to look like
            System.out.println:
    */
             PrintWriter pw = new PrintWriter(fw);
    /* The following code synthesizes HTML. A better way to do this
            is described in Section 17.2:
    */
            pw.println("<HTML>");
            pw.println("<BODY>");
            pw.println("<ul>");
            for (int i=0; i < files.length; i++){
              pw.println(
                "<LI><a href = \"" +
                files[i]+
                "\">"+
                   files[i]+
                "</a><P>");
                System.out.println(files[i]);
            }
          pw.println("</ul>");
          pw.println("</BODY>");
          pw.println("</HTML>");
          Futil.close(fw);
      }

    /* Like the BufferedWriter the FileWriter should be closed when
            writing is finished. Closing a FileWriter is handled by
            the Futil class:
    */
      public static void close(FileWriter fw) {
       try {
          fw.close();
          }
        catch (IOException e) {
          e.printStackTrace();
         }
       }
```

To obtain the *FileWriter* instance, we use the *Futil* method:

```
  public static FileWriter getFileWriter(String prompt) {
    return getFileWriter(getWriteFile(prompt));
```

```
    }
    public static FileWriter getFileWriter(File f) {
      try {
        return new FileWriter(f);
      }
      catch (IOException e) {
        e.printStackTrace();
        return null;
      }
    }
```

17.6 Summary

This chapter showed how to get a file name and use it to create a text file. While the text can be in any format, the HTML format was used to demonstrate a kind of data processing that can be performed with simple Java code.

 In subsequent chapters, we will see that the use of writers to output text is a central theme in server-side Java programs.

17.7 Exercises

17.1 Create an array of customers and save them to a file.

17.2 Write a program that can output to a file all possible letter-number combinations that correspond to a telephone number. For example, DOCJAVA = 3625282. Use the digit-symbol map shown in Figure 17.7-1.

17.3 Output a CSV file to a file whose name ends with a *.csv* suffix. The data should be a list of 100 random numbers that range from 1 to 10. Open the file using a spreadsheet program, graph the data using the spreadsheet program, and submit your results (along with a printout).

17.4 Consider the following snippet of code from the *Futil* class:

```
    public static void copyFile() {
      File f = getReadFile(
        "select an input file");
      BufferedWriter bw =
        getBufferedWriter(
            "enter an output file");
```

Digit	Symbols
1	1
2	abc
3	def
4	ghi
5	jkl
6	mno
7	prs
8	tuv
9	wxy
0	0

FIGURE 17.7-1
Digit-Symbol Map

```
BufferedReader br =
  getBufferedReader(f);
String line = null;
try {
  while ( (line =
  br.readLine()) != null) {
  println(bw, line);
 }
}
catch(IOException e) {
}
close(bw);
}
```

Write your own program that reads in a file and outputs another file with the contents convert-ed to lowercase.

17.5 Use the *Ls* class to create a list of all of the files in a given directory. Output this list to a file.

17.6 You are told to manipulate a price list so that all prices are increased by 10%. Write a program that reads the price list and outputs a revised price list.

17.7 Write a program that outputs a file given a two-dimensional array of integers. Make sure that one row of the array corresponds to a line in the file.

17.8 Write a program for reading and writing gzip-compressed CSV files. You may modify the CSV reader to work with compressed CSV files. Read in an uncompressed CSV file, and then write it out in gzip format. Read in the compressed CSV file, and write it out again in an uncom-pressed format. What are the sizes of the compressed and uncompressed files?

CHAPTER 18

Introduction to Swing

The hardest person to awaken is the one already awake.

–Tagalog saying

In this chapter, you will learn about:

- The Swing API
- The significance of the AWT API
- Components
- Panels
- Layout
- Getting a file name using a GUI

This chapter will provide an overview of some basic ideas behind the window toolkit of Java. Two APIs are of interest to us: AWT and Swing. We will learn about AWT because many of the older AWT classes are still in use by the newer Swing API. The more interesting issue is that of the process of design. When we design the interface to our system, we engage in an iterative process.

18.1 The Historical View

The first GUI available for Java, back in 1995, was called AWT.

 AWT consists of a large class library that is mostly subclassed from the *Component* class.

Figure 18.1-1 shows the *Component* class hierarchy. As we shall see in the following section, AWT classes became the foundation for the next-generation GUI class library, called *Swing*.

The *Component* class is a base class in AWT.

 A *Container* class can hold (i.e., contain) subclasses of the *Component* class. For example, the *Container* class can hold *Button, Panel*, or *Applet* instances.

 Sun has a nasty habit of deprecating its public interfaces to its GUI code, so be careful about its propagating too deeply into your code.

FIGURE 18.1-1
The Component Hierarchy

A *Container* instance has an *add* method that takes a *Component* instance as an argument. A new and improved GUI has been created that is built on top of the AWT class set. This new API is called *Swing*. *Applets* subclass the *Panel* class.

18.2 The Swing/AWT Relationship

Figure 18.2-1 shows an image of some of the basic Swing components.

- *JButton*—Provides a button with an icon.
- *JCheckBox*—Provides a checkbox with a label.
- *JComboBox*—Provides a drop-down list of items selected by clicking or typing multiple items.
- *JLabel*—Provides text or icons to an interface.
- *JList*—Allows the user to select multiple items by clicking and dragging.
- *JTextField*—Provides input and text display.

Because the Swing API is built upon AWT, an understanding of some of the elements of both is required.

FIGURE 18.2-1
The Basic Swing *JComponent* Hierarchy

FIGURE 18.2-2
The Swing/AWT Relationship

 Figure 18.2-2 shows the relationship between the major AWT and Swing classes. We can see that *JApplet* subclasses *Applet*

Figure 18.2-2 shows the deep relationship between Swing and AWT. Swing was not created from the ground up, but instead was added alongside the AWT design.

 On some platforms, Swing offers a poor implementation characterized by reduced speed and reliability.

In exchange, Swing offers a more flexible look-and-feel than AWT, as well as a richer feature set.

18.3 The *Screen* Class

In order to illustrate how dependent we are upon the older AWT API, we provide the following example called the *Screen* class. The *Screen* class gets the screen resolution and the dot pitch [i.e., how many pixels per inch or dots per inch (DPI) there are in the screen]. The output of the program follows:

```
DPI=72
size in pixels (width,height)= (630,435)
```

Consider that the following source code cannot be written without AWT and the assorted tools that we can find there:

```
import java.awt.*;

public class Screen {
    public static int getDpi() {
        Toolkit t=Toolkit.getDefaultToolkit();
        return t.getScreenResolution();
    }

    public static Dimension getSize() {
        Toolkit t=Toolkit.getDefaultToolkit();
        return t.getScreenSize();
    }

    public static void main(String args[]) {
        System.out.println("DPI="+getDpi());
```

```
                   Dimension d = getSize();
                   System.out.println("size in pixels (width,height)= ("
                     +d.width + ","+d.height+")");
               }

           }
```

Toolkit is a class that contains many different methods for manipulating graphic elements in the display. The ability to get the screen properties is only one of its many features. There is little educational benefit to describing the *Toolkit* class in great detail, as there are too many methods to learn all at once.

18.4 Heavyweight versus Lightweight

AWT components often are said to be *heavyweight components*. A heavyweight component is one that makes use of a local subroutine library in order to render the elements of the GUI. For example, on a Macintosh, a *FileDialog* instance will look like the standard file dialog box used in the MacOS toolkit. Under X-Windows, *FileDialog* will be created using an *X-Window* file dialog invocation. Under Windows XP, the dialog will look (and be created by) a Windows XP dialog.

Thus, AWT gives the programmer a portable API that looks and feels different on various platforms. *AWT* is based on native implementations of its components, which are wrapped with *peer* methods.

The *lightweight components* of Swing enable the drawing to be more controlled so that the elements can establish a consistent look and feel. Such consistency was never a goal of AWT.

Lightweight components:
- have no peers
- render in the heavyweight's window
- can appear transparent
- can appear non-rectangular
- have rectangular bounds
- have more than 40 components in Swing
- can control their look-and-feel variations (e.g., Windows, Motif, Macintosh, and Java)
- have many packages

Swing does not replace *AWT*. Instead, it is built on top of it! Swing also has heavyweight components, which directly subclass *AWT* heavyweight components. For example, *JFrame, JWindow*, and *JDialog* are all heavyweight components in Swing. The lightweight components are based on *Component, Container, Graphics, Font, ToolKit, LayoutManagers*, etc. The astute reader will wonder why Swing was built on AWT. The answer to this question is not clear. One theory is that building on such a foundation was the fastest way to deliver an improved product to the marketplace.

18.5 Simple Input and Output

Recall the *Out* class from Chapter 7. The *Out* class uses static methods as a means for providing simple output using functional style programming. We can continue this example by providing a means to invoke Swing methods directly, which can improve the design of the code and the user's experience. For example,

FIGURE 18.5-1
A Message Dialog

```
public class Out {
    public static void messageDialog(Object o) {
      JOptionPane.showMessageDialog(null, o);
    }
}
```

Figure 18.5-1 shows an image of the dialog box output by the *main* method in the *Out* class.

DESIGN PATTERN
A series of methods (like those of the *Out* class) are said to form a toolkit. A *toolkit* is a collection of related classes or methods in a class. The methods in a class form a library of procedures and functions that enable some code reuse. A toolkit represents a procedural design, not an object-oriented design. To make the design object oriented, you would create a *Framework*, which is a collection of cooperating classes with known responsibilities and interfaces.

Such a collection of methods forms a foundation for higher-level programming. Classes like *Out* can be written for input as well. For example,

```
import javax.swing.JOptionPane;

public class In {
    public static String getString(Object o) {
      return JOptionPane.showInputDialog(o);
    }

    public static int getInt(Object o) {
      return
        Integer.parseInt(JOptionPane.showInputDialog(o));
    }
    public static double getDouble(Object o) {
      return
        Double.parseDouble(JOptionPane.showInputDialog(o));
    }

    public static void main(String args[]) {
      System.out.println( "Hello "+getString("Please Enter
      your class:"));
```

FIGURE 18.5-2
A Sample Input Dialog

```
    System.out.println( "There are "
            +getInt("Please Enter the number of students:")
            +"Students in your class");
    System.out.println( "your grade= "+
        getDouble("Please Enter your grade:"));
    }
}
```

Figure 18.5-2 shows a sample input dialog generated by the *main* method in the *In* class.

As a final example, consider the following program for running the game of Hi-Lo. The user is asked for his or her name and for a number that ranges from 1 to 100. The user keeps on guessing until the guess is correct. The only hint the computer give is whether the guess is low or high. The number of trys is printed at the end of the game, along with the user's name.

```java
package utils;
import javax.swing.*;

class In {
  public static String getString(Object o) {
    return JOptionPane.showInputDialog(o);
  }

  public static int getInt(Object o) {
    return Integer.parseInt(getString(o));
  }
}

class MyMath {
  public static int getRandom() {
    return (int) ((Math.random() * 100) + 1);
  }
}

public class RandomNumberGame {
  public static void main(String args[]) {
    RandomNumberGame g = new RandomNumberGame();
    g.hiLo();
  }

  public void hiLo() {
    int r = MyMath.getRandom();
    String name = In.getString("what is your name?");
```

```
System.out.println("Hello " + name +
  "\n Welcome to my new game");
int i = In.getInt("please enter a number from 1 to 100");
int trys = 0;
System.out.println("you typed a " + i);
while (i != r) {
  trys++;
  if (i < r)
    i = In.getInt("to low, try again!");
  if (i > r)
    i = In.getInt("to high, try again!");

}
System.out.println(name + " wins! after only "
  + trys + " trys");

}
}
```

Figure 18.5-3 shows some sample Hi-Low game output.

To make use of the *print* methods within the *out* class, the *main* example in the *In* class can be rewritten as

```
public static void main(String args[]) {
  In.println( "Hello "+getString(
    "Please Enter your class:"));
  In.println( "There are "
        +getInt("Please Enter the number of students:")
        +"Students in your class");
  In.println( "your grade= "
    +getDouble("Please Enter your grade:"));
}
```

The simple dialog example used in the *In* and *Out* classes are often sufficient for simple programming tasks. However, more complicated GUI presentations are needed in order to prevent a user from having a negative experience with your program. For example, if you want to input 10 parameters into your program, the *In* class would require 10 dialog boxes. This process can be improved when you take control of the GUI by using *layouts*.

FIGURE 18.5-3
Sample Hi-Lo Output

18.6 An Introduction to Layouts

Java's *AWT* provides a series of *layout manager* classes that are used by both *AWT* and *Swing* for providing the *layout* service. The layout service arranges components in a container by altering their size and location. In *java.awt*, the *Component* class is subclassed by several elements, including *JButton* and *JCheckBox*. In Swing, *javax.swing.JComponent* is a subclass of *java.awt.Component* and, as such, supports many of the same methods (via inheritance).

The layout service is provided by a series of classes in the *java.awt* and *javax.swing* packages. These classes use *setSize* and *setLocation* to arrange components in a *container*. For example, you can add *JButton*s to a *JPanel* and arrange them by an instance of a layout class.

WARNING

It is unwise to program without a layout manager in place. Screens often have different resolutions.

The reason why layouts are used is that they enable flexibility in the size of the display. For example, if a user with a 640 × 480 pixel monitor wants to use an application that is designed for a 1024 × 768 monitor, it would make sense for the program adapt to the user (rather than for the user to adapt to the program). Many users (including the author) would rather make use of a lower resolution setting on a large monitor in order to make the display easier to view. In addition, some users have very small screens (e.g., palm-tops or hand-helds). Such displays do not have high resolutions. In fact, a 320 × 240 pixel screen is high for some PDAs. As an added benefit, using a layout manager hides the complexity of the layout from the programmer.

The following subsections introduce three basic layouts in *java.awt*: *FlowLayout*, *GridLayout*, and *BorderLayout*. There are many such layouts, but these are among the most common and simple.

18.6.1 FlowLayout

FlowLayout is a layout that arranges components so that they appear from left to right, top to bottom, as they are added to a container. Each component has the ability to compute its own preferred size and minimum size. Based on these sizes, the layout manager will resize the components to make them fit well together.

As an example, consider Figure 18.6.1-1, which shows two buttons in *FlowLayout*. The buttons are of different sizes because their labels are of different sizes. The *FlowLayout*

FIGURE 18.6.1-1
Two Buttons in
FlowLayout

FIGURE 18.6.1-2
Ten Buttons in
FlowLayout

manager uses the number of characters in the label, as well as the data about the font size, in order to compute the correct dimension for the button. All of this computation is done within the button.

Figure 18.6.1-2 shows 10 buttons that appear in the order in which they were added. They have been added to a container and thus appear from left to right, top to bottom.

Figure 18.6.1-3 shows what happens to a container when it is resized. *FlowLayout* swings into action and rearranges the buttons, this time neatly in columns.

The code to add 10 buttons to a container using *FlowLayout* follows:

```java
package gui;
import javax.swing.*;
import java.awt.*;

public class Layout {
    public static void flowLayoutExample() {
        JFrame jf = new JFrame();
        Container c = jf.getContentPane();
        c.setLayout(new FlowLayout());
        c.add(new JButton("OK"));
        c.add(new JButton("cancel"));
        c.add(new JButton("OK"));
        c.add(new JButton("cancel"));
        c.add(new JButton("OK"));
        c.add(new JButton("cancel"));
        c.add(new JButton("OK"));
```

FIGURE 18.6.1-3
Ten Buttons Resized
in *FlowLayout*

```
                    c.add(new JButton("cancel"));
                    c.add(new JButton("OK"));
                    c.add(new JButton("cancel"));
                    jf.setSize(200, 200);
                    jf.setVisible(true);
                }

            public static void main(String args[]) {
                    flowLayoutExample();
                }
        }
```

We have not connected the events generated by the buttons to any business logic yet. Event processing is discussed in Chapter 19.

18.6.2 GridLayout

GridLayout is a class in *java.awt* that arranges components in either a fixed number of rows or a fixed number of columns. If the programmer knows that there will be two columns of buttons with an unknown number of rows, the *GridLayout* is created using

```
    new GridLayout(0,2);
```

GridLayout is not sensitive to the size of its components. Normally an OK button takes up less room than a cancel button because the label in the button is smaller. However, the *GridLayout* style of layout makes all components take up the same amount of space. Such equalization might be inappropriate depending on the look and feel you are trying to achieve.

Figure 18.6.2-1 shows *GridLayout* with the same 10 buttons used with *FlowLayout*. Each button takes the same amount of space as every other button, and the size of the label is ignored.

FIGURE 18.6.2-1
GridLayout with 10 Buttons

The code for Figure 18.6.2-1 follows:

```
public static void GridLayoutExample() {
     JFrame jf = new JFrame();
     Container c = jf.getContentPane();
     c.setLayout(new GridLayout(0, 2));
     c.add(new JButton("OK"));
     c.add(new JButton("cancel"));
     c.add(new JButton("OK"));
     c.add(new JButton("cancel"));
     c.add(new JButton("OK"));
     c.add(new JButton("cancel"));
     c.add(new JButton("OK"));
     c.add(new JButton("cancel"));
     c.add(new JButton("OK"));
     c.add(new JButton("cancel"));
     jf.setSize(200, 200);
     jf.setVisible(true);
}
```

18.6.3 BorderLayout

 BorderLayout sets components on the borders of a container.

Borders are selected using the compass directions north, east, south, west, and center.

 Placing two components in the same location will cause one to cover the other. For example, if you place a checkbox on a button, all you will see is the checkbox.

Figure 18.6.3-1 shows some examples of *BorderLayout*. As components are added, space is reallocated to enable the components to fill the available space. For example, when both the east and west components are present, the center component becomes smaller. The code example that produces the left-most image in Figure 18.6.3-1 is shown below:

```
public static void BorderLayoutExample() {
     JFrame jf = new JFrame();
     Container c = jf.getContentPane();
```

FIGURE 18.6.3-1
Some Examples of *BorderLayout*

```
                    c.setLayout(new BorderLayout());
                    c.add(new JButton("N"), BorderLayout.NORTH);
                    c.add(new JButton("S"), BorderLayout.SOUTH);
                    c.add(new JButton("E"), BorderLayout.EAST);
                    c.add(new JButton("C"), BorderLayout.CENTER);
                    c.add(new JButton("W"), BorderLayout.WEST);
                    jf.setSize(200, 200);
                    jf.setVisible(true);
                }
```

It is possible to use strings rather than constants to control the *BorderLayout*. However, using strings is discouraged since a misspelling of the string cannot be checked at compile time.

As illustrated in the following section, *BorderLayout* often is used in combination with other layouts to give design flexibility to a display.

18.6.4 Mixing Layouts

Layouts often are mixed in the same display in order to give more flexibility to the design. Such designs are often better done on paper, before coding starts. When design is done by a team, using a drawing board for a brainstorming discussion is quite helpful when doing the initial design. Such sessions can save many hours of programming time.

The best program designs start at the drawing board. The real work is done between the ears, not with the fingers!

A *panel* is a container that can be held inside another container. In this way, hierarchies of panels can be nested inside one another, unlike a frame, which may not be nested inside another container. What follows is a list of properties that generally summarize the differences between panels and frames:

- Frames have a title, a close box, and a resize box, whereas panel(s) do not.
- Frame(s) have their own main menu bar, whereas panels do not.
- Frames can sit by themselves, whereas panels cannot.
- Frames have a visibility that can be set.
- Panels can be nested inside panels.
- Panels can be nested inside frames.
- Frames cannot be nested inside frames.
- Frames cannot be nested inside panels.

Since each panel can have its own layout, designers have the freedom to reuse components with a given layout in compound interfaces.

Figure 18.6.4-1 shows the result of mixing *GridLayout* for the dial buttons and the text fields and *BorderLayout* for an address book dialer. The following code shows how each group of three elements in the display was created by a different method:

```
        public static JPanel getDialPanel() {
            JPanel jp = new JPanel();
            jp.setLayout(new GridLayout(0, 1));
            jp.add(new JButton("dial"));
            jp.add(new JButton("dial"));
```

FIGURE 18.6.4-1
Mixing Layouts

```
        jp.add(new JButton("dial"));
        return jp;
    }

    private static JPanel getPhoneNumberPanel() {
        JPanel textPanel = new JPanel();
        textPanel.setLayout(new GridLayout(0, 1));
        textPanel.add(new JTextField(20));
        textPanel.add(new JTextField(20));
        textPanel.add(new JTextField(20));
        return textPanel;
    }

    public static void addressBook() {
        JFrame jf = new JFrame();
        Container c = jf.getContentPane();
        c.add(getDialPanel(), BorderLayout.EAST);
        c.add(getPhoneNumberPanel(), BorderLayout.CENTER);
        c.add(getDialPanel(), BorderLayout.WEST);
        jf.setSize(200, 200);
        jf.setVisible(true);
    }
```

WARNING

Don't mix business logic with your GUI code. Doing so will make it that much harder to maintain.

18.6.5 Panels, Frames, and FlowLayout

Figure 18.6.5-1 shows two stacked touchtone pads. Each pad is using a grid layout; however, the pads are in a frame that is using a flow layout.

Figure 18.6.5-2 shows what happens when you resize the frame. Flow layout takes control of the touchtone pad layout without altering the layout of the keys.

A flexible interface experience occurs when the display's resolution can be altered without losing important graphic elements. Also, GUI design reuse leads to code that is more reliable and easier to maintain. The code for *TouchToneFrame* follows:

```
package gui;
import javax.swing.*;
```

FIGURE 18.6.5-1
Two Stacked Touchtone Pads in
FlowLayout

FIGURE 18.6.5-2
Two Unstacked Touchtone Pads in FlowLayout

```
import java.awt.event.*;
import java.awt.*;
// The code for ClosableJFrame will be given
// in chapter 19.
public class TouchToneFrame extends ClosableJFrame {
    Container c = getContentPane();
    JPanel leftPad = new JPanel();
    JPanel rightPad = new JPanel();

    TouchToneFrame() {
// invoke the constructor in order to give the
```

```
// frame a title.
        super("TouchToneFrame");
        new JPanel();
        new TouchTone(leftPad);
        new TouchTone(rightPad);
        c.add(leftPad);
        c.add(rightPad);
        c.setLayout(new FlowLayout());
        setSize(200,200);
        setVisible(true);
    }
    public static void main(String args[]) {
        new TouchToneFrame();
    }
}
```

18.6.6 Custom Layouts

FlowLayout invokes *getPreferredSize* from the component(s), laying them out from left to right, top to bottom. *GridLayout* uses the minimum size and enlarges the component to fit the cell that can be packed into a container of a given size. *GridLayout* ignores the maximum and preferred sizes of a component.

Standard layouts are fine, but sometimes you want something just a bit different from the other layout managers. This section shows you how to write your own custom layout manager, called *PreferredSizeGridLayout*. *PreferredSizeGridLayout* will never grow a component beyond its preferred size, though it will shrink a component below its minimum size if it does not fit in the available space.

You must control your layout manager, or your layout manager will control you!

You can use *PreferredSizeGridLayout* just like *GridLayout*, though it behaves differently. For example,

```
public static void PreferredSizeGridLayoutExample() {
    JFrame jf = new JFrame();
    Container c = jf.getContentPane();
    c.setLayout(new PreferredSizeGridLayout(0,2));
    for (int i=0; i < 5; i++) {
        c.add(getOkButton());
        c.add(getCancelButton());
    }
    jf.setSize(200, 200);
    jf.setVisible(true);
}
public static void main(String args[]) {
    PreferredSizeGridLayoutExample();
}
```

Figure 18.6.6-1 shows that the buttons do not expand to fill the available space, as with *GridLayout*, though the number of columns and rows is correct.

Figure 18.6.6-2 shows that the buttons will shrink if the container gets too small to handle the preferred size of the buttons. To implement our new layout manager, we create

FIGURE 18.6.6-1
Buttons Will Not Expand to Fill Available Space

FIGURE 18.6.6-2
Buttons Will Shrink If Container
Gets Small

a simple interface for controlling how a component is sized and placed:

```
package gui.layouts;
import java.awt.*;
public interface BoundableInterface {
    void setBounds(Component c, int x, int y, int w, int h);
}
```

Different applications will require different implementations of *BoundableInterface*. For example, mailing labels must keep a fixed size or they will not line up when printed. On the other hand, many images can be made smaller and larger, though they must keep the same width-to-height ratio (aspect ratio). In the following implementation, we do not enlarge components beyond their preferred size to fill the cell of the layout:

```
package gui.layouts;

import java.awt.*;

public class PreferredBoundable
```

```
        implements BoundableInterface {
    public void setBounds(Component c,
                            int x, int y,
                            int w, int h) {
        Dimension wantedSize = new Dimension(w,h);
        Dimension d = c.getPreferredSize();
        d = min(d,wantedSize);
        c.setBounds(x,y,d.width,d.height);
    }

    public Dimension min(Dimension d1, Dimension d2) {
        if (d1.width < d2.width) return d1;
        if (d1.height < d2.height) return d1;
        return d2;
    }
}
```

The *PreferredSizeGridLayout* manager follows:

```
package gui.layouts;

import java.awt.*;

public class PreferredSizeGridLayout
        extends GridLayout {
    private BoundableInterface boundableInterface =
            new PreferredBoundable();
    public PreferredSizeGridLayout() {
        this(1, 0, 0, 0);
    }

    /**
     * Creates a grid layout with the specified number of rows
       and
     * columns. All components in the layout are given equal
       size.
     * <p>
     * One, but not both, of <code>rows</code> and
       <code>cols</code> can
     * be zero, which means that any number of objects can be
       placed in a
     * row or in a column.
     * @param      rows    the rows, with the value zero meaning
     *                     any number of rows.
     * @param      cols    the columns, with the value zero
       meaning
     *                     any number of columns.
     */
    public PreferredSizeGridLayout(int rows, int cols) {
        this(rows, cols, 0, 0);
    }

    /**
     * Creates a grid layout with the specified number of rows
```

```
    and
 * columns. All components in the layout are given equal
   size.
 * <p>
 * In addition, the horizontal and vertical gaps are set to
   the
 * specified values. Horizontal gaps are placed at the left
   and
 * right edges, and between each of the columns. Vertical
   gaps are
 * placed at the top and bottom edges, and between each of
   the rows.
 * <p>
 * One, but not both, of <code>rows</code> and
   <code>cols</code> can
 * be zero, which means that any number of objects can be
   placed in a
 * row or in a column.
 * @param     rows   the rows, with the value zero meaning
 *                   any number of rows.
 * @param     cols   the columns, with the value zero
   meaning
 *                   any number of columns.
 * @param     hgap   the horizontal gap.
 * @param     vgap   the vertical gap.
 * @exception   IllegalArgumentException  if the of
   <code>rows</code>
 *                   or <code>cols</code> is invalid.
 */
public PreferredSizeGridLayout(int rows, int cols, int
   hgap, int vgap) {
    super(rows,cols,hgap,vgap);
}

/**
 * Lays out the specified container using this layout.
 * <p>
 * This method reshapes the components in the specified
   target
 * container in order to satisfy the constraints of the
 * <code>PreferredSizeGridLayout</code> object.
 * <p>
 * The grid layout manager determines the size of
   individual
 * components by dividing the free space in the container
    into
 * equal-sized portions according to the number of rows and
    columns
 * in the layout. The container's free space equals the
    container's
 * size minus any insets and any specified horizontal or
    vertical
```

```java
 * gap. All components in a grid layout are given the
 * Minimum of the same size or the preferred size.
 *
 * @param      target   the container in which to do the
   layout.
 * @see        java.awt.Container
 * @see        java.awt.Container#doLayout
 */
public void layoutContainer(Container parent) {
    synchronized (parent.getTreeLock()) {
        Insets insets = parent.getInsets();
        int ncomponents = parent.getComponentCount();
        int nrows = getRows();
        int ncols = getColumns();
        if (ncomponents == 0) {
            return;
        }
        if (nrows > 0) {
            ncols = (ncomponents + nrows - 1) / nrows;
        } else {
            nrows = (ncomponents + ncols - 1) / ncols;
        }
        int w = parent.getWidth() - (insets.left +
insets.right);
        int h = parent.getHeight() - (insets.top +
insets.bottom);
        w = (w - (ncols - 1) * getHgap()) / ncols;
        h = (h - (nrows - 1) * getVgap()) / nrows;

        for (int c = 0, x = insets.left; c < ncols; c++, x
+= w + getHgap()) {
            for (int r = 0, y = insets.top; r < nrows;
r++, y += h + getVgap()) {
                int i = r * ncols + c;
                if (i < ncomponents) {

boundableInterface.setBounds(parent.getComponent(i),x,
y, w, h);
                }
            }
        }
    }
}

public BoundableInterface getBoundableInterface() {
    return boundableInterface;
}

public void setBoundableInterface(BoundableInterface
    boundableInterface) {
    this.boundableInterface = boundableInterface;
}

}
```

FIGURE 18.6.6-3
Keeping the Aspect Ratio in the Grid

The programmer who uses the *PreferredSizeGridLayout* manager may override the default implementation of *BoundableInterface* by invoking *setBoundableInterface* before the layout manager is used by the container. For example, to retain the rectangular shape-and-aspect ratio of components, as shown in Figure 18.6.6-3,
we write

```java
public static void PreferredSizeGridLayoutExample() {
    JFrame jf = new JFrame();
    Container c = jf.getContentPane();
    PreferredSizeGridLayout psgl =
            new PreferredSizeGridLayout(0, 2);
    psgl.setBoundableInterface(new AspectBoundable());
    c.setLayout(psgl);
    for (int i = 0; i < 5; i++) {
        c.add(getOkButton());
        c.add(getCancelButton());
    }
    jf.setSize(200, 200);
    jf.setVisible(true);
}
```

where *AspectBoundable* is given by

```java
/*
 * Created by DocJava, Inc.
 * User: lyon
 * Date: Mar 20, 2003
 * Time: 9:05:23 AM
 */
package gui.layouts;

import java.awt.*;

public class AspectBoundable
        implements BoundableInterface {
    public void setBounds(Component c,
                          int x, int y,
                          int w, int h) {
```

```
            Dimension wantedSize = new Dimension(w, h);
            Dimension d = c.getPreferredSize();
            d = scale(d, wantedSize);
            c.setBounds(x, y, d.width, d.height);
        }

    /**
       * scale returns a new dimension that has
       * the same aspect ratio as the first dimension
       * but has no part larger than the second dimension
       */
    public Dimension scale(Dimension imageDimension,
                             Dimension availableSize) {
        double ar =
        imageDimension.width/(imageDimension.height*1.0);
        double availableAr =
        availableSize.width/(availableSize.height*1.0);

        int newHeight = (int)(availableSize.width / ar);
        int newWidth = (int)(availableSize.height * ar);
        if (availableAr < ar )
         return new Dimension(availableSize.width,newHeight);
        return new Dimension(newWidth, availableSize.height);
    }

    public Dimension scaleWidth(Dimension d1, Dimension d2) {
        double scaleFactor =
                d2.width / (d1.width * 1.0);
        return scale(d1, scaleFactor);
    }

    private Dimension scale(Dimension d1, double scaleFactor)
        {
        return new Dimension((int) (d1.width * scaleFactor),
                (int) (d1.height * scaleFactor));
    }

    public Dimension scaleHeight(Dimension d1, Dimension d2) {
        double scaleFactor = d2.height / (d1.height * 1.0);
        return scale(d1, scaleFactor);
    }
    }
```

Thus, we are able to obtain a modicum of control over our layout by implementing
BoundableInterface.

18.7 Getting a File from the User

In chapter 14, we presented the *futils* package and showed a series of methods for getting
files from a user. In this section, we show how these routines are implemented. Our approach
will be to show how to use AWT to prompt the user for a file and then to use Swing. Finally,
we will show a way to prompt a user for a file that could use either API.

Don't let your code become tightly bound to any particular API for GUIs. Such APIs
are likely to change as you change from desktop to embedded platforms.

18.7.1 The Dialog Class

The *Dialog* class resides in the *java.awt* package. An instance of a *Dialog* class is like a low-overhead *Frame* instance. A *Dialog* instance may be resizable. In addition, a *Dialog* instance has a title, a border and a layout.

A *Dialog* instance has a modal property. If a *Dialog* instance is modal, then the user is forced to interact with it. If a *Dialog* instance is non-modal, then the user may choose other *Window* instances (such as *Frame* instances). The default layout is *BorderLayout*.

Dialog Class Summary

```
public class Dialog extends Window {
      public Dialog(
        Frame parent, boolean modal)
      public Dialog(
        Frame parent, String title, boolean modal)
      public synchronized void addNotify()
      public boolean isModal()
      public String getTitle()
      public void setTitle(String title)
      public boolean isResizable()
      public void setResizable(boolean resizable)
}
```

Dialog Class Usage. Suppose the following variables are predefined:

```
String title;
boolean resizable, modal;
Dialog dialog;
Frame parent;
```

To make an (initially invisible) instance of Dialog, use

```
dialog = new Dialog(parent, modal);
```

To make an (initially invisible) instance of Dialog with a title, use

```
dialog = new Dialog(parent, title, modal);
```

To create a peer, use

```
dialog.addNotify();
```

To see if a Dialog instance is modal, use

```
modal = dialog.isModal();
```

To get and set the title, use

```
title = dialog.getTitle();
dialog.setTitle(title);
```

To get and set the resizable property, use

```
resizable = dialog.isResizable();
dialog.setResizable(resizable);
```

18.7.2 The FileDialog Class

The *FileDialog* class is used to extract a file name so that the name is not hardcoded into a file, which is generally better than trying to rely upon a file to be in a specific location.

WARNING

Embedding absolute path names can make code very fragile.

The *FileDialog* class is a subclass of the *Dialog* class. Instances of *FileDialog* are used by the *futils* package to obtain file and directory information from the user. *FileDialog* will block the invoking thread when it is shown since it is always modal.

FileDialog Class Summary

```
public class FileDialog extends Dialog
      public static final int  LOAD
      public static final int SAVE
      public FileDialog(Frame parent, String title)
      public FileDialog(Frame parent, String title, int mode)
      public synchronized void addNotify()
      public int getMode()
      public String getDirectory()
      public void setDirectory(String dir)
      public String getFile()
      public void setFile(String file)
      public FilenameFilter getFilenameFilter()
      public void setFilenameFilter(FilenameFilter filter)
}
```

FileDialog Class Usage. Suppose the following variables are predefined:

```
FileDialog fileDialog;
Frame parent;
String title, path;
int mode;
FileNameFilter filter;
```

Mode must be either *FileDialog.LOAD* or *FileDialog.SAVE*.
To create a *FileDialog* instance for reading a file, use

```
fileDialog = new FileDialog(parent, title);
```

To specify a mode during instantiation, use

```
fileDialog = new FileDialog(parent, title, mode);
```

To get the mode, use

```
mode = fileDialog.getMode();
```

To get and set the directory, use

```
path = fileDialog.getDirectory();
fileDialog.setDirectory(path);
```

To get the file name, use

```
path = fileDialog.getFile();
```

To set the default file name before the dialog is shown, use

```
fileDialog.setFile(path);
```

To get and set *FilenameFilter*, use

```
filter = fileDialog.getFilenameFilter();
fileDialog.setFilenameFilter(filter);
```

Futil.getDirFile. This section describes several helper methods in the *futils* package. The *futils* package contains a *Futil* class and is used as a primary means of providing file utilities.

The *Futil* class contains a series of static methods that serve as examples of how to make use of *FileDialog* classes to prompt a user for a file. Typically, these methods can be used from any place in a program and provide a central point for getting a file. For example,

```
public static File getDirFile(String prompt) {
    FileDialog fd =
            new FileDialog(
                    new Frame(),
                    prompt);
    fd.show();

    String dirName = fd.getDirectory();
    fd.dispose();
    return new File(dirName);
}
```

The *File* instance that is returned can be used for several types of data processing applications. For example,

```
File f = Futil.getDirFile("select a file");
```

Having all of the GUI code in a single place makes maintenance easier. Later we will show how to switch to *Swing* (a competing API) while making few changes to the central business logic.

Futil.getReadFile. *Futil.getReadFile* is a static method that creates a file-open dialog box. The dialog box is used by the user to select a file. Once the file is selected, *Futil.getReadFile* returns an instance of *File*. For example,

```
public static  File getReadFile(String prompt) {
            FileDialog fd = new FileDialog(
                    frame,
                    prompt);
        fd.setVisible(true);
        return new File(fd.getDirectory()+fd.getFile());
}
```

The path name for the file is concatenated explicitly into the file string before the return. Typically, a programmer would prompt the user to select a file by using

```
File inputFile =
        Futil.getReadFile("select the employee database");
```

Such helper methods can greatly simplify code.

Futil.getWriteFile. To get a file for write, the mode of *FileDialog* must be set to *FileDialog.SAVE*. For example,

```
public static File getWriteFile(
    String prompt) {
  if (isSwing())
    return getWriteFileSwing(prompt);
  return getWriteFileAWT(prompt);
}

private static File getWriteFileAWT(
    String prompt) {
  FileDialog fd =
      new FileDialog(
          new Frame(),
          prompt,
          FileDialog.SAVE);
  fd.setVisible(true);

public static File getWriteFileSwing(
    String prompt) {
  JFileChooser fd =
      new JFileChooser(

          prompt);
  fd.showSaveDialog(new JFrame());

  return
      fd.getSelectedFile();
}
```

The idea behind the *getWriteFile* method is that it makes use of a boolean flag:

```
public final class Futil {
  /**
   * Don't let anyone instantiate this class.
   */
  private Futil() {
  }

  public static boolean isSwing() {
    return swingEnabled;
  }

  private static boolean swingEnabled = false;
```

Thus, the facility for getting a file is implemented in both Swing and AWT. The programmer just wants a file, and invoking

```
File f = Futil.getWriteFile("please select a file");
```

does not provide an indication of which toolkit to use. The following section describes the details of how the Swing API can be used to get a file.

18.7.3 Using Swing to Get a File

This section shows how to use Swing to obtain a file. An image of the Swing file dialog appears in Figure 18.7.3-1.

FIGURE 18.7.3-1
The Swing Dialog

The Swing dialog has the advantage of having a uniform look and feel across different platforms. For example,

```
public static File getWriteFileSwing(
    String prompt) {
  JFileChooser fd =
      new JFileChooser(prompt);
  fd.showSaveDialog(new JFrame());

  return fd.getSelectedFile();
}
```

The disadvantages are that Swing is slower and that it cannot seem to remember where you were looking last. As a result, every time user(s) want to open a file, they must start from the same location in the directory structure. To make the GUI API more agile, we add a bit of logic in the form of a global static variable. The programmer can set this to switch from Swing to AWT without having to alter any code:

```
public static File getWriteFile(
        String prompt) {
    if (isSwing())
        return getWriteFileSwing(prompt);
    return getWriteFileAWT(prompt);
}
public static boolean isSwing() {
```

```
        return swingEnabled;
    }

    private static boolean swingEnabled = false;
```

At a later time, the code can be adapted to another API (e.g., a wireless API for cell phones does not use Swing or AWT). In such cases, adding a bit more logic to handle the new API is a trivial matter.

18.8 Summary

In this chapter, we learned a little bit about the *Swing* API and the *AWT* API. The *Swing* API is built on top of the *AWT* API, and, as a result, programmers must still be aware of the *AWT* API.

The brief introduction to layout mangers allowed us to begin to design interfaces. Using just three basic layout managers—*FlowLayout*, *GridLayout*, and *BorderLayout*—a remarkably diverse array of displays can be arranged. This diversity is particularly true when layouts are mixed together in nested containers. We also learned that:

1. Components are laid out with a layout manager.
2. Components are added to a container.
3. Layout elements should be devoid of specific pixel coordinates.
4. There is no limit to the number of panels that a panel can contain.
5. A helper method is a very good way to break up the creation of an interface.

What we have not discussed is how to handle the events that the components generate. This is a topic for the next chapter.

18.9 Exercises

18.1 Create *AddressBookPanel* shown in Figure 18.9-1.
AddressBookPanel has the date, the time, three telephone number text fields, a name text field at the top, and two text fields that follow.

18.2 Write the inverse of the Hi-Lo game. Before, the computer selected a number and the user tried to guess it. Now, the user will select a number between 1 and 100 and the computer will try to guess it. You may tell the computer if its guess is too high or too low. The computer should print the number of guesses that it had to make to guess the user's number.

18.3 Write a game called *Guess the Interest Rate*. Use the *In* and the *Out* classes to help you, if you want. Your program should be interactive and will need a simple GUI. The user must guess an approximation for the interest rate r that will yield an annuity value of \$250,000 if 240 monthly payments of \$250 are made over a 20-year period. Use the starting values of $r = 0.11$ to 0.12 as the yearly interest rate and compute the value using the annuity-due equation:

$$v = \frac{12p}{r}[(1 + r/12)^n - 1]$$

v = value = \$250,000

p = payment = \$250

r = interest rate per year = a number input by the user

n = number of compounding intervals = 240

```
┌──────────────────────────────────────────────────────────┐
│ □            Using All 2222 Records In "addresses"         │
├──────────────────────────────────────────────────────────┤
│ EZ Pass Customer Service Center                            │
├──────────────────────────────────────────────────────────┤
│ PO Box 15928                                               │
│ Wilmington DE 19850-5928                                   │
│                                                            │
│                                                            │
│                                                            │
├──────────────────────────────────────────────────────────┤
│                                                            │
│                                                            │
│                                                            │
│                                                            │
│                                                            │
├──────────────────────────────────────────────────────────┤
│ ┌────┐ ┌──────────────────────────────────┐   ┌────────┐ │
│ │Dial│ │ 888-288-6865                     │   │  Prev  │ │
│ └────┘ └──────────────────────────────────┘   └────────┘ │
│ ┌────┐ ┌──────────────────────────────────┐   ┌────────┐ │
│ │Dial│ │                                  │   │  Next  │ │
│ └────┘ └──────────────────────────────────┘   └────────┘ │
│ ┌────┐ ┌──────────────────────────────────┐   ┌────────┐ │
│ │Dial│ │                                  │   │  Index │ │
│ └────┘ └──────────────────────────────────┘   └────────┘ │
│ Aug 5  8:40:34                                             │
└──────────────────────────────────────────────────────────┘
```

FIGURE 18.9-1
The *AddressBookPanel*

Keep track of the total number of guesses and print out the total at the end. When you guess a number that lies between two intervals, you are using a *bracketing method*. Such methods can be automated, but it can be educational to do it manually.

An automated solution follows:

```
package utils;

interface Function {
  public double f(double x);
}

class AnnuityFunction implements Function {
  public double f(double r) {
    return (12 * 250 / r) * Math.pow((1 + r / 12), 240) - 1 -
      250000;
  }
}

public class Bisection {
  private static final double stopCriterion = 0.00001;

  public static void main(String args[]) {
    double i = bisection(0.1, 0.2, new AnnuityFunction());
    System.out.println("i=" + i);
  }
```

```
public static double bisection(double a, double b,
       Function fi) {
    double m = 0.0;
    int trys = 0;
    while (isNotCloseEnough(a, b)) {
      m = (a + b) / 2;

      // Check to see if root was hit at midpoint
      if (fi.f(m) == 0) break;
      if (fi.f(a) * fi.f(m) < 0)
        b = m;
      else
        a = m;
      trys++;
    }
    System.out.println("done in:"+trys+" trys");
    return m;
  }
  private static final boolean isNotCloseEnough(double a,
       double b) {
    return Math.abs(a - b) > stopCriterion;
  }
}
```

18.4 Modify the *In* class so that methods are present that take valid ranges for:

a. integers

b. doubles

18.5 The *In* class blocks the thread of execution while the user is entering data. Reimplement the *In* class using a new class based in *JDialog* boxes. Do not block the thread of execution in your implementation.

C H A P T E R 1 9

Introducing Events

**The scientific foundation for software
engineering should not be soft.**

–Douglas Lyon

In this chapter, you will learn about:

- The event model
- The command pattern
- The observable-observer pattern

DESIGN PATTERN

A design pattern is a solution to a recurrent problem. Design patterns have names, and these names create a kind of object-oriented design jargon that can be used for efficient communication. Design patterns also have a specific problem that is being addressed.

As the software engineering discipline continues to get in touch with itself, design continues to be the theme that distinguishes the software engineer from the programmer. In the tradition of engineering design, therefore, we use GUIs to perform *just-in-time* teaching of design patterns.

DESIGN PATTERN

The patterns described in this chapter and the next include *command, observer-observable, mediator*, and *model-view-controller*. These terms will be defined as needed. See [Gamma] for a formal introduction to design patterns.

Observables generate events via notification. It is typical for components to generate events. There may be multiple listeners for any particular observable. For example, a TV station is an observable, and the many TV sets receiving the broadcast are the listeners.

DESIGN PATTERN

The events of Java use a model-view-controller (MVC) design pattern.

FIGURE 19.1
Model-View-Controller

To handle	implement an	using
JButton	ActionListener	actionPerformed(ActionEvent e)
JCheckbox	ItemListener	itemStateChanged(ItemEvent e)
keyboard input	KeyListener	public void keyTyped(KeyEvent e) public void keyPressed(KeyEvent e) public void keyReleased(KeyEvent e)
Window, Dialog, Frame	WindowListener	public void windowOpened(WindowEvent e) public void windowClosing(WindowEvent e) public void windowClosed(WindowEvent e) public void windowIconified(WindowEvent e) public void windowDeiconified(WindowEvent e) public void windowActivated(WindowEvent e) public void windowDeactivated(WindowEvent e)

FIGURE 19.2
Common Events

The MVC design pattern is depicted in Figure 19.1.

In the MVC design, the *view* is used for the GUI. The *model* represents the computational model, and the *controller* represents the interaction between the user and the view. Swing components can be used as controllers or views.

All Swing components inherit from the *JComponent* class. As a result, they can handle key events and mouse events. They also can have borders, tool tips, and auto scrolling. Some of the common events are shown in Figure 19.2.

One of the basic problems in Java is that the API is large and sometimes asymmetric. This size and asymmetry make learning the API difficult and can make the systems built using it fragile.

 To protect ourselves from changes in the API, it is a good idea to create a layer on top of the API, one that allows us to centralize the alterations in case the underlying API becomes obsolete. This is done by creating a series of classes that are used as *proxies* for the underlying class. Thus, the real work is performed by the underlying class (also called the *delegate*). The proxy class is a kind of substrate (i.e., layer) that protects us from too much intimacy with the Sun API.

The precedence of events (e.g., which event will be generated first, when events are consumed) is up to the programmer. For example, we may equate the selection of the *quit* button with the key-combination *command-q*. Instead, these decisions are left to the programmer.

19.1 ClosableJFrame

In this section, we show how to create an instance of a class called *ClosableJFrame*. *ClosableJFrame* is a subclass of the *JFrame* class, which in turn subclasses the *AWT* Frame. A rendering of the *ClosableJFrame* is shown in Figure 19.1-1.

FIGURE 19.1-1
ClosableJFrame

The *ClosableJFrame* class is used to provide event handling and display services. Classes that extend the *ClosableJFrame* class typically add GUI elements called *widgets*. Widgets include elements such as checkboxes, scrollbars, and menu items. When widgets are added to a *ClosableJFrame*, they alter both the appearance and functionality of the frame. Typically, a drawn widget is an instance of a class that extends the *Component* class. The reader should know that a collection of instances of classes that subclass the *Component* class are sometimes called *components*. Generally, a widget is the appearance of an instance of a class, but this does not have to be the case. For example, in [Lyon and Rao], widgets are presented that bypass the (then-current) event handler in favor of a (now-current) observer-observable model.

DESIGN PATTERN

The *Observer-Observable* classes in *java.util* are a direct implemention of the *observer* design pattern. The *observer* design pattern defines a one-to-many dependency between instances in order to facilitate updating.

User interaction with widgets causes an *event* to be instanced. Starting with the JDK 1.1 event model, instances interested in an event must *listen* for the event. Typically, a class will implement a *Listener* interface. The *Listener* interface requires an implementation of *action* methods that are invoked when an event occurs. Instances of classes that subclass the *Component* class will keep a list of interested class instances.

The relationship between event generators and event listeners is like the *observer* design pattern in object-oriented programming. The observer pattern is a behavioral pattern that defines a one-to-many notification list between instances. For example, suppose that the user clicks on a button. An instance of a button will update all instances on its notification list. Thus, the button has a subscription list for any events that it generates. The subscribers must be qualified before they can obtain a subscription. To be qualified, they must implement a listener interface. A qualified class is subscribed to an event broadcast by use of a special *add* method. Communication is typically one way.

DESIGN PATTERN

The observer design pattern is sometimes called the *observer-observable* relationship. It is also called the *publish-subscribe* relationship.

The publish-subscribe design pattern is available in some word processors. For example, in Microsoft Word, several documents can subscribe to the same file (i.e., a chart in a spreadsheet). In the observer design pattern, however, the document must pull in the changes when it is activated. In the action-listener event model, call-back methods affect the publish-subscribe mechanism. In comparison, the publish-subscribe dependency in Word has a non-automatic update mechanism rather than the automatic action-listener update.

In order to create an abstract coupling between the subject and the observer, the observer must implement an interface. The interface requires implementations of an update method to be invoked by the subject. The subject has a list of observers that conform to the requirement that they implement an *Observer* interface.

The JDK 1.1 event model implements the observer design pattern using a series of interfaces. Each interface is designed around a special event. For example, there is an interface called the *ActionListener* for observers of the *ActionEvent* class. Thus, a subscriber to the subject that publishes *ActionEvent* instances must implement the *ActionListener* interface before a subscription can be processed. The *ActionListener* interface requires that the *actionPerformed* method be implemented. Thus, it is the programmers' responsibility to implement the *actionPerformed* method to process an *ActionEvent* in the subscribing class.

An observer must be qualified to subscribe to a subject's events.

The qualification for a *WindowEvent* subscription is the implementation of *WindowListener*, something for which *ClosableJFrame* is designed. Thus, the *ClosableJFrame* instance subscribes itself to its own window events. *ClosableJFrame* provides the service of handling the mouse event for closing the frame. By extending *ClosableJFrame*, we are able to close the frame via *inheritance*. Perhaps the most interesting thing about *ClosableJFrame* is not what it does, but how it works. To use Swing, you typically must import the following packages:

```
import javax.swing.*; // get the widgets
import java.awt.event.*; // get the events
import java.awt.*;
```

What follows is the code for *ClosableJFrame*:

```
1.      public class ClosableJFrame extends JFrame {
2.          public ClosableJFrame(String title) {
3.              super(title);
4.          addWindowListener(
5.              new WindowAdapter() {
/*
The WindowAdapter class makes use of the Adapter pattern. The
        Adapter pattern  implements all of the methods in an
            interface with a null implementation. It is up to the
            programmer to override the null implementation. The
            WindowAdapter implements the WindowListener.
*/
6.                  public void windowClosing(WindowEvent e) {
7.                      setVisible(false);
8.                      dispose();
9.                  }
```

```
10.                    });
11.              }

12.      public static void main(String args[]) {
13.              ClosableJFrame cf = new
         ClosableJFrame("ClosableJFrame");
14.              cf.setSize(200,200);
15.              cf.setVisible(true);

16.          }
17.  }
```

On line 4, we see that we are adding *WindowListener* to *ClosableJFrame*. *WindowListener* is subscribed to *WindowEvents* that it must handle. *ClosableJFrame* is said to be *Observable*.

 The *Listener* waits to hear and react to an *Observable* event, which is depicted in the drawing of Figure 19.1-2.

As shown in the figure, *Listeners* are all ears, but *Observables* are all mouth! In the lines

```
4.       addWindowListener(
5.          new WindowAdapter() {
6.              public void windowClosing(WindowEvent e) {
7.                       setVisible(false);
8.                       dispose();
9.                   }
10.          });
```

Listener is instanced from an anonymous inner class called *WindowAdapter*. *WindowAdapter* provides *null* implementations for the following methods:

```
public void windowClosing(WindowEvent e) {}
public void windowClosed(WindowEvent e) {};
public void windowDeiconified(WindowEvent e) {};
public void windowIconified(WindowEvent e) {};
public void windowActivated(WindowEvent e) {};
public void windowDeactivated(WindowEvent e) {};
public void windowOpened(WindowEvent e) {};
```

Listeners Observables

FIGURE 19.1-2
Listeners and Observables

For example,

```
6.      public void windowClosing(WindowEvent e) {
7.        setVisible(false);
8.        dispose();
9.      }
/*
We override the default behavior of the windowClosing event, so
        that the frame will be collected and made invisible. By
        default, there is no implementation for the
        windowClosing event.
*/
```

The example usage

```
12.           public static void main(String args[]) {
13.                   ClosableJFrame cf =
                           new ClosableJFrame("ClosableJFrame");
14.                   cf.setSize(200,200);
15.                   cf.setVisible(true);
```

shows that *ClosableJFrame* must have its width and height set (in pixels), as well as its visibility (otherwise, the frame cannot be seen).

19.2 The *actionPerformed* Method

It is typical for programmers to create a GUI using a four-step process:

1. Make a new button (or *Component*).
2. Add the button to the container.
3. Add an *ActionListener* to the button.
4. Create a long dispatch in an *actionPerformed* method that decides what to do, given an event.

Visiting code in several places in order to add a feature is a fruitful source of error and makes the code hard to maintain.

Such an approach is error-prone since it requires that the code be visited in four different places. When the number of different components increases, these places can be separated by many lines of code. For example, consider *CommandFrame*:

```
import java.awt.*;
import java.awt.event.*;
public class CommandFrame extends Frame
 implements ActionListener{
        Button okButton = new Button("ok");
        // 1. make a new button.
        Button cancelButton = new Button("cancel");
     public CommandFrame() {
        add(okButton);
        add(cancelButton);
        // 2. add the button to the container.
```

```
                okButton.addActionListener(this);
                cancelButton.addActionListener(this);
                // 3. add action listener
                setLayout(new FlowLayout());
                setSize(200,200);
                show();
            }
        public void actionPerformed(ActionEvent e) {
                Object o = e.getSource();
                    // 4. dispatch the new button.
                if (o == okButton)
                  System.out.println("OK!");
                if (o == cancelButton)
                  System.out.println("cancel");
            }

                public static void main(String args[]) {
                  new CommandFrame();
                }
        }
```

19.3 RunButton

DESIGN PATTERN

Now consider *RunButton*, which is a button that knows how to run itself. Such a button makes use of what is known as the *CommandPattern*.

We define the *RunButton* class as a subclass of the *JButton* class. *RunButton* works by implementing the *Runnable* interface without providing a *run* method, which causes the class to be *abstract*. A rendering of *RunButton* is shown in Figure 19.3-1.

FIGURE 19.3-1
RunButton

The code for the implementation of *RunButton* follows:

```
import javax.swing.*;
import java.awt.event.*;
import java.awt.*;

public abstract class RunButton extends
        JButton implements ActionListener, Runnable {
/*
```

The *RunButton* implements an *ActionListener* because it is an
 observer of its own events. It also implements the
 Runnable interface so that it can have access to the *run*
 method, without defining its implementation. There are
 several constructors available from the *JButton* and they
 are all supported:

```
*/
        public RunButton(String label) {
                super(label);
                addActionListener(this);
        }
        public RunButton(String l, Icon i) {
                super(l,i);
                addActionListener(this);
        }
        public RunButton(Icon i) {
                super(i);
                addActionListener(this);
        }
        public RunButton() {
                addActionListener(this);
        }
/*
```

The *actionPerformed* method is required of classes that
 implement the *ActionListener*. We map this invocation to
 the *Runnable* interface's *run* method:

```
*/
        public void actionPerformed(ActionEvent e) {
                run();
        }
/*
```

The following code shows the abstract *RunButton* class defined
 using an anonymous inner class. This is an example of a
 design pattern called the *command pattern*. The *command
 pattern* encapsulates an action in an instance. Often,
 the instance is identified by the interface it
 implements. In the case of the *RunButton* the command is
 performed with an invocation to the *run* method. So, if
 you get an instance of the *RunButton* you need only
 invoke *run*. However, this is done for you by the
 actionPerformed method built into the *RunButton*.
 Therefore, you need only supply the implementation of
 the command that is to be run. This can be done via an

```
                    anonymous inner class. For example:
*/
                public static void main(String args[]) {
                  ClosableJFrame cf =
                        new ClosableJFrame("Run Button");
                  cf.getContentPane().add(new RunButton("OK") {
                            public void run() {
                                    System.out.println("I am running!");
                                    }
                            }
                  );
                  cf.setSize(200,200);
                  cf.setVisible(true);
                }
        }
```

Some students have said that the above code is difficult to understand. However, consider the alternative.

Using procedural coding, we place an instance of a button as a member of the class (generally at the top of the class). During component initialization, we add the button to a container (in the midsection of the class). During the event-handling dispatch, we check the event to see if it is the selected button, then do the button thing. Thus, we have created a situation where we have to visit the code in several places. This complicated procedure for adding code also complicates maintenance, decreases the reliability of the program, and adds more code.

19.4 Historical Perspective

The *Observable* class resides in the *java.util* package. An instance of the *Observable* class makes use of an instance of a list of the observer instances that have registered themselves. The list is called *ObserverList* and resides invisibly within the *java.util* package.

19.4.1 The Observer Interface

The *java.util.Observer* interface is used to maintain consistency in an object-oriented environment.

DESIGN PATTERN
The relationship between the class that implements the *Observer* interface and the class that extends the *Observable* class is the relationship between a view and a model.

An example of the model-view relationship is that between the gas tank of a car and a fuel gauge. If the amount of fuel in the tank changes, the fuel gauge readout changes. In Java, the simulation of a fuel tank notifies the fuel gauge readout so that the screen is consistent with the underlying simulation of the fuel tank.

There is a directed flow of information between an instance of a class that extends *Observable* and the instance of the class that implements *Observer*. The *Observable* instance keeps a list of all of the *Observer* instances that have registered an interest in the state of the *Observable* instance. Whenever the *Observable* instance changes, it broadcasts

Observable

update()

FIGURE 19.4.1-1
The *Observable* and *Observer* Observer

an update message to each of the *Observer* instances that have registered. This relationship
is shown in Figure 19.4.1-1.

 A class that implements the *Observer* interface supports an update method that
takes an *Object*-type argument.

19.4.2 The *Observer* and *Observable* Summary

```
package java.util;

public interface Observer {
    void update(Observable o, Object arg);
}

package java.util;
public class Observable{
    public synchronized void addObserver(Observer o)
    public synchronized void deleteObserver(Observer o)
    public void notifyObservers()
    public synchronized void notifyObservers(Object arg)
    public synchronized void deleteObservers()
    public synchronized boolean hasChanged()
    public synchronized int countObservers()
}
```

The following section describes the *NamedObservable* class.

19.5 *NamedObservable*

The *NamedObservable* class provides a mechanism to associate a *String* instance with the *Observable* instance. The code for *NamedObserver* follows:

```
package observers;
import java.util.*;
// The NameObservable is just like an Observable
// only it has a name property associated with
// every Observable instance.
public abstract class NamedObservable extends Observable {

    private String name;

    public synchronized void setName(String nm) {
        name = nm;
    }

    public synchronized String getName() {
        return name;
    }
}
```

The *get* and *set* methods in the *NamedObservable* class are synchronized to prevent contention problems from occurring during multi-threaded operation.

It is common to see class variables such as the *name* string being accessed only through the synchronized method.

19.6 *ObservableDouble*

DESIGN PATTERN
ObservableDouble contains the support methods to keep a list of *Observers* interested in a double-precision value.

When the *setValue* method is invoked on an instance of the *ObservableDouble* class, the *setChanged* method is invoked and the *notifyObservers* method causes an *update* method to be broadcast to all of the interested *Observer* instances.

```
package observers;
import java.util.*;

public class ObservableDouble extends NamedObservable {

    // The value of interest
    private double value;

    public ObservableDouble(double newValue, String nm) {
        value = newValue;
        setName(nm);
    }
```

```
    public synchronized void setValue(double newValue) {
        if (newValue != value) {
            value = newValue;
            super.setChanged();
            super.notifyObservers();
        }
    }
    public synchronized double getValue(){
            return value;
    }
}
```

19.7 ObserverOfPoint3d

In the following example, we find a class called *ObserverOfPoint3d*. This class is updated by an invocation to a call-back method called *update*:

```
package examples.observables;

import java.util.Observable;
import java.util.Observer;

public class ObserverOfPoint3d implements Observer {
    public void update(Observable observable,
                        Object o) {
        System.out.println("observable =" +
                observable);
        System.out.println(observable.getClass().getName());
        System.out.println("argument=" +
                o);
        ObservablePoint3d p3d = (ObservablePoint3d) (observable);
        System.out.println("got points! d1,d2,d3=" +
                p3d.getD1() + "," + p3d.getD2() + "," +
        p3d.getD3());
    }

}
```

Based on our read of *ObserverOfPoint3d*, we see that there is a class called *ObservablePoint3d*. When instances change, we are notified with a call back. The *Mediator* class is responsible for hooking up the observer of data with the observable data. That is, it is responsible for wiring up the observer-observable association:

```
class Mediator {
    ObservablePoint3d op3d = new ObservablePoint3d();
    ObserverOfPoint3d observer = new ObserverOfPoint3d();

    public void wire() {
        op3d.addObserver(observer);
        op3d.setD1(-99);
        op3d.notifyObservers();
    }
```

```
        public static void main(String args[]) {
            Mediator m = new Mediator();
            m.wire();
        }
    }
```

The following class shows how a reference data type (like a three-dimensional point) can be made observable:

```
package examples.observables;

import java.util.Observable;

public class ObservablePoint3d extends Observable {
    private double d1 = 0;
    private double d2 = 0;
    private double d3 = 0;

    public void setD1(double _d) {
        if (d1 != _d) {
            d1 = _d;
            setChanged();
            super.notifyObservers(this);
        }
    }

    public void setD2(double _d) {
        if (d2 != _d) {
            d2 = _d;
            setChanged();
            super.notifyObservers(this);
        }
    }

    public void setD3(double _d) {
        if (d3 != _d) {
            d3 = _d;
            setChanged();
            super.notifyObservers(this);
        }
    }

    public double getD1() {
        return d1;
    }

    public double getD2() {
        return d2;
    }

    public double getD3() {
        return d3;
    }
```

```
    public String toString() {
        return "d1,d2,d3=" + d1 + "," + d2 + "," + d3;
    }
}
```

The observer-observable design pattern is not complete without a mediator. The novice often is tempted to combine the responsibility of the mediator with other classes (either the observer or the observable). This combination is often an error, as unwanted coupling can occur between the classes. If we can imagine, for example, the creation of a visual programming language, where observers and observables are blocks on the screen, and then the wires are added and subtracted using the mediator. On the other hand, the observer does know about the reference data type of the observable item. What remains unspecified at compile time is which observable instances will be updating the observer.

19.8 Summary

In this chapter, we saw how the event model works using the *observer* design pattern to define a one-to-many dependency between instances. These dependencies enabled state changes to be propagated to dependents via call-back method notifications through the implementation of a sequence of listeners (*ActionListener, ItemListener, KeyListener,* and *WindowListener*).

DESIGN PATTERN
We also saw how the *adapter* design pattern was able to convert the interface of one class into another (thus creating runnable components), which also served as an example of the *command* pattern encapsulating a request.

19.9 Exercises

19.1 Write a GUI that lets the user select a thread in the JVM and kill it.

19.2 Name three real-time situations where the *observer* design pattern can be applied.

19.3 Your business requires a database of customers. Write an implementation of the *observer* design pattern that updates database listeners whenever the database is updated. Use a *vector* to store the customers.

19.4 Write observers and observables for all of the primitive data types. You will need eight classes, including *ObservableInt, ObservableLong,* etc. Demonstrate each of your classes.

CHAPTER 20

Design Patterns and Events

Nothing endures but change.

–Heraclitus (540 BC – 480 BC)

In this chapter, you will learn how to apply the following to the creation of well-designed GUIs:

- The adapter pattern and the command pattern
- The mediator pattern
- The MVC pattern

This chapter provides a framework and example series that demonstrates how to deploy the Command pattern through the Swing GUI.

Many people confuse object-oriented design with object-oriented programming. These are different things! An object-oriented design can be implemented with an object-oriented program, though such an implementation is not required. Take, for example, a subway card that contains information about how much money is left on it. This is an object-oriented design (i.e., the card contains the data needed for the card to be processed). Or, consider a kitchen with a cook, cookbooks, food, and cooking equipment. We input a message (the order) and obtain meals from the output. This is an object-oriented design too (and you don't need programs to implement it!).

An essential first step in good object-oriented design is the identification of the *roles* of the elements in a system. For example, a waitress has the role of taking orders and delivering meals, whereas a cook has the role of preparing meals.

Interfaces between elements in a system should be well defined and stable. For example, the cook and the waitress communicate using an order slip. The order slip represents a message to the cook. When the meal is done, the cook sends a message

back to the waitress by ringing a bell. The bell represents a call-back *event*. The waitress listens for this message, queueing her response for when she has time to pick up the next order.

20.1 The *Adapter* Pattern and the Command Pattern

This section shows that we combine the command pattern (i.e., components that know how to run themselves) with the adapter design pattern. The *adapter* design pattern is used to alter the interface to an instance of an object.

Design Pattern
Adapters are used to enable instances with different interfaces to communicate with each other.

In the case of *RunButton*, we have altered the interface for the call-back method from *actionPerformed* to *run*. This simple mapping of one interface to another is a typical example of the adapter pattern in action. In the *run* package, we have a collection of components that map their actions to the *run* method. By incorporating *runnable* components into your design, you greatly simplify the procedure of adding components to a system. Also, the location of the *run* method in an anonymous inner class encourages programmers to make the implementation as small as they can. Smaller implementations, in turn, tend to encourage a clean separation of GUI code from business logic (the mark of a well-designed program).

As an aside, it is also possible to make a *ThreadedButton*. Consider the following code:

```
public abstract class ThreadedButton extends JButton
       implements Runnable, ActionListener {
       RunButton(String label) {
        super(label);
        addActionListener(this);
       }
       Thread t = null;
       public void actionPerformed(ActionEvent e) {
          t = new Thread(this);
        t.start();
       }
}
```

Using *ThreadedButton*, a new thread is started every time the user selects a button. This technique enables all components to run their commands in their own threads, which is excellent for stopping an asynchronous process (particularly a multi-threaded one).

Design Pattern
The command design pattern places an instance of a command into an instance of another class, call the *issuer*. For example, *MenuItem* can have the role of the issue, holding a reference to an instance of a command. Thus *RunMenuItem* will invoke a *run()* command on the command instance. The command instance has the role of either forwarding the command to a specific recipient or executing the command itself.

Thus, *run* components are an example of both the adapter pattern and the command pattern. They use the command pattern because they know how to run themselves and they use the adapter pattern because they map the *actionListener* interface into the *Runnable* interface.

20.2 The Command Pattern and the Touchtone Keypad

In this section, we show how to use the command pattern to bind event processing to the touchtone keypad shown in Figure 20.2-1.

Recall that in Chapter 18 we used the *GridLayout* manager to build a *TouchTone* GUI. We repeat that code here and then develop a method for adding observer pattern code for event processing:

```
import javax.swing.*;
import java.awt.event.*;
import java.awt.*;

public class TouchTone {
      Container c;
      public TouchTone(Container _c) {
        c = _c;
/*
The new GridLayout is set to have 4 rows and 0 columns. When
      the number of the columns is set to zero, the layout
      manager permits any number of columns. When the number
      of rows is set to zero, the layout manager permits any
      number of rows.
*/
      c.setLayout(new GridLayout(4,0));
      addButtons();
    }
    private void addButtons() {
      for (int i=1; i <=9; i++)
        addRunButton(""+i);
```

FIGURE 20.2-1
A Touchtone Keypad

```
        addRunButton("*");
        addRunButton("0");
        addRunButton("#");
    }
/*
The use of the helper method, addRunButton greatly simplifies
        the addButtons code. The method getLabel allows the run
        method to have access to the text in the label of the
        button. The getLabel method is local to the JButton
        class.
*/
    private void addRunButton(String s){
        c.add(new RunButton(s) {
                public void run() {
                        System.out.println(getLabel());
                }
            }
        );
    }

    public static void main(String args[]) {
            ClosableJFrame cf = new ClosableJFrame(
             "Touch Tones");
            TouchTone tt = new TouchTone(cf.getContentPane());
            cf.setSize(200,200);
            cf.setVisible(true);
    }
}
```

20.3 *RunTextField*

In this section, we apply what we have learned about *RunButton* to create a new compo-
nent called *RunTextField*. An example of *RunTextField* is shown in Figure 20.3-1. It is also
based on the command pattern.

RunTextField allows for only a single line of text and uses its *run* method whenever
the return key is pressed. The code follows:

```
import javax.swing.*;
import javax.swing.text.*;
import java.awt.event.*;
import java.awt.*;
public abstract class RunTextField extends
        JTextField implements ActionListener, Runnable {
        String sTxt;
/*
Just like the RunButton, the RunTextField wrappers all the
        constructors with the addActionListener method. This
        enables the RunTextField to keep all the features of the
        JTextField super class.
*/
        public RunTextField(String text) {
                super(text);
```

FIGURE 20.3-1
RunTextField

```
            addActionListener(this);
    }
    public RunTextField() {
            addActionListener(this);
    }
    public RunTextField(int columns) {
      super(columns);
      addActionListener(this);
    }
    public RunTextField(String text, int columns) {
      super(text, columns);
      addActionListener(this);
    }
    public RunTextField(Document doc,
            String text, int columns) {
      super(doc, text, columns);
      addActionListener(this);
    }
    public void actionPerformed(ActionEvent e) {
            run();
    }
      public static void main(String args[]) {
      ClosableJFrame cf =
            new ClosableJFrame("RunTextField");
      Container c = cf.getContentPane();
      c.add(new RunTextField("What is your name?") {
                public void run() {
                        System.out.println(getText());
                }
```

```
            }
        );
        c.setLayout(new GridLayout(4,0));
        cf.setSize(200,200);
        cf.setVisible(true);
    }
}
```

RunTextField and *RunButton* are treated the same in the sense that both incorporate the *run* method as a means of call back when actions are performed.

20.4 *BorderLayout* and *RunTextField*

In this section, we use *BorderLayout* to add *RunTextField* to the container, as shown in Figure 20.4-1.

The code follows:

```
import javax.swing.*;
import java.awt.event.*;
import java.awt.*;

public class TouchToneReadout extends ClosableJFrame {
    Container c = getContentPane();
    JPanel keyPadPanel = new JPanel();
    TouchTone tt = new TouchTone(keyPadPanel);
    RunTextField readOut = new RunTextField() {
      public void run() {
      }
    };
      TouchToneReadout() {
        super("TouchToneReadout");
```

FIGURE 20.4-1
BorderLayout and the Touchtones

```
            setSize(200,200);
    /*
    What follows is the new border layout directive. You can use
            BorderLayout.NORTH, BorderLayout.SOUTH,
            BorderLayout.EAST and BorderLayout.WEST. There are also
            variations that permit the use of strings, but these do
            not have strong type checking and their use is to be
            discouraged.
    */
            c.setLayout(new BorderLayout());
            c.add(readOut,BorderLayout.NORTH);
            c.add(keyPadPanel,BorderLayout.CENTER);
                setVisible(true);
        }
        public static void main(String args[]) {
         new TouchToneReadout();
        }
    }
```

20.5 *RunCheckBox*

In this section, we apply the idea of the command pattern to the *JCheckbox* class in *Swing*. An example of *RunCheckBox* is shown in Figure 20.5-1.

RunCheckBox has a label associated with it, as well as a checkbox that is either checked or unchecked. The code follows:

```
import javax.swing.*;
import java.awt.event.*;
```

FIGURE 20.5-1
An Image of *RunCheckBox*

```
import java.awt.*;

public abstract class RunCheckBox extends
      JCheckBox implements ItemListener, Runnable {
/*
The JCheckBox requires an ItemListener implementation, in order
      to observe its own events. This is a bit different from
      the RunButton that implements an ActionListener.
      However, we map all elements toward the run method. This
      simplifies the API greatly.
*/
      public RunCheckBox(String label) {
      super(label);
      addItemListener(this);
      }
      public RunCheckBox(Icon i, boolean b) {
      super(i,b);
      addItemListener(this);
      }
      public RunCheckBox(String s, boolean b) {
      super(s,b);
      addItemListener(this);
      }
      public RunCheckBox(Icon i) {
      super(i);
      addItemListener(this);
      }
```

 The *itemStateChanged* method is required by *ItemListener*. The following lines subscribe *RunCheckBox* to its own events and provide an implementation for the *itemStateChanged* method.

```
      public RunCheckBox() {
      addItemListener(this);
      }

      public void itemStateChanged(ItemEvent e) {
      run();
      }

      public static void main(String args[]) {
          ClosableJFrame cf = new
        ClosableJFrame("RunCheckBox");
          Container c = cf.getContentPane();
          c.add(new RunCheckBox ("RunCheckBox") {
                    public void run() {

          System.out.println(getText()+"="+isSelected());
                    }
              }
          );
          c.setLayout(new GridLayout(4,0));
          cf.setSize(200,200);
```

```
                    cf.setVisible(true);
            }
    }
```

20.6 *RunPasswordField*

In this section, we show how to create a text field that allows the user to enter a password. Much of the code in this section is identical to the code in the *RunTextField* class. An example of *RunPasswordField* is shown in Figure 20.6-1. The code follows:

```
import javax.swing.*;
import javax.swing.text.*;
import java.awt.event.*;
import java.awt.*;

public abstract class RunPasswordField extends
        JPasswordField implements ActionListener, Runnable {
        String sTxt;
        public RunPasswordField(String text) {
                super(text);
                addActionListener(this);
        }
        public RunPasswordField() {
                addActionListener(this);
        }
        public RunPasswordField(int columns) {
          super(columns);
```

FIGURE 20.6-1
An Image of the *RunPasswordField* Frame

```
      addActionListener(this);
    }
    public RunPasswordField(String text, int columns) {
      super(text, columns);
      addActionListener(this);
    }
    public RunPasswordField(
          Document doc,
          String text,
          int columns) {
      super(doc, text, columns);
      addActionListener(this);
    }
    public void actionPerformed(ActionEvent e) {
          run();
}
      public static void main(String args[]) {
        ClosableJFrame cf = new
ClosableJFrame("RunPasswordField");
      Container c = cf.getContentPane();
      c.add(new RunPasswordField(
      "What is your password?") {
                public void run() {
                      System.out.println(getText());
                }
          }
    );
    c.setLayout(new GridLayout(4,0));
    cf.setSize(200,200);
    cf.setVisible(true);
    }

}
```

One of the basic problems with a language that lacks multiple inheritance is that there is a large duplication of code. It would be really nice to devise a method whereby the code of *RunTextField* had been reused by *RunPasswordField*. Instead, we wrapped all of the constructors just to add the line

```
      addActionListener(this);
```

20.7 *RunList*

The *RunList* class subclasses the *JList* class in the *Swing* package. The basic idea of *RunList* is that it gives an invocation on the *run* method whenever an element in a list is selected. The string representation is presented to the user, but the element itself is returned when *getSelectedValues* is invoked on the *RunList* instance. An image of *RunList* in action is shown in Figure 20.7-1.

The user may select one or several elements from *RunList*. The code follows:

```
import javax.swing.*;
import javax.swing.text.*;
import java.awt.event.*;
```

FIGURE 20.7-1
RunList

```java
import java.awt.*;
import javax.swing.event.*;
import java.util.*;

public abstract class RunList extends
     JList implements ListSelectionListener, Runnable{
/*
```
The *RunList* is different from the other components we have seen
 so far in that it implements the *ListSelectionListener*
 interface. This requires a *valueChanged* method as a part
 of the callback.
```java
*/
     public RunList(Vector v){
       super(v);
       addListSelectionListener(this);
     }
     public RunList(){
       addListSelectionListener(this);
     }
     public RunList(ListModel dataModel){
       super(dataModel);
       addListSelectionListener(this);
     }
     public RunList(Object[] listData){
       super(listData);
       addListSelectionListener(this);
     }
     public void valueChanged(ListSelectionEvent e) {
       run();
     }
/*
```
Just like the other components, we have mapped the *valueChanged*
 into a *run* invocation.
```java
*/
        public static void main(String args[]) {
            ClosableJFrame cf = new ClosableJFrame("RunList");
            Container c = cf.getContentPane();
            String list[] = {"this", "is", "a","test"};
            c.add(new RunList(list) {
                    public void run() {
```

```
                        Object o[] = getSelectedValues();
                        for (int i=0; i < o.length; i++)
                            System.out.println(o[i]);
                }
            }
        );
        c.setLayout(new GridLayout(1,0));
        cf.setSize(200,200);
        cf.setVisible(true);
    }
}
```

20.8 The Scrollbar and the Slider

This section is divided into two subsections. One covers scrollbars, and the other covers sliders. When *AWT* first came out, there was no built-in way to show the value of a scroll-bar. Programmers added labels that updated when the scrollbar was adjusted. To answer this problem, Javasoft provided a new component called *JSlider*. *JSlider* has features that include major and minor tick marks and numeric labels. The following section discloses the command pattern as it applies to a scrollbar to create the *RunScroll* class.

20.8.1 *RunScroll*

The *RunScroll* class provides a scrollbar that implements the *Runnable* interface. An image of the *RunScroll* class is shown in Figure 20.8.1-1.

Scrollbars have a box that travels the length of the scrollbar. The box is called the *elevator*. You can take the elevator up or down. Clicking on an arrow moves the elevator one tick. A *tick* is an increment whose size may be set. Clicking on the blank area to one side of the scrollbar can move the elevator an elevator width. Elevators also can be dragged.

The *orientation* of the *RunScroll* class is either *JScrollBar.VERTICAL* or *JScrollBar.HORIZONTAL*. For example,

```
import java.awt.*;
import java.awt.event.*;
import javax.swing.*;

public abstract class RunScroll
        extends JScrollBar implements
```

FIGURE 20.8.1-1
RunScroll

```
                 AdjustmentListener, Runnable{
        public RunScroll(int orientation,
               int value, int extent,
               int min, int max) {
            super(orientation, value, extent, min, max);
            addAdjustmentListener(this);
        }
        public RunScroll(int orientation) {
            this(orientation, 0, 10, 0, 100);
        }
        public RunScroll() {
            this(VERTICAL);
        }
          public void adjustmentValueChanged(
              AdjustmentEvent ae){
            run();
        }
        public static void main(String args[]) {
          ClosableJFrame cf = new ClosableJFrame();
          cf.setSize(200,200);
          Container c = cf.getContentPane();
          c.setLayout(new FlowLayout());
          c.add(new RunScroll() {
            public void run() {
                System.out.println("value="+getValue());
                // getValue comes from the JScrollBar
            }
          });
          cf.setVisible(true);
        }
    }
```

20.8.2 *RunSlider*

RunSlider is just like *RunScroll* except that it has tick marks and labels. These are set to reasonable defaults, but they can be reset by the programmer. Javasoft made the base *JSlider* class turn off labels and tick marks by default. I turn them on by default in *RunSlider*. The programmer always can turn them back off.

An image of the default *RunSlider* is shown in Figure 20.8.2-1.

RunSlider makes use of an event that only appears in the *javax.swing.event* package. This new event is called *ChangeEvent* and requires *ChangeListener*. Not to worry, as all of the *Run* components only require the programmer to implement the *Run* method. For example,

FIGURE 20.8.2-1
RunSlider

```java
import java.awt.*;
import java.awt.event.*;
import javax.swing.*;
import javax.swing.event.*;

public abstract class RunSlider
        extends JSlider implements
        ChangeListener, Runnable{

    public RunSlider(
        int orientation,
        int min, int max, int value) {
        super(orientation, min, max, value);
        setPaintTicks(true);
        int majorTickSpacing = (max-min)/4;
        setMajorTickSpacing(majorTickSpacing);
        setMinorTickSpacing(majorTickSpacing/5);
        setPaintLabels(true);
        addChangeListener(this);
    }
    public RunSlider() {
      this(JSlider.HORIZONTAL,0,100,50);
    }
    public RunSlider(int orientation) {
      this(orientation, 0, 100, 50);
    }

    public RunSlider(int min, int max) {
      this(JSlider.HORIZONTAL, min, max, 50);
    }

      public void stateChanged(ChangeEvent ae){
          run();
      }
    public static void main(String args[]) {
      ClosableJFrame cf = new ClosableJFrame();
      cf.setSize(200,200);
      Container c = cf.getContentPane();
      c.setLayout(new FlowLayout());
      c.add(new RunSlider() {
        public void run() {
            System.out.println(
                "value="+getValue());
            // getValue comes from the JSlider
        }
      });
      cf.setVisible(true);
    }

}
```

To get the value of *RunScroll* or *RunSlider*, the programmer only needs to invoke the *getValue* method.

20.9 *RunRadio*

The *RunRadio* class makes a command pattern out of *JRadioButton*. An image of a frame with the *RunRadio* button in it appears in Figure 20.9-1.

The code that appears below puts in a single *RunRadio* button into a frame. The buttons typically are grouped together, which will be shown in the following section.

```java
import java.awt.event.*;
import javax.swing.*;
import java.awt.*;

public abstract class RunRadio extends
    JRadioButton implements ItemListener, Runnable{

  public RunRadio() {
    addItemListener(this);
  }

  public RunRadio(Icon i) {
    super(i);
    addItemListener(this);
  }

  public RunRadio(String s) {
    super(s);
    addItemListener(this);
  }

  public RunRadio(String s, Icon i) {
    super(s, i);
    addItemListener(this);
  }

  public RunRadio(Icon i, boolean b) {
    super(i, b);
    addItemListener(this);
  }

  public RunRadio(String s, boolean b) {
    super(s, b);
    addItemListener(this);
  }

  public RunRadio(String s, Icon i, boolean b) {
    super(s, i, b);
    addItemListener(this);
  }
```

FIGURE 20.9-1
The *RunRadio* Button

```
      public void itemStateChanged(ItemEvent e){
      run();
      }
  public static void main(String args[]) {
      ClosableJFrame cf = new ClosableJFrame("RunRadio");
      Container c = cf.getContentPane();

      c.add(new RunRadio() {
              public void run() {
                      System.out.println(isSelected());
              }
          }
      );
      c.setLayout(new GridLayout(1,0));
      cf.setSize(200,200);
      cf.setVisible(true);
  }
}
```

20.10 *RunRadioButton*, *ButtonGroup*, and *FlowLayout*

This section shows how to use button groups to obtain *mutual exclusion*. The term *radio button* refers to the button selector switch on some car radios. When a favorite station is selected, none of the other stations can be played. This is a form of mutual exclusion, and it often is built into an interface. Figure 20.10-1 shows an image of the radio buttons used in a button group.

Another goal of this section is to show the use of a new layout manager, called *FlowLayout*. The code for *RadioButtonTest* follows:

```
import javax.swing.*;
import java.awt.event.*;
import java.awt.*;

public class RadioButtonTest extends ClosableJFrame {
    Container c = getContentPane();
    ButtonGroup bg = new ButtonGroup();

    public void addColorButton(RunRadio rr) {
        c.add(rr);
        bg.add(rr);
    }

    public RadioButtonTest() {
        super( "Using Button Groups" );
```

FIGURE 20.10-1
Button Groups

FlowLayout is used to arrange the components from left to right, top to bottom. It resizes components to make better use of available space. For example,

```
      c.setLayout(new FlowLayout());
      addColorButton(new RunRadio("cyan") {
       public void run() {
          c.setBackground(Color.cyan);
       }
      });
      addColorButton(new RunRadio("yellow") {
       public void run() {
          c.setBackground(Color.yellow);
       }
      });
      addColorButton(new RunRadio("green") {
       public void run() {
          c.setBackground(Color.green);
       }
      });
      c.setBackground( Color.white );
      setSize( 250, 300 );
      setVisible(true);
   }

   public static void main( String args[] ) {
      RadioButtonTest app = new RadioButtonTest();
   }

}
```

20.11 The *MainMenuBar* and *RunCheckBoxMenuItems*

A frame has a main menu bar, and the menu bar has a title. When you select the menu bar title, a pop-down menu appears and menu items are exposed. These items can implement *Runnable* just like the other components in this chapter. In this section, we show how to create a main menu bar with *RunCheckBoxMenuItems*. *RunCheckBoxMenuItem* is a class that implements the *Runnable* interface and subclasses *JCheckBoxMenuItem*. An image of the interface we will construct is shown in Figure 20.11-1.

FIGURE 20.11-1
Main Menus and *RunCheckBoxMenuItem*

The code for RunCheckBoxMenuItem follows:

```java
import java.awt.event.*;
import javax.swing.*;
import java.awt.*;
public abstract class RunCheckBoxMenuItem extends
    JCheckBoxMenuItem implements ItemListener, Runnable {
  public RunCheckBoxMenuItem(String label) {
        super(label);
        addItemListener(this);
  }
  public RunCheckBoxMenuItem(String s, boolean b) {
        super(s,b);
        addItemListener(this);
  }
  public RunCheckBoxMenuItem(Icon i) {
        super(i);
        addItemListener(this);
  }

  public RunCheckBoxMenuItem() {
        addItemListener(this);
  }

  public void itemStateChanged(ItemEvent e) {
        run();
  }
    public static void main(String args[]) {
    ClosableJFrame cf = new ClosableJFrame("RunRadio");
    Container c = cf.getContentPane();
/*
In the following line, we create a new JMenuBar instance. Onto
    this instance we add a new instance of a JMenu. To the
    JMenu instance we add the new RunCheckBoxMenuItem.
*/
        JMenuBar mb = new JMenuBar();
        JMenu m = new JMenu("Checkable");
        m.add(new RunCheckBoxMenuItem("Check1"){
                public void run(){
                        System.out.println("Check1");
                        }
                });
        m.add(new RunCheckBoxMenuItem("Check2"){
                public void run(){
                        System.out.println("Check2");
                        }
                });
/*
Finally, we add the JMenu instance to the JMenuBar and set it
    in the ClosableJFrame.
*/
        mb.add(m);
        cf.setJMenuBar(mb);
```

```
                    c.setLayout(new GridLayout(1,0));
                    cf.setSize(200,200);
                    cf.setVisible(true);
                    }
        }
```

20.12 *RunRadioButtonMenuItem* Groups

In this section, we show how to combine radio buttons into button groups and then add these groups as menu items into the main menu bar of a frame by using a new class called *RunRadioButtonMenuItem*. Since the mutual exclusion of the button group is applied, only one item in this group may be selected. Figure 20.12-1 shows an example of one of the *RunRadioButtonMenuItem* groups.

Naturally, these groups also can be used with *RunCheckBoxMenuItem*, which was discussed in the previous section. The code for *RunRadioButtonMenuItem* follows:

```
import javax.swing.*;
import java.awt.event.*;
import java.awt.*;

public abstract class RunRadioButtonMenuItem extends
        JRadioButtonMenuItem
            implements ActionListener, Runnable {
        public RunRadioButtonMenuItem(String label) {
                super(label);
                addActionListener(this);
        }
    /*
```

FIGURE 20.12-1
RunRadioButtonMenuItem Groups

As a matter of style, we have added the button group as one of
the over-loading operations, so that the
RunRadioButtonMenuItem can add itself to the *ButtonGroup*
instance:
```
*/
        public RunRadioButtonMenuItem(
          String label,ButtonGroup bg) {
                super(label);
                bg.add(this);
                addActionListener(this);
        }
/*
```
We have also added the *JPopupMenu* instance that the component
 belongs to, as a part of the constructor.
```
*/
        public RunRadioButtonMenuItem(
          String label,
          ButtonGroup bg,
          JPopupMenu jpum) {
                super(label);
                bg.add(this);
                jpum.add(this);
                addActionListener(this);
        }
        public RunRadioButtonMenuItem(String l, Icon i) {
                super(l,i);
                addActionListener(this);
        }
        public RunRadioButtonMenuItem(Icon i) {
                super(i);
                addActionListener(this);
        }
        public RunRadioButtonMenuItem() {
                addActionListener(this);
        }
        public void actionPerformed(ActionEvent e) {
                run();
        }
        public static void main(String args[]) {
          ClosableJFrame cf = new
        ClosableJFrame("RunRadioButtonMenuItem");
          Container c = cf.getContentPane();
          ButtonGroup bg = new ButtonGroup();

            JMenuBar mb = new JMenuBar();
            JMenu m = new JMenu("Radio Button");

          m.add(new RunRadioButtonMenuItem("item 1", bg) {
                  public void run() {

        System.out.println(getText()+"="+isSelected());
                }
            }
```

```
                   );
          m.add(new RunRadioButtonMenuItem("item 2", bg) {
                        public void run() {
             System.out.println(getText()+"="+isSelected());
                        }
               }
          );

          mb.add(m);
          cf.setJMenuBar(mb);
          c.setLayout(new FlowLayout());
          cf.setSize(200,200);
          cf.setVisible(true);
        }

    }
```

20.13 The MVC Design Pattern

The MVC design pattern is used to identify three roles in a system. The state of the system, along with business logic, is stored in the *model*. The *view* provides a user interface that monitors the state of the system. The *controller* represents the user interface for manipulating the state of the system. Systems engineers have known about the MVC pattern for decades, only they called it the observer-plant model and provided sensors to improve the observer's estimate of the plant's state. Plant controllers often are implemented with a combination of control laws and computer-human interfaces.

The controller manages events from the different components in a GUI design. The idea is that the controller class should not have any interaction with the appearance of the system. Features that we want from a separate controller class include improved clarity, simplified maintenance, reduced direct coupling between GUI elements, and support for increased reuse.

The controller is never a user interface element, yet it has associations with user interface elements. The following implementation of *TouchToneController* shows that it uses an instance of *RunTextField* as an output:

```
public class TouchToneController {
        String s = "";
//The String is used to store the state,
//or model of the keypad.
        RunTextField readOut;
```

/* The programmer must set the readout or there will be a null reference error: */

```
        public void setReadOut(RunTextField _readOut) {
          readOut = _readOut;
        }
/* When a key is pressed, both the state and read out are updated:
*/
        public void dialPadKey(String _s) {
          s = s + _s;
```

```
        updateReadOut();
      }
      public void setState(String _s) {
        s = _s;
      }

      public void updateReadOut() {
        readOut.setText(s);
      }
    }
```

The *setState* method will replace the internal string for the model of the keypad. This replacement should occur when the user hits enter in *RunTextField*. Later, if we wanted a modem to dial the number, *setState* would be a logical place to add the invocation to the new dial method. Such a feature should not alter the layout of our system at all.

WARNING

Do not mix business logic and GUI code.

An artifact of using the controller is that the GUI elements inform the controller of events, but they do not take responsibility for fulfilling them. The controller is fitted to the *TouchTone* class. In fact, every *TouchTone* class is responsible for creating a controller:

```
import javax.swing.*;
import java.awt.event.*;
import java.awt.*;

public class TouchTone {
      Container c;
      TouchToneController ttc = new TouchToneController();
      public TouchTone(Container _c) {
        c = _c;
        c.setLayout(new GridLayout(4,0));
        addButtons();
      }
/*
Other instances that need access to the controller, must ask the
      TouchTone class for it.
*/
      public TouchToneController getController() {
        return ttc;
      }
      private void addButtons() {
        for (int i=1; i <=9; i++)
          addRunButton(""+i);
        addRunButton("*");
        addRunButton("0");
        addRunButton("#");
      }

      private void addRunButton(String s) {
          c.add(new RunButton(s) {
                  public void run() {
                        ttc.dialPadKey(getLabel());
                  }
```

```
                              }
                         );
                 }

       public static void main(String args[]) {
                 ClosableJFrame cf =
                   new ClosableJFrame("Touch Tones");
             TouchTone tt = new TouchTone(cf.getContentPane());
             cf.setSize(200,200);
             cf.setVisible(true);
       }

   }
```

The code for the new version of *TouchToneReadout* follows:

```
import javax.swing.*;
import java.awt.event.*;
import java.awt.*;

public class TouchToneReadout extends ClosableJFrame {
    private Container c = getContentPane();
    private JPanel keyPadPanel = new JPanel();
/*
The following is a bit disturbing. The TouchToneReadout has the
        responsibility for making a new TouchTone pad. The pad
        makes an instance of the TouchToneController. The pad then
        informs the controller of its changes in state.
In the next section (20.14) we will see how the Mediator design
        pattern can take responsibility for hooking up the
        Observer pattern.
*/
    private TouchTone tt = new TouchTone(keyPadPanel);
    private TouchToneController ttc = tt.getController();

    private RunTextField readOut = new RunTextField() {
      public void run() {
        ttc.setState(getText());
      }
    };
      public TouchToneReadout() {
        super("TouchToneReadout");
        ttc.setReadOut(readOut);
        setSize(200,200);
        c.setLayout(new BorderLayout());
        c.add(readOut,BorderLayout.NORTH);
        c.add(keyPadPanel,BorderLayout.CENTER);
          setVisible(true);
      }
      public static void main(String args[]) {
       new TouchToneReadout();
      }
   }
```

20.14 The *Mediator* Design Pattern

Thus, three different classes must be instanced and properly related: *TouchToneController*, the *TouchTone* pad, and *TouchToneReadout*. Distributing the responsibility for the creation of the different classes and hooking them up is poor design practice because it creates direct associations between all of the different classes.

DESIGN PATTERN
The Mediator design pattern uses a class that is responsible for controlling and coordinating the interactions of a group of other instances. The Mediator promotes loose coupling by keeping instances from directly referring to each other.

A better design would be to use a *mediator* to centralize the creation of and hook up the different classes. A mediator promotes loose coupling between instances and prevents them from explicitly referring to each other. In a way, it is like the wiring hub on a network.

The decision about where to place the role of a mediator is not easy. It is often better to make the mediator a separate class.

The decision to assign the mediator role to just one class often makes the code cleaner, but can require refactoring the code.

Refactoring code means altering the roles of the objects in a system's design and thus moving the code around. In the following implementation of *TouchToneReadout*, we have selected the class to take on the role of mediator by creating new instances (including the controller) and wiring up the controller.

While it might be more interesting to create a new mediator class just for this purpose, the class would be so small as to create too much overhead for too little reward.

An example of *TouchToneReadout* follows:

```
import javax.swing.*;
import java.awt.event.*;
import java.awt.*;

public class TouchToneReadout extends ClosableJFrame {
    private Container c = getContentPane();
    private JPanel keyPadPanel = new JPanel();

    private TouchToneController ttc = new
        TouchToneController();
```

The constructor for the *TouchTone* class has changed to require an instance of a *TouchToneController*:

```
    private TouchTone tt = new TouchTone(keyPadPanel,ttc);

    private RunTextField readOut = new RunTextField() {
      public void run() {
        ttc.setState(getText());
      }
    };
      public TouchToneReadout() {
```

```
            super("TouchToneReadout");
            ttc.setReadOut(readOut);
            setSize(200,200);
            c.setLayout(new BorderLayout());
            c.add(readOut,BorderLayout.NORTH);
            c.add(keyPadPanel,BorderLayout.CENTER);
                setVisible(true);
        }
    }
```

The *TouchTone* class delegates to the controller the event of a key press, which is why the controller is required as a part of the *TouchTone* class. It is generally good design to pass the controller to the GUI element, even if the controller does nothing at first. Doing so will obviate the necessity of refactoring the code later. For example,

```
public class TouchTone {
        private Container c;
        private TouchToneController ttc;
        public TouchTone(Container _c, TouchToneController _ttc)
          {
          c = _c;
          c.setLayout(new GridLayout(4,0));
          ttc = _ttc;
          addButtons();
        }

        private void addButtons() {
          for (int i=1; i <=9; i++)
          addRunButton(""+i);
          addRunButton("*");
          addRunButton("0");
          addRunButton("#");
        }

        private void addRunButton(String s) {
            c.add(new RunButton(s) {
                        public void run() {
                            ttc.dialPadKey(getLabel());
                        }
                    }
            );
        }
    }
```

20.15 A Word about the Design Process and *JTabbedPane*

The process of design is an iterative one. Often several rough prototypes are required and multiple refinements are needed.

WARNING

One sure-fire way to make a bad design is to sit in front of a computer and start typing. You should refrain from writing any code at all until you have a firm idea of what the interface should look like and how it should behave.

FIGURE 20.15-1
RunTab

My favorite technique for design is to brainstorm. The process starts with a quiet room, a white board, and several interested people. The people do not even have to be experienced programmers. In fact, anyone with an aesthetic sense can help with the design process. The initial stage of a design is a creative one, and all input should be welcome.

When designing the interface, sketch out the basic overall look and feel from the top-down. Thus, start with the containing frame, and break out subpanels and components later. When you build the interface, you will build from the bottom-up. That is, you will start with the smallest panels and components and gradually build up into the designed interface.

 Design from the top-down; implement from the bottom-up

The following example makes use of *JTabbedPane* to create the interface shown in Figure 20.15-1.

 Placing more than eight tabs in an interface can make the interface hard to use.

RunTab is a frame that contains *JTabbedPane*. As the user selects one tab after another, various panels appear. Each panel is defined by its own class, but the classes are inner classes contained by the *RunTab* class. The controller for all of the panels is *RunTabController*, which appears below:

```
import javax.swing.*;
import java.awt.event.*;
import java.awt.*;

 class RunTabController {
      public void println(Object o) {
        System.out.println(o);
      }
}
/*
```
What we can see from the controller implementation is that it
 does not do much, but that is OK. Later, if we build
 functions into our interface, the *RunTabController* acts
 as the repository for the implementations. All GUI

```
      elements will have a reference to the RunTabController
      instance. The RunTabMediator has the role of starting
      the program (using a main method). As a mediator, it
      creates the controller and passes it to the RunTab
      constructor:
*/
 class RunTabMediator {
     RunTabController rtc = new RunTabController();
     RunTab rt = new RunTab(rtc);

     public static void main(String args[]) {
       new RunTabMediator();
     }

}
/*
The RunTab class is really a frame that contains an instance of
      the JTabbedPane and all the panel definitions so that it
      can build an interface.
*/
public class RunTab extends ClosableJFrame {
      Container c = getContentPane();
      RunTabController rtc;
/*
The JTabbedPane is the new component here. It enables each tab
      to automatically display a panel when the user selects it:
*/
      JTabbedPane jtp = new JTabbedPane();

      public RunTab(RunTabController _rtc) {
        super("run tab");
        rtc = _rtc;
       setSize(200,200);
/*
The addTab method can take an optional icon instance. As we do
      not have one, a null value was passed in instead:
*/
          jtp.addTab("Button Panel",null,
                  new RunButtonPanel(rtc),
                  "Examples of JButton,
                  Quit Button is here!");
          jtp.addTab("CheckBox Panel",null,
                  new CheckBoxPanel(rtc),
                  "Examples of JCheckBox");
          jtp.addTab("Menu Bar Panel",null,
                  new MenuBarPanel(rtc),
                  "Examples of JMenuBar");
          jtp.addTab("Label Panel",null,
                  new LabelPanel(),
                  "Examples of JLabel");
       c.add(jtp);
       c.setLayout(new GridLayout(1,1));
       setVisible(true);
      }
```

FIGURE 20.15-2
MenuBarPanel

Each one of the new panels is passed as an instance of *RunTabController*, if it is needed. All of the panels are inside the *RunTab* class. Figure 20.15-2 shows an image of *MenuBarPanel*.

 MenuBarPanel has some *RunCheckBoxMenuItem* components in it. All make use of *RunTabController*:

```
class MenuBarPanel extends JPanel {
    RunTabController rtc;
    JMenuBar bar = new JMenuBar();
    JMenu menu = new JMenu("Checkable");

      MenuBarPanel(RunTabController _rtc) {
      super(false);
      rtc = _rtc;
      bar.add(menu);
       menu.add(new RunCheckBoxMenuItem("Top Check"){
            public void run() {
                    rtc.println("topCheck!");
                }
           });
        menu.add(new RunCheckBoxMenuItem("Check Me"){
            public void run(){
                    rtc.println("Check box menu item!!");
                }
           });
        add(bar);
      }
}
```

The advantage of having one panel class for each panel is the modularity available. Figure 20.15-3 shows an image of *LabelPanel*. A *label* is a component that generally creates no events. As a result, *LabelPanel* does not need a reference to a *RunTabController*.

 The benefit of grouping *LabelPanel* labels into a single, well-named class is that it is clear where the code is that must be modified in order to alter the interface:

FIGURE 20.15-3
LabelPanel

FIGURE 20.15-4
CheckBoxPanel

```
class LabelPanel extends JPanel {
    LabelPanel() {
        add(new JLabel("I'm Label 1      "));
        add(new JLabel("I'm Label 2      "));
        add(new JLabel("I'm Label 3"));
    }
}
```

Figure 20.15-4 show an image of *CheckBoxPanel*.
The *CheckBoxPanel* class follows:

```
class CheckBoxPanel extends JPanel {
    RunTabController rtc;
    CheckBoxPanel(RunTabController _rtc) {
/*
The false constructor is used to turn off double-buffering in
    the JPanel. The implementation of double-buffering is
    beyond the scope of this chapter.
```

```
*/
        super(false);
        rtc = _rtc;

            RunCheckBox cbx1 = new RunCheckBox("Check #1"){
                    public void run() {
                        rtc.println("First Check Box!");
                    }
            };
            RunCheckBox cbx2 = new RunCheckBox("Check #2"){
                    public void run() {
                            rtc.println("check #2");
                    }
            };
            RunCheckBox cbx3 = new RunCheckBox("Check #3"){
                    public void run() {
                            rtc.println("check #3");
                    }
            };
        add(cbx1);
        add(cbx2);
        add(cbx3);

    }
}
```

Figure 20.15-5 shows an image of the *RunButtonPanel*.
The code for *RunButtonPanel* follows:

```
class RunButtonPanel extends JPanel {
        RunTabController rtc;

        RunButtonPanel(RunTabController _rtc) {
            super(false);
            rtc = _rtc;
            add(new RunButton("Left"){
                            public void run() {
                                    rtc.println("Left");
```

FIGURE 20.15-5
RunButtonPanel

```
                                    }
                               }
                        );
                 add(new RunButton("Right"){
                                public void run() {
                                       rtc.println("Right");
                                }
                        }
                );
                add(new RunButton("Quit"){
                                public void run() {
                                       setVisible(false);
                                }
                        }
                );
        }
    }
}
```

20.16 Summary

This chapter gave a whirlwind overview of the *Swing* and *AWT* class libraries, discussing heavyweight vs. lightweight components. From the start, with *ClosableJFrame*, the emphasis was on providing many examples of how to construct your own components.

The event processing emphasized the command pattern, and a sequence of *Runnable* components was created. The reader should now understand how to create new *Runnable* components from the existing Swing library.

Layouts were introduced just as they were needed. Interleaving layout introductions with the creation of *Runnable* component(s) was an intentional choice, as grouping all of the *Runnable* elements together would have made the text appear both monolithic and boring.

ButtonGroup showed how procedural elements can be combined with GUI elements to create new behaviors. Also, the Controller design pattern was used to create interfaces that clearly separate procedural logic from the layout. Finally, the mediator was used in the role of connector, hooking up controllers and GUI elements.

20.17 Exercises

20.1 An event in the *java.awt.event* package uses an event *Listener*. Name the listeners for the following events:

 a. *ActionEvent*
 b. *ItemEvent*
 c. *ContainerEvent*
 d. *WindowEvent*
 e. *TextEvent*
 f. *KeyEvent*

20.2 The *javax.swing.event* package also uses an event *Listener*. Name the listeners for the following events (hint: there is an *AncestorListener*):

a. *AncestorEvent*

b. *CaretEvent*

c. *ChangeEvent*

d. *DocumentEvent*

e. *HyperlinkEvent*

f. *InternalFrameEvent*

g. *ListDataEvent*

h. *ListSelectionEvent*

i. *MenuDragMouseEvent*

j. *MenuEvent*

k. *MenuKeyEvent*

l. *PopupMenuEvent*

m. *TableColumnModelEvent*

n. *TableModelEvent*

o. *TreeExpansionEvent*

p. *TreeModelEvent*

q. *TreeSelectionEvent*

r. *UndoableEditEvent*

20.3 Create *AddressBookPanel* shown in Figure 20.17-1.

□ Using All 2222 Records In "addresses"

EZ Pass Customer Service Center

PO Box 15928
Wilmington DE 19850-5928

Dial	888-288-6865		Prev
Dial			Next
Dial			Index

Aug 5 8:40:34

FIGURE 20.17-1
The *AddressBookPanel*

FIGURE 20.17-2
The *EditPanel*

a. Ensure the *AddressBookPanel* has the date and time, three telephone number text fields, a name text field at the top, and two text fields that follow.

b. Create an *AddressBookDataBase* class and put five addresses in this class. When the user selects the *Prev* or *Next* button, display the previous or next address from the database.

c. When the user double-clicks on *AddressBookPanel*, *EditPanel* appears, which is shown in Figure 20.17-2.

Using the *EditPanel*, the user can alter the elements in the various text fields. These elements are entered into *AddressBookDataBase* when the user selects *Done*. The panel then changes back to *AddressBookPanel*.

d. Implement the *Revert* button so that the text will revert to the state it was in before the user started to edit it.

e. Implement the *Prev* and *Next* buttons so that the user will be able to sequence through the database.

f. Add a main menu bar to the frame that will hold *AddressBookPanel*. Put *FileMenu* in this main menu and add the *Save* and *Open* menu items. When these items are selected using *ObjectSerialization*, save a compressed version of *AddressBookDataBase* and then make sure that you can read it back in. Test your work by adding new addresses interactively, saving them, and then reading them back in.

20.4 Find a component in the *Swing* API and create a Command pattern component from it. Show an example of its use.

20.5 Read about the custom table renderer on your own. Make up a small but original example of its use. Is there any way to make use of the Command pattern for the table renderer? Why or why not?

20.6 Swing now supports an drag-and-drop subsystem. Read about this subsystem on your own and make up as small and simple an example as you can. The example should be original. Explain your example.

20.7 The constructor for a URL can work with several different protocols. If the protocol is other than http, you need to specify it, along with the host. For example,

```
try {
        String protocol = "file";
        String host = "localhost"
        String file = "/app/java1.1/index.html";
        URL u = new URL(protocol, host, file);
        URL u1 = new URL(protocol+"://"+host+"/");
        URL u2 = new URL(u1,file);

} catch (MalformedURLException e) {...}
```

Known protocols include ftp. Unknown protocols throw *MalformedURLException*. Write a program that lets you open local HTML files and display them.

20.8 In order to print *Frame* or a subclass of *Frame* in Java, you can use

```
public static void print(Component c) {
    Toolkit tk = Toolkit.getDefaultToolkit();
    PrintJob printJob =
            tk.getPrintJob(
                    new Frame(),
                    "print me!",
                    null);
    Graphics g = printJob.getGraphics();
    c.PrintAll(g);
    printJob.end();
}
```

Write a program that can print Avery 5160 labels (30 per sheet, 10 per column). See *<http://www.avery.com/>* for specifications on the labels. In order to make your program general, you will need to create a GUI that can control the label output. A sample is shown in Figure 20.17-3.

FIGURE 20.17-3
Label GUI

A simple interface to your API follows:

```
public interface LabelPrinter {
        public void print(String s); // print one label
        public void print(String s[]); // print many labels
}
```

20.9 Repeat exercise 8, only write a program that can take custom label sizes. You will also need a
GUI to set the dimensions of the labels.

Consider the diagram in Figure 20.17-4 as an indication of the various label dimensions
that your program can handle. You will need to devise an interface that takes arguments (in mil-
limeters) for your label dimensions. By using millimeters, you will not need fractional inches.
Your interface should look like the following:

```
public interface LabelDimensions {
        public int getA();
        public int getB();
        public int getC();
        public int getD();
        public int getE();
        public int getF();
        public int getNumberOfLabelsOnASheet();
        public int getNumberOfColumns();
}
```

FIGURE 20.17-4
Setting the Label Dimensions

CHAPTER 21

Viewing HTML in Swing

quidquid latine dictum
sit, altum viditur.

**Anything is more impressive
if you say it in Latin**

–Unknown

In this chapter, you will learn:

- How to build an HTML viewer
- About MIME types
- How to synthesize HTML
- How to generate HTML forms

This chapter shows how to make use of *Swing* to create a frame with two *JScrollPanes* that enable the user to see both HTML and a rendering of HTML, which is used for viewing HTML. Other applications for this technology include the output of Rich Text Format (RTF), an MS Word format, the creation of help files, the creation of a browser, and assistance in middleware debugging. We will learn more about middleware later in the book.

21.1 HtmlViewer

The *HtmlViewer* class has the facilities to display HTML from any source.

Figure 21.1-1 shows an image of *HtmlViewer*.

The Swing HTML rendering process does not work like a regular browser. It does not handle cookies, nor does it handle Javascript.

FIGURE 21.1-1
The *HtmlViewer*

The rendering of HTML into a scrollable frame is very simple using the *Swing* class library, which enables us to write our own browser. The viewer even is able to view GIF and JPEG images. The code for *HtmlViewer* follows:

```java
import javax.swing.text.html.*;
import java.awt.*;
import java.awt.event.*;
import java.io.*;
import javax.swing.*;
import javax.swing.text.*;

public class HtmlViewer extends ClosableJFrame {
    private JEditorPane htmlPane = new JEditorPane();
    private JEditorPane textPane = new JEditorPane();

    public HtmlViewer() {
        super("HtmlViewer");
        Container c = getContentPane();
        c.setLayout(new GridLayout(1,0));
        c.add(new JScrollPane(htmlPane));
        c.add(new JScrollPane(textPane));
        setSize(400,400);
        setVisible(true);
    }
```

JEditorPane can have one of three content types:

- *text/html*
- *text/plain*
- *test/rtf*

These strings are called Multipurpose Internet Mail Extension (*MIME*) *types*. See <*http://trade.chonbuk.ac.kr/~leesl/rfc/rfc1521.html*> for more information about MIME types and their origins.

 MIME was devised to enable mail messages to transport application-specific data. It since has been applied in many other areas that require data transport.

The following code shows How the Html Synthesizer is used.

```
public void setHtml(String s) {
  htmlPane.setContentType("text/html");
  htmlPane.setText(s);
}
public void setText(String s) {
  textPane.setContentType("text/plain");
  textPane.setText(s);
}
public void setString(String s) {
  setText(s);
  setHtml(s);
  System.out.println(s);
}
public static void main(String args[]) {
  HtmlViewer hv = new HtmlViewer();
  HtmlSynthesizer hs = new HtmlSynthesizer() ;
  hv.setString(hs.testForm());
}
}
```

While HTML can be input from any string, the *main* method in *HtmlViewer* makes use of a custom class for the creation of HTML called *HtmlSynthesizer*.

21.2 HtmlSynthesizer

 HTML synthesis is faster and more type-safe than using Java Server Pages (JSPs). (JSPs are discussed in Chapter 31.) However, JSP generally is more accepted. Both, however, have a role in server-side applications.

HtmlSynthesizer gives a *functional programming* approach to the synthesis of HTML. The functional programming aesthetic enables the compiler to balance the tags of HTML using parentheses. Often, in HTML, the start and finish tags are close together in a document. For example,

```
<html>
        <body>
        </body>
</html>
```

 How large will the HTML document be? There is no way to know in advance! The HTML synthesizer will provide strong typing, programmatic generation, and a means by which we can protect the output from missing tags. Even with all of these added features, it is still possible to generate incorrect HTML.

The code for *HtmlSynthesizer* follows:

```
public class HtmlSynthesizer {
```

The *imageHome* class is used to access images placed on the local drive. This is an element that the programmer likely will want to set. Recall that the backslash must be escaped with another backslash in strings:

```
String imageHome ="d:\\images\\";
 void print(double x) {
  System.out.println(x);
}
 void print(String s) {
  System.out.println(s);
}
```

Here is the first example of a functional wrapper of a string with an HTML tag:

```
String getHtml(String s) {
  return "<html>\n" + s + "\n</html>";
}
```

The *getHomePage* method is a likely candidate for change:

```
String getHomePage() {
  return "<a
  href=\"http://www.docjava.com\">home</a>\n";
}
```

The following will get *n* home pages, where *n* is positive:

```
String getHomePage(int n) {
  String s = getHomePage();
  for (int i=0; i < n; i++ )
    s = s + getHomePage();
  return s;
}
```

The HTML *List* tag enables the enumeration of nonnumbered items:

```
String getListItem(String s) {
  return "<li>\n" + s + "\n</li>";
}
```

The HTML *Break* tag forces a new line. Note that the wrapping of the break around another string is not needed. Also note that the HTML has been liberally sprinkled with \n newline characters, which will be seen in the HTML, but not in the browser.

```
String getBreak() {
  return "\n<br>\n ";
}

String getH1(String s) {
  return "<h1>\n" + s + "\n</h1>";
}
```

The following *getSubmit* will return a button. It should be modified to submit to the method appropriate for the application. To learn more about this topic requires a discussion of servlets, which is beyond the scope of this chapter.

```
String getSubmit() {
  return
    "<input type=submit"
    +" value=submit>\n";
}
```

The *Option* element appears as a part of a *select* statement. Typically, there is an array of options from which the user selects:

```
String getOption(String s) {
  return "\t<option value=" + s + " >"+s+'\n';
}
```

The *Select* element creates an enumerated list of *Option* values:

```
String getSelect(String name, String options[]) {
  String s = "";
  for (int i=0; i < options.length; i++)
    s = s + getOption(options[i]);
  return "<select name="+name +">"+s+"</select>";
}
String getSelect(String name) {
  String sn []={"1","2","3","4","5"};
  return getSelect(name,sn);
}
```

HTML, typically has only six levels of headings. So Headings 2..6 follow:

```
String getH2(String s) {
  return "<h2>\n" + s + "\n</h2>";
}
String getH3(String s) {
  return "<h3>\n" + s + "\n</h3>";
}
String getH4(String s) {
  return "<h4>\n" + s + "\n</h4>";
}
String getH5(String s) {
  return "<h5>\n" + s + "\n</h5>";
}
String getH6(String s) {
  return "<h6>\n" + s + "\n</h6>";
}
```

The *getP* method outputs a wrapped paragraph. Paragraph appearance is a function of tags and style sheets:

```
String getP(String s) {
  return "<p>\n" + s + "\n</p>";
}
```

The *Body* element contains the text of the document:

```
String getBody(String s) {
   return "<body>\n" + s + "\n</body>";
}
```

The *Head* element contains a collection of document information (often including the title):

```
String getHead(String s) {
   return "<Head>\n" + s + "\n</Head>\n";
}
```

HTML documents must contain a *Title* element:

```
String getTitle(String s) {
   return "<title>\n" + s + "\n</title>\n";
}
```

The *Caption* element typically is used for table captions:

```
String getCaption(String s) {
   return
     "<caption>"
     +s
     +"</caption>";
}
```

The *Tr* element is used for creating table rows. Parameters that indicate row width and height in pixels can be included as well. When the parameters are omitted, the default behavior is generally reasonable (though it is browser specific):

```
String getTr(String s) {
   return "<tr>" + s + "</tr>\n";
}
//<td width="91" height="39">c11</td>
```

The *Td* element is used to indicate table data. As with the *Tr* element, width and height parameters can be included:

```
String getTd(int w, int h, String s) {
   return "\n\t<td width=\""
     +w
     +"\" height=\""+h+"\">"
     +s+
     "</td>\n";
}
String getTd( String s) {
   return "\n\t<td>"
     +s+
     "</td>\n";
}
```

The *getRow* method is a testing method that yields *nc* columns with a designation of row *r*.

```
public String getRow(int r, int nc) {
   String s = "";
   for (int c = 1; c <= nc; c++)
```

```
                       s=s+getTd(r+","+c+" ");
         return s;

      }
```

The *getSheet* method takes a two-dimensional array of string and returns a two-dimensional HTML table:

```
         public String getSheet(String a[][]) {
           String s = "";
           for (int i=0; i < a.length; i++) {
             s = "<tr>"+s  ;
             for (int j=0; j < a[i].length; j++) {
                 s = s + getTd(a[i][j]);
             }
             s = s + "</tr><p>\n";
           }
           return s;
         }
```

The *getTable* method returns the *Table* element, which is useful for the *getSheet* method. Note that the border is a parameter that can be passed to a table element:

```
         public String getTable(String s) {
           return "\n<table border=1>\n" + s + "\n</table>\n";
         }
```

The *Input* element has variations that are a function of the *type*. The *type* may be *text*, *password*, *checkbox*, *image*, *hidden*, *submit*, or *reset*:

```
         public String getInput(
             String type,
             String name,
             String value,
             int size) {
           return
             "\n<input type=" + quote(type)
             + "name=" + quote(name)
             + " value="+ quote(value)
             + "size=" + size
             +">\n";
         }
```

Type is *quoted* using the *quote* method to simplify the code. The *Img* element refers to an image via hyperlink. The *Alt* attribute gives an alternative presentation to the user when the image is not loaded. For example,

```
         public String getImage(String imageName) {
           return "<img src="
           +quote(imageName)
           +"alt="+imageName
             +">";

         }
         public String getInput(
             String type,
```

```
      String name,
      String value) {
   return
     "\n<input type=" + type+' '
     + "name=" + name
     + " value="+ value
     +" >";
}
// <input type="radio" name="B1_Rating"
   value="Excellent">
```

A *Radio* type for an *Input* element gives a one-of-many selection that appears like a GUI radio button:

```
public String getRadio(String name, String value) {
   return
     getInput("radio",name,value)+value;
}
//<INPUT TYPE="text" NAME="UID" VALUE="" SIZE=30>
```

The *Text* type for an *Input* element works just like the text field in a GUI. The size is in characters and the value is an initial value:

```
public String getTextField(
   String name, String value, int size) {
   return
     getInput("text", name, value, 30);
}
```

The *getRadioButtons* method yields a list of *b* radio buttons, each named with its number. This is very good for selecting a number from 1 to *b*:

```
public String getRadioButtons(String name, int b) {
   String s ="";
   for (int i=1; i <= b; i++)
     s = s + getRadio(name, i+"");
   return "<p>"+s+"";
}
```

The *getPassField* method makes use of the *password* attribute in the *Input* element:

```
public String getPassField(String name, String value,
   int size) {
   return
     getInput("password", name, value, 30);
}
public String getTextField(String name, String value) {
   return
     getTextField(name, value, 30);
}
public String getPassField(String name, String value) {
   return
     getPassField(name, value, 30);
}
public String getPassField(String name) {
```

```
    return
      getPassField(name, "", 30);
  }
  public String getTextField(String name) {
    return
      getTextField(name, "", 30);
  }
  //<FORM action="" method="POST">
```

The *getForm* method returns a *Form* element that serves as a template in HTML. The template has a sequence of name/value pairs composed of *Input* elements. The *method* used for input is typically *GET* or *POST*, which is discussed later in the book.

```
  public String getForm(
      String action, String method, String s) {
    return "\n<form action=" + quote(action)
    + "method=" + quote(method) +">\n"
    + s +' '
    + "\n </form >\n";
  }
```

The *quote* method is a helper method that properly escapes the quotes needed to surround a string:

```
  public String quote(String s) {
    return '\"'+s+"\" ";
  }
```

The *getTable* method returns a table that is *nr* by *nc* and that has each cell numbered. This method is used for testing the HTML synthesis. For example,

```
  public String getTable(int nr, int nc) {
    String s = "<TABLE BORDER=1>";
    for (int r = 1; r <= nr; r++) {
      s = s +
      getTr(getRow(r, nc));
      // assume number of columns is the
      // same for each row
    }
    return s+"</table>";
  }
```

The *testForm1* class shows an example of how to use *HtmlSynthesizer*. The balanced parentheses help the programmer to make sure that the tags are balanced.

The functional style requires that indentation be correct, or the code will appear sloppy.

```
  public String testForm1() {
    return
      getHtml(
        getHead(getTitle("testForm"))+
          getBody(
              getForm("", "GET",
                  getP(getTextField("name"))+
```

```
                                    getPassField("password")+
                                    getRadioButtons("q1",5)
                     )
                 )
           );
      }
```

The *getSelects* method returns selections that range from 1 to 5 on any given *name* string:

```
public String[] getSelects(String name, int n) {
  String s[]= new String [n];
  s[0]=name;
  for (int i=1; i < n; i++)
    s[i]= getSelect(name);
  return s;
}
```

An image of the selector appears in Figure 21.2-1.

The following *testForm* method shows how to create an array with selectors. The first row appears on the top of the table. For example,

```
public String testForm() {

  String a [][] = {
    {"Student Name","Analytic Skills",
        "Communication Skills",
        "creative problem solving"},
    getSelects("doe",4),
    getSelects("shmoe",4),
    getSelects("wanker",4),
    getSelects("spanker",4),
    getSelects("peabody",4),
  };
  return
    getHtml(
      getHead(
        getTitle(
            "my title!"))+
            getBody(
```

FIGURE 21.2-1
An Image of the Selector

Here we insert 10 links to the home page:

```
                              getHomePage(10)+
                              getForm(

    "http://localhost/examples/servlet/HelloWorldExampl
e",

                                  "GET",
                                  getTable(
                                  getCaption("My Caption")
                                  +getSheet(a))
                          +getSubmit()
                          +getImage(

    "http://www.docjava.com/consulti/docjava.jpe")

                      )
                  )
              );
      }
```

The *main* method tests *HtmlSynthesizer* without using *HtmlViewer*:

```
    public static void main(String args[]) {
      HtmlSynthesizer co = new HtmlSynthesizer() ;

      System.out.println(
        co.getHtml(
            co.getForm("", "GET",
                co.getTextField("name")) +
                co.getTable(9,20)));
      }
    }
```

Not all HTML tags are used by the HTML synthesizer code. However, adding your own tags is not difficult.

21.3 Summary

The generation of HTML programmatically helps to promote code reuse and the creation of a stable substrate upon which to build middleware. Often, we let HTML authors write HTML files, which is fine for static data. However, when we want to generate HTML dynamically, a programmatic method is required. Such components are developed firmly in the domain of the programmer, and as such, a high-quality means of generating correct HTML is required.

21.4 Exercises

21.1 Write five HTML tags that are not covered by the synthesizer and add them to the synthesizer. Show the tags being rendered in the *HTMLViewer*. Write some JavaDoc explaining the new API. JavaDoc is explained in Appendix E.

21.2 Add a form generator for synthesizing a guest book form. An example of such a form appears in Figure 21.4-1.

FIGURE 21.4-1
The Guest Book Form

Create a way for a user to input a link name and an address and generate a page with the appropriate links. The goal is to allow a person who doesn't know HTML to create a page with links.

21.3 Expand exercise 3 to by adding the following buttons: *Title*, *Link*, *Paragraph*, *Break Line*, and *Table*. The goal is to allow a user who doesn't know HTML to generate code data for a page. For example, if the user presses the *Title* button, a prompt will ask for the title and then store it. When a user presses the *Paragraph* button, the user will be prompted for the paragraph input. When the *Table* button is pressed, the user will be prompted for the values for each cell.

21.4 What are MIME types used for? List at least two MIME types.

21.5 How does *HtmlSythesizer* keep HTML output tags balanced? Is it possible to generate unbalanced tags? How? How could you prevent this from happening?

21.6 Add a form generator for the password prompt.

21.7 Add a form generator for synthesizing a table five pixels in width and in height. Fill each cell with a background color. Display the hex number for each cell color as text.

21.8 When is it appropriate to use HTML to create a GUI on a client machine? When should you use *Swing* for the GUI? When should you use *AWT* for the GUI?

C H A P T E R 2 2

Using the Keyboard

> **Never travel the easy road for out there is a world of wonders to explore.**
>
> *–Moroccan Proverb*

In this chapter, you will learn:

- How to handle keyboard events
- How to link keyboard events to a text field
- How to program keyboard accelerators

This chapter describes the use of the keyboard for input. In the last chapter, the keyboard was used indirectly by the widgets in the GUI (e.g., *RunTextField*). This chapter introduces *KeyEvent* and describes several methods for decoding *KeyEvent* instances.

22.1 Getting Key-Event Information

This section shows how to build a controller that will enable the interception of all of the keyboard information available during a key press. Generally, this information includes keyboard modifiers as well as the character code that corresponds to the key. The output of the interception and decoding follows:

```
KeyPressed, consumed: false src
      is:KeyTest[frame0,0,0,200x200,layout=java.awt.BorderLa
      yout,resizable,title=,defaultCloseOperation=HIDE_ON_CL
      OSE,rootPane=javax.swing.JRootPane[,0,0,200x200,layout
      =javax.swing.JRootPane$RootLayout,alignmentX=null,alig
      nmentY=null,border=,flags=2,maximumSize=,minimumSize=,
      preferredSize=],rootPaneCheckingEnabled=true]
  id: 400, code:0(Unknown keyCode: 0x0),
  char:48
modifiers:Meta+Ctrl+Alt
```

The last line

```
modifiers:Meta+Ctrl+Alt
```

indicates that the *Meta*, *Ctrl*, and *Alt* keys were all pressed at the same time. These keys are called keyboard modifiers. There are four keyboard modifiers: *Alt*, *Ctrl*, *Meta*, and *shift*.

WARNING

Keyboard combinations on one computer can have a different effect on another computer. The operating system generally intercepts special key combinations before the JVM can process them.

DESIGN PATTERN

The *KeyTest* frame creates an instance of *KeyController* and delegates the reponsibility of handling the key events to it. The *main* method acts in the role of mediator, creating new classes and hooking them together.

```java
package keyboard;
import java.awt.*;
import java.awt.event.*;

public class KeyTest extends ClosableJFrame  {

    public static void main(String args[]) {
        KeyController kc = new KeyController();
        KeyTest kt = new KeyTest();
        kt.addKeyListener(kc);
        kt.setSize(200,200);
        kt.setVisible(true);
    }
}
```

DESIGN PATTERN

The new listener is called *KeyListener*, and it is required for any controller that is to be added as a key listener to a component.

For example,

```java
package keyboard;
import java.awt.event.*;
import java.awt.*;

public class KeyController implements KeyListener {
    public void keyTyped(KeyEvent evt) {
        System.out.println("KeyPressed, consumed: " +
        evt.isConsumed()
        + " src is:" + evt.getSource()
        + "\n id: " + evt.getID()
        + ", code:" + evt.getKeyCode()
        + "(" + evt.getKeyText(evt.getKeyCode())
        + "), \n char:"
        + (int)evt.getKeyChar()
        + "\nmodifiers:" +
        evt.getKeyModifiersText(evt.getModifiers()));
    }
```

```
public void keyPressed(KeyEvent e) {
}

public void keyReleased(KeyEvent e) {
}
}
```

The reader will notice that there are three methods that are needed for nonabstract implementors of *KeyListener*: *keyTyped*, *keyPressed*, and *keyReleased*. The *keyPressed* and *keyReleased* methods are invoked whenever any key is pressed or released, even a modifier key (like the *Control key*).

The *keyTyped* method is invoked whenever a character key is generated.

22.2 Programming Key Modifiers

The last section showed how to print a list of all of the key modifiers. The string returned by *getKeyModifiers* is not something that you want to decode when writing your keyboard controller. A more type-safe way to do the decoding is to make use of the constants in the *InputEvent* class:

```
InputEvent.SHIFT_MASK
InputEvent.CTRL_MASK
InputEvent.META_MASK
InputEvent.ALT_MASK
InputEvent.BUTTON1_MASK
InputEvent.BUTTON2_MASK
InputEvent.BUTTON3_MASK
```

The *InputEvent* constants are *masks*, which means that bitwise operations are needed to screen out the bits that are relevant to the particular information. For example,

```
keyChar=21
keyText=U
modifiers=15
modifierText=Meta+Ctrl+Alt+Shift
processModifiers=M-^-A-Shift-U
```

The *processModifiers* string is a shortcut representation, devised locally, to indicate that Meta + Ctrl + Alt + Shift-U was pressed. A revised *KeyController* follows:

```
package keyboard;
import java.awt.event.*;
import java.awt.*;

public class KeyController implements KeyListener {
    public void keyPressed (KeyEvent e) {
        char keyChar = e.getKeyChar();
        int keyCode = e.getKeyCode();
        String keyText = e.getKeyText(keyCode);

        int modifiers = e.getModifiers();
        String modifierText =
        e.getKeyModifiersText(modifiers);

        System.out.println("keyChar=" + (int)keyChar);
        System.out.println("keyText=" + keyText);
```

```
                        System.out.println("modifiers=" + modifiers);
                        System.out.println("modifierText=" + modifierText);

                        System.out.println(
                        "processModifiers="+processModifiers(e));

                    }
                    private String processModifiers(KeyEvent e) {
                      int modifiers = e.getModifiers();
                      int keyCode = e.getKeyCode();
                      String keyText = e.getKeyText(keyCode);

                      String s = "";
                       if ((modifiers & InputEvent.META_MASK) != 0)
                            s = s +"M-";

                       if ((modifiers & InputEvent.CTRL_MASK) != 0)
                          s = s +"^-";

                       if ((modifiers & InputEvent.ALT_MASK) != 0)
                          s = s +"A-";

                       if ((modifiers & InputEvent.SHIFT_MASK) != 0)
                          s = s +"Shift-";

                      return s+keyText;
                    }

                      public void keyTyped(KeyEvent e) {
                      }

                      public void keyReleased(KeyEvent e) {
                      }
                }
```

The bitwise operations used in the *if* statements are required because the masks only permit a test of which bits are on.

22.3 Adding Key-Events to *TouchTone*

In this section, we show how to add key-events to the *TouchTone* class. For example,

```
        package keyboard;

        // keyboard.KeyTest
        public class KeyTest extends gui.ClosableJFrame {
            public static void main(String args[]) {
                KeyController kc = new KeyController();
                KeyTest kt = new KeyTest();
                touchTone.TouchToneController ttc =
                    new touchTone.TouchToneController();
                touchTone.TouchTone tt =
                    new touchTone.TouchTone(kt.getContentPane(), ttc);
                kt.addKeyListener(kc);
                kt.setSize(200, 200);
                kt.setVisible(true);

            }
        }
```

FIGURE 22.3-1

The Keypad

Figure 22.3-1 shows an image of the keypad without the readout. Note that you must press keyboard keys to generate a keyboard event. The button actions are not implemented.

22.4 Mnemonics and RunMenuItem

This section presents a new *Runnable* menu item, along with an example of how to set keyboard shortcuts for the item.

Figure 22.4-1 shows an image of the *RunMenuItem* frame.

FIGURE 22.4-1

The *RunMenuItem* Frame

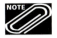 Using keyboard shortcuts, we can type the alt-F key combination to obtain a pop-down file menu. Each of the items in that menu has had its first character automatically added as a keyboard shortcut.

Thus, combinations such as *alt-f* and *alt-o* will open a file. To add keyboard shortcuts to *RunMenuItem*, automatically we have subclassed *JMenuItem* and made it *Runnable*:

```java
package run;
import javax.swing.*;
import java.awt.event.*;
import java.awt.*;

public abstract class RunMenuItem extends
        JMenuItem implements ActionListener, Runnable {
        public RunMenuItem(String label) {
                this(label,null);
        }
        public RunMenuItem(String l, Icon i) {
                super(l,i);
                addActionListener(this);
                if (l != null)
                        setMnemonic(l.charAt(0));
        }
        public RunMenuItem(Icon i) {
                this(null,i);
        }
        public RunMenuItem() {
                this(null,null);
        }
        public void actionPerformed(ActionEvent e) {
                run();
        }
        public static void main(String args[]) {
ClosableJFrame cf =
        new ClosableJFrame("RunMenuItem");
Container c = cf.getContentPane();

    JMenuBar mb = new JMenuBar();
    JMenu m = new JMenu("File");

    m.setMnemonic('F');

RunMenuItem om = new RunMenuItem("open") {
                public void run() {
                        System.out.println(getText());
                }
        };

RunMenuItem sm = new RunMenuItem("save") {
                public void run() {
                        System.out.println(getText());
                }
        };
```

```
        m.add(om);
        m.add(sm);

        mb.add(m);
        cf.setJMenuBar(mb);
        c.setLayout(new FlowLayout());
        cf.setSize(200,200);
        cf.setVisible(true);
    }
}
```

The decision to set mnemonics with menu items automatically easily could be extended to apply to other components. However, the GUI loses considerable flexibility. For example, if the *TouchTone* element used the above mnemonics, then the user would have to depress the alt key in order to type in a number, which is probably bad form.

22.5 MnemonicMenu

The *MnemonicMenu* class extracts the first character from the menu label and uses it to create the mnemonic.

In the following *MnemonicMenu* class, we create a *JMenu* that automatically intercepts the first character of the text in the label of the menu and uses it to assign a mnemonic.

 The programmer must take care not to have menus that start with the same character, or the results will be hard to predict.

```
package keyboard;
import javax.swing.*;
import java.awt.event.*;
import java.awt.*;
import run.RunMenuItem;

public class MnemonicMenu extends
        JMenu   {
    public MnemonicMenu() {
        this("");
    }

    public MnemonicMenu(String s) {
        this(s,false);
    }
```

The following code allows for the addition of the mnemonic:

```
    public MnemonicMenu(String s, boolean b) {
        super(s,b);
        if (s != null)
            setMnemonic(s.charAt(0));
    }
```

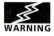 The decision above was to make use of the first character (location 0) as the keyboard mnemonic.

 Care is needed to make sure that menus at the same level have different first characters.

```
public static void main(String args[]) {
        ClosableJFrame cf =
            new ClosableJFrame("RunMenuItem");
        Container c = cf.getContentPane();

        JMenuBar mb = new JMenuBar();
        MnemonicMenu m = new MnemonicMenu("File");

    RunMenuItem om = new RunMenuItem("open") {
                public void run() {
                    System.out.println(getText());
                }
            };

        RunMenuItem sm = new RunMenuItem("save") {
                public void run() {
                    System.out.println(getText());
                }
            };
    m.add(om);
    m.add(sm);

      mb.add(m);
      cf.setJMenuBar(mb);
    c.setLayout(new FlowLayout());
    cf.setSize(200,200);
    cf.setVisible(true);
    }
  }
```

22.6 Summary

This chapter disclosed the keyboard event model and the API for handling the events. It also showed how to handle *meta*, *control*, *alt*, and *shift* keys. The handlers had to implement key listeners. Finally, we saw how to handle event from a keypad.

22.7 Exercises

22.1 If *ke* is an instance of *KeyEvent*, then what is the type of:
 a. *ke.getModifiers()*
 b. *ke.getKeyChar()*

22.2 Write the boolean method of
```
isAlt(ke)
```

so that it returns *true* if the *Alt* key is pressed. Hint: *InputEvent.ALT_MASK* can be used with *getModifiers* to answer this question.

22.3 Repeat exercise 2 for the *Ctrl* key. Hint: *InputEvent.CTRL_MASK* can be used with *getModifiers* to answer this question.

22.4 Repeat exercise 3 for the *Shift* key. Hint: *InputEvent.SHIFT_MASK* can be used with *getModifiers* to answer this question.

22.5 Design an interface that makes use of menu items with keyboard accelerators. For example,

```
menuItem.setAccelerator(KeyStroke.getKeyStroke(
        KeyEvent.VK_B, Event.CTRL_MASK));
```

Here are some nice masks you can try:

```
java.awt.Event.SHIFT_MASK,
java.awt.Event.CTRL_MASK,
java.awt.Event.META_MASK and
java.awt.Event.ALT_MASK.
```

VK stands for virtual key. You can find about virtual keys from the *java.awt.event.KeyEvent* class. There are lots of virtual keys for a variety of keyboards (including non-US keyboards). Here are some common keys: *VK_0* thru *VK_9* are the same as ASCII 0 thru 9, and *VK_A* thru *VK_Z* are the same as ASCII A thru Z. Here are some of the special keys:

```
VK_ENTER, VK_BACK_SPACE, VK_TAB, VK_CANCEL, VK_CLEAR,
         VK_SHIFT, VK_CONTROL, VK_ALT, VK_PAUSE, VK_CAPS_LOCK,
         VK_ESCAPE, VK_SPACE, VK_PAGE_UP, VK_PAGE_DOWN, VK_END,
         VK_HOME, VK_LEFT, VK_UP, VK_RIGHT, VK_DOWN, VK_COMMA,
         VK_MINUS, VK_PERIOD, VK_SLASH, VK_SEMICOLON,
         VK_EQUALS, VK_OPEN_BRACKET, VK_BACK_SLASH,
         VK_CLOSE_BRACKET, VK_NUMPAD0, VK_NUMPAD1, VK_NUMPAD2,
         VK_NUMPAD3, VK_NUMPAD4, VK_NUMPAD5, VK_NUMPAD6,
         VK_NUMPAD7, VK_NUMPAD8, VK_NUMPAD9, VK_MULTIPLY,
         VK_ADD, VK_SEPARATER, VK_SUBTRACT, VK_DECIMAL,
         VK_DIVIDE, VK_DELETE, VK_NUM_LOCK, VK_SCROLL_LOCK,
         VK_F1, VK_F2, VK_F3, VK_F4, VK_F5, VK_F6, VK_F7,
         VK_F8, VK_F9, VK_F10, VK_F11, VK_F12, VK_F13, VK_F14,
         VK_F15, VK_F16, VK_F17, VK_F18, VK_F19, VK_F20,
         VK_F21, VK_F22, VK_F23, VK_F24, VK_PRINTSCREEN,
         VK_INSERT, VK_HELP, VK_META, VK_BACK_QUOTE, VK_QUOTE,
         VK_KP_UP, VK_KP_DOWN, VK_KP_LEFT, VK_KP_RIGHT
```

22.6 Create a keyboard application where 26 keys or buttons are on the screen. When a button is pressed, that letter will be displayed in a frame above it similar to a PDA touch-screen keyboard.

22.7 What methods must be implemented by classes that implement the *KeyListener* interface?

22.8 List the four keyboard modifiers.

22.9 *InputEvent* constants are masks. What does this mean?

22.10 Create a simple text editor. Implement *space*, *enter*, *tab*, *caps_lock*, and *back_space*.

22.11 Expand on exercise 10. Add the following mnemonics: keyboard file $(alt + f)$, $->$ new $(alt + n)$, Save as $(alt + s)$, and close $(alt + c)$.

22.12 How do *InputEvent* constants (masks) work?

22.13 *RunMenuItem* only implements *ActionListener* and *Runnable* interfaces How come it can handle keyboard and mouse events?

22.14 Is there any way to determine the type of keyboard/keys being used, such as probing for the system-type identity?

22.15 Name the interface required for handling the events generated by a keyboard and list the required methods when a nonabstract class implements it.

CHAPTER 23

Mouse Input

In nature, the spineless creatures have the hardest shells.

–Unknown

In the last chapter, we learned how to handle *KeyEvents* and how to link *KeyEvents* to *TextFields*. In this chapter, you will learn how to:

- Handle input from a mouse
- Move and scale components
- Link *KeyEvents* to mouse motions (e.g., shift-click)

This chapter addresses the use of the mouse (a kind of pick device) to alter the appearance of a GUI. The mouse has a special set of events associated with it, just like the keyboard.

In this chapter, we will examine mouse events that result from a mouse being pressed, a mouse being released, a mouse being clicked, a mouse entering the area near a component, and a mouse leaving an area near a component. Such events are handled by call-back methods to classes that implement the *MouseListener* interface. We also will examine events that occur when the mouse moves. These events are handled with the call-back methods *MouseDragged* and *MouseMoved*, which are specified in *MouseMotionListener*. Finally, we will show how you can set the cursor in response to mouse events.

23.1 MouseController

DESIGN PATTERN
Recall that in the MVC design pattern, the controller's role is to handle the events. The state of the system is stored in the model.

The *MouseController* class is different from the *Run* components discussed in Chapter 20. It has call-back methods that actually take arguments, which show points of the location where the mouse is pressed and released. When the mouse is moved and the mouse button

is pressed, we output information about the events as a continuous stream. The output of *MouseController* follows:

```
pressed:x,y=43,28
dra:x1,y1,x2,y2=43,28:  43,29
dra:x1,y1,x2,y2=43,28:  44,29
dra:x1,y1,x2,y2=43,28:  45,30
dra:x1,y1,x2,y2=43,28:  47,32
dra:x1,y1,x2,y2=43,28:  50,34
dra:x1,y1,x2,y2=43,28:  51,35
dra:x1,y1,x2,y2=43,28:  52,35
rel:x,y=52,35
import java.awt.*;
import java.awt.event.*;

public abstract class MouseController
       implements MouseListener, MouseMotionListener {
       private int x=0;
       private int y=0;
       public void mouseMoved(MouseEvent e) {
       }
```

When the mouse is released, we invoke the *released* call-back method. *MouseEvent* enables us to obtain the location of the mouse:

```
public void mouseReleased(MouseEvent e) {
  released(e.getX(), e.getY());
}
public void mouseEntered(MouseEvent e) {
}
public void mouseExited(MouseEvent e) {
}
public void mouseClicked(MouseEvent e) {
}
```

When the mouse is first pressed, we invoke the *pressed* method with the mouse location. The location is stored as a part of the *MouseController* state. Then we make use of the location where the mouse was pressed in order to give a start point and an end point to the *dragged* method:

```
public void mousePressed(MouseEvent e) {
  x=e.getX();
  y=e.getY();
  pressed(e.getX(), e.getY());
}
```

The *dragged* method makes use of the start point given by the *pressed* method, which is important for features like rubberbanding.

 In graphics, *rubberbanding* is a drawing technique that extends a figure from one or more points to the current cursor position.

```
public void mouseDragged(MouseEvent e) {
  dragged(x, y, e.getX(), e.getY());
}
```

```
        public abstract void released(int x, int y);
        public abstract void dragged(
            int x1, int y1, int x2, int y2);
        public abstract void pressed(int x, int y);

        public static void main(String args[]) {
          ClosableJFrame cf = new ClosableJFrame();
          cf.addMouseController(new MouseController() {
            public void pressed(int x, int y) {
                System.out.println("pressed:x,y="+x+","+y);
            }
            public void released(int x, int y) {
                System.out.println("rel:x,y="+x+","+y);
            }
            public void dragged(
                    int x1, int y1, int x2, int y2) {
                System.out.println(
                    "dra:x1,y1,x2,y2="
                        +x1+","+y1+": "+x2+","+y2);
            }
          });
          cf.setSize(200,200);
          cf.setVisible(true);
        }

    }
```

DESIGN PATTERN

Normally we would provide a means to hook into the model of the system as it is being altered by the controller. Sometimes an observer-observable design pattern is a good way to do this. Other times a simple call-back method is sufficient.

23.2 Combining Keyboard and Mouse Events

The version of *MouseController* of the last session ignored keyboard events. Keystroke information is contained in *MouseEvent* in the form of different modifier key methods. For example,

```
e.isShiftDown()
e.isAltDown()
e.isControlDown()
```

Devising call-back methods for each of these modifiers in various states requires a method call-back explosion:

```
dragShift,
dragAlt,
dragControl,
dragShiftAlt,
dragShiftControl,
dragShiftAltControl
```

WARNING

Having methods that respond to *dragShiftAltControl* is cumbersome for the user (it's a finger-twister!).

In fact, *dragShift* probably is used more often than any of the other modifier-mouse combinations. If we only restrict ourselves to *sensible* modifier-mouse combinations, we need to know *double-click, single-click, shift-click,* and *drag-shift.* For example, when a mouse is pressed and released we get

```
pressed:x,y=83,65
rel:x,y=83,65
clicked:x,y=83,65
```

The press and release constitute a click. If we double-click, we want output like

```
pressed:x,y=83,65
rel:x,y=83,65
d 2 clicked:x,y=83,65
```

where *d 2* is used to show a double-click. If we drag, the output should be

```
pressed:x,y=83,65
dra:x1,y1,x2,y2=java.awt.Point[x=83,y=65]:
        java.awt.Point[x=83,y=66]
dra:x1,y1,x2,y2=java.awt.Point[x=83,y=65]:
        java.awt.Point[x=84,y=67]
dra:x1,y1,x2,y2=java.awt.Point[x=83,y=65]:
        java.awt.Point[x=84,y=68]
rel:x,y=84,68
```

where *dra :* shows the drag taking place. If we press the *Shift* key during the drag, we obtain

```
pressed:x,y=84,68
draShift:x1,y1,x2,y2=java.awt.Point[x=84,y=68]:
        java.awt.Point[x=84,y=69]
draShift:x1,y1,x2,y2=java.awt.Point[x=84,y=68]:
        java.awt.Point[x=85,y=69]
draShift:x1,y1,x2,y2=java.awt.Point[x=84,y=68]:
        java.awt.Point[x=85,y=70]
rel:x,y=85,70
```

Finally, if we shift-click on an object, we get

```
pressed:x,y=78,63
rel:x,y=78,63
Sh clicked:x,y=78,63
```

The revised *MouseController* follows:

```
import java.awt.*;
import java.awt.event.*;

public abstract class MouseController
        implements MouseListener, MouseMotionListener {
```

The *MouseController* introduces a built-in class called *Point*. *Point* holds *int* values for both *x* and *y* coordinates and makes parameter passing cleaner in appearance. For example,

```
private Point pressPoint;
public void mouseMoved(MouseEvent e) {
}
public void mouseReleased(MouseEvent e) {
  released(e.getPoint());
}
public void mouseEntered(MouseEvent e) {
}
public void mouseExited(MouseEvent e) {
}
public void mouseClicked(MouseEvent e) {
```

MouseEvent records the number of clicks using *getClickCount*:

```
  if (e.getClickCount()==2) {
    doubleClicked(e.getPoint());
    return;
  }
  if(e.isShiftDown() && e.getClickCount()==1) {
      shiftClicked(e.getPoint());
      return;
  }
  clicked(e.getPoint());
}
public void mousePressed(MouseEvent e) {
  pressPoint = e.getPoint();
  pressed(pressPoint);
}
  public void mouseDragged(MouseEvent e) {
    if(e.isShiftDown())
     dragShift(pressPoint, e.getPoint());
    else dragged(pressPoint, e.getPoint());
}
  public abstract void released(Point p);
  public abstract void dragged(
      Point p1, Point p2);
  public abstract void dragShift(
      Point p1, Point p2);
  public abstract void pressed(Point p);
  public abstract void doubleClicked(Point p);
  public abstract void clicked(Point p);
  public abstract void shiftClicked(Point p);

  public static void main(String args[]) {
    ClosableJFrame cf = new ClosableJFrame();
    cf.addMouseController(new MouseController() {
      public void pressed(Point p) {

      System.out.println("pressed:x,y="+p.x+","+p.y);
      }
      public void released(Point p) {
```

```
            System.out.println("rel:x,y="+p.x+","+p.y);
        }
        public void dragShift(
                Point p1, Point p2) {
            System.out.println(
                "draShift:x1,y1,x2,y2="+p1+": "+p2);
        }
        public void doubleClicked(Point p) {
            System.out.println(
                    "d 2 clicked:x,y="+p.x+","+p.y);
        }
        public void clicked(Point p) {

        System.out.println("clicked:x,y="+p.x+","+p.y);
        }
        public void shiftClicked(Point p) {
            System.out.println(
                    "Sh clicked:x,y="+p.x+","+p.y);
        }
        public void dragged(
                Point p1, Point p2) {
            System.out.println(
                "dra:x1,y1,x2,y2="+p1+": "+p2);
        }

    });
    cf.setSize(200,200);
    cf.setVisible(true);
    }

}
```

It is a syntax error to subclass *MouseController* without defining the required call-back methods.

Such a definition provides a discipline (and an aesthetic) in programming that goes with strongly typed and reliable code.

This section deals with mouse and keyboard modifiers. In the following section, we will show how to use *MouseController* to move and scale components in a container.

23.3 Moving and Scaling Components with *MouseComponentMover*

This section shows how to use *MouseController* to move components in a container. Chapter 18 showed how to set the location of a component using a layout manager. The layout manager enables displays to adapt to a variety of different monitor resolutions. As an alternative, it is possible to turn the layout manager off by setting the layout manager to *null*. To set the location of a component without using the layout manager, use

```
setLocation(Point p);
```

To set the size of a component, use

```
setSize(int width, int height);
```

The width and height are set in pixels. Figure 23.3-1 shows the original label before manipulation by the mouse.

Figure 23.3-2 shows an image of the label after the mouse has moved it. When the mouse is within the bounds of the label, the cursor automatically changes to the shape of a hand.

Figure 23.3-3 shows scaling in the horizontal direction, which is done with a shift-drag of the mouse. During this process, the cursor automatically changes shape to a two-directional arrow with a south-easterly direction.

Figure 23.3-4 shows the label after resizing in the vertical direction.

The code for all of these features, to be imposed on any component, comes from the *MouseComponentMover* class:

```
import java.awt.*;
import java.awt.event.*;
import javax.swing.*;
public class MouseComponentMover extends MouseController {
```

FIGURE 23.3-1
An Image of *MoveLabel*

FIGURE 23.3-2
An Image After the Mouse
Moved the Label

FIGURE 23.3-3
Scaling in the Horizontal Direction

FIGURE 23.3-4
Scaling in the Vertical Direction

```
    Component c;
/*
The MouseComponentMover must have a reference to the
        component that it is going to move. As this is a
        requirement, we make sure that a component is
        available by passing it in the constructor:
*/
    MouseComponentMover(Component _c) {
        c = _c;
/*
When the mouse enters the boundary of a component, the cursor
        changes from an arror cursor to a hand cursor. This
        gives the user the feedback needed to know that
        operations are possible with the component.
*/
        c.setCursor(Cursor.getPredefinedCursor(
                Cursor.HAND_CURSOR));
        c.addMouseMotionListener(this);
        c.addMouseListener(this);
    }
/*
Mouse coordinates passed to a component are in local
        component coordinates. To turn these into screen
        coordinates, we use
        SwingUtilities.convertPointToScreen which alters its
        arguments
*/
    public void dragShift(Point p1, Point p2) {
        SwingUtilities.convertPointToScreen(p2,c);
/*
The bounds of a Component are defined by a rectangle specifying
        the location of the Component relative to its parent.
        The getBounds method returns an instance of the
        Rectangle class. The Rectangle class suppports the x
        and y coordinate members. The setSize method will
        alter the width and height of the component.
*/
        c.setSize(
          p2.x - c.getBounds().x, p2.y - c.getBounds().y);
        c.setCursor(Cursor.getPredefinedCursor(
                Cursor.SE_RESIZE_CURSOR));
    }
    public void dragged(Point p1, Point p2) {
        c.setCursor(Cursor.getPredefinedCursor(
                Cursor.HAND_CURSOR));
```

```
        SwingUtilities.convertPointToScreen(p2,c);
        c.setLocation(p2.x,p2.y);
    }
    public void clicked(Point p) {
    }
    public void shiftClicked(Point p) {
    }
    public void pressed(Point p) {
    }
```

When a component is *doubleClicked*, we might like to pop up a properties dialog box that allows us to alter the public properties in the model of the component. (This process will be described in more detail after we look into *reflection* later in the book.) For example,

```
    public void doubleClicked(Point p) {
    }
    public void released(Point p) {
        c.setCursor(Cursor.getPredefinedCursor(
                Cursor.HAND_CURSOR));
    }
}
```

23.4 MoveLabel

This section presents the *MoveLabel* class. The *MoveLabel* class makes use of *MouseComponentMover* in order to obtain *scale*, *translate*, and *property edit* behavior. The new behavior comes from having *MouseComponentMover* act as the controller for the mouse with keyboard-modifier events. In addition to the sequence of translate and scale properties shown in the previous section, a double-click of the label brings up the dialog box shown in Figure 23.4-1.

Once the user selects the *Ok* button, the label text property changes, as shown in Figure 23.4-2.

The remarkable thing is how little code is needed in order to get the new behavior. The code for the *MoveLabel* class follows:

```
    import java.awt.*;
    import java.awt.event.*;
```

FIGURE 23.4-1
String Query Dialog Box

FIGURE 23.4-2
The New Label

```
import javax.swing.*;

public class MoveLabel extends JLabel {
    public MoveLabel(String text) {
        this(text, null, LEFT);
    }
```

 The anonymous inner *MouseComponentMover* instance overrides the *doubleClicked* method in order to set the text of the label. For a prompt, the existing text in the label (obtained via *getText*) is used.

The code for MouseComponentMover follows:

```
    public MoveLabel(String text, Icon icon, int
        horizontalAlignment) {
        super(text, icon, horizontalAlignment);
        new MouseComponentMover(this){
            public void doubleClicked(Point p) {
                setText(IO.getString(getText()));
            }
        };
    }

    public MoveLabel(Icon image, int horizontalAlignment) {
        this(null, image, horizontalAlignment);
    }

    public MoveLabel(Icon image) {
        this(null, image, CENTER);
    }

    public MoveLabel() {
        this("", null, LEFT);
    }
    public static void main(String args[]) {
        ClosableJFrame cf = new ClosableJFrame();
        Container c = cf.getContentPane();
        cf.setSize(200,200);
```

 The following setting for the layout manager, *null*, is critical to proper operation.

```
        c.setLayout(null);
        MoveLabel ml = new MoveLabel("hello move label");
        ml.setSize(150,10);
```

```
        ml.setLocation(20,30);
        c.add(ml);
        cf.setVisible(true);
    }
}
```

23.5 Summary

This chapter showed how to combine keyboard modifiers with mouse events in order to provide translate and scale functions to any component. This combination was applied to a new component called *MoveLabel*. We found that we could alter the behavior of the component when presented with a double-click by overriding the *doubleClicked* method of *MouseComponentMover*.

23.6 Exercises

23.1 Write a program that draws lines using the mouse. Use rubberbanding to give feedback to the user. Rubberbanding is a kind of feedback that draws a continuously updated version of the graphic display. An anchor paint and current cursor location are used as input to rubberbanding.

23.2 Extend the program in exercise 1 so that the user can select the line thickness.

23.3 Extend the program in exercise 1 so that the user can specify the line color.

23.4 Which method is used to get the count of clicks made by a mouse button?

23.5 Write a Java program to illustrate the various events generated when moving a mouse.

23.6 Why is mouse event handling important?

23.7 What are local component coordinates? What are screen coordinates? What is the difference between the two?

23.8 How do you determine which mouse button the user clicked?

23.9 Write a program that has a toolbar with three different shapes. By double-clicking on the shape, the size of the shape will appear on the center of the frame.

23.10 Expand exercise 9 by adding three different colors squares to the toolbar. By right-clicking on the colored square on the toolbar, the shape will change color to the one selected.

23.11 Create a drawing tool by tracking the mouse. When the mouse is pressed down, a dot is drawn at that x and y coordinate. As the mouse is moved and the key remains pressed, a series of dots are drawn, making a line.

23.12 Expand exercise 11 and add an eraser to it. When the erase button is pressed, anywhere the mouse is clicked will erase the dot, if one is there.

23.13 Where is the business logic stored in the MVC design pattern?

23.14 List at least five types of mouse events and the methods that handle them.

CHAPTER 24

Reflection

> Words are also actions,
> and actions are a kind of words.
>
> –Ralph Waldo Emerson (1803–1882)

In this chapter, you will learn how to:

- List the classes known to your JVM
- List the methods in a class
- List the parameters in those methods
- Use the *class* class.

The reflection API is key to an understanding of dynamic displays of classes (e.g., Unified Modeling Language (UML) diagrammers, bean editors, and dynamic help displays). It is also key for an understanding of serialization and the design and construction of command-line interpreters.

It is possible, using reflection and general patterns of development, to identify mutators (setter methods) and accessors (getter methods). Reflection lets you list properties, methods, return types, and parameters. It also enables the invocation of methods by using string search techniques.

The reflection API provides classes that have names like *Class, Field, Method,* and *Constructor.* These classes enable the programmer to extract information about an instance of a class.

This chapter covers:

- The reflection API
- The *ReflectUtil* class
- Elementary command-line interpreters

24.1 *ReflectUtil* Gets Information about an Instance

To get information about an instance, a class called *ReflectUtil* was created. The *ReflectUtil* class is constructed with an instance of the class under inspection. *ReflectUtil* can be used to

perform reflection upon itself. The following is a code snippet; the entire *ReflectUtil* class is shown in Section 24.10:

```java
import java.lang.reflect.*;

public class ReflectUtil {
    Class c;
    ReflectUtil(Object o) {
      c = o.getClass();
    }
    ReflectUtil() {
      c = this.getClass();
    }
    public Constructor[] getConstructors() {
      return
        c.getDeclaredConstructors();
    }
    public Field[] getFields() {
      return c.getDeclaredFields();
    }
    public Method[] getMethods() {
      return c.getDeclaredMethods();
    }
    public void print(Object o[]) {
      for (int i = 0; i < o.length; i++)
        System.out.println(o[i]);
    }
    public String getName() {
      return c.getName();
    }
    public static void main(String args[]) {
      ReflectUtil ru = new ReflectUtil();
      System.out.println("Info on class "+ru.getName());
      System.out.println("Constructors:");
      ru.print(ru.getConstructors());
      System.out.println("Fields:");
      ru.print(ru.getFields());
      System.out.println("Methods:");
      ru.print(ru.getMethods());
    }
}
```

The output from *ReflectUtil* follows:

```
        Info on class ReflectUtil
Constructors:
ReflectUtil(java.lang.Object)
ReflectUtil()
Fields:
java.lang.Class ReflectUtil.c
Methods:
public java.lang.reflect.Constructor[]
        ReflectUtil.getConstructors()
public java.lang.reflect.Field[] ReflectUtil.getFields()
```

```
public java.lang.reflect.Method[] ReflectUtil.getMethods()
public void ReflectUtil.print(java.lang.Object[])
public java.lang.String ReflectUtil.getName()
public static void ReflectUtil.main(java.lang.String[])
```

DESIGN PATTERN

The *delegation pattern* reuses an implementation in an existing class by writing another class with additional functionality, which in turn uses instances of the original class to provide the original functionality.

Thus, the *ReflectUtil* class is just a wrapper around the reflection API. This class is implemented using a design pattern called *delegation*. That is, *ReflectUtil* delegates the implementation to the classes in the *java.lang.reflect* package. Using reflection, it is possible to use a *String* to make a new instance of a class. For example,

```
try {
        // create an instance of your applet class
        a = (Applet) Class.forName(className).newInstance();
}
catch (ClassNotFoundException e) {
    System.out.println(
            "ClassNotFoundException in AppletFrame");
    return;
}
catch (InstantiationException e) {
    System.out.println(
            "InstantiationException in AppletFrame");
    return;
}
catch (IllegalAccessException e) {
    System.out.println(
            "IllegalAccessException in AppletFrame");
    return;
}
```

24.2 Printing the Name of a Class

In Java, there is a class whose name is *Class*. Every instance in Java has a corresponding instance of the *Class* class. A reference to the corresponding *Class* class is available by invoking the *getClass* method on an instance. The *Class* instance supports a *getName* method that returns a *full-class name*. The full-class name is a string that contains all package prefixes, as well as the class name.

Thus, if we are given an instance of a class in Java, we may obtain a string representation of the instance of the class from which the instance was made. For example,

```
import java.util.*;
public class ReflectionUtil {
    public static String getString(Object o) {
        Class c = o.getClass();
        return c.getName();
    }
}
```

For any instance of any *Object*, a full-class name is available with all package prefixing. For example, an instance of the *Date* class has the string representation

```
java.util.Date
```

24.3 Printing an Array of Objects *println(Object o[])*

In order to print an array of instances returned by one of the *ReflectUtil* methods, there is a static method called *println*:

```
public static void println(Object o[]) {
  System.out.println(toString(o));
}
```

24.4 Methods with *N* Parameters

Let *N* be the number of parameters to be passed to a method. In this section, use *N* to list the methods that take exactly *N* parameters. Later, we will use the *getParameterTypes* method to list the parameters into an array. The following code shows how you filter out the methods by number of parameters:

```
Method[] getMethodsWithNArgs(int n) {
 Method m[] = getMethods();
 Vector v = new Vector();
 for (int i=0; i < m.length; i++) {
   Class ca[] = m[i].getParameterTypes();
   if (ca.length == n)
        v.addElement(m[i]);
 }
 Method ma[] = new Method[v.size()];
 for (int i=0; i < v.size(); i++)
   ma[i] = (Method)v.elementAt(i);
 return ma;
 }
```

If *ru* is an instance of the *ReflectUtil* class, then

```
System.out.println("Methods with 0 arguments");
ru.print(ru.getMethodsWithNArgs(0));
```

will output

```
Methods with 0 arguments
public java.lang.reflect.Constructor[]
        ReflectUtil.getConstructors()
public java.lang.reflect.Field[] ReflectUtil.getFields()
public java.lang.reflect.Method[] ReflectUtil.getMethods()
public java.lang.String ReflectUtil.getName()
```

All of the methods printed have exactly zero parameters.

24.5 Accessor Methods

Accessor methods (also known as *getter* methods) permit inspection of the properties of the class. The operative assumption is that programmers will use a method of the form

```
type getxxx();
```

in order to obtain a property from an instance. For those types that are *boolean*, the accessor method has the form

```
boolean isxxx();
```

Never use *is* or *get* methods unless a property is returned; otherwise, it will confuse the reflection system.

The *ReflectUtil* class has a method that will return an array of string names of accessor methods in any instance. It is invoked as follows:

```
ReflectUtil ru =
   new ReflectUtil(new java.util.Date());
ru.println(ru.getReadMethodNames());
```

DESIGN PATTERN
Using the *get* and *set* methods as templates for getting and setting properties is not a design pattern. Instead, it is a style of programming supported by reflection in Java.

The output of the above follows:

```
getYear
getMonth
getDate
getDay
getHours
getMinutes
getSeconds
getTime
getTimezoneOffset
getField
getYear
getMonth
getDate
getDay
getHours
getMinutes
getSeconds
getTime
getTimezoneOffset
getField
```

The code for the implementation of *getReadMethodNames* works by first building a vector of all known methods whose names start with *is* or *get*. Then, the vector is converted to a string and returned:

```
public String[] getReadMethodNames() {
  Method m[] = getMethods();
```

```
Vector v = new Vector();
for (int i=0; i < m.length; i++) {
  String s = getName(m[i]);
  if (s.startsWith("get")||s.startsWith("is")) {
      v.addElement(s);
      System.out.println(s);
  }
}
String getterArray[] = new String[v.size()];
for (int i=0; i < getterArray.length; i++)
  getterArray[i] = (String)v.elementAt(i);
return getterArray;
}
```

24.6 Mutator Methods

Mutator methods (also known as *setter* methods) permit modification of the properties of the class. The operative assumption is that programmers will use a method of the form

```
void setxxx();
in order to set a property in an instance.
```

Never use *set* methods unless you want to alter a property; otherwise, it will confuse the reflection framework.

The *ReflectUtil* class has a method that will return an array of string names of mutator methods in any instance. It is invoked as follows:

```
ReflectUtil ru =
   new ReflectUtil(new java.util.Date());
ru.println(ru.getWriteMethodNames());
```

The output of the above follows:

```
setYear
setMonth
setDate
setHours
setMinutes
setSeconds
setTime
setField
setYear
setMonth
setDate
setHours
setMinutes
setSeconds
setTime
setField
```

The code for the implementation of *getWriteMethodNames* works by first building a vector of all known methods whose names start with *set*. Then, the vector is converted to a string and returned:

```
public String[] getWriteMethodNames() {
  Method m[] = getMethods();
  Vector v = new Vector();
  for (int i=0; i < m.length; i++) {
    String s = getName(m[i]);
    if (s.startsWith("set")) {
        v.addElement(s);
        System.out.println(s);
    }
  }
  String setterArray[] = new String[v.size()];
  for (int i=0; i < setterArray.length; i++)
    setterArray[i] = (String)v.elementAt(i);
  return setterArray;
}
```

24.7 Converting a String into a Method

Getting the instance of a method from a corresponding string is an important subproblem in building a command-line interpreter. Often, commands are typed into a command line, and the computer must read in these commands and invoke a corresponding method. In this section, we show a method that maps a *String* into a *method* instance. Such an approach is useful in server-side Java programming. For example,

```
public Method getMethod(String s) {
  Method m = null;
  try {
    m =  c.getMethod(s, new Class[]{});
  }
  catch(NoSuchMethodException e) {
    System.out.println(e);
  }
  return m;
}
```

An invocation of

```
ReflectUtil ru = new ReflectUtil();
System.out.println(ru.getMethod("getFields"));
```

will output

```
public java.lang.reflect.Field[] ReflectUtil.getFields()
```

WARNING

The *try-catch* block is wrappered by the *ReflectUtil* class, thus simplifying the invoking code. In the case of printing, a return of *null* is an acceptable approach to handling a *NoSuchMethodException*. Such an exception will result when method invocations are incorrect.

24.8 Invoking a Method from a String

For this next operation, we intend to invoke a method with no arguments. As an example, we obtain a list of all of the getter methods that take no arguments and print the value of the property that they return.

As an example, consider printing out the properties in an instance of the *Date* class:

```
ReflectUtil ru = new ReflectUtil(
  new java.util.Date());
String getterNames[] = ru.getReadMethodNames(0);
for (int i=0; i <getterNames.length; i++)
  System.out.println(
      getterNames[i]+"="+ru.invoke(getterNames[i]));
```

The output of the above follows:

```
getYear=101
getMonth=2
getDate=7
getDay=3
getHours=9
getMinutes=21
getSeconds=36
getTime=983974896193
getTimezoneOffset=300
```

In order to make sure that the number of parameters used to get a property is zero, we need to modify *getReadMethodNames* to take a number of parameters:

```
public String[] getReadMethodNames(int n) {
  Method m[] = getMethodsWithNArgs(n);
  Vector v = new Vector();
  for (int i=0; i < m.length; i++) {
    String s = getName(m[i]);
    if (s.startsWith("get")||s.startsWith("is"))
        v.addElement(s);
  }
  String getterArray[] = new String[v.size()];
  for (int i=0; i < getterArray.length; i++)
    getterArray[i] = (String)v.elementAt(i);
  return getterArray;
}
```

We also need to add an invocation method that permits the invocation of a method from a string on the internally held instance, *o*:

```
public Object invoke(String methodName) {
  Method m = getMethod(methodName);
  Object ret = null;
  try {
    ret = m.invoke(o,null);
  }
  catch (InvocationTargetException e) {
    e.printStackTrace();
  }
  catch (IllegalAccessException e) {
    e.printStackTrace();
  }

  return ret;
}
```

enter command:

getYear

OK Cancel

FIGURE 24.9-1

The Command Dialog Box

24.9 A Command-Line Interpreter Using Reflection

In this section, we describe a class that is able to read a string from the user and process it by invoking a method that matches the string. The code is invoked using

```
ReflectUtil ru =
   new ReflectUtil(new java.util.Date());
ru.startCommandLineInterpreter();
```

WARNING

The command-line interpreter does not prevent users from typing in bad commands. However, it will throw an exception (in a dialog box) if a bad command is issued.

which brings up the dialog box shown in Figure 24.9-1.

The output is printed on the console as

```
101
```

The implementation follows:

```
public void startCommandLineInterpreter() {
  System.out.println(
    invoke(
        getString("enter command:")));
}
public static String getString(String prompt) {
  return JOptionPane.showInputDialog(prompt);
}
```

Far more complex interfaces (with more sophisticated string processing) are possible. Often, these interfaces use combinations of scrollable text areas, input text fields, and string parsers.

24.10 ReflectUtil.java

The full source code example for the *ReflectUtil.java* class appears below:

```
1.    import java.lang.reflect.*;
2.    import java.util.*;
3.    import java.beans.*;
4.    import java.io.*;
5.    import javax.swing.*;
6.
7.    public class ReflectUtil {
8.       protected Class c;
```

```
9.        private Object o;
10.
11.       public ReflectUtil(Object _o) {
12.           o = _o;
13.           c = o.getClass();
14.       }
15.
16.       public Constructor[] getConstructors() {
17.           return
18.               c.getDeclaredConstructors();
19.       }
20.
21.       public Field[] getFields() {
22.           return c.getDeclaredFields();
23.       }
24.
25.       public Method[] getMethods() {
26.           return c.getDeclaredMethods();
27.       }
28.       /**
29.          getClasses gets inner classes.
30.          @author D. Lyon
31.          @version 0.1
32.          @date 3/6/01
33.       */
34.       public Class[] getClasses() {
35.           return c.getClasses();
36.       }
37.       public String[] getReadMethodNames() {
38.           Method m[] = getMethods();
39.           Vector v = new Vector();
40.           for (int i=0; i < m.length; i++) {
41.               String s = getName(m[i]);
42.               if (s.startsWith("get")||s.startsWith("is")) {
43.                   v.addElement(s);
44.                   System.out.println(s);
45.               }
46.           }
47.           String getterArray[] = new String[v.size()];
48.           for (int i=0; i < getterArray.length; i++)
49.               getterArray[i] = (String)v.elementAt(i);
50.           return getterArray;
51.       }
52.       public String[] getReadMethodNames(int n) {
53.           Method m[] = getMethodsWithNArgs(n);
54.           Vector v = new Vector();
55.           for (int i=0; i < m.length; i++) {
56.               String s = getName(m[i]);
57.               if (s.startsWith("get")||s.startsWith("is"))
58.                   v.addElement(s);
59.           }
60.           String getterArray[] = new String[v.size()];
61.           for (int i=0; i < getterArray.length; i++)
```

```
62.               getterArray[i] = (String)v.elementAt(i);
63.           return getterArray;
64.       }
65.     public String[] getWriteMethodNames() {
66.           Method m[] = getMethods();
67.           Vector v = new Vector();
68.           for (int i=0; i < m.length; i++) {
69.               String s = getName(m[i]);
70.               if (s.startsWith("set")) {
71.                   v.addElement(s);
72.                   System.out.println(s);
73.               }
74.           }
75.           String setterArray[] = new String[v.size()];
76.           for (int i=0; i < setterArray.length; i++)
77.               setterArray[i] = (String)v.elementAt(i);
78.           return setterArray;
79.       }
80.     /**
81.         getMethod takes a string and returns a
        corresponding method.
82.     */
83.     public Method getMethod(String s) {
84.           Method m = null;
85.           try {
86.               m =  c.getMethod(s, new Class[]{});
87.           }
88.           catch(NoSuchMethodException e) {
89.               System.out.println(e);
90.           }
91.           return m;
92.       }
93.     /**
94.         invoke a methodName string with no arguments.
95.     */
96.     public Object invoke(String methodName) {
97.           Method m = getMethod(methodName);
98.           Object ret = null;
99.           try {
100.                  ret = m.invoke(o,null);
101.              }
102.              catch (InvocationTargetException e) {
103.                  e.printStackTrace();
104.              }
105.              catch (IllegalAccessException e) {
106.                  e.printStackTrace();
107.              }
108.
109.              return ret;
110.          }
111.
112.          public int getModifiers(Method m) {
113.              return m.getModifiers();
```

```
114.                }
115.
116.                public String getModifierString(Method m) {
117.                    return Modifier.toString(
118.                        getModifiers(m));
119.                }
120.            /**
121.                Print an array of objects
122.                @author Douglas Lyon
123.                @version 1.0
124.            */
125.                public static void println(Object o[]) {
126.                    System.out.println(toString(o));
127.                }
128.
129.            /**
130.                convert an array of string into a big
        string with new lines
131.            */
132.                public static String  toString(Object o[]) {
133.                    String s="";
134.                    for (int i = 0; i < o.length; i++)
135.                        s = s + o[i]+"\n";
136.                    return s;
137.                }
138.                public void printInfo() {
139.                    System.out.println("Info on class
        "+getClassName());
140.                    System.out.println("Constructors:");
141.                    println(getConstructors());
142.                    System.out.println("Fields:");
143.                    println(getFields());
144.                    System.out.println("Methods:");
145.                    println(getMethods());
146.                    System.out.println("Methods with 0
        arguments");
147.                    println(getMethodsWithNArgs(0));
148.                    System.out.println("read methods");
149.                    println(getReadMethodNames());
150.                    System.out.println("write methods");
151.                    println(getWriteMethodNames());
152.                    System.out.println("Classes");
153.                    println(getClasses());
154.                }
155.
156.                public String getClassName() {
157.                    return c.getName();
158.                }
159.
160.                Method[] getMethodsWithNArgs(int n) {
161.                    Method m[] = getMethods();
162.                    Vector v = new Vector();
163.                    for (int i=0; i < m.length; i++) {
```

```
164.                      Class ca[] = m[i].getParameterTypes();
165.                      if (ca.length == n)
166.                          v.addElement(m[i]);
167.                  }
168.                  Method ma[] = new Method[v.size()];
169.                  for (int i=0; i < v.size(); i++)
170.                      ma[i] = (Method)v.elementAt(i);
171.                  return ma;
172.              }
173.          public String getName(Method m) {
174.              return m.getName();
175.          }
176.          public String getInfoString(Method m) {
177.              return
178.                  "for method "+m.getName()+
179.                  "\nThe modifier = " +
180.                  getModifierString(m)+
181.                  "\nThe return type ="+
182.                  m.getReturnType().getName()+
183.                  "\n The arguments for this method are
      "+
184.                  toString(m.getParameterTypes());
185.          }
186.          public void printInfo(Method m) {
187.              System.out.println(getInfoString(m));
188.          }
189.
190.          public static void main(String args[]) {
191.
192.              ReflectUtil ru =
                  new ReflectUtil(new java.util.Date());
193.              ru.startCommandLineInterpreter();
194.              //ru.printInfo();
195.          }
196.          public void startCommandLineInterpreter() {
197.              String s = null;
198.              String prompt = "enter command:";
199.              while (
            ! (s = getString(prompt)).startsWith("quit"))
200.                  try{
201.                   prompt=s+"="+invoke(s);
202.                  }
203.                  catch(Exception e) {
                          prompt = e.toString();};
204.          }
205.          public static String getString(
                          String prompt) {
206.              return
      JOptionPane.showInputDialog(prompt);
207.          }
208.      }
209.
210.
```

24.11 Summary

This chapter demonstrated code that lists classes, methods in the classes, and all of the parameters in the methods. We saw how to transform a collection of reference data types into detailed descriptions of those types.

We also saw how to build a utility that uses reflection to create a command-line interpreter. It was shown that the addition of classes to the JVM results in an addition of commands to the interpreter, without altering the interpreter. A few points to remember about reflection:

- The *Class* class has many methods for reflection.
- Reflection is used by introspection (see Chapter 35).
- Reflection enables dynamic discovery about superclasses, interfaces, methods, fields, parameters, visibility, and return types.
- Reflection enables dynamic invocation without strong typing.

However, reflection does have some limitations. For example, the class must be loadable, which has several implications:

- Byte codes are accessible.
- Source code is ignored (in other words, you must compile first).

24.12 Exercises

24.1 Write a program that inputs a *class* instance and returns an array of *reference data types* that the class *uses*. A class is defined as using a type if it has a member of that type, a method that returns that type, or a parameter in a method that uses that type; extends the type; or implements the type.

24.2 Write a program that uses a list of classes and draws a graph that depicts the associations between the classes. A program that can draw a graph and help to arrange the elements in the graph is available in the examples distributed with the J2SE SDK *demos in /demo/applets/ GraphLayout.java*. Use this program and update it so that it no longer uses deprecated methods. Refactor the business logic from the GUI.

24.3 Write a command-line interpreter that takes command-line arguments and invokes

```
public static void main(String args[])
```

For example, if *main* resides in a class called *Hello*, then typing

```
Hello this is a nice program
```

will pass "this is a nice program" as the first five arguments to the *main* method in *Hello*.

24.4 Write a display program using Swing that shows all of the values of all of the public getter methods in an instance, as well as the getter method names.

24.5 Write a display and input program that shows all of the inputs available for all of the setter methods. If a getter method is associated with the setter method, show the present value and allow the user to alter it.

24.6 Write a small application that illustrates the use of reflection.

24.7 Using the code in Section 24.6, refactor the code in the methods *getWriteMethodNames* and *getReadMethodNames* so that there is little common code between them. Hint: Write an interface called

```
interface MethodFilter {
    public boolean accept();
}
```

Use *MethodFilter* as a parameter to build the list of methods.

24.8 The program *ClassUtils.gui.ComponentEditor* provides a GUI building tool for adding and manipulating components, which is shown in Figure 24.12-1. When the user control-clicks on a component, a series of properties is displayed, as shown in Figure 24.12-2.

However, there is no way to add the property for color. Modify the code (or write your own version) so that color properties also can be displayed and set.

FIGURE 24.12-1

The GUI Building Tool

FIGURE 24.12-2

The Component Property Display

Automatic Message Forwarding

Trust in Allah—but tie your camel.

–Persian Proverb.

In this chapter, you will learn:

- How to use proxies to perform delegation
- How to add features to a system without having access to source code
- How to refactor code automatically
- How to perform type-safe automatic delegation

DESIGN PATTERN

The proxy for an instance message forwards any invocations to that instance. It is different from the adapter design pattern because the adapter alters the interface. If additional methods are added, then we can use the decorator design pattern.

This chapter shows a technique that enables the generation of message-forwarding code (called *proxy* classes) in an automatic manner. The system supports fast and automatic generation of proxy classes and interfaces that are able to reuse implementations, simulate multiple inheritance, and refactor legacy systems, even when faced with missing source code. Advantages of the technique include type safety, speed of execution, automatic disambiguation (i.e., name-space collision resolution), and ease of maintenance.

The approach generates Java source that does method forwarding and creates interfaces as a means to achieve polymorphism. Disambiguation can be automatic, semi-automatic, or manual. The proxy class can be changed over time to an *adapter* as the delegates change specification, thus protecting client classes from change. The interface and proxy are generated automatically via *reflection*. This type of simulation of multiple inheritance was previously available only to Java programmers who performed manual delegation or who made use of dynamic proxies. The technique has been applied at a major aerospace corporation.

25.1 Introduction

 Refactoring is defined as changing a system to improve its internal structure without altering its external behavior.

We often are faced with legacy code that has to be refactored. Refactoring typically is done in order to improve some feature, such as design or readability. Refactoring is a key approach for improving object-oriented software systems [Tichelaar et. al.]. Sometimes the code has no source available or the design is poor. Typically, a large number of dependencies between classes complicates the analysis [Korman and Griswold]. While consulting for one aircraft manufacturer, we were faced with more than 300,000 lines of legacy code written by FORTRAN programmers. This code was turned into a strange-looking form of Java code (dubbed *JavaTran*). Over time, maintenance changed the original program structure and specifications. Additionally, the specifications had not been maintained, which is a common problem in the industry [Postema and Schmidt].

Our goal was to try to reuse the existing code and add features to this software system. We elected to take an approach to refactoring the existing use by using *delegation*.

 According to one definition, delegation uses a receiving instance that forwards messages (or invocations) to its delegate(s), which is sometimes called a consultation [Kniesel 1994].

 DESIGN PATTERN
Variations on this theme give rise to several of the so-called *design patterns*. For example, if methods are forwarded without change to the interface, then you have an example of the *proxy pattern*.

 DESIGN PATTERN
If you simplify the interface with a subset of methods to a set of delegates, then you have a *facade pattern*.

 DESIGN PATTERN
If you compensate for changes (e.g., deprecations) in the delegates and keep the client classes seeing the same contract, then you have the *adapter pattern*.

 DESIGN PATTERN
If you add responsibilities to the proxy class, then you have the *decorator pattern* [Gamma et. al.].

Thus, we define *static delegation* as a compile-time type-safe message forwarding from a proxy class to some delegate(s).

Compare this to the definition given by Henry Lieberman [Lieberman]. With Lieberman, delegation using the communications pattern is decided at run time, and so it is called *dynamic delegation*. Thus, compile-time checks are not performed, and the message forwarding is not type-safe. In JDK 1.3, dynamic delegation is more automatic (i.e., it is Lieberman-style). Using the JDK 1.3, version of dynamic delegation, you build a proxy object from the reflection API. These also are called *dynamic proxy classes*.

Our goal was to refactor the code in a *type-safe* way without having to rewrite it.

Improper refactoring can break subtle properties in a system.

As a result, refactoring generally is followed by a testing phase [Kataoka et. al.]. To eliminate the testing phase, after refactoring we created an automatic means of generating the proxy classes. The technology for the automatic generation of the message forwarding in the proxy classes and its application are the subject of this chapter.

DESIGN PATTERN
A *toolkit* is an object-oriented subroutine library that contains a set of related methods in a class. Toolkits are very good for code reuse.

Proxy classes are like toolkits that provide access to domain-specific frameworks [Gamma et. al.]. The result is a stable interface to a large collection of methods in a single proxy class, rather than a weak coupling of many instances of several different classes. Since old code is unchanged (and even unneeded!) in our system, new code becomes an example of the facade pattern (i.e., a central point for client classes to interface to existing implementations).

Before the invention of the technologies described in this chapter, proxy classes were written manually using a process we call *manual static delegation*. In manual static delegation, an instance is passed to a proxy class as a parameter. A programmer writes wrapper code that delegates to the contained instance. The code that contains the wrapper code is called the *proxy* class and the code that contains the implementation code is called the *delegate*. For example,

```
final class Movable {
    int x = 0;
    int y = 0;

    public void move(int _x, int _y) {
      x = _x;
      y = _y;
    }
}
```

To add a feature to the *Movable* class, we cannot subclass it because the class is *final*. We might be tempted to modify the *Movable* class: However, source code might not be available. For example, suppose we want *MovableMammal*. To leave the existing code unchanged, we use manual static delegation:

```
class Mammal {
    public boolean isHairy() {
      return true;
    }
}
```

Our manually written delegation code follows:

```
public class MovableMammal {
    Mammal m;
    Movable mm;
    MovableMammal(Mammal _m, Movable _mm) {
      m = _m;
      mm = _mm;
    }
```

```
// this is message forwarding
    public void move(int x, int y) {
       mm.move(x,y);
    }
    public void isHairy() {
       return m.isHairy();
    }
}
```

The automatic static-proxy delegation generates code, such as that for the *MovableMammal* class, automatically.

There are several alternatives to automatic proxy delegation for reusing implementations. For example, we can:

1. Deepen the subclass for processing data. This is the solution I took with *Image Processing in Java* [Lyon 1999]. Each chapter built another subclass until the classes were nine levels deep. Subclassing is not always the best way to extend the functionality of a class. While subclassing is an object-oriented design technique, lack of multiple inheritance keeps Java from scaling this approach to large programs.

2. Use delegation. We can keep adding references to *helper* classes that can process the data, and then delegate to the other classes for the implementation. Imagine that you run a country. All requests from the citizens go directly to you. Then you make a phone call and delegate the requests to the right person. Here, you are acting in the role of the proxy class, dispatching tasks to the correct task implementors. Delegation has long been thought of as a generalization of inheritance (a point of view with which there is disagreement) [Aksit and Dijkstra] [Bracha].

3. Use multiple inheritance. The exclusion of multiple inheritance from Java is a design decision that forces people into doing what is good for them. This is exactly what Bjarne Stroustrup says that he tried to avoid in the design decisions that he made when creating C++ [Stroustrup 1994]. Grady Booch has said that "Multiple inheritance is like a parachute; you don't need it very often, but when you do it is essential" [Booch]. In contrast, it also has been said that multiple inheritance is an inessential programming idiom [Compagnoni and Pierce]. The multiple inheritance debates appear to be devoid of solid data. Programmers who use Java are innocent victims of the design decision to leave out multiple inheritance [Stroustrup 1987].

Generally, inheritance enables shared behavior. Some have argued that subtyping (i.e, the multiple inheritance of interfaces in Java) is not inheritance. In fact, our approach divorced inheritance from subtyping by creating new proxy classes with new interfaces. Furthermore, there is even disagreement on the appropriate semantics for multiple inheritance [Bracha] [Compagnoni and Pierce]. Stroustrup says that multiple inheritance is the ability of a class to have more than one base class (i.e., superclass). Thus, multiple inheritance of interfaces is not multiple inheritance in the Stroustrup sense [Stroustrup 1987].

Our system is like Gilad Bracha's *JigSaw* system in that it has rigorous semantics based upon a denotational model of delegation [Bracha]. We decouple proxy delegation from subtyping (unlike the Lieberman-style of delegation). Extending an existing language with a new API Produces several benefits:

1. Gain an upwardly compatible extension
2. Achieve realistic performance
3. Obtain a practical and useful tool
4. Obtain polymorphism by implementing synthesized interfaces
5. Restrict inheritance to subtypes only
6. Resolve name collisions by topological sorting or programmer interaction

It has been asserted that refactoring also will be language dependent because it must understand the language of the programs that it is manipulating. I shall show that this assertion is generally untrue. Our automatic static proxy generation does not use source and can be used in any language with a reflection API [Johnson and Opdyke].

25.2 Delegation versus Multiple Inheritance

Delegation (i.e., composition or aggregation) is as legitimate a means of object-oriented design as multiple inheritance (i.e., specialization). The question of which representation to use for knowledge about the world is a philisophical one. The argument about composition versus specialization is really a knowledge representation argument. It is not clear that such an argument should be settled by computer language designers. After all, we shape our tools, and, thereafter, our tools shape us!

For example, is polluted water a kind of water, or is it water that has pollution in it? Or, do we say that polluted water is made of water and pollution? That is, do we use aggregation, composition, or specialization to model polluted water? Since all three representations are legitimate models of polluted water, depending on the application, all should be permitted.

On the other hand, specialization is often an inadequate way of modeling associations [Frank]. For example, roles in a multiple-inheritance structure may change. For example, an insurance company's software system sees the children of clients as dependents. However, after the children grow up, they can change from dependents to customers. In a static multiple-inheritance relationship, role changing is not easy, which is a failure to model dynamic evolution of the world [Kniesel 1998]. Thus, in the example of the role, we delegate to role instances that represent kinds of roles that a person may have. Frank suggests the association of *acts-as* be used for various kinds of roles. For example, a *person acts-as* a *student* [Frank].

Thus, the multiple-inheritance battle rages on without hard data [Tempero and Biddle]. Multiple inheritance gives us code reuse and polymorphism; delegation enables code reuse without polymorphism. The uncertainties that arise from the use of multiple inheritance of implementation have been cited as the rationale for leaving this language feature out of Java [Arnold and Gosling 1998]. In fact, the primary rationale for leaving out this language feature is programmer abuse.

Despite these concerns, multiple inheritance remains more popular than delegation. One reason for this popularity might be that classes transparently inherit operations from their superclasses in multiple inheritance. Thus, synthesizing proxy classes automatically reduces the possibility of introducing errors and should encourage programmers to use delegation more often [Johnson].

Trying to tease apart multiple inheritance by hand is an error-prone process. It is a much better idea to use a good tool if you can find (or build) one.

Both delegation and inheritance are mechanisms for extending a design [Coad and Mayfield]. For example, if multiple inheritance of implementations existed in Java, our *MovableMammal* might be written like this:

```
public class MovableMammal extends Movable, Mammal {
}
```

This design would work using the multiple-inheritance model of C++. However, such a model has been shown to have several disadvantages. For example:

1. Subclasses must inherit only a single implementation from a superclass.
2. The topological sorting of the superclasses has been cited as a fruitful source of bugs [Arnold and Gosling 1996].
3. Inheritance compromises the benefits of encapsulation [Coad and Mayfield].
4. Inheritance hierarchy changes are unsafe [Snyder].
5. Even in a single-inheritance-type language like Java, conflicts between multiple parents are not reported. Ambiguity resolution has long been known as a problem with inheritance [Kniesel 1999].
6. Taxonomically organized data has become automatically associated with object-oriented programming [Cardelli].

Some have said that multiple inheritance is hard to implement, is expensive to run, and complicates a programming language [Cardelli]. These conjectures, however, were debunked by Stroustrup [Stroustrup 1987].

Multiple inheritance provides for subtyping, a feature that the interface mechanism of Java embraces by providing multiple inheritance of specification without implementation. Thus, an interface *x* is a subtype of interface *y* if *x* is a descendant of *y*. This relationship also works for classes in Java, but such relationships are only subject to single inheritance.

Systems, like *Kiev,* extend the Java language so that it has multiple inheritance of implementation *<http://www.forestro.com/kiev/kiev.html>*. Such language extensions are nonstandard and unportable solutions (as opposed to ours).

The LAVA language also extends Java to provide for delegation. However, Günter Kniesel says that current implementations of LAVA have an unacceptable efficiency level [Kniesel 1998] [Kniesel 1999]. In comparison, our solution is fast. In fact, with in-lining enabled, there is no performance degredation.

K. Fisher and J.C. Mitchell provide a new delegation-based language [Fisher and Mitchell]. Sorry to say, though, that the language is untyped and therefore has the unsoundness of any dynamic delegation system. The primary advantage of the Fisher-Mitchell system appears to be in resolving method-name conflicts at compile time (something that most multiple-inheritance systems fail to do). In comparison, our system is strongly typed, and this type checking occurs at compile time.

Reverse engineering programs, such as *Lackwit*, are able to discover inheritance relationships with greater ease than composition associations [O'Callahan and Jackson] because the inheritance association implies a specialization semantic. This is a deficiency in our approach.

Delegation has been cited as a mechanism to obtain implementation inheritance via composition [Lieberman 1986] [Johnson and Zweig]. Delegation was introduced in a prototype-based object model by Lieberman in 1986 [Lieberman 1986]. Lieberman indicated that delegation is considered safer than inheritance because it forces the programmer to select which method to use when identical methods are available in two delegate classes.

WARNING Any means of synthesizing code that contains methods with identical signatures causes syntax errors. These errors require the programmer to think about which method to use, rather than simply to use automatic mechanisms based on topological sorting of superclasses.

Topological sorting (as in C++ and ZetaLisp) has been shown to be a fruitful source of bugs in multiple-inheritance-type languages, which is why it has been omitted from languages like Modula-3, Objective C, and Java [Harbison] [Cox]. Our system enables topological sorting to be introduced into the proxy class generation phase as a programmer option. The primary advantage of our system is that it automates the synthesis of code that does the message forwarding.

Message forwarding is a kind of implementation sharing mechanism [Kniesel 2001]. Experts have disagreed on this point, saying that delegation is a form of class inheritance (since the execution context must be passed to the delegate). I take the opposite view, since the class-inheritance type of sharing of context involves name sharing, property sharing, and method sharing. Sharing via delegation is instance sharing. The semantics of instance sharing enables a control of the coupling between instances. This control provides a mechanism for reuse without introducing uncontrolled cohesion (which increases brittleness in the code) [Bardou and Dony].

Delegation has the disadvantage that:

1. The computational context must be passed to the delegate.
2. There is no straightforward way for the delegate to refer back to the delegating object [Viega].
3. The proxy class is coupled to the delegates.

NOTE With JDK 1.3, there is a new technique called *dynamic proxies* [Sun 2000].

Dynamic proxies have all of the disadvantages of delegation. In addition,

1. They are harder to understand than more static software.
2. Dynamic delegation is slower than static delegation.
3. The design has a counterintuitive class structure [Korman and Griswold].
4. Type-safe dynamic delegation is impossible [Kniesel 1998].

Point 4 above requires some discussion. Unlike static delegation, dynamic proxies do not give you compile-time checking of unresolved messages. This is a critical difference. Even multiple inheritance will provide compile-time checking of unresolved messages. Thus, in the spectrum of type safety, we have, in order of most-safe first:

1. Static delegation
2. Multiple inheritance
3. Dynamic proxy classes

WARNING Multiple inheritance is less type safe than static delegation because method ambiguity typically is resolved without warning at compile time. Thus, some unexpected behavior can result, which is the problem of automatic disambiguation.

We implement disambiguation using a GUI that requires selection between an automatic topological technique and a semi-automatic one. Finally, we also can output ambiguous code so that the programmer can resolve the ambiguities at compile time. The last technique is probably the least reliable method since the programmer is in the code synthesis loop.

Kniesel has defined delegation as having automatic method forwarding (i.e., Lieberman delegation). We prefer to use the term *dynamic delegation*. Static method forwarding (which Kniesel says is not "true" delegation) is what I define as static delegation [Kniesel 1999] [Kniesel 2001]. Static delegation is type safe: Dynamic delegation is not. The methods invoked remain the same, but the change in behavior comes from a change in implementation.

Others have tried to automate delegation by using dynamic delegation. For example, Stroustrup tried an implementation of dynamic delegation in C++, and he reported that every user of the delegation mechanism "suffered serious bugs and confusion." He says that the primary reasons are that functions in the proxy do not override functions in the delegate, and functions in the delegate cannot get back to the proxy (i.e., the *this* is in a different context). Stroustrup mentions a solution, which is to forward a request to another object manually (i.e., static delegation) [Stroustrup 1994].

The static delegation we propose is able to alter its behavior in a type-safe way at run time. To show that static proxy delegation will change the behavior, depending on the instance of the delegate, one need only make use of polymorphic delegates. A proxy that interfaces to a numerical computing toolkit, for example, could take an instance that defines a function. Naturally, the toolkit would be useless if it only worked for a single function. A different function will cause different behavior in the toolkit. Yet the function always conforms to an interface that requires a double-precision number on input and output. Thus, our system is a type-safe example of proxy delegation.
Manual delegation has the following disadvantage(s):

1. Tedious wrappers need to be written for each method.
2. Manually writing forwarding methods is an error-prone process.
3. Programmers write arbitrary code in a forwarding method, which can give an object an inconsistent interface.
4. Programmers must decide which message subset must be forwarded.

Automatic proxy synthesis overcomes these problems in the following ways:

1. The synthesis does not generate arbitrary code.
2. The interface to the instances remains consistent.
3. The delegation is subject to in-line expansion and is more efficient than multiple inheritance.
4. The mechanism for forwarding is obvious and easy to understand.
5. The proxy is coupled to the delegate in a more controlled manner than automatic dynamic delegation.

6. Classes that use the proxy are presented with a more stable interface than the proxy class. For example, a method may become deprecated, but changes need only be seen in the proxy class, not in its clients.

The additional advantage is that we can lower the cost of software maintenance and improve reusability of the code.

Problems that remain unsolved by automatic static proxy delegation include:

1. Programmers can write arbitrary code in a forwarding method.
2. There is no straightforward way for the delegate to refer back to the delegating object [Viega et. al.].
3. Programmers could limit the message-forwarding subset (i.e., make the proxy into a facade).
4. The computational context must still be passed to the delegate [Kniesel 1994].
5. The proxy class is fragile. If the interface to the delegate changes, the forwarding method in the proxy must change [Kniesel 1998].

An additional step, the compilation of generated code, is required with static proxy delegation (automatic or manual). This compilation step disambiguates. In comparison, dynamic proxy classes generate errors at run time. We favor compile-time errors over run-time errors, so we find our technique superior in this regard.

It is a bad idea to use dynamic proxies because they can generate run-time errors.

Semi-automatic synthesis of delegation code addresses the time-consuming and error-prone drawback of manual delegation. It is also easier to understand. The basic issue is that a balance must be struck between code reuse and the fragility that arises from *coupling*, a measure of component interdependency. This balance is obtained by good object-oriented design (and is hard to automate!). We follow some basic rules for the synthesis of our proxy classes that were suggested by Stroustrup when implementing C++ classes:

1. Ambiguities are illegal.
2. Only public methods are available.
3. The methods are all public in the proxy class.
4. Subtyping is done with interfaces, not proxies.
5. Both proxy classes and interfaces are synthesized automatically.
6. Type checking is static.
7. Ambiguity resolution is static (i.e., done at code-synthesis time).

When ambiguities arise, the synthesizer resolves them either by performing topological sorting or by interacting with the programmer. Thus, the code is synthesized without ambiguities. If ambiguities existed in the output code, it would cause a syntax error. Our code, once compiled, will guarantee that we will never get messages like "can't find method" [Wand].

Shadowing methods in subclasses can occur without any warning from a compiler and can lead to unexpected side effects.

Multiple inheritance of interfaces enables the use of polymorphism just like multiple inheritance of classes. In Java, interfaces are used as a means to achieve polymorphism. Typically, the interfaces are coded manually; as they change, so too must the implementing classes. I call this the fragile-interface problem. This problem generally is solved by adding new interfaces and new classes without altering old ones.

The problem with this approach is that the new interface cannot make old methods more restrictive in their access. Even worse, as we elect to shift our code to the new interface, often we are performing maintenance in parallel on identical implementations.

We solve the problem of implementation reuse by automating proxy-class generation. We solve the problem of creating new interfaces (and detecting name collisions) using the reflection API. This API enables the automatic synthesis of interfaces based on sample instances and allows us to achieve polymorphism. For example, the following code was generated automatically:

```
interface MammalMovableStub extends
      MammalStub, MovableStub {
}
 interface MammalStub {
      public boolean isHairy();
}
 interface MovableStub {
      public void move(int v0,int v1);
}
```

25.3 Related Work

Tools for refactoring code automatically are not new [Opdyke 1992b], [Opdyke and Johnson 1993a], [Johnson 1993b]. Language independent tools for refactoring code are not new either [Tichelaar et al.]. Even the use of explicit and parametrical bindings to create type-safe inheritance is not new [Hauck].

However, in the literature that we have reviewed, we have yet to find a means for automatically creating the proxy classes shown in this chapter. In addition, the tools that we have found for refactoring code are like the *Elbereth* system in that they require source code [Korman and Griswold]. Other source code-based tools for automatic refactoring include the Smalltalk Refactoring Browser [Roberts 1997], add [Roberts 1984] to Lit. Cited and [Roberts 1987] to Lit Cited, the IntelliJ Renamer *<http://www.intellij.com>*, which supports renaming of identifiers, and the *Xref-Speller* *<http://www.xref-tech.com/speller/>*, which supports set refactorings. The Daikon invariant detector reads source code and depends on instrumentation of the source code for full function *<http://sdg.lcs.mit.edu/~mernst/daikon/>*. None of the aforementioned tools automate proxy class synthesis. This is also true for the class composition proposed by William Harrison, Harold Ossher, and Peri Tarr [Harrison et al.]. Our technique, on the other hand, does not require any source code, though our technique can still generate it.

Our technique for static delegation requires that every instance be passed to a proxy class, along with its execution context. Thus, a programmer's updates in the protocol for communicating the means to pass parameters will have to be updated in the proxy class. This is the solution I took in *Java Digital Signal Processing* [Lyon 1998].

The trouble is that updates for the interfaces to the delegates may change, which requires proxy-class maintenance.

DESIGN PATTERN

When the proxy protects the client from changes in the delegate specifications, the proxy is making use of the *adapter* pattern. If additional responsibilities are added to the wrappers around the delegates, we are using the *decorator* pattern [Gamma]. Once manual additions are made to the proxy class, it can no longer be regenerated automatically without a loss of the changes. Thus, adding responsibilities to an instance of a proxy probably should be left to a new decorator class. Similarly, if a totally new interface is needed in the proxy class, a new adapter class should be constructed. If a subset of methods is needed to simplify subsystem use, then a *facade* class should be created to interface to the proxy class. It is generally poor design to make the proxy the facade, adapter, and decorator (though such a design is likely to be the case as the code evolves over time).

When a language like Java lacks multiple inheritance, we only can rely upon single inheritance or delegation as a means toward code reuse. The drawback of delegation is the constant updating of the proxy code needed to communicate the computing context to the delegate. Our means of automating the synthesis of delegation code is like the pre-processor approach of the *Jamie* system used by John Viega [Viega et al.]. A problem with *Jamie* is that it extends the language by creating a macro preprocessor. Aside from JSP technology, Java has no macros, which enables symbolic debuggers to work directly with source code that has been seen by (and perhaps written by) humans.

Jamie provides a means for performing dynamic delegation, which is inherently less efficient than static multiple inheritance. Static multiple inheritance, in turn, is less efficient (and less safe) than static delegation. Our technique of semi-automatic static-proxy delegation enables inlining of code so that invocations are expanded, something *Jamie* and the JDK 1.3 dynamic proxy classes cannot do.

The use of reflection to generate static delegation code automatically, even if the original source code is unavailable, is new. This code generation can assist in the creation of facades and toolkits [Gamma et al.].

25.4 A Real Example

In this section, we describe an example of the *Proxy* class that is generated by the *DelegateSynthesizer* class and the *ReflectUtil* class. The effect is to alter the interface to the delegates so that it is simpler to use without having to change any of the existing code. For example, in order to use *ReflectUtil* and *DelegateSynthesizer* in the past, we would write

```java
public static void main(String args[]) {
  DelegateSynthesizer ds = new DelegateSynthesizer();
  ReflectUtil ru = new ReflectUtil(ds);
  ds.add(new java.util.Vector());
  ds.process();
  System.out.println(
    ds.getClassString());
}
```

Now we write

```
public static void main(String args[]) {
  Proxy p = new Proxy();
  p.add(new Vector());
  p.process();
  System.out.println(
    p.getClassString());
}
```

The *Proxy* class contains all of the methods of the *ReflectUtil* class and the *DelegateSynthsizer* class with a different constructor than either of the two delegates. The constructor was coded by hand, and the class was renamed. Other than that, the code output by

```
public static void main(String args[]) {
  DelegateSynthesizer ds = new DelegateSynthesizer();
  ReflectUtil ru = new ReflectUtil(ds);
  ds.add(ds);
  ds.add(ru);
  ds.process();
  System.out.println(
    ds.getClassString());
}
```

was all that was required to construct the *Proxy* class. We now are able to generate an interface called the *ProxyStub* automatically by executing

```
public static void main(String args[]) {
  Proxy p = new Proxy();
  p.add(p);
  p.process();
  System.out.println(p.getInterfaces());
}
```

As a result, we are able to obtain the multiple inheritance of typing that we otherwise would have missed if we only used delegation. The *Proxy* class can now implement *ProxyStub*. In fact, the methods of any number of instances can be folded into a synthesized interface.

25.5 DelegateSynthesizer

This section details the implementation of the automatic proxy code synthesis via reflection. Reflection enables a listing of methods and their signatures, which are used to forward invocations to the delegates contained by a proxy class. I call this *static proxy delegation* in order to differentiate it from the *dynamic proxy classes* that have been introduced in JDK 1.3 [Sun 2000].

The *DelegateSynthesizer* class generates Java source code that automatically wrappers all of the invocations to a list of delegate instances. As an example, consider the programmer who establishes a set of classes based on mammals and humans:

```
class Mammal {
    public boolean isHairy() {
    return true;
    }
}
```

```
class Human extends Mammal {
      public String toString() {
        return "human";
      }
}
```

This seems like standard stuff. A *Human* is a kind of *Mammal*. As a result, the *extends* shows
a subclassification of the *Mammal* class. Also, we recognize that the cardinality of the set
of all mammals is smaller than the set of all humans. Thus, *extends* represents a kind of
knowledge about taxonomic hierarchies.

Suppose we want graphics in our system. We define a new class called *Movable*:

```
class Movable {
      int x = 0;
      int y = 0;

      public void move(int _x, int _y) {
        x = _x;
        y = _y;
      }
}
```

To add features to the *Movable* class, we create the *Graphics* class:

```
class Graphic extends Movable {
          public void erase() {
            move(-1,-1);
          }
}
```

The subclassification of *Mammal* has a different intention than the extension of the
Movable class. We only extended *Movable* to inherit an implementation, not to describe a
taxonomy!

In order to obtain a graphic human (i.e., a class that represents a human that can be
drawn), we require delegation. To invoke *DelegateSynthesizer*, we write

```
Vector v = new Vector();
v.addElement(new Human());
v.addElement(new Graphic());
DelegateSynthesizer ds = new DelegateSynthesizer(v);
ds.print();
```

The output follows:

```
// automatically generated by the DelegateSynthesizer
public class HumanGraphic {

// constructor:
public HumanGraphic(
      Human _human,
      Graphic _graphic){
      human = _human;
      graphic = _graphic;
}
  Human human;
```

```
    public java.lang.String toString(){
      return human.toString();
    }
    public boolean isHairy(){
      return human.isHairy();
    }
  Graphic graphic;
    public void move(int v0,int v1){
      graphic.move(v0,v1);
    }
    public void erase(){
      graphic.erase();
    }
  }
```

Thus, the *HumanGraphic* class has all of the *public* methods in both the *Human* class and the *Graphic* class.

Several policy decisions were made during the generation of the proxy class. First, it was decided that only public methods would be exposed using this technique. Second, it was decided that the base *java.lang.Object* class should be eliminated from the generated proxy class. Thus, no member variables are made visible in the generated proxy class. Also, any *native, abstract,* or *final* modifiers are removed. Finally, any *static* declarations are re-declared to be dynamic, since an instance of the delegate is required for the proxy to work.

25.5.1 Implementation of *DelegateSynthesizer*

The implementation of *DelegateSynthesizer* was filled with special cases of various string manipulations and reflection routines. The goal is to provide support for a GUI that enables the programmer to disambiguate conflicting method signatures. Figure 25.5.1-1 shows an image of a GUI that enables the programmer to disambiguate conflicting method names using a manual selection technique.

The *disambiguation dialog* will generate a proxy class using either topological sorting or manual selection. In fact, if the preference is automatic selection, there is no need for a GUI at all (i.e., we can let the process work automatically). If the programmer would like to select the methods to be used, some sort of GUI simplifies the process.

Several string manipulation procedures are used to simplify the presentation of instances and methods. For example, to strip the package name from a string, we use

```
    public static String stripPackageName(String s) {
      int index = s.lastIndexOf('.');
      if (index == -1) return s;
      index++;
      return s.substring(index);
    }
```

Proper naming also is required. For example, the default string representation of the name of an array of classes is

```
    [Ljava.lang.Class
```

To get the type name to look like an array, we use

```
    public static String getTypeName(Class type) {

      if (! type.isArray())
        return type.getName();
```

FIGURE 25.5.1-1
The Disambiguation Dialog

```
Class cl = type;
int dimensions = 0;
while (cl.isArray()) {
    dimensions++;
    cl = cl.getComponentType();
}
StringBuffer sb = new StringBuffer();
sb.append(cl.getName());

for (int i = 0; i < dimensions; i++)
    sb.append("[]");

return sb.toString();
}
```

Which yields types like

```
java.lang.Class[]
```

To get the parameters for a method, we use

```
public String getParameters(Method m) {
  StringBuffer sb = new StringBuffer("");
  Class[] params = m.getParameterTypes(); // avoid clone
    for (int j = 0; j < params.length; j++) {
    sb.append(
      getTypeName(params[j])+ " v"+j);
  if (j < (params.length - 1))
      sb.append(",");
  }
  return sb.toString();
}
```

which allows for multiple parameters with synthesized variable names, such as

```
public java.lang.reflect.Method getMethod(
    java.lang.String v0,java.lang.Class[] v1){
  return class.getMethod(v0,v1);
}
```

To get the parameters for a lengthy delegation constructor, we use

```
public String getConstructorParameters() {
  StringBuffer sb = new StringBuffer("\n\t");
  for (int i=0; i < instanceList.size(); i++) {
    ReflectUtil ru = new ReflectUtil(
        instanceList.elementAt(i));
    String instanceName =

    stripPackageName(ru.getClassName()).toLowerCase();
    sb.append(ru.getClassName()
        + " _"
        + instanceName
    );
    if (i < instanceList.size() - 1)
        sb.append(",\n\t");
  }
  return sb.toString();
}
```

The above code allows us to get the parameters of a constructor formed from the *Class* class and the *ReflectUtil* class. For example,

```
// constructor:
public ClassReflectUtil(
    java.lang.Class _class,
    ReflectUtil _reflectutil){
    class = _class;
    reflectutil = _reflectutil;
}
```

The constructor's body is obtained using

```
private String getConstructorBody() {
  StringBuffer sb = new StringBuffer("\n\t");
```

```
          for (int i=0; i < instanceList.size(); i++) {
            ReflectUtil ru = new ReflectUtil(
                instanceList.elementAt(i));
            String instanceName =

            stripPackageName(ru.getClassName()).toLowerCase();
            sb.append(
                instanceName
                + " = _"
                + instanceName
                + ";"
            );
            if (i < instanceList.size() - 1)
                sb.append("\n\t");
        }
        return sb.toString();
    }
```

25.5.2 *DelegateSynthesizer*

The code for *DelegateSynthesizer* follows:

```
1.      import java.lang.reflect.*;
2.      import java.util.*;
3.
4.      public class DelegateSynthesizer {
5.        private String className = "";
6.        private String methodList = "";
7.        private Vector instanceList ;
8.
```

 Vector holds a list of instances that are processed during the construction. For example,

```
9.      public DelegateSynthesizer(Vector _instanceList) {
10.         instanceList = _instanceList;
11.         for (int i=0; i < instanceList.size(); i++)
12.             processInstance(instanceList.elementAt(i));
13.     }
14.
```

 The *getConstructorParameters* method returns a string that will pass in the instances to be used for the delegation. Instance names are formulated by taking class names, converting them to lowercase, and prepending them with an '_' character. For example,

```
15.     public String getConstructorParameters() {
16.         StringBuffer sb = new StringBuffer("\n\t");
17.         for (int i=0; i < instanceList.size(); i++) {
18.             ReflectUtil ru = new ReflectUtil(
19.                 instanceList.elementAt(i));
20.             String instanceName =
21.
            stripPackageName(ru.getClassName()).toLowerCase();
```

```
22.                    sb.append(ru.getClassName()
23.                       + " _"
24.                       + instanceName
25.                    );
26.                    if (i < instanceList.size() - 1)
27.                        sb.append(",\n\t");
28.                }
29.                return sb.toString();
30.        }
```

 The *getConstructorBody* method performs a series of operations so that the delegates are held internally by the synthesized class. The member variable names are formulated by using the class names, without the package prefix, after conversion to lowercase. For example,

```
31.        private String getConstructorBody() {
32.            StringBuffer sb = new StringBuffer("\n\t");
33.            for (int i=0; i < instanceList.size(); i++) {
34.                ReflectUtil ru = new ReflectUtil(
35.                    instanceList.elementAt(i));
36.                String instanceName =
37.
           stripPackageName(ru.getClassName()).toLowerCase();
38.                sb.append(
39.                    instanceName
40.                    + " = _"
41.                    + instanceName
42.                    + ";"
43.                );
44.                if (i < instanceList.size() - 1)
45.                    sb.append("\n\t");
46.            }
47.            return sb.toString();
48.        }
49.
```

 The *processInstance* method is invoked by the constructor. It synthesizes the proxy class using a name that concatenates the class names without the package names. For example,

```
50.        private void processInstance(Object o) {
51.            ReflectUtil ru = new ReflectUtil(o);
52.            String cn = stripPackageName(ru.getClassName());
53.            String instanceName = cn.toLowerCase();
54.            className = className +
55.                stripPackageName(cn);
56.            Method m[] = ru.getAllMethods();
57.            methodList = methodList
58.                + " "+ ru.getClassName() +" "+ instanceName + ";\n"
59.                + getMethodList(m,instanceName);
60.        }
```

The *getMethodList* method uses an array of methods to create the Java code needed to delegate to an instance. For example,

```
61.     public String getMethodList(Method m[],String
        instance Name) {
62.         String s = "";
63.         for (int i=0; i < m.length; i++)
64.             s = s + getMethodDeclaration(m[i],
        instanceName) + "\n";
65.         return s;
66.     }
```

The *getMethodDeclaration* method works on public methods. The declaration makes use of parameters and an instance that is to serve as the delegate for the implementation of the method. For example,

```
67.     public String getMethodDeclaration(Method m, String
        instanceName) {
68.         if (isPublic(m))
69.             return "\t"
70.                 + "public" // strip out other modifiers.
71.                 + " "
72.                 + getReturnType(m)
73.                 + " "
74.                 + m.getName()
75.                 + "("
76.                 + getParameters(m)
77.                 + "){\n\t"
78.                 + getInvocation(m,instanceName)
79.                 + "\t}";
80.         return "";
81.     }
```

The *getReturnType* method uses reflection to obtain the type of the return. It then uses *getTypeName* to map that type into a string. The string papers over the string normally returned to make it Java compatible. For example,

```
82.     public static String getReturnType(Method m) {
83.         return  getTypeName(m.getReturnType());
84.     }
85.
```

The *isReturningVoid* method returns *true* if the method returns *void*. For example,

```
86.     public static boolean isReturningVoid(Method m) {
87.         return getReturnType(m).startsWith("void");
88.     }
```

The *getModifiers* method returns a string of all of the modifiers (e.g., public static abstract). For example,

```
89.        public static String getModifiers(Method m) {
90.            return Modifier.toString(m.getModifiers());
91.        }
```

When formulating the delegation, we must not return in the body of the delegation method if the method returns *void*. Thus, we get a string that represents an *optional* return:

```
92.        private String getOptionalReturn(Method m) {
93.            if (isReturningVoid(m)) return "";
94.            return "return ";
95.        }
```

The *getInvocation* class synthesizes a series of variables (e.g., *v0, v1*, and *v2*), which are used when formulating the delegation. For example,

```
96.        private String getInvocation(Method m, String
           instanceName) {
97.            StringBuffer sb = new StringBuffer(
98.                "\t"
99.              + getOptionalReturn(m)
100.                     + instanceName
101.                     + "."
102.                     + m.getName()
103.                     + "("
104.                );
105.            Class[] params = m.getParameterTypes();
106.
107.            for (int j=0; j < params.length; j++) {
108.                sb.append("v"+j);
109.                if (j < (params.length - 1))
110.                    sb.append(",");
111.            }
112.            sb.append(");\n");
113.            return sb.toString();
114.        }
```

The *getParameters* method is used by *getMethodDeclaration* to obtain the arguments to the proxy classes' presentation to the outside word. For example,

```
115.            public String getParameters(Method m) {
116.                StringBuffer sb = new StringBuffer("");
117.                Class[] params = m.getParameterTypes();
// avoid clone
118.                for (int j = 0; j < params.length; j++) {
119.                    sb.append(
120.                        getTypeName(params[j])+ " v"+j);
121.                    if (j < (params.length - 1))
122.                        sb.append(",");
123.                }
124.                return sb.toString();
125.            }
126.
```

 The *getTypeName* method is a helper method that maps the type into a name that can be compiled by Java. The work occurs when the type is not an array. For example,

```
127.         public static String
                 getTypeName(Class type) {
128.
129.             if (! type.isArray())
130.                 return type.getName();
131.
132.             Class cl = type;
133.             int dimensions = 0;
134.             while (cl.isArray()) {
135.                 dimensions++;
136.                 cl = cl.getComponentType();
137.             }
138.             StringBuffer sb = new StringBuffer();
139.             sb.append(cl.getName());
140.
141.             for (int i = 0; i < dimensions; i++)
142.                 sb.append("[]");
143.
144.             return sb.toString();
145.         }
146.
147.
```

 The *isPublic* method is used to determine if a method will be used for delegation. The policy is that only public methods will be available for delegation. If you want to change this policy, you could create an *isPublicOrDefault* method, which would return *true* if default visibility were to be passed to delegates. This method might be used to transform methods with default visibility into *public* methods for interpackage communication via a *facade*. See Section 25.1 for more information about facades.

```
148.         public static boolean isPublic(Method m) {
149.             return
150.             Modifier.toString(
                 m.getModifiers()).startsWith("public");
151.         }
```

 We lop off the package name to create instance names for the delegates, which is done via a simple string manipulation. A more robust approach might be used that senses if the resulting string, when converted to lowercase, is a reserved word. In such cases, a simple alteration to the string is in order, and this might be a good place to do it.

```
152.         public static String stripPackageName(String s) {
153.             int index = s.lastIndexOf('.');
154.             if (index == -1) return s;
155.             index++;
156.             return s.substring(index);
157.         }
```

The first pass, performed during construction, instantiates a series of member variables in *DelegateSynthesizer*. These variables are used to permit the creation of the constructor body. If this code were to be optimized, it would be to transform it into a single-pass process. As it is, speed is not a factor.

```
158.                    private String getConstructor() {
159.                        // public className(class1 _class1Instance,
         class2 _class2Instance...) {
160.                        //    class1Instance = _class1Instance;
161.                        //  class2Instance = _class2Instance;
162.                        //}
163.                        return "\n// constructor: \npublic "
164.                            + className
165.                            + "("
166.                            + getConstructorParameters()
167.                            +"){"
168.                            + getConstructorBody()
169.                            + "\n}\n\n";
170.                    }
```

The *getClassString* method is the top-level means for generating the proxy class. If the output is to be retargetted to a live on-line compiler, a swing interface, or a file, this would be the method to call. It can be wrapped easily so that the code generated can be redirected.

```
171.                    public String getClassString() {
172.                        return
173.     "// automatically generated by the DelegateSynthesizer"
174.                        +"\npublic class "
175.                        + className
176.                        + " {\n"
177.                        + getConstructor()
178.                        + methodList
179.                        + "}\n";
180.                    }
181.                    public void print() {
182.                        print(getClassString());
183.                    }
184.                    private void print(Object o) {
185.                        System.out.println(o);
186.                    }
187.
188.
```

The following code example generates a proxy for the *DelegateSynthesizerReflectUtil* class. This class combines the public methods of both the *DelegateSynthesizer* and the *ReflectUtil* classes. Thus, *DelegateSynthesizer* can generate delegates for itself.

```
189.                    public static void main(String args[]) {
190.                        Vector v = new Vector();
```

```
191.                              v.addElement(
                                     new DelegateSynthesizer(v).getClass());
192.                              v.addElement(new ReflectUtil(v));
193.                              v.addElement(new DelegateSynthesizer(v));
194.                              DelegateSynthesizer ds =
                                     new DelegateSynthesizer(v);
195.                              ds.print();
196.                        }
197.            }
```

25.6 Summary

We have reviewed different techniques for adding features to classes. We discussed using language extension to add delegation, language extension to add multiple inheritance, API extension to add delegation, and API extension to add manual delegation. Approaches that use language extension fail for pragmatic reasons (e.g., lack of compatible tools, slow adoption, and slow code). Approaches that use API extension are easier to deploy in general since they work with existing frameworks.

There are two basic kinds of delegation: dynamic and static. Dynamic delegation works at run time and makes type safety impossible. Static delegation works at compile time and is generally type safe. In addition, there are two kinds of static delegation: manual and automatic. Manual delegation requires programmers to generate method-forwarding code, a process that is both error prone and tedious. Automatic static delegation has been shown to be an easy-to-deploy technique that gives programmers the freedom to generate large proxy classes that are both type safe and easy to understand.

DESIGN PATTERN
Automatic synthesis of the proxy-class technique makes modification of the method-forwarding mechanics trivial. It also isolates client code from changes in the interfaces in the delegates (called the *adapter* pattern). The adapter controls the brittleness of a subsystem from propagating to client classes. As changes (i.e., deprecations) are introduced into an API, the rest of the system can remain unchanged. The synthesis technique shown here allows for incremental checking of the synthesized code in an interactive system. It also allows for the resolution of ambiguity using topological sorting in an automatic fashion.

There are several problems with the automatic-delegation code generated from reflection. Exception handling will have to be supported explicitly, if desired, inside the delegate method. It was clear that the throws clause should be added to the methods that throw exceptions, or that they should be handled locally. As a result, exceptions are propagated automatically to the invoking methods.

DESIGN PATTERN
If the programmer wants to handle exceptions in the proxy class, doing so would alter the responsibility of the proxy class and make it into an example of the *decorator* pattern [Gamma et. al.].

Any methods that commonly are held in two or more delegate instances will have a name-space conflict. It is not clear how to resolve these conflicts automatically. If we use topo-logical sorting, as does C++, we may have the same fruitful source of bugs that C++ has. As a result, we have adopted a policy that programmers must decide how to resolve con-flicting method names. Such decisions are not easy. For example, if the generated code re-moved duplicate method declaration, what would be a reasonable policy to use? Suppose that a *Human* knows how to print itself using a *print* statement and suppose that the *Graphic* class has a *print* statement. It might be reasonable to print both delegates. On the other hand, suppose both have a *toString* method. In that case, it might be reasonable to concatenate the *toString* results from both instances. Thus, the programmer must intervene to correct the duplication of method signatures.

If the name of a class has an uppercase version of a reserved word (like the class *Class*), then the delegate synthesizer will generate code that will fail to compile because it is not smart enough to know the reserved word when it sees one. Aside from making the code smarter, a simple replace string (executed by the programmer) will fix the problem.

The *facade* design pattern creates a single class that communicates with a collection of related classes. For example, *ReflectUtil, Class, and DelegationSynthesizer* all are relat-ed to introspection. The *DelegationSynthesizer* can be used to create a proxy class that del-egates to itself and to the *ReflectUtil* and *Class* classes. Client instances need only be aware of the new *ReflectUtilClassDelegationSynthesizer*, which protects clients from changes in the API (i.e., deprecation). It can also shield clients from the complexity of using individ-ual classes, which is particularly true if the programmer takes care to simplify the con-structor of the facade. This also prevents knowledge of the order of construction from being required in the client classes.

DESIGN PATTERN
If the specification changes on the delegate and the proxy alters the forwarding methods to protect the client classes from the change, then the proxy ceases to be a simple proxy. Instead, the proxy becomes an example of the *adapter* pattern, stabiliz-ing the interface seen by the clients [Gamma et. al.].

The approach to delegation using static binding enables inlining of code. Inlining optimizes the code by eliminating forwarding methods by the compiler when possible. Thus, unlike dynamic delegation, static delegation does not suffer from performance degradation.

In brief:

1. Dynamic delegation is more automatic than static delegation.
2. Dynamic delegation is not type safe, but static delegation is.
3. Automatic static delegation is almost as automatic as dynamic delegation, and it is just as type safe as static delegation.

The choice between static and dynamic typing is like the choice between safety and flexi-bility. [Agesen et. al.].

Multiple inheritance is not an option in Java. The following are some heuristics for the use of the approach outline in this chapter:

- If polymorphism is needed, then use the automatically generated interface stubs that our API provides.
- If proxies are needed, then use our API for generating proxies.

- If source code is unavailable, there may be little other choice.
- If source code is available, refactoring by hand may lead to better code, but it also may have an effect on a large number of client classes and require testing.
- If many programmers require a stable interface, then use the automatically generated interface stubs and create a facade for a contract that enables control and use of the subsystem.
- The proxy should be used to reuse the implementations. In the case where contracts shift in the delegates, allow the facade to become an adapter facade proxy in order to protect your clients.

Deepening subclasses in order to add features is a fast way to create poor code that is very fragile. It is also a poor way to introduce subtyping. Only use subclasses if the class theoretic approach is appropriate to the domain, and then only if the taxonomic hierarchy is unlikely to change.

25.7 Exercises

25.1 What is a proxy? Give some examples.

25.2 What is the bridge pattern? Why do you need it? What are some examples where a bridge pattern is used?

25.3 What is message forwarding? Can message forwarding be done in a procedural language? Why or why not?

25.4 (See Appendix E for more info on Javadoc.) The generated code of *DelegateSynthesizer* would improve if it included the Javadoc from the delegate's method in its output code, which would enable preservation of the input documentation. Unfortunately, access to the source code would be required for this to work. Modify the program so that the user is prompted for the source code and pass the Javadoc in the source code to the proxy class.

25.5 Alter the GUI so that it presents an option to generate code using ambiguous output, semi-automatic disambiguation, or topological sorting.

Introduction to Drawing Shapes

by Douglas Lyon and Allison McHenry

> **Many men go fishing all of their lives without knowing that it is not fish they are after.**
>
> *–Henry David Thoreau 1817–1862*

In this chapter, you will learn:

- How to draw with Java
- Some of the more important methods in the *Graphics* class
- How to take an equation and use it to draw

This chapter provides an overview of simple two-dimensional graphics in Java. Thorough coverage of this topic can be found in [Chan et. al.]. Our approach is to cover the material that is essential to understanding how to make graphic programs draw simple shapes. The following chapter covers the *Color* class, the drawing of text, and the elements needed to create simple business graphics.

AWT in Java provides several services including:

- Two-dimensional drawing
- Paint, repaint, and update

In AWT, events are centered on a method called *paint*. The *paint* method is called asynchronously upon initialization of a class or if the screen display is damaged. A sketch depicting the methods and their relationship is shown in Figure 26.1.

 It is typically up to the window system to invoke the *paint* method.

An exception to this rule is *buffered-image drawing*. In buffered-image drawing, the *paint method* is used to draw on an off-screen buffer. After the drawing is done, the buffered image is drawn all at once, avoiding flicker.

FIGURE 26.1

Relationship between Drawing Methods

The *update* method is invoked by the AWT event dispatcher. Typically, the programmer schedules *update* and *paint* invocations with an invocation of the *repaint* method.

The *paint*, *repaint*, and *update* methods are known as *Component* class methods. The *Component* class resides in the *java.awt* package and is the base class of all classes in AWT. The *repaint* method has three common forms:

```
public void repaint();
public void repaint(long t);
public void repaint(int x, int y, int w, int h);
public void repaint(long t, int x, int y, int w, int h);
```

An invocation of *repaint* with an argument for time, *t*, will schedule an invocation of the *update* method within *t* milliseconds. *Update* is a method that repaints a component by invoking the *paint* method.

26.1 The Graphics Class

The *Graphics* class is used to draw lines, shapes, images, and characters. The *Graphics* class resides in the java.awt package and is an abstract base class. Since the *Graphics* class is abstract, it may never be created by the invocation of *new*. Instead, it is created by an instance of a *Component*. The *Graphics* class has a default coordinate system, as shown in Figure 26.1-1.

When drawing in AWT, it is typical for a *Component* to invoke its *paint* method. As a result, the program writes code in the form

```
public void paint(Graphics g) {
        g.draw......//insert draw commands here.
// coordinates are expressed in pixels.
}
```

When using *JComponents* (as with *JPanel*), it is better practice to override the *paintComponent* method rather than the *paint* method because Swing performs *double buffering*.

Double buffering means that the drawing occurs off-screen and then is swapped in for the display image all at once. Either way, an instance of the *Graphics* class is passed, and the programmer must have a good idea of what methods are available.

FIGURE 26.1-1

The Default Coordinate System of the
Graphics Class

26.1.1 *Graphics* Class Summary

The *Graphics* class has many methods in it that relate to low-level drawing. It is a good idea to have at least a passing glance at some of these methods, even if you cannot memorize them:

```
public abstract class Graphics {
  public abstract Graphics create()
  public Graphics create(int x, int y, int width, int height)
  public abstract void translate(int x, int y)
  public abstract Color getColor()
  public abstract void setColor(Color c)
  public abstract void setPaintMode()
  public abstract void setXORMode(Color c1)
  public abstract Font getFont()
  public abstract void setFont(Font font)
  public FontMetrics getFontMetrics()
  public abstract FontMetrics getFontMetrics(Font f)
  public abstract Rectangle getClipRect()
  public abstract void clipRect(
      int x, int y, int width, int height)
  public abstract void copyArea(
      int x, int y, int width, int height, int dx, int dy)
  public abstract void drawLine(
      int x1, int y1, int x2, int y2)
  public abstract void fillRect(
      int x, int y, int width, int height)
  public void drawRect(int x, int y, int width, int height)
  public abstract void clearRect(
      int x, int y, int width, int height)
  public abstract void drawRoundRect(
      int x, int y, int width, int height, int arcWidth, int
        arcHeight)
```

```
            public abstract void fillRoundRect(
                int x, int y, int width, int height,
                int arcWidth, int arcHeight)
            public void draw3DRect(
                int x, int y, int width, int height, boolean raised)
            public void fill3DRect(
                int x, int y, int width, int height, boolean raised)
            public abstract void drawOval(
                int x, int y, int width, int height)
            public abstract void fillOval(
                int x, int y, int width, int height)
            public abstract void drawArc(int x, int y, int width, int
                    height, int startAngle, int arcAngle)
            public abstract void fillArc(int x, int y, int width, int
                    height, int startAngle, int arcAngle)
            public abstract void drawPolygon(
                int xPoints[], int yPoints[], int nPoints)
            public void drawPolygon(Polygon p)
            public abstract void fillPolygon(
                int xPoints[], int yPoints[], int nPoints)
            public void fillPolygon(Polygon p)
            public abstract void drawString(String str, int x, int y)
            public void drawChars(
                char data[], int offset, int length, int x, int y)
            public void drawBytes(
                byte data[], int offset, int length, int x, int y)
            public abstract boolean drawImage(
                Image img, int x, int y,  ImageObserver observer)
            public abstract boolean drawImage(
                Image img, int x, int y,
                int width, int height,  ImageObserver observer)
            public abstract boolean drawImage(
                Image img, int x, int y,
                Color bgcolor, ImageObserver observer)

            public abstract boolean drawImage(
                Image img, int x, int y,
                int width, int height,
                Color bgcolor, ImageObserver observer)
            public String toString()
        }
```

As you can see from the list, the *Graphics* class is not designed to be memorized and is not very object oriented. It is easy to forget, for example, the order of the parameters needed for *drawString*. Was the order string and then location (yes!), or was the order location and then string (no!). I always get the order backwards.

WARNING
The idea that programmers should have to memorize parameter order is probably not a good one. No programmers I know can memorize an API (nor should they!).

26.1.2 *Graphics* Class Methods

The *Graphics* class supports a simple raster graphics package. Suppose the following constants are predefined:

```
Color aColor;
Graphics g;
Rectangle aRectangle;
int x, y, x1, y1, x2, y2;
Boolean raised;
int height, width, arcHeight, arcWidth;
int nPoint;
int xArray[];
int yArray[];
char charArray[];
int numberOfItemToDraw;
int offsetIntoArray;
byte byteArray[];
Image img;
ImageObserver anImageObserver;
```

A *Graphics* instance is passed to a programmer in the *paint* method. For example,

```
public void paint(Graphics g) {
       // your graphics code here.
}
```

The color methods for getting and setting the foreground color of the *graphics* instance are

```
aColor = g.getColor();
g.setColor(aColor);
```

The paint methods for setting the *graphics* instance to overwrite or to erase XOR mode :

```
g.setPaintMode();
g.setXORMode(aColor);
```

The *Graphics* class supports a method for painting a rectangle with the background color:

```
clearRect(int x, int y, int width, int height);
// number of coordinates in the xArray, yArray
// to process (i.e., draw)
```

To translate the coordinates of the *Graphics* instance, use

```
g.translate(x, y);
```

To get and set the fonts of the *Graphics* instance, use

```
aFont = g.getFont();
g.setFont(aFont);
```

To get the font metrics for a *graphics* instance or for a font, use

```
theFontMetrics = g.getFontMetrics();
theFontMetrics = g.getFontMetrics(aFont);
```

To get the clipping rectangle, use

```
aRectangle = g.getClipRect();
```

To shrink the clipping rectangle, use

```
g.clipRect(x, y, width, height);
```

To copy and translate a rectangular area of the screen by *dx*, *dy*, use

```
g.copyArea(x, y, width, height, dx, dy);
```

To draw a line between *x1*, *y1* and *x2*, *y2*, use

```
g.drawLine(x1, y1, x2, y2);
```

To fill a rectangle with the current color, use

```
g.fillRect(x, y, width, height);
```

To draw a rectangle outline with the current color, use

```
g.drawRect(x, y, width, height);
```

To clear a rectangular area of the screen, AWT draws a rectangle with the current background color:

```
g.clearRect(x, y, width, height);
```

AWT provides rounded-shape drawing. When a rounded shape is drawn, *arcWidth* and *arcHeight* are used. The *arcWidth* and *arcHeight* are the width and height of an ellipse used to draw the rounded corners. To draw the outline of a rectangle with rounded corners using the current color, use

```
g.drawRoundRect(x, y, width, height, arcWidth, arcHeight);
```

To draw a filled rectangle with rounded corners using the current color, use

```
g.fillRoundRect(x, y, width, height, arcWidth, arcHeight);
```

To draw a highlighted three-dimensional rectangle using two colors, use

```
g.draw3DRect(x, y, width, height, raised);
```

If *raised* is *true*, the rectangle appears raised, which currently is implemented using darker and brighter colors to create highlights. The same rectangle also may be drawn filled:

```
g.fill3DRect(x, y, width, height, raised);
```

To draw an oval outline or a filled oval, use:

```
g.drawOval(x, y, width, height);
g.fillOval(x, y, width, height);
```

To draw an arc inscribed in a rectangle starting at *startAngle* and ending at *startAngle* + *arcAngle*, use:

```
g.drawArc(x, y, width, height, startAngle, arcAngle);
```

Angles are measured in degrees. Zero degrees is parallel to the *X*-axis, and positive angles are measured in a counterclockwise direction. For the filled form of the arc, use

```
g.fillArc(x, y, width, height, startAngle, arcAngle);
```

To draw a polygon using an array of *x* and *y* coordinates, use

```
g.drawPolygon(xArray, yArray, nPoints);
```

To draw a polygon using an instance of the Polygon class, use

```
g.drawPolygon(aPolygon);
```

The drawPolygon method is implemented with a call to

```
drawPolygon(aPolygon.xpoints, aPolygon.ypoints,
        aPolygon.npoints);
```

To fill the polygon with the current color, use

```
g.fillPolygon(xArray, yArray, nPoints);
```

There must be more than three points or the Polygon call is ignored. Further, if the polygon has overlapping parts, the even-odd fill rule is used. The even-odd fill rule typically is implemented using a scan line that is drawn from left to right. If the scan line crosses the edge of the polygon an odd number of times, the pixels are inside the polygon and will be filled; otherwise the pixels fall outside the polygon. This is a typical approach to filling concave polygons.

```
g.fillPolygon(aPolygon);
```

To draw a string using the current font and color starting at *x, y*, use

```
String str = "Java is fun";
g.drawString(str,x,y);
```

To draw a character array using the current font and color starting at *x, y*, use

```
g.drawChars(charArray, offsetIntoArray, numberOfItemToDraw,
        x, y);
g.drawBytes(byteArray,  offsetIntoArray,
        numberOfCharactersToDraw, x, y)
```

To draw an image at *x, y* and notify *anImageObserver*, use

```
aBoolean = g.drawImage(img, x, y, anImageObserver);
```

To draw an image inside a rectangle (with optional scaling), use

```
aBoolean = g.drawImage(
    img, x, y, width, height, anImageObserver);
```

To draw an image with a background color, use

```
aBoolean = g.drawImage(img, x, y, aColor, anImageObserver);
```

To draw an image with a background color and in a rectangle, use

```
aBoolean = g.drawImage(
    img, x, y, width, height, aColor, anImageObserver);
```

See Chapter 27 for a discussion on how to draw an image.

To convert the Graphics instance into a string, use

```
g.toString();
```

The following code snippet shows an animation loop that is displaying images in a synchronized method. We wait for the image to be drawn before we try to get the next image to draw. For example,

```
class Animation implements Runnable {
    public void synchronized run() {
```

```
        while (moreImages()) {
           repaint();
           try { wait();} catch (InterruptedException e){}
        }
      }
      public synchronized void paint(Graphics g) {
         g.drawImage(getNextImage(),0,0,null);
         notify();
      }
   }
```

So, when an image is painted, it happens all at once, blocking execution of other threads. When the paint is done, the instance notifies itself that it can check for more images and then schedules a repaint using the implicit AWT damage-control managers thread.

The following sections give practical examples for the use of the methods in the *Graphics* class.

26.1.3 The *Radar* Class

In this section, we show how to use the *Graphics* class to make an animated radar sweep across the screen. Two screen shots of the radar at various positions are shown in Figure 26.1.3-1.

We use a parameterized equation for a circle to perform the drawing:

$$x_r = x_c + r\cos(\theta) \tag{26.1.3-1}$$

$$y_r = y_c + r\sin(\theta)$$

where

> circle center $= (x_c, y_c)$
> point on radius $= (x_r, y_r)$
> circle radius $= r$
> and
> angle in radians $= \theta$.

This equation is shown in Figure 26.1.3-2.

As the radial arm of the circle sweeps the perimeter, it appears to look like a radar sweep.

 The *Radar* class extends the *Canvas* component from AWT, which enables it to be treated just like any other component. The layout manager will be able to move it around, and other components can be added to the same container that holds instances of the *Radar* class.

FIGURE 26.1.3-1

The Radar at Various Positions

FIGURE 26.1.3-2

Sketch of the Circle

```
package gui;

import java.awt.*;
import java.awt.event.*;
import javax.swing.*;

public class Radar extends Canvas {

      double thetaInRadians = 0;

// The size of the Radar is set upon construction:
      Radar(int w, int h) {
        setSize(w,h);
      }

      public void paint(Graphics g) {
/*
The Radar can be resized at any time. It is best if drawing
      is relative to the given size of the component. The
      Dimension class holds both the width and the height
      members. These numbers are in pixels.
*/
      Dimension d = getSize();
      double deltaTheta =
        Math.PI/180.0;
      int width = d.width;
      int height = d.height;
      int xc=width/2;
      int yc=height/2;
/*
If the Radar is to be rectangular, we don't want its sweep
      arm to extend beyond the boundaries:
*/
      int r = Math.min(xc,yc);
/*
An implementation of (26.1.3-1) follows:
*/
```

```
        double xr =
           r*Math.cos(thetaInRadians) + xc;
        double yr =
           r*Math.sin(thetaInRadians) + yc;
   /*
   Altering the deltaTheta will alter the increment that we see
           for each line drawn:
   */
        thetaInRadians = thetaInRadians + deltaTheta;
```

 The *repaint* method schedules another *repaint* in 10 milliseconds. See Section 15.7 for more information.

```
        g.drawLine(xc,yc,(int)xr,(int)yr);
        repaint(10);
      }
    public static void main(String args[]) {
      ClosableJFrame cf = new ClosableJFrame();
      Container c = cf.getContentPane();
      c.add(new Radar(200,200));
      c.setLayout(
        new FlowLayout());
      cf.setSize(200,200);
      cf.setVisible(true);
      }
   }
```

26.2 Spiral Components

> The reasonable man adapts himself to the world; the unreasonable one persists to adapt the world to himself. Therefore all progress depends on the unreasonable man.
>
> *–George Bernard Shaw,*
> *writer, Nobel laureate (1856–1950)*

This chapter shows how to build custom components using the *Graphics* and *JComponent* classes. These components will be used to draw spirals. Components are important because we can use the layout manager to lay them out automatically.

A *spiral* is a curve that traces out a path around a point called the *pole*. The pole is the center of the tracing activity. The distance from the pole to a point on the trace of the curve is called the *radius*. The radius for a spiral is an increasing function of the angle the trace makes with respect to a coordinate axis embedded in the plane. The actual function that controls the radius determines the type of spiral.

Figure 26.2-1 shows how to place a point in a Cartesian coordinate plane using polar coordinates. Typically, the point is located at

$$x_1 = r \cos(\theta)$$

$$y_1 = r \sin(\theta) \qquad (26.2\text{-}1)$$

assuming that the origin of the plane is at location (0,0).

FIGURE 26.2-1

Polar Coordinates

The reason we study spirals is that they allow us to use what we have learned in this chapter to create systems that model nature. The spiral can be found in conch shells, the layout of seeds in a daisy, and in the arts. Polar coordinate geometry leads to decentralized eye movement, which has been used as an aid to meditation. The mandala of Hinduism and Buddism is an example of a spritual symbol that assists in mediation. It, too, has a polar-coordinate symmetry with symbols that vary in radius from the center, just like the spiral.

All of this suggests that it may be possible to create a kind of computer-animated wallpaper that has meditational use.

26.2.1 The *Spiral* Class

The *Spiral* class provides a framework for the creation of spirals. For example,

```
public static void main(String args[]) {
   ClosableJFrame cf = new ClosableJFrame();
   Container c = cf.getContentPane();
   c.add(getArchimedesSpiral());
   cf.setSize(200,200);
   cf.setVisible(true);
}
```

will output the image shown in Figure 26.2.1-1.

FIGURE 26.2.1-1

Archimedes' Spiral

Thus, the *Spiral* class has the ability to create Swing components that may be added to containers.

26.2.2 Archimedes' Spiral

Archimedes' spiral is given by

$$r = k * \theta. \qquad (26.2.2\text{-}1)$$

Equation (26.2.2-1) says that Archimedes' spiral has a radius that increases as a function of the product of the angle and some constant k. We implement equation (26.2.2-1) using

```
public double archimedes(
    double k, double theta) {
  return k * theta;
  }
/*
In order to create a drawing method that traces the locus of
        point on the spiral, we use a for loop to generate the
        angles and compute the various radii:
*/
public void archimedesSpiral(
    double k,Graphics g) {
  double theta=0;
  double r=archimedes(k,theta);
  movep(r,theta);
  for (int s=1; s < 12000;s++,theta+=3){
      r=archimedes(k,theta);
    drawp(r,theta,g);
  }
}
/*
We can see invocations of the polar coordinate graphics
        routines, movep and drawp. These methods are
        available, in source code, in the Spiral class:
*/
public void movep(int r, double a) {
  a = a * Math.PI/180 ;
  move((int)(r*Math.cos(a)), (int)(r*Math.sin(a)));
}
/*
The move method translates the current x and y locations by
        some fixed offset (tx and ty).
*/
public void move(int x, int y) {
  cx = x+tx;
  cy = y+ty;
}
/*
This enables the origin to be located at the center of the
        graph. This is done whenever the size of the spiral is
        set:
```

```
      */
            int tx = 60;
            int ty = 60;
         public  void setSize(Dimension d) {
           tx = d.width/2;
           ty = d.height/2;
         }
      /*
```
The polar coordinate draw routine *drawp* does a move after the
 drawing is complete:
```
      */
         public  void drawp(int r, double a, Graphics g) {
           a = a * Math.PI/180 ;
           draw((int)(r*Math.cos(a)), (int)(r*Math.sin(a)),g);
         }
         public  void draw(int x, int y, Graphics g) {
           g.drawLine(cx, cy, x+tx, (y+ty));
           move(x,y);
         }
      /*
```
Drawing using polar coordinates greatly simplifies the
 equations for expressing the spirals.
To get the spiral, we use the *factory* pattern to make an
 instance of an anonymous inner class that returns a
 lightweight component:
```
      */
         public static JComponent getArchimedesSpiral () {
           return new  JComponent() {
             Spirals s = new Spirals();
             public void paint(Graphics g) {
                 s.setSize(getSize());
                 s.archimedesSpiral(0.1,g);
             }
             public Dimension getPreferredSize() {
                 return new Dimension(200,200);
             }
           };
         }
```

The above code enables us to perform a layout using standard layout manager tools.

Archimedes' components are laid out using a *FlowLayout* manager instance and displayed in Figure 26.2.2-1. The code for laying out the components follows:

```
public static void main(String args[]) {
  ClosableJFrame cf = new ClosableJFrame();
  Container c = cf.getContentPane();
  c.setLayout(new FlowLayout());
  c.add(getArchimedesSpiral());
  c.add(getArchimedesSpiral());
  cf.setSize(200,200);
  cf.setVisible(true);
}
```

FIGURE 26.2.2-1

Archimedes' Components

26.2.3 Fermat's *SpiralComponent* Class

In this section, we demonstrate how to create Fermat's spiral as a component. The technique is to refactor the code of Section 26.2.2 Figure 26.2.3-1 shows an instance of Fermat's spiral.

Fermat's spiral is given by

$$r = k\sqrt{\theta}. \tag{26.2.3-1}$$

To demonstrate another way to create a *Component* and a means by which we can re-use code via sound object-oriented design, we present the *SpiralComponent:*

```
package gui;
import java.awt.*;
import javax.swing.*;

public abstract class SpiralComponent
      extends JComponent {
      Spirals s;
      public SpiralComponent(Dimension d) {
        s = new Spirals();
        s.setSize(d);
        setPreferredSize(d);
      }
/*
The rationale for creating an abstract paint method is to
      require subclasses of the SpiralComponent to implement
      paint.
*/
      public abstract void paint(Graphics g);
/*
Every SpiralComponent instance will delegate to a specific
```

FIGURE 26.2.3-1

Fermat's Spiral

```
      Spirals class instance.
*/
      public void setSize(Dimension d) {
        s.setSize(d);
      }
      public static void main(String args[]) {
        Dimension d = new Dimension(400,400);
        SpiralComponent sc = new SpiralComponent(d) {
          public void paint(Graphics g) {
              s.setSize(getSize());
              s.fermatsSpiral(1.1,Math.PI,g);
          }
        };
        ClosableJFrame cf = new ClosableJFrame();
        Container c = cf.getContentPane();
        c.setLayout(new FlowLayout());
        c.add(sc);
        cf.setSize(d);
        cf.setVisible(true);
      }
```

```
}
/*
The implementation of Fermat's spiral, in the Spirals class
        follows:
*/
      public    void fermatsSpiral(
          double k,
            double c,
            Graphics g) {
        double d = 360 / c;
        double a=0;
        for (int s=-600; s < 600;s++,a+=d){
            double r=Math.sqrt(a)*k;
          movep(r,a);
          drawHex(r,a,g);
        }
      }
/*
The new draw method is called drawHex. It draws a hexagon,
        given polar coordinates. The implementation of drawHex
        follows:
*/
      public void drawHex(double r, double a, Graphics g) {
        for (int t=0; t <= 6; t++) {
          double aa = 360 * t / 6 + a;
          double rr = 3;
          double x = rr * cos(aa) + r * cos(a);
          double y = rr * sin(aa) + r * sin(a);
          if (t==0) move(x,y);
          draw(x,y,g);
        }
      }
```

26.3 The Poor Man's Thread and Damage Control

In this section, we show how the AWT damage control manager can be used to cause a multithreaded repaint to occur in the background without making explicit references to any threads! You may recall that in Chapter 13 we mentioned that many threads run in the background. One of the threads manages damage when a window is hidden and then exposed. This damage is managed by the *damage control manager*. The damage control manager runs in a thread and schedules a *paint* invocation when damage is detected. We can take advantage of the damage control manager by invoking the *repaint* method. The *repaint* method takes a *long* integer that represents a length of time in milliseconds. For example,

```
public class PoorMansThread extends Frame {
      PoorMansThread() {
        setSize(200,200);
        setVisible(true);
      }
      public void paint(Graphics g) {
        g.drawString(
```

```
                    (new java.util.Date()).toString(),
                        50,50);
                repaint(1000);
            }
            public static void main(String args[]) {
                new PoorMansThread();
            }
        }
```

Such a program relies upon the built-in threading that permits a *paint* method to be invoked.

26.4 Summary

This chapter illustrated how to draw with Java. The native window systems association with the drawing methods showed that Java provides an API that is really just a wrapper around high-speed subroutines for drawing. The wrapper uses *Peet* methods to promote the procedural subroutines to a uniform, object-oriented API that is portable.

Central to the API for drawing is the *Graphics* class. The *Graphics* class was shown to be an abstract class that requires implementation by a subclass in order for drawing to work. Sometimes subclasses of the *Graphics* class do not draw on the screen at all, but instead output data. For example, when a printout is needed, it is probably better to output postscript to a file or a printer rather than display graphics on the screen. As a result, the *Graphics* class is reimplemented to output postscript. This enables polymorphism for the *Graphics* class.

This chapter also illustrated how to do simple 2D animation as well as draw simple 2D equations. Finally, we saw how to use a *repaint* method to take advantage of the AWT's damage control manager to perform simple screen updates.

26.5 Exercises

26.1 Write a program that draws a flower.

26.2 *SpiralComponent* has a *drawTree* method. Use *drawTree* to draw several trees. Use a random number to make the trees look a little different from one another.

26.3 Draw an animated stick figure using *repaint* to make the figure appear as though it is running.

26.4 Write a program that simulates a game called *Roach Motel*. In this game, five threads are created that draw a figure that represents a roach on the screen. The roach moves at random every time the thread is run. When roaches run into one another, a new thread, with a roach, is created. When the user clicks on a roach, the thread, along with the roach, is killed. In the center of the screen is a rectangle representing the motel. If the roaches touch the motel, they die. (Roaches check in, but they don't check out!)

26.5 Write a program that draws a house with walls and a roof. Using the *House* class, make instances of classes like *Wall* and *Roof*. Now, add an instance of a *Door* class. How can you arrange it so that each element is responsible for knowing how to paint itself?

26.6 Modify exercise 5 so that you are drawing 100 houses of different sizes in different locations.

C H A P T E R 2 7

Business Graphics with Color and Images

by Douglas Lyon and Allison McHenry

**Have more than thou showest,
Speak less than thou knowest.**

–William Shakespeare

In this chapter, you will learn how to:

- Create simple animation
- Use the color API
- Use fonts
- Generate business graphics
- Draw images

27.1 The Color Class

The *Color* class is a *public final class* that is based on a red, green, blue. (RGB) color model. The *Color* class has several *public final static* colors that are predefined. An instance of the *Color* class may be specified using two variants of the additive color synthesis system: (1) RGB or (2) hue, saturation, brightness (HSB). The **additive color synthesis** system is based on the premise that black is the absence of color and that white is the combination of all colors. For example, when red, green, and blue are combined in equal amounts, the resulting color is white, which is consistent with electronic displays that emit light. The complement color system, **subtractive synthesis**, is based on the premise that black is the combination of all colors and that white is the absence of color, which is a result of light-absorbing pigments that are applied to a white background. The subtractive synthesis color primaries are cyan, magenta, yellow (CMY).

 AWT does not support subtractive synthesis.

27.1.1　Color Class Summary

The *Color* class has several built-in color names that violate the naming convention that says constants should appear in all uppercase letters.

Also, as shown below, the color names do not represent a very complete list of colors.

```
public final class Color {
  public final static Color white
  public final static Color lightGray
  public final static Color gray
  public final static Color darkGray
  public final static Color black
  public final static Color red
  public final static Color pink
  public final static Color orange
  public final static Color yellow
  public final static Color green
  public final static Color magenta
  public final static Color cyan
  public final static Color blue
  public Color(int r, int g, int b)
  public Color(int rgb)
  public Color(float r, float g, float b)
  public int getRed()
  public int getGreen()
  public int getBlue()
  public int getRGB()
  public Color brighter()
  public Color darker()
  public int hashCode()
  public boolean equals(Object obj)
  public String toString()
  public static Color getColor(String nm)
  public static Color getColor(String nm, Color v)
  public static Color getColor(String nm, int v)
  public static int HSBtoRGB(
      float hue, float saturation, float brightness)
  public static float[] RGBtoHSB(
      int r, int g, int b, float[] hsbvals)
  public static Color getHSBColor(float h, float s, float b)
}
```

27.1.2　Color Class Usage

Suppose that the following variables are defined:

```
Color c,c1;
int r, g, b;
float rf, gf, bf;
int anInt;
```

Then, to access the built-in color names, use

```
c = Color.white;
c = Color.gray;
```

```
c = Color.lightGray;
c = Color.darkGray;
c = Color.black;
c = Color.red;
c = Color.pink;
c = Color.orange;
c = Color.yellow;
c = Color.green;
c = Color.magenta;
c = Color.cyan;
c = Color.blue;
```

To construct a new color, use

```
c = new Color(r, g, b);
```

WARNING

It is assumed that the *r*, *g*, and *b* quantities will range from 0 to 255. Truncation results if the range assumption is violated.

In fact, the color is typically a packed *int* consisting of a blue component in bits 0–7, a green component in bits 8–15, and a red component in bits 16–23. To instantiate a new color from an existing instance, use

```
c1 = new Color(c);
```

In Java, a pixel is stored as a 32-bit *int*. The *int* consists of 4 packed bytes that represent the alpha, red, green, blue (ARGB) planes, as shown in Figure 27.1.2-1. The 24 bits of RGB color depth give a total of 16.7 million colors ($16.7 \text{ million} = 2^{24}$).

The packed pixel is the most tightly packed storage technique available for a 32-bit pixel. However, there are problems with this approach. For example, encoding and decoding both require bit shift and masking operations, thus increasing computation time.

Suppose you are given a packed color pixel, as shown in Figure 27.1.2-1, and you want to average the RGB channels. A method that accomplishes this task follows:

```
public int filterRGB (int rgb) {
    int red   = (rgb & 0xff0000) >>16;
    int green = (rgb &   0xff00) >>  8;
    int blue  =  rgb &     0xff;
    int gray  = (red + green + blue) / 3;
    return (
           0xff000000 |
           (gray << 16) |
           (gray <<  8) |  gray);
}
```

The *filterRGB* method unpacks the pixel, performs the filtering operation, and then repacks the pixel. Three AND operations, three OR operations, and four SHIFT operations are needed to access the three colors. Consider that images typically range in size from a few

Alpha (8-bits)	Red (8-bits)	Green (8-bits)	Blue (8-bits)

|← ———————————— 32 bits ————————————→|

FIGURE 27.1.2-1
A Packed Pixel

hundred bytes to a few megabytes. In fact, million-pixel images are not that uncommon, particularly with modern scanner and camera technologies. This unpack-process-repack approach places overhead on pixel access.

To instantiate a new color from RGB components in the range from 0 to 1, inclusive, use

```
c = new Color(rf, gf, bf);
```

To get the components of a color, use

```
r = c.getRed();
r = c.getGreen();
r = c.getBlue();
```

To get a 24-bit RGB color packed into an *int* and typed as an *int*, use

```
anInt = c.getRGB();
```

To brighten or darken a color, use

```
c.brighter();
c.darker();
```

To obtain the color hashCode, which is implemented as *getRGB()*, use

```
anInt = c.hashCode();
```

To compare color values, use

```
aBoolean = c.equals(c2);
```

To convert to string, use

```
str = c.toString();
```

To get a color from the system property, use

```
String str; // The non-null name of a system property.
c = getColor(str);
```

If *nm* is a valid color property name, the *Integer* class can use the *getInteger* method to map the property name into a color, which is done with the following static methods:

```
c1 = Color.getColor(nm);
```

To return a color if the property name is undefined, use

```
c1 = Color.getColor(nm, aColor);
```

To return a color based on a 24-bit RGB color *int*, if the name is undefined, use

```
c1 = Color.getColor(nm, anInt);
```

Color properties must be set by the Java application; they are not predefined.
To convert a floating-point description of HSB to the RGB model (with a 24-bit int), use

```
float hue, saturation, brightness; // ranging from 0..1
          inclusive
anInt = Color.HSBtoRGB(hue, saturation, brightness);
```

To convert from RGB to HSB, there are two methods from which to choose:

```
float hsbvals[];
int r, g, b; // r, g and b range from 0..255
```

```
hsbvals = Color.RGBtoHSB(r, g, b, null);
Color.RGBtoHSB(r, g, b, hsbvals);
```

Both methods return three values in the *hsbvals* array.
To make an instance of a color from an HSB floating-point triplet, use

```
Color aColor = Color.HSBtoRGB(h, s, b);
```

27.1.3 Adding Color to the Radar

Color may be added to a component in several ways. If only a single background color and a single foreground color are needed, the simplest way to color a container and all of the components in it is

```
public static void main(String args[]) {
  ClosableJFrame cf = new ClosableJFrame();
  Container c = cf.getContentPane();
  c.add(new Radar(200,200));
```

To set the background and foreground colors, use

```
  c.setBackground(Color.red);
  c.setForeground(Color.green);
  c.setLayout(
    new FlowLayout());
  cf.setSize(200,200);
  cf.setVisible(true);
}
```

 WARNING

The trouble with this solution is that all of the components, including the button, etc., will inherit the same colorization scheme.

A better way is to colorize the components at a lower level, an example of which is shown in the following code fragment:

```
package gui;

import java.awt.*;
import java.awt.event.*;
import javax.swing.*;
public class Radar extends Canvas {

    double thetaInRadians = 0;

    Radar(int w, int h) {
      setSize(w,h);
      setBackground(Color.red);
      setForeground(Color.green);
    }
```

Another way to set the color is to set it for each item that you draw. This method is a very good one if you want several items of different colors to share the same component. In

such cases, the all items must share the same background, but the *drawing* color is set by a *Graphics.setColor* invocation, as illustrated in the following code fragment:

```
package gui;

import java.awt.*;
import java.awt.event.*;
import javax.swing.*;
public class Radar extends Canvas {

    double thetaInRadians = 0;

    Radar(int w, int h) {
      setSize(w,h);
      setBackground(Color.red);
    }

    public void paint(Graphics g) {

      Dimension d = getSize();
      double deltaTheta =
        Math.PI/180.0;
      int width = d.width;
      int height = d.height;
      int xc=width/2;
      int yc=height/2;
      g.setColor(Color.green);
```

27.1.4 Building a Color Map

The palest ink is better than the best memory.

–Chinese proverb

Sometimes we are given a finite number of data sets that are to be graphed in a system, and we must find a way to present the data. Often people employ color to identify a data point. One of the open questions in research is; "How can colors be selected automatically to represent data?" This is called the color assignment problem. My theory is that bright, saturated colors are easier to identify than soft pastels when viewing data.

In order to address the color assignment problem, we assume that we know in advance how many colors are needed. By using the *Color.HSBtoRGB* method, we can select maximum saturation and brightness colors (the loudest colors) and evenly select them from the various available hues. (For a description of the human visual system and color transforms in Java, see *Image Processing in Java* [Lyon 1999].) For example,

```
package charts;
import java.awt.*;

public class ColorUtils {

    private Color colorMap [] = null;

    public ColorUtils(int nc) {
      initColorMap(nc);
    }
```

 Here we create a fixed number of colors in an array.

These colors are evenly spaced in hue according to an increment of $1/n$. Thus, if there are 10 colors, the hue will change in 0.1 increments until it reaches 1.0. The HSB components are normalized to vary from 0 to 1.0 in the *Color* class:

```
private void initColorMap(int n) {
  Color c [] = new Color[n];
  int i=0;
  for (float h=0; i<c.length; h = (float)(h + 1.0/n)){
    c[i] = new Color(Color.HSBtoRGB(h,1,1));
    i++;
  }
  colorMap = c;
}
```

To guard the input to the array index, we use a modulus operator to make sure we don't exceed the length of the array:

```
public Color  getColor(int i) {
  return colorMap[i % colorMap.length ];
}
}
```

27.1.5 The Color Grid

The *ColorGrid* class displays the colors in the color map, as shown in Figure 27.1.5-1. *ColorGrid* is a small *Canvas* that can be added to any *Container* instance. The code follows:

```
import java.awt.*;

public class ColorGrid extends Canvas {
```

FIGURE 27.1.5-1
A Color Grid

```
        int rows, cols;
        Color colors[];
        ColorGrid(int numColors) {
          setSize(200,200);
            ColorUtils cu = new ColorUtils(numColors);
            colors = cu.getColorMap();
            cols = Math.min(16, numColors);
            rows = (numColors - 1) / cols + 1;
        }

        // Returns the color value at (x, y).
        Color getColor(int x, int y) {
          Dimension d = getSize();
            int cellW = d.width / cols;
            int cellH = d.height / rows;

            x /= cellW;
            y /= cellH;

            // Return the last color if out of bounds.
            return colors[
              Math.min(colors.length-1, y * cols + x)];
        }

        public void paint(Graphics g) {
          Dimension d = getSize();
            int cellW = d.width / cols;
            int cellH = d.height / rows;
            for (int i=0; i<colors.length; i++) {
                int r = i / cols;
                int c = i % cols;

                g.setColor(colors[i]);
                g.fillRect(c * cellW, r * cellH, cellW, cellH);
            }
        }
        public static void main(String args[]) {
          ClosableJFrame cf = new ClosableJFrame();
          Container c = cf.getContentPane();
          c.add(new ColorGrid(64));
          c.setLayout(new FlowLayout());
          cf.setSize(200,200);
          cf.setVisible(true);
        }
    }
```

The following code will allow the user to select a color using the standard *JColorChooser*:

```
    public static Color getColor() {
        return
          javax.swing.JColorChooser.showDialog(
            new Frame(), "Choose a color",
          java.awt.Color.white);
    }
```

Figure 27.1.5-2 shows the various options that appear when you make use of *JColorChooser*.

FIGURE 27.1.5-2
JColorChooser Options

27.2 The *FontMetrics* Class

The *FontMetrics* class is a public abstract class in the java.awt package. Font metrics are based on dimensions that are special to fonts. Font dimensions include baseline, ascent, descent, leading, and height.

 Distances generally are given in pixels when they are returned by *FontMetrics* attribute methods.

FIGURE 27.2-1
FontMetrics Dimensions.

Font metrics are shown in Figure 27.2-1

 Leading is the space between lines. The name comes from the lead strips that used to be inserted between lines of printed text.

Typical font metrics use the point system (at 72 points per inch). The raster orientation of *java.awt* leads all font metrics to use pixels. The number of pixels per inch is a function of the display's pitch. The *Font* class constructor takes three arguments: font name, font style, and font size. For example,

```
Font f = new Font("Times",Font.BOLD,24);
Font font
     = new Font("Times", Font.PLAIN, 12);
Font f2 = new Font("SansSerif", Font.PLAIN, 12);
JLabel label = new JLabel("Drag this text", JLabel.CENTER);
    label.setFont(new Font("Serif", Font.BOLD, 32));
```

Or, in a *Graphics* context, use

```
public void paint(Graphics g) {

    Font f = new Font("TimesRoman", Font.PLAIN, 12);
    g.setFont(f);
....
```

To get a list of fonts, use

```
public static Font [] getAllFonts() {
    GraphicsEnvironment ge =
      GraphicsEnvironment.getLocalGraphicsEnvironment();
  return ge.getAllFonts();
}
```

27.2.1 FontMetrics Class Summary

```
public abstract class FontMetrics {

/* Instance Variables */
    protected java.awt.Font font;
```

```
/* Methods */
    protected void FontMetrics(java.awt.Font a);
    public java.awt.Font getFont();
    public int getLeading();
    public int getAscent();
    public int getDescent();
    public int getHeight();
    public int getMaxAscent();
    public int getMaxDescent();
    public int getMaxDecent();
    public int getMaxAdvance();
    public int charWidth(int a);
    public int charWidth(char a);
    public int stringWidth(java.lang.String a);
    public int charsWidth(char a[], int b, int c);
    public int bytesWidth(byte a[], int b, int c);
    public int getWidths()[];
    public java.lang.String toString();
}
```

27.2.2 FontMetrics Class Usage

Suppose that the following constants are defined:

```
Graphics g;
FontMetrics theFontMetrics = g.getFontMetrics();
Font aFont;
int distanceInPixels;
char ch;
char charArray[];
byte byteArray[];
int offset, length
```

To get the instance of the Font class upon which theFontMetrics are based, use

```
afont = theFontMetrics.getFont();
```

To get the standard leading (the line spacing between descent and ascent), use

```
distanceInPixels = theFontMetrics.getLeading();
```

To get the ascent, descent, and height, use

```
distanceInPixels = theFontMetrics.getAscent();
distanceInPixels = theFontMetrics.getDescent();
distanceInPixels = theFontMetrics.getHeight();
```

To get the maximum ascent and descent for a font, use

```
distanceInPixels = theFontMetrics.getMaxAscent();
distanceInPixels = theFontMetrics.getMaxDescent();
```

To get the maximum height for a font, add the maximum descent and ascent. To get the width of a character in the font, use

```
distanceInPixels = theFontMetrics.charWidth(ch);
```

To get the width of a string in the font, use

```
distanceInPixels = theFontMetrics.stringWidth(str);
```

To get the width of an array of characters in the font, starting at the offset and proceeding for *length* characters, use

```
distanceInPixels = theFontMetrics.charsWidth(charArray,
        offset, length);
```

To get the width of an array of bytes in the font, starting at the offset and proceeding for *length* characters, use

```
distanceInPixels = theFontMetrics.bytesWidth(byteArray,
        offset, length);
```

To get the width of the first 256 characters in the font, use

```
distanceInPixels = theFontMetrics.getWidths();
```

To get the string representation of theFontMetrics, use

```
str = theFontMetrics.toString();
```

27.2.3 How to Draw a String with a Background

Often, the user will wish to draw a string that has a background imposed, which is important if the string is to be changed dynamically. In the following example, we show how to draw the date and time. The *clearRect* call will erase a part of the display so that the string does not overwrite itself:

```
synchronized private void draw() {
Dimension dim = f.size();
int height = dim.height - 60;
int width = dim.width;
Date theDate = new Date();
String date_string = theDate.toString();
int xloc = 10;
int yloc = dim.height - 60;
// g.setFont(f);
// get the string width in pixels this always returns 0.
int string_width = getFontMetrics(
        g.getFont()).stringWidth(date_string);
int string_height = getFontMetrics(
        g.getFont()).getHeight();
g.clearRect(xloc,yloc,string_width,string_height);
g.drawString(date_string, xloc,height+xloc);
}
```

To make your code portable, you should not assume the existence of any particular font.

FIGURE 27.2.4-1
A Target on the Radar

27.2.4 How to Draw a Vertical String Using the Target Class

The following method takes a string and draws it vertically (something AWT normally does not do). We define a target for the radar that makes use of the vertical string:

```java
package gui;
import java.awt.*;

public class Target {
        String s;
        int x;
        int y;

        Target(String _s, int _x, int _y) {
          s = _s;
          x = _x;
          y = _y;
        }
        public void draw(Graphics g) {
          int str_height = g.getFontMetrics().getHeight();
          int y1 = y-(str_height*s.length())/2;
          for (int i = 0; i<s.length(); i++) {
            int char_width =
                  g.getFontMetrics().stringWidth(
                        s.substring(i,i+1));
            g.drawString(
                  s.substring(i,i+1),x-char_width/2,y1);
            y1+=str_height;
          }
        }
}
```

Figure 27.2.4-1 shows an image of the vertical string-based target.

27.3 Charts

In this section, we show a series of classes that subclass the *JComponent* class to enable simple charting. Some commercially available packages do the same thing, but our code is open-sourced. There are elementary examples to plot bar charts, line graphs, and pie charts. The classes reside in the *charts* package.

The charts use a class called *DoubleData*. The *DoubleData* class contains arrays of double-precision data and methods for manipulating that data.

27.3.1 The LineGraph Class

The *LineGraph* class enables the plotting of *x* versus *y*. An example of usage appears in Figure 27.3.1-1.

The *LineGraph* class has a sample invocation in its *main* method:

```
public static void main(String args[]) {
    ClosableJFrame cf = new ClosableJFrame();
    Container c = cf.getContentPane();
// Lets draw 100 points around a circle:
    double numberOfPoints = 100;
// The increment on the angle, in radians, should take us
// to 2 * π radians, plus a little bit,
// so that the end-points touch:
    double eps = (2*Math.PI+.1)/numberOfPoints;
    double theta = 0;
    double x[] = new double[(int)numberOfPoints];
    double y[] = new double[x.length];
/*
Now we use the parametric form of the circle to get our
    points:
*/
    for (int i=0; i < x.length;i++){
      x[i]=Math.cos(theta);
      y[i]=Math.sin(theta);
      theta = theta + eps;
    }
/*
The DoubleData instance is required to build any of the
    charts.
*/
```

FIGURE 27.3.1-1
Sample Output from
LineGraph

```
                    DoubleData dd = new DoubleData(300,300);
                    dd.setXLabel("x label");
                    dd.setYLabel("y label");
                    dd.setXVals(x);
                    dd.setYVals(y);
                LineGraph lg = new LineGraph(dd);
                c.add(lg);
                c.setLayout(
                    new FlowLayout());
                c.setBackground(Color.white);
                cf.setSize(200,200);
                cf.setVisible(true);
            }
```

27.3.2 The BarGraph Class

Figure 27.3.2-1 shows a sample bar graph made using the *BarGraph* class.

Since the *DoubleData* class has reasonable defaults, the amount of code required to try *BarGraph* is minimal:

```
public static void main(String args[]) {
  ClosableJFrame cf = new ClosableJFrame();
  Container c = cf.getContentPane();
  c.add(new BarGraph(
    new DoubleData(200,200)));
  c.setLayout(
    new FlowLayout());
  cf.setBackground(Color.white);
  cf.setSize(200,200);
  cf.setVisible(true);
}
```

FIGURE 27.3.2-1
A Sample Bar Graph

This is the Title

FIGURE 27.3.2-2
A Thin Bar Graph

This code resides in the *main* method of BarGraph. The *width* of the bars in the graph is a property that may be set using *BarGraph.setBarWidth*. Figure 27.3.2-2 shows an image of a thin bar graph.

The code for generating the thin bar graph follows:

```
public static void main(String args[]) {
    ClosableJFrame cf = new ClosableJFrame();
    Container c = cf.getContentPane();
/*
Here we keep a reference to the BarGraph so that we can set
    the barWidth property:
*/
    BarGraph bg = new BarGraph(new
      DoubleData(200,200));
    bg.setBarWidth(1);
    c.add(bg);
    c.setLayout(
      new FlowLayout());
    cf.setBackground(Color.white);
    cf.setSize(200,200);
    cf.setVisible(true);
}
```

27.3.3 The PieGraph Class

Figure 27.3.3-1 shows an image of a pie chart made by the *PieGraph* class. The wedges are colored according to the *ColorUtils* color map. As a result of using consistent colors, the key to the chart appears colored as well. The colors in the wedges match those colors in the key.

In order to display the pie chart, it must be added to a *Container* instance just like the other charts:

```
public static void main(String args[]) {
    ClosableJFrame cf = new ClosableJFrame();
```

FIGURE 27.3.3-1
A Pie Chart

```
        Container c = cf.getContentPane();
        PieGraph pg = new PieGraph(200,200);
        c.add(pg);
        c.add(pg.getLegendPanel());
        c.setLayout(new FlowLayout());
        c.setBackground(Color.white);
        cf.setSize(200,300);
        cf.setVisible(true);
    }
```

27.4 Images

The Java AWT model for storing an image stores a pixel in a 32-bit *int*. The *int* consists of 4 packed bytes that represent the ARGB planes, as shown in Figure 27.4-1.

However, there are problems with this approach. For example, encoding and decoding both require bit shift and masking operations, thus increasing computation time.

Suppose you are given a packed color pixel, as shown in 27.4-1, and you want to convert it to a monochrome pixel by averaging the three colors. A method that accomplishes this task follows:

```
public int filterRGB (int rgb) {
    int red   = (rgb & 0xff0000) >>16;
    int green = (rgb &   0xff00) >>  8;
    int blue  =  rgb &     0xff;
    int gray  = (red + green + blue) / 3;
    return (
        0xff000000 |
        (gray << 16) |
        (gray <<  8) |  gray);
}
```

The *filterRGB* method unpacks the pixel, performs the filtering operation, and then repacks the pixel. Three AND operations, three OR operations, and four SHIFT operations are needed to access the three colors. Consider that images typically range in size from a few hundred bytes to a few megabytes. In fact, million-pixel images are not that uncommon, particularly with modern scanner and camera technologies.

Alpha (8-bits)	Red (8-bits)	Green (8-bits)	Blue (8-bits)

FIGURE 27.4-1
A Packed Pixel

This unpack-process-repack approach places overhead on pixel access.

Worse still, the code has become less clear. To encapsulate these operations, AWT provides a series of methods that reside in an instance of a *ColorModel* class. These accessor methods add even more overhead on pixel access.

The astute reader probably will conclude that we have missed something. Java has a scalar data type called a *byte*, so why not unpack all of the packed ints into bytes and then just use bytes? Been there, done that! Java does not have an *unsigned* byte!

Thus, when two bytes are combined, they both must be checked for their sign, which adds even more overhead than unpacking and repacking.

In addition to the problem of access to color pixels in Java, we find that Java image-processing programs typically use a one-dimensional array to store pixel values. A one-dimensional array is used, in part, because the Java language specification does not mention if two-dimensional arrays are stored in row-major or column-major order.

27.4.1 The ImageUtils Class

The *ImageUtils* class resides in the *gui* package. It is able to open images from a file and print components. Examples of the use of *ImageUtils* are shown in Section 27.7. The code for *ImageUtils* follows:

```
package gui;

import java.awt.*;
import java.io.*;
import futils.*;
import javax.swing.*;
/*
The ImageUtils class is a repository for static methods, and
        as such, should never be instanced:
*/
public final class ImageUtils {
        private ImageUtils() {
        }
/*
The open  method is overloaded. When invoked as
        ImageUtils.open() it brings up a file dialog and
            prompts the user. It returns an instance of an Image.
*/
public static Image open() {
        File f =
          Futil.getReadFile();
        if (f == null) return null;
        return open(f);
}
```

The alternative version of the *open* method takes an instance of a file. It uses the AWT *Toolkit* class, which contains a number of related AWT tools that are able to perform important functions. This tool, called *getImage*, obtains an image when given a full file name. A helper method called *waitForImage* is local to the *ImageUtils* class:

```
public static Image open(File f) {
        Image i = Toolkit.getDefaultToolkit().getImage(
```

```
                        f.toString());
                waitForImage(new ClosableJFrame(), i);
                return i;
        }
```

The job of *waitForImage* is to handle the details of creating an instance of the *MediaTracker* class. The *Image* instance is added to the *MediaTracker* instance, and *waitForID* is invoked. This blocks the thread of execution, which becomes IO bound. The image may take time to load (particularly if it is large), which may cause some delay. The *waitForImage* method makes the loading of the image *atomic*:

```
public static void waitForImage(Component c, Image image) {
  MediaTracker tracker = new MediaTracker(c) ;
  try {
        tracker.addImage(image, 0);
     tracker.waitForID(0);
     }
   catch(InterruptedException e) {   }
}
/*
The print method creates a print dialog and prompts the user
        for output. The print dialog is the standard one used
        by the operating system. The component to be printed
        must be supplied, along with the title of the print-out.
        The reader is cautioned that under some JVM
        versions this code throws an exception at run time.
        This is a bug found so far in Jdk 1.3, and 1.3.1.
*/
public static void print(Component c,String title) {
        Toolkit tk = Toolkit.getDefaultToolkit();
        PrintJob printJob =
            tk.getPrintJob(
                null,
                title,
                null);
        c.paint(printJob.getGraphics());
        printJob.end();
}
/*
An example of the print invocation follows:
*/
public static void main(String args[]) {
        ImageUtils.print(
          new charts.BarGraph(
            new charts.DoubleData(200,200)
            ),
        "bar graph");

}
```

The *main* method resides in the *ImageUtils* class. When it executes, it prints an instance of *BarGraph*.

The *getImage* method transforms a *Component* instance into an *Image* instance. It does this by using the built-in *createImage* method in the *JFrame* class. The *addNotify* method is used to create an instance of the peer class. A *peer* class is an operating system-supplied

instance of *JFrame*. This heavyweight *Frame* instance never is shown, but its construction is required in order for the *createImage* method to succeed. For example,

```
public static Image getImage(Component c) {
   Dimension d = c.getSize();
   JFrame f = new JFrame();
   f.addNotify();
   f.setSize(d);
   Image i=f.createImage(d.width,d.height);
/*
Every Image instance has a graphics context upon which
         drawing can occur. The getGraphics method allows the
         paint invocation in the Component instance to be
         redirected toward the Image instance's graphics
         context. This creates a buffered image (i.e., an image
         where all the draw methods are invisible to the user).
         The image bit plane is then returned for later use.
*/
   Graphics g = i.getGraphics();
   c.paint(g);
   return i;
   }

}
```

The problem with AWT is that there is a lot of it to learn. To explain all of the methods used in the above code would not be very educational. By wrappering all of these functions in the *ImageUtils* class, you can get an idea of how to use *ImageUtils* and how it works.

27.4.2 The ImageFrame Class

The *ImageFrame* class provides a way to load and display images for the user to view. It also gives us a test bed for trying out the *ImageUtils* class. *ImageFrame* not only will load and display images, it also will print them and save them to files. First we establish the framework:

```
package gui;

import java.awt.*;
import javax.swing.*;
import java.awt.image.*;
import java.io.*;
import java.awt.event.*;
import java.util.*;
import futils.*;
import charts.*;
/*
The ImageFrame will need the charts package because we want
         it to draw charts and convert them into images that it
         can save.
*/
public class ImageFrame
      extends ClosableJFrame {
/*
```

```
    The Image instance will be stored locally. If it is null we
        won't try to draw it (or an exception will be thrown).
        When we do draw it, we want the Bounds of the
        containing ClosableJFrame instance. This will provide
        drawImage with an idea about the size of the image.
        This will cause the image to be scaled for display.
*/
private Image image;

public void paint(Graphics g) {
        if (image != null) {
          Rectangle r = getBounds();
          g.drawImage(image, 0,0,r.width, r.height,
            this);
        }
}

public void setImage(Image i) {
        image = i;
        ImageUtils.waitForImage(this, i);
}
public Image getImage() {
        ImageUtils.waitForImage(this, image);
        return image;
}
/*
The ImageFrame serves as a proxy for the ImageUtils delegate.
        Because the ImageFrame contains an instance of the
        Image class, it is able to simplify the API. The
        getImage works atomically, as does the setImage.
The open method delegates to the
*/
public void open() {
        setImage(ImageUtils.open());
}
```

For example,

```
public static void main(String args[]) {
        ImageFrame imgFrm =
          new ImageFrame();
        imgFrm.open();
}
```

Figure 27.4.2-1 shows the file open dialog created by the *Futil.getReadFile* invocation. Figure 27.4.2-2 shows an image opened by the *ImageFrame.open* invocation.

In order to transform a *Component* instance into an *Image* instance and display it, we use

```
public void grab(Component c) {
        setImage(ImageUtils.getImage(c));
}
public static void main(String args[]) {
        ImageFrame imgFrm =
          new ImageFrame();
```

FIGURE 27.4.2-1
The File Open Dialog

FIGURE 27.4.2-2
An Opened Image

```
        BarGraph bg = new BarGraph(new DoubleData(200,200));
        imgFrm.grab(bg);
        imgFrm.setVisible(true);
}
```

With this example, we transform an instance of *Component* into an instance of *Image*. This transformation is very important when trying to reduce flicker (for animation) and when saving an image out to a file (which we will do next).

This is the Title

FIGURE 27.4.2-3
The Result of a *Grab*

To save the image stored in *ImageFrame* to a file, we use

```
public void save() {
      WriteGIF.toFile(i,
        Futil.getWriteFile(
          "Enter *.gif for output"
        ).toString()
      );
}
```

The *save* method delegates to the *WriteGIF* class the writing of an *Image* instance to a *Graphics Interchange Format (GIF)* file. GIF is documented in *Image Processing in Java* [Lyon 1999].

27.4.3 The WriteGIF Class

The *WriteGIF* class has an implementation whose explanation is better left to a book on image processing. However, programmers who write clients for *WriteGIF* do need to know how to do a few basic tasks. For example, to write a GIF image to a file, use

```
    public static void toFile(Image img, String fname) {
// The file name, fname must be an absolute path name.
// encode the image as a GIF
      try {
        WriteGIF wg = new WriteGIF(img);
/*
Internally, the toFile class makes an instance of an
        OutputStream, writing the GIF image out to it:
*/
        wg.toOutputStream(
```

```
        new BufferedOutputStream(
            new FileOutputStream(fname))
        );
    }
    catch(Exception e){
        System.out.println("Save GIF Exception!");
    }
}
```

The implementation of the *toFile* method shows how to output GIF data to any *OutputStream*, which adds to its flexibility. One of the limitations is that the *Image* instance only can have 256 colors. To reduce the number of colors in an image, you need a *color quantization* algorithm, which is discussed in *Image Processing in Java* [Lyon 1999].

GIF images used to be subject to a compression patent held by the Unisys Corporation. The compression algorithm was invented by Z. Lempel and J. Ziv [Ziv and Lempel]. However, the patent recently has been released into the public domain.

27.5 The ImagePanel Class

In this section, we describe the *ImagePanel* class. *ImagePanel* can be added to any panel or frame. It is designed to display an image after it has been processed and it implements a simple listener:

```
package j2d;

import java.awt.event.ActionEvent;
import java.awt.*;

public interface ImageProcessListener  {
    public void update(ImageProcessor ip);
    public void setImage(Image img);
}
```

Classes that implement the *ImageProcessor* interface, such as

```
public interface ImageProcessor {
    public Image process(Image image);
}
```

can be used as arguments to the *update* method in *ImageProcessListener*.

```
// ImagePanel.java
// ImagePanel contains an image for display.  The image is
// converted to a BufferedImage for filtering purposes.
package j2d;

// Java core packages

import graphics.ImageUtils;

import javax.swing.*;
import java.awt.*;
import java.awt.image.ImageObserver;
```

```java
public class ImagePanel
        extends JPanel
        implements ImageProcessListener {

    private Image originalImage;
    private Image processedImage;

    // ImagePanel constructor
    public ImagePanel(Image _img) {
        originalImage = _img;
        processedImage = _img;

        ImageUtils.waitForImage(this, getImage());

    } // end ImagePanel constructor

    public void update(ImageProcessor ip) {
        if (ip== null) {
            setImage(originalImage);
            return;
        }
        processedImage = ip.process(originalImage);
        repaint();
    }

    public void revert() {
        processedImage = originalImage;
    }

    // draw ImagePanel
    public void paintComponent(Graphics g) {
        super.paintComponent(g);
        Dimension d = getPreferredSize();
        ImageObserver io = this;
        Image img = processedImage;
        int w = d.width;
        int h = d.height;
        g.drawImage(img, 0, 0, w, h, io);
    }

    // get preferred ImagePanel size
    public Dimension getPreferredSize() {
        return new Dimension(originalImage.getWidth(this),
                originalImage.getHeight(this));
    }

    // get minimum ImagePanel size
    public Dimension getMinimumSize() {
        return getPreferredSize();
    }

    public Image getImage() {
        return originalImage;
    }

    public void setImage(Image image) {
        originalImage = image;
```

```
            processedImage = image;
            repaint();
        }
    }
```

27.6 Summary

This chapter provided an introduction to computer graphics in Java. This introduction covered drawing lines, strings, bar graphs, pie charts, colors, and animations.

We touched on several topics in order to give a feel for graphics. To do justice to this topic, it can be helpful to attend a full course or two on the subject.

27.7 Exercises

27.1 Write a program that can plot two functions passed in an array. The functions are defined by implementing an interface:

```java
public interface FcnY {
    public double getY(double x);
    public double getXMin();
    public double getXMax();
}
```

For example,

```java
public class Cosine implements FcnY {
    public double getY(double x) {
      return Math.cos(x);
    }
    public double getXMin() {
      return 0;
    }
    public double getXMax() {
      return 2 * Math.PI;
    }
    public double getYMin() {
      return 1;
    }
    public double getYMax() {
      return -1;
    }
}
```

The interface is used to define a single-value function that, given x, returns a double-precision value, y. You will use font metrics and draw data as well as labels for the x and y axes. Your program will generate its own axis tick marks and will generate axis labels. Use at most three significant figures (e.g., 3.14 instead of 3.1415926). Use your judgment when designing the display. You should have, at a minimum, labels for the axes and a minimum and maximum range. Your frame should be resizable and should have a close box.

Figure 27.7-1 shows a sample plot of two functions. There is no option to specify the number of tick marks on the axes.

FIGURE 27.7-1
A Sample Plot

FIGURE 27.7-2
The Tangent Function

27.2 Extend exercise 2 to work with functions that have an infinite range. For example, the tangent function can extend to infinity, which is shown in Figure 27.7-2.

Use the extent of the function with the larger range to limit the range of your plot. In the case of the tangent function shown in Figure 27.7-2, the range of the tangent function is -4 to 4. This range is used for the range of the graph rather than for the smaller cosine function.

27.3 Using the "poor man's thread," create an analog clock with hands for hours, minutes, and seconds. The sweeping second hand should move every second.

27.4 Simulate an analog thermometer. Draw the scale so that it shows both Fahrenheit and Celsius. Recall that Celsius $= 5/9$ (Fahrenheit $- 32$).

27.5 Write a program that allows the user to select a font, font size, and font style (e.g., bold, italic, plain, or bold-italic).

C H A P T E R 2 8

JDBC

**If the camel once gets his nose in a tent,
his body will soon follow.**

–Arabian proverb

This chapter describes Java's features for connecting to relational database management systems (RDBMSs). These systems can serve as important facilities for the storage and retrieval of data. Most modern database systems can store text of binary data. To learn how to set up a database management system (DBMS), see Appendix H.

28.1 JDBC–What Is It?

Java Database Connectivity (JDBC) is a Java API that enables the execution of Structural Query Language (SQL). SQL is the defacto industry standard for connecting to a RDBMS. SQL commands consist of non-Java language instructions that are contained in Java strings. These commands are passed without syntax checking to the RDBMS.

 Care is needed to prevent SQL from pervading an entire Java program (waiter, there's a camel in my soup!).

**Trust in Allah,
but tie your camel.**

–Arabic saying

JDBC provides facilities to:

1. Establish a connection to the RDMS
2. Send an SQL statement
3. Process the results

FIGURE 28.2-1
The Two-Tier Model of Computation

28.2 Multitier Models of Computation

The use of JDBC provides a clean separation between the logic used to process data and the means to retrieve the data. This separation has gained increasing popularity in enterprise computing because it allows domain specialists who are nonprogrammers to contribute to database administration (DBA), while programmers contribute to the *business logic* needed to process the data.

There is also a kind of coarse-grained parallelism that is enabled when a CPU is dedicated as an RDBMS server. Such a separation of services is called a *multitier* model of computation. This section shows the role of JDBC in two-tier and three-tier models of distributed computation.

Figure 28.2-1 shows a diagram depicting the two-tier model of computation.

The two-tier model of computation normally is called the client-server model.

Figure 28.2-2 depicts a sketch of the three-tier model of computation.

In the three-tier model of computation, a thin client (a Java Applet or an HTML-based browser) is used as the GUI front end. A means of communication (RMI or HTTP) is used to communicate with the *application server*, which runs the business logic that contains invocations of the JDBC API. The JDBC API then uses a RDBMS protocol to communicate with the database server. Thus, we have what might be termed client-side Java (the Java Applet) and server-side Java (Java that is running on the application server). The database server then becomes the third tier of the three-tier system.

28.3 The Javasoft Framework

DESIGN PATTERN
A *framework* is defined as a collection of classes that are designed to support a related task.

The Javasoft framework for connecting to a variety of RDBMSs includes drivers for Sybase, DB2, Microsoft's Open Database Connectivity (ODBC) API, Oracle, and JDBC-Net. JDBCNet is a middleware protocol driver that provides the most flexibility of all Java drivers.

FIGURE 28.2-2
The Three-Tier Model of Computation

FIGURE 28.3-1
JDBC Drivers

Beyond the Javasoft framework for the connection to RDBMSs, there are often third-party drivers available that add to the framework. For example, at *<http://www.mysql.com>*, a free version of a RDBMS is available that includes a driver and sample software for a variety of operating systems.

Such high-performance solutions enable industrialgrade multitier systems to be constructed without a high-cost database product.

Figure 28.3-1 shows the JDBC API Examples of JDBC Drivers including Oracle, mySql, JET, msql, DB2, and SQL Server with a product-specific drivers, which are used to interface to a proprietary database.

Once the correct driver is loaded, the rest of the Java code should not have to be changed.

The exception would be code that generates SQL that is dependent on a feature that is not present in all database products.

28.4 Opening a Connection to an RDBMS

In order to obtain access to the JDBC API, it first must be imported, which typically is done at the head of the JDBC program with an invocation of

```
import java.sql.*;
```

To connect to an RDBMS, a driver is needed. Often, the driver first must be loaded into the system, which is done by using the fully qualified driver name to load the class that drives the database. For example, *Odbc* uses

```
String driver = "sun.jdbc.odbc.JdbcOdbcDriver";
Class.forName(driver);
```

The above code loads the JDBC-ODBC driver for a windows-based system and is almost never portable code.

In other words, the *driver* string must be altered when the RDBMS changes or when platforms change. This is an unfortunate circumstance. ODBC enables connection to a wide variety of database systems. The *Class.forName* invocation loads the class that contains the driver into the system. ODBC is not a requirement, however. To learn how to get drivers and set up your system for a RDBMS, see Appendix H. Suffice it to say that the *DriverManager* class is used to obtain a connection to an RDBMS using a *URL* string. For example,

```
Connection c = DriverManager.getConnection(url);
```

The format of the *url* string is vendor specific, but is generally in the form of

```
String url = "jdbc:dbnet://localhost:356/Books";
```

where *dbnet* is an example of a subprotocol, and *//localhost:356/Books* is an example of a subname. The *DriverManager* class also can take an optional user name and password. For example,

```
Connection c = DriverManager.getConnection(url, "userid",
        "password");
```

The *url* is another element that is likely to change as RDBMS vendors or platforms change.

For more details, see Appendix H.

28.5 Making an Instance of the SQL Statement

Once a connection is established with the RDBMS, an instance of the *Statement* class is obtained from a *factory* method contained in the *connection* instance. For example,

```
Class.forName(driver);
c = DriverManager.getConnection(url);
Statement s = c.createStatement();
```

The database query then may be executed using a properly formatted SQL statement. A code snippet from a class called *SqlBean* follows:

```
public ResultSet query(String sql) {
    try {
      Statement s = c.createStatement();
      return s.executeQuery(sql);
    }
     catch (SQLException e) {
      e.printStackTrace();
    }
    return null;
}
```

 The *ResultSet* instance is returned when an SQL *Select* statement is executed. An instance of the *Statement* class is used to execute SQL statements.

The *executeQuery()* method enables the reading of the RDBMS and the *executeUpdate()* enables the writing of the RDBMS. An example from *SqlBean* follows:

```
public void insert(String sql) {
    try {
      Statement s = c.createStatement();
      int insertResult = s.executeUpdate(sql);
    }
    catch (SQLException e) {
      e.printStackTrace();
    }
}
```

28.6 DatabaseWriter

There is a class of SQL statements that is used to insert data into a database system. We typically do not care what the returns are from these SQL statements as long as they do not create any SQL errors.

The JDBC API makes it possible to create SQL statements without any SQL syntax checking. It is therefore important to validate your SQL statements before you embed them in your Java code.

From the JDBC point of view, an SQL statement is just a string. It is to our advantage to separate the process of synthesizing SQL from the process of executing SQL.

In fact, it is much more efficient if we can execute a series of insert statements in a *batch* mode on a single database connection and then close the connection when we are done.
The implementation for *DatabaseWriter* follows:

```java
import java.io.*;
import java.sql.*;

public class DatabaseWriter {
    private String url = null; // "jdbc:odbc:udb";
    private String uid = "";
    private String pw = "";
    private String driverName = null;
      // "sun.jdbc.odbc.JdbcOdbcDriver";
    private Connection c = null;

    public DatabaseWriter(
        String _url,
        String _uid,
        String _password,
        String _driverName) throws
      ClassNotFoundException {
      url = _url;
      uid = _uid;
      pw = _password;
      driverName = _driverName;
      Class.forName(driverName);
      }
    public void execute(String sql[])
      throws SQLException {
      c = DriverManager.getConnection(
        url, uid, pw);
      Statement s = c.createStatement();
      for (int i=0; i < sql.length; i++)
        s.execute(sql[i]);
      s.close();
      c.close();

      }
    }
```

Opening and closing SQL connections can take a long time. It is a good idea to batch process your SQL commands.

DatabaseWriter will process all of the *sql* statements in a single *for loop*, which permits the reuse of both the *Connection* instance and the *Statement* instance. Further, if arrays of *SQL* strings need to be sent via an alternative route (e.g., via e-mail for a more secure connection), only minimal changes are needed to the logic.

28.7 ResultSetMetaData

In the JDBC API, the *ResultSetMetaData* class is used to obtain information about the result set returned from an SQL query.

We wrapper the exceptions and handle them locally. This process is called creating an *exception-free wrapper.* Such wrappers can result in cleaner, easier-to-use code (particularly in areas that need a reduction of clutter, like JSPs). *SqlBean* provides an exception-free wrapper for getting an instance of *ResultSetMetaData*:

```
public ResultSetMetaData
        getResultSetMetaData(ResultSet rs) {
    try {
      return rs.getMetaData();
    }
    catch(SQLException e) {
      e.printStackTrace();
    }
    return null;
}
```

The result set returned from *SqlQuery* is like a small table with rows and columns. By using *ResultSetMetaData*, we can find out information about how many columns are in the result set. An exception-free method for finding this information is provided in *SqlBean*:

```
public int getColumnCount(ResultSetMetaData rsmd) {
    try {
      return rsmd.getColumnCount();
    }
    catch(SQLException e) {
      e.printStackTrace();
    }
    return null;
}
```

Now that we know how many columns there are in a *ResultSet* instance, we can convert all of the elements in the row to an array of strings:

```
public String []
        getRowAsString(ResultSet rs) {
    int n = getColumnCount(
      getResultSetMetaData(rs));
    String s[] = new String[n];
```

```
      try {
        for (int i =0; i < n; i++)
          s[i] = rs.getString(i+1);
      }
      catch(SQLException e) {
        e.printStackTrace();
      }
      return s;
}
```

WARNING

Inputs and outputs of RDBMS transactions often are not object oriented, which means that repeated parsing may be required on input.

Not all of the elements in the *ResultSet* instance may be of type *String*. However, the names of all of the primitive data types stored in the columns are available as an array of string using an *SqlBean* method:

```
public String []
          getcolumnTypeNames(ResultSetMetaData rsmd) {
      int count = getColumnCount(rsmd);
      String sa [] = new String[count];
      try {
        for (int i=0; i < sa.length; i++) {
          sa[i] = rsmd.getColumnTypeName(i);
        }
      }
      catch(SQLException e) {
        e.printStackTrace();
      }
      return sa;
}
```

Using *ResultSetMetaData*, *SqlBean* also provides a mean to obtain an array of *String* that contains all of the column names:

```
public String[] getColumnNames(ResultSetMetaData rsmd) {
      String s []
          = new String[getColumnCount(rsmd)];
      try {
        for (int i=1; i <= s.length; i++)
          s[i]=rsmd.getColumnLabel(i);
      }
      catch(SQLException e) {
        e.printStackTrace();
      }

      return s;
}
```

In order to provide an exception-free means of advancing along a *ResultSet* instance, *SqlBean* provides a wrapper method:

```
public boolean nextRow(ResultSet rs) {
      try {
        return rs.next();
```

```
        }
        catch(SQLException e) {
          return false;
        }
  }
```

Now that we know how to advance from one row to the next in a *ResultSet* instance, it is a simple matter to add a print method to *SqlBean:*

```
public void print(ResultSet rs) {
      int i;
      String cn[] =
        getColumnNames(getResultSetMetaData(rs));
      println(cn);
      boolean more = false;
      while (more = nextRow(rs))
        println(getRowAsString(rs));
}
public void println(String s[]) {
      for (int i=0; i < s.length; i++)
        System.out.print(s[i]+'\t');
      System.out.println();
}
```

28.8 DataBaseMetaData

The *DataBaseMetaData* class is obtained automatically by *SqlBean* during the initialization phase, as indicated below:

```
    public void init() {
    try {
    Class.forName(driver);
        c =
      DriverManager.getConnection(url,userId,password);
        dbmd = c.getMetaData();
      catalogName =
        c.getCatalog();
      isReadOnly = c.isReadOnly();
      usesLocalFiles =
        dbmd.usesLocalFiles();
      driverName =
        dbmd.getDriverName();
    }
     catch (ClassNotFoundException e) {
      e.printStackTrace();
     }
    catch (SQLException e) {
       e.printStackTrace();
     }
    System.out.println("Opened Connection:"+url);
    }
```

A getter method is provided in the *SqlBean* class for those who need to gain access to the *DatabaseMetaData* instance:

```
public DatabaseMetaData getDatabaseMetaData() {
  return dbmd;
}
```

Additionally, there are getter methods for all of the locally held properties in *SqlBean*, including

```
public boolean getUsesLocalFiles() {
      return usesLocalFiles;
}
public boolean getReadOnly() {
      return isReadOnly;
}
public String getCatalogName() {
      return catalogName;
}
public String getDriverName() {
      return driverName;
}
```

WARNING

It is possible to write SQL commands that only work on a particular product (e.g., Oracle or SQL Server). It is a good idea to use only generic SQL commands for the sake of portability.

28.9 Code for SQLBean

The following code wrappers the invocations of the SQL JDBC API invocations. It permits the usage of some limited SQL features without the client class having to import the *java.sql* package.

NOTE

All of the exceptions are wrappered and handled locally, which is a design decision that enables the streamlining of some types of code (particularly JSP code).

```
1.      package DB;
2.
3.      import java.sql.*;
4.
5.      public class SqlBean {
6.
7.        private String url = "jdbc:odbc:address";
8.        private String driver =
          "sun.jdbc.odbc.JdbcOdbcDriver";
9.        private String userId = "";
10.       private String password = "";
11.       private Connection c;
12.       private DatabaseMetaData dbmd;
13.       private boolean isReadOnly = false;
14.       private boolean usesLocalFiles = false;
15.       private String driverName = null;
```

```
16.      private String catalogName = null;
17.      private String productName = null;
18.
19.   public boolean getUsesLocalFiles() {
20.    return usesLocalFiles;
21.    }
22.   public boolean getReadOnly() {
23.    return isReadOnly;
24.    }
25.   public String getCatalogName() {
26.    return catalogName;
27.    }
28.   public String getDriverName() {
29.    return driverName;
30.    }
31.   public String getProductName() {
32.    return productName;
33.    }
34.   public void setUserId(String _userId) {
35.        userId = _userId;
36.      }
37.     public void setPassword(String _password) {
38.        password = _password;
39.      }
40.     public void setUrl(String _url) {
41.        url = _url;
42.      }
43.     public void setDriver(String _driver) {
44.        driver = _driver;
45.      }
46.
47.     public SqlBean() {
48.      }
49.     public void init() {
50.        try {
51.          Class.forName(driver);
52.            c =
      DriverManager.getConnection(url,userId,password);
53.             dbmd = c.getMetaData();
54.             catalogName =
55.            c.getCatalog();
56.         isReadOnly = c.isReadOnly();
57.         usesLocalFiles =
58.            dbmd.usesLocalFiles();
59.         driverName =
60.            dbmd.getDriverName();
61.         productName =
62.            dbmd.getDatabaseProductName();
63.       }
64.        catch (ClassNotFoundException e) {
65.           e.printStackTrace();
66.        }
67.        catch (SQLException e) {
```

```
68.              e.printStackTrace();
69.          }
70.       System.out.println("Opened Connection:"+url);
71.      }
72.      public void printInfo() {
73.    println("productName="+productName);
74.    println("catalogName="+catalogName);
75.    println("is ReadOnly="+getReadOnly());
76.    println("usesLocalFiles="+getUsesLocalFiles());
77.    println("driverName="+driverName);
78.      }
79.
80.      public void close() {
81.          try {
82.              c.close();
83.              System.out.println("closed connection");
84.          }
85.        catch (SQLException e) {
86.              e.printStackTrace();
87.          }
88.      }
89.
90.      public ResultSet query(String sql) {
91.          try {
92.              Statement s = c.createStatement();
93.              return s.executeQuery(sql);
94.          }
95.           catch (SQLException e) {
96.              e.printStackTrace();
97.          }
98.          return null;
99.      }
100.     public ResultSetMetaData
       getResultSetMetaData(ResultSet rs) {
101.          try {
102.              return rs.getMetaData();
103.          }
104.          catch(SQLException e) {
105.             e.printStackTrace();
106.          }
107.          return null;
108.      }
109.     public int getColumnCount(
             ResultSetMetaData rsmd) {
110.          try {
111.             return rsmd.getColumnCount();
112.          }
113.          catch(SQLException e) {
114.             e.printStackTrace();
115.          }
116.          return 0;
117.      }
```

```
118.      public String []
          getcolumnTypeNames(ResultSetMetaData rsmd) {
119.          int count = getColumnCount(rsmd);
120.          String sa [] = new String[count];
121.          try {
122.              for (int i=0; i < sa.length; i++) {
123.                  sa[i] = rsmd.getColumnTypeName(i);
124.              }
125.          }
126.          catch(SQLException e) {
127.              e.printStackTrace();
128.          }
129.          return sa;
130.      }
131.      public String []
          getRowAsString(ResultSet rs) {
132.
133.
134.          int N = getColumnCount(
135.              getResultSetMetaData(rs));
136.          String s[] = new String[N];
137.          try {
138.              for (int i =0; i < N; i++)
139.                  s[i] = rs.getString(i+1);
140.          }
141.          catch(SQLException e) {
142.              e.printStackTrace();
143.          }
144.          return s;
145.      }
146.      public void print(ResultSet rs) {
147.          int i;
148.          String cn[] =
          getColumnNames(getResultSetMetaData(rs));
149.          println(cn);
150.          boolean more = false;
151.          while (more = nextRow(rs))
152.              println(getRowAsString(rs));
153.      }
154.      public void println(Object o) {
155.          System.out.println(o);
156.      }
157.      public void println(String s[]) {
158.          for (int i=0; i < s.length; i++)
159.              System.out.print(s[i]+'\t');
160.          System.out.println();
161.      }
162.      public boolean nextRow(ResultSet rs) {
163.          try {
164.              return rs.next();
165.          }
166.          catch(SQLException e) {
167.              return false;
```

```
168.                        }
169.           }
170.        public String[]
              getColumnNames(ResultSetMetaData rsmd) {
171.              String s []
172.                    = new String[getColumnCount(rsmd)];
173.              try {
174.                  for (int i=1; i <= s.length; i++)
175.                      s[i-1]=rsmd.getColumnLabel(i);
176.                  }
177.              catch(SQLException e) {
178.                  e.printStackTrace();
179.              }
180.
181.              return s;
182.        }
183.              public DatabaseMetaData
                    getDatabaseMetaData() {
184.                  return dbmd;
185.              }
186.
187.        public void insert(String sql) {
188.           try {
189.               Statement s = c.createStatement();
190.               int insertResult = s.executeUpdate(sql);
191.           }
192.           catch (SQLException e) {
193.               e.printStackTrace();
194.           }
195.        }
196.        public static void main(String args[]) {
197.              SqlBean sb = new SqlBean();
198.              sb.init();
199.              sb.printInfo();
200.              sb.close();
201.        }
202.
203.     }
```

28.10 Summary

RDBMSs represent a legacy technology that was developed in a time before object-oriented programming.

DESIGN PATTERN
We have seen that our code needs to be isolated from the non-object-oriented nature of the RDBMS by using a variety of *facades*. These facades (like *SqlBean*) allow the rest of our code to remain object oriented.

As object-oriented programmers, we do our best to keep raw SQL statements from appearing in our programs. We also saw that batch processing inserts and queries into a database

can enable an extremely efficient record-oriented operation. Rather than connect to databases directly, it is often better to use an object-oriented means of communication. One example of such a means of communication is found in the Enterprise Java Bean (EJB) framework, a topic that appears in later chapters.

Keypoints to remember about JDBC:

1. JDBC minimizes the code that needs to be changed when altering RDBMSs.
2. Different RDBMSs need different drivers and connection strings.
3. Native drivers are often more efficient than JDBC-ODBC bridge-type systems.
4. The *Connection* factory yields a *Statement* instance, which passes an SQL statement to the RDBMS.
5. The *ResultSet* instance results from the execution of a *Statement* instance.
6. Metadata is available for result sets (*ResultSetMetaData*) and databases (*DataBaseMetaData*).
7. *ResultSet* is based on the SQL standard. It is best to build a facade from the data for domain-specific applications. The data also should be verified for correctness.

28.11 Exercises

28.1 List the different connection strings you need to connect to three different RDBMSs.
28.2 Design a GUI that enables the formulation of an SQL query into a database. Design the SQL query formulation so that it cannot have any syntax errors when it is executed. Display the results in a table.
28.3 Write a program that computes statistics from a database (e.g., number of rows, number of columns, number of tables, and table names). Print your results in a table.
28.4 Design a GUI that inputs an SQL statement (with no verification) and prints the results in a Swing table.
28.5 Create a package that performs connection pooling for a multitier application.
28.6 Devise a way to store serialized instances of classes, along with their byte codes, in a database record.

CHAPTER 29

Network Programming

> **When spiders unite, they can tie down a lion.**
>
> *–Ethiopian proverb*

In this chapter, you will learn how the Transmission Control Protocol/Internet Protocol (TCP/IP) suite can be used to perform network computing. You will learn:

- About the OSI reference model
- How to perform socket programming
- How to use a proxy to do network programming through a firewall
- About the client-server paradigm
- How to use domain name servers from Java
- How to get the time from an atomic clock
- How to write a Web server
- How to use sockets to send e-mail
- How to send instances of classes across the Internet for execution
- How to read URL data from the Web
- How to use URLs to read a stock quote
- How to write a browser

Network programming is a term that refers to communication-based programming. Typically, we write a program that makes use of an API that facilitates communication between one or more processes. Often, the processes can run on different physical CPUs.

 As mentioned in Chapter 13, when multiple CPUs are involved in a computation, we have a distributed programming environment.

The TCP/IP suite forms the basis of several distributed computing technologies, including RMI (a topic that will be covered in later chapters).

29.1 The OSI Reference Model

Figure 29.1-1 shows a sketch of the Open Systems Interconnect (OSI) reference model.

WARNING

Some books will claim that there are only four layers in a network. However, keep in mind that the OSI model is just a reference model. Not every network needs all of the layers.

In the physical layer, the basic physical-layer data unit is the bit. Issues of how bits are transmitted (via various energy modulation techniques) are beyond the scope of this book.

The data-link-layer data unit is a *frame*. The frame is surrounded by header information (start and stop bits). It also may contain error-correcting or error-detecting codes (e.g., parity or cyclic redundancy check bits). Data-link-layer communications transmit data from one point to another. For example, Point to Point Protocol (PPP) is a data-link-layer protocol used by modems on telephone lines.

In the network layer (what some people call the *Internet* layer), IP addresses are used to communicate. This communication can involve routing between different subnetworks (hence the term *Internetworking*).

Figure 29.1-2 shows a sketch of an Internetworking system. The square blocks represent network stations and the circles represent nodes on the network. The nodes are able to route Internet-protocol data units (e.g., packets) to the correct next node.

FIGURE 29.1-1
The OSI Reference Model

FIGURE 29.1-2
An Internetworking System

 Routing is a service reserved for the *network* layer.

A packet-switched network is a store-and-forward network that uses IP-addressed packets placed into a shared media. A packet is stored and forwarded at each node along its path. In comparison, a circuit-switched network has a dedicated communication path. For example, a telephone can have a dedicated path between one handset and the next.

The transport layer does flow control. TCP is responsible for making sure that the packets arrive in the correct order. Thus, we can treat TCP/IP services as a bit pipe, with bits going in and out in the correct order.

The session layer is used to open and close connections. The protocol for a telephone, for example, is to pick up the handset, wait for the dial tone, dial, wait for the ringing and the answer, and then begin the session. The protocol may involve login with a password.

The presentation layer is responsible for data representation consistency. For example, in the File Transfer Protocol (*FTP*), carriage returns can be mapped to line feeds. Sometimes a presentation-layer protocol is used to transport a specific kind of data. For example, HTTP is used to transport HTML.

 The application layer provides a user interface, such as a browser, kermit, FTP, or Telnet.

29.2 The Client-Server Paradigm

The client-server paradigm lies at the root of the modern *distributed computing environment*. In such a milieu, processing functions reside in different address spaces (clients or servers). A front end runs on a client, and a back end runs on a server. A distributed computing environment uses network protocols and spreads its logic across the server and the client. Such a programming technique has the advantages of improved flexibility, scalability, and extendibility.

Scalability is accomplished by adding more servers to improve performance, which leads to load balancing and fault tolerance. Fault tolerance, in turn, leads to improved reliability.

29.3 Mapping Your First Domain Name

This section introduces the concept of a domain name and shows how to get one from an IP address. It also shows how to map an IP address back into a domain name.

 A *domain name* resides in a hierarchical name-space that comes in the form of peri-od-delimited identifiers (just like package names).

For example, *www.docjava.com* is a domain name. The top-level domain is *com*.
Figure 29.3-1 shows a listing of top-level domains and their assigned uses. The names *biz, info, name, pro*, and *museum* are new top-level domains. To learn more about top-level domains, see *<http://www.icann.org/tlds/>*. To view the 239 country codes, see *<http://www.din.de/gremien/nas/nabd/iso3166ma/codlstp1/en_listp1.html>*. To get a country code, you must be on the United Nations list of countries. This number has grown from 51 in 1945 to 189 in 2000 *<http://www.un.org>*.

All official domain names end with a top-level domain. Inside an *intranet* (i.e., a network not directly tied to the Internet), it is possible to create unofficial domain names. The domain-name owner typically has control over the parts of the domain name that precede the top-level domain. For example, DocJava, Inc., owns the *docjava.com* domain and controls the *www.docjava.com* mapping. This section describes how to perform the mapping between domain names and addresses using Java. An Internet address is a period-delimited set of four numbers that range from 1 to 254 called *dotted-decimal notation*. For example, 192.168.1.1 is a valid address. A domain name server (DNS) performs the service of mapping the domain name to an Internet address. DNSs use protocols that enable them to communicate their results. The *DNS* class provides an API that uses these protocols to communicate with DNSs.

 Mapping a machine name to an IP address is the first step toward getting a connection to a machine, which often is done implicitly by many of the classes.

Domain Name	Meaning
com	Commercial organizations
edu	Educational institutions
gov	Government institutions
mil	Military groups
net	Network support centers
org	Organizations other than the above
biz	Businesses
info	Unrestricted use
name	Registration by individuals
pro	Accountants, lawyers, and physicians
museum	Museums
country code	Geographic country scheme

FIGURE 29.3-1
Top-Level Domains

The following code shows how to map a domain name to an IP address and how to map an IP address back to a domain name:

```
package net;

import java.net.InetAddress;
import java.net.UnknownHostException;

public class Dns {
    public static void main(String args[]) {
        print(getNumericAddress("www.fairfield.edu"));
        System.out.println(getHostName("12.23.55.212"));
        // The above outputs:
        // 12.23.55.212
        // www.fairfield.edu
    }

    /**
     *   get the host name for this IP address.
     *
     */
    public static String getHostName(String s) {
        try {
            InetAddress ia = InetAddress.getByName(s);
            return ia.getHostName();
        } catch (UnknownHostException e) {
        }
        return null;
    }

    /**
     * map the host name to an IP address.
     */
    public static byte[] getNumericAddress(String name) {
        InetAddress ia =
                null;
        try {
            ia = InetAddress.getByName(name);
        } catch (UnknownHostException e) {
        }
        return ia.getAddress();
    }

    /**
     * print out a well-formatted dot notation for an array
     * of byte. For example: 192.168.1.1
     */
    public static void print(byte IP[]) {
        for (int index = 0; index < IP.length; index++) {
            if (index > 0) System.out.print(".");
            System.out.print(((int) IP[index]) & 0xff);
        }
        System.out.println();
    }
}
```

A mathematical treatment of network analysis is beyond the scope of this book. Coverage here is far from complete and only is designed to give an executive summary of network programming.

29.4 Sockets and Ports

Figure 29.4-1 shows a diagram of the OSI reference model and the role of the TCP/IP connection between two systems. TCP provides a reliable, full-duplex byte stream with packet ordering and end-to-end flow control. It is used by most Internet applications. Since TCP is based on IP, we often call it TCP/IP. IP is responsible for routing and hop-by-hop flow control.

Around 1982, Berkeley UNIX started to make use of the socket. A *socket* is an entity that can map a stream to a specific process on a machine using TCP/IP and an assigned number called a port. The *port* is an integer that ranges from 1 to 65535.

A connection to a machine requires both an IP address and the port number for interprocess communications, which enables the communication between any two processes even if they are on different machines. The Berkeley socket became the de facto standard for inter-machine communication.

FIGURE 29.4-1
The Socket Connection

When communicating using sockets, you need both an IP address and a *port* number.

The IP address typically is assigned to the server and mapped to a machine name. For example, the name *www.nsf.gov* maps to the IP address 128.150.4.107. At this address, there are open ports willing to accept connections. One of those ports is port 80. *Port 80* is a well-known port used by default for web servers.

Under UNIX, a port map is printed using

```
more /etc/services
```

On my Redhat 7.1 system, this file has more than 500 lines of service descriptions. For example,

```
...
echo            7/tcp
echo            7/udp
discard         9/tcp           sink null
discard         9/udp           sink null
systat          11/tcp          users
systat          11/udp          users
daytime         13/tcp
daytime         13/udp
...
```

shows that *ping* is on port 7 and that day and time services are on port 13.

If a port is already in use, it is a contention error to try to listen on it. Thus, it is the server programmer's job to find a free port for his or her service.

When a request for a connection is obtained by a server, the server creates a *socket*, which arranges the data in the transport layer of the OSI reference model. The data streams in and out using a connection-oriented protocol. The job of arranging the data packets that arrive out of order into sequential order requires a buffer, which creates latency. An algorithm (called *Nagle's algorithm*) is used to improve throughput at a cost of increased latency.

Algorithms for distributed routing can be complex. Many excellent books on networking can give you more details.

29.4.1 Reading Your First Socket by Building an Atomic Clock

In this section, you will learn how to connect to a port using the *Socket* class. We are starting with a client because there is already a server on a specific host and port. Port 13 is a well-known port for getting the day and time. As an experiment, try typing

```
telnet time-A.timefreq.bldrdoc.gov 13
```

Under UNIX you get

```
Trying 132.163.4.101...

Connected to time-A.timefreq.bldrdoc.gov.
Escape character is '^]'.
```

After a few carriage returns, the time is printed:

```
52100 01-07-10 09:52:54 50 0 0 515.2 UTC(NIST) *
```

Then the connection is closed. In this section, we open a socket to the atomic clock server, parse the response, and then set our system clock to the time.

We have created a *SimpleClock* class that uses the atomic clock at *<time-A.time-freq.bldrdoc.gov>* to get and set the time on your local machine. The code example follows:

```java
package net;

import java.io.BufferedReader;
import java.io.IOException;
import java.io.InputStreamReader;
import java.net.Socket;
import java.net.UnknownHostException;

public class SimpleClock {
    private static BufferedReader getTimeReader()
            throws UnknownHostException,
            IOException {
        Socket s = new Socket(
                "time-A.timefreq.bldrdoc.gov", 13);
        return new BufferedReader(
                new InputStreamReader(
                        s.getInputStream()));
    }
    /**
     *  return a string representing the time from NIST
     *  output looks like:
     * 52520 02-09-03 11:06:08 50 0 0 537.5 UTC(NIST) *
     */
    public static String getTime() {
        String time = "";
        try {
            BufferedReader in = getTimeReader();
            String s = null;
            while ((s = in.readLine()) != null)
                time = time + s;
        } catch (IOException e) {
        }
        return time;
    }

    public static void main(String[] args) {
        System.out.println(SimpleClock.getTime());
    }
}
```

For an example of how to use the ideas in *SimpleClock* to set your computer's time, see the *AtomicClock* class.

If the code for connecting to a socket does not work on your system, then you might be behind a proxy server. If this is true, see Section 29.7.

29.4.2 Serving Your First Socket by Building a Web Server

This section shows how to create a Web server that uses an instance of the *ServerSocket* class. A *ServerSocket* provides a communication end point that is used to listen for a connection request.

Figure 29.4.2-1 shows that *ServerSocket* is running on the server. *Socket* originates a connection request and *ServerSocket* replies because it is running in a *listening process* that is willing to accept connections from a *Socket* instance. During the listening process, the thread of execution is blocked. The thread becomes unblocked when a request arrives. Thus, *ServerSocket* is IO bound and must be used inside of a thread. In summary, a server socket blocks the thread of execution until a connection request is entered. As soon as a connection request is obtained, the *ServerSocket.accept* method is invoked, which returns an instance of a *Socket* class that is passed to a thread. Thus, we present a multithreaded web server:

```java
package web;

import java.io.*;
import java.net.ServerSocket;
import java.net.Socket;
import java.util.StringTokenizer;
public class WebServer {
        public static void main(String args[]){
          WebServer ws = new WebServer(80);
        }

        WebServer(int port) {
            try {
            ServerSocket ss
                  = new ServerSocket(port);
            while (true) {
                    startClient(ss.accept());
             }
           }
          catch(Exception e) {
            e.printStackTrace();
          }
        }
        public void startClient(Socket s)
          throws IOException {
          ClientThread
            ct = new ClientThread(s);
          Thread t = new Thread(ct);
          t.start();
        }
}
```

FIGURE 29.4.2-1
Socket and ServerSocket

The *WebServer* class forms a framework that is generally correct no matter what the proto-
col is (i.e., we could write any type of server using this technique). *ClientThread* imple-
ments *Runnable* because it is used as an argument to the *Thread* constructor. The *Socket*
instance is used for the source of both *BufferedReader* and *PrintWriter*, which means that
Socket provides two-way communications (called *full-duplex*). The *http* protocol is defined
in *<http://www.faqs.org/rfcs/rfc2068.html>*. The protocol strings are treated as constants
in the program:

```
class ClientThread implements
       Runnable {
    Socket s;
    BufferedReader br;
    PrintWriter pw;

    public static final String
     notFoundString =
     "HTTP/1.0 501 Not Implemented\n"
     +"Content-type: text/plain\n\n";
    public static final String
     okString =
     "HTTP/1.0 200 OK\n"
     +"Content-type: text/html\n\n";
/* Given an instance of a Socket the following code shows how
       to obtain an InputStream instance and an OutputStream
       instance. These are going to transport text
       information, and so a BufferedReader and PrintWriter
       are used for input and output.
*/
    ClientThread(Socket _s) {
      s = _s;
    try{
      br =
         new BufferedReader(
              new InputStreamReader(
                   s.getInputStream()));
      pw =
         new PrintWriter(
              s.getOutputStream(),true);
    }
    catch(IOException e) {
      e.printStackTrace();
    }
    }
/* When reading a line of text from the BufferedReader
       instance, the server expects to see a series of client
       commands. There are a series of predefined Request
       Methods that are permitted as commands in the http.
       Our simple server only supports the GET request. If
       the GET request is made, we answer by counting to 10
       (a very simple response!).
*/
    public void run() {
```

```
        try {
          String line =
               br.readLine();
          StringTokenizer
               st =
                    new StringTokenizer(
                         line);
          System.out.println(line);
          if (st.nextToken().equals("GET"))
              //getAFile(st);
              countTo10();
          else
              pw.println(notFoundString);
         pw.close();
         s.close();
        }
        catch(Exception e) {
        }
     }
/* The countTo10 method answers by supplying the http header
      and a MIME-TYPE. MIME stands for Multipurpose Internet
      Mail Extensions. MIME is used to permit the transport
      of nontext message bodies via e-mail. It has been
      extended to map to a number of different applications.
      The supplied MIME-TYPE  must be understood by the
      browser. Every browser is different. Often browsers
      have helper applications or plug-ins that assist them
      in interpreting data of a specific MIME Type. See
      <http://trade.chonbuk.ac.kr/~leesl/rfc/rfc1521.html>
      for more information about MIME types.
*/
      public void countTo10() {
        pw.println("HTTP/1.0 200 OK");
        pw.println("Content-type: text/plain");
        pw.println();
        for (int i=0; i < 10; i++)
          pw.println("i="+i);
      }
/* The getAFile method is a first crack at supplying a file
      to the client, without first checking what type the
      file is. This is a basic text file service. In order
      to first determine the file type, we might like to use
      the StreamSniffer given in Chapter 15.
*/
      public void getAFile(StringTokenizer st)
          throws FileNotFoundException,
               IOException {
        pw.println(okString);
        String fileName
          = st.nextToken();
        pw.println("date="+new java.util.Date());
        BufferedReader
          fileReader= new
```

```
                        BufferedReader(new
                            FileReader(
                                "d:\\www\\"+fileName));
            String fileLine=null;
            while(
              (fileLine =
                    fileReader.readLine())
              != null)
              pw.println(fileLine);
            }
      }
```

To understand the operation of the web server better, use the *telnet* command to Telnet into port 80 of the web server. Type *GET* and hit enter twice and you should get a response. You can also visit the web server using a browser.

Sometimes writing your own web server can open up security holes. Make sure you don't accidentally share any secure documents.

29.4.3 Using Sockets to Send E-mail via SMTP

In this section, we assume that we are communicating with a mail server using Simple Mail Transfer Protocol (SMTP). SMTP uses a communication protocol that is specified in RFC 822 *<http://sunsite.dk/RFC/rfc/rfc822.html>*. SMTP servers typically appear on port 25 of a mail-server machine. The easiest way to understand the protocol is to simulate it by hand using *telnet*. What follows is a record of a Telnet session with a mail server. I used **bold** to indicate the part that I typed:

```
www.docjava.com{lyon}215: telnet localhost 25
Trying 127.0.0.1...
Connected to localhost.localdomain.
Escape character is '^]'.
220 www.docjava.com; ESMTP Tue, 17 Jul 2001 21:37:20 -0400
HELO LYON
250 www.docjava.com Hello localhost.localdomain [127.0.0.1],
      pleased to meet you
MAIL FROM: lyon@docjava.com
250 2.1.0 lyon@docjava.com... Sender ok
RCPT TO: lyon@docjava.com
250 2.1.5 lyon@docjava.com... Recipient ok
DATA
354 Enter mail, end with "." on a line by itself
This is some mail
.
250 2.0.0 f6I1cHU10938 Message accepted for delivery
```

As you can see, there is a very simple text-based protocol for sending mail to a mail server. After typing the above, I got some mail:

```
Date: Tue, 17 Jul 2001 21:38:34 -0400
From: "D. Lyon" <lyon@docjava.com>
Status:

This is some mail
```

The following code shows how to emulate the above session using sockets in a Java program:

```
 package net;

import java.net.*;
import java.io.*;
/* The Smtp class is multithreaded, so we implement
        Runnable:
*/
public class Smtp implements Runnable {

        String recipientEmail = null;
        String senderEmail = null;
        String serverHostName = null;
        String message = null;

        int smtpPort = 25;
/*
The socket will be used for both input from and output to the
 mail server:
*/
        Socket socket;
/*
The output stream will be promoted to a PrintWriter instance.
*/
        PrintWriter pw;
// The input stream will be promoted to a
// BufferedReader instance.
        BufferedReader br;
        InetAddress ia;
        InetAddress lina;
        Thread thread = new Thread(this);
/* The emailLyon method will send mail to me, using an IP
        address that is local to the www.docjava.com site. You
        will want to write your own emailUser method, using a
        local mail server:
*/
        public void emailLyon(String msg) {
                email(msg,
                    "192.168.1.95",
                    "lyon@docjava.com",
                    "lyon@docjava.com");
        }
/*
   The more general email method will typically be used to send
        mail. It is multithreaded:
   */
        public void email (String msg,
                        String serverHostName,
                        String recipientEmail,
                        String senderEmail) {
                setSenderEmail (senderEmail);
                setRecipientEmail (recipientEmail);
                setMailServerHostName (serverHostName);
```

```
                        setMessage (msg);
                        thread.start();
            }
/*
   When the thread starts to run the message will actually be
            sent. Until the message is done, the parameters of the
            message should not be altered.
   */
            public void run() {
                    try {
                            send();
                    }
                    catch (IOException e) {
                            e.printStackTrace();
                    }
            }
            public void start() {
                    thread.start();
            }

            public void send() throws IOException {
                    socket =
                        new Socket(serverHostName, smtpPort);
                    try {
                        ia = socket.getInetAddress();
                        lina = ia.getLocalHost();

                        pw = new
                        PrintWriter(socket.getOutputStream());
                          br = new BufferedReader(
                                    new InputStreamReader(
                                    socket.getInputStream()
                                    )
                                );
/*
        What follows is an implementation of the SMTP protocol:
   */
                            sendline("HELO " + lina.toString());
                            sendline("MAIL FROM:" + senderEmail);
                            sendline("RCPT TO:" + recipientEmail);
                            sendline("DATA");
                            sendline(message);
                            sendline(".");

                    } catch (Exception c) {
                            socket.close();
                            System.out.println (
                            "Error; message send failed:\n "
                            + c.getMessage());
                    }
                    socket.close();
            }
   /* After we send a line to the SMTP server, we have to read
            back the reply:
```

```
        */
                void sendline(String data) throws IOException {
                        pw.println(data);
                        pw.flush();
                        String s = br.readLine();
                        System.out.println("sendline in:" + s);
                }

                public void setMessage (String msg) {
                        message = msg;
                }

                public void setSenderEmail (String email) {
                        senderEmail = email;
                }

                public void setRecipientEmail (String email) {
                        recipientEmail = email;
                }
                public void setMailServerHostName (String host) {
                        serverHostName = host;
                }
        /* As you can see from the main the SendMail class is easy to
           use:
        */
                public static void main(String args[] ) {
                        Smtp sm = new Smtp ();
                        sm.emailLyon("This is a test!!");
                        System.out.println(
                                "Thread was started to send an email");
                }
        }
```

 SMTP passes login IDs and passwords in clear text. You should only do this behind a firewall.

WARNING

29.4.4 Sockets Send Instances

In this section, we show how to use sockets to pass instances of classes across the network. The primary advantage of using sockets is that a strongly typed object can be passed, which eliminates the need for parsing. Sockets also provide for remote invocation of methods, thus enabling true concurrency.

Another feature of the code in this section is that the server and client are communicating via sockets, but both reside in the same virtual machine. This has the effect of simplifying setup and testing of concurrent programming systems. It is typically much easier to debug a client-server computing system if you take a single-computer multithreaded approach for debugging. For example,

```
package net;

import java.net.*;
```

```java
import java.io.*;
import java.util.Date;

/* Our MainServer class serves as a mediator that launches
        both the serverThread and the date client. Because the
        system runs so quickly, a race-condition occurs if we
        start the server and then the client right away. That
        is because it takes time to set up the ServerSocket. A
        race-condition is a transiently inconsistent state
        that occurs because we did not incorporate a
        notification call back to notify us when the
        ServerSocket is in place. As a result, we incorporate a
        1000 ms (1 second) wait after we launch the server
        thread:
*/
public class MainServer implements Runnable {
    public static void main(String args[]) {
        Thread serverThread = new Thread(new MainServer());
        serverThread.start();
        try {
            Thread.sleep(1000);
        } catch(InterruptedException e) {
        }
// Now that the server is awake, we can test the server:
        DateClient dc = new DateClient();
        dc.run();
        dc.run();
        dc.run();
    }
/* The MainServer starts a new DateServer thread every time
        it gets a connection. In this way, it should be
        unlikely for any dateClient to be denied access, since
        there is always a ServerSocket instance accepting
        connections:
*/
    public void run() {
    try {
      ServerSocket ss =
        new ServerSocket(13);
        while (true) {
            System.out.println("waiting");
            Socket socket = ss.accept();
            DateServer ds =
                    new DateServer(socket);
            ds.start();

        }
    }
    catch(IOException e) {
      e.printStackTrace();
    }
    }
}
```

DateServer runs in its own thread, serving the requests of *DateClient*:

```
package net;

import java.net.*;
import java.io.*;
import java.util.Date;
/* The DateServer has an instance of the ObjectOutputStream
        class. This is used to write instances of reference
        types that implement Serializable:
*/
public class DateServer extends Thread {
        ObjectOutputStream oos;

        public DateServer(Socket s)
          throws IOException {
          oos =
            new ObjectOutputStream(
                  s.getOutputStream());
        }
/* By writing an instance of the Date to the
        ObjectOutputStream instance, we pass a full reference
        data type across the socket. This is better than a
        remote procedure call, because the instance and its
        implementation are passed:
*/
        public void run() {
          try {
            oos.writeObject(new Date());
            oos.close();
          }
          catch(IOException e) {
            e.printStackTrace();
          }
        }
}
```

Now we present *DateClient*. The communication is based on our foreknowledge about the type of instance that we expect from the server. The host name, *localhost*, and port *13* may need to be changed if you want the program to work on two different machines. Port 13 is typically a day-time port used by *UNIX*. For example,

```
package net;

import java.util.Date;
import java.net.*;
import java.io.*;
public class DateClient implements Runnable {
        public void run() {
          try {
          Socket s
            = new Socket("localhost",13);
/* When an instance is read from an ObjectInputStream
        instance, it comes in as a reference of type Object.
```

```
                       We use instanceof to make sure that the instance is
                       a Date, before we cast it.
          */
                       ObjectInputStream
                         ois = new ObjectInputStream(
                               s.getInputStream());
                       Object o =ois.readObject();
                       if (o instanceof Date)
                         System.out.println((Date)o);
                       ois.close();
                       }
                       catch(Exception e) {
                         e.printStackTrace();
                       }
                     }
          }
```

Distributed programming can work using the techniques in this section only if both the client and the server have the same version of the class files.

29.4.5 The Compute Server

This section shows how to perform full-duplex (i.e., two-way) communication between the client and the server so that computations can be performed. Ideally, we only should have to set up our computation server once. After configuration, it becomes a network resource that permits anyone who has access to our network to access the computation server(s). The steps involved in the distributed computation are described below.
On the server:

1. Read an instance of *ComputableObject*
2. Perform the computation
3. Send back the answer

On the client:

1. Send an instance of *ComputableObject*
2. Get back an instance of the answer
3. Process the answer

The computation server must be multithreaded (just like a web server) so that it will not block during computations. The client must be able to stop and wait for an answer so that functions like

```
          a = f(x);
```

will execute automatically. In order to minimize configuration problems, we propose an interface that every *ComputableObject* implements:

```
          package net;

          import java.io.*;

          public interface ComputableObject extends Serializable {
                  public Object compute();
          }
```

An example implementation follows:

```
package net;

public class ComputeMe implements ComputableObject {
      public Object compute() {
        return new Integer(4*4+3);
      }
}
```

In order to stress test our system, we would like to create several computation clients. In order to create these clients, we make *ComputeClient Runnable*:

```
package net;

import java.net.*;
import java.io.*;

public class ComputeClient implements
      Runnable {
      public void run() {
        try {
/* The hostname and port number will likely change, as you
      move the server from one platform to another. Here we
      simulate concurrency, using a multithreaded
      arrangement:
*/
          Socket s
            = new Socket("localhost",
                13);
          ObjectInputStream
            ois =
                new ObjectInputStream(
                    s.getInputStream());
          ObjectOutputStream
            oos =
                new ObjectOutputStream(
                    s.getOutputStream());
// Submit the job for computation:
          oos.writeObject(new ComputeMe());
// Get back the answer:
          Object o=ois.readObject();
/* Reading the object from the socket can block the current
      thread of execution. As a result, it may be desirable
      to launch the clients in a thread.
*/
          System.out.println(o);
          ois.close();
          oos.close();
        }
        catch(Exception e) {
          e.printStackTrace();
        }
      }
}
```

On the server side, we run a server thread that launches a new thread every time a connection is accepted on the *SocketServer* instance:

```
package net;

import java.net.*;
import java.io.*;
import java.util.Date;

public class ComputeServer implements Runnable {
    public static void main(String args[]) {
        Thread serverThread = new Thread(new ComputeServer());
        serverThread.start();
/* A small pause is required when starting a SocketServer,
        since the accept method is invoked within a thread:
*/
        try {
          Thread.sleep(1000);
        } catch(InterruptedException e) {
        }
        ComputeClient cc = new ComputeClient();
        cc.run();
        cc.run();
        cc.run();
    }
    public void run() {
    try {
      ServerSocket ss =
        new ServerSocket(13);
        while (true) {
            System.out.println("waiting");
/* A new ComputeThread is used to handle the computation for
        each new client that requests a connection:
*/
            Socket socket = ss.accept();
            ComputeThread ct =
                new ComputeThread(socket);
            ct.start();

        }
        }
        catch(IOException e) {
          e.printStackTrace();
        }
    }
}
```

In summary, we have a framework for developing concurrent computation that is distributed over a network of workstations. However, the implementation of the methods must be known to both the client and the server.

 The need to know both of these elements in advance requires that the *classes be loaded* before instances of the classes are transmitted. I call this the *class-configuration problem.*

29.4.6 Solving the Class-Configuration Problem

This section defines and suggests solutions for the *class-configuration problem*. When a class is loaded (even by the loader of this section), the definition verifies the byte codes before installation. Thus, all method names and signatures are valid, field names and signatures are valid, and no final methods of classes are being overridden. That is all you get!

A verified class can do damage. To prevent this damage, you need to make an instance of *SecurityManager* (a topic that is beyond the scope of this chapter).

We are given a client that has an implementation of a computation to be computed remotely. The implementation resides in a class file that is local to the client. When we invoke the computation on a remote server, we get *ClassNotFoundException*. Thus, we need to find a way to provide the class files to the remote computation server so that implementations are up to date.

There are several ways in which this task can be accomplished. Since the class files are located locally on the client's disk, we could search for them in the class path, just as the system's class loader does. If this method fails, you can prompt the user for help in locating the class file. Our approach is to locate the class in the present directory (rather than to perform a search through the *zip* and *jar* files). Then, if this approach fails, we prompt the user. The entire *RemoteClassLoader* is declared as *Serializable* so that the byte codes that define a class can be reloaded. The process of reloading a class is important because the class implementation is likely to change while the computation server is running. For example,

```
package net;
import java.io.*;
import java.net.*;
import java.util.*;
import futils.*;
/**
        pass an instance of this via an ObjectOutputStream
        instance to the remote host and invoke reload().
        That will redefine the class.
*/
/* The RemoteClassLoader is constructed on the client,
        serialized, then transmitted to the server. In this
        way, all the servers will get an update on the byte
        codes. This adds overhead and latency to the
        processing time, but it eases the configuration
        problem that occurs when implementations change.
*/
public class RemoteClassLoader
        extends ClassLoader implements Serializable {
/* The className often includes a package name. This is
        generally a part of the path that is used to search
        for the file.
*/
        String className;
/* The byteCodes in the file are to be loaded into the class.
        Most of the pain in this program is spent in trying to
        locate the byte codes for a class. I have no idea why
```

```
                  Sun does not make this easier. After all, the class is
                  already loaded!
    */
          byte byteCodes[];

          ClassLoader loader;

          public static RemoteClassLoader
            getRemoteClassLoader(Object o) {
            try {
              return new
                    RemoteClassLoader(o);
            }
            catch(IOException e) {
              System.out.println("Could not make instance");
              e.printStackTrace();
              return null;
            }
          }
    /* The following printPath will show all the paths defined in
          the environment. A better implementation would search
          all the jar and zip files, looking for the class
          definition:
    */
          public static void printPath() {
            String path = System.getProperty("java.class.path");
            String sep = System.getProperty("path.separator");
            StringTokenizer st = new StringTokenizer(path,sep);
            while(st.hasMoreElements())
                System.out.println(st.nextToken());
          }
          // strip package name and
          // add the .class suffix
    /* The getFileName is really the heart of the program. First
          we substitute the "." for the path separator, then we
          add the ".class" suffix. If that does not work, we ask
          the user for help. If the user can't find the file, we
          are sunk!
    */
          private String getFileName() {
            String sep = System.getProperty("path.separator");
            if (className.indexOf(".") < 0)
              return className + ".class";
            return
              gui.ReplaceString.sub(className,".",sep)
                    + ".class";
          }
    /* This getClassFile method really should be more robust. It
          needs to check the jar and zip files.
    */
          private File getClassFile() {
            File f = new File(getFileName());
            if (f.exists()) return f;
            // lets play find the file...
```

```
      printPath();
      return
         Futil.getReadFile(getFileName()
               + " not found, please help me find it!");
   }
   public RemoteClassLoader(Object o) throws IOException {
     Class c = o.getClass();
     className = c.getName();
     loader = c.getClassLoader();
     if (loader == null)
        System.out.println("Default system class loader");
     else
        System.out.println(loader);
     File f = getClassFile();
     System.out.println("file="+f);
     FileInputStream fis =
        new FileInputStream(f);
  byteCodes = new byte[fis.available()];
  fis.read(byteCodes);
     fis.close();
     System.out.println("#bytes="+byteCodes.length);
   }
/* If you can ever find a better way to get the byte codes of
      a class, this is the constructor to use:
*/
   public RemoteClassLoader(String cn, byte bc[]) {
     className = cn;
     byteCodes = bc;
   }
   public void loadIt() {
     loadClass(className, true);
   }
/* On the server, we invoke reload in order to get a fresh
      copy of the byte codes for multi-threaded the class.
*/
   public void reload() {
     // force the class to be reloaded,
     // in case it has changed.
     Class c= defineClass(
        className, byteCodes, 0, byteCodes.length);
     System.out.println("resolving:"+className);
     resolveClass(c);
   }
/* Since loadClass is required by the super class, we define
      it. However, RemoteClassLoader instances typically
      don't need it. They use reload which forces a
      reloading of the byte codes.
*/
   protected synchronized Class loadClass(String s,
     boolean b) {
     Class cl = findLoadedClass(s);
     try {
```

```
        if (cl == null)  // not in cache!
            return findSystemClass(s);
    }
    catch(ClassNotFoundException e) {
    }
    System.out.println("defining:"+s);
    Class c= defineClass(
        className, byteCodes, 0, byteCodes.length);
    System.out.println("resolving:"+className);
    if (c != null && b) resolveClass(c);
    return c;
}

public static void main(String args[]) {
    RemoteClassLoader
    rcl = RemoteClassLoader.getRemoteClassLoader(
        new ComputeMe());
    rcl.reload();
    }
}
```

29.5 Reading Your First URL by Building a Quote Client

Based on our work with the *Browser* class, it is a simple matter to get a stock quote from the Internet. The hard part of the program is to know where to go to get the stock quotes. Try typing the following URL:

```
<http://quote.yahoo.com/download/javasoft.beans?SYMBOLS=aapl&
    format=sl>
```

The output is

```
"AAPL",22.70,"7/9/2001","4:00PM",+0.67,22.09,23,21.68,6026200
```

To formulate URLs to communicate with the *Yahoo!* service, we use the *Quote* class:

```
package net;
import java.util.Vector;
import java.util.StringTokenizer;
import java.util.Date;
import java.io.InputStreamReader;
import java.io.BufferedReader;
import java.io.IOException;
import java.net.URL;
import java.awt.*;
import java.awt.event.*;

public class Quote {
    public static void main(String args[]) {
/* First, we need a list of valid symbols of trading stocks.
    These symbols can be NYSE, AMEX or NASDAQ:
*/
    Vector s = new Vector();
    s.addElement("aapl");
```

```
                 s.addElement("xlnx");
                 s.addElement("altr");
                 s.addElement("mot");
                 s.addElement("cy");
                 s.addElement("crus");
                 s.addElement("sfa");
                 s.addElement("adbe");
                 s.addElement("msft");
                 s.addElement("sunw");
                 Browser.print(
                    Browser.getUrl(makeQuoteURLString(s)));

              }
/* The heart of the program is the makeQuoteURLString, which
        iterates through each symbol, creating comma separated
        elements (i.e., "SYMBOLS=aapl,ibm..."):
*/
 public static String makeQuoteURLString(Vector symbols) {
        String symbolsString = "";
      for(int i = 0; i < symbols.size(); i++) {
        String symbol = (String)symbols.elementAt(i);
        symbolsString += ((i != 0) ? "," : "")
          + symbol.toUpperCase();
      }
      return

        "http://quote.yahoo.com/download/javasoft.beans?SYMBOL
        S="
      + symbolsString
      + "&format=sl";
  }
}
```

The output of the program follows:

```
url=http://quote.yahoo.com/download/javasoft.beans?SYMBOLS=AA
        PL,XLNX,ALTR,MOT,CY,CRUS,SFA,ADBE,MSFT,SUNW&format=sl
Vector print
"AAPL",22.70,"7/9/2001","4:00PM",+0.67,22.09,23,21.68,6026200
"XLNX",37.45,"7/9/2001","4:00PM",-
        0.21,37.80,38.43,36.65,4993600
"ALTR",27.28,"7/9/2001","4:00PM",+0.67,26.65,27.71,26.40,4731
        500
"MOT",15.37,"7/9/2001","4:00PM",0.00,15.21,15.79,15.04,959150
        0
"CY",21.34,"7/9/2001","4:01PM",-
        0.44,21.08,21.93,21.08,1390400
"CRUS",25.14,"7/9/2001","4:00PM",+0.89,24.35,25.34,24.16,1168
        000
"SFA",42.36,"7/9/2001","4:01PM",+0.76,42.28,43.30,42.02,24569
        00
"ADBE",43.98,"7/9/2001","4:00PM",+0.62,43.02,44.20,42.88,4681
        300
"MSFT",65.69,"7/9/2001","4:00PM",-
```

```
       0.37,66.20,66.91,65.04,33238500
"SUNW",14.82,"7/9/2001","4:00PM",+1.14,14.18,14.95,13.97,4334
   4900
```

29.6 Reading a URL by Building a Browser

In this section, we show how to build your very own web browser. The output of the program, after it visits the *<http://www.docjava.com>* web page, is:

```
web browser started
url=http://www.docjava.com/
Vector print
<HTML>
<HEAD>
    <TITLE>Distance Learning</TITLE>
```

.....*text deleted for brevity....*
```
</BODY>
</HTML>
```

The code for the *Browser* class follows:

```java
package net;
import java.io.*;
import java.util.*;
import java.net.*;
/* The url is hard coded into the program for demonstration
         purposes. This is a simple web browser, and so it does
         not attempt to provide an interface.
*/
public class Browser {
        public static void main(String args[]) {
        System.out.println("web browser started");

        print(
          getUrl("http://www.docjava.com"));
        }
/* The Browser.getUrl method is a generally useful one that
         will return a Vector of all the lines read from a URL.
         The getUrl method will block the current thread of
         execution, so it might be wise to put it in a thread,
         if the connection is slow.
*/
        public static Vector getUrl(String
         _urlString) {
        try {
          URL url
                = new URL(_urlString);
          System.out.println("url="
                +url);
          return
                getUrl(url);
        }
        catch(Exception e) {
          e.printStackTrace();
```

```
                              return null;
                        }
                  }
      /* The getUrl method runs in a for loop until the last line
            is read.
      */
            public static Vector getUrl(
              URL url)
              throws IOException {
              Vector v = new Vector();
              BufferedReader br
                = new BufferedReader(
                      new InputStreamReader(
                            url.openStream()));
              for (String l=br.readLine();
                l != null;
                l=br.readLine())
               v.addElement(l);
              return v;
            }
            public static void print(Vector v) {
              System.out.println("Vector print");
              for (int i=0;i < v.size(); i++)
               System.out.println(
                 (String)v.elementAt(i));
            }
      }
```

Adding a GUI to the browser is easy, particularly because we already have *HTMLViewer* in the *gui* package.

Figure 29.6-1 shows an image of *HtmlViewer*, along with the rendered HTML. A small change to the *Browser* class enables the display:

FIGURE 29.6-1
HtmlViewer

```
    public static void main(String args[]) {

      gui.HtmlViewer hv = new gui.HtmlViewer();
      String s =
        Browser.toString("http://www.docjava.com");
      hv.setHtml(s);
      hv.setText(s);
    }
/* The new toString class takes the url string and
      concatenates a large string, with all the HTML in it.
      This is returned and rendered in the HtmlViewer.
*/

    public static String toString(String url) {
      Vector v = getUrl(url);
      String s="\n";
      for (int i=0; i < v.size(); i++)
        s = s + v.elementAt(i);
      return s;
    }
```

29.7 Help, I Am Behind a Firewall!

Some companies use a proxy-based firewall in order to provide internal network security.
The *proxy* is a service that manages connections between the intranet and the Internet.

Java clients must be adjusted to work with the proxy-based firewall, or you will get
connection exceptions.

If you have a direct connection to the Internet, and you can skip this section. Otherwise,
read on!

Figure 29.7-1 shows the *Advanced:Proxies* preference dialog in Netscape. Using this
dialog, you can determine how Netscape's browser is set up to determine the HTTP-based
proxy server.

FIGURE 29.7-1
Proxy Setup in Netscape

FIGURE 29.7-2
Proxy Setup in Internet Explorer

Figure 29.7-2 shows the Internet Explorer *Proxy Setup Dialog* box, which enables you to see how Internet Explorer is configured to work with your company's proxy-based firewall. Once this information is known, you should use it to set the system properties using a method invocation like the following:

```
/*
 * @author Douglas A. Lyon
 * @version  Nov 17, 2002.1:37:08 PM
 */
package net;

import java.net.Authenticator;
import java.net.InetAddress;
import java.net.PasswordAuthentication;
import java.util.Properties;

public class Proxy {
  /**
   *  use a proxy server when connecting to the
   * web. SOE = School of Engineering at Fairfield.
   */
  public static void setSoeProxy() {
    setHttpProxy("172.16.2.206", "8080");
  }

  public static void setHttpProxy(String host, String port) {
    Properties p = System.getProperties();
    p.put("proxySet", "true");
    p.put("proxyHost", host);
    p.put("proxyPort", port);
  }

  public static void setFtpProxy(String host, String port) {
    Properties p = System.getProperties();
```

```
        p.put("ftpProxySet", "true");
        p.put("ftpProxyHost", host);
        p.put("ftpProxyPort", port);
    }
}
```

 The above code typically is not needed unless the programmer is running code behind a firewall that proxies connections to the Internet.

29.8 Summary

In this chapter, we introduced the notion of using low-level, application-specific protocols to perform a specific service on the Internet. We created a simple DNS client, a web server, and a simple browser, all based on the TCP/IP suite. We also showed how to create a stock quote program that is able to get a list of stock quotes and a clock client that is able to set a computer's clock. We also used the TCP/IP suite to send mail.

In addition, we used the TCP/IP suite and object serialization to send instances of classes across the network, which enabled a kind of remote execution that has become popular with the advent of Networks of Workstations (NOWS). In fact, such low-cost approaches to parallel computing have become so popular that more expensive, special-purpose parallel machines have fallen out of vogue (though this may change).

In later chapters, we will show how these techniques can be extended to create a set of server-side Java programs with distributed computing abilities.

29.9 Exercises

29.1 Modify the *DateClient* class to use compressed streams (as was done in Chapter 19).

29.2 Modify *RemoteClassLoader* to search for classes in all of the directories, *jar* files, and *zip* files in order to locate the byte codes for a class.

29.3 AutoServer and AutoClient classes come with the book software. Set them up to work remotely. Then, alter the implementation for *ComputableObject*. Does it work? Why or why not?

29.4 Alter *RemoteClassLoader* to transfer the class file from the client to the server. Store the file in the correct path on the server and then load the file using *Class.forName*. Does this process work more reliably? Why or Why not? Hint: You will have to force the reloading of the class files, for which you will need a file class loader. File class loaders are described in *<http://developer.java.sun.com/developer/onlineTraining/Security/Fundamentals/magercises/ClassLoader/solution.html>*

29.5 Test *RemoteClassLoader* on two different computers with different virtual machines. Does it work reliably? Why or why not?

29.6 Write a web server that serves up the class files needed remotely. Use *java.rmi.server.RMIClassLoader(url)* to load the classes. Use serialization to provide the URL plus class name to the remote class loader so that it can find the class file in question. Did you have any security problems?

29.7 Build your own network class loader. A sample implementation follows:

```
class NetworkClassLoader extends ClassLoader {
        String host;
        int port;

        public Class findClass(String name) {
```

```
            byte[] b = loadClassData(name);
            return defineClass(name, b, 0, b.length);
        }

        private byte[] loadClassData(String name) {
            // load the class data from the connection
                . . .
        }
    }
```

29.8 Write a program to create a CSV-type file of vendor addresses. How will you parse the HTML?
Hint: The Swing API already has the ability to parse HTML. The following code may help you
start:

```
package net;
import java.util.Vector;

/**
    VendorList allows you to save a list of
    vendors to a file. The list comes from
    YellowPages.com
*/
public class VendorList {
// a Typical search URL is:
    String url = "http://www.yellowpages.com/"
    + "asp/search/Searchform.asp?"
    + "CategoryIDs=&CategoryPath=&"
    + "ResultStart=1&ResultCount=2000&"
    + "NameOnly=YES&TypeOnly=&SearchRelation=&"
    + "BName=computer&SearchMethod=&SearchMethod="
    + "&SearchMethod=&SearchBy=NAME&state=CT&City=";
    public Vector getCsv() {
      Vector raw = Browser.getUrl(url);
      return toAddressList(raw);
    }
    public static Vector toAddressList(Vector in) {
      Vector out = new Vector();
      //search for addresses
      for (int i=0; i < in.size();i++) {
        String s = (String)in.elementAt(i);
        if (contains(s,"Phone:"))
            out.addElement(getAddress(in,i));
      }
      return out;
    }
    public static boolean contains(String s1, String s2) {
      return s1.lastIndexOf(s1) != -1;
    }
    public static String getAddress(Vector v, int i) {
      String s = "";
      try {
      for (int j=-3; j < 0; j++) {
            s = s +"," +(String)v.elementAt(j+i);
      }
      }catch(Exception e) {}
      return s;
    }
    public static String vector2String(Vector raw) {
      String s = " ";
```

```
                  for (int i=0; i < raw.size();i++)
                    s = s + raw.elementAt(i);
                  return s;
                }
                public static void main(String args[]) {
                  VendorList vl = new VendorList();
                  Browser.print(vl.getCsv());
                }
            }
```

29.9 Write a program that gets the byte codes for a class by using the *Class.getResourcesAsStream* method. Pass the class name in by using the *Class.getName* method. For example,

```
public static byte[] getByteCodes(Object o) throws
        IOException {
    Class c = o.getClass();
    InputStream is = c.getResourceAsStream(c.getName());
    //... add more code here
}
```

How else can you get the byte codes for an *Object*?

29.10 Write a program that will parse the return output and place it into classes that break down the values into primitive data types. Use a *StringTokenizer* that uses comma and quotes as delimiters. For example,

```
StringTokenizer t = new StringTokenizer(line, ",\"");
System.out.println(line);

String symbol = t.nextToken();
double price = Double.valueOf(t.nextToken()).doubleValue();

t.nextToken();
Date date = new Date();
t.nextToken();
Date lastTrade = date;

double change = Double.valueOf(t.nextToken()).doubleValue();
double open = Double.valueOf(t.nextToken()).doubleValue();
double bid = Double.valueOf(t.nextToken()).doubleValue();
double ask = Double.valueOf(t.nextToken()).doubleValue();
int volume = Integer.valueOf(t.nextToken()).intValue();
```

Have your program return a list of these quotes.

29.11 Modify the program in exercise 10 so that the quotes scroll across the screen on a ticker.

29.12 Modify the program in exercise 11 to add a Swing interface so that users can add symbols to their stock listing and save them to a file.

29.13 Build a Swing interface that enables a user to send mail. Make use of the SMTP class. Be sure to allow the user to alter the message (e.g., with a scroll-down panel, the server host name, the recipient's e-mail address, and the sender's e-mail address). There should also be a way to alter the name of the mail server.

CHAPTER 30

Servlets

> If you plan for one year, plant rice. If you plan
> for 10 years, plant a tree. If you plan for 100
> years, educate a child.
>
> *–Chinese proverb*

This chapter shows how to:

- Write a servlet
- Use servlets to do three-tier programming
- Use *get* and *post* to send data to the server
- Manage the session state using cookies and URL rewriting

Servlets are Java programs that run on a Java web server and conform to the *servlet* API. A Java web server is a web server written in Java that provides a call-back interface to Java programs that are designed to formulate output for a web browser. The servlet framework assists the programmer in decoding parameters that are used in web forms and in generating output. The framework is able to decode presentation-layer protocols, particularly *http*. Figure 30.1 shows the OSI Model with Common Gateway Interface (CGI) used for a presentation Layer Protocol.

The servlet API resides in the presentation layer of the OSI reference model, which is shown in Figure 30.1. Chapter 29 used the socket API to enable programmers to use transport-layer (i.e., TCP/IP) protocols. Thus, servlet programmers are really presentation-layer programmers. To learn how to set up for servlet programming, see Appendix I.

30.1 Your First Servlet

 To learn much more about servlets, you should install and run your own web server. See Appendix I for more information.

After the web server is started, you should try some of the servlet examples. Click on the *Servlet Examples* link, and you should see an image like the one shown in Figure 30.1-1.

FIGURE 30.1
Presentation-Layer
Programming

Servlet Examples

Please sign the guest book!

The DocJava Proxy Server

EchoEnvironmentServlet

TestWebServlet

FIGURE 30.1-1
The Servlet Examples
Page

Select the *TestWebServlet* link.

Figure 30.1-2 shows the output from *TestWebServlet*. It also shows the URL for *TestWebServlet* as *http://www.docjava.com:8080/examples/servlet/TestWebServlet*. The source code and class files reside in

```
jswdk-1.0.1/examples/WEB-INF/servlets/TestWebServlet.java
```

FIGURE 30.1-2
Output from TestWebServlet

The servlet API is designed to help with the generation of responses to the browser, which includes a protocol known as *HTTP Headers*. This protocol is a part of the HTTP specification and may be found at *http://www.w3.org/Protocols/rfc2616/rfc2616.html*.

The code is simple, but support for the code is not. What follows is a line-by-line analysis of *TestWebServlet*:

```
import javax.servlet.*;
import javax.servlet.http.*;
import java.io.*;
/*
The javax.servlet and the javax.servlet.http packages contain
        the classes that support the coding of the http
        protocols. These are used during the browser to web
        server communications. When a browser visits a
        designated servlet directory, like WEB-INF/servlets it
        decodes the http protocols created by the browser and
        makes an instance of an HttpServletRequest class. This
        decoding process is a long one. It also provides a
        class that assists in the encoding of the response.
        This class is called the HttpServletResponse class.
        The request and response instance variables are the
        input and output for the servlet. Servlet programmers
        rarely have to deal with creating a GUI (with some
        notable exceptions). The data in the response is
        typically MIME-encoded so that a browser knows how to
        decode it.
*/
public class TestWebServlet
    extends HttpServlet {
/*
The HttpServlet is an abstract class. By subclassing the
        HttpServlet the Java web server is able to make an
        instance of the subclass and invoke one of the call-
        back methods that enable data processing on the
        request and response. One of the call-back methods is
        called service:
*/
```

```
        protected void service(
                        HttpServletRequest request,
                        HttpServletResponse response)
            throws ServletException, IOException {
/*
In order to protect the web-server, all the call-back methods
        throw IOException and ServletException. The Java web
        server will catch these exceptions in order to keep it
        from crashing.
*/
            String clientIPAddress = request.getRemoteAddr();
/*
The servlet programmer uses the request to decode information
        about the browser. The information is used to create a
        response, typically encoded as an HTML-based reply
        page:
*/
            String replyPage =
                "<HTML><HEAD><TITLE>Test Web
        Servlet</TITLE></HEAD>"
                + "<BODY>"
                +  "<P>Thanks for calling the servlet from "
                + clientIPAddress
                + "</BODY></HTML>";
/*
Since the browser only understands MIME encoded data, it is
        important to set the content type on response. This is
        done with an invocation to the setContentType. The
        reply encodes the response into the header transmitted
        back to the browser:
*/
            response.setContentType("text/html");
/*
The HTML is then sent to the browser using a PrintWriter:
*/
            PrintWriter out =
                new PrintWriter(response.getOutputStream());
            out.println(replyPage);

            out.close();
        }
    }
```

30.2 Decoding *EchoEnvironmentServlet*

After a servlet uses an instance of *HttpServletRequest* to decode information about the browser, the data is transmitted to the server.

Figure 30.2-1 shows a table of *request* variables that are available to the servlet programmer. Most of the variables are not used by a typical servlet. The method name *GET* is used to invoke the *doGet* method in an *HttpServlet* instance, which will be described in greater detail later. *EchoEnvironmentServlet* serves as an example of how to get all of the environment variables from a *request*:

Server Name:	www.docjava.com
Server Port:	8080
Server Protocol:	HTTP/1.1
Servlet Name:	/servlet/EchoEnvironmentServlet
Method:	GET
Path Info:	null
Path Translated:	null
Query String:	null
Request URI:	/examples/servlet/EchoEnvironmentServlet
Remote Host:	mac.docjava.com
Remote Addr:	192.168.1.100
Remote User:	null
Authorization Type:	null
Content Type:	null
Content Length:	-1

FIGURE 30.2-1
Table of Request Variables

```java
import javax.servlet.*;
import javax.servlet.http.*;

import java.io.*;
import java.util.*;
import gui.HtmlSynthesizer;

public class EchoEnvironmentServlet
    extends HttpServlet {
/*
One of the problems with servlet code is that it tends to
        become clogged with print statements and embedded
        HTML. The HtmlSynthesizer is a good way to reduce the
        amount of HTML embedded in the servlet:
*/
    gui.HtmlSynthesizer synth = new gui.HtmlSynthesizer();

    public void service(HttpServletRequest request,
                        HttpServletResponse response)
            throws IOException    {
/*
The following two-dimensional array shows all the properties
        available from the request header:
*/
        String requestString[][] = {
            { "Server Name:", request.getServerName() },
            { "Server Port:" ,""+ request.getServerPort() },
            { "Server Protocol:" ,""+ request.getProtocol() },
```

```
        { "Servlet Name:" ,""+ request.getServletPath() },
        { "Method: ", ""+ request.getMethod() },
        { "Path Info:" ,""+ request.getPathInfo() },
        { "Path Translated:" ,""+ request.getPathTranslated() },
        { "Query String:" ,""+ request.getQueryString() },
        { "Request URI:" ,""+ request.getRequestURI() },
        { "Remote Host:" ,""+ request.getRemoteHost() },
        { "Remote Addr:" ,""+ request.getRemoteAddr() },
        { "Remote User:" ,""+ request.getRemoteUser() },
        { "Authorization Type:" ,""+ request.getAuthType() },
        { "Content Type:" ,""+ request.getContentType() },
        { "Content Length:" ,""+ request.getContentLength()}
    };
```

When constructing the reply, we make use of the *HtmlSynthesizer* instance to transform the given array into a table, which makes the code a lot neater:

```
String replyPage =
    "<HTML>"
  + "<BODY>"
  + synth.getTable(
                    synth.getSheet(requestString)
                    )
  + "<hr>"
```

In the following lines, we get header names and their values:

```
  + "<H2>  Request Header Information </H2>";
Enumeration e = request.getHeaderNames();
String name;

while (e.hasMoreElements())              {
  name = (String) e.nextElement();
  replyPage +="<p><b>"
      + name
      + ": </b>"
      + request.getHeader(name);
}
replyPage += "<hr>";

replyPage += "</BODY> </HTML>";

response.setContentType("text/html");

PrintStream out = new PrintStream(
  response.getOutputStream());
out.println(replyPage);
out.close();
    }
  }
```

The output from the *getHeaderNames* invocation follows:

```
Request Header Information
Host: www.docjava.com:8080
Accept: */*
Accept-Language: en
Connection: Keep-Alive
```

```
If-Modified-Since: Thu, 12 Jul 2001 17:35:56 GMT
Referer: http://www.docjava.com:8080/examples/servlets/
User-Agent: Mozilla/4.0 (compatible; MSIE 5.0; Mac_PowerPC)
UA-OS: MacOS
UA-CPU: PPC
Cookie: SESSIONID=To1023mC9800482913824243At
Extension: Security/Remote-Passphrase
```

Information about the host's operating system can assist the servlet programmer in identi-fying the correct version of a program to download. *User-Agent* allows the servlet pro-grammer to identify the kind of browser the client is using. *Cookies* are a topic that we defer until later.

30.3 GuestBook and Three-Tier Programming

In this section, we show how to write a three-tier program to build a servlet called *GuestBook*. Figure 30.3-1 shows a sketch of a three-tier system.

 In Tier 1, we have a thin client, typically a browser, without Java. A network connection is used between Tier 1 and Tier 2. Tier 2 typically consists of a web server that is able to run servlets. The servlets have access to JDBC. Tier 3 consists of a RDBMS that can reside on a different physical computer from the Tier 2 host.

Communication delay between the tiers second and third can slow the performance of a system. You should cache your transactions when possible.

In our system, we present the user with an interface shown in Figure 30.3-2.

 Figure 30.3-2 was created using an HTML editor that generated the following source code:

```
<HTML>
<HEAD>
   <TITLE>guestBook.html</TITLE>
   <X-SAS-WINDOW TOP=66 BOTTOM=480 LEFT=8 RIGHT=538>
</HEAD>
<BODY>
```

The *form* tag in HTML is used to define the name of the servlet that will be called by the web server. The *GET* method tag is used to define the call-back method to be used by the servlet. For example,

FIGURE 30.3-1
A Three-Tier System

Guest Book

Last Name: Munster
First Name: Herman
address1: 1313
address2: Mockingbird Ln
Email: frank@enstien
Voice phone: boo
Fax Phone:

Add **Reset**

FIGURE 30.3-2
The Guest Book
Interface

```
<FORM action=
"http://www.docjava.com:8080/examples/servlet/GuestBook"
     method="GET">

<P><HTML><HEAD><TITLE>Guest Book</TITLE></HEAD></P>

<H1><CENTER>Guest Book</CENTER></H1>

<P><CENTER><TABLE >
   <TR>
      <TD>
         <P>Last Name
      </TD><TD>
```

The *input* tag is used with a *NAME* = parameter. This parameter is passed to the servlet, so it should be unique and meaningful. For example,

```
      <P><INPUT TYPE="text" NAME="lastname" VALUE=""
      SIZE=20>
      </TD></TR>
   <TR>
      <TD>
         <P>First Name
      </TD><TD>
         <P><INPUT TYPE="text" NAME="firstname" VALUE=""
      SIZE=20>
      </TD></TR>
   <TR>
      <TD>
```

```
       <P>address1
   </TD><TD>
      <P><INPUT TYPE="text" NAME="address1" VALUE=""
      SIZE=20>
   </TD></TR>
 <TR>
    <TD>
       <P>address2
   </TD><TD>
      <P><INPUT TYPE="text" NAME="address2" VALUE=""
      SIZE=20>
   </TD></TR>
 <TR>
    <TD>
       <P>Email
   </TD><TD>
      <P><INPUT TYPE="text" NAME="phone1" VALUE="" SIZE=20>
   </TD></TR>
 <TR>
    <TD>
       <P>Voice phone
   </TD><TD>
      <P><INPUT TYPE="text" NAME="phone2" VALUE=""
      SIZE=20>
   </TD></TR>
 <TR>
    <TD>
       <P>Fax Phone
   </TD><TD>
      <P><INPUT TYPE="text" NAME="phone3" VALUE="" SIZE=20>
   </TD></TR>
</TABLE><INPUT TYPE="submit" NAME="Add" VALUE="Add"
new entry><INPUT TYPE="reset" VALUE="Reset"></CENTER></P>
</FORM>
</BODY>
</HTML>
```

When the user selects *submit*, the following URL is generated:

```
http://www.docjava.com:8080/examples/servlet/GuestBook?last
       name=Munster&firstname=Herman&address1=1313&address2
       =Mockingbird+Ln&phone1=frank@enstien&phone2=boo
       &phone3=&Add=Add
```

The format is

```
url/servletName?parm1=val1&parm2=val2&....
```

where *parm1* is parameter1 and *val1* is the value. These elements are encoded into the *request*. The goal is to decode the parameters and create an *SQL* statement for insertion. Toward that end, we have created the following *GuestBook* servlet:

```
import java.io.*;
import java.text.*;
import java.util.*;
import javax.servlet.*;
```

```
import javax.servlet.http.*;

public class GuestBook extends HttpServlet {
/*
The getSql statement takes the parameters used in the HTML
        form and creates an SQL string. Such an effort is
        called SQL Synthesis and can be relegated to a special
        method, or class. It is good software engineering to
        refactor such code out of the primary servlet body.
*/
    public static String getSql(
                                 String firstname,
                                 String lastname,
                                 String address1,
                                 String address2,
                                 String phone1,
                                 String phone2,
                                 String phone3){
        return "insert into phonelist"
           + "(firstname,lastname,"
           + "address1,address2,phone1,phone2,phone3) values
           "
           + "("+quote(firstname)
           + quote(lastname)
           + quote(address1)
           + quote(address2)
           + quote(phone1)
           + quote(phone2)
           + nocommaQuote(phone3) +")";
    }
```

An example SQL statement might be

```
insert into
        phonelist(firstname,lastname,address1,address2,phone1,
        phone2,phone3) values
        ('Herman','Munster','1313','Mockingbird
        Ln','frank@enstien','boo','')
```

The *nocommaQuote* method provides single quotes around a string, which helps to create HTML without many \` embedded in it:

```
public static String nocommaQuote(String s) {
    return "'"+s+"'";
}
```

The *quote* method is like the *nocommaQuote* method only it adds a comma by default:

```
public static String quote(String s) {
    return "'"+s+"',";
}
```

It is important to have consistency between HTML parameters and servlet parameters or your program will break. Parameter names should be consistent with the parameters the servlet expects. The drawback is that only Java programmers will be creating the form. For example,

```
public static String getForm() {
    return
        "<HTML>"
      +"<HEAD>"
      +"<TITLE>Phone Book</TITLE></HEAD>"
      +"<BODY>"
      +"<CENTER>"
      +"<H1>Telephone Book</H1>"
      +"<FORM ACTION=GuestBook METHOD=GET><TABLE>"
      +"<TR>"
      +"  <TD>Last Name</TD>"
      +"  <TD><INPUT TYPE=TEXT SIZE=20
NAME=lastname></TD></TR><TR>"
      +"  <TD>First Name</TD>"
      +"  <TD><INPUT TYPE=TEXT SIZE=20
NAME=firstname></TD></TR><TR>"
      +"  <TD>address1</TD>"
      +"  <TD><INPUT TYPE=TEXT SIZE=20
NAME=address1></TD></TR><TR>"
      +"  <TD>address2</TD>"
      +"  <TD><INPUT TYPE=TEXT SIZE=20
NAME=address2></TD></TR><TR>"
      +"  <TD>Phone1</TD>"
      +"  <TD><INPUT TYPE=TEXT SIZE=20
NAME=phone1></TD></TR>"
      +"  <TD>Phone2</TD>"
      +"  <TD><INPUT TYPE=TEXT SIZE=20
NAME=phone2></TD></TR>"
      +"  <TD>Phone3</TD>"
      +"  <TD><INPUT TYPE=TEXT SIZE=20
NAME=phone3></TD></TR>"
      +"</TABLE>"
      +"<INPUT TYPE=Submit NAME=Add VALUE=Add New
Entry>"
      +"<INPUT TYPE=Reset VALUE=Reset>"
      +"</FORM><BR>"
      +"</BODY></HTML>";
}
```

The *doGet* method is a primary call-back method for an *HTTPServlet* class.

```
public void doGet(HttpServletRequest request,
                  HttpServletResponse response)
    throws IOException, ServletException
{
    response.setContentType("text/html");
    PrintWriter out = response.getWriter();
/*
Parameters passed in the request are obtained via a String
    query called getParameter. As a result, there is a
    problem with the synchronization of the parameter
    names in the form and those that are to be entered in
    the servlet. If the parameters are not the same, the
```

```
*/
getParameter invocation will fail. Even worse, the
type of the parameter being passed is not known. Thus,
there is no strong typing in this sort of interface
and a parameter typo can cause a failure.
*/
        String fn = request.getParameter("firstname");
        String ln = request.getParameter("lastname");
        String a1 = request.getParameter("address1");
        String a2 = request.getParameter("address2");
        String p1 = request.getParameter("phone1");
        String p2 = request.getParameter("phone2");
        String p3 = request.getParameter("phone3");
        out.println("<html>");
        out.println("<body bgcolor=\"white\">");
        out.println("<body>");
        if (fn != null) {
/*
We assume that we should output a form if there have been no
parameters placed on input, otherwise, we use the
parameters to synthesize some SQL. We output the SQL
for confirmation and then invoke Execute.statement.
*/
            String sql =getSql(fn,ln,a1,a2,p1,p2,p3);
            out.println("sql inserted="+sql);
            Execute.statement(sql);
        } else out.println(getForm());

        out.println("</body>");
        out.println("</html>");
    }
}
```

The above code returns a confirmation page:

```
sql inserted=insert into
        phonelist(firstname,lastname,address1,address2,phone1,
        phone2,phone3) values
        ('Herman','Munster','1313','Mocking bird
        Ln','frank@enstien','boo','')
```

When we check the *sql* database, we find

```
mysql> select * from phonelist;
...
| Herman    | Munster | 1313            | Mocking bird
        Ln | frank@enstien
        | boo           |             |
...
```

In summary, we have seen that strings are used to obtain parameters by name from the *request*. The return values are strings and otherwise are not strongly typed. The strings must be parsed, and any error control must be performed within the servlet.

 To execute the SQL command, we have a helper class called *Execute*.

30.4 SQL and the *Execute* Class

It is generally a good idea to separate SQL synthesis code from the code that executes SQL statements. The reason is that SQL code contains elements that are specific to a system (like the driver). Also, doing so simplifies the other code in a system. Finally, it centralizes the changes that need to be made, thus lowering the cost of maintenance.

Section 30.3 showed an invocation of the *Execute* class in a three-tier system:

```
String sql =getSql(fn,ln,a1,a2,p1,p2,p3);
out.println("sql inserted="+sql);
Execute.statement(sql);
```

The *Execute* class source code follows:

```
import java.sql.*;
import java.io.*;
import java.util.*;

public class Execute {
    public static void main(String args[]) {
            Execute.statement(
"insert into phonelist(firstname,lastname) values
          ('doug','lyon')"
);
    }
    public static void statement(String sql) {
        try {

        Class.forName("org.gjt.mm.mysql.Driver") .newInstance()
        ;
            Connection c = DriverManager.getConnection(
                "jdbc:mysql://localhost:3306/test","lyon",null
                );
             Statement s = c.createStatement();
             s.execute(sql);
             s.close();
             c.close();
        }
        catch (Exception e) {
            e.printStackTrace();
        }
        }
    }
}
```

The name of the driver used, user ID, and password all are being stored as plain text and in the clear (i.e., easy to read):

```
Connection c = DriverManager.getConnection(
                "jdbc:mysql://localhost:3306/test","lyon",null
                );
```

WARNING Anyone on the network should be able to connect to localhost using the login *lyon* and password *null*. Use of a firewall at the site prevents the transport of TCP/IP packets directed at port *3306*.

A firewall keeps people from hacking into an RDBMS, which is another excellent ratio-nale for a three-tier system. Now, only the middleware can get access to the RDBMS even though the RDBMS is not password protected. The assumption is that people inside the firewall can be trusted (which might be a bad assumption). Security typically involves a balancing act between freedom and safety.

30.5 Server-Side Graphics

Using servlets, you can supply any type of data you like to the browser as long as the browser knows how to decode it.

In order to assist the browser in deciding what type of data you are supplying, you set the MIME-type in the *response*. This section shows how to generate GIF images and send them to the client using the *charts* package described in Chapter 26. Figure 30.5-1 shows an image of the browser's display after the code in this section is executed as a servlet.

Several interesting bugs can cause you to be nonproductive for days at a time if you are unaware of them.

FIGURE 30.5-1
The Server-Side Chart

Under Linux, a well-known bug is that AWT invocations require that the *DISPLAY* variable be set to an X server. At your console, under *csh* type

```
setenv DISPLAY localhost:0.0
```

Test the X-window service by typing

```
xclock
```

Which should make a clock appear on your screen. If you are on a server and do not want to run X, then you need a virtual X server like *Xvfb*.

WARNING

A common error for the middleware programmer is to start using *Writer* for a request and then to start a binary output stream.

Doing so throws *IllegalStateException.* Thus, it is a good idea for a binary output servlet to be separated from a text output servlet. The URL for a servlet that generates GIFs can be treated just like an embedded image by using *href* tags. The *ChartTest* code follows:

```java
import java.io.*;
import javax.servlet.*;
import javax.servlet.http.*;
import charts.*;
import net.ChartServer;

public class ChartTest extends HttpServlet {

    public void doGet(HttpServletRequest request,
                      HttpServletResponse response)
        throws IOException, ServletException {
        BarGraph bg = new BarGraph(new DoubleData(200,200));
        ChartServer.writeComponentToResponse(response,bg);
    }
}
```

The *ChartTest* class shows an invocation of *ChartServer.writeComponentToResponse*, which is able to grab a snapshot of an AWT *Component* and write it to *HttpServlet Response*. This saves the programmer a lot of work and greatly implies the code in the servlet. The *ChartServer* code follows:

```java
import javax.servlet.*;
import javax.servlet.http.*;
import java.io.*;
import gui.*;
import charts.*;
import java.awt.*;

public class ChartServer {
/*
The writeGif method uses the ImageUtils.getImage method to
 transform a component into an Image instance.
*/
        public static void writeGif(
                HttpServletResponse response,
                Component c) {
            writeGif(response, ImageUtils.getImage(c));
        }
```

```
/*
Once we have an Image instance, we can write a GIF image out
        to a stream.
*/
    public static void writeGif(
        HttpServletResponse response,
        Image img) throws IOException {
/*
First we announce to the browser that image/gif data is on
        the way:
*/
        response.setContentType("image/gif");
/*
Now we use some header settings that will require the browser
        to display the stream, before it is closed, or
        flushed. This is a technique that is very useful for
        streaming video to the browser:
*/
        // avoid caching in browser
        response.setHeader ("Pragma", "no-cache");
        response.setHeader ("Cache-Control","no-cache");
        response.setDateHeader ("Expires",0);
        ServletOutputStream sos=response.getOutputStream();
        toServlet(img, sos);
        }

         public static void toServlet(Image img,
                ServletOutputStream sos) {
     // encode the image as a GIF
/*
The WriteGIF can output to any stream, even if it is a
        ServletOutputStream. This is an example of
        polymorphism.
*/
    try {
        WriteGIF wg = new WriteGIF(img);
        wg.toOutputStream(sos);
      }
      catch(Exception e){
         System.out.println("Save GIF Exception!");
      }
    }
}
```

30.6 Get versus Post and the RequestUtil Class

The *doGet* method is invoked with parameters that are shown in the URL. For example,

```
http://www.docjava.com:8080/login.html?username=lyon&pw=foo
```

It is clear from the URL that the user can see and manipulate the parameters being passed to the *request*. However, so can anyone else looking over the user's shoulder.

An alternative means of sending parameters in the body of the request is the *doPost* method, which is done in HTML using

```
<form method="post" ACTION=
"http://localhost:8080/servlet/HTTPPoserServlet">
```

The parameters then are passed to the *request* as with the *GET* method. In order to get the parameters and values from a *request*, we have written the *RequestUtil* class:

```
package survey;
import java.io.*;
import javax.servlet.*;
import javax.servlet.http.*;
import java.util.*;
*/
The RequestUtil class is able to get all the parameter names
  and values as arrays of String. This enables servlet code to
          be written to get all the names and values easily. The
          reader is cautioned, however, that the name-values
          will pair up correctly, but will NOT come in any
          particular order.
*/
/**
 * RequestUtil Class
 */

public class RequestUtil {

    /**
    * getParmNames        Method
    *
    * @parm                        HttpServletRequest
    * @return              String[]
    */
/*
The names will be consistent with the values, but the overall
        order of appearance of parameters in the URL is not
        being mapped to the array index:
*/
    public static String [] getParmNames(HttpServletRequest
        request) {

        Vector v = new Vector();

        Enumeration e =
            request.getParameterNames();

        while (e.hasMoreElements())
            v.addElement(e.nextElement());

        String s[] = new String[v.size()];

        for (int i=0; i < s.length; i++)
            s[i] = (String) v.elementAt(i);

        return s;

    }
```

```
/**
 * getParmValues Method
 *
 * @parm                    String[]
     field names
 * @parm                    HttpServletRequest
 * @return          String[]
 */

public static String[] getParmValues(String pn[],
                                    HttpServletRequest

    request) {

    String pv[] = new String[pn.length];

    for (int i=0; i < pn.length;i++)
        pv[i] = request.getParameter(pn[i]);

    return pv;

    }

}
```

To get the names and values, use

```
String [] iNames  =
    RequestUtil.getParmNames(request);
String [] iValues =
    RequestUtil.getParmValues(iNames, request);
```

These parameters all are being sent in the clear. Anyone can intercept them by inspecting the packets on the network.

30.7 Cookies and Sessions

HTTP is a stateless protocol.

A stateless protocol has no memory, which means that a request is served without any record of the request being stored. State management is used to give memory to clients and typically is performed using an instance of a data structure called a cookie.

A *cookie* is a means to make shopping carts, record transactions, and store user information.

In order for cookies to be used, they must be stored on the *client*, which means that the browser must accept the cookies. Cookies are passed in the HTTP header, as specified in RFC 2109, "HTTP State Management Mechanism." Typically, the head is of the form

```
set-cookie: <name> = < value>; expires=<date>; domain =
        <dname>; path = <path>; secure
```

where the *set-cookie* tag tells the client to store the cookie. For example,

```
HTTP/1.0 200 OK

...
set-cookie: customerID=1234; domain=docjava.com, path=/orders
```

 The client stores a maximum of 300 cookies at 4 KB each. Only 20 cookies are permitted per domain.

30.7.1 Cookies and the Servlet API

 The servlet API sets cookies on the *response* header.

For example,

```
response.setHeader("set-cookie", "customerID=1234");
response.setHeader("set-cookie", "domain=docjava.com");
```

Thus, cookies consist of parameter strings. A more object-oriented way to use cookies is to make use of the *javax.servlet.http.Cookie* class. With the *Cookie* class, you can invoke a series of *set* methods:

```
Cookie c = new Cookie("user", "lyon");
c.setDomain("docjava.com");
c.setMaxAge(120); // 2 minutes
c.setPath("/");
c.setSecure(true);
response.addCookie(c);
```

 The cookie is sent in the response header as soon as the writing process begins.

For example,

```
PrintWriter out = response.getWriter();
out.println("cookies away!");
out.close();
```

Since the number of cookies per domain is limited, you should eat your cookies when you are done with them. To eat the cookies, just set the age to zero. Also, make sure that the cookie name matches the one you want to eat:

```
Cookie c = new Cookie("user", "lyon");
c.setMaxAge(0); // eat cookie
response.addCookie();
```

In order to get cookies from the *request*, you used the *getCookies* command. The following code snippet will look at all of the cookies and stop when it gets to the one it wants. It then parses the value stored in the cookie:

```
package utils;
import javax.servlet.*;
import javax.servlet.http.*;

public class CookieUtil {
    public static String getValue(HttpServletRequest request,
                                  String cookieName) {
        Cookie cookies[] = request.getCookies();
        for (int i=0; i < cookies.length; i++)
```

```
            if (cookies[i].getName().equals(cookieName))
                return cookies[i].getValue();
        return null;
    }
```

Thus, the programmer can write

```
String value = CookieUtil.getValue(request, "cookieName");
```

If the cookie cannot be found, a *null* value will be returned.

The following method, *countVisits*, uses *getValue* in order to get the *string* instance associated with a cookie. It is the server-side Java programmer's job to parse this string into a correct data-type. For example,

```
static int countVisits(HttpServletRequest request,
                HttpServletResponse response) {

        int numberOfVisits = 0;
        String numberOfVisitsS =
            getValue(request, "CounterCookie");
        try {
            numberOfVisits =Integer.parseInt(
                numberOfVisitsS)+1;
        }
        catch(NumberFormatException e) {
        }
        Cookie c
            = new Cookie("CounterCookie",numberOfVisits+" ");

        response.addCookie(c);
        return numberOfVisits;
    }
}
```

This code records the number of times the client has visited the server in the cookie. As long as the client retains the cookie, we can track the number of visits.

For more examples of using cookies, see Chapter 31.

30.7.2 Session Management

Session management is different from state management. State management provides a memory for the client (e.g., preferences and purchases), whereas session management provides memory for *identity*.

For example, after a user logs in, we can send a session ID that allows us to identify the user. After the http session begins, the user can request a logout, or an expiration can log the user out automatically.

For example, an on-line brokerage firm can use a short expiration period (e.g., 5 minutes) so that no one can execute a trade from an unattended terminal. This expiration period provides a kind of security. Typically, the session is set up using the *HttpSession* interface. We can obtain an instance of this interface using the following code:

```
HttpSession session = request.getSession(true);
```

The *getSession* method takes a boolean parameter. If it is *true*, the *getSession* invocation will create a session if one does not already exist:

```
String id = session.getID();
```

The *session* name is a standard variable name, which is used by JSPs (a topic addressed in Chapter 31). The *getID* method returns a unique session ID that was assigned to the session:

```
long t = session.getLastAccessedTime();
```

This above code returns the time in milliseconds, as does

```
long ts = session.getCreationTime();
Object o = session.getValue("login");
```

If the above code returns *null*, then the "login" value was undefined:

```
String names[] = session.getValueNames();
```

The *isNew* method returns *true* if the client is requesting the page for the first time (i.e., if the session is new).

```
boolean n = session.isNew();
```

In order to bind an instance (so that *getValue* can get it from future sessions), use

```
session.putValue("java is great", new Boolean(true));
```

In order to make the session time out, use

```
session.setMaxInactiveInterval(120); // seconds
```

In Chapter 31, we will show how to store a shopping cart in the *session* variable in order to keep track of the number of items a customer has selected.

30.8 Exercises

30.1 Take an existing GUI written in Swing. Try to create a corresponding HTML form that is delivered using a servlet. List the components used in the Swing API and the HTML tags used in the servlet.

30.2 Write a program that scans for Swing components in a *Container*. Map a subset of them to HTML tags and synthesize the Java source code you need to create a servlet that can emulate the Swing GUI.

30.3 Use introspection to create a servlet that will prompt the user for the properties in an instance. Instantiate the instance only after performing error checking.

30.4 Build a spiral server that presents a form to the user to generate a spiral.

30.5 Build a GUI server that is able to convert a Swing GUI into an image and present it as a GIF for the browser to display.

30.6 Use the *ImageMap* tag in HTML to allow a user to enlarge or shrink a chart image. An example of the HTML follows:

```
<HTML>
<HEAD>

   <X-SAS-WINDOW TOP=200 BOTTOM=200 LEFT=0 RIGHT=200>
</HEAD>
<BODY>
```

```
<P><MAP NAME="map1">
  <AREA SHAPE=RECT COORDS="100,0,200,200"
      HREF="http://www.docjava.com:8080/examples/servlet/Cha
      rtTest&size=bigger">
  <AREA SHAPE=RECT COORDS="0,0,100,100"
      HREF="http://www.docjava.com:8080/examples/servlet/Cha
      rtTest&size=smaller">
</MAP><IMG USEMAP="#map1"
SRC="http://www.docjava.com:8080/examples/servlet/ChartTest"
WIDTH=200 HEIGHT=200 X-SAS-UseImageWidth X-SAS-UseImageHeight
ALIGN=bottom></P>
</BODY>
</HTML>
```

30.7 Build a server-side file system that does not require Java to be running on the client. Allow the user to create, delete, list, and rename files or directories.

FIGURE 30.8-1
A Sample File Listing

Figure 30.8-1 shows a server-side list. To select a file or directory for an operation, you select the file or directory. You are then presented with a series of options (i.e., create, delete, list, and rename). If you select a directory and a list, the directory is expanded. If you select a file, it is viewed. If you select a file and perform the create operation, the file is left untouched unless there is a file name conflict, in which case the file is overwritten and a warning appears.

30.8 Discuss trade-offs between using servlets with graphics being written out to a stream and graphics written to a file that is referred to by an HTML *href*. Will one method be faster than the other? How about the potential for reuse of graphics? What happens to disk space clutter?

30.9 Create an example program that keeps a user logged in. Prompt the user for a password and a user ID. Will you use cookies? Why or why not?

C H A P T E R 3 1

JSP

In this chapter, you will learn:

- How to build a JSP page
- How to perform compilation on demand
- About the limits of JSP pages

This chapter describes Java Server Pages (JSP). JSP represents a compile-on-demand server-side technology that provides, a way to reference the dynamic part of a web page in an otherwise static HTML document.

 JSP's consist of modified HTML and *JSP* tags that guide the source expansion. Thus, JSP is a *macro language*. The main purpose of JSP is string processing and code synthesis.

JSP gives Java programmers a chance to write Java code embedded directly in a web page, which can lead to several development management problems unless care is exercised.

 Since the process of compilation is generally a slow one, the first visit to JSP is the longest. After the first visit, the page typically runs much faster. Thus, it is up to the server-side JSP author to be the first visitor to the JSP. Deployment of JSP without an initial visit is like deployment of source code without checking it for a clean compile!

31.1 What Is a JSP?

Java Server Pages is a Java technology that provides a macro pre-processor facility to Java. JSP is the de facto industry standard for server-side Java programming.

Now when we revisit the refactored JSP code, we obtain the new and improved version:

```
<head><title>CookieCounter</title></head>
<body bgcolor="white">
<font size=4>
You have visited this page
<%
        out.print( utils.CookieUtil.countVisits(request,
        response));
 %>
 times.

  Care to <a href="cookieCount.jsp">try again</a>?
</font>
</body>
</html>
```

The above code is a much easier document for HTML designers to use.

31.5 Sniffing out the Header in JSP

In this section, we show how to access all of the information in the JSP *response*. After it
executes, the output will look like

```
Cookies found:

cookie #0=SESSIONID value=To1010mC2729405209622806At
cookie #1=CounterCookie value=12

Request Information

Method: GET
Request URI: /examples/jsp/count/util.jsp
Protocol: HTTP/1.1
PathInfo: null
Remote Address: 192.168.1.100

Header Names

Host = www.docjava.com:8080
Accept = */*
Accept-Language = en
Connection = Keep-Alive
If-Modified-Since = Tue, 17 Jul 2001 15:32:25 GMT
Referer = http://www.docjava.com:8080/examples/jsp/count/util.jsp
User-Agent = Mozilla/4.0 (compatible; MSIE 5.0; Mac_PowerPC)
UA-OS = MacOS
UA-CPU = PPC
Cookie = SESSIONID=To1010mC2729405209622806At; CounterCookie=12
Extension = Security/Remote-Passphrase

Request Information

JSP Request Method: GET
```

```
Request URI: /examples/jsp/count/util.jsp
Request Protocol: HTTP/1.1
Servlet path: /jsp/count/util.jsp
Path info: null
Path translated: null
Query string: null
Content length: -1
Content type: null
Server name: www.docjava.com
Server port: 8080
Remote user: null
Remote address: 192.168.1.100
Remote host: mac.docjava.com
Authorization scheme: null
The browser you are using is Mozilla/4.0 (compatible; MSIE 5.0;
Mac_PowerPC)
```

Care to try again?

JSP produces the above output on the browser as follows:

```
<!--
  util.jsp
  Written by Doug Lyon <lyon@docjava.com>, President, DocJava,
        Inc.
  Copyright 2000, DocJava, Inc
-->

<%@ page import = "java.util.*" %>

<html>
<head><title>Util.jsp</title></head>
<body bgcolor="white">
<font size=4>
<%
        int nof = 0;
        Cookie cookies[] = request.getCookies();
        out.println("<p><hr><h3>Cookies found:</h3>");
        for (int i=0; i < cookies.length; i++)
                out.println("<li>cookie
        #"+i+"="+cookies[i].getName()+" value="+
        cookies[i].getValue());
    out.println("<p><hr><h3>Request Information</h3>");
    out.println("<li>Method: " + request.getMethod());
    out.println("<li>Request URI: " +
        request.getRequestURI());
    out.println("<li>Protocol: " + request.getProtocol());
    out.println("<li>PathInfo: " + request.getPathInfo());
    out.println("<li>Remote Address: " +
        request.getRemoteAddr());
    out.println("<p><hr><h3>Header Names</h3>");
    Enumeration e = request.getHeaderNames();
    while (e.hasMoreElements()) {
            String name = (String)e.nextElement();
```

```
            String value = request.getHeader(name);
            out.println("<li>"+name + " = " + value);
        }
    %>
    <h1> Request Information </h1>
<font size="4">
```

The following is called an *XML* style expression. XML requires a start tag and an end tag. It is equivalent to the <% = JSP expression. Also, it eliminates the need to insert a semi-colon at the end of the statement. JSP expressions, like this, are sometimes considered more readable, though such preferences are a matter of style and personal taste.

```
JSP Request Method: <jsp:expr>  request.getMethod()
        </jsp:expr>
<br>
Request URI: <jsp:expr> request.getRequestURI()  </jsp:expr>
<br>
Request Protocol: <jsp:expr> request.getProtocol() </jsp:expr>
<br>

Servlet path: <jsp:expr> request.getServletPath() </jsp:expr>
<br>
Path info: <jsp:expr> request.getPathInfo() </jsp:expr>
<br>
Path translated: <jsp:expr> request.getPathTranslated()
        </jsp:expr>
<br>
Query string: <jsp:expr> request.getQueryString() </jsp:expr>
<br>
Content length: <jsp:expr> request.getContentLength() </jsp:expr>
<br>
Content type: <jsp:expr> request.getContentType() </jsp:expr>
<br>
Server name: <jsp:expr> request.getServerName() </jsp:expr>
<br>
Server port: <jsp:expr> request.getServerPort() </jsp:expr>
<br>
Remote user: <jsp:expr> request.getRemoteUser() </jsp:expr>
<br>
Remote address: <jsp:expr> request.getRemoteAddr() </jsp:expr>
<br>
Remote host: <jsp:expr> request.getRemoteHost() </jsp:expr>
<br>
Authorization scheme: <jsp:expr> request.getAuthType() </jsp:expr>
<hr>
The browser you are using is <jsp:expr>
        request.getHeader("User-Agent") </jsp:ex
pr>
<hr>
  <p>Care to <a href="util.jsp">try again</a>?

</font>
</body>
</html>
```

31.6 Sending Mail from a JSP

This section shows how to make JSP solicit information using a form, and then send an e-mail receipt with the date and a timestamp. We also show how to make use of a class that will help to send email from the server, which can assist in communication between the server-side Java program and the outside world.

The HTML for creating the form follows:

```
<HTML>
<HEAD>
    <TITLE>feedback</TITLE>
    <META NAME=GENERATOR CONTENT="Claris Home Page 2.0">
    <X-SAS-WINDOW TOP=36 BOTTOM=450 LEFT=58 RIGHT=588>
</HEAD>
<BODY BGCOLOR="#FFFFFF">
<FORM action="examples/jsp/sendMail/sendMail.jsp"
        method="GET">

<P>Feedback form. Please use the following area to send
        feedback. You
may send feedback about any topic you like, courses, web pages,
software, books, etc. Your feedback is unsigned and may be
        sent with
complete privacy. Please send constructive feedback, i.e.,
suggestions for improvement.</P>

<P>Thanks!</P>

<P> </P>

<P>- DL</P>

<P> </P>

<P><TEXTAREA NAME="message" ROWS=21 COLS=48>Here are my
        constructive comments:</TEXTAREA>
</P>

<P><INPUT TYPE="submit" NAME="Submit" VALUE="Submit"></P>
</FORM>
</BODY>
</HTML>
```

Figure 31.6-1 shows an image of the form used to submit comments. A *submit* button appears on the bottom of the form, though it is not shown in the figure. The *action* is

FIGURE 31.6-1
A Form for Submitting Comments

Your message:

Here are my constructive comments: If a man points at the moon, an idiot will look at the finger. -Sufi wisdom

was sent on Tue Jul 17 14:52:01 EDT 2003

Thanks!

FIGURE 31.6-2
A Sample Constructive Comment

examples/jsp/sendMail/sendMail.jsp. The job of *sendMail.jsp* is to obtain the parameters from the input form and use the value of the *message* to send mail. The code for *sendMail.jsp* follows. Note the technique used to import multiple packages:

```
<%@ page import = "java.io.*,java.net.*,net.*" %>
<HTML>
<HEAD>
   <TITLE>sentMessage</TITLE>
   <X-SAS-WINDOW TOP=40 BOTTOM=454 LEFT=78 RIGHT=608>
</HEAD>
<BODY BGCOLOR="#FFFFFF">

<%
        String message = request.getParameter("message");
         Smtp sm = new Smtp();
         sm.setMailServerHostName ("192.168.1.95");
         sm.setRecipientEmail ("lyon@docjava.com");
         sm.setSenderEmail ("lyon@docjava.com");
         sm.setMessage (message);
         sm.start();
%>
<P>
Your message: <p>
<% out.println(message); %>
<p>
   was sent on
<% out.println(new java.util.Date()); %>
<p>
 Thanks!

</BODY>
</HTML>
```

The response message is shown in Figure 31.6-2.

The key element in the JSP for sending the email was the use of the *sendmail.Smtp* class, which was described in Section 29.11.

31.7 Multimedia Server Pages

Multimedia server pages (MSP) is a term that I coined for JSP. MSP can provide more than just text.

 One of the basic problems with a JSP is that it typically occupies the *response OutputStream* instance with a *JspWriter* instance called *out*. Therefore, you cannot send binary (i.e., multimedia) data directly to the stream.

Your only hope is to rewrite the JSP engine or to save the binary file to disk and ask browsers to visit the file.

Figure 31.7-1 shows a sample of the prototype MSP output.

The JSP program for sending the image follows:

```
<!--
  This program will save an image to the
  web servers docbase and provide an
  href for download
  CopyLeft DocJava, Inc. 2001
-->
<%@ page import =
        "java.awt.image.*,java.awt.*,java.io.*,gui.*" %>

<html>
        <head>
                <title>
                        GifSaver
                </title>
        </head>
        <body bgcolor="white">

<%

        out.println("Hello world");
        Frame f = new Frame();
        f.addNotify();
        Image i = f.createImage(200,200);
        Graphics g = i.getGraphics();
        g.drawLine(0,0,200,200);
        g.drawLine(0,200,200,0);
        g.drawLine(0,100,100,100);
        WriteGIF.toFile(i,"/home/lyon/java/jswdk-
```

Hello world

Another fine Multimedia server page!

FIGURE 31.7-1
MSP Output

```
                    1.0.1/webpages/foo.gif");
         %>

                    <img src="http://www.docjava.com:8080/foo.gif">
                    <h1>
                              Another fine Multimedia server page!
                    </h1>
                    </body>
         </html>
```

31.8 Charts in MSP

In our final installment on MSP, we show how to provide server-side charts from JSP. Figure 31.8-1 shows an image of the server-side chart.

The following JSP is simplified by the use of the *ImageUtil.getImage* method, which is used to paint any component onto the screen.

```
<!--
   This program will save an image to the
   web servers docbase and provide an
   href for download
   CopyLeft DocJava, Inc. 2001
-->
<%@ page import =
        "java.awt.image.*,java.awt.*,java.io.*,gui.*,charts.*"
        %>

<html>
```

FIGURE 31.8-1
A Server-Side Chart

```
              <head>
                      <title>
                              Chart Saver
                      </title>
              <h1>
                      chart.jsp
              </h1>
              </head>
              <body bgcolor="white">
      <%

              BarGraph bg = new BarGraph(new DoubleData(200,200));
              Image i = ImageUtils.getImage(bg);
              WriteGIF.toFile(i,"/home/lyon/java/jswdk-
              1.0.1/webpages/foo.gif");
      %>

              <img src="http://www.docjava.com:8080/foo.gif">
              <h1>
                      Another fine Multimedia server page!
              </h1>
              </body>
      </html>
```

One alteration that should be made is that the *foo.gif* file may conflict with other programs that write to the file at the same time. As a result, a unique file probably should be used. Also, such files should be destroyed after a time.

 The entire premise that images must be saved to files before being transmitted sounds wrong, particularly since we already have servlets that can send images directly to *response* output streams.

31.9 Building a Meta-Search Engine

This section shows how to build a meta-search engine. A meta-search engine uses other search engines to perform a more complete search. Typically, such a search takes longer than using any single search, but the search is more complete.

Figure 31.9-1 shows an image of the meta-search engine page. The HTML for the search page follows:

```
<HTML>
<HEAD>
    <TITLE>The DocJava, Inc. Search Engine</TITLE>
</HEAD>
<FORM action="examples/jsp/sendMail/nowsearch.jsp"
        method="GET">

<H1>MetaSearch Engine</H1>

<P><INPUT TYPE="text" NAME="searchString" VALUE=""
SIZE=30><INPUT TYPE="submit" NAME="Submit" VALUE="Submit"></P>

<P>Copyright 2000, DocJava, Inc.</P>
</FORM>
</BODY>
</HTML>
```

MetaSearch Engine

| catalog jsp | **Submit** |

Copyright 2000, DocJava, Inc.

FIGURE 31.9-1
The Meta-Search Engine Page

The arguments to *nowsearch.jsp* are passed to a search thread. The heart of the thread formulates a series of URL queries. For example, to search for "catalog jsp," we can formulate a series of query strings like

```
http://www.alltheweb.com/cgi-
       bin/search?exec=FAST+Search&type=all&query=catalog+jsp
       yields:
http://www.go.com/Split?pat=go&col=WW&qt=catalog+jsp yields:
http://www.google.com/search?q=catalog+jsp&btnG=Google+Search
       yields:
http://www.northernlight.com/nlquery.fcg?cb=0&qr=catalog+jsp&
       search.x=28&search.y=8 yields:
http://search.excite.com/search.gw?c=web&s=catalog+jsp yields:
http://search.yahoo.com/bin/search?p=catalog+jsp yields:
http://www.lycos.com/srch/?lpv=1&loc=searchhp&query=catalog+
       jsp yields:
http://hotbot.lycos.com/?MT=catalog+jsp&SM=MC&DV=0&LG=any&DC=1
       0&DE=2&AM1=MC yields:
```

Each query string uses a search engine to perform a query. All we need to do is get the contents of the URL and invoke *out.println* to send it to the browser:

```
<%@ page import = "java.net.*" %>

<html>
<!--
  nowsearch.jsp
  Written by Douglas Lyon
  On-line meta search facility
  Copyleft 2000, DocJava, Inc.
-->
```

```
<jsp:useBean id="search" class="sendmail.WebSearch" scope="page"/>
<jsp:setProperty name="search" property="*" />
<head><title>Multiple Web Search Project</title>
<h2><font color=blue>Multiple Web Search</font></h2>
</head>
<body bgcolor="white">
<%
        String ss =
                URLEncoder.encode(
                        request.getParameter ("searchString"));

        String sa[] = {
                "http://www.alltheweb.com"
                        +"/cgi-
        bin/search?exec=FAST+Search&type=all&query="
                        + ss,

        "http://www.go.com/Split?pat=go&col=WW&qt="+ss,
                "http://www.google.com/search?q="
                        + ss+"&btnG=Google+Search",

        "http://www.northernlight.com/nlquery.fcg?cb=0&qr="
                        + ss + "&search.x=28&search.y=8",

        "http://search.excite.com/search.gw?c=web&s="+ss,
                "http://search.yahoo.com/bin/search?p="+ss,

        "http://www.lycos.com/srch/?lpv=1&loc=searchhp&query="
                        +ss,
                "http://hotbot.lycos.com/?MT="
                        +ss

        +"&SM=MC&DV=0&LG=any&DC=10&DE=2&AM1=MC"
        };

                out.println("Search for "+ss +"
        yields:<hr><p>");
                for (int i=0; i < sa.length; i++) {
                        String s ="<hr><p>"+sa[i]
                         + " yields:<p>"
                         + net.Browser.toString(sa[i]);
                        out.println(s);
                }
%>

</body>
</html>
```

Sorry to say, the above code does have a bit of logic in it. For each element in the area of search engines, a string is used to fetch a URL, which, in turn, is pumped out to the *JspWriter* instance.

All of this code runs in a single thread. In other words, if any one of the search engines is slow, then the response of the entire system will be slow. This is called a *slow trivial response time*.

31.10 Building a Fast Off-Line Meta-Search Engine

Most of the CPU muscle that server farms have is required as a result of a trivial-turnaround response time specification. This specification promises that no user should have to wait more than *X* seconds for results after making a query. To make good on that promise, large server farms are needed to dispatch queries to the least loaded machine, which requires major capital expense with high operating costs.

An alternative service promises an off-line search that can take several minutes. It is performed as a batch job, and the results are e-mailed back to the customer.

WARNING

As the search engine becomes more popular, the results will take longer to be e-mailed back.

Generally, it takes no more than several minutes to obtain results. Some people, however, are willing to trade a thorough search for a fast search.

Figure 31.10-1 shows an image of the off-line meta-search engine interface.

Figure 31.10-2 shows an image of a confirmation page, which is generated in less than a second. JSP for the *websearch.jsp* page follows:

```
<html>
<!--
  websearch.jsp
  CopyLeft, DocJava, Inc.
-->
<head><title>Multiple Web Search Project</title>
```

Multiple Web Search

Please enter your search criteria and email address.
Results will be emailed to you.

Search Criteria `java shopping cart` Email Address `lyon@docjava.com`

`[submit]`

FIGURE 31.10-1
The Off-Line Meta-Search

Multiple Web Search

Please enter your search criteria and email address.
Results will be emailed to you.

Search Criteria `[]` Email Address `[]`

`[submit]`

Thank you.
Your search results for " java shopping cart " will be emailed to you shortly.

FIGURE 31.10-2
The Meta-Search Confirmation Page

```
<h2><font color=blue>Multiple Web Search</font></h2>
</head>

<body bgcolor="white">
<font size=4>
                    <form method=POST action=websearch.jsp>
        Please enter your search criteria and email address.<br>
                            Results will be emailed to you.<br><br>
                            <table>
                                    <tr>
                                    <td>Search Criteria</td>
                                    <td><input type='text'
        name='searchString'></td>

                            <td>Email Address</td>
                            <td><input type='text' name='email'></td>
                                    </tr>

                            </table>
                            <br>
                            <input type='submit' value='submit'>
                    </form>
<%
        String searchString =
                request.getParameter("searchString");
        String email =
                request.getParameter("email");
        if (
            (searchString != null) &&
            (email != null)) {
                new net.MetaSearch(searchString,email);
%>

        <font color=red>Thank you.<br>
        Your search results for "
        <font color=blue><%= searchString %></font>
        " will be emailed to you shortly.<br>
        </font>
<%
        }
%>
</font>

</body>
</html>
```

The JSP has conditionally generated HTML that detects when arguments are present in the form. First-time visitors, for example, do not receive the *thank you* paragraphs. Also, the JSP has been simplified greatly because the search-engine code has been refactored into the *net* package:

```
package net;
import java.net.*;
import java.io.Writer;
import java.util.Vector;
```

The *MetaSearch* class implements *Runnable* so that it can run in its own thread. It starts the thread upon construction and enables an immediate return. For example,

```
public class MetaSearch
      implements Runnable {
        String ss ;
        String email;

        Thread thread = new Thread(this);
/*
The sv is the vector of search URL's needed to get search
      results from various web sites.
*/
        Vector sv = new Vector() ;

        private void initSearchVector() {
          sv.addElement(
              "http://www.alltheweb.com"
              +"/cgi-bin/search?"
              +"exec=FAST+Search&type=all&query="
              + ss
               );
              sv.addElement(
              "http://www.go.com/Split?pat=go&col=WW&qt="
              +ss);
              sv.addElement("http://www.google.com/search?q="
                      + ss+"&btnG=Google+Search");
          sv.addElement(
              "http://www.northernlight.com/nlquery.fcg?"
              +"cb=0&qr="
               + ss
               + "&search.x=28&search.y=8");
          sv.addElement(
              "http://search.excite.com/search.gw?"
              +"c=web&s="+ss);
          sv.addElement(
              "http://search.yahoo.com/bin/search?p="
              +ss);
          sv.addElement(
              "http://www.lycos.com/srch/?"
              +"lpv=1&loc=searchhp&query="
               + ss);
          sv.addElement(
              "http://hotbot.lycos.com/?MT="
               + ss
               + "&SM=MC&DV=0&LG=any&DC=10&DE=2&AM1=MC");
        }

        public MetaSearch(String searchString,
              String _email) {
        ss = URLEncoder.encode(searchString);
        email = _email;
        initSearchVector();
        thread.start();
        }
```

 Once we get the search results, we launch a child thread for sending the mail. These elements (like *ServerHostName* and *SenderEmail*) will have to be altered by the middleware programmer:

```
public void run() {
    String message = getSearchResults();
    Smtp sm = new Smtp();
    sm.setMailServerHostName ("192.168.1.95");
    sm.setRecipientEmail (email);
    sm.setSenderEmail ("lyon@docjava.com");
    sm.setMessage (message);
    sm.start();
}
```

To get the search results, we iterate through all of the URLs stored in the search vector and build up a single string. This blocks the thread, but we don't care since *getSearchResults* is invoked from the *run* method and is already in a nonmain thread:

```
public String getSearchResults() {
    String searchResults =
        "Search for "+ss +" yields:<hr><p>";
      for (int i=0; i < sv.size(); i++) {
          String url = (String)sv.elementAt(i);
          String s ="<hr><p>"+url
                + " yields:<p>"
              + net.Browser.toString(url);
              searchResults += s;
      }
    return searchResults;
}
public static void main(String args[]) {
        new MetaSearch(
            "java server pages",
            "lyon@docjava.com");
        System.out.println("Thread Running!");
    }

}
```

31.11 Building a Shopping Cart with Session Beans

This section shows how to build a shopping cart using a JSP.

Figure 31.11-1 shows a shopping cart with $200 in products. The user can decide to delete the *Image Processing in Java* product by clicking *remove*. Figure 31.11-2 shows the cart after the removal of the *Image Processing in Java* product.

The shopping cart shows that the running total has been reduced by the price of the book. Based on the *Cart* class, from Section 8.3, the JSP code that follows resides in *carts.jsp*. The *jsp:useBean* tag makes an instance of the *net.Cart* class and associates it with the *session*. The *scope* = "*session*" attribute requires that the *cart* instance of the *net.Cart* class persists in the *HttpSession* instance. Thus, the instance is *shared* across the different servlets in the *session* variable, which preserves the state of the JSP:

You have the following items in your cart:

1. name:Java for Programmers price:$35.0 productCode:11
2. name:Java DSP price:$70.0 productCode:10
3. name:Image Processing in Java price:$25.0 productCode:12
4. name:Java DSP price:$70.0 productCode:10

total=200.0

Please enter item to add or remove:

Add Item: [Image Processing in Java ↕]
[add] [remove]

FIGURE 31.11-1
The Current State of the Shopping Cart

You have the following items in your cart:

1. name:Java for Programmers price:$35.0 productCode:11
2. name:Java DSP price:$70.0 productCode:10
3. name:Java DSP price:$70.0 productCode:10

total=175.0

Please enter item to add or remove:

Add Item: [Image processing in Java ↕]
[add] [remove]

FIGURE 31.11-2
The Cart after Removal of an Item

```
<html>
<FONT size = 5 COLOR="#CC0000">
 <body bgcolor="white">
<%@ page import = "net.*" %>

<jsp:useBean id="cart" scope="session" class="net.Cart" />

<form type=POST action=carts.jsp>
```

The user can select from a small database of three products. Naturally, this is not a scalable solution, just a simple one. For example,

```
<%
        Product p1 = new Product("Image processing in Java",
        25f,12);
```

```
            Product p2 = new Product("Java for Programmers", 35f,11);
            Product p3 = new Product("Java DSP", 70f,10);

            String submit =request.getParameter("submit");
            String productName = request.getParameter("productName");
            Product p = p1;
            if (productName.equals(p2.getName()))
                    p = p2;
            if (productName.equals(p3.getName()))
                    p = p3;
            if (submit.equals("add") )
                    cart.addProduct(p);
            if (submit.equals("remove"))
                    cart.removeProduct(p);

    %>

    <br> You have the following items in your cart:
    <ol>
    <%
            net.Product pa[] = cart.getProducts();
            for (int i=0; i< pa.length; i++)
                    out.println("<li>"+pa[i]);
            out.println("<p> total="+cart.getTotal());
    %>
    </ol>

    </FONT>

    <font size = 5 color="#CC0000">

    <BR>
    Please enter item to add or remove:
    <br>
    Add Item:

    <SELECT NAME="productName">
    <OPTION> <%= p1.getName() %>
    <OPTION> <%= p2.getName() %>
    <OPTION> <%= p3.getName() %>
    </SELECT>

    <br>
    <INPUT TYPE=submit name="submit" value="add">
    <INPUT TYPE=submit name="submit" value="remove">
    </form>

    </FONT>

    </body>
    </html>
```

31.12 Summary

Syntax cannot be stated easily for the JSPs because JSP's use a macro language that enables the creation of new macro entities.

The JSP provides facilities to:

1. Do almost everything a servlet does.
2. Use a rich set of *tags* that represent the JSP language.
3. Enable extensions to the JSP language.
4. JSP expressions are written using $<\% = express\%>$.
5. Scriptlets that are inserted into JSP output code using $<\%Java\ Code\%>$.

JSP's cannot output binary data to *ServletOutputStream*, which prevents streaming multimedia data from JSP.

Further, JSP is a macro language that is expanded at visitation time. Thus, the complexity of the language and its ability to be updated as a large body of code are limited.

Writing large JSP programs with embedded Java source is probably a bad idea.

31.13 Exercises

31.1 Write a JSP that submits a URL to five different search engines. Which search engines will you use?

31.2 Write a JSP that modifies the HTML being sent from a meta-search so that you only list URLs, not advertisements.

31.3 Write a JSP that orders the URLs returned from exercise 2 and eliminates the duplicates.

31.4 Write a JSP that takes the URLs from exercise 3 and eliminates those that do not respond.

31.5 Modify the shopping cart so that adding duplicate products increases a unit quantity. For example, if I add two books that are the same, then the quantity of books should be reflected when the cart is printed (rather than printing the same book multiple times).

31.6 Write a JSP and bean for adding URLs to a search engine. Compile a list of five search engines and show how your program can add a given URL to them. What are the basic elements that are needed in order to add a URL? For example, aside from the URL, must you supply keywords? A form with all of the elements required should be generated in order for the user of your JSP to submit a URL.

31.7 Learn how to write JSP tags and provide some simple examples.

31.8 List some suggestions for server-side problems that JSP can solve. (The problems should not be the ones listed in this chapter.)

CHAPTER 32

XML

> Since I came to the White House I got two hearing aids, a colon operation, skin cancer, a prostate operation and I was shot. The damn thing is, I've never felt better in my life.
>
> *–Ronald Reagan, 40th US President*

This chapter shows:

- How to install XML libraries
- How to define your own markup language
- How to convert from CSV files to XML

32.1 What Is XML?

 Extensible Markup Language (XML) is a meta language for defining hierarchical markup languages.

XML is plain text that contains tags and attributes for delimiting data. XML data and rules for describing that data are associated with one another. The flexibility of defining rules for defining data is what give XML its power.

 XML allows data to be portable. XML + Java = portable data + portable code.

Typically, XML data is parsed by a computer program. XML provides HTML-like tags and attributes to delimit data. Just like HTML, XML represents a structure of tags with or without values.

XML tags may be defined in an XML schema or a Document Type Definition (DTD) that describes the nature of each tag present in the XML. Tags in XML files often are referred to as *elements* and their values (if any) as *attributes*, which is mainly due to the fact that XML structures tend to be viewed as tree structures. Consequently, such an approach makes XML stricter about the correct representation of each tag. For example, an XML-like structure that does not close a tag properly is considered an invalid

XML structure. For example,

```
<docjavaProducts>
      <bookList>
       <book>
         <title>
              Image Processing in Java
         </title>
         <author>
              Douglas A. Lyon
         </author>
         <isbn>
              0139745777
         </isbn>
         <srp>
              49.99
         </srp>
         <discountedPrice>
              39.99
         </discountedPrice>
       </book>
      </bookList>
</docjavaProducts>
```

While using XML from within Java, we will require an API for XML manipulation called a Simple API for XML (*SAX*).

 SAX provides an event-based framework for XML data processing.

32.2 Why Use XML?

XML provides a presentation layer substrate for the transmission of structured data. It has several business-to-business (B2B) applications. For example, a web-based API of a bookstore allows a retail associate to query the database for books. If the reply is in XML, the data is downloaded and reused for the purpose of helping to market the materials.

In fact, anytime we seek to transmit a database from one place to another, XML is the preferred method. In the past, *CSV* was used. However, CSV had the drawback of losing important information about the database. XML overcomes such limitations.

By using XML, data sets can be decoded and processed easily. Excellent tools exist to process XML data and this obviates the need for custom parsers and generators. XML also is used to describe EJB. Further, EJB 1.1 uses XML in the *deployment descriptors*, and it is used in J2EE. XML fills a business need for B2B data sharing. It is simple, extensible, and portable.

32.3 How Do I Install XML Libraries?

In order to install the basic examples in this book, you only need to place *parser.jar* and *jaxp.jar* in your search path. Updates are available from *<http://java.sun.com/xml/ archive.html>*. The code is open source and freely available. The XML parser will work with JDK 1.1.8 or better.

32.4 How Do I Define My Own XML?

 The XML definition usually will control two aspects of the final XML: its size and its clarity, or structure.

XML tags need to be selected in such a way that they accurately describe the data to the smallest level of detail preferred and also that they are not too lengthy so that the final XML size is preserved.

For example, in the XML sample from Section 32.1, replacing

```
<book>
<title>Image Processing in Java
</title>
```

with

```
<booktitle> Image Processing in Java
</booktitle>
```

would be an inefficient design. Recall the *Product* and *Cart* classes from Section 8.3. A shopping cart could contain many products. Each product was known by a unique *ProductCode*, *UnitPrice*, and *Name*.

This is a section of the XML document that limits the tags in the XML. It serves as a grammar statement, defining the syntax, but not the semantics of the XML. The contents of the *Product.xml* file follow:

```
1.     <?xml version="1.0" encoding="ISO-8859-1"
         standalone="yes"?>
2.     <!DOCTYPE Cart [
3.     <!ELEMENT Product (Name, UnitPrice, ProductCode)>
4.     <!ELEMENT Name (#PCDATA)>
5.     <!ELEMENT UnitPrice (#PCDATA)>
6.     <!ELEMENT ProductCode (#PCDATA)>
7.     <!ELEMENT Cart (Product*)>
8.     ]>
9.     <Cart>
10.     <Product>
11.      <Name>Image Processing in Java</Name>
12.      <UnitPrice>25</UnitPrice>
13.      <ProductCode>12</ProductCode>
14.     </Product>
15.     <Product>
16.      <Name>Java for Programmers</Name>
17.      <UnitPrice>35</UnitPrice>
18.      <ProductCode>11</ProductCode>
19.     </Product>
20.     </Cart>
```

The *DTD* part of the XML document defines the *Cart* document type. The statement

```
3.     <!ELEMENT Product (Name, UnitPrice, ProductCode)>
```

indicates that a *Product* has a *Name*, *UnitPrice*, and *ProductCode*. This definition is called a *rule for a Product element.*

The line

```
7.    <!ELEMENT Cart (Product*)>
```

indicates that a *Cart* can have several *Products* (i.e., 0 to N *Product* elements).

The line

```
5.    <!ELEMENT UnitPrice (#PCDATA)>
```

indicates that the element should be treated as character data. Line 5 is known as an *element-type declaration.*

XML syntax is quite involved.

XML can be defined by using a DTD or an XML schema. DTDs still are held in common use. Here are some rules:

A '*' indicates an element can appear zero or multiple times.

A '|' indicates the data can be entered in any order.

A '+' indicates the element is required (one or more times).

A ',' indicates the elements is required in that order.

Elements in "()" are grouped.

For example,

```
<?xml version="1.0" encoding="ISO-8859-1" standalone="yes"?>
<!DOCTYPE AddressBook [
    <!ELEMENT Address (
        (title | firstName| lastName)*,
        (streetAddress|address1 | address2| address3 )*,
        (homePage | emailAddress)*,
        (homePhone | businessPhone | faxPhone)*,
        city,
        state,
        zip?)>
    <!ELEMENT title (#PCDATA)>
    <!ELEMENT firstName (#PCDATA)>
    <!ELEMENT lastName (#PCDATA)>
    <!ELEMENT address1 (#PCDATA)>
    <!ELEMENT address2 (#PCDATA)>
    <!ELEMENT address3 (#PCDATA)>
    <!ELEMENT streetAddress (#PCDATA)>
    <!ELEMENT emailAddress (#PCDATA)>
    <!ELEMENT homePage (#PCDATA)>
    <!ELEMENT city (#PCDATA)>
    <!ELEMENT state (#PCDATA)>
    <!ELEMENT zip (#PCDATA)>
    <!ELEMENT homePhone (#PCDATA)>
```

```
                <!ELEMENT businessPhone (#PCDATA)>
                <!ELEMENT faxPhone (#PCDATA)>
                <!ELEMENT AddressBook (Address*)>
        ]>
        <AddressBook>
            <Address>
                <firstName>FirstNameFirst</firstName>
                <lastName>Lyon </lastName>
                <streetAddress>300 North Benson Rd.</streetAddress>
                <homePage>http://www.docjava.com</homePage>
                <homePhone>203-555-1212</homePhone>
                <city>Fairfield</city>
                <state>ct</state>
                <zip>06460</zip>

            </Address>
                <Address>
                <lastName>Lyon </lastName>
                <firstName>FirstNameSecond</firstName>
                <streetAddress>300 North Benson Rd.</streetAddress>
                <city>Fairfield</city>
                <state>ct</state>
                <zip>06460</zip>

            </Address>
        </AddressBook>
```

If the DTD does not match the data, then a *validation error* will occur during the XML parsing stage. In order to learn XML, it is a good idea to get an XML authoring tool to help discover validation errors. There are many such tools, but *Oxygen*, available from *<http://www.oxygenxml.com>*, was used to generate the above example.

32.5 Xml2Cart

This section shows how to parse XML for a series of *Product* items that are to be stored in a *Cart* class. To help ease the XML parsing problem, we borrow from the *javax.xml.parsers* package.

The *Xml2Cart* class reads a file in the (URI) Universal Resource Identifier form and returns an instance of *Cart*. The *Cart* instance represents an instance of a shopping cart. Both the *Cart* and *Product* classes reside in the *net* package. Our first step is to create an error handler for the parsing of XML documents:

```
/*
 * @author Douglas A. Lyon
 * @version  Nov 6, 2002.8:07:44 AM
 */
package xml;

import org.xml.sax.HandlerBase;
import org.xml.sax.SAXParseException;

public class SimpleErrorHandler
    extends HandlerBase {
```

```
        // treat validation errors as fatal
        public void error(SAXParseException e)
            throws SAXParseException {
          throw e;
        }

        /** When parse warnings occur, it is
         * really nice if you have the
         * line number in the XML so that
         * you can correct the syntax error:
         */
        public void warning(SAXParseException e)
            throws SAXParseException {
          System.out.println(
              "** Warning"
              + ", line " + e.getLineNumber()
              + ", uri " + e.getSystemId()
              + "\n\t" + e.getMessage());
        }
    }
```

The error handler is not document specific, so it is left as a public class in the *xml* package. The following code will enable the construction of a *SAXParser* instance:

```
package xml;
import javax.xml.parsers.ParserConfigurationException;
import javax.xml.parsers.SAXParserFactory;
import javax.xml.parsers.SAXParser;

public class XmlUtil {
  /**
   *  get a sax parser
   */
  public static SAXParser getParser()
      throws ParserConfigurationException {
    // The SAXParserFactory is a a
    // factory class that enables productions
    // of XML parsers:
    SAXParserFactory spf
        = SAXParserFactory.newInstance();
    // setValidating (true) specifies that
    // the parser will validate documents
    // during parsing:

    spf.setValidating(true);
    return spf.newSAXParser();
  }
}
```

When a parser encounters specific tags in an XML document, some action needs to be taken. These actions are performed in an *event-driven* manner in the form of a callback to

methods in a class that extends the *DefaultHandler* class. For example,

```java
package xml;

import net.Cart;
import net.Product;
import org.xml.sax.AttributeList;
import org.xml.sax.DocumentHandler;
import org.xml.sax.Locator;
import org.xml.sax.SAXException;
import org.xml.sax.helpers.DefaultHandler;

import java.util.Vector;

/**
 *    The CartDocumentHandler gets notification in
 * the form of a callback method. These
 * callbacks are like the Listener model
 * used for event handling. When a new element
 * is encountered, for example, that creates
 * a callback. The callbacks are handled
 * in the DocumentHandler:
 */
public class CartDocumentHandler
    extends DefaultHandler {

 private Cart c = new Cart();
 private Vector stringVector = new Vector();

 public Cart getCart() {
   return c;
 }
 /**
  *      The Locator  instance must be
  * used locally to identify
  * the origin of a SAX event.
  */
 public void setDocumentLocator(Locator l) {
 }

 public void startDocument()
     throws SAXException {
 }

 public void endDocument()
     throws SAXException {
 }
 /** The AttributeList is not
  * going to have any attributes
  * in it for our example (i.e.
  * <book isbn=10> provides an
  * attribute of isbn whose value is 10).
  */
 public void startElement(String tag, AttributeList al)
     throws SAXException {
 }
```

```java
/**
 * When we get the </Product> tag, then
 * we want to invoke
 * addProduct otherwise, just return:
 */
public void endElement(String name)
    throws SAXException {
  if (!name.equals("Product")) return;
  addProduct();
}

/**
 * addProduct will
 * make an instance of a
 * Product class and add it to the
 * Cart instance. It is added by parsing
 * the last three strings that
 * have been pushed into the StringVector.
 */
public void addProduct()
    throws SAXException {
  String sa[] = new String[stringVector.size()];
  stringVector.copyInto(sa);
  if (sa.length < 3) return;

  String name = sa[0];
  float price = Float.valueOf(sa[1]).floatValue();
  int productId = Integer.valueOf(sa[2]).intValue();

  Product p
      = new Product(name, price, productId);
  c.addProduct(p);
  stringVector = new Vector();
}

/**
 *
 * when characters are found, we add them to
 * the string vector for latter use.
 */
public void characters(char buf [], int offset, int len)
    throws SAXException {
  stringVector.addElement(new String(buf, offset, len));
}

public void ignorableWhitespace(
    char buf [], int offset, int len)
    throws SAXException {
}

/**
 * The processingInstruction is
 * called back when a non XML
 * declaration is made.
 */
```

```
    public void processingInstruction(
        String target,
        String data)
        throws SAXException {
  }

}
```

Now, after all of that preparatory work, we finally are ready to read in the XML for creating a cart:

```
package xml;

import futils.Futil;
import net.Cart;

import javax.xml.parsers.ParserConfigurationException;
import javax.xml.parsers.SAXParser;
import javax.xml.parsers.SAXParserFactory;
import java.io.IOException;

import org.xml.sax.SAXParseException;
import org.xml.sax.SAXException;

public class Xml2Cart {

  public static void main(String argv [])
      throws IOException {
    try {

      getCart();

    } catch (SAXParseException e) {
      System.out.println(
          "** Parsing error"
          + ", line " + e.getLineNumber()
          + ", uri " + e.getSystemId()
          + "   " + e.getMessage()
      );

    } catch (SAXException e) {
      e.printStackTrace();
    } catch (ParserConfigurationException e) {
      e.printStackTrace();
    }
  }

  private static void getCart()
      throws SAXParseException, SAXException,
      ParserConfigurationException, IOException {
    Cart c = read("file:" +
                Futil.getReadFile(
                    "select an XML
        file").getAbsolutePath());
    System.out.println("Cart=" + c);
  }

  public static Cart read(String uri)
      throws SAXParseException,
```

```
          SAXException,
          ParserConfigurationException,
          IOException {
      SAXParserFactory spf =
            SAXParserFactory.newInstance();
      spf.setValidating(true);
      SAXParser sp = spf.newSAXParser();

      CartDocumentHandler cdh = new CartDocumentHandler();
      sp.parse(uri,cdh);
      sp.parse(uri, cdh);
      return cdh.getCart();
   }
}
```

This section shows that there is a lot of API to support before the parsing of XML can work.

In a way, this is a complex API. The reward is that a well-tested parser is being reused. Alternatives to SAX parsing of XML are shown in Chapter 33.

32.6 Csv2XML

In this section, we take a CSV file and turn it into XML. We start by reading the CSV file into memory, using the first row to define the XML record tags. Then we output the DTDs to a file, along with the XML data, one record per line. For example, suppose we have an *Address* class, and we want to output *Address* records. The *Address* class should have a method that allows its conversion into an XML record. However, not all fields of the *Address* class will be known, which is particularly true if the addresses come from several different places. So, when we make an instance of an *Address* from an array of *String*, we must be sensitive to the length of the *String*. If we have standardized the order of the fields, we should be able to map the *String* elements into semantically meaningful record labels:

```
package xml;

public class Address {
/**
    <!ELEMENT Address (
                  (title | firstName| lastName)*,
                  (streetAddress|address1 | address2| address3
          )*,
                  (homePage | emailAddress)*,
                  (homePhone | businessPhone | faxPhone)*,
                  city,
                  state,
                  zip?)>
                  */
    private String title = null;
    private String firstName = null;
    private String lastName = null;
    private String street = null;
```

```java
    private String company = null;
    private String address1= null;
    private String address2= null;
    private String address3= null;
    private String homePage= null;
    private String emailAddress= null;
    private String homePhone= null;
    private String businessPhone= null;
    private String faxPhone= null;
    private String city = null;
    private String state = null;
    private String zip = null;

    public Address() {
    }

    public Address(String s[]) {

       if (s.length == 6)
         setFirst6(s);

    }
    public void setFirst6(String s[]) {
    //
           lastName,streetAddress,address1,homePhone,businessPhone
           ,faxPhone
         lastName = s[0];
         street = s[1];
         address1 = s[2];
         homePhone = s[3];
         businessPhone = s[4];
         faxPhone = s[5];
    }

    public  void setAddress2(String s){
         address2 = s;
    }

    public  void setAddress3(String s){
      address3 = s;
    }
    public  void setEmailAddress(String s){
         emailAddress = s;
    }

    public  void setHomePhone(String s){
         homePhone = s;
    }

    public  void setHomePage(String s){
         homePage = s;
    }
    public  void setBusinessPhone(String s){
      businessPhone = s;
    }
```

```java
public  void setFaxPhone(String s){
    faxPhone = s;
}
 public  void setCompany(String s){
    company = s;
}
    public void setAddress1(String s) {
      address1 = s;
    }

public void setTitle(String s) {
  title = s;
}

public void setFirstName(String s) {
  firstName = s;
}

public void setLastName(String s) {
  lastName = s;
}

public void setStreet(String s) {
  street = s;
}

public void setCity(String s) {
  city = s;
}

public void setState(String s) {
  state = s;
}

public void setZip(String s) {
  zip = s;
}
public String toCsv() {
  StringBuffer sb = new StringBuffer("");
  if (title != null)
    sb.append( title + ",");
  if (firstName != null)
    sb.append(firstName + ",");
  if (lastName != null)
    sb.append(lastName + ",");
  if (street != null)
    sb.append(street + ",");
  if (city != null)
    sb.append(city + ",");
  if (state != null)
    sb.append( state + ",");
  if (zip != null)
    sb.append(zip);
  return sb.toString()+"\n";
}
```

```
    public String toXml() {
      StringBuffer sb = new StringBuffer("");
      if (title != null)
        sb.append("\n\t<title>" + title + "</title>");
      if (firstName != null)
        sb.append("\n\t<firstName>" + firstName + "</firstName>");
      if (lastName != null)
        sb.append("\n\t<lastName>" + lastName + "</lastName>");
      if (street != null)
        sb.append("\n\t<street>" + street + "</street>");
      if (city != null)
        sb.append("\n\t<city>" + city + "</city>");
      if (state != null)
        sb.append("\n\t<state>" + state + "</state>");
      if (zip != null)
        sb.append("\n\t<zip>" + zip + "</zip>\n");

      return "\n<Address>"
          + sb.toString()
          + "\n</Address>";
    }
  }
```

Now that we have an *Address* class that can convert itself to XML, it remains for us to write *AddressBook* so that it can open CSV files and save them to XML. The difficult problem of mapping a variable number of fields in a CSV file to meaningful XML tags has been taken care of for us by the *Address* class. For example,

```
package xml;
import futils.CsvParser;
import futils.ReaderUtil;
import futils.WriterUtil;

import java.io.BufferedReader;
import java.io.BufferedWriter;
import java.io.IOException;
import java.util.Vector;
```

 The xml.AddressBook class is responsible for holding Address instances and converting them to XML or CSV format.

```
public class AddressBook {
  Vector v = new Vector();
  // v is a vector of address instances.
    String dtd =
      "<?xml version=\"1.0\" encoding=\"ISO-8859-1\"
        standalone=\"yes\"?>\n" +
      "<!DOCTYPE AddressBook [\n" +
      "    <!ELEMENT Address (\n" +
      "          (title | firstName| lastName)*,\n" +
      "          (streetAddress|address1 | address2| address3
        )*,\n" +
```

```
  "                 (homePage | emailAddress)*,\n" +
  "                 (homePhone | businessPhone | faxPhone)*,\n" +
  "                 city,\n" +
  "                 state,\n" +
  "                 zip?)>\n" +
  "     <!ELEMENT title (#PCDATA)>\n" +
  "     <!ELEMENT firstName (#PCDATA)>\n" +
  "     <!ELEMENT lastName (#PCDATA)>\n" +
  "     <!ELEMENT address1 (#PCDATA)>\n" +
  "     <!ELEMENT address2 (#PCDATA)>\n" +
  "     <!ELEMENT address3 (#PCDATA)>\n" +
  "     <!ELEMENT streetAddress (#PCDATA)>\n" +
  "     <!ELEMENT emailAddress (#PCDATA)>\n" +
  "     <!ELEMENT homePage (#PCDATA)>\n" +
  "     <!ELEMENT city (#PCDATA)>\n" +
  "     <!ELEMENT state (#PCDATA)>\n" +
  "     <!ELEMENT zip (#PCDATA)>\n" +
  "     <!ELEMENT homePhone (#PCDATA)>\n" +
  "     <!ELEMENT businessPhone (#PCDATA)>\n" +
  "     <!ELEMENT faxPhone (#PCDATA)>\n" +
  "     <!ELEMENT AddressBook (Address*)>\n" +
  "]>\n" ;

public void addAddress(Address a) {
  v.addElement(a);
}

public String getAddressXml() {
  String s = "\n";
  for (int i = 0; i < v.size(); i++)
    s = s + ((Address) v.elementAt(i)).toXml();
  return s;
}

public String toXml() {
  return dtd
      + "\n<AddressBook>"
      + getAddressXml()
      + "\n</AddressBook>";
}

public String toCsv() {
  String s = "\n";
  for (int i = 0; i < v.size(); i++)
    s = s + ((Address) v.elementAt(i)).toCsv();
  return s;
}

public String toString() {
  return toXml();
}

public void processLine(String l) {
  v.addElement(new Address(
      new CsvParser(l).getTokens()
  )
```

```
      );
    }

    public void getLines(BufferedReader br) {
      try {
        for (String l = br.readLine();
             l != null; l = br.readLine())
          processLine(l);
      } catch (IOException e) {
        e.printStackTrace();
      }
    }

    public void open(BufferedReader br) throws IOException {
      getLines(br);
      br.close();
    }

    public void open() {
      try {
        open(
          ReaderUtil.getBufferedReader("select *.csv"));
      } catch (IOException e) {
      }
    }

    public void save() {
      BufferedWriter bw =
          WriterUtil.getBufferedWriter("output xml");
      WriterUtil.println(bw, toXml());
      WriterUtil.close(bw);
    }

    public void saveAsCsv() {
      BufferedWriter bw =
          WriterUtil.getBufferedWriter("output xml");
      WriterUtil.println(bw, toCsv());
      WriterUtil.close(bw);
    }

    public void saveAsXml() {
      BufferedWriter bw =
          WriterUtil.getBufferedWriter("output xml");
      WriterUtil.println(bw, toXml());
      WriterUtil.close(bw);
    }

    public static void main(String args[]) {
      AddressBook ab = new AddressBook();
      ab.open();
      //System.out.println(ab.toXml());
      ab.saveAsXml();
      System.out.println("done generating XML");
    }
  }
```

Here is some example input:

```
title,firstName,lastName,title2,company, address, city, state,
       zip
Dr., D., Lyon, Chair, Fairfield University, 300 North Benson
       Rd., Fairfield, CT\
, 06460
```

And here is the program's output:

```
<?xml version="1.0"
encoding="ISO-8859-1" standalone="yes"?><!DOCTYPE AddressBook
       [
       <!ELEMENT Address (
          title,firstName, lastName,
          title2, company,
          city, state, zip
          )>
    <!ELEMENT title (#PCDATA)>
    <!ELEMENT firstName (#PCDATA)>
     <!ELEMENT lastName (#PCDATA)>
     <!ELEMENT title2 (#PCDATA)>
     <!ELEMENT company (#PCDATA)>
     <!ELEMENT addBk.address (#PCDATA)>
     <!ELEMENT city (#PCDATA)>
     <!ELEMENT state (#PCDATA)>
     <!ELEMENT zip (#PCDATA)>
     <!ELEMENT AddressBook (Address*)>
]>
<AddressBook>

<Address>
       <title>title</title>
       <firstName>firstName</firstName>
       <lastName>lastName</lastName>
       <title2>title2</title2>
       <company>company</company>
       <address>address</address>
       <city>city</city>
       <state>state</state>
       <zip>zip</zip>

</Address>
<Address>
       <title>Dr.</title>
       <firstName>D.</firstName>
       <lastName>Lyon</lastName>
       <title2>Chair</title2>
       <company>Fairfield University</company>
       <address>300 North Benson Rd.</address>
       <city>Fairfield</city>
       <state>CT</state>
       <zip>06460</zip>

</Address>
</AddressBook>
done generating XML
```

32.7 Displaying XML

Although there are a few commercial XML parsing and displaying mechanisms, they tend to fall behind the actual needs and growing variety and complexity of XML content.

 XML content often ends up being displayed in web browsers.

Unlike with HTML content, browsers are not able to understand and display XML data directly. Many rookies using XML for the first time will take an XML file, drag it into their web browser, and disappointedly ask "Why doesn't my browser understand XML?" Since XML has no limitation on the nodes being used and on the type of information nodes contain in the attributes, it certainly cannot be displayed universally. Oftentimes, rather than display some of the data, it makes more sense to pass it along for further processing.

A web browser either will have to be upgraded with XML parsing capabilities or a display mechanism will need to be implemented to render XML tags into corresponding HTML tags.

 For memory and CPU efficiency, the best alternative is to be able to implement and use browser-based rendering models, thus freeing the server from the rendering burden.

If the XML has been parsed and stored in a data structure (like a shopping cart), conversion to HTML is a simple matter.

32.8 Should I Convert My RDBMS to XML?

 Although there are common aspects between relational database models and XML representations, both have distinct applications.

Both relational databases and XML allow a fine descriptive sense of the data they contain. Databases also can store and query massive data blocks, while XML can offer easy data transport.

If data only is stored in a relational database to preserve its relational character and is not subject to query or if data is of a relatively small size or is intended for electronic transport, you probably want to use XML.

Data formats in files are subject to constant revision and improvement. XML provides a technology whereby these changes can eliminate version-specific readers of the data. As new data formats are created, XML can be extended.

32.9 The Problems and Limitations of XML

Although a very flexible and elegant technology for representing and transporting data, XML has some constrictive limitations and problems. A main problem derives from its rather large size. Parsing through large XML blocks is costly. Even when XML is stored in efficient forms such as Document Object Model (DOM) trees, size limitations can be noticed.

WARNING
Using XML as an extensive communication method is not recommended.

A second problem derives from the expensive computing that currently is needed for converting and using XML. The commercial XML parsing mechanisms available are not always adequate, and the display mechanisms are very limited. Therefore, when used professionally (which is the actual target of XML), the robustness of XML consumer applications can be costly.

32.10 Summary

XML is to data, what Java is to programs. It makes data platform independent, language independent, portable, and stuctured. The usages for XML are varied and appear in areas of data-translation, data-mining, and distributed computing. XML is simple to parse, given the correct tools. As a result, a parser for XML can be written in almost any computer language.

The XML substrate really shines when moving company proprietary data off a vendor specific database system. Many people are working on data from a wide variety of different sources. Placing all that data into XML format greatly simplifies data processing tasks. This chapter showed how to convert CSV format to XML, but that is just the tip of the iceberg. Major limits to XML include a general inability to store binary data file formats (i.e., image or audio). Since the binary data is not encoded directly in XML, the format would have to leave it as an unparsed (or Base64) entity. Since it is not the role of XML to specifically parse binary data, this must be handled at a higher layer in the code, i.e., database layer, not the XML layer.

32.11 Exercises

32.1 Write a program that converts a table in an RDBMS to XML. Use the table labels as the tags for the XML generation.

32.2 Write a program that converts a given class into XML. Use introspection to obtain the fields and use these fields as the tag names in the XML synthesizer. Don't forget to generate the DTD for your file.

32.3 Write a program that reads in an XML file, given a class. Use the tag name to create a setter method, and use introspection to determine if the setter method exists. If the setter method exists, determine the type of the argument that it takes. Map the string obtained during the document parse into the type of parameter. Assume that all of the parameters for the setters are primitive types.

32.4 Your new job with the intelligence community (Spooky Software a Beltway Bandit) is to take HTML data and convert it to XML. Write a program to download the HTML at *<http://www.gsansom.demon.co.uk/vfaero/lists/natoname.htm>* (this site includes a table of aircraft and their code names). Use this table to create and save an XML document, and use the headers in the table as indicators of the tags in XML. Your program should save the XML to a file.

32.5 Your first job with Spooky Software went well. Now you need to take the code you wrote for exercise 4 and incorporate all of the public information you can gather on Soviet MiGs. Use the MiG home page at *<http://www.armscontrol.ru/atmtc/Arms_systems/Avia/Russia/MiG_Aircraft.htm>*, to perform this activity and ignore the image data. How will you incorporate the new data into the existing data? Will you need to devise new tags? Is there any way to make this process more automatic?

32.6 The MiG-21 was in production from 1957 to 1993 (a very popular air frame!). As a result, the aircraft either can be modern or very old, depending on the type of MiG-21. Use the URL at *<http://www.armscontrol.ru/atmtc/Arms_systems/Avia/Russia/MiG21/mig21family_tree.htm l>* to incorporate a *family tree* into your XML. A family tree forms a kind of graph. Generally, the members of the family have ascendents and descendents. Incorporate this relationship into your XML. For example, the North Vietnamese version of the MiG-21 is a descendant of the Finnish version of the MiG-21.

32.7 Mechanical engineers are very concerned with fasteners. A fastener is any device that is able to hold together two or more objects. There are many different kinds of fasteners. Some fastener references are larger than phone books. The URL at *<http://www.pacificfasteners.com/ catalog/page2.htm>* lists some stainless steel nuts. Write an HTML2XML transformation program that automates the XML generation by converting HTML to XML. How will you formulate the XML tags?

32.8 Nuts generally are used with screws. The URL at *<http://www.pacificfasteners.com/catalog/ page9.htm>* shows a list of stainless steel screws. Extend your answer to exercise 7 to incorporate the screws from the given URL and output XML. In other words, your XML output will now contain both screw and fasteners data. Notice that the tags have changed in this new document. How will you create tags that are equivalent?

32.9 Using your answers to exercises 7 and 8, match the nuts and screws that will be able to fasten to one another. For example, a 6-32 machine screw is a number 6 screw with 32 threads per inch. It will fasten to a 6-32 nut, which is shown to be in stock.

32.10 Write a program that reads the XML data output by the *xml.AddressBook* class and then prints the CSV data to the screen.

32.11 Automating XML maintenance is an important role for the programmer. What happens if someone adds a new field to a class? How should XML support this field? What changes need to be made in the XML parsers to handle any new tags introduced? What new setter and getter methods need to be added? Could reflection help in performing these tasks? How would you automate the addition of a new field to a class?

32.12 (Advanced Project) Write a program that implements the items suggested in exercise 11.

C H A P T E R 3 3

More XML Techniques

by Thomas Rowland

**With time and patience the mulberry
leaf becomes a silk gown.**

–Chinese proverb

In this chapter, you will learn how to

- Differentiate between SAX and DOM
- Build a DOM-parsing application
- Use XML name-spaces to qualify element and attribute names
- Use XML schema to restrict XML content
- Transform XML into other forms using XSLT

33.1 Evolving XML

This chapter describes *DOM* as an alternative to *SAX*. It also describes the use of *name-spaces, XML schemas*, and *XML Stylesheet Language transformations* (XSLT). The specifications for these are derived from the recommendation of the recent World Wide Web Consortium (W3C), which is one of the organizations that provides standardization to the XML community *<http://www.w3.org>*.

33.2 The SAX and DOM Models

 XML is a family of technologies originally developed by W3C with input from other organizations.

Though many methods exist for the processing of XML, the SAX and DOM models are the two most popular that are in use today. SAX was developed by the XML-DEV mailing list *<http://www.xml.org/xml/xmldev.shtml>*, an open discussion list site supporting the development of XML. DOM was developed by the W3C DOM Working Group, and its

specification is located at *<http://www.w3.org/TR/DOM-Level-2-Core>*. The current standards are SAX2 and DOM Level 2. The set of APIs you use for your application will depend on what your application needs to do with XML.

SAX is an event-driven, serial-access model, which means that XML is parsed serially, element by element, and events are triggered each time a piece of information is encountered.

SAX sends callbacks to event handlers. SAX provides better performance than DOM because no XML structure resides in memory, making SAX preferable for server-side operations or when parsing large XML structures. However, SAX is read only. Elements cannot be modified, and events must be handled as they occur during a parse. The SAX API can be downloaded from *<http://sax.sourceforge.net/>*.

DOM organizes XML data into a tree structure, called a *DOM document.*

A DOM document is a collection of *nodes,* which represent the XML data, and includes *elements, attributes*, and other types of nodes. Once the XML is parsed, this document tree resides in memory, allowing random access to any of the nodes. As a result, DOM provides the ability to modify or add XML content and to write the modified XML back again.

DOM holds its entire structure in memory. Thus, if there is not enough memory, DOM will throw an exception.

33.3 Where JAXP Fits In

JAXP is part of a set of Java APIs for XML that was developed by Sun Microsystems.

JAXP provides a thin layer acting as an interface to the SAX and DOM APIs in order to separate an XML application from a specific vendor's implementation. In other words, using JAXP will allow any SAX- or DOM-compliant parser to be plugged in without recoding or recompiling.

The main JAXP APIs are defined in the `javax.xml.parsers` package, which contains two factory classes: *SAXParserFactory* and *DocumentBuilderFactory*. These factories, in turn, allow you to create vendor-neutral implementations of *SAXParser* and *DocumentBuilder*. The SAXParser class is the JAXP wrapper class that allows access to the *XMLReader* interface, which SAX provides to parsers for reading XML using callbacks. The *DocumentBuilder* class is the JAXP class used to obtain access to the *Document* interface, which DOM provides to allow access to parsed XML data.

33.4 Building a DOM Level 2 Application Using JAXP

As an example, we will use the *Product.xml* XML file used in the previous chapter to illustrate how DOM is capable of parsing, modifying, and writing back XML content. This application raises all of the *Product* prices by a percentage input by the user.

DOM borrows the SAX mechanism for handling exceptions thrown during parsing and validation. In fact, we import *org.xml.sax* in order to have access to the *SAXException*

and *SAXParseException* classes. One difference between the SAX and DOM parsers is that *DOMParser* never throws *SAXParseExceptions* during parsing, so only *SAXException* needs to be handled in the parsing routine. SAXParseExceptions still will be handled, however, in our error handler:

```
import java.io.*;
import futils.*;
import javax.xml.parsers.*;    //JAXP api
import org.w3c.dom.*;          //DOM api
import org.xml.sax.*;          //for SAX exceptions
```

 A DOM document is a collection of nodes.

The root node is always an *Element* node, called the *document element*. Any tags such as *<Product>* are *Element* nodes, also called simply *elements*. An element can have attributes, which are represented by *Attr* nodes. An element also can have child nodes, which may be text nodes, *CDATASection* nodes, or several other types of nodes. While the *Product.xml* file contains no attributes, the example in this section illustrates how to obtain the collection of attributes for an element and access each one. Strictly speaking, although attributes extend from the *Node* interface, an attribute is not a child node of an element, but rather is a property of an element. An example of a *<book>* element containing an attribute and a child element with a text node is structured as follows:

```
<book type="hardcover">
  <author>Dr. Douglas A. Lyon</author>

  ...
</book>
```

Traversing the document tree is much the same as traversing any tree data structure. We move from node to node, and if the node is one we are interested in, we extract the data or perform some manipulation on it. Node types are represented as integers, so we can assign them as fields in our class. The three most common node types are illustrated in this example, and we have assigned their integer values to the *ELEMENT_NODE, TEXT_NODE,* and *DOCUMENT_NODE* constants:

```
public class ModifXmlPrices {
    static final int ELEMENT_NODE       = 1;
    static final int TEXT_NODE     = 3;
    static final int DOCUMENT_NODE      = 9;
    static float incr = 0;
    static BufferedWriter out = null;
```

Our *main* method prompts the user to enter a number that will be the percentage by which the Product prices will be increased. It also sets up *BufferedWriter*, which will be used to write out our new file when we are done. It then allows the user to open an XML file (in

this case, *Product.xml*) and passes a String representation of the file to the *parse* method:

```
public static void main (String argv [])
        throws IOException {

    System.out.println("Enter percent price increase:");
    BufferedReader in = new BufferedReader(
                     new InputStreamReader(System.in));
    incr = new Float(in.readLine()).floatValue() * .01f;
    File inFile = Futil.getReadFile("select an XML file");

    File file = new File(inFile.getParent() +
                     "\\NewProduct.xml");
      out = new BufferedWriter(new FileWriter(file));
    parse("file:" + inFile.getAbsolutePath());
    out.flush();
    out.close();
}
```

In order to parse the file, we create *DocumentBuilderFactory*, which defines the API that allows applications to obtain a parser that produces DOM object trees from XML documents [JAXP API]. We also use it to enable functionality such as validation.

The next step is to create a *DocumentBuilder* object, which defines the API to obtain a *DOM document* from an XML document. When we call our *parse* method, we get back an instance of a DOM document. *Document* is an interface that represents the XML document tree structure and allows access to all of the data within it. We use it to traverse and manipulate nodes in the document tree. In order to traverse our document tree, we need to get the root element. We do this by calling the *getDocumentElement* method. Now that we have the root element, we can use it as a starting point to traverse the tree and extract the data:

```
private static void parse (String uri)
 throws IOException {
DocumentBuilderFactory dbf =
DocumentBuilderFactory.newInstance();
try {
  DocumentBuilder db = dbf.newDocumentBuilder();
  db.setErrorHandler(new MyErrorHandler());
  Document doc = db.parse(uri);
  Element root = doc.getDocumentElement();
  traverse(root);
  write(doc);
}
catch (ParserConfigurationException e) {
  // Factory unable to create parser.
  System.out.println(
      "** ParserConfigurationException\n"
      + e.getMessage ));
}
catch (SAXException e) {
  // Parsing error.
  System.out.println(
      "** SAXException\n"
      + e.getMessage());
```

```
                Exception ex = e.getException();
             if (ex != null)
                   ex.printStackTrace();
         }
      catch (IOException e) {
        e.printStackTrace();
      }
    }
```

 In the SAX model, parsing causes callbacks to our event-handler methods.

In the DOM model, we need to write the code that walks the tree, node by node. The *traverse* method performs this task, recursively searching for the *UnitPrice* elements and then modifying their value. The value really exists in *TEXT_NODE*, a child node of *Unit-Price*, so, as we traverse, we check if the current node is a text node. If it is, we check if the parent is an element whose name is *UnitPrice*. For example,

```
private static void traverse (Node elem) {
  try {
    if (elem.hasChildNodes()) {
        NodeList children = elem.getChildNodes();
        int length = children.getLength();

        for (int i=0; i<length; i++) {
            Node n = children.item(i);
            String name = n.getNodeName();

            if (n.getNodeType() == ELEMENT_NODE) {
                if (name.equals("UnitPrice")) {
                }
                traverse(n);
            }
            else
            if (n.getNodeType() == TEXT_NODE) {
                String pname =
                n.getParentNode().getNodeName();
                if (pname.equals("UnitPrice")) {
                    String price =
                        n.getNodeValue();
                    System.out.println(
                        pname + " = " + price);
                    float f = (new Float(price)
                      .floatValue()) * (1 + incr);
                    int newPrice =
                        new Float(f).intValue();

                    n.setNodeValue(
                    String.valueOf (newPrice));
                    System.out.println(
                        "new value of " + pname +
                        " = " + n.getNodeValue()
                        + "\n");
                return;
```

```
                            }
                    }
            }
            return;
        }
    }
    catch (DOMException e) {
      System.out.println("*** DOMException\n"
                            + e.getMessage());
    }
  }
```

The *write* method takes *Node* as a parameter, which in this case is *DocumentElement*, or the root element of the document. It first writes out an XML prolog and then writes out the DTD content that appears inside the *DOCTYPE* section. Finally, it proceeds to recursively traverse the document tree, writing each node out to file:

```
private static void write (Node node)
        throws IOException {
    switch (node.getNodeType()) {
    case Node.DOCUMENT_NODE:
                out.write("<?xml version=\"1.0\""+
        "encoding=\"ISO-8859-1\"" +
        "standalone=\"yes\"?>\n\n");

        Document doc = (Document)node;

        out.write("<!DOCTYPE " +
          doc.getDocumentElement().getNodeName()
          +  " [" + doc.getDoctype().getInternalSubset()
          + "]>\n");

        //recurse on each child
         NodeList nodes = node.getChildNodes();
         if (nodes != null) {
              for (int i=0; i<nodes.getLength(); i++) {
              printNode(nodes.item(i));
            }
        }
        break;

        case Node.ELEMENT_NODE:
            String name = node.getNodeName();
            out.write("<" + name);
            NamedNodeMap attributes = node.getAttributes();
              for (int i=0; i<attributes.getLength(); i++) {
                   Node current = attributes.item(i);
                 out.write(" " + current.getNodeName()
                   + "=\"" + current.getNodeValue() + "\"");
                   out.newLine();
              }
            out.write(">");

            //recurse on each child
```

```
                    NodeList children = node.getChildNodes();
                    if (children != null) {
                    for (int i=0; i<children.getLength(); i++) {
                                    printNode(children.item(i));
                    }
                  }
                out.write("</" + name + ">");

            case Node.TEXT_NODE:
                String val = node.getNodeValue();
                if (val != null)
                out.write(val);
                break;
        }
    }
```

The error-handler class is the same one used in the SAX application:

```
    private static class MyErrorHandler
    implements ErrorHandler {

      //returns a string describing parse exception details
      private String getParseExceptionInfo(
        SAXParseException spe) {
            String systemId = spe.getSystemId();
        if (systemId == null)
            systemId = "null";
        String info = "URI=" + systemId +
                    "\nLine=" + spe.getLineNumber() +
                    "\n" + spe.getMessage();
        return info;
      }

      //Override the SAX ErrorHandler methods:
      public void warning(SAXParseException spe)
      throws SAXException {
        System.out.println(
        "Warning: " + getParseExceptionInfo(spe));
        }

      public void error(SAXParseException spe)
      throws SAXException {
            String message = "Error: " +
      getParseExceptionInfo(spe);
        throw new SAXException(message);
        }

      public void fatalError(SAXParseException spe)
      throws SAXException {
        String message = "Fatal Error: " +
      getParseExceptionInfo(spe);
            throw new SAXException(message);
      }
    }
```

33.5 XML Name-Spaces

Name-spaces allow multiple XML vocabularies to coexist within the same document. Both
SAX 2.0 and DOM Level 2 support name-spaces.

 As defined by the W3C, "XML name-spaces provide a simple method for qualifying
element and attribute names used in Extensible Markup Language documents by as-
sociating them with name-spaces identified by URI (Uniform Resource Identifier) ref-
erences" [W3C Name-spaces].

Up to this point, we have assumed all element-type names within an XML document and
all attribute names to be unique. Consider the following two XML fragments, which both
make use of an element called *Title*:

```
<Book>
  <Title>Image Processing in Java</Title>
  <Author>Douglas A. Lyon</Author>
</Book>
<Instructor>
  <Name>Douglas A. Lyon</Name>
  <Title>PhD</Title>
</Instructor >
```

As long as these XML fragments exist in separate documents, there is no problem. How-
ever, if they are combined in the same XML document, a name conflict will occur. There is
no way for an application to distinguish between *Title* of a *Book* and *Title* of an *Instructor*.
The way to resolve this problem would be to rename one or both of the elements (e.g., as
BookTitle and *InstructorTitle*) or to provide extra code in the application so that it validates
each case. However, these may not be viable solutions.

Using name-spaces solves this problem by allowing each element to be assigned to a
different name-space. A *name-space* is a collection of element types and attribute names. It
uses a two-part naming convention for elements and attributes. This naming convention re-
solves any conflict because we refer to an element using its *universal name*, which is made
up of its *name-space name* (the URI) and its *local name* (the actual name of the element).
And, because name-space names are almost always URLs, they work across the Internet.
The example above now can be rewritten as follows:

```
<Course>
  <bk:Book xmlns:bk="http://www.docjava.com/books">
    <bk:Title>Image Processing in Java</bk:Title>
    <bk:Author>Douglas A. Lyon</bk:Author>
  </bk:Book>

<instr:Instructor
xmlns:emp="http://www.docjava.com/instructors">
    <instr:Name>Douglas A. Lyon</instr:Name>
    <instr:Title>PhD</instr:Title>
  <instr:Instructor>
</Course >
```

 An XML name-space is declared with the *xmlns* attribute. This attribute associates a
prefix with a name-space name (i.e., its URI).

This URI actually does not need to point to anything. A name-space may be declared on any element or attribute in an XML document, and it is in the scope for that element and all of its descendants unless it is overridden by another name-space declaration. Name-space declarations do not apply to DTDs, and name-spaces are not a means of binding to multiple DTDs in an XML document. In the above example, the *bk*: prefix refers to the *http://www.docjava.com/books* name-space, and any element or attribute with a *bk*: prefix belongs in that name-space. Similarly, the *instr*: prefix refers to the *http://www.docjava.com/instructors* name-space.

A *default name-space* may be used in order to reduce the clutter of an XML document. In this case, if the element is not specified with a prefix, then that element is considered to be in the default name-space. The default name-space refers only to elements, not to attributes. An attribute that is not specified with a prefix is never in any name-space [Bourret].

To declare a default name-space, leave out the name-space prefix after the xmlns attribute, as follows:

```
<Course xmlns="http://www.docjava.com/books"
xmlns:emp="http://www.docjava.com/instructors">
  <Book>
    <Title>Image Processing in Java</Title>
    <Author>Douglas A. Lyon</Author>
  </Book>
  <instr:Instructor>
    <instr:Name>Douglas A. Lyon</instr:Name>
    <instr:Title>PhD</instr:Title>
  <instr:Instructor>
</Course>
```

Name-spaces help developers process the elements and attributes that are important to them. Name-spaces are important when dealing with XML schemas and XSLTs.

33.6 XML Schemas

The concept of a *schema* comes from database systems, where a schema defines how data is to be structured and what kinds of data are valid.

While DTDs are able to provide validation constraints on *data structures* by specifying the kinds of tags that can exist in an XML document, it is the additional ability of providing validation on *data content* that makes XML schemas a much more powerful alternative to DTDs.

XML schemas are written using XML syntax, and they can be parsed, modified, and rewritten using an XML parser. They also make it easier for humans to read. DTDs are written using an older-style syntax that many XML parsers can't read. However, DTDs have been around longer and currently are employed in a vast number of applications. While DTDs are well understood, XML schema is an evolving standard that has been slow to mature. Developers currently happy using DTDs may see no reason to switch to XML schema, although new developers may see that the power that lies in XML schema overcomes many of the limitations of DTDs.

In order for an XML document to be considered valid, it must correspond to some DTD or schema.

When an XML document is linked to a schema, the document is referred to as an instance document. An *instance document* is a valid representation of a schema, and if the validation feature on the parser is turned on, the parser will catch any errors where the instance document violates any of the schema constraints.

The following instance document resides in a file called *ClassInfo.xml* and contains information about a class, its instructor, and its students:

```
<ClassInfo
 xmlns='http://tfr.com/myClassSchema'
 xmlns:xsi='http://www.w3.org/2001/XMLSchema-instance'
 xsi:schemaLocation='http://tfr.com/myClassSchema
 ClassInfo.xsd'>

<CourseNo>SW409</CourseNo>
<Title>Web Development With Java</Title>
<Section>02</Section>
<Semester>Fall</Semester>
<Year>2001</Year>

<Instructor>
   <Name>Douglas A. Lyon</Name>
   <Title>PhD</Title>
   <ID>012345678</ID>
   <Email>lyon@docjava.com</Email>
   <Phone>203-555-0000</Phone>
</Instructor>

<Student>
   <Name>Student One</Name>
   <ID>111111111</ID>
   <YOG>2001</YOG>
   <Email>student1@myemail.com</Email>
   <Phone>203-555-1111</Phone>
   </Student>
<Student>
   <Name>Student Two</Name>
   <ID>222222222</ID>
   <YOG>2002</YOG>
   <Email>student2@myemail.com</Email>
   <Phone>203-555-2222</Phone>
   </Student>
</ClassInfo>
```

The instance document starts with a root element, *ClassInfo*, that contains the attributes and subelements holding the data. Within the root element, the first attribute specifies the name-space to which our data types (defined in our schema below) belong. We also make this the default name-space to avoid having to prefix every tag with a name-space identifier.

Next, we specify that we are using the W3C XML schema name-space for instance documents and assign *xsi:* as its prefix. The *schemaLocation* attribute belongs to that name-space, which is why we need to specify it. Remember that name-space URLs do not need to point to anything. Instead, these URLs merely provide hints, and in this case the hint is being used by the processor, which recognizes *http://www.w3.org/2001/XMLSchema-instance* as a special name-space.

 The *schemaLocation* attribute within the root element provides the link to our schema and thus characterizes this XML document as an instance document.

This attribute takes two parameters: the name-space URL, which must match the name-space defined within the schema itself, and the location of the schema document, which in our case is in the same directory as the instance document, in a file called *ClassInfo.xsd*.

If the schema does not define a name-space for itself, then instance documents may use the *noNamespaceSchemaLocation* attribute in place of the schemaLocation attribute, as follows:

```
xsi:noNamespaceSchemaLocation='ClassInfo.xsd'
```

Now, let's take a look at our schema, which is contained in the ClassInfo.xsd file:

```
<xsd:schema
  xmlns='http://tfr.com/myClassSchema'
  xmlns:xsd='http://www.w3.org/2001/XMLSchema'
  targetNamespace='http://tfr.com/myClassSchema'
  elementFormDefault='qualified'>

<xsd:annotation>
  <xsd:documentation>
      XML Schema defining information about a class
  </xsd:documentation>
</xsd:annotation>
<xsd:simpleType name="CourseNumType">
  <xsd:restriction base="xsd:string">
      <xsd:pattern value="[A-Z]{2}[0-9]{3}"/>
  </xsd:restriction>
</xsd:simpleType>
<xsd:simpleType name="ID9Type">
  <xsd:restriction base="xsd:integer">
      <xsd:totalDigits value="9"/>
      <xsd:minInclusive value="000000000"/>
  </xsd:restriction>
</xsd:simpleType>
<xsd:simpleType name="YearType">
  <xsd:restriction base="xsd:integer">
      <xsd:totalDigits value="4"/>
      <xsd:minInclusive value="2001"/>
  </xsd:restriction>
</xsd:simpleType>

<xsd:element name="ClassInfo" type="ClassInfoType"/>
<xsd:element name="Instructor" type="InstructorType"/>
<xsd:element name="Student" type="StudentType"/>
<xsd:element name="ID" type="ID9Type"/>
<xsd:element name="Name" type="xsd:string"/>
<xsd:element name="Title" type="xsd:string"/>
<xsd:element name="Email" type="xsd:string"/>
<xsd:element name="Phone" type="xsd:string"/>

<xsd:complexType name="InstructorType">
  <xsd:sequence>
```

```
                  <xsd:element ref="Name"/>
                  <xsd:element ref="Title"/>
                  <xsd:element ref="ID"/>
                  <xsd:element ref="Email"/>
                  <xsd:element ref="Phone"/>
        </xsd:sequence>
    </xsd:complexType>
    <xsd:complexType name="StudentType">
      <xsd:sequence>
                  <xsd:element ref="Name"/>
                  <xsd:element ref="ID"/>
                  <xsd:element name="YOG" type="YearType"/>
                  <xsd:element ref="Email"/>
                  <xsd:element ref="Phone"/>
        </xsd:sequence>
    </xsd:complexType>
    <xsd:complexType name="ClassInfoType">
      <xsd:sequence>
                  <xsd:element name="CourseNo"
                  type="CourseNumType"/>
                  <xsd:element ref="Title"/>
                  <xsd:element name="Section" type="xsd:string"/>
                  <xsd:element name="Semester" type="xsd:string"/>
                  <xsd:element name="Year" type="YearType"/>
                  <xsd:element ref="Instructor" minOccurs="0"/>
                  <xsd:element ref="Student" minOccurs="0"
                  maxOccurs="unbounded"/>
        </xsd:sequence>
    </xsd:complexType>
  </xsd:schema>
```

An XML schema starts with a *schema* element. Contained within the schema element is an XML schema name-space declaration. Our name-space is specified as the default. Next is the name-space belonging to the XML schema itself, whose purpose is to identify those elements and types that belong to the vocabulary of the XML schema language. The prefix *xsd:* is a convention that is used to refer to it. Then, we declare our target name-space, which is used to define which name-space is being described in this schema. The target name-space is needed so that other documents, in this case our instance document, can reference it. And finally, we set the *elementFormDefault* attribute to "*qualified*," which exposes our name-space to the instance document.

 Documentation about the schema can be inserted with the use of the *annotation* element.

The annotation element contains the *appInfo* and *documentation* subelements. The *appInfo* element typically contains information for use by other applications and tools, and we will not use it here. The *documentation* element is used to hold descriptive information about the schema or about a particular element. It is the recommended location for information that humans will read. A schema document may contain more than one annotation section.

The schema element contains a structure of subelements and type definitions. These subelements, mainly the *element*, *complexType*, and *simpleType* element types, are defined by associating a name with a data type, which may be one of the built-in types belonging

to the XML schema language or one created by a schema author. *ComplexType* is an element type that refers to elements that contain subelements or attributes. *SimpleType* is an element type that refers to elements that do not contain subelements or attributes.

The ability to define new types allows us to impose certain constraints on and determine the appearance of elements and their content in an XML instance document, as well as allows us to reuse these types on other elements.

In our schema example, we have created three complex types: *ClassInfoType*, *InstructorType*, and *StudentType*. These types characterize the structures of the elements we wish to expose to our instance document. For example, *InstructorType* contains the following sequence of elements in the following order: *Name*, *Title*, *ID*, *Email*, and *Phone*. The *sequence* attribute allows us to specify this order. We also may place further restrictions on an individual element within our new type. For example, *ClassInfoType* always must contain one *Instructor* and one or more *Students*.

We also have created several simple types: *CourseNumType*, *ID9Type*, and *YearType*. These types are created in order to place restrictions on elements. For example, *CourseNumType* is derived from *string*, which is one of the XML schema language's built-in data types. Furthermore, we have added the restriction that the data must begin with two letters and follow with three numbers.

Elements may be declared globally or locally.

In our schema, we have declared several global elements in order to foster reuse. For example, the *Title* element is used both as the title of the instructor and as the title of the course. The other elements are declared as local to the types in which they belong. In the schema element, we set the *elementFormDefault* attribute to *"qualified"* in order to expose our local element types to the instance document. We could have set this attribute to *"unqualified"* (or omitted it altogether, since *"unqualified"* is the default) and made all of our element types global.

In order to create a validating parsing application, we need to set attributes on *DocumentBuilderFactory* so that the resultant parser will recognize name-spaces, turn validation on, and use the W3C XML schema language:

```
//Constants used for JAXP 1.2
static final String JAXP_SCHEMA_LANGUAGE =
"http://java.sun.com/xml/jaxp/properties/schemaLanguage";
static final String W3C_XML_SCHEMA =
"http://www.w3.org/2001/XMLSchema";

DocumentBuilderFactory dbf =
 DocumentBuilderFactory.newInstance();
dbf.setNamespaceAware(true);
dbf.setValidating(true);

try {
  dbf.setAttribute(JAXP_SCHEMA_LANGUAGE, W3C_XML_SCHEMA);
}
catch (IllegalArgumentException e) {
  //parser does not support JAXP 1.2
}
```

An instance document may reference more than one schema. A schema also may reference other schemas.

A common method of including definitions from multiple schemas is to create one single schema, which the instance document references. The instance document is then responsible for incorporating any additional schema definitions required. Doing so removes the additional clutter from the instance document and provides a single location that contains all schema referencing. To make use of multiple schemas, the use of name-spaces becomes very important. There are several ways you can structure a set of schemas with the use of *<include>* and *<import>* elements. Both elements allow a single schema to contain definitions from other schemas. The *<include>* element is used when all schemas use the same name-space, and *<import>* is used when pulling in schemas from different name-spaces. See the examples on the CD for more information.

W3C released its XML schema recommendation on May 2, 2001. For more in-depth information regarding XML schemas, you can refer to the W3C recommendation documentation. The specifications are discussed in three documents:

```
[XML Schema Part 0: Primer]
[XML Schema Part 1: Structures]
[XML Schema Part 2: Datatypes]
```

33.7 XSLT

In this section, we give a brief introduction to XSLT.

XSLT is a language for transforming XML into other formats.

The specification is defined by W3C in the form of a recommendation. JAXP 1.1 provides an XSLT engine, which is an API in a file called *xalan.jar*, located in the same directory as *jaxp-api.jar* in the JAXP 1.1 download. XSLT is a large topic, so we will focus on performing two relatively simple though useful tasks: printing out an XML DOM document to a file and transforming an XML document into HTML output.

The XSLT specification defines how to transform a *source* into a *result*. Sources and results can take the form of DOM, SAX, or IO stream. The source and result classes are located in the following packages:

- *javax.xml.transform.dom* contains *DOMSource* and *DOMResult*
- *javax.xml.transform.sax* contains *SAXSource* and *SAXResult*
- *javax.xml.transform.stream* contains *StreamSource* and *StreamResult*

The abstract *TransformerFactory* class is used to obtain an instance of *Transformer*, which processes the source into a result. These classes are located in the *javax.xml.transform* package.

Writing out XML once we have a DOM document that we want to save can be somewhat cumbersome.

In this example, we will see how we can write out the XML rather easily using XSLT. We will use our basic DOM parser and add a method to convert our DOM document into a form that can be written to *OutputStream*. We will accomplish this task by using the *DOMSource* and *StreamResult* classes.

Start by creating a class containing a basic DOM parsing application with exception handlers, as discussed in Section 33.4. The application should allow you to parse an XML file and define the output file for the result. You should end up with a DOM document, which you can modify if you want. The listing for this class is as follows:

```java
import java.io.*;
import futils.*;

import javax.xml.parsers.*;
import org.w3c.dom.*;
import org.xml.sax.*;

public class XsltDomWriter {
    private static File outFile = null;

    public static void main (String[] argv)
        throws IOException {

        File inFile = Futil.getReadFile(
         "select an XML file");
        outFile = new File(
         inFile.getParent() + "\\NewFile.xml");
        Document document = parse("file:" +
         inFile.getAbsolutePath());
        transform(document);
    }

    private static Document parse (String uri)
        throws IOException {

        DocumentBuilderFactory dbf =
         DocumentBuilderFactory.newInstance();
        try {
         //dbf.setValidating(true);
         //dbf.setNamespaceAware(true);

         DocumentBuilder db =
             dbf.newDocumentBuilder();
         Document doc = db.parse(uri);
         Element root = doc.getDocumentElement();
         return doc;
        }
        catch (ParserConfigurationException e) {
         // Factory unable to create parser.
         System.out.println(
             "DBFactory cannot be instantiated.\n"
             + e.getMessage());
        }
        catch (SAXException e) {
         // Parsing error.
         System.out.println(
             "** SAXException\n"
             + e.getMessage());
            Exception x = e.getException();
            if (x != null)
             x.printStackTrace();
```

```
            }
            catch (IOException e) {
             e.printStackTrace();
            }
            return null;
        }

        private static void transform (Node node) {}
    }
```

Next, add *xalan.jar* to your class path, and then add the necessary imports:

```
import javax.xml.transform.*;
```

Our *transform* method accepts a *Node* object, which allows you to pass in any node from the DOM document. To write out the entire document, pass in the root element, which is *DocumentElement.*

Add the code to the transform method. First, we obtain an instance of *TransformerFactory* by calling its static method, *newInstance.*

This method throws *TransformerFactoryConfigurationError* if the factory cannot be instantiated.

Using the factory, we *Obtain Transformer.* The *newTransformer* method throws *TransformerConfigurationException*:

```
try {
        // Obtain a Transformer
        TransformerFactory tf =
         TransformerFactory.newInstance();
        Transformer t = tf.newTransformer();

/*
A DOMSource object acts as a holder for a DOM source tree. The
        node represents our source tree, which we use to create
        an input source by passing it into the DOMSource
        constructor:
*/
        // Create a source object
        DOMSource source = new DOMSource(node);
/*
The StreamResult object acts as a holder for our result. We pass
        in the output file into its constructor. We then call the
        transform method to process the source and direct it to
        the result. We can also send the output to System.out:
*/
        // Create a result object and
        // perform the transform
        StreamResult result = new StreamResult(outFile);
        t.transform(source, result);

        result = new StreamResult(System.out);
        t.transform(source, result);
    }
/*
```

```
Add exception handling:
*/
        catch (TransformerConfigurationException e) {
          // Exception generated by the TransformerFactory
          System.out.println("Error creating the Transformer\n"
              + e.getMessage());
          Throwable x = e;
          if (e.getException() != null)
              x = e.getException();
          x.printStackTrace();
        }
        catch (TransformerException e) {
          // Exception generated by the transformer
          System.out.println("Error during transformation\n"
              + e.getMessage());
          Throwable x = e;
          if (e.getException() != null)
              x = e.getException();
          x.printStackTrace();
        }
```

Now you have a simple method for writing a DOM document to a new XML file.

This next example shows how to transform XML into HTML using a stylesheet. A *stylesheet* contains a set of template rules by associating patterns with templates. A *pattern* is matched against the nodes in a source tree (our XML file) and against a *template* that can be instantiated to form part of the result tree (our HTML file) [XSLT-W3C].

Before looking at the syntax of the stylesheet, let's create a simple XML file that will act as our source tree. We will use the XML file from Section 33.6; however, we don't care about name-spaces or validation here:

```
<ClassInfo>
      <CourseNo>SW409</CourseNo>
      <Title>Web Development With Java</Title>
      <Section>02</Section>
      <Semester>Fall</Semester>
      <Year>2001</Year>

      <Instructor>
        <Name>Douglas A. Lyon</Name>
        <Title>PhD</Title>
        <ID>012345678</ID>
        <Email>lyon@docjava.com</Email>
        <Phone>203-555-0000</Phone>
      </Instructor>

      <Student>
        <Name>Student One</Name>
        <ID>111111111</ID>
        <YOG>2001</YOG>
        <Email>student1@myemail.com</Email>
        <Phone>203-555-1111</Phone>
      </Student>

      <Student>
        <Name>Student Two</Name>
```

```
        <ID>222222222</ID>
        <YOG>2002</YOG>
        <Email>student2@myemail.com</Email>
        <Phone>203-555-2222</Phone>
    </Student>
</ClassInfo>
```

Our goal is to transform this data into HTML, include some formatting, and save it out to a new file. First, we create the stylesheet, which is an XML document containing the `xsl:stylesheet` element and name-space and version attributes. The XSLT name-space is declared with the *xsl* prefix, and the name-space URL defines the context for the XSLT elements and attributes that the XSLT processor can recognize:

```
<?xml version="1.0"?>
<xsl:stylesheet
  xmlns:xsl="http://www.w3.org/1999/XSL/Transform"
  version="1.0">
</xsl:stylesheet>
```

To specify that we want to output in HTML, add an `xsl:output` element and set its `method` attribute to "html." The `xsl:` `output` element must be a child of the `xsl:stylesheet` element.

```
<xsl:output method="html"/>
```

Next, we begin adding templates. Each template contains a `match` attribute, which selects the elements in our XML document to which the template will be applied. The value "/" indicates the root element. We also could have specified it explicitly as "ClassInfo."

```
        <xsl:template match="/">
            ...
    </xsl:template>
```

Inside the template, any tags not belonging to the XSLT name-space simply are copied to the output. If we want to display our results in a table, we can write the HTML to do so here. The `<xsl:apply-templates/>` tag applies the template to the current node and all of its children. So, for this template, when the XSLT processor encounters the root tag, it outputs the HTML start tags, processes any templates that apply to children of the root, and then outputs the HTML end tags [Armstrong]:

```
<html><body>
    <table border='6'>
        <th colspan='2'>Course Info</th>
        <xsl:apply-templates/>
    </table>
</body></html>
```

That's all we need to know to set up our stylesheet. We can apply the same principle for all nodes. The following is the complete listing for our stylesheet, which is saved as *ClassInfo.xsl*.

```
<?xml version="1.0"?>
<xsl:stylesheet
    xmlns:xsl="http://www.w3.org/1999/XSL/Transform"
    version="1.0">
    <xsl:output method="html"/>
```

```
<!-- Match the root element -->
<xsl:template match="/">
  <html><body>
    <table border="6">
          <th colspan="2">Course Info</th>
          <xsl:apply-templates/>
    </table>
  </body></html>
</xsl:template>

<!-- Match the children of root -->
<xsl:template match="/ClassInfo/Instructor">
  <th colspan="2">Instructor</th>
  <xsl:apply-templates/>
</xsl:template>

<xsl:template match="/ClassInfo/Student">
  <th colspan="2">Student</th>
  <xsl:apply-templates/>
</xsl:template>

<!-- Match the remaining children -->

<xsl:template match="/ClassInfo/Course/CourseNo">
  <tr><td>Course Number</td>
    <td><xsl:apply-templates/></td></tr>
</xsl:template>

<xsl:template match="/ClassInfo/Course/Name">
  <tr><td>Course Name</td>
  <td><xsl:apply-templates/></td></tr>
</xsl:template>

<xsl:template match="/ClassInfo/Course/Section">
  <tr><td>Section</td><td>
  <xsl:apply-templates/></td></tr>
</xsl:template>

<xsl:template match="/ClassInfo/Course/Semester">
  <tr><td>Semester</td><td>
  <xsl:apply-templates/></td></tr>
</xsl:template>

<xsl:template match="/ClassInfo/Course/Year">
  <tr><td>Year</td><td>
  <xsl:apply-templates/></td></tr>
</xsl:template>

<xsl:template match="/ClassInfo/Instructor/Name">
  <tr><td>Instructor Name</td>
  <td><xsl:apply-templates/></td></tr>
</xsl:template>

<xsl:template match="/ClassInfo/Instructor/Title">
  <tr><td>Title</td>
  <td><xsl:apply-templates/></td></tr>
</xsl:template>
```

```
<xsl:template match="/ClassInfo/Instructor/Email">
  <tr><td>Email</td><td>
  <xsl:apply-templates/></td></tr>
</xsl:template>

<xsl:template match="/ClassInfo/Instructor/Phone">
  <tr><td>Phone</td>
  <td><xsl:apply-templates/></td></tr>
</xsl:template>

<xsl:template match="/ClassInfo/Student/Name">
  <tr><td>Student</td>
  <td><xsl:apply-templates/></td></tr>
</xsl:template>

<xsl:template match="/ClassInfo/Student/StudentID">
  <tr><td>Student ID</td>
  <td><xsl:apply-templates/></td></tr>
</xsl:template>

<xsl:template match="/ClassInfo/Student/YOG">
  <tr><td>Grad Year</td>
  <td><xsl:apply-templates/></td></tr>
</xsl:template>

<xsl:template match="/ClassInfo/Student/Email">
  <tr><td>E-mail</td>
  <td><xsl:apply-templates/></td></tr>
</xsl:template>

<xsl:template match="/ClassInfo/Student/Phone">
  <tr><td>Phone</td>
  <td><xsl:apply-templates/></td></tr>
</xsl:template>

</xsl:stylesheet>
```

Now that we have our source and our stylesheet, we need to write the Java program that will perform the transformation to the result. We follow the same basic structure as before by first creating *TransformerFactory* and getting *Transformer*. This time, however, we create *StreamSource* using the stylesheet, and *DOMSource* is created using *BufferedWriter*:

```
TransformerFactory tf = TransformerFactory.newInstance();
StreamSource stylesource = new StreamSource(stylesheet);
Transformer t = tf.newTransformer(stylesource);
DOMSource source = new DOMSource(node);
StreamResult result = new StreamResult(out);
t.transform(source, result);
```

The following is the complete program listing for our *XsltXml2Html* program:

```
import java.io.*;
import futils.*;

// for DOM parsing
import org.xml.sax.*;
```

```java
import org.w3c.dom.*;
import javax.xml.parsers.*;

// for XSLT transformation
import javax.xml.*;

public class XsltXml2Html {

    public static void main (String[] argv) {
        try {
         File xmlFile = Futil.getReadFile(
             "select an XML file");
         File stylesheet = Futil.getReadFile(
             "select a stylesheet");
         String fn = xmlFile.getName();
         fn = fn.substring(0, fn.lastIndexOf("."));
         File htmlFile = new File(xmlFile.getParent() +
             "\\" + fn + ".html");
             BufferedWriter out = new BufferedWriter(
             new FileWriter(htmlFile));
             Document document = parse(xmlFile);

         transform(document, stylesheet, out);
         out.flush();
         out.close();
         System.out.println("done.");
         }
         catch (IOException e) {
         e.printStackTrace();
         }
    }

    private static Document parse (File xmlFile)
    throws IOException {
        try {
         DocumentBuilderFactory factory =
         DocumentBuilderFactory.newInstance();
         //factory.setNamespaceAware(true);
         //factory.setValidating(true);

         DocumentBuilder db = factory.newDocumentBuilder();
         Document document = db.parse(xmlFile);
         return document;
         }
         catch (SAXException e) {
         // Parsing error
         Exception x = e;
         if (e.getException() != null)
             x = e.getException();
         x.printStackTrace();
         }
         catch (ParserConfigurationException e) {
         // Factory unable to create parser
         e.printStackTrace();
         }
```

```
        return null;
    }

    public static void transform (Node node,
        File stylesheet, BufferedWriter out) {

        try {
         // Instantiate the TransformerFactory
         TransformerFactory tf =
             TransformerFactory.newInstance();

         // Create a source object from the stylesheet
         StreamSource stylesource =
             new StreamSource(stylesheet);

         // Obtain a Transformer
         Transformer t = tf.newTransformer(stylesource);

         // Create a source object from the DOM document
         DOMSource source = new DOMSource(node);

         // Create a result object from the BufferedWriter
         StreamResult result = new StreamResult(out);

         // Perform the transform
         t.transform(source, result);
        }
        catch (TransformerConfigurationException e) {
         // Exception generated by the TransformerFactory
         System.out.println("Transformer Factory error\n" +
             e.getMessage());
         Throwable x = e;
         if (e.getException() != null)
             x = e.getException();
         x.printStackTrace();
        }
        catch (TransformerException e) {
         // Exception generated by the transformer
         System.out.println("Transformation error\n" +
             e.getMessage());
         Throwable x = e;
         if (e.getException() != null)
             x = e.getException();
         x.printStackTrace();
        }
    }
}
```

The HTML file produced as the output is shown below:

```
<html>
<body>
<table border="6">
<th colspan="2">Course Info</th>
```

```
<tr>
<td>Course Number</td><td>SW409</td>
</tr>

<tr>
<td>Course Name</td><td>Web Development with Java</td>
</tr>

<tr>
<td>Section</td><td>02</td>
</tr>

<tr>
<td>Semester</td><td>Fall</td>
</tr>

<tr>
<td>Year</td><td>2001</td>
</tr>

<th colspan="2">Instructor</th>

<tr>
<td>Instructor Name</td><td>Douglas A. Lyon</td>
</tr>

<tr>
<td>Title</td><td>PhD</td>
</tr>

<tr>
<td>Email</td><td>dlyon@docjava.com</td>
</tr>

<tr>
<td>Phone</td><td>203-555-1234</td>
</tr>

<th colspan="2">Student</th>

<tr>
<td>Student</td><td>Student 1</td>
</tr>

<tr>
<td>Student ID</td><td>111111111</td>
</tr>

<tr>
<td>Grad Year</td><td>2002</td>
</tr>

<tr>
<td>E-mail</td><td>student1@mymail.com</td>
</tr>

<tr>
<td>Phone</td><td>203-555-1111</td>
```

```
</tr>

<th colspan="2">Student</th>

<tr>
<td>Student</td><td>Student 2</td>
</tr>

<tr>
<td>Student ID</td><td>222222222</td>
</tr>

<tr>
<td>Grad Year</td><td>2001</td>
</tr>

<tr>
<td>E-mail</td><td>student2@mymail.com</td>
</tr>

<tr>
<td>Phone</td><td>203-555-2222</td>
</tr>

</table>
</body>
</html>
```

The browser will display an image that looks like the one in Figure 33.7-1.

Course Info	
Course Number	SW409
Course Name	Web Development with Java
Section	2
Semester	Fall
Year	2001
Instructor	
Instructor Name	Douglas A. Lyon
Title	PhD
Email	dlyon@docjava.com
Phone	203-555-1234
Student	
Student	Student 1
Student ID	111111111
Grad Year	2002
E-mail	student1@mymail.com
Phone	203-555-1111
Student	
Student	Student 2
Student ID	222222222
Grad Year	2001
E-mail	student2@mymail.com
Phone	203-555-2222

FIGURE 33.7-1
Browser Display

For more information on XSLT, please refer to the XSLT Version 1.0 W3C Recommendation *<http://www.w3.org/TR/xslt>*.

33.8 Summary

XML offers a powerful way to describe data, and Java is an effective language for making full use of the benefits that XML offers. Aside from being a markup language, XML is a family of technologies and standards, and only a few of the most fundamental have been described here. Operating in an open community process, the XML community consists of many different and diverse organizations that are producing solutions that leverage XML and providing input to the standards that W3C is putting into place. While standards have been slow to mature, it seems that new XML technologies are popping up every day as new uses for XML are being discovered, thus governing how data can be exchanged between applications. In fact, XML's importance in Web applications is already being felt. JavaBeans, JSP, object persistence, and conversion of XML into other types of documents all are leveraging XML technology. In short, XML is still young and evolving.

33.9 Exercises

33.1 Write a DOM-parsing application that prints out each element and attribute in the DOM document. The application should be generic to work with any XML document. For each element, print the element name, the element value (which is really a text node), the attribute name, and the attribute value.

33.2 Repeat exercise 1 for a SAX application.

33.3 Write a DOM-parsing application that searches for a particular element by name and add a child element to it. Assign a value (a text node) to this new element. Print out the modified document to a file of a different name.

33.4 Create an XML schema for the following XML structure:

```
<address>
      <street></street>
      <city></city>
      <state></state>
      <zip></zip>
</address>
```

Define data types for each of the elements:

- street and city are of type String.
- state is of type String and uses the two-letter abbreviation.
- zip is a five-digit integer.
- address is a *complexType* that contains all of these elements in the order shown.

Set the *targetNamespace* attribute in the schema to *<http://myschema.com/MyAddressSchema>*, which you define, and make sure the schemaLocation attribute in the instance document points to it. Save the schema in a file named Address.xsd. Add values to each of the elements in the instance document. Using the parsing application created in exercise 1, turn it into a validating parser with the *setValidating* method, and parse the instance document. After successfully parsing the instance document, try adding a new element and see what happens. Also try breaking one of the data content rules and see what happens.

33.5 A schema can contain data types defined in other schemas. If both schemas are defined within the same name-space, the *<include>* element is used. The syntax for using the *<include>* element is as follows and comes after the *schema* element:

```
<xsd:include schemaLocation='schemaFilename.xsd'/>
```

Using *<include>*, create an XML schema for the following XML structure:

```
<contactInfo>
        <name></name>
        <org><org>
        <email></email>
        <address>
          <street></street>
          <city></city>
          <state></state>
          <zip></zip>
        </address>
        <phone></phone>
</contactInfo>
```

Define data types for the elements as follows:

- name and org are of type *String*.
- email is of type *String* and must contain an "@".
- phone is a *String* with the pattern xxx-xxx-xxxx.
- address is a data type defined in the schema created in exercise 4.

Set the schema's *targetNamespace* attribute to the same as the included schema's target-Name-space, and set the *elementFormDefault* attribute in both schemas to "qualified." Save this new schema as "ContactInfo.xsd." Then, make sure the *schemaLocation* attribute in the instance document references this new schema. Finally, using the validating DOM parser you created, parse the instance document.

33.6 A schema can contain data types defined in other schemas. If the schemas are defined within different name-spaces, the *<import>* element is used. The syntax for using the *<import>* element is as follows and comes after the *schema* element:

```
<xsd:import namespace='schemaURI'
        schemaLocation='schemaFilename.xsd'/>
```

Using <import>, create an XML schema for the same XML structure as in exercise 6 using the same data-type definitions. Set the *targetNamespace* attribute of this new schema to "http://myschema.com/MyContactInfoSchema2," set the *elementFormDefault* attribute in both schemas to "qualified," and save this new schema as "ContactInfo2.xsd." Declare both name-spaces in the root element of the instance document. Each element in the instance document needs to be prefixed with the appropriate name-space identifier (unless you have made one of the name-spaces the default name space). Using the validating DOM parser you created, parse the instance document.

C H A P T E R 3 4

Bean Properties

by Diane Asmus, Douglas Lyon, and Carl Weiman

**It was once stated that
"Algorithms + Data Structures = Programs."
Now, Algorithms + Data Structures = Components.**

–Douglas Lyon

In this chapter, you will learn about:

- Component software development
- How to manage properties using the bean API
- How properties propagate using the event-listener pattern

34.1 History of the Problem of Code Reuse

In the early days of software development, standards for writing programs did not exist. As a result, there was little or no code reuse. In order to promote code reuse, subroutine libraries were developed. As the libraries grew in size and complexity, software engineers realized that this approach did not scale well for large projects. In order to find an object-oriented approach to software reuse, a new model for framing development was created called *Component Software Development* (CSD). CSD treated each instance of a class as a component and sought to create a framework for the reuse of these components.

 Java has a support technology for the support of CSD called *Java beans*.

FIGURE 34.2-1
Component Diagram

34.2 Components

Components have a specification for their inputs and outputs, and they can be intercon-
nected to create complex systems. The basic idea is that components create modules or
building blocks with a clear responsibility. For example, a furnace is responsible for warm-
ing a house. During the warming process, however, the house air can become dry. A hu-
midifier is a component that is used in combination with a furnace to keep the house warm
and prevent the air from becoming too dry. Figure 34.2-1 shows the connection between
these two components.

The input and output connections of components are known as interfaces. In the case
of the furnace and the humidifier, the output of the furnace, which is warm air, is put through
an interface (tube) to the input of the humidifier that is expecting warm air. The humidifier,
thus, is responsible for producing humid air.

34.3 The Bean

A Java bean encapsulates behavior by using Java's component architecture.

A Java bean only enables access to its methods (not to its member variables). Within this
chapter, a Java bean will be referred to as a bean.

Beans can be visual or nonvisual. Visual beans typically subclass the *java.awt.Com-
ponent* class. Nonvisual beans include EJBs, a topic that is discussed in Chapter 37.

The bean framework provides a series of support features, including introspection,
customization, properties, and support for persistence. Some advantages of a bean are
source code maintainability and software reliability, reuse, efficiency, and functionality.
This chapter will cover the events and properties of a Java bean.

Beans can be a little harder to write than regular code. The extra time it takes, how-
ever, is worth it in the long run.

34.4 The Event

A change in a bean's state can trigger a *bean event*.

Bean events propagate through an object-oriented system as a means of interobject com-
munication. As with the *observer-observable* design pattern discussed in Chapter 19, there
can be many listeners for each event.

34.5 Properties

Properties are named attributes associated with a bean that can be written or read by calling the methods of the bean. There are four types of properties: *simple, indexed, bound,* and *constrained.*

A *simple property* is a variable within a class that represents a single value. It is defined and retrieved with getter and setter methods. In the following example, *title* is a simple property, but *customers* is not:

```
package bean;

public class Bean1 {

    private String title = "Bean1";

    private String customers[] ={"tom","dick","harry"};

    private String getCustomer(int i) {
      if (i < 0) return null;
      if (i >= customers.length) return null;
      return customers[i];
    }
    public String getTitle() {
      return title;
    }
    public void setTitle(String _title) {
      title = _title;
    }
}
```

Indexed properties are like arrays of simple properties. In the above example, *customers* is an indexed property, and the access to the array is protected with bound checking so that *null* is returned if the index is out of range.

 A *bound property* is any bean property that sends a property-change event to notify the change listeners.

A *constrained property* is like a bound property, except that just before the property value actually is modified, the bean sends a property-change event to notify vetoable change listeners of the requested change. A vetoable change listener can veto the requested change, which results in canceling the property change.

34.6 The *InverterGate* Example

The bean example below sends an event in response to a property change. Figure 34.6-1 shows the schematic representation of an inverter, which is an electronic gate. When an electrical pulse is sent into the input of an inverter, the inverse is sent to the output, as shown in the inverter logic table in Figure 34.6-2.

The *BeanListener* class is set up to be a listener for the *InverterGate* class. This setup is accomplished in the declaration of the *BeanListener* class by a reference to the listener interface *PropertyChangeListener:*

```
class BeanListener implements PropertyChangeListener{
```

PropertyChangeListener listens for events that are fired when a property of the specified bean is changed. This capability requires implementation of the *propertyChange* method, which is illustrated shortly.

FIGURE 34.6-1
InverterGate

Input	Output
TRUE	FALSE
FALSE	TRUE

FIGURE 34.6-2
Inverter Logic Table

To indicate a bean is to be listened for by *PropertyChangeListener*, the bean must be instantiated, and *PropertyChangeListener* must be told to listen for the bean. These tasks are accomplished with the following code segment:

```
ig = new InverterGate();
ig.addPropertyChangeListener(this);
```

The *addPropertyChangeListener* method will tell *PropertyChangeListener* to listen for property changes in the *InverterGate* class. If there is a change in one of the designated properties of *InverterGate*, *PropertyChangeListener* will have the *InverterGate* bean fire a change event, which will prompt the Listener class to call the *propertyChange* method. The *propertyChange* method can evaluate what property was changed within the bean. The name of the property and both the old and new values can be passed to it.

PropertyChangeEvent is fired by a bean in response to a change in one of the bean's properties. This event is fired to notify any *PropertyChangeListener* of the change, as shown in Figure 34.6-3.

A *PropertyChangeEvent* informs the *PropertyChangeListener*.

Property-change event members include property name, old property value, and the new property value. The *getPropertyName()* method is used to return the property's name, the *getOldValue()* method is used to return the property's old value, and the *getNewValue()* method is used to return the property's new value.

WARNING

Be sure not to loop events. Endless event-notification loops in your code (especially multithreaded ones) are very hard to debug.

The following code tests if *pce.getPropertyName* is equal to the property "Output." If it is equal, a message is sent to the console indicating that the output has been changed. For example,

```
public void propertyChange(PropertyChangeEvent pce){
        System.out.println(
          "property change test from BeanListener.java = "
          + pce.getPropertyName());
```

PropertyChangeEvent

PropertyChangeListener

FIGURE 34.6-3
PropertyChangeEvent Diagram

```
System.out.println(
  "property "
  + pce.getPropertyName()
  + " as "
  + pce.getOldValue());
System.out.println(
  "property "
  + pce.getPropertyName()
  + " now is "
  + pce.getNewValue());

if (pce.getPropertyName().equals("Output")){
  System.out.println(
       "There has been an output change:");
}
}
```

The *BeanListener* class code follows:

```
package Gate;
import java.awt.*;
import java.awt.event.*;
import java.beans.*;
class BeanListener implements PropertyChangeListener{
InverterGate ig = null;
    BeanListener(){
        //create the bean
        ig = new InverterGate();
        ig.addPropertyChangeListener(this);
        System.out.println("Call to bean.setInput(true)");
        ig.setInput(true);
        System.out.println("out = " + ig.getOutput());
        System.out.println("***************************");
        System.out.println("Call to bean.setInput(false)");
        ig.setInput(false);
        System.out.println("out = " + ig.getOutput());
        System.out.println("***************************");
        System.out.println("Call to bean.setInput(true)");
        ig.setInput(true);
```

```
            System.out.println("out = " + ig.getOutput());
            System.out.println("*************************");
            System.out.println("Call to bean.setInputs(true)");
            ig.setInput(true);
            System.out.println("out = " + ig.getOutput());
            System.out.println("*************************");
        }

        public void propertyChange(PropertyChangeEvent pce) {
            System.out.println("property change test from
              BeanListener.java = " + pce.getPropertyName());
            System.out.println("property "
              + pce.getPropertyName()
              + " was "
              + pce.getOldValue());
            System.out.println("property "
              + pce.getPropertyName()
              + " now is "
              + pce.getNewValue());
        }

        public static void main(String args[]){
              new BeanListener();
        }

    }
```

34.7 The *InverterGate* Class

The *InverterGate* class uses the *PropertyChangeListener* interface, the *PropertyChange-Support* class, and the *firePropertyChange* method.

 The *PropertyChangeSupport* instance maintains a list of property-change event listeners.

As an example, consider the *inverter* and its input. The method *setInput* is where the *InverterGate* class input is set. The old input value is assigned to a holding variable, *oldInput*, and the *newInput* value is assigned to the *InverterGate* bean's property, *input*. The *firePropertyChange* event will compare the *oldInput* value to the *newInput* value. If the two values are different, the *firePropertyChange* event will fire. When this event fires, it will create a new property change event and send it to all of the listeners. The information it sends first is the name of the property. This name is hardcoded by the bean developer and is used to indicate which bean's property has been changed. The next values are the old property value and the new property value. For example,

```
    public void setInput(boolean newInput){
      boolean oldInput = input;
      input = newInput;
      pceListeners.firePropertyChange(
        "Input",
        oldInput, newInput);
    }
```

34.8 Code for the InverterGate Class

```
package Gate;
import java.awt.*;
import java.awt.event.*;
import java.beans.*;
public class InverterGate {
boolean   input=false;
boolean   output=true;
//create the listener list
PropertyChangeSupport pcs = new
      PropertyChangeSupport(this);
// The listener list wrapper methods
public synchronized void addPropertyChangeListener(
      PropertyChangeListener la){
      pcs.addPropertyChangeListener(la);
}
public boolean getInput(){
      return input;
}
public boolean getOutput(){
      return output;
}
public void setInput(boolean newInput){
      boolean oldInput = input;
      input = newInput;
      System.out.println("newInput = " + newInput + " oldInput =
        " + oldInput);
      pcs.firePropertyChange(
        "Input", oldInput,  newInput);
      output =(getInput()==true)?false:true;
      System.out.println("Exit from InverterGate.java -
        setInputs method");
}
}
```

34.9 The Console Window Output

Compile and run *BeanListener* and *InverterGate* to obtain

```
Call to bean.setInput(true)
newInput = true oldInput = false
property change test from BeanListener.java = Input
property Input was false
property Input now is true
Exit from InverterGate.java - setInputs method
out = false
*****************************************
Call to bean.setInput(false)
newInput = false oldInput = true
property change test from BeanListener.java = Input
property Input was true
```

```
property Input now is false
Exit from InverterGate.java - setInputs method
out = true
******************************************
Call to bean.setInput(true)
newInput = true oldInput = false
property change test from BeanListener.java = Input
property Input was false
property Input now is true
Exit from InverterGate.java - setInputs method
out = false
******************************************
Call to bean.setInputs(true)
newInput = true oldInput = true
Exit from InverterGate.java - setInputs method
out = false
******************************************
```

The stars represent a separation between the change input values sent to *ig.setInput()*.

The *oldInput* value displays the value the *ig.setInput()* method was set to last time the method was called. The *newInput* value displays the value the *ig.setInput()* method is set to now.

The lines

```
property change test from BeanListener.java = Input
property Input was false
property Input now is true
```

are from the *propertyChange* method. Each time an input is changed, an event is sent to the calling object. In this case, the *BeanListener* class is listening for the notification.

The line

```
Exit from InverterGate.java - setInputs method
```

indicates that the flow of the code is exiting the *setInput()* method.
The line

```
out = false
```

indicates the new value of the *InverterGate* bean.

34.10 Summary

In this chapter, you learned how to implement a bound property. We saw how to handle the change in a property by processing *PropertyChangeEvent*. We also learned that the *PropertyChangeSupport* class can be used to help manage *PropertyChangeEvent* instances.

To use a *PropertyChangeSupport* instance, we need to invoke *addPropertyChange-Listener* so that it can be captured by a bean listener.

34.11 Exercises

34.1 Why use CSD?

34.2 What is an event?

34.3 How many property types are there?

34.4 Will the property-change listener fire if a property has not changed?

34.5 Using three *InverterGate* beans, create a circuit.

34.6 Using the techniques described in this chapter, design an *And* gate bean.

34.7 Using the *And* gate bean and the *InverterGate* bean, create a *Nand* gate.

C H A P T E R 3 5

Introspection

by Diane Asmus and Douglas Lyon

**If fortune turns against you even
jelly will break your tooth.**

–Persian Proverb

In this chapter, you will learn about:

- Introspection
- The *BeanInfo* class
- The *SimpleBeanInfo* class

35.1 History of Introspection

Prior to introspection, Java developers used the reflection API, as described in Chapter 24, to examine and analyze classes. Reflection, however, does not allow the bean designer to customize the information that is returned from a bean. The Java class that is used to encapsulate the underlying methods is the *java.beans.Introspector* class.

35.2 What Is Introspection?

 Introspection is a reflection-based mechanism that extracts information about a bean using an instance of the *BeanInfo* class.

The *FeatureDescriptor* class enables access to information about properties, methods, and events. When a bean is loaded the, *Introspector* extracts *FeatureDescriptor* instances.

An *Introspector* uses *getters* and *setters* to get *BeanInfo* instances. For example, if a bean has *getInput()* and *setInput()*, as in the following code segment, introspection deduces the existence of the *Input* property:

```
public boolean getInput()
public void setInput(boolean _input)
```

The programmer must use *getters* and *setters* to enable the introspection mechanism.

There are two types of *FeatureDescriptor* instances: implicit and explicit. *Implicit FeatureDescriptor* instances are extracted using introspection. *Explicit FeatureDescriptor* instances are obtained using *BeanInfo*, which is created by the bean programmer in order to alter the appearance of the bean.

35.3 *BeanInfo*

BeanInfo is an interface that allows the bean designer to control which methods, properties, and events are exposed through introspection.

The bean developer can decide not to provide explicit information on all of the methods, properties, or events. *BeanInfo* uses the bean's class file when performing introspection.

The reflection mechanism is used to extract information about the bean if it is not available from *BeanInfo*. When an *Introspector* instance retrieves a list of *FeatureDescriptor* instances, it tries to locate the bean's *BeanInfo*. This class is named by taking the bean's name and concatenating "BeanInfo" onto the end if it. For example, if the bean's name is *Bean1*, then you would write a class called *Bean1BeanInfo* and subclass *SimpleBeanInfo* as shown below:

```
public class Bean1BeanInfo extends java.beans.SimpleBeanInfo
     {
   /* Small icon is in Bean1.gif
    * Large icon is in Bean1L.gif
    * [It is expected that the contents of the icon files
    will be changed to suit your bean.]
    */
   public java.awt.Image getIcon(int iconKind) {
       java.awt.Image icon = null;
       switch (iconKind) {
       case ICON_COLOR_16x16:
       icon = loadImage("Bean1.gif");
         break;
       case ICON_COLOR_32x32:
         icon = loadImage("Bean1L.gif");
         break;
       default:
         break;
       }
       return icon;
   }
}
```

As another example, consider the *Inverter* class, where the *Introspector* instance looks for a class whose name is *InverterBeanInfo*. The *getBeanInfoSearchPath()*/*setBeanInfoSearchPath()* methods can specify the directories to be searched for *BeanInfo*.

To get an instance of *BeanInfo*, use

```
try{
   beanInfo = Introspector.getBeanInfo(
         Inverter,
         Inverter.getSuperclass());
}
catch (IntrospectionException e){
   System.out.println("Can not find BeanInfo.");
}
```

35.4 SimpleBeanInfo

The *InverterGateBeanInfo* class extends the *SimpleBeanInfo* class, which implements the *BeanInfo* interface. Typically, a bean developer overrides *SimpleBeanInfo* methods, which is generally easier than writing your own *BeanInfo* implementation. If the attributes are not present, then they will not be overridden, and the default *FeatureDescriptor* values will be used. Thus, when using *SimpleBeanInfo*, the bean developer only needs to override the methods that are needed.

The following code segment demonstrates how *InverterGateBeanInfo* is extended from *SimpleBeanInfo*:

```
public class InverterGateBeanInfo extends SimpleBeanInfo {
```

35.5 Naming Convention

Within beans, naming conventions allow tools and libraries to be written that can decode bean properties.

A method like *isInput()* indicates that *Input* is a boolean property. The *isInput()* method is an accessor method. For example,

```
public boolean isInput();
```

Methods that have *is*, *get*, or *set* in their names are treated as properties. For example,

```
public boolean setInput(boolean b)
or
public boolean getInput()
```

Both setter and getter methods do not need to be present within a bean for introspection to be able to identify a property name. For example, the code segment

```
public boolean getInput()
```

indicates that there is a property named Input of boolean type. The method *decapitalize()* decapitalizes the first letter in the property name and *input* is returned as the property name.

The *decapitalize* method turns the first character of a method into a lowercase character. If the first two letters of a property are capitalized, then the property name is returned unchanged. For example, if the name was *WWW*, then *WWW* is returned.

Indexed properties are used to form an *indexed property descriptor*. The following code shows a property whose name is *state*. The *state* property is of *index* type because it is an array:

```
public String[] getState()
public String getState(int index)
public void setState(String[] x)
public void setState(int index, String x)
```

To declare the indexed property *state* in a bean, use

```
public String[] state = {"on","off"};
public String getState(int index) {
       return state[index];
}
```

35.6 IntrospectionException

IntrospectionException is thrown when inconsistent property types are discovered during introspection.

For example, if the *getInput()* method returns a boolean type but *setInput* requires a string, then the inconsistently typed properties cause *IntrospectionException*. For example,

```
// This is a bug, don't do this!
public boolean getInput()
public void setInput(String _input)
// an IntrospectionException will be thrown
```

To catch *IntrospectionException*, use a try-catch block:

```
try{
       BeanInfo bi = Introspector.getBeanInfo(Bean.class);
}catch(IntrospectionException  e){
       e.printStackTrace();
}
```

35.7 Summary

We discussed how the introspection framework uses naming conventions to analyze a bean. For example, the *BeanInfo* interface has an implementation called the *SimpleBeanInfo* class. There is a common bean descriptor called *FeatureDescriptor* and a series of subclasses of *FeatureDescriptor*, including *BeanDescriptor, PropertyDescriptor, IndexedProperty-Descriptor, MethodDescriptor, ParameterDescriptor*, and *EventSetDescriptor*.

The *Introspector* class, along with *BeanInfo* and *FeatureDescriptor*, lie at the heart of introspection. *FeatureDescriptor* and its subclasses are described in more detail in Chapter 36.

35.8 Exercises

35.1 How does introspection work if the *BeanInfo* class is missing?

35.2 How is a property name determined using introspection?

35.3 What happens when introspection produces an error?

35.4 When is introspection used?

35.5 How does *SimpleBeanInfo* make the bean designer's job easier?

35.6 Write a reflection-based GUI tool that automates the construction of *BeanInfo*.

C H A P T E R 3 6

FeatureDescriptors

by Diane Asmus and Douglas Lyon

> **Knowing others is intelligence; knowing yourself is true wisdom. Mastering others is strength, mastering yourself is true power.**
>
> *–Lao-Tzu*
> *philosopher (6th century B.C.)*

In this chapter, you will learn how to use the:

- FeatureDescriptor
- BeanDescriptor
- EventSetDescriptor
- MethodDescriptor
- ParameterDescriptor
- PropertyDescriptor
- IndexedPropertyDescriptor
- BeanInfo

36.1 What Are FeatureDescriptors?

A *FeatureDescriptor* class is used during introspection to retrieve information about methods, events, and listeners. Subclasses of *FeatureDescriptor* include:

1. *BeanDescriptor*
2. *EventSetDescriptor*
3. *MethodDescriptor*
4. *ParameterDescriptor*
5. *PropertyDescriptor*
6. *IndexedPropertyDescriptor*

These descriptors are described in the following sections. All of the descriptors come from a *BeanInfo* class.

 A *BeanInfo* class is a class whose name starts with the bean name and ends with the suffix *Info*.

For example, a *CustomerBean* class has a *CustomerBeanInfo* class. The *CustomerBeanInfo* class implements the *BeanInfo* interfaces or subclasses a class that implements the *BeanInfo* interface. The *BeanInfo* interface implementor is responsible for supplying descriptors, as shown by the interface specification that follows:

```java
public interface BeanInfo {
    BeanDescriptor getBeanDescriptor();
    EventSetDescriptor[] getEventSetDescriptors();
    int getDefaultEventIndex();
    PropertyDescriptor[] getPropertyDescriptors();
    int getDefaultPropertyIndex();
    MethodDescriptor[] getMethodDescriptors();
    BeanInfo[] getAdditionalBeanInfo();
    java.awt.Image getIcon(int iconKind);
    final static int ICON_COLOR_16x16 = 1;
    final static int ICON_COLOR_32x32 = 2;
    final static int ICON_MONO_16x16 = 3;
    final static int ICON_MONO_32x32 = 4;
}
```

A trivial implementation of the *BeanInfo* interface called *SimpleBeanInfo* is available. However, use of *SimpleBeanInfo* typically involves overriding the trivial implementations for the bean to work properly. The code for *SimpleBeanInfo* follows:

```java
package java.beans;
public class SimpleBeanInfo implements BeanInfo {
    public BeanDescriptor getBeanDescriptor() {
        return null;
    }
    public PropertyDescriptor[] getPropertyDescriptors() {
        return null;
    }
    public int getDefaultPropertyIndex() {
        return -1;
    }
    public EventSetDescriptor[] getEventSetDescriptors() {
        return null;
    }
    public int getDefaultEventIndex() {
        return -1;
    }
    public MethodDescriptor[] getMethodDescriptors() {
        return null;
    }
    public BeanInfo[] getAdditionalBeanInfo() {
        return null;
    }
```

```
                    public java.awt.Image getIcon(int iconKind) {
                      return null;
                    }
                    public java.awt.Image loadImage(final String resourceName)
                        {
                      try {
                          final Class c = getClass();
                          java.awt.image.ImageProducer ip =
                      (java.awt.image.ImageProducer)
                    java.security.AccessController.doPrivileged(
                      new java.security.PrivilegedAction() {
                          public Object run() {
                      java.net.URL url;
                      if ((url = c.getResource(resourceName)) == null) {
                          return null;
                      } else {
                          try {
                           return url.getContent();
                          } catch (java.io.IOException ioe) {
                           return null;
                          }
                      }
                        }
                      });
                      if (ip == null)
                    return null;
                      java.awt.Toolkit tk =
                    java.awt.Toolkit.getDefaultToolkit();
                        return tk.createImage(ip);
                  }    catch (Exception ex) {
                        return null;
                  }
                }
              }
            }
```

36.2 FeatureDescriptor

The *FeatureDescriptor* class is the base class for the bean, event set, method parameter, property, and indexed property descriptors. These are used by the introspector to derive data about the class automatically.

Considerable effort can be spent by the bean designer in providing a proper set of descriptors for the sake of appropriate introspective response.

The information is accessed via an instance of the *BeanInfo* class. Attributes in a *FeatureDescriptor* include the bean name, the display name, and a short description.

Bean designers even can add their own attributes, called *Extension* attributes. These attributes are retrieved though introspection.

The method summary of *FeatureDescriptor* follows:

```
public class FeatureDescriptor extends Object {
    // Public Constructor
```

```
    public FeatureDescriptor();
// Public Instance Methods
    public Enumeration attributeNames();
    public String getDisplayName();
    public String getName();
    public String getShortDescription();
    public Object getValue(String attributeName);
    public boolean isExpert();
    public boolean isHidden();
    public void setDisplayName(String displayName);
    public void setExpert(boolean expert);
    public void setHidden(boolean hidden);
    public void setName(String name);
    public void setShortDescription(String text);
    public void setValue(String attributeName, Object value);
}
```

36.3 BeanDescriptor

 The *BeanDescriptor* class is a subclass of the *FeatureDescriptor* class.

BeanDescriptor is one of the descriptors returned by *BeanInfo*. A *BeanDescriptor* instance has data about a bean's class and the *Customizer* class (if it exists). The *Customizer* class helps to formulate a GUI for editing properties. To gain access to a string representation of *BeanDescriptor*, use

```
public static String
    getBeanDescriptorString(java.beans.BeanInfo bi) {
    java.beans.BeanDescriptor bd = bi.getBeanDescriptor();
  return bd.getBeanClass().toString()
        + "\n"
        + "name=" + bd.getName()
        + "\ngetDisplayName=" + bd.getDisplayName()
        + "\nisHidden=" + bd.isHidden()
        + "\ngetShortDescription=" + bd.getShortDescription();
}
```

The bean's class is the instance of the *Class* class from which the bean was derived. The default *Customizer* class is *null*. The other attributes that *BeanDescriptor* accesses all are derived from *FeatureDescriptor*. They are *name*, *DisplayName*, *ShortDescription*, *Expert*, *Preferred*, and *Hidden*. The following code segment demonstrates how to instantiate *BeanDescriptor* by indicating the *InverterGate* bean:

```
BeanDescriptor bd = new
        BeanDescriptor(InverterGate.class);
```

The *setValue* method is inherited from the *FeatureDescriptor* superclass and defines the extension attributes "*SClass*" and "*Manufacture*." The value of "*SClass*" is "*Inverter Series Class 707*," which is used to describe the type of inverter gate. The second defined attribute is the "*Manufacture*" attribute. Its value is "*Intel*," which is used to describe the manufacturer of the inverter gate.

A code segment from *InverterGateBeanInfo.java* follows:

```
// ***********************
// *** Bean Attributes ***
// ***********************
 public BeanDescriptor getBeanDescriptor(){
     BeanDescriptor bd = new
      BeanDescriptor(InverterGate.class);
     bd.setDisplayName("The Inverter Gate Stuff!!");
     bd.setName("Inverter Bean");
     bd.setShortDescription(
      "An Inverter's output is the inverse of the Input.");
     bd.getBeanClass();
     bd.getCustomizerClass();
     bd.setValue("SClass", "Inverter Series Class 707");
     bd.setValue("Manufacture", "Intel");
     return bd;
 }
```

For example, to retrieve the bean's attributes, use

```
InverterGateIntrospector.java
// ***********************
// *** Bean Attributes ***
// ***********************
System.out.println("");
System.out.println("*** Bean Attributes ***");
BeanDescriptor bd = beanInfo.getBeanDescriptor();
Enumeration enum = bd.attributeNames();
for(Enumeration e=enum; e.hasMoreElements();){
    String name = (String)e.nextElement();
    Object value = bd.getValue(name);
    System.out.println(space
      + "Bean Attributes = "
      + name
      + " bean value = "
      + bd.getValue(name));
}
System.out.println(space
      + "Bean Class = " + bd.getBeanClass());
System.out.println(space
      + "Bean Customizer Class = " +
bean.getCustomizerClass());
System.out.println(space
      + "Bean Name: " + bd.getName());
System.out.println(space
      + "Display Name: " + bd.getDisplayName());
System.out.println(space
      + "Short Description: "
      +  bd.getShortDescription());
System.out.println(space
      + "For Experts only?: " + bd.isExpert());
System.out.println(space
      + "is hidden?: " + bean.isHidden());
```

To retrieve the extension attributes, *Enumeration* is used for *bd.attributeNames()*. The *attributeNames()* attribute is derived from *FeatureDescriptor*. The output follows:

```
Bean Attributes = Manufacture bean value = Intel
Bean Attributes = SClass bean value = Inverter Series Class 707
```

Additional output follows:

```
Bean Class = class IntroSpec.InverterGate
Bean Customizer Class = null
Bean Name: Inverter Bean
Display Name: The Inverter Gate Stuff!!
Short Description: An Inverter's output is the inverse of
    the Input.
For Experts only?: false
is hidden?: false
```

If there is no *Customizer* class value, *null* is displayed. The rest of the attributes are derived attributes from *FeatureDescriptor*.

36.4 *EventSetDescriptor*

An *EventSetDescriptor* instance describes the events that the bean can generate, which is relevant to listener methods and listener interfaces.

A unicast event has the same naming convention as other events except that it only allows a single event listener to be registered at a time. If more than one listener is registered, the *java.util.TooManyListenersException* is thrown:

```
public void
   addPropertyChangeListener(PropertyChangeListener l)
         throw java.util.TooManyListenersException;
public void
   removeEventNameListener(EventListenerName l);
```

As an example of how to read and display event sets, consider the following snippet of code:

```
// cutils.reflection.IntrospectUtil
public static void main(String args[]) {
   try {
     testEventSetDescriptors();
   } catch(java.beans.IntrospectionException e) {
     e.printStackTrace();
   }
}
public static void testEventSetDescriptors()
       throws java.beans.IntrospectionException {
     print(getEventSetDescriptors(new javax.swing.JButton()));
}
public static java.beans.EventSetDescriptor[]
     getEventSetDescriptors(Object o)
       throws java.beans.IntrospectionException {
```

```
        Class c = o.getClass();
        java.beans.BeanInfo bi =
          java.beans.Introspector.getBeanInfo(c);
        return bi.getEventSetDescriptors();
  }

  public static void print(
          java.beans.EventSetDescriptor esd[]) {
    System.out.println ("\n\tListeners\n\t---");
    for (int i=0;i<esd.length;i++) {
      System.out.println (
        "(" + (i+1) + ")\t"
        + esd[i].getName()
        + " - "
        + esd[i].getListenerType());
    }
  }
}
```

The output follows:

```
        Listeners
        ---------
(1)     action - interface java.awt.event.ActionListener
(2)     ancestor - interface javax.swing.event.AncestorListener
(3)     change - interface javax.swing.event.ChangeListener
(4)     component - interface java.awt.event.ComponentListener
(5)     container - interface java.awt.event.ContainerListener
(6)     focus - interface java.awt.event.FocusListener
(7)     hierarchy - interface java.awt.event.HierarchyListener
(8)     hierarchyBounds - interface
        java.awt.event.HierarchyBoundsListener
(9)     inputMethod - interface
        java.awt.event.InputMethodListener
(10)    item - interface java.awt.event.ItemListener
(11)    key - interface java.awt.event.KeyListener
(12)    mouse - interface java.awt.event.MouseListener
(13)    mouseMotion - interface
        java.awt.event.MouseMotionListener
(14)    mouseWheel - interface java.awt.event.MouseWheelListener
(15)    propertyChange - interface
        java.beans.PropertyChangeListener
(16)    vetoableChange - interface
        java.beans.VetoableChangeListener
```

The following example shows how bean designers can create their own *EventSetDescriptors*:

```
// **************
// *** Events ***
// **************
public EventSetDescriptor[] getEventSetDescriptors(){
    EventSetDescriptor inverter[]
      = new EventSetDescriptor[1];
    try{
```

```
            String listenNames[] ={"propertyChange"};
            inverter[0] = new EventSetDescriptor(
              InverterGate.class,
              "property change event stuff",
              java.beans.PropertyChangeListener.class, listenNames,
              "removePropertyChangeListener",
              "addPropertyChangeListener");
          }
          catch(IntrospectionException e){
           throw new Error(e.toString());
          }
          EventSetDescriptor rv[] = inverter;
          return rv;
      }
```

The following code resides in the *InverterGateIntrospector* class and displays its properties:

```
// **************
// *** Events ***
// **************
System.out.println("");
System.out.println("*** Events ***");
EventSetDescriptor[] events = beanInfo.getEventSetDescriptors();
for (int i = 0; i < events.length; i++){
      System.out.println(space + "Name: " +
        events[i].getName());
      System.out.println(
        space + "Display Name: "
        + events[i].getDisplayName());
      System.out.println(space + "Short Description: "
        + events[i].getShortDescription());
      System.out.println(space + "In expert mode? "
        + events[i].isExpert());
      System.out.println(space + "Is hidden? "
        + events[i].isHidden());
      System.out.println("");
}

Method[] lm = events[0].getListenerMethods();
for (int i=0; i<lm.length; i++)
      System.out.println(space + "Event Name = " +
        lm[i].getName());
Class lt = events[0].getListenerType();
System.out.println(space + "Listener Type = " + lt.getName());
Method rl = events[0].getRemoveListenerMethod();
System.out.println(space
      + "Remove Listener Type Method = "
      + rl.getName());

Method al = events[0].getAddListenerMethod();
System.out.println(space
      + "Add Listener Type Method = "
      + al.getName());
```

```
MethodDescriptor[] lmd =
      events[0].getListenerMethodDescriptors();
for (int i=0; i<lmd.length; i++)
    System.out.println(
      space
      + "Listener Method Descriptors = "
      + lmd[i].getName());

if (lmd.length == 0)
      System.out.println(
        space +
        "getListenerMethodDescriptors == nothing!");
```

EventSetDescriptor listener methods include *getListenerMethods*(), *getListenerType*(), *getRemoveListenerMethod*(), *getAddListenerMethod*(), and *getListenerMethodDescriptors*():

```
Event Name = propertyChange
Listener Type = java.beans.PropertyChangeListener
Remove Listener Type Method = addPropertyChangeListener
Add Listener Type Method = removePropertyChangeListener
Listener Method Descriptors = propertyChange
```

The method *getListenerMethods()* returns the event set's listener method, *propertyChange*. The method *getListenerType()* returns the event set's listener interface, *java.beans.PropertyChangeListener*. The method *getRemoveListenerMethod()* returns the events and removes the listener's support methods. The method *getAddListenerMethod()* returns the events and adds the listener's support methods. The method *getListenerMethodDescriptors()* returns the listener method descriptor, *propertyChange*.

36.5 *MethodDescriptor*

 A *MethodDescriptor* instance provides information about public methods in the bean.

The values retrieved include a method return value, its name, and its parameters. The following code snippet shows how to read and display method descriptor names:

```
public static void testMethodDescriptors()
    throws java.beans.IntrospectionException {
    print(getMethodDescriptors(new java.util.Date()));
}

public static void print(
      java.beans.MethodDescriptor md[]) {
    System.out.println("Method Names");
    for (int i=0;i<md.length;i++) {
      System.out.print(md[i].getName()+" ");
    }
}

public static java.beans.MethodDescriptor[]
      getMethodDescriptors(Object o)
        throws java.beans.IntrospectionException {
```

```
        Class c = o.getClass();
        java.beans.BeanInfo bi =
          java.beans.Introspector.getBeanInfo(c);
        return bi.getMethodDescriptors();
    }
```

The output for *java.util.Date* follows:

```
Method Names
UTC after before clone compareTo compareTo equals getClass
        getDate getDay getHours getMinutes getMonth getSeconds
        getTime getTimezoneOffset getYear hashCode notify
        notifyAll parse setDate setHours setMinutes setMonth
        setSeconds setTime setYear toGMTString toLocaleString
        toString wait wait wait
```

Some method names repeat because they are overloaded. Custom method descriptors also can be created, as shown in the following example:

```
public MethodDescriptor[] getMethodDescriptors(){
        Method mgetInput,mgetOutput, msetInput;
        MethodDescriptor setInput= null;
        ParameterDescriptor pBoolean = new
          ParameterDescriptor();
        pBoolean.setName("newInput");
        pBoolean.setShortDescription("This is a boolean");
        ParameterDescriptor[] pd = {pBoolean};

        try{
          mgetInput =
            InverterGate.class.getMethod("getInput", null);
          mgetOutput =
            InverterGate.class.getMethod("getOutput", null);

        }
        catch(Exception e){
          throw new Error("Method " + e + " not found");
        }

        Method x[] = InverterGate.class.getMethods();
        for (int i=0; i<x.length; i++){
          if (x[i].getName().equals("setInput")){
            setInput = new MethodDescriptor(x[i],pd);
            setInput.setDisplayName("Set Input");
            setInput.setShortDescription(
                "Set the input of the inverter gate.");
          }
        }
        MethodDescriptor getOutput = new
        MethodDescriptor(mgetOutput, null);
        MethodDescriptor getInput = new
        MethodDescriptor(mgetInput, null);

        getOutput.setDisplayName("Get Output");
        getInput.setDisplayName("Get Input");
```

```
              getOutput.setExpert(true);
              getInput.setExpert(true);
              getOutput.setShortDescription(
                "Get the output of inverter gate.");
              getInput.setShortDescription(
                "Get the input of inverter gate.");
              MethodDescriptor rv[] = { getOutput, getInput,setInput };

              return rv;
        }
```

Code for *InverterGateIntrospector* follows:

```
        System.out.println("");
        System.out.println("*** Methods ***");
        MethodDescriptor[] methods = beanInfo.getMethodDescriptors();
        for (int i = 0; i < methods.length; i++){
              System.out.println(space + "Method: "
                + methods[i].getMethod());
              System.out.println(space + "Name: "
                + methods[i].getName());
              System.out.println(space + "Display Name: "
                + methods[i].getDisplayName());
              System.out.println(space + "Short Description: "
                + methods[i].getShortDescription());
              System.out.println(space + "In expert mode? "
                + methods[i].isExpert());
              System.out.println(space + "Is hidden? "
                + methods[i].isHidden());
              System.out.println("");
        }
```

The output from the preceding code follows:

```
*** Methods ***
      Method: public boolean IntroSpec.InverterGate.getOutput()
      Name: getOutput
      Display Name: Get Output
      Short Description: Get the output of inverter gate.
      In expert mode? true
      Is hidden? false
```

36.6 ParameterDescriptor

ParameterDescriptor contains information about method parameters. *MethodDescriptor* is used to obtain a reference to *ParameterDescriptor*. For example,

```
        MethodDescriptor setInput= null;
        ParameterDescriptor pBoolean = new
        ParameterDescriptor();
        pBoolean.setName("newInput");
        pBoolean.setShortDescription("This is a boolean");
```

```
ParameterDescriptor[] pd = {pBoolean};

Method x[] = InverterGate.class.getMethods();
for (int i=0; i<x.length; i++){
    if (x[i].getName().equals("setInput")){
        setInput = new MethodDescriptor(x[i],pd);
        setInput.setDisplayName("Set Input");
        setInput.setShortDescription(
        "Set the input of the inverter gate.");
    }
}
```

The output follows:

```
Method: public void IntroSpec.InverterGate.setInput(boolean)
Name: setInput
Display Name: Set Input
Short Description: Set the input of the inverter gate.
```

36.7 *PropertyDescriptor*

A *PropertyDescriptor* instance holds information about a bean's properties.

There is a *PropertyDescriptor* instance for each property. As an example, consider the property names and type for the *java.util.Date* class:

```
public static void testPropertyDescriptors()
    throws java.beans.IntrospectionException {
    print(getPropertyDescriptors(new java.util.Date()));
}

public static void print(java.beans.PropertyDescriptor
        pd[]) {
    System.out.println("Property Names\tProperty Type");
    for (int i=0;i < pd.length;i++) {
      System.out.println(
        pd[i].getName()
        + "\t\t"
        + pd[i].getPropertyType());
    }
}

public static java.beans.PropertyDescriptor[]
        getPropertyDescriptors(Object o)
        throws java.beans.IntrospectionException {
    Class c = o.getClass();
    java.beans.BeanInfo bi =
      java.beans.Introspector.getBeanInfo(c);
    return bi.getPropertyDescriptors();
}
```

The output for this snippit follows:

```
Property Names   Property Type
class            class java.lang.Class
date             int
day              int
hours            int
minutes          int
month            int
seconds          int
time             long
timezoneOffset   int
year             int
```

The bean designer will want to control the properties in order to customize their appearance. The following code shows how to create a property called *input*:

```
PropertyDescriptor input = new
    PropertyDescriptor("input",InverterGate.class);
```

 PropertyDescriptor has the ability to indicate a bound property constraint.

For example,

```
// *****************
// *** Properties ***
// *****************
public PropertyDescriptor[] getPropertyDescriptors(){
        try{
        PropertyDescriptor input = new
            PropertyDescriptor("input",InverterGate.class);
            input.setDisplayName("Input!");
            input.setShortDescription(
                "This is the input for the Inverter Gate!");
             input.getPropertyType();

            PropertyDescriptor rv[] = {input};
            return rv;
            }
        catch (IntrospectionException e){
                throw new Error(e.toString());
            }
}
//Code segment from InverterGateIntrospector.java
// *****************
// *** Properties ***
// *****************
System.out.println("");
System.out.println("*** Properties ***");
PropertyDescriptor[] properties =
        beanInfo.getPropertyDescriptors();
for (int i = 0; i < properties.length; i++){
```

```
            System.out.println(space + "Display Name: "
                + properties[i].getDisplayName());
            System.out.println(space + "Short Description: "
                + properties[i].getShortDescription());
            System.out.println(space + "Property Type: "
                + properties[i].getPropertyType());
            System.out.println(space + "Read Method: "
                + properties[i].getReadMethod());
            System.out.println(space + "Write Method: "
                + properties[i].getWriteMethod());
            System.out.println(space + "get Property Editor: "
                + properties[i].getPropertyEditorClass());
            System.out.println(space + "is Constrained?: "
                +        properties[i].isConstrained());
            System.out.println(
                space
                + "is Bound?: "
                + properties[i].isBound());
    }
```

The output follows:

```
*** Properties ***
    Display Name: Input!
    Short Description: This is the input for the Inverter Gate!
    Property Type: boolean
    Read Method: public boolean
        IntroSpec.InverterGate.getInput()
    Write Method: public void
        IntroSpec.InverterGate.setInput(boolean)
    get Property Editor: null
    is Constrained?: false
    is Bound?: false
```

36.8 *IndexedPropertyDescriptor*

 An *IndexedPropertyDescriptor* instance describes an array of items.

An explicit indexed property descriptor is used if the *BeanInfo* file is present; otherwise, an implicit *IndexedPropertyDescriptor* is constructed. Implicit *IndexedPropertyDescriptor* values are found by performing introspection on the bean.

36.9 *BeanInfo* Example

This section shows how introspection works on an instance of an *InverterGate* class. The goal of this example is to demonstrate how feature descriptors can be modified to display a more readable feature list. This modification is done using introspection rather than *InverterBeanInfo*.

What follows is some output obtained using *SimpleBeanInfo:*

```
*** Bean Attributes ***
     Bean Attributes = Manufacture bean value = Intel
     Bean Attributes = SClass bean value = Inverter Series Class
        707
     Bean Class = class IntroSpec.InverterGate
     Bean Customizer Class = null
     Bean Name: Inverter Bean
     Display Name: The Inverter Gate Stuff!!
     Short Description: An Inverter's output is the inverse of
        the Input.
     For Experts only?: false
     is hidden?: false
*** Properties ***
     Display Name: Input!
     Short Description: This is the input for the Inverter Gate!
     Property Type: boolean
     Read Method: public boolean
        IntroSpec.InverterGate.getInput()
     Write Method: public void
        IntroSpec.InverterGate.setInput(boolean)
     get Property Editor: null
     is Constrained?: false
     is Bound?: false
*** Methods ***
     Method: public boolean IntroSpec.InverterGate.getOutput()
     Name: getOutput
     Display Name: Get Output
     Short Description: Get the output of inverter gate.
     In expert mode? true
     Is hidden? false
     Method: public void
        IntroSpec.InverterGate.setInput(boolean)
     Name: setInput
     Display Name: Set Input
     Short Description: Set the input of the inverter gate.
     In expert mode? false
     Is hidden? false
     Method: public boolean IntroSpec.InverterGate.getInput()
     Name: getInput
     Display Name: Get Input
     Short Description: Get the input of inverter gate.
     In expert mode? true
     Is hidden? false
*** Events ***
     Name: property change event stuff
     Display Name: property change event stuff
     Short Description: property change event stuff
     In expert mode? false
     Is hidden? false
     Event Name = propertyChange
     Listener Type = java.beans.PropertyChangeListener
```

```
Remove Listener Type Method = addPropertyChangeListener
Add Listener Type Method = removePropertyChangeListener
Listener Method Descriptors = propertyChange
```

36.10 Summary

BeanDescriptor, EventSetDescriptor, MethodDescriptor, ParameterDescriptor, Property-Descriptor, and *IndexedPropertyDescriptor* all are derived from the *FeatureDescriptor* class. The constructor of the *ParameterDescriptor* class takes no arguments and typically is used to create an instance of *MethodDescriptor.*

Introspection is just a way to extend reflection so that bean designers have more control over the results. Bean-builder tools typically use introspection to obtain properties, method descriptions, and event data. Having an implementation of the *BeanInfo* interface is important to bean-builder tools. The *BeanInfo* implementor enables the discovery of bean properties.

 Customization enables control over bean appearance and behavior. Such Customization typically is done using a property editor.

Events control interbean coherance. Some beans are event listeners, some are event broadcasters, and some are both. Introspection can reveal bean events.

36.11 Exercises

36.1 Create a *BeanInfo* class from an existing bean.

36.2 Create a *BeanInfo* class that only supplies information on properties and events.

36.3 Is *SimpleBeanInfo* always used during introspection?

36.4 Does *SimpleBeanInfo* require all of the attributes to be set?

36.5 What base attributes do *BeanDescriptor, EventSetDescriptor, MethodDescriptor, ParameterDe-scriptor, PropertyDescriptor*, and *IndexedPropertyDescriptor* have in common?

36.6 Download the Graph Editing Framework (*GEF*) system at: *<http://gef.tigris.org/>* and use it to build a visual programming language. GEF allows you to use beans to construct a visual programming language. Think about how to apply GEF to your project. What will you represent in your connected graph?

 GEF has a lot of deprecations in it (as of version 0.8). It is also dependent on a non-standard IBM XML parser.

C H A P T E R 3 7

Introduction to Enterprise Java Beans

by James Linn

If you must play, decide on three things at the start: the rules of the game, the stakes, and the quitting time.

–Chinese Proverb

In this chapter, you will learn:

- The rationale for EJBs
- The costs and the benefits of a server-side architecture
- The J2EE architecture in the context of server-side architectures
- The requirements for an effective server-side architecture
- How the J2EE architecture fulfilled those requirements
- About competing architectures and how they compare to the J2EE architecture

EJBs typically are used as a part of a server-side architecture, which is a part of the new trend to move more computation into the server and away from the client. This shift simplifies deployment and maintenance of centralized services at a cost of increasing the server load. This is an engineering trade-off. However, for large centralized databases, searches are best conducted on the server.

Computations that can bog down a server are best offloaded onto a server farm, or, if possible, kept on the client.

The use of a browser as a thin client generally makes the assumption that the server should handle the computations.

37.1 EJBs and Server-Side Architecture

A server-side architecture can be well suited to enterprise applications. Java 2, Enterprise Edition (J2EE) is a reference implementation of a server-side architecture released by Sun.

It uses the server-side CSD centered around *servlets, JSPs*, and EJBs. The servlets reside in a *container* and typically are used to interact with a browser.

EJBs reside in the application server and typically contain business logic.

The server-side architecture contains a framework for managing distributed components that is operating-system independent. Sun Microsystems has published EJB standards (*<http://java.sun.com/products/ejb/>*) and servlet specifications in the *Java Servlet Specification*, v2.3 (*<http://java.sun.com/products/servlet/index.html>*) and JSP specifications in *JavaServer Pages*. 1.1(*<http://java.sun.com/products/jsp/index.html>*). These standards and specifications allow independent companies to produce software that will run EJBs and JSP/servlets.

In a nutshell, with Microsoft .NET you get a product. With J2EE you get a widely supported specification.

EJBs are deployable components that run on the server in a container and provide services for client tiers. EJBs provide for rapid server-side application development. As you will see later, the container relieves J2EE application developers of the necessity of doing the transaction, security and database-access coding. The container also takes care of the task of managing distributed components. Application developers instead can concentrate on implementing the business logic, which can take months off of the time needed to deploy applications. By using EJBs and a J2EE-compliant application server, you can write scalable, reliable, and secure applications without writing your own distributed object framework.

37.2 Requirements for an Enterprise Server-Side Architecture

37.2.1 Support for Component Development

The following information provides details about component architectures:

- A *component* is code that implements a well-defined interface.
- An *interface* is a contract between developers. The developer contracts to provide services or methods. The manner in which the developer provides those services is hidden (encapsulated) behind the interface.
- A *component architecture* supports object-oriented design and development and brings numerous advantages to server-side applications.
- A component architecture allows the use of third-party components. Development problems can be solved by buying thoroughly debugged components and plugging them into the application server. The option of buying components means that companies need less in-house expertise. Even if the company decides to build components, using a component architecture makes shifting from a build position to a buy position relatively painless later on.
- The architecture should allow the distribution of component development, component assembly, and component deployment responsibilities among different members of the application development team, if so desired.

The bottom line is that component architectures can provide a lower cost of ownership. The economic case for component architectures often is quite compelling to enterprises large and small.

Server-side components run in a container. The container framework (called the *application server*) supports a set of common services and APIs. Server-side Java components are called EJBs, and they require an EJB container.

Several application-server technologies are available. For example, Microsoft provides an application server for Component Object Model (COM) objects with the Windows operating system, and the J2EE SDK includes an EJB container. Open-source alternatives to the J2EE application server include *JBoss <http://www.jboss.org>*. Open-source IDEs that make use of JBoss are also available (see, for example, *<http://download.eclipse.org>*).

37.2.2 Scalability

Scalability can come from increasing the power of the server or by increasing the number of servers. Monolithic applications thus are forced to look to more powerful servers to scale. Both scalability mechanisms are available to a component architecture, and increasing server power works well with component architectures. In addition, components can be distributed across multiple servers easily. High-end application servers will handle the complexity of managing distributed components automatically, thus freeing application developers from having to code that complex functionality.

The distribution of components over several servers also provides for failover.

37.2.3 Portability

Application portability among application servers is another feature Sun brings to the table. Is a result of the requirement that all J2EE application servers adhere to the J2EE specification, applications are not tied to specific application-server manufacturers.

Portability is not 100%. In fact, choosing an application server requires careful research. Even though all application servers fulfill the J2EE EJB specification, requirements there are significant differences among servers. For example, there are issues with how state is maintained between servers in a cluster. Some application servers just replicate stateful EJBs, while other application servers replicate servlets as well. If a company's application stores state in servlets, the company should make sure that its choice of application servers will replicate the servlets across all of the servers in the cluster.

If an enterprise application makes use of Java messaging, the enterprise should make sure that the application server of choice distributes queue information over the servers in a cluster.

Anyone involved in making decisions as to what application server to use for an enterprise situation will have to start with a good knowledge of how existing applications are architected and then study exactly how the application designers have implemented the J2EE specification.

While Sun provides basic SDKs for free, the most productive way to develop J2EE applications by far is with an Integrated Development Environment (IDE) that supports debugging servlets and EJBs while they are running in their containers.

Eclipse IBM (Visual Age For Java), Sun (Studio), and Borland (JBuilder) are some of the companies that market IDEs for J2EE development. These IDEs all provide support for debugging in servlets and EJBs and come with industrial-strength application servers.

Some of these companies charge at least $3,000 a seat for an IDE that can debug servlets and EJBs. Eclipse with JBoss, however, is free.

Code maintenance generally is performed in an IDE. Most application servers have tools that deploy EJBs. In addition, they often provide tools to monitor performance and to help in tuning application servers.

37.3 MultiTier Applications

Server-side architectures allow the application architect to divide functionality into layers. Server-side architectures are, by definition, distributed architectures. *Distributed architectures* allow the partitioning of the different layers onto different computers.

These layers are logical entities. They are translated into physical designs in many different ways. The most common tiers are:

- The *presentation layer*, which handles the presentation to the user, including data, static text, and images.
- The *business-logic layer*, which includes the code that handles business logic and the application of business rules.
- The *data layer*, which includes the logic necessary to interact with the objects responsible for maintaining persistence (e.g., databases and file systems).

By partitioning the application into layers, the pieces can be distributed among 1 to N tiers, thus providing a multitier architecture.

In addition, since Java is the development language for J2EE applications, different layers can be distributed among different operating systems. This distribution reflects the reality of most existing businesses: Significant functionality resides on legacy systems and is not going to be rewritten. The J2EE architecture can integrate legacy systems into a J2EE application easily.

Many difficulties are associated with multitier, distributed architectures, including scalability, transaction and security management, and reliability, to name a few. Dealing with these problems is the responsibility of the application server.

The J2EE framework is in its second major release. J2EE has developed considerable maturity and is suitable for enterprise application development and deployment.

A multitier architecture offers the following advantages:

1. The tiers are all specialized, which means that the hardware also can be specialized for the duties of the tiers. For example, the web server tier will have different hardware requirements than the database tier. The database then, can be ORACLE running on UNIX, and the web server can be an Internet Information Server (IIS) running on Windows 2000. The main point is that the development team is less constrained in its choices with a multitier architecture.
2. Each tier can vary independently to reflect the realities of use. In other words, if the web tier is overloaded, more hardware can be devoted to it or the hardware can be upgraded without disturbing the other tiers.
3. Applications on different tiers do not interact. For example, the application server can have a CLASSPATH that could interfere with the CLASSPATH of the database tier.

CHAPTER 38

EJB Container

by James Linn

**He whom the gods love,
dies young.**

*–Titus Maccius Plautus, dramatist
(circa 254-184 BCE)*

Only the young die good.

–Douglas Lyon

In this chapter, you will learn about:

- The EJB container
- The EJB paradigm in which all access to EJBs is through the container
- Home and remote interfaces and their significance
- The concept of the deployment descriptor and how much of the programming of any EJB application is carried out through it
- The players in the EJB container market

38.1 Introduction

Server components run in a container, which provides common services that EJB components need. For J2EE applications, that container is called an *EJB container*.

Make sure you are satisfied with how security is addressed in your EJB container.

In this section, we will look at the J2EE container and the services described in the J2EE specification. Then, we will look at the J2EE development paradigm.

38.2 Requirements for J2EE-Compliant EJB Containers

 The EJB container must provide component pooling and component lifetime control.

In the client-server world, a component is created every time an application asks for it and is destroyed when the application is finished with it. In the case of objects, such as database connections, this process markedly slows applications. In the case of large, complex objects, the create-destroy cycle loads the server. The EJB container manages component lifecycles. In the case of entity beans, which represent data, many clients can use a single instance of that data. In the case of session beans, which represent conversations between the application and the user, the lifetime of the component can span a long period of time. The EJB container is free to "hibernate" the session bean to persistent storage using serialization, thus freeing resources. In the case of costly resources, such as database connections, the EJB container can make a connection pool. In addition, the EJB container can control the size of the connection pool dynamically.

 Incompatible changes to EJBs can cause a failure in currently save instances.

This is due to the change in the serialized form that occurs when classes change.

 The EJB container provides *persistence management* for the entity beans within it.

Having the container take care of persistence can speed up development. The section on entity beans shows the methods that the container uses to manage persistence. Programmers still are able to handle persistence management by writing their own JDBC code.

 The EJB container provides *transaction management*, whose configuration is controlled by an XML *deployment descriptor* file.

Deployment descriptors are described in Chapters 39 and 41. If a method executes in a transaction, the container propagates the transaction to resource managers and to the other EJBs called. The container also performs the transaction commit protocol.

 The EJB container performs security checks on the caller before allowing access to any resources it manages.

Security can be set on entire objects or on individual functions. For example, as part of login management of an application, you could have a login object with many methods. The *checkForUidAndPwd(String uid, String pwd)* method could have no security restrictions on it. However, the *ChangeUidAndPwd(String uid, String pwd)* method only should be available to administrators. As with transactions, security policies are set in the deployment descriptor.

To handle all situations, the option for user-written security management also exists, which is detailed in Chapter 42.

 An EJB container has a *distributed object protocol*. By definition, EJBs are distributed objects, which means that the EJB's physical location (in which process on what machine) is immaterial to other objects attempting to interact with it.

Writing the code for and managing distributed objects can be quite challenging. However, the EJB container manages all of these tasks for you. RMI Internet Inter-ORB Protocol (IIOP) is the most popular distributed object protocol among EJB containers, but there is

no requirement for a EJB container vendor to use it. Vendors can use a proprietary protocol if they wish. The only restriction placed on vendors is that the part that the EJB sees and interacts with must conform to the J2EE specification.

That said, the EJB specification mandates that whatever distributed protocol the vendor uses must conform to the RMI/IIOP API *<http://java.sun.com/products/ejb/docs.html>*. In particular, the data types passed must be valid RMI/IIOP data types. IIOP brings along *CORBA*, which means that not all Java types can be passed. In practice, all Java primitives and objects that implement `serializable` can be passed by value, and objects that implement the `remote` interface can be passed by reference. See one of the many RMI/IIOP references for further information.

Beyond the restrictions on data types, it is not necessary for the EJB developer to understand RMI. The container manages all of the communication between components in whatever means it sees fit. All of the details of the implementation of the distributed object protocol thus are hidden from the developer.

 An EJB container provides *thread management and synchronization*. The *container* starts and stops threads, as necessary, to service multiple requests.

In addition, the *container* manages all of the thread synchronization, which means that developers should write their objects as if only one client will be interacting with them at a time. In practical terms, if a client connects to *xyzObject* and then another invocation for *xyzObject* is received by the container, the container will spin up another thread, create another *xyzObject* (or retrieve one from the object pool), and connect the second client to that other object. In this fashion, the EJB container serializes all calls to EJBs, keeping them in what is effectively a single-threaded environment. This thread management can simplify development enormously. However, some development problems are best solved with a multithreaded solution. Such situations can be difficult to port to an EJB architecture.

 An EJB container performs *process management*. The container is responsible for starting, stopping, and managing all processes on a server machine, which means that developers do not have to concern themselves with process management.

 An EJB container provides *state management*. The EJB container manages the state of all objects as a part of its resource-management functions, which means that the container can activate and deactivate objects to free resources.

Effective management of resources can make an application much more scalable. This responsibility is removed from the shoulders of the application developer.

 An EJB container provides *system administration support*. The container provides all of the system administration tools needed to manage the deployed objects, which frees the developer from having to write that code.

An example of a system administration task is the classification of applications as to priority and as to the limits on resources that are put on low-priority applications. These are all container issues, and the container must provide the solutions to these issues.

 An EJB container provides for *failure recovery*. Enterprise application architectures include provisions for the automatic restart of failed transactions or applications.

Since the container is now responsible for failure recovery, the application developer no longer has to try to write the code to recover from failures.

 An EJB container has *high availability*. The container is free to implement strategies to mask network and hardware failures from the user without involving any additional work on the part of the developer.

Therefore, an EJB application can be made to satisfy 24X7 availability by just being deployed on a high-availability EJB container.

 Clustering is taken care of by the EJB container, not by a third-party add-on product. Code to implement clustering is inevitably vendor-specific.

Removing the necessity of writing clustering from the EJB developer is part of making applications portable and maintainable.

In short, the J2EE specification and the EJB scheme have separated vendor-specific responsibilities (e.g., failure recovery, clustering, and system administration) from application-specific responsibilities (e.g., implementation of business rules), thus making J2EE applications much quicker and easier to write and to maintain.

In addition, volunteering to handle tasks such as security, transaction management, and persistence also makes application development faster and easier.

In order to make life easier for the vendors who create EJB containers, the J2EE specification has marked such activities as thread and synchronization management as off limits to EJB developers. In some instances, life will be made easier for the developer, but in other instances life will be made harder.

Given those responsibilities, the EJB container is the only entity allowed to create and interact with EJBs. This is a vital point to understand. In sum, outside objects and EJBs interact only with the container.

This insistence that the EJB container intercept all calls to and from the objects inside it is necessary for the container to fulfill its responsibilities.

 The following point must be understood completely: The EJB container is the only entity allowed to create and interact with EJBs. This point calls for developers to learn a new paradigm.

As can be seen from Figure 38.2-1, all outside objects interact only with the container. This container is hosting an EJB that represents (contains) the price of *xyzObject*. The outside application calls the EJB container with a request for that price. Since the EJB container is managing the EJB, it intercepts the call and does the security and transaction tasks that it

FIGURE 38.2-1
Basic EJB Container Architecture

has been mandated to do for this application. The EJB container then makes the function call requested and it returns the result to the calling party.

38.3 Programming Restrictions for Enterprise Beans

The following programming restrictions are from the documents that are a part of the J2EE SDK download.

Enterprise beans make use of the services provided by the EJB container, such as lifecycle management. To avoid conflicts with these services, enterprise beans are restricted from performing certain operations:

- Managing or synchronizing threads
- Accessing files or directories with the *java.io* package
- Using AWT functionality to display information or to accept information from a keyboard
- Listening on a socket, accepting connections on a socket, or using a socket for multicast
- Setting a socket factory used by *ServerSocket, Socket,* or the stream handler factory used by the URL class

 Access to EJBs is through interfaces.

The J2EE specification mandates that the designer of components publish two interfaces: the home interface and the remote interface. The container consumes these interfaces and produces objects that allow clients to access the actual EJB.

An application gains access to the functionality in EJBs through the EJBs' home and remote interfaces.

 The *home interface* defines the methods that allow a client to create, find, or remove an enterprise bean.

 The following barebones interface for a session bean does not show the exceptions involved:

```
public interface BasicBeanHome
       extends javax.ejb.EJBHome {
       // there should be a
       // create method for every constructor in the EJB class
       public BasicBean create();
       // default constructor
       public BasicBean create(int x String y);
       // constructor with input params
       // ... through the other constructors
       // Entity beans are required to have the following method.
       // Session beans can't have the following method.
       public BasicBean findByPrimaryKey(BeanPK primaryKey);
       // Remove methods are defined in the EJBHome interface, you can
       // use those methods. Override with your own remove() method
       // if you need additional functionality.
}
```

The *remote interface* defines the business methods that a client may call.

These interfaces are implemented in the EJB, and the EJB container uses the methods defined in the remote interface to set up the actual classes to allow distributed connections to these methods.

The following barebones remote interface does not show the exceptions involved:

```
public interface BasicBeanRemote extends javax.ejb.EJBObject {
    // all of your business functionality goes here
    public String businessFunction1();
    public int businessFunction2();
    // rest of the business methods …
}
```

Not only do the home and remote interfaces allow the EJB container to manage the associated EJB, but they also allow the EJBs to be distributed objects.

38.4 Four Components of an EJB Application

The four components of an EJB application are the home and remote interfaces, the EJB class, and the deployment descriptor.

38.4.1 Business Logic: The EJB Class

The implementation of the business logic is contained in a Java class. This class may contain all of the logic, or it may access other EJBs or other Java classes to carry out its responsibilities.

This EJB class will contain, at a minimum, all of the functions in the remote and home interfaces as public methods. In addition, it might contain public and private data members and any other private or protected method that is necessary for the business functionality. The EJB class implements either *javax.ejb.EntityBean* or *javax.ejb.SessionBean*, depending upon whether it is an entity or a session bean. The differences between these two types of objects will be discussed in later sections.

Since the container guarantees that all of the calls to the EJB will be as if it were single-threaded, the application developer is free to code as if the EJB class is used by only one user. The home and remote interfaces, in conjunction with the container, provide the distributed capabilities so the EJB developer does not have to write that code either.

Since EJBs are networked objects, it is best to make your EJB class as large-grained as possible when designing enterprise Java applications. That is, cut down on the network calls by encapsulating all of the functionality required to process the input data in your class. Once the component design phase is finished, look for other required functionality in EJBs that other people have developed. If something suitable cannot be found in that pool, perhaps it can be purchased. If developers decide to implement the functionality themselves, then the component(s) should be designed for reuse. Unfortunately, fine-grained objects are much easier to reuse than large objects, so the goal of cutting down on network traffic can run counter to designing for reuse.

The potential for reuse of components is one of the selling points of the J2EE architecture. Careful component design is required to make such reuse a reality.

38.4.2 Deployment Descriptor

The deployment descriptor is a document that declares the information that the developer wants to convey to the EJB container. Examples of the information that might be included in a deployment descriptor are:

- Should this EJB be part of a transaction?
- Should the container provide the persistence code, or will the developer provide it?
- What is the name and the location of the home interface on the hard drive or network?
- What is the name and the location of the remote interface?
- What are the security requirements of these objects?
- Will this EJB refer to other EJBs?
- Does the EJB need information from the environment?
- Are there any resource factories that the EJB needs to use?

The deployment descriptor in J2EE applications is an XML file. While it is possible for developers to write that file themselves using a text editor, normally the EJB container provides a tool to automate this procedure. Even the free EJB container that ships with the J2EE SDK contains a deployment tool.

38.5 How Interfaces Are Used

Developers define both home and remote interfaces in Java files. Developers then write the actual code that is going to do the work (using standard Java coding) and put that code in another Java file, the EJB file. Next, the home and the remote interfaces and the EJB files are turned over (deployed) to the EJB container. During this deployment process, the information that will go into the deployment descriptor is entered into the EJB container's deployment tool. The EJB container will create classes from the remote interface and from the home interface and compile both of these classes and the EJB class that the developer wrote into a functioning application. Each EJB container implements the J2EE specification differently, so the EJB container itself is responsible for turning the interfaces into code that it understands.

 The bottom line: The developer defines the home and the remote interfaces and writes the actual business logic into the EJB itself. The EJB container turns these interfaces into code that it can understand and uses that code to allow outside applications to interact with the EJB.

Developers tell the EJB container what functionality they want to see in the finished object via the interface that they define. The EJB container is then free to implement that contract in any manner it sees fit. Developers neither know, nor care how the EJB container fulfills its functionality.

Encapsulating the functionality enables outside applications to interact with EJBs. Any EJB container written to J2EE specifications can consume a properly written home and remote interface and, along with the EJB, produce a fully functional EJB application.

38.5.1 EJB Function Call Sequence

This section describes the sequence of events that occurs during the creation and calling of a function on an EJB.

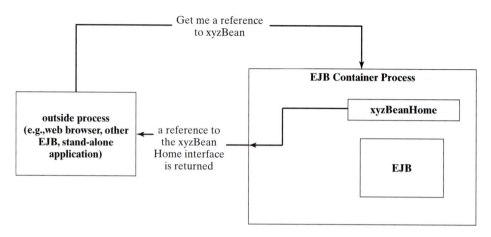

FIGURE 38.5.1-1
Step 1: Get a Reference to the EJB Home Interface.

Figure 38.5.1-1 shows the first step, which is getting a reference to the EJB home interface. The first step to tell the container that you want a reference to the *xyzBeanHome* interface. The container will use the Java Naming and Directory Interface (JNDI) to look up the location of the *xyzHomeInterface* class and return a reference to it.

Figure 38.5.1-2 shows the second step, where *xyzBean* creates the *xyzBeanRemote* instance. Once the outside process has a reference to the object implementing the home interface, it can call *home.create()*. This call, in turn, will cause the home object to find or create an instance of *xyzBeanRemote*, which is the class created by the EJB container that implements the *xyzBeanRemote* interface. The *remote* instance also is called the EJB Object in EJB literature. The EJB container manages this call.

Figure 38.5.1-3 shows the third step, where the *xyzBean* instance returns a reference to the *xyzBeanRemote* instance. The home object returns the reference to the remote object and then steps out of the picture.

Figure 38.5.1-4 shows the fourth step, where the outside process invokes methods via the *xyzBeanRemote* instance. Once the outside process has a reference to a remote instance, it can invoke the public methods. The container delegates the invocations from the *xyzBeanRemote* instance to xyzEJB.

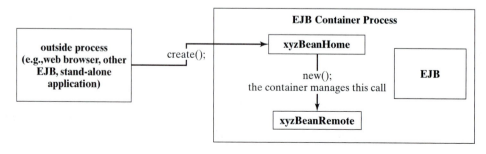

FIGURE 38.5.1-2
Step 2: *xyzBean* Creates *xyzBeanRemote*.

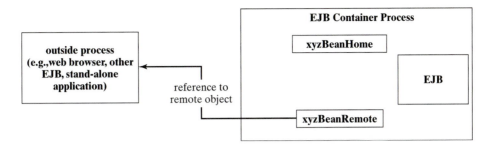

FIGURE 38.5.1-3
Step 3: *xyzBean* and *xyzBeanRemote*

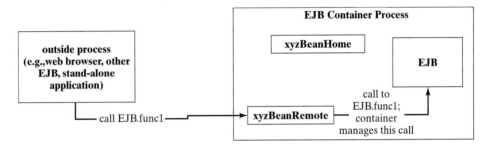

FIGURE 38.5.1-4
Step 4: The Outside Process and *xyzBeanRemote*

38.5.2 EJB Application Servers

The commercial term for EJB containers is *application server*. However, commercial application servers provide much more that an EJB container. For example, WebLogic version 7.1 from BEA has a web container, an EJB container, a web server, an Object Request Broker (ORB) for CORBA and RMI applications, and a *Java messaging* server.

It should be noted that the term *application server* has many meanings in the information technology arena. In terms of COM and .NET, an application server provides the run time for Microsoft's distributed objects. Application service providers (ASPs) have their own meanings for the term *application server*. Therefore, in this class on EJBs, when talking about the process that hosts EJBs, we will use the term *EJB container*, not *application server*.

The following is a list of some EJB container (application server) vendors:

- Allaire JRun *<http://www.allaire.com>*
- Bluestone, which is now a part of HP has a series of products with the "total-e-" moniker *<http://www.Bluestone.com/>*
- iPlanet *<http://www.iPlanet.com/>*
- JBoss has an open-source and free EJB container *<http://www.jboss.org>*
- SilverStream *<http://www.Silverstream.com>*
- WebLogic *<http://www.Weblogic.com/>*
- WebSphere *<http://www.Websphere.com/>*

 Oracle has developed its own application server, which allows entity beans to be run on the same machine as the database.

Since it is now possible to write stored ORACLE procedures in Java, the fact that EJBs can interact in the same virtual machine with stored procedure objects opens up interesting possibilities.

38.6 Summary

In this chapter, we introduced one of the key players in the EJB architecture, the EJB container. We discussed the EJB paradigm in which all access to EJBs is through the container. Then, the home and remote interfaces were introduced, and their significance was discussed. Next, we brought in the concept of the deployment descriptor and showed how much of the programming of any EJB application is carried out through this descriptor. Finally, we took a quick survey of the EJB container market.

38.7 Exercises

38.1 Visit the websites for JRun, WebSphere, and WebLogic. Read some of the white papers found there, and compare the specifications of the different application-server manufacturers.

38.2 Install an EJB container on your system. Why did you select the one that you did? Did you have any problems with the installation?

38.3 Record how much space the EJB container took in exercise 2. Are there other EJB containers you could have used? Name three that were not mentioned in this chapter.

CHAPTER 39

Session Beans

by James Linn

**One who walks in another's tracks
leaves no footprints.**

– Proverb

In this chapter, you will learn:

- About stateless and stateful session beans
- About home and remote interfaces
- How to code a home and remote interface
- How to code a simple session bean with a business method
- How to call a business method from a client

39.1 Introduction

In this chapter, we will learn about one of the two basic EJB types: session beans.

There are two types of session beans, those that maintain state and those that do not.

We will show the basics of programming a simple session bean and show how to connect to this session bean from an external client.

Session beans, like all J2EE components, must satisfy a contract. To see how the EJB 1.1 Specification defines session beans, see page 79 of *<http://java.sun.com/products/ejb/docs.html>*.

The following are the nine requirements for the session bean class:

1. The class must implement the *javax.ejb.SessionBean* interface directly or indirectly.
2. The class must be defined as public, must not be final, and must not be abstract.
3. The class must have a *public* constructor that takes no parameters. The container uses this constructor to create instances of the session bean class.

4. The class must not define the *finalize*() method.

5. The class may, but is not required to, implement the session bean's *remote* interface.

6. The class must implement the business methods and the *ejbCreate* methods.

7. If the class is a stateful session bean, it may implement the *javax.ejb.SessionSynch-ronization* interface.

8. The session bean class may have superclasses and/or superinterfaces. If the session bean has superclasses, then the business methods, the *ejbCreate* methods, the methods of the *SessionBean* interface, and the methods of the optional *SessionSynchronization* interface may be defined in the *session bean* class or in any of its superclasses.

9. The *session bean* class is allowed to implement other methods (e.g., helper methods invoked internally by the business methods) in addition to the methods required by the EJB specification.

Session beans represent distributed business instances or business processes. Being distributed, the EJB container can manage these beans effectively, creating and removing them as necessary, directing calls to a particular EJB to the most lightly-loaded server, and keeping instances of them in reserve in case one server fails.

 Unlike entity beans, session beans are nonpersistent. They last only for the duration of the session, hence their name.

Ideally, these components are fine-grained, containing only one business method. These components then are assembled into larger applications. Sometimes these components are purchased from third parties, and sometimes they are created in-house.

Session beans do not represent persistent data. They can make database queries to get the data that they require, or they can use entity beans for that purpose. However, if you need to create or modify persistent data, use an entity bean.

Session beans come in two flavors: stateless and stateful. *Stateless session beans* do not maintain any information from one call to another. They are used for quick, one-shot conversations. *Stateful session beans*, on the other hand, carry on protracted conversations and maintain information from call to call. Session beans are not meant to survive the crash of a server. This very important point must be considered when designing your applications. A conversation should be thought of as all of the work necessary to carry out a business process.

Even though session beans don't represent persistent data, all of a session bean's methods and data can be serialized by the container. The J2EE Specification guarantees that no other client will be allowed to use that instance after you have made a connection to a session bean. What happens if another client wants to use that instance while the first client is making up its mind as to what will be its next step? In this case, the container directs the client to another instance of that bean from its pool of session beans. However, there are times when the memory available to the server runs low. In such cases, the server will serialize beans to persistent storage. Then, when that particular instance of that session bean is required once more, the container will deserialize it and present it to the client. The EJB container manufacturer is free to use whatever algorithm it chooses in deciding which particular bean to serialize. Do not be confused by this fact. While there are cases where a session bean and its data are saved to disk, this is not any sort of persistent storage that the developer can count on or exploit. Also, if the server goes down, serialized beans probably will be inaccessible when the server finally restarts.

39.2 Stateless Session Beans

Stateless session beans encapsulate a business process that can be carried out with one input of data from the client. Since the human-machine interface is by far the slowest link in the chain, a single stateless session bean can service hundreds of users. The implications for performance and scalability are obvious. Normally, an EJB container will create a pool of stateless session beans when it starts and then assign them to users as needed. If the use of a bean increases, the container is free to create more beans and add them to the pool at will. When demand decreases, the container may well destroy session beans to restore the default pool size. If there are several servers, each will have its own pool of stateless session beans, and new conversations will be directed to the most lightly-loaded server. If one server goes down, normally the user never will be aware of it because other servers in the cluster can fill the gap.

An example of a stateless session bean might be an instance that performs a financial calculation on an input data item and returns the result.

 When architecting an application, stateless session beans should be used whenever possible because of their extreme performance and scalability.

39.3 Stateful Session Beans

Stateful session beans carry on long-running conversations with clients, and they usually have to maintain data or state between calls. Since the client will expect to be connected to an instance that contains the results of all of the previous conversations that they have had, each client session requires its own stateful session bean. This requirement has obvious implications for scalability and performance.

Stateful session beans even can participate cleanly in transaction processing by implementing the *SessionSynchronization* interface, which enables them to receive notification of the session's involvement in transactions. The fields of the stateful session bean that are part of the state are called *conversational state fields*.

An example of a place where a stateful session bean might be employed is as a shopping cart on an eCommerce website.

39.4 How to Write Session Beans

A complete session bean consists of reference data types, the home interface, the remote interface, and the session bean itself.

A client calls the home interface to get a reference to the session bean. Here is an example of a home interface:

```
/** Home interface for Demo project. */
    public interface DemoHome extends EJBHome {
        public Demo create() throws RemoteException,
    CreateException;
}
```

The create method is the customary way to pass in the data that the session bean needs to accomplish its mission. If there are several different ways to start your bean, you will need a create method for each scenario.

This interface is used by the EJB container, and it creates an instance that client applications can call to get a reference to the *remote* interface of the session bean.

 The remote interface has all of the business methods that the session bean implements.

Here is an example of a remote interface:

```
/** Remote interface for Demo project. */
        public interface Demo extends EJBObject, Remote {
            public String demoSelect() throws RemoteException;
        }
```

This business instance only has one public method, so the *remote* interface only has one method.

 As with the home interface, the EJB container uses the remote interface and produces an instance that the client can use to communicate with the actual session EJB.

The session bean implements the business task as well as the *java.javax.ejb.SessionBean* interface. The deployment descriptor (not the interface) is used to distinguish between stateful and stateless session beans. A *SessionBean* interface summary follows:

```
    SessionBean extends javax.ejb.EnterpriseBean {
    public abstract void setSessionContext(SessionContext cts)
            throws RemoteException;
    public abstract void ejbActivate()
            throws RemoteException;
    public abstract void ejbPassivate()
            throws RemoteException;
    public abstract void ejbRemove()
            throws RemoteException;
    }
```

The *setSessionContext()* method allows your session bean to cache *SessionContext*. The *SessionContext* instance allows access to information from the container, such as the session bean's security and transaction state.

The EJB container can serialize EJBs. When you create your session bean, be aware that it could be serialized, and mark the data members as *transient* so that they cannot survive serialization in a meaningful way. Before the container serializes your bean, it will call *ejbPassivate*. This function should release any resources that it holds, such as files, database connections or Java Messaging Service (JMS) connections. When the session bean is deserialized, *ejbActivate* will be called, and you can reacquire those resources.

When the *container* is finished with this instance of your session bean, it will call `ejbRemove`. At that time, you should release all held resources and do whatever cleanup is required. The EJB session bean contract states that the bean never will be called again after *ejbRemove* has been called. It says nothing about if and when the actual instance will be destroyed.

The client can call `ejbRemove`, and the reference that the client holds to the session bean will no longer be valid. Whether or not the session bean is removed is up to the container.

39.4.1 How to Connect to an EJB from a Client

The following describes how to call any EJB. Session and entity beans don't vary according to the method used to call them. As we have indicated previously, EJBs can be called from:

1. An application running in a browser (JSP or Java servlet)
2. A stand-alone application (it makes no difference if the application is running locally or on another machine connected via a LAN or the Internet)
3. Another enterprise bean, running locally or remotely

The stand-alone applications can be Java applications communicating via RMI or (IIOP) (Internet Inter-Operability Photocal) or they can be applications written in other languages communicating via CORBA.

 Java and web clients will locate the instance using JNDI, and CORBA clients will use CORBA Service (COS), a naming service, to locate the EJB.

Whatever the client, the sequence of events is as outlined previously. The client will obtain a reference to the home instance and call `create()` on it. The call to create will return a reference to the EJB via the remote interface. The client is then free to call the business methods on the EJB. When finished, the client normally will call `remove()` on the EJB.

39.4.2 Example

We will use the standard "hello world" example.

The first task is to download and install the necessary software. Then, you will have to meet the following requirements:

1. You will need a recent Java 2 SDK installed on your machine. If you don't have it installed already, it may be obtained from *http://java.sun.com/j2se/?frontpage-javaplatform*. Download both it and the documentation and perform the installation.
2. You also will have to download a compatible J2EE SDK (which includes an EJB container) and documentation from Sun's J2EE download site. Both the software distribution and the documentation site include installation instructions.

Navigate to the *doc* directory and open index.html, which contains links to Release Notes, a Configuration Guide, JavaDoc documentation on the J2EE API, a guide to the tools provided with the J2EE SDK, and a example of an entity EJB that uses container-managed persistence. In addition, there are links to a J2EE tutorial, a JMS tutorial, the J2EE Documentation page, and documentation on the *Cloudscape* database.

The J2EE SDK comes with a database system. The J2EE SDK supports container-managed persistence to the database out of the box.

The J2EE SDK also comes with a copy of Tomcat to use as its Web container.

Once the Java 2 Standard Edition (J2SE) SDK and the J2EE SDK have been installed (or unzipped in the case of the documentation), you should set up and run the EJB container that comes with the J2EE SDK. Set up and run this container as follows:

1. Set the *J2EE_HOME* environment variable to point to the base directory where you installed the *J2EE SDK*.
2. Put *J2EE_HOME/bin* into your *PATH* environment variable.

You now can start the J2EE EJB container by opening a DOS prompt using the command-line command *j2ee -verbose*. If you have set *J2EE_HOME* and *JAVA_HOME* properly and if the \bin directory of your *J2EE SDK* installation is in your path, the J2EE Reference Implementation EJB container server will start and you will see Figure 39.4.2-1.

J2EE now is installed and running. Explore the J2EE Reference Implementation (Reference Implementation refers to the reference implementation of an EJB container that comes with the J2EE SDK) documentation within the documentation site to gain more familiarity with J2EE familiarity.

Once the installation is accomplished, start the J2EE SDK Reference Implementation EJB container. There are two ways to accomplish this task:

1. Open a DOS prompt in *j2sdkee\bin* and type *j2ee -verbose*. If you have set the environment variables properly, the server will start. By setting the *-verbose* switch, the server will give you a list of the applications, that it has started. If it has problems starting an application, it will tell you so.

2. Double-click on *j2ee.bat*. This process is quick and easy, but if there are any problems, the DOS box will close before you can see any error messages. If double-clicking on *j2ee.bat* doesn't work, you will be forced to use the first method of starting the EJB container.

The J2EE Reference Implementation can be shut down by opening another DOS box and typing *j2ee -stop*.

```
Command Prompt (2) - j2ee -verbose                                    _ □ ×

C:\>j2ee -verbose
J2EE server listen port: 1050
Naming service started:1050
Binding DataSource, name = jdbc/DB1, url = jdbc:cloudscape:rmi:CloudscapeDB;create=true
Binding DataSource, name = jdbc/InventoryDB, url = jdbc:cloudscape:rmi:CloudscapeDB;create=true
Binding DataSource, name = jdbc/Cloudscape, url = jdbc:cloudscape:rmi:CloudscapeDB;create=true
Binding DataSource, name = jdbc/DB2, url = jdbc:cloudscape:rmi:CloudscapeDB;create=true
Binding DataSource, name = jdbc/EstoreDB, url = jdbc:cloudscape:rmi:CloudscapeDB;create=true
Binding DataSource, name = jdbc/XACloudscape, url = jdbc/XACloudscape__xa
Binding DataSource, name = jdbc/XACloudscape__xa, dataSource = COM.cloudscape.core.RemoteXaDataSource@62e295
Starting JMS service...
Initialization complete - waiting for client requests
Binding: < JMS Destination : jms/Queue , javax.jms.Queue >
Binding: < JMS Destination : jms/Topic , javax.jms.Topic >
Binding: < JMS Cnx Factory : jms/TopicConnectionFactory , Topic , No properties >
Binding: < JMS Cnx Factory : TopicConnectionFactory , Topic , No properties >
Binding: < JMS Cnx Factory : QueueConnectionFactory , Queue , No properties >
Binding: < JMS Cnx Factory : jms/QueueConnectionFactory , Queue , No properties >
Starting web service at port: 8000
Starting secure web service at port: 7000
J2EE SDK/1.3
Starting web service at port: 9191
J2EE SDK/1.3
Loading jar:/c:/j2sdkee1.3/repository/hightscct041027/applications/Converter1004580790363Server.jar
/c:/j2sdkee1.3/repository/hightscct041027/applications/Converter1004580790363Server.jar
Loading jar:/c:/j2sdkee1.3/repository/hightscct041027/applications/Demo1004720758467Server.jar
/c:/j2sdkee1.3/repository/hightscct041027/applications/Demo1004720758467Server.jar
Binding name:`java:comp/env/ejb/TheConverter`
Created Context:/converter
J2EE server startup complete.
```

FIGURE 39.4.2-1
J2EE -verbose Output

39.4.3 Code the Application

We now will write the session bean and the home and remote interfaces for our application. In addition, we will create a Java application that uses our EJB.

The name of our application will be *Demo*. Before we begin, a discussion of nomenclature is in order. The standard EJB naming scheme is to use the name of the application as the name of the remote interface, the application name + Home as the name of the home interface, and the application name + Bean as the name of the session or the entity bean. Life will be much simpler and easier for you if you follow this convention, and we will follow that convention here.

All EJB applications involve a fair amount of boilerplate code. Many Java IDEs will generate this code for you automatically, which can be a great time saver, especially if you are working from a class diagram.

I like to start coding from the EJB. It contains the business methods that must appear in the remote interface and the create methods that must appear in the home interface, so I think it is the logical place to begin.

Here is the code for the session bean:

```java
package com.enterpriseEJB.Demo;

        import javax.ejb.*;
        import java.util.*;
        import javax.naming.*;
        import java.security.Principal;

/**
 * EJB demonstration project
 * @stereotype SessionBean
 * @remoteInterface com.enterpriseEJB.Demo.Demo
 * @homeInterface com.enterpriseEJB.Demo.DemoHome
 * @statemode Stateless
 */
public class DemoEJB implements javax.ejb.SessionBean {
  public DemoEJB()  {
  }

  // --------------------------------------------------
  // SessionBean interface implementation
  public void ejbActivate()    {
  }

  public void ejbPassivate()          {
  }

  public void ejbRemove()      {
  }

  public void setSessionContext(SessionContext ctx)  {
      this.ctx = ctx;
  }
  // --------------------------------------------------
  // create methods
```

```
public void ejbCreate()    {
}

// --------------------------------------------------
// business methods
public String getInfo()    {
    return message;
}

// --------------------------------------------------
// private fields
private SessionContext ctx;
private String message = "Hello World";
}
```

This is a standard *ejb.SessionBean* interface implementation. There is one instance variable, *String message*, and one business method, *getInfo()*. In addition there is the getter and the setter for the instance variable. I have chosen to make this application part of a larger package, *com.enterpriseEJB*. If you choose to follow my lead, make sure that your directory structure reflects the package structure. In any case, you should create a package for your application. For many reasons, using the default package is not recommended.

Now let's look at the home interface:

```
package com.enterpriseEJB.Demo;
import javax.ejb.*;
import java.rmi.RemoteException;
public interface DemoHome extends EJBHome {
    public Demo create()throws CreateException, RemoteException;
}
```

Once more, this is a very standard implementation of the *EJBHome* interface. Remember, if you have more than the default no-arguments constructor in your session bean, you will have to put *create* methods in for each constructor in your EJB.

Now, write the remote interface:

```
package com.enterpriseEJB.Demo;
import javax.ejb.*;
import java.rmi.RemoteException;
public interface Demo extends EJBObject {
    public String getInfo() throws RemoteException;
}
```

The preceding code is a standard implementation of the *EJBObject* interface. The remote interface contains the one business method that we defined in the session bean.

Lastly, we will write a client for this session bean. The client will be a stand-alone Java application. Later, we will demonstrate how to access the session bean from a JSP.

The client it will have to locate the EJB container, ask the container for the proper application, and then call the *getInfo()* business method.

Here is the code for the client:

```
import com.enterpriseEJB.Demo.*;

import javax.ejb.*;
import javax.naming.*;
import java.util.*;
```

```java
import javax.rmi.*;

public class DemoClient {
  private static String user = null;
  private static String password = null;

  public static Context getInitialContext() throws
NamingException {
      Properties p = new Properties();

      if (user != null)              {
          p.put(Context.SECURITY_PRINCIPAL, user);
              if (password == null)
                  password = "";
          p.put(Context.SECURITY_CREDENTIALS, password);
      }
      return new InitialContext(p);
  }

  public static void main(String[] args) {
      if (args != null && args.length > 0) {
          for (int i = 0; i < args.length; i++) {
              switch(i)
              {
                  case 0:
                  user = args[i];
                  break;
                  case 1:
                  password = args[i];
                  break;
                  default:
              }
          }
      }
      try {
          Context ctx = getInitialContext();

          // First get an instance from the context
          Object obj = ctx.lookup("Demo");

          // Then get the home interface
          DemoHome home = (DemoHome)
PortableRemoteObject.narrow
              (obj,DemoHome.class);

              // Now create the remote interface
              Demo demo = home.create();

              System.out.println(demo.getInfo());

              demo.remove();
      }
      catch (javax.ejb.RemoveException e)    {
          e.printStackTrace();
      }
      catch (javax.ejb.CreateException e)    {
```

```
                      e.printStackTrace();
           }
           catch (java.rmi.RemoteException e)      {
                 e.printStackTrace();
           }
           catch (javax.naming.NamingException e) {
                 e.printStackTrace();
           }
       }
   }
```

The preceding code is for the *DemoClient*. In particular, let's look at the code to generate the `InitialContext` instance, which is our entrance to the JNDI.

39.4.4 JNDI

All EJB clients, whether they are JSPs, stand-alone applications, or other EJBs, use JNDI to get a reference to the remote interface of an EJB.

JNDI is a specification not a product. In particular, it is a specification for a naming service that allows the location of distributed instances and a means of binding those instances. The J2EE specification mandates that JNDI be used as the lookup and binding API for EJBs.

JNDI specifies an interface, a contract between instances seeking to use EJBs and the EJB container. The EJB container is free to use whatever means it chooses to store and locate the EJBs that are running in the container. This store, or directory service, must be capable of returning a reference to an EJB when given its name.

The naming service JNDI provides allows a component to be handled by an EJB container or distributed across a network without having to change the component's source code.

The actual naming service that an EJB will use is provided by the EJB container in which it runs. Clients only know the JNDI interfaces they need in order to get a JNDI naming context. The client will create a *javax.jndi.naming.InitialContext* and use it to pass a name into the JNDI implementation that the container has provided.

The directory that JNDI is using may well be part of an enterprise directory service. The naming service will be part of a subcontext in the naming service. No matter how the JNDI naming service is implemented, there will be a root element named "java:". Furthermore, there will be a subcontext named *comp/env* for storing environmental entries such as Java Transaction API (JTA) user transactions. Beyond that, there will be a */ejb* subcontext for EJBs.

Let's look at the code that gets us our `InitialContext` instance:

```
public static Context getInitialContext() throws NamingException {
     Properties p = new Properties();
     p.put(Context.INITIAL_CONTEXT_FACTORY, "");
     p.put(Context.PROVIDER_URL, url);
     if (user != null) {
       p.put(Context.SECURITY_PRINCIPAL, user);
     if (password == null)
       password = "";
     p.put(Context.SECURITY_CREDENTIALS, password);
     }
     return new InitialContext(p);
   }
```

The standard way to get an *InitialContext* instance is to create a *Properties* instance, insert some property names and property data, and then create an *InitialContext* instance, passing in the *Properties* instance. In our case, we will have to pass in a URL that will allow the JNDI implementation in the J2EE Reference Implementation EJB container to locate the *Demo* remote interface, as well as pass in a user name and a password that the J2EE Reference Implementation EJB container will accept as having the right to access the *DemoEJB* and its *getInfo()* business method. We will cover the proper input parameters later.

Once the initial context is obtained, it can be used to get a reference to the proper home interface as follows:

```
// First get an instance from the context
Object obj = ctx.lookup("java:/comp/env/ejb/DemoHome");

// Then get the home interface
DemoHome home =
        (DemoHome)PortableRemoteObject.narrow(obj,DemoHome.class);
// Now create the remote interface
Demo demo = home.create();
```

You will note that when asking for the home reference for the EJB, we use the full name, *java:/comp/env/ejb/DemoHome,* specifying not only the name we gave the EJB but also the subcontext it is in.

Since J2EE specifies that the remote protocol is RMI/IIOP, when getting the actual reference to an instance of class *DemoHomeEJBs*, we use the *PortableRemoteObject's narrow()* method. We could use the exact same code to access a CORBA instance that has been registered with JNDI.

39.4.5 Local Interfaces

The EJB 2.0 specification introduced the concept of local interfaces. Local interfaces are used when the client runs in the same Java Virtual Machine as the client. The advantage of using a local interface is that performance usually is enhanced because there are no remote calls from the client to the EJB. Therefore, all of the overhead associated with RMI-IIOP is eliminated. However, the advantages that accrue to using distributed instances are lost when local interfaces are used.

WARNING

It's important to understand that local interfaces pass function arguments in the same way that normal Java programs deal with function arguments. That is, primitive data types are passed by value and instances are passed by reference. This change in reference passing semantics always must be kept in mind when designing an EJB that will be accessed via a local interface. The state of one enterprise bean never must be stored as part of the state of another enterprise bean. In addition, all of these references are local and cannot be used outside of the local instance call chain.

When doing EJB programming using local interfaces, you must implement the *EJBLocalHome* interface and the *EJBLocalObject* interface.

The *EJBLocalHome* interface has one method, *remove()*. In addition, the developer will define a *create* method for every *create* method that is in the enterprise bean itself. Also, if the enterprise bean is an entity bean, all of the necessary *findByPrimaryKey* methods will be defined in the local home interface file.

If we were using local interfaces in the demo EJB project, our home interface would look like

```
package com.enterpriseEJB.Demo;
        import javax.ejb.CreateException;
        import javax.ejb.EJBLocalHome;
        public interface DemoHome extends LocalEJBHome {
           public Demo create()throws CreateException;
        }
```

The *EJBLocalObject* interface has the following methods:

- *getEJBLocalHome()*, which is used to obtain a reference to the enterprise bean's local home interface
- *getPrimaryKey()*, which is used to get the primary key of the EJB local instance
- *isIdentical()*, which is used to test if two EJBs are identical
- *remove()*, which is used to remove the EJB local instance

If we were using local interfaces in the demo EJB project, our local interface would look like

```
package com.enterpriseEJB.Demo;
        import javax.ejb. EJBLocalObject;
        public interface Demo
              extends EJBLocalObject {
          public String getInfo();
        }
```

Once more, since this is a local instance, the *RemoteException* requirement disappears.

39.5 Summary

In this chapter, we took a summary look at session beans and discussed the two types of session beans, stateless and stateful. In addition, we covered the basic elements of all EJBs, the home and remote interfaces, and the *EJB bean* itself. The example provided real home and remote interface code and a simple session bean with a business method. Finally, the process for calling the business method from a client was demonstrated.

39.6 Exercises

39.1 What would have to be done to make a stateless session bean into a stateful session bean?
39.2 Read the session bean section in the J2EE version 2 specification.

C H A P T E R 4 0

Session Bean Deployment

by James Linn

**A name which the author had not
the power to reject or happiness
to approve,
Ambross Blerce (1842–1914)**

In this chapter, you will learn:

- All of the steps necessary to deploy a session bean
- How to run your session bean as a stand-alone Java application
- How to run your session bean as a JSP

40.1 Introduction

Deployment is the process of moving all of the classes that your EJB requires into a specific operational environment. An operational environment means a specific EJB container, security environment, database environment, messaging environment, network environment, clustering/failover environment, and set of duties in a particular application. Much of the complexity of using distributed components has been moved from application code to the deployment process. Deployment can be simple and quick, or it can be a complex process that involves extensive enterprise interfacing.

In this section, we will deploy and test the *Demo* session bean we created. This chapter examines the process of deploying an EJB into the J2EE Reference Implementation EJB container. We examine the contents of the deployment descriptor XML file and discuss the declarative options available to the person responsible for deploying EJBs.

In addition, we demonstrate how to access the EJB from a JSP.

40.2 Deploying the EJB

EJB deployment methods are strongly EJB-container specific. There is no standard for deployment tools.

The good news is that all EJB container manufacturers provide good GUI tools to automate the process of deployment.

To deploy an EJB, you will have to understand and use the tools the EJB container manufacturer provides. Since we will be using the J2EE Reference Implementation EJB container, I will walk you through the process of using its deployer tool. The concepts involved are similar across all deployment tools.

Before you can deploy an EJB, you must compile all of the files into Java class files.

This requirement applies to Java servlets as well as EJB classes. The only exception are JSPs, since the J2EE Reference Implementation EJB container will take in JSPs and compile them itself. However, life is much easier if you are using an IDE that compiles JSPs. If, for example, the J2EE Reference Implementation EJB container runs into errors when compiling the JSP, the information it gives is sometimes so cryptic as to be useless. The IDE, however, will give much better feedback on compilation errors than the J2EE Reference Implementation's *Application Deployment Tool*. In addition, the *Application Deployment Tool* will want files packaged into *JAR* files. Not only do the class files have to be in the *JAR*, but the deployment descriptor must be there too, in the META-INF directory. However, the J2EE Reference Implementation EJB deployment tool will create the *JAR* file and the deployment descriptor for you.

Unless you know the exact format for the deployment descriptor that the *Application Deployment Tool* requires, do not attempt to write it yourself and to package it manually into a *JAR* file.

40.3 Start Server

The first task is to start the J2EE Reference Implementation EJB container server. Open a DOS prompt there and type

```
j2ee –verbose
```

If you get a "file not found" error, the *<J2EE SDK installation>\bin* directory is not in your path. After you have started the server, you should see an image that looks like Figure 40.3-1.

This screen tells you that the server has created a CORBA ORB listening port at 1050 and a CORBA ORB naming service port, also at 1050. You can see that the J2EE SDKEE Reference Implementation EJB container created several data-source bindings (which are JDBC database connections) to Cloudscape. If you add other data sources to other databases, you should see them enumerated as the server starts. In addition, the server has set up the basic JMS bindings so that you can use JMS. The J2EE Reference Implementation server comes with Tomcat as a Web server. It is running on port 8000. HTTPS is on port 7000, and the HTTP port for EJBs is 9191. If you run into any port conflicts, all of these ports are configurable. Look into the *<J2EE SDK installation>\config* directory for the configuration files that control these port mappings.

FIGURE 40.3-1
J2EE -verbose Output

Once the J2EE Reference Implementation EJB container has been started, you can start the *Application Deployment Tool*, which is in the *j2sdkee1.3.1\bin* directory. Double-click on *deploytool.bat*, and you should see the main screen of the *Application Deployment Tool*. On Linux, type

```
deploytool
```

40.4 Create the Application

The first step is to create an application. From the *Application Deployment Tool*, select

```
File>New Application
```

or click on the ![icon] icon on the toolbar. The dialog box shown in Figure 40.4-1 appears.

FIGURE 40.4-1
New Application Dialog Box

The *Application File Name* text field contains the name of the enterprise archive (*.ear*) file (*.ear* files are a kind of *JAR* files for EJB applications) and the directory where you should place the *.ear* file.

 When you are building an application that involves a Java application as a client, it is crucial that the .ear file is put into the same directory as the client-application files.

This application is going into the *D:\Java\BEI\Source* directory, so the *Application File Name* is *D:\Java\BEI\Source\Demo*.

 A word about .ear files. Everything pertaining to an EJB application goes into the *.ear* file. For example, WAR files, deployment descriptors, and all of the Java class files will go into the *.ear* file.

Choose Demo as the display name and click on the OK button. You now should see that the *Application Deployment Tool* has created the Demo application, as shown in Figure 40.4-2.

Now we need to add the class files to the application. We next use the *Application Deployment Tool* to create the bean's deployment descriptor, package it and the bean's classes in an EJB *JAR* file, and then insert the EJB *JAR* file into the application's *.ear* file. Select

```
File>New Enterprise Bean
```

FIGURE 40.4-2
Application Deployment Tool Dialog Box

or click on the icon in the toolbar. The Wizard that creates the EJB *JAR* file appears. The introductory page of the Wizard describes what the process will accomplish.

> **NOTE** Read this information carefully to make sure that you have the proper inputs ready before you proceed.

The Wizard asks a lot of questions, so you must understand the specific environment into which you are preparing to deploy the bean before you start the deployment process. Select

 next

The tool already has filled in the *Enterprise Bean will Go In:* combo box. Type

 DemoJAR

in the *JAR Display Name* combo box. This is the name that will be displayed in the tree view of applications. If you wish to add a description for the *Demo* EJB *JAR*, select the *Description* button and type it in.

We will not have a special class path for the Manifest file, so ignore that text box. (Manifest files were deprecated with EJB 1.1.) However, if you are trying to deploy an application developed under EJB 1.0, it might be useful to tell the container about the Manifest file you created.

Now we are going to add the class files to our *JAR*. Select the *Edit* button next to the *Contents* box, and the *Edit Contents of DemoJAR* dialog box appears, as shown in Figure 40.4-3. Check to make sure the *Starting Directory* entry is correct. Select the file tree in the *Available Files* box, and then select the *Add* button. The directory opens up in the Contents of *DemoJAR* pane. Navigate to the *com\enterpriseEJB\ Demo* directory, highlight *Demo.class*, *DemoEJB.class*, and then *DemoHome.class*, and then select the *OK* button.

The files you chose should appear in the *Contents* pane of the *New Enterprise Bean Wizard* – EJB *JAR* dialog box.

If there were any icons to be associated with this *JAR*, you could specify their paths at this point. There aren't any, so click on the *Next* button. The *New Enterprise Bean Wizard - General* dialog box then appears.

We are now ready to describe our EJB to the container (i.e., build the deployment descriptor). The Wizard has chosen the proper bean type, *Session*, but it has chosen *Stateful* as the type of session bean. Click on the *Stateless* radio button in the *Bean Type box*. Then, click on the *Enterprise Bean Class* drop-down list and choose *com.enterpriseEJB.Demo.DemoEJB*.

Use the *Remote Home Interface* drop-down list to select

 com.enterprise.ejb.Demo.DemoHome

Use the *Remote Interface* drop-down list to select

 com.enterprise.ejb.Demo.Demo

which is the name that will show up for the EJB in the tree view. Select the *Description* button and type

 Demonstration session bean

in the *Description* text box. Your screen should look like the one in Figure 40.4-4 when you are finished.

FIGURE 40.4-3
Edit Contents of DemoJAR Dialog Box

Click on the *Next* button. The *Transaction Management dialog* box appears. This dialog allows us to tell the container if we will be managing the transactions or if we expect the container to do it. Furthermore, if we want the container to manage the transactions, we will have to tell the container which level of management we want it to enforce. (Transaction management will be covered in a later chapter.) There will not be any transactions involved with the bean at this point, so leave *Transaction Management* as *Bean-Managed* and click on the *Next* button.

The *Environment Entries* dialog box appears next. Anything that the code in your EJB is expecting to get from the environment should be entered here. Entries go in in the form of name, type, and value. (See the Sun Microsystems Enterprise JavaBeans Specification for the exact syntax *<http://java.sun.com/products/ejb/docs.html>*.) However, we are not expecting to get anything from the environment, so click on the *Next* button.

Now we tell the container about any EJBs that our EJB references. EJBs can and often do call other EJBs to help them carry out their functions. If your EJB does make use of other EJBs, this is the place to tell the container about them. The container needs to know if the EJBs are session or entity EJBs.

FIGURE 40.4-4
The Enterprise Bean Wizard Dialog Box

 Strictly speaking, the container should be able to figure out this information from the signature; nonetheless, this container makes you enter this information.

The container will need the class names of the EJB and of the home and remote interfaces. Our EJB is acting on its own, however, so click on the Next button.

Now the Resource References dialog box appears. JDBC drivers are the most common type of resource your EJB might require. You will need to enter:

- Coded name, which is the *JNDI* name that the container would use to find the resource
- Type, which is the name of the Java class or interface that would be returned
- Authentication, which would be Bean or Container
- Shareable, which tells the container that it can allow other EJBs to use a single instance of a resource
- Description, which is where other descriptive information on the resource manager would be entered

FIGURE 40.4-5
Security Dialog Box

We will not be using any *Resource* factories, so click on the *Next* button. The *Resource Environment References* dialog box appears. At this time, this dialog only is used to specify JMS destinations. Click on the *Next* button, and the *Security* dialog box appears, as shown in Figure 40.4-5.

Here is where we give the container the security information that it will need. All EJB containers provide the ability to define roles and to limit access to individual beans and even to limit individual methods with in a bean to certain roles. (The intricacies of EJB security management will be discussed in a later chapter.) We will not be putting any security restrictions on our bean, so click on the *Next* button.

Click on the *Next* button, and the XML file that the *Application Deployment Tool* proposes to generate for us appears. If we wish to change anything in it, we can click on the *Back* button until we reach the proper dialog box and make our changes. We don't wish to make any changes, so click on the *Finish* button and you will return to the *Application Deployment Tool* dialog box.

FIGURE 40.4-6
Setting *JNDI* Names

Now we can see our *JAR* with our EJB in it. We still need to set the *JNDI* name for
our EJB so that clients can locate it. Click on *DemoJAR* in the left pane and then click on
the *JNDI* Names tab. Type

 Demo

in the *JNDI* Name text field, and you will see an image like that shown in Figure 40.4-6.
 This dialog shows that our bean is not referenced by anyone and that someone wish-
ing to use the Demo bean should ask *JNDI* for "Demo."

 It is possible to change these settings and many more using the *Application Deploy-
ment Tool*. This tool allows us to accommodate future changes without needing to
create an entirely new application.

40.5 Add the Application Client

This section shows how to add a client in order to access the *Demo* bean. The *Application
Deployment Tool* will be used to put the client in a *JAR* file and to add that *JAR* file to the
.ear file for the *Demo* application. Select

 File > New Application Client

FIGURE 40.5-1
Edit Contents of <Application Client> Dialog Box

or the icon from the toolbar. The *New Application Client Wizard* appears. Read the first page and select the *Next* button. Select the *Edit* button, and the *Edit Contents of <Application Client>* dialog box appears. Open the *Source* directory in the *Starting Directory* drop-down list and then select *DemoClient.class* from the *Available Files* list. Select the *Add* button to add *DemoClient.class* to the *Contents of* the *<Application Client> dialog* box. Your screen should resemble the one shown in Figure 40.5-1.

Click on the *OK* button to return to the *New Application Client Wizard – JAR* screen. Select the *Next* button, and the *New Application Client Wizard – General screen* should appear. You will see that the *Application Deployment Tool* has figured out that *DemoClient* contains the main() function that we will use. *DemoClient* should be selected as the *Display*. The *Callback Handler Class* list specifies where authentication will occur. Use *container-managed authentication*.

Select the *Next* button, and the same *Environment Entries* screen that you saw when creating the EJB *JAR* appears. Clicking on the *Next* button brings you to the *Enterprise*

FIGURE 40.5-2
Altering the Application Deployment Dialog Box

Bean References screen. If the client references any EJBs, you could put in the reference information in here. As a matter of fact, our client does reference an EJB, the *Demo* session bean. However, we will not put the reference information in here; instead, we will enter this information from the main screen after we exit the Wizard. Click on the *Next* button.

We now see the *Resource References* screen and then the *Resources Reference* screen for JMS resources. Click through all of these screens, and you will see the XML file that the *Application Deployment Tool* will create. Click on the *Finish* button, and *Demo-Client* will appear as a part of the Demo Application.

As previously mentioned, we have put off setting the EJB references for the client. We will take care of this bit of business now. Click on DemoClient in the leftmost pane and then on the *EJB Refs* tab, and the same dialog that the Wizard presented to you appears. Select the *Add* button and type the element into the *EJB's Referenced in Code* combo box, as shown in Figure 40.5-2.

40.6 Deploy the Application

Once the EJB and client *JAR* file have been created, we can deploy the application onto the J2EE Reference Implementation EJB container. Open the *Tools* menu to reveal a pop-down menu like that shown in Figure 40.6-1.

FIGURE 40.6-1
Pop-Down Tools Menu

Using the *Tools menu*, we can deploy the application, as well as update the application files (e.g., by making changes in some of the Java files). If there are major changes in the application, you can select *Update* and *Redeploy*. Select *Verifier* to ensure that your application and its components conform to the J2EE specification. *OK*, manage the server through the *Server Configuration* menu option.

Select the *Deploy* button to display the *Deploy Demo Introduction* dialog box. This dialog box enables server selection for deployment. Then, follow the steps below:

1. Select *localhost*.
2. Select the *Return Client JAR* checkbox since the EJB is to be accessed by a stand-alone Java application.
3. Make sure that the directory in the *Client JAR* checkbox points to the location of your client application. The *Application Deployer* Tool will generate the necessary RMI/IIOP stub classes that will allow *DemoClient* to access the home and remote classes, put them into a *JAR* file, and place that *JAR* file where the Demo application can find it.
4. Select the *Next* button to open the *Deploy Demo JNDI Names* dialog box. You should see *Demo* in both of the *JNDI Name* text boxes.
5. Select the *Next* button to be informed that the *Application Deployment Tool* is ready to deploy our *Demo* application.
6. Select the *Finish* button. Creating and compiling the home and remote interfaces and the actual EJB is only part of the work that needs to be done to make the EJB usable in the container. Many more classes will have to be created and compiled successfully before the deployment is finished. This process occurs when you click the *Finish* button. When the *Application Deployment Tool* is finished, you should see the *Deployment Progress* dialog box, as shown in Figure 40.6-2.
7. Select the *OK* button. It is possible to have a class that compiles in the IDE but that is unable to compile in the container.
8. Dismiss the dialog box to return to the main *Application Deployment Tool* dialog box. If you open up the *Servers* node in the leftmost panel, you will see that the

FIGURE 40.6-2
Deployment Progress Dialog Box

Demo application is running under the local host. It was deployed on the J2EE Reference Implementation EJB container while the container was still running. Explore the *j2sdkee1.3/repository* directory, and you will see all of the objects that the *Application Deployment Tool* generated in the process of deploying our simple application. Check the directory with your client application to make sure that the *Application Deployment Tool* correctly placed *DemoClient.jar* with all of the RMI/IIOP classes that you will need in order to contact the home and remote interface there.

Even though there are significant differences in each application server's deployment tool, a consistent pattern is used. In general, the person doing the deployment will need to have compiled Java class files in hand, to have exact knowledge of the other EJBs and resource factories that the EJB being deployed will need to use, and to understand which environment variables the EJB is expecting to find. As we will see in the next chapter, if the EJB is an entity bean that is using container-managed persistence, the deployer will have to understand the schema of the data with which the entity bean will be dealing. Finally, the deployer will need a complete understanding of the security environment into which the EJB is going. With the Java classes and this information in hand, just start the *Application Deployment Tool* and let the Wizard(s) do the rest.

40.7 Run the Client

 To run the client, *j2ee.jar* and the *DemoClient.jar* have to be on your *classpath*.

Write a *testClient.bat* file to set *classpath* and start the client application. Here are the contents of *testClient.bat*:

```
set CPATH=.;%J2EE_HOME%\lib\j2ee.jar;DemoClient.jar
java -classpath "%CPATH%" DemoClient
```

FIGURE 40.7-1
The *testClient.bat* Output

Open a DOS prompt in the directory that contains your client class file and type Demo-Client. You will see the *testClient.bat* output, as shown in Figure 40.7-1.

This output is not the desired result. What is happening here? Security is built into the J2EE Reference Implementation EJB container. Our *DemoEJB* is a protected resource, and anything that accesses it must be authenticated. When we built the deployment descriptor, we told the J2EE Reference Implementation EJB container that it was supposed to take care of authentication.

The J2EE SDK provides a *bat* file called runclient that will allow us to authenticate ourselves and then run our application. First we must set the *APPCPATH* environment variable to point to the RMI stubs in *DemoClient.jar*. At the DOS prompt, type

```
set APPCPATH=DemoClient.jar
```

and hit the carriage return. Then type

```
runclient -client Demo.ear -name DemoClient -textauth
```

and hit the carriage return. After a pause, you will be asked to enter a *Username*. Type guest. Next, you will be asked to enter a password. Type *guest123*.

The computer will churn for a moment, inform you that it is binding the Demo JNDI name, print Hello World, and then inform you that it is unbinding the Demo JNDI name. The *testClient.bat* output, after passwords are set, is shown in Figure 40.7-2.

FIGURE 40.7-2
The *testClient.bat* Output after Password Entry

Select

```
Tools > Configure Servers
```

and then go into the *Users* folder. You will see that *guest* has been preregistered as a user as a part of the J2EE Reference Implementation EJB container installation. Go into the *\config* directory of your *j2sdkee1.3* installation and examine the *auth.properties* file. It shows that *guest* is the *default principal*, and the plain text password is given as *guest123*.

40.8 Run the EJB in a JSP

The J2EE Reference Implementation EJB container provides a simple and effective *Wizard* for automating the process of adding web components (JSPs and Java servlets) to an application. We will create a JSP that interacts with our *Demo session* EJB and use that tool to add it to our *Demo* application.

The first step is to create the JSP. This JSP will contain the code to call the EJB directly, which is a quick and dirty solution. It is not the sort of solution that you will use in an industrial situation, where you will have the JSP call a bean that will act as a proxy between the JSP and the session EJB.

40.8.1 Code the JSP

Our JSP will have to contain all of the code that our client used to get a reference to the home interface of the Demo EJB from *JNDI* and to use the home interface to create or get a reference to the remote interface. Once we have the remote interface object in hand, we will be able to call our business method `getInfo()`.

Here is the code for the JSP:

```
<% /*
         * File name Demo1.jsp
         * Demonstrates calling an EJB directly from a JSP page. */
        %>

        <%@ page import="com.enterpriseEJB.Demo.Demo,
                         com.enterpriseEJB.Demo.DemoHome,
                         javax.ejb.*,
                         javax.naming.*,
                         javax.rmi.PortableRemoteObject,
                         java.rmi.RemoteException" %>
        <%!
        private Demo demo = null;
        public void jspInit() {
            try{
                InitialContext ic = new InitialContext();
                Object objRef = ic.lookup("TheDemo");
                DemoHome home=(DemoHome)PortableRemoteObject.narrow(
                                          objRef, DemoHome.class);
                demo = home.create();
            }
            catch (RemoteException e) {
                System.out.println(e.getMessage());
            }
            catch(CreateException e){
```

```
                System.out.println(e.getMessage());
        }
        catch(NamingException e){
                System.out.println(e.getMessage());
        }
}
%>
<html>
<head>
    <title>Demo</title>
</head>

<body bgcolor="white">
<h1><center>Demo</center></h1>
<hr>
        <p>
        <% out.println(demo.getInfo()); %>
    </p>
</body>
</html>
```

40.8.2 Deploy the JSP

The process of deploying any web component into an application server first involves creating a Web ARchive (WAR) file and then adding it to the *Demo.ear* file.

Start the J2EE Reference Implementation EJB container. After it has started, start the deploy tool. First set the focus to the Demo application. Select

```
File > New > Web Component
```

or click on the [icon] icon on the toolbar and select the *Wizard* to add the *WAR* file to the *Demo* application.

The first screen is an introductory one that explains the purpose of the *Wizard*. Next is the *New Web Component WAR File General Properties* screen. Right at the top, it puts forth the J2EE party line: A WAR file is required to contain web applications. Developers who wish to work with J2EE must become used to packaging applications to be run in a web container into *WAR* files. See the documentation that comes with the Tomcat J2EE reference web server for a good discussion of how to create a WAR file that will deploy on any J2EE-compliant web server. (Tomcat is free. It can be downloaded from *http://java.sun.com/products/jsp/tomcat/*.)

In the *New Web Component WAR File General Properties* screen, *Demo* should be in the *Web Component will Go In: box*. Put *WebDemo* in the *WAR Display Name* box and put "JSP to access the Demo session bean" in the description box. Then click on the *Add* button under the *Contents* box to bring up the *Add Files to WAR – Add Content Files* dialog box.

The first thing to do is to set the *Root* directory. Click on the *Browse* button to the right of the *Root Directory* box, navigate to the directory that contains your JSP file, and click on it. Then click on the *Choose Root Directory* button to view a list of the files in that directory. Click on *Demo1.jsp* and then click on the *Add* Button. *Demo1.jsp* appears in the box under the *Add* button. Click on the *Next* button and then on the *Finish* button.

The *New Web Component WAR File General Properties* screen reappears. Click on *Next* and the *New Web Component - Choose Component Type* screen appears. Click on the *JSP* radio button and on the *Next* button.

The next dialog asks you to identify the JSP file or servlet class. Click on the JSP filename list box and choose *Demo1.jsp*. Put *Demo1.Jsp* as its display name and put "JSP file to access Demo session bean" as its description. Then click on the *Next* button.

The next dialog box allows you to set initialization parameters for the JSP. Click on the *Next* button.

The *Component Aliases* dialog box appears. Component aliases are an extremely useful way to simplify access to your applications. Instead of forcing the user to type in a complicated list of directories to find the start page for your application, you can enter an alias that will take the user directly to your start page. Click on the *Add* button, type *Demo1*, and press *Enter*. Then click on the *Next* button.

The *Component Security* screen appears. If there were security restrictions on this component, you would enter the aliases or role names that were allowed to access this web application.

Next is the WAR file environment, the *Enterprise Bean References* screen, the *Resource Reference* screen, and the *Context Parameters* screen. See the discussion that accompanies Section 40.6 for more detailed explanation of these screens. Click on the *Next* button to continue past each of these screens.

After the *Context Parameters* screen, the *File* references screen appears. This screen provides a useful way to associate welcome files with your application and to map error codes such as *404* to your own error JSP pages. Click on the *Next* button.

The *Security* screen, which allows you to set the *Authentication Methods, Security Constraints*, appears next and web resources that will be part of the security environment of this *WAR* file. Click on the *Next* button to see the deployment descriptor that will be generated for this *WAR* file. You may wish to study it to get an idea of the parameters that the web container is seeking. When you are done studying the file click on the Finish button.

The JSP in the *WAR* file will be trying to contact *Demo EJB*. You will have to tell it what *JNDI* name to use, as well as the names of the EJB, the home interface, and the remote interface. In the main *Application Deployment Tool* screen, click on *WebDemo* and then click on the EJB References tab in the *Inspecting: Demo.\WebDemo* pane. In the *Coded Name* cell, enter *TheDemo*, which we have hardcoded in our JSP as the name to ask *JNDI* for to get the *DemoHome* interface.

40.9 Summary

In this chapter, we have reviewed all of the steps necessary to deploy a session bean. We then successfully ran our *Demo* session bean as a stand-alone Java application. Finally, we demonstrated that the same approach can be used in a JSP. This very simple application illustrates two important points:

- The EJB model is significantly different than the conventional Java programming model, since the presence of the EJB container imposes a level of indirection on the application that is not present in a regular Java program.
- Once the EJB model is learned and followed, EJB programming comes back to regular Java programming as the developer implements the necessary business methods in the session or entity beans. In the end, it is all about Java.

In sum, this simple EJB can provide the framework for much more sophisticated applications.

40.10 Exercises

40.1 Move the demo *ClientProgram* to another computer. What additional steps do you have to take to allow you to connect the DemoClient program to DemoEJB, which is running on the original server computer?

40.2 Import an existing *.ear* file into the deployment tool. Start the server and start the deployment tool. Select

```
File > Open
```

and navigate to the *docs* directory of your *j2ee* installation. Open the Samples directory and then the cmpcustomer directory and click on the *cmpcustomer.ear* file. Examine the contents of the *CMPCustomer* application in the deployment tool. Deploy this application and then run it.

CHAPTER 41

Entity Beans

by James Linn

**In nature, the spineless creatures
have the hardest shells.**

–Douglas Lyon

This chapter describes *entity beans*. Entity beans are just like session beans except that entity beans persist in an EJB container. This container is used for storing the state of a shopping session (like a shopping cart) over a long period of time. Topics in this chapter include:

- How to code business instances
- How the entity bean is stored by the container
- How developers can use the container to manage persistence

41.1 Introduction

For example, an employee entity bean can contain an employee ID, the department for which the employee works, the address at which the employee lives, the employee's telephone number, etc. As you can see, this entity bean represents information that may have been gotten from several tables in a database. As far as client programs are concerned, the employee entity bean is the data. So, as a developer, you need to get into the habit of thinking of the entity bean as representing the data and forgetting about the tables in the database in which this data is stored in a permanent form.

If you remove the employee entity bean, data in that entity bean is removed from the tables in a corresponding database. If you modify or update data in the employee entity bean, the data in the underlying tables will change.

41.2 Design Considerations

When creating J2EE applications, it is vital to start with a design architecture. Such an architecture is particularly important when working with applications that involve entity beans.

The first question that must be asked is, should we use entity beans? Session beans can read data from databases using JDBC and can present that data in a read-only fashion. Entity beans, however, can alter the data.

When an EJB container starts, it will load all of the entity beans. If you abstract a one-million-row table into entity beans, the container will load all entity beans when it starts. This process can take considerable time.

Furthermore, when the client asks for entity beans, it means that the data will have to be sent out over the network. If the work that your client has to perform involves 1,000 entity beans, 1,000 network calls will have to be made. As a result, you should take special care in the network load that you create in your application design. If you have to return a significant number of entity beans to your client, you should rework your architecture so that you package that data into a larger structure such as a *Value Object* [Deepak et. al.].

41.3 Structure of an Entity Bean

Entity beans are very similar to session beans in that they are composed of a home interface, a remote interface, and an entity bean Java file. As with session beans, the home interface provides a way to create and remove entity beans. In addition, it contains one or more methods that allow you to find entity beans by using their primary key. In fact, the remote interface provides methods to access all of the public business methods of the entity bean.

The actual entity-bean Java file contains all of the public methods exposed in the remote interface, all of the private or protected methods necessary to carry out the business methods, and several methods unique to entity beans.

41.4 Home Interface

The J2EE specification for entity beans mandates that there will be one or more create methods and one or more find-by primary-key methods. When you are looking for a particular set of data that is encapsulated in an entity bean, you use the primary key.

The following entity bean reads a database and returns *sayings*. The home interface for our entity bean extends *EJBHome*, as does the home interface for our session bean. For example,

```
/*
 * DemoEntityHome.java
 *
 * Home interface for Demo entity bean
 */
```

```
package com.enterpriseEJB.Demo;
import java.rmi.RemoteException;
import javax.ejb.CreateException;
import javax.ejb.FinderException;
/**
 * Home interface for the Demo entity bean
 * @version
 */
public interface DemoEntityHome extends javax.ejb.EJBHome {
    // Create method
    SayingPrimeKey create(String saying);
    // Finder method
    public DemoEntityBean findByPrimaryKey(SayingPrimeKey
        sayingKey)
            throws RemoteException, FinderException;

}
```

The home interface above is similar to the home interface in our session bean. Our create method returns a *SayingPrimeKey* instance, and our finder method accepts an instance of a primary key that it uses to locate the proper *DemoEntityBean*. Java also allows you to define other finder methods. The remote interface follows:

```
/*
 * DemoEntity.java
 * Remote interface for Demo entity bean
 * Created on November 11, 2001, 9:28 AM
 */
package com.enterpriseEJB.Demo;
import java.rmi.RemoteException;
/**
 *
 * @version
 */
public interface DemoEntity extends javax.ejb.EJBObject {
    public String getSaying(SayingPrimeKey sayingKey) throws
        RemoteException;
}
```

The interface above also is quite similar to the remote interface for our session bean. As you can tell from the remote interface, there will be one business method in our entity bean, and it will return a string. The primary-key class follows:

```
/*
 * SavingPrimeKey.java
 *
 * Primary key class for the Demo Entity Bean
 *
 */
package com.enterpriseEJB.Demo;
/**
 * Primary key class for the Demo Entity Bean
 * @version
 */
```

```
public class SayingPrimeKey extends java.lang.Object implements
     Java.io.Serializable {
  /** Primary key for the Demo application is an integer. */
  private int id;

  /** Mechanism to increment the key by one for the next
  SayingPrimeKey. */
  private static int currentId = 0;

  /** Creates new SayingPrimeKey. ID is the current id
  incremented by 1 */
  public SayingPrimeKey() {
       id = ++currentId;
  }

  /** Provides access to the int that represents the primary
  key. */
  public int getId() {
       return id;
  }
  // so that the SayingPrimeKey instance can be a part of a
     collection
  public boolean equals(Object obj) {
       if(obj==null || !(obj instanceof SayingPrimeKey))
            return false;
       else if( ((SayingPrimeKey)obj).id==id)
            return true;
       else
            return false;
  }
  public int hashCode() {
       return id;
  }

  public String toString()  {
       return String.valueOf(id);
  }
}
```

The key class encapsulates an integer that functions as the primary key in the database. In more advanced applications, primary key instances can become quite complex. Since the primary key is used in remote invocations, it is subject to all of the restrictions imposed by Java RMI–IIOP. That is, it must be serializable, and it must be an acceptable Java RMI–IIOP type. The entity bean follows:

```
/*
 * DemoEntityBean.java
 *
 * Created on November 11, 2001, 9:39 AM
 */
package com.enterpriseEJB.Demo;
import javax.ejb.EntityContext;
/**
 * Demo entity bean instance
 * @version
```

```
        */
    public class DemoEntityBean implements javax.ejb.EntityBean {
        private EntityContext context;

        public int id;
        public String saying;

        public SayingPrimeKey ejbCreate(String saying) {
            return null;
        }

        public String getSaying(SayingPrimeKey sayingKey) {
            return saying;
        }

        public void setEntityContext(javax.ejb.EntityContext p1)
                throws javax.ejb.EJBException,
                    java.rmi.RemoteException {
            context = p1;
        }

        public void unsetEntityContext()
                throws javax.ejb.EJBException,
                    java.rmi.RemoteException {
            context = null;
        }

        public void ejbActivate()
                throws javax.ejb.EJBException,
                    java.rmi.RemoteException {
        }

        public void ejbPassivate()
                throws javax.ejb.EJBException,
                    java.rmi.RemoteException {
        }

        public void ejbStore()
                throws javax.ejb.EJBException,
                    java.rmi.RemoteException {
        }

        public void ejbLoad()
                throws javax.ejb.EJBException,
                    java.rmi.RemoteException {
        }

        public void ejbRemove()
                throws javax.ejb.RemoveException,
                    javax.ejb.EJBException,
                    java.rmi.RemoteException {
        }
    }
```

Our entity bean has several methods that also are found in session bean instances. We have an *ejbCreate* method, and we have a *setEntityContext* method.

 The *ejbActivate* and *ejbPassivate* methods in the entity bean encompass the same functionality and processes as the methods with the same names in a session bean.

However, our entity bean has several very significant differences from a session bean. To begin with, it implements the *EntityBean* interface, which brings several new methods into the class. In particular, we see an *ejbStore* and an *ejbLoad* method. These methods are key players in the interaction between our entity bean and the database. In addition, the *ejbCreate* and *ejbRemove* methods have a very different meaning in an entity bean than they have in a session bean.

Let's start with the *setEntityContext* method. To understand the importance of the *EntityContext*, you have to realize that an EJB is really a composite class that consists of an entity bean and a wrapper. The wrapper uses *EntityContext* to obtain an key integer. *EntityContext*, then, provides a reference to the entity bean.

41.4.1 Container-Managed Persistence

 All J2EE-compliant EJB containers will handle the tasks involved in reading and writing persisting data.

Let's use the employee object for an example. Employee data, such as name, age, Social Security Number, etc., all are derived from one table. All of the employee address information is mapped into a second table. The J2EE 2.0-compliant EJB containers are capable of dealing with the multiple linked tables.

41.4.2 Bean-Managed Persistence

A developer can implement custom persistence code in order to obtain control over persistence. Such customization requires extra work, but it makes for a persistence mechanism that can be specific to the computing environment. One way to implement custom persistence is to use JDBC. For example,

```
    private Connection con;
    private Statement stmt;
    private ResultSet rs;
/*
For our bean managed example the first thing that we will need to
      create is a function that will get us a database connection.
      Here is our getConnection  function.
*/
    // Private methods
    private Connection getConnection() throws SQLException {
      try {
          javax.naming.Context jndiCntx
            =new javax.naming.InitialContext();
          DataSource ds
            =(DataSource)jndiCntx.lookup(
            "java:/comp/env/jdbc/DemoDB");
          return ds.getConnection();
      }
      catch(javax.naming.NamingException e) {
          throw new javax.ejb.EJBException(e);
      }
```

```
        }
/*
Then we will need a function to clean up the JDBC objects.
*/
    private void cleanUp() {
        try {
            if(rs != null)
                rs.close();
            if(con != null)
                con.close();
            if(stmt != null)
                stmt.close();
        }
        catch(SQLException e) {
        }
    }
```

When using JDBC with entity beans, we get a database connection via a *DataSource* object, which we get from JNDI via the *InitialContext* object. JNDI stores the *DataSource* object in the JDBC section of the directory. The information necessary to create a *DataSource* object is given to the EJB container during the deployment of the entity bean, and it goes in the resource factories section. The look-up process can throw *NamingException*. Once we have the data source object in hand, we can ask for *Connection.*

The *ejbCreate* method is also the responsibility of the developer when using bean-managed persistence.

For example,

```
public SayingPrimeKey ejbCreate(String aSaying) {
    saying = aSaying;
    SayingPrimeKey sayingKey = new SayingPrimeKey();

    try {
        id = sayingKey.getId();

        con = getConnection();
        stmt = con.createStatement();
        StringBuffer buf = new StringBuffer(
                    "insert into Sayings (id,saying) values (");
        buf.append(sayingKey.getId());
        buf.append(", '");
        buf.append(saying);
        buf.append("')");
        stmt.executeUpdate(buf.toString());
    }
    catch(SQLException e) {
    }
    finally {
        cleanUp();
    }

    return sayingKey;
}
```

The first step is to create a new primary-key object. We then get its *id* field and use it to set the *id* field for the entity bean. A JDBC connection is used to obtain a *Statement* instance, which enables the creation of an row-insert SQL statement.

 The EJB container has the right to reclaim resources, such as memory, by saving an entity bean to a file.

Before the container detaches the entity bean and serializes it, it calls the *ejbStore* method. If you are managing persistence, then you must insert JDBC code that will save the current saying and the *id* associated with it. For example,

```java
public void ejbStore()
          throws javax.ejb.EJBException,
              java.rmi.RemoteException {
    try{
        con = getConnection();
        stmt = con.createStatement();

        StringBuffer buf =
            new StringBuffer("update Sayings saying = '");
        buf.append(saying);
        buf.append("' where id = ");
        buf.append(id);

        stmt.executeUpdate(buf.toString());
    }
    catch(SQLException e) {
    }
    finally {
        cleanUp();
    }
}
```

When a client makes a call on an object that is wrapping an entity bean, and when that entity bean has been serialized, the container will deserialize the bean and reattach it to the wrapping object. It then will call the *ejbLoad* method. The developer will have to write the code to query the database for the latest values associated with that primary key. Here is an *ejbLoad* method that performs such a query:

```java
public void ejbLoad()
          throws javax.ejb.EJBException, java.rmi.RemoteException {
    // Get the id from the primary key in the entity instance
    SayingPrimeKey sayingKey =
    (SayingPrimeKey)context.getPrimaryKey();
    id = sayingKey.getId();
    try {
        con = getConnection();
        String sql = "select saying from Sayings where id = "+id;
        rs = stmt.executeQuery(sql);
        if(rs != null)
            while(rs.next())
                saying = rs.getString("saying");
    }
    catch(SQLException e) {
    }
```

```
        finally {
            cleanUp();
        }
    }
```

As you can see, the preceding code includes a JDBC select statement. We use the *id* associated with the entity bean that is wrapped to query the database for the saying associated with this *id*. Upon return from serialization, the *id* contained in the wrapper instance is not guaranteed to be meaningful. However, the J2EE specification mandates that there be a valid primary-key instance in the context instance. Hence, developers always should look to the context instance for the primary key and get any *id* information.

The last method we shall consider is the *ejbRemove* method. For example,

```
public void ejbRemove()
        throws javax.ejb.RemoveException,
            javax.ejb.EJBException,
            java.rmi.RemoteException  {
    try {
        con = getConnection();
        stmt = con.createStatement();

        String sql = "delete from Sayings where id = "+id;
        stmt.execute(sql);
    }
    catch(SQLException e) {
    }
    finally {
        cleanUp();
    }
}
```

41.5 Summary

In this chapter, we discussed the second kind of EJB, the entity bean. We introduced the key concept that entity beans contain business data and that, when data in the entity bean is changed or an entity bean is removed, data disappears from the system and from the underlying persistent stores. We also discussed how application developers either can have the container manage persistence or can write the persistence code themselves.

 By encapsulating all of the data in a business process or instance in an entity bean, we produce a very powerful instance that can be distributed efficiently across the network and shared among a multitude of clients.

41.6 Exercises

41.1 Create a project in your favorite Java IDE. Convert the *home* interface, the *remote* interface, and the actual bean class itself to Java files and compile the application.

41.2 Start the deployment tool and deploy this application using container-managed persistence. Use the *Cloudscape* database and the same JNDI name as that used in the *CMPCustomer* application.

C H A P T E R 4 2

EJB Security

by James Linn

**People who are willing to give up freedom
for the sake of short term security,
deserve neither freedom nor security.**

–Benjamin Franklin (1706–1790)

In this chapter, you will learn:

- The role of the EJB container in providing security
- The security tasks that the J2EE specification mandates that the EJB container fulfill
- The complexities of providing security in a distributed environment
- The J2EE security API

42.1 Introduction

 Security is a concern of every enterprise. Attention to the security needs of the orga-
nization is required of every enterprise Java developer.

Threats to enterprise information fall into the following general categories:

1. Disclosure of information to unauthorized individuals
2. Destruction or modification of information
3. Unauthorized appropriation of resources
4. Compromising of the audit trail
5. Actions that interfere with the availability of enterprise resources

This chapter will not attempt to provide a wide-ranging or thorough discussion of corporate security. Instead, our intent is to provide sufficient background information and details of the EJB security API so that a developer will be able to produce secure J2EE applications. If you are tasked with deploying EJB applications in a corporate environment, you will have to seek more detailed information. The chapter on security in [Kassem] is an excellent place to begin.

Current security systems begin with *authentication* and *authorization*. Individuals accessing the system must provide credentials to establish who they are. Once authenticated, those individuals will be authorized to access certain subsets of information and functionality and will be denied access to all of the rest of the information and functionality of the system.

In a distributed architecture, there are many other considerations. In an EJB architecture, security exists on many levels and involves many different actors, as can be seen in Figure 42.1-1.

In a J2EE (i.e., distributed) architecture, information flows freely over various networks, and business logic is decentralized.

Requests and information flow in from the World Wide Web over HTTP into the proxy server. From the proxy server, this information is sent to application servers where it is given to a component for processing. The component, in turn, might involve other components. In a decentralized architecture, these other components could be out on another server, thus necessitating a trip over a LAN, WAN, or Virtual Private Network (VPN). At various times, databases may become involved, which usually requires a trip over a network of some sort.

In the J2EE architecture, there are numerous places where information can be compromised or modified. EJB developers are concerned with what happens between EJB components and between the EJB container and its contained EJBs. Due to the distributed nature of EJBs, EJB developers will be partners in helping to maintain security over the various networks that are involved in the enterprise architecture. However, the bottom line is that the J2EE programming model does not introduce new security functionality or requirements; instead, it leverages existing enterprise security apparatus.

FIGURE 42.1-1
Flow of Information in a J2EE Architecture

The EJB container can be expected to have mechanisms to provide or participate in the following security services:

- *Authentication*—The container will provide the authentication boundary between incoming calls and the components it hosts.
- *Authorization*—The application deployer will provide a list of who is permitted to do what in the deployment descriptor.
- *Signing*—All containers will have mechanisms to provide, recognize, and propagate certificates.
- *Auditing*—Auditing support is suggested but not required.

Developers should not implement these security services. Instead, EJB containers are mandated to provide these services.

In addition to the general security services mentioned above, EJB containers are mandated to provide the following component-level security services as part of the J2EE specification:

1. Ensure that concurrent instances of the same application can run under different security credentials without compromising security.
2. Handle the mapping of clients between different security domains so that a principle can log onto one domain and have its security credentials assigned to the proper roles on another domain that may be running on a different computer in a different part of the world. The mapping of principles among different domains means that users only need to sign on once to gain access to the applications that they need. When applications are decentralized across a network, the ability to map principles is vital.

The security provided by the EJB container is analogous to the security provided by operating systems.

The operating system, like the container, will handle the task of logging users on and, once they are on, of restricting them to the resources to which the administrator has allowed them access. The operating system also manages certificates and provides security logs that audit the actions users perform.

The standard approach to EJB security is to let the container manage it. This approach has many advantages. Normally, each enterprise has its own distinctive approach to security. In fact, different divisions within an enterprise often will have differing security policies. If all of the security management is provided by the container, applications will be very portable within an enterprise and even portable between enterprises.

The development burden, then, is on the individual, who will need a detailed and exact knowledge of the application. In addition, sometimes the security management tools available to the deployer are incapable of providing the granularity of security required. In these cases, application developers will find themselves adding security code to the application.

42.2 Security Guidelines

It is not recommended that the developer write authentication functionality because it takes a security expert to develop bulletproof authentication code. In addition, writing your own authentication code makes your application much less portable. Rather than attempting to write authentication code, the developer should rely on the container's authentication.

However, as a developer you still might wind up writing *authorization* code. These are the best-practice recommendations:

1. Don't code rules that apply to roles or groups into the application. Doing so decreases the portability of the application and introduces maintenance headaches. Every time a group is changed, created, or destroyed, all of the security code embedded in applications will have to be examined and retested. The access rules should be declarative and rather than hardcoded put in the EJB deployment descriptor. *Declarative* means that rules and procedures are declared and that it is up to the container to implement them, which is in contrast to programmed rules and procedures that are hardcoded. An example of a declarative rule would be should be a security rule stating that members of a personnel department may access all of an employee's personal records. This implementation would be done via an entry in the deployment descriptor.

2. Some rules are so fine-grained that it is difficult or even impossible to enforce them at the declarative level, and some rules rely on application-specific data. These rules should be treated as application logic and coded as part of the Java object.

An example of this sort of rule would be a rule stating that a department manager may authorize any purchase up to $500 unless the purchase is of computers or software. The container knows if a person is part of the department manager group; however, it would be out of the question for it to know the value of a particular purchase order or what items the purchase order contains. As a result, the developer will have to put the proper security code into an *if* statement that will combine knowledge of the user's role with knowledge of the amount of the purchase order.

42.3 Security for an Enterprise Application

This section describes the principles of J2EE security, giving examples from the insurance industry. Let's say an insurance company called MegaInsure has thousands of agents, most of them independent. The company offers a service called an *insurance score rating* to the agents who write commercial insurance. The insurance score will be derived from the a company's rating by Dun and Bradstreet. An insurance score rating is used to help agents balance the premium against risk.

In addition, agents who have written more than $1 million in business during the past year also will get a credit score that is based on data from Equifax. Some restrictions are applied to the data available to agents. For example, agents cannot get information on MegaInsure, insurance agencies that are affiliated with MegaInsure, or on any of MegaInsure's subsidiaries. However, certain departments at MegaInsure are allowed to see all of the data, including information on MegaInsure.

The first step is to define a security architecture from the use cases in MegaInsure's Software Development Plan, which offers MegaInsure's point of view on the proper security architecture. MegaInsure has decided that it needs to define the following security roles:

1. The *agent* security role.
2. The *MegaInsure-admin* security role, which represents the departments and individuals within MegaInsure that are allowed access to the insurance score application data.

3. The *insuranceScore-app* security role, which represents the application itself. It describes the method permissions that the application will need to perform its functions. It is important to note that this security role is often the most comprehensive role of all. If this security role is compromised, there can be grave consequences.

After MegaInsure has identified a set of security roles, all of the other entities involved in this particular implementation of the architecture will have a chance to modify the security architecture. For example, Dun and Bradstreet wants to specify additional security roles to satisfy its security requirements. Remember, EJBs that are part of this application will be running at both MegaInsure's and Dun and Bradstreet's sites, and these EJBs will be offering data from both of these providers.

For example, Dun and Bradstreet specified that the application EJBs that run at its site and that provide data to MegaInsure can have read-only access to the information from Dun and Bradstreet. However, Dun and Bradstreet has a customer site administrator role that allows people employed by Dun and Bradstreet to log into its site from MegaInsure and have access to a greater range of functionality than that offered to MegaInsure. These roles are mapped to megaInsure-customer and customerSite-admin roles, respectively.

In addition, Equifax has its own view of security. The system administrator at Equifax defined one security role, that of customer. When MegaInsure is interacting with Equifax, the application components running at MegaInsure all will be in that role.

After the roles have been defined, the application is scrutinized on a bean and method level, and the proper roles that are allowed to access those methods are specified.

In short, container-level security is managed at the method level. The deployment descriptor will contain the name of a security role and a list of the methods.

In both cases, the external entities, Dun and Bradstreet and Equifax, have security needs and policies that are different from the needs and policies of MegaInsure.

No EJB in this system has knowledge of the security policies of any of the other entities.

By using a distributed application and the services provided by the EJB containers that run at the various sites, all of these security needs can be satisfied using declarative security. As you have seen in Chapter 40, these needs are declared to the container during the deployment of the EJB. The proper security declarations are put into the XML of the EJB deployment descriptor by the EJB container's deployment tool.

All of the above mentioned specifications could have been hardcoded into the application using the EJB security API, but doing so would have increased the development time and effort substantially. In addition, think about what hardcoded security rules would mean if the security rules change. Suppose MegaInsure suddenly decides that it doesn't want any of its employees below the executive vice president to have access to Dun and Bradstreet and Equifax information on MegaInsure. If the security information were hardcoded, all of the code would have to be scrutinized and some of it would need to be changed. If the container is managing the security, however, all that is required is to change the deployment descriptor and restart the server(s) running the EJB container.

42.4 The EJB Security API

Sometimes it is not possible to define security needs completely and declaratively.

Consider the business requirement that agents who have written more than $1 million in business also get access to a credit score from Equifax. Information about an agent's sales is in the component's domain rather than in the domain of the container. In these circumstances, the security code will have to be inserted by the application developer.

The EJB API provides the *getCallerPrinciple*() and *isCallerInRole*() methods of the Context object to allow developers to get security information from the EJB container:

```
import java.security.Principal;
…
private SessionContext ctx;
…
// This is from the EJBObject interface. All EJBs
// must implement it.
public void setSessionContext(SessionContext ctx) {
this.ctx = ctx;
}
…
Principal prince = ctx.getCallerPrincipal();
String empID = prince.getName();
if(empId.equals("xyz"){
    // Do the right thing
}
if(ctx.isCallerInRole(ph-plan-admin)){
    // Do the right thing here too
}
```

The EJB container is aware of all of the roles that have been defined. In addition, it knows the credentials passed in from the caller. This information is available from the Context object, and the application queries it through the foregoing method calls.

To get back to our MegaInsure example, the developer could write code similar to

```
String sql =
"select sum(business_written)"
+ " from agency_business where id = xyzAgency";
rs = stmt.executeQuery(sql);
float businessWritten = rs.getFloat
if(rs >= 1000000 && ctx.isCallerInRole("agency")) {
    // show both insurance and credit scores
}
else if(ctx.isCallerInRole("agency")) {
    // show insurance score only
}
else if(ctx.isCallerInRole("megaInsure-admin") {
    // Show what is appropriate for this role
}
else {
    throw new SecurityException("Caller in unknown role");
}
```

42.5 Summary

In this chapter, we discussed the role of the EJB container in providing security. We looked at the security tasks that the J2EE specification mandates that the EJB container fulfill, which gave us a look into the complexities of providing security in a distributed environment.

Under normal circumstances, security will be delegated to the EJB container. However, there are situations where this delegation is not a viable choice. For those situations, the J2EE provides a security API to allow the developer to provide custom security access.

42.6 Exercise

42.1 Create a new role on the J2EE Reference Implementation EJB container by selecting to *Tools > Server Configuration > Users*. Make the changes necessary in the *Demo* application so that *DemoEJB* uses that role.

C H A P T E R 4 3

RMI

by James Linn and Douglas Lyon

> **Quidquid latine dictum sit, altum sonatur.**
> **Whatever is said in Latin sounds profound.**
>
> *–Unknown*

In this chapter, you will learn

- The role of RMI
- How to write RMI-based programs
- The RMI security API

43.1 Introduction

 RMI enables programs to be invoked in a remote address space.

A remote address space is one that exists on another CPU with its own memory. Each CPU can have its own data and its own instructions, making this a multiple instruction multiple data (MIMD) architecture for parallel computing.

RMI is used in *middleware* frameworks (e.g., J2EE and EJBs). It also has made inroads in the area of distributed CORBA programming by adopting IIOP for communication with CORBA servers. RMI is central to EJBs, Enterprise Application Integration (EAI), web services, and grid computing, to cite a few examples.

Figure 43.1-1 shows a simplified diagram depicting two computers communicating using RMI protocol. The protocol can be transported using standard Internet protocols like TCP/IP.

FIGURE 43.1-1
The Role of the RMI Protocol

43.2 RMI Architecture

Distributed computing must deal with transmitting data from one computer to another. For example, text files use different character encoding on different systems. Java, .NET, and COM have instances, whereas C and COBOL do not. Most of the computing world sends text in the ASCII format, while IBM mainframes use Extended Binary Coded Decimal Interchange Code (EBCDIC).

Figure 43.2-1 shows the RMI architecture for Java distributed computing. In essence, a proxy (called the *stub*) is placed in the memory space of the client application. The stub has the plumbing to communicate with a delegate running on the server. The proxy is compiled from the delegate. The client program then communicates with the proxy, and the proxy uses a protocol to marshal parameters to the server. The server, in turn, can unmarshal the data, compute a result, and send an answer. The marshaling makes use of serialization.

 The architecture outlined above is the RMI v1.2 architecture. RMI v1.2 is the latest version, and it is what we will be using here. However, many books on the Java 2 language use the v1.1 architecture in their examples. If skeleton instances are mentioned in the RMI example, the authors are using the v1.1 RMI.

FIGURE 43.2-1
RMI Architecture.

43.3 RMI Marshaling

Java instances are serialized before being sent over the wire and are deserialized on the other end. The goal is to place an instance in the memory space of the server so that methods in that instance can be invoked. Thus, instances are sent by value in RMI and are serializable.

The RMI registry is a service that helps to locate instances. The registry refers to interface repositories. Using RMI registries and folders, you can create a servant or client adapter. The RMI registry in our example runs on the local host and listens to port 1099.

Complete the following steps in order to create an RMI application:

1. Define an interface(s) for the remote class(es). Compile the interface(s).
2. Create and compile classes that implement the interface(s).
3. Use the Java rmic compiler to create stub class(es) from the implementation class(es).
4. Create a server application and compile it.
5. Start *rmiregistry*.
6. Start the server application.
7. Create a client program that accesses the remote interface(s). Compile the client program.
8. Test the client program.

Begin by creating an *RmiCode* directory, which will be the top-level directory for the project. Next, create the package directory for this project, which will be *RemoteHello*.

As the first step, open your editor and create an interface class that implements Remote. Add a method that returns a string and throws RemoteException. For example,

```
/ * Remote interface for the RmiHello application.
      *   @author James Linn.
      */

   package RemoteHello;

   import java.rmi.Remote;
   import java.rmi.RemoteException;

   public interface RmiHello extends Remote {
      public String getMsg() throws RemoteException;
}
```

Save this in the *RmiCode/RemoteHello.java* file and compile it. As the second step, create a Java class that implements the `RmiHello` interface:

```
/* Implements RmiHello interface.
      *   @ author James Linn
      */

   package RemoteHello;

   import java.rmi.RemoteException;
   import java.rmi.server.UnicastRemoteObject;

   /**
    * @author   JLinn
```

```
     * @version 1.0
     */
    public class RmiHelloImpl
           extends UnicastRemoteObject
           implements RmiHello {

        String msg = "Hello World";
        /** Creates new RmiHelloImpl */
        public RmiHelloImpl()
           throws RemoteException {
        }

           public String getMsg()
             throws RemoteException {
           return msg;
        }

    }
```

Save this class in the *RmiCode/RemoteHello.java* file and compile it.

As the third step, use the *rmic* compiler to create the stub. The *rmic* compiler takes in the interface implementation classes and creates stubs from them.

Open a command prompt, navigate to the RmiCode directory, and execute the following command:

```
rmic -v1.2 -d . RemoteHello.RmiHelloImpl
```

The -v1.2 command tells the compiler to compile for RMI version 1.2. The -d command tells the compiler where to put the generated stub. Finally, you must specify the full package name for the implementation class for which you wish to generate a stub. The compiler will churn for a while, and *RmiHelloImpl_Stub.class* will appear in the *RemoteHello* directory.

As the fourth step, create a server class for *RmiHelloImpl*. The server class serves up the remote interface, and it is the class upon which applications in other JVMs make method calls. This is how your server class should look:

```
/*      Server for RmiHello.
        *   @author James Linn
        */

    package RemoteHello;

    import java.rmi.Naming;

    public class RmiHelloServer {
        public static void main(String[] args) {
           try {
              System.out.println("Starting server.");

               RmiHello hello = new RmiHelloImpl();

              System.out.println(
                "Binding remote instance.");

              Naming.rebind("RmiHello",hello);

              System.out.println("Waiting for calls...");
           }
```

```
catch(Exception e) {
    System.out.println("Error " + e);
    }
  }
}
```

As you can see from the example, there is no RMI code in this class. It is a clean implementation of the interface, and it returns a *String*, which is serializable. This class can be called from the same machine, but there will be some overhead due to the RMI protocols being used.

The single clue that this is not a plain-vanilla Java application is the *Naming.rebind("RmiHello",hello)*; code line. This code puts a reference to the newly created *RmiHelloImpl* delegate into the *rmiregistry* service along with a name. The *rmiregistry* service comes with the J2SE v.1.3 RMI package and is a means for locating the *RmiHello* service. The *Naming* instance interacts with *rmiregistry*, allowing you to add (bind) instances to *rmiregistry*. I have used the *rebind* function rather than the more obvious *bind* function because the *Naming* instance will bind a instance if it hasn't been bound yet. If you call *bind* and the instance is already bound, *Naming* will throw an exception, and your server program will terminate.

 The simple name that I used to register the *RmiHelloImpl* instance with the *rmiregistry* is not acceptable for real-world applications. You must use a name that is guaranteed to be unique.

It is possible to use CORBA ORBs as the repository or, if this is a J2EE application, to use JNDI.

As the fifth step, start *rmiregistry*. Open a DOS box and type *start rmiregistry*. By using the *start* command, you will open *rmiregistry* in a new window. To kill the registry, type CTRL+c.

As the sixth step, start the server. Open a DOS box in the *RmiCode* directory and type

```
start java RmiHelloServer
```

Use the *start* command so that the server runs in a separate process. You should see

```
Starting server.
Binding remote instance.
Waiting for calls...
```

If the command prompt (i.e., DOS box) flashes open and then immediately closes, an exception has been thrown. To see the exception message, type

```
java RmiHelloServer
```

 If an exception is thrown, the most common problems are forgetting to start the server and not having the stub class in the */RemoteHello* directory where *RmiHelloServer* can find it.

As the seventh step, create the client instance. The client must call whatever repository service you are using with the instance's name to get a reference to the instance. Once the reference is in hand, the instance's method(s) can be called. This is what my client looks like:

```
/* Client for the RmiHello application.
 *   @author James Linn.
 */
```

```
package RemoteHello;
import java.rmi.Naming;

public class RmiHelloClient {
    public static void main(String[] args) {
        //System.setSecurityManager(
            // new rmiSecurityManager());

        String rmiUrl = "rmi://localhost/";
    /* When running the client remotely, put in the name
    of the remote server in in place of localhost. */

        try {
            RmiHello hello =
              (RmiHello)Naming.lookup("RmiHello");
              System.out.println(hello.getMsg());
        }
        catch(Exception e) {
            System.out.println("Error " + e);
        }
    }
}
```

The foregoing coding is pretty painless. Simply call the naming service, cast the return instance to the *RminHello* interface, and call the *getMsg()* function.

A security manager is required for remote operation.

If you are running the client on the same machine as the server, you won't need a security manager. If you are running the client on a different machine than the server, you will need a security manager and a security file that specifies what you want to do. The reason that you will need a security manager is because the client may not have all of the classes associated with the instance that it is attempting to interact with. As a result, the client will have to download these classes from the machine that is running the server code. In that case, the machine that is running the client will throw a security exception unless the client has a security manager and a security file that dispenses the proper privileges.

As the eighth step, run the client. Open a command prompt in the *RmiCode* directory and type

```
java RmiHelloClient
```

You will see

```
Hello World
```

43.4 Wrapping Existing Java Classes

Existing classes can be wrapped so that they can accept remote method calls.

To review the basics of RMI, methods can be invoked remotely only on classes that implement the *Remote* interface. Consider the example in Figure 43.4-1.

In the example shown in Figure 43.4-1, the concrete class *Remote1Impl* implements the *Remote1* interface, which itself implements *Remote*. This instance can expose *func1*

FIGURE 43.4-1
Inheritance from the *Remote* Interface

and *func2* via RMI. Note that *func3* cannot be accessed via RMI; instead, it only can be accessed locally.

One strategy to make existing instances RMI-enabled is to use the facade pattern:

1. Create an interface that implements *Remote* and that has all of the functions you wish to expose remotely.

2. Create a class that only implements this interface. This class will have to extend *UnicastRemoteObject*, and the methods in this class will have to throw remote exceptions.

3. Add your class as a member variable of the implementation class, and forward all of the remote calls to the functions on that class.

In this way, your existing classes can become distributed instances without your having to rewrite any of the code in them.

43.5 EJB and RMI/IIOP

One of the big attractions of J2EE and EJBs is that many of the distributed computing details are handled by the EJB container, thus leaving the development team free to concentrate on the software engineering necessary to put together the application.

However, it is necessary for EJB developers to have some sort of understanding of what goes on under the hood of the EJB container. To begin with, while all EJBs that define a remote interface will be communicating via RMIs, they will be using the Java RMI/IIOP protocol instead of the Java RMI protocol. RMI/IIOP is an adaptation of the CORBA IIOP for Java. EJB v. 1.0 and v. 1.1 used RMI for distributed computing, but Sun adopted RMI/IIOP for EJB v 2.0. The rationale is that RMI/IIOP is more robust and universally accepted.

Whatever the reasoning behind the decision to switch, the adoption of RMI/IIOP has the following practical consequences for the EJB developer:

- When retrieving *home* interfaces from the EJB container, you can no longer do a Java cast on the instance that you receive; instead, you have to use *portableRemoteObjectNarrow()*. This function is borrowed from CORBA, and it allows connection to systems such as C and COBOL that have no notion of an instance.

- RMI/IIOP makes it possible for any application that can use CORBA to communicate with EJBs (e.g., C programs, legacy COBOL code, C++, and VB). If your goal is EAI, this is an important addition.

- RMI/IIOP imposes some restrictions on the programmer. A full discussion of all of the restrictions is beyond the scope of this chapter. Most of the restrictions are of academic interest as long as the developer sticks to Java primitive types and instances that can be serialized. Two restrictions do merit mention.

(1) A remote interface may not directly extend two interfaces that have methods with the same name, even if their arguments are different.

As you can see from Figure 43.5-1, the problem arises when directly implementing more than one interface, in this case because IIOP extends to languages that do not allow the same instance to have methods with the same name. However, in the case where inheritance is indirect, overloading is acceptable. In addition, it is acceptable for the interface to overload its own methods. These rules apply to overriding too.

FIGURE 43.5-1
Permissible and Impermissible Overloading in RMI/IIOP

(2) *Serializable* types may not implement the *java.rmi.Remote* interface directly or indirectly.

For further information, you will have to consult a good CORBA reference.

43.6 Summary

This chapter provided a quick overview of RMI. The keys to Java's RMI capabilities are the *Remote* interface, which allows a stub (proxy) to be passed from one JVM to another, and the Java serialization mechanism, which allows the data that an instance encapsulates to be abstracted from the instance and inserted into a new instance of the same type.

While the coding of an instance that you want to be part of RMI can be straightforward, the real difficulties in RMI lie in deploying the application, getting all of the pieces in the right place, and getting the security right.

The transformation of serial programs into parallel programs for RMI usage is a topic of current research. See [Lyon 2002] for an article that uses the book's code to create RMI support for existing code automatically.

43.7 Exercises

43.1 Deploy the application. I strongly suggest that you get the application running with all of the pieces on the same machine before you attempt to move the client to a remote machine. Here is how to distribute the components:

- Server directory, which contains all of the class files that the server needs, including *RmiHelloServer.class, RmiHello.class, RmiHelloImpl.class*, and *RmiHelloImpl_Stub.class*.

- Download directory, which contains all of the class files that need to be downloaded to the client(s). It must contain *RmiHello.class* and *RmiHelloImpl_Stub.class*. This directory must be accessible from the client machine. The best place is on a web server running on the client machine. Place the download directory in the directory where the web server wants the HTML files placed.

- Client directory, which is on the remote machine and which should contain all of the files needed to start the client, including *RmiHelloClient, RmiHello.class*, and *RmiHelloImpl_Stub.class*.

Now you need to craft a security file for the client. I suggest the following for a security file:

```
grant
{   permission java.net.SocketPermission
        "*:1024-65535", "connect,accept";
    permission java.net.SocketPermission
        "localhost:80", "connect";
};
```

The first line allows the client to connect to *rmiregistry*, which usually runs on port 1099, and the second line allows connection to the web server.

Start *rmiregistry* from a directory that has no class files in it and from a DOS box that has no CLASSPATH set. Start the server.

In *RmiHelloClient*, replace *localhost* with the proper URL for the machine to which you are attempting to connect. Compile the client and start it with the switch pointing to the security file.

43.2 RMI-enable an existing class of yours using the facade pattern.

43.3 Print out the article cited in [Lyon 2002] on *CentiJ*. This code is included with the book code. Use *CentiJ* to create an RMI version of an existing class. What problems did you encounter during the process?

C H A P T E R 4 4

Literature Cited

Goals are dreams with deadlines.

–Benjamin Franklin

Some of the references cited are available at *<http://www.DocJava.com/>*.

Agesen, Ole, Jens Palsberg, and Michael I. Schwartzbach. 1993. "Type Inference of SELF: Analysis of Objects with Dynamic and Multiple Inheritance." *ECOOP* 1993 Conference Proceedings, Kaiserslautern, Germany: 247–267.

Aghajan, Hamid K., and Thomas Kailath. 1993. "Sensor Array Processing Techniques for Super Resolution Multi-Line-Fitting and Straight Edge Detection." *IEEE TIP* 2 (4): 454–465.

Aksit, Mehmit, and Jan Willem Dijkstra. 1991. "Atomic Delegation: Object-oriented Transactions." *IEEE Software* March: 84–92.

Allen, Arnold. 1990. *Probability, Statistics, and Queueing Theory with Computer Science Applications*. 2nd Edition. Cambridge, MA: Academic Press, Inc.

Alur, Deepak, John Crupi, and Dan Malks 2001. *Core J2EE Patterns: Best Practices and Design Strategies*. Englewood Cliffs, New Jersey: Prentice Hall.

Amazigo, John C., and Lester A. Rubenfeld. 1980. *Advanced Calculus and Its Applications to the Engineering and Physical Sciences,* New York: John Wiley & Sons.

Ammeraal, Leen. 1998. *Computer Graphics for Java Programmers*. New York: John Wiley & Sons.

Anton, Howard. 1977. *Elementary Linear Algebra*. New York: John Wiley & Sons.

Armstrong, Eric. 2001. *Working with XML - The Java API for XML Parsing (JAXP) Tutorial*. *http://java.sun.com/xml/jaxp-1.1/docs/tutorial/index.html*.

Arnold, Ken, and James Gosling. *The Java Programming Language*. Addison-Wesley, Reading, MA. 1996.

Arnold, Ken, and James Gosling. 1998. *The Java Programming Language*. 2nd Edition. Reading, MA: Addison-Wesley.

At Home Corporation, a distributor of a hybrid fibre coax network services. *http://www.home.net/corp/network.html*.

Baker, Louis. 1991. *More C Tools for Scientists and Engineers*. New York: McGraw-Hill.

Ballard, D. H. 1981. "Generalizing the Hough Transform to Detect Arbitrary Shapes." *Pattern Recognition* 13 (2): 111–122.

Banerjee, Partha P., and Ting-Chung Poon. 1991. *Principles of Applied Optics*. Boston, MA: Aksen Associates Inc.

Bardou, D., and C. Dony. 1996. "Split Objects: A Disciplined Use of Delegation Within Objects." In Proceedings of OOPSLA'96, San Jose, California. Special Issue of *ACM SIGPLAN Notices* (31) 10: 122–137. *http://citeseer.nj.nec.com/bardou96split.html*.

Barr, Avron, and Edward A. Feigenbaum. 1981. *The Handbook of Artificial Intelligence*. New York: Addison Wesley.

Bentley, Jon Louis, and Jerome H. Friedman. 1979. "Data Structures for Range Searching." *Computing Surveys* 11 (4): 397–409.

Bishop, Judy. 1997. *Java Gently*. New York: Addison Wesley.

Böhm and Jacopini. 1966. "*Flow Diagrams, Turning Machines and Languages with only Two Formation Rules*." CACM 9 (May): 366–371.

Booch, Grady. 1991. *Object-Oriented Design*. Redwood City, CA: Benjamin Cummings.

Boomgaard, Rein Van Den, and Richard Van Balen. 1992. "Methods for Fast Morphological Image Transforms Using Bitmapped Binary Images." *CVGIP* 54 (3): 252–258.

Born, Gunter. 1995. *The File Formats Handbook*. Floppy disk. Boston, MA: International Thompson, Computer Press.

Bourret, Ronald. *XML Namespaces FAQ*. August 2001. *http://www.rpbourret.com/xml/NamespacesFAQ.htm*.

Boyce, William E., and Richard C. DiPrima. 1977. *Elementary Differential Equations and Boundary Value Problems*. New York: John Wiley & Sons.

Bracewell, Ronald N. 1995. *Two-Dimensional Imaging*. Englewood Cliffs, New Jersey: Prentice Hall.

Bracha, G. 1992. "The Programming Language JIGSAW: Mixins, Modularity and Multiple Inheritance." PhD thesis, Department of Computer Science, University of Utah.

Brant, John, Brian Foote, Ralph E. Johnson, and Donald Roberts. 1998. "Wrappers to the Rescue." In Proceedings of ECOOP'98, July 1998. *http://citeseer.nj.nec.com/189005.html*.

Calderbank, A. R., Ingrid Daubechies, Wim Sweldens, and Boon-Lock Yeo. 1997. "Lossless Image Compression Using Integer to Integer Wavelet Transforms." *http://cm.bell-labs.com/who/wim/papers/papers.html*.

Campione and Walwalrath. 1996. *The Java Tutorial*. CD-ROM. New York: Addison Wesley.

Canny, John. 1986. "A Computational Approach to Edge Detection." *Transactions on Pattern Analysis and Machine Intelligence* PAMI-8 (6): 679–698.

Canny, John. 1983. *Finding Edges and Lines in Images*. Technical Report No. 720, AI-TR-720, MIT Artificial Intelligence Laboratory, Cambridge, MA.

Cardelli, L. 1988. "Semantics of Multiple Inheritance." *Information and Computation* 76: 138–164. *http://citeseer.nj.nec.com/cardelli88semantics.html*.

Carlson, A. Bruce. 1986. *Communication Systems*. New York: McGraw-Hill.

Castleman, Kenneth R. 1996. *Digital Image Processing*. Englewood Cliffs, New Jersey: Prentice Hall.

CCIR-601-2. 1990. "Encoding Parameters of Digital Television for Studios." Recommendation 601-2. *http://www.igd.fhg.de/icib/tv/ccir/rec_601-2/scan.html*.

Chan, Lee, and Kramer. 1998. *The Java Class Libraries*. 2nd Edition. Vol. 1. New York: Addison Wesley.

Chan and Lee. 1998. *The Java Class Libraries,* 2nd Edition. Vol. 2. New York: Addison Wesley.

Chan and Lee. 1996. *The Java Class Libraries*. New York: Addison Wesley.

Chapin. 1974. "New Format for Flowcharts." *Software Practice and Experience*. 4 (4): 341–357.

Char, Bruce W., Kieth O. Geddes, Gaston H. Gonnet, Benton L. Leong, Michael B. Monagan, and Stephen M. Watt. 1991. *Maple V Language Reference Manual*. New York: Springer-Verlag.

Churchill, Ruel V., James W. Brown, and Roger F. Verhey. 1976. *Complex Variables and Applications*. New York: McGraw-Hill.

Clark, James. *XML Namespaces*. February 4, 1999. *http://www.jclark.com/sml/smlns.htm*.

Clocksin, W. F., and C. S. Mellish. 1981. *Programming in Prolog*. New York: Springer-Verlag.

Coad, Peter, and Mark Mayfield. 1997. "Java-Inspired Design: Use Composition Rather than Inheritance." *American Programmer* Jan.: 23–31.

Cohen, Michael F., and John R. Wallace. 1993. *Radiosity and Realistic Image Synthesis*. Cambridge, MA: Academic Press, Inc.

Compagnoni, A. B., and B. C. Pierce. 1993. "Multiple Inheritance via Intersection Types." Technical report ECS-LFCS-93-275, LFCS, University of Edinburgh. Also available as Catholic University Nijmegen computer science technical report 93–18. *http://citeseer.nj.nec.com/compagnoni93multiple.html*.

Cornell, Gary, and Cay S. Horstmann. 1997. *Core Java*. 2nd Edition. Englewood Cliffs, New Jersey: Prentice Hall. CD.

Cowan, William, William Ware, and Colin Ware. 1985. "Colour Perception Tutorial Notes." ACM SIGGRAPH, July 22–26, San Francisco, CA.

Cox, B. 1982. "Message/Object Programming: An Evolutionary Change in Programming Technology." *IEEE Software* (1): 1.

Crane, Randy. 1997. *A Simplified Approach to Image Processing Classical and Modern Techniques in C*. Floppy Disk. Englewood Cliffs, New Jersey: Prentice Hall.

Debabelizer Program. Equilibrium, Sausalito, CA.

Déforges, O., and N. Normand. 1997. "Recursive Morphological Operators for Gray Image Processing. Application in Ganulometry Analysis." IEEE International Conference on Image Processing, October 26–29, 1997, Santa Barbara, CA.

Deitel and Deitel. 1997. *Java: How to Program*. Englewood Cliffs, New Jersey: Prentice Hall.

Demeyer, S., S. Ducasse and S. Tichelaar. 1999. "Why Unified Is Not Universal. UML Shortcomings for Coping with Roundtrip Engineering." In Proceedings from UML'99. LNCS 1723, ed. B. Rumpe, Springer-Verlag, October 1999. *http://citeseer.nj.nec.com/demeyer99why.html*.

Deutsch, L. P. 1996. "DEFLATE Compressed Data Format Specification." *ftp://ftp.uu.net/pub/archiving/zip/doc/*.

Deutsch, L. P. 1996. "GZIP File format specification version 4.3." RFC1952. *http://ds.internic.net/rfc/rcf1952.txt*. *ftp://ftp.uu.net/graphics/png/documents/zlib/zdoc-index.html*.

DeWitt, Thomas D., and Douglas Lyon. 1995. "Three-Dimensional Microscope Using Diffraction Grating." Optcon, SPIE - International Society for Optical Engineering. Philadelphia, PA, October 24, 2599B-35. *http://www.DocJava.com*.

Dougherty. 1992. "An Introduction to Morphological Image Processing." Bellingham, WA: Optical Engineering Press.

Dyer, Charles R. 1983. "Gauge Inspection Using Hough Transform." *IEEE PAMI* 5 (6): 621–623.

Embree, Paul M., and Bruce Kimble. 1991. *C Language Algorithms for Digital Signal Processing*. Floppy Disk. Englewood Cliffs, New Jersey: Prentice Hall.

Espeset, Tonny. 1996. *Kick Ass Java*. CD-ROM. Coriolis Group Books.

Etter, Delores M. 1995. *Engineering Problem Solving with ANSI C*. Englewood Cliffs, New Jersey: Prentice Hall.

Feitelson, Dror G. 1989. *Optical Computing*. Cambridge, MA: The MIT Press.

Feller, William. 1968. *An Introduction to Probability Theory and Its Applications*. New York: John Wiley & Sons.

Fisher, K., and J. C. Mitchell. 1995. "A Delegation-based Object Calculus with Subtyping." In Procedures of FCT, Lecture Notes in Computer Science. Springer-Verlag. 965: 42–61. *http://citeseer.nj.nec.com/104746.html*.

Foley, van Dam, Feiner, and Hughes. 1996. *Computer Graphics Principles and Practice.* 2nd Edition. New York: Addison Wesley.

Forney, G. David. 1989. "Introduction to Modem Technology: Theory and Practice of Bandwidth Efficient Modulation from Shannon and Nyquist to Date." Distinguished Lecture Series, vol. II. Video. University Video Communications. Stanford, CA.

Fowler, Martin. 2000. *UML Distilled: A Brief Guide to the Standard Object Modeling Language.* 2nd Edition. New York: Addison Wesley.

Frank, Ulrich. 2000. "Delegation: An Important Concept for the Appropriate Design of Object Models." *Journal of Object Oriented Programming,* June: 13–17, 44.

Fraser, Timothy, Lee Badger, and Mark Feldman. 1999. "Hardening COTS Software with Generic Software Wrappers." In *IEEE Symposium on Security and Privacy.* *http://citeseer.nj.nec.com/fraser99hardening.html.*

Galbiati, Louis J. Jr. 1990. *Machine Vision and Digital Image Processing Fundamentals.* Englewood Cliffs, New Jersey: Prentice Hall.

Gamma, Erich, Richard Helm, Ralph Johnson, and John Vlissides. 1995. *Design Patterns.* New York: Addison Wesley.

Geary, David M. 1997. *Graphic Java Mastering the AWT.* 2nd Edition. CD-ROM. Englewood Cliffs, New Jersey: Prentice Hall.

Geary, David M., and Alan L. McClellan. 1997. *Graphic Java Mastering the AWT.* CD-ROM. Englewood Cliffs, New Jersey: Prentice Hall.

Gersho. 1978. "Principles of Quantization." *IEEE Transactions on Circuits and Systems* CAS-25 (7): 427–436.

Glassner, Andrew S., ed. 1989. *An Introduction to Ray Tracing.* Cambridge, MA: Academic Press, Inc.

Gonzalez, Rafael C., and Paul Wintz. 1977. *Digital Image Processing.* New York: Addison Wesley.

Gonzalez, Rafael C., and Richard Woods. 1992. *Digital Image Processing.* New York: Addison Wesley.

Gordon, R. 1998. *Essential JNI: Java Native Interface.* Englewood, NJ: Prentice Hall.

Gosling, James, Bill Joy, and Guy Steele. 1996. *The Java Language Specification.* New York: Addison Wesley.

Graf, Rudolf F., and William Sheets. 1987. *Video Scrambling & Descrambling for Satellite & Cable TV.* Carmel, IN: SAMS, a division of Prentice Hall.

Guil, N., J. Villalba, and E.L. Zapata, 1995. "A Fast Hough Transform for Segment Detection."

Hall, Ernest L. 1974. "Almost Uniform Distributions for Computer Image Enhancement." *IEEE Transactions on Computers,* February: 207–208.

Halliday, David, and Robert Resnick. 1978. *Physics.* New York: John Wiley & Sons.

Harrison, William, Harold Ossher, and Peri Tarr. 1999. "Using Delegation for Software and Subject Composition." Research Report RC 20946, IBM Thomas J. Watson Research Center, August.
http://www.research.ibm.com/sop/soppubs.htm.

Harbison, S. 1992. *Modula-3*. Englewood Cliffs, New Jersey: Prentice Hall.

Hauck, F. J. 1993. "Inheritance Modeled with Explicit Bindings: an Approach to Typed Inheritance." Procedures of the Conference on Object-Oriented Programming, System Languages, and Applications (OOPSLA), Washington, D.C., September 26–Oct. 1; SIGPLAN Notices 28 (10).
http://citeseer.nj.nec.com/hauck93inheritance.html.

Heckbert, Paul S. 1980. *Color Image Quantization for Frame Buffer Display*. B.S. thesis, Architecture Machine Group, MIT, Cambridge, MA.
http://www.cs.cmi.edu/~ph.

Heckbert, Paul. 1982. "Color Image Quantization for Frame Buffer Display." *Computer Graphics* 16 (3): 297–307. *http://www.cs.cmi.edu/~ph*.

Heckbert, Paul S. 1990. "Digital Line Drawing." In *Graphics Gems*, ed. Andrew S. Glassner, 99–100 and 685. Cambridge, MA: Academic Press, Inc.

Heckbert, Paul. 1989. "Fundamentals of Texture Mapping and Image Warping." master's thesis, Dept. of Electrical Engineering and Computer Science, University of California, Berkeley. UCB/CSD 89/516.
http://www.cs.cmi.edu/~ph.

Heckbert, Paul. 1986. "Survey of Texture Mapping." Nov.: 56–67. IEEE CGA.
http://www.cs.cmi.edu/~ph.

Hennessy, John, and David Patterson. 1996. *Computer Architecture: A Quantitative Approach*. 2nd Edition. Morgan Kaufman, New York

Hockney, Roger W. 1996. *The Science of Computer Benchmarking*. Philadelphia, PA: Society of Industrial and Applied Mathematics.

Holzmann, Gerard J. 1988. *Beyond Photography*. Englewood Cliffs, New Jersey: Prentice Hall.

Huffman. 1952. "A Method for the Construction of Minimum Redundancy Codes." *Proceedings of the Institute of Radio Engineers* 40 (9): 1098–1101.

Hunt, R. W. G. 1991. *Measuring Color*. 2nd Edition. West Sussex, England: Ellis Horwood.

Hussain, Zahid. 1991. *Digital Image Processing*. West Sussex, England: Ellis Horwood.

IEEE Standard for Binary Floating-Point Arithmetic. 1985. ANSI/IEEE Standard 754–1985. Global Engineering Documents, Englewood, CO.

Inglis, Andrew F. 1993. *Video Engineering*. New York: McGraw-Hill.

Jähne, Bernd. 1993. *Digital Image Processing, Concepts, Algorithms, and Scientific Applications*. 2nd Edition. New York: Springer-Verlag.

Jain, Anik K. 1989. *Fundamentals of Digital Image Processing*. Englewood Cliffs, New Jersey: Prentice Hall.

Johnson, Ralph E., and William F. Opdyke. 1993. "'Refactoring and Aggregation': Object Technologies for Advanced Software." First JSSST International Symposium, Lecture Notes in Computer Science, Springer-Verlag. 742; 264–278.

Johnson, Ralph E., and William F. Opdyke. 1993. "Refactoring and Aggregation." In International Symposium on Object Technologies for Advanced Software, eds. S. Nishio and A. Yonezawa, 264–278, Kanazawa, Japan, November 1993. Also in JSSST, Springer Verlag, Lecture Notes in Computer Science. *http://citeseer.nj.nec.com/johnson93refactoring.html*.

Johnson and Zweig. 1991. "Delegation in C++." *Journal of Object-Oriented Programming*, 4 (11): 22–35.

Kassem, N. 2000. *Designing Enterprise Applications with the Java 2 Platform*. New York: Addison Wesley.

Kasson, J. 1992. "An Analysis of Selected Computer Interchange Color Spaces." 11 (4): 373–405. ACM Transactions on Graphics archive.

Kataoka, Yoshio, Michael D. Ernst, William G. Griswold, and David Notkin. 2001. "Automated Support for Program Refactoring Using Invariants." *http://citeseer.nj.nec.com/kataoka01automated.html*.

Kay, David C., and John R. Levine. 1995. *Graphics File Formats*. Windcrest, an imprint of M.H. New York: McGraw-Hill.

Kientzle, Tim. 1995. *Internet File Formats*. Scottsdale, AZ: Corilois Group Books.

Kniesel, Günter. 1998. "Delegation for Java: API or Language Extension?" Technical report IAI-TR-98-5, May 1998, University of Bonn, Germany. *http://citeseer.nj.nec.com/kniesel97delegation.html*.

Kniesel, Günter. 2001. E-mail message to author.

Kniesel, Günter. 1994. "Implementation of Dynamic Delegation in Strongly Typed Inheritance-Based Systems." Technical report IAI-TR-94-3, Oct. 1994, University of Bonn, Germany. *http://citeseer.nj.nec.com/kniesel95implementation.html*.

Kniesel, Günter. 1999. "Type-Safe Delegation for Run-Time Component Adaptation." In Proceedings of ECOOP99, ed. R. Guerraoui. Springer LNCS 1628. *http://citeseer.nj.nec.com/kniesel99typesafe.html*.

Korman, W., and W. G. Griswold. 1998. "Elbereth: Tool Support for Refactoring Java Programs." Technical report, University of California, San Diego Department of Computer Science and Engineering, May 1998. *http://citeseer.nj.nec.com/korman98elbereth.html*.

Kruger, Anton. 1994. "Median-Cut Color Quantization: Fitting True-Color Images into VGA Displays." *Dr. Dobb's Journal of Software Tools*. 19 (10): 46. *http://www.ddj.com/*.

Kwok, S. H., and A. G. Constantinides. 1997. "A Fast Recursive Shortest Spanning Tree for Image Segmentation and Edge Detection." *IEEE Transactions on Image Processing* 6 (2): 328–332.

Lai, Kok Fung. 1994. *Deformable Contours: Modeling, Extraction, Detection and Classification.* Ph.D. thesis, Electrical Engineering Department, University of Wisconsin-Madison.

Laurel, Brenda, ed. 1990. *The Art of Human-Computer Interface Design.* New York: Addison Wesley.

Lea, Doug. 1997. *Concurrent Programming in Java.* New York: Addison Wesley.

Leiberman, Henry. 1986. "Using Prototypical Objects to Implement Share Behaviour in Object-oriented Systems." In *Object-oriented Programming Systems, Languages and Applications Conference Proceedings*: 214–223.

Lemay, Laura, and Charles L. Perkins. 1996. *Teach Yourself Java in 21 Days.* CD-ROM. Sam's Publishing.

Lempel, A., and Ziv J. 1977. "A Universal Algorithm for Sequential Data Compression." *IEEE Transactions on Information Theory* 23 (3): 337–343.

Levine, Martin. 1985. *Vision in Man and Machine.* New York: McGraw-Hill.

Lyon, Douglas. 1990. "Ad-Hoc and Derived Parking Curves." SPIE - International Society for Optical Engineering, Boston, MA, November 8.

Lyon, Douglas. 1997. "Apparatus and Method for the Generation of Nth Order Markov Events with Improved Management of Memory and CPU Usage." Number 60/034,303, December 23. United States Patent and Trademark Office, Patent Pending.

Lyon, Douglas. 2002. "CentiJ: An RMI Code Generator." *Journal of Object Technology (JOT)* 1 (5): 1–32. *http://www.jot.fm/issues/issue_2002_11/article2.*

Lyon, Douglas. 1999. *Image Processing in Java.* CD-ROM. Englewood Cliffs, New Jersey: Prentice Hall.

Lyon, Douglas. 1991. "Parallel Parking with Nonholonomic Constraints." Ph.D. thesis, Computer and Systems Engineering Department, RPI, Troy, NY. *http://www.DocJava.com.*

Lyon, Douglas. 1985. *Raster-To-Vector Conversion with A Vector Ordering Post-process. Image Processing Laboratory User Bulletin* U-170, June 25, Computer and Systems Engineering Department, RPI, Troy, NY.

Lyon, Douglas. 1995. "Using Stochastic Petri Nets for Real-time Nth-order Stochastic Composition." *Computer Music Journal* 19 (4): 13–22.

Lyon, Douglas, and H. Rao. 1998. *Java Digital Signal Processing.* New York: M&T Books.

MacLinkPlus. DataViz, Inc., Trumbull, CT.

Marr, D., and E. Hildreth. 1980. "Theory of Edge Detection." *Proc. Royal Soc. London.* Series B 207:187–217.

Martelli, Alberto. 1976. "An Application of Heuristic Search Methods to Edge and Contour Detection." *CACM* 19 (2): 73–83.

Martelli, Alberto. 1972. "Edge Detection Using Heuristic Search Methods." *CGIP* 1 (2):169–182.

Martindale, David, and Alan W. Paeth. 1991. "Television Color Encoding and 'Hot' Broadcast Colors." *Graphics Gems* II: 147–158.

Mattison, Philip E. 1994. *Practical Digital Video with Programming Examples in C*. New York: John Wiley & Sons.

McGee, Kiaran P., Timothy E. Schultheiss, and Eric E. Martin. 1995. "A Heuristic Approach to Edge Detection in On-line Portal Imaging." *Int. J. Radiation Oncology Biol. Phys.* 32 (4): 1185–1192.

Mehrotra, Rajiv, and Shiming Zhan. 1996. "A Computational Approach to Zero-Crossing-Based Two-Dimensional Edge Detection." *Graphical Models and Image Processing* 58 (1): 1–17.

Mehtre, Babu M., Mohan S. Kankanhalli, A. Desai Narasimhalu, and Guo Chang Man. 1995. "Color Matching for Image Retrieval." *Pattern Recognition Letters* 16 (March): 325–331.

Merlin, Philip M., and David J. Farber. 1975. "A Parallel Mechanism for Detecting Curves in Pictures." *IEEE Transactions on Computers* January: 96–98.

Meyer, J., and T. Downing. 1997. *Java Virtual Machine*. Sebastopol, CA: O'Reilly and Associates.

Mitra, Sanjit K., and James F. Kaiser. 1993. *Handbook for Digital Signal Processing*. New York: John Wiley & Sons.

Moore, F. R. 1990. *Elements of Computer Music*. Englewood Cliffs, New Jersey: Prentice Hall.

Moore, Theral O. 1964. *Elementary General Topology*. Englewood Cliffs, New Jersey: Prentice Hall.

Mullet, Kevin, and Darrell Sano. 1995. *Designing Visual Interfaces*. Englewood Cliffs, New Jersey: Prentice Hall.

Murray, James D., and William Vanryper. 1996. *Graphics File Formats*. CD-ROM. Sebastopol, California. O'Reilly & Associates.

Myler, Harley R., and Arthur R. Weeks. 1993. *Computer Imaging Recipes in C*. Floppy Disk. Englewood Cliffs, New Jersey: Prentice Hall.

Nadler, Morton, and Eric P. Smith. 1993. *Pattern Recognition Engineering*. New York: John Wiley & Sons.

Nanzetta and Strecker. 1971. *Set Theory and Topology*. Tarrytown-on-Hudson, New York: Bogden and Quigley, Inc.

NetPBM. 1993. Public domain image processing package. *ftp://wuarchive.wustl.edu/graphics/graphics/packages/NetPBM*.

Netravali, Arun, and Barry Haskell. 1988. *Digital Pictures*. New York : Plenum Press.

Newman, William M., and Robert F. Sproull. 1979. *Principles of Interactive Computer Graphics*. New York: McGraw-Hill.

Nilsson, Nils J. 1980. *Principles of Artificial Intelligence*. Palo Alto, CA: Tioga Publishing Company.

Oaks, Scott, and Henry Wong. 1997. *Java Threads*. Sebastopol, CA: O'Reilly and Associates, Inc.

O'Callahan, R., and D. Jackson, 1997. "Lackwit: A Program Understanding Tool Based on Type Inference." Proceedings of the 1997 International Conference on Software Engineering (ICSE'96), Boston, MA, May 1997: 338–348. *http://citeseer.nj.nec.com/329620.html*.

Opdyke, William F. 1992. *Refactoring Object-Oriented Frameworks*, PhD diss., University of Illinois. *ftp://st.cs.uiuc.edu/pub/papers/refactoring/*.

Opdyke, William F., and Ralph E. Johnson. 1993. "Creating Abstract Superclasses by Refactoring." Proceedings CSC'93, ACM Press.

Pal, Nikhil R., and Sankar K. Pal. 1993. "A Review on Image Segmentation Techniques." *Pattern Recognition* 26 (9) 1277–1294.

Peli, Tamar, and David Malah. 1982. "A Study of Edge Detection Algorithms." *Computer Graphics and Image Processing* 20: 1–21.

Pettofrezzo, Anthony J. 1996. *Matrices and Transformations*. New York: Dover Publications, Inc.

Poole, David, Alan Mackworth, and Randy Goebel. 1998. *Computational Intelligence, A Logical Approach*. New York: Oxford University Press.

Postema, Margot, and Heinz W. Schmidt. 1997. *Reverse Engineering and Abstraction of Legacy Systems. http://citeseer.nj.nec.com/151140.html*.

Poynton, Charles. 1996. *Frequently Asked Questions about Gamma. http://www.inforamp.net/~poynton/Mac_gamma.pdf*.

Poynton, Charles. 1998. *Frequently Asked Questions about Gamma. http://www.inforamp.net/~poynton*.

Poynton, Charles. 1996. *A Technical Introduction to Digital Video*. New York: John Wiley & Sons. Chapter 6 available at *http://www.inforamp.net/~poynton/TIDV/Gamma.pdf*.

Pratt, William K. 1991. *Digital Image Processing*. New York: John Wiley & Sons.

Preparata, Franco P., and Michael Ian Shamos. 1985. *Computational Geometry*. New York: Springer-Verlag.

Rabuka, Scott. 1998. Personal communications with MapleSoft technical support. *support@maplesoft.com*.

Ralston, Anthony, ed. 1983. *Encyclopedia of Computer Science and Engineering*. 2nd Edition. New York: Van Nostrand Reinhold Company.

Resnick, Robert, and David Halliday. 1978. *Physics*. 3rd Edition. New York: John Wiley & Sons.

Roberts, Don, John Brant, and Ralph Johnson. 1997. "A Refactoring Tool for Smalltalk." *Theory and Practice of Object Systems* 3 (4):253–63.

Roberts, Eric. 1993. "Using C in CS1 Evaluating the Stanford Experience." *SIGCSE Bulletin* 24 (2): 117–121.

Roberts, Fred S. 1984. *Applied Combinatorics*. Englewood Cliffs, New Jersey: Prentice Hall.

Royce, W. W. 1970. "Managing the Development of Large Software Systems: Concepts and Techniques." ESCON Technical Papers, Western Electronic Show and Conventions, Los Angeles: A/1-1–A/1-9.

RP 37-1969. 1969. SMPTE Recommended Practice. White Plains, New York. Society of Motion Picture and Television Engineers.

Said, A., and W. A. Pearlman. 1996. "An Image Multiresolution Representation for Lossless and Lossy Image Compression." *IEEE TIP* 5 (September): 1303–1310.

Schalkoff, Robert J. 1989. *Digital Image Processing and Computer Vision*. New York: John Wiley & Sons.

Shamma. 1989 "Spatial and Temporal Processing in Central Auditory Networks." in *Methods in Neuronal Modeling*, eds. Koch and Segev. Cambridge, MA: The MIT Press: 247–289.

Shirai, Yoshiaki. 1987. *Three-Dimensional Computer Vision*. New York: Springer-Verlag.

Shneidermand. 1987. *Designing the User Interface: Strategies for Effective Human-Computer Interaction*. New York: Addison Wesley.

Singhal, S., and B. Nguyen. 1998. "The Java Factor." *Communications of the ACM* 41 (6): 34–37.

Snyder, Alan. "Encapsulation and Inheritance in Object-Oriented Programming Languages." Affiliation Software Technology Laboratory, Hewlett-Packard Laboratories, Palo Alto, CA. *http://citeseer.nj.nec.com/328789.html*.

Standish, Thomas A. 1998. *Data Structures in Java*. New York: Addison Wesley.

Stevens, Roger T. 1997. *Graphics Programming with Java*. Rockland, MA: Charles River Media, Inc.

Stockham, Thomas G. Jr. 1972. "Image Processing in the Context of a Visual Model." *Proceeding of the IEEE* 60 (July): 828–842.

Stollnitz, Eric, Tony DeRose, and David Salesin. 1996. *Wavelets for Computer Graphics*. Morgan Kaufman.

Stroustrup, Bjarne. 1994. *The Design and Evolution of C++*. Addison-Wesley, Reading, MA.

Stroustrup, Bjarne. 1987. "Multiple Inheritance for C++." In Proceedings of the spring 1987 European Unix Systems User's Group Conference, Helsinki, Finland, May 1987. *http://citeseer.nj.nec.com/stroustrup99multiple.html*.

Stroustrup, Bjarne, James Gosling, and Dennis Richie. 2000. "The C Family of Languages: Interview with Dennis Ritchie, Bjarne Stroustrup, and James Gosling." *Java Report* 5 (7) and *C++ Report* 12 (7). *http://www.gotw.ca/publications/c_family_interview.htm*.

Sturrock, Walter, and K. A. Staley. 1956. *Fundamentals of Light and Lighting*. Bulletin LD-2, General Electric, Large Lamp Department, Albany, NY.

Subramanian, Kalpathi R., and Bruce F. Naylor. 1997. "Converting Discrete Images to Partitioning Trees." *IEEE TVCG* 3 (3) : 273–288.

Sun Microsystems, Inc. 2001. *Java API for XML Parsing 1.1*. February 12. *http://java.sun.com/xml/download.html#prodspec*.

Sun Microsystems. 2001. "The JavaBeans Runtime Containment and Services Protocol Specification." May 24. *http://java.sun.com/products/javabeans/glasgow/#containment*.

Sun Microsystems. 2000. "Using Dynamic Proxies to Layer New Functionality over Existing Code." May 30. *http://developer.java.sun.com/developer/TechTips/2000/tt0530.html*.

Sun Microsystems. 1998. *http://java.sun.com/pr/1998/05/spotnews/sn980520.html*.

Sweldens, Wim. 1995. "The Lifting Scheme: A New Philosophy in Biorthogonal Wavelet Constructions." In *Wavelet Applications in Signal and Image Processing III*, eds. A. F. Laine and M. Unser, 68-79, Proc. SPIE 2569. *http://cm.bell-labs.com/who/wim/papers/papers.html*.

Teevan, Richard C., and Rovert C. Birney, eds. 1961. *Color Vision*. Princeton, NJ: Van Nostrand.

Tempero, Ewan, and Robert Biddle. 2000. "Simulating Multiple Inheritance in Java." *The Journal of Systems and Software* 55: 87–1000.

Thomas, Spencer W. 1991. "Efficient Inverse Color Map Computation." In *Graphics Gems*, vol. II, ed. James Arvo, 116–125. Cambridge, MA: Academic Press, Inc.

Thompson, Tom. 1996. *PowerPC™ Programmers Toolkit*. CD-ROM. Indianapolis, Indiana. Hayden Books.

Tichelaar, Sander, Stéphane Ducasse, Serge Demeyer, and Oscar Nierstrasz. "A Meta-model for Language-Independent Refactoring." IEEE Proceedings ISPSE, 2000. *http://citeseer.nj.nec.com/379788.html*.

Tognazzini, Bruce. 1992. *Tog on Interface*. New York: Addison Wesley.

Torre, Vincent, and Tomaso A. Poggio. 1986. "On Edge Detection." *IEEE-PAMI* PAMI-8 (2): 147–163.

Travis, David. 1991. *Effective Color Displays*. Cambridge, MA: Academic Press, Inc.

Tyma, P. 1998. "Why Are We Using Java Again?" *Communications of the ACM* 41 (6): 38–42.

Umbaugh, Scott E. 1998. *Computer Vision and Image Processing*. New York: Addison Wesley.

The Unicode Standard: Worldwide Character Encoding. 1996. New York: Addison Wesley.

Uytterhoeven, Geert, Filip Van Wulpen, Maarten Jansen, Dirk Roose, and Adhemar Bultheel 1997. "Waili: Wavelets with Integer Lifting." Report TW262, July,

Katholieke Universiteit Lueven, Department of Computer Science, Celestijnenlaan 200 A - B-30001, Heverlee, Belgium. *http://www.cs.kuleuven.ac.be/publicaties/rapporten/tw/TW262.abs.html*.

Viega, John, Bill Tutt, and Reimer Behrends. 1998. "Automated Delegation Is a Viable Alternative to Multiple Inheritance in Class Based Languages." CS-98-03, Microsoft Corporation. Feb. *http://citeseer.nj.nec.com/3325.html*.

Vliet, Lucas J. van, Ian T. Young, and Guus L. Beckers. 1989. "A Nonlinear Laplace Operator as Edge Detector in Noisy Images." *Computer Vision, Graphics and Image Processing* 45: 167–195.

Wand, Mitchell. 1989. "Type Inference for Record Concatenation and Multiple Inheritance." Fourth Annual IEEE Symposium on Logic in Computer Science, Pacific Grove, CA. June: 92–97. *http://citeseer.nj.nec.com/wand89type.html*.

Watkins, Christopher, Alberto Sadun, and Stephen Marenka. 1993. *Modern Image Processing: Warping, Morphing and Classical Techniques*. Cambridge, MA: Academic Press, Inc.

Watson, Mark. 1993. *Portable GUI Development with C++*. New York: McGraw-Hill.

Weeks, Arthur R. Jr. 1996. *Fundamentals of Electronic Image Processing*. IEEE Los Alamitos, CA: Computer Society Press.

Wehmeier, Udo, D. Dong, C. Koch, and D. Essen. 1989. "Modeling the Mammalian Visual System." In *Methods in Neuronal Modeling*, eds. Koch and Segev, 335–359. Cambridge, MA: The MIT Press.

Widder, David V. 1947. *Advanced Calculus*. Englewood Cliffs, New Jersey: Prentice Hall.

Williams, L. G. 1966. "The Effect of Target Specification on Objects Fixated During Visual Search." *Perception and Psychophysics* 1: 315–318.

Winkler, Dean. 1992. "Video Technology for Computer Graphics." Course Notes 4, SIGGRAPH 1992, McCormick Place, Chicago, July 26–31.

Winston, Patrick Henry, and Sundar Narasimhan. 1996. *On to Java*. On-line material. New York: Addison Wesley.

Wolberg, George. 1990. *Digital Image Warping*. Los Alamitos, CA: Computer Society Press.

Woods and Gonzalez. 1981. "Real-Time Digital Image Enhancement." *Proceedings of the IEEE* 69 (5): 643–657.

World Wide Web Consortium. 1999. *Namespaces in XML*. January 14, 1999. *http://www.w3.org/TR/REC-xml-names/*.

World Wide Web Consortium. 2001. *XML Schema Part 0: Primer*. May 2. *http://www.w3.org/TR/xmlschema-0/*.

World Wide Web Consortium. 2001. *XML Schema Part 1: Structures*. May 2. *http://www.w3.org/TR/xmlschema-1/*.

World Wide Web Consortium. 2001. *XML Schema Part 2: Datatypes*. May 2. *http://www.w3.org/TR/xmlschema-2/*.

Wright, Anthony, and Scott T. Acton. 1997. "Watershed Pyramids for Edge Detection." IEEE International Conference on Image Processing, October 26–29, 1997, Santa Barbara, CA.

Wu, Xiaolin. 1991. "Efficient Statistical Computations for Optimal Color Quantization." *Graphics Gems* vol. II, ed. James Arvo, 126–133. Cambridge, MA: Academic Press, Inc.

Wu, Xiaolin. 1997. "Lossless Compression of Continuous-Tone Images via Context Selection, Quantization and Modeling." *IEEE TIP* 6 (5): 656–664.

Wyszecki, Günter, and W. S. Stiles. 1967. *Color Science*. New York: John Wiley & Sons.

XSL Transformations (XSLT) Version 1.0 W3C Recommendation. November 16, 1999. *http://www.w3.org/TR/xslt*.

Yu, Tian-Hu, and S. K. Mitra. 1993. "A New Adaptive Contrast Enhancement Method." *SPIE* 1903 (Image and Video Processing): 103–110.

Ziv, J., and Z. Lempel. 1977. "A Universal Algorithm for Sequential Data Compression." *IEEE Transactions on Information Theory*. IT-23 (May): 337–343.

Zmuda, Michael A., and Louis A. Tamburino. 1996. "Efficient Algorithms for the Soft Morphological Operators." *IEEE PAMI* 18 (11): 1142–1147.

APPENDIX A

Syntax

A turtle makes progress when it sticks its neck out.

–Proverb

A.1 Introduction to Grammar

In this book, we use Modified Back us Naur Formalislm (MBNF) to describe the syntax of Java. We use the translate functor of Prolog, " \rightarrow ", as a digraphic symbol meaning "can be written as" [Clocksin and Mellish].

People who study formal languages refer to the " \rightarrow " symbol as a production. We have found the standard notation, as used in the Java specification, to be hard to replicate on a blackboard during lectures. We wanted a compact notation that would have a typeset appearance that does not deviate significantly from the handwritten appearance, which means no boldface or italics could be used in the syntax definition.

The meta-symbols of MBNF are shown in Figure A.1-1.

Meta-Symbol	Meaning
\longrightarrow	can be written as
(X\|Y)	grouping alternatively, X or Y
< >	syntactic construct, nonterminal symbol meta identifier
[X]	0 or 1 instance of X
{X}	0 or more instances of X
" "	terminal
.	end of production

FIGURE A.1-1
Meta-Symbols of MBNF

698

The term *meta* comes from the Greek, meaning *after, along with, behind*, or *beyond*. A *meta language* is a language that defines a language. Thus, MBNF is a meta language because we can use it to define other languages.

As an example, we show MBNF in MBNF in Figure A.1-2.

```
syntax          →   { production }.
production      →   identifier  " → "  expression "." .
expression      →   term { "|" term } .
term            →   factor { factor } .
factor          →   identifier |
                    quotedSymbol |
                    "("  expression  ")" |
                    "["  expression  "]" |
                    "{"  expression  "}" .
identifier      →   letter { letter | digit } .
quotedSymbol    →   """ { anyCharacter } """ .
```

FIGURE A.1-2
MBNF

The metalinguistic variable *syntax* can be written as a series of productions. The metalinguistic variable *production* can be written as an *identifier* followed by the translate functor, an expression, and a period.

MBNF enables the formulation of languages that compile. It defines the grammar of a language (also called the *syntax* of a language). However, syntax does not describe the meaning of the statement, nor does it describe the common usage. To describe meaning and common usage, we use examples and prose. As another example, the syntax of the *while* statement is given by

whileStatement →

"while" "(" expression")" statement .

which can be read as follows: "a *while* statement can be written as the keyword *while* followed by the symbol "(", followed by an *expression*, followed by the symbol")", followed by a statement.

The MBNF rules of Java are:

1. compilationUnit →

 [packageStatement]

 < importStatement >

 < typeDeclaration >.

2. packageStatement →

 "package" packageName ";" .

3. importStatement →

 "import" ((packageName "." "*" ";") |

 (className | interfaceName)) ";" .

4. typeDeclaration →
> [docComment] (classDeclaration | interfaceDeclaration) ";" .

5. docComment →
> "/**" "... text ..." "*/" .

6. classDeclaration →
> < modifier > "class" identifier ["extends" className]
> ["implements" interfaceName < "," interfaceName >]
> "{" < fieldDeclaration > "}" .

7. interfaceDeclaration →
> < modifier > "interface" identifier ["extends" interfaceName < "," inter-
> faceName >] "{" < fieldDeclaration > "}" .

8. fieldDeclaration →
> ([docComment] (methodDeclaration | constructorDeclaration | vari-
> ableDeclaration)) | staticInitializer | ";" .

9. method_declaration →
> < modifier > type identifier "(" [parameterList] ")" < "[" "]" > (statement-
> Block | ";") .

10. constructorDeclaration →
> < modifier > identifier "(" [parameterList] ")" statementBlock .

11. statementBlock →
> "{" < statement > "}" .

12. variableDeclaration →
> < modifier > type variableDeclarator < "," variableDeclarator > ";" .

13. variableDeclarator →
> identifier < "[" "]" > ["=" variableInitializer] .

14. variableInitializer →
> expression | ("{" [variableInitializer < "," variableInitializer > [","]] "}") .

15. staticInitializer →
> "static" statementBlock .

16. parameterList →
> parameter < "," parameter > .

17. parameter →
> type identifier < "[" "]" > .

18. statement →
> variableDeclaration |
> (expression ";") |
> (statementBlock) |
> (ifStatement) |
> (doStatement) |
> (whileStatement) |
> (forStatement) |
> (tryStatement) |

(switchStatement) |
("synchronized" "(" expression ")" statement) | ("return" [expression] ";") |
("throw" expression ";") | (identifier ":" statement) | ("break" [identifier] ";") | ("continue" [identifier] ";") | (";").

19. ifStatement →

"if" "(" expression ")" statement ["else" statement].

20. doStatement →

"do" statement "while" "(" expression ")" ";".

21. whileStatement →

"while" "(" expression ")" statement.

22. forStatement →

"for" "(" (variableDeclaration | (expression ";") | ";") [expression] ";" [expression] ";" ")" statement.

23. tryStatement →

"try" statement < "catch" "(" parameter ")" statement > ["finally" statement].

24. switchStatement →

"switch" "(" expression ")" "{" < ("case" expression ":") | ("default" ":") |
statement > "}".

25. expression →

numericExpression | testingExpression |
logicalExpression | stringExpression | bitExpression |
castingExpression | creatingExpression |
literalExpression | "null" | "super" | "this" | identifier | ("(" expression ")") |
(expression (("(" [arglist] ")") | ("[" expression "]") | ("." expression) | (","
expression) | ("instanceof" (className | interfaceName)))).

26. numericExpression →

(("−" | "++" | "−−") expression) |
(expression ("++" | "−−")) |
(expression ("+" | "+=" | "−"
| "−=" | "*" | "*=" | "/" | "/=" | "%" | "%=") expression).

27. testingExpression →

(expression (">" | "<" | ">=" | "<=" | "==" | "!=") expression).

28. logicalExpression →

("!" expression) | (expression ("&" | "&=" | "|" | "|=" | "^" | "^ =" | ("&&") |
"|=" | "%" | "%=") expression) | (expression "?" expression ":" expression)
| "true" | "false".

29. stringExpression = (expression ("+" | "+=") expression).

30. bitExpression →

("~" expression) | (expression (">=" | "<<" | ">>" | ">>>") expression).

31. castingExpression →

"(" type ")" expression .

32. creatingExpression \rightarrow

"new" ((className "(" [arglist] ")") | (type_specifier ["[" expression "]"] < "[" "]" >) | ("(" expression ")")).

33. literalExpression \rightarrow

integerLiteral | floatLiteral | string | character .

34. arglist \rightarrow

expression < "," expression > .

35. type \rightarrow

typeSpecifier < "[" "]" > .

36. typeSpecifier \rightarrow

"boolean" | "byte" | "char" | "short" | "int" | "float" | "long" | "double" | className | interfaceName .

37. modifier \rightarrow

"public" | "private" | "protected" | "static" | "final" | "native" | "synchronized" | "abstract" | "threadsafe" | "transient" .

38. packageName \rightarrow

identifier | (packageName "." identifier) .

39. className \rightarrow

identifier | (packageName "." identifier) .

40. interfaceName \rightarrow

identifier | (packageName "." identifier) .

41. integerLiteral \rightarrow

(("1..9" < "0..9" >) | < "0..7" > | ("0" "x" "0..9a..f" < "0..9a..f" >)) ["l"] .

42. floatLiteral \rightarrow

(decimalDigits "." [decimalDigits] [exponentPart] [floatTypeSuffix]) | ("." decimalDigits [exponentPart] [floatTypeSuffix]) | (decimalDigits [exponentPart] [floatTypeSuffix]) .

43. decimalDigits \rightarrow

"0..9" < "0..9" > .

44. exponentPart \rightarrow

"e" ["+" | "−"] decimalDigits .

45. floatTypeSuffix \rightarrow

"f" | "d" .

46. character \rightarrow

"based on the unicode character set" .

47. string \rightarrow

""" < character > """ .

48. identifier \rightarrow

"a..z,$,_" < "a..z,$,_,0..9,unicode character over 00C0" > .

A.2 Reserved Words

Figure A.2-1 shows a list of reserved words in Java.

abstract	else	long	switch
assert	extends	native	synchronize
boolean	final	new	this
break	finally	null	throw
byte	float	package	throws
case	for	private	transient
catch	goto	protected	try
char	if	public	void
class	implements	return	volatile
const	import	short	while
continue	instanceof	static	
do	int	strictfp	
double	interface	super	

FIGURE A.2-1
Reserved Words of Java

Reserved words cannot be used as identifiers.
The primitive data types of Chapter 5 are shown in Figure A.2-2.

boolean
char
byte
float
double
short
int
long

FIGURE A.2-2
The Primitive Data Types of Chapter 5

The control structures of Chapter 7 are shown in Figure A.2-3.

if
else
do
while
continue
break
switch
case
return
for

FIGURE A.2-3
The Control Structures of Chapter 7

Figure A.2-4 shows the reference related reserved words Chapter 8.

class
interface
null
new
instanceof
extends
super
this
void
implements

FIGURE A.2-4
Reference Related Reserved Words

Figure A.2-5 shows the *static, abstract*, and *final* modifiers of Chapter 9.

FIGURE A.2-5
The static, abstract, and final
Modifiers of Chapter 9

static
abstract
final

Figure A.2-6 shows the exception-related keywords of Chapter 13.

FIGURE A.2-6
The Exception-Related
Keywords of Chapter 13

throw
throws
try
catch
finally

Figure A.2-7 shows the reference-related keywords of Chapter 14.

FIGURE A.2-7
The Reference-Related Keywords of
Chapter 14

import
package
private
protected
public

Figure A.2-8 shows some miscellaneous keywords. The *native* keyword is used for the Java Native Interface (JNI) API (which is beyond the scope of this book). The *synchronized* keyword is covered in Chapter 16. The keywords *goto* and *const* are not used in Java. The keywords *transient* and *volatile* are covered in Chapter 19. Many of the keywords shown in Figure A.2-8 were introduced in Chapter 14.

Streams	Unused
transient	goto
volatile	const
Interfacing	**Threads**
native	synchronized

FIGURE A.2-8
Miscellaneous Keywords

A.3 Summary

MBNF is a compact grammatical statement of a language. Not all languages have such a compact statement. For example, C and C++ have no such compact statements because these languages have macros, which permit the extension of the grammar of the language. For example, in C you can type

```
#define begin {
#define end }
```

which alters the grammar of the language so that *if* statements like

```
if (x < 3) {
        printf("x is small");
}
```

instead look like

```
if (x < 3)
begin
        printf("x is small");
end
```

Being able to change the grammar of the language is not a feature that the Java language designers wanted for their language. As a result, Java's grammar is more compact.

Java: The Good, the Bad, and the Ugly

by Douglas Lyon and Frances S. Grodzinsky, Ph.D.

> We see but dimly through the mists and vapors;
> Amid these earthly damps
> What seem to us but sad, funeral tapers
> May be heaven's distant lamps.
>
> *–Longfellow (1819–1892)*

Many books gush over Java. Before they learn a language, however, people want to know about that a language's drawbacks and strengths. After all, a computer language is just a tool. We shape our tools, and thereafter our tools shape us!

This chapter contains a dialogue between three Java instructors: Professor Good, Professor Bad, and Doctor Ugly. Professor Good is a strong proponent of Java. Professor Bad is a strong opponent of Java. Doctor Ugly has been focusing on an aesthetic analysis of the language, particularly with an eye toward teaching. Our "gang of three" evaluate aspects of the language, the Java environment, and Java as a teaching tool.

B.1 Introduction

Arguments about preferences in programming languages, especially when those languages are used as a teaching tool, often become akin to religious ones. Although we may be motivated to attempt to quantify the criteria for measuring the "goodness" of a language, this is an ongoing debate where even the criteria themselves become hotly contested. Instead, we intend to focus on how choices made by Java language designers have an impact, either directly or indirectly, on the use of the language as a teaching tool.

Many computer science departments have opted to teach an object-oriented language in introductory computer science classes. Java is becoming more and more the language of choice. How does this choice affect students as we extend the use of Java beyond these introductory classes?

What subtleties of the language should we be aware of when we take the Java paradigm into more advanced courses like Image Processing, Graphics, and Real-Time Applications?

This appendix poses a debate about Java among three professors: Professor Good (PG), Professor Bad (PB), and Doctor Ugly (DU). Together, the three explore the nuances of the Java language and of the Java environment.

B.2 The Java Language

In discussing Java, we have to separate issues of the Java language from issues of the Java environment.

B.2.1 Java Is Object Oriented

PG: Java is strongly-typed and object-oriented language. It offers an object-oriented model with multithreading and platform independence. It has a simpler object model than C++, and its standard API library helps students get results quickly [Tyma].

PB: But Java has primitive data types, and these are not really object oriented as compared to the atoms of Smalltalk or ZetaLisp.

DU: Even worse, Java has static methods that look a lot like functions that reside in a class-name space.

PG: Well, OK, but every instance can be treated the same, to a point. For example, I can always use

```
public void printName (Class c){
  System.out.println(c.getName())
};
```

to print the name of the instance of any class, which is a kind of polymorphism.

DU: Right, but the *printName* method never will work within a static method. That's because you can't get the name of a class before it is instanced!

PG: Well then, just make an instance of the class.

PB: You can't always make an instance of a class without knowing the class name. For example, suppose you have a frame that needs to be named for the class name. You might write

```
public class OpenFrame extends Frame{
    public static void main(String args[]) {
      OpenFrame f = new OpenFrame ("OpenFrame");
      f.show();
      }
  }
```

Notice how *OpenFrame* requires a string for the title of the frame and how this string must be embedded in the program. Since the instance of *OpenFrame* cannot exist before the string is given, the string must be embedded in the program. That is bad!

PG: OK, I acknowledge that Java is a hybrid language. It has procedural, functional, and object-oriented elements. It allows the programmer to choose which style to use and when.

PB: The ability to choose, however, is clearly a problem. Beginners in Java all but ignore the object-oriented features of the language. Often, they are not used to thinking about objects and try to fit Java into a procedural mode with which they feel more comfortable.

DU: I have students who write large programs in a single main method!

PB: And if you are teaching Java after students have been using a functional language, watch out! Often students think that

```
public class hi {
    public static void main (String args []) {
        hi h = new hi()
    }
}
```

is an example of recursion, and they wonder how it can compile.

DU: To make it worse,

```
public static void main (String args[] )
```

assumes a command-line interface that some computers do not have (e.g., MacOS 9 or earlier). In fact, it is command-oriented, which is inappropriate for applications on a pre-MacOS X system.

B.2.2 Java Has Simula-Like Classes

PG: Java does have classes, which allow the creation of reference types that work just like the built-in classes in the Java API. You know, Stroustrup says that he borrowed the C++ classes from SIMULA 67 [Stroustrup 2000].

PB: But this capability does not apply at all to the built-in primitive types. Java does not allow user-defined types to be treated the same as built-in types. For example, Java will not allow you to create an unsigned byte, which is really bad news. It means that if you want three arrays of red, green, and blue, they can't be bytes that range from 0–255 or combinations like

```
r[i] = b[i] + g[i];
```

Instead, they will have to be rewritten to avoid magnitudes that are above 127:

```
r[i] = Math.abs(b[i])+Math.abs(g[i]);
```

This restriction basically makes Java unsuitable for digital-signal processing.

PG: All you have to do is define the byte arrays as *short*, which will give you the dynamic range you need without your having to resort to arrays of byte.

PB: But doing so will double the storage requirements, which makes you pay for a feature that nobody ever wanted. After all, what is so wrong with allowing users to define their own primitive data types?

PU: It makes the compiler harder to write!

B.2.3 Overloaded Operators

PG: It is very good that Java has no overloaded operators because bugs due to overloading are hard to track down. You see, it is very hard to know exactly which overloaded-operator method is being invoked.

PB: Overloaded-operator methods are useful. Even the designers of Java couldn't escape them. What about the " + " sign? After all,

```
int x=2;
int y=3;
```

```
String z = "4";
System.out.println(x+y+z);
// outputs 54
System.out.println(x+z+y);
//outputs 243.
```

DU: Java has to have the overloaded " + " because the alternative is too ugly to consider! How would you handle the un-overloaded " + " when concatenating strings? For example,

```
String s = Integer.toString(x+y);
s= s.cat(z);
System.out.println(s);
```

What a mess! So, we have to have overloaded string operators.

PB: So, is Sun saying that they can be trusted to do overloading, but that the computer science community can't be trusted? Just think, if Java really had overloaded operators, we could write

```
Complex c = a * b
```
rather than
```
Complex c =a.multiply(b);
```

PG: Look, the basic design objective for Java was to make the language more reliable. By excluding operator overloading, you take away a tool that has been abused in the past. We have to get people to do what is good for them, which means taking away choice!

PB: So, now it looks as if Java was designed by idealists. People have been using operator overloading since ALGOL 68 [Ralston]. Operator overloading allows a program's notation to approach that of mathematics. Mathematics symbols can provide an elegant and simple statement for a problem. No overloaded operators means no conventional notation. So why did they leave out this feature?

B.3 Multiple Inheritance

PG: Java designers made a wise choice in opting for no multiple inheritance. When there is a method or class variable name conflict, multiple inheritance requires topological sorting to determine the order in which things are overridden, which is exceedingly hard to debug.

PB: But inheritance is supposed to be an is-a knowledge representation. If a person is-a human and is-a graphic object, then the person instance inherits the traits of a human and can be drawn on the screen. What is wrong with that? Why doesn't Java allow such a representation?

DU: Even worse, the relationship of an is-a only can be simulated with an interface that serves as a prototype for all drawable objects. When this interface is changed, all of the subclasses may have to be recompiled, which is called the fragile base-class problem.

PG: You have to admit that the lack of multiple inheritance removes some of the problems that students were having with C++ and leads to fewer programming errors. Although a class can be declared to implement multiple interfaces, it can only inherit from one implementation class [Singhal and Nguyen].

PB: It may be OK for beginning Java students, but it is a disadvantage for advanced

Java programmers!

PG: Not really. If you want to share implementations, you should use the *delegation* pattern, not inheritance. Thus, the relationship is changed so that a class will invoke an instance of another class that supports the implementation of the method. This change is better for two reasons. The first is that multiple inheritance only should happen on a *pure interface definition* not on an implementation, which is consistent with CORBA Interface Definition Language (IDL) and Microsoft Object Linking and Embedding (OLE). By using interfaces, a translator (like *javah*) is able to generate headers in other languages. The second reason is that the delegation pattern is an extreme example of *composition*, which permits dynamic invocation. In other words, inheritance structures and implementations are defined at *compile time* with Java. However, if you use the delegation pattern, you can alter the implementation at run time.

In the following example, we see how the *Face* class delegates the implementation of the *draw* method to *faceElements*:

```
public class Face implements Drawable {
    private Drawable faceElements;

    public void setDrawableElements(Drawable fe) {
        faceElements = fe;
    }

    public void draw() {
      faceElements.draw();
    }
}
```

In the preceding example, the only inheritance is in the interface. This must be what the designers of Java were thinking when they selected not to include multiple inheritance [Gamma et al.].

B.4 Arrays Can Be C-Style or Java Style

PG: Arrays in Java can be either C-style or Java-style arrays, which means you either can write

```
int a[][];
```
or
```
int [][] a;
```
This flexibility is really good because it really can help when you are returning arrays from a method.

DU: Yes, but you also can mix the styles on the same line:

```
int [] a[];
```
The mixing of styles really does put the UG in Ugly!

PG: Actually, the mixing of styles could be eliminated; all Sun would have to do is deprecate the practice. In other words, you can write bad code in any language.

B.5 Platform Independence: Compile Constantly

PG: One of the more highly-touted features of Java is its portability. We can have one set of class files that runs on any virtual machine.

PB: If you compile under a new API and attempt to run your program on an older JVM, however, you will get a *class not found exception*.

PG: Exactly! It is good that you get that exception. This exception tells the programmer that the feature is present. So, yes, when APIs that we invoke are missing, we must react.

PB: Sun has a nasty habit of *deprecation*. The dictionary defines deprecation as a mild expression of disapproval. However, for Sun there is more to it. Not only will the method be disapproved, but future support may be withdrawn. Thus, your code can break.

DU: In fact, if you want to avoid having Sun deprecate your code, you must rewrite for every change in the API, and many of the changes add no real features. For example

```
public void goAway(FileDialog fd) {
  fd.hide();
}
```

is now:

```
public void goAway(FileDialog fd) {
  fd.setVisibility(false);
}
```

It almost looks like Windows code.

PB: So the new motto should be: Rewrite (for each version of the API), recompile (if you are lucky), and run anywhere (the new API is supported).

PG: But the program really is compile once, run everywhere once you have debugged it for all of the platforms.

B.6 New APIs Support Multimedia

PG: Sun is starting to support all of the latest multimedia technologies: speech, sounds, image processing, 3D. Why, I could teach all of my courses in Java!

PB: Very nice, but I still cannot write to a serial port.

DU: And, most of the APIs that you mentioned are noncore APIs, which means that they will not have been implemented in most browsers. It will be some time before they are available on many platforms.

PB: Before you can teach these APIs in a course, you had better have a textbook that covers them.

DU: That is why I love Java: Every time Sun writes a new API, I get to write another book!

B.7 The Virtual Machine

PG: The JVM is great. I don't have to program in Java at all. I can just write a compiler for any language I like (e.g., Smalltalk) and then compile it to run on the virtual machine. Thus, the virtual machine ends up being a means towards writing portable programs in any language!

PB: But you are always at the mercy of the vendors. Who knows if your virtual machine will be implemented correctly. Consider the following code:

```
public class TrivialApplication {
public static void
        main(String args[]) {
    double k[][] ={
        {0,1},
        {2,3}
      };
System.out.println("k[0][0]="+k[0][0];
System.out.println("k[0][1]="+k[0][1];
System.out.println("k[1][0]="+k[1][0];
System.out.println("k[1][1]="+k[1][1];
    }
}
The output printed is:
    k[0][0]=Infinity
    k[0][1]=1.0
    k[1][0]=2.0
    k[1][1]=3.0
```

Please note that k[0][0] was set to 0!

This error was acknowledged, and I was told that I should use another JVM because the JVM I had was not going to be fixed … ever! The compiler vendor said that the computer manufacturer was going to provide JVMs from now on. But the computer manufacturer had a critically-flawed product (e.g., full of bugs or noncompliant). Sun does not support distributions of all platforms from its site.

B.8 Javadoc

PG: Javadoc is an excellent part of the JDK. It allows me to generate HTML code automatically, which is really an improvement over C and C++ and is sound software engineering.

PB: Actually, HTML is able to document equations only recently. If you really want to document an algorithm, you still need graphics and equations, as well as everything you would expect to see in a formal paper.

B.9 Performance

**Up with this
we will not put.**

–Winston Churchill

PB: Java is slow. Its high level of abstraction pushes it further and further away from machine code. In fact, we can't even know if arrays are stored internally as row major or column major [Tyma].

PG: Java's Just-In-Time (JIT) compilers are alleviating the problem by changing Java executable into native code before it executes on your machine.

PB: Java also imposes Memory Allocator (MALLOC)-type overhead when using "New."

DU: In fact, benchmarks show that making a new instance of a complex number is six times slower than using an existing instance. When taking Fast Fourier Transform [Lyon and Rao], we found it is always worthwhile to keep large arrays of primitives for both the real and imaginary parts of a complex number. Thus, speed considerations alone defeat the object-oriented nature of Java because it takes so long to make a new instance.

PG: Java chips will address all of the problems that we are having with speed. We have even seen a Reduced Instruction Set Computer (RISC) technology announcement with a four-stage pipeline and variable length instructions. The chip will be called picoJava, and it is going to be a rocket!

DU: Perhaps the only impact will be in embedded systems.

B.10 Deployment

PG: Java's write-once, run-anywhere systems allow for the widest portability options of any other platform.

PB: True, but double-clickable applications are still hard to write.

DU: I have had so many problems with setting class paths on customer systems that customers give up on my applications!

PG: Well, you can buy *Install Anywhere* to solve configuration and installation problems.

PB: Yes, I have tried it. It works great, but it costs hundreds of dollars. Most developers can't afford it.

DU: Not only that, but when the JVMs change, all of the downloads that are supposed to be double-clickable need updating. With APIs changing every 4 months, this can be a real problem.

PG: The better solution is Java Web Start, which Sun has made free and transparent.

PB: I tried this product, but I could not figure out how to use it.

DU: Did Sun forget to document this deployment tool? It seems that a Java Web Start tutorial is missing!

PG: Oh, you just missed the latest and greatest tools for building Web Start. Try *<http://rachel.sourceforge.net/index.html>* for an open-source deployment package for Java Web Start.

PB: Hey, this does look like what the doctor ordered. But wait, they don't even use Web Start to deploy the application!

B.11 Other Languages

PG: Have you seen the new JNI? It lets you integrate Java code and non-Java code.

PB: Yes, I have seen it. Linking to native libraries, however still is not easy. The translation from a C struct, for example, is time-consuming [Lyon and Rao].

DU: Java lacks layout compatibility, which means that conversion between the internal data structures of Java and those of other languages is required.

PG: Well, everything should be rewritten in the new language anyhow.

PB: But rewriting makes it hard to create a gradual transition from old code to new code.

B.12 Summary

Java was not designed as a teaching tool. Even so, Java has been widely adopted for teaching, which is due, in part, to its object-oriented character, strong typing, portability, and availability for Web applications. Java is not a perfect language. Several design decisions have not been laid open for public scrutiny.

Java technology combines language + virtual machine + API + hardware. Unlike most other languages, Java technology represents a system that is still relatively immature, particularly since the API (more than 1,900 classes with more than 21,000 members) changes frequently. In addition, Java's isolation of the programmer from the hardware is both a source of benefit and hardship. If the objective is to write programs that run fast, Java is probably the wrong tool at the moment. If the objective is to teach a first language to students, then faculty are cautioned to provide a simplified API for use. By understanding the good, the bad, and the ugly about Java, computer science faculty can guide their students judiciously towards better programming practice and software-engineering methodologies.

B.13 Acknowledgements

This work was made possible, in part, by a grant from the National Science Foundation, DUE-9451520, and by a grant from the Educational Foundation of America.

How to Set Up Your System for Java

All that is necessary for the triumph of evil is for good men to do nothing.

–Edmund Burke (1729–1797).

In this appendix, you will learn:

- How to get Java software
- How to install Java software
- How to set up environment variables
- How to run your first Java program
- Where to find development environments for Java
- About JDK
- About JRE
- About IDE's
- About Javac

The setup of the Java programming environment can be problematic. It cannot be stressed enough how important it is to perform the setup early in the process of a course or of reading a book. Getting the software can be difficult, and sometimes it takes several days for a software order to arrive. In addition, reading about Java is like watching others exercise: It can make you tired, but you really don't get any benefits! You must try examples if you really want to learn the language!

The servlet and JSP software must be downloaded before the software can be run. Several systems are available for free. A list is available at *<http://java.sun.com/products/servlet/ industry.html>*. The two covered tools are *Apache Tomcat* and *JavaServer Web Development Kit* (JSWDK). Tomcat is the official reference implementation of the servlet specification. JSWDK is very small, but it takes some time to set up.

C.1 Running Java under UNIX

This section shows how to run Java under UNIX. If you don't use UNIX, you should skip to the next section.

To run Java programs under UNIX, you need a Java development environment. There are several available. JDK, a popular and freely-distributed development tool, is available from Sun. To find out if JDK is installed on your machine, use the *which* command. For example

```
% which java
/home/lyon/bin/JDK1.2/bin/java
```

shows the full path name for the location of the *java* command. If the *java* command is not in your path, then you must either contact your system administrator or download and install the JDK on your own. The Java compiler that comes with the JDK is called *javac*.

It is worthwhile to check the version of Java installed on your system. As of this writing, the default version of Java for some Linux systems is 1.1:

```
lyon{lyon}5: java -version
Kaffe Virtual Machine
Copyright (c) 1996-1999
Transvirtual Technologies, Inc.  All rights reserved
Engine: Just-in-time   Version: 1.0b4   Java Version: 1.1
```

A more recent version emitted

```
java version "1.2"
Classic VM (build Linux_JDK_1.2_pre-release-v2, native threads,
sunwjit)
```

An even more recent version is

```
java version "1.3.1"
Java(TM) 2 Runtime Environment, Standard Edition (build
      1.3.1-b24)
Java HotSpot(TM) Client VM (build 1.3.1-b24, mixed mode)
```

You should attempt to track down and install the latest version of Java. A good place to look for the JDK is *<http://www.javasoft.com/>*. Sun has changed the name of the JDK and is now calling it SDK.

To run *HelloWorld* under UNIX, you will need an editor with which you are familiar. I use *emacs*, but any editor will do. The following example shows a new Java source code file being started using *emacs*:

```
% mkdir hello             #create a directory
% cd hello                #change the attach point to the directory
% ls                      #list the files in the directory
% emacs Hello.java        #start a new Java source code file.

class Hello {
        public static void main (String args[]) {
```

```
                        System.out.println("Hello World");
              }
      }
```

Save the preceding file as Hello.java. Java files always should be saved with a file name suffix of *.java*. To compile the Java program, type

```
% javac Hello.java
```

The result of the compilation will be

```
Hello.class
```

After compiling, you can run the Java program by typing

```
% java Hello
```

To run the code first download the code from *<http://www.docjava.com>* and uncompress it into a directory called *j4p*. List the files and you should see

```
README.txt   audioFiles/   images/       jars/
         rmiScripts/   src/
```

Create a directory for your classes. For example,

```
mkdir classes
```

Then, use a script to set your class path and compile and run the project. A sample script follows:

```
setenv PROJ /home/lyon/current/java/j4p/
setenv CLASSPATH .
setenv CLASSPATH ${CLASSPATH}:${PROJ}/jars/dom.jar
setenv CLASSPATH ${CLASSPATH}:${PROJ}/jars/jaxp-api.jar
setenv CLASSPATH ${CLASSPATH}:${PROJ}/jars/jspengine.jar
setenv CLASSPATH ${CLASSPATH}:${PROJ}/jars/sax.jar
setenv CLASSPATH ${CLASSPATH}:${PROJ}/jars/servlet.jar
setenv CLASSPATH ${CLASSPATH}:${PROJ}/jars/tools.jar
setenv CLASSPATH ${CLASSPATH}:${PROJ}/jars/webserver.jar
setenv CLASSPATH ${CLASSPATH}:${PROJ}/jars/xalan.jar
setenv CLASSPATH ${CLASSPATH}:${PROJ}/jars/xercesImpl.jar
setenv CLASSPATH ${CLASSPATH}:${PROJ}/jars/xml.jar
setenv CLASSPATH ${CLASSPATH}:${PROJ}/jars/xsltc.jar
setenv CLASSPATH ${CLASSPATH}:${PROJ}/classes/
javac -sourcepath ${PROJ}/src -d classes src/*/*.java
java ip.Main
```

The *PROJ* variable contains the location of your *j4p* folder and probably will not be

```
setenv PROJ /home/lyon/current/java/j4p/
```

C.2 Running Java under Windows

This section shows how to set the class path under Windows. It also shows how to address one of the limitations of the default memory allocations at program startup.

C.2.1 Setting the Class Path

In the *autoexec.bat* file, you should set your path to include the binary directory for the JDK. If you have a server, then you should establish the *server home* or *shome*, which should be used to append classes to your class path. For example,

```
set shome = d:\javacourse\server\jswdk-1.0.1\lib\
set classpath=c:\jdk1.2.2\lib\dt.jar
set classpath=%classpath%;%shome%xml.jar
set classpath=%classpath%;%shome%jspengine.jar
set classpath=%classpath%;%shome%servlet.jar
set classpath=%classpath%;%shome%tools.jar
```

C.2.2 Out of Environment Space

Sometimes readers get an error from their Windows NT/95/98 machines that reads "Out of environment space." This error is due to the environment size limit on COMMAND.COM. The limit is extended by adding a command line into the config.sys file (Windows 95/98) or the config.nt file (Windows NT). For Windows 95/98, add the following line to your config.sys file:

```
shell=C:\COMMAND.COM /p /e:3200
```

For Windows NT, add the following line in your config.nt file:

```
shell=%systemroot%\system32\COMMAND.COM /p /e:3200
```

In both examples, 3200 is the length in bytes that COMMAND.COM allocates for each program. The default is 256 bytes, and the maximum is 32K.

C.3 Metrowerks IDE Usage

Metrowerks CodeWarrior is an IDE available for Windows 95/98/NT/2000, RedHat Linux, Sun Solaris, and MacOS operating systems.

The primary reason for using Metrowerks is its nearly cross-platform look and feel. Often, students come from many walks of life and have very different computers in their homes. By adopting a uniform IDE in the classroom, there is one less variant with which to contend.

Figure C.3-1 shows an image of the installation window used for installing the IDE. Select *Full Installation* and select the *Next* button.

C .3.1 Making a New Project

When using Metrowerks CodeWarrior, many beginners get lost in setup. This subsection shows how to make a new project in CodeWarrior.

Select *File > New* in the IDE, as shown in Figure C.3.1-1.

FIGURE C.3-1
The Installation Window

FIGURE C.3.1-1
Selecting a New Project

A pop-up dialog box appears that asks for the selection of the *project stationery*. Select *Java Stationery* and input a *Project name*, as shown in Figure C.3.1-2.

FIGURE C.3.1-2
Project Stationery and
Project Name Selection

On a Macintosh, select *Java Application*, as shown in Figure C.3.1-3.

FIGURE C.3.1-3
Macintosh Users Must Use JDK 1.1

Sometimes a *Project Messages* window appears, as shown in Figure C.3.1-4.

FIGURE C.3.1-4
The Project Messages Window

If the *Project Messages* window appears, close it to reveal the *JDK 1.1* project window shown in Figure C.3.1-5.

Run the program by selecting *Project > Run*. When you run the program, the *Java Console* should appear, printing the string *Hello World!*, as shown in Figure C.3.1-6.

FIGURE C.3.1-5
Project Window

FIGURE C.3.1-6
Java Console

C.3.2 Changing the Target Class

This subsection shows how to change the target class, or *main* class, in a Java application under CodeWarrior.

Select *Edit > Java Application Settings*. A pop-up dialog box appears, as shown in Figure C.3.2-1.

Select *Java Target* in the *Java Application Settings* dialog box and alter the *Main Class* to read *TrivialApplication1*. Then click on the *Save* button.

Select the project window and double-click on the source code entry, as shown in Figure C.3.2-2.

Alter the source code so that the class name is called *TrivialApplication1*, as shown in Figure C.3.2-3.

The code should now run.

FIGURE C.3.2-1
Alter the Main Class

FIGURE C.3.2-2
The Project Window Showing the Source File

```
public class TrivialApplication1 {

    public static void main(String args[]) {
        System.out.println( "Hello World!" );

    }
}
```

FIGURE C.3.2-3
The Altered Code

C.3.3 How to Add a File in Java

Up to now, we have been working with a single file that contains every element in the Java program. When you want to add a new *public* reference data type (e.g., a class or an interface), some programming environments require these elements to be stored in their own

files. CodeWarrior does not have this requirement, but the Sun JDK does. Such a constraint is not a function of the language specification, but of the software development product.

In order to make the CodeWarrior IDE behave like the Sun JDK, select *Edit > Java Application Settings > Java Language* and check *Use Strict Java Filenames* and *Use Strict Source/Package Hierarchy*, as shown in Figure C.3.3-1.

FIGURE C.3.3-1
Java Language Settings

Now, code will compile only when the public reference data types are stored in files that have names in the form of *className.java*. To add a new *public* class to an existing project, select *File > New*, as shown in Figure C.3.3-2.

File	Edit	Search	Project	Del
New Text File			⌘N	
New...			⇧⌘N	
Open...			⌘O	
Open Recent			▶	
Find and Open File...			⌘D	

FIGURE C.3.3-2
Select *File > New*

Select *File > Text File*, and *then* select *Name, Location,* and *Add to project*, as shown in Figure C.3.3-3.

The name *Mammal.java* implies that a *public* reference data type named *Mammal* will be placed in a file called *Mammal.java*.

FIGURE C.3.3-3
Select *File > Text File*

C.3.4 How to Edit XML and Other Data Formats

In order to make the CodeWarrior IDE recognize XML and various other data formats, open the *Application Settings Dialog* under the *Edit* menu.

Select *html* from the *File Mappings dialog* and add new extensions by altering the suffix in the *Extension* text field as shown in Figure C.3.4-1. Add *dtd, xml, xslt*, and *xsd* to enable editing of files of these types, which is important in some of the more advanced topics of the book.

FIGURE C.3.4-1
The File Mappings Dialog Box

C.4 IntelliJ Usage

A new refactoring savy IDE called *ideaj* is available from *<http://www.intellij.com>*. Start the *ideaj* IDE and set it so that the project is located in the *j4p* folder. Create an output *classes* file to hold the compiler output and select a JDK. Figure C.4-1 shows what the initial screen looks like after the setup.

FIGURE C.4-1
Initial Set-Up Screen

Select the *Next* button and a project screen appears, as shown in Figure C.4-2.

FIGURE C.4-2
The *New Project Wizard* Screen

Select the *Next* button twice and browse for the jar files, as shown in C.4-3.

After you select the *OK* button in the dialog box shown in Figure C.4-3, select the *Finish* button, as shown in Figure C.4-4.

FIGURE C.4-3
Setting up the .jar Paths

The default key combination, <shift-F10>, opens the *Run Dialog Box*, as shown in Figure C.4-5.

Select the <+> icon in the dialog box and set the Main class as *ip.Main*, as shown in Figure C.4-6.

Select the *Run* button, and the project will compile, link, load, and then execute the main class.

FIGURE C.4-4
The *ClassPath* Panel

FIGURE C.4-5
The *Run Dialog Box*

FIGURE C.4-6
The *Run Setup*

C.5 Summary

In this chapter, we learned how to get JDK and install it on our own computer. To reiterate, starting this process early in your learning of Java is critical. You really never will learn a language unless you try it!

We focused on only one IDE, Metrowerks CodeWarrior; however, there are many IDEs from which to choose. Excellent on-line tutorials exist for several products. For example, JBuilder (a Borland product) has an on-line tutorial at <*http://www.borland.com/ jbuilder/jb5/tour/welcome_UI.html*>. Sun has an excellent tutorial for its IDE called Forte at <*http://www.sun.com/forte/ffj/*>. IBM's entry is called Visual Age and is available at <*http://www-4.ibm.com/software/ad/vajava/*>. Web Gain (formally Symantec) has a product called Visual Café available at <*http://www.webgain.com/ products/visual_cafe/*>.

For a list of IDE tools, see <*http://www.javaworld.com/javaworld/tools/jw-tools-ide.html*>

C.6 Exercises

C.1 Get Java!

Install a JDK or an IDE on your home computer by downloading it from the Sun Web site. JDK download and installation instructions are available at

```
<http://java.sun.com/j2se/1.3/>
```

The preceding line may have to be altered depending on the specific version that you download. It is generally a good idea to get the latest version of the software.

C.2 Install and configure the JDK. For Windows 98, edit the *autoexec.bat* file to attach the line

```
PATH=%PATH%;c:\jdk1.3.1\bin
```

The preceding line may have to be altered depending on the specific version that you download. Then type

```
c:>autoexec.bat
```

To see if the path was set, use

```
c:>PATH
```

To check the version, used

```
c:> java -version
```

C.3 Type in your first program and put it in a file called "Cake.java." Use CodeWarrior or your favorite editor to enter the following code:

```
public class Cake {
        public static void main(String args[]) {
                System.out.println("Hmmm, cake!");
        }
}
```

C.4 Compile your program:

```
javac Cake.java
```

C.5 Run your program:

```
java Cake
```

The following should print

```
Hmmm, cake!
```

C.6 Finally, edit the program in exercise 3 to print out your first and last name. Change the name of the class from *Cake* to your last name, capitalize the first letter, rename the file *Name.java*, recompile and run the program, and capture the screen run. Windows users should use the *alt-printscreen* button to paste the screen data into a Word document in order to print it.

APPENDIX D

Coding Style

Strike while the irony is hot.

–Douglas Lyon

Until lions have their historians, tales of the hunt shall always glorify the hunter.

–African proverb

This section describes how to format Java code. A consistent coding style is called a convention for coding, or a *code convention*. General wisdom has it that 80 percent of the cost of software is in the maintenance. Coding conventions tend to improve readability and thus reduce the cost of maintenance.

There are several coding conventions, and their selection may be a matter of taste. It is probably a good idea for programmers to adhere to JavaSoft code conventions for the purpose of readability. The code conventions have been established for a variety of programming situations. A program that violates style conventions generally still will work, though it may look unconventional.

Aesthetics that are built into a good programming style should make a program easy to read and understand. Code should look neat and organized. On the other hand, this author knows of people who actually will alter code to make it conform to their own style. Perhaps this is over the top, since one style can be as good as any other. So, take the conventions described in this appendix with a grain of salt.

Telling people about bad habits is a bad habit.

–Douglas Lyon

D.1 Naming Conventions

Class and interface identifiers all should use mixed-case characters and start with an uppercase character. Constants all should use uppercase letters and include an underscore ("_") to delimit words.

File names in Java generally are used to identify the file type. For example, a file that ends with a *.java* suffix is treated as a Java *source* file. A file with a *.class* suffix is treated as a Java *bytecode* file. A file with an *.html* suffix is an *HTML* file. File names like *README* generally summarize the contents of a file.

D.1.1 Method, Package, and Variable Names

Variable, method, and package names all should use mixed-case characters and start with a lowercase letter. Some examples of the correct use of the method name convention include

```
thisIsAGoodMethodName,
dspStartsWithAnAbbreviation.
```

Some examples of improper use of the naming convention for a method or variable include

```
ThisLooksMoreLikeAClassName,
mIXEDCaseSHOULDBEconsistent.
```

Using the default package is not a good idea, since it cannot be imported and it does not enable internal naming. For example, to gain access to the *java.awt.Frame* class, you can write

```
import java.awt.Frame;
```

If the *Frame* class were in the default package, then no class in any other package would be able to use it, which is a direct result of being unable to import a package with no name.

Sun suggests that verbs be used as method names.

D.1.2 Constant Names

Constants should use uppercase characters, and the delimiter should be underscored ("_"). Some examples of valid constants include

```
THIS_IS_A_CONSTANT,
PI,
E,
JINI,
DSP,
NASA.
```

Examples of identifiers that follow the lowercase-letter-first convention include package names, variables, and method names:

```
thisIsAVariable,
thisIsAMethod and
thisIsAPackage.
```

D.1.3 Class and Interface Names

An uppercase letter typically is used as the first letter in a class or interface name. Class and interface names should use mixed-case characters. Examples of identifiers that follow the uppercase-letter-first convention follow:

```
ThisIsAClassName.
ThisIsAnInterface,
TheGoodExampleClass,
JavaStudent,
QuantityContainer,
Quantity.
```

Underscores ("_") are not used as class or interface name delimiters. Examples of identifiers that violate the naming convention include

```
The_Bad_Name, The_nonworking_Name, A_NON_CLASS_NAME.
```

Sun suggests that nouns be used as class names.

D.1.4 Visibility

Instance variables should not be declared as public; instead, use getters and setters. Doing so will enable you to control access to the variables and take advantage of bean-building tools (which make use of getter and setter method names).

It is probably a good idea to declare a class, interface, or method public only if you intend to publish it (i.e., if you intend to keep the public element consistent so that others can use it without fear of deprecation). Consider simplifying the interface to your packages subsystem using a *facade* pattern.

It is acceptable to use public constants, but be sure to declare them as final and static. By declaring them final, you can be sure that the instance variables never have their values changed during the life of the instance. By declaring them static, you can be sure that their storage is not reallocated (i.e., that they are global).

It is probably a good idea to declare a class, interface, or method private unless you intend to reuse it outside of a class. Consider that private methods may not have to be documented as well as public, default, or protected methods. As a result, if you are going to have nonprivate methods, be sure to follow the Javadoc conventions described in Appendix E.

D.2 Avoid Ambiguous Variable Names

It is a good idea to strive for clarity in code. While it is possible to make use of the same identifier in different contexts, it is probably poor practice. For example,

```
class a {
    static int a=10;
    public static void main(String args[]) {
        System.out.println("a=" + a);
    }
}
```

will output

```
a=10
```

This confusing class example can be avoided by using the convention that classes should begin with an uppercase letter. For example,

```
class A {
    static int a=10;
    public static void main(String args[]) {
        System.out.println("a="+a);
    }
}
```

D.3 Avoid Shadowed Variables

Shadowing occurs in a class when a parameter has the same name as the class instance variable. There are two ways to resolve this ambiguity. One way is to use the *this* operator. Another way is to invent a new variable name, as shown below:

```
class Shadow {
    int a = 10;
    int b = 20;
    void setA(int a) {
      this.a = a;
    }
    void setB(int _b) {
      b = _b;
    }
}
```

The code

```
this.a = a;
```

is required because the *a* instance variable shadows the parameter *a*. The use of the *this* operator eliminates the ambiguity that occurs in

```
void setA(int a) {
  a = a;
}
```

The *setB* method makes use of the creation of a new variable name technique. The author is biased in favor of the new variable name style, but the selection of the style used is actually a matter of taste.

D.4 Formatting

You generally should try to write one statement per line. Avoid lines like

```
int i=5; double j=10;i++;j--;
```

A more readable treatment is

```
int i=5;
double j=10;
i++;
j--;
```

You should put a space around an operator. For example,

```
i=a+b;
i = a + b; // this is easier to read
```

There should be no space between a method name and parentheses. For example,

```
public static void main(String args[]) {
```

is better than

```
public static void main (String args[]) {
```

There should be an open brace at the end of the declaration statement on the same line. For example,

```
public static void main(String args[]) {
```

is better than

```
public static void main(String args[])
        {
```

Closing braces should be on a line by themselves. For example,

```
public static void main(String args[]) {
}
```

is better than

```
public static void main(String args[]) {
      System.out.println("hi");}
```

except when the statement is null. For example,

```
public static void main(String args[]) {}
```

is acceptable.

The "else if" command should be coded in a single line. For example,

```
         if (Bexp) { // Bexp means "Boolean expression"
             ...
         }
         else if (Bexp) { // else-if is on the same line
             ...
         }
```

Variables should be initialized when they are declared. For example,

```
for (int i=0; i < 10; i++) {...
```

initializes *i* so that it is local in scope with respect to the *for loop*. It is a syntax error to refer to the *i* variable outside of the body of the loop.

D.5 Organization

The Java JDK requires that each public interface and class be placed in a separate file (by default). It is probably a good idea to place each interface and class in a separate file even if they are not public.

Directories should be organized in accordance with the Java package organization. For example, if you have a package called *java.awt*, then you should have a *java* directory with an *awt* directory in it. This structure is required by the JDK, but not by all of the IDEs. Many IDEs will make this an option of normal compilation in order to ensure JDK compatibility.

Figure D.5-1 shows the *Java Application Release Settings* dialog box in CodeWarrior's IDE. In it, we see the checkboxes for *Use Strict Java Filenames* and *Use Strict Source/Package Hierarchy*. These two checkboxes require that each public class be placed in a separate file and that packages be placed in accordance with the Java package convention.

It is typical to keep the classes and the source code in different directories. Use *-d* to show the class file destination and *-sourcepath* to indicate the source file location. For example,

```
javac -sourcepath src -classpath classes:lib/Banners.jar \
            src/farewells/GoodBye.java -d classes
```

I have a theory that human memory for things is strained at three bits. Ideally, humans learn and remember best with one bit! To learn more about why this is true, see *<http://www.well.com/user/smalin/miller.html>*.

For example, there are two kinds of data types:

1. Reference
2. Primitive

Figure D.5-1

Java Application Release Settings Dialog Box

There are two kinds of reference data types:

1. Class
2. Interface

There are two kinds of primitive data types:

1. Signed
2. Unsigned

My theory is that the physiological limits to human memory should play a role in the organization of computer programs. For example:

1. If you have more than eight parameters in a function, you are doing something wrong!
2. If you have more than eight inner classes in a class, you are doing something wrong!
3. If you have more than eight packages in a superpackage, you are doing something wrong!

Thus, the java package can have only eight subpackages: *awt, io, lang, math, net, text, util,* and *beans.*

Adding the Java-applet package was a mistake (if we adhere to the rule of eight items).

This is generally not accepted practice and is really quite radical. However, if you think about it, the goals of such a discipline must be:

1. Subsystems that are totally understood
2. BUG-FREE code
3. Maintainable code
4. Limits to complexity
5. Unbreakability
6. Reusability

At present, I limit complexity with the following rule: Only one programmer per package. This is the best I can do to segment the job and keep people from stepping on each others toes.

D.6 Summary

The seven most important rules of coding style are:

1. Class names should begin with an uppercase letter.
2. Curly braces should start just after a method. For example,
 foo() { // <- curly brace
3. Method and instance names should begin with a lowercase letter.
4. Constants should use uppercase letters.

5. Underscore "_" should be used to separate two words in Constants.

6. Mixed case letters should be used to separate two words for nonconstant identifiers.

7. The "else if" command should be coded in a single line. For example,

```
if (Bexp) { // Bexp means "Boolean expression"
    ...
}
else if (Bexp) { // else-if is on the same line
    ...
}
```

APPENDIX E

Learning to Use Javadoc

Drive safe, drive often.

--Douglas Lyon

In this appendix, you will learn about:

- Javadoc
- Command-line invocations of Javadoc
- IDE setup of Javadoc
- HTML tags
- Javadoc tags

E.1 Introduction to Javadoc

Javadoc is a tool that automates the production of from Java source code. The documentation is placed into several files using one of several available file formats. A full description of Javadoc usage for Windows is available at

`<http://java.sun.com/products/jdk/javadoc/writingdoccomments.html>`

Javadoc comments always are preceded by "/**" and followed with "*/". For example,

```
/**
        This is a Javadoc comment
*/
```

In order to run *Javadoc* from the command line and check the version, use

```
javadoc -J-version
```

which outputs

```
java version "1.3.1"
Java(TM) 2 Runtime Environment, Standard Edition (build 1.3.1-b24)
Java HotSpot(TM) Client VM (build 1.3.1-b24, mixed mode)
```

The *Javadoc* command has many options. In order to build the full Javadoc for the *Java for Programmers* source code, you need to allocate 128 MB of memory. In order to increase the memory available to *Javadoc* to 128 MB, use

```
-Xmx128m
```

In order to output only public visible elements, create a split index, and output the tags for @use, @author, and @version, use

```
-public -splitindex -use -author -version
```

To provide links to external APIs, use the *-link* command. For example,

```
-link http://java.sun.com/products/jdk/1.3/docs/api/
```

E.2 The Tags of Javadoc

In this section, we cover the following Javadoc tags:

> @author, {@docRoot}, @deprecated, @exception, @param, @return,
> @see, @since, @throws, @version, {@link}.

These tags each are covered in their own subsection. It is important to remember that many of these tags were introduced in JDK 1.2 and that more tags will be introduced after new versions of the JDK are released. The version number of the JDK under which the tag was released is shown next to the tag in parentheses.

E.2.1 The @author Tag (Since JDK 1.0)

The *author* tag is used to name the author of the code. Authors can be listed in a comma-delimited list. For example,

```
/**
        @author Douglas Lyon, Joe Blow

*/
```

E.2.2 The {@docRoot} Tag (Since JDK 1.3)

The {@docRoot} tag represents the relative path to the generated output of the *Javadoc* command. It is used to include files that are co-located as resources for the HTML output. You may make reference to these resources in the HTML or on the command line. For example, on the command line, where the header/footer/bottom are defined, use

```
javadoc -bottom '<a  href="{@docRoot}/copy-
        right.html">Copyright</a>'

/**
 * See the <a href="{@docRoot}/copyright.html">Copyright</a>.
 */
```

E.2.3 The @deprecated Tag (Since JDK 1.0)

The *deprecated* tag is used to add a comment stating that the method or instance variable should not be used. Support for deprecated features can be withdrawn at any time. For example,

```
/**
        @deprecated As of Kahindu 1.0, replaced by {@link
          show()}
*/
```

E.2.4 The @exception Tag (Since JDK 1.0)

The *exception* tag is used to indicate that an exception may be thrown. The *exception* tag adds a *throws* subheading with the *class name* and the *description* text. For example,

```
/**
        @exception OutOfMemoryException Thrown when too many
          windows are open.
*/
```

Further examples of *exception* tags are shown in Chapter 13.

E.2.5 The @param Tag (Since JDK 1.0)

The *param* tag is used to denote a passed-in parameter with a description. While Java permits multiple instance variables on a single line, better practice would be to place instance variables on different lines. For example,

```
/**
        @param g is a graphics context
        @param c is the color
*/
```

E.2.6 The @return Tag (Since JDK 1.0)

The *return* tag denotes the type of the value returned by a method. For example,

```
/**
        @return a copy of the frame {@link java.awt.Frame Frame}
*/
```

E.2.7 The @see Tag (Since JDK 1.0, Broken in 1.2, Fixed in 1.2.2)

The *see* tag is used to introduce a link to a Web page or to another part of the API. For example,

```
/**
        @see java.awt.Frame
        @see java.awt.Frame#setVisible
        @see <a href="www.docjava.com"> DocJava, Inc.</a>
*/
```

The following example shows a multiline comment

```
    /**
     * This is a <b>doc</b> comment.
     * @see gui.InterfaceBean
     */
```

E.2.8 The @since Tag (Since JDK 1.1)

The *since* tag takes a description that indicates when the method or instance variable was introduced. It also can be used to indicate when a method was deprecated. For example,

```
/**
 * The famous <code> HelloWorld</code> program.
 * @author     J. Doe
 * @version    1.1
 * @since      JDK1.0
 */
public class HelloWorld {
      public static void main(String args[]) {
        System.out.println("hello world");
      }
}
```

E.2.9 The @throws Tag (Since JDK 1.2)

The *throws* tag is just like the *exception* tag. For example,

```
/**
        @param arg is the argument to a method
        @throws ArithmeticOverflowException if argument is zero.
*/
public void f(double arg) throws ArithmeticOverflowException
        {...}
```

E.2.10 The @version Tag (Since JDK 1.0)

The *version* tag is used to indicate the version of the class where the method or member was introduced. For example,

```
/**
        @version 1.2
*/
```

E.2.11 The {@link} Tag (Since JDK 1.2)

The *link* tag is used to introduce a hyper-text reference in the produced Javadoc code. The reference can be to a literal *href*, a class, or a method. For example,

```
/**
        @deprecated as of version 0.9
          replace by {@link #setN(int)} and the
          {@link gui.AdaptiveLog#setVisible AdaptiveLog}
*/
```

Only the *AdaptiveLog* label is seen in the link. A reference is generated that will locate the *setVisible* method in the *AdaptiveLog* dialog.

The "#" sign is a relative link within the HTML document that is used to link to a specific method in a class.

<A> Anchor	<HEAD> Head	<P> Paragraph
<ADDRESS> Address	<HTML> HTML	<PLAINTEXT> Plain Text
 Bold	<I> Italic	<PRE> Preformatted Text
<BASE> Base	 Inline Image	<SAMP> Sample
<BLOCKQUOTE> Block Quote	<INPUT> Form Input	<SELECT> Form Select
<BODY> Body	<KBD> Keyboard	<STRIKE> Strikethrough
 Line Break	 List Item	 Strong
<CITE> Citation	<LINK> Link	<TEXTAREA> Form Text Area
<CODE> Code	<LISTING> Listing	<TITLE> Title
<DIR> Directory List	<MENU> Menu List	<TT> Teletype
<DL> Definition List	<META> Meta	<U> Underlined
 Emphasized	<OBJECT> Object	 Unordered List
<FORM> Form	 Ordered List	<VAR> Variable

FIGURE E.3-1
Summary of Common HTML Tags

E.3 Common HTML Tags

The HTML tags used to formulate Javadoc comments almost always are authored without the aid of a WYSIWYG composition tool. As a result, most programmers need to know at least a few of the basic HTML tags in order to make the API documentation more readable. Figure E.3-1 shows a summary of some of the more common HTML tags.

Structural tags (e.g., *h1, h2,* and *head*) may interact with the structure of the Javadoc-generated HTML in unanticipated ways and should be used with care. As a result, they are not listed in Figure E.3-1.

The tags typically take the form of <a> *anchor text* . Often, an *href* is embedded in the first anchor tag. For example,

```
<A HREF="backups/backups.html">Backup Services!</A>
```

For a complete list of tags in a variety of HTML versions, see <*http://www.w3.org*>.

E.4 How to Run Javadoc in CodeWarrior

In order to run Javadoc in CodeWarrior, select the *Java Application Settings* option from the Edit menu, as shown in Figure E.4-1.

A pop-up dialog box appears that enables the selection of *Target Settings*, as shown in Figure E.4-2.

Use the *Pre-linker* setting to select *JavaDoc* Pre Linker, as shown in Figure E.4-3.

Now, when the program is compiled, the Javadoc output will be generated automatically, as shown in Figure E.4-4.

Once the Javadoc output settings are saved, you can compile the program, and Javadoc will be invoked as a part of the post-process. The output folder will be a *Docs* folder in the project, as shown in Figure E.4-5.

The Javadoc that is generated may be missing the links to the GIF images, as shown in Figure E.4-6.

Edit	Search	Project	Debug

Can't Undo	⌘Z
Can't Redo	⇧⌘Z
Cut	⌘X
Copy	⌘C
Paste	⌘V
Clear	clear
Select All	⌘A
Balance	⌘B
Shift Left	⌘[
Shift Right	⌘]
Insert Reference Template	
Preferences...	
Java Application Settings...	
Version Control Settings...	
Commands & Key Bindings...	

FIGURE E.4-1
Selecting the Application Settings

Target Settings Panels

▽ **Target**
 Target Settings
 Access Paths
 Build Extras
 Runtime Settings
 File Mappings
 Source Trees
 Java Target

Target Settings

Target Name: Java Application
Linker: Java Linker
Pre-linker: None
Post-linker: None

FIGURE E.4-2
Select the Target Settings

Pre-linker: JavaDoc Pre Linker

FIGURE E.4-3
Select JavaDoc Pre Linker

FIGURE E.4-4
Set the Javadoc Output Settings

FIGURE E.4-5
The Docs Output Folder

FIGURE E.4-6
Missing Links to the GIF Images

Standard GIF images, distributed with the JDK API documentation, are available from the book's Web site at

```
<http://www.docjava.com/>.
```

Figure E.4-7 shows an image of the *images* folder after it has been downloaded and co-located with the rest of the Javadocs. The *images* folder is less than 36 KB in size. Once the images are loaded, the standard GIF images become visible, as shown in Figure E.4-7.

The standard images can be modified to give the Javadoc a custom look.

FIGURE E.4-7
Standard GIF images

E.5 How to Run Javadoc Using JDK

In this section, we assume that the JDK is installed and that a series of Java source-code files are available in the current directory. UNIX allows you to list the files using

```
show.docjava.com{lyon}36: ls
DateClient.java  DateServer.java  MainServer.java
```

The "show.docjava.com{lyon}36:" prompt is the local prompt on my system.
Under DOS/Windows, you can type

```
dir
```

The *javadoc* command is run by typing

```
show.docjava.com{lyon}37: javadoc *.java
```

The following is printed on the console:

```
Loading source file DateClient.java...
Loading source file DateServer.java...
Loading source file MainServer.java...
Constructing Javadoc information...
Building tree for all the packages and classes...
Building index for all the packages and classes...
Generating overview-tree.html...
Generating index-all.html...
Generating deprecated-list.html...
Building index for all classes...
Generating allclasses-frame.html...
Generating index.html...
Generating packages.html...
Generating DateClient.html...
Generating DateServer.html...
Generating MainServer.html...
Generating serialized-form.html...
Generating package-list...
```

```
Generating help-doc.html...
Generating stylesheet.css...
```

As seen in the output, a sequence of *.html* files is generated by the invocation. A common option is the *-d* option, which lets you specify a destination directory. If the destination directory does not already exist, you first must create it. For example,

```
show.docjava.com{lyon}43: mkdir doc
show.docjava.com{lyon}44: javadoc -d doc *.java
Loading source file DateClient.java...
Loading source file DateServer.java...
Loading source file MainServer.java...
Constructing Javadoc information...
Building tree for all the packages and classes...
Building index for all the packages and classes...
Generating doc/overview-tree.html...
Generating doc/index-all.html...
Generating doc/deprecated-list.html...
Building index for all classes...
Generating doc/allclasses-frame.html...
Generating doc/index.html...
Generating doc/packages.html...
Generating doc/DateClient.html...
Generating doc/DateServer.html...
Generating doc/MainServer.html...
Generating doc/serialized-form.html...
Generating doc/package-list...
Generating doc/help-doc.html...
Generating doc/stylesheet.css...
```

For a more advanced discussion that includes topics on *doclets*, see Appendix C. There are also excellent *man* pages on Javadoc under UNIX. Finally, for Windows and Macintosh users, you can refer to the *Javadoc Tool Home Page* at *<http://java.sun.com/j2se/javadoc/>*.

E.6 Summary

Javadoc is a tool for low-level API documentation. Its output is able to embed HTML code. Sorry to say, HTML is beyond the scope of this section and will have to be covered elsewhere. There are excellent primers on HTML and excellent tools available for the generation of HTML.

As of this writing, most HTML documents do not represent vector images or mathematics very well. Typically, images and mathematics are not used in Javadoc.

E.7 Exercises

E.1 Modify the following code: so that your name appears as the author.

```
/**
 * The famous <code> HelloWorld</code> program.
 * @author    J. Doe
 * @version   1.1
 * @since     JDK1.0
 */
```

```
public class HelloWorld {
        public static void main(String args[]) {
          System.out.println("hello world");
        }
}
```

Generate the Javadoc output and provide a printout of the HTML that you created. Print the source that generated the Javadoc tags.

E.2 Add the @*param* tag to the code in exercise 1:

```
/**
 * The famous <code> HelloWorld</code> program.
 * @author    J. Doe
 * @version   1.1
 * @since     JDK1.0
 */
public class HelloWorld {
        /**
         * Entry point to the program.
         * @param args is ignored
         */
        public static void main(String args[]) {
          System.out.println("hello world");
        }
}
```

Generate the Javadoc output and provide a printout of the HTML that you created. Print the source that generated the Javadoc tags.

E.3 Determine what happens if you generate Javadoc output from the following code:

```
/**
 * The famous <code> HelloWorld</code> program.
 * @author    J. Doe
 * @version   1.1
 * @since     JDK1.0
 */
import java.awt.*;
public class HelloWorld {
        /**
         * Entry point to the program.
         * @param args is ignored
         */
        public static void main(String args[]) {
          System.out.println("hello world");
        }
}
```

Hint: A logic error occurs, and something odd happens to the output.

E.4 Add the @*return* tag to the code in exercise 2:

```
/**
 * The famous <code> HelloWorld</code> program.
 * @author    J. Doe
 * @version   1.1
 * @since     JDK1.0
 */
public class HelloWorld {
        /**
         * Entry point to the program.
         * @param args is ignored
         * @return <code>void</code>
```

```
        */
    public static void main(String args[]) {
      System.out.println("hello world");
    }
  }
```

Generate the Javadoc output and provide a printout of the HTML that you created. Print the source that generated the Javadoc tags. (It is good style to declare the *@param tag* before the *@return tag*.)

E.5 It is possible to generate code automatically using Javadoc (see *<http://www.javaworld.com/javaworld/jw-08-2000/jw-0818-javadoc_p.html>* for details). Read this article and try to generate code automatically with Javadoc. Submit the output and the setup steps you needed to get this code generation to work.

E.6 It is possible to generate UML automatically from Javadoc (see *<http://www.esm.co.jp/divisions/open-sys/java/uml-doclet/index.html>* for details). Read this article and try to generate code automatically with Javadoc. Submit the output and the setup steps you needed to get this UML generation to work.

E.7 It is possible to generate Javadoc automatically from Java source (see *<http://www.mindspring.com/~chroma/docwiz/index.html#top>* for details). Read this article and try to generate Javadoc automatically from the HelloWorld example of Chapter 2. Submit the output and the setup steps you needed to get this Javadoc generation to work.

E.8 It is possible to view Javadoc automatically from Java source (see *<http://www.dengers.de/professional/javadoc/>* for details). Read this article and try to view Javadoc automatically. Submit the output and the setup steps you needed to be able to view Javadoc.

E.9 Does the Javadoc tag {*@link package.class#member label*} make the *label* visible text with an *href* to the *link*?

APPENDIX F

Object-Oriented Design and Documentation

Time is the best teacher; unfortunately, it kills all its students.

–Proverb

In this appendix, you will learn about:

- Classes
- Methods
- Object-oriented design
- Petri Nets
- Petri diagrams
- Structured programming
- Flowcharts
- Action diagrams
- Three kinds of documentation
- MUML

This chapter describes various kinds of documentation and a kind of design called *object-oriented* design. These two topics are linked because the process of design can help to generate high-level documentation. We introduce a simple version of UML called *Modified Unified Modeling Language* (MUML). MUML is designed to be a kinder, gentler version of full-blown UML, since it is geared specifically toward programmers new to object-oriented thinking. A more detailed look at UML is given in Appendix G.

F.1 The Three Kinds of Documentation

Three basic kinds of documentation are associated with a finished product: the user manual, technical documentation, and programmer documentation.

The user manual is aimed at nonprogrammers who want to understand how to use an application to solve some problem. Such documentation generally does not include code

examples and often is written as an afterthought. For a large project with multiple programmers, such an oversight can be an error. In fact, continually updating a user manual can be an effective way to provide a specification for a program.

Technical documentation consists of a high-level design specification that shows how to implement a project. Typically, it consists of formulas and principles that govern the behavior of software. For example, if software generates a table of interest rates and monthly payments, the formula for the computation should be given. Often, such formulas are best stated along with restrictions for their use. For example, a formula may be valid for:

1. A positive interest rate
2. Investment for a positive number of years

If the above assertions are not valid, we should inform the user of the error. Java requires the programmer to write code that checks for valid input. Even with these checks in place, a program still can be misused.

Programmer documentation describes how a program is implemented from the programmer's point of view. There are many kinds of programmer documentation. For example, programmer comments are low-level notes to other programmers that are written alongside the code. Another kind of programmers documentation, *Javadoc* comments, are used to generate documentation pages in a programmatic way. Javadoc comments are the subject of Appendix E.

F.2 The Software Architect

In this section, we describe a high-level blueprint that results from the design of a software system.

An architect is a planner and a designer. Writing code is the role of a programmer. A software architect knows how to program, but only programs when in the programming role. Architects may know how to dig, but if you hire them to build your house, you would not expect them to show up with a shovel. An architect establishes the needs of a client and the limitations on resources and then creates a design. Often, several designs are presented before the client will accept one. Feedback from the client, thus, prompts alterations in the design. Feedback comes from objections, like sticker shock, lack of an important feature, or a constraint in the landscape.

The software architect can see the big picture. The software architect may resort to block diagrams to communicate ideas about customers and products. Software architects invent systems that interact with other systems. A *system* is any collection of interacting elements for which there are cause-and-effect relationships among the variables. A general system representation is shown in Figure F.2-1.

The general system diagram shows inputs (u), *state variables* (s), and outputs (y). The state variables are selected so that they can describe the current state of the system.

FIGURE F.2-1

Inputs Are on the Left, Outputs Are on the Right

Thus, if the system's state is saved, it can recover and continue. The architect must identify the inputs and outputs of the system, as well as the state variables. The details of how this identification is done depends on the discipline used by the architect. Modern software architecture makes use of a design technique called *object-oriented design*.

F.3 Object-Oriented Design

In order to perform object-oriented design, the architect needs to start by providing a model of what exists and by defining the roles of the various elements in the system. A *role* is a form of participation by some *noun* in a natural-language description of the system. The following sample transaction demonstrates a typical transaction system. The nouns are italicized:

1. The *customer* shops using a *catalog*.
2. The *customer* fills a *shopping cart* with *goodies*.
3. The *customer* goes to the *checkout counter*.
4. The *customer* provides *payment*.
5. The *retailer* provides the *goodies*.

Nouns, like those listed above, can describe the existing system. The job of the architect is to identify the need in the above business and to invent a solution. For example, the *retailer* needs a way to automate the transaction, and the architect designs the system (hardware + software).

The *nouns* in the sample transaction are listed below, along with their descriptions:

N1. Customer (e.g., a person, business, or software)

N2. Shopping cart (e.g., a physical entity or software)

N3. Checkout counter (e.g., a place or software)

N4. Payment (e.g., cash, check, money order, or credit card)

N5. Goodies (e.g., which are some product or service supplied upon completion of the transaction)

N6. Retailer, which is a business where customers go that has goodies, checkout counters, shopping carts, and catalogs.

Note that every noun in the system has a specific *role*!

R1. The customer shops with a *cart* and a *catalog* to make *payment* for *goodies*.

R2. The shopping cart contains *goodies*.

R3. The checkout counter collects a *payment*.

R4. The payment is an element that passes from the *customer* to the *checkout counter*.

R5. The goodies are items listed in catalogs, stored in *shopping carts*, and shipped to a *customer*.

R6. The retailer operates a *checkout counter* and provides *goodies* to customers.

The *roles* describe the relationships between the various elements in the system. As you can see, there is no code, per se, only a kind of formalism that describes some *word concepts*. There are various techniques for representing word concepts visually, but these techniques are all knowledge representations. The term *knowledge* is a loaded one. In the broadest

sense, knowledge denotes information, principles, facts, or ideas. The graphic depiction of knowledge started with work on *semantic networks*. In a *semantic network*, a dictionarylike definition is encoded with nodes interconnected with associative links.

The actions of a typical transaction often are encoded into action diagrams. A sample transaction might be:

1. Customer asks for catalog from retailer.
2. Customer fills shopping cart with goodies from catalog.
3. Customer provides payment to checkout counter.
4. Checkout counter lists goodies to retailer.
5. Retailer ships goodies to customer.

The action diagram is depicted in Figure F.3-1.

Figure F.3-1 shows that the *shopping cart* is the subject of two actions: *add goodies* (which adds a goodie) and *get goodies* (which gets a list of goodies). A way to represent the *Cart* is shown in Figure F.3-2.

Figure F.3-2 shows the noun *cart* along with the verbs *addGoodie* and *getGoodies*. These verbs always are listed under the noun upon which they operate. In other words, we tell a *cart* to *addGoodie*. The cart is responsible for allocating storage so that it can fit all of the goodies. We ask a cart for the goodies with *getGoodies*. Thus, it is the cart's responsibility to provide a list of all of the goodies in the cart.

In Java, we call nouns *classes*, and we call verbs *methods*, but this language-specific feature is only a detail. The important thing is to learn how to think in terms of object-oriented designs. Thus, the nouns of our system are the objects in the design.

In our example system, a *cart* is filled with *goodies*. The cart can be empty (i.e., have zero goodies) or have some positive whole number of goodies (e.g., 0,1,2 …).

In UML, lines are drawn to represent associations. An association between elements is a relationship and elements in a system have many kinds of relationships. For example,

FIGURE F.3-1
Sample Action Diagram

FIGURE F.3-2
The Cart

the *cart* has an *association* with *goodies* that is called a *has-a* relationship. The *has-a* relationship comes about because the *cart* has goodies. The has-a relationship often is shown with an open diamond, but writing the word *has-a* on the association link is probably more clear. The open diamond just adds another literal to a visual language; however, it is a standard. This has-a relationship is shown in Figure F.3-3.

Multiplicity is shown with the number (0..*N*), which indicates that a cart may have anywhere from 0 to *N* goodies in it, where *N* is some positive integer. As previously mentioned, with UML the *has-a* association is represented with a diamond rather than the word *has-a*. In our experience, it is more clear to write out the association on the link between objects. However, the choice of representation is a matter of preference, and it is probably acceptable to refer to Figure F.3-3 as MUML.

In English, a *verb phrase* is a *verb* or a *verb* followed by a *noun phrase*. A *noun phrase* is a *determiner* (e.g., the, and a) followed by a *noun*. Associations are generally *verbs* or *verb phrases*. For example, the sentence a *customer buys* a "*book*" is shown in Figure F.3-4. The arrow points at *book*, which is the object of the action.

Another kind of customer is a *corporate customer*. Figure F.3-5 shows that corporate customers are customers with *deep pockets*. The association between a customer and a corporate customer is an A-Kind-Of (AKO) association.

The AKO relationship also sometimes is called a *discriminator*. In some UML books, it is represented with an open arrow. Figure F.3-5 shows that a customer buys-a book. It also shows that a corporate customer is a kind of customer that has deep pockets and that also can buy a book. Figure F.3-6 in turn, shows that DocJava, Inc., is a kind of corporate customer that is-owned-by *shareholders*.

vs. the UML

FIGURE F.3-3
The Cart and the Goodie

FIGURE F.3-4
The Customer and the Book

FIGURE F.3-5
The Customer, the Corporate Customer, and the AKO Association

FIGURE F.3-6
A Is Owned by B

Figure F.3-6 says that DocJava, Inc., must have deep pockets, because it is a kind of corporate customer. Sorry to say, though, that this is far from reality!

F.4 Procedural Design

In the previous section, we showed how to set up a system using nouns and verbs. Nouns were represented by *classes*, and verbs were represented by *methods*. At a lower level of detail, we need to describe the various states of a system and the conditions for the transition

FIGURE F.4-1
A Finite State Machine Diagram for a
Gum Machine

between those states. One way in which this description can be accomplished is with a state diagram. A *state diagram* is a directed graph that shows the input and output of a finite state machine. A *finite state machine* has a limited number of different states. An example of a finite state machine diagram that represents a gum machine is shown in Figure F.4-1.

Figure F.4-1 shows that the addition of a nickel causes the gum machine to reach the 5¢ state. Adding a dime causes the machine to reach the 15¢ state. The machine does not give change, so the addition of two dimes causes the machine to release the gum and keep the extra nickel. Many complex algorithmic systems can be represented by finite state machine descriptions.

Another means of algorithmic design is based on the Petri Net. A *Petri Net* is a bipartite, directed graph that uses tokens to enable computations. The graph is bipartite because it uses two kinds of nodes called *places* and *transitions*. The graph is directed because all connections in the graph consist of *directed arcs* that lead from places to transitions or from transitions to places. Data entities, known as *tokens*, travel along the arcs and enable computation.

In a Petri Net, places symbolize conditions and transitions symbolize computations. In addition, every transition is connected to *input* and *output places*.

A Petri Net may be represented graphically using a Petri Net diagram, or it may be represented textually using a Petri Net table. The primitives of the Petri Net diagram are shown in Figure F.4-2. The diagram is better suited for human communication, while the table is better suited for machine communication. Figure F.4-3 shows an example of a Petri Net for a gum machine represented by a Petri Net diagram. Figure F.4-4 shows a Petri Net table for the same example.

As shown in Figure F.4-3, at each transition we wait for an enabling token. Once the token is present, we take the transition and go to the next place.

FIGURE F.4-2
Petri Net Primitives

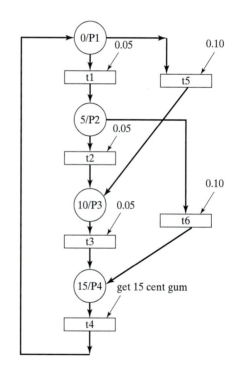

FIGURE F.4-3
Petri Net Diagram for a Gum Machine

Name	Place	Enabling Tokens	Transitions	Actions	Next Place
0¢	p1	0.05	t1	-	p2
5¢	p2	0.05	t2	-	p3
10¢	p3	0.05	t3	-	p4
15¢	p4	get gum	t4	get gum	p1
0¢	p1	0.10	t5	-	p3
5¢	p2	0.10	t6	-	p4

FIGURE F.4-4
Petri Net Table for a Gum Machine

F.5 Flowcharts

A flowchart is a graphic depiction of an operation sequence performed on data. A flowchart also can be called a *block diagram, flow diagram, logic diagram, system chart, run diagram, process chart, procedure chart*, or *logic chart* [Chapin]. The shapes used for a system chart and a flow diagram are different, but one can be mapped to the other.

Flowcharts are used to describe data processing without knowing about a programming language. They are written at various levels of detail and can improve communication for people who think visually.

Flowcharts take time to produce, and they consume area on a page. Some visual programming languages use flowcharts as the basis for their programming, which has given way to a series of visual programming languages that have modified flowchart standards to make them more expressive (e.g., STELLA *<http://www.hps-inc.com/>* and Simulink *<http://www.mathworks.com/>*). Visual Basic, however, is not a visual programming language; instead, it just helps build interfaces visually. A visual program expresses a system with a diagram that can be executed (i.e., "executable graphics").

Figure F.5-1 shows a sample flowchart. The parallelograms show the input and output from the system, the rectangle shows that some process is performed, the diamond is used as a decision block, and the circle can be used for connectors that exit from the given system (often to another system). Figure F.5-1 shows a system that reads in data and checks if there are errors in the data. If there are errors, the program exits. If there are no errors, the program will process the data and output the result.

Figure F.5-2 shows a flowchart of a program that counts to 10 and then stops. To print and then add 1 to i is called a *sequence*. To decide if $i > 10$ and then take a branch to continue or stop is called *selection*. To loop back to the addition and then continue until $i > 10$ is called *iteration*. Thus, *iteration* combines sequence and selection. Any flowchart can be depicted using iteration, sequence, and selection [Böhm and Jacopini].

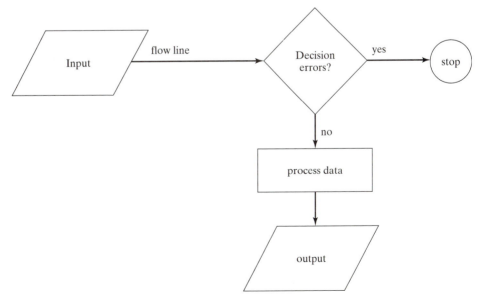

FIGURE F.5-1
A Sample Flowchart

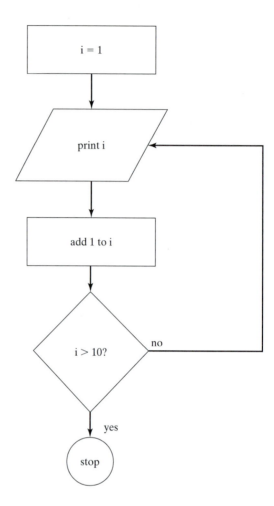

FIGURE F.5-2
A Flowchart of a Program That Counts to 10

This realization led to the foundation of structured programming. *Structured pro-gramming* is programming based on iteration, selection, sequence, a single point of entry, and a single exit.

Flowcharts were devised in a time when there were no object-oriented languages. As a result, flowcharts can assist us in incorporating procedural elements into our object-oriented designs.

F.6 Combining Procedural and Object-Oriented Design

This section shows a nonstandard way in which to combine procedural and object-oriented designs into a visual language. This hybrid representation of a system provides an extension to the MUML diagram by adding iteration, selection, and sequence.

Figure F.6-1 shows a flowchart with the MUML for a *Rocket*. The *Rocket* has a built-in flowchart that enables it to *blastoff*. Thus, the countdown: 10, 9, 8, 7, 6, 5, 4, 3, 2, 1: *Rocket.blastoff*. *Rocket.blastoff* indicates that the object *Rocket* contains the method that it needs in order to blast off. For more information about the shortcomings of UML, see [Demeyer et.al.].

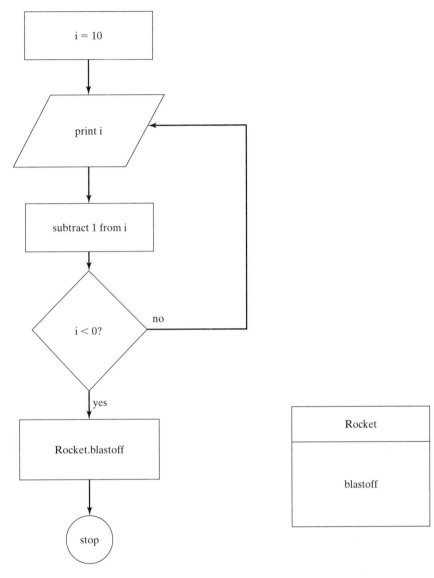

FIGURE F.6-1
MUML and Flowcharts

F.7 Software Lifecycle Models

Often, a software project begins with an idea. For example, why not build a Web-based application that automatically signs Java applets so that they will be trusted? If we had such an application, we could make millions of dollars while enabling people to avoid purchasing a security certificate. We would just use our own certificate!

The product needs a specification, a design, an implementation, a deployment, and some maintenance. As a final step, it must be decommissioned. This process is called the *lifecycle* model of the software.

Often, a product is built and then fixed. Fixes can occur several times until the product becomes so fragile that people are afraid to try to fix it, at which point the product must be replaced. This approach often can work well with code that is small, but the approach generally will not scale to 1,000 or more lines of code. Such an approach is called the *build-and-fix model.*

Another model is called the *waterfall model*, which first was suggested in 1970 [Royce]. This model has several phases:

1. Requirements
2. Specification (which may require revisiting phase 1)
3. Design (which may require revisiting phase 2)
4. Implementation (which may require revisiting phase 3)
5. Integration (which may require revisiting phase 4)
6. Operations (which may require revisiting phases 2 through 5)
7. Retirement

The assumption is that the requirements phase can be complete and correct after phase 3. If this assumption is not true, there is only room for retirement, since the waterfall model has no way to change requirements. Testing is done at each phase in the form of a verification step. Of course, if the requirements or specification is wrong, the software that results will not be acceptable. Naturally, the requirements are almost never complete, so the waterfall model generally is not suitable for most projects.

Another model is called the *rapid-prototyping model*. This model also has several phases:

1. Rapid Prototype
2. Specification (which may require revisiting phase 1)
3. Design (which may require revisiting phase 2)
4. Implementation (which may require revisiting phase 3)
5. Integration (which may require revisiting phase 4)
6. Operations (which may require revisiting phases 2 through 5)
7. Retirement

Note how requirements have been replaced by a prototype. This rapid-prototyping model is just like the *build-and-fix* model, except that it has structured phases. But how can we dispense with requirements by building a prototype? The answer is that WE CAN'T! The requirements are stated informally before the rapid prototype is constructed, and the prototype has to capture the formal requirements of the project. Now we can change the requirements during the specification phase by changing the prototype, which is designed to be thrown away.

Another model is called the *incremental model*. This model also has several phases:

1. Requirements
2. Specification
3. Design
4. Tasks to Perform for Each Build

 a. Detailed Design

 b. Implementation

 c. Integration

 d. Test

5. Operations (which may require revisiting phase 4)

6. Retirement

Perhaps the incremental model can be characterized by designing from the top down, but building from the bottom up.

 The *synchronize-and-stabilize* model is characterized by builds that implement features in order of importance:

1. Requirements

2. Specification

3. Design

4. Tasks to Perform for Each Build

 a. Detailed Design

 b. Implementation

 c. Synchronize (another name for integration)

 d. Stabilize (i.e., debug and test)

5. Operations (which may require revisiting phase 4)

6. Retirement

The *spiral model* is characterized by risk analysis at almost every phase of development:

1. Rapid Prototype

2. Risk Analysis; Specification (which may require revisiting phase 1)

3. Risk Analysis; Design (which may require revisiting phase 2)

4. Risk Analysis; Implementation (which may require revisiting phase 3)

5. Risk Analysis; Integration (which may require revisiting phase 4)

6. Operations (which may require revisiting phases 2 through 5)

7. Retirement

In all other respects, the *spiral model* is the same as the *rapid prototype* model.

 With *object-oriented lifecycle* models, we have a small departure from the waterfall model:

1. Requirements

2. Object-Oriented Analysis (which may require revisiting phase 1)

3. Object-Oriented Design (which may require revisiting phase 2)

4. Implementation (which may require revisiting phase 3)

5. Integration (which may require revisiting phase 4)

6. Operations (which may require revisiting phases 2 through 5)

7. Retirement

Note that phase 2 replaced the *specification* phase of the waterfall model.

Since this book is about Java (a mostly object-oriented language), it would be sensible to adopt the object-oriented lifecycle model. However, doing so requires buy-in for the waterfall model, a model that assumes correct requirements. However, this assumption is probably without foundation. In fact, the sequential waterfall model for systems development is a disaster for most projects.

I have devised my own object-oriented rapid prototyping model:

1. Problem Statement.
2. Object-Oriented Specification (which may require revisiting phase 1).
3. Object-Oriented Design (which may require revisiting phase 2)
4. Rapid Object-Oriented Prototype (which may require revisiting phase 3).
5. Tasks to Perform for Each Build

 a. Detailed Design
 b. Implementation
 c. Synchronize (another name for integration)
 d. Stabilize (i.e., debug and test)

6. Operations (which may require revisiting phases 2 through 5)
7. Retirement

In the preceding model, a *problem statement* is a possible solution to some given problem. Possible constraints include limits to the domain of the problem, assumptions of use, boundaries, resources, our motivation to solve the problem, and our approach to the solution. An overview of existing solutions or a literature survey may be appropriate here. In addition, a problem statement describes the differences between your proposed solution and any existing solutions.

Also with regard to the preceding model, an *object-oriented specification* provides details on inputs and outputs from the system and on system performance. An object-oriented design provides details on how to control and use the system.

One of the details left out of all of the systems that I could find is that only one programmer should work on a package at a time. This policy is discussed further in Chapter 11.

F.8 Summary

This chapter showed how to set up a flowchart, a Petri diagram, a Petri table, and finite state machines. The process of design is an iterative one that distinguishes the field of engineering from the field of science. Engineers design and build, whereas scientists explore and derive principles. Scientists discover what is, but engineers invent what does not yet exist!

Software engineers may know how to program, but not all programmers are software engineers. An element characterizes that software engineers is the ability to invent new software designs. While computer scientists may discover new principles of operation, software engineers build new systems. The elements of this chapter lay the groundwork for sound software engineering of systems.

F.9 Exercises

F.1 Write out the MUML diagram that represents the sample transaction in Section F.3.

F.2 Devise and document your own MUML diagram for a system with which you are familiar. Identify the nouns and verbs in your system. List the roles for each noun, as was done in Section F.3.

F.3 A retailer of wedding decorations wants to know if an odd or an even number of customers is in the store. When a customer walks in or out of the store, a sensor outputs a 1. Write a finite state machine diagram for a parity checker. A *parity checker* examines a stream of 1s and 0s. If there are an even number of 1s, the output is 0. If there are an odd number of 1s, the output is 1. For example,

```
0001110001100110010001 input
0001011110111011101110 output
```

F.4 Draw the Petri diagram for Figure F.3-1. Be sure to include all of the possible actions, not just the ones shown.

F.5 Write out the Petri table for your answer to exercise 4.

F.6 A farmer is a producer of food. A customer is a consumer of food. Draw a MUML diagram showing the producer-consumer relationship.

F.7 In a proposed computer engineering masters program, you must take a seminar course before you start your thesis. Also, before you take a course called SW 409, you first must take SW 408. In fact, there are a whole chain of prerequisites, as shown in Figure F.9-1.

Create a Petri table that encodes the prerequisite relationships in Figure F.9-1.

F.8 In a library catalog system, we catalog books by title, author, and subject. Our customers expect to be able to locate books using these three types of catalogs. We store the books by their unique ISBN number. Book subjects form a taxonomy. For example, a Java book is a kind of computer book, which is a kind of technical book. So, in this case, the subject would be technical:computer:Java. This subject contains a smaller number of books than the subject technical:computer. Write the MUML to depict the relationships described in the library system. Exclude the customer for the sake of brevity. Recall that in the AKO hierarchy, we can say that a Java book is a-kind-of computer book, which should be depicted directly in the MUML. Define the associations between books and subjects.

F.9 Whenever Bill Gates has a bad day, Scott McNealy has a good day. This is a *causal relationship*. That is, Scott McNealy has a good day *because* Bill Gates is having a bad day. Show the MUML that represents this causal relationship.

F.10 John entered a movie theater and went to the ticket counter. He might buy a ticket, but he might not. He might buy some popcorn, but he might not. He might see the whole movie, or he could leave in the middle. Describe the system using MUML and a Petri diagram.

FIGURE F.9-1
Course Prerequisites

F.11 A grading policy is posted on a web page:

Score	Letter/QPA	
95-100	A	4.00
90-94	A-	3.67
87-89	B+	3.33
84-86	B	3.00
80-83	B-	2.67
77-79	C+	2.33
74-76	C	2.00
70-73	C-	1.67
67-69	D+	1.33
64-76	D	1.00
60-63	D-	0.67
00-59	F	0.00

All scores are to be input using whole numbers only (e.g., you can't get an 85.5 on a test). Write a flowchart that outputs the letter grade given the input score.

F.12 Write a flowchart that reads in a list of scores, as defined by exercise 11, and prints out the average score.

F.13 Write the finite state machine that implements the counter shown in Figure F.5-2.

F.14 A retailer sells product via the Internet. Sales tax is computed at 6% if the customer is from Connecticut. Combine MUML and a flowchart to represent the system and its computations.

F.15 A car is a system. The inputs are the fuel, brake pedal, gas pedal, and steering wheel. The outputs are the speedometer, odometer, fuel gauge, and the car's pose (position and orientation). Identify the state variables, draw the MUML, and show the finite state diagram for the car when it runs out of fuel. (If the car has no fuel, it cannot go.) How can you incorporate the finite state diagram with the MUML?

UML: Lingua Franca for Object-Oriented Design

by Rodrigo A. Obando, Ph.D.

People who are late are often happier than those who have to wait for them.

–Chinese Fortune Cookie

In this appendix, you will learn about:

- UML
- User requirements
- Use-case diagrams
- Object diagrams
- Class diagrams
- Collaboration diagrams
- Sequence diagrams
- Statechart diagrams

G.1 Introduction to UML

UML is a language based upon object-oriented analysis and design (OOA&D) methods that were shaped by Grady Booch, James Rumbaugh, and Ivar Jacobson in the late 1980s and early 1990s. UML is now an Object Management Group (OMG) standard [Fowler].

UML is used to model, document, and visualize the different elements of an object-oriented system. Typically, UML is realized using diagrams, whose synthesis involves the use of a methodology. A *methodology* is just a systematic approach to the software lifecycle. Many methodologies use UML as their language, including Rational Unified Process (RUP)

and Extreme Programming (XP). Explanation of these methodologies is beyond the scope of this book. This chapter presents a simplified process to demonstrate the creation and use of these diagrams.

The primary use of the diagrams is to communicate with others, users and developers alike, and to understand the overall structure and behavior of a software system better. The use of these diagrams depends on the size of the system and on the development team. The bigger a system is, the more meaningful diagrams become for documentation, communication, and a better understanding of the overall system and how its components relate to and interact with each other. These two verbs, *relate* and *interact*, refer to the major characteristics of systems: static and dynamic.

G.2 Static and Dynamic Characteristics

Static characteristics are those that express positional or containment aspects of components. If we use a bicycle as an example, we say that the seat is attached to the frame. This is a static characteristic of the seat with respect to the frame. There is no interaction between the seat and the frame, but they are placed together as part of the bicycle. *Dynamic characteristics* are those that express actions exercised from one component to another. In the case of the bicycle, when the main gear turns, it pulls the chain that then turns the other gear in the rear tire. This dynamic characteristic of the bicycle shows interactivity between the components.

Diagrams can be divided into these two major categories. The static category encompasses diagrams that primarily describe relationships among components. Static diagrams include the *Object Diagram* and the *Class Diagram*. The dynamic category includes diagrams that present how the components of the system interact with each other. Dynamic diagrams include the *Use Case Diagram*, the *Collaboration Diagram*, the *Sequence Diagram*, and the *Statechart Diagram*. These diagrams are created by a systems analyst and are based on an understanding of the software system to be created. A *systems analyst* collects information from various sources (e.g., brochures interviews) and includes this information in *user requirements documentation*. The following subsections provide additional details about user requirements documentation and about these diagrams.

G.3 User Requirements

We start the creation of a system by defining *user requirements* documentation which states everything that the user requires the system to provide. One type of requirement is a description of the tasks that the system needs to accomplish. These tasks are documented using scripts and are designated as *use cases*.

Let us assume that we are designing a system to track all activity in a store. We have a script or use case that describes how a customer purchases items in the store. For example, when the customer comes to the counter to check out, a clerk takes the items and starts a sales transaction. The clerk takes the items and scans or enters the item codes into the system. The system starts generating an invoice that contains all of the items for which codes are entered. The system generates a total amount to be paid at the end of this transaction. Once the customer pays this amount, an invoice is printed and tendered, and the customer then leaves the store with the purchased items.

This script also can be presented in a series of numbered statements, as follows:

1. The customer comes to the counter to check out.
2. A clerk takes the items and starts a sale transaction.
3. The clerk scans or enters the item codes into the system.
4. The system starts generating an invoice that contains all of the items for which codes are entered.
5. The system generates a total amount to be paid at the end of this transaction.
6. Once the customer pays this amount, an invoice is printed and tendered, and the customer leaves the store with the purchased items.

G.4 Use-Case Diagram

The *use-case diagram* is a way to capture the main components in use cases. By scanning this script in our preceding example, we can identify the entities that interact with the system: *customer* and *clerk*. We call these two entities actors, and we call the task or activity that takes place between them *purchase items*. These are the main components used to construct a use-case diagram, as shown in Figure G.4-1.

The diagram shows the main components of this use case: customer, clerk, and their interaction through the purchase items task. The box that contains the task is called the *boundary box*, and it represents the store. The diagram may be expanded to include other tasks within the boundary. In order to keep the example simple, we are not going to pursue this avenue.

A series of these diagrams serves as an overview of the system and provides a common ground that allows users and developers to discuss the major tasks that the system must perform.

Many methodologies start the process by finding the class diagram for the task depicted in the use-case diagram. We are going to start with an object diagram and then use it to build a class diagram. This process of abstraction serves as a systematic way to obtain class diagrams by discovering the relationships that exist among sample objects.

FIGURE G.4-1
Use-Case Diagram

G.5 Object Diagram

The objects in a system can be divided into three types: entities, interfaces, and controls. *Entity objects* represent objects found in the real world such as employees, customers, buildings, and trucks. *Interface objects* are primarily those used to create graphical or text-based user interfaces, such as dialog boxes, menus, and buttons. *Control objects* are general objects that may contain utility functions that are used throughout the system.

We will look at entity objects in our present example. We may identify three main entities or objects: *customer, clerk*, and *invoice*. By finding the nouns in the script that describes the *use case*, we can identify these objects. We also find the entity items and, even though they represent objects in the real world, they are related to the entity *invoice*. An invoice is composed of items or invoice details.

The clerk will create Invoice objects and associate them with Customer objects. The printout of an Invoice object is a picture of the object it represents. This printout of the Invoice object is given to a Customer, and a record of this association is stored inside the system. We create an object diagram by representing the objects with boxes and the relationships among objects with lines. We use specific objects in the diagram by given them values. A typical object diagram for our example is shown in Figure G.5-1.

FIGURE G.5-1
Object Diagram

Examination of the object diagram reveals a series of facts: An Invoice may be related to many Invoice Details, a Clerk may be related to many Invoices, and a Customer may be related to an Invoice. We may expand on this last observation by assuming that a Customer is likely to come back to the store. Thus, we can assert that a Customer may be related to many Invoices.

The relationship that exists between the different objects may be expressed by verbs. The Clerk *creates* Invoices for Customers. Customers *get* an Invoices from the Clerk. The Invoice *contains* many Invoice Details. These are the elements we need to create a class diagram.

G.6 Class Diagram

Until now, we have drawn the relationships among objects in only one direction. In reality, relationships exist in both directions. An Invoice is created by a Clerk. An Invoice Detail is contained in an Invoice. An Invoice is provided to a Customer.

We can create a class diagram with the information we have collected so far. We take all Invoice objects and represent them with one class, Invoice. Similarly, we represent all Customer objects with the class Customer and all Clerk objects with the class Clerk. We use lines to represent the relationships between the classes. This class diagram is shown in Figure G.6-1.

FIGURE G.6-1
Class Diagram

After we label these relationships with the verbs used previously, we make the following observation: One Clerk creates many invoices. This kind of information is called *multiplicity*, and in this particular case multiplicity means that one creates many. Every relationship is labeled with this multiplicity. If a Clerk can create one or more Invoices, we use the label 1..*. Since every line in the class diagram represents two relationships, we use two labels to represent the multiplicity of both relationships.

Each one of the classes contains characteristics or attributes that describe the classes in more detail. The Customer class has an attribute, CustomerID, that uniquely identifies a particular customer. The Invoice class has an attribute that states the total dollar value of an invoice. The names of these attributes should suggest their purpose to simplify the reading of the diagram and the documentation of the system.

The class diagram also is used to represent operations that each one of the classes is capable of doing. For this example, we will use only the Invoice and Invoice Detail classes. We show that the Invoice class is capable of adding items to the invoice and of updating the total amount of the Invoice by using the labels *addItem()* and *updateTotal()*. The *Invoice Detail* class only shows only the operation *Invoice_Detail()*, which is a particular kind of operation that creates an *InvoiceDetail*. On the same note, the class Invoice also has an operation, Invoice(), that creates an Invoice.

By examining the class diagram, we are in a position to create our next diagram: the collaboration diagram. This diagram describes how different classes interact to accomplish a particular task.

G.7 Collaboration Diagram

When a system carries out a task, the system needs more than one class to perform that task. Let's take the creation of an invoice as an example. The clerk creates an invoice by adding items, or invoice details, to it. The invoice, in turn needs to update the total amount after each invoice detail is added. We may show which classes interact or collaborate to accomplish this task by using the existing symbols to create a collaboration diagram. For this particular example, we use an actor, the Clerk, and two classes, Invoice and Invoice Detail. Figure G.7-1 shows a collaboration diagram for the task of creating an invoice.

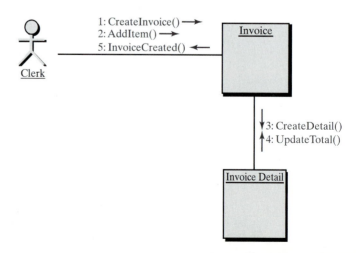

FIGURE G.7-1
Collaboration Diagram

The lines between the actor and the Invoice class and between the two classes represent messages or communications between them. The arrows indicate the source and the destination of these communications, and the numbers to the left of the labels denote the order in which these communications take place. The first message is *CreateInvoice()*, which is actually the execution of the Invoice() operation shown in the class diagram. The second message is *AddItem()*, which starts the operation of including items in the Invoice. This operation, in turn, causes the Invoice to generate the next communication, *Createdetail()*. As in the case of the creation of the Invoice, this message executes the operation *Invoice_Detail()* to create an Invoice Detail. The next message, *UpdateTotal()*, will update the total in the Invoice. The process eventually will finish with the sending of a message, *InvoiceCreated()*, to the Clerk indicating that the Invoice has been created.

This diagram stresses the relationship between the actor and the classes. Although it shows certain sequence information, the primary purpose for the diagram is to identify the entities, actors, and classes involved in the execution of a task. The diagram shows the collaboration of these entities with some of the sequence information.

The collaboration diagram is one of the diagrams in the dynamic category. The sequence diagram also belongs to this category. This diagram essentially shows the same information as the collaboration diagram, but stresses the sequence of messages instead of the collaboration of classes.

G.8 Sequence Diagram

In the creation of a particular invoice, more than one item may be added to that invoice. The collaboration diagram cannot show how multiple invoice details are created since more interaction lines between the actor and the classes would need to be added, thus making the diagram more difficult to interpret. The sequence diagram is more appropriate for this task because it delineates the timing of events and the manner in which events relate to the different classes. The use of either the collaboration diagram or the sequence diagram depends on the desired objective. Both diagrams show the same dynamic aspects of the task.

A collaboration diagram is shown in Figure G.8-1. The objects or classes that are involved in the creation of an invoice are shown at the top of the diagram. The long rectangles under these boxes indicate the activation of these objects. The messages between the entities involved in the task are shown as lines with arrows to indicate their direction. The name for these messages should match the names of the operations in the class diagram. To enhance the readability of the diagram, we decided to keep the names *CreateInvoice()* and *CreateDetail()* instead of the correct names, *Invoice()* and *InvoiceDetail()*.

G.9 Statechart Diagram

Each invoice that is created in the system undergoes changes through its lifetime. These changes can be tracked with the use of a statechart diagram. The state of an invoice, or, for that matter, of any object in a system, can be characterized by the values of one or more of its attributes. We can use the attribute status to characterize the state of an invoice. The present example does not lend itself to depiction in a statechart diagram unless we assume that the invoice is not paid immediately at the counter. If we allow the invoice to be paid at a later time, we can show how the status or state of the invoice changes throughout its lifetime.

A plausible statechart diagram for the invoice is shown in Figure G.9-1. There are four possible states of an *Invoice*: *Creating*, *Open*, *Paid*, and *Overdue*. These states are

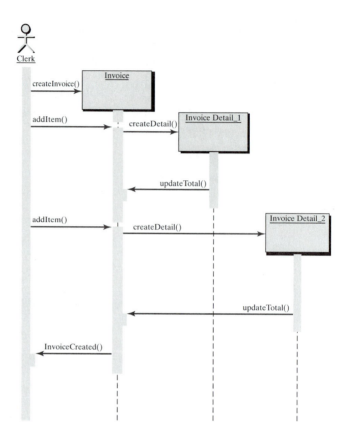

FIGURE G.8-1
Sequence Diagram

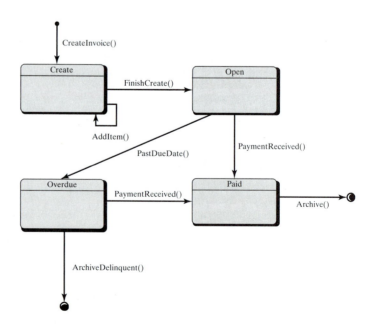

FIGURE G.9-1
Statechart Diagram

drawn as rounded rectangles with the name of the states in the top section. The lines between these rectangles indicate which events change the state of the Invoice. The starting point for any statechart diagram is a filled circle. A filled circle inside another circle shows the ending point for the diagram. We start the process by creating the *Invoice*, and the *Invoice* remains in the state of *Creating* while items are added to it. When we are done creating the *Invoice*, its state changes to *Open* (or unpaid). When the customer pays the *Invoice*, its state changes to *Paid*. If the customer does not pay the Invoice before its due date, the state changes to *Overdue*. The *Invoice* will remain in the *Overdue* state until it is either paid or categorized as delinquent. The *Invoice* will remain in the *Paid* state until it is archived.

This diagram encapsulates the conditions or rules under which an Invoice changes its status. Similar diagrams may be derived for the objects *Customer* and *Clerk*.

G.10 Summary

In this chapter, we introduced UML by using some of its diagrams to describe a simple system. We started with a script called a use case that described the user requirements for the system. Based on the use case, we were able to create our first diagram, the use-case diagram. Using the use case, we also derived a sample object diagram containing possible objects found in the system.

The class diagram was constructed by abstracting the information contained in the object diagram. The class diagram contained classes and relationships, and the classes showed their attributes and operations.

The next step involved constructing the collaboration diagram showing the intercommunication between actors and classes. In a similar fashion, the sequence diagram was constructed showing the sequence of communications between sample objects. Lastly, we presented a statechart diagram depicting the different states that an invoice could reach. Figure G.10-1 shows the process outlined above of using one diagram to create another.

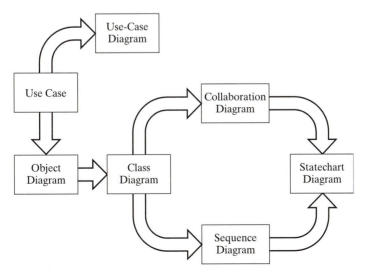

FIGURE G.10-1
General Process Outline

G.11 Exercises

G.1 Construct a use-case diagram using a script involving a student's registration for classes. The student who wants to register at a university comes to a registration window. A registration clerk takes the information from the student and verifies with a clerk at the financial office that the student is in good standing. Verification of prerequisites needs to take place before the registration process can be completed. After the registration is completed, the student gets a receipt as a confirmation of the process.

G.2 Draw an object diagram and the corresponding class diagram based on the use case stated in exercise 1.

G.3 Assuming that you have a class diagram with two classes, Checking Account and Savings Account, derive a collaboration diagram and a sequence diagram showing the transfer of money from one account to the other.

G.4 Assume we have a class representing a *Purchase Order* (PO) with an attribute representing its status. The possible values for status are Proposed, Reviewed, Approved, and Rejected. Draw a statechart diagram showing how a PO changes between all possible states or values of status.

G.5 A class has $0..N$ methods that may be dynamic or static. There may be $0..N$ variables in a class, and these variables can be dynamic or static. Represent the preceding information using UML.

APPENDIX H

Setting up JDBC

Judge not the horse by his saddle.

—Chinese Proverb

This chapter describes the setup of JDBC using a variety of Relational Database Management Systems (RDBMs) and IDEs. Often, an RDBMS will have directions specific to the product. In fact, setup is one of the most challenging aspects of JDBC programming, and one of the most neglected.

In this appendix, you will learn how to:

- Set up your RDBMS
- Get drivers for JDBC
- Load the drivers
- Set up a select few IDEs for programming

H.1 Opening a Connection to an RDBMS

In order to obtain access to the JDBC API, it first must be imported, which typically is done at the head of the JDBC program with an invocation of

```
import java.sql.*;
```

In order to connect to an RDBMS, a driver is needed. Often, the driver first must be loaded into the system, which is done by using the fully-qualified driver name to load the class that drives the database. For example, *ODBC* uses

```
String driver = "sun.jdbc.odbc.JdbcOdbcDriver";
Class.forName(driver);
```

to load the JDBC-ODBC driver for a Windows-based system. This code, however, is almost never portable code, which means that the *driver* string must be altered when the RDBMS changes or when platforms change. This is an unfortunate circumstance. Microsoft's ODBC API enables connection to a wide variety of database systems. The *Class.forName* invocation loads the class that contains the driver into the system.

ODBC is not a requirement, however. For example, if you are using ORACLE, you can follow the directions in H.4

A class called *DriverManager* is used to obtain a connection to a RDBMS using a *URL* string. For example,

```
Connection c = DriverManager.getConnection(url);
```

The format of the *URL* string is vendor-specific but generally is of the form

```
String url = "jdbc:dbnet://localhost:356/Books";
```

where *dbnet* is an example of a *subprotocol*, and *//localhost:356/Books* is an example of a subname. The *DriverManager* class also can take an optional user name and password. For example,

```
Connection c = DriverManager.getConnection(url, "userid",
        "password");
```

The *URL* is another element that is likely to change as RDBMS vendors or platforms change.

H.2 Setting a Data Source Name in Windows

Using a Windows 98 system, it is possible to set the *setting source name* to a regular file name, assuming that the programmer does not have access to a network-based network server. In such a case, the subprotocol is *odbc* and the *URL* is written

```
String url = "jdbc:odbc:myDataSourceName";
```

The *data source name* (DSN) can be set using one of several techniques. Under *Windows*, double-click on the *ODBC Data Sources (32bit)* control panel, as shown in Figure H.2-1.

The *ODBC Data Source Administrator* screen appears. Select the *MS Access Database* driver and click on the *Add* button, as shown in Figure H.2-2.

Selecting the *Add* button in the *MS Access Database* dialog box brings up the *Create New Data Source* dialog box shown in Figure H.2-3.

FIGURE H.2-1
The *ODBC Data Sources* Control
Panel

FIGURE H.2-10
The Machine Data Source Name

FIGURE H.2-11
Selecting the Tables of Interest

FIGURE H.2-12
The Tables Listed in the Database Window

```
Type 'help' for help.
mysql> show grants for lyon;
+---------------------------------------------------------------------------+
| Grants for lyon@%       |
+---------------------------------------------------------------------------+
| GRANT ALL PRIVILEGES ON *.* TO 'lyon'@'%' IDENTIFIED BY PASSWORD
     '3141a07c4a8feb89'                                                     |
+---------------------------------------------------------------------------+
1 row in set (0.00 sec)
mysql> use test;
Database changed
mysql> create table guest (a int auto_increment primary key, message char(20));
Query OK, 0 rows affected (0.02 sec)
mysql> explain guest;
+----------+----------+------+-----+----------+----------------+--------------
          -------+
| Field    | Type     | Null | Key | Default  | Extra          | Privileges
          |
+----------+----------+------+-----+----------+----------------+--------------
          -------+
| a        | int(11)  |      | PRI | NULL     | auto_increment |
          select,insert,update,references |
| message  | char(20) | YES  |     | NULL     |                |
          select,insert,update,references |
+---+----+--+--+---+------+----------+
          -------+
```

```
2 rows in set (0.01 sec)
mysql>
```

Other commands useful for setting up mySQL include

```
mysql --host=localhost --user=lyon
Welcome to the MySQL monitor.  Commands end with ; or \g.
Your MySQL connection id is 274 to server version:
        3.23.22-beta-log

Type 'help' for help.

mysql>show grants for lyon;

mysql> ERROR 1045: Access denied for user:
        'root@localhost' (Using password: NO)
[root@www lyon]# mysql -p
Enter password:
Welcome to the MySQL monitor.  Commands end with ; or \g.
Your MySQL connection id is 276 to server version:
        3.23.22-beta-log

Type 'help' for help.

mysql> show grants for root@localhost;
...
mysql> grant create on *.* to guest;
Query OK, 0 rows affected (0.08 sec)

mysql> use test;
Database changed
mysql> create table flatfile (message char(255));
Query OK, 0 rows affected (0.02 sec)

mysql>
```

The preceding code permits the insertion of records of 255 characters each into a database. For example,

```
mysql> insert into flatfile values("some junk here");
Query OK, 1 row affected (0.00 sec)

mysql> select * from flatfile;
+----------------+
| message        |
+----------------+
| some junk here |
+----------------+
1 row in set (0.00 sec)
```

Use the *load* command to import data from a text file. For example,

```
mysql> LOAD DATA LOCAL INFILE "fileList.txt" INTO TABLE
        fileList FIELDS TERMINATED by '\t' (name, kind,
        createdDate, modifiedDate);
```

Given a list of records, use

```
mysql> LOAD DATA LOCAL INFILE  "fileList.txt" INTO TABLE
          flatfile;
```

To load a CSV file, use

```
FIELDS TERMINATED BY    ',';
```

Note that if the fields are in the correct order, there is no need to specify the file names.

To create a primary key automatically (and help to speed up searches with large files), use

```
create table keyFileList (
    -> file_number INT(8) AUTO_INCREMENT PRIMARY KEY NOT
       NULL,
    -> file_record VARCHAR(255));
mysql> LOAD DATA LOCAL INFILE  "fileList.txt" INTO TABLE
          keyFileList;
```

If a large file has no commas that are meaningful, it might be useful to strip out the commas since extraneous commas (can confuse the mySQL file loader). An example of how to strip out commas in UNIX follows:

```
sed -e s/,//g <fileList.txt > file.txt
```

The foregoing code uses UNIX Stream Editor (sed) to strip out all of the commas from a file. In UNIX, you always can find out what the characters are in a text file using

```
od -cb file.txt | more
0000000   N   a   m   e   \t   S   i   z   e   \t   K   i
          n   d   \t   C
          116 141 155 145 011 123 151 172 145 011 113 151
          156 144 011 103
0000020   r   e   a   t   e   d       D   a   t   e   \t
          M   o   d   i
          162 145 141 164 145 144 040 104 141 164 145 011
          115 157 144 151
0000040   f   i   e   d       D   a   t   e   \n   1   0
          -   2   5   -
          146 151 145 144 040 104 141 164 145 012
```

It is clear from the preceding code that *file.txt* is tab-delimited. Also, there are exactly five fields (name, size, kind, created date, and modified date). So,

```
CREATE TABLE fileList (file_record INT(8) AUTO_INCREMENT
          PRIMARY KEY NOT NULL, name VARCHAR(255), size
          VARCHAR(25), kind VARCHAR(255), created_date
          VARCHAR(255), modified_date VARCHAR(255));
load data local infile "file.txt" into table fileList
          fields terminated by '\t';
```

A search on such a database can be very slow. One way to trade space for time is to build an index. An index can take a long time to build and can require a lot of space to store, but it can increase the speed of a search greatly. For example,

```
mysql> alter table fileList add index(name);
Query OK, 1317410 rows affected (22 min 35.70 sec)
Records: 1317410  Duplicates: 0  Warnings: 0

select * from fileList where name like("%thesis%");
....
185 rows in set (3 min 23.69 sec)

On the other hand:
select * from fileList where name = "thesis";
...
17 rows in set (1.53 sec)

and
select * from fileList where name like("thesis%");

...
124 rows in set (9.75 sec)
```

To speed up processing further, it can help to add a key:

```
ALTER TABLE fileList ADD  KEY(name);
```

Query OK, 1317410 rows affected (34 min 34.61 sec)

```
Records: 1317410  Duplicates: 0  Warnings: 0
```

The times quoted above are for a 500 MHz Celeron processor with 128 MB RAM running RedHat Linux. For general string searches, the *grep* command under UNIX can be faster than a database search.

H.4 Using ORACLE

ORACLE drivers support the standard JDBC API, with extensions to support ORACLE-specific datatypes. The use of these data extensions will result in nonportable code.

H.4.1 Installation of the ORACLE JDBC Driver on Windows 98/NT

Install ORACLE 8i personal edition on your machine and JDK 1.2.x. Download oracle\jdbc\driver\classes12.zip if the zip file does not exist in the [ORACLE_HOME]\jdbclib folder. This file contains the classes for use with the JDK 1.2.x (all of the JDBC driver classes). Unzip the zip file to <d:\oracle8\jdbc> and add it to CLASSPATH. Add the d:\oracle8\bin folder to PATH.

You must set CLASSPATH to include one of the following:

- [Oracle Home] \jdbc\lib\classes12.zip (and optionally [Oracle Home]\jdbc\lib\nls_charset12.zip) for full NLS character support)
- [Oracle Home]\jdbc\lib\classes111.zip (and optionally [Oracle Home]\jdbc\lib\nls_charset11.zip) for full NLS character support)

If you are installing the JDBC thin driver, you do not have to set any other environment variables.

To test the setup, try the samples in

```
<C:\oracle\ora81\jdbc\demo\samples>.
```

To register your driver, use

```
DriverManager.registerDriver (new
        oracle.jdbc.driver.OracleDriver());
```

The URL string should be set to

```
jdbc:oracle:<drivertype>:@<database>
```

For example,

```
Connection conn = DriverManager.getConnection
        ("jdbc:oracle:thin:@localhost:1521:orcl",
        "user id",
        "password");
```

After the connection is established, the rest of the program appears as standard JDBC/SQL.

H.4.2 Setting up CodeWarrior

Drag and drop the ORACLE folder from <d:\oracle8\jdbc> into the project window.

Figure H.4.2-1 shows the CodeWarrior project window after the ORACLE classes have been added to the project. This window shows updates to the access paths in the project, which enables code to find the Oracle drivers.

Once the project is set up, SQL statements can be issued via JDBC in a portable manner.

FIGURE H.4.2-1
The CodeWarrior Project Window

H.5 Summary

This chapter showed how the setup of open-source freeware (like MySQL) can be just as easy as the setup of expensive systems. It also shows that setup can be performed on a wide variety of systems (e.g., Windows, Mac, and Linux). MySQL performance is sufficient for heavy-duty use. Organizations like Yahoo! Finance, MP3.com (Vivendi Universal), Motorola, NASA, Silicon Graphics, HP, Xerox, and Texas Instruments use MySQL. For benchmarks on MySQL, see *<http://www.mysql.com/information/benchmarks.html>*.

APPENDIX I

Setting up Servlets

No man can serve two masters.

–Matthew 6:24

This appendix shows how to set up a servlet engine. Setting up a servlet engine is an important first step in trying out the servlet examples in this book. In fact, one of the hardest things about servlets is setting up the servlet engine.

I.1 Setting up a Servlet Engine

Several Java web servers are available for a variety of platforms. As a programmer, you have your choice of web servers, and, since there are too many products to cover, only a few are mentioned here. When selecting a web server, it is important to select a server that is able to claim compliance with the servlet and the JSP APIs. Generally, any Java web server will be compliant. Some web servers (like Apache) are not Java web servers, but have modules available to extend their ability to run Java servlets. Other Java web servers are written in Java and may be limited by the number and type of server-side languages that they can support. Using its own module technology enables Apache to support languages like PHP, SSI, ASP, JSP, servlets, and Fast Perl, thus enabling a rich server-side computing experience, as well as complicating installation and deployment. Sometimes simplicity is a feature! Thus, we present a few simple alternatives that may not be very suitable for production servers, but that are excellent for learning and development. Some features include:

1. Size of installation
2. Freely-available software
3. Freely-available source code
4. Simplicity of installation
5. Ease of deployment
6. Liberal licensing policy

These features are all deciding factors. Speed was not a factor in the selection, though even the slowest of the lot generally is fast enough to provide a good response to hundreds of hits per second on even a modest machine (I performed testing on a 400 MHz Celeron processor with 64 MB RAM). Of course, response time depends on the computational burden imposed on the platform.

I.2 Setting up Tomcat

Tomcat is a free, open-source web server that is available from *<http://jakarta.apache. org>*. The latest binary release is available from *<http://jakarta.apache.org/builds/jakarta-tomcat-4.0/release/v4.0.1/>*. It is modern, endorsed by Sun, and easy to install. Installation details depend on the platform, and excellent directions are available from the Tomcat home page. Prebuilt binaries are available for several platforms at *<http://jakarta.apache. org/builds/>*. On a UNIX system, I used

```
jakarta-tomcat-4.0.1.tar.gz
```

For a Windows system, I used

```
jakarta-tomcat-4.0.1.zip
```

These zip files are uncompressed to show a list of files that look like

```
cd jakarta-tomcat-4.0.1
www.docjava.com{lyon}12: ls
bin/                          RELEASE-NOTES-4.0-B4.txt
classes/                      RELEASE-NOTES-4.0-B5.txt
common/                       RELEASE-NOTES-4.0-B6.txt
conf/                         RELEASE-NOTES-4.0-B7.txt
lib/                          RELEASE-NOTES-4.0-RC1.txt
LICENSE                       RELEASE-NOTES-4.0-RC2.txt
logs/                         RELEASE-NOTES-4.0.txt
README.txt                    RELEASE-PLAN-4.0.1.txt
RELEASE-NOTES-4.0.1-B1.txt    RELEASE-PLAN-4.0.txt
RELEASE-NOTES-4.0.1.txt       RUNNING.txt
RELEASE-NOTES-4.0-B1.txt      server/
RELEASE-NOTES-4.0-B2.txt      webapps/
RELEASE-NOTES-4.0-B3.txt      work/
```

CodeWarrior can be used with Tomcat by following a few simple steps:

1. Add {tomcat_home}/*common/lib* and *examples* to the CodeWarrior project. The *JAR* files in *lib* are

```
activation.jar
jdbc2_0-stdext.jar
jndi.jar
jta.jar
mail.jar
naming-common.jar
naming-resources.jar
servlet.jar
tyrex-0.9.7.0.jar
xerces.jar
```

FIGURE I.2-1
Alter the *Output Type*

2. Change the Output Type to *Class Folder* and delete the name from the *Name* text field, as shown in Figure I.2-1.

3. Alter the *Target Settings* and change the *Output Directory* to {tomcat_home}/ *webapps/ examples/WEB-INF/classes*, as shown in Figure I.2-2.

Figure I.2-3 shows an image of the absolute path to the output directory.

4. Delete the pre-existing class files in {tomcat_home}/*webapps/examples/WEB-INF/classes* if you are going to output classes. These files need to be deleted because they will be generated during the development stage when you are using an IDE.

5. Force *tomcat* to reload the classes after they are generated; otherwise, you must restart the server each time. Open *server.xml* in the *conf* directory, which is shown in Figure I.2-4. Then, make sure *reloadable* is set to *true*, as shown in Figure I.2-5.

6. Alter your browser's settings so that it always will reload a page when you visit a URL, which is shown (for *Internet Explorer*) in Figure I.2-6.

A browser neutral way to accomplish the same thing is to provide a special string in the response header. For example, it is possible to output a header string that includes the phrase

```
Cache-Control: no-cache
```

in order to force any intermediate caches to obtain a new copy from the original server.

FIGURE I.2-2
Alter the *Output Directory*

FIGURE I.2-3
The Location of the Classes for Output

FIGURE I.2-4
Open the server.xml File

```
<!-- Tomcat Examples Context -
<Context path="/examples" docB
        reloadable="true">
    <Logger className="org.apach
               prefix="localhost.
```

FIGURE I.2-5
Make Sure *reloadable* Is Set to True.

FIGURE I.2-6
Alter the Browser Settings

I.3 Setting up JSWDK

JSWDK is an older distribution of a servlet engine. You are probably better off with Tomcat unless you are looking for a very lightweight installation for an embedded servlet engine. Also, the servlet version supported with JSWDK will not be the latest (though the version may not matter in some embedded applications). JSWDK is a pure Java web server that resides in several *JAR* files that must be added to the *CLASSPATH* of your system. It is available from Sun or as a series of *JAR* files available from the book's website at *<http://www.docjava.com>*. A more modern web server is a good idea if you plan to try the latest features in the servlet or JSP specifications.

Figure I.3-1 shows an image of the additional *JAR* files. The *JAR* files are Java archives that hold classes for processing servlets, JSPs, XML, a web server, and demo programs.

The system requires JDK 1.2 or later. Figure I.3-2 shows a CodeWarrior project after the *JAR* files have been added. These files can be added with a drag-and-drop interface on most modern IDEs.

FIGURE I.3-1
The JAR Files That Come with
This Book

FIGURE I.3-2
CodeWarrior Project after the *JARs* Files Are Added

Under a modern version of Sun's Studio ONE, the servlet and JSP engine already are added. The same is true for the enterprise version of JBuilder. However, the full versions of these programs are not free.

To set the CLASSPATH under a Linux system, I use

```
setenv SERVERHOME /home/lyon/java/jswdk-1.0.1/

setenv LWS ${SERVERHOME}lib/

setenv SERVLETS ${SERVERHOME}examples/WEB-INF/servlets/
setenv LIBHOME /usr/java/jdk1.3/lib/

setenv CLASSPATH ${LWS}/servlet.jar
setenv CLASSPATH ${CLASSPATH}:.
setenv CLASSPATH ${CLASSPATH}:${LWS}all.jar
setenv CLASSPATH ${CLASSPATH}:${LWS}jspengine.jar
setenv CLASSPATH ${CLASSPATH}:${LWS}servlet.jar
setenv CLASSPATH ${CLASSPATH}:${LWS}xml.jar
setenv CLASSPATH ${CLASSPATH}:${LWS}kahindu.jar
setenv CLASSPATH ${CLASSPATH}:${LWS}mm.mysql-2.0.2-bin.jar
setenv CLASSPATH ${CLASSPATH}:${LWS}mysql.jar
setenv CLASSPATH ${CLASSPATH}:${SERVLETS}
setenv CLASSPATH ${CLASSPATH}:${LIBHOME}tools.jar
setenv CLASSPATH ${CLASSPATH}:${LIBHOME}util.jar
setenv CLASSPATH ${CLASSPATH}:${LIBHOME}dt.jar
```

To set the CLASSPATH under a Windows system, I use

```
set lws = d:\javacourse\server\jswdk-1.0.1
set shome = %lws%\lib\
set servlets = %lws%\examples\WEB-INF\servlets\
classpath=c:\jdk1.2.2\lib\dt.jar
set classpath=%classpath%;%shome%xml.jar
set classpath=%classpath%;%shome%jspengine.jar
set classpath=%classpath%;%shome%servlet.jar
set classpath=%classpath%;%shome%tools.jar
set classpath=%classpath%;%servlets%
```

The location of the JSWDK *JAR* files may vary (e.g., some people do not have a D drive). Also, the *CLASSPATH* variable set above may have to point to a different directory, depending on which version of the JDK you have installed. Sorry to say, setup is not easy.

Once you have installed the web server, you launch it with

```
java com.sun.web.shell.Startup
```

Most IDEs will let you set this class as your *main* target, is as shown in Figure I.3-3.

Under a UNIX system, a *startserver* shell script can be run. Under *Windows*, a *startserver.bat* file can be run. These scripts are shown in Figure I.3-4.

JSWDK is just one example of a Web server, and, in fact, there are many other Web servers around. In addition, each Web server has different setup procedures. Visit *<http://localhost:8080>* to find the machine (or use the machine's name, if you have one).

Figure I.3-5 shows a sample homepage seen when a browser visits a Java Web server homepage.

```
╔══════ Java Application Settings ══════════════════╗
║ Java Target                                        ║
║   Target Type │Application    ⬍│                   ║
║                                                    ║
║      Main Class: │com.sun.web.shell.Startup      │ ║
║                                                    ║
║     Parameters:  │                               │ ║
║                                                    ║
║ Working Directory: │                  │  │Choose...│║
║                                                    ║
╚════════════════════════════════════════════════════╝
```

FIGURE I.3-3
Setting the Target in CodeWarrior

```
www.docjava.com{lyon}22: ls
etc/          LICENSE    src/              stopserver*        webserver.xml
examples/     restart*   startserver*      stopserver.bat     webserver.xml~
jps1.1/       restart~   startserver~      webpages/          work/
lib/          sql/       startserver.bat   webserverlog.txt
www.docjava.com{lyon}23: ▮
```

FIGURE I.3-4
The JSWDK Start Scripts

DocJava™, Inc.

JSP Engine

- /home/lyon/java/jswdk-1.0.1/webpages/index.html
- The verto project
- The feedback page
- email archives
- The OffLine JSP Search engine (fast!)
- The On-line JSP search engine (slow)
- CookieCount
- util
- **JSP Examples**
- **Servlet Examples**

FIGURE I.3-5
The Servlet Home Page

A P P E N D I X J

Bitwise Operators

by Douglas Lyon and Maynard Marquis

Let him that would move the world, first move himself.

–Socrates

In this chapter you will learn how to perform bit manipulations on binary numbers.

Bitwise operations enable data communications of all types. For example, in the transmission of an e-mail attachment, binary data often is blocked by a mailer. As a result, a base-64 encoding is used to allow the data to pass by the mail processing software.

Most modern coding systems require bit manipulations. In fact, bit manipulations enable most message authentication. We will find bit manipulations used in code that has to read and process binary data streams (see Chapter 15 for the *StreamSniffer* example).

Figure J-1 lists the bitwise operators.

The unary operator, \sim, performs a bitwise complement. Like modern computer languages, such as C and C++, Java uses a twos complement representation of negative numbers. Twos complement is discussed in Section J.1.

Two of the bitwise operators, \wedge and $|$, are overloaded operators as logical boolean operators and as bitwise operators.

The operator $<<$ shifts bits to the left, and $>>$ is a bitwise operator that shifts bits to the right with a sign extension. The operator $>>>$ is a bitwise right shift with a zero extension. These operators are binary, and their associativity is from left to right.

The following six bitwise operators are combined with the assignment operator, $=$, to perform assignments of their operations to a specified variable: $\&$, \wedge, $|$, $<<$, $>>$, and $>>>$.

J.1 Complement Operator

Four of the fundamental operations in mathematics are add, subtract, multiply, and divide. Multiply and divide even can be thought of as subsets of add and subtract. Subtraction, in

Operator	Operation	Java Expression	Meaning
~	bit negation	a = ~ b	reverses the bits in b
&	bitwise AND	a = b & c	a is equal to the bitwise ANDing of b and c
^	bitwise XOR	x^y	x is exclusive OR'd with y
\|	bitwise OR	a\|b	a OR b
>>	shift right	a = a >> 4	a has its bits shifted 4 places, excluding the SIGN bit
>>>	shift right	a = a >>> 4	a has its bits shifted 4 places, including the SIGN bit
<<	shift left	a = a << 4	a has its bits shifted left 4 places

FIGURE J-1

Bitwise Operators

turn, can be performed using addition with negative numbers. Formulating negative numbers is a process that varies depending on the numbering system used. One numbering system that represents negative numbers is called *twos complement*. Twos complement numbers are formed by inverting the bits and then adding one.

In binary, we write the twos complement of six as

$$(0110)' + 1 = (1001).$$

The relationship given by the twos complement is

$$-x = \tilde{\ }x + 1$$

where $-x$ is the twos complement and $\tilde{\ }x$ is the ones complement.

The decimal number $(427)_{10}$ is written below as a 16-bit number with its ones complement.

number	0000 0001 1010 1011
ones complement	1111 1110 0101 0100
twos complement	1111 1110 0101 0101

J.2 And, OR, and XOR Operators

The AND operator, &, does a bitwise computation between two fixed-point primitive data types. For example, the following statement prints the decimal number eight:

```
System.out.println ("13&8 = " + Integer.toString(13 & 8));
```

To understand the result, the numbers need to be converted to binaries:

$$
\begin{array}{r}
1101 \\
\&\quad \underline{1000} \\
1000
\end{array}
$$

Then, each position in the binaries is compared. Where they both contain a one, a one is placed in that position for the result: Otherwise, a zero is placed in the position. So, in this example, only the third position (starting with zero) in both numbers contains a one, resulting in the binary 1000, or decimal 8.

The inclusive OR operator, |, operates in the same fashion, except that this operator places a one for the positions for the result where a one exists in either number. So, $(13\,|\,8)$ yields 13:

$$
\begin{array}{r}
13 = 1101 \\
\text{OR}\quad \underline{8 = 1000} \\
1101 = 13.
\end{array}
$$

Figure J.2-1 shows the truth table for the inclusive OR. The OR operation is true if any of the inputs are true.

The exclusive OR operator, \wedge, also operates in a similar way. This operator places a one in the result for those positions where only one of the numbers contains a one. If both numbers have a one in the same position, the result contains a zero. So, $(13 \wedge 8)$ yields 5:

$$
\begin{array}{r}
13 = 1101 \\
\text{XOR}\quad \underline{8 = 1000} \\
0101 = 5.
\end{array}
$$

Figure J.2-2 shows the truth table for the exclusive OR. The XOR operation excludes the combination of both inputs being one at the same time. In fact, a multiple-input exclusive OR excludes all inputs being equal to one.

A	B	A\|B
0	0	0
0	1	1
1	0	1
1	1	1

FIGURE J.2-1
Truth Table for the Inclusive OR

A	B	A^B
0	0	0
0	1	1
1	0	1
1	1	0

FIGURE J.2-2
Truth Table for the Exclusive OR

J.3 Shift Operators

The shift operators, $<<$, $>>$, and $>>>$, shift the positions of binary numbers by the amount specified.

The left-shift operator shifts the positions of the binary numbers to the left by the amount specified. The impact is to add zeros to the left of the number. For example, the expression $(12<<2)$ yields 48, which is the same as multiplying 12 by 2^2. For example,

```
System.out.println ("12<<2 = " + Integer.toString( 12 << 2 ));
```

$$12 = 1100$$
$$12<<2 = 110000 = 48.$$

The right-shift operator, with a sign extension, eliminates the number of digits on the right specified by the shift. So, $(12>>2)$ yields 3, which is the same as integer division, $12/2^2 = 3$.

$$12 = 1100$$
$$12>>2 = 11\cancel{00} = 11 = 3$$

$$13 = 1101$$
$$13>>2 = 11\cancel{01} = 11 = 3.$$

This operator also takes negative numbers, but in this case it is only the same as integer division when the real number division has no remainder. Thus, $-12>>2$ yields -3 just as $-12/4$ does. However, $-13>>2$ yields -4 and not -3. So, in this latter case, the shift is not the same as integer division. The reason can be explained using the twos complement. The twos complement for 3, 4, 12, and 13 is shown below. Only eight bits are shown, but there are actually more to the left of each number:

$$\text{Twos complement for } 3 = 11111101 = -3$$
$$\text{Twos complement for } 4 = 11111100 = -4$$
$$\text{Twos complement for } 12 = 11110100 = -12$$
$$\text{Twos complement for } 13 = 11110011 = -13$$
$$-12>>2 \qquad\qquad = 1111110\cancel{100}$$
$$-13>>2 \qquad\qquad = 1111110\cancel{011}$$

Shifting two positions on -12 eliminates the two zeros on the end. Now the binary number is the same as that for -3. Doing the same to -13, however, produces the binary number for -4. So, more care needs to be exercised for shifts when dealing with a negative number.

The right-shift operator with a zero extension works the same as the previous operator, but only for positive numbers. The $>>>$ operator handles only unsigned integers. For example,

$$12>>>2 = 1100 = 11\cancel{00} = 3.$$

Combining the assignment operator with the shift operators assigns the result of the shift to the specified variable, thus operating the same as the $+=$ and $-=$ operators:

```
i >>= 3; // is the same as:
i = i >> 3; // a right shift with sign in the extension

i >>>= 9; // is the same as:
i = i >>> 9; // a right shift with zeros in the extension
```

The following code example will reverse the bits in an int. Bit-reversal code is used to perform transforms such as the Fast Hartley Transform (FHT) and the Fast Fourier Transform (FFT), which are described in [Lyon 1999]:

```
int bitr(int j) {
      int ans = 0;
      for (int i = 0; i< nu; i++) {
        ans = (ans <<1) + (j&1);
        j = j>1;
      }
      return ans;
}
```

The variable *nu* is declared as an int and is equal to the number of bits to be processed. It is common to replace the preceding bit-shifting code with look-up tables that group the bits into 8-or 16-bit groups.

An example of some code that demonstrates the bit operations follows:

```
public class BitTest {
      public static void printlnBits(String prompt, int x)
        {
        String s = Integer.toString(x,2);
        prompt = padString(prompt, 16, ' ');
        s = padString(s,16,'0');
        System.out.println(
          prompt+
          "= "+
          s
          );
      }
      /**
        padString - pads string s
        with char c so that it has k total characters.
      */
      public static String
          padString(String s, int k, char c) {
        int n = k - s.length();
        for (int i=0; i < n; i++)
          s = c+s;
        return s;
      }

      public static void main(String args[]) {
        int a = 960;
        int b = 1<<8 ;
```

```
            printlnBits("a\t",a);
            printlnBits("b\t",b);
            printlnBits("a&b\t",a&b);
            printlnBits("a|b\t",a|b);
            printlnBits("a^b\t",a^b);
        }
    }
```

What follows is the output of *BitTest*

```
  a = 0000001111000000
  b = 0000000100000000
a&b = 0000000100000000
a|b = 0000001111000000
a^b = 0000001011000000
```

As a final example, consider how Java stores color information in a packed 32-bit integer. In Java, a pixel is stored as a 32-bit *int*. The *int* consists of 4 packed bytes. These bytes represent ARGB planes, as shown in Figure J.3-1.

The packed pixel is the most tightly-packed storage technique available for a 32-bit pixel. However, there are problems with this approach. For example, encoding and decoding both require bit-shift and masking operations, thus increasing computation time.

Suppose you are given a packed color pixel, as shown in Figure J.3-1, and you want to average the red, green, and blue channels. A method that accomplishes this task follows:

```
public int filterRGB (int rgb) {
  int red   = (rgb & 0xff0000) >>16;
  int green = (rgb &   0xff00) >> 8;
  int blue  =  rgb &     0xff;
  int gray  = (red + green + blue) / 3;
  return (
    0xff000000 |
    (gray << 16) |
    (gray <<  8) |  gray);
}
```

The basic idea is that bitwise operations do not interpret the sign bit; instead, they treat it as just another bit, which is important when doing binary manipulations on signed scalars. Such techniques can be used to convert a signed byte into a value that ranges from 0..255 without worrying about twos complement conversions.

Alpha (8 bits)	Red (8 bits)	Green (8 bits)	Blue (8 bits)

← 32 bits →

FIGURE J.3-1

A Packed Pixel

J.4 Summary

This chapter described some of the more popular bases and how to convert between them. Position notation was introduced as a means of representing decimal, binary, octal, and hexadecimal numbers. By extension, other bases may be represented in a similar way. Grouping was used to map from bases 2, 8, and 16.

The mechanics of the most elementary of bit operations also was examined. These mechanics were used to show how computers subtract numbers (via twos complement).

J.5 Exercises

J.1 What do the following *Integer* methods return? (Hint: Some throw *NumberFormatException*.)

```
A. parseInt("0", 10)
B. parseInt("473", 10)
C. parseInt("-0", 10)
D. parseInt("-FF", 16)
E. parseInt("1100110", 2)
F. parseInt("2147483647", 10)
G. parseInt("-2147483648", 10)
H. parseInt("2147483648", 10)
I. parseInt("99", 8)
J. parseInt("Kona", 10)
K. parseInt("Kona", 27)
```

J.2 Bitwise operations enable communication to embedded systems. For example, a popular barcode scanner called *CueCat* (available for free from RadioShack) outputs an encoded bit stream. Bitwise operations can convert the bit stream into UPCs, or ISBNs. Go to a Radio Shack and get your free barcode scanner, and then write a Java program to decode the output. See *<http://www.timpatton.com/jcat/>* for more information on *CueCat*.

J.3 The *Integer* class has a *decode* method that can take a string and build an instance. For example,

```
public class BaseDemo3 {
  public static void main(String args[]) {
    Integer in = Integer.decode("0xFF");
    int i = in.intValue();
    System.out.println(
               "i=" + i);
  }
}
```

Write your own version of *decode* that works with base-64 strings. What will you use for your leading base-64 character?

J.4 In the following code, Java is used to help output base-16 numbers:

```
public class BaseConversion {

  public static void main(String args[]) {
    System.out.println(Integer.toString(0xff,16));
    System.out.println(Integer.toString(0xdead,16));
    System.out.println(Integer.toString(0xdead & 0xff,16));
    System.out.println(Integer.toString((0xdead & 0xff) << 8,16));
    System.out.println(Integer.toString((0xdead >> 8),16));
    System.out.println(Integer.toString(0xad | (0xde << 8),16));

  }
}
```

The above code outputs:

```
ff
dead
ad
ad00
de
dead
```

Rerun the preceding program so that it outputs in base 2. Show the output.

J.5 What does the following code output?

```
public class DisplayString {

  public static void main(String args[]) {
    int number1 = 960;
    int display_mask = 1 << 15;
    printlnBits("number1      \t                ", number1);
    printlnBits("display_mask\t                ", display_mask);
    printlnBits("number1<< 8 \t                ", number1 << 8);
    printlnBits("number1>> 8 \t                ", number1 >> 8);
    printlnBits("display_mask | number1\t", display_mask | number1);
    printlnBits("display_mask & number1\t", display_mask & number1);
    printlnBits("display_mask ^ number1\t", display_mask ^ number1);
    printlnBits("display_mask ^~number1\t", display_mask ^ ~number1);
  }
  public static void printlnBits(String s, int x) {
    System.out.println(s + "= " + Integer.toString(x, 2));
  }

}
```

J.6 Write a program to compute the Hamming distance between two numbers. The *Hamming distance* is defined as the number of different bits between two binary numbers. One way to compute the Hamming distance between two integers is to perform an exclusive OR (\wedge) and then to sum up the number of different bits.

A	B	C	D	F
0	0	0	0	
0	0	0	1	
0	0	1	0	
0	0	1	1	
0	1	0	0	
0	1	0	1	
0	1	1	0	
0	1	1	1	
1	0	0	0	
1	0	0	1	
1	0	1	0	
1	0	1	1	
1	1	0	0	
1	1	0	1	
1	1	1	0	
1	1	1	1	

FIGURE J.5-1

A Truth Table

J.7 Write a program to compute a truth table for the following function:

$$F(A,B,C,D) = A + ABD + AC'D + A'CD'. \tag{J.5-1}$$

The truth-table is shown in Figure J.5-1. For example, for the first term, $F(0,0,0,0) = 0$. We can represent equation (J.5-1) using the boolean expression:

```
f = A || A && B && D || A && !C && D || !A && C && !D
```

J.8 Repeat exercise 7 using bitwise operations. We can represent equation (J.5-1) using the bitwise expression

$$f = A | A \& B \& D | A \& {\sim}C \& D | {\sim}A \& C \& {\sim}D.$$

APPENDIX K

Collections

by Thomas Rowland

To talk goodness is not good... Only to do it is.

–Chinese Proverb

Java 2 provides a *collections framework*, offering a more robust architecture for managing collections than in earlier versions of Java. The collections framework consists of a hierarchical set of *interfaces*, the *implementations* that represent the objects that store the collections, and a set of *algorithms* that provide reusable functionality that the developer can use. Together, these pieces make programming easier by handling low-level details so that the developer does not have to handle them. Additionally, the framework promotes software reuse by offering a standard API and implementation choices that are designed for quality and performance. All of the JDK interfaces and implementation classes in this chapter reside in the *java.util* package unless stated otherwise.

K.1 The Collections Framework Interfaces

At the highest level of abstraction, a set of interfaces makes up the foundation of the collections framework. These collections interfaces are a set of abstract data types that allow access to the underlying collections. Six interfaces form the collections framework, and they are arranged into a tree structure, as shown in Figure K.1-1.

K.2 The *Collection* Interface

The *Collection* interface is the root of the hierarchical tree structure for *lists* and *sets*. It is never extended directly. Instead, the *List* and *Set* interfaces both extend the *Collection* interface, providing more specific versions. The *Collection* interface itself primarily is used

FIGURE K.1.-1
The *Collections* Interfaces

to pass around collections of objects and manipulate them because it provides the most general definition of a collection. It provides basic functionality for adding, removing, and iterating through a collection. It can report its size, whether it is empty, and whether it contains a specific object. In addition, it provides the ability for the collection to be converted into an array. The *List* and *Set* interfaces inherit all of the behavior from the *Collection* interface, and they have additional methods or restrictions to provide more specific functionality. The `Collection` interface contains the following method declarations:

```
// Basic Operations
int size();
boolean isEmpty();
boolean contains(Object element);
boolean add(Object element);
boolean remove(Object element);
Iterator iterator();

// Bulk Operations
boolean containsAll(Collection c);
boolean addAll(Collection c);
boolean removeAll(Collection c);
boolean retainAll(Collection c);
void clear();

// Array Operations
Object[] toArray();
Object[] toArray(Object a[]);
```

Many of the preceding methods are optional, meaning that an interface that extends the `Collection` interface need not include them in their method declarations. Also notice that there are no *getter* methods (i.e., there is no way to retrieve a specific element from the collection). This type of functionality is defined in the interfaces that extend it, thus defining functionality that is more specific (e.g., restrictions on the types of objects that can be contained in

FIGURE K.2.1-1
Set A

the collection, determination as to whether or not the use of nulls is allowed, or determination as to whether or not the collection can be updated). This interface also acts as the most generic type of collection for the purpose of passing and manipulating collections.

K.2.1 The *Set* Interface

The *Set* interface is a Collection that contains no duplicate elements. It is meant to model the *set* abstraction, which is a mathematical concept that can be described simply as a grouping of elements. It is the simplest type of collection. Sets have no particular order. For example, a set *A* can be defined as

$$A = \{a, b, c, \ldots, x\}$$

and depicted as Figure K.2.1-1.

The `Set` interface extends the `Collection` interface. It includes in its method declarations all of the methods from *Collection* and does not include any additional functionality. Furthermore, it places constraints on the constructors and on certain methods to ensure that no duplicate elements exist. These constraints are stipulated in the interface specification, which defines a *contract* that all implementations must follow. The implementations of Set that we will discuss are `HashSet` and `TreeSet`. Which is a new addition to JDK 1.4, `LinkedHashSet`, will not be discussed here.

K.2.2 The *List* Interface

The `List` interface is an ordered `Collection`. It is meant to model the *list*, or *sequence* abstraction, which is a mathematical concept that can be described as a collection of elements with a natural order. Lists are stored in a linear fashion similar to arrays. For example, a List B can be defined as

$$B = \{x_0, x_1, x_2, \ldots, x_n\}$$

and depicted as Figure K.2.2-1.

List B:

x_0	x_1	x_2	...	x_n

FIGURE K.2.2-1
List B

The `List` interface extends the `Collection` interface. Like the `Set` interface, it includes in its method declarations all of the methods from `Collection`, and it includes additional methods for adding, removing, and getting elements at specific locations within the collection. Examples of implementations of `List` are `ArrayList` and `LinkedList`.

K.2.3 The *Map* Interface

Although included as part of the collections framework, the `Map` interface is not a true `Collection` because it does not extend the `Collection` interface. It is meant to model the *map* abstraction, which is a grouping of elements where each element is mapped to a *key*. Each key provides a type of pointer, which determines where to store the element. Given a key, you have direct access to the associated element. For example, a map C can be defined as

$$C = \{e_0, k_0, e_1, k_1, e_2, k_2, \ldots, e_n, k_n\}$$

and depicted as Figure K.2.3-1.

A map provides a way of storing data that minimizes the need for searching when you want to retrieve an element by storing key-element pairs and using a process called *hashing* for fast lookup (hashing will be discussed later in this chapter).

The `Map` interface contains the following method declarations [Map]:

```
// Basic Operations
Object put(Object key, Object value);
Object get(Object key);
Object remove(Object key);
boolean containsKey(Object key);
boolean containsValue(Object value);
int size();
boolean isEmpty();

// Bulk Operations
void putAll(Map t);
void clear();

// Collection Views
public Set keySet();
public Collection values();
public Set entrySet();
```

Key	element				
		key	element		
Key	element				
Key	element			key	element

FIGURE K.2.3-1
Map C

```
                // Interface for entrySet elements
        public interface Entry {
                Object getKey();
                Object getValue();
                Object setValue(Object value);
        }
```

Examples of Map implementations are *HashMap* and *TreeMap*.

K.2.4 The Iterator, ListIterator, and Enumeration Interfaces

Iterator is an interface that provides the ability to iterate forward through and remove elements from a collection. *List* and *Set* implementations provide methods that return an implementation of *Iterator*. These iterators are *fail-fast*, meaning that they will fail quickly and cleanly if there is an attempt to modify the underlying object from outside of the iterator while it is being iterated.

ListIterator is an interface that extends the *Iterator* interface and provides additional functionality specifically for lists. In addition to the methods provided by *Iterator*, *ListIterator* offers the ability to move backwards and to add and replace elements in the list. ListIterator is also fail-fast, which is why the example above used the *ListIterator* remove method instead of the ArrayList remove method. If we had used list.remove(o) instead of li.remove(), *ConcurrentModificationException* would have been thrown.

As part of the collections framework, Iterator and ListIterator are meant to replace the older *Enumeration* interface, which initially was supported by the Vector and HashTable classes. They all have essentially the same functionality, except that:

- *Iterator* provides the ability to remove elements from a collection.
- *Iterator* and *ListIterator* are fail-fast; *Enumeration* implementations are not fail-fast and thus risk unpredictable and undesirable results if the collection is modified during an enumeration.
- ListIterator offers additional methods for manipulating lists.
- Iterator and ListIterator provide shorter method names.

Enumeration methods include

```
        boolean hasMoreElements()
        Object nextElement()
```

Iterator methods include

```
        boolean hasNext()
        Object next()
        void remove()
```

ListIterator methods (in addition to Iterator) include

```
        int nextIndex()
        int previousIndex()
        boolean hasPrevious()
        Object previous()
        void add()
        void set()
```

Vector and *HashTable* both continue to support the ability to enumerate through their elements while also offering the ability to iterate. However, the use of iterators is the preferred technique.

K.3 Collection Implementations

The JDK provides several collection implementations. The three basic types are summarized as follows:

- *Sets* are collections that contain no duplicate elements and that generally have no guaranteed order to the elements. However, sorting can be imposed on a set.
- *Lists* are collections that are ordered (though not sorted) and that allow duplicate elements to exist.
- *Maps* are table-based structures that store key-value pairs of objects and allow fast lookup.

Once an implementation is chosen, it may be necessary to implement certain methods in the classes that will be contained in the collection in order to make them work efficiently. The following sections will show when and how to:

- Use the *Comparable* and *Comparator* interfaces to impose an ordering on a collection and determine how this ordering must be consistent with *equals*
- Override the *equals* and *hashCode* methods to provide a definition for equality
- Use *getClass* versus *instanceof*

A class implementation may choose to implement some, all, or none of the optional methods provided by an interface. When implementing optional methods, a class must state in its documentation which optional methods are supported. Any attempt to call a method that is not supported should result in *UnsupportedOperationException.*

Additionally, a *Collections* class containing static convenience methods can be used on collections to perform sorting, searching, synchronization, conversion to arrays, and other functionality.

K.3.1 The HashSet Class

The HashSet class implements the Set interface. It is designed for fast access to its objects, and it is the best choice for storing a basic collection of objects in a *Set* when no ordering is required. The following example illustrates the use of a *HashSet* to store a collection of different types of objects and then remove objects of a certain type:

```java
import java.util.Set;
import java.util.HashSet;
import java.util.Iterator;

public class HashSetTest {
    public static void main (String[] args) {
        Set hs = new HashSet();
        hs.add("Jerry");
        hs.add("Bob");
        hs.add("Phil");
```

```
                                // print out the names
                                Iterator i = hs.iterator();
                                while (i.hasNext()) {
                                        System.out.println
                                        ((String) i.next());
                                }
                        }
                }
```

The *HashSet* add method allows us to add new objects to the collection. The *iterator* method returns an *Iterator* object, which is used to iterate through all of the objects in the collection. As each object is encountered, we cast it to its *String* type and print out the name.

It is a strongly recommended programming practice that you declare your collection object by its interface type (*Set*), rather than by its implementation type (*HashSet*). Doing so gives you the flexibility to change implementations merely by changing the constructor:

```
        Set hs = new TreeSet();
```

The rest of the code remains unchanged.

K.3.2 Uniqueness Means Overriding the `hashCode` and `equals` Methods

An object may be stored in a set only once, and the *HashSet's* add method will return *false* if an attempt is made to add an object that is equal to an existing object in the set. This test for equality relies on both the *equals* and the *hashCode* methods inherited from *java.lang.Object*. Using the preceding example,

```
        hs.add("Bob");
        hs.add("Bob");                     //add method returns false!
```

A *hash code* is an **int** value that represents some relatively unique characteristics about an object [Eckel]. It is generated by the *hashCode* method, which returns a value based on an object's memory address. A hash code quickly locates a key-value pair of objects stored in a *hash table* using a process called *hashing* (hashing is discussed later in this chapter). Objects often override the *hashCode* method to provide a more appropriate value for representing themselves. Many of the JDK classes, such as *String* and *Integer*, provide overridden versions of *hashCode* and *equals*. Typically, an object's hash code is based on one or more of the fields in the class. Multiple fields can be used by adding the individual hash codes of each significant field [Bloch]. The goal is to produce uniformly distributed values for unequal objects. (This extensive topic is beyond the scope of this chapter.) The following example shows how a simple but effective *hashCode* method might be implemented. Consider the *Employee* class, which contains a unique field named *employeeNumber*:

```
        private int employeeNumber;
        . . .

        public int hashCode () {
                return employeeNumber;
        }
```

Alternatively, if *employeeNumber* were a String:

```
private String employeeNumber;
...

public int hashCode () {
      return employeeNumber.hashCode();
}
```

Here, we make use of the overridden *hashCode* method in class *String*. Most often, your hash codes will be based on simple types like *Strings*. However, there may be times when performance is crucial or when the field(s) on which to base your hash code are custom objects. In these cases, you may need to write a more comprehensive custom *hashCode* method [Uzgalis].

Internally, a *HashSet* is implemented by a *HashMap* (an object based on a hash table). Hash tables rely on hash codes for fast lookup (this topic will be discussed later in this chapter). Each time a *HashSet* add method is called when adding an object to the set, the object's hash code is compared against the hash codes of the existing elements in the set. If there is no match, then the add is granted. If there is a match (because it is possible that two different objects may possess the same hash code) the *equals* method is called to determine if the object being added is equal to an existing object in the set [Sun HashMap source]. Relying on the *Object hashCode* and *equals* methods may not produce the desired results, so when adding your own custom classes to a collection, it usually is necessary to override the *hashCode* and *equals* methods [Eckel]. When doing so, it is important that *equals* be consistent with *hashCode* because if a class's *hashCode* method returns different values for objects that are equal, results may be undesirable or unpredictable [Sun Comparable] [Sun Comparator].

Consider the concept of adding products to a cart. We want to store a collection of Product objects in a collection called Cart. Since a product's uniqueness is determined by its ID, we can base our hash-code value, and thus our test for equality, on the id field:

```
public class Product {
      private int id;
      private String name;
      private String descr;
      private int qty;
      private double price;

      public Product (int _id, String _name,
            String _descr, int _qty, double _price) {
            id = _id;
            name = _name;
            descr = _descr;
            qty = _qty;
            price = _price;
      }

      public int hashCode () {
            return id;
      }

      public boolean equals (Object o) {
            if (o != null &&
            o.getClass() == this.getClass()) {
```

```
                      return id == ((Product)o).getId();
              }
              return false;
      }
}

public class Cart {
    private static Set products = new HashSet();

        ...

    public static void main (String[] args) {
        Cart cart = new Cart();
        Product product;

        //add an object to the hashset
        product = new Product(
              1234,"Pasta","Ziti, 16oz box",3,1.45);
        cart.addProduct(product);

        //adding the "same" object again will fail
        product = new Product(
              1234,"Pasta","Ziti, 16oz box",1,1.45);
        cart.addProduct(product);

        //so it must first be removed then added
        cart.removeProduct(product);
        cart.addProduct(product);

        //list the objects
        Iterator iter = products.iterator();
        while (iter.hasNext()) {
               System.out.println((Product)iter.next())
        ;
        }
    }

    public boolean addProduct (Product product) {
        if (products.add(product))
             System.out.println
             ("New product added.");
        else System.out.println
             ("Product already exists!");
    }

    public boolean removeProduct (Product product) {
        if (products.remove(product))
             System.out.println
             ("Product removed.");
        else System.out.println
             ("Product not found!");
    }
}
```

Without overriding *equals* and *hashCode*, the default methods in class *Object* will be called and will consider two elements equal only if they are the same *instance*.

Not all types of collections actually rely on both the `hashCode` and `equals` methods. However, it is strongly suggested that you always implement both methods in any custom objects being added to a collection. The contract for `Object.hashCode` states that equal objects must have equal hash codes [Sun Object], which will allow your objects to be generic enough to be used in different collection types and will prevent bugs when doing so. Joshua Bloch's *Effective Java Programming Language Guide* is an excellent reference containing information on implementing `hashCode` and `equals` [Bloch].

K.3.3 Using *getClass* in Place of *instanceof*

Whenever implementing the `equals` method, the `getClass` method in `java.lang.Object` should be used instead of the `instanceof` operator. The `instanceof` operator can cause problems when inheritance is used to subclass your class without properly overriding the `equals` method in the derived class [Eckel] [Roulo]. As an example, suppose you create a class *Parent* and someone else creates a class *Child* that extends *Parent* without overriding your equals method:

```
public class Parent {
    private static int id;
    ...

    public boolean equals (Object o) {
        //using instanceof, should use getClass()
        if (o instanceof Parent)
            return ((Product)o).getId() == id);
        return false;
    }
}

public class Child extends Parent {
    private static int id;

    ...
    //does not override equals

}
```

For two objects with different values for id,

```
Parent parent = new parent();
Child child = new Child();
child.equals(parent);          //returns true
parent.equals(child);          //returns false!
```

Not only is the preceding code wrong, but it also breaks the contract for the `equals` method defined in class *Object*, which states that "for any reference values *x* and *y*, *x.equals(y)* should return true if and only if *y.equals(x) returns true*" [Sun Object].

Using `getClass` in the `equals` method of the base class will help ensure that the two objects compare correctly, regardless whether the derived class fails to override `equals` or overrides it using `instanceof`.

K.3.4 The *TreeSet* Class

The `TreeSet` class implements the `Set` interface. It is used when order among objects must be maintained. Its usage is similar to that of `HashSet`. For example,

```
import java.util.Set;
import java.util.TreeSet;
import java.util.Iterator;

public class TreeSetTest {
        public static void main (String[] args) {
            Set ts = new TreeSet();
                ts.add("Jerry");
                ts.add("Bob");
                ts.add("Phil");

                // Print out all names
                Iterator i = ts.iterator();
                while (i.hasNext()) {
                            System.out.println (
                            (String) i.next());
            }
        }
    }
```

To use `TreeSet` or `TreeMap`, objects added to the set must be *sortable*. Many of the JDK classes (like `String` in the preceding example) are sortable, and, in fact, custom classes need to be made sortable. There are two ways for an object to be sortable: by implementing the `Comparable` interface or by providing a separate comparator that is passed into the constructor when the collection is created. These two methods are detailed in the sections below.

K.3.5 Natural Ordering by Making Your Classes Comparable

For an object to be comparable, its class implements the `Comparable` interface and overrides the *compareTo* method. It also should override the *hashCode* and *equals* methods. The *compareTo* method defines how objects are to be compared so they can be ordered properly within the set. This ordering is referred to as the class's *natural ordering*. The *compareTo* method compares an object with another object and returns zero, a negative integer, or a positive integer if this object is equal to, less than, or greater than the object provided as the argument Comparable. Many of the classes *(e.g., String, Date, and Integer)* residing in the JDK's `java.lang` package are already comparable, which allows them to be used in `TreeSet` directly.

When using `TreeSet`, the equals and *hashCode* methods are not used when comparing objects. Instead, the *compareTo* method is used exclusively. However, it is strongly advised to include *equals* and *hashCode*. Furthermore, *compareTo* should be consistent with *equals* as stipulated in the specification for the `Comparable` interface, which states that "A class's natural ordering is said to be consistent with equals if and only if (e1.compareTo((Object)e2))==0 has the same boolean value as e1.equals((Object)e2)) for every e1 and e2 of class C" [Sun Comparable].

Furthermore, as the specification further notes, "It is strongly recommended (though not required) that natural orderings be consistent with equals.

It is strongly recommended, but not strictly required that (*x.compareTo(y)* ==0)==(*x.equals(y)*) [Sun Comparable].

Also, an object containing consistency between *hashCode* and *equals* will be able to be passed freely from one collection type to another and to minimize bugs when doing so.

To expand on the example using the `Product` class, suppose we need to retrieve products ordered by *id*. The `SortableProduct` class now looks like this:

```java
public class SortableProduct implements Comparable {
    private int id;
    private String name;
    private String descr;
    private int qty;
    private double price;

    public SortableProduct (int _id, String _name,
        String _descr, int _qty, double _price) {
        id = _id;
        name = _name;
        descr = _descr;
        qty = _qty;
        price = _price;
    }

        ...

    public int compareTo (Object o) {
        SortableProduct p = (SortableProduct)o;
        //we can use Integer's compareTo method:
        return (new Integer(id)).compareTo (
            new Integer(p.getId());
    }

    public boolean equals (Object o) {
        if (o != null &&
        o.getClass() == this.getClass()) {
            return (id ==
        (SortableProduct)o).getId());
        }
        return false;

    }

    public int hashCode () {
        return id;
    }
}
```

The `compareTo` method is implemented to maintain products in ascending order by *id*. Alternatively, we could choose to sort the collection by name and description, as follows:

```java
public int compareTo (Object o) {
    SortableProduct p = (SortableProduct)o;
    return (name + descr).compareTo (
            p.getName() + p.getDescr());
}
```

```
        public boolean equals (Object o) {
            if (o != null &&
            o.getClass() == this.getClass()) {
                SortableProduct p = (SortableProduct) o;
                return (name + description).compareTo (
                    p.getName() + p.getDescr()) == 0;
            }
            return false;
        }

        public int hashCode () {
            return (name + description).hashCode();
        }
```

We ensure that *compareTo* is consistent with *equals* by forwarding the test for equality in *equals* to *compareTo*.

K.3.6 Total Ordering by Providing an Explicit Comparator

The second way to make an object sortable is to pass an explicit *Comparator* into the constructor of the collection class upon creation. A comparator is used to impose a *total ordering* of the elements in the set. Multiple comparators can be created to impose multiple sorting orders. The same rules for implementing *hashCode* and *equals* apply when making a class comparable.

For efficiency, when using large collections of objects, it is often desirable to store elements in a basic collection and then convert to a more specialized collection when specific behavior is required. In the following example, elements are stored in *HashSet* for efficiency and then converted to *TreeSet*, relying on the comparable objects, or an explicit comparator, when specific ordering is desired:

```
import java.util.Comparator;
import java.util.Set;
import java.util.HashSet;

public class SortableProduct implements Comparable {

    public static final Comparator
    PRICE_COMPARATOR = new PriceComparator();

    public static final Comparator
    QTY_COMPARATOR = new QtyComparator();

    private int id;
    private String name;
    private String descr;
    private int qty;
    private double price;

    public SortableProduct (int _id, String _name,
            String _descr, int _qty, double _price) {
        id = _id;
        name = _name;
        descr = _descr;
        qty = _qty;
        price = _price;
    }
```

```
            //equality based on product id
        public boolean equals (Object o) {
                if (o != null &&
                o.getClass() == this.getClass()) {
                        return (id ==
((SortableProduct)o).getId());
                }
                return false;
        }

        //hash code value consistent with equals
        public int hashCode () {
                return id;
        }

        //natural ordering based on product id and
        //consistent with equals
        public int compareTo (Object o) {
                SortableProduct p = (SortableProduct)o;

                return (new Integer(id)).compareTo(
                        new Integer(p.getId()));
        }
//Price Comparator
private static class PriceComparator
        implements Comparator {
        public int compare (Object o1, Object o2) {
                return (new
Double(((SortableProduct)o1)
                        .getPrice()))
                        .compareTo(new Double(
                        ((SortableProduct)o2).getPrice()))
                ;
        }
}

//Quantity Comparator
private static class QtyComparator
        implements Comparator {
        public int compare (Object o1, Object o2) {
                return (new
                Double(((SortableProduct)o1)
                        .getQty()))
                        .compareTo(new Double(
                        ((SortableProduct)o2).getQty()));
        }
    }
}

public class Cart {
        public static void main (String[] args) {
                Cart cart = new Cart();
                Set products = new HashSet();

                //add some products to the hashset
```

```
                           products.add(new SortableProduct (
                                    88888, "Lawn Mower",
                                    "24inch reverse side attachment",
                                    1, 249.99));
                           products.add(new SortableProduct (
                                    22222, "Baseball Glove",
                                    "Tom Seaver autographed",
                                    3, 595));
                           products.add(new SortableProduct (
                                    99999, "Pencil",
                                    "No.2", 500, .15));
                           products.add(new SortableProduct (
                                    33333, "Eraser",
                                    "Ergonomic", 200, .35));

                           //sort different ways using a TreeSet
                           cart.sort(products);
                           cart.sort(products,
    Product.PRICE_COMPARATOR));
                           cart.sort(products,
    Product.QTY_COMPARATOR));
            }

        //Return a new treeset sorted according to
        //its natural ordering
        public void sort (Set set p) {
                TreeSet sortedset = new TreeSet(set);
                retrieve(sortedset);
        }

        //Return a new TreeSet sorted according to
        //the specified comparator
        public void sort (Set set, Comparator comparator)
    {
                TreeSet sortedSet = new TreeSet(comparator);
                sortedSet.addAll(set);
                retrieve(sortedSet);
        }

        //Print out the products in order
        public void retrieve (Set s) {
                Iterator i = s.iterator();
                while (i.hasNext()) {
                        System.out.println(
    ((SortableProduct)i.next()).toString());
                }
        }
```

The preceding example demonstrates how sorting can be performed using explicit comparators. When this example is run, products first will be listed according to the natural ordering of products as defined by the *compareTo* method, which imposes ordering by the *id* field. Next, products will be listed according to the total ordering as defined by the Price Comparator, which operates on the *price* field. And finally, prices will be listed according to the total ordering as defined by the Quantity Comparator, which operater on the *qty* field.

K.3.7 The ArrayList Class

The *ArrayList* class implements the *List* interface. It allows duplicate elements, including null elements, and maintains the order in which elements are added. *ArrayList* is fast, and it is the best choice for storing a basic collection of objects when arrays are not sufficient due to growing size. *ArrayList* is essentially a resizable array similar to *Vector*, but it leaves out much of the overhead of *Vector*, which consists mainly of support for synchronization.

The following example shows some of the methods that can be used on *ArrayList*. Consider waiting for a table at a restaurant. You enter your name and the size of your party on the waiting list and then sit down for a drink until you are called:

```java
import java.util.List;
import java.util.ArrayList;
import java.util.ListIterator;

public class PartyProcessor {
      private List parties = new ArrayList ();

      public static void main (String[] args) {
            PartyProcessor proc = new PartyProcessor();

            //add some objects
            proc.addParty("Rowland", 5);
            proc.addParty("Apusen", 3);
            proc.addParty("Terry", 5);
            proc.addParty("Tiffany", 2);

            //display the objects
            proc.showParties();

            //update an object
            proc.updateParty("Apusen", 8);
            proc.showParties();

            //locate objects with certain criteria
            proc.showNextPartyOf(3);
            proc.showPartyInQueue("Rowland");

            //remove an object
            proc.removeParty("Tiffany");
            proc.showParties();
      }

      // add an element to the end of the list
      public void addParty (String name, int number) {
            parties.add(new Party(name, number));
      }

      // replace an element with the one specified
      public void updateParty (String name) {
            Party party = new Party(name, number);
            int index = parties.indexOf(party);
            if (index == -1) {
                  System.out.println("Party not found");
                  return;
```

```
            }
            parties.set(index, party);
            System.out.println("Party updated");
        }

        // remove an element from the list
        public void removeParty (String name) {
            Party party = new Party(name);
            int index = parties.indexOf(party);
            if (index == -1) {
                System.out.println("Party not found");
                return;
            }
            parties.remove(index);
            System.out.println("Party removed");
        }

        // get an element in the list with specified
criteria
        public void showNextPartyOf (int partySize) {
            ListIterator iter = parties.listIterator();
            while (iter.hasNext()) {
                Party party = (Party) iter.next();
                if (party.getPartySize() == partySize) {

System.out.println(party.toString());
                    return;
                }
            }
        }

        // get the list index for an element
        public void showPartyInQueue (String name) {
            if (! parties.contains(name)) {
                System.out.println("Party not found");
                return;
            }
            System.out.println("\nParty: " + name
                    + " No. in queue: "
                    + (parties.indexOf(
                    new Party(name)) + 1));
        }

        // display the list of parties
        public void showParties () {
            ListIterator iter = parties.listIterator();
            System.out.println("\nCurrently "
                    + parties.size() + " parties...");
            Party party;
            while (iter.hasNext()) {
                party = (Party)iter.next();
                System.out.println(party.toString);
            }
        }
    }
}
```

The Party class looks like this:

```java
public class Party {
    private String partyName;
    private int partySize = 0;

    public Party (String name, int size) {
        partyName = name;
        partySize = size;
    }

    public Party (String name) {
        partyName = name;
    }

    public int getPartySize () {
        return partySize;
    }

    public boolean equals (Object o) {
        if (o != null &&
        o.getClass() == this.getClass())  {
            return
((Party)o).getName().equals(partyName);
        }
        return false;
    }

    public int hashCode () {
        return partyName.hashCode();
    }

    public String getName () {
        return partyName;
    }

    public int getSize () {
        return partySize;
    }

    public String toString () {
        return partyName + ", party of " + partySize;
    }
}
```

Party objects are maintained in the order they are inserted. The *equals* method is implemented to establish, uniqueness based on *partyName* and is used when calling the lists *indexOf* method, as well as when calling the *contains* and *lastIndexOf* methods, which are not shown here. Although lists allow duplicate elements, it is assumed here that all parties will have unique names, which could have been enforced in the add routine. An overridden *hashCode* method consistent with *equals* also is provided, which is important in the event that a *Party* object, or the *ArrayList* itself, is passed to another collection type that requires both *hashCode* and *equals*.

K.3.8 The LinkedList Class

The *LinkedList* class implements the *List* interface. It represents an ordered sequence of objects that are stored in nodes. Each node contains a link to the next and previous nodes in the sequence. *LinkedList* allows duplicate elements, including null elements, and maintains the order in which elements are added. It is the best choice for storing a large collection of objects when many insertions and deletions will be performed.

LinkedList often is used to implement *stacks* and *queues*.

To use a *LinkedList* as a stack:

```
LinkedList stack = new LinkedList();

// push an object onto the top of the stack
stack.addFirst(o);

// pop an object off the top of the stack
stack.removeFirst();

// peek at an object on the top of the stack
stack.getFirst();
```

To use a LinkedList as a queue:

```
LinkedList queue = new LinkedList();

// add an object to the tail of the queue
queue.addLast(o);

// remove an object from the head of the queue
queue.removeFirst();
```

LinkedList performs much worse than *ArrayList* for accessing elements by index [i.e. *ArrayList.get(index)* versus *LinkedList.get(index)*]. Since *ArrayList* is backed by an array, locating an element by index is easy since the index is offset from the beginning of the array. *LinkedList*, on the other hand, must iterate through each element until the desired index is reached [Shirazi]. The JDK *LinkedList* implementation actually locates a node by first locating the midpoint of the list and iterating the half of the list that contains the desired index, as follows [Sun LinkedList]:

```
if (index < size/2) {
      for (int i=0; i<=index; i++)
            //get the next node
} else {
      for (int i=size; i>index; i--)
            //get the previous node
}
```

Accessing an element at the beginning or end of *LinkedList* is the best-case, scenario; accessing an element at midpoint is the worst-case scenario.

LinkList performs much better than *ArrayList* for inserting and removing objects. For example, removing an element from the end of *ArrayList* is easy. Removing an element from the middle or the beginning of *ArrayList,* however, causes poor performance because the array elements above the insertion index must be moved up by one before assignment can occur [Shirazi]. This process involves a lot of expensive data movement because the elements need to be copied to a new array. *LinkedList*, on the other hand,

simply needs to create a node object and adjust a couple of *links* [McCluskey]. The performance penalty here is mostly dependent on the distance from the insertion or deletion point to the ends of the list for the reasons stated above.

It may be more efficient to store elements in *ArrayList* and then convert to *HashList* when additional functionality is needed:

```
List list = new ArrayList();
List llist = new LinkedList(list);
```

K.3.9 The HashMap Class

The *HashMap* class implements the *Map* interface. It does not implement the *Collection* interface, so it is not a true Collection. *HashMap* is the best choice for storing a basic collection of objects in a *Map* when no sorting is required. *HashMap* allows fast lookup of objects by using a hash code to locate a key quickly rather than iterating through a collection to find objects. As a result, *HashMap* is more efficient than lists or sets at locating objects. If iterating in a sorted order is required, then *TreeMap* would be a better choice.

HashMap does not guarantee that objects will be stored in any particular order. *HashMap* operation is similar to that of *Hashtable*, but without the synchronization and other overhead that *Hashtable* involves. Additionally, *HashMap* allows the use of *null* values and a *null* key, whereas *Hashtable* does not allow nulls.

To add an object to *HashMap*, you use the put(Object key, Object value) method. To retrieve an object, you use the get(Object key) method:

```
Map map = new HashMap();
map.put(accNo, account);
Account acc = Map.get(accNo);
```

The following example demonstrates how *HashMap* can be used to implement a **switch** that uses *Strings*:

```
import java.util.Map;
import java.util.HashMap;

/**
 * StringSwitch class - shows how to build a
 * class that supports switch based on strings.
 */
class StringSwitch {

    /**
     * Map used to store String-int
     * mappings and provide fast lookup
     */
    private Map map = new HashMap();

    /**
     * Add a key-value pair to the hashmap
     * Map.put provides constant-time performance
     */
    protected final void add (String key, final int
       value) {
       map.put (key, new Integer(value));
    }
```

```
    /**
     * Given a key, retrieve a value from the hashmap
     * Map.put provides constant-time performance
     */
    protected int getIdForString (String key) {
        return ((Integer)map.get(key)).intValue();
    }
}
```

The *SwitchTest* program shows how to use *StringSwitch*:

```
/**
 * SwitchTest class - Shows how to use the
 * StringSwitch class to use switch based
 * on strings.
 */
public class SwitchTest extends StringSwitch {

    static SwitchTest st;

    // StringSwitch constants
    public final int QUIT   = 0;
    public final int DIR    = 1;
    public final int RUN    = 2;
    public final int STOP   = 3;
    public final int DEBUG  = 4;
    public final int FWD    = 5;
    public final int REV    = 6;

    public SwitchTest() {
        // Add the String/int pairs to the hashmap.
        // key=String, value=static final int
         add("quit", 0);
         add("dir", 1);
         add("run", 2);
         add("stop", 3);
         add("debug", 4);
         add("forward", 5);
         add("reverse", 6);
    }

    // Test StringSwitch
    public static void main (String[] args) {
        st = new SwitchTest();
        st.doSwitch("reverse");
    }

    /**
     * switch structure that accepts Strings.
     */
    private void doSwitch (String s) {
        switch (getIdForString (s)) {
        case QUIT:
            System.out.print("QUIT=" + QUIT);
            break;
```

```
              case DIR:
                  System.out.print("DIR=" + DIR);
                  break;
              case RUN:
                  System.out.print("RUN=" + RUN);
                  break;
              case STOP:
                  System.out.print("STOP=" + STOP);
                  break;
              case DEBUG:
                  System.out.print("DEBUG=" + DEBUG);
                  break;
              case FWD:
                  System.out.print("FWD=" + FWD);
                  break;
              case REV:
                  System.out.print("REV=" + REV);
                  break;
              }
        }
    }
```

A little extra work is needed, but the result is approximately twice as fast as using an *if-then-else* block. As the number of case statements increases, the performance benefit also increases.

K.3.10 Hashing

Earlier in this chapter, we discussed how to implement the *hashCode* and *equals* methods to provide uniqueness. This section discusses the process of *hashing*. During hashing, a hash code is used to locate objects in a hash table, which is much faster than using iteration.

Hash tables are data structures that store key-element pairs in an array, allowing element lookup to be performed using the key rather than performing a sequential search through a collection. The index to this array is determined by the key's hash code and a process called hashing. Hashing is a process with "the goal of producing a uniform random distribution of a key set" [Uzgalis]. This even distribution is what allows elements to be located quickly and accounts for a hash table's speed in looking up elements.

During hashing, the key's hash code is obtained by calling its overridden *hashCode* method (refer to the discussion earlier in this chapter on how to override the *hashcode* method). The resultant hash code determines the offset into the array. Located at this offset is a "bucket," which is actually an *Entry* object. Each *Entry* object stores the key-object pair, along with the key's hash-code value and a reference to the next *Entry* object containing another key-object pair, if any. In this way, a single array index can contain a linked list of *Entry* objects.

Usually, there will be zero or one key-object pairs within a single bucket. However, it is possible that two different keys can produce the same hash code, which is called a *collision*. Collisions do not result in any loss of data, but they will reduce performance because, upon locating a bucket in the array, the list of entries within that bucket must be searched sequentially, and the key in each entry must be compared to the key being searched for by calling their respective *equals* methods. For this reason, it is important

that custom objects implement a `hashCode` method that produces unique hash-code values.

Collisions also can result from the hashing algorithm itself generating the same array index for keys with different hash-code values. In JDK 1.4.1, `HashMap`'s hashing algorithm uses a bitwise AND operation to determine the array offset:

```
/*Returns index for hash code h */
static int indexFor(int h, int length) {
      return (h & (length-1));
}
```

For example, if the capacity of a hash table (the length of the array) is 16, hash code values of 0, 16, and 32 all will hash to the first bucket:

length-1 = 15 = 0000 1111
hash code = 0 = 0000 0000, (0000 0000) & (0000 1111) = 0000 0000 = array index 0
hash code = 16 = 0001 0000, (0001 0000) & (0000 1111) = 0000 0000 = array index 0
hash code = 32 = 0010 0000, (0010 0000) & (0000 1111) = 0000 0000 = array index 0

A larger array of buckets will result in fewer collisions, as we shall see below. A hash table's performance is affected by two parameters: its *initial capacity* and its *load factor*. The initial capacity is an `int` value representing the number of buckets in the hash table at the time of creation. The load factor is a float value ranging from 0 to 1.00 that determines how full the hash table can get before its capacity is increased. The product of (initial capacity) × (load factor) is called the *threshold*. When the threshold is reached, *rehashing* occurs. When a hash table is rehashed, its size is doubled, and any buckets containing collisions will be rehashed so that key-value pairs with unique hash-code values will be dispersed. However, buckets containing collisions due to duplicate hash codes will *not* be dispersed; instead, they will retain their collisions. Each time rehashing occurs, a new array is created, and the values are rehashed and copied to the new array. However, there is a penalty performance. Sun states that a sufficiently large initial capacity will "allow the mappings to be stored more efficiently than letting it perform automatic rehashing as needed to grow the table." [Sun HashMap].

The load factor can be specified at the time of creation. In JDK 1.4.1, `HashMap` uses a default load factor of 0.75, which is considered to provide a good compromise between time and space costs. A value too low will provide faster lookup due to fewer collisions, but result will in excessive rehashing when adding elements, and will use more RAM. A value too high will result in many collisions and increased lookup times [Sun HashMap].

If you know the approximate number of elements you will be adding, you can specify the initial capacity at the time of creation, which will reduce the amount of resizing that takes place. The default value for initial capacity depends on which version of the JDK you are using. In JDK 1.2.2, 1.3.1, and 1.4.1, the values are 101, 11, and 16, respectively. There are also differences in the hashing algorithms, which affect how collisions will occur, so if performance is critical, two then you are urged to investigate these details. In JDK 1.4.1, `HashMap` uses a power-of-two capacity when setting the initial capacity and when increasing the size when the threshold is reached, which is a result of the bitwise AND operation used to determine the array indices, as discussed above. So, passing in a value for initial capacity when creating `HashMap` does not mean it will be the actual initial capacity. If the initial capacity you specify is not a power-of-two, it will bump up to the next power-of-two.

Let us take a look at this power-of-two capacity and how actual hash code values and hash table size affect collisions [Sun HashMap source]. The following program simulates

the way `HashMap` creates its array of buckets and determines an array index to a bucket given a key's hash code:

```java
import java.util.ArrayList;
import java.util.List;

/**
 * Demonstrates the effect that hash code values
 * and initial capacity have on collisions in a HashMap.
 */
public class SimpleBucketTest {
    static Object[] buckets;      //array of buckets

     //-- Test data - key Objects
    static Integer[] keyvalues
                = {new Integer(0),
                   new Integer(1),
                   new Integer(2),
                   new Integer(7),
                   new Integer(15),
                   new Integer(16),
                   new Integer(17),
                   new Integer(31),
                   new Integer(32),
                   new Integer(33),
                   new Integer(47),
                   new Integer(48),
                   new Integer(49),
                   new Integer(62),
                   new Integer(63),
                   new Integer(64),
                   new Integer(101),
                   new Integer(102),
                   new Integer(103)};

    public static void main(String[] args) {
        // test for different initial capacity values
        runTest (20);
    }

    private static void runTest (int initialCapacity)
    {
        //-- Test initial capacity of array of buckets
        System.out.println(
            "\nSpecified Initial Capacity = "
            + initialCapacity);
        createArray(initialCapacity);
        System.out.println(
            "Real Initial Capacity = "
            + buckets.length);

        //-- Test index of each populated bucket
        List indices = new ArrayList();
        int collisionCount = 0;
```

```
          System.out.println (
              "key " + "\thashcode " + "\tindex");

          for (int i=0; i<keyvalues.length; i++) {
              Integer k = keyvalues[i];
              int h = k.hashCode();
              int modh = hash(k);
              int idx = indexFor(modh, buckets.length);

              if (indices.contains(new Integer(idx)))
                    collisionCount++;    //collision
              indices.add(new Integer(idx));
              System.out.println(
              k + "\t" + h + "\t\t" + idx);
      }
      System.out.println ("Collisions: " +
collisionCount);
    }

    /**
     * Creates an array with a capacity
     * of a power of 2 >= initialCapacity
     */
    static void createArray (int initialCapacity) {
        int capacity = 1;
        while (capacity < initialCapacity) {
            capacity <<= 1;
        }
        buckets = new Object[capacity];
    }

    /**
     * Returns index for hash code h.
     */
    static int indexFor(int h, int length) {
        return (h & (length-1));
    }

    /**
     * Returns a hash value for the specified object.
     * In addition to the object's own hashCode, this
     * method applies a "supplemental hash function,"
     * which defends against poor quality hash functions.
     */
    static int hash (Object key) {
        int h = key.hashCode();
        h += ~(h << 9);
        h ^=  (h >>> 14);
        h +=  (h << 4);
        h ^=  (h >>> 10);
        return h;
    }
}
```

The output produces:

```
Specified Initial Capacity = 20
Real Initial Capacity = 32
key        hashcode           index
0          0                  0
1          1                  7
2          2                  14
7          7                  18
15         15                 30
16         16                 23
17         17                 15
31         31                 23
32         32                 15
33         33                 9
47         47                 30
48         48                 22
49         49                 17
62         62                 30
63         63                 22
64         64                 15
101        101                0
102        102                8
103        103                19
Collisions: 7
```

The initial capacity of 20 gets bumped up to the next power-of-two, which is 32. Seven keys have resulted in collisions. For larger values of initial capacity, we get the following (partial) results:

```
Specified Initial Capacity = 33
Real Initial Capacity = 64
Collisions: 4

Specified Initial Capacity = 65
Real Initial Capacity = 128
Collisions: 3

Specified Initial Capacity = 129
Real Initial Capacity = 256
Collisions: 0
```

Note that the number of keys that results in collisions is reduced as more of the higher-order hash codes are able to hash to new buckets. This example demonstrates that the size of the hash table and the hash-code values both contribute to collisions and thus are factors that affect performance.

K.3.11 The TreeMap Class

Like *HashMap*, the *TreeMap* class implements the Map interface and does not implement the *Collection* interface. *TreeMap* is used when the need is for a constantly sorted map. Keys are maintained in ascending order. This ordering is governed by the key's natural ordering (using the *Comparable* interface) or by providing an explicit comparator passed into the constructor when creating *TreeMap*. *TreeMap* provides the backing for *TreeSet*.

To add an object to *TreeMap*, you use the put (*Object key*, *Object value*) method. To retrieve an object, you use the *get (Object key)* method:

```
Map map = new TreeMap();
map.put(accNo, account);
Account acc = Map.get(accNo);
```

The following example demonstrates the use of a *HashSet* to store images and then populate *TreeMap* for sorting. An image of a star is stored as a value, and a *StarInfo* object containing *name* and *distance from the Sun* information is stored as a key:

```java
import java.util.Map;
import java.util.HashMap;
import java.util.TreeMap;
import java.util.Iterator;
import java.util.Comparator;

class StarInfo {
    private String name;
    private double distance;

    public static final Comparator
    NAME_COMPARATOR = new NameComparator();

    public static final Comparator
    DIST_COMPARATOR = new DistanceComparator();

    StarInfo (String _name, double _dist) {
        name = _name;
        distance = _dist;
    }

    public String getName() {
        return name;
    }

    public double getDistance() {
        return distance;
    }

    //equality based on name field
    public boolean equals (Object o) {
        if (o != null &&
        o.getClass() == this.getClass())
            return ((StarInfo)o).getName().equals(name);
        return false;
    }

    //hash code based on name field
    public int hashCode () {
        return name.hashCode();
    }

    //Name Comparator
    private static class NameComparator
    implements Comparator {
      public int compare (Object o1, Object o2) {
```

```
            return ((StarInfo)o1).getName()
                .compareTo(
                ((StarInfo)o2).getName());
      }
    }

    //Distance Comparator
    private static class DistanceComparator
    implements Comparator {
      public int compare (Object o1, Object o2) {
        return (new Double(
                ((StarInfo)o1).getDistance()))
                .compareTo(
                new Double(
                ((StarInfo)o2).getDistance()));
        }
      }
}

public class MapTest {
    static String IMG = "<THE_IMAGE>";

    public static void main (String args[]) {
        MapTest maptest = new MapTest();
        Map hashmap = new HashMap();
        Map treemap;

        //add some data to hashmap
        maptest.fill(hashmap);

        //copy data into treemap using comparator for sorting
        treemap = maptest.toTreeMap(
            hashmap, StarInfo.DIST_COMPARATOR);
        maptest.printData(treemap);

        //copy data into treemap using comparator for sorting
        treemap = maptest.toTreeMap(
            hashmap, StarInfo.NAME_COMPARATOR);
        maptest.printData(treemap);
    }

    private Map fill (Map map) {
        map.put(new StarInfo("Sun",0),IMG);
        map.put(new StarInfo("Sirius A,B", 8.60),IMG);
        map.put(new StarInfo("Alpha Centauri A,B",
      4.39),IMG);
        map.put(new StarInfo("Barnard's Star", 5.94),IMG);
        map.put(new StarInfo("Epsilon Eridani", 10.50),IMG);
        map.put(new StarInfo("Proxima Centauri", 4.22),IMG);
        return map;
    }

    private Map toTreeMap (Map map, Comparator comp) {
        System.out.println("Using comparator " + comp +
      "\n");
        Map treemap = new TreeMap(comp);
        Treemap.putAll(map);
```

```
            return map;
        }

        private void printData () {
            Iterator keys = map.keySet().iterator();
            Iterator values = map.values().iterator();
            while (keys.hasNext()) {
                StarInfo key = (StarInfo)keys.next();
                System.out.println(key.getName());
                System.out.println(key.getDistance());
                System.out.println(values.next());
                System.out.println();

            }
        }
    }
```

K.3.12 The Collections Class

The *Collections* class offers several static methods that support convenience operations on collections. Operations include wrappers for synchronization and for making collections unmodifiable, as well as algorithms that provide binary searching, sorting, shuffling, swapping, rotating, and replacing of elements.

This example demonstrates how the *Collections* class can be used for sorting and replacing elements in a collection. Sorting can be controlled by passing an explicit comparator into the *sort* method. In this example, the *reverseOrder* method returns a comparator that imposes *reverse natural ordering*:

```
public static void main (String[] args) {
    List list = new ArrayList();
    list.add("C");
    list.add("A");
    list.add("D");
    list.add("B");

    System.out.print("Insertion order: ");
    displayList(list);

    System.out.print("Natural order: ");
    Collections.sort(list);
    displayList(list);

    System.out.print("Reverse natural order: ");
    Collections.sort(list, Collections.reverseOrder());
    displayList(list);

    System.out.print("Replace all B's with an X: ");
    Collections.replaceAll(list, "B", "X");
    displayList(list);
}

private static void displayList (List lst) {
    ListIterator iter = lst.listIterator();
    while (iter.hasNext()) {
        System.out.print(iter.next());
    }
}
```

The output follows:

```
Insertion order: CADB
Natural order: ABCD
Reverse natural order: DCBA
Replace all B's with an X: DCXA
```

The rest of the operations supported by the *Collections* class are left to the reader to investigate.

K.4 Summary

The Java collections framework offers the developer a much broader set of choices for storing data than the traditional *Vector* and *Hashtable* offer. This framework provides a set of interfaces and implementations representing three types of collections: *lists, sets,* and *maps*. An understanding of the following areas will help to use these interfaces and implementations effectively:

- Custom classes stored in collections most likely will need to override the *hashCode* and equals methods to provide a more desirable definition of object equality. They should be overridden together. The JDK value classes (e.g., *String* and *Integer*) have these methods overridden.

- For the *TreeSet* and *TreeMap* classes, a *natural ordering* of objects can be maintained by implementing the *Comparable* interface and overriding the compareTo method.

- For the *TreeSet* and *TreeMap* classes, a *total ordering* of objects can be imposed by creating explicit *Comparators* that implement the *Comparator* interface and define the compare method.

- Consistency with *equals* should always be maintained.

- An understanding of hashing and of how to produce good hash codes can improve performance significantly.

- The static methods in the *Collections* class can be used to simplify manipulation of collections.

K.5. Exercises

K.1 Given the User class, implement the *hashCode* and *equals* methods based on the userid field. The userid can contain mixed-case characters. However, use the String *equals-IgnoreCase* method so that case is ignored when testing for equality. Make sure your *hashCode* method is consistent with *equals*. Test by adding *User* objects to a *HashSet* and iterating to display the output. Make sure that new *User* ("Abc") and new User *("abC")* are treated as equal objects and are added to the collection only once. The User class follows:

```java
public class User {
    private String userid;
    public User (String id) {
        this.userid = id;
    }
```

```
            public String getUserId() {
                return userid;
            }
        }
```

K.2 Make the *User* class from exercise 1 *comparable* by implementing the *Comparable* interface and defining a *compareTo* method. Make sure this method is consistent with equals. Test by adding *User* objects to *TreeSet* and iterating to display the output. Make sure that *new User ("Abc")* and *new User ("abC")* are treated as equal objects and are added to the collection only once. Comment out the *hashCode* and *equals* methods temporarily to make sure the *compareTo* method is doing its job. The results should be the same.

K.3 Add a new *String* field to the *User* class called: "username" and modify the constructor to set this value. Create two comparators: one that orders by *userid*, and one that orders by *username*. Test by adding *User* objects to *TreeSet*, passing in each comparator into the constructor. Verify that the output is sorted according to the order imposed by each comparator.

K.4 Add *User* objects to *ArrayList* and iterate to view the elements. Experiment with the *Collections* class by using it to get the following information about *ArrayList*:

- Minimum and maximum values
- Minimum and maximum values for each comparator
- Sort according to the natural ordering of elements
- Sort according to the ordering of each comparator
- Swap, shuffle, rotate

K.5 Add User objects to HashMap using *userid* as the key. Iterate on the collection of values and view the output. Iterate on the keyset and view the output. Why is it that new *User ("Abc", "Tom")* and new *User ("abC", "Tom")* are not treated as equal objects as they were before? Repeat by using a *User* object as the key and *userid* as the value. View the difference produced in the output.

References

[1] Bloch, Joshua. 2001. *Effective Java Programming Language Guide*. Addison-Wesley,

[2] Eckel Bruce. *Thinking in Java*. 1998, 3d Edition. Microsystems Revision 1.0., Prentice Hall, UpperSaddle River, N.J.

[3] Sun JDK 1.4.1 API documentation for interface *Map*.
http://java.sun.com/j2se/1.4.1/docs/api/java/util/Map.html

[4] Sun JDK 1.4.1 API documentation for interface *Comparable*.
http://java.sun.com/j2se/1.4.1/docs/api/java/lang/Comparable.html

[5] Sun JDK 1.4.1 API documentation for interface *Comparator*.
http://java.sun.com/j2se/1.4.1/docs/api/java/util/Comparator.html

[6] Sun JDK 1.4.1 API documentation for class *Object*.
http://java.sun.com/j2se/1.4.1/docs/api/java/lang/Object.html

[7] Sun JDK 1.4.1 API documentation for class *HashMap*.
http://java.sun.com/j2se/1.4.1/docs/api/java/util/HashMap.html

[8] Sun JDK 1.4.1 source code for class *HashMap*.

[9] Sun JDK 1.4.1 source code for class *LinkedList*.
http://java.sun.com/j2se/1.4.1/docs/api/java/util/LinkedList.html

[10] McCluskey Glen. 2002, "Using ArrayList and LinkedList." Core Java Technologies Technical Tips. September 10

[11] Roulo, Mark. 1999. How to Avoid Traps and Correctly Override Methods from java.lang. Object. *JavaWorld*. Jan. 1999.

[12] Shirazi, Jack. *The Performance of Java Lists*. The O'Reilly Network. http://www.oreillynet.com

[13] Uzgalis, Robert 1996. *Hashing Concepts and the Java Programming Language*. Computer Science Department, University of Auckland, Auckland, New Zealand.

L. Glossary

I do not think there is any thrill that can go through the
human heart like that felt by the inventor as he sees some
creation of the brain unfolding to success ... Such emotions
make a man forget food, sleep, friends, love, everything.

–Nikola Tesla, 1856–1943

& – bitwise AND.
~ – Bitwise negation.
| – bitwise inclusive OR
^ – Bitwise exclusive OR.
<< – Left shift.
>> – Right-shift sign fill.
>>> – Right-shift zero fill.
? – A ternary operator, called the conditional operator.

A

abstract – A keyword that defines a class that may not be instanced or a method without an
 implementation.
Abstract Window Toolkit (AWT) – A class library used to support GUIs.
access modifier – A keyword (i.e., private, protected, or public) that defines the level of visibility.
 There is also a default access.
accessors – Getter methods that enable the reading of properties in an instance. Compare with mutators.
API – Application program interface. A collection of classes and interfaces.
applet – A class in AWT that subclasses the *Panel* class. Also refers to an instance of the subclass of
 the Applet class.
AppletViewer – A JDK program.
application program interface (API) – A class library.
argument – A method parameter.
array – An immutable, homogeneous reference data type with a scalar index (e.g., **int i[]=new
 int**[99];, *i* is an array whose size cannot be changed except by creating a new array).
ASCII – American Standard Code for Information Interchange. An isomorphic mapping between
 seven-bit numeric codes and characters.
atomic – An operation that occurs without interruption.

B

binary – A base-two numbering system.
binary operator – An operator with two arguments.
bipartite – A two-part entity (e.g., bipartite graphs have two basic icons or parts).

bit – Binary digit.

bitwise operator – An operator that treats the bits in a fixed-point quantity as a vector (e.g., &,
|, ^, <<, >>, >>>, and ~).

block – Code between matching braces.

boolean – A primitive data type whose value is true or false.

branch statement – A statement that alters the local flow of control (i.e., ?, *if*, and *switch*).

break – A keyword that causes termination of a loop. The optional label identifies a location for the
transfer of control. The implicit location is the containing break target.

buffered IO – IO performed to temporary storage.

byte – A signed eight-bit fixed-point quantity.

byte code – Opcodes used to program the JVM.

C

case – A keyword that defines a group of statements to begin executing if a specified value matches a
defined value by a preceding "switch" keyword.

casting – Type conversion.

catch – A keyword that precedes a block of code that handles run-time errors.

catch clause – The target of the try clause, invoked when exceptions are thrown.

char – A keyword that declares an unsigned fixed-point 16-bit primitive data type.

child class – A subclass of a superclass. Also called a descendent class.

class – An inhomogeneous reference data type that can hold method implementations.

class method – A static method.

class variable – A static variable.

classpath – An environmental variable used to inform the JVM of class-file locations.

client – An entity that seeks to obtain services.

command-line arguments – An array of string passed into *main* as *args[]*.

comments – Statements ignored by javac, but sometimes processed by javadoc, that typically begin
with //, /* */, and /** */.

compiler – A program that translates a programming language into executable code. Before 1954, the
term meant a program that performed the link-and-load function for a series of subroutines.

conditional operator – The '?' operator.

const – An unused reserved word in Java.

constructor – The method whose name is identical to the class name in which it resides. It returns
nothing, not even void. It is invoked using the new keyword.

container – A class that is designed to hold references.

continue – A keyword that causes termination of the current iteration of a loop. The optional label
that follows the *continue* keyword indicates where execution continues.

CORBA – Common Object Request Broker Architecture. A distributed object model specified by the
Object Management Group (OMG).

core API – A set of often-supported APIs that change as a function of version.

D

daemon – Disk and Execution Monitor. A background entity (a thread, or job).

data chunk – A group of bits, often larger than a native computer word.

data type – A group of data that forms useful data chunks.

deadlock – A situation where no progress can be made because a resource is unavailable. For example, if I
assign a tape drive to my login, then no one else can use it. Thus, I have locked the resource to my
login in order to prevent someone else from writing to my tape. After I unmount the tape, I unas-
sign the drive, which performs an unlock on the resource and enables others to mount a tape. If you

are unable to make progress while I use the tape drive, then you are deadlocked. If my process hangs and your process waits for mine to free the resource, a policy is needed to break the deadlock. For example, you may ask the system administrator to kill my job so that you can proceed.

decimal – A base-10 numbering system.

declaration – A statement that establishes and initializes an identifier.

default – An optional keyword used after *case* or *switch* statements.

delegation – A design pattern that enables an instance of one class to make use of an implementation in another.

deprecated – A term used for an API that has been updated.

disambiguation – The process of making clear the otherwise ambiguous.

dispatch – A branch that alters the flow of control. For example, an *if* and a *switch* are kinds of dispatches.

do – A keyword that declares a loop over a block of statements, followed by a *while* keyword.

double – A keyword that defines a primitive signed 64-bit data type.

E

else – A keyword that executes a block of statements when the argument to an *if* statement is false.

Emacs – An editor.

exception – A run-time error.

exception handler – A block of code invoked after a run-time error occurs.

extends – A Java keyword that enables one class to subclass another. It also enables an interface to subclass another interface.

F

field – A class data member.

final – A modifier used to indicate a constant data member.

finally clause – Code that always is executed at the end of a try-*catch* block.

float – A keyword that defines a signed, 32-bit primitive variable.

for – A keyword that declares a loop, providing initialization, termination, and iteration elements.

FTP – File Transfer Protocol.

G

garbage collection – The detection and freeing of memory that is no longer useful for a computation in progress. Typically, it runs in the JVM as a background thread.

GIF – Graphics Interchange Format. A copyrighted format that uses a patented algorithm (Lempel-Ziv) for storing 256 color images.

goto – An unused keyword.

graphical user interface (GUI) – A visual representation of a system that sometimes can support user input.

graphics context – A class in AWT.

GUI – Graphical User Interface.

H

heavyweight – A component that makes use of a local subroutine library, often via a *peer* method, in order to render a *GUI* element.

hexadecimal – A base-16 numbering system. Hexadecimal literals are preceded with 0x.

HTML – Hyper Text Markup Language. A format for storing data.

HTTP – Hyper Text Transfer Protocol. A presentation-layer protocol.

HTTPS – Hyper Text Transfer Protocol, Secure. HTTP that uses the secured-socket layer.

I

IDE – Integrated Development Environment. Often an editor with a compiler that is somewhat integrated.

identifier – The name of a Java construct.

if – A keyword used to test a boolean expression and conditionally execute a block code.

IIOP – Internet Inter-ORB Protocol. A CORBA presentation-layer protocol.

immutable – A data type that, once created, cannot be altered.

implements – A keyword that is used by a class declaration to specify interfaces that are implemented.

import – A keyword that enables access to APIs using abbreviated names. It appears at the beginning of a source file.

inheritance – The passing of properties to children (e.g., subclasses, descendents).

instance – A reference to a class that is created using the new operator.

instance variable – A dynamic item of data contained by a reference.

instanceof – A binary boolean keyword that returns *true* if its first argument is an instance of its second argument.

int – A signed, fixed-point, 32-bit primitive data type.

interface – An implementation-free reference data type that can be implemented by a class.

internet – A network of networks.

interpreter – A program that decodes and executes some input language (like a byte-code interpreter).

introspection – An API built on top of the reflection API that allows the listing of getter and setter methods.

IP – Internet Protocol. A network layer protocol.

ISBN – International Standard Book Number. In 1967, W. H. Smith, the largest book retailer in Great Britain, moved to a computerized warehouse with the company's invention, the Standard Book Numbering (SBN) system. Further development finally led to the approval in 1970 of ISO 2108, which is the ISBN system we know today. The ISBN system is used in 150 countries. See *<http://www.isbn.org>* for more information.

J

JAR – Java Archive. A format based on the UNIX *tar* command that can contain any number of files with very long file names. It also can support compression and directories.

Java – The Java run-time command that comes with the JDK. Also, it is the name given to the technology designed to support the Java language.

Java Server Pages (JSP) – A macro pre-processor for servlets.

javac – The Java compiler that comes with the JDK.

JDBC – Java Database Connectivity. An API for database connectivity.

JDK – Java Development Kit. Software tools for Java development.

JPEG – Joint Photographic Experts Group. – A lossy, discrete cosine transform-based image compression that takes advantage of intraframe coherence.

JRE – Java Run Time Environment. A distribution of Java technologies that enables deployment of Java programs.

just-in-time (JIT) compiler – A program that converts bytecodes into native machine code at run-time.

JVM – Java Virtual Machine. A program that interprets bytecodes.

K

keywords – Reserved words in Java.

L

lightweight – A component that has a nonnative implementation, typically used to refer to a GUI element.

linker – A program that loads classes and libraries into an executable format.

literals – Elements that are defined at compile time.

local variable – A variable known only to the containing block of code.

lock – A technique used to prevent corruption of a shared resource. For example, if I assign a tape drive to my login, then no one else can use it. Thus, I have locked the resource to my login in order to prevent someone else from writing to my tape. After I unmount the tape, I unassign the drive, which performs an unlock on the resource and enables others to mount a tape.

long – A keyword that describes a fixed-point, signed, 64-bit quantity.

loop – A means of iteration (i.e., while, for, or do).

M

MBNF – Modified Backus Naur Form. A metalangauge used to describe grammars. See Appendix A for more details.

mediator – A design pattern that encapsulates instance interaction, such as an Ethernet hub.

main method – The entry point for a Java application.

member – A variable or method declared at the class level.

message – A ZetaLisp term used to describe the invocation of a method.

method – A function that can return a data type.

multitasking – The ability to have many jobs.

multithreading – The ability to have many threads.

mutator – The setter method that allows the altering of properties in an instance. Compare with accessor.

mutex – An abbreviation for *mut*ual *ex*clusion. It is used to lock a resource to keep it from being corrupted.

N

native – A modifier used to indicate a nonnative implementation.

new – A keyword that creates an instance of a class.

null – A keyword that denotes a reference to nothing.

O

object – An instance of a class.

object class – The primordial Java class.

object oriented – Having both algorithms and data structures in a single entity.

octal – A radix 8 numbering system whose symbols are 0, 1, 2, 3, 4, 5, 6, 7. In Java, octal numbers are preceded with a 0.

ones complement – Another way to say "invert the bits."

operator – An element that manipulates other elements.

overloaded methods – To use duplicate method names with unique signatures to obtain different behavior.

override – To replace an inherited property.

P

package – A collection of reference data types.

peer – A method that wrappers an invocation to a native method in the AWT API.

PersonalJava(TM) – A non-PC version of J2ME.

polymorphism – A term that literally means *many shapes*. It refers to the use of a method to process several different reference data types.

primitive data type – A built-in, nonreference data type.

private – A visibility modifier that prevents access from another class or subclass.

process – A job in an operating system.

protected – A visibility modifier that prevents access from another class but that permits access from subclasses.

public – A visibility modifier that permits access from anywhere.

Q

R

radix – The base of a numbering system. See Chapter 10 for more details.

RDBMS – Relational Database Management System.

reader – An abstract class that is subclassed to provide character-input streams.

refactoring – A reorganization of software.

reference – A data element whose value is an address.

reference data type – Any nonprimitive data type (e.g., a class or interface).

reflection – An API that lets you list properties, methods, returns types, and parameters in an instance.

return – A keyword that causes an immediate transfer of control to the invoking code. It takes an optional argument.

run-time error – An exception.

S

sandbox – A reference to the area that is permitted to be played in by an unsigned applet running in a browser. In order to access files (and other resources), an applet must play outside of the sandbox.

SAX – Simple API for XML.

scope – A term that refers to the "life" of an identifier. Typically, the scope is restricted by access modifiers and location in the code (e.g., class scope, method scope, or locally scoped).

SDK – Software Development Kit. The new name for the JDK.

server – An entity that provides features to a client.

servlet – A Java program that conforms to a specific API. Typically, such programs are invoked by a visitation to a URL. This association is called a *servlet mapping*.

short – A keyword that defines a signed, 16-bit, fixed-point quantity.

singleton pattern – The pattern to have when you're only having one. A design pattern that allows a class to make sure that it is the only instance of the class available in the system. Typically, this pattern is implemented using a private constructor and a public getter method. If the class is declared as *final*, no one can subclass it and create a constructor. For example,

```
public final class Database {
    private static Database db = new Database ();
    private Database ()   {}
    public Database getDatabase ()   {
      return db;
    }
}
// outside of the class use:
Database db = Database.getDatabase();
```

socket – A network transport layer element that is established at the beginning of a session.

SQL – Structured Query Language. An RDBMS language.

static – A keyword that defines a class variable or method.

static field – A class variable. Such variables exist at compile time.

static method – A class method. Such methods exist at compile time.

stream – An unformatted sequence of bytes.

string – A reference that groups many characters and provides methods for manipulating them.

subclass – An extension of a parent class.

super – A keyword that references the parent class.

superclass – An ancestor of a subclass. Sometimes called the parent class.

Swing – An AWT-based API that implements some GUI features.

switch – A keyword used to dispatch based on the evaluation of a fixed-point data element.

synchronized – A modifier used to indicate a method that is to be executed atomically.

syntax error – An error generated at compile time.

T

taxonomy – The A K O relationship characterized by Java classes that extends one another. When used to form a sketch, the diagram is said to be a directed-acyclic graphic (i.e., an acyclic digraph).

TCP/IP – Transmission Control Protocol/Internet Protocol. This is an Internet protocol that provides for the reliable delivery of streams of data from one host to another.

this – A keyword that refers to the containing class.

thread – A shared memory task that is locally scoped with respect to the currently executing process. Thread is characterized as having lower overhead than tasks.

thread group – A branch of descendants of a parent thread, accessed via the thread API.

throw – A nonlocal change of control that occurs in response to a run-time error.

throws – A keyword that defers exception handling to the invoking method.

tokenizer – An instance of a class that is able to parse strings in a stream.

transient – A modifier used to indicate a nonpersistent data member.

true concurrency – Having more than one CPU that is being used to solve a problem.

try – A keyword in Java used to group a block of code that might throw an exception.

U

Unicode – An unsigned, 16-bit fixed-point character defined by ISO 10646.

URL – Uniform Resource Locator. A WWW location.

V

void – A keyword that indicates that a method returns nothing.

volatile – A Java(TM) programming language keyword used in variable declarations that specifies that the variable is modified asynchronously by running threads concurrently.

W

widget – A GUI element. The term was borrowed from X-Windows.

while – A keyword that declares a loop with an exit condition.

wrapper – A class that proxies invocations to a delegate and that can alter the interface.

writer – An abstract class that is subclassed to provide character output streams.

WWW – World Wide Web. A GUI on the Internet.

X

XML – Extensible Markup Language. A language that permits the definition of new tags.

Y

Z

M. Index

Coffemate lite makes me feel alright
cause its filled with titanium white.
Disappearing like a vortex in the dark
brown night. Makes me get up in the
morning and fight fight fight.

—*Douglas Lyon*

Colophon

This book was written in Microsoft Word 5.1a on an Apple Macintosh Cube with a G4 400 MHz processor and Mac OS X.

Code was tested under Windows 98, Windows NT, Windows 2000, Windows XP, and RedHat Linux 7.3, 8.0, and 9.0.

Equations were typeset using Math typer. The code was typeset with a monospaced font.

Equations were set with the Design Science Equation Editor using MT Extra, Symbol, and Times fonts.

Class images were drawn using Metrowerks class browser. The exception class-tree layout was done with Theo Vosse's TreeParse program (under Mac OS).

Some of the graphs were prepared using the graphing calculator built into Mac OS 8.1. The plots were performed using data output from Java and pasted into Microsoft Excel 5.0a. Three-dimensional functions were plotted using Maple.

All development was done using CodeWarrior Pro by Metrowerks and Intellij's IDEA. All programs were tested using the compiler produced by Sun Microsystems, Inc.

This book was written while drinking vast amounts of Kahindu Kenya AA coffee. I roast coffee daily in the DocJava, Inc., roaster. For fresh coffee (green or roasted), contact Doug Lyon at DocJava, Inc., *lyon@docjava.com*. DocJava, Inc., sells small quantities of roasted coffee.

Now that the book is done, I can sleep. Good Night!

JAVA™ TRAINING